History of the Surrealist Movement

HISTORY

of the

SURREALIST
MOVEMENT

Gérard Durozoi

Translated by Alison Anderson

THE UNIVERSITY OF CHICAGO PRESS

CHICAGO AND LONDON

GÉRARD DUROZOI is the coauthor, with Bernard Lecherbonnier, of the books *André Breton: L'Écriture surréaliste* and *Le Surréalisme: Théories, thèmes, techniques* and the editor of *Dictionnaire de l'art moderne et contemporain.* During the 1950s and 1960s, he was closely affiliated, as a philosopher, with the Surrealist movement.

ALISON ANDERSON holds a degree in translation from the University of Geneva, Switzerland. She has translated extensively from French and is also a novelist.

Originally published as *Histoire du mouvement surréaliste,* © Éditions Hazan, 1997

The University of Chicago Press gratefully acknowledges a subvention from the government of France, through the French Ministry of Culture, Centre National du Livre, in support of the costs of translating this volume.

The University of Chicago Press, Chicago 60637
The University of Chicago Press, Ltd., London
© 2002 by The University of Chicago
All rights reserved. Published 2002
Printed in China

11 10 09 08 07 06 05 04 03 02 1 2 3 4 5

ISBN: 0-226-17411-5 (cloth)

Library of Congress Cataloging-in-Publication Data

Durozoi, Gérard.
 [Histoire du mouvement surréaliste. English]
 History of the Surrealist Movement / Gérard Durozoi; translated by Alison Anderson.
 p. cm.
 Includes bibliographical references and indexes.
 ISBN: 0-226-17411-5 (cloth : alk. paper)
 1. Surrealism—History. 2. Art, Modern—20th century. I. Title.

NX456.5.s8 D8713 2002
709'.04'063—dc21

 2001037743

♾The paper used in this publication meets the minimum requirements of the American National Standard for Information Sciences—Permanence of Paper for Printed Library Materials, ANSI Z39.48-1992.

Contents

1919–1924

"GET READY FOR SOME FINE EXPLOSIONS . . ."*

Littérature

Opposite page: opening of the Max Ernst exhibition at the Au Sans Pareil Bookstore, May–June 1921. *From left to right:* bookstore manager René Hilsum, Benjamin Péret, Serge Charchoune, Philippe Soupault (on the ladder), Jacques Rigaut (hanging upside down), and André Breton.

*André Breton and Philippe Soupault, "Eclipses," in Breton and Soupault, *Les Champs magnétiques* (Paris: Au Sans Pareil, 1920), reprinted in Breton, *Œuvres complètes,* ed. Marguerite Bonnet, with the collaboration of Philippe Bernier, Étienne-Alain Hubert, and José Pierre, Bibliothèque de la Pléiade, 3 vols. (Paris: Gallimard, 1988–2000), 1:67.

The three young men who, on March 19, 1919, published the first issue of a little periodical called *Littérature* were not altogether unknown to the Parisian intellectual milieu. To be sure, they had published only a few things: Philippe Soupault, a fairly slim volume of poetry; and André Breton and Louis Aragon, a few pieces in various periodicals (*Les Trois roses,* in Grenoble, *L'Éventail,* in Geneva, and *Nord-Sud, Le Livret critique, Les Écrits nouveaux*). But they were full of admiration for Guillaume Apollinaire—it was Apollinaire, after all, who introduced Soupault to Breton at the Café de Flore—though they faulted him for his patriotic bluster, and they still admired Paul Valéry. (It was said that Breton knew *La Soirée avec Monsieur Teste* by heart, and Valéry called them his "three musketeers.") They were regular patrons of Adrienne Monnier's bookstore (where Breton met Aragon before introducing him to Soupault) and of several literary salons, where you could discuss poetry and listen to music and where, on occasion, there were enthusiastic recitals of "modern" verse (at the home of Rachilde or Madame Muhlfeld). More important, the three young men shared an enthusiasm for Rimbaud and Alfred Jarry, over and above the later symbolists, even if Jarry, in their opinion, had an indisputably higher standard of writing. They particularly admired Lautréamont but also Matisse, Braque, André Derain, Chagall, Marie Laurencin, and Picasso, whose prints were regularly tacked to the walls of their various places of residence, including military dormitories. For they also knew how to keep up with the latest trends in painting, and they would visit Paul Guillaume's or Rosenberg's gallery, where the works of cubists or futurists were exhibited.

"Our tastes (facts without explanation, etc.) are more or less those of Clarisse, Paul Morand's beautiful, mysterious heroine," wrote Breton at the end of 1917 in an article devoted to Apollinaire.[1] "Little objects that you would never imagine, never dream of, ageless: a wild child's museum, knickknacks from insane asylums, a collection belong-

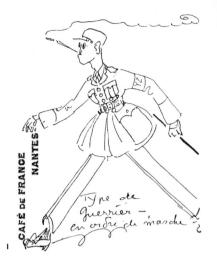

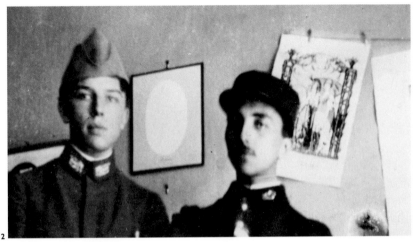

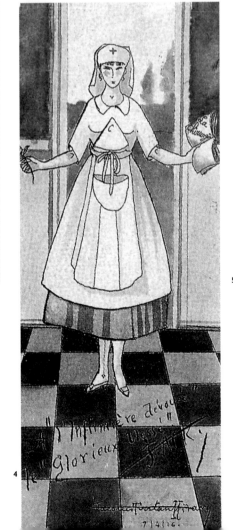

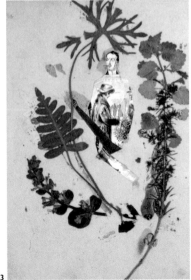

ing to a consul made anemic by the Tropics, broken mechanical toys, burned milk, steam organs, the odor of priests, corsets of black silk with leafy patterns, and glass bouquets of the flowers referred to in Shakespeare." This recalls the delirium of *A Season in Hell:* "I loved idiotic paintings, the lintel of a doorway, stage sets, acrobats' safety nets, street signs." Alongside the paintings exhibited in museums and galleries, life's ruins also had to be taken into consideration—reflections of daily life that, in a mysterious, unchangeable way, resonate within one's consciousness. None of that however was apparent in the first issues of *Littérature,* which was a fairly eclectic and tasteful publication. Listed in the table of contents were established representatives of the best examples of "modern" or new writing: André Gide, Valéry, Léon-Paul Fargue, André Salmon, Max Jacob, Pierre Reverdy, Blaise Cendrars, Jean Paulhan, Jules Romains, Paul Morand, Raymond Radiguet, Pierre Drieu la Rochelle, alongside tributes to particularly notable deceased authors: Apollinaire, Mallarmé, Rimbaud, and the like. Nor was there anything very shocking about the pieces the three editors-in-chief published: at the very most, the poem "Clé de sol," which Breton dedicated to Pierre Reverdy in the first issue, might be viewed as an attempt to loosen up the structure of poetry. [2] In the first column of "Recommended Books," which would appear at the end of each issue, Aragon referred obliquely to Tristan Tzara's *Twenty-Five Poems*—"Nothing but wind and all the junk in the bazaar at a discount: preinventory sales"—in order to prepare the reader for the imminent confusion between critical reaction and poetic act. But there was nothing there, at least not yet, to arouse the slightest hostility on the part of the literary milieu: they actually reacted rather favorably to the appearance of a journal that looked as if it might become a replacement for the famous *Soirées de Paris* and constituted the only noteworthy new publication since the war.

For nearly a year, the periodical appeared regularly every month: fifteen hundred copies were printed and there were roughly two hundred subscribers, a considerable number of whom were probably recruited by Adrienne Monnier. (Until September 1919, *Littérature* was on sale in her bookstore on the rue de l'Odéon, La Maison des Amis des Livres.) The success of the periodical was established with number 8 (October 1919) because at that time its administrative address was that of the Sans Pareil Publishing House, recently founded by René Hilsum, an old schoolmate of Breton's from the Lycée Chaptal (Hilsum is said to have found the name for the publishing house on a sign outside a shoe store); the editorial offices were still located at 9, place du Panthéon, that is, at the Hotel des Grands Hommes, where Breton was living at the time. Its founders' intentions must have been fairly clear in order for "Captain W. Redstone" to affirm in the fourth issue of Paul Guillaume's periodical *Les Arts à Paris:* "The first issue of *Littérature* has just been born. André Gide, Paul Valéry, and Léon-Paul Fargue have contributed a few lines. But Blaise Cendrars, André Breton, Philippe Soupault and Louis Aragon have resolved to play a more significant role." And in the same column ("Newspapers and Journals in France and Abroad"), one learned that "the eighth issue of *391* has appeared in Zurich with the vivid, exclusive collaboration of Messieurs Francis Picabia and Tristan Tzara." Instead of Cendrars, it was Tzara who would in fact join the founding trio to take on more and more importance at *Littérature.*

From Jacques Vaché to Tristan Tzara

In the very first letter he sent to Tzara on January 22, 1919, at a time when *Littérature*

was still only a project, Breton would share with him the sorrow caused by the death of his friend Jacques Vaché. Thus the two names were linked that would, in the shadow of Lautréamont, further prevent him from indulging in any poetic droning. Breton had already composed several "Mallarméan poems" when in 1916 as an intern at the military hospital in Nantes he met the convalescent Vaché. Vaché was a "past master in the art of 'attaching very little importance to everything'"; "I must say," Breton admitted in *La Confession dédaigneuse,* "that he did not share my enthusiasm and that for a long time he saw me as 'the po-het,' someone who had not learned the lesson of the era."[3] The lesson of the era was clearly that of the war, which doomed choices or values of any nature to insignificance (the only exception Vaché made was for Jarry, whom he too admired to the exclusion of all other writers); and all that remained were indifference, a taste for gambling, and travesty—in appearance as well as in thought—and a somewhat gratuitous sense of scandalousness or dandyism in reverse; all attitudes could be summed up in one word, "umour," meaning "a sensation—I nearly said a sense, also, of the theatrical (and joyless) uselessness of everything."[4]

Tzara, in contrast, had learned an angrier, less phlegmatic lesson from the war by the time he founded the Cabaret Voltaire in Zurich together with Hugo Ball, Jean Arp, and Marcel Janco, establishing the origin of the Dadaist movement: if the history of art and culture in the West lead only to disaster and world war, one will just have to do without them, and conclude that they are of no importance, in order to build on new foundations or models (children, madmen, primitive people), and create written or artistic works that are capable of staying in touch with reality and a life emptied of all convention. The rich ambiguity of Dadaism, viewed in the long term and not, of course, at the moment of its development, stems precisely from its rejection of an age-old world where disorder was condemned, yet Dadaism was itself the very soul of disorder, given the apparently muddleheaded and senseless excess that seemed to its members the only possible blueprint for a bearable future (for art in particular). Combining chance and accident, mindful of the material potential of language or plastic media, the Dadaists transgressed forms and hierarchies, moving with ease from one technique to another, from theater to the creation of a *papier collé* (preferred overall to the slowness of painting), from a parody of dance or music to the composition of a "poem" more or less according to the rules established by Tzara in his *Dada manifeste sur l'amour faible et l'amour amer* from 1920: "Take a newspaper. Take some scissors. Choose an article in the newspaper that is the length you wish to give your poem. Cut out the article. Then cut out each of the words that make up this article and put them into a bag. Shake gently. Then remove each cutting one after the other. Copy them carefully in the order they leave the bag. The poem will resemble you."[5]

To such radical principles, Tzara added a remarkable skill as organizer and agitator, and this enabled him, even before the end of the war, to establish contacts very quickly with all those who in one way or another belonged to Europe's avant-garde. At Apollinaire's place, in the spring of 1918, Breton would come across the first two issues of the periodical *Dada,* which had come out in July and December of the previous year. Interspersed with texts by Tzara, Alberto Savinio, Pierre Albert-Birot, and a few Italians with whom Tzara would soon part ways were reproductions by Arp, Kandinsky, Marcel Janco, Walter Helbig, and others. The exchange of books and texts was in fact a good means of dissemination, be it with Pierre Albert-Birot, the editor of *SIC,* or with Pierre Reverdy, or Francis Picabia, who published his periodical *391* wherever he hap-

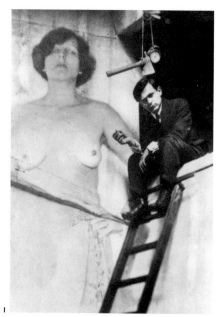

1

4

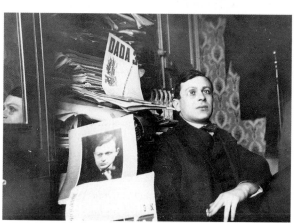

2

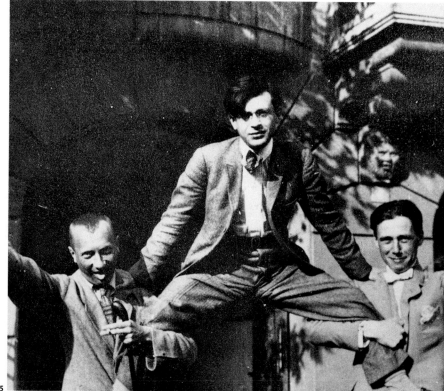

5

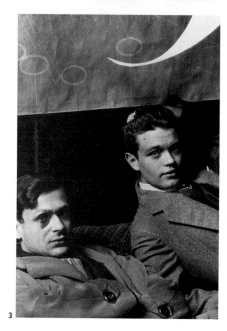

3

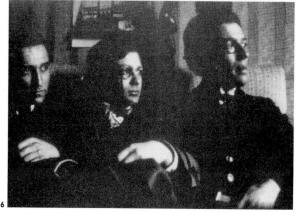

6

1 Francis and Gabrielle Picabia with Guillaume Apollinaire in 1913 at Luna Park, the amusement fair in the Bois de Boulogne.

2 Francis Picabia, *Portrait d'une jeune fille américaine dans l'état de nudité* (Portrait of a young American girl in a state of nudity; 1915); ink on paper. Published in *291*, number 5–6 (July–August 1915).

3 Francis Picabia and Tristan Tzara (1920). Photograph reproduced in *Cannibale*, number 2 (May 25, 1920).

4 Francis Picabia on his "dada" (hobbyhorse) (ca. 1919). Behind him are Germaine Everling and other unidentified individuals.

pened to be, or with Paul Dermée, soon to be with Breton and his friends and who was published by Tzara along with Cocteau, Raymond Radiguet, Gabrielle Buffet, and Georges Ribemont-Dessaignes in *Dada,* numbers 4–5 (May 1919).[6]

Tzara appeared in *Littérature* from the second issue onward, with a poem, "Maison Flake," which had been scheduled to come out in *Nord-Sud* but did not because Pierre Reverdy's journal had ceased to exist. He became a regular contributor, particularly actively beginning with the fifth issue (an insert advertising *Dada* was included with that issue of the periodical). Tzara's presence would reinforce the antiliterary meaning of the texts that followed in succession in the journal to make up an ever less discreet offensive. First of all, there were the "Poems" of Isidore Ducasse, which Breton copied out at the National Library (nos. 2 and 3); then there was "Le Corset mystère," a collage-poem by Breton (no. 4 included an unpublished text by Rimbaud, "Les Mains de Jeanne-Marie"), then the "Letters" of Jacques Vaché (in nos. 5–7, published at the same time in book form by Sans Pareil, with a preface by Breton). And above all, starting with number 8 (October 1919), there was the inclusion of excerpts of the work composed in May by Breton and Soupault, *Les Champs magnétiques,* the long-term consequences of which would be considerable, even as its lesson remained, in the short-term, somewhat confused even for the writers themselves. Viewed alongside texts such as these, the collaborations of Max Jacob, Blaise Cendrars, or Drieu la Rochelle seemed more and more out of place, to such a degree that it began to seem that trust in literature was, on the contrary, in a state of crisis, through alternate yet diverging ways, depending on what the editors of the journal deemed to be the most important. The survey begun in the ninth issue (November 1919)—"Why Do You Write?"—was proof of this: the aim of the survey was to ridicule professional writers; most of the answers, published in the next three issues, were truly appalling, even when their authors performed "witty" pirouettes to elude the serious implications of the question.

Picabia Enters the Scene

In November 1919, Picabia published volume 9 of *391* in Paris with a print run of one thousand—double the size of previous issues. Contributors included Tzara, Ribemont-Dessaignes, and Picabia himself, who had just caused a sensation at the Salon d'Automne with his exhibition of *mécaniste* paintings (in particular, *L'Enfant carburateur* and *Serpentins,* both from 1919). On December 11, Breton, who had said he was moved by the collection Picabia had just published, *Pensées sans langage,* asked him to collaborate on *Littérature.* Picabia's participation dates from February 1920, introducing another aspect of Dadaism to the journal.

Picabia was every bit as restless and out of place as Tzara, though his methods differed. Tzara would come to stay with him when he arrived in Paris on January 17, 1920. Picabia belonged to an older generation, thus he had already been able to experiment with several different pictorial styles during his youth (from postimpressionism, to which he owed his early success, to pre-1910 fauvism). He had become close to Apollinaire and the Duchamp brothers quite early on and, by 1912, was using geometric shapes, without, however, spending too much time on cubism. He acquired additional notoriety in New York, exhibiting abstract works at the 1913 Armory Show. He met the photographer Alfred Stieglitz and exhibited in his 291 Gallery, which was a gathering place for progressive American intellectuals. On another trip to the United

1

HP 85
MERCER NEW YORK
1920

3

2

F Picabia
1 Juillet 1915
New York

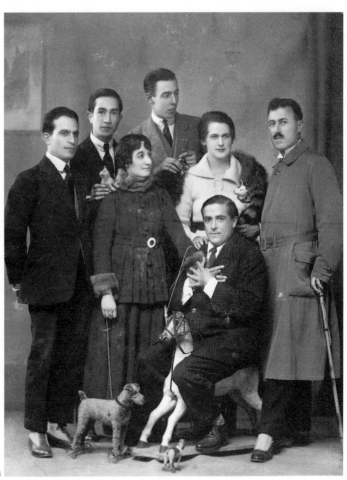

4

States in 1915, he met Marcel Duchamp, who had come over during the war and who had achieved fame with his *Nu descendant un escalier numéro 2,* which caused its own sensation at the Armory Show; he also met a young painter-photographer, Man Ray, who was producing truly astonishing experimental work. Picabia published his first drawings inspired by *mécanisme* (*Fille née sans mère,* that is, the machine invented by man in his own image) in Stieglitz's periodical, *291* (no. 4), as well as a series of object-portraits (Stieglitz, e.g., was represented by a broken camera; and "a naked young American woman" is depicted as an automobile spark plug—an "allumeuse," in other words).[7] He took this inspiration still further in a series of mecanomorphic paintings of complex intention, *Parade amoureuse* (1917), with its scarcely rational juxtaposition of mechanical models and distorted perspective, or its title caption, like that of a pedagogical image. All these elements contributed to a radical challenge to the legitimacy of any image: the meticulousness of the fabrication contradicts the apparent quest for a lack of seriousness, and this simultaneously depreciates painting, eroticism, and technique, while exposing the extent of modern malaise—yet it continues all the while to place abstraction and classical representational painting, or even academic painting, side by side within the same movement and on an equal basis.

In 1916, Picabia began to compose poetry, subsequently published in Barcelona (where he went to live in August) under the title *Cinquante-deux miroirs.* The following year, at his own expense, he printed the first issue of *391:* its title was a tribute to Stieglitz's gallery. Publication of the periodical accompanied him from then on as he moved from place to place, appearing in succession in Barcelona (the first four issues), New York (nos. 5–7), Zurich (no. 8, with Picabia's collaboration), and finally Paris, from November 1919 to October 1924 (no. 19, the final issue). Mixing text and graphic works with information or ironic gossip, Picabia showed a gift for an often aggressive humor with regard to life and the artistic milieu. Particularly during its Parisian period, *391* showed itself to be fully representative of the Dadaist spirit: that which is potentially serious is always masked by derision; relations between individuals swing from consideration to insult; the collective activity of a group is constructed on a model of permanent tension, made of affinity and rivalry in both rigorousness and exaggeration.

Dada in Paris

Picabia and Tzara's joint activities in Paris were decisive in causing the founders of *Littérature* to convert to Dadaism. Tzara was fervently awaited in Paris: "I feel that for me nothing more is possible in Paris without you," wrote Breton in November 1919, and at the end of the following month: "I'm waiting for you, waiting for nothing else but you." On January 14, 1920, when it looked as if Tzara's trip might be postponed: "Can you imagine that between January 6th and 8th I went to the Gare de Lyon five times to meet you; Francis Picabia was moved when I told him this. I hardly see anyone else in Paris, and it is reciprocal. With him there can be no misunderstanding. He is perhaps the only man besides yourself with whom I can speak without reservation. . . . I have met M. Janco. . . . Picabia, Soupault and I got a very detailed story about what happened in 1916 at the Cabaret Voltaire. Yes, what a wealth of details! I don't think any of us has had such a good laugh in ages."

Tzara arrived at Picabia's place on January 17, 1920.[8] Aragon, Breton, Paul Éluard, and Soupault came to visit without delay: although they may have been a bit surprised, even

disappointed, by this first meeting, they immediately invited Tzara to take part in the "First Matinee of Literature," planned since December to put an end to the muddled "literary" reputation into which the periodical, despite their efforts, seemed to be slipping.[9] The program for the matinee had already been set, but Tzara agreed to be a flesh-and-bone incarnation of the Dadaist spirit by giving an unannounced presentation.

Aragon affirmed that they had planned to "give a matinee where all the avant-garde poets would be represented, however we may judge them personally"—and that is what justified the reading of pieces by Cendrars, Cocteau, Raymond Radiguet, Paul Dermée, and others. "Thus," added Aragon, "we reckoned that by confronting those whom we confounded on a daily basis we would clearly define their divergences."[10] Tzara impressed his new friends with his awareness of the audience, a skill he had acquired in Zurich; he took part in the last-minute preparations, and was assigned the presentation of the only "antipoem demonstration," planned to interrupt the "readings ad infinitum" that could offer nothing but profound boredom.

For their first "Literary Friday," a hall was rented for a modest sum in the Palais des Fêtes of the Faubourg Saint-Martin—a working-class neighborhood also chosen in order to demonstrate a certain scorn with regard to so-called intellectual venues. A fairly mixed audience had gathered: neighboring shopkeepers, art lovers (since they had planned to exhibit some paintings for commentary in the middle of the session) and musicians (Georges Auric, Erik Satie, Darius Milhaud, and Francis Poulenc had agreed to participate), artists and poets, journalists, and columnists drawn by the promise of a talk by André Salmon, reputed at the time to be an adept connoisseur of the art milieu. (He was one of the few critics who as early as 1912, in *La Jeune peinture française,* would mention Braque, Picasso, and Matisse alongside the Douanier Rousseau or Picabia.) His talk was to be devoted to "La Crise du change."

In fact, to everyone's general consternation, André Salmon gave a "provincial banquet speech" (Aragon) attempting to prove that *Littérature* was the culmination of the history of modern sensibility. In the absence of any protest, this caused a few of the attendees to flee. The first poetry readings, devoted to the "elders" (Apollinaire, Pierre Reverdy, Max Jacob) took place in a dreary atmosphere, scarcely enlivened by the exhibition of pictorial works (Fernand Léger, Juan Gris, Georges Ribemont-Dessaignes, Giorgio De Chirico, Picabia). The only real event consisted of the presentation of a blackboard covered with hastily scribbled lines and inscriptions by Picabia, which Aragon later erased; according to Aragon, it was primarily the cubists present in the room who were shocked. Picabia was not present that evening, nor would he attend any of the later Dadaist events. Neither the musical interludes nor the resumption of the poetry readings (this time by much younger authors) aroused much of a reaction, and it was only when Tzara arrived, introduced by Aragon, that a real ruckus broke out: "So he began to read. But you couldn't hear a thing; at the same moment André Breton on one side and myself on the other began to ring our little bells, shaking our wrists so hard we thought we'd dislocate them, drowning out Tzara's voice as he read the latest speech by Léon Daudet in his irresistible Romanian accent.[11] It lasted for three minutes, amidst an indescribable commotion—the audience was furious, never imagining there could be such a lack of respect for them. . . . Some people even cried, 'Go back to Zurich!,' others shouted more offensive things, and someone—I regret to say that it was Monsieur Florent Fels, the director of *Action*—even shouted: 'String him up!' Juan Gris too couldn't get over it. . . . André Salmon was biting his tongue about

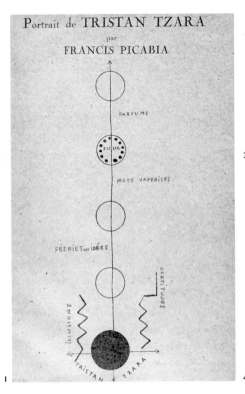

1

3

4

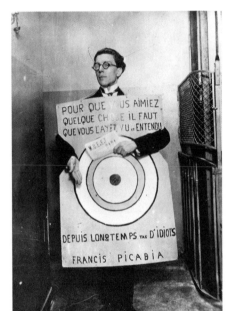

7

2

5

6

1 Francis Picabia, *Portrait de Tristan Tzara*, published in *Cannibale*, number 1 (April 25, 1920).

2 Front page of the monthly *Proverbe*, number 5 (May 1, 1920); edited by Paul Éluard from February 1920, to July 1921.

3 Cover of *Cannibale*, number 1 (April 25, 1920).

4 Cover of *391*, number 3 (March 1917), with an illustration by Francis Picabia.

5, 6 Covers of *Littérature*, numbers 5 and 7 (October and December 1922), with an illustration by Francis Picabia.

7 André Breton as a sandwich man with a poster by Francis Picabia at the Théâtre de l'Œuvre in Paris during the Dada Festival, March 27, 1920.

what he'd said earlier."[12] Then the atmosphere calmed down; the room was nearly empty when Aragon ended by reading a poem by Pierre Albert-Birot. The experience was ambiguous: at the time, the *Littérature* people came out feeling demoralized, even discouraged (according to Soupault, they felt it had been a "failure"), while Tzara, no doubt, thought the event had been fairly positive, since at least as far as he was concerned he had managed get a reaction out of people, thanks to his experience of provocation. At least the first Dadaist performance in Paris had the merit of arousing hostility, and the immediate effect was, despite everything, to bring about an even stronger affinity among the members of the little group.

1920: The First Glorious Feats

There were more and more Dadaist events over the next months, as well as an increase in the number of periodicals. Under Tzara's direction, two journals came out one right after the other: *Bulletin Dada,* where there was a long list of "some (80) *Présidents* and *Présidentes*" of the movement, emphasized by the aphorism "Everyone is a leader of the Dada movement"; and *Dadaphone,* where Tzara continued to round up all the collaborators he could, including Cocteau, along with Paul Dermée and his wife Céline Arnauld.[13] Their signatures could also be found alongside those of Jean Paulhan, Jean Arp, Benjamin Péret, Jacques Rigaut, Ribemont-Dessaignes, Picabia, Theodore Fraenkel, Tzara, and the group from *Littérature* in *Proverbe,* the monthly newsletter that Paul Éluard brought out between February 1920 and July 1921; its subscription form stated that it existed "for the justification of words." The same collaborators, here referred to as "all the Dadaists of the world," were also brought together by Picabia in two issues (April and May 1920) of *Cannibale,* illustrated by Picabia himself and with a drawing by Duchamp. These titles, and two issues of *Z* (Dermée) were all registered with Sans Pareil (37, avenue Kléber, Paris 16); René Hilsum's publishing house was taking on, more and more, the role of the official distributor of Dadaist publications. After the " literature collection"—inaugurated by Rimbaud's *Les Mains de Jeanne-Marie* and followed by Breton's *Mont de piété,* Vaché's *Lettres de guerre,* Cendrars's *Dix-neuf poèmes élastiques,* Soupault's *Rose des vents,* Paul Morand's *Lampes à arc,* and Aragon's *Feu de joie,* which all came out in 1919 (sales for which, with the exception of Rimbaud's work, slow and difficult)—a Dada Collection would appear in February 1920, with Picabia's *Unique Eunuque,* prefaced by Tzara. A second volume would not be published until a year later, *L'Empereur de Chine,* by Ribemont-Dessaignes, while Tzara's *Vingt-Cinq Poèmes,* illustrated by Arp, was distributed by Sans Pareil as was *391.*

For the Dadaists, publication alone was not enough; it was almost a priority that they perform in public. In the framework of the Salon des Indépendants, where Picabia in particular was exhibiting his canvasses, a body of manifestos was read on February 5, after the announcement by the press that Charlie Chaplin was a member. The event took place before an audience who by now had heard the rumors about the "Literary Friday," and whose reactions were quite turbulent. Two days later, they renewed the experiment at the Club du Faubourg, where the director, Léo Poldès, had invited the Dadaists to take part in a series of discussions on art.[14] After a speech by Raymond Duncan on art and morality, followed by a fairly confused debate on Dostoyevsky, Henri Barbusse, and the beauty of desertion, the audience called for Dada by chanting slogans. Aragon then began a vigorous protest against any attempts at vulgar-

ization, beginning with the Club du Faubourg itself, then Breton's reading of Tzara's *Manifeste Dada 1918* was greeted with boos from the crowd. Meanwhile, a group of anarchists seemed to be standing up for the movement and almost came to blows with the socialists in the audience. Duncan took the floor again to congratulate the Dadaists on their "sincerity," and the meeting ended in utter confusion.

On February 19, a new series of manifestos was read in public, this time at the Université Populaire in the Faubourg Saint-Antoine. The participants found the audience problematic: they were neither hostile nor favorable but were simply trying to grasp what the Dadaists actually wanted and what their point was. However, if the Dada manifestos, with their verbal violence, could on occasion shock or induce strong emotions in their audience, to comment on the manifestos or, even more difficult, to explain them was another matter altogether; thus, the event ended once again on a rather flat note. Tzara understood that this type of event could not be repeated. The following one, which was held on March 27 at the Maison de l'Œuvre, rue de Clichy, was therefore organized in such a way that a certain variety could be introduced: they alternated readings, musical pieces (a completely aleatoric composition by Ribemont-Dessaignes, performed however with great seriousness, amid utter chaos), and dramatic skits (notably *S'il vous plaît,* by Breton and Soupault, and *Le Serin muet,* by Ribemont-Dessaignes); the program even announced "prestidigitation" by Aragon and the "latest Dada creations" by the famous actress Musidora. Her performance was the only moment of calm among the audience, who were subjugated by her presence but remained fairly aggressive during the rest of the performance.[15] They reacted violently both to the incoherence of *S'il vous plaît* and to its costumes (huge paper bags inscribed with the names of the characters) worn by the eight narrators whose task it was to recite *La Première aventure céleste de M. Antipyrine de Trava.* For the first time, the evening performance attained its goal: it scandalized an audience who had paid their way only to find that all effort at meaning or even artistic exploration was being called into question. But the fact that the event took place also indicated that a part of the audience at least was beginning to know what to expect, since an anti-Dadaist publication, *Non,* edited by René Edme and André du Bief, was handed out in the theater. The leaflet challenged Dada's "imperialism" and denounced its "nihilistic, burlesque, absurd snobbery."[16] Thus only a few weeks after Tzara's arrival, Dada had already attained an indisputable notoriety, and, above all, it had already provoked negative reactions in several "modern" circles.

Despite the exhibition of several paintings in the course of joint events (in particular, on March 27, Picabia's *Tableau vivant:* a stuffed toy monkey glued onto a canvas, surrounded by inscriptions: "Portrait of Cézanne," "Portrait of Rembrandt," "Portrait of Renoir," "Still Life"—explicitly aimed against the entire history of art, including cubism), the plastic aspect of Dadaism remained clearly underrepresented. Picabia's exhibition, held during the second half of April at the Au Sans Pareil bookshop (avenue Kléber, in the same building as the publisher), which René Hilsum had opened in January 1920 to expand his publishing activity, would go some way toward making up for this lack by showing mecanomorphic works. But the exhibition was a failure and caused very little comment. A similar fate awaited the exhibition one month later by Ribemont-Dessaignes at the same venue: there was a sense of repetitiveness, for Ribemont-Dessaignes, in his loyalty to Picabia, had produced canvasses and drawings that were too similar to Picabia's own work.

Littérature number 13 (May 1920) published an exclusive article titled "Twenty-

Three Manifestos of the Dada Movement," which contained those manifestos that had been read in public. This particular issue, the first since February, marked the official conversion of *Littérature* and its editors to Dada, and underscored the international nature of the movement: contributions to this issue included pieces by Arp, by the American poet and collector Walter Crane Arensberg, and by the Dadaist of Czech origin, Walter Serner, who had recently caused a major sensation in Zurich by reading his manifesto *Dernier dérangement*. Given this issue of *Littérature,* along with Ribemont-Dessaignes's exhibition and the Dada festival in the Salle Gaveau, the month of May that year seemed to mark a high point for Dada's first Parisian period, and the movement was now active on all fronts.

The festival at the Salle Gaveau (the venue was chosen for the quality of the events that took place there) was particularly animated. Visitors were numerous, drawn perhaps by the promise of unusual attractions ("All the Dadas will have their heads shaved on the stage") and, at any rate, by the presence of members of the intelligentsia (Gide, Jules Romains, Georges Duhamel, Valéry, Constantin Brancusi, Jacques Rivière, Jacques Copeau, Rachilde, Albert Gleizes, and Léger) even though the program was, by and large, a repetition of their previous event: *Vous m'oublierez,* a skit by Breton and Soupault, replaced *S'il vous plaît,* just as *Le Nombril interlope* replaced *Pas de la chicorée frisée,* another musical piece composed by Ribemont-Dessaignes, and the *Première aventure de Monsieur Antipyrine* was simply followed by the *Deuxième.* The performance was rounded off by the usual reading of manifestos and virulent texts and, as a parting shot, by a collective performance of Tzara's *Vaseline symphonique.* The costumes, which had been in use since Zurich, went from tall white cylinders and huge bathrobes (Soupault as an illusionist) to an enormous funnel to collect the missiles thrown by the audience, a sack of yellow tarlatan, and so on. A new element was introduced in the form of a collaboration between the audience—who bombarded the players not only with fruit and vegetables in various stages of decomposition and even a few steaks or chops but also with insults, catcalls, and animal cries—and the players, who refused to be upstaged by the audience where verbal aggression was concerned.[17] Dada was learning how to answer back, and although at the end of the performance the spectators were once again overcome by a surge of patriotism (the same that accused cubism of being a "Kraut" art form), singing *La Madelon* and urging the opera singer Marthe Chenal, a friend of Picabia's who was famous for her rendition of *La Marseillaise,* to sing the national anthem once again, there was a certain good humor about the proceedings, as at the end of a jousting match or the rivalry at the end of a banquet: to counter Dadaist agitation, perhaps it was enough simply to shout louder than the movement's partisans?

Ambiguous Recognition

Beyond the intellectual circles, the press gave considerable coverage to the evening's event, but what was worrisome to the *Littérature* group, more than to Tzara or Picabia, was that Dada was beginning to be co-opted: word was spreading that Dada was the latest fashionable entertainment or the cutting edge of snobbishness:

> Several young men thought that they could rejuvenate the tradition of *farces d'atelier,* and our own snobbishness almost took them seriously. These young men with their grave expressions were most solemn as they introduced us to Dadaism, an art form which is not a

form, a school which denies that it is a school, a simple pretext for hilarious gatherings. . . . Such fraud is typical of our era: bitter, as joyless as our funeral tango or our black velvet cushions. The laughter of these complicated esthetes rings hollow, because one must be simple to have a simple good time.[18]

Already misrepresented as a sort of intellectual music hall, Dada was also in danger of being prematurely relegated to the history of literature. The article published by Gide in *La Nouvelle Revue française* in April 1920 already predicted such an outcome: "It is important," he wrote, "that the mind not lag behind the matter (destroyed by four years of war): the mind too has a right to ruin. Dada will take care of that." But Gide was careful to underline that it was already time for the more interesting of the Dadaists to abandon a movement which, in itself, had already exhausted its ability to fabricate "absolute insignificance" by the invention of its name alone. Gide had no fear of scandal in calling Tzara a "foreigner" and a "Jew" and suggested that the other members of the movement (the good Frenchmen, in other words) "escape" from Tzara's circle.[19]

Pour Dada, which Breton also published in *La Nouvelle Revue française* (August 1920), was doubtless a response to Gide's article.[20] But as the coeditor of *Littérature,* he intervened as the representative of the entire Dada movement, interpreting Gide's words in a way that was unlikely to satisfy Tzara or even Picabia, by situating him relative to Rimbaud, Lautréamont, and Vaché and by sketching out ideas that would be those of surrealism about the unconscious, about poetic inspiration, or even about psychoanalysis. What was worse, Breton stated that "our common exception to the rules of art or morality only brings us a passing satisfaction," and thus he seemed, already, to envisage a life beyond Dadaism, which was out of the question for Tzara at that time.[21]

In *La Nouvelle Revue française,* Breton's article immediately preceded an analysis by Jacques Rivière, the journal's editor-in-chief. His "Gratitude to Dada" constituted without doubt the best approach to the movement made thus far, but at the same time, even more than Gide's article, it conferred an official status upon Dada's literary dimension.[22] By showing how Dada replaced the search for beauty with the search for an original totality of the mind (or of "absolute psychological reality"), Rivière showed that "all logic must be made subordinate" to that which enabled apparently contradictory formulas emanating from mankind to emerge. He underlined a significant consequence—"It is impossible for man to say anything which has absolutely no sense"— and approved Breton's declaration that Dada's primary target was language, restored at last to its primeval state, independently of any classical relation with a referent. Essentially in favor of Dada, in any case very attentive to the movement, Rivière saw it as the cutting edge of "centrifugal literature" that, from romanticism to Apollinaire, sought to find "its culminating point outside of literature." Thus Dada seemed to be a positive culmination, beyond its offensive negativity, of "the implicit dream of several generations of writers," and Rivière did not hesitate to affirm in passing that "even when they do not dare openly admit it, the Dadas continue to move toward this *surrealism,* which was Apollinaire's ambition"—taking the term used by Apollinaire in a direction that prefigured, at least in part, the orientation that Breton would soon give it.

1921: New Offensives

Since the literary world had come to see that there might be more serious substance to

(Les Signataires de ce manifeste habitent la France, l'Amérique, l'Espagne, l'Allemagne, l'Italie, la Suisse, la Belgique, etc-, mais n'ont aucune nationalité).

DADA SOULÈVE TOUT

DADA connaît tout. DADA crache tout.

MAIS......

DADA VOUS A-T-IL JAMAIS PARLÉ :

de l'Italie
des accordéons
des pantalons de femmes
de la patrie
des sardines
de Fiume
de l'Art (vous exagérez cher ami)
de la douceur
de d'Annunzio
quelle horreur
de l'héroïsme
des moustaches
de la luxure
de coucher avec Verlaine
de l'idéal (il est gentil)
du Massachussetts
du passé
des odeurs
des salades
du génie . du génie . du génie
de la journée de 8 heures
et des violettes de Parme

JAMAIS JAMAIS JAMAIS

DADA ne parle pas. DADA n'a pas d'idée fixe. DADA n'attrape pas les mouches

LE MINISTÈRE EST RENVERSÉ. PAR QUI? PAR DADA

Le futuriste est mort. De quoi ? De DADA

Une jeune fille se suicide. A cause de quoi ? De DADA

On téléphone aux esprits. Qui est-ce l'inventeur ? DADA

On vous marche sur les pieds. C'est DADA

Si vous avez des idées sérieuses sur la vie,

Si vous faites des découvertes artistiques

et si tout d'un coup votre tête se met à crépiter de rire,

si vous trouvez toutes vos idées inutiles et ridicules, sachez que

C'EST DADA QUI COMMENCE A VOUS PARLER

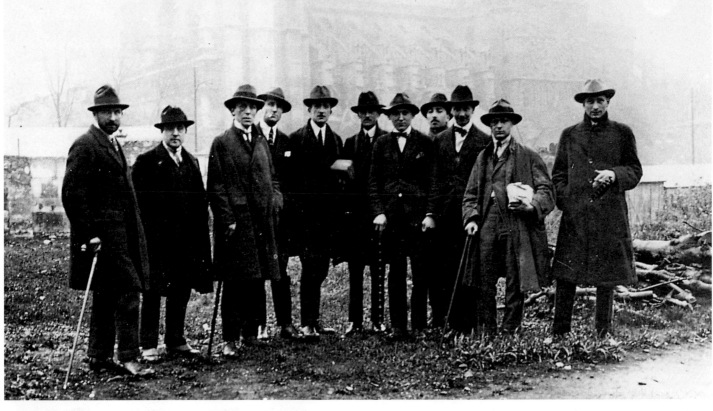

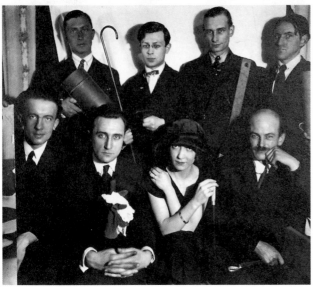

1 The Dada group's visit to the church of Saint-Julien-le-Pauvre in 1921. *From left to right:* Jean Crotti, Asté d'Esparbès, André Breton, Jacques Rigaut, Paul Éluard, Georges Ribemont-Dessaignes, Benjamin Péret, Théodore Fraenkel, Louis Aragon, Tristan Tzara, and Philippe Soupault.

2 The Dada group in 1921. *Top row:* Paul Chadourne, Tristan Tzara, Philippe Soupault, Serge Charchoune. *Bottom row:* Paul Éluard, Jacques Rigaut, Marie-Louise Soupault, Georges Ribemont-Dessaignes.

3 Pamphlet announcing Dada's first visit to Saint-Julien-le-Pauvre, 1921.

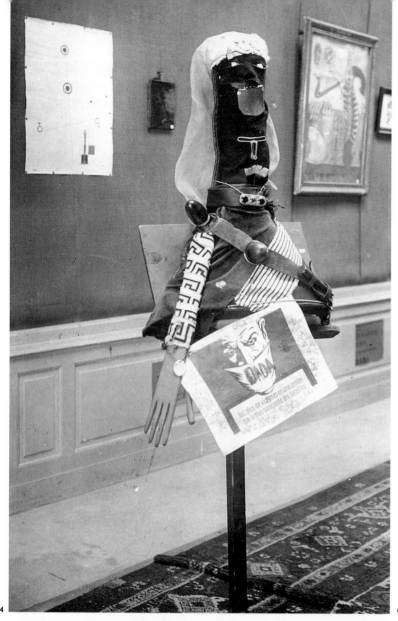

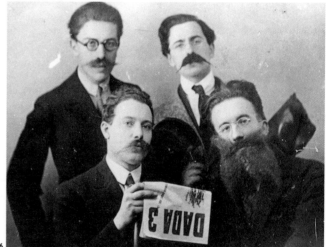

4, 5 Salon Dada at the Galerie Montaigne, Paris, 1921: a Dada mannequin and, on the wall, a collage by Max Ernst.

6 André Breton, René Hilsum, Louis Aragon, and Paul Éluard reading *Dada 3,* in which the 1918 "Dada Manifesto" was published.

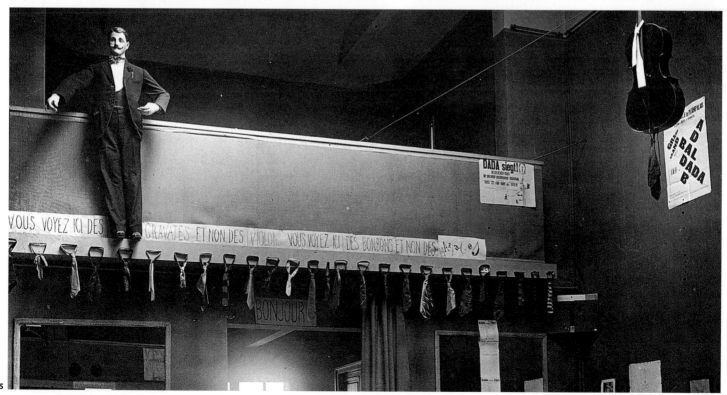

4

6

5

Parisian Dadaism than was first apparent, it seemed appropriate for the members of the group to renew the offensive—and, if possible, by different means. Breton and Aragon made this their priority during the first half of 1921, and their undertaking would become all the more urgent in that they had to deal with Picabia's about-face as he began to foster enmity within: in December 1920, at the opening of his exhibition in Povolozky's gallery where anyone who was anyone in Paris had gathered, Tzara could be seen proclaiming his *Dada manifeste sur l'amour faible et l'amour amer* next to the jazz band led by none other than Jean Cocteau![23] Recalling the period some years later, Aragon would remark that "the press must have been tired of Dada, which no longer had the attraction of being a novelty"; yet "the point was to prepare for, and to decree, quite suddenly, the Terror. Everything was happening as if the Revolution had arrived and we were leading it. Moreover we had decided that we wouldn't wait until ninety-three, that we'd have the Terror right away: in eighty-nine."[24]

Dated January 12, the pamphlet "Dada soulève tout" ([Dada stirs up everything], at the bottom of which were not only the usual Paris signatures but also those of Clément Pansaers, Richard Huelsenbeck, Julius Evola, and Johannes-Theodor Baargeld) displayed a vigorous opposition to any artistic interpretation, deliberately taking its distances from any recent movements in the art world (cubism, expressionism, simultaneism, futurism, ultraism, vorticism, and so on): "Citizens, comrades, ladies and gentlemen, Beware of counterfeits! The imitators of DADA want to give DADA to you in an unprecedented <u>artistic</u> form. CITIZENS, today we present to you, in a pornographic form, a vulgar, baroque spirit which is not the PURE IDIOCY prescribed by DADA, BUT DOGMATISM AND PRETENTIOUS IMBECILITY!"[25] The pamphlet was handed out during a lecture by Filippo Tommaso Marinetti on tactilism and was directed primarily against futurism ("Futurism is dead. What did it die of? DADA."), insofar as its "words of freedom " and its habit—like Dada's—of multiplying its manifestos were in danger of causing a confusion between the two movements. By proclaiming its own global import, Dada relegated futurism to its strictly Italian origin, thus also implicitly challenging its nationalist positions.[26]

In March, in number 18 of *Littérature,* the chart "Liquidation" listed the marks given by the principal Dadaists (except for Picabia) to a certain number of famous names, and its aim was clearly "not to rank, but to demote." The marks went from −25 (the greatest aversion) to +20, with zero for absolute indifference. Tzara gleefully handed out some −25s, and when it came time to rank the names according to the averages obtained, it turned out that except for the Dadaists themselves and those for whom they might have some admiration (Chaplin, Rimbaud, Isidore Ducasse [Lautréamont], Jarry, Sade, etc.), the celebrities of the era fared quite poorly: Henri de Régnier came in last with −22.90; Anatole France and the Maréchal Foch both earned −18; Paul Fort had a −16.54, Charles Maurras a −14.90, and so on. Worthy of note is the fact that Picabia himself did not get higher than 8.63, somewhat better than Picasso's score, but far behind either Tzara or Breton; no doubt, the poor score aimed, among other things, to sanction the confused reception given his most recent opening.

Also in March, Breton elaborated his project for "visits" of various sites in Paris: these visits, which would bring together artists and intellectuals, were meant to underline Dada's demoralizing nature in relation to various sites (the Louvre was planned, as well as a forest near Paris) and to "fight the ultra-aristocratic concept of art and intellectual life which reigns in our time."[27] Only one of these visits actually took place, and

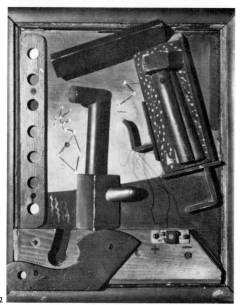

1

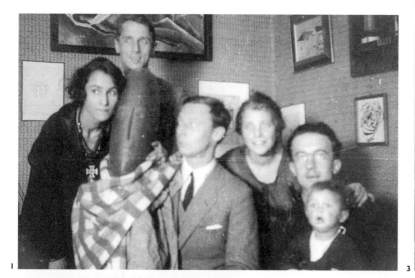

3

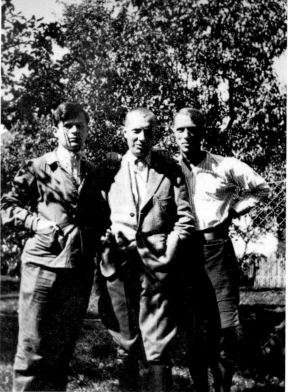

2

4

it inaugurated a first phase of the Grande Saison Dada 1921: at the church of Saint-Julien-le-Pauvre, on Thursday April 14, in the rain, a dozen or so Dadaists gathered before an audience of fifty people. Manifestos were read, speeches were made, ad lib, but neither managed to warm up the atmosphere or to rouse the spectators from their apathy, even when, at the end of the performance, surprise envelopes were handed out. The grand season was off to a bad start, but fortunately the second stage would be another matter altogether: the Max Ernst exhibition, from May 3 to June 3, at the Au Sans Pareil bookstore.

The First Max Ernst Exhibition in Paris

Breton had been corresponding with Ernst since April 1920, and together with Aragon, Simone Kahn, Péret, and Rigaut they prepared the exhibition—apparently suggested by Tzara—with great enthusiasm. Ernst had already contributed to number 19 of *Littérature*, which came out at the end of April with an illustrated article devoted to Jean Arp and with a reproduction of *Relief tricoté*. There was a full-page advertisement for the exhibition in the periodical, and Ernst's first works had been greeted by the people at *Littérature* with transports of delight. (He himself could not come to Paris for administrative reasons.) What they discovered in the paintings, collages, and *surpeintures* that arrived from Cologne (where most had been created in 1919) was an authentic originality—and this was all the more astounding given the fact that in Cologne no one had ever heard of Dada.

Demobilized after the Armistice, Ernst rapidly established contacts with "subversive circles in Munich, Berlin and Zurich. Beyond borders," he reiterated in his *Notes pour une biographie*, "the Dadas shared the desire to denounce, mercilessly, the infernal condition which idiotic patriotism, supported by human stupidity, had imposed upon the era in which they were condemned to live. France's military victory was as odious to the Dadas of Paris as Germany's military defeat, warmly cheered by Dadas on either side of the Rhine."[28] In Germany, both in Cologne and in Berlin (where Huelsenbeck, Raoul Hausmann, John Heartfield, Hannah Höch, Johannes Baader, and George Grosz were participants and where the "scandalous" International Dada Fair was held in July and August of 1920), Dada had deliberately become more explicitly political than in Paris: at the factory gates, Ernst handed out *Der Ventilator*, the organ of political struggle that he published with Baargeld's help. But he was also in charge of two other Dada publications: *Die Shammade* and *Bulletin D*, which was used in particular as a catalog for the first exhibition organized by Ernst and Baargeld in Cologne, where alongside their own work and that of Freundlich were displayed pieces created by illiterate and mentally ill people, as well as various items from the lost and found. While they were setting up, Katherine Dreier happened to be there, waiting for a train, and she suggested to the two artists that they send their exhibit to her gallery in New Haven, Connecticut, for she felt that her friend Marcel Duchamp would like their work a great deal. But the occupying British authorities would not allow the exhibit to be exported. The following year, after Arp's visit to Cologne, Ernst and Baargeld prepared a second exhibition. Certain works were destroyed by an enraged public and then immediately replaced, but the police forced them to close down the exhibition for "pornography." It was nevertheless reopened after the pretext for the accusation was removed: a reproduction of Dürer's *Adam and Eve* had been used in one of Ernst's collages.

The invitation from Paris was well timed: "Max Ernst, who has read *Les Champs magnétiques,* is delighted to accept. Breton's brave and brotherly gesture might determine his future—brave, because nothing less than aplomb was required to show the works of a German painter in France."[29] A great deal of publicity went into announcing the exhibition, and once again it drew crowds from among anyone who was anyone in Paris on the opening evening, which was the pretext for a Dada event in due form: insults hurled as guests arrived, unfunny practical jokes, diverse vociferations (Ribemont-Dessaignes repeating over and over, "It is raining on a skull"), enigmatic whispering, and so on. The works on display, presented as "mechano-plastic, plasto-plastic drawings, and anaplastic, anatomic, antizymic, aerographic, anitphonary, sprayable and republican paint-paintings," were utterly disconcerting to the audience, and their general reaction was to burst out laughing.

The modest catalog included fifty-six items, of which there were four *Fatagagas* (for "Fabrication de tableaux garantis gazométrique"—Manufacture of paintings guaranteed "gazometric," a qualification reserved for collaborative works, in this case by Arp and Baargeld). Breton, in his preface, far from adopting the Dada tone that Tzara used for Picabia ("Art is a poet with broken ribs—Picabia breaks all bones and glass roses") or Ribemont-Dessaignes ("He has dissected a reservoir of nervous matter and poured into the canal, one after the other, the rhythm of the cascade saber hail fox-trot"), tried to give a rigorous demonstration of the irreplaceable quality of what painting had to offer and drew a parallel with the poetics of language.[30] While he initially stated that the advent of photography had dealt "a mortal blow to older modes of expression, both in painting and in poetry," Breton underlined that it would be equally sterile to return to readymade images or to the so-called rejuvenation of the meanings of words—whence the failure of symbolism and cubism. The only thing that would work would be to "make use of the given acceptations" and then group them "according to the order we like best," a procedure that, although the term is not to be found in the text, is perfectly dialectic, assuming as it does an initial feigned acceptance, then a negation, of what has been established, followed by its own negation in the new subsequent ordering. And that is what Max Ernst achieved in his exploration, without going beyond our experience since the elements of his work pointed toward known and cataloged objects (even if only in those catalogs whose images he had borrowed) and toward the possibility of new relations between "distant realities," and their "rapprochement."[31] Thus, his "collages" (strictly speaking, the exhibition only showed a dozen or so) no longer had anything to do with the methods of the cubists, for whom the glued fragment was an allusion to reality in its very materiality, conferring to the canvas what Braque referred to as his "certitude," or else it was valued for its pure color alone; in either case, the added element was integrated into the composition. With Ernst, however (besides the fact that he generally made use of drawn or printed elements that he would then color himself), the glued element underwent a transformation, sometimes to such a degree that one could not immediately perceive it for what it was and, on the contrary, a painted element might seem glued; above all, its significance would change, for example, once it had been transformed into something other than the object of which it was originally an image. In performing these metamorphoses, Ernst would naturally make poor use of perspective, as well as of classical (absolute) time and space, but he managed to "make us feel that our own memory is foreign," which seemed to announce a crisis of one's own individual identity. Thus

das schlafzimmer des meisters es lohnt sich darin eine nacht zu verbringen

1 la chambre à coucher de max ernst cela vaut la peine d'y passer une nuit/max ernst

2

1 Max Ernst, *La Chambre à coucher de Max Ernst cela vaut la peine d'y passer une nuit* (1920); collage, pencil and tempera, 6²/₃ × 8⁴/₅. (16.5 × 22.1 cm) Private collection.

2 Max Ernst, *Dada in usum delphini* (1920).

These two works were presented at the Max Ernst exhibition at the Au Sans Pareil Bookstore in May and June 1921.

Max Ernst can be saluted as offering us "infinite possibilities"—after the text had stated in passing that "Dada does not profess to be modern."

If the pieces sent from Cologne gave Breton the idea to create new links between painting and poetry, it was also because of the titles, often very long, which Max Ernst had given to them. These titles tended to divert the original sense of the image toward other meanings rendered by the artist's spontaneity. If, on top of that, the "collages" (of which, it seemed, Picabia was momentarily very jealous) were for the team of *Littérature* something of a revelation, it was perhaps less because of their strictly technical novelty (which Breton moreover does not even mention in his preface) than because of the visual system proposed. Rosalind Krauss perceives this system as the opposite of the "modernist" vision (for which painting is self-sufficient and should not be concerned with anything other than to respect its own constitutive agenda) or as an "optical unconscious."³² Independently of the collages in the strictest sense of the term, the *surpeintures* sent by Ernst were produced by covering over parts of preexisting images with a fine layer of gouache, allowing only certain elements to appear, whose coexistence now seemed incongruous. On occasion the painter would also add lines of perspective to those elements that had remained visible—all the more "abnormal" for the perspective that no longer defined the size of the objects portrayed, since size was predetermined by the original composition of the image used. This was the case in particular for a work exhibited at the 1921 exhibition (no. 39 in the catalog), *La Chambre à coucher de Max Ernst cela vaut la peine d'y passer une nuit* (Max Ernst's bedroom it's worth spending a night there) (in its German version, written at the top, the bedroom is designated as being the "master's"): the layer of gouache is thin enough to enable one to make out some of the figures covered over, in such a way that one can presume that the choice of elements left visible was made depending on a preexisting supply (readymade, as it were), both hidden and still present (since it was the original order that also determined the positioning of the figures)—just as elements of memory, impulse, desire, and all the childlike story of the subject (Max Ernst or someone else) were also hidden and yet already there, present in a system of preconsciousness-consciousness. The discovery of *La Chambre à coucher de Max Ernst* (who had himself read Freud, fairly seriously) coincided for Breton and his friends with what they were trying to derive from their own experiences—from what they knew about Freud, from their knowledge of Rimbaud and Lautréamont (the preface suggests that it was in their texts, or at least in certain passages, that "automatic writing appeared at the end of the 19th century"), and from the experience of automatism during the composition of *Les Champs magnétiques*.³³ Under these conditions, the painter's work, which "does not lose the grace of a smile, illuminating all the while, with an extraordinary daylight, that which is deepest in our inner life" (and each expression is to be taken here in the strongest sense) constituted for them a discovery of unparalleled importance, confirming the possibility of pursuing their research, within the scope of Dada, into that which would soon be named "the true functioning of thought."

The Barrès Trial

On May 11, Picabia announced his split with Dada in an article published in *Comœdia*: "The spirit of Dada only really existed between 1913 and 1918, an era during which it did not cease to evolve, to change; but after that it became as uninteresting as the pro-

1 Invitation to "The Barrès Trial,"
1921.

2 "The Barrès Trial," at the hall of
the Sociétés Savantes, May 13, 1921.
From left to right: Louis Aragon,
unidentified person, André Breton,
Tristan Tzara, Philippe Soupault,
Théodore Fraenkel, the dummy
representing Barrès, Georges Ribe-
mont-Dessaignes, Benjamin Péret,
Jacques Rigaut, René Hilsum, and
Serge Charchoune.

3 The Dada group around the Bar-
rès dummy. On the left is André
Breton, and to the right in the back
row is Tristan Tzara.

duction of the École des Beaux-Arts. . . . Dada, you see, was not serious and that is why
it conquered the world like wildfire; if a few people now have begun to take it seri-
ously, it's because it is dead! . . . Existence is only really tolerable if one lives among
people who have no ulterior motives."[34] Nevertheless, two days later, in the Salle des
Sociétés Savantes on the rue Serpente, he attended the indictment (there was a charge
for admission) of Maurice Barrès. "The Barrès Trial" was to be the first of a series
planned in the framework of the Grande Saison Dada 1921: in fact it would be the
only event, an indication of the discord between Tzara and the team from *Littérature*—a
discord that was already perceptible in the marks handed out during "Liquidation" and
that was now plain to all.

The organization of the trial fell mainly to Breton and Aragon, who had some
scores to settle with Barrès. Barrès was the author of *L'Ennemi des lois* and had become
the spokesman of the worst nationalism. Tzara was completely indifferent to him and
had probably never even read a line of his work. The influence of Barrès on the direc-
tors of *Littérature* as adolescents could be attributed, in fact, to the history of the strict
French mentality, and Dada should not even have been involved. It was simply because
Breton and Aragon were Dadas that the movement found itself involved in a problem-
atic issue that had nothing to do with it, if it was true that the question the organizers
intended to debate was indeed an ethical one. To accuse Barrès of "crimes against the
security of the mind" was to imply that Barrès had a minimum of responsibility where
the recognition and respect of certain values was concerned. This was a thesis to which
Tzara, for one, could not subscribe, and that is why his participation in the trial, to
which he finally consented after lengthy discussions, differed greatly in tone from the
other interventions and brought home a sense of derision and universal mediocrity
that annihilated, at least in part, the seriousness Breton had hoped to confer to the
event.

It is conceivable that the audience, who now knew Dada by reputation, was expect-
ing nothing other that a grotesque parody of a trial that would give them the opportu-
nity to demonstrate or cause an uproar. The costumes (medical students' white
blouses), the banner suggested by Péret ("No one is supposed to be unaware of
Dada"), and the use of a mannequin to represent Barrès did at first strengthen their
hopes. Breton read an act of accusation consisting of eight counts, during which the
examples of Rimbaud and Lautréamont were evoked, and from the start this created a
very different atmosphere. The same was true of the various testimonies (Serge
Romoff, Giuseppe Ungaretti, Rachilde, Drieu La Rochelle, Rigaut, and Tzara), which
were met with a mood of greater seriousness than expected—except when Tzara dis-
missed out of hand the possibility of any judgment: "You will agree with me, Your
Honor, that we are all nothing but a gang of bastards and that consequently the little
differences between us, greater bastards or lesser bastards, are of no importance. I am
not judging. I am judging nothing. I judge myself all the time and I find myself to be a
disgusting little individual, not unlike Maurice, but a bit less so all the same." Ribe-
mont-Dessaignes's indictment turned into a reminder of the Dada mentality, while the
defense, taken on by Soupault and Aragon, also turned into a violent requisitory, at
least in Soupault's pleading (it seems that Aragon's text has been lost). The arrival of
Péret in a German uniform to represent the Unknown Soldier provoked a frankly
patriotic reaction, which seemed however to be the only moment of true unrest
among the spectators.

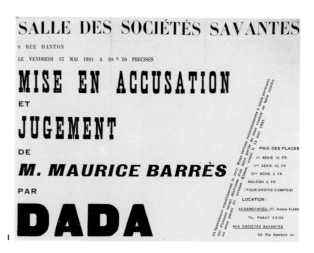

SALLE DES SOCIÉTÉS SAVANTES

8 RUE DANTON

LE VENDREDI 13 MAI 1921 A 20 H 30 PRECISES

MISE EN ACCUSATION

ET

JUGEMENT

DE

M. MAURICE BARRÈS

PAR

DADA

PRIX DES PLACES

1re SÉRIE 16 FR

IIme SÉRIE 10 FR

IIIme SÉRIE 6 FR

BALCON 5 FR

(TOUS DROITS COMPRIS)

LOCATION :

AU SANS PAREIL, 37, AVENUE KLÉBER

TEL. PASSY 29-22

AUX SOCIÉTÉS SAVANTES

28, RUE SERPENTE 1921

1

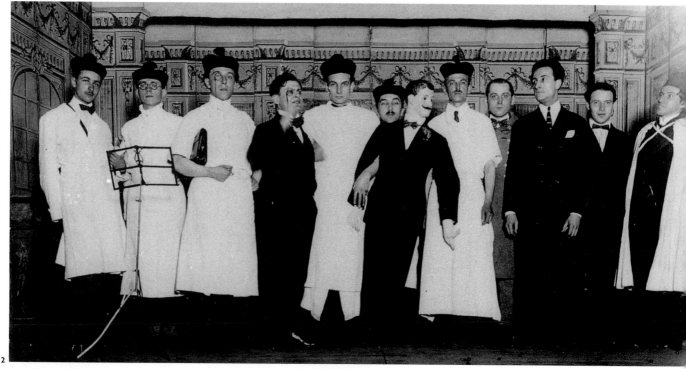

2

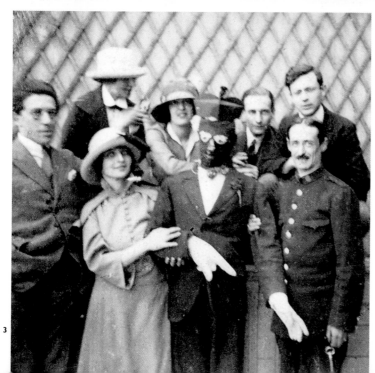

3

1

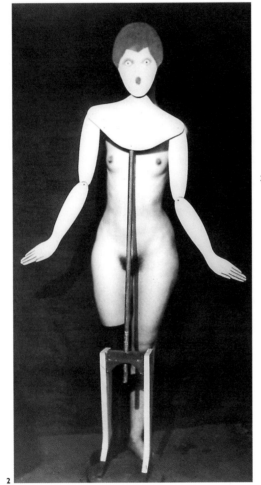

2

3

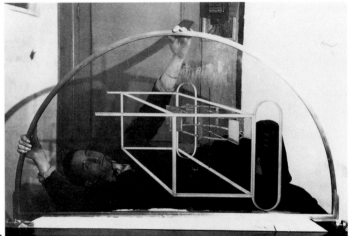

4

Incontestably, confusion reigned during the trial, which closed with Barrès's con-
demnation to twenty years of hard labor, but at least Breton and his friends from *Lit-
térature* had managed to infuse a certain spirit of rigor into the trial, and the need for an
attitude that would no longer simply be that of systematic derision: following Picabia's
defection, Tzara remained virtually the only partisan of the original Dadaist "purity."

The August 1921 issue of *Littérature* (no. 20) was devoted entirely to a summary of
the "Barrès Affair."[35] Before its release, to close the Grande Saison, Tzara organized a
Salon Dada—initially with Picabia's consent, although he declined from participating.
Twenty or so French and foreign Dadas presented their works from June 6 to June 30
in the hall of the Studio des Champs-Élysées, rebaptised "Galerie Montaigne," where
they applied one of Tzara's principles: that the writers produce plastic work (Aragon
contributed a *Portrait de Théodore Fraenkel;* Soupault, a mirror inviting visitors to check
their appearance, which was entitled *Portrait d'un Imbécile*). Pseudo-paintings and accu-
mulated objects recaptured to some degree the atmosphere of the successive Salons des
Incohérents of the end of the nineteenth century, but it is probable that Tzara and his
friends did not know this.[36] There were two noteworthy absences in addition to
Picabia's: Breton and Duchamp. Duchamp had initially been invited by Picabia and
encouraged by his brother-in-law Jean Crotti to come, but he replied that he no
longer wanted to exhibit at all (it was the period he was devoting to chess), and he sent
a laconic cable, "Pode bal," to confirm his withdrawal.[37]

Four days after the opening (opportunity, once again, for a lively crowd), a "Soirée
Dada" was organized. Soupault, his face bootblacked to represent the president of the
republic of Liberia, inaugurated the gallery hanging with great pomp, handing a burn-
ing candle to each participant; Aragon parodied (not too successfully, it seems) a high-
powered evangelist; Ribemont-Dessaignes read a poem (far too long); and Tzara read a
text that Éluard had given to him. In between, there were musical acts and, above all,
the reactions, more or less aggressive, of the audience. Following the intermission, the
first representation of Tzara's play *Le Cœur à gaz* concluded on a note of general hilar-
ity, but the room emptied quickly to the chanting of the *Marseillaise* (the now-ritual
response to Dadaist provocation). Two other evenings were planned but in the end
were not held due to a disagreement with the managers of the venues, who
reproached the Dadas for having sabotaged in the very same location (the Théâtre des
Champs-Élysées) an evening of futurist "bruitist" music by Luigi Russolo (a disruption
that precipitated the closing of the Salon Dada!) and then the opening of the *Mariés de
la tour Eiffel,* by Cocteau and the Group of Six. It was indeed in Dada's interest not to
be confused with futurism or with Cocteau's brand of avant-gardism; but Dada did
find itself confounded by the nasty tricks that economic concerns (simply, the meeting
hall's profitability) could play.[38]

During the summer of 1921, some of the tension among the Parisian Dadaists
seemed to have abated. Tzara joined Ernst and Arp in the Tyrol, and together they
composed *Dada au grand air* to respond to Picabia, who had accused Tzara in *Pilhaou-
Thibaou* of not being the true founder of the movement. Their meetings in Paris were
held in a mood of calm, and in September André and Simone Breton, along with Paul
and Gala Éluard, went in turn to the Tyrol, shortly before Tzara went back to Paris and
after Ernst's departure. It was in order to meet Ernst that they made a double trip: first
to Vienna, where Breton visited Freud—he would write about the disappointing
nature of the visit in the new series of *Littérature* (vol. 1)—then on to Cologne, where

Éluard immediately formed such close ties with Ernst that this friendship soon became a pleasant ménage à trois between the two of them and Gala.

Despite the publication in Paris of *Dada au grand air*, it was Picabia who remained the star of the autumn of 1921, thanks to the double sensation provoked by the canvasses he exhibited at the Salon d'Automne, *Les Yeux chauds* and *L'Œil cacodylate*. The first painting (which worried the jury and the public at first, as the painter had described it as "explosive") was a juxtaposition of the drawing of a speed regulator with a few ironic inscriptions ("Homage to Frantz Jourdain"—president of the Salon d'Automne; "L'Onion fait la force"; "Our thanks to the Salon d'Automne").[39] The second, with its accumulation of signatures and phrases by the artist's friends surrounding the drawing of an eye, was described as "the interior of a pisspot livid with truth" by *Le Canard enchaîné,* to which Picabia replied that his "painting, which is framed, was made to be hung on the wall and looked at, and can be nothing but a painting."[40] Picabia, who had broken with Dada, accomplished a major tour de force by appearing to the audience to be Dada's best representative.

The Arrival of Man Ray

Man Ray arrived from New York in Le Havre on July 14, 1921, and headed straight for Paris, where he was reunited with Duchamp, who had come in June. Duchamp introduced him to the Café Certa, in the passage de l'Opéra. The Parisian Dadaists who met there every day gave him the warmest of welcomes, even though he could hardly take part in the discussion, for his French at the time was less than rudimentary. Once the work he had shipped from the United States arrived, he decided to have an exhibition; it opened on December 3 in the premises of the Librairie Six (5, avenue Lowendal, Paris VII), the bookstore recently acquired by Soupault for his wife.

After studying for a career in architecture, Man Ray exercised a number of professions (apprentice engraver, tracer in a publicists' office, graphic designer for a publisher of technical manuals) and in 1912 began to exhibit a few paintings in a social center run by New York libertarians. Thanks to Stieglitz's Gallery 291, Man Ray discovered European modern art and met with young American artists. He began producing canvases that he described in his autobiography as "somewhat cubist in form, and very colorful." At the same time, the poor quality of the photographic reproductions he had been offered of his paintings drew him to photography. His meeting with Duchamp inspired him to become more daring. From 1917 on, his first paintings were made using airbrush techniques (*Admiration of the Orchestrelle for the Cinematograph* [1919]), and the work he produced was indisputably Dadaist in spirit. He then collaborated on *391,* and in 1921 he published, with Duchamp, the sole issue of *New York Dada*.

Warmly praised by Man Ray's new friends (from Aragon to Tzara), the exhibition at the Librairie Six had thirty-five paintings on display. During the opening Man Ray, who had just drunk a few grogs with Erik Satie to get warm in the neighboring café, assembled the first example of his *Cadeau* (Gift), an iron whose flat underside was spiked with rows of nails; it disappeared in the course of the evening. This evening was typical of Dada events: the paintings were visible only once the balloons hiding them were burst. But nothing was sold, despite the modest prices. Man Ray decided nevertheless to settle in Paris. After having been "persecuted in New York, like a drug addict, like a madman" for of his painting, he appreciated the welcome given him by certain

1

2

3

4

MAN RAY

Monsieur Ray est ne on ne sait plus où.
Après avoir été successivement mar-
chand de charbon, plusieurs fois mil-
lionnaire et chairman du chewing-gum
trust, il a décidé de donner suite à
l'invitation des dadaïstes et d'expo-
ser à Paris ses dernières toiles.
A l'issue d'un banquet quelques-uns de
de ses amis ont cru devoir prononcer
des paroles définitives qu'il est
indispensable de reproduire dans le
catalogue de la première exposition
européenne de Man Ray.

à Man Ray nous devons tous le jour à un mo-
ment d'inattention, et notre vie entière se
souvient à tout moment de ce moment sans
mesure qu'elle imite sans cesse au gré des pas-
sages, des chansons, des capitales, des amis
soudain sur un banc d'avenue; et de la fuite
des idées, pareille à nos visages mobiles, à nos
sens parfaits, que rien ne pourra jamais dis-
traire de leur distraction éternelle.
LOUIS ARAGON

Avec des larmes dans mes dents vides je vous
remercie du printemps poétique. Je compte
vos articles dont vous avez dit tout le monde
ne sait je ne mets comme une fleur sous vos
chaussures je vous sers servir de charbon en
hiver et du chapeau de paille en été. Je sup-
porte les frais de détectives chiens policiers
taxis mais sachez que je suis chaste comme
une fiancée comme une forêt dans l'objectif.
ARP

Les dents empoisonnées de la charmeuse d'é-
chelles au long du chemin vert et de la côte
empoisonnée et la candeur des lions que nous
mangeons avec Max Ernst et Man Ray, celui-
ci et celui-là plus avides que la menthe.
PAUL ELUARD

Je vous aime de force comme vous réunissez
la toupie qui danse et la toupie qui court, vous
trouverez toujours des acheteurs, vous ne
m'ennuyez pas pour fixer le manche maudit au
balai muni d'un marteau.
MAX ERNST

Pensées sur l'art. Après avoir habillé une
moyenne carpe de Seine, vous la coupez par
tronçons (ayez soin d'ôter la pierre d'amer-
tume qui se trouve à la naissance de la tête).
Parmi les artistes, 281 ont été mis en nourrice,
dont un seulement à Paris; et d'autre part, il
est à remarquer que, sur ce nombre, il n'y en
a que 4 qui sont nourris au sein.
MAN RAY

L'oeil bleu des étoiles qui se balance
sur la pointe d'une aiguille
Balaie les larmes du parquet de coeur
Et tous les petits anges suceurs de soeur
Ont fait leur nid dans un chapeau haut de forme
Alors la fleur écarte les jambes
G. RIBEMONT DESSAIGNES

La lumière ressemble à la peinture de Man Ray
comme un chapeau à une hirondelle comme
une tasse à café à un marchand de dentelle
comme une lettre à la poste.
PHILIPPE SOUPAULT

New-York nous envoie un de ses doigts d'a-
mour qui ne tardera pas à chatouiller la sus-
ceptibilité des artistes français. Espérons que
ce chatouillement marquera encore une fois
la plaie déjà célèbre qui caractérise la somno-
lence fermée de l'art. Les tableaux de Man Ray
sont faits de basilic de maïs d'une pincée de
mignonnette et de persil en branches de
dureté d'âme.
TRISTAN TZARA

CATALOGUE DE L'EXPOSITION

1	Portrait	1914
2	Admiration of the orchestrelle	1919
	for the cinematograph	
3	Invention	1917
4	Suicide	1917
5	Anpor	1919
6	Volière	1919
7	Narcisse	1917
8	Seguidille	1919
9	La fatigue des marionnettes	1919
10	Mon premier né	1918
11	Sculpture	1919
12	Portrait	1916
13	Chanson espagnole	1919
14	Silhouette	1919
15	Doigts d'amour	1917
16	Trammutation	1916
17	La clé	1918
18	Légende	1916
19	La mer de dieu	1919
20	Selbstbildniss	1914
21	Intérieur de X	1915
22	Chemin de fer	1916
23	Alcool à brûler	1917
24	Araignée du soir	1914
25	Isadora Duncan nue	1916
26	Mélange	1918
27	L'impossibilité	1917-1920
28	Deux portraits	1923
29	Tempo Club	1921
30	Le Cheval entre les	
	deux extrémités	1917
31	Ziegfield Follies	1919
32	Suie 1	1916
33	Suie 2	1916
34	Percolator	1918
35	Transatlantique	1921

GALERIE
16, rue Pierre
MONTROUGE
Tél. ALE

Parisians—"not everybody of course, but the Dadaists had their little group, and they accepted me, it was marvelous"—even if, to live, he would have to play the professional photographer, producing portraits and art reproduction (of Picabia's work, in particular). But very often in this milieu of artists and writers whose very archives he was creating, his own work went unpaid.

Failure of the "Paris Conference"

In the January 3, 1922, issue of *Comœdia* there was an appeal for the organization of an "International Conference to Determine the Directives and the Defense of the Modern Spirit," signed by Breton, its author, along with Georges Auric, Robert Delaunay, Léger, Amédée Ozenfant, Jean Paulhan, and Roger Vitrac.[41] Although Tzara was irritated by the heterogeneity of the organizing committee—moreover he had claimed any number of times that "Dada is not modern" and therefore did not feel concerned, initially, with the project—the committee rapidly obtained the support not only of Aragon and Éluard but also of Dermée, Malraux, Franz Hellens, Marinetti, Théo van Doesburg, Matthew Josephson, Jean Crotti, Suzanne Duchamp, and others. Tzara was invited to be on the committee, but he declined, "not to encourage an activity I consider harmful to the *search for novelty,* which I like too much, even if it often takes shape as indifference."[42] Breton then persuaded the committee to adopt the text of a press release containing certain terms that, clearly, were poorly chosen: public opinion was warned to beware of "the scheming of a certain person, well known as the promoter of a 'movement' which originated in Zurich and needs no further elucidation, and *which today no longer corresponds to any reality.*" Besides the fact that Dada was thus buried without protest and that Tzara's role therein was diminished, Breton set himself up for accusations of xenophobia. Tzara immediately counterattacked, and on February 17 Breton was disowned by the committee members, as well as by Ribemont-Dessaignes and Éluard, while Picabia lent him support of a somewhat ambiguous nature. These incidents were the cause of defections (Jacques Rivière announced the withdrawal of the *La Nouvelle Revue française*) and the project failed.

The controversy between Breton and Tzara did not cease there, but it already meant that a break between the Tzara faction and the Breton faction had become inevitable.[43] It was now impossible for Dada to assume the project for the conference as first envisaged by Breton, and it was proof of the permanence of a number of Breton's interests that were incompatible with the systematically critical—not to say, nihilistic—dimension typical of Dada. For Breton and his close allies (who, like Éluard, did not hesitate to stand by him even if the turmoil caused by the plans for the conference, along with Breton's tactlessness, did cause a temporary rift between them), certain works or poetic and artistic ventures did not lose their fascination despite the Dadaist agitation. This was certainly the case with Lautréamont, Jarry, and Rimbaud but also with Picasso, De Chirico, and the Douanier Rousseau. To this almost "ancient" admiration, one could now add Ernst and Man Ray, who were discovered in the midst of the Dadaist environment but whose work indicated a chance to escape a strictly negative attitude. Duchamp also joined in: Breton had met Duchamp during his stay in Paris (from June 1921 to January 1922), and he seemed exemplary, in particular for his sublime indifference to all the factions that had come on the scene (cubist or Dadaist), as well as for the manner in which he surpassed narrowly artistic preoccupations in order to work

toward a primarily intellectual definition of creativity. The impact of their encounter would only become public with the publication, in number 4 (September 1922) of *Littérature* (the new series), of an article by Breton simply entitled "Marcel Duchamp," which revealed the identity of the person in whom their hopes were now placed. "This name," affirmed Breton from the start, "is a true oasis for all those who are still *searching,* and may well lead, with a particular intensity, the assault capable of liberating modern consciousness from this terrible mania of fixation which we do not cease from denouncing." Reminding his readers that Duchamp had successively avoided cubism, futurism and even Dadaism, Breton underlined that with the production of his ready-mades, Duchamp had proclaimed the independence of the "personality of choice"; he intended to prevent "any future systematization of Duchamp's attitude, such as it cannot help but appear to simple people, with its 'love for novelty.'"[44] Breton concluded his portrait by pointing out that "what gives Duchamp strength, and has saved his life when in the presence of cutthroats, is above all his *disdain of the thesis,* which will never cease to astonish those less favored than he." Thus Duchamp owed his exemplary status to his lightness and to the way in which he avoided turning his skepticism into dogma or his irony into a postulate: that is what allowed him to become—paradoxically, if you like—the contrary of Parisian Dadaism, particularly once Dadaism, as promoted by Tzara, had seized up and was no longer effective except through negation.

This intellectual and artistic affinity was confirmed by Breton's acquisitions at the three sales of the Kahnweiler estate, held between May 1921 and July 1922, along with the recommendations he made to the couturier Jacques Doucet. Hired as artistic adviser and librarian, Breton was entrusted with, first of all (from December 1920), the composition of a monthly information letter, just like his predecessors Pierre Reverdy, Max Jacob, André Salmon, and André Suarès; then, from June 1921 on, he was assigned the task of putting together the most important collection possible. In both of these assignments, the same names came up again and again: Picasso, Braque, Derain, and Léger, to which were added the Douanier Rousseau (for Doucet—an acquisition, through Delaunay, of *La Charmeuse de serpents*) as well as Man Ray, Ernst, Arp, and Duchamp himself. It is a matter of record that Breton long urged Doucet to purchase *Les Demoiselles d'Avignon,* as if he had foreseen the "undeniable historical importance" of the work and that it would, for that very reason, be "regrettable to see it leave the country."[45] Along with selections of artwork, the lists he compiled—with the help of Aragon who had also been hired by the couturier in February 1922 to put together a library—show, in the words of François Chapon, that "the collection of books and the collection of paintings are linked by a similar receptivity to movements of a common inspiration: there is an osmosis between the results of differing methods, both fusing to create a mentality which can only be affirmed by their fusion."[46] In retaining those plastic or literary works that together formed the outline of an authentic coherence, Breton and Aragon were practically establishing a panorama of the "modern spirit," which the failed conference had been unable to define. These activities, however, were organized—at least partially—while the Dada events were in full swing with a very active participation. As the Dada events seemed to be doomed to repeat themselves, it also seemed inevitable that Dada, at least in its Parisian version, would be abandoned.[47] The manner in which Breton spoke of Dada in 1952 might seem severe: "Clearly, methods for astounding and 'cretinizing'—in the Maldororian sense of the word—had been exploited ad nauseam, along with, above all, the danger-free provocation per-

1

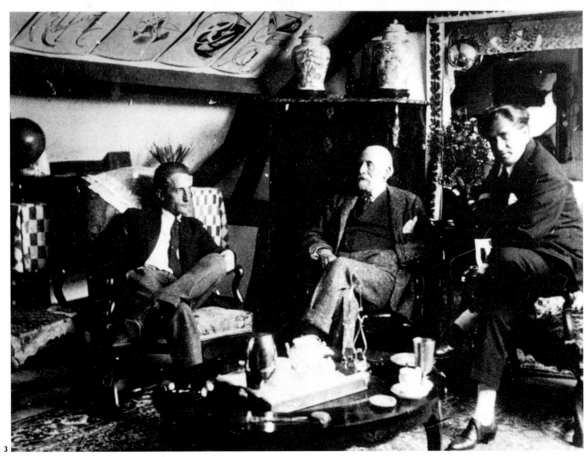

2

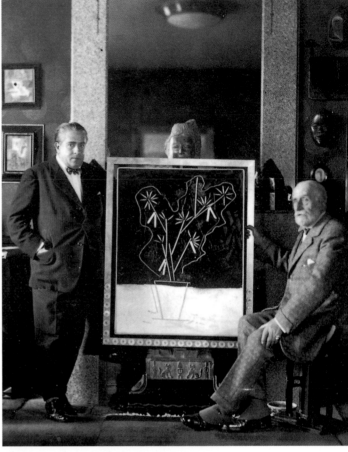

4

3

1 Marcel Duchamp as Rrose Sélavy; photograph by Man Ray (1921).

2 Sophie Tauber and Jean Arp in their studio, with Sophie's puppets (Zurich, 1918).

3 Marcel Duchamp, Jacques Doucet, and Francis Picabia at the Tremblay, 1922–24.

4 Francis Picabia and Jacques Doucet at the collector's house in Neuilly-sur-Seine in 1927, sitting beside *Brins de paille et cure-dents* (Blades of straw and toothpicks; 1925).

5 Louis Aragon in 1922. Photograph by Man Ray.

6 Philippe Soupault, circa 1925.

7 Paul Éluard in 1922. Photograph by Man Ray.

8 Georges Ribemont-Dessaignes, circa 1922. Photograph by Man Ray.

9 Jacques Rigaut in 1922. Photograph by Man Ray.

10 Benjamin Péret, circa 1920–25.

11 André Breton in 1921.

12 Georges Malkine in 1924.

5

6

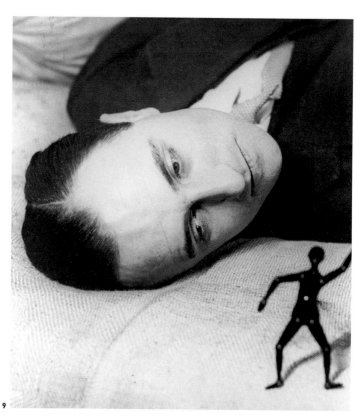
9

7

10

12

8

11

fected in Zurich or elsewhere. Every time a Dada event was planned—by Tzara, naturally, who never grew tired of them—Picabia got us together in his drawing room and *ordered* us, one after the other, to come up with *ideas* for the event. In the end, the harvest was not very bountiful. The pièce de résistance, invariably, was reserved for the first, or second, or umpteenth *Aventure de M. Antipyrine* by Tristan Tzara, performed by his friends who were forever cramped inside tall Bristol board cylinders. There were at least two or three of us who wondered if this battle, like the one over Hernani, begun again indulgently every month and whose tactics very quickly became stereotyped, was enough in and of itself."[48] This evocation points toward a double disappointment: that which, obviously, was produced by repetition but, more significantly, that which, in the hopes that Dada would be able to come up with something, had delayed examination of what was beginning to take place in the pages of *Littérature*. This could be either the quest for the validation of writing (through Vaché's irony, the disturbing dialectic of Lautréamont, or the absence of a traditional response revealed by the survey "Why Do You Write?") the analysis of the contribution of automatic writing of which *Les Champs magnétiques* had proven the fruitfulness, to which it was fitting to add whatever could be retained from Freud, as well as the need for a more precise definition of what constituted intellectual dignity or the unity of one's career ("The Barrès Trial"). These concerns were momentarily eclipsed by Dadaist agitation, and during that time, Breton and his close colleagues found themselves serving principles that, whatever they may have thought of them initially, were not altogether their own.[49]

Littérature at a Distance from Dada

The debate provoked by the project for the Paris Conference and the tension created among those who were partisans of Tzara or of Breton only served to accelerate the distancing process for Breton, who in "After Dada" (*Comœdia* [March 2, 1922]) referred to Dada as a phenomenon whose time had passed.[50] After once again evoking the exaggerated importance that Tzara assigned himself in the paternity of the movement,[51] he affirmed that "[Dada's] funeral, around May 1921, gave no cause for a fight. There were few people in the procession, and they followed in the steps of the adepts of cubism and futurism. Dada, even though it had its hour of fame, so to speak, caused few regrets: in the long run, its omnipotence and tyranny had made it unbearable." The article praised the "marvelous detachment from all things," of which Picabia was the prime example, and ended on a note of absolute gravity: although there was no intention of "acting as a judge," it remained vital nevertheless to continue the search for "a place and a formula." "That is why," remarked Breton, "there is now a great void which we must make within ourselves": the confession of a lasting error of orientation cannot be made lightly, but at least he revives the possibility of a new and deeper commitment, elsewhere. "Even if all the ideas," concluded Breton, "were of a nature to disappoint, I would still put myself forward, by beginning to devote my life to them."[52]

However, that did not constitute a plan of action: in the course of the two years that followed; the constitution of a unified group would come about with much hesitation, periodic doubt, and even anxiety at times. For although Breton and his close colleagues (who were to be found in the café, holding almost daily meetings that took on the semi-institutional air they would acquire during the surrealist movement, for they corresponded more and more frequently to a need to clarify certain things) were

becoming increasingly aware of what they were leaving behind, they were far from knowing exactly what new direction they might take.

The publication of two further texts in the tone of the article in *Comœdia* was proof of this, confirming that the break had indeed taken place, as if it were still necessary to emphasize what was a foregone conclusion: in "Lâchez tout" (Drop everything) Dada, accused of philosophical mediocrity, was once again referred to as a thing of the past, which "had been for some people merely a way of sitting."[53] But leaving Dada behind opened onto a mental void, an absence of values: "Forgive me for thinking that, unlike ivy, I will die if I become attached." Whence the final invitation to a general letting go, to an aimless, directionless wandering:

> Drop everything.
> Drop Dada.
> Drop your wife, drop your mistress.
> Drop your hopes and your fears.
> Scatter your children in a corner of the forest.
> Drop your prey for the shade.
> Drop if need be your comfortable life, and whatever you planned for the future.
> Head off along the road.[54]

Even if one allows for rhetorical exaggeration (Breton, who had just got married, hardly seemed ready to drop his wife), there is a sense in this demand of a deeper element of dissatisfaction, of a disinterest in whatever is offered or imposed.

In "Clairement," which defined the evolution of the periodical (the first three deliveries of the new series, the cover of which was adorned with a top hat, courtesy of Man Ray, were considered to have "tried without any great success to create a diversion"), it was once again Tzara's role that was diminished: Breton had merely transferred onto Tzara "some of the hope which Vaché himself would never have disappointed."[55] Above all, there was a distancing from certain artists who were hovering close to "collapse," out of a concern for the pure and simple future of their artistic profession: Matisse, Valéry, Derain, Marinetti—while Cocteau was saluted as possessing "the genius of misinterpretation." Others, however, such as Picabia, Duchamp, Picasso, Aragon, Éluard, Soupault, and some more recent adepts—Jacques Baron, Robert Desnos, Max Morise, Roger Vitrac, and Pierre de Massot—managed to avoid a debasement that was not altogether generalized.[56] Breton, in passing, gave poetry a greatly expanded definition: it "emanates to a greater extent from the life of men, whether they are writers or not, than from what they have written or from what one supposes they might write." But he went on to say that the life of man is nothing other than "the manner in which he seems to have accepted the unacceptable human condition." Thus, a relation between writing or art and "life" was slowly being formulated, a relation that should lead beyond Dada, viewed with hindsight as still too eager to change artistic formulas alone. "L'Esprit nouveau," which appeared in the first of the new series of *Littérature,* pointed out the direction that relation should take: apparently, this short text related nothing more than the encounter on rue Bonaparte, in front of the gate of Saint-Germain-des-Prés, that Aragon, Breton, and Derain all had with one and the same young woman whose behavior was most strange. Beyond the coincidence and the surprising interest that all three men expressed in this enigmatic creature—her clothes, her manner, the impression she gave of searching for something—there was a

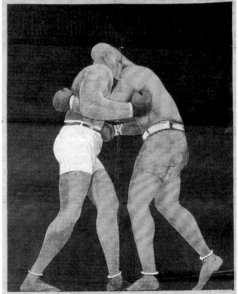

PLAZA DE TOROS MONUMENTAL
DOMINGO 23 ABRIL DE 1916
A las 3 de la tarde
GRAN FIESTA DE BOXEO
en la cual tendrán lugar
6 interesantes combates entre notables luchadores, 6

Finalizará el espectáculo con el sensacional encuentro entre el campeón del mundo

Jack Johnson
Negro de 110 kilos
y el campeón europeo

Arthur Cravan
Blanco de 105 kilos

En este match se disputará una bolsa de 50.000 ptas. para el vencedor.

Veanse programas

PRECIOS (incluidos los impuestos)

SOMBRA Y SOL Y SOMBRA

sense that the significant was about to find a formula; it escaped, yet again, but at least the desire to understand was there. A chance encounter, the brief suggestion that there was a deeper meaning—all concerned life as it could be reconstructed by writing. What might initially seem to be only a simple factual anecdote allowed glimpses of a background infinitely richer than the anecdote itself. It would be in this fashion, not in a written or painted work of little importance, that the richest significance would take shape, in the web it should be possible to weave between the work and that which underpins it and justifies it: the everyday, which provides the initial pretext but which gives of itself to be modified by the work, at the conclusion of a dialectic of which Dada had no knowledge and was even, it seemed, incapable of conceiving.

In November 1922, Breton and his wife accompanied Picabia and his companion Germaine Everling to Barcelona. The painter, who had been designing increasingly disturbing cover art for *Littérature* from number 4 on, was holding an exhibition in Barcelona, and Breton wrote the preface to the catalog. For the event, he gave a talk— "The Characteristics and Nature of Modern Evolution"—in the Catalan capital in which he explained that the intentions behind the failed conference in Paris had not disappeared.[57] After describing the "theatrical gestures" of Jarry and Arthur Cravan, who provoked their audience with their attitude during their speeches, Breton declared that the "sense of provocation is still what is most appreciable in this matter. Truth will always improve if it uses an outrageous stunt to express itself." But he immediately went on to declare that whatever his point of view, he would only keep to it to the extent that he had not yet managed to convince others to share it. If he had declared that he would, along with a few close friends, maintain "a certain aristocracy of thought," it would be through a greater reliance on the communication of "sensations" rather than "the persuasive virtue of ideas." Evoking "a few individuals for whom art . . . has ceased to be an end in itself," he referred to the failure of the Paris Conference and deplored the fact that the expression "modern spirit," too hackneyed, had proved to be inadequate to describe the pursuits that interested him. Drawing a broad outline of the history of the trends that had followed symbolism and impressionism, Breton included cubism, futurism, and Dada in a "more general movement of which we cannot yet gauge the meaning or the amplitude." He then went on to analyze the contributions of painters and poets who belonged to this general movement. First and foremost came Picasso, whose decisiveness "is of interest to thought and life to the highest degree," well beyond mere painting. He then went on to talk about Picabia and Duchamp whose activities, "complement each other, and seem [to me] to be truly inspired." Picabia's exhibition of drawings opening the next day actually dealt with "some of the inner landscapes of a man who had set off long before in search of his own pole." He then praised De Chirico, who even if he seemed now to have made a sad return to the style of the academy, had known how to express "the irresistible and unjust voice of seers" in his paintings. Finally, he presented Max Ernst and Man Ray; Man Ray enabled one to evoke an art of objects, "more richly surprising than that of painting, for example," whose foundation had been established by Picasso's constructions, by Man Ray's rayographs, or by Duchamp's cage decorated with pieces of marble (titled *Why Not Sneeze, Rrose Sélavy?*). "These six living men," said Breton in conclusion to his overview of new trends in plastic arts, "have no antecedent."

This was not the case where poetry was concerned, since Lautréamont, Rimbaud, Germain Nouveau, Jarry, and Apollinaire had shown the way. Even if Jarry and Apolli-

1 Robert Desnos in André Breton's studio. Photograph by Man Ray, 1922.

2 Georges Malkine.

3 Roger Gilbert-Lecomte.

4 Paul Éluard and André Breton.

5 Paul Nougé, *Les Profondeurs du sommeil* (The depths of sleep; 1929); excerpt from the series *La Subversion des images*.

naire had "behaved as professional men of letters," Jarry, in any case, had also made of his life a "fantastic flourish of ink and alcohol," and Apollinaire, although he was "still a specialist," had shown proof of "a fairly great relative liberty" and remained, in a sense, exemplary. After these "ancestors," the first living example was Pierre Reverdy, whose life and work certainly did not lack imagination.

Vaché and Cravan were then recognized as belonging to "phenomena precursory to Dada," but they were also responsible for the fact that "we had, perhaps, expected more of Dada than it knew how to give us." Dada's shortcomings were obvious from that point on: the movement had not understood the one thing that would "enable [us] to escape, momentarily at least, from the terrible cage in which we were struggling"; "it is revolution, an ordinary revolution, as bloody as one likes, which I am calling for even today, with all my strength." The sudden appearance of the term "revolution" after considerations about painting and poetry that seemed less immediately political, may have surprised the listeners in Barcelona; it showed how much it was life itself, and the conception one could have of life, that were at stake.[58] Nevertheless, it was this "revolution" that directly determined certain expressions in the lines that followed: "It would not be a bad thing," warned the speaker, "to reinstate the laws of the Terror, for the spirit"—a terror for which Tzara seemed to have kept, at his discretion, "some of the machines," before his "fine assurance" proved itself to be incapable of being "equal to a true coup d'état."[59]

Thus Dada's disappearance was confirmed once again, and all that remained was to take a census of those who had now set off down a different path—unlike Soupault, who was "perhaps condemned to remain Dada's plaything just as we saw Jarry remain that of Ubu."[60] There were not many of them: the only ones who were mentioned were Aragon, Éluard, Péret, Baron, and Desnos.[61]

Sleeping Fits

Before Breton and Picabia's stay in Barcelona, experiments into hypnotic sleep had begun in Paris, and a first account appeared in *Littérature* (number 6) in November 1923, entitled, "The Arrival of the Mediums."

At the very time the conference in Barcelona was speaking only in the most general terms of a movement capable of proposing an afterlife for cubism, futurism, and Dadaism, "The Arrival of the Mediums" clarified the meaning that Breton and his friends ascribed to the word "surrealism" at the time: "By surrealism we have decided to refer to a certain psychic automatism that corresponds fairly well to the dream-state, a state to which it is, these days, quite difficult to assign limits." Two major possibilities were described: first of all, the phrases one hears in half-sleep that appear to be "poetic elements of the first order," and of which the composition of *Les Champs magnétiques*— governed by the will to "reproduce, voluntarily . . . the state where dreams were formed"—represented a certain milestone; second, the relating of dreams, on the condition that they be clearly stenographic, at a remove from any effort of stylization. The first possibility however, according to Breton, did jeopardize "the murmur which is sufficient unto itself" the moment the two authors of *Les Champs magnétiques,* however briefly, became attentive to the possibility of critical reaction with relation to the text they produced; as for the second method, it had the shortcoming of making use of memory, and "the question hardly seemed to be making progress."

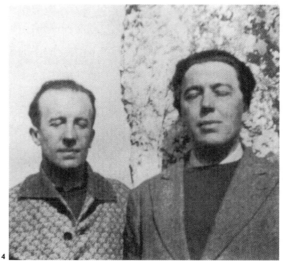

Max Ernst, *Au rendez-vous des amis*
(The gathering of friends; 1923), 52
× 78 in. (130 × 95 cm). Hamburg,
private collection. *1*, René Crevel;
2, Philippe Soupault; *3*, Jean Arp;
4, Max Ernst; *5*, Max Morise;
6, Fyodor Dostoyevsky; *7*, Raphael;
8, Théodore Fraenkel; *9*, Paul Éluard;
10, Jean Paulhan; *11*, Benjamin
Péret; *12*, Louis Aragon; *13*, André
Breton; *14*, Johannes Theodor
Baargeld; *15*, Giorgio De Chirico;
16, Gala Éluard; *17*, Robert Desnos.

Thus it was on the heels of a double disappointment, which confirmed that any intrusion of conscious elements would render the influx of surrealist material at least partially sterile, that a third solution was put forward, "where a substantially smaller number of the causes of errors intervene, which is subsequently a most thrilling solution" and which caused all who witnessed it to marvel. René Crevel had been partially initiated into spiritism by one of his girlfriends, who recognized the qualities of a medium in him, and so he began to teach the *Littérature* circle the principles of hypnotic sleep. He gave a first demonstration of its possibilities on September 25, 1922. Subsequently Desnos, then Péret, took part in the experiments, proclaiming, writing, and answering the questions of those who were present. On October 7, Crevel improvised a long "story" that demonstrated a singular virtuosity.[62] Desnos broke the lead of the pencil he used to write with, and Péret, persuaded that he could see water, "threw himself onto the table on his stomach and pretended he was swimming."

In October Breton invited Man Ray to take photographs of these sleeping-fit sessions, particularly of Desnos, and he clearly and unambiguously stated that in order to record such phenomena there was no need to subscribe to spiritualist theses (communication with the dead, etc.). The only important thing was their experimental nature. And he added that Éluard, Ernst, Morise, and he himself, despite all their good will, had never been able to fall asleep in the required manner.

In November the experiments continued in Breton's absence but took on a progressively disquieting nature: Péret may have continued to speak in amiable tones, but Crevel, during one session, invited the participants to join him in a collective suicide, and Desnos acted very aggressively toward Éluard, running after him with a kitchen knife. Not everything was this dramatic, however; borrowing the personality of Rrose Sélavy, Duchamp's female alter ego, Desnos invented a series of word games that was published in *Littérature* (no. 7), preceded by "Les Mots sans rides" and followed by "Rêve," both by Breton: "Who is dictating to the sleeping Desnos the sentences we will read and in which Rrose Sélavy is the heroine; is Desnos's brain joined, as he claims, to Duchamp's, to the degree that Rrose Sélavy only speaks if Duchamp's eyes are open? Given the present state of the matter, it is no longer up to me to make that clear. One should take note that when he is awake Desnos is incapable, as we all are, to go on with his word games, even with sustained effort." Even if it seemed to open new roads toward a native language, liberated from any conscious control, hypnotic sleep created more problems than it offered solutions. Alarmed by the harrowing form it could sometimes take, Breton decided to end the experimentation in the first weeks of 1923; it had not lasted for long, but at least it had the merit of reviving the quest and of showing that it was still necessary.

Which Meeting, and for Which Friends?

In December 1922, Max Ernst, finally settled in Paris since August, completed his painting *Le Rendez-vous des amis*. The painting portrayed, against a mountain backdrop, the people whom he considered to be of some importance: Crevel, who seems busy manipulating the elements of a little theater; Soupault, Arp, and Ernst himself, all sitting on one of Dostoyevsky's knees; Max Morise, Raphael, Theodore Fraenkel, Éluard, and Jean Paulhan sitting on Dostoyevsky's other knee; Péret wearing a monocle, Aragon and Breton sporting a short red cape with a blue lining, Baargeld, De Chirico, Gala

Éluard—the only woman—and Robert Desnos. Although not all of these people were equally friends with the members of *Littérature,* and others who were close to them were actually absent—Duchamp, Man Ray, and Picabia, among others—this group portrait is interesting nevertheless in that it gives an idea of the indecision, at the end of 1922, in which the group found itself: frozen in positions that reveal little, they hardly seem ready to agree on a common agenda.[63] Everyone is looking in a different direction, even if the majority are looking at the spectator; Gala seems poised to walk off the stage, Éluard seems to concentrate on himself, Crevel turns his back on everyone, and so on. If "friendship" was the point of the gathering, as stated in the title, it was still difficult to see where this affective community would lead. It is possible that the allusions to the gestures of deaf-mutes prefigured, as affirmed by W. Spies, "the surrealist attempt to express an inner voice by means other than words," but this might also reveal the involuntary confession of a difficulty of communication among the friends gathered there. After the period of Dadaist effervescence, the movement that would encompass cubism, futurism, and Dada and to which the speech in Barcelona had referred had apparently not yet been formulated.

At the same time, Dada was officially chronicled in contemporary histories of literature. Although René Lalou only mentioned Aragon, Breton, and Tzara, before concluding the few paragraphs devoted to them with considerations on Cocteau of all people, Paul Neuhuys seems fortunately to have been better informed, even though he was only interested in the French sector of the movement.[64] He placed Dada in an intellectual context characterized by relativism, in which the teaching of Einstein, Henri Poincaré, and Henri Bergson converged, and the chapter he devoted to the movement was not lacking in judicious formulas: "Dada does not proceed by the usual paths of reason. Dada is a radical disorientation of common sense," he affirms with regard to Tzara. In talking of *Les Champs magnétiques,* he sketched a rapid but pertinent portrait of Breton: "Nothing appeals to André Breton anymore. Words have become rusty and things have lost all power of attraction. He sees the world as a 'vacant lot.' He has no appetite for the 'rotting delights' which life offers." For Soupault, the "idea of space is an illusion which matter imposes upon our senses. Everything happens on one and the same plane. He is persuaded that the Gaurinsankar juxtaposes Notre-Dame." As for Aragon, Neuhuys pointed out that he "had not renounced all scruples where art was concerned," and conceded that *Feu de joie* (published three years earlier) expressed the sacrifice of "all the vain acquisitions of the mind for a new order of things which will arise from the absurd suggestions of one's consciousness." He pointed out Éluard's effort to obtain "a complete transformation of language," as well as his prejudice in favor of simplicity. Neuhuys noted Picabia's "complete absence of moral sense," and opined that his Dadaism, suspicious with regard to any values, was physiological, so to speak. He rounded out his overview with Clément Pansaers, "the only representative of Dada in Belgium," who "makes one think of a Des Esseintes responding to the maddest audacities of the new man."[65] Neuhuys concluded his chapter by noting that Dada was a "return to the disorganized" or "the art of being likable in an era when all superiority has become unbearable and where all human grandeur seems facetious": Neuhuys surely did not mean to describe the relative failure of the movement in this way, for Tzara and Breton were in quest of something quite different from "the art of being likable"!

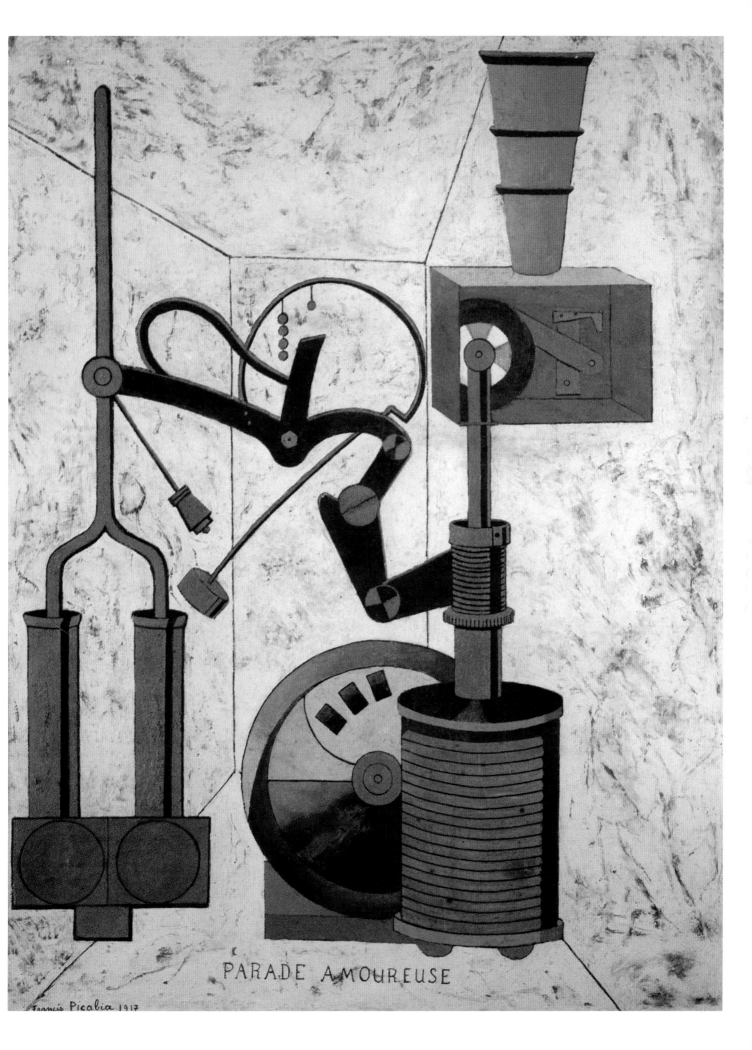

PARADE AMOUREUSE

Francis Picabia 1917

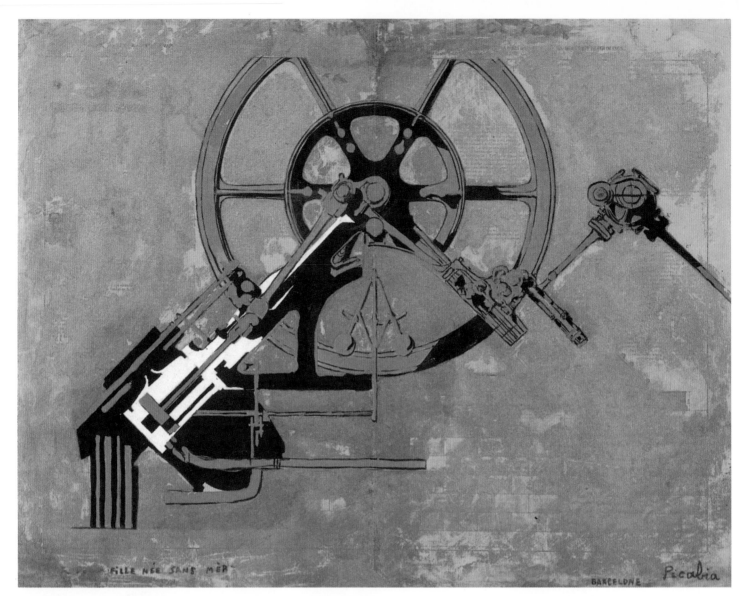

FILLE NÉE SANS MÈR BARCELONE *Picabia*

PORTRAIT A L'HUILE DE RICIN !

M'AMENEZ-Y

PONT-L'EVÊQUE FRANCIS PICABIA

SERPENTINS

Picabia

Previous page: Francis Picabia, *Parade amoureuse* (1917); oil on canvas, 38 1/4 × 29 1/2 in. (96.5 × 73.7 cm).

Above: Francis Picabia, *Fille née sans mère* (Girl born without a mother; 1916–17); gouache and oil on paper, 20 × 26 in. (50 × 65 cm) Private collection.

Far left: Francis Picabia, *M'amenez-y (Portrait à l'huile de ricin!)* (Take me there [portrait in castor oil!]; 1919); oil on canvas, 57 × 41 in. (142.5 × 102.9 cm) Museum of Modern Art, New York.

Left: Francis Picabia, *Serpentins II* (1921–22); oil on wood, 24 1/2 × 18 1/3 in. (61 × 45.8 cm).

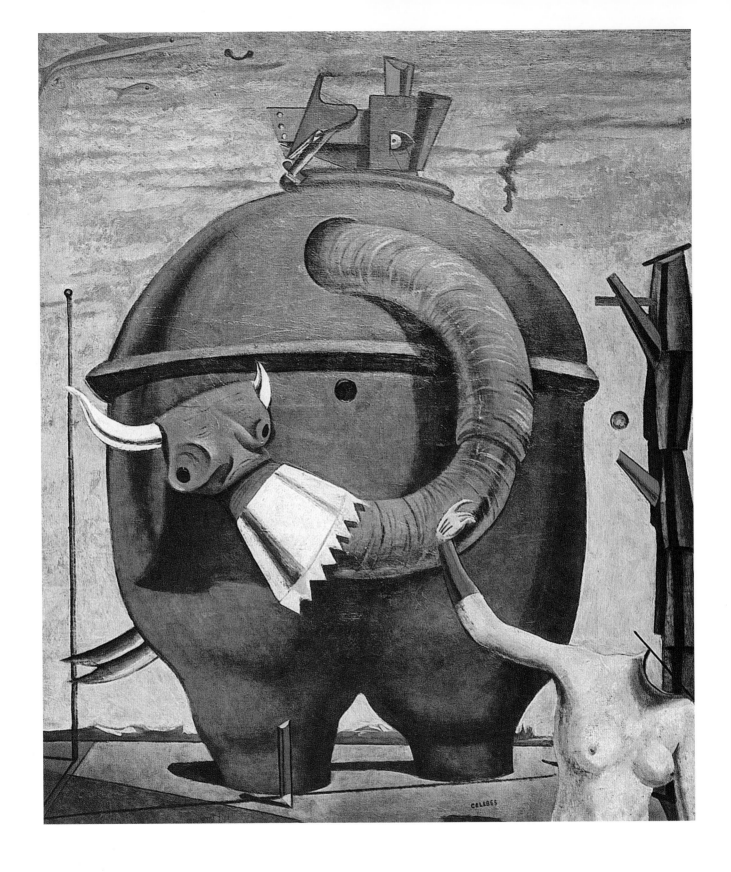

Facing page: Max Ernst, *L'Éléphant
Célèbes* (1921); oil on canvas, 50 ×
42⁴/₅ in. (125 × 107 cm). Private
collection.

Above: Max Ernst, *La Puberté proche
. . . ou les Pléiades* (Approaching
puberty . . . or the Pleiads; 1921);
"surpeinture," gouache on photog-
raphy, 9⁴/₅ × 6²/₃ in. (24.5 × 16.5 cm).
Private collection.

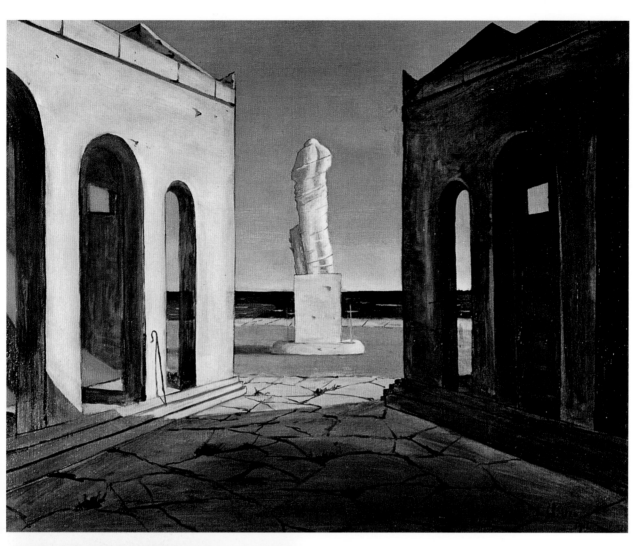

Facing page: Giorgio De Chirico, *Le Mauvais Génie d'un roi* (The king's evil genius; ca. 1914–15); oil on canvas, 24²/₅ × 20 in. (61 × 50.2 cm), Museum of Modern Art, New York.

Above: Giorgio De Chirico, *La Méditation automnale* (Autumnal meditation; 1910–11); oil on canvas, 24²/₅ × 20¹/₅ in. (61 × 50.5 cm), Museum of Modern Art, New York.

Left: Giorgio De Chirico, *Self-portrait* (1920); oil on canvas, 20 × 15⁴/₅ in. (50 × 39.5 cm), Staatsgalerie Moderner Kunst, Munich.

Above: Jean Arp, *Larmes d'Enak:
Formes terrestres* (The tears of Enak:
earthly forms; ca. 1916–17); painted
wood, 16⁴/₅ × 11¹/₅ in. (42 × 28 cm),
Kunstmuseum, Basle.

Right: Jean Arp, *La Planche à œufs*
(The egg board; 1922); painted
wood, 30 × 39²/₃ in. (75 × 99 cm).
Private collection.

Last Dadaist Fireworks

On December 11, 1922, the *Littérature* group, at Breton's suggestion, attended a performance of *Locus Solus* by Raymond Roussel, a play that the vast majority of the audience considered incomprehensible, but the group did not fail to show its support for the writer's strange genius in the noisiest fashion possible. During the evening at the Théâtre Antoine, those still considered Dadaist by the public showed for the first time their approval of a contemporary work that was outside Dada. But the act that followed Roussel's after the intermission was a patriotic one (*La Guerre en pantoufles*), by Gabriel Timmory and Félix Galipeaux, clearly of a very different inspiration, and this time Breton and his friends were loud and clear in voicing their utter disgust. The performance was interrupted, the manager of the theater called the police, and everyone (spectators, actors, stage hands) tried to get back at the troublemakers, but finally everything was resolved without too much difficulty.

It was not until July 1923 that Dada gave its final grand fireworks display in Paris. This time the aim was not so much to make a massive attack on taste and the public as to reveal the internal crisis from which the movement was dying. The performance of Tzara's *Cœur à gaz,* which was the pretext for the event, put the participants in a paradoxical situation: by integrating his play into a genuine spectacle and by conceiving a "Soirée du cœur à barbe" (Bearded heart evening) destined to be appreciated (or not) in normal conditions of receptivity, Tzara certainly did not aim to reproduce the deliberately shocking representations of 1921.[66] He intended, rather, to present his text in a body of works that constituted the avant-garde of the era—although it was not altogether clear who this avant-garde was: once again, Cocteau was on the program, and what was more, in the company of Éluard, Soupault, and Baron, who had not been consulted. On the contrary, it was because they wanted to remain faithful to a spirit of intransigence and were determined to make no compromises with art or literature— even in a supposedly progressive version—that the people from *Littérature,* Éluard first and foremost, had every intention of preventing the evening's event from unfolding in a normal fashion, and this gave their public appearance a Dadaist slant, even though their intentions were now totally different from those that might have motivated them a year or two previously. As Roger Vitrac explained on August 4,

> If Mr. Tristan Tzara thought he had to dress up his play with costumes by Madame Delaunay and cubist sets, if he wanted to give it to the audience in a potpourri of works by so-called 'modern' celebrities, it was with an undeniably artistic aim, to which his former friends could no longer subscribe. They had only one method at their disposal: to sabotage not only the performance, but also to announce their differences of opinion, publicly and irremediably. The best way was to put Dada in the theater and systematically to provoke both the author and the actors. And that is what they did.[67]

The first incident occurred when Pierre de Massot came on stage to read the list of a number of famous dead people, a list that included not only Gide but also Duchamp, Picabia, and Picasso (who, sitting in the audience, was outraged). Breton, furious, came up on stage to defend Picasso, and after an initial exchange of blows, struck Massot with a cane and fractured his left arm (this did not stop him from later going back on stage). Breton, Desnos, and Péret were forced to leave by the police, who may have

been called by Tzara; at any rate they had been ready to intervene. The rest of the evening's performance was met with relative indifference by the audience, even when Aragon and Éluard protested the reading of a poem by Soupault. Éluard began to demonstrate again, demanding explanations from Tzara on Breton's expulsion, once the actual performance of *Cœur à gaz* began (it seems it was not very exciting: the actors, including Crevel, Baron, and Massot, were cramped by Sonia Delaunay's cardboard costumes, and the direction and projection of the text in "zaum" added nothing to the play).[68] The police reappeared to calm him down, and a fistfight broke out between the officers, backed by employees of the theater and a few spectators, and Éluard's friends, Aragon, Georges Limbour, Max Morise, Marcel Noll, and Yvan Goll, who were eager to protect him. Relative calm returned, then Éluard again began to call for Tzara, and when Tzara appeared, Éluard hit him in the face and also turned on Crevel and Baron. A new fight broke out, and the play ended "quickly and miserably," while the discussions and altercations continued outside the Théâtre Michel after the end of the performance.[69]

Thus the break—no longer merely a break with Dada—with Tzara was finalized. But the evening also caused some brief tension within the *Littérature* group itself: Crevel and Baron were implicated, since they had taken Tzara's side, "objectively," by taking part in the performance of his play. If one attempts to relativize such declarations of hostility, not forgetting in the meanwhile the strength of the emotions that fueled them, one is forced to admit that the resulting disappointments were all the more pronounced for having corresponded to hopes that were as charged emotionally as they were intellectually.

Tension and Waiting

With the exception of these two events in December and July, those who, in 1923, already referred to themselves as "surrealists" behaved with a discretion that confirmed the difficulties they were encountering in their search for something to unite them more authentically than their shared refusal.

The table of contents of the four issues of *Littérature* published in 1923 does, however, indicate lasting admiration for certain artists (Rimbaud, Nouveau, Lautréamont, and Picasso), as well as the existence of an almost constant nucleus of contributors: Aragon, Éluard, Breton, Péret, Desnos, and Picabia, present in each issue, were joined by Baron, Vitrac, and Ernst, followed by Joseph Delteil (beginning with no. 10 [May 1923]), and then Limbour and Morise (October 1923). But even though, incontestably, Picabia's pieces preserved their ironic aggressiveness (colored, surprisingly, by lingering Dadaist hues), the poems, articles, aphorisms, and notes published evinced a certain vagueness and, despite everything, were evidence more of a sort of literary dandyism than of a true collective position. Number 11–12 (October 1923), which opened with an anonymous piece, was, moreover, "especially devoted to poetry," making it difficult for the reader to grasp what the periodical's editor and his collaborators really wanted: now, only a few months after shouting in protest against any form of coherent expression, did they not seem to be reverting to acceptable modes of expression? It was easy to forgive them a few grammatical distortions and the pretense of a scornful attitude:

André means reef,
Paul means etc.

but your name is dirty:
Be on your way!
 (Desnos)

Or to cultivate irreverence, as Péret did in "Un oiseau a fienté sur mon veston salaud":

A shadow, quote block:

The wireless bit him on the right foot
and a bear bit him on the left hand
As he was young he didn't die
He got a medal
Was made an ambassador
Paul Claudel

It was easy, that is, as long as they still proved they could practice good old rhyme schemes (Vitrac), or publish "La Chanson du troubadour" by Germain Nouveau, or rejuvenate the elegy, as Eluard did so eloquently:

A shadow
All the world's misfortune
And my love thereupon
Like a naked beast.

In this "anthology," it seems as if Breton himself is close to the well-bred sonnet ("L'Herbage rouge") or that Delteil is proposing, with "Arétins," a few amiably licentious verses that would not cause the admirers of Pierre Louÿs to blush. The most disturbing thing in this poetry issue remained the double central page, entitled "Erutarettil," where the names of artists of varying degrees of fame were printed in apparent disorder (Breton and Aragon singled out a good number of them for Doucet, in order to put together a library collection of those texts that contributed to "the formation of our generation's poetic mentality"). There seemed to be a desire to modify the cultural hierarchy: poets of greater or lesser notoriety, marginal writers, philosophers, a psychiatrist, representatives of the modern spirit, and even a character from a popular novel figured there willy-nilly, but the reader could quickly discern a hierarchy indicated by the size of the type. Lautréamont stood to the fore, on an equal plane with Sade, Matthew Gregory Lewis, Vaché, Edward Young, and Rabbe (who did not belong to the scholarly references of the time), while Victor Hugo was no greater than Jarry, Hegel, or Aloysius Bertrand, and Eugène Sue was of equal importance with Racine, and so on. The marks given earlier in *Littérature* had openly aimed to lower the status of its subjects; now the idea was to raise their status but by placing them in a different order, and the publication of this double page in an issue entirely devoted to poetical texts suggested that poetry should henceforth be perceived as something other than a privileged genre of literature, since Hegel, Swift, or Fantômas were, apparently, as important as Baudelaire.[70]

The work that Breton published at the time was ample testimony to the indecision that reigned. "La Confession dédaigneuse," composed in March 1923, was a reassessment of Dada, but also, at length, of Vaché, and was an attempt to formulate certain demands: "To escape, as much as possible, from the human species to which we all belong—that is all that seems worthwhile to me. To try to break the psychological rules even to a minor degree is the equivalent of inventing new ways of feeling. . . .

[Poetry]'s role must be situated beyond philosophy; consequently, it fails in its mission each time it falls under the influence of some restriction on the part of philosophy."[71] But this was set against deep dissatisfaction. At least Breton did reaffirm his scorn for the minds of those who were eager to "take sides," even though he also seemed eager to find out if it was indeed possible to avoid "fixation" of the self on experience, even if only by chance.

"Distances" offered a parallel evaluation of the situation in the plastic arts, which since the end of the war had ceased to correspond to the advances of the mind and seemed ready to lapse back into a veneration of the "trade," subject all the while to financial speculation.[72] Many artists were themselves responsible for this situation, either because they were loath to accept the remarks of those who were not artists themselves—thus depriving themselves of intellectual input—or because they had an insufficient conception of their work (like Renoir who, according to Breton, "considered a nude to be finished when he felt like smacking her on the bottom"). In opposition to such poor definitions, Breton professed his faith: "A painting or a sculpture can only be envisaged on a secondary level from the point of view of taste" and can be of no real interest unless it is susceptible of "causing our actual abstract cognition to evolve." This was demonstrated by Gustave Moreau, Gauguin, Seurat, Odilon Redon, and Picasso, whose works led one to think that "there is no reason to distinguish 'literary' painting from painting, as some people so maliciously and stubbornly try to do."

As Breton was publishing these articles, tension was growing within the group. In addition to the fact that Picabia's contributions to *Littérature* were satisfactory to no one but himself (repeated irreverence was becoming conventional like anything else), relations with Aragon were becoming strained. Aragon had just agreed to relaunch the weekly *Paris-Journal:* would he not risk finding himself progressively sucked into the traps of journalism? The debate lasted until April 21, when Aragon gave up on *Paris-Journal* and left for Giverny to stay with his friend M. Josephson.[73]

Desnos, who collaborated regularly on *Paris Journal* after his position as a polygraph in 1921 and 1922 for *Merle blanc,* had the feeling that he was losing importance within the group since the end of the experiments in hypnotic sleep in which he had played a leading role of a nature to satisfy his "need to affirm himself and prove to his surrealist friends that he too was capable of creating new inspiration," if one is to believe Soupault.[74] Soupault himself was growing ever more distant, caught up in editing *La Revue européenne,* where pieces were published that did not satisfy all his former friends equally.[75] There were incidents that could hardly improve the mood of the weekly meetings on rue Fontaine, at Breton's house, or at the café: in a few letters to his wife, Breton judged these meetings to be too often empty and uselessly tiring.

In these conditions, it was hardly surprising that Breton announced in an interview with Vitrac that he was giving up writing, evoking only the possibility that he would publish, a few weeks later, a manifesto signed together with Éluard and Desnos—who were of the same disposition.[76] He stated that *Littérature* had fewer and fewer readers, announced that it would soon cease publication, and affirmed: "I consider the situation of the things I defend to be desperate. I even think that the match is virtually lost. I've never strived for anything else, I repeat, than to ruin literature. Poetry? There's no poetry where we think there is. Poetry exists outside of words, of style, and so on, and that's why I'm delighted when I read a book that is really badly written. Only the system of emotions is inalienable." Despite the criticism that appeared in "Distances,"

there were still some opportunities for satisfaction where painting was concerned, or at least one need not totally despair of the situation. In December 1922, Breton envisaged the foundation of a new artistic salon (his faith in the Salon des Indépendants had begun to be fairly limited) that could be managed with the collaboration of Picasso, Brancusi, Duchamp, Man Ray, Ernst, Picabia, and Cendrars. The project did not materialize. Without doubt, Breton's passionate interest in painting was reinforced by a professional aspect, since he continued to work for Doucet (who, periodically, financed *Littérature*), selling him works by Ernst, Duchamp (*Glissière contenant un moulin à eau en métaux voisins* [1913–15]), and Matisse (*Bocal aux poissons rouges*); advising him to look into Chagall and Klee, and, in 1924, to buy a sketch by Seurat for *Le Cirque,* and then, before he had even met him, André Masson. (Doucet would buy three canvasses.) In October 1923, Breton bought two paintings by De Chirico for himself from Paul Guillaume (*L'Étonnante Matinée* and *Le Mauvais Génie d'un roi*), and the following month, he thought of buying a Picasso from the Galerie Simon. Éluard, too, was becoming a passionate collector for his house at Eaubonne: paintings by Ernst (*Oedipus Rex* and *L'Éléphant Célèbes* were bought as soon as they were completed in 1922), Picasso, De Chirico, primitive objects, and so on. There was some correspondence with the galleries and painters (eventually to ask them to participate in a volume): Éluard, Breton, and Desnos attended the last sale of the Kahnweiler estate (May 1923), no doubt also to purchase at a low price some of Picasso's papers, which could later be sold again. In 1923, Ernst did paintings on the walls of Éluard's Eaubonne house.[77] Breton did not like them at all when he saw them for the first time in October, nor did he like the way Éluard's collection was displayed, which seemed dull and incapable of showing the works in their best light, whereas he would try to arrange them in such a way as to establish connections between the works that were unexpected but conferred meaning.

In February 1924, on the advice of Desnos, Breton visited André Masson's first exhibition at the Galerie Simon, and immediately acquired *Les Quatre Éléments,* a painting that was neither close to Dada, nor typical of the work in graphic automatism in which the painter, unbeknownst to *Littérature,* had been experimenting since the previous winter. The painting did, however, suggest an unexpected way out for the application of cubist principles of the decomposition of forms that, at that very period, had been exhausted by many artists. By disposing his forms in a space that refused orthogonality, through the integration of curves and allusions to rounded volumes, Masson began to lead painting toward a poetry of active contradiction, already capable of sublimating allegory and representational or mythological allusion, even as its chromatism remained, for the time, very restrained. The forms and objects painted seemed to be captured in a movement that obliged the viewer to look over the composition, moving from one element to another without finding the restfulness of a departure or an ending. Although the influences of cubism and Derain seem to have been incorporated, the canvas is held by a sort of internal palpitation, a throbbing, which prohibits it from evoking the slightest serenity; on the contrary, struggle, possible combat, and unrest are suggested, which before and beyond the painted surface refer back to a physical, if not physiological, presence. Although the female body figures only very allusively in *Les Quatres Éléments,* the canvas as a whole suggests a sexualization of the elements themselves and of the world.[78] Masson would say that, for the first time (more than in *Poissons* or *Joueurs,* from 1923) he had succeeded in instilling "philosophy into a

1

2

4

3

5

6

painting," a philosophy that was still far from explicit but that drew the outlines of an affinity with the *Scène érotique* of 1920—a drawing on a panel that troubles one's gaze by its presentation of two female sex organs. When Masson joined the surrealist group, it would be with the singular desire to experiment with a certain aspect, or version, of automatism, more physical than psychical—the source of considerable incomprehension.

For the time being, however, it was Picasso who remained the primary reference, and this was confirmed by his participation, in June 1924, in the performances of the ballet *Mercure,* for which Satie composed the music. Breton and Aragon, who were very reticent where Satie was concerned, showed great enthusiasm for the curtain, for the "scenic constructions" (more than an actual set, it was made up of volumes and shapes that changed on stage during the different scenes, as if in competition with the dancers), and Picasso's costumes.[79] "As far as I'm concerned," wrote Breton to Doucet on June 18, "I think Picasso's collaboration on *Mercure* is the most important artistic event in recent years, an act of genius—which is hardly surprising coming from him, for it follows upon so many others, and displays more than ever a marvelous liberation from any form of constraint imposed by reputation or taste."[80] If Picasso always opened the way, it was also because he made all notions of what was acceptable, admissible, or bearable in painting, and of course in any artistic form, obsolete: his lesson was freedom and was of equal if not greater importance to the evolution of thought as it was to painting. On June 20, the surrealists published in *Paris-Journal* an "Homage to Pablo Picasso," reprinted the very next day in *Le Journal littéraire* and in *Le Journal du Peuple,* and then in *391,* number 18 (where Picabia joined in with a few mocking commentaries).[81] Picasso was saluted as having never "ceased to create modern disquiet and to express it in the highest form possible," again provoking the "general incomprehension"; he also appeared to be the "eternal personification of youth and, incontestably, master of the situation."

From March 1924, automatic writing was once again a happy occupation for Breton: words again began to flow generously, and he noted down the results in his notebooks, where he would later choose the texts that went to make up *Poisson soluble.* At the same time, Desnos "discovered he had a marvelous new faculty, which consisted in being able to tell stories in the dark without being asleep, splendid stories, very long and complicated, unspoiled by contradiction or hesitation. This is more worrying than ever, his mental state is very disturbing: he has predicted his death within three months," wrote Breton to his wife Simone.[82] But that certain faculties of the mind could be worrying in this way was now seen as a positive thing: if it seemed one had gone beyond the frontiers of normality, and if at the same time one's mind proved capable of performing in a way that was quite different from what one ordinarily expected of it, that could only confirm the need to pursue the research carried out thus far through automatism and hypnotic sleep. Experimental procedures did not necessarily imply a heavy atmosphere, as shown by the collective games played at the rue Fontaine: they were a form of entertainment, with a mixture of destructive pleasure and a lively gravity. Notes were kept (particularly about famous peers); whole evenings were devoted to the game of truth, which tried the sincerity and the ability of all to test the limits of one's own intimacy; poems were constructed by cutting out phrases from the newspaper—all ways of sharing, in a sort of productive anonymity, their writing, their thoughts, and their inventions.[83]

1

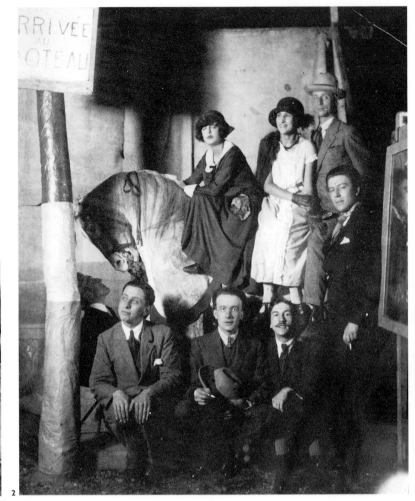

2

3

The publication of *Les Pas perdus* seemed to indicate that a page had been turned: the collection of texts and declarations of the Dadaist period, three months after the collection of poems *Clair de terre* from the same period, was a kind of leave-taking from an era that Aragon would refer to, in his preface to *Libertinage,* as something he liked to call, with his friends, "the vague movement . . . with its illusory and, for me, marvelous expression."[84]

Not everything, however, had been finalized, both from a theoretical or normative point of view and with regard to the relations among members of the group. On March 24, the day before the publication of his collection *Mourir de ne pas mourir,* dedicated to Breton "to simplify everything," Éluard abruptly left Paris, without telling anyone his plans. After sending a pneumatic to his father, he boarded ship in Marseilles and set off on a long journey, about which he would reveal few secrets, saying only that it was "idiotic": Tahiti, the Cook Islands, New Zealand, Australia, Java, Sumatra, and Ceylon.[85] Finally in Saigon Gala, notified by telegram, came to join him, while Ernst took advantage of the opportunity to travel for several weeks in Indochina, using a false passport that Desnos had provided for him. Éluard would bring a number of primitive objects back with him from this journey that were destined to replace the pieces that Gala had placed on sale at Drouot's in his absence.[86]

At the beginning of May 1924, Breton, Morise, and Vitrac undertook their own voyage, but it corresponded to very different intentions. Setting off on foot from Blois, a town chosen at random on a map, they would go as far as Romorantin, leaving their encounters to chance, ready to welcome any manifestation of wonder to be found in reality itself, provided it came along. The experience, which was a distant response to the poem "Lâchez tout" of April 1922, turned out to be, in Breton's words, "very special and even filled with danger. The trip was due to last ten days or so but would end up being curtailed, and right from the start there was something initiatory about it. The absence of any goal cut us off from reality very quickly and gave rise to ever more numerous and frightening phantasms [*sic*] beneath our very feet. Tension was just beneath the surface, and broke out between Aragon and Vitrac, turning to violence." But their endeavor was not a disappointment, taking place as it did "at the edge of waking life and dream life," in zones that were also the domain of automatisms and sleep.[87] No doubt this experience gave rise to the exaltation of another quality that informed the support given once again to Raymond Roussel at the premiere of *L'Étoile au front* and that the ordinary theatergoing crowd was still not ready to accept—even if on the evening of May 5 it provoked a now-famous retort from Desnos, who in response to the "Slap them hard!" of a dissatisfied spectator, said, "Yes, we're the slap, but you're the cheek," adding the gesture to his words.

On June 22, the *Almanach des lettres françaises et étrangères* announced the publication of the last issue of *Littérature,* whose collaborators now intended to "devote themselves to surrealism in poetry and, above all, in life."[88] On July 5, Breton published an article about Desnos in *Le Journal littéraire:* "Symbolism, cubism, Dadaism have had their day; SURREALISM is on the agenda and Desnos is its prophet." A few days earlier, Aragon had submitted to the periodical *Commerce* a few pages describing his career and that of his friends, "dreamers" framed in "surrealist light," settled, like him, on the "edge of the world and of the night." His list was abundant: Limbour (whom Breton had met in January), Masson ("at every crossroads, presiding at the release of pigeons"), Morise, Éluard, Delteil, Man Ray (who "has given meaning to light, and now light can speak"),

Suzanne (Musard), Antonin Artaud, Mathias Lubeck, Jacques Baron, Breton, Soupault (who is mentioned in the past tense), Denise (Lévy), Jacques-André Boiffard, Vitrac ("who is preparing a Theater of Conflagration"), Jean Carrive ("the youngest known surrealist": he was only nineteen), Pierre Picon, Francis Gérard, Simone (Breton), Desnos, Ernst ("who paints cataclysms as others paint battles"), Crevel, Pierre Naville, Marcel Noll, Charles Baron, Péret ("a great poet of the kind no longer made, alas, who at the end of his leash has a whale, or perhaps a sparrow"), Georges Malkine, Renée Gauthier, Alberto Savinio, and finally Georges Bessière.

Une vague de rêves was published in October and it ends magnificently: "Who's there? Ah, all right, let infinity come in."[89] Regardless of their initial intention, these pages came to confirm that which was announced by the good pages of a text—first undertaken by Breton as the preface to the automatic writing of *Poisson soluble* and that had in the meantime become the *Manifeste du surréalisme*—that appeared on September 6 in *Le Journal littéraire:* surrealism was now a force to be reckoned with.

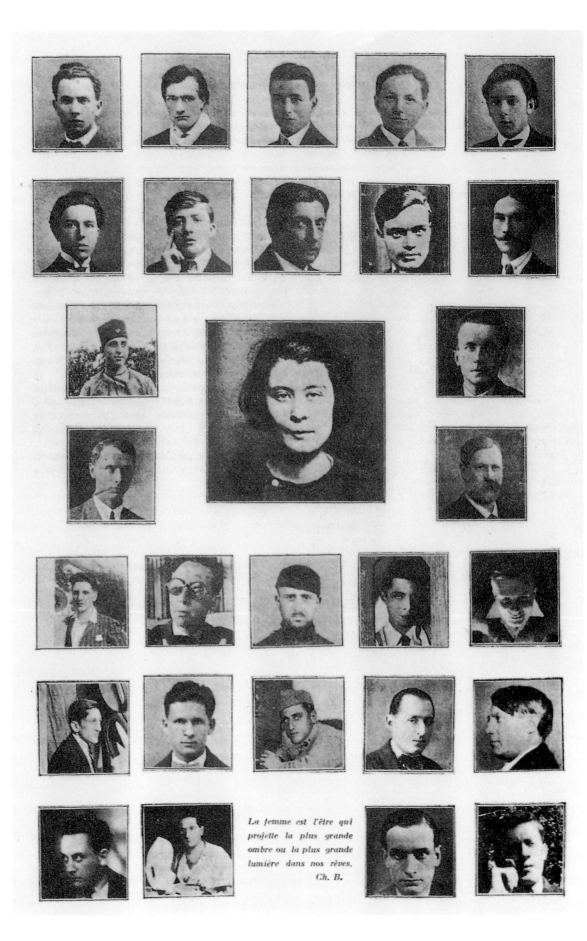

La femme est l'être qui
projette la plus grande
ombre ou la plus grande
lumière dans nos rêves.
Ch. B.

1924-1929

SALVATION FOR US IS NOWHERE*

Opposite page: the surrealists surrounding Germaine Berton; a photomontage published in *La Révolution surréaliste*, number 1 (December 1, 1924).

Lettre ouverte à Paul Claudel, ambassadeur de France au Japon, joint declaration (July 1, 1925), reprinted in José Pierre, *Tracts surréalistes et déclarations collectives,* 2 vols. (Paris: Le Terrain Vague, 1980–82), vol. 1.

On October 11, 1924, the existence of a surrealist group was publicly confirmed by the opening at 15, rue de Grenelle (the premises were on loan from Pierre Naville's father) of a Bureau for Surrealist Research, whose aim was to "gather all the information possible related to forms that might express the unconscious activity of the mind." The press was notified of the opening and of the imminent publication of a new periodical, *La Révolution surréaliste*—an undertaking Breton had decided on by the beginning of July, while he was correcting the proofs of the *Manifeste du surréalisme*. Word of the opening spread quickly enough for the *Journal littéraire* to publish an account of the event the very same day: "The promoters of the surrealist movement, in their desire to appeal to the unconscious and to set surrealism along the path of greatest freedom, have already begun to organize a Bureau to unite all those who are interested in expression where thought is freed from any intellectual preoccupations; . . . all those who are closely or remotely concerned with surrealism will find all the information and documentation relative to the *Mouvement surréaliste*."[1] The same commentary in *Les Nouvelles littéraires:* "No domain has been specified, a priori, for this undertaking, and surrealism proposes a gathering of the greatest possible number of experimental elements, for a purpose that cannot yet be perceived. All those who have the means to contribute, in any fashion, to the creation of genuine surrealist archives, *are urgently* requested to come forward: let them shed light on the genesis of an invention, or propose a new system of psychic investigation, or make us the judges of striking coincidences, or reveal their most instinctive ideas on fashion, as well as politics, etc., or freely criticize morality, or even simply entrust us with their most curious dreams and with what their dreams suggest to them."

Not only did such announcements emphasize the collective nature of the movement, they also indicated the bureau's primary intention of remaining open to all those

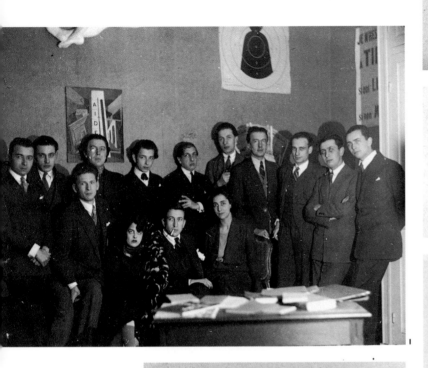

PARENTS !

racontez vos rêves à vos enfants

15, rue de Grenelle, Paris-7e

5

1

VOUS QUI NE VOYEZ PAS

pensez à ceux qui voient

15, rue de Grenelle, Paris-7e

2

LA PERMANENCE
fonctionnera à nouveau
à partir du
MARDI
23
FÉVRIER

De garde à ce jour : MM. Paul Éluard et B. Péret
fait Colmdi 22 Février, Louis Aragon

6

JE DEMANDE
le Rétablissement
de la PERMANENCE
nominale

pour l'expédition du travail
courant (voir les notes sur la
table) - Question : Est-ce le
plaisir de faire des connaissances
qui faisait accepter cette corvée à ces Messieurs

3

who dared venture into the vicinity. The bureau was indeed organized in such a way that a daily presence was assured by two people, who were responsible for greeting visitors (journalists, writers, onlookers, even students) and for taking note of their suggestions and reactions in a daily "Notebook"; the office would also guarantee a regular amount of daily publicity for the movement (press relations, various mailings), while in another room, on the first floor, other members of the group could meet for discussions, or exchange ideas and projects, or work on their own texts, or help to edit the first issue of *La Révolution surréaliste.*

The premises were "decorated," as captured in a famous photograph by Man Ray, with a few paintings (De Chirico: *Le Rêve de Tobie;* a watercolor by Robert Desnos; a canvas by Max Morise), posters, and, before long, a headless plaster statue of a boar in a stairway. The surrealists archived works that had already been exhibited, as well as the notebooks in which they would jot down their automatic texts and manuscripts. An atmosphere of effervescent research reigned, where the gifts of chance were always welcome (a poster glimpsed on a wall might be pointed out or the ludicrous content of a classified advertisement), along with the marvelous, thought to be ever latent in everyday life and ready to suggest incongruous juxtapositions of objects and arouse the imagination by reinforcing the victory over mental habits. But the bureau was anything but a simple place for accomplices to gather, even if their affinity was confirmed daily by the communication of dreams and fantasies and by shared laughter, spontaneous exchange, and the joy of the ongoing discovery: the bureau, like the *Manifeste* or *La Révolution surréaliste,* also served a strategic purpose.

In 1924, a specter haunted Paris—at any rate, the specter of surrealism—and it was up to Breton and his friends to prove that they did not intend to allow anyone else to clarify its significance (or, inversely, to trivialize it). An evening at the Comédie des Champs-Élysées was the occasion for a first skirmish: "surrealist dances" were scheduled to be performed by Valeska Gert, whose impresario was Ivan Goll; the group disrupted the performance with a concert of whistles, and then a row broke out between Goll and Breton, and the event ended abruptly with the arrival of the police.[2] On August 23, Breton and ten of his friends printed a collective text in *Le Journal littéraire,* "Encore le surréalisme," in response to Goll's declarations maintaining that a surrealist school had existed at least since the time Apollinaire first used the adjective to describe *Les Mamelles de Tirésias,* and among its proponents were not only Goll himself but also Pierre Albert-Birot and Paul Dermée. The collective declaration affirmed that "Monsieur Dermée involuntarily exploited the grotesque usefulness of Dadaism and his activity was always foreign to surrealism"; also, it stated that "surrealism is something quite different from the literary wave imagined by M. Goll," before introducing texts that were soon to be published (*La Révolution surréaliste,* the manifesto, texts by Desnos, Péret, Aragon, and Roger Vitrac) that would reinforce their claim that they had "nothing to do with Mr. Goll, or with his friends either."[3] *Le Journal littéraire* then published Goll's replies (reiterating the definition he put forward in 1919, to describe playwrighting: "The surrealist poet will evoke the distant realm of the truth, by keeping his ear to the wall of the earth") as well as those of Dermée (who, in the journal *L'Esprit nouveau* went back over his efforts to "ensure that the term surrealism is still in force" and "keep it separate from petty cliquish quarrels"; he also reproached Breton for wanting to "monopolize a movement of literary and artistic renewal that dates from well before his time and that in scope goes far beyond his fidgety little person"). Breton responded

with countersignatures from his close collaborators: "One cannot get into a discussion with such phonies and nitwits," followed by an excerpt from the manifesto that outlined the history of the issue. The quarrel did not bring an end to the debate: *Le Figaro* and *L'Intransigeant,* on October 11, both confused the opening of the bureau and the publication of a journal edited by Ivan Goll whose title alone, *Surréalisme,* continued to feed the confusion.[4] The unique issue of *Surréalisme* opened with a "Manifeste du surréalisme," followed by an "Exemple du surréalisme: Le cinéma" (Goll cited as a model *La Roue* by Abel Gance); among the contributions were pieces by Albert-Birot, Dermée, Pierre Reverdy, Joseph Delteil, Marcel Arland, Jean Painlevé, René Crevel, and Goll himself (an interview with Robert Delaunay). Though such eclecticism might have seemed spicy or even, from a distance, in good taste, in the actual context of the era it only contributed to the obscurity. At almost the same time, a special issue of *L'Esprit nouveau* was devoted to Apollinaire; Dermée brought together a good number of writers who were opposed to Breton (Albert-Birot, Céline Arnauld, Goll, Picabia, Tzara, and Ungaretti, among others) to remind people of the fact that surrealism did indeed begin with Apollinaire. As proof, he published the letter sent to him by Apollinaire, the author of *Alcools,* in March 1917: "All things considered, I believe it would in fact be better to adopt surrealism rather than the marvelous I had initially used. Surrealism does not yet exist in the dictionary, and it will be easier to handle than the marvelous as already practiced by Messrs. the Philosophers. . . ." The following month, it was Albert-Birot's turn, in his periodical *Paris* (published only that once), to protest the way in which Breton and his friends were appropriating surrealism; then Dermée, again in turn, published the first (and sole) issue of *Le Mouvement accéléré,* in which he reproduced with a few variations his response to "Encore le surréalisme" with the title "Pour en finir avec le surréalisme" (To finish with surrealism once and for all). He was joined by Céline Arnauld, Satie, Ribemont-Dessaignes, Picabia (with his clever gift of aggressing the group by sparing the individual), Vicente Huidobro, René Crevel, and Goll. Although Goll maintained his intention to remain faithful to what he called "surrealism," Dermée abandoned the term, and replaced it with "panlyricism."

On October 11, a letter was sent from the Bureau for Surrealist Research to Pierre Morhange, a collaborator on the periodical *Philosophies,* where he had recently evoked surrealism in terms that were particularly vague: "This art form, invented by the genial Max Jacob . . . finds beauty only when rounded out by a lively lyrical painting, in other words, instinctive and natural." The letter is brief: "We would like to notify you once and for all that if you give yourself the right to use the word 'Surrealism' spontaneously and without notifying us, more than fifteen of us will be there to cruelly set you right." The response this provoked was Messianic in tone: "Unfortunate gentlemen, I will not address you with words of hate. You are coming forward for me to fight you. I will fight you. And I will vanquish you with Goodness and Love. And I will convert you to the Almighty," and so on. This letter hardly improved their relations.[5]

These skirmishes show just how much Breton and his friends sought to disengage surrealism from any narrowly literary, or even poetic, significance—if one persists in seeing poetry as nothing more than a somewhat refined form of literature.[6] The bureau, from this point of view, was also the place where this principle could be periodically reasserted—because it needed to be—within the group itself: preparations for a first issue of *La Révolution surréaliste,* noted in the logbook, showed the efforts made

to gather texts, illustrations, human interest stories, and anonymous information. Such heterogeneity would assure a multifaceted relation with life in all its aspects rather than with the aseptic, inefficient world of literature.

The Surrealist Manifesto

Breton's work, the subject of much discussion in the weeks before its publication, was published on October 15, 1924, in a volume with *Poisson soluble* by Simon Kra's Éditions du Sagittaire. Although it hardly took the author's close friends by surprise, it immediately took on the significance of a global challenge for the intellectual public. Initially conceived as a preface to *Poisson soluble* (traces of this initial intention can still be felt in its composition), the manifesto quickly acquired the status of an independent text, delineating the goals and challenges of surrealism, even if its insistence on the supremacy of the poetic image was due to its originally intended application.

The manifesto begins with a defense of the rights of the imagination (even as far as the limits of madness) as being the only rights capable of helping the individual avoid a "fate without light " and of compensating for the burden of "imperious practical necessity." The text establishes a relation between the imagination and a taste for freedom: "Dear imagination," says Breton, "what I love most about you is that you are unforgiving," and he added right away that "the word of freedom alone is all that still exalts me."

It was vital, therefore, to reevaluate the realistic attitude born of the positivist tradition, which was "hostile to any intellectual and moral uplift." In passing, this reevaluation seemed to criticize the novel, guilty of preventing the reader's imagination from taking flight because of its descriptive nature and also of stifling emotions by the use of psychological analysis, perforce simplistic and sterile. To the professionalism of novelists—always ready to fill pages in order to conceal the lack of necessity of what they were writing, Breton opposed a categorical objection: "I want one to be silent, when one ceases to feel . . . I'm saying only that I do not report the vacant moments of my life, and that it might be unworthy for anyone to crystallize those moments that do seem vacant."

But realism was also the fetishism of logical procedures, which were in fact incapable of solving the authentic problems of existence, while their overestimation had banished from the mind "anything that could be rightfully or wrongfully accused of being a superstition, a chimera . . . any means of searching for truth that does not conform with standard usage." Given such an ossification, Freud's contributions naturally deserved the highest praise, thanks to which "imagination may be about to regain its rights."

Subsequently, the importance of dreams was emphasized, because they reinforced the idea that thought, in humankind, had a much wider scope than the dominant tradition. Breton formulated four questions to try to define a terrain for research: What are the possibilities for the continuity of dreams and their application to life's problems? Do dreams explicitly harbor the causes of our preferences and our desires? What form of reason "broader than all others" gives dreams their "natural allure," where everything seems possible, for as long as the dream lasts? How can one conceive the "future resolution" of dreams and reality, apparently so utterly contradictory, in "the surreal?" [7]

In the sparing tone of the manifesto, the attention given to dreams led to praise for the marvelous, synonymous with beauty, capable in and of itself both of instilling interest into the fabrication of novels, as witnessed by Matthew Gregory Lewis's *The Monk,* and of lending a character a dimension of "continuous temptation." While the marvelous had taken on different forms throughout history, Breton proposed giving it a contemporary form by evoking a castle that he and his friends could haunt at their leisure; any attempt to contrast its existence with what could be known of the place where Breton "really" lived would be in vain. This appeal to the poetic imagination invited an examination of its very sources, and Breton, using elements already evoked in "Entrée des médiums," retraced his itinerary, from his first experiments, which sought a definition of lyricism, to the crucial experiment of *Les Champs magnétiques.* The definition proposed by Reverdy in 1918 had had a considerable impact in helping to define the nature of the poetic image (it "is born, let's say, of the rapprochement of two relatively distinct elements. The greater and more just the distance between the two approaching realities, the stronger the image"). Also influential was the strange phrase of half-sleep captured one evening ("There is a man cut in two by the window"), as was the long quest for "spoken thought," encouraged by Freud's discoveries and by psychiatric activity during the war.

After this historical reminder, which enabled him to sweep aside, once and for all, surrealism's very inadequate references—such as Goll or Dermée—Breton went on to state his definition and did not hesitate to give it the allure of a dictionary item, since the aim was to make up for a lack that Apollinaire himself had felt.[8]

> SURREALISM, *n.* Pure psychic automatism with which one proposes to express the real process of thought, either orally or in writing, or in any other manner. Thought's dictation, in the absence of any control exercised by reason, outside any esthetic or moral concerns.
>
> ENCYCL. *Philos.* Surrealism rests on the belief in the superior reality of certain forms of hitherto neglected associations, in the omnipotence of dreams, in the disinterested play of thought. It tends banish, once and for all, any other psychic mechanisms and to replace them in the resolution of the principal problems of existence. Have professed to absolute surrealism Messieurs Aragon, Baron, Boiffard, Breton, Carrive, Crevel, Delteil, Desnos, Éluard, Gérard, Limbour, Malkine, Morise, Naville, Noll, Péret, Picon, Soupault, and Vitrac.

"These individuals seem to be the only surrealists so far," added Breton, "and there would be no doubt about this, were it not for the fascinating case of Isidore Ducasse." But this list was followed by a second list, specifying that point of view, or aspect of their work or existence qualified others (relatively) to be considered surrealists—among them Young, Roussel, Jarry, Rimbaud, Saint-Pol-Roux, and Vaché (of whom Breton would say, maintaining an ongoing and flawless spiritual continuity between Vaché and himself: "Vaché is surrealist within me.") Nor was this list definitively closed, but it united those thinkers who were still subjugated, sometimes quite voluntarily, to a "certain number of preconceived ideas" and who clung to them "because they had not heard *the surrealist voice*" and were thus condemned to be "instruments of too much pride," too tensely concerned with controlling their production, instead of allowing themselves to become, like the "absolute" surrealists, simple and "modest *recording instruments*" in the service of that surrealist voice that they were preventing from welling up freely within them.

1

3

2

4

5

Breton gave a few examples of that voice, quoting excerpts from Soupault, Vitrac, Éluard, Morise, Delteil, and Aragon. These were excerpts from written work; Desnos, in contrast, "*speaks surrealist* as much as he likes," and this was a confirmation that the true functioning of thought could be, as the definition suggested, expressed "either orally, or in writing." It was also, if need be, a reminder to those who insisted on seeing surrealism as nothing more than a new conception of literature that it was possible to be very genuinely surrealist, that is, given over to automatism, without, however, feeling obliged to write. It should have been clear that the apprehension of "the real functioning of thought" could not be confined to a narrowly literary goal or, more precisely, that the constraints imposed by the practice of literature were not compatible with the exploration of true thought, of thought as it takes shape, well short of reason and logic as they are ordinarily defined. Insofar as human activity, however, was organized by logic and reason, it was foreseeable that thought would feel narrowly enclosed therein and that it would declare a necessary war of independence on the limits reality was trying to impose on it: as the penultimate paragraph of the manifesto affirms, "only very relatively is the world a match for thought." This, in sum, was the basis of the revolt that for years now had been drawing those who refused to submit. The control exerted by reason and aesthetic or moral concerns could only stifle authentic thought and confine it to too narrow a framework. Doubtless this framework might appear to have the advantage of corresponding to a material or social reality, as it was initially responsible for what that reality became; but if thought freed itself from its censorship yet still found itself in disagreement with that same reality, it should by rights endeavor to modify it. Thus, as soon as surrealism was historically defined, it was able to claim a political dimension. In the manifesto however, any political dimension remained implicit, although Breton, using as his starting point the experimentally demonstrated principle that "language was given to man so that he might make a surrealist use of it," envisaged the so-to-speak local effects of surrealism, where certain social relations could be legitimately questioned. The enumeration—a parody of ancient books of magic—of the "Secrets of the Surrealist Art of Magic" was fairly ambiguous, for as soon as it had listed the conditions for automatic writing, it went on to suggest recipes for avoiding boredom in company (it would suffice to formulate some revolting banality), for making speeches (the surrealist "will be sitting pretty amidst all the failings" and "will be truly elect"), and for writing fake novels (and become rich as a result). Then came the transformations that surrealism would work on conversation, letter writing, and dialogue. The pages of *Barrières,* in *Les Champs magnétiques,* exemplified the absolute truth reestablished by "poetic surrealism" in dialogue: interlocutors would be freed from any obligations to be polite and words and images would spring up spontaneously.[9] Breton went on to describe the responsibility of the writer and said that he could respond in all good faith to any accusation his text might evince, that he was not its author; it would be enough for this type of situation to become widespread for one to surmise that when surrealist methods were widely practiced, one would need "a new moral code to replace the current one, which is the cause of all evil."

On the nature of the poetic image, Breton demonstrated, using a number of examples, that it could not be premeditated: "It is the somewhat fortuitous rapprochement of two terms that has caused a particular light to give off a spark, *the light of the image,* to which we are infinitely sensitive." The image, instead of being manufactured, imposes itself on the poet as if in spite of himself, and Breton disagreed with Reverdy

on this point: "The two terms of the image are not deducted one from the other by the mind *with a view to* the necessary spark . . . they are the simultaneous products of the activity I will call surrealist, and reason confines itself to the recognition and appreciation of this luminous phenomenon." Moreover, the beauty (or, according to the assimilation suggested above, the marvelous) of images constitutes an enrichment for the mind itself: if the mind initially submits to the images, "it soon realizes that images flatter its reason" and discovers, thanks to their fleetingness, the "unlimited expanses where its desires are manifest." Finally, the power of images is proportional to the degree of arbitrariness that they display as the terms draw closer: the more contradictory the referents seem, the more satisfaction the images offer, and the more paradoxically incontestable yet, in a certain still enigmatic fashion, justified they seem. What they can reveal in this way is an underlying current of controlled thought, an effervescence operating in fits and starts, or the immediate passage from one word to another and, beyond the words placed in an unexpected juxtaposition, from one designated reality to another. It is in this multiplicity of paths—which "normal" reason seeks, precisely, to ignore and against which it raises its logical, aesthetic, or moral barriers—that the complete and complex reality of thought resides, the reality that surrealism, heard as if it were a dictation emanating from the mind, has begun to push to the surface.

If, from this point on, on everything is possible in this realm of expanded thought, it becomes clear that the mind that gives itself to surrealism can relive "the best moments of childhood, exultantly"—and is childhood, evoked at the beginning of the manifesto, not the too brief period of existence where imagination dominates and enchants reality? To relive those best moments is to experiment once again with the ability to detach oneself from the world as we know it and to find in oneself the freedom to place that given world at a distance—even if that means one will return to it at some later point to consider it in a new way, with a deeper awareness of what it lacks to satisfy one's desires. Genuine thought goes beyond the limits of a narrow "reality," and that is also why, once its wealth has been rediscovered, there is a risk that it will no longer consent to be mutilated.

When referring to ways in which thought might emerge in written surrealism, Breton had complete faith in an extension of surrealist methods to prevent the appearance, in the immediate, of "surrealist clichés": if one considered how effective the cubist *papiers collés* were in bringing about unexpected associations, it was conceivable that poetry, too, could work in this way, and in multiple ways, to create associations with all the desired suddenness. These might be texts obtained by reorganizing fragments of lines cut out of newspapers, and Breton gave an example that respected the diversity of the initial typographical characters.[10] But he immediately insisted on his lack of interest in what "surrealist techniques" might consist of: all that mattered was the result—either those techniques would contribute toward that result or not—and the relation that they would establish with the founding automatism or not.

Mingling autobiography, theoretical points of view, and references to the definite existence of a surrealist collective, whose members were listed, the manifesto provided an unambiguous outline of the movement's aims and axes of research. Instead of announcing the appearance of a new school or trend in the arts (as the futurist or Dada manifestos had done), it validated the ambitions that for some time had already been those of Breton and his close circle. Moreover, the list of authors who had formerly been surrealist only in part suggested that the movement had gained a legiti-

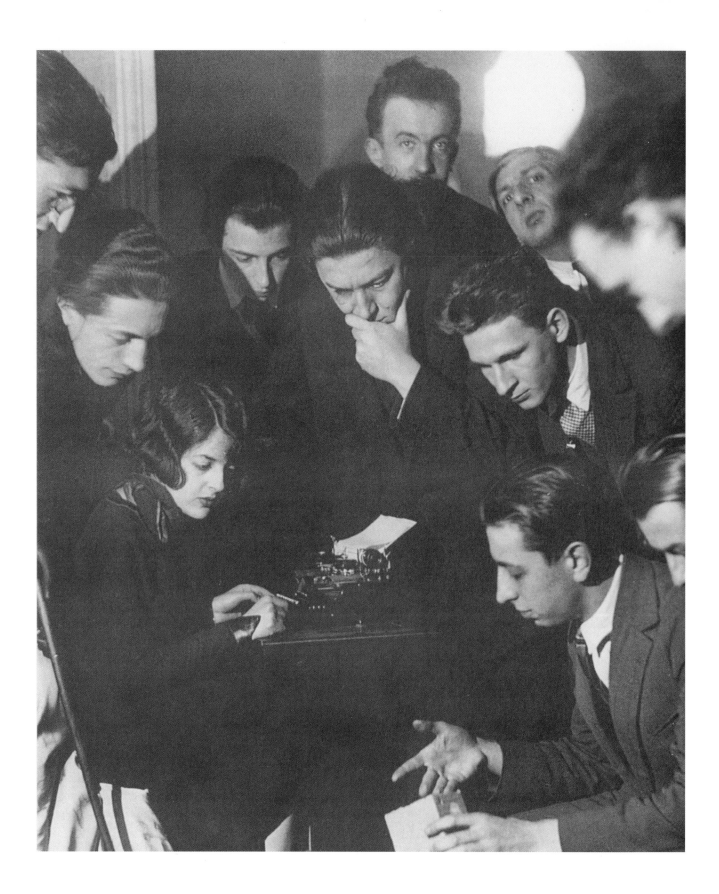

macy rooted in a particular interpretation of the history of writing, which confirmed all the while that this writing had nothing to do with literature alone; literature remained "one of the saddest roads leading to everything."

The scope of the surrealist agenda—nothing less than altering one's conception of humankind and of thought—was such that the publication of the manifesto sufficed for Goll and Dermée's endeavors to seem like simple literary replastering, and they immediately suffered the consequences: from October 1924, both the press and the public considered that "surrealism" referred to the movement led by Breton alone, even if some people (Maurice Martin du Gard, e.g.) continued to believe that Breton was making too much use of a term that belonged to Apollinaire.[11] However, the work was not viewed unanimously by contemporary critics as the de facto inauguration of a new era of ideas: Henri Poulaille saw it as nothing more than a useless and sterile restlessness; Jean de Gourmont viewed *Poisson soluble* as a variation on the futurist "words at liberty" and surrealism as a mixture of Bergson and Freud; Louis Laloy judged the primacy of the unconscious to be inadmissible; Edmond Jaloux, who devoted a chronicle to the manifesto, *Une vague de rêves,* and *Deuil pour deuil,* judiciously found this first work comparable to Novalis and Poe, but feared the development of a literature that would be even more artificial than the one criticized; and Jean Cassou, who asserted that poetry must indeed resist the excesses of rationalism, was disappointed by the criticism of the novel and feared that Breton was preventing himself from obeying his "lyrical power."[12]

In *Le Disque vert* (January 1925), Henri Michaux questioned the possibility of complete automatism ("It won't be that easy to reach such a complete letting go. . . . There are always concerns."), and as a result he judged *Poisson soluble* a disappointment, "monotonous, like a clown," envisaging all the while "a fusion of automatism and volition" and the subsequent production of surrealist texts that would "no doubt yield admirable works." In his periodical *Manomètre,* where in early 1924 he had greeted the "beautiful, pure language, Rimbaldian and personal at the same time," of *Clair de terre* and announced the foundation of "suridealism," Émile Malespine also revealed his hostility toward automatism, which, as a professional psychiatrist, he intended to reduce to a clinical case: "[The insane] who write in the manner of Monsieur André Breton are a very special category of patient: they are maniacs. Mania is a state of continual agitation, where the patients speak quickly and incessantly. The carping baptized surrealist writing by Monsieur André Breton is called verbal automatism by the alienists."[13] As a result, Malespine considered the manifesto to be a pointless preface to the texts of *Poisson soluble;* paradoxically, the text as a whole "lacks spontaneity" and suffers from "an impeccable style."

Virtually all of these articles betrayed the obvious difficulty in situating the tenets of the manifesto in the project Breton had defined as extraliterary. Praise and reservations both were applied to a literary context, and it was not so much the life of the mind that concerned these observers as, logically, the life of letters.

Among Breton's close collaborators, reactions were obviously very different. They had agreed long ago with the principles he put forward, so the articles they devoted to his book were more a confirmation of affinity than a critical reaction. For Aragon, Breton "knows the ways between the constellations, and if he doesn't know them, he'll discover them."[14] Éluard was primarily interested in *Poisson soluble* and accompanied his chosen excerpts with a prose that was poetic in itself; Victor Crastre, more of a theo-

retician, praised the manner in which Breton linked inspiration, genius, and the uncon-
scious.[15]

A Cadaver

While the manifesto clearly aimed to situate surrealism outside the bounds of litera-
ture, it also recommended "that one just take the trouble to practice poetry," which
meant resorting to a language that allowed the capacities of liberated thought to be
revealed. This practice rapidly became widely known through the publication of a col-
lective pamphlet commemorating, after a fashion, the death of Anatole France, who at
the time was seen as a veritable national, if not international, hero or as the best repre-
sentative of the nobility that one could possibly attain within and through literature. In
April 1924, the eighty-fourth birthday of the author of *L'Ile aux pingouins* was cele-
brated unanimously by the press, from *L'Action française* to *L'Humanité*.[16] Well-known
for his antimilitaristic position, a great defender and exponent of the French language,
a bourgeois ending his career in the company of socialists, if not communists, Anatole
France was among those who inspired a ritual of awestruck admiration.[17] Comparisons
to Goethe or Montaigne abounded, and France, the "Patriarch of la Béchellerie" was
placed alongside the "Patriarch of Ferney" (Voltaire)—which acknowledged in the for-
mer a more amiable version of the latter. After his death, a bookshop closed in mourn-
ing, the National Library exhibited his manuscripts and rare editions, and the
Comédie-Française arranged a dozen window displays filled with autographs. Georges
Martin, who chronicled the era, went so far as to maintain that the death of Anatole
France signified "night expanding over the universe."

The surrealists would not join in the chorus of praise; this was a fine opportunity
for them to proclaim their values, which set them apart from the consecrated literary
values.

Un cadavre was an idea of Aragon's, with his friend Drieu la Rochelle, who financed
it (and took advantage of the opportunity, no doubt, to contribute the longest, but not
the most forceful, essay); it consisted of six pieces, two of which were by authors who
were outside the group (Drieu and Delteil) but who actually strengthened the position
of the members (Soupault, Éluard, Breton, and Aragon). The volume opened with
Soupault's text, and right away the tone was set: "When one has the courage to peruse
the obituaries, one is astonished by the poverty of the praise awarded to the late Mr.
France. What sad, imitation celluloid crowns! The phrase by Barrès is repeated over and
over: 'He was a preserver.' Such cruelty! The preserver of the French language: it makes
one think of an adjutant or an extremely pedantic schoolmaster. What a strange idea, to
take a few minutes to say farewell to a corpse that has had its brain removed!" Éluard
defined the elements that separated France's world from his own: "Skepticism, irony,
cowardice, French wit—what are they? A great wind of oblivion will blow me far away
from all of that." Drieu compared the death of an old man who belonged to ancient
history with that of the people of his own generation: "It's the Grand-Dad who did
the saving, but he has left behind a clever miser's fortune. . . . Yet another one who lived
during that golden age before the war, something we'll never be able to understand. . . .
But you'll see that all our pity is directed elsewhere, since it is not available for this
gentle death. . . . No, our pity is for those who died young; words did not linger in
their mouths like old sugar cubes." Delteil pointed out the writer's mortal absence of

UN CADAVRE

*Il était devenu si hideux,
qu'en passant la main sur son
visage il sentit sa laideur.*

A. FRANCE (*Thaïs*)

L'erreur

[column text largely illegible]

PHILIPPE SOUPAULT.

Un vieillard comme les autres

[column text largely illegible]

PAUL ÉLUARD.

Le gouvernement et la foule des admirateurs du Maître sont venus ce matin apporter leur hommage

[column text largely illegible]

REFUS D'INHUMER

Si, de son vivant, il était déjà trop tard pour parler d'Anatole France, bornons-nous à jeter un regard de reconnaissance sur le journal qui l'emporte, le méchant quotidien qui l'avait amené. Loti, Barrès, France, marquons tout de même d'un beau signe blanc l'année qui coucha ces trois sinistres bonhommes : l'idiot, le traître et le policier. Ayons, je ne m'y oppose pas, pour le troisième, un mot de mépris particulier. Avec France, c'est un peu de la servilité humaine qui s'en va. Que ce soit fête le jour où l'on enterre la ruse, le traditionnalisme, le patriotisme, l'opportunisme, le scepticisme, le réalisme et le manque de cœur ! Songeons que les plus vils comédiens de ce temps ont eu Anatole France pour compère et ne lui pardonnons jamais d'avoir paré des couleurs de la Révolution son inertie souriante. Pour y enfermer son cadavre, qu'on vide si l'on veut une boîte des quais de ces vieux livres « qu'il aimait tant » et qu'on jette le tout à la Seine. Il ne faut plus que mort cet homme fasse de la poussière.

ANDRÉ BRETON.

Tours, 8 octobre (*par téléphone*). — L'état d'Anatole France, à midi, était station-

1 First page of *Un cadavre* (1924).

2 *Un cadavre* (1924): André Breton's text.

N° 1 — Première année 1er Décembre 1924

LA RÉVOLUTION SURRÉALISTE

IL
FAUT
ABOUTIR A UNE
NOUVELLE DÉCLARATION
DES DROITS DE L'HOMME

SOMMAIRE

Préface : J.-A. Boiffard, P. Eluard, R. Vitrac.
Rêves : Georgio de Chirico, André Breton, Renée Gauthier.
Textes surréalistes :
Marcel Noll, Robert Desnos, Benjamin Péret, Georges Molkine, Paul Eluard, J.-A. Boiffard, S. B., Max Morise, Louis Aragon, Francis Gérard.
Le rêveur parmi les murailles : Pierre Reverdy.

Chroniques :
Louis Aragon, Philippe Soupault, Max Morise, Joseph Delteil, Francis Gérard, etc.
Notes.
Illustrations : Photos Man Ray, Max Morise, G. de Chirico, Max Ernst, André Masson, Pablo Picasso, Pierre Naville, Robert Desnos.

ABONNEMENT,
les 12 Numéros :
France : 45 francs
Etranger : 55 francs

Dépositaire général : Librairie GALLIMARD
15, Boulevard Raspail, 15
PARIS (VIIe)

LE NUMÉRO :
France : 4 francs
Étranger : 5 francs

N° 11 — Quatrième année 15 Mars 1928

LA RÉVOLUTION SURRÉALISTE

LA PROCHAINE CHAMBRE

SOMMAIRE

Itinéraire du Temps : Max Morise.
Traité du Style : Aragon.
LE DIALOGUE en 1928
Nadja : André Breton.
L'Osselet toxique : Antonin Artaud.
TEXTES SURREALISTES
Raymond Queneau.
REVES
Max Morise.
Consuella : Roger Vitrac.
Sans titre : Xavier Forneret.

Le Cinquantenaire de l'Hystérie : Aragon, Breton.
Programme : Jacques Baron.
La Maladie n° 9 : Benjamin Péret.
POEMES
Robert Desnos, Aragon.
Correspondance : Antonin Artaud, Jean Genbach.
RECHERCHES SUR LA SEXUALITE
ILLUSTRATIONS :
Arp, Chirico, Max Ernst, Georges Malkine, André Masson, Francis Picabia, Picasso, Man Ray, Yves Tanguy, etc.

ADMINISTRATION : 16, Rue Jacques-Callot, PARIS (VIe)

ABONNEMENT,
les 12 Numéros :
France : 55 francs
Etranger : 100 francs

Dépositaire général : Librairie GALLIMARD
15, Boulevard Raspail, 15
PARIS (VIIe)

LE NUMÉRO :
France : 5 francs
Etranger : 7 francs

N° 8 — Deuxième année 1er Décembre 1926

LA RÉVOLUTION SURRÉALISTE

CE QUI MANQUE C'EST LA

A TOUS DIALECTIQUE

CES MESSIEURS (ENGELS)

SOMMAIRE

Revue de la Presse : P. Eluard et B. Péret.
TEXTES SURRÉALISTES :
Pierre Unik, Cl.-A. Puget.
Moi l'abeille j'étais chevelure : Louis Aragon.
D. A. F. de Sade, écrivain fantastique et révolutionnaire : P. Eluard.
POÈMES
Max Morise, André Breton, Benjamin Péret, Michel Leiris.
Dze·jinski, président de la Tchéka : Pierre de Massot.
Lettre à la voyante : Antonin Artaud.
Opération : règle d'étroit : Pierre Brasseur.

Les dessous d'une vie ou la pyramide humaine : Paul Eluard.
Confession d'un enfant du siècle : Robert Desnos.
Uccello le poil : Antonin Artaud.
CHRONIQUES :
La saison des bains de ciel : G. Ribemont-Dessaignes.
Correspondance : Marcel Noll, E. Gengenbach.
Légitime défense : André Breton.
ILLUSTRATIONS :
Max Ernst, Georges Malkine, André Masson, Joan Miró, Man Ray, Yves Tanguy, Paolo Uccello.

ADMINISTRATION : 16, Rue Jacques-Callot, PARIS (VIe)

ABONNEMENT,
les 12 Numéros :
France : 55 francs
Etranger : 100 francs

Dépositaire général : Librairie GALLIMARD
15, Boulevard Raspail, 15
PARIS (VIIe)

LE NUMÉRO :
France : 5 francs
Étranger : 7 francs

La Révolution surréaliste

1 Number 1 (December 1, 1924).

2 Number 8 (December 8, 1926).

3 Number 11 (March 15, 1928).

true passion: "He played no role in our lives, in our research, in our struggles. He lived alone, hermetically sealed. A vase, an empty vase. Such a trinket might amuse the eye for a moment, but could never cause a man to feel something deep in his guts. . . . Such an amiable skeptic simply leaves me cold. I am passionate about passion." In his text, the shortest one of the collection, Breton compared three cadavers: "Loti, Barrès and France: let us go ahead and mark the year with a fine white symbol, for it is a year that laid three sinister fellows to rest: the idiot, the traitor and the policeman. . . . A bit of human servility is departing, with France. . . . Now that he's dead, this man must not kick up any more dust." After France himself, "saluted today both by the tapir Maurras and doddering Moscow," Aragon went on to attack the throng of France's admirers: "I hold any admirer of Anatole France to be a degraded being. . . . Go ahead and babble away about that rotting creature, . . . scrapings from the bottom of the human barrel, utterly ordinary people, shopkeepers and blabbermouths, servile in your very being, slaves to your bellies, curled up in your dirt and your money."[18]

Upon publication, *Un cadavre* caused a sensation and brought on a virulent debate in the columns of *L'Intransigeant*. Some, like Romain Rolland, deplored the fact that the surrealists waited until France's death to contest his worth.[19] Whatever the case, it would seem that the scandal did not actually last that long or that people preferred to forget about it or censure it as if this were, on the part of the surrealists, little more than another opportunity to get themselves talked about (a bit excessively): *L'Ami du lettré* from 1925, which sought to compile an overview of the literary year by faithfully chronicling books, events, and debates, did not write a word about it.[20] As for the monthly allowances Breton and Aragon were receiving from Jacques Doucet, they were interrupted, though perhaps it was not only, despite what they themselves said, because of the publication of *Un cadavre*. Doucet did not seem to appreciate France to any particular degree, but the pamphlet, no doubt, did nothing to assuage the weariness that the couturier was now beginning to feel toward his young collaborators, although he did not break with them entirely.[21]

La Révolution surréaliste

The title of the periodical that first appeared on December 1, 1924 (though available only after the fifteenth of the month, in fact) clearly announced the group's intentions: to bring about an authentic revolution in the strongest sense of the term in the intellectual and cultural domain, a revolution to be defined and guided by surrealism alone and by what the movement sought to bring to light.

In other words, as the formula printed on the cover beneath three photographs of the bureau proclaimed: "The ultimate aim must be a new Declaration of the Rights of Man"—first and foremost the rights of the dreamer. Thus the preface, signed by Boiffard, Éluard, and Vitrac, insisted on dreams and their powers, since the act of dreaming could no longer be perceived as a simple compensation for or means of escape from everyday reality but as a medium to inform us, in a simultaneous movement, of the power of the unconstrained mind and the possibility of giving form, however briefly, to another reality. Quite logically, descriptions of dreams (from De Chirico, Breton, and Renée Gauthier) follow the preface, and precede a series of nine "Surrealist Texts"—examples of automatic writing exalting the imagination and its triumphs.[22] Reverdy's contribution (there would be only one), "Le Rêveur parmi les murailles"

4

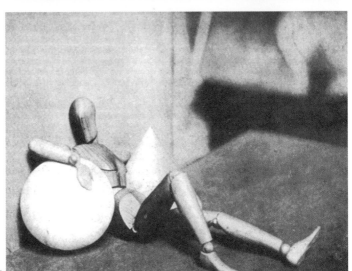

1

5

2

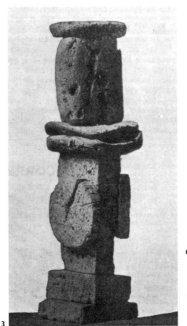

3

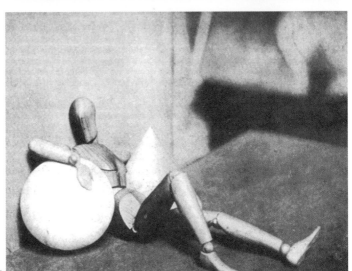

6

1 Photogram from Man Ray's film, *Retour à la raison* (1923); published in *La Révolution surréaliste* number 1 (December 1924).

2 Photograph by Man Ray, published in *La Révolution surréaliste*, number 8 (December 1926).

3 Man Ray, *L'Idole des pêcheurs*, photograph published in *La Révolution surréaliste*, number 8 (December 1926).

4 Drawing by André Masson published in *La Révolution surréaliste*, number 3 (April 1925).

5 Man Ray, *L'Engime d'Isidore Ducasse* (1920); published in *La Révolution surréaliste*, number 1 (December 1924).

6 Photograph by Man Ray (ca. 1926); published in *La Révolution surréaliste*, number 7 (June 15, 1926).

(The dreamer amidst the walls) kept to the dominant themes of that issue. As for the final chronicles, they immediately implemented the program formulated in the preface: "This periodical will contain chronicles of invention, of fashion, of life, of fine arts and of magic."[23] Aragon became interested, therefore, in the "maneuvers that questioned the significance of small familiar objects" (magic tricks performed with flaming matches, e.g.), which he saw as examples of pure imagination and a model of surrealist invention: when an object was diverted from its ordinary application, this diversion conferred on it an undefined and surreal usage. Soupault advocated a close scrutiny of the press for human-interest stories or classified advertisements in order to oppose the reign of common sense and public opinion ("this old skull full of dried-out bugs and scraps") and discover the "only honest voice"—our desires. Delteil reserved a rather rough irony for love: "Such a rare thing nowadays, so abnormal, old-fashioned, old moon; so much clowning around, boorishness, and mucus that to my knowledge *La Révolution surréaliste* is the only great European Periodical that devotes a regular column to Love."[24] Francis Gérard shared his thoughts on "The State of a Surrealist" by emphasizing the desirability, during automatism, of attaining "a white space of consciousness when writing" that would ensure complete disinterestedness for as long as the mind was giving dictation. In his chronicle devoted to fine arts, Morise defined the difficulty peculiar to painting that attempts to submit itself to automatism. After asserting that "what surrealist writing is to literature, surrealist plasticism must be to painting, photography, and anything that is made to be seen," he objects that the inherent slowness of the act of painting risks distracting or interrupting the mind's dictation: a simple effort of memory would doubtless be enough to reconstruct, in a plastic form, a dream or hallucination, but one must ask oneself whether the painter was not obliged to "create, using conscious and acquired faculties, elements that the writer finds ready-made in memory."[25] Luckily, cubism had shown, at least according to Morise's interpretation, that the stroke of a brush can in itself bring an intrinsic meaning or that a pencil line can be the equivalent of a word: "Painting has never been more quick-tempered." Moreover, the activity of madmen and mediums confirmed the possibility of immobilizing the most fugitive visions, in two ways: either recognizable (and namable) figures would appear all together, reproduced "as sketchily as possible" or, the reverse: shapes and colors, without objects, could represent the most subtle variations in the flow of thoughts, giving birth, in this case, to a truly surrealist activity. All that remained for the painter, therefore—who was neither a madman nor a medium—was to discover the mental state that would allow him a comparable exploration of his thoughts, for, said Morise, "the whole difficulty is not in getting started, but in *forgetting what has just been done,* or better still, remaining unaware of it." Although he did not deny the possibility of a pictorial surrealism, Morise seemed to be holding out for its confirmation; he eventually gave an example by evoking Man Ray's ability to transform everyday basic appliances into "the latest luxury items."

Despite such scruples, *La Révolution surréaliste* was illustrated. In order to set the periodical clearly apart from futurist or Dadaist publications, Naville and Péret, the initial editors, managed to ensure that the typographical characters that were scattered throughout avant-garde newspapers would be absent from *La Révolution surréaliste*. (Desnos, for one, would have liked the periodical to use pages with different formats.) The layout was vaguely inspired by that of *La Nature,* a "periodical of science and its application to art and industry," published since 1873 by the Editions Masson. There

were two columns of text, with illustrations of various sizes, and it included chronicles, a "correspondence" section, and brief information. This classical, almost severe appearance, in addition to confirming the nonliterary nature of the publication, was particularly appropriate for conferring the most disturbing message possible on the various illustrations: the "Enigma of Isidore Ducasse," by Man Ray (no credit was listed for the photographer however), was inserted into the text of the preface. Two other plates by Man Ray, which also had no credits, were of female nudes and accompanied Breton's dream as well as a surrealist text by Morise. A dream sketch by Morise himself ended the section devoted to dreams, while an (anonymous) photograph of a carnival float inaugurated the series of "surrealist texts." Masson (two automatic drawings, one of which, on page 27, was turned upside down by mistake), De Chirico, Ernst (three drawings), Picasso (a guitar "construction"), Naville, and Desnos were also represented, with Naville and Desnos confirming the nonspecialized nature of the group. But the most astonishing page, suggestive of a collective declaration of a new art form, was incontestably the one in which a photograph of Germaine Berton, surrounded by twenty-eight portraits of surrealists and a few personalities to whom they gladly referred (including Picasso, De Chirico, Freud, and Alberto Savinio) was accompanied by a quotation from Baudelaire, with no other commentary. The quotation was Éluard's idea: "Woman is the being who projects the greatest shadow or the greatest light upon our dreams." This was a brilliant way of visually uniting love, dreams, different aspects of intellectual activity, and the unequivocal declaration of admiration for a woman who had dared to defy social convention. In January 1923, Germaine Berton had shot with a revolver the editorial secretary of *L'Action française* and may have provoked, a few months later, the suicide of Philippe Daudet, the anarchist son of the royalist Léon Daudet; after her acquittal in December, she received a basket of roses and red carnations, brought by Simone Breton, Aragon, and Morise. In the same issue, Aragon said that such a woman was the incarnation of the "greatest challenge to slavery [he] knew, the finest protest thrown in the face of the world against the hideous lies of happiness."

Dreams, automatism, passion, and a call for the most extreme freedom were often accompanied, in a more subdued tone, by a theme that was disturbing in its own way: the first issue of *La Révolution surréaliste* launched a survey, "Is Suicide a Solution?" in which a temptation from previous years became evident, the "let go" (*lâchez tout*) without looking back, the temptation of the final, definitive break, that could still appear as the fascinating dark side of the values that had become the movement's quest. The periodical's pages were dotted with excerpts from the press relating various astonishing suicides, insofar as, according to Jacques-André Boiffard's formula, "not only the nature but also the number of these acts is important."[26] At the very moment the editors were contemplating the survey, the Belgian periodical *Le Disque vert* announced the publication of a special edition, "On Suicide."[27] On November 14, the members of the group decided nevertheless to begin their survey on the same subject, and, in number 2, they would publish over fifty responses to the survey (a certain number consisted of quotations, by Rabbe, Constant, and so on), while the memory of Jacques Vaché, an exemplary suicide, would be revived by the publication of a sketched self-portrait and a short story.[28]

From October 30, while the first issue of *La Révolution surréaliste* was being prepared, Breton began to jot down criticisms in the bureau's notebook, some of which

LA RÉVOLUTION SURRÉALISTE

Directeurs :
Pierre NAVILLE et Benjamin PÉRET
15, Rue de Grenelle
PARIS (7e)

Le surréalisme ne se présente pas comme l'exposition d'une doctrine. Certaines idées qui lui servent actuellement de point d'appui ne permettent en rien de préjuger de son développement ultérieur. Ce premier numéro de la Révolution Surréaliste n'offre donc aucune révélation définitive. Les résultats obtenus par l'écriture automatique, le récit de rêve, par exemple, y sont représentés, mais aucun résultat d'enquêtes, d'expériences ou de travaux n'y est encore consigné : il faut tout attendre de l'avenir.

seemed pertinent once the periodical came out: "No reactions, no anonymous messages, no announcements, no fine publicity, no lucky finds, nothing to speak of a real extraliterary life. As we feared, the bulk of it will be artistic. . . . Nor is there anything to make one expect or hope for a second issue. Nothing, outside vague declarations, to justify the existence of a Bureau of Research. . . . Without wishing to be overly pessimistic, one still wonders where the surrealist spirit is in all of this. . . . I strongly urge everyone to contribute . . . to editing an anonymous part of the periodical. . . . *It's indispensable.*"[29] One had to admit that even if the periodical was not "artistic," anonymous comments or the justification of a bureau for research seemed to be sorely lacking, and any curiosity with regard to the responses to the survey on suicide may well have been one of the rare reasons for looking forward to a second issue.

The second issue (dated January 15, although it would not actually come out until February 15, 1925) was not radically different from the first, but it did, however, offer a few elements that were considerably more aggressive. The cover consisted of the photograph of a scarecrow entitled "French Art. Early Twentieth Century" and suggested an anti- or extra-artistic attitude, confirmed perhaps even more than in the first issue by the diversity of the illustrations, defying any stylistic unification. There were photographs (Man Ray's or anonymous), the juxtaposition of a metaphysical composition by De Chirico, and a collaboration between Desnos and Naville; a self-portrait by Kokoschka, drawings by Masson, Picasso (on two pages), Ernst, and the enigmatic Dédé Sunbeam, and "Marcel Proust" (in fact a very realistic drawing of an isolated eyeball) by Georges Bessière.[30] While this second issue included in turn a series of "surrealist texts," dreams (including those of the newcomer Michel Leiris), and an abundance of chronicles, it also offered enough to indicate clearly the distance the group intended to maintain between itself and cultural specialization, and how it intended to intervene in an unequivocal fashion in daily life. The place occupied by the suicide survey, Breton's opening text, "La Dernière grève" (The last strike), the collective declaration "Open the prisons. Disband the army" (possibly written by Desnos), and the tone of the chronicles "La Liquidation de l'opium" (The liquidation of opium), "Libre à vous!" and Aragon's "Freedom is now known as Perpetual Revolution") were beginning to form the outline of what Breton had evoked on December 23, 1924: "Would it not be fitting . . . parallel to the surrealist activity per se, to carry out an *unequivocal* revolutionary action?"[31]

"The Last Strike" did reveal, however—involuntarily—that the articulation of surrealist action and revolutionary action might turn out to be more complex than the simple addition of two terms in the title of a periodical. The text asserted, on the one hand, the specificity of the intellectuals, who did not "work" in the ordinary sense of the term but who could, however, be victims of utter material deprivation, and on the other hand, it compared them to manual workers, borrowing from workers the model of the strike, justified both by demands of a material nature and by the general defense of freedom of thought at a time when censorship and laws against anarchists were still in force. The principle of an intellectual strike of this kind, which strongly suggested that all written production might come to a halt, also allowed one to envisage the fictional passing of *La Révolution surréaliste:* "One would be regretfully leafing through the first two issues of *La Révolution surréaliste*—still open to subversive ideas, but already emanating something soft and sad"—the divide between subversive ideas and genuinely revolutionary practice was already implicitly defined. "It's plainly obvious," Nav-

OUVREZ LES PRISONS
LICENCIEZ L'ARMÉE

Il n'y a pas de crimes de droit commun.

Les contraintes sociales ont fait leur temps. Rien, ni la reconnaissance d'une faute accomplie, ni la contribution à la défense nationale ne sauraient forcer l'homme à se passer de la liberté. L'idée de prison, l'idée de caserne sont aujourd'hui monnaie courante : ces monstruosités ne vous étonnent plus. L'indignité réside dans la quiétude de ceux qui ont tourné la difficulté par diverses abdications morales et physiques (honnêteté, maladie, patriotisme).

La conscience une fois reprise de l'abus que constituent d'une part l'existence de tels cachots, d'autre part l'avilissement, l'amoindrissement qu'ils engendrent chez ceux qui y échappent comme chez ceux qu'on y enferme, — et il y a, paraît-il, des insensés qui préfèrent au suicide la cellule ou la chambrée, — cette conscience enfin reprise, aucune discussion ne saurait être admise, aucune palinodie. Jamais l'opportunité d'en finir n'a été aussi grande, qu'on ne nous parle pas de l'opportunité. Que MM. les assassins commencent, si tu veux la paix prépare la guerre, de telles propositions ne couvrent que la plus basse crainte ou les plus hypocrites désirs. Ne redoutons pas d'avouer que nous attendons, que nous appelons la catastrophe. La catastrophe ? ce serait que persiste un monde où l'homme a des droits sur l'homme. L'union sacrée devant les couteaux ou les mitrailleuses, comment en appeler plus longtemps à cet argument disqualifié ? Rendez aux champs soldats et bagnards. Votre liberté ? Il n'y a pas de liberté pour les ennemis de la liberté. Nous ne serons pas les complices des geôliers.

Le Parlement vote une amnistie tronquée ; une classe au printemps prochain partira ; en Angleterre toute une ville a été impuissante à sauver un homme, on a appris sans stupeur que pour la Noël en Amérique on avait suspendu l'exécution de plusieurs condamnés parce qu'ils avaient une belle voix. Et maintenant qu'ils ont chanté, ils peuvent bien mourir, faire l'exercice. Dans les guérites, sur les fauteuils électriques, des agonisants attendent : les laisserez-vous passer par les armes ?

Ouvrez les Prisons Licenciez l'Armée

1

1 "Open the prisons, disband the army"; collective declaration published in *La Révolution surréaliste*, number 2 (January 15, 1925).

2 Benjamin Péret insulting a priest, photograph by Marcel Duhamel published in *La Révolution surréaliste*, number 8 (December 1926).

2

ille would soon remark, "that a concern for practical action was penetrating the naiveté of these words." But he immediately added that "the entire article reveals the latent opportunist preoccupations within surrealism. Surrealism is now ready to lend support to all the demands that go against the omnipotence of bourgeois culture. It is now aware that it must take part in the revolutionary movement by all means possible."[32]

Artaud's Influence

"Open the prisons. Disband the army." These words attacked more than just the bourgeois culture; they also aimed at the foundations of the power of the ruling class: "We must not be afraid to admit that we are awaiting and calling for the catastrophe. The catastrophe? That would mean a world in which man continues to have rights over man," specified the text in questioning the validity of patriotism and justice as expressed by society. It was all social organization that was being attacked through two of its major institutions, those that would later be called the "ideological apparatus of the State."

While one might expect that to bring this mission of general upheaval to a successful conclusion, the group would seek an alliance with the greatest possible number of sympathizers. A notice placed at the end of the second issue of *La Révolution surréaliste* informed the public that its bureau would be closed as of January 30, 1925 (it was closed just after the release of the second issue). One was informed that this was "with a view to more direct and effective action," under Artaud's direction, who would henceforth be in charge of the bureau. The revolutionary cause also led to a recentering of the group within itself, which revealed moreover that the contributions of the public to the bureau at the rue de Grenelle had been disappointing in spite of everything, and within the group itself there were still a number of difficulties that were preventing it from attaining a unified vision of the desired revolution.

On January 23, during a meeting at the café Certa and at Breton's suggestion, the decision was made to entrust Artaud with the future of the bureau. At first Breton saw this as a declaration (written with Aragon) formulating the demand to take surrealism still further into a "very different terrain." The declaration revealed the shortcomings of the present group: an increase in the number of personal quarrels and an office that was barely functioning.[33] Under these conditions, the "only hope of salvation" was to "place all our strength at the service of East against West," not in a Platonic but in a very active fashion, which would necessitate an immediate examination of the two aspects representing the Orient in 1925: the Jewish question, and bolshevism.[34] During the subsequent discussion, Masson emphasized the need to ensure that everyone share the desire to break with Western civilization, Fraenkel asked that everyone specify what they meant by "revolution," and Queneau found bolshevism to be a more interesting issue than the Jewish question because it constituted an immediate "danger" for the West. Everyone did, however, agree on one thing: "The point is not simply eventually to participate in a revolution, but to prepare The Revolution and to lead it." This underscored the scope of the upheaval that the group was envisaging, once it determined its specific nature; but at the end of the meeting, "the discussion of the eastern question has been postponed until a later date, given the inadequate knowledge of the issue on the part of the majority of those attending."

Four days later, the debate centered on the contents selected by Artaud for the third

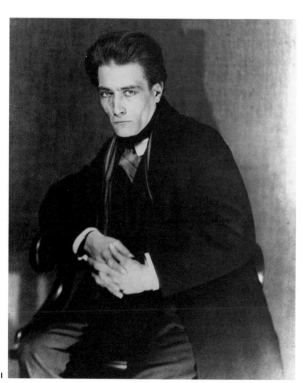

1

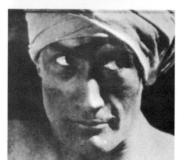

Les membres soussignés de la Révolution Surréaliste, réunis le 2 avril 1925, dans le but de déterminer lequel des deux principes, surréaliste ou Révolutionnaire, était le plus susceptible de diriger leur action, sans arriver à une entente sur ce sujet, se sont mis d'accord sur les points suivants :

1) Qu'avant toute préoccupation surréaliste ou révolutionnaire, ce qui domine dans leur esprit est un certain état de fureur.

2) Ils pensent que c'est sur le chemin de cette fureur qu'ils sont le plus susceptibles d'atteindre ce qu'on pourrait appeler l'illumination surréaliste.

3) Qu'un des premiers buts à atteindre est l'élucidation des quelques points auxquels devrait s'attaquer plus particulièrement cette fureur.

4) Ils discernent pour l'instant un seul point positif auquel ils pensent que tous les autres membres de la Révolution Surréaliste devraient se rallier :

à savoir que l'Esprit est un principe essentiellement irréductible et qui ne peut trouver à se fixer ni dans la vie, ni au delà.

5) Les signataires de cette motion s'engagent en ce qui les concerne à rester indéfectiblement fidèles aux principes qu'ils viennent de formuler, quels que soient les abandons qui pourraient se produire par la suite et quelques formes détournées que puissent revêtir ces abandons.

Antonin ARTAUD
Jacques A. BOIFFARD
Michel LEIRIS
André MASSON
Pierre NAVILLE

2

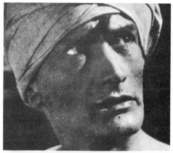

4

3

issue of the periodical: the plan for an article on the Jewish question, "considered the first stage of contamination of the western mind by the eastern mind," was criticized by Desnos and Soupault, who viewed Zionism as an ordinary nationalism and therefore indefensible. Desnos tried to validate his point, moreover, that "the exodus of the Jews to Zion could only harm the penetration of the West by the East, for one, and that the Jews, once they got to Palestine, would become a western factor for the East." The collective response was that they should support "a party that decides to renounce the West." Finally, a "Pamphlet against Jerusalem" appeared in *La Révolution surréaliste* on April 15, signed by Desnos: it was, he said, because he admired the way in which the Jews, who "came to the West following Jesus," changed the aspect of the places where they settled and contributed an element of disorder by constantly renewing the passions that the Mediterranean civilization was trying to repress that he felt such hostility toward a "sentimental movement that is pushing for the reconstruction of Zion." On the contrary, the "Israelites [must] remain in exile for as long as the western cause has not been lost." Set aside from what might be its spiritual dimension, Zionism was presented as a veritable betrayal with regard to the forces susceptible of destroying the West. This pamphlet was in fact part of an issue that Artaud had devoted entirely to indications of an eventual disappearance of the West or, at least, the collapse of its principle values, which would be confirmed by the terms of the *Déclaration du 27 janvier 1925,* edited by Artaud for the benefit of "the entire droning cohort of contemporary literary, theater, philosophical, exegetic and even theological critics."[35] Twenty-eight members signed it: "We have nothing to do with literature. . . . Surrealism . . . is a means of total liberation of the mind and OF EVERYTHING WHICH RESEMBLES IT. We are determined to have a revolution. . . . Wherever it turns its thoughts, Society will find us. We are specialists in revolt. There is no plan of action we are not capable, if need be, of using. We address the western world in particular: SURREALISM exists. . . . It is a cry from the mind turned in upon itself, desperately determined to break its shackles, if need be with real hammers." This declaration, of an unrelenting violence, bore Artaud's singular mark: he favored the aspects of surrealism that concerned the life of the mind itself, as validated in the East and stifled in the West; he also considered "revolution" and "revolt" to be synonyms, calling all the while for an eventual use of "real hammers." Breton would comment, in 1952: "Language was stripped of anything ornamental, and it escaped the wave of dreams of which Aragon spoke, it wanted to seem sharp and gleaming, like a weapon."[36] The fact remains that by wanting to take on the "West" in its entirety, the projected revolution risked slipping into idealism without being able to agree with any political undertaking whatsoever.

The global nature of the revolution was confirmed by texts published in the third issue of *La Révolution surréaliste* (the cover greeted 1925 as marking the "end of the Christian era"). Although the issue did include dreams (including those of children), surrealist texts, and waking sentences, it also published the beginning of Michel Leiris's "Glossary," which showed that words, once dissected and recomposed, make language "a thread to guide us, in the Babel of our mind"; an anticolonialist article by Éluard titled "The Suppression of Slavery"; "Description of a Coming Revolt" by Desnos, who declared in passing that "for a revolutionary, there is only one possible regime: REVOLUTION, and that means THE TERROR"; the translation of a text by Theodore Lessing on "Europe and Asia"; and above all, highlighted by special typographical characters, the famous series that had the value of a collective declaration: "Letter to the Rec-

Adresse au Pape

Le Confessionnal, ce n'est pas toi, ô Pape, c'est nous, mais, comprends-nous et que la catholicité nous comprenne.

Au nom de la Patrie, au nom de la Famille, tu pousses à la vente des âmes, à la libre trituration des corps.

Nous avons entre notre âme et nous assez de chemins à franchir, assez de distances pour y interposer tes prêtres branlants et cet amoncellement d'aventureuses doctrines dont se nourrissent tous les chatrés du libéralisme mondial.

Ton Dieu catholique et chrétien qui, comme les autres dieux a pensé tout le mal :

1° Tu l'as mis dans ta poche.

2° Nous n'avons que faire de tes canons, index, péché, confessionnal, prétraille, nous pensons à une autre guerre, guerre à toi, Pape, chien.

Ici l'esprit se confesse à l'esprit.

Du haut en bas de ta mascarade romaine ce qui triomphe c'est la haine des vérités immédiates de l'âme, de ces flammes qui brûlent à même l'esprit. Il n'y a Dieu, Bible ou Evangile, il n'y a pas de mots qui arrêtent l'esprit.

Nous ne sommes pas au monde. O Pape confiné dans le monde, ni la terre, ni Dieu ne parlent par toi.

Le monde, c'est l'abîme de l'âme, Pape déjeté, Pape extérieur à l'âme, laisse-nous nager dans nos corps, laisse nos âmes dans nos âmes, nous n'avons pas besoin de ton couteau de clartés.

Lettre aux Médecins-Chefs
des Asiles de Fous

Messieurs,

Les lois, la coutume vous concèdent le droit de mesurer l'esprit. Cette juridiction souveraine, redoutable, c'est avec votre entendement que vous l'exercez. Laissez-nous rire. La crédulité des peuples civilisés, des savants, des gouvernants pare la psychiatrie d'on ne sait quelles lumières surnaturelles. Le procès de votre profession est jugé d'avance. Nous n'entendons pas discuter ici la valeur de votre science, ni l'existence douteuse des maladies mentales. Mais pour cent pathogénies prétentieuses ou se déchaine la confusion de la matière et de l'esprit, pour cent classifications dont les plus vagues sont encore les seules utilisables, combien de tentatives nobles pour approcher le monde cérébral ou vivent tant de vos prisonniers ? Combien êtes-vous, par exemple, pour qui le rêve du dément précoce, les images dont il est la proie sont autre chose qu'une salade de mots ?

Nous ne nous étonnons pas de vous trouver inférieurs a une tache pour laquelle il n'y a que peu de prédestinés. Mais nous nous élevons contre le droit attribué a des hommes, bornés ou non, de sanctionner par l'incarcération perpétuelle leurs investigations dans le domaine de l'esprit.

Et quelle incarcération ! On sait, — on ne sait pas assez — que les asilés loin d'être des *asiles*, sont d'effroyables geoles, ou les détenus fournissent une main-d'œuvre gratuite et commode, ou les sévices sont la règle, et cela est toléré par vous. L'asile d'aliénés, sous le couvert de la science et de la justice, est comparable a la caserne, a la prison, au bagne.

Nous ne soulèverons pas ici la question des internements arbitraires, pour vous éviter la peine de dénégations faciles. Nous affirmons qu'un grand nombre de vos pensionnaires, parfaitement fous suivant la définition officielle, sont, eux aussi, arbitrairement internés. Nous n'admettons pas qu'on entrave le libre développement d'un délire, aussi légitime, aussi logique que toute autre succession d'idées ou d'actes humains. La répression des réactions antisociales est aussi chimérique qu'inacceptable en son principe. Tous les actes individuels sont antisociaux. Les fous sont les victimes individuelles par excellence de la dictature sociale ; au nom de cette individualité qui est le propre de l'homme, nous réclamons qu'on libère ces forçats de la sensibilité, puisqu'aussi bien il n'est pas au pouvoir des lois d'enfermer tous les hommes qui pensent et agissent.

Sans insister sur le caractère parfaitement génial des manifestations de certains fous, dans la mesure ou nous sommes aptes a les apprécier, nous affirmons la légitimité absolue de leur conception de la réalité, et de tous les actes qui en découlent.

Puissiez-vous vous en souvenir demain matin a l'heure de la visite, quand vous tenterez sans lexique de converser avec ces hommes sur lesquels, reconnaissez-le, vous n'avez d'avantage que celui de la force.

"Letter to the Chief Physicians of the Insane Asylums"; collective declaration based on a first version written by Desnos and published in *La Révolution surréaliste*, number 3 (December 1925).

tors of European Universities," "Address to the Pope," "Address to the Dalai Lama," "Letter to the Schools of Buddha," and "Letter to the Chief Physicians of the Insane Asylums."[37] Although they had not been written solely by Artaud (he was entirely responsible only for the addresses to the Pope and the Dalai Lama and the letter to the schools of Buddha), these five pieces all display, in varying proportions, the mark of the frenetic understanding Artaud had of surrealism: one must oppose repressive institutions (education, religion, psychiatry) with the singularity of a wholly renewed spirit, one that in the "Orient" would find not only mere models but the proof of what the mind could be under different circumstances. The point was not, by any means, to convert to Buddhism (and the Dalai Lama was called on only as a sort of anti-Pope, as suggested by the page layout—facing pages—of the two addressees); but the reference to this elsewhere of (non-)Western thought could only confirm, for Artaud, that "surrealism records a certain order of repulsions rather than beliefs."

This tendency toward a paroxysmal expression of the necessary struggle could also be seen in other surrealists of the same era. There was Desnos's refutation of Zionism in the name of the struggle against the West and attacks on the League of Nations; there was Aragon's obvious scorn toward the Soviet revolution and, in addition, the exalted tone of some of his declarations: "Western world, you are condemned to die. We are the defeatists of Europe, beware, or rather, no, have a good laugh. We will sign a pact with all your enemies, we have already signed with that demon the Dream, the parchment has been sealed with our blood and that of poppies. We will form a league with the great reservoirs of the unreal. That the East, your terror, will finally answer our call."[38]

It was necessary to state the aim of surrealism clearly; it was not at all certain that by placing it at such a height it would not be totally ineffective. Artaud might well affirm, for example, that "the immediate reality of the surrealist revolution is not so much to change the slightest element of the physical and apparent order of things, but to create a movement in people's minds. The idea of any surrealist revolution takes aim at the profound substance and order of thought." On March 27, 1925, Breton seemed to agree: disappointed by what he suspected was inauthenticity on the part of his new companions (with the exception of Masson and Leiris), and having just declared two days earlier that he was "no longer interested *in anything* to do with the surrealist Revolution," he asked Artaud "not to subordinate, in any way, the immediate interest of the mind to a political or any other necessity, under the pretext that there are twenty-six of us and that it is discouraging."[39]

Homage to Saint-Pol Roux

On May 9, 1925, a collective tribute by the surrealists to the symbolist poet Saint-Pol Roux was published in *Les Nouvelles littéraires*: welcoming his return to Paris after thirty years' retreat in Camaret, the collection included texts by Aragon, Vitrac, Desnos, Leiris, Péret, Morise, Breton, Éluard, and Baron and was accompanied by excerpts of Saint-Pol Roux's own works.[40]

Such a sign of interest seemed to revive in the group members a concern for writing and a certain notion of the dignity that could accompany demanding poetry, when it was not confused with a quest for literary success.[41] If symbolism (besides Saint-Pol Roux, René Ghil, Francis Vielé-Griffin, and early Valéry) remained acceptable on the

1 Portrait of Saint-Pol Roux illustrating "Le Merveilleux contre le mystère: À propos du symbolisme"; article published in *Minotaure*, number 9 (1936).

2 Rachilde (1860–1953), ca. 1895.

3 Michel Leiris in the 1920s.

4 "Open letter to Monsieur Paul Claudel, ambassador of France to Japan," signed by the group (July 1, 1925).

whole, it was, as Breton would remind us in his *Entretiens,* both because of the restraint in the symbolists' language, and their refusal to compromise; they were supremely indifferent to the expectations of the public during that era. From this last point of view, Saint-Pol Roux was a particularly good example, as Breton pointed out in 1923 in his dedication for *Clair de terre:* "To the great poet / SAINT-POL ROUX / To those who give themselves / as he does / THE MAGNIFICENT / pleasure of being forgotten." Breton also underlined, in his letter sent to Camaret on September 18, 1923, a few days after having met Saint-Pol Roux: "I have long been outraged by certain literary customs, and I am weary of seeing so many honors bestowed on so much baseness. As always, a disinterested and noble attitude, from Baudelaire to yourself, remains perfectly unknown and exposed to that which can most easily ruin it. You are, of all the living poets, the one most affected by this ancient curse, and I honor you for it. I have managed, without difficulty, to persuade my best friends of the necessity of undertaking effective action on your behalf."[42]

Such praise for the author of the *Reposoirs de la procession*—the very same who had hung the famous sign on his bedroom door, "The poet is at work"—showed that the group remained in opposition to literary professionals by valuing a certain attitude that could never be that of the professionals. The collection of articles echoed the campaign against Anatole France but reversed the intent, for this time the idea was to honor the man who, twenty-seven years before the *Manifeste du surréalisme,* had written: "Inspiration appears before me like an inner dictation—a dictation, in truth, subjected to the personal amendments and contributions of the poet, at the mercy of the hour—and my surprise as unassuming collaborator is so absolute at times, when confronted with the emissary responsible, that a poem of my own seems to be a borrowing."[43]

On July 2 a banquet was organized in honor of Saint-Pol Roux by the team of Mercure de France at the Closerie des Lilas, in the manner of the "old-fashioned, ridiculous feasts" (Breton) that the surrealists despised. They went there all the same, mindful of proving their admiration for the poet. But they were careful to arrive somewhat early and to place, under each plate, a copy of their *Lettre ouverte à M. Paul Claudel, ambassadeur de France au Japon,* dated the previous day.[44]

This letter, with twenty-eight signatures, was in response to declarations Claudel had made to the Italian press, partially reprinted in *Comœdia:* after confirming the inanity of "current movements" from the point of view of renewal or creativity, Claudel could find in Dadaism and surrealism "only one rationale: a pederastic one." He stubbornly maintained that it was perfectly normal to be, simultaneously, a "writer, diplomat, French ambassador and poet." The surrealists' response was violent and did not miss the opportunity to recall the necessary links between writing and morality, along with the desire to have done with so-called civilization: "We hope with all our strength that revolution, war and colonial insurrection will annihilate this western civilization whose vermin you defend all the way to the far East. . . . There is only one moral idea that remains intact, and that is, for example, that one cannot be at the same time a French ambassador and a poet . . . Catholicism, Greco-Roman classicism, we abandon you to your unspeakable piety . . . may you put on weight and be crushed to death beneath the admiration and respect of your fellow citizens. Write, pray and drool." It goes without saying that the distribution of such a text was hardly conducive to an atmosphere of serenity among the guests at the banquet.

Moreover, that very morning, in *L'Humanité,* a "Call to Intellectual Workers"

1

3

2

4

Lettre ouverte à M. Paul Claudel

Ambassadeur de FRANCE au JAPON

« Quant aux mouvements actuels pas un seul ne peut conduire à une
« véritable rénovation ou création. Ni le *dadaïsme*, ni le *surréalisme* qui
« ont un seul sens : pédérastique.
« Plus d'un s'étonne non que je sois bon catholique, mais écrivain,
« diplomate, ambassadeur de France et poète. Mais moi, je ne trouve en
« tout cela rien d'étrange. Pendant la guerre, je suis allé en Amérique du
« Sud pour acheter du blé, de la viande en conserve, du lard pour les
« armées et j'ai fait gagner à mon pays deux cents millions ».

M. Ségoto, *interview de Paul Claudel reproduite
par* "*Comœdia*", *le 17 Juin 1925.*

Monsieur,

Notre activité n'a de pédérastique que la confusion qu'elle introduit dans l'esprit de ceux qui n'y participent pas.

Peu nous importe la création. Nous souhaitons de toutes nos forces que les révolutions, les guerres et les insurrections coloniales viennent anéantir cette civilisation occidentale dont vous défendez jusqu'en Orient la vermine et nous appelons cette destruction comme l'état de choses le moins inacceptable pour l'esprit.

Il ne saurait y avoir pour nous ni équilibre ni grand art. Voici déjà longtemps que l'idée de Beauté s'est rassise. Il ne reste debout qu'une idée morale, à savoir par exemple qu'on ne peut être à la fois ambassadeur de France et poète.

Nous saisissons cette occasion pour nous désolidariser publiquement de tout ce qui est français, en paroles et en actions. Nous déclarons trouver la trahison et tout ce qui, d'une façon ou d'une autre, peut nuire à la sûreté de l'État beaucoup plus conciliable avec la poésie que la vente de " grosses quantités de lard " pour le compte d'une nation de porcs et de chiens.

C'est une singulière méconnaissance des facultés propres et des possibilités de l'esprit qui fait périodiquement rechercher leur salut à ces goujats de votre espèce dans une tradition catholique ou gréco-romaine. Le salut pour nous n'est nulle part. Nous tenons Rimbaud pour un homme qui a désespéré de son salut et dont l'œuvre et la vie sont de purs témoignages de perdition.

Catholicisme, classicisme gréco-romain, nous vous abandonnons à vos bondieuseries infâmes. Qu'elles vous profitent de toutes manières ; engraissez encore, crevez sous l'admiration et le respect de vos concitoyens. Écrivez, priez et bavez ; nous réclamons le déshonneur de vous avoir traité une fois pour toutes de cuistre et de canaille.

Paris, le 1er Juillet 1925.

Maxime Alexandre, Louis Aragon, Antonin Artaud, J.-A. Boiffard. Joe Bousquet, André Breton, Jean Carrive, René Crevel, Robert Desnos, Paul Éluard, Max Ernst, T. Fraenkel, Francis Gérard, Eric de Haulleville, Michel Leiris, Georges Limbour, Mathias Lübeck, Georges Malkine, André Masson, Max Morise, Marcel Noll, Benjamin Péret, Georges Ribemont-Dessaignes, Philippe Soupault, Dédé Sunbeam, Roland Tual, Jacques Viot, Roger Vitrac.

("Appel aux travailleurs intellectuels") had appeared, subtitled "Do you condemn war, yes or no?" The appeal had garnered a good number of signatures, including the surrealists', and it denounced the imperialist origins of the war in the Rif region of Morocco, proclaiming "the right of peoples, of all peoples, of whatever race, to self-determination," demanding the immediate cessation of hostilities. It is likely that the majority of the guests at the banquet for Saint-Pol Roux had already seen the text, and although its humanist tone was quite far removed from any revolutionary stance, it was nevertheless strongly opposed to national policy and eager to denounce its intrigues and false pretexts.[45]

Under such conditions it is understandable that the personalities present at the banquet hardly appreciated the remarks made about them by the surrealists: these personalities included Joseph-Henri Rosny the elder, Jean Royère, Édouard Dujardin, and notably, at the table of honor (another institution that found little favor with the surrealists), Rachilde—who had just distinguished herself in the French press by her blatant Germanophobia—was seated alongside Lugné-Poé, who had worked in French counterespionage during the war. Very soon, voices were raised, then fistfights broke out, and soon the police were sent for; they made a mistake and began by detaining Rachilde herself. Leiris, who shouted "Down with France!" and "Long live Germany!" from the window, then down on the sidewalk, barely escaped a lynching. In the days that followed, the press unleashed its anger against the group, whose members—the reporters felt obliged to point out the foreigners among them—were accused of treason; the "literary" institutions (Société des Gens de Lettres, Association des Écrivains Combattants) tried to outdo each other in their dispatches avenging the honor of Rachilde, the flag, and civilization, and Orion, the columnist of *L'Action française,* urged all his colleagues to punish all the rowdy characters by vowing to speak no more of them.

Beyond such more or less ridiculous repercussions, the incident, for Breton and his followers, had a radical effect: "It signals the definitive split between surrealism and all the conformist elements of the era. . . . From this moment on the bridges between surrealism and all the rest have been destroyed. We'll manage very well. Still, from now on this means that the common rebellion will tend to channel its efforts on the political level."[46] During the months that followed, discussions on the revolutionary aims of the movement and the means to attain them would be numerous and intense indeed.

Affirmation of Pictorial Surrealism: Priority to Picasso

It was not politics, however, that occupied the foreground in the fourth issue of *La Révolution surréaliste* (July 15, 1925): in his opening piece, "Why I Have Taken over the Editor's Chair at *La Révolution surréaliste,*" Breton tended rather, in a fairly elliptical way, to expound on the difficulties still had to be overcome within the group and on the need for complete agreement among all the periodical's collaborators on the goals to be attained.[47] Yet again the aim was "to be done with the ancien régime of the mind," but the frenetic pace with which Artaud had led the publication was no longer maintained: "We were surely somewhat hasty in decreeing that spontaneity should be given a free rein, or that we ought to let ourselves go to the grace of events, or that the only means we had to intimidate people was through brutal warnings. Each one of these notions, successively taking precedence one over the other, had the effect of

occulting the original validity of the surrealist *cause,* and of inspiring a regrettable detachment." If the issue was still that of "obeying the orders of the marvelous," it was also necessary to reconfirm an absolute refusal to comply with "the assault man perpetrates upon man." Initially, the agreement between these two demands was concluded by adopting the principles of revolutionary action, "even if it took class struggle as its departure point, and provided that it was fairly far-reaching."

The publication of such a text fifteen days after the scandal of the Saint-Pol Roux banquet was symptomatic of the group's internal hesitancy and conflict: the definition of potential "revolutionary acts" was far from established. And in this context the class struggle seemed to be a very restrictive concept. It was not surprising therefore that the theories of "Why I Have Taken over the Editor's Chair at *La Révolution surréaliste* " seemed very vague to the reader; the whole point now was to give a sense of direction, or new sense of direction, to the group without causing any internal scission—whence the dual reminder made in the text of the movement's initial principles (the marvelous) and its potential political impact, though neither was made entirely clear.

The novelty of the issue was anything but political as well, with the beginning of the publication of *Le Surréalisme et la Peinture,* which brought a timely rectification of the almost total silence in the manifesto with regard to painting, although in his speech in Barcelona in November 1922 ("Caractères de l'évolution moderne et ce qui en participe") Breton had made parallel references to progress in both poetry and painting. It was important, therefore, to confirm that painting was also of concern to surrealism or, at least, that surrealism had something to say about visual art, and it was all the more urgent given the fact that in the previous issue of *La Révolution surréaliste* Pierre Naville in his column on fine arts had given a peremptory response to an earlier query by Morise: "It is no longer a secret to anyone that there is no such thing as *surrealist painting.* It is obvious that neither pencil strokes made with chance gestures, nor an image retracing the figures of a dream, nor imaginative fantasies can be qualified as such." Nor did the title chosen by Breton directly contradict this viewpoint: it announced not the existence of "surrealist painting" but, rather, the analysis of the relations possible between surrealism and pictorial activity and what one could expect from that activity in line with the movement.

The explanations offered by *Le Surréalisme et la Peinture* also seemed justified, given the fairly casual use of the adjective "surrealist" by both critics and the art market: just as the situation regarding the pretensions of Dermée and Noll was clarified with the publication of the manifesto, this volume dealt with the confusion over the plastic arts, insofar as nothing else had established what might legitimately be qualified as surrealist in contemporary art. Under these conditions, there had been several exhibitions where works by Masson, Miró, Georges Papazoff, Ernst, or Klee were hung side by side, and this gave rise to any amount of confused appraisal on the part of the reporters.[48]

"The eye exists in a wild state": from the start Breton's text suggested that painting, as it continued to be practiced by the majority of artists, offered nothing that could satisfy this "wildness," and yet it was wildness that must be taken into consideration if one were to cease "going like a madman through the slippery halls of museums." It was time for the painters themselves to bring about a "disalienation" of the gaze and indeed of painting at the same time, so that the work of art would (once again) be capable of giving the viewer something other than a "passing emotion." For, as Breton insisted, "there is not one work of art that can withstand our integral *primitivism* in this regard."

In this context, the criticism of imitation in painting had the same impact in the manifesto as that of the psychological novel: "It is a paltry use of the magical power of representational painting, whose charm certain practitioners possess, to have it serve to preserve and reinforce that which would exist regardless of that power. It's an inexcusable abdication."[49] This abdication was indeed all the more serious in that it ultimately validated the world that the surrealists had rejected. Thus the reference to a "purely interior model," without which the plastic work simply "will not be," came to oppose the model borrowed from the painter's exterior reality.

This interior model would play the same role in painting as automatism did in writing. And when it came time to clarify the nature and consequences of such a model, Picasso was chosen as a key example. "It has been said that there could be no surrealist painting. Painting, literature, what's that—oh Picasso, you who have raised the mind to the highest degree not of contradiction, but of evasion!" The point was not to define surrealist painting—painting had been described, in passing, as a "an appalling expedient," for in some ways Breton was only too aware, through his activity for Doucet, in particular, of the existence of the market; he had no illusions about the way in which this or that artist could be tempted to compromise for the market—but to delimit what, in contemporary painting, might harmonize or coincide with surrealism's efforts to leave behind the old world and old forms of thought. Picasso, from this point of view, was the movement's torchbearer, the one who proved through his work that an artist could take every liberty with the visible and who created versions of the visible that had never yet been perceived or dreamed. The most important thing of all was the supreme freedom with which he deformed and reshaped his material, accumulating his daring gestures, defying his own followers. As a result Picasso was invested with an "immense responsibility," insofar as "all it would take would be a failure on the part of this man's will for the match we were playing to be postponed indefinitely, if not lost." So much depended on Picasso's evolution that it went beyond the evidence one would normally expect of painting and its development: at stake was the possibility of seeing the world differently, of thinking things according to one's desire, and that is why no school could exist to impose limits on such a program. Even though in his text Breton was primarily interested in the upheaval that had followed cubism,[50] he asked that the label "cubist" no longer be applied to Picasso (along with the label "surrealist," just in case certain people might be tempted to use it for him).

After this tribute to Picasso's iconoclastic effect on the conception and impact of painting, *Le Surréalisme et la Peinture* went on to deal with the weakness of certain once-admired painters throughout issues 6, 7, and 9–10 of *La Révolution surréaliste*. The judgment was severe: "Those who referred to themselves as 'Fauvists' . . . do nothing more now than perform insignificant tricks behind the bars of time, and any dealer or tamer can protect himself with a chair from these latest, hardly fear-inspiring, tricks. . . . They have moved from the forest and the desert, for which they have not kept the slightest nostalgia, to this tiny arena: gratitude to those who subjugate them and give them a living." "Careers" like these showed to what degree painting—precisely because it must be sold and its value has no common measure with that of a text—was likely, by renouncing the intellectual ambition that alone could justify it, to become a "trade" and be governed by a professionalism that had always been held in contempt. As for Braque, who in principle was highly respectable since he was once the only painter to accompany Picasso in his more risky ventures, his evolution was proving to be some-

Michel Leiris :

1º Je suis mort. Je vois le ciel poudroyer comme le cône d'air traversé, dans une salle de spectacle, par les rayons d'un projecteur. Plusieurs globes lumineux, d'une blancheur laiteuse, sont alignés au fond du ciel. De chacun d'eux part une longue tige métallique et l'une d'elle perce ma poitrine de part en part, sans que j'éprouve aucune douleur. J'avance vers les globes de lumière en glissant doucement le long de la tige et je tiens par la main d'autres hommes qui montent comme moi vers le ciel, suivant chacun le rail qui les perfore. On n'entend pas d'autre bruit que le crissement de l'acier dans nos poitrines.

2º Je perçois si nettement le rapport entre le déplacement rectiligne d'un corps et une palissade perpendiculaire à a direction de ce mouvement, que je pousse un cri aigu.

3º J'imagine la rotation de la terre dans l'espace, non d'une façon abstraite et schématique, l'axe des pôles et l'équateur rendus tangibles, mais dans sa réalité. Ruguosité de la terre.

4º André Masson et moi évoluons dans l'air comme des gymnasiarques.

Une voix nous crie : « Acrobates mondiaux. allez-vous bientôt descendre tous les deux ? » A ces mots, nous renversons par-dessus l'horizon et tombons dans un hémisphère concave.

LES DEMOISELLES D'AVIGNON *Picasso 1908*

2

3

explicable qui traîne et c'est autant qu'emporte le vent d'une chanson d'émigrant, si vous voulez. »

Il faut ne se faire aucune idée de la prédestination exceptionnelle de Picasso pour oser craindre ou espérer de lui un renoncement partiel. Que, pour décourager d'insupportables suiveurs ou arracher un soupir de soulagement à la bête réactionnaire, il fasse mine de temps

au journal immémorial « LE JOUR... » On a dit qu'il ne saurait y avoir de peinture surréaliste. Peinture, littérature, qu'est-ce là, ô Picasso, vous qui avez porté à son suprême degré l'esprit, non plus de contradiction, mais d'évasion ! Vous avez laissé pendre de chacun de vos tableaux une échelle de corde, voire une échelle faite avec les draps de votre lit, et il est probable

ÉCOLIÈRE *Picasso 1920*

à autre d'adorer ce qu'il a brûlé, rien ne me me semble plus divertissant, ni plus juste. Du laboratoire à ciel ouvert continueront à s'échapper à la nuit tombante des êtres divinement insolites, danseurs entraînant avec eux des lambeaux de cheminées de marbre, tables adorablement chargées, auprès desquelles les vôtres sont des tables tournantes, et tout ce qui reste suspendu

que, vous comme nous, nous ne cherchons qu'à descendre, à monter de notre sommeil. Et ils viennent nous parler de la peinture, ils viennent nous faire souvenir de cet expédient lamentable qu'est la peinture !

Enfants nous avions des jouets qui aujourd'hui nous feraient pleurer de pitié et de rage. Plus tard, qui sait, nous reverrons comme ceux de

1 Page 1 of *La Révolution surréaliste*, number 6 (March 1926): "La Dame de carreau" by Paul Éluard, with De Chirico's *L'Après-midi d'Ariane*.

2 Giorgio De Chirico, *Self-portrait, Georgius De Chirico se ipsum* (1920); oil on canvas, 12 × 9³/₅ in. (30 × 24 cm). Private collection.

3 Giorgio De Chirico, *Self-portrait* (1924–25); oil on canvas, 30 × 24⁴/₅ in. (75 × 62 cm) Private collection.

4 Giorgio De Chirico, *Self-portrait* (1920); oil on canvas, 24 × 20¹/₅ in. (60 × 50.5 cm). Private collection.

5 Giorgio De Chirico, *Self-portrait* (1922–23); oil on canvas, 23⁴/₅ × 19⁴/₅ in. (59.5 × 49.5 cm). Private collection.

what disturbing, insofar as he sought to "correct" emotion by the book: "I am afraid," said Breton, "that in a year or two I shall not be able to say his name." But in the meantime a "virtue of fascination" continued to emanate from his work.

De Chirico

The break with De Chirico was a clean one, in keeping with the disappointment it caused. His metaphysical period had been an important reference for Breton and the surrealists for everything it taught them about the artist's visionary capabilities, but the artist was henceforth determined to reject that period, thus contesting the surrealists' interpretation. In the fourth issue of *La Révolution surréaliste,* Max Morise published a piece ("About the De Chirico Exhibition") in which he set out his concerns regarding the painter's new style, which seemed to him to be transforming the statues, monuments, and other objects in his canvasses from the enigmatic signs they had always been into evocations that conformed to "human proportions." Morise even wondered if this did not constitute a "new enigma" worthy of closer scrutiny. In the sixth issue of the periodical, the debate seemed settled by the reproduction of a recent canvas, *Oreste et Electre,* which had been simply crossed out. But the next installment of *Le Surréalisme et la Peinture* in the following issue would make the grievances more explicit. De Chirico had betrayed his genius not only for venal reasons that had led him to the pretense of "correcting" his earlier paintings but also—and this accusation is clearly more serious—because he claimed that henceforth he was "master of his dreams": instead of letting himself be guided like a sleepwalker by his hallucinations, he aimed to control his production, to place it at the service of noble themes (portraits, figures from antiquity), and therefore he could no longer allow his vision to wander in the way he had between 1910 and 1917.

For Breton this rejection deserved particular condemnation because De Chirico was betraying not only the surrealists' trust but also Apollinaire's, who had been the first to praise him and who remained, for Breton and his fellows, the leading advocate of the forms of modernity that concerned them. Breton emphasized the role played by De Chirico in defining the mental path that gave the movement its sense of direction: "Just between us, and I'll lower my voice, in the growing incertitude about the mission with which we've been entrusted, we often looked to this landmark the way we looked to Lautréamont; together with De Chirico they were enough to keep us on a straight course." Given equal weight with Lautréamont, De Chirico had been endowed with considerable responsibility, which made the disappointment all the more intense. When *Le Surréalisme et la Peinture* was published in a collected volume, Breton replaced one footnote reproaching De Chirico for accepting a preface by the "ignoble cretin Albert-C. Barnes" for his latest exhibition with another equally long note, quoting a text written by the painter in 1913, the better to emphasize his catastrophic evolution: "For a work of art to be truly immortal, it must thoroughly transcend the limits of the human: common sense and logic must be lacking. In this manner it will be more like a dream, closer to the mentality of children . . . The revelation we have of a work of art, the conception of a painting reproducing whatever it might be, which has no sense on its own, no subject, which from the point of view of human logic *doesn't mean a thing*—that revelation, that conception *must* be so strong within us that they procure such joy or such pain that we are obliged to paint, driven by a force greater than that

LA DAME DE CARREAU

L'APRÈS-MIDI D'ARIANE *Chirico.*

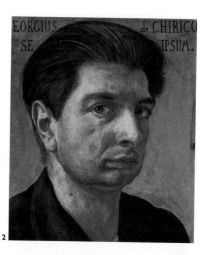

Tout jeune, j'ai ouvert mes bras à la pureté. Ce ne fut qu'un battement d'ailes au ciel de mon éternité, qu'un battement de cœur, de ce cœur amoureux qui bat dans les poitrines conquises. Je ne pouvais plus tomber.

Aimant l'amour. En vérité, la lumière m'éblouit. J'en garde assez en moi pour regarder la nuit, toute la nuit, toutes les nuits.

Toutes les vierges sont différentes. Je rêve toujours d'une vierge.

A l'école, elle est au banc devant moi, en tablier noir. Quand elle se retourne pour me demander la solution d'un problème, l'innocence de ses yeux me confond à un tel point que, prenant mon trouble en pitié, elle passe ses bras autour de mon cou.

Ailleurs, elle me quitte. Elle monte sur un bateau. Nous sommes presque étrangers l'un à l'autre, mais sa jeunesse est si grande que son baiser ne me surprend point.

Ou bien, quand elle est malade, c'est sa main que je garde dans les miennes, jusqu'à en mourir, jusqu'à m'éveiller.

Je cours d'autant plus vite à ses rendez-vous que j'ai peur de n'avoir pas le temps d'arriver avant que d'autres pensées me dérobent à moi-même.

Une fois, le monde allait finir et nous ignorions tout de notre amour. Elle a cherché mes lèvres avec des mouvements de tête lents et caressants. J'ai bien cru, cette nuit-là, que je la ramènerais au jour.

Et c'est toujours le même aveu, la même jeunesse, les mêmes yeux purs, le même geste ingénu de ses bras autour de mon cou, la même caresse, la même révélation.

Mais ce n'est jamais la même femme.

Les cartes ont dit que je la rencontrerai dans la vie, *mais sans la reconnaître.*

Aimant l'amour.

Paul ELUARD.

which drives a famished person to throw himself like an animal onto the piece of bread he has suddenly found." Disdain for all logic, obedience to a complete necessity, suspension of attached, preestablished meanings outside the painting, to the objects portrayed, the fatal character of painting: everything, in these lines, seemed attuned with what Breton termed "an interior model." By renouncing this, De Chirico put an end to the elaboration of a modern mythology, turning away from its apparitions and from the latent life of things, heavy with inexplicable menace. His recurrent objects (artichokes, gloves, geometric volumes), his outsized shadows, his hardly compatible perspectives, gave way to the depiction of animals (horses by the seaside) or humans (mythological heroes replaced anonymous mannequins), whose disposition now obeyed only narrowly artistic motivations (the point was to paint well, or "better," and to compose well). Something that had designated a possibility beyond painting, a hallucinated exploration of the mental, and at the same time what was possible in the world, had yielded to painting in its most ordinary incarnation. It was now left to the surrealists, and the surrealists alone, to continue to explore and interrogate the irrational juxtapositions that the former reader of Schopenhauer and Nietzsche had given to them at the brink of what would become his "career": "We will question them for as long as we live," said Breton, "without the embarrassing presence of their author attempting to turn us away from them."[51]

Ernst, Man Ray, Masson

Once the shortcomings of De Chirico had been noted, and Picabia had been praised—despite his perfect failure to understand surrealism—for continuing in spite of everything to be of importance (because he, according to Breton, "had a particularly violent disgust for the dealings that every pictorial work results in these days"), it was Max Ernst who won the place of honor.[52] He stood apart because of his " extraordinary sense of culture—captivating, paradoxical, priceless culture," where the tastes of Rimbaud, Ducasse, Jarry, and Apollinaire converged. But above all he was capable of placing it in the service of a newer form of disorientation. As soon as he arrived in Paris, his collages established "other relations than those habitually established between beings and things, which had been considered as given *in favor of the image.*" Thus, said Breton, "everything that he released from the absurd oath of appearing or not appearing all at once, everything that his hands opened or closed on is as much as I hoped thus to see, and that is what I saw." The human figures he portrayed went beyond anything one might expect, as can be seen in *Deux enfants sont menacés par un rossignol* (1924) as well as in *L'Inquisiteur: À 7 h 07 justice sera faite* (1925).

It was in 1925 that Max Ernst created his first frottages on paper (the Histoire naturelle series; the collection was published in 1926 by the Éditions Jeanne Bucher). Ernst described the discovery of this new technique—thanks to which, said Breton, he began to "question the substance of objects, to give that substance full permission to decide upon the new shape its shadow would take, to decide on its attitude and form":

> I found myself one rainy day in an inn by the seaside, and I was struck by the fascination that the floor exerted upon my irritated gaze; the grooves in the floorboards had been accentuated by a thousand scrubbings. I decided to question the symbolism of this obsession and, to come to the aid of my meditative and hallucinatory faculties, I drew a series

Previous pages, verso: Pablo Picasso, *Femme au bord de la mer* (Woman by the shore; 1929); oil on canvas, 51⁴/₅ × 38⁴/₅ in. (129.5 × 97.2 cm). Private collection.

Previous pages, recto: Max Ernst, *Deux enfants sont menacés par un rossignol* (Two children are threatened by a nightingale; 1924); paint and collage, 27⁹/₁₀ × 22⁴/₅ × 4¹/₂ in. (69.8 × 57 × 11.4 cm). Museum of Modern Art, New York.

Right: Max Ernst, *La Vierge corrigeant l'Enfant Jésus devant trois témoins: André Breton, Paul Éluard et le peintre* (The Virgin spanking the Christ child before three witnesses: André Breton, Paul Éluard, and the painter; 1926); 78²/₅ × 52 in. (196 × 130 cm). Museum Ludwig, Cologne.

Opposite page: Max Ernst, *Pietà ou La Révolution la nuit,* (Pietà or revolution by night; 1923); oil on canvas, 46¹/₂ × 35¹/₂ in. (116.3 × 88.9 cm). Tate Gallery, London.

Following pages, verso: André Masson, *Les Quatre éléments* (The four elements; 1923–24); oil on canvas, 29¹/₅ × 24 in. (73 × 60 cm). Musée National d'Art Moderne, Centre Georges Pompidou, Paris.

Following pages, recto: André Masson, *L'Oiseau mort* (The dead bird; ca. 1924–25); oil on canvas, 29¹/₅ × 21⁴/₅ (73 × 54.6 cm). Private collection.

Left: Georges Malkine, *La Nuit d'amour* (The night of love; 1926); oil on canvas, 23³/₅ × 36²/₅ (59 × 91 cm). Private collection.

Below left: Georges Malkine, *Le Baiser* (The kiss; 1927); oil on canvas, 29²/₅ × 24¹/₅ in. (73.5 × 60.5 cm). Private collection.

Below right: Georges Malkine, *Untitled* (1928); oil on canvas, 32²/₅ × 21³/₅ in. (81 × 54 cm). Private collection.

Joan Miró, *The Farm* (1921–22); oil
on canvas, 52⁴/₅ × 58⁴/₅ in. (132 ×
147 cm). National Gallery of Art,
Washington, D.C.

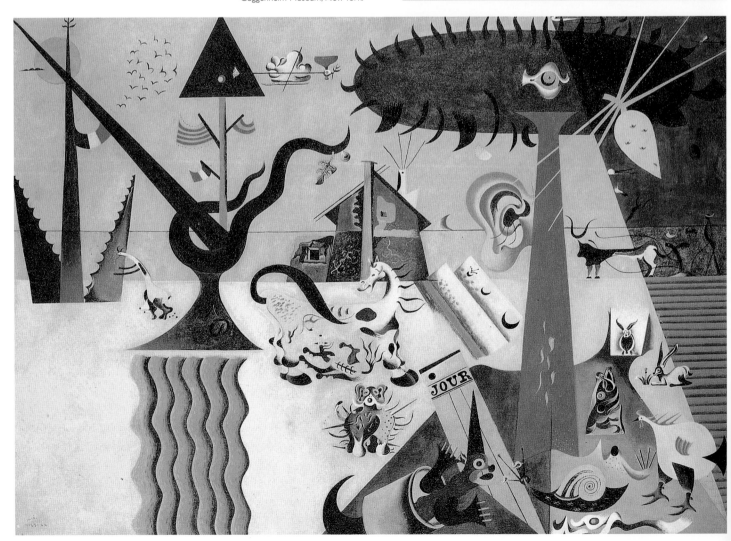

Right: Joan Miró, *Cap de pages catala* (Head of a Catalan peasant; 1925); oil on canvas, 36²/₅ × 29¹/₅ in. (91 × 73 cm). Private collection.

Below: Joan Miró, *Terra llaurada* (The tilled field; 1923); oil on canvas, 26²/₅ × 37³/₅ in. (66 × 94 cm). Solomon R. Guggenheim Museum, New York.

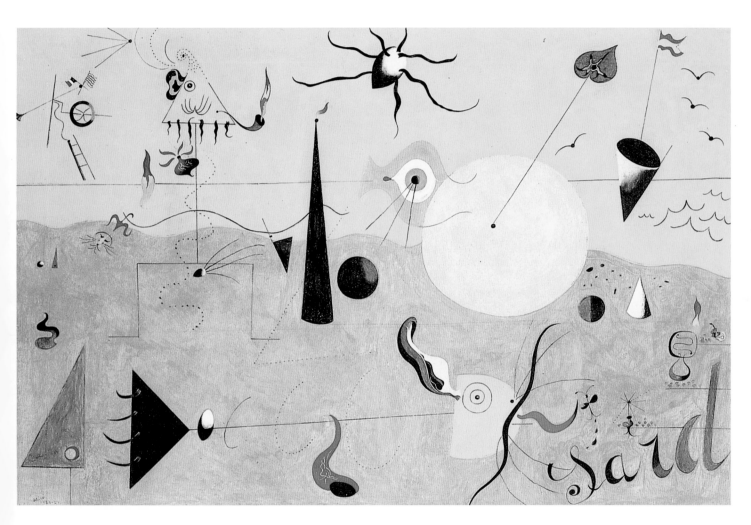

Joan Miró, *Paisage catala (El Cacador)* (Catalan landscape [the hunter]; 1923–24); oil on canvas, 26 x 40 in. (65 x 100 cm). Museum of Modern Art, New York.

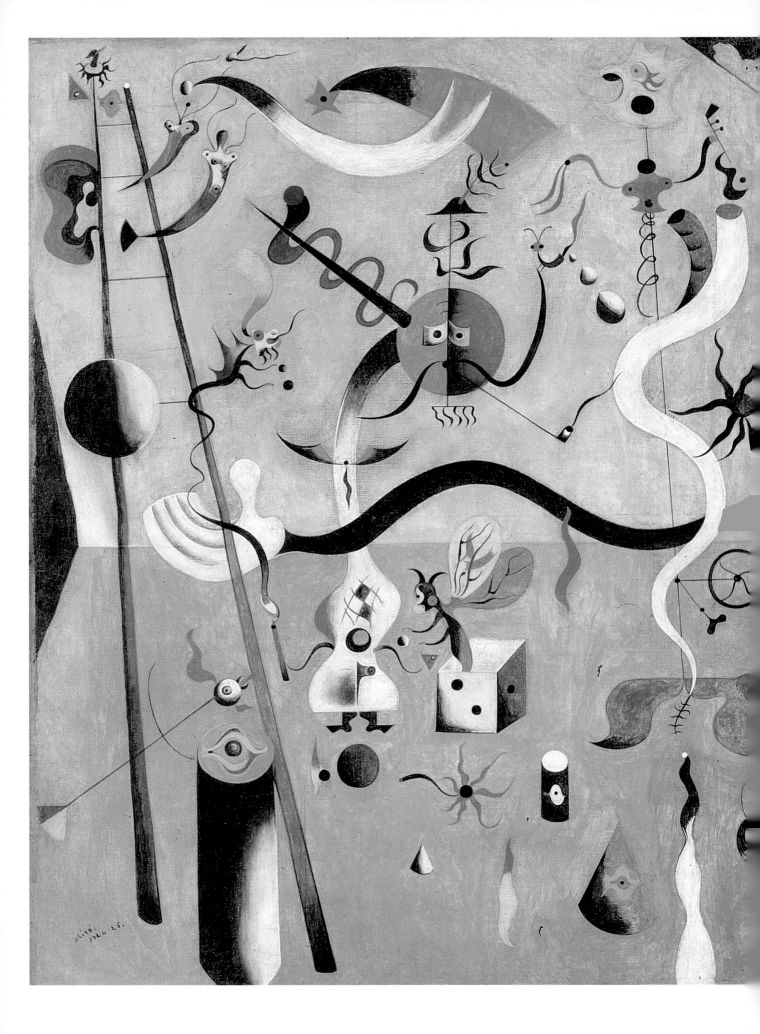

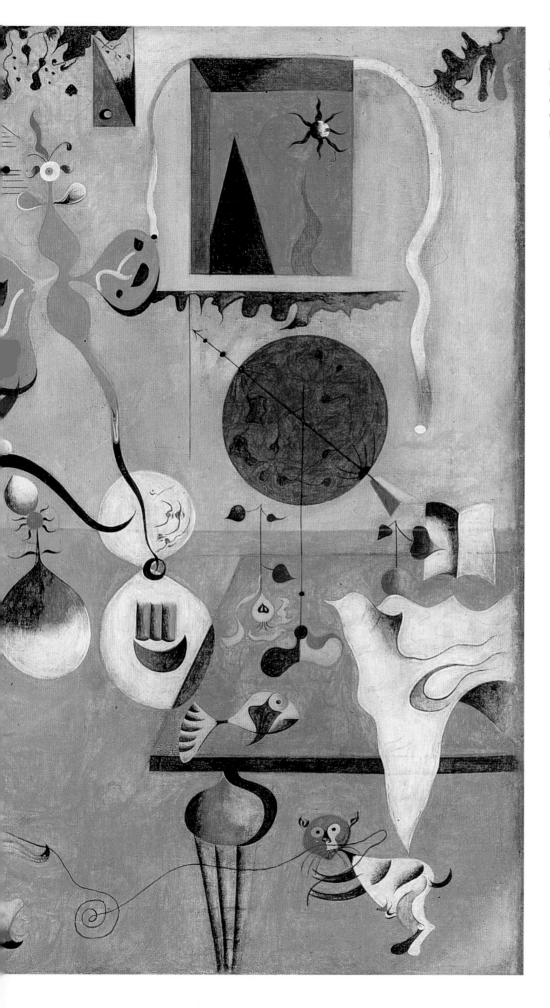

Joan Miró, *Le Carnaval de l'Arlequin*
(Carnival of Harlequin; 1924–25);
oil on canvas, 26²/₅ × 37¹/₅ in. (66 ×
93 cm). Albright-Knox Art Gallery,
Buffalo, N.Y.

Yves Tanguy, *Le Pont* (The bridge;
1925); oil on canvas, 16 × 13⅛ in.
(40 × 33 cm). Private collection.

Yves Tanguy, *Untitled* (1927); oil on
canvas, 24²/₅ × 20 in. (61 × 50 cm).
Private collection.

Yves Tanguy, cover for Benjamin
Péret's *Dormir, dormir dans les pierres*
(Paris: Éditions Surréalistes, 1927).

of sketches of the floorboards by placing the sheets of paper at random directly on the boards and rubbing over them with a pencil lead. . . . My curiosity was awakened, enchanted, and as a result I began to examine, indifferently, using the same method, all sorts of substances that might be within my visual field: leaves with their veins, the shredded edges of a piece of sackcloth, brushstrokes on a "modern" painting, a thread unwound from its spool, and so on. My eyes then saw human heads, various animals, a battle ending in a kiss (*La Fiancée du vent*), boulders, the *sea* and the *rain, earthquakes, the sphinx in his stable, little tables around the earth.*[53]

He rapidly transposed the rubbing onto canvas and was able thus to confer a faultless proof on the most improbable figures (*La Mariée du vent,* or *Enfant, cheval, fleur et serpent* [1927]).

This ease, which enabled Ernst to give the hitherto unseen an almost everyday appearance, making each painting the pretext for a sensory and mental experience in which surprise mingled with the impression that an imprecise and vague expectancy had at last been fulfilled, may have won him Breton's trust but did not, however, give him permission to do whatever he liked. In May 1926, he designed the decor for Diaghilev's ballet *Roméo et Juliette* together with Miró, and this provoked a "protest" from Aragon and Breton, who viewed the collaboration as "an attitude that arms the worst partisans of moral equivocation."[54] Breton and Aragon insisted, moreover, that the collaboration would in no way imply "the downgrading of the *surrealist* idea." The conflict was short-lived, however: the following issue of *La Révolution surréaliste* reproduced *La Belle Saison* and *La Vierge corrigeant l'Enfant Jésus devant trois témoins: André Breton, Paul Éluard, et l'artiste,* along with a statement by Éluard: "Once again, we must recognize ourselves, and once again, our enemies must abandon their judgment of us. The purest are staying with us."[55]

The text of *Le Surréalisme et la Peinture,* in its periodical form, ended with a study of Man Ray and Masson. Man Ray's various activities—photographic portraits, rayographs, pictorial works—were described as stemming from "a same mental process," but Breton emphasized his photography above all. He emphasized Man Ray's exploration, with his own specific methods, of a "region that painting had thought was its own preserve." Man Ray had obtained the privilege of "successfully navigating the photographic vessel through an almost incomprehensible turbulence of images," by granting an equal presence to the ghostly allure of the objects captured by his rayographs and to the "very elegant and very beautiful women" whose portraits he took.[56]

As for Masson, Breton initially suggested that the affinity that united them was founded on a sentiment of "life, reluctantly," but his wariness toward art also pushed him to praise Masson as the representative of a chemistry of the intelligence that created paintings that were "so many inevitable and brilliant 'precipitates.'" The tribute was significant, in 1927—all the more so coming at the end of the series of publications in *La Révolution surréaliste.*

It was all the more warranted, too: since the final days of 1926, or the early weeks of 1927, Masson had been working on his sand paintings, thanks to which he hoped to close the gap between his automatic drawings characterized by a lightning speed of execution, and his oil paintings, which were nearly always, of necessity, subject to what he called a "fatal reflection." During a stay in Sanary, he discovered the solution while contemplating the shoreline. Recalling the process in 1961, Masson wrote:

As soon as I got home, on the floor of my room I laid an unprepared canvas onto which I squeezed spurts of glue, then I covered it over with the sand I had brought back from the beach. In my fashion, I was recreating Leonardo da Vinci's exemplary wall. . . . With successive layers of glue and sand of varying texture and different grains, I improved on the procedure. The best was when I did not mix colored powder to the sand. Still, as with ink drawings, the figure that appeared had been sought after, and this heterodox painting was completed thanks to the help of a stroke of the brush, at times a spot of pure color. Allusively. . . .

In the sand paintings, the image rose up from the material itself, from its dispersion and relief, which called on the painter to perform several gestures to make the basic suggestions more precise: curved lines and colored impact. This is how *Le Chasseur* (The hunter [1926–27]), for example, formed its outline—broken lines that caused the figure to emerge from the sand as if torn in pieces. Later Masson would be astonished, or would even complain, that creations like this were, at that time, less interesting to his friends than more static works (he was thinking of De Chirico and Ernst, then of Dalí), whereas from his point of view they corresponded to a pictorial surrealism that was more authentic than the reconstitution of a dream image, and this underevaluation of the contribution of his sand paintings would be one of the reasons for his unstable, to say the least, relations with the group.

Miró

When *Le Surréalisme et la Peinture* was published as a volume, it was enriched by studies of three additional artists, whose works had earlier been reproduced in *La Révolution surréaliste:* Miró, from number 4 (two paintings: *Le Chasseur* and *Maternité,* which both already belonged to Breton), Jean Arp in number 6, and Tanguy from number 7 on.[57]

At the time of his second Paris exhibition in June 1925 (Galerie Pierre, 13, rue Bonaparte; sixteen paintings and fifteen drawings), Miró was initiated into the group: the opening's preface was written by Péret, and the invitation bore the signature of twenty-two surrealists. Since 1919 Miró had been working alternately in Montroig and Paris where, at rue Blomet, he was Masson's neighbor and began, from 1922 on, to receive regular visits from Limbour, Artaud, Desnos, Leiris, and Roland Tual. But it was not until June 1924 that he would meet Aragon and Éluard, who were soon followed by Naville in their praise, to Breton, of Miró's paintings, but in such a vague fashion, however, that Breton would write to his wife that they "are incapable of formulating a decisive opinion about the paintings." No doubt, Miró's painting did indeed have something disconcerting about it, with its mixture of a meticulous observation of reality and its treatment of space as a juxtaposition of mass and objects, without any apparent concern for coherence other than a pictorial one—as shown in, for example, *La Ferme* (The farm [1921–22]), in which visual rhymes abound; the painting seems simultaneously to scrutinize reality in its tiniest details and to escape from it toward a universe of signs that has not yet won its autonomy. "My *Ferme* and my still life paintings never interested [Breton and Éluard]. They only became aware of my existence when my painting freed itself into poetry and dreams with *Terre labourée, Carnaval d'Arlequin* (Labored earth, Harlequin carnival), and the others that followed," Miró would later comment.[58] It was actually with these two paintings, created in 1923 and 1924–25

1

4

2

5

3

6

7

respectively, that a pictorial metamorphosis took place: the dismemberment of visible appearances engendered a universe swarming with shapes, graphic signs, animals, aggressive or ironic people; the world depicted was of an astonishing richness and effervescence. On the painter's own admission, this evolution was due to contact with writers and poets: "You literary people, all my friends, have helped me a lot, and made it easier for me to understand so many things. . . . I've made a series of little objects in wood, where I start off using the shape of the wood itself. Starting like this from an artificial thing is, in my opinion, similar to the process writers might use starting from a certain sound. . . . I have freed myself from the poison of any pictorial convention," he wrote in August 1924 to Michel Leiris, before adding, "My latest paintings have been conceived as if from a bolt of lightning, utterly free of the outside world (the world of men who have two eyes in the hollow beneath their forehead). . . . So it's hardly painting but I don't give a damn."[59] The *Carnaval d'Arlequin* is made up of a number of drawings in which Miró recorded the hallucinations caused by the hunger from which he frequently suffered at the time: the figures moving in the painting are no longer a product of the visible but of a sort of clairvoyance imposed by physiology, and their dance defines a space that is, above all, mental, despite the allusions to objects (a ladder, a table) and the discreet opposition between an interior (a room or the studio) and the exterior (a window open onto the night). *Maternité* and *Le Chasseur* (also entitled *Paysage catalan*), reproduced in *La Révolution surréaliste,* reduce their motives to a game of graphic, colored signs, true pictograms whose ties to their pretext are sufficiently slack to enable them to seem totally indifferent to what they evoke: geometric forms take on an almost organic life, while the surface of the sea is suggested, as in childhood, by a few wavy lines. The freedom of conception that reigns in these paintings ravishes the viewer, allowing one to enter a universe whose dreamlike atmosphere is not the result of earlier dreams but of a work of reflection to define and situate form-signs. There was therefore a paradox in the work Miró was beginning to create, if one considers the central role played by automatism in the very definition of surrealism: the initial sketches might have been the result of a feverish and hasty execution, but long and careful reflection always went into the ultimate creation of the painting.

In the paragraphs devoted to Miró, Breton viewed his work with a mixture of admiration and reticence. If, on the one hand, Miró might "seem to be the most surrealist among us," Breton was concerned, on the other hand, that "a thousand problems . . . don't seem to worry him in the least, although they are the ones that shape the human spirit"; no one else "is prepared, as he is, to associate that which cannot be associated; to break, indifferently, that which we dare not wish to see broken." But did not the ease with which Miró could hold convention up to ridicule risk making him its own victim one day, if he so much as forgot that he was "only an instrument" for the imagination (and one could guess where that might lead—to the situation that was now De Chirico's)? Very early on in his encounters with the group, Miró made it clear that he would retain his independence as a painter; if at times he joined in the meetings at the café, he remained silent ("Masson took part in the discussion, but I generally remained silent"), he quickly grew bored, and his name was never to be found at the bottom of a collective text. The only things that mattered to him were painting, the discussions he might have about painting with Masson, and his work, "in silence, with an ascetic discipline."

1, 2 Joan Miró, preparatory sketches
for *Tête de paysan catalan*
(1924–25). Miró Foundation,
Barcelona.

3 Joan Miró, preparatory sketch for
Le Carnaval d'Arlequin (1924–25).
Miró Foundation, Barcelona.

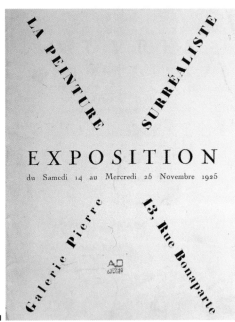

1

LA PEINTURE SURRÉALISTE

EXPOSITION

du Samedi 14 au Mercredi 25 Novembre 1925

Galerie Pierre 13, Rue Bonaparte

2

Vous êtes invité à assister au Vernissage de

L'EXPOSITION DE PEINTURE SURRÉALISTE

le Vendredi soir 13 Novembre 1925, à MINUIT

à la GALERIE PIERRE, 13, Rue Bonaparte

3

4

Vous êtes invité à visiter fréquemment

la Galerie Surréaliste

16, Rue Jacques Callot
(Rue de Seine)

PARIS . 6e
Téléphone : Fleurus 44·96

ÉDITIONS SURRÉALISTES

Livres et Manuscrits .

Tableaux et Dessins de : Arp, Braque, Chirico,
Duchamp, Ernst, Klee, Malkine, Masson,
Miró, Picabia, Picasso, Man Ray, Tanguy, etc.
Objets sauvages : Nouveau-Mecklembourg,
Nouvelle-Poméranie, Nouvelle-Guinée, etc.
Objets Surréalistes : Boules de neige, Disques

The Surrealist Gallery and Publications

After November 13, 1925, at midnight (a time already chosen for the opening of Miró's exhibition), the surrealists' taste in art became known by other means than text alone. On that date, the exhibition *La Peinture surréaliste* was inaugurated at the Galerie Pierre. This first collective event displayed nineteen works by Man Ray, Picasso, Arp, Klee, Masson, Ernst (*Monument aux oiseaux, Maison aux étoiles,* and *Deux enfants sont menacés par un rossignol*), Miró (*Carnaval d'Arlequin* and *Dialogue d'insectes*), Pierre Roy, and De Chirico (*Le Revenant* and *J'irai... Le chien de verre*).[60] Breton and Desnos coauthored the preface of the catalog, in which the paintings' titles provided the narrative thread. The public came in droves, and if one report is to be believed, there were "ten times as many people as could fit in the tiny gallery, so that as soon as you went through the door you were swallowed up by the crowd." But some were not at all appreciative: Georges Charensol seemed to prefer "the cubist paintings of a Picasso or a Braque" to Miró or Masson's work, and Maurice Raynal saw only "likable bibelots, fashions of a day, already tarnished by an unbearable intellectual and graphic jargon."[61]

With the opening on March 26, 1926, of the Surrealist Gallery (16, rue Jacques-Callot), the movement's preferences in art became even clearer.[62] The gallery was officially managed by Marcel Fourrier, and successive directors would be Roland Tual and Marcel Noll, while Breton played the role of adviser. The gallery was inaugurated by an exhibition that assembled *Paintings by Man Ray and Objects from Islands:* for the era this was perfectly incongruous and therefore all the more sensational, as the statue that presided in the window and on the poster (a fetish from the island of Nias) was considered indecent. The scope of the group's "primitive" appreciation was becoming obvious, for they showed their interest both in Man Ray's paintings, where something of the Dada spirit lingered, and in primitive works, some of which (masks from New Guinea and New Ireland, objects from the Marquesas islands and Easter Island) were on loan from Breton. The program of the Surrealist Gallery was an application of the theoretical overviews in *Le Surréalisme et la Peinture.* The artists exhibited were proof of that: Masson, Tanguy, De Chirico, Man Ray, Rrose Sélavy, Picabia, Malkine, Miró, Picasso, and Ernst were all displayed alongside "wild objects" (according to a notice that appeared in *La Révolution surréaliste,* no. 8). Some were honored by their own exhibition: *Yves Tanguy and Objects from America* (May 1927), Ernst (October 1927), Arp (November 1927), and De Chirico (earlier works, February 1928).[63] The gallery also housed the editorial offices of the Éditions Surréalistes, as well as of *La Révolution surréaliste,* from the eighth issue on. The aim of the gallery was certainly to exhibit and sell works of art (with no brilliant results, however—the last exhibition of any size was Man Ray's in April 1928), but it was also a place for publishing and for live events, for it was the role of the events held there to revive the spirit of the surrealist bureau. Thus, the gallery was also a place where people could meet or drop in.[64]

In two years, no less than eleven books, objects, and catalogs were produced by the Éditions Surréalistes. That is not a great deal, if one compares this with the number published by other Parisian publishers during the same period, but it is also a lot, insofar as each production required a financial input that was entirely backed by the surrealists themselves. As for poetry collections, the solution was to finance them through subscription prior to publication, particularly for first editions. Political brochures however (*Légitime défense* in 1926, *Au grand jour* in 1927) and catalogs were distributed

and were obviously less profitable. In addition to these classical publications, there were more unusual publications: "snowballs," in which the traditional monument gave way to an object conceived by an artist, a sculpture by Max Ernst (*Ci-fut une hirondelle* [This was a swallow], a painted plaster in twelve copies), and an album of ten watercolors by Man Ray, dating from 1916–17, reproduced in ten colors and 105 copies (*Revolving Doors* [September 1926]).[65] An anthology of modern poetry on phonograph records was even envisaged, with recordings by Aragon, Artaud, Breton, Desnos, Éluard, Morise, Péret, and Soupault; this was doubtless the most audacious project, but nothing ever came of it. Various means were considered to objectivize thought, and it might be possible to think of the snowballs as prefiguring what surrealist objects would become.[66] An exhibition of objects, with its catalog, was announced in *La Révolution surréaliste* number 8, but surrealist objects would only compel recognition from December 1931 on.

Yves Tanguy, Jean Arp

Of the prefaces written for the exhibitions at the Surrealist Gallery, the ones Breton devoted to Tanguy and Arp were reprinted in the collected volume of *Le Surréalisme et la Peinture*.

Yves Tanguy only met the surrealists in 1925—Desnos, Malkine, and Masson to begin with, then Péret and Aragon, and finally, in December, Breton. At the time he was part of the joyful gang who frequented 54, rue du Château, along with Marcel Duhamel and Jacques Prévert, and after glimpsing two paintings by De Chirico in the window display at Paul Guillaume's gallery in 1923, Tanguy decided to take up painting. His first work on paper enabled him to take part in the Salon de l'Araignée, devoted to illustrators, but his first oils revealed a singular concept of expressionism resonant of De Chirico's work (*Rue de la Santé, Le Pont* [1925]) and likely to integrate off-balance perspectives and a desolate atmosphere. In *Les Forains* or *Fantomas* (1925–26), he conveyed his taste for popular performances and cinema, a taste that was shared by several members of the group, who also enjoyed serialized episodes, music hall, and American imports, where the imagination could go wild with no concern for plausibility.

His meeting with the group was a determining factor for his later work. While at the rue du Château, not only the long-time members—Leiris, Masson, Tual, and Queneau—but also Breton and Man Ray were intensely playing collective games, including exquisite corpse, and from the end of 1925 Tanguy had begun a series of automatic drawings enriched by frottages and grattages of the base. In 1926 his first authentically surrealist paintings (*Genèse, l'orage* [Genesis, the storm]) established new relations between the few remaining representational elements and an undetermined space in which they proposed an enigmatic symbolism. It very quickly became superfluous to resort to representational painting, even on a small scale: Tanguy invented shapes one is at a loss to define, what one might best refer to as vague allusions to a cellular life anterior to the genesis of organisms, spreading and sometimes accompanied by their shadows against a line of horizon that was unreliable, or set in "landscapes" that no geographer would be able to locate. These inhabited areas, of which each painting was little more than a sort of fragmentary view and the evolution of which from one canvas to the next was a product of a purely mental activity, were the result of complete automatism: it was in the lengthy contemplation of his canvas, initially covered with colors

du 15 Février au 1er Mars 1928

Œuvres anciennes
de
Georges de Chirico.

Cet opuscule a été tiré à 1500 exemplaires numérotés, sur les presses
de M. Keller, 88, rue Rochechouart, pour les Éditions Surréalistes.

Galerie Surréaliste
16 Rue Jacques Callot
PARIS (sixième)

1

Éditions Surréalistes {petits caractères}
16, rue Jacques-Callot
Paris (VIe)

Courier
Paul Éluard

Paul Éluard : Défense de savoir
avec un frontispice par G. de Chirico
90 ex. sur Hollande Van Gelder ____ 75f
10 ex. sur Japon Impérial ____ 150f

2

ANDRÉ BRETON ET PAUL ÉLUARD

L'Immaculée
Conception

ÉDITIONS SURRÉALISTES
A PARIS
chez José Corti, Libraire, 6, Rue de Clichy
1930

3

4

spread on at random, that Tanguy discovered the forms that he had only to clarify and make more credible by doubling them with their shadow.

Tanguy's painting was particularly representative of what might make up an "internal model": *Extinction des lumières inutiles, Je suis venu comme j'avais promis, Finissez ce que j'ai commencé* (Extinguishing useless lights, I've come as I promised, Finish what I began), painted in 1927, were presented that same year at the Surrealist Gallery with twenty or more other paintings in the exhibition *Yves Tanguy and Objects from America* organized by Tual and Breton (who in Ernst's company had recently discovered the dolls of Pueblo Indians from New Mexico). From then on, several members of the group (Aragon, Tual, Eluard, and Breton) would acquire paintings by Tanguy, and Breton underlined in his preface to the exhibition catalog that "the great subjective light that permeates Tanguy's paintings never leaves us alone or in a deserted place. There is not one creature here which does not partake, metaphorically, of the life we have chosen to live, or that fails to respond to our expectations, or that does not originate in an order (superior, inferior?) to which we are drawn. This, coming from a man who yields to nothing that is not of the purest nature, is a true glimpse into the mystery of his presence among us. It is also a door closed to any concessions and, where many would like to see only the preferred site of obscure and superb metamorphoses, this is the first nonlegendary view onto a considerable expanse of the mental world in the process of being born."

In number 7 (June 1926), *La Révolution surréaliste* reproduced a work by Tanguy, and Tanguy provided three plates enhanced by watercolors and ten drawings to illustrate a poem by Péret, *Dormir, dormir dans les pierres* (Sleep, sleep in the stones).[67] It established an astonishingly intimate harmony with the text, first witnessed on the cover itself, where the typographical characters matched the lines of the drawing, and yet it was impossible to tell that aspect determined the other.

Jean Arp, who had returned to Paris at the end of 1925, was hardly unknown, since he had collaborated earlier on *Littérature,* and his affinity with Ernst began with the foundation in Cologne in 1919 of a Dadaist cell. His first reliefs in wood dated from 1917, but their forms had grown progressively more supple, a result not only of a chance find (driftwood or worn pieces of wood) but also of a cutting of the material, which was then painted in deliberately lively colors: Arp's aesthetic definitively belonged to the play between nature's suggestions and the artist's procedures, which set about refining and perfecting found shapes. Thus it coincided, at least in part, with Breton's conception of "surreality," which "would be contained in reality itself, neither superior nor exterior to it." Between 1926 and 1933, Arp's collection of forms composed a sort of basic vocabulary (moustache, eyebrow, table, bellybutton, fork, breasts, and so on), the words of which went to compose his reliefs in a playful or humorous way, while a mood of gravity could nevertheless be faintly detected from time to time. Beneath their joyful appearance, his paintings did indeed represent an endeavor where a great deal was at stake, since the aim was to deliver these word-shapes from their usual context in order to place them in very irregular "situations." *Une nature morte* (Still life) from 1927 enumerated its contents in its subtitle: *table, mountain, anchors and bellybutton,* and one did not even dream of being surprised by such juxtapositions, so naturally complicitous had these elements become thanks to their appreciable transposition. Breton, when presenting the exhibit of reliefs at the Surrealist Gallery, would declare that "*in reality,* if we now know what we mean by reality, a nose is quite at

1

3

2

4

home next to an armchair, it even fits the shape of the armchair." Thanks to Arp, poetic metaphor had found its realization: words could be transformed objectively and come to inhabit a concrete world.

The Political Question

The solid implantation of pictorial surrealism coincided with the group's commitment to the Communist Party, although the articulation of these two aspects of revolutionary activity was not self-evident. As a result, Breton repeated his distrust of the temptations of the art market, which risked causing the artists to swing to the side of a professionalism that cared little for ethics. In addition, the democratization of artistic practices—part of the desacralization of art inherited from Vaché and Dada—seemed easier to accomplish in writing than in painting. From December 1924, a number of surrealist leaflets ("Le SURRÉALISME est-il le communisme du génie?" "Le SURRÉALISME c'est l'écriture niée"—"Is SURREALISM the communism of genius?" "SURREALISM is writing denied") emphasized that automatism was within everyone's reach, while a minimal knowledge of the "trade" always seemed to interfere where painting was concerned. *La Révolution surréaliste* may have reproduced drawings by Desnos, Pierre Naville, Georges Bessière, or Dédé Sunbeam, but such examples were rare. Besides, *Le Surréalisme et la Peinture* offered no conclusions concerning the possibilities of a pictorial work produced by just anybody.[68] Éluard, in November 1925, after quoting Lautréamont ("Poetry must be made by everyone, not just one"), went on to declare, in *Clarté,* that "all the ivory towers have been demolished, all words will be sacred, and once reality has been turned upside down, man will need do no more than close his eyes for the doors of wonder to open to him." It seems that his hopefulness concerned poetry even more than painting.

This specificity of the visual was all the more important in that it would also convince the surrealists, once they wanted to collaborate with political leaders, to claim to be acting as specialists where culture was at stake, capable as such of bringing to the Communist Party the knowledge and strategies that the party was lacking, while the party could only accept them as one group of militants among many and was scarcely willing to concede them any particular competence. This did not make their encounters any easier.

In August 1925, the tract called *La Révolution d'abord et toujours!* was signed by the members of *Clarté,* the group from the periodical *Philosophies,* and the Belgian directors of *Correspondance.*[69] Four thousand copies were printed and sent to newspapers, deputies, and senators and to the subscribers of *Clarté* and *La Révolution surréaliste.* It was published on September 21 in *L'Humanité* with a fairly appreciative introductory chapter, then on October 15 in *La Révolution surréaliste* and *Clarté.* Because Henri Barbusse's earlier *Appel* against the war in Morocco did not satisfy the surrealists and those in charge of *Clarté,* they decided to take over the composition of this new text, where the war in Morocco was evoked alongside the "unappeasable conflict of the demands of workers and society," against the much vaster horizon of a purification of "the ideas that form the basis of European civilization . . . and even of any civilization founded on the unbearable principles of necessity and duty." This was followed by the declaration of "a need for Freedom, but a Freedom modeled on our deepest spiritual needs, on the strictest and most human demands of our flesh." All signatories would share the "feel-

1

3

2

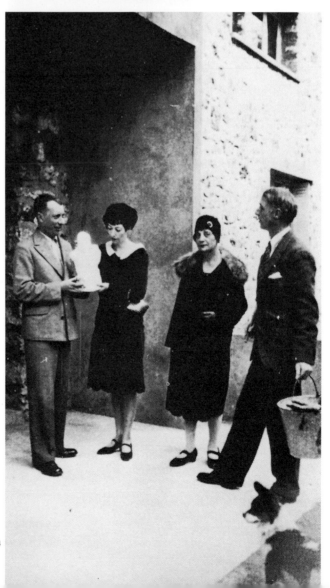

4

LA RÉVOLUTION D'ABORD ET TOUJOURS!

Le monde est un entre-croisement de conflits qui, aux yeux de tout homme un peu averti, dépassent le cadre d'un simple débat politique ou social. Notre époque manque singulièrement de voyants. Mais il est impossible à qui n'est pas dépourvu de toute perspicacité de n'être pas tenté de supputer les conséquences humaines d'un état de choses *ABSOLUMENT BOULEVERSANT*.

Plus loin que le réveil de l'amour-propre de peuples longtemps asservis et qui sembleraient ne pas désirer autre chose que de reconquérir leur indépendance, ou que le conflit inapaisable des revendications ouvrières et sociales au sein des états qui tiennent encore en Europe, nous croyons à la fatalité d'une délivrance totale. Sous les coups de plus en plus durs qui lui sont assénés, il faudra bien que l'homme finisse par changer ses rapports.

Bien conscients de la nature des forces qui troublent actuellement le monde, nous voulons, avant même de nous compter et de nous mettre à l'œuvre, proclamer notre détachement absolu, et en quelque sorte notre purification, des idées qui sont à la base de la civilisation européenne encore toute proche et même de toute civilisation basée sur les insupportables principes de nécessité et de devoir.

Plus encore que le patriotisme qui est une hystérie comme une autre, mais plus creuse et plus mortelle qu'une autre, ce qui nous répugne c'est l'idée de Patrie qui est vraiment le concept le plus bestial, le moins philosophique dans lequel on essaie de faire entrer notre esprit (1).

Nous sommes certainement des Barbares puisqu'une certaine forme de civilisation nous écœure.

Partout où règne la civilisation occidentale toutes attaches humaines ont cessé à l'exception de celles qui avaient pour raison d'être l'intérêt, « le dur paiement au comptant ». Depuis plus d'un siècle la dignité humaine est ravalée au rang de valeur d'échange. Il est déjà injuste, il est monstrueux que qui ne possède pas soit asservi par qui possède, mais lorsque cette oppression dépasse le cadre d'un simple salaire à payer, et prend par exemple la forme de l'esclavage que la haute finance internationale fait peser sur les peuples, c'est une iniquité qu'aucun massacre ne parviendra à expier. Nous n'acceptons pas les lois de l'Economie ou de l'Echange, nous n'acceptons pas l'esclavage du Travail, et dans un domaine encore plus large nous nous déclarons en insurrection contre l'Histoire. L'Histoire est régie par des lois que la lâcheté des individus conditionne et nous ne sommes certes pas des humanitaires, à quelque degré que ce soit.

C'est notre rejet de toute loi consentie, notre espoir en des forces neuves, souterraines et capables de bousculer l'Histoire, de rompre l'enchaînement dérisoire des faits, qui nous fait tourner les yeux vers l'Asie (2). Car, en définitive, nous avons besoin de la Liberté, mais d'une Liberté calquée sur nos nécessités les plus profondes, sur les exigences les plus strictes et les plus humaines de nos chairs (en vérité ce sont toujours les autres qui auront peur). L'époque moderne a fait son temps. La stéréotypie des gestes, des actes, des mensonges de l'Europe a accompli le cycle du dégoût (3). C'est au tour des Mongols de camper sur nos places. La violence à quoi nous nous engageons ici, il ne faut craindre à aucun moment qu'elle nous prenne au dépourvu, qu'elle nous dépasse. Pourtant, à notre gré cela n'est pas suffisant encore, quoi qu'il puisse arriver. Il importe de ne voir dans notre démarche que la confiance absolue que nous faisons à tel sentiment qui nous est commun, et proprement au sentiment de la révolte, sur quoi se fondent les seules choses valables.

Plaçant au-devant de toutes différences notre amour de la Révolution et notre décision d'efficace, dans le domaine encore tout restreint où pour l'instant le nôtre, nous : CLARTÉ, CORRESPONDANCE, PHILOSOPHIES, etc. déclarons ce qui suit :

1° Le magnifique exemple d'un désarmement immédiat, intégral et sans contre-partie qui a été donné au monde en 1917 par LÉNINE à *Brest-Litovsk*, désarmement dont la valeur révolutionnaire est infinie, nous ne croyons pas *votre* France capable de le suivre jamais.

2° En tant que, pour la plupart, mobilisables et destinés officiellement à revêtir l'abjecte capote bleu-horizon, nous repoussons énergiquement et de toutes manières pour l'avenir l'idée d'un assujettissement de cet ordre, étant donné que pour nous la France n'existe pas.

3° Il va sans dire que, dans ces conditions, nous approuvons pleinement et contresignons le manifeste [...] Comité d'action contre la [...] Maroc, et cela d'autant pl[...] auteurs sont sous le coup d[...] judiciaires.

4° Prêtres, médecins, prof[...] térateurs, poètes, philosoph[...] listes, juges, avocats, policie[...] ciens de toutes sortes, vous [...] taires de ce papier imbécile : [...] lectuels aux côtés de la Pa[...] vous dénoncerons et vous [...] en toute occasion. Chiens dr[...] profiter de la patrie, la seu[...] cet os à ronger vous anime.

5° Nous sommes la révolte de l'esprit ; nous considérons la Révolution sanglante comme la vengeance inéluctable de l'esprit humilié par vos œuvres. Nous ne sommes pas des utopistes : cette Révolution nous ne la concevons que sous sa forme sociale. S'il existe quelque part des hommes qui aient vu se dresser contre eux une coalition telle qu'il n'y ait personne qui ne les réprouve (traîtres à tout ce qui n'est pas la Liberté, insoumis de toutes sortes, prisonniers de droit commun), qu'ils n'oublient pas que l'idée de Révolution est la sauvegarde la meilleure et la plus efficace de l'individu.

Georges ALTMANN, Georges AUCOUTURIER, Jean BERNIER, Victor CRASTRE, Camille FÉGY, Marcel FOURRIER, Paul GUITARD, G. MONTREVEL.
Camille GOEMANS, Paul NOUGÉ.
André BARSALOU, Gabriel BEAUROY, Emile BENVENISTE, Norbert GUTERMANN, Henri JOURDAN, Henri LEFEBVRE, Pierre MORHANGE, Maurice MÜLLER, Georges POLITZER, Paul ZIMMERMANN.
Maxime ALEXANDRE, Louis ARAGON, Antonin ARTAUD, Georges BESSIÈRE, Monny de BOULLY, Joe BOUSQUET, Pierre BRASSEUR, André BRETON, René CREVEL, Robert DESNOS, Paul ÉLUARD, Max ERNST, Théodore FRAENKEL, Michel LEIRIS, Georges LIMBOUR, Mathias LUBECK, Georges MALKINE, André MASSON, Douchan MATITCH, Max MORISE, Georges NEVEUX, Marcel NOLL, Benjamin PÉRET, Philippe SOUPAULT, Dédé SUNBEAM, Roland TUAL, Jacques VIOT.
Hermann CLOSSON.
Henri JEANSON.
Pierre de MASSOT.
Raymond QUENEAU.
Georges RIBEMONT-DESSAIGNES.

(1) Ceux mêmes qui reprochaient aux socialistes allemands de n'avoir pas « fraternisé » en 1914 s'indignent si quelqu'un engage ici les soldats à lâcher pied. L'appel à la désertion, simple délit d'opinion, est tenu à crime : « Nos soldats » ont le droit qu'on ne leur tire pas dans le dos. (Ils ont le droit aussi qu'on ne leur tire pas dans la poitrine).

(2) Faisons justice de cette image. L'Orient est partout. L'Orient c'est le conflit de la métaphysique et de ses ennemis, lesquels sont les ennemis de la liberté et de la contemplation. En Europe même qui peut dire où n'est pas l'Orient ? Dans la rue, l'homme que vous croisez le porte en lui : l'Orient est dans sa conscience.

(3) Spinoza, Kant, Blake, Hegel, Sche[...] Marx, Stirner, Baudelaire, Lautréam[...] Nietzsche : cette seule énumération e[...] ment de votre désastre.

Une lettre du Cardinal Dubois

Sous la forme d'une « lettre à un catholique de Paris » le cardinal Dubois répond à des objections qu'aurait soulevées l'appel qu'il a fait à ses diocésains en faveur de l'emprunt. Il y dit, notamment :

« Je vous entends. Souscrire à l'emprunt, c'est, pour les catholiques, apporter de l'argent à un gouvernement qui n'a pas renié d'une législation hostile à l'Eglise, qui, même aujourd'hui, sanctionne l'application de lois spoliatrices ; qui ne nous a donné aucune garantie pour l'avenir ; qui ne réagit pas suffisamment contre les partis extrêmes, partisans d'une révolution... Telles sont les principales objections. Je ne prétends pas qu'elles soient sans fondement.

« Il est regrettable, en effet, que la paix religieuse condition essentielle de la paix sociale — n'ait pas obtenu jusqu'ici des garanties suffisantes ; les catholiques de France, auxquels le gouvernement fait appel en ce moment, méritent d'être mieux traités dans leur propre pays : le redire, ce n'est pas offenser personne, c'est simplement réclamer les droits qui finiront bien un jour par triompher.

« Mais là n'est pas la question. A quoi bon récriminer quand il s'agit du salut de la France ? C'est la France qui a besoin de notre concours ; c'est à la France que nous le donnons...

« Que l'emprunt ne réussisse pas, un nouveau ministère — socialiste, celui-là — prendra le pouvoir. Ce sera le commencement d'une désorganisation sociale et religieuse dont il est impossible de prévoir les désastreux effets ; un pas de plus, et peut-être décisif, vers l'oppression sanglante dont nous menacent ceux dont le programme est « Révolution d'abord et toujours ». Est-ce cela que vous voulez ?...

« Dieu d'abord », dans le plan religieux auquel tout se ramène, et « France... d'abord » dans le plan social où se pose et où se doit résoudre la question présente. »

Voilà ce qu'en quinze mois le Cartel a fait de la France : la guerre au Maroc et en Syrie, le défaitisme à l'intérieur, la banqueroute à nos portes, l'anarchie triomphante, l'insolence des révolutionnaires, la capitulation des pouvoirs publics et la résignation de l'élite.

La France est mûre pour la révolution. Ou pour le coup d'Etat.

Camille AYMARD.

Actuellement, la Bourse est mauvaise et les bijoux se vendent bien. Il est donc plus logique de réaliser ses diamants, perles et métaux précieux que de perdre 30 ou 40 % sur ses valeurs.

Vendez en toute confiance sur expertise gratuite aux fabricants. Strop et Pauliet, 222, rue Saint-Martin (près rue Turbigo). Téléphone : Archives 01-69.

(*Liberté*, 17 septembre 1925.)

Le Gérant : Louis ARAGON Impr. spéciale de la *Révolution Surréaliste*, 42, Rue Fontaine, Paris-9e

1,2 *La Révolution d'abord et toujours!* pamphlet; signed by all the members of the surrealist group and by their collaborators from the periodicals *Clarté, Philosophies,* and *Correspondance* (1925). It was reprinted in *La Révolution surréaliste* number 5 (October 15, 1925), as well as in *L'Humanité* and *Clarté.*

ing of rebellion, upon which the only valid things are based," and the text concluded with five major points: a challenge to France to follow the "magnificent example of immediate disarmament" given by Lenin at Brest-Litovsk in 1917; a rejection of any eventuality of military enlistment "given that for us, France does not exist"; approval of the manifesto of the action committee against the war in Morocco; a denunciation of all those who had signed an appeal to support the motherland against the rebels in Morocco; and a confirmation that intellectuals must make revolution their priority ("We are the revolt of the mind; we consider bloody Revolution to be the ineluctable revenge of the spirit humiliated by your deeds. We are not Utopians: we conceive of this Revolution in its social form alone").[70]

This declaration, while it did not yet signal an espousal of communist ideals, nevertheless indicated that the group's point of view had evolved considerably since the time of "doddering Moscow" and the "vague ministerial crisis" that had taken place there. Breton had recently read Trotsky's *Lenin* and gave an enthusiastic account in the same issue of *La Révolution surréaliste* in which *La Révolution d'abord et toujours!* had appeared. Éluard's appraisal was equally fervent, and their opinion of the book no doubt played a role in the drafting of the declaration, as did the vigorous support for internationalism—the counterpart of antipatriotism, as practiced by Aragon, for example, in *Clarté.*[71] "Any idea that gives legitimacy to a war must be condemned; since there are men being sent to die in the name of France, may this idea, like all nationalist ideas, disappear from the face of the earth." During the summer of 1925, members of the group engaged in serious political reflection, which led them from a still fairly anarchist rebelliousness to a concept of revolution that was much closer to that of the communists.

It was initially through contact with the editors of *Clarté* that the emphasis to be granted to the revolution was clarified and that a true desire for political intervention took shape; the principal members of the group became involved, determined no longer to be content with a "revolutionary instinct" alone (Masson). From September 1925, surrealists and "Clartéists" (some of whom, like Fourier, were already members of the Communist Party) met periodically, first with the people from *Philosophies,* and then together they made up a "grouping" that adopted a strict organization: a first general assembly (October 5, on the premises of *Clarté*) appointed a committee, who worked at an intense rhythm (October 14, 19, 23, 26, 27, and 28). After a second general assembly on October 30, the committee met again on November 2, 5, 10, 13, and 20. Following the November 5 meeting, specialized commissions were created (reading, documentation and archives, current affairs, budget and financial control, strategy): each numbered three members and was headed by a person from the committee. This fairly complex organization was accompanied by a constant concern for discipline and a certain penchant for secretiveness: there was talk of the need to use pseudonyms or for the composition of a coded language. These precautions might seem excessive from a distance, merely evidence of a fascination with the bolshevik organization that both surrealists and Clartéists had a tendency to magnify, but they were partially justified by the real repression that, in the final months of 1925, affected the opponents of the war in Morocco—particularly, but not exclusively, the communists.

During the general assembly on October 5, the position with regard to the French Communist Party (FCP) was clarified: if, on the one hand, "all public debate about the F.C.P. is counterrevolutionary," insofar as it was recognized as "one of the cornerstones of the Communist International, and its voice in France," it did not seem necessary for

all that to "simply adhere to the F.C.P. . . . We are a force—how great a force we do not know, and that alone may be a topic for discussion, but we are a new force in the service of the revolution as it gains self awareness. We have a strength at our disposal, in keeping with our age and our individualities, which would be lost if we simply sign up to the F.C.P."[72]

Independently of the issues of personalities or the multiple aspects of internal organization (delegations of signatures, excused or unexcused absences from the meetings, authorized leaves, for military service, etc.) with which the committee had to deal, its primary theoretical contribution consisted in a definition of the revolution, set down on October 23: "We cannot conceive of the revolution in any other form than its economic and social definition: the Revolution is the sum total of events that determine the transfer of power from the hands of the bourgeoisie into the hands of the proletariat, and the preservation of that power by the dictatorship of the proletariat." Such a definition was a definite regression in comparison with the scope of the revolution formerly envisaged by the surrealists: what Breton himself had refused a few months earlier was now accepted, and commitment to communism could hardly go any further. A few days later, *L'Humanité* took note of this definition by publishing an account of the "major debate on the revolution" held on November 3 by the Club of Rebels, so that "all political and philosophical tendencies" could confront one another. As this club of basically anarchist members had placed Aragon on their list of chosen speakers (where he was in the company of the anarchist André Colomer; a delegate of the Communist Party; and a representative of revolutionary union leaders), the group wrote a protest that Desnos came to read during the session and that was proof, for *L'Humanité* of "a significant evolution toward communism. . . . We can only note with satisfaction declarations of this sort and such a categorical espousal of communist doctrine by young intellectuals." Desnos's text did indeed confirm this: "There has never been a surrealist theory of revolution. We never believed in a 'Surrealist Revolution.' We have never sought to invent a revolutionary strategy. We want the Revolution, consequently we want revolutionary means. Who, then, is responsible for them today? The Communist International, and, for France, the French Communist Party, which is the French section of the Communist International; it is not the responsibility of individual theoreticians, however ingenious they might be, for their action is perforce counterrevolutionary, whether they want it to be or not."[73]

L'Humanité's approval of this apparent alignment of the surrealists with the positions of official Communism was not simply a pure formality: from November 1925, certain surrealists worked for the newspaper, either with regular columns (Noll with an overview of the journals, Crastre, Péret—who had been publishing film reviews since September) or through a collective chronicle—"Petit marché des Arts et des Lettres"—signed "the Bolsheviks," where criticism in due form of the institutions and officials of literature (from Claudel to Montherlant) evolved.[74] Thus they were able to question at least some of the bourgeois values of the culture, even if they were the same as those that readers of *L'Humanité* tended to respect quite willingly and that Barbusse himself upheld.

La Guerre civile

Yet all this did not suffice for harmony to reign within the "grouping": the definition of

the revolution adopted on October 23 provoked the criticism of Henri Lefebvre, who refused to reduce all his intellectual activity to defending or preparing a revolution conceived purely on an economic basis. As Pierre Morhange seemed to display a willingness for fractional work, it was the people from *Philosophies* who were finally excluded from the grouping. Henceforth both surrealists and Clartéists agreed to an even closer collaboration, albeit somewhat precipitously, since on November 9 Breton addressed a letter to the committee in which he expressed his concern over "a manifest desire to succeed too quickly," which risked discouraging "in us and in those around us certain personal feelings we cannot get rid of so easily. . . . If I take a close look at the work being done, and the work that will be done, I'm not altogether certain," he added, "that it is as valuable and as definitive as we would like to think." This was his way of pointing out that between the demands and the decisions of the committee and the individuals whom he addressed—in a fashion that was indeed very directive—there was the risk of a difference in tension remaining, the causes of which might just as easily be the relative passivity of the members of the grouping as their unequal knowledge of revolutionary theory: if the theory could be mastered by the communists at *Clarté,* this was far from being the case for the surrealists. There were no guarantees that they all felt the same way about the need for a transition from a protest against bourgeois values to revolutionary practice. One month later, Breton finished writing an article that would be published by *Clarté:* "The Strength to Wait."[75] Giving an overview of the intellectual history of the last century, Breton showed that surrealism's efforts to redefine poetry were all the more justified for having raised public awareness overall of the necessity for the revolution with which it was converging and that the distance that still remained between the poet and the public was the result of the persistence of certain social conditions and, therefore, had nothing binding about it: "The isolation of the poet, the thinker, the artist, an isolation from the masses that is equally harmful to both artist and masses—is the result, I believe, of the maneuvering of those who feel that if they remain in contact they have everything to lose. . . . I want to believe that there is no labor of the mind that has not been conditioned by a desire for the real improvement of the conditions of existence of an entire world." Thus, one was invited to grasp that historically (as illustrated by Rimbaud), it was indeed the poetical revolution that preceded political upheaval It could hardly seem astonishing, then, if the surrealists joined the push for revolution—after all, they were the ones who had preached for "destruction in all its forms" and to whom political revolution could only seem "far less general" than the one undertaken by their own movement from its inception. Under these conditions, it would be out of place to expect the surrealists to give up their specificity: it was in the domain of the mind that they mastered their effectiveness, and it was in that same domain that they must continue to concentrate their efforts while waiting for the revolution to take place—at the end of which it was to be hoped that their positions would become those of the masses. The position they adopted was clear: one should not hope for surrealism to disappear for the benefit of activities that had nothing to do with it, under the pretext that surrealism was now on the side of the revolutionaries. Simply, the revolution was not a novelty for surrealism, since surrealism had already adopted certain aspects of revolution in the domain of the mind. "The strength to wait" referred, thus, to the danger of any hasty conversion of poets into people who were strictly politicians, but the expression might also indicate the patience of the surrealists themselves, who were brought by their own advances to have to wait for the politicians to catch up with them.

The decision to maintain *La Révolution surréaliste* when there was some discussion of founding a new common periodical entitled *La Guerre civile* (Civil war) to replace *Clarté* showed that, as far as the group was concerned, they intended to preserve their autonomy, even if they helped to formulate revolutionary ideas. According to issue number 79 (December 1925) of *Clarté*, which announced that it would be the last and set its publication date for February 15 or March 1, 1926, *La Guerre civile* would unite surrealists and Clartéists in the struggle against different facets of the bourgeois mind. *L'Humanité* gave the date of February 20, whereas *La Révolution surréaliste* announced publication for the month of April, but in fact *La Guerre civile* would never be published.[76] This was perhaps due to an unsatisfactory content but also to the reactions of the Communist Party, which made it known that they would not support by any means whatsoever a periodical for which editorial decisions were made outside of its authority and for which probable content would not be altogether satisfactory, if for no other reason than that it would contain critical attacks on Barbusse and the party's cultural policy.[77] Although strictly speaking this did not lead to a veto, Fourrier was urged to show more restraint. The project of *La Guerre civile* consequently brought about an interruption in the surrealists' collaboration on *L'Humanité* as well as reinforcing Barbusse's position, whereas Breton, Fourrier, the surrealists, and the Clartéists had hoped to place him in serious difficulty.

In an article in *Clarté,* Fourrier did indeed deplore Barbusse's deliberately misleading behavior, along with his predilection for an outmoded rationalism: what served as a cultural doctrine for the author of *Feu* was no more than "bloatedness" and "verbalism," perfectly representative of a "bourgeois pacifism" and as such both anti-Marxist and antirevolutionary. To attack Barbusse was, precisely, to attack head on, or clearly to designate, something that was only a semblance of cultural policy but that gave the party the advantage of being placed under the authority of a writer whose fame was well established. Barbusse had become very famous after winning the Prix Goncourt in 1916 and was the very type of novelist who could have had a perfectly bourgeois career: his allegiance to the party had therefore something of an exemplary value, whereas the agitation of the surrealists (creating scandals, attacks on Anatole France, even their anticlericalism) were hardly positive assets for the party, in any case where recruiting a maximum number of fellow travelers was concerned. The novelist's ecumenism, accompanied moreover by a solid sense of discipline, was preferable to the surrealists' intransigency. During the months that followed the failure of *La Guerre civile,* Barbusse was given a free rein in *L'Humanité* to defend those ideas that showed that the Communist Party had not the slightest inclination to welcome the surrealists to its ranks. Barbusse called for a "popular art—healthy, young, strong and clear, both enlightening and supportive as it expresses the great cry of the masses for liberation"; he reiterated the complete trust he placed in reason, without which "it is heresy . . . to claim that one is contributing to the evolution of art"; he denounced the partisans of "incoherence" and "delirium"; and he praised Claudel and Cocteau, along with Anatole France, an "incomparable artist . . . master of all delicacy, all nuances of writing and thought"—and so on, and so forth.[78]

Pierre Naville: *Légitime défense*

The surrealists' collaboration on the new series of *Clarté,* which began on June 15,

1926, did not improve relations with Barbusse and his followers. Thanks to Fourrier and Naville, who organized the editorial content, Aragon, Desnos, Leiris, and Éluard could deal with intellectual developments as they saw fit, particularly where Sade and Lautréamont's "revolutionary intelligence" (Éluard) were concerned. In the spring of 1927, Naville wrote a scathing critique of Barbusse and the "fairly intolerable" volumes he had just devoted to Jesus. Pranks like this were hardly viewed with indulgence by the Communist Party, and the Political Bureau published its opinion in *L'Humanité:* "Comrade Barbusse, who was the victim of these attacks, is the director of the literary column of *L'Humanité* and, as such, the Political Bureau can only congratulate itself on his collaboration. The bureau declares that his devotion, his activity, and his writings serve the cause of the proletariat."[79] However, *L'Humanité* not only did not refrain from severely criticizing Éluard's *Capitale de la douleur* but even went on to attack Lautréamont and Rimbaud. Éluard sent a letter of protest to the newspaper, which did not publish it:

> I am quite willing to admit that a French communist newspaper has, at the present time, more important concerns than literature or poetry, but it fills me with indignation that it has taken sides, along with all the reactionaries, against two of the greatest revolutionary poets of all time—I'm referring to Lautréamont and Rimbaud. The genius of Lautréamont and Rimbaud is united with that of the people. Their intelligence is *shared*. It can have no master. The people can understand everything. No "true poet" is incomprehensible to the people, and they would have long appreciated Lautréamont and Rimbaud if the bad shepherds—demagogues and bourgeois—had not come between them and the light of the poets. These are procedures revived from the Holy Catholic and Roman Church.[80]

Naville was divided among his interest in communism (he joined the party in 1926), his sympathies for surrealism, and the role he intended to play at *Clarté*. At the end of the winter 1925–26 he wrote the pamphlet *La révolution et les intellectuels. Que peuvent faire les surréalistes? Position de la question,* in which he would attempt to "recognize and establish the incompatibilities and dissonances, and exacerbate the contradictions, without fear of *being kept there* myself for any length of time." Addressing his friends in the group first of all, he boldly asked a question to which the surrealists themselves did not yet have an answer—perhaps because they had not formulated it in these terms, preferring to evoke a complementary relationship while Naville conceived of a chronological one: "Do the surrealists believe the mind can be liberated before the bourgeois conditions of material life are abolished, or do they consider that a revolutionary spirit can only be created once the revolution has been achieved?" This was a question that for Naville had particular importance, given the fact that in France there "still lives in an atmosphere of bourgeois intellectualism" from which "the surrealists' diversions, so to speak, are but paltry escapes." In other words, they needed to find out whether the willingness of the surrealists to collaborate with the communists meant the total abandonment of any idealistic (if not spiritualist) positions and an unreserved allegiance to historical materialism. Quoting the end of "The Strength to Wait," in which Breton said that the rapprochement between the surrealists and revolutionary action "will take place in favor of the revolution," Naville found the formula to be dangerous because it clarified neither the modalities of the connection envisaged nor the nature of a possible collaboration. And, he added, for a proletarian revolution,

"the rapprochement of intellectuals can only mean the help of technicians and men who are used to the demands of the pen. . . . Even those who live in opposition to the bourgeoisie have always, more or less, profited from it in some way or other; traces of this involuntary profit linger." Underlining that after all, the bourgeoisie had little to fear from the surrealists' scandals insofar as they were doing nothing to overturn the social structure governed by the bourgeoisie, Naville concluded that the surrealists, despite what they had said, "envisaged a liberation of the mind before the abolition of the bourgeois conditions of material life, one that, to a certain degree, would be independent from that life."

These ideas had a very different impact from the remarks in *L'Humanité* and Breton took this into account when he wrote *Légitime défense* (which was published on September 30 by the Éditions Surréalistes), since it was indeed to Naville that he addressed the final pages.[81] But, in order to reconfirm the autonomy of surrealism within the whole revolutionary movement, the pamphlet immediately went after Barbusse and denounced the mediocrity of *L'Humanité*'s cultural position. The newspaper was accused of being "puerile, bombastic, uselessly *cretinizing*," and, above all, it seemed "altogether unworthy of the role of a proletarian education" that it claimed to fulfill— even if this was only to grant itself the right to question the validity and revolutionary impact of surrealist poetry, by deeming itself (although the revolution had not yet taken place) capable of deciding which writings and which minds could in fact prepare the revolution: "The revolutionary flame burns where it wants to," said Breton, "and it is not up to a small group of men, *in the period of expectation in which we live,* to decree that it is only here or there that it will burn."

As for Barbusse, his articles on September 1 and 9 were particularly unforgivable, summarizing what for him replaced a theory of literature; for Breton he was "a well-known bloody old fool," and the "worst sort of fraud," who collected the worst platitudes, one after the other ("It's a fact that one cannot think without language"), viewed style as a simple apparel worn by preconceived ideas, and found his announcement for the "great collective and proletarian art" of tomorrow in formal research, with examples provided by Giraudoux, Morand, Claudel, and Cocteau! This was not only a return to the old distinction between form and content but also a suggestion that the efforts of surrealism, both to give writing an authentic substance and to examine the question of what justified or finalized writing, were insignificant. Breton's reaction, in *Légitime défense,* was particularly scathing: praise of Claudel or Cocteau, "authors of loathsome patriotic poems, nauseating Catholic professions of faith, ignominious profiteers of the regime and arrant counter-revolutionaries," signified an "abuse of the workers' trust," and would divert them from authentically revolutionary texts. Breton also demanded that the surrealists be allowed to take part in the elaboration of revolutionary thought: "It might not be too much to ask, that we be held for something more than a negligible factor," on the condition that they be called on for their own competence, and not, as Barbusse had done, to write up the news stories!

As for the question that Naville had asked, it implied an opposition between inner reality and the world of facts that was too artificial and seemed to ignore dialectics. At least it offered one unambiguous response: "In the domain of facts, there is no equivocation possible where we are concerned: we all, without exception, want for power to pass from the hands of the bourgeoisie to the proletariat. But in the meantime it remains no less important, in our opinion, that the experiments into the inner life be

LA RÉVOLUTION SURRÉALISTE

Directeur :
André BRETON

42, Rue Fontaine, PARIS (IX^e) Tél. Trudaine 38-18

EN AVRIL PARAITRA

LA GUERRE CIVILE

FONDATEURS :

Louis Aragon, Jean Bernier, André Breton, Victor Crastre, Robert Desnos, Paul Eluard, Marcel Fourrier, Paul Guitard, Michel Leiris, André Masson, Benjamin Péret, Philippe Soupault, Victor Serge

Le numéro : 2 francs. — Abonnements : 1 an, 95 francs ; Étranger : 50 francs.

LE DIX MARS

OUVERTURE

DE

LA

GALERIE

SURRÉALISTE

PARIS (6°) — 16, Rue Jacques-Callot, 16 — PARIS (6°)

1

1^e ANNÉE. — NOUVELLE SÉRIE

N° 1 NUMERO MENSUEL **3 fr. 50** 15 juin 1926

CLARTÉ

SOMMAIRE. : Editorial. — L'impérialisme français triomphe au Maroc. par *Clarté*. — Nouvelles positions de l'impérialisme : prolétariats occidentaux et peuples opprimés, par *Marcel Fourrier*. — Le prix de l'esprit, par *Louis Aragon*. — Le capitalisme a fait son temps (extrait d'un discours de *L. Trotsky*). — Ce que représente dans le monde l'impérialisme américain : Puissance capitaliste des Etats-Unis ; les Etats-Unis et l'or ; les Etats-Unis et l'U.R.S.S. — L'agonie du franc, par *Mécat*. — « Fordisme », par *Malleret*. — A la mémoire de Serge Essénine, par *Léon Trotsky* (traduit du russe par *Georges Altman*). — Documents : L'Anatolie en 1925, par *Kerim Sadi*. — Le Charnier : Le cardinal Mercier est mort, par *Benjamin Péret*. — Appel, par *Paul Eluard*. — Anatole France et la Commune. — Les livres : « Amœnitates Belgicæ » de Beaudelaire, par *Michel Leiris*. — « Souvenirs familiers à propos de Rimbaud », de D. Delahaye, par *Victor Crastre*. — Lettre aux lecteurs de « Clarté », par *Marcel Fourrier*.

ABONNEMENTS { France......... 1 an : 35 fr. 6 mois : 20 fr. 3 mois : 12 fr.
{ Etranger......... 1 an : 50 fr. 6 mois : 30 fr. 3 mois : 18 fr.

8, Boulevard de Vaugirard — Paris (15°). — Chèque postal : 330-80.

2

ANDRÉ BRETON

LÉGITIME DÉFENSE

PRIX : 75 CENTIMES

ÉDITIONS SURRÉALISTES
16, Rue Jacques-Callot, 16
PARIS

SEPTEMBRE 1926

3

allowed to continue, obviously without any control from outside, even Marxist." Moreover, if Breton had thought it unnecessary to join the Communist Party, even though the party was "from a revolutionary point of view, the only force we can count on," it was because he knew that any demands, however legitimate, on behalf of the surrealists' standing within the party would have been curtailed, so Breton repeated that the communist program could only be, for him and his close followers, a "minimal program"—yet another way of demanding that the group's own work be continued as the only work capable of elaborating a truly revolutionary cultural line.

Légitime défense did state the surrealists' common position, as witnessed in a letter from Masson to Leiris, for example:

> Like you, I think that the timing of *Légitime défense* is excellent and it will deliver us—even if it shows our position to be difficult and joyless—That's fine.—For six months I've been reading *L'Humanité* closely, and not without some anger, but no surprises. The same prejudices are spread out there in "better" or "worse" form than those of the Bourgeoisie—the same disapproval of anything that is unusual or strange, the same artistic and literary rubbish and the same Religion of work. But we know all that perfectly well. Nevertheless, as far as I am concerned, I am ready, once again, to help out with anything that must lead to a social catastrophe and to the recognition that the dictatorship of the Proletariat is the only legitimate one.[82]

Although the text once again confirmed the surrealists' allegiance to the principles of Marxist revolution, *Légitime défense* was not enough to put a halt to the attacks and misunderstandings on the part of the communists. While the brochure was distributed to the editors of *L'Humanité* by Fourrier or Péret, the Communist Party leadership condemned its contents and called on Fourrier and Péret to denounce it; Aragon's request to join, transmitted by Fourrier, also had no effect. The result was that the group feared it would find itself totally rejected by the communists—and this would cut off all its contact with organized revolutionary circles and relegate it to a type of intellectual dilettantism that it refused to accept.[83]

Disappointing Enrollment in the Communist Party

Thus the question of joining the Communist Party became imperative in the weeks that followed. In meetings in November and December between Clartéists and surrealists, in which Naville, Bernier, and Fourrier took part, along with Hooreman and Goemans, who had recently arrived from Belgium, the topic was widely discussed. Individual positions were examined, along with the possibility of a common position and the possible future course of action for surrealism, both outside and within the party. At the very first assembly, Artaud broke with the group. ("If for me what is meant by revolution . . . has to be what is meant by revolution for you, then no, I don't give a damn."), and the group's positions were far from homogeneous. Breton, on the one hand, who was "for joining the Communist Party unconditionally, while pursuing their present activity in spite of everything," declared himself prepared to renounce surrealism's outside activity insofar as it might be judged "contrary to the communist line" and even contemplated retracting *Légitime défense,* while Desnos dwelled on the surrealists' major shortcomings from a revolutionary point of view: "Are we capable of becoming bureaucrats? If I am asked to join, I'll do it, but it would be in the worst

conditions."[84] Éluard said he "felt communist" but feared that if he joined, the internal discipline of the Communist Party might eventually oblige him to give up his surrealist activity. Morise felt that it was not "useful to envisage a group membership," and Prévert, having underlined his inability to read Marx ("I can't be bothered"), deemed that as far as he was concerned, "it would be very easy to join the Communist Party, but it wouldn't have any meaning." Leiris "had absolutely no idea" how he could be "more useful in the Communist Party than outside the Communist Party."

Naville himself acknowledged that it was not really necessary to decide on a collective or mandatory membership; Tual refused "to join just to add to the numbers and to obey a decision taken out of hand," and Pierre Unik, on the contrary, thought it would be "a good thing for the surrealists to join the Communist Party." It was during the meeting on November 23 that Soupault came up against his friends' suspicions: they reproached him for reinforcing bourgeois culture through his many publications, but he replied that in his opinion "literature is only a detail among others in a man's life, like trade, work at the office or business, etc. It does not have more importance."[85] However, there were three distinct points of view: surrealist, revolutionary, and communist, and this put him in an awkward position relative to his friends. He considered that "surrealism cannot lead to an effective revolution" and, therefore, came down on the side of "absolute compliance with all the disadvantages this implies"—the only way, in his opinion, to deal conclusively with the lack of a precise line of conduct characterizing surrealism at the time. While for Breton and his close circle the idea was above all to find a link between surrealism and communism, Soupault asserted that this was impossible: "I would like to ask you to view me no longer as a member of your group, but rather, as an ordinary communist" (the second part of this declaration would not be followed by a true commitment to the communist cause). Consequently, on November 27, Soupault was officially excluded from the group, and the principle of joining the Communist Party on an individual basis was adopted, after a resolution presented by *Clarté* underlined that the activity of a surrealist group was not likely to fit in with the organization of the Communist Party but could, however, "by working outside the Party, with no constraints, help the Party's ideological revolutionary action." A motion put forward by Aragon, Éluard, and Morise confirmed that "the enrollment of a member of the surrealist grouping into the Communist Party is a requirement insofar as it will resolve the problem of the transition from absolute idealism to historical materialism, and that of the reconciliation of his absolute nonconformity with a certain relative conformity"—which shows once again that the difficulties surrealists and communists had in finding a common ground were of both an ideological or philosophical and an ethical nature.

During the meeting on December 24, eight surrealists asked to join: Breton, Aragon, Duhamel, Éluard, Leiris (although he said that he had not yet managed, as he hoped, to complete "the transition from idealism to materialism"), Prévert, Tanguy and Unik.[86] Baron, Desnos, Malkine, Morise, and Tual, however, refused to join. Breton feared that his request would be rejected, but this was not the case: he was made a member the Communist Party on January 14, 1927 (at the same time as Éluard, Georges Sadoul, and Noll). Breton was assigned to a cell of gas factory employees and, quickly wearied by the incomprehension he encountered, he would attend their meetings for only two months: according to Sadoul, he was already ready to "quit the Party" because of the numerous attacks he had been subjected to and that proved to

him that he was still being reproached—in his role as editor of *La Révolution surréal-iste*—for having published texts and illustrations that were "incomprehensible" to "the people" or, even, of wanting, out of simple personal ambition, to gain hold over *L'Hu-manité!*[87]

In May 1927 the brochure *Au grand jour* was published, signed by Aragon, Breton, Éluard, Péret and Unik.[88] An introductory text stated, first of all, that after the recent crisis in surrealist activity, resulting in the defections of Artaud (violently attacked in a footnote by Péret) and Soupault alone, the five letters that went to make up the pub-lished "file" focused on an account of the "first attempt at recognition" made by the signatories with their enrollment in the Communist Party. It also specified in passing that even if membership did not concern all the surrealists, "at least not one of us has taken it upon himself to deny that the communists and surrealists share their aspira-tions to a large degree."

As for the letters, they were addressed successively to Paul Nougé and Camille Goe-mans, who were in charge of *Correspondance* in Brussels and who deplored the carica-ture of surrealism "that was current in the Communist Party both in France and in Belgium"; to Marcel Fourrier, who was reproached for having an ambiguous attitude, to say the least, toward the surrealists' collaboration with *Clarté,* since he had recently declared that "*Clarté* is not surrealist, and the surrealists are not the editors of *Clarté*"; to the noncommunist surrealists, to remind them that they could not claim, in 1927 less than ever, to adhere to simply anarchic principles and that there was no barrier between their belief that they could still give their life "a meaning of pure protest" and that of the writers of the letter, who chose to subject their life to an "outside element capable . . . of carrying this protest as far as possible"; and to Naville, whose qualities were recognized, but who was reminded that between his rapid evolution and those who feared anything precipitate, there remained a nuance, and the weighty question of the ends versus the means: "The ends, which require the means, do not preclude dis-cussion of the means. Whatever tool one takes in hand to repair a street, if the work crews are poorly put together, the tool will nevertheless be in danger of leaving the street in a state of collapse, full of grass. . . . We still have certain fears. Who's in charge, here or there? Who answers, every minute, for the adequacy of what has been under-taken?" Thus the moral issue, which surrealism was far from ready to forget, had resur-faced to overshadow the harmony between surrealism and communism.

The fifth letter however, addressed "to the communists," began by declaring that "we never had any idea of proclaiming ourselves to be surrealists to you," which was then explained by the denial that surrealism had any "political leanings." But it then immediately emphasized that the right to criticize must be respected within a revolu-tionary party and that it would be pointless to oblige the surrealists to express them-selves on issues that were not (or not yet) within their competence: "Purely economic debates, discussions requiring an advanced knowledge of political methodology, or even some experience of trade union life—these are things . . . for which we are not at all prepared." Inversely, it would be equally pointless for the communists to refuse to use the surrealists "in a sphere where we could really be useful," which was that of "everything that in any degree touches upon moral truth." But the wariness remained and risked growing greater: it was because the surrealists could not view the commu-nists as adversaries that they would not respond: "In this case, we will wait regretfully for better days, when the Revolution will have to recognize its own." In the mean-

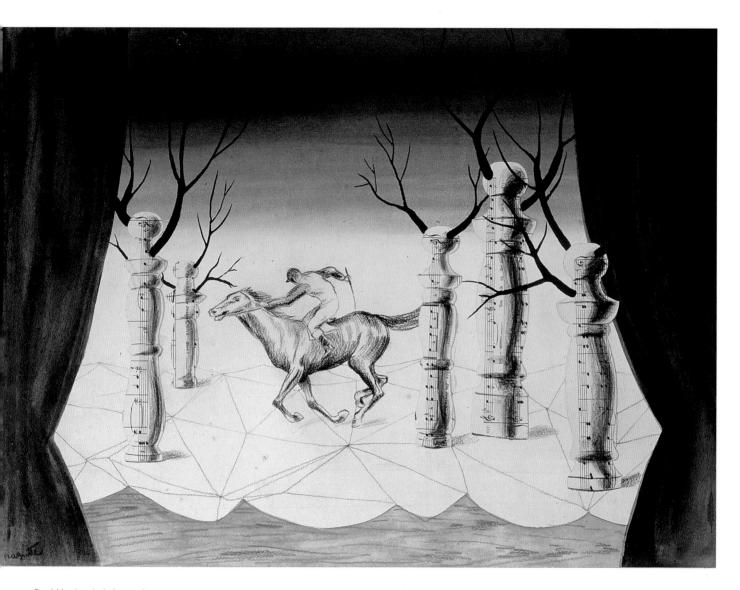

René Magritte, *Le Jockey perdu*
(The lost jockey; 1926); glued paper,
watercolors, lead pencil, and India
ink, 15³/₄ × 21²/₃ in. (39.3 × 54.2 cm).
Private collection.

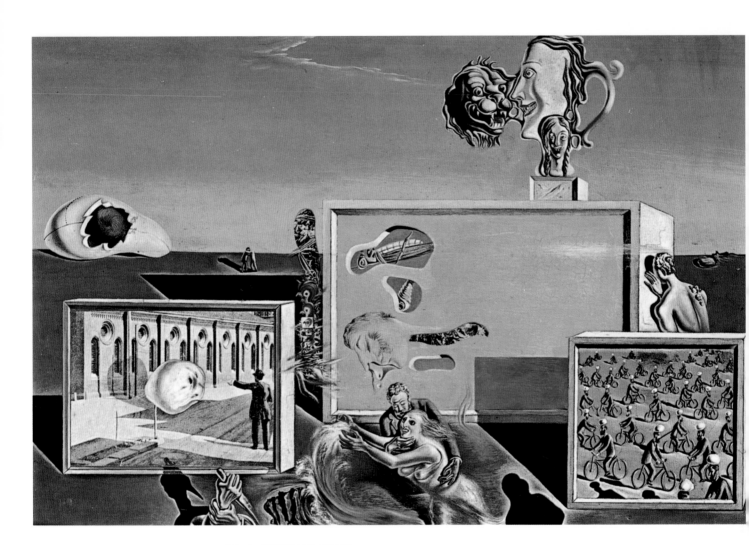

Salvador Dalí, *Plaisirs illuminés* (Illumined pleasures; 1929); oil and collage on wood, 9¹/₂ × 13⁹/₁₀ in. (23.8 × 34.7 cm). Museum of Modern Art, New York.

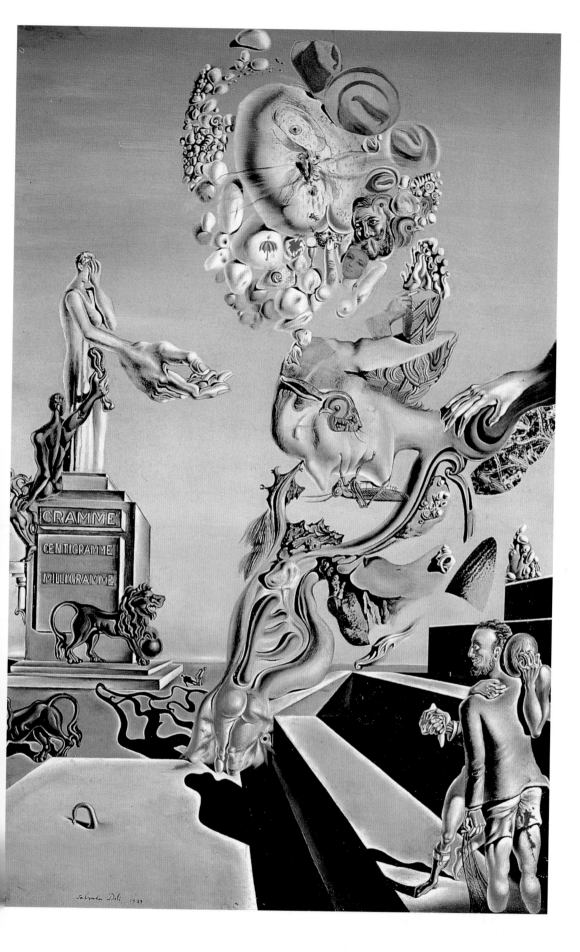

Salvador Dalí, *Le Jeu lugubre* (The lugubrious game; 1929); oil and collage on canvas, 16²/₅ × 12²/₅ in. (41 × 31 cm). Private collection.

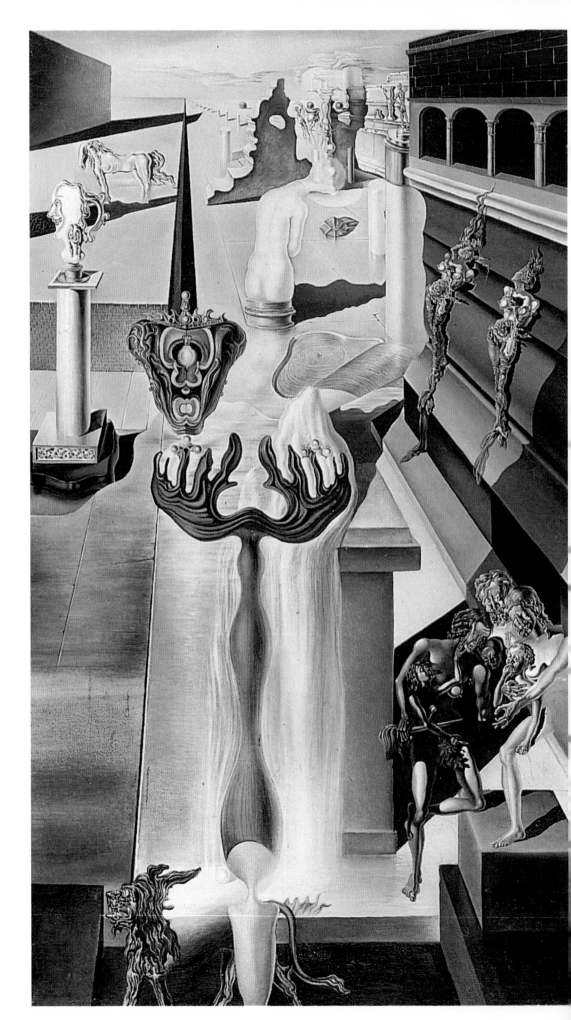

Salvador Dalí, *L'Homme invisible* (The invisible man; 1929–32); oil on canvas, 41³/₅ × 32²/₅ in. (104 × 81 cm). Museo Nacional Reina Sofia, Madrid.

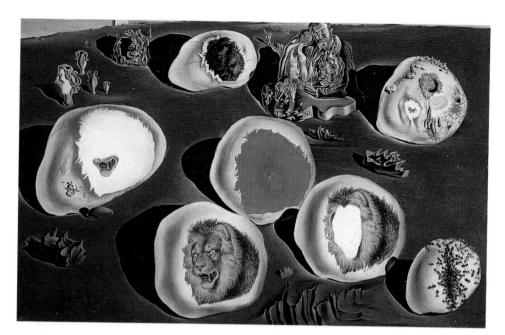

Above: Salvador Dalí, *L'Accommodation du désir* (The accommodation of desire; 1929); oil and collage on wood, 8⁴/₅ × 14 in. (22 × 35 cm). Private collection.

Right: Salvador Dalí, *Le Sacré-cœur (parfois je crache par plaisir sur le portrait de ma mère),* (The sacred heart [sometimes I spit for the fun of it on my mother's portrait]; 1929); ink on canvas, 27¹/₃ × 20 in. (68.3 × 50.1 cm). Musée National d'Art Moderne, Centre Georges Pompidou, Paris.

A		5°
C		10°
H		15°
D		20°
K		25°
N		30°
B		35°

Above: Jacques Prévert, André Breton, Yves Tanguy, and Camille Goemans, *Cadavre exquis* (Exquisite corpse; March 7, 1927); pencil and colored pencils on paper; 6 x 7⁹/₁₀ (14.9 x 19.7 cm). Musée national d'art moderne, Centre Georges Pompidou, Paris.

Right: Joan Miró, Max Morise, Man Ray, Yves Tanguy, *Cadavre exquis* (Exquisite corpse; 1927); ink, pencil, colored pencils, collage of silver paper onto paper; 14¹/₂ x 9¹/₅ in. (36.3 x 23 cm). Musée National d'Art Moderne, Centre Georges Pompidou, Paris.

Opposite page: Joan Miró, Yves Tanguy, Man Ray, and Max Morise, *Cadavre exquis* (Exquisite corpse; 1927–28); 14²/₅ x 9²/₅ in. (36 x 23.5 cm). Manou Pouderoux Collection.

Georges Hugnet, five collages from *La Septième Face du dé* (The seventh side of the die; 1935).

while they would, "without saying a thing," have to go on reading the drivel (by Cendrars or Romains) that *L'Humanité* continued to churn out.

Au grand jour confirmed both the surrealists' willingness to commit alongside the Communist Party and the role they would play in the Party, even though this public confirmation occurred at a time when Breton, Aragon, and Éluard had already determined that such a commitment would encounter serious manipulating obstacles. The credence given to political slogans inspired less trust than ever in the party's cultural policy, and it was suggested once again to the party that it would do better, in this domain, to listen to the opinions of those who had already done revolutionary work in writing and ideas. This suggestion was an admission of failure but was not enough to deter the surrealists from the Communist Party, from the hopes and strengths that it incarnated: "They thought that the hostility they had encountered . . . was due to a misunderstanding that would disappear over time. This misunderstanding, for us, seemed to result solely from the inability, which was after all quite natural, of people preoccupied by very different problems to understand our intellectual position to even a minor degree, and to credit the general significance of our creativity. The illusion that their defiance would wear off persisted among us from 1928 to 1932."[89]

In Belgium

In July 1925, Breton and Éluard contacted Paul Nougé and Camille Goemans in Brussels; they were in charge of *Correspondance* and were among those who had signed *La Révolution d'abord et toujours!*

Correspondance was the result of the complex relations forged since 1919 among future proponents of surrealism in Belgium but also displayed some of the discretion typical of Dada, whose only representative of importance was Clément Pansaers. He was initially editor of the periodical *Résurrection* and began exchanging letters with Tzara, who dubbed him "Dada President" in his *Bulletin Dada,* number 6, at the end of 1919. In 1920, he published *Pan-pan au Cul du Nu Nègre,* collaborated on *Littérature,* and corresponded with Picabia. In 1921 he published *Bar Nicanor* and *L'Apologie de la Paresse,* and in November of the same year brought out a special issue of the periodical *Ça ira,* entitled, "Dada, Birth, Life and Death," which he researched in Paris. As a result it would seem that the appearance of Dadaism in Belgium "took on a posthumous aspect" (M. Mariën).

Edouard Léon Théodore Mesens however, who had met René Magritte in 1919 at a time when the young painter was trying to digest the lessons of cubism and futurism and was interested in nonrepresentational trends such as those developed by Servranckx and Flouquet, was also in contact with Dada in Paris in 1921. A musician, he admired Satie but also frequented the expressionists of the periodical *Sélection* and the abstract constructivists of *Het Overzicht.*[90] He published a few texts in a Dadaist mode in *Mecano,* the journal of Bonset (pseudonym of Theo van Doesburg, Dutch artist, 1883–1931) where he was in the company not only of Tzara but also of Mondrian and Man Ray. Easily irreverent, with a taste for intrigue and the pleasures of more or less well-founded intellectual sparring, he became the agent in Brussels for *391* and sent some of his aphorisms to the periodical (no. 19, the last) along with others by Magritte.

At the beginning of the summer of 1924, Mesens announced in a Dadaist-inspired

pamphlet (in which there were also contributions by Magritte, Marcel Lecomte, and Camille Goemans) the forthcoming publication of the periodical *Période*. In October, a counterpamphlet put together by Paul Nougé altered the meaning of the announcement according to a method of plagiarism that he practiced frequently during the 1920s: where the first announcement declared, "Help PÉRIODE to live, PÉRIODE will help you to live," the second one said, ironically, "Help PÉRIODE to live, PÉRIODE will help us to live," or added to the initial wording, moving from "Beware of sculpture (architecture)" to "Beware also of sculpture (architecture)." Fearful that *Période* was obeying literary or artistic intentions of which he was extremely suspicious and that he traced back to Dada, Nougé managed to bring Lecomte and Goemans over to his side—with the result that it was only in March 1925 that Mesens and Magritte, alone, would publish the unique issue of *Œsophage* (where *Période* was to be found, as a subtitle and between brackets), adopting as their motto "Hop-là, Hop-là."[91] It was presented as a collection of texts and illustrations of a (henceforth) classically Dadaist spirit, enabling Tzara to declare, "Shit is realism; surrealism is the smell of shit," once *Correspondance* had begun to explore the virtues of a very different way of doing things.

The first pamphlet of *Correspondance,* which was Nougé's work, was dated November 22, 1924; the twenty-second and last, signed Goemans, came out on June 20, 1925. The birth of this publication coincided with that of *La Révolution surréaliste,* even though it was shorter-lived. The sheets, different colors for each issue (and whose color and order were regularly labeled, in large characters, on the upper right-hand side of the sheet: *Bleu 1, Rose 2, Vert 3, Orange 4,* etc.), were printed in runs of a hundred copies destined not for sale but to be sent by post to the representatives of literary circles, and the list could change for each issue since the idea was to attract the attention of a handful of intellectuals and writers to the implications of a text that had already been published or to the repercussions of what such texts contained. It did require some effort to read the pamphlets, with their dry, irrevocable tone, but also because of the allusions, veiled quotations, and not always identifiable parodies that were scattered throughout the text. From the start, the cause of art seemed clear: "Art has been demobilized, elsewhere; it's time to live. . . . We're continuing on our walk, liberating a few differences from our own traps along the way," wrote Nougé, who—no doubt voluntarily—borrowed the last word from the *Manifeste du surréalisme,* "elsewhere," for his own text. Frequently turning to texts by Paulhan, attentive to the "very pure sentiment of what is effective" that animated the surrealists, *Correspondance* proved to be a vehicle for the denunciation of thought, which had become flabby: the editors were ever watchful for contradictions, weaknesses, or hasty theorizing, and their pastiches, or compliments regarding Gide or Valéry also aimed to reveal what these writers might have done had they been a bit more demanding. It was therefore also an ethical point of view that inspired the authors of the pamphlets; "The idea," Lecomte would say, "was to show the authors themselves, for it was primarily the authors whom we were addressing, not any eventual readers, but accomplices—the idea was to show them by going back over some of their own texts, show them perhaps what they might have missed in their novels, their poems, their stories. . . . We did not consider ourselves to be marked by literature, but by a concern for what was beyond literature. It was already an ethical concern, so to speak, which characterized the French surrealist project, but all of us, in our way, had created it."[92] The dense writing of the texts, the intimate knowledge of the plagiarized passages, the rigorous attitude—strictly maintained

Œsophage 1

(PERIODE)

MARS 1925

Rédaction-Administration

RUE DE COURTRAI, 55
BRUXELLES-OUEST ... BELGIQUE

Compte Chèque Postal :
E. L. T. MESENS — N 138916

ont collaboré à ce numéro ———
HANS ARP ... MAX ERNST ... PAUL
JOOSTENS ... PIERRE de MASSOT
ALFRED de MUSSET ... RENE MA-
GRITTE .. E.L.T. MESENS ... BETTY
van NES-LIPPELMAN ... GEORGES
RIBEMONT-DESSAIGNES ... FRAN-
CIS PICABIA ... PAULUS PROQUET
KURT SCHWITTERS ET TRISTAN
— TZARA —

2 fr.
LES 5 COMMANDEMENTS

1. — Comme politique nous pratiquerons l'auto-
destruction à tour de bras et la confiance dans
les vertus humaines.

2. — Tous nos collaborateurs devront être beaux
afin que nous puissions publier leur portrait.

3. — Nous protesterons énergiquement contre
toutes les décadences : l'érudition, la Chartreu-
se de Parme, le dadaïsme et ses succédanés, la
morale, la jonction nord-midi, la syphilis à ses
divers degrés, la cocaïne, le poil à gratter, l'in-
struction obligatoire, la polyrythmie, la polyto-
nie, la polynésie, les vices charnels et en parti-

culier l'homosexualité sous toutes ses formes.

4. — Notre fraîcheur ne subira pas les tuyaux usés
ni les femmes de nos amis.

5. — Nous refuserons en toutes circonstances d'ex-
pliquer ce que précisément l'on ne compren-
dra pas.

Notre entreprise est folle comme nos espérances.
Les plus grandes précautions étant prises pour les
choses de la moindre importance, nous ne réclam-
mons rien, l'amour de l'état-major des jeunes filles
importe davantage.

« Hop-là, Hop-là » telle est notre devise.

RENE MAGRITTE et E. L. T. MESENS.

gARAgE

E. L. T. MESENS

PHILIPPE SOUPAULT

ÉDITION " MUSIC „
25 - BOULEVARD
BISCHOFFSHEIM
BRUXELLES

4

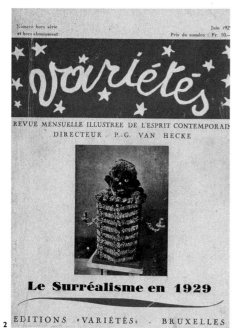

Numéro hors série
et hors abonnement

Juin 1929

Prix du numéro : Fr. 10.—

Variétés

REVUE MENSUELLE ILLUSTRÉE DE L'ESPRIT CONTEMPORAIN
DIRECTEUR : P.-G. VAN HECKE

Le Surréalisme en 1929

EDITIONS «VARIÉTÉS» . BRUXELLES

2

CLEMENT PANSAERS

Le Pan Pan au Cul
du Nu Nègre

avec une gravure par l'auteur

COLLECTION AIO
BRUXELLES
ÉDITIONS ALDE
55, rue des Fabriques, 55

3

Bifurcation

les mers disparates propageant l'onde de leur indolence
dans les lits aux draps de blanche écume
au bruit des pages des vagues tournées par le lecteur du ciel inassouvi
l'aimable caresse des nuages
se dissoud derrière la brume
la promesse tant attendue à l'horizon de ton sourire
la terre à sa rupture déploie la pierre blanche et fine
d'un sein solide de géante offert à la longueur du temps
et le vent se mord les lèvres dans sa rage noire
brisée est la transparence traversant les verres de nos existences
le vent étrangle la parole dans le gosier du village pauvre village
sa vie d'étranges éclaircies
cassée est la chaîne des paroles couvertes d'hivers et de drames
qui reliait les intimes éclaircies de nos existences
et le vent nous crache à la figure
l'animale brutalité de tout cela Tristan TZARA.

Venge-toi, Philippe, lais-
se-nous te venger. Que ta
Louise soit notre Lucrèce!
Nous ferons boire à Alexan-
dre le reste de son verre.

Alfred de Musset.

Waar het hart leeg van
is loopt de neus van over.

I. K. Bonset.

Tant qu'on ne tanne pas
un con on peut tenter d'être
comptable ou érudit.
Ceci dit :
ECRAN
E. L. T. Mesens.

Dessin René Magritte

5

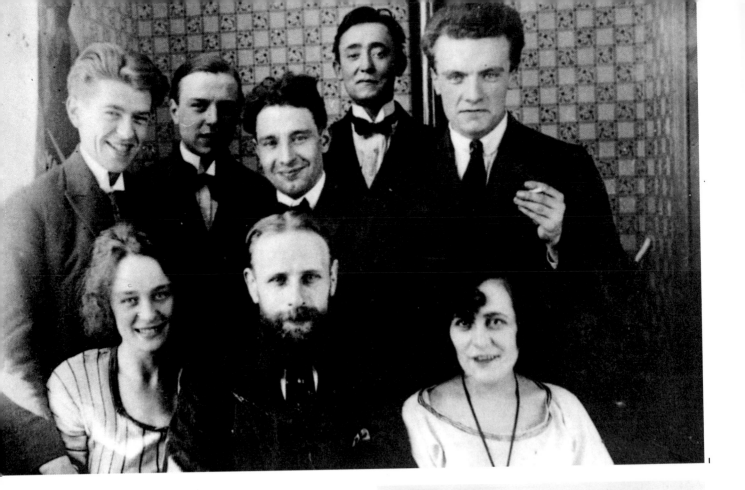

ÇA IRA

DADA

SA NAISSANCE, SA VIE, SA MORT

COLLABORATIONS DE :

CÉLINE ARNAULD, PIERRE ALBERT BIROT, CHRISTIAN, JEAN CROTTI, PAUL ELUARD, PIERRE DE MASSOT, CLÉMENT PANSAERS, BENJAMIN PÉRET, FRANCIS PICABIA, EZRA POUND, G. RIBEMONT-DESSAIGNES, RENÉE DUNAN.

PRIX : 1 Fr. 50 N° 16

through the entire series of publications, which consisted in looking down on anything that was being written elsewhere, officially—all implied a desire for total control over every pamphlet, where nothing could be left up to chance. Under such conditions, it was no surprise that on April 20, 1925, *Rouge 16* produced a harsh criticism of automatic writing, objecting notably to what Breton himself had written in 1924 in his *Introduction au discours sur le peu de réalité* (Introduction to the discourse on the lack of reality): "Words have a tendency to collect in groups according to particular affinities, which generally have the effect of making them recreate the world according to its old model." Nougé noted: "If the drama one divines crosses these lips that are obstinately, tightly closed, and ends up playing out in the deceptive light of unreserved confession, how then can we not be moved? Language offers similar surprises; habits die hard and return to intervene. Should we think of unhappy audacity, of rebellions with no tomorrow?"[93]

Such reservations with regard to automatism would be a constant feature of surrealism in Belgium, with the late exception of Chavée. Nougé practiced an extremely lucid writing, the aim of which was to ward off safely "habit" and to elude the "deceptive light" that enabled the results of automatic writing to be interpreted as "confessions without reticence." Poetry, in his opinion, must radically disturb the mental habits of the reader, causing a crisis of one's formal and stylistic convictions; therefore, it could only be practiced experimentally, based on everyday materials that were then diverted from their ordinary use to reveal unexpected hidden potential. Examples of this were *Quelques écrits et quelques dessins* (Some writings and some drawings [1927]), attributed to Clarisse Juranville, the author of a manual of *Conjugaison enseignée par la pratique* (Conjugation through practice), which Nougé used to compose poems and which were then illustrated by Magritte; and the two "'Samuel' Catalogs," conceived in 1927 and 1928 at the request of a Brussels furrier, the first with commentary by Goemans, the second with poetic texts by Nougé to complement Magritte's images. As suggested in Goeman's introduction, "Vigilance knows no such thing as an unworthy object," and Nougé and his friends had every intention of intervening, in their way, in the different realms of daily life.

The composition in 1925 of *La Publicité transfigurée* (Publicity transfigured), a suite of poems in which the typography played an essential visual role, was also in response to that same intention; these poems were destined, beyond the "page that locks them in the moment," to "invade deserted or little-visited expanses" through their large-format reproduction.[94] The text was "poor" in appearance, but the variable size of the letters gave certain terms an impact that modified their significance. And it was always the active diversion from the habitual relation to the everyday, to reality, which was at work in the photographs taken between December 1929 and February 1930. These photographs were accompanied by captions that explained what was at stake, confirming Nougé's constant desire to master every aspect of every picture. He clarifies, for example, the precautions one must take "not to discourage the good will and sympathy of the spectator": "One must preserve, in the performance, a maximum number of familiar elements and present an everyday image containing only those subversions that are strictly necessary."[95] Consequently one could see in one of the photographs two male figures performing the gesture of raising their glasses in a toast, but they had no glasses; "this photo is the result of the following process: choose an action that is performed with an object or on an object and modify the object by maintaining the

1 *Défiez-vous,* collective pamphlet dated October 6, 1926.

2 Pamphlet by E. L. T. Mesens announcing the publication of the periodical *Période* in the summer of 1924.

3 E. L. T. Mesens, frontispiece for his poetry collection, *Alphabet sourd aveugle* (Deaf and blind alphabet; 1928); collage, 10 × 10½ in. (25 × 26.3 cm). Musées Royaux des Beaux-Arts de Belgique, Brussels.

4 Counterpamphlet by Paul Nougé, in response to E. L. T. Mesens's (October 1924).

5 Text by Paul Nougé reproduced in *Adieu à Marie* (Brussels [February or March 1927]).

precise gesture or attitude of the chosen action." Manifestations like this, however discreet (but they were not always discreet—Nougé had devised a theory of "overwhelming objects" that consisted, among other things, of carrying publicity posters printed with surprising statements through the streets of Brussels), acquired a power that was undeniably disturbing, and in their way confirmed the social impact of poetic activity. Nougé considered this poetic activity to be a real danger for social order, particularly when it sought to change habits, morality, taste.

From this point of view, it seems logical that Goemans and Nougé signed *La Révolution d'abord et toujours!* Nevertheless, on September 28, 1925, *Correspondance* was fleetingly reborn in the form of a pamphlet entitled *À l'occasion d'un manifeste* (On the occasion of a manifesto), which voiced the reservations felt by those in Brussels with regard to the temptation of politics. Written by Nougé and cosigned by Goemans, the text began by regretting "that the word REVOLUTION is enough to send any number of heads spinning, heads that one would have thought less susceptible." He then suggested that if an individual "discovered the duty of linking his activity in the closest way possible with the development of a social revolution," he must without further ado give himself unrestrainedly to his commitment (a way of warning the French surrealists that they might find it difficult to be surrealists and communists at the same time), and his closing words leave no ambiguity: "Our activity cannot be reduced to the activity of parties working for social revolution. We are opposed to the notion of situating our activity on a political level that is not one we have chosen. . . . We refuse to see ourselves in the distorting mirrors that are constantly shoved before us." Nougé knew exactly what he was talking about—at least as far as the Belgian situation was concerned—particularly when he referred in passing to "the profound disintegration of the Western communist parties"; since 1919 he had been among the founders of the Belgian section of the Third International. When Goemans took part in Paris in the preparatory debates for enrollment into the French Communist Party, he insisted that although the Communist Party had "an enormous importance" in Belgium, it was no doubt mistaken about the surrealists and did not always give a correct account of their activities in its own press; one could nevertheless agree with its leaders when they said, "the services we [the surrealists] can offer the revolution through our literary activity are greater now than if we join."[96]

In Brussels, the news at the end of 1926 did not revolve around the need for political commitment; but on October 6 a pamphlet appeared, *Défiez-vous,* which brought together certain signatories for the first time: Goemans, Magritte, Mesens, Nougé, and André Souris.[97] What united them was the announcement of a theatrical program featuring Geo Norge, Cocteau, Ribemont-Dessaignes, and Charles Péguy: the first performance was disrupted in a noisy fashion, and on November 3, a second collective declaration was specially devoted to the *Mariés de la tour Eiffel:* "As long as we're alive, certain atrocities remain impossible."[98] The two texts, although inspired by minor events, signaled the appearance of a real surrealist group in Brussels, and Mesens placed at Nougé's disposal a "bimonthly periodical for a fine youth" called *Marie,*[99] whose first issues (June and July 1926) were still faithful to a certain, even expanded, Dadaist spirit. This collaboration eventually led to the *Adieu à Marie,* the journal's last issue, which appeared without a date (probably in February or March of 1927). Nougé's influence was obvious: the presentation was both more rigorous and more aggressive, if for no other reason than the presence of a page ("let us test our gaze") with a text by Nougé

1

6 Octobre 1926

Quelques turpitudes de Monsieur Geo Norge, de Monsieur Raymond Rouleau ou de Monsieur Baugniet ne sauraient nous émouvoir.

Il conviendrait cependant de les mettre en garde.

Nous leur abandonnons bien volontiers Messieurs Jean Cocteau et Michel de Ghelderode.

Mais pour Apollinaire, Tzara, Ribemont-Dessaignes et Aragon, pour Odilon-Jean Périer, ils sont des nôtres, Messieurs,

DEFIEZ-VOUS

Gaston Burssens -- Camille Goemans -- Eric de Haulleville -- Paul Hooreman -- René Magritte -- E. L. T. Mesens -- Paul Nougé -- Paul van Ostayen -- André Souris.

86, rue de Courtrai BRUXELLES

1

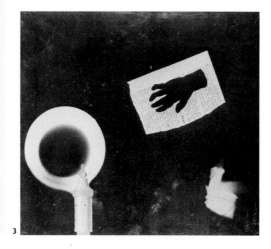

3

DIMANCHE

Lundi Mardi Mercredi Jeudi Vendredi Sam...
Tous les jours l'étonnement devient meilleu...

M. LECOMTE :

Et moi aussi, je dis : BOVRIL.

E. L. T. MESENS :

nous avons pris parti.
A mauvais jeu bonne figure. Il est trop tar...
Mais nous avons choisi de parler et d'écrir...

C. GOEMANS :

Les salons seront éclairés avec des bougies.
à un grand dîner.
de vous inviter
à l'honneur
d'un beau pays
L'ambassadeur

R. MAGRITTE :

QUE VOUS NOUS AIMIEZ

FAITES VIVRE

PERIODE

VOUS FERA VIVRE

OU QUE VOUS NE NOUS AIMIEZ

PAS. | SI PEU QUE CE SOIT

P.S. — E.L.T. MESENS reçoit à son compte chèque n° 138.916 ou 55, Rue de Courtrai, Bruxelles.

attendons pas moins de vous
nous le sommes et n'en
rien de fait
puisque sans lui
à mépriser le geste du donateur
mais on n'est pas arrivé encore
malgré ou parce que
nous ne pouvons mépriser
tout le monde la recevra
une revue gratuite en somme

MÉFIEZ-VOUS
DE LA SCULPTURE (ARCHITECTURE)

4

(image 4 — mirrored/rotated composition)

(DE LA SCULPTURE (ARCHITECTURE)
MÉFIEZ-VOUS AUSSI

une revue gratuite en somme
personne ne la lira
mais tout est consommé déjà
malgré ou parce que
nous ne pouvons mépriser
le geste du donateur
puisque rien de fait
ou plutôt c'est nous qui le sommes
puisque Dieu vous le pardonne
ce geste ne viendra jamais

SI PEU QUE CE SOIT

P. S. - E. L. T. MESENS reçoit tous les jours au BON MARCHÉ, rue Neuve (rayon soldes et occasions); le soir, 55, rue de Courtrai.

PAS.
OU QUE VOUS NE NOUS AIMIEZ

NOUS FERA VIVRE
PERIODE
FAITES VIVRE

QUE VOUS NOUS AIMIEZ

R. MAGRITTE :

L'ambassadeur
d'un sombre pays
a l'honneur
à ce qu'il dit
de vous prier
à ce dîner
vous l'avez dit
nos funérailles auront eu lieu l'après-midi

C. GOEMANS :

Mais il ne nous est resté que de parler et d'écrire.
A triste jeu pâle figure. Il était trop tard on nous avait vraiment tout pris.

E. L. T. MESENS :

Et moi seulement je dis : MESENS

Je dis : mesens
Je dis
Je
je
J

M. LECOMTE :

Tous les jours on croit dissiper la torpeur
LUNDI mardi mercredi jeudi vendredi samedi
DIMANCHE

éprouvons nos regards :

attention,ilsuf firaitd'unpeud' attentiond'un emainlibrede quelqueadres sepourjoindre d'untraitpurle straitséparsd uplusbeauvis agedumonde.

P. N.

5

in an uninterrupted typographical block: "look, allitwouldtakeisabitofattentionafree-handsomeskilltojoininonepurelinethescatteredfeaturesofthemostbeautifulfaceinthe-world," along with two photographs by Mesens, reproduced on two facing pages: fingers curled into brass knuckles, turning inward on the left-hand photograph ("the way they see it"), and outwards on the right ("the way we see it").

Adieu à Marie, on the back cover, displayed an advertisement for the Galerie "À la Vierge poupine," in which one could see "paintings, books, surrealist publications, Negro objects." The gallery was run by Geert (Gérard) Van Bruaene, and it was in these premises that the Brussels group sponsored an exhibit of naive painting by Edmond de Crom, in November 1926. The catalog preface consisted of declarations by Goemans, Magritte, Nougé, and Mesens ("monsieur edmond de crom lives in a world that we do not know but that we can easily guess. everyday reality serves as wonder for him"). This type of exhibit had the value of a manifesto, for naive painting was still totally unknown in Brussels, and it created a sensation, as expected, in the official art circles and their periodicals.

Magritte

Magritte held an exhibition in April 1927 at the Galerie le Centaure; the preface to his catalog was by P.G. Van Hecke and Nougé, who qualified his painting as "aggressive and forceful. More than that, it lends itself to oblivion, it seems to decompose, to be recognized, abandoned. It is insinuating. Suddenly, one realizes that its unfamiliar shapes take up all the space. In this way it eludes judgment, or praise, as does René Magritte." In September 1926, Goemans had decided that Magritte was not a surrealist, perhaps because of the somewhat contrived aspect of his representational montages and the lack of stylistic unity of canvases like *Souvenir de voyage* or *Les Signes du soir,* in which the juxtaposition of figures and background are set once again in a fairly mannerist style, but the work exhibited at the Centaure several months later—among them *Le Jockey perdu* (The lost jockey), which Magritte himself considered to be his first surrealist painting—showed the progress that the painter had made. He had learned from De Chirico that he must explore what he called, relentlessly, the "mystery." *Le Jockey perdu* preserved a geometrical use of space, something Magritte had experimented with earlier in a few abstract endeavors, and the illusion of relief in the double row of ninepins down the middle of which the central horseman was "galloping" (rather slowly) was still somewhat awkwardly rendered. Thus, both these factors meant that the painting did not yet display the deceptively academic front of later paintings. But some of the elements that would become typical of Magritte were already present: play on the relative size of the elements depicted, graft of living elements on inert ones (the ninepins act like tree trunks), theatrical staging represented by a curtain blocking either side of the canvas. The aims of his painting were now set: to use everyday objects (the list was fairly limited: bells, busts, apples, a cannon, clouds, a banal facade, musical instruments, birds, a person wearing a melon on his head,[100] a mirror, etc.) and then suggest new arrangements, which became disconcerting when the usual material, size, spatial relations or function was altered. In its appearance, or if one prefers, in its stylistic appearance, Magritte's work has nothing in common with automatism, but his many declarations concerning the way in which he discovered the images he painted nevertheless confirmed that he did indeed obey an "inner model," even if that model

MaRiE

Journal bimensuel pour la belle jeunesse

| N° 1 1er JUIN 1926 | DIRECTEUR : E.-L.-T. MESENS SECRÉTAIRE DE RÉDACTION : PIERRE MOULAERT Rédaction-Administration : 55, rue de Courtrai, Bruxelles | Abonnement : 24 numéros, 18 francs Prix au numéro : frs. 0,75 |

Gaston Burssens, Hermann Closson, Marcel Lecomte, René Magritte, E.-L.-T. Mesens, Pierre Moulaert, Paul van Ostayen, Man Ray, ont collaboré à ce numéro.

Petits Signes
ou

VOILA POURQUOI NOTRE FILLE EST MUETTE...

Pierre Bourgeois *téléphone mal.*
Marcel Lecomte téléphone bien.
Victor Bourgeois... *ne téléphone pas.*
René Magritte téléphone bien.
Pierre Flouquet *téléphone trop!*
Pierre Moulaert téléphone bien.
Paul Werrie *téléphone peu!*
E.-L.-T. Mesens téléphone bien.
Albert Lepage *téléphone mieux* (hum!)
O.-J. Périer téléphone bien.
Aimé Declercq *téléphone plus.*
Paul van Ostayen téléphone bien.
Georges Monier *téléphone dur.*
Hermann Closson téléphone bien.
Louis Vander Swaelmen... *jardine.*
Camille Goemans téléphone bien.
Georges Ramaekers *ne croit qu'en Dieu.*
Eudore Lambeau *ne croit en rien (sic).*
Paul Valéry téléphone bien.
Paul Nougé *téléphone loin.*

« *MARIE* » *TELEPHONE TOUT.*

P.-S. — Paul Vanderborght et paul hooreman *téléphonent-ils?*

Il faut encore scier un barreau de l'échelle.
R. M.

On reconnaît généralement les indigènes à la couleur de leur peau.
e. l. t. M.

Avez-vous toujours la même épaule?
R. M.

Thématique

« Seul l'utile est susceptible d'être beau.
Seul le susceptible est utile d'être beau.
Seul le beau est susceptible d'être utile.
Seul le beau est utile d'être susceptible.
Seul l'utile est beau d'être susceptible.
Seul Maurice est susceptible d'être Casteels.
Seul Casteels est susceptible d'être Maurice.
Seul Maurice est Casteels d'être susceptible.
Seul susceptible est Casteels d'être Maurice.
Seul à Seul
Saule pleureur au lorgnon.
P. van OSTAYEN.

Mon proverbe bimensuel :
Lorsque finit le mois de Mai
Tournez la page s'il vous plait.
e. l. t. M.

Art contemporain
et jeune peinture française

Au Salon annuel de l'Art contemporain (qui s'est ouvert le 15 mai dans la Salle des Fêtes de la ville d'Anvers), réservé, cette année, à la « jeune peinture française », celle-ci est brillamment représentée par l'Espagnol Picasso, le Roumain Brancusi, les Russes Chagall, Pascin et Zadkine, les Polonais Kisling et Marcoussis, l'Italien (!) Modigliani, le Flamand (!!) de Vlaminck, etc. etc. Pourquoi le visiteur le plus indifférent ne s'inquiéterait-il de l'absence du *Français* Giorgio de Chirico, du *Français* Max Ernst, du *Français* Juan Gris, du *Français* Joan Miró, du *Français* Hans Arp, du *Français* Man Ray, du *Français* André Masson même et de Henri Rousseau, le douanier français? Mais nous ne sommes guère étonnés...

1

aDiEU

A

MaRiE

2.00 francs dernier numéro

Administration : E. L. T. Mesens, 55, rue de Courtrai, Bruxelles

2

Dessin René MAGRITTE.

3

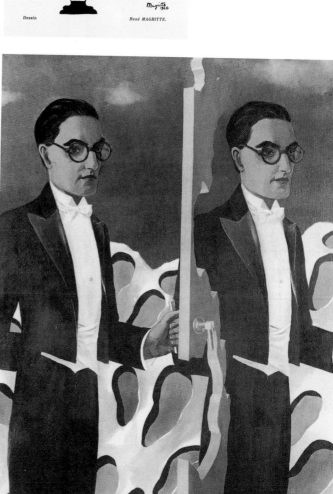

4

1 *Comme ils l'entendent* (The way they see it; *left*) and *Comme nous l'entendons* (The way we see it; *right*). Photographs by E. L. T. Mesens reproduced in *Adieu à Marie*, Brussels (February or March 1927).

2

3

5

4

6

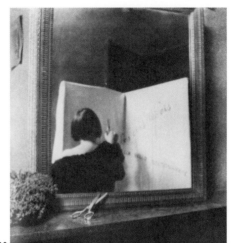

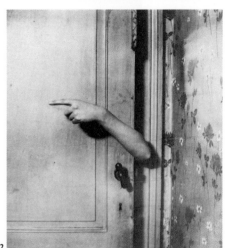

2–13 Paul Nougé, photographs from *La Subversion des images* (1919–30); 7¹/₅ × 7¹/₅ in. (18 × 18 cm). *2, Table aimantée, tombeau du poète* (Magnetic table, the poet's tomb.) *3, Cils coupés* (Cut eyelashes). *4, La Naissance de l'objet* (The birth of the object). *5, Les Buveurs* (The drinkers). *6, La Vengeance* (Vengeance). *7, Femme effrayée par une ficelle* (Woman terrified by a string). *8, Yeux clos, bouche scellée (Les Vendanges du sommeil)* (Eyes closed, lips sealed [the harvest of sleep]). *9, La Jongleuse* (Woman juggling). *10, . . . Les Oiseaux vous poursuivent* (. . . The birds are pursuing you). *11, Mur murmure* (Murmur wall). *12, Le Bras révélateur* (The revealing arm). *13, Femme dans l'escalier* (Woman in the stairway).

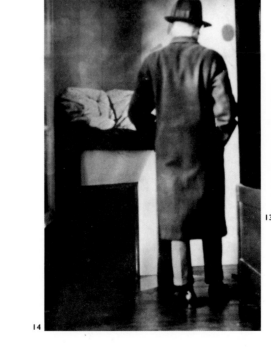

14 René Magritte, *La Mort des fantômes* (The death of phantoms), photograph (1928).

was reflected on at length and preconceived before its pictorial realization. Magritte's work habits became progressively impersonal (almost perfected in 1926 in *L'Assassin menacé*), and thus he confirmed that in his opinion it was not painting that had any intrinsic value; it must, on the contrary, serve something other than itself, it must, he would henceforth insist, become a "way of thinking," as precise as possible. What must be considered was the variability of one's relation with the world and its appearances. Every painting was an opportunity for the objectification of ideas—Breton's major preoccupation at that time—but the ideas at stake could only be revealed in a finished painting. As Magritte stated in *Adieu à Marie,* "The finished painting is a surprise, and its author is the first one to be surprised."

Magritte's exhibition was all the more joyfully massacred by official criticism in Brussels for having been a success, so he decided to leave for Paris. In August 1927, he settled with his wife Georgette in Perreux-sur-Marne. Thus he was now able to come into close contact with the surrealists and to attend, perhaps on a regular basis, the group's meetings—all the more gladly now that Goemans, his fellow artist from Brussels, would soon join them. Still, it is not clear whether his importance was immediately recognized: besides the fact that on his arrival his work was virtually unknown in Paris (since no one had seen his exhibitions in Belgium), what still seemed to be the result of a stylistic quest (or astylistic, if one prefers) must have left his new friends somewhat undecided. In any case, he held an exhibition in Brussels in January 1928, at the Galerie l'Époque, with a preface written by Nougé (and countersigned by all the local surrealists), who suggested at the time replacing the hackneyed notion of friendship with a "sort of affinity."[101] This affinity was a shield against the scorn of the public, insofar as it showed that they shared principles that held little appeal for the crowds.

Magritte also published some texts and drawings in the new periodical of his friends from Brussels, *Distances* (three issues from February to April 1928): his first contribution to *La Révolution surréaliste* came only with the last issue, number 12 (December 1929)—but it was a particularly noteworthy contribution: *Les Mots et les images,* a reproduction of his canvas with the inscription *Je ne vois pas la... caché dans la forêt,* symbolically surrounded by photographic portraits of sixteen surrealists with their eyes closed. This was an illustration of the responses to the survey on love. There was also a collage of a few cows grazing in front of the Opéra in Paris (where, as José Pierre suggested, one might easily detect Magritte's feelings toward the Parisians).

Love

In his *Entretiens,* Breton suggested that, "independently of the deep desire for revolutionary action" that motivated the group at the time, "all the subjects of exaltation typical of surrealism converge . . . toward love." This was made clear in Éluard's poems (his collection *L'Amour la poésie* [Love, poetry] came out in 1929) as well as in Desnos's (*La Liberté ou l'amour!* [Freedom or love!], 1927—and if one puts this title alongside Éluard's, the three values promoted by surrealism stand out).

It was also their conception of love that caused the surrealists to take up Charlie Chaplin's defense in a pamphlet, draw attention to the importance of Sade, suggest a reinterpretation of hysteria, and circulate surveys.

In the United States, Chaplin was targeted by a vast campaign in the press, fomented by his mother-in-law while he was in the process of getting divorced. He was por-

trayed as a depraved individual: certain morality leagues did not hesitate to demand that his films be outlawed on the entire American territory. For the surrealists, already at the time of *Littérature,* the character of the Little Man symbolized in a poetic way indifference or opposition to the laws of society and its representatives. In a chronicle on the cinema for *L'Humanité* Péret asserted, for example, when writing of the *Gold Rush* and *The Pilgrim,* that the first film showed us "in a synthetic form the individual effort each person makes to escape as much as possible from the terrible obsession of one's daily bread" and that *The Pilgrim* showed again how Chaplin, "hounded by the police, had been obliged on many occasions to deal with the lackeys of capitalism."[102] The surrealists could not remain indifferent to the fact that the inventor of such a character was being accused because, in the name of love, he had flaunted the rules of bourgeois marriage and its attendant morality. Their collective declaration was first published (in a translation into English by Nancy Cunard) in the American periodical *Transition* (published in Paris), then reprinted in French in *La Révolution surréaliste* (nos. 9–10 [October 1927]). With the help of cinematographic examples, the article stressed that Chaplin "had always obeyed the orders of love," then listed Mrs. Chaplin's grievances against her husband in order to criticize American morality. The article saluted Chaplin as a genius who "sought to show moral truth to the world, which universal stupidity has obscured and is trying to annihilate."

Simply because love was linked with moral truth did not mean one should conceive of it only as something luminous: the darkness of Sade also conveyed truth. Éluard sought to remind people of this in his article "D.A.F. de Sade, Writer of Fantasy and Revolutionary": "Sade validated those men who had singular ideas in the realm of love, and stood up to those who saw love only as an indispensable means to perpetuate their filthy race."[103] He then went on to tie this in with the Marquis' struggle for absolute equality and justice, the duration of his imprisonment, and the way in which his work had been distorted. Twelve years later, the defender of absolute freedom would be portrayed by Man Ray in his *Portrait imaginaire du marquis de Sade,* with his stonewall face against the background of the burning Bastille.

Independently of Sade, love could be treated from the angle of eroticism: Éluard (and Gala) offered proof of this in their unique edition of a text by Pierre Louÿs, *Trois filles et leur mère* (Three girls and their mother). This stemmed from an edition made in 1926 "at the expense of an amateur, and for his friends" and was progressively enriched not only with texts by Louÿs himself but also twenty-eight original drawings by Valentine Hugo, twelve by Dalí, one by Tanguy (in 1936), two by Bellmer, and one by Toyen from 1935.[104] In 1928 the publication of a veritable erotic trilogy was planned by the publisher R. Bonnel: this would include *Histoire de l'œil* by Lord Auch (Georges Bataille, whose presence in the group was discreet: his only contribution to *La Révolution surréaliste* was the publication of "Fatrasies" in no. 6), *Le Con d'Irène* (Irene's cunt) by Aragon, and *Les Couilles enragées* (Enraged balls) by Satyremont (Péret, with a frontispiece by Tanguy). The first two were published in a small number with illustrations by Masson—Breton, in August, wrote enthusiastically of *L'Histoire de l'œil:* "It is the most beautiful erotic book I know," even though he found the eight lithographs by Masson "not of the same standard"—but publication of Péret's text was blocked by a police raid.[105] It remains, nevertheless, in its excesses in which all earthly kingdoms are seized by a sensual frenzy, one of the high points of the genre.[106] The following year another erotic work, *1929,* came out with no reference to the publisher but clearly

1 Toyen, *Untitled* (1932); drawing, 10⁴/₅ × 8²/₅ in. (27 × 21 cm), reproduced in the periodical *Erotikon* published in Prague.

2 Photograph by Man Ray, published in *1929*, a clandestine work published with no indication of place or date; print run of 215 copies. The book includes four photographs by Man Ray and poems by Louis Aragon and Benjamin Péret.

3 André Masson, illustration for *Histoire de l'œil* (The story of the eye) by Lord Auch (Georges Bataille) (1928).

4 Man Ray, *Scène sado-masochiste*.

5 Hans Bellmer, *Tour menthe poivrée à la mémoire des petites fille goulues* (Peppermint tower in memory of greedy little girls; 1942); oil on canvas.

aligned on the cover were the names of its authors, Aragon and Péret, and the illustrator, Man Ray; it was in the format of an almanac, with a poem and a photograph—far more "realistic" than Masson or Tanguy's drawings—for each month and by season. "It was as if the surrealists' erotic expression, too long contained, suddenly exploded all at once, one great explosion to break out of clandestinity," said the publisher J.-J. Pauvert.[107] But such an explosion, which did in fact break with the tradition of pseudonyms and clandestinity that were both a boon and a bane for erotic literature, was of less importance than the publication (which it may have helped) of "Research into Sexuality."[108] There could be no clandestinity in this case but only strict reporting on collective research (hardly alluring, to be sure: small print and no illustrations likely to attract attention). It was presented as a document designed—as stated in its subtitle—to shed light on "the part of objectivity, individual determination, and the degree of consciousness" that could play a role in love relationships.

First undertaken in January 1928, the research would last until August of that year, thanks to Breton's obstinacy in leading the investigation and despite all the political and personal problems within the group. Forty participants would eventually exchange questions and answers,[109] with a frankness that was all the more surprising in that "sixty years ago," as José Pierre reminded them, "a survey on sexuality was not even, as it now is, one of those somewhat spurious methods that the editor-in-chief of a newspaper or a weekly would utilize, without too much faith, in order to try to win back lost readers. It simply wasn't done."[110] It wasn't done also for the simple reason that whenever sexuality was mentioned in specialized journals, it was either in a typically French salacious tone (Freud himself would state that it risked becoming an obstacle to the comprehension of his theories) or it was in the form of more or less explicit "classified advertisements," or "publicity," where it was not the personal sexuality of an editor, or even that of a possible reader, but a repetitive and interchangeable collection of anonymous fantasies. The surrealists, however, spoke of their sexuality, and, after a fashion, their intention was to speak of it to themselves, rather than to their readers, who were invited nevertheless, at least implicitly, to demonstrate a comparable frankness. The material that was collected, published only in part (two sessions out of twelve), was seen as an opportunity to compare experiences, taste, and concepts. Very quickly it became apparent that the surrealists were not linked, any more than any other group of individuals, by a common vision of physical or emotional relationships in love: Was a discovery of their differences not also a means to become better acquainted? Their friendship could only be reinforced if they confided in each other. As for the significance that their intimate secrets could take on when divulged to a wider public, it was easy to see that it would depend on the quality of that public. Might one interpret the interruption of the publication (which, it was noted, was "to be continued") as indicative of a fear of global misinterpretation, which might consist, for example, in diverting confessions into pretexts for gossip or in finding motives to create a scandal, although the surrealists' intentions were far removed from anything of the sort?

Number 12, the last issue of *La Révolution surréaliste,* did not come out until December 1929, which was twenty months after the previous issue, and it contained fifty-three responses to a "Survey on Love," which in their way—not always exemplary—took up where the "Research into Sexuality" had left off. Comparing these responses with those of the surrealists in their research was enough to reveal the breadth of the

1

3

4

5

2

I Drawings of Nadja.

2–4 Photographs by Jacques-André
Boiffard, illustrations for André
Breton's *Nadja*. 2, "The luminous
'Mazda' poster along the large
boulevards...." 3, "I will set off from
the Hôtel des Grands Hommes...."
4, "We have the wine merchant
serve us outside...."

gap separating their search for knowledge and lucidity from the almost unbearable, conventional responses of those who were not surrealists.[111]

The Struggle against Dominant Values

Love also underlay the new definition of hysteria, and Breton and Aragon would celebrate the fiftieth anniversary of that definition in number 11 of *La Révolution surréaliste*: since medical notions had continually evolved with regard to hysteria, the time seemed ripe to approve the dialectic that would define its future—hence the insistence on the role of seduction in hysteria, and on its value as a supreme means of expression. Such a definition went beyond psychiatric specialization and set the limits of comprehension by which it was governed, even if it was by referring to their past as medical students that Breton and Aragon came up with their definition. Hysteria appeared to be a highly poetic behavior, in which it was the body itself that addressed the other person; obviously, it would seem particularly unwarranted to want to restore a so-called normality by healing that body.

Breton's protest against the psychiatric profession culminated in the end of *Nadja,* which was published in May 1928; excerpts had been published, before the book came out at Gallimard, in *Commerce* (autumn 1927, before the last part was written, in December, in which Breton's passion for Simone Muzard was resonant) and in number 11 of *La Révolution surréaliste*. The writing of *Nadja* was unique in that Breton closely intertwined his own experience, particularly the problems he had in what was a very complex emotional life, with the actual time of the writing and his current intellectual concerns. Moreover, he made use of photography in place of description (condemned four years earlier in the manifesto), even if the images he chose did not fully satisfy him (some would be changed for the corrected, definitive, edition of the text in 1962). The relationship had been a failure because Breton—who had a guilty conscience about it—could not respond to the love of this childlike, fairy-woman, encountered by chance; but at the end of the penultimate section of the book, he declared that it was because of the "scorn that he felt for the psychiatric profession in general, its pomp and works," that he had not yet dared inquire into "what had become of Nadja."[112] He then revealed his pessimism regarding her fate, "as well as that of others like her," due to her poverty: a wealthy patient would be better cared for, would be shown more concern, whereas poverty "in our era is enough to condemn her, the moment she dares to step beyond the boundaries of an imbecilic code of good sense and good morality." The inequality of psychiatric treatment was linked to social inequality: mental health care reflected the poor social organization.

But that was not the only fault of psychiatry: earlier in the book Breton accused the system of asylums, which "*produced* madmen in the same manner as reform schools produce hooligans."[113] He also faulted the physicians' lack of comprehension with regard to their patients' efforts at expression, referring in particular to the "professor Claude at Sainte-Anne, with his forehead of an ignoramus, his stubborn air, so typical," or the systematic interpretation of any behavior on the part of the patient from an unfavorable point of view—all of which could only encourage, if not determine, a "near-fatal passage from an acute crisis to a chronic condition." The conclusion was imperative—"Any internment is arbitrary. I persist in refusing to see why one should deprive human beings of their freedom"—and carried with it a warning: "I know that

1

2

3

4

if I were mad, and had been interned for a few days, I would take advantage of a *remission* from my delirium in order to assassinate in cold blood anyone—preferably the doctor—I could get my hands on. At least that way I'd be allowed, like the manics, to be in solitary. Maybe they would leave me in peace." This position, supported here by emotional reasons, was close to the one underlying the *Lettre aux médecins-chefs des asiles de fous* (Letter to the chief physicians of insane asylums) of 1925, but its plea was colder.

The protest against psychiatry provoked a reaction among those concerned, as witnessed by the excerpts of the *Annales médico-psychologiques* of November 1929, which Breton would place at the head of the *Second manifeste du surréalisme*. In October 1930 (no. 2 of *Surréalisme au service de la Révolution*), Breton renewed his attacks with "Mental Health Medicine and Surrealism"—a title that alone served to indicate his intention to put mental health medicine in the dock, and he reproached its practitioners for having no other aim than to repress and "consider everything in man that is not the pure and simple adaptation to the external conditions of life as pathological "; thus, any sense of individual rebellion was systematically eclipsed, and the institution of medicine was nothing other than a refined means of maintaining human beings in a mental and social framework over which they had no control.

As for the various official expressions of this social order, there was no risk, at the end of the 1920s, of the surrealists forgetting them—to a degree that, at the time, some of their attacks were considered excessive by the communists, who were easily more conformist (where morality was concerned) or more "open-minded" (where religion was concerned) than the editors of *La Révolution surréaliste*.

In number 5 of *La Révolution surréaliste,* a lead article welcomed a certain Ernest Gengenbach, who had sent in a strange letter describing his past. He had once been a resident abbot among the Jesuits, who chased him out, and then he attempted suicide after he was abandoned by an actress (she would have liked to have been his mistress had he continued to wear the gown, but rejected him as soon as he wore civilian clothing). His testimony—"It is precisely because I was a clergyman," he said, "that I want people to know what the men of the Church have made of me: a desperate, rebellious nihilist"—was welcome, for it contained more than mere anticlericalism, and it would nurture a contemplation, originating with *The Monk* by Matthew Gregory Lewis, of the deviations of the religious spirit and Satanic obsession. Breton alluded to Lewis's work when, in April 1927, he introduced a talk by Jean Genbach devoted, precisely, to "Satan in Paris."[114]

Anticlericalism and the antireligious struggle were waged with considerable exhilaration. In the toilets at the rue du Château, a crucifix was used as a handle for the chain flush, and Man Ray photographed this setting designed by Aragon. Breton, in a comment in *Le Surréalisme et la Peinture,* had said, "Someone recently suggested describing God 'as a tree,' and once again I saw the caterpillar but I didn't see the tree. Besides, you cannot describe a tree, you can't describe something that has no shape. You can describe a pig and that's all. God, who isn't described, is a pig." Crastre denounced "God the policeman," "God the magistrate," of the Church, and finally it was the turn of Ribemont-Dessaignes to lead the attack with "La Saison des bains de ciel" in *La Révolution surréaliste* number 8, in which he ridiculed the wave of conversions (even Cocteau) that had spread through "intellectual" or "artistic" circles, emphasizing that "it would suffice to never again pronounce the name of God for that dangerous character to cease to exist. What a fine dream, that of exterminating God." In

LE CINQUANTENAIRE DE L'HYSTERIE

(1878-1928)

Nous, surréalistes, tenons a célébrer ici le cinquantenaire de l'hystérie, la plus grande découverte poétique de la fin du XIX⁰ siècle, et cela au moment même ou le démembrement du concept de l'hystérie paraît chose consommée. Nous qui n'aimons rien tant que ces jeunes hystériques, dont le type parfait nous est fourni par l'observation relative a la délicieuse X. L. (Augustine) entrée a la Salpétrière dans le service du Dr Charcot le 21 octobre 1875, a l'âge de 15 ans 1/2, comment serions-nous touchés par la laborieuse réfutation de troubles organiques, dont le procès ne sera jamais qu'aux yeux des seuls médecins celui de l'hystérie ? Quelle pitié ! M. Babinski, l'homme le plus intelligent qui se soit attaqué a cette question, osait publier en 1913 : « Quand une émotion est sincère, profonde, secoue l'âme humaine, il n'y a plus de place pour l'hystérie ». Et voila encore ce qu'on nous a donné a apprendre de mieux. Freud, qui doit tant a Charcot, se souvient-il du temps où, au témoignage des survivants, les internes de la Salpétrière confondaient leur devoir professionnel et leur gout de l'amour, où, a la nuit tombante, les malades les rejoignaient au dehors ou les recevaient dans leur lit ? Ils énuméraient ensuite patiemment, pour les besoins de la cause médicale qui ne se défend pas, les attitudes passionnelles soi-disant pathologiques qui leur étaient, et nous sont encore humainement, si précieuses. Après cinquante ans, l'école de Nancy est-elle morte ? S'il vit toujours, le docteur Luys a-t-il oublié ? Mais où sont les observations de Néri sur le tremblement de terre de Messine ? Où sont les zouaves torpillés par le Raymond Roussel de la science, Clovis Vincent?

Aux diverses définitions de l'hystérie qui ont été données jusqu'à ce jour, de l'hystérie, divine dans l'Antiquité, infernale au Moyen-Age, des possédés de Loudun aux flagellants de N.-D. des Pleurs (Vive Madame Chantelouve!), définitions mythiques, érotiques ou simplement lyriques, définitions sociales, définitions savantes, il est trop facile d'opposer cette « maladie complexe et protéiforme appelée hystérie qui échappe a toute définition » (Bernheim). Les spectateurs du très beau film « La Sorcellerie a travers les Ages » se rappellent certainement avoir trouvé sur l'écran ou dans la salle des enseignements plus vifs que ceux des livres d'Hippocrate, de Platon où l'utérus bondit comme une "petite chèvre, de Galien qui immobilise la chèvre, de Fernel qui la remet en marche au XVIᵉ siècle et la sent sous sa main remonter jusqu'a l'estomac; ils ont vu grandir, grandir les cornes de la

"Fifty Years of Hysteria," article by André Breton and Louis Aragon, published in *La Révolution surréaliste*, number 11 (March 15, 1928).

1

2

3

the twelfth installment of the periodical, Jean Koppen ended "How to Accommodate a Priest" with these unequivocal words: "As everything that is done against priests is well done, it is only the willingness to harm them that is lacking; let all those who are not willing find their faces covered with our spittle." Finally, from the famous photograph taken by Marcel Duhamel in the summer of 1926, which showed "Our collaborator Benjamin Péret insulting a priest" (no. 8, in which there was also a reproduction of *La Vierge corrigeant l'Enfant Jésus devant trois témoins: André Breton, Paul Éluard. et l'artiste,* by Ernst [The virgin correcting the child jesus in front of three witnesses: André Breton, Paul Éluard, and the Artist]), came a principle of conduct: "Every time you meet a servant of the Bearded Whore of Nazareth in the street, you must insult him in a tone that leaves no doubt as to the quality of your disgust."

As religion came under attack, other bourgeois ideals were not neglected. On the cover of *La Révolution surréaliste* number 4 was the formula: "War on Work," and André Thirion, in his "Comment on Money" (no. 12) tried to reconcile the principles of a Marxist analysis of the circulation of money, poverty, and the exploitation of the working class with a certain surrealist fury: "In order to abolish money, there must be corpses. So get rich and famous, and get your stripes, young men—later we'll be in need some fine victims!" As for the police, who had always been seen as accomplices of the bourgeois and capitalist order, Fourrier predicted ("Police, Hands Up!" [no. 12]) that the police would disappear in postrevolutionary society, on the condition that the "police spirit" was also abolished, something that was far from being the case in the Soviet Union. The blotting paper used by the Council of Ministers was published so that the public could "admire" and analyze the drawings and obsessive doodling that revealed a great deal about the more or less secret thoughts and not always admissible ambitions of those who governed. Éluard, in "De l'usage des guerriers morts" (On the utilization of dead warriors), attacked the new religion that honored "those who died for the homeland"—guilty, in his opinion, of failing to understand that their true enemies were those who sent them to be killed, and Alexandre published two articles ("Liberté, liberté chérie" [no. 7] and "A propos de la morale" [no. 12]) that reiterated that the appeal for the highest form of liberty must go hand in hand with a moral strictness.

In this context, Lautréamont and Rimbaud continued to symbolize for the group the true values that should be kept well away from the despised practices, thus from official recognition on the part of the bourgeoisie. Soupault wrote a preface to a new edition of the complete works, but it was awkward and overly journalistic in its attempt to assert that Lautréamont had also been concerned with politics. In April 1927, Aragon, Breton, and Éluard reacted violently to this preface with a pamphlet entitled *Lautréamont envers et contre tout.*[115] They denounced the confusion of the preface—they had broken with Soupault several months earlier—with regard to Félix and Isidore Ducasse and, in passing, pointed out that while they had just joined the Communist Party, they cared little "whether Lautréamont was a militant revolutionary or not." "Lautréamont's place is elsewhere," concluded the text, elsewhere than in history, particularly that of literature; elsewhere than within reach of merchants and venal commentators who would agree to cheat in exchange for what they could get out of publication—something they also reproached Soupault with.

In October 1927, the municipality of Charleville inaugurated a monument to Rimbaud: the pamphlet *Permettez!* emphasized, through a montage of quotations, the incongruous and even scandalous—since it was poetry that was being subverted—

1

2

3

7

8

9

5

6

11

1–11 *Les Tribulations de M. WZZZ....*
Excerpts from a novel in photos by
Max Morise, Marcel Duhamel, and
Man Ray (1929).

nature of such a tribute to the spirit of a man who, relentlessly, had denounced father-land, family, work, and his own native town.[116] "Everything that goes to make up your filthy little lives was repugnant to him; he abhorred it. . . . Don't try to cheat: you're not erecting a statue to a poet 'like any other'; you're erecting a statue out of spite, out of petty-mindedness, out of vengeance." Rimbaud's place was also "elsewhere" than on a pedestal available to passers-by whose entire existence was the negation of what he sought to evoke through his poetry.

Surrealist Paris

For the surrealists, commemorative statues were no more neutral than the urban land-scape in general: everything could point toward the revelation of the unknown or toward a confirmation of their intellectual and emotional concerns of the moment.

It was clear that, where Paris was concerned, the surrealists definitely preferred the Right Bank—from the flea market at Saint-Ouen to the Tour Saint-Jacques, by way of Buttes-Chaumont and the Porte Saint-Denis. But initially, three distinct geographical regions converged within the group: there was of course the rue Fontaine, but there was also the rue du Château and the rue Blomet. Masson strongly emphasized how this last location had "always been, fundamentally, a hotbed of dissidence," opposing it to the rue Fontaine, which was perceived as "the seat of orthodoxy." As for the rue du Château, it was where the Prévert brothers, Tanguy, and Duhamel nurtured an atmos-phere of constant upheaval: the absence of seriousness was practiced magnificently, as an art of survival.

There was a great deal of exchange between the three locations not only because Aragon, Éluard, and Breton visited the painters' studios but also because the collective games—in particular exquisite corpse, first enjoyed at the rue du Château—required them to meet up periodically. The Left Bank only gradually lost its charms. It is likely that the international Bohemian crowd of Montparnasse held little appeal for the sur-realists: its brilliance consisted of so much mere show, and in its *laisser-aller* there was too much indifference to the very idea of a quest for the meaning of life. Nevertheless, Man Ray, Desnos, Tanguy, and a few others willingly spent a part of their evenings there, for professional reasons or to meet their acquaintances from bar to bar. Duhamel told of how "in the Montparnasse of the Jockey, the Jungle, and other cabarets" he would, together with Tanguy, obtain the cocaine that made them, on their first meeting with Breton, so talkative that their guest could not get a word in edgewise. Subse-quently, they would meet on an almost daily basis at the Cyrano, place Blanche, to par-ticipate in the meetings of the group.

The different cafés in which these meetings were held—the Certa in the passage de l'Opéra during the Dada era, the Cyrano, the Café du Globe near the Porte Saint-Denis, the Café d'Angleterre at the carrefour Richelieu-Drouot, right up to the Prom-enade de Vénus, near the Halles, in the 1960s—were far from the Montparnasse of the 1920s. They were neither worldly nor particularly "literary," and they were chosen pri-marily for practical reasons, because they were near the rue Fontaine where Breton had been living since 1922 or near the newspaper neighborhood where Aragon, Desnos, or Péret had their business. They were public venues where the group could meet, where they could be beguiled by a poster or a chance meeting of two gazes, where they could exchange information, ideas, and projects, but where, in the end,

they were only stopping by, on their way from one errand to another or as they strolled around. For Paris was above all a place for idle wandering, and it was during one's wandering that one might discover the city's magical or "magnetic" places.

According to the responses published in April 1922 in *Littérature* regarding the Paris *quartier* that each member of the group preferred, their tastes quickly became apparent: carrefour Belleville-Oberkampf (Aragon), Porte Maillot (Baron), Porte Saint-Denis (Breton), Opéra (Éluard), Bercy (Morise), boulevard Sébastopol (Péret), Chaussée-d'Antin (Soupault), and the Halles (Vitrac). As for the public gardens, there were fewer chosen spots: Buttes-Chaumont (Aragon), square du Bon Marché (Baron), square des Arts et Métiers (Breton and Éluard), square de la Trinité (Péret), Tuileries (Soupault), and place des Vosges (Vitrac). This emotional geography offered the possibility of a number of itineraries or walks without any particular destination, during which mystery and wonder would reveal themselves to those who were receptive.

The city offered a wealth of incongruous encounters and pretexts for hallucinations or premonitions. It might be the way in which, for Aragon, canes and umbrellas glimpsed in a window display along the passage de l'Opéra were transformed into seaweed. Or it might be the sign *Bois et charbons* (wood and coal) that became the conclusion of *Les Champs magnétiques* and that Breton again mentioned in *Nadja,* describing how such signs gave him "a strange talent as a prospector" with regard to shops that displayed such signs; the image of the wooden log became obsessive, indiscriminately qualifying a merry-go-round tune and the head of the statue of Jean-Jacques Rousseau. The glass of the covered passages transformed objects into magical props, advertising posters decorated walls with irrational landscapes of disproportionate heroes, and those that covered the walls of the Métro came to life for Desnos in 1930: "The Blooker Cocoa Dutch girl steps forward, enormous. A white bear is following her. The Pierrot in thermogenic cotton sinks, luminously, into the shadows of the underground" (*Les Mystères du métropolitain*). In shop windows items were juxtaposed that were as diverse as those in the stalls of a flea market: the city offered the elements of multiple collages, a space of potential poetry, provided one's desire was open to it. All these elements contributed to the erotic charge of an anticipated encounter: it could be Georgette, woman-child and young prostitute from Soupault's *Dernières nuits de Paris* (The last nights of Paris), who "became in herself a city"; and it certainly was Nadja, the archetype of the fairy-woman revealing her power in relation to the open-mindedness of her companion.

To wander was to be open to whatever might happen: such openness transformed what was there to satisfy one's desire. Even if the actual setting was mediocre, the stroller could intuit a deeper meaning, more secretive and intimate. This was the case of commemorative statues: "In their plush bathrobes, their familiar jackets, their smiling good natures, the enactments of modern times borrow from the very anodyne nature of their get-ups a magical strength unknown in Ephesus or Angkor," said Breton. He also noted that he had always been "drawn" to the statue of Étienne Dolet on the place Maubert, at the same time that it gave him "an unbearable malaise"; Éluard was fascinated by the statue of Joan of Arc. Beyond the Paris that was visible and anonymous there existed a latent city, to be decoded by the poet-seer.

But the city was rarely perceived in relation to its social usage, nor was it even interesting from that angle. If the surrealists preferred to evoke the neighborhoods considered to be working class, it was less for directly political reasons (and in *Nadja,* the

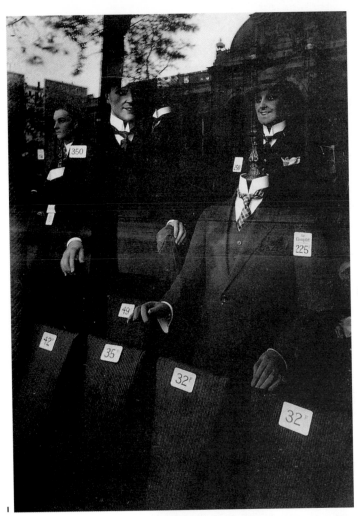

7 Plaster sculpture in a shop window, 1930. Photograph by Man Ray.

8 Galerie du Baromètre in the Passage de l'Opéra, circa 1870. Photograph by Charles Marville.

9 A window on the Quai Voltaire, 1928. Photograph by André Kertesz.

9

10

11

10 Paris, 1929. Photograph by André Kertesz.

11 Entry to the Galerie de l'Horloge, Passage de l'Opéra, circa 1925.

crowds pouring out of office and workplace hardly seemed capable of starting a revolution) than because of their absence of any artistic or cultural pretension: the chance find, object, building, or face, it hardly mattered, was all the more moving. This confirmed that the surreal lay beneath the most extreme banality and that one could discover it by lending to banality a sort of "floating attention," capable of capturing the incongruous at the heart of the ordinary.

It was for similar reasons that the surrealists gathered in places where the most naive performances were held. The aim was no longer, as in the Dada era, to inhabit certain established seats of bourgeois culture but to explore the unexpected wealth of serialized films or the reels of Mack Sennett, the Musée Grévin, or melodramas (*Les Détraqués* [The unhinged]), fairgrounds, and flea markets—or even the stalls of the Concours Lépine: when Péret went there in 1933 to write a sort of report for the periodical *Vu,* he focused on "objects whose invention did not correspond to any immediate necessity," where the poetic spirit "was much more at home than in the production of a new bicycle."[117]

It was in these unpretentious dance or music halls that one began the descent to what in *Nadja* was referred to, positively, as the "lower depths of the spirit": what one saw there was disturbing and moving not only because it offered an opportunity for furtive encounters in the audience but also because it addressed what was both simplest and most intimate in people. An image, an object, a scene, could unleash an immediate emotional or passionate reaction—there would always be time to look for explanations later—and in the immediate, all that mattered was one's response to an unexpected magnetic pull, or what amounted, secretly, to a beckoning. These resonant sexual undertones also surely encouraged certain members of the group to frequent the Bal Nègre on the rue Blomet or, for some, to become regulars, like Leiris, at the cabarets where black jazz musicians played (Soupault was also a frequent patron).

Compared to such activities, society events had little appeal. Some surrealists (Georges Sadoul or André Thirion) felt, for ideological reasons, somewhat ill at ease at the soirées held by art lovers—whose patronage, like that of Noailles, was sometimes necessary to finance a film or a publishing project. But if, more generally, the surrealists were hardly attracted to "society," it was primarily because they surmised that there would be no surprises to be found there: customs were so codified that any derogation took on the immediate air of a scandal with no real impact, and risked devitalizing their work and everything that inspired it by reducing it to the rank of a passing fashion.

Meeting at the rue du Château

On February 12, 1929, Breton and Aragon wrote a letter inviting their correspondents to voice their opinion on whether a new collective action should be undertaken. It seemed all the more problematic in that the periodicals that might make their action known (*La Lutte des classes, Le Grand jeu, Distances, L'Esprit, La Révolution surréaliste*) were not published on a regular basis. On March 11, therefore, a meeting was held at the rue du Château, and a report on the meeting was published a few months later in a special issue of *Variétés,* "Le Surréalisme en 1929," as an article entitled "To Be Continued: A Small Contribution to the File of Certain Intellectuals with Revolutionary Tendencies," cosigned by Aragon and Breton.[118]

Of the responses they garnered during the meeting presided by Max Morise, it would seem that four of them (Bataille, Leiris, Masson, and Paul Guitard) were frankly hostile to any common action. Four others (Fraenkel, Ribemont-Dessaignes, Miró, and Hooreman) were undecided.[119] Thirty-six, however, came out in favor of a joint action, but with variations. Some of them (Goemans, Magritte, Desnos, Souris, Morise, and Nougé) had questions about the very nature of the action. Joë Bousquet, Marko Ristitch, Malkine, and Ernst were for continuing the surrealist activity, while others (among them Éluard, Alexandre, Mesens, and Albert Valentin) thought it ought to be complemented with activities of a different nature. As for the members of the Grand Jeu, they intended to respond as a group rather than as individuals—which seemed to pose a disturbing precedent to the issue at hand.

Additional divisions arose with regard to the significance to be granted personal issues: if collaboration with certain individuals (most often Artaud and Vitrac but also, on several occasions, the members of the Grand Jeu, particularly where Unik and Thirion were concerned) seemed impossible, a minimum agreement seemed to have been reached regarding the definition of a revolutionary position that did not necessarily go hand in hand with militant activity when it concerned "people whose employable faculties were of another sort."

While the meeting was supposed to focus on the possibility of a common stance regarding Trotsky's recent exile (he was expelled from the USSR that January), it was actually the Grand Jeu that found itself on the hot seat, to such a degree that its members and their friends, indisputably, had the feeling that they'd been tricked. The Grand Jeu, which brought together young people who were already extraordinarily united, since most of them had known each other since their lycée days, published its first issue during the summer of 1928. In his editorial, Roger Gilbert-Lecomte affirmed, "We will always devote ourselves with all our strength to all new revolutions," and the table of contents included, in addition to the contributions collected under the title "The Need to Rebel," a good number of texts or collaborations (Desnos, Saint-Pol Roux) likely to receive a warm reception from the surrealists; later, the interest in Rimbaud, Nerval, or Lautréamont would confirm their shared aspirations.[120] For the present, those aspirations did have to be clarified, insofar as *Le Grand jeu* still seemed somewhat unreliable. It was reproached, in fact, not only for a tendency to mysticism that meant the alarmingly frequent use, in its pages, of the word "God" but also for having an unclear attitude during a recent affair involving some rebellious students of the École Normale Supérieure and for including among its collaborators Roger Vailland, who had written an article for *Paris-Soir* that seemed to praise the *préfet* Chiappe.

The confused debate that then ensued caused first Ribemont-Dessaignes to get up and leave, then Thirion, who considered Chiappe to be a policeman and reproached his friends of *Le Grand jeu* for not stating clearly their disapproval of the man. A solution that was hardly satisfactory was found: insofar as only the *Le Grand jeu* collaborators, among those present, had declared that they would continue to trust Vailland, it seemed that it would not be possible to engage in a joint action unless—and this was not what they wanted—they were to be considered as individuals and not as members of a constituent group. A collaboration would only be possible with their periodical once Vailland had published a letter of self-criticism regarding his article on Chiappe.

The pretext for such a trial seemed flimsy, and during the meeting Vailland did not refrain from asserting that he had to make a living somehow, so he attributed no

importance to what he published in *Paris-Soir.* Beyond the anecdote, beyond even the wary attitude toward journalism that was periodically voiced among members of the group and of which Desnos and Soupault had already been victim, what was at stake was serious all the same: the movement was weathering a crisis, evidenced by the responses of Leiris, Masson, Limbour, and Desnos and by the interruption (however temporary) of the publication of *La Révolution surréaliste.* Surrealism continued to be subject to criticism in *Monde,* Barbusse's periodical, and Naville himself, although he had defected to the Trotskyist opposition, declared his ongoing solidarity with communism. Thus the group found itself condemned both from within and from without for its inability to participate in revolutionary activity by any other means than ineffective declarations.

Moreover, a number of periodicals were starting up that were staffed by former friends of Aragon and Breton. In February 1929 came *Documents,* to which Leiris, Masson, Baron, Boiffard, Desnos, Limbour, and Vitrac would offer their collaboration; the secretary general was Bataille. Bataille, to be sure, had never been a very active member of the group: his sole contribution to *La Révolution surréaliste* was the publication, in number 6, of "Fatrasies," and he was very suspicious of automatism. Closer to Leiris and Masson than either Aragon or Breton (who described him as "obsessed"), he had nevertheless won unanimous admiration for his *Histoire de l'œil* in 1928, and his desire for philosophical materialism was enough to alert those who claimed to be interested in the marxist version of materialism.[121]

Three months after *Documents,* it would be the turn of *Bifur:* the editor-in-chief was Ribemont-Dessaignes, and in the very first issue he included works by Soupault, Tzara, and Limbour (who would later be joined by Picabia and Desnos, as well as René Daumal and Gilbert-Lecomte; Ribemont-Dessaignes reacted favorably to the endeavors of *Le Grand jeu*).

In this atmosphere conducive to casual alliances, where the possibility of publishing seemed more decisive than any doubts over the identity of those with whom one would be sharing the table of contents, Aragon and Breton sought, on the contrary, to make the question of moral qualifications a priority: even if action had to be limited to a declaration of principle concerning a common revolutionary position, one should not embark on it with just anybody. To be sure, such an ethical requirement was in danger of delaying an explicitly political commitment. And yet it constituted the condition that made it possible: from this point of view, the meeting at the rue du Château constituted both an appeal and a declaration of failure. The *Second manifeste du surréalisme* would absorb the lessons of that failure with an extreme virulence.

"Surrealism in 1929"

The special issue of the periodical *Variétés* titled "Le Surréalisme in 1929" was prepared by Breton, Aragon, and Éluard, who took a trip to Brussels in April to do so. Mesens and Albert Valentin would subsequently act as intermediaries between Paris and Brussels. *Variétés,* a "monthly review of the contemporary spirit," had been edited since May 1928 by Paul Gustave Van Hecke, who organized the exhibitions at the Galerie le Centaure and who had previously managed the Galerie l'Epoque together with Mesens, where he readily exhibited Belgian surrealists, Magritte for a start. "Le Surréalisme en 1929" took up where *La Révolution surréaliste* had left off and was partially financed

Musée des Arts et Métiers

British Columbia

2

Ainsi font...

Eléphants

Trotsky

Freud

3

Cathédrales

Le cadavre exquis

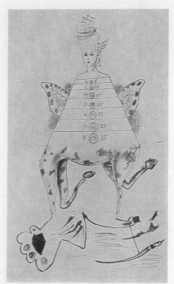

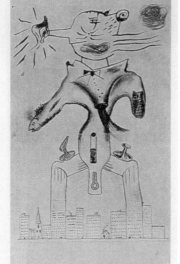

Quatre dessins en collaboration

4

1

3

2

4

5

thanks to the sale of the erotic collection *1929;* with its title it announced a clearly dated desire to make an impact, and this was the very news item that was honored from its first pages with the dossier "To Be Continued." The table of contents gave a fairly accurate and thorough picture of what constituted, at the time, the surrealist spirit and included a maximum number of contributors from Paris (among them, from the rue du Château, Sadoul, Queneau, Frédéric Mégret, and Thirion) and two Belgian collaborators, Nougé and Mesens.[122] It opened with a text by Freud devoted to humor, immediately followed by an example of those surrealist games (in this case the one of unpremeditated proposals made by two players) that easily resembled poetic oracles, while offering the advantage of strengthening solidarity among members of the group and reducing internal tension. The selection of poems by Éluard, Unik, Aragon, Desnos, Mesens, and Mégret in "Le Surréalisme en 1929" alternated the different tones that the surrealists had at their disposal: from virulent criticism on the part of Crevel ("A l'heure où l'écriture se dénoue," which criticized the *préfet* Chiappe in passing, decidedly an honored subject), to systematic disorientation with Nougé (in this case criteria of time and space), uncontrolled narration from Péret, tales of dreams (Sadoul), dreamy prose (Valentin), the opposition of the magical mentality to short-sighted rationalism (Eluard: "L'Art sauvage [Introduction]"), cosmogonic reverie and a parody of a prescientific speech by Queneau, social intervention ("Down with work!" by Thirion), and, finally, the *Trésor des jésuites* (Treasure of the Jesuits), a play written by Aragon and Breton, originally destined to be performed by Musidora, in which allusions to their favorite films were abundant.

The illustrations in the issue were indicative of the group's preferences and were presented in order to add information and meaning to the texts themselves, in the form of little notebooks of four or eight pages. The first one, following an autograph of Lautréamont, consisted of superimposed aerial views of the Place de l'Étoile and the cemetery of Montparnasse; a photograph of elephants copulating above a montage of two cathedrals copulating; and finally, a juxtaposition, in "Homage," of the portraits of Trotsky and Freud. Then came a series of paintings (two by Émile Savitry, two by Tanguy), followed by photographs by Man Ray and Malkine, two excerpts from *La Femme 100 têtes,* more portraits (Unik and Crevel), two sculptures by Arp ("Heads"), photographs of Queneau and Péret, and two drawings by Picabia. Thus members of the group, or artists once close to them who had not participated directly in the issue, were nevertheless represented, as Miró and Magritte would be later on. Another journal played on significant opposites: between a robot from the Musée des Arts et Métiers and a sculpture from British Columbia ("Fetishes"), then within a sequence of eight images, among four different artistic representations of dreams (an anonymous licentious etching, Courbet, Detaille, and Rousseau) and four more "brut" testimonies: the representation of a dream scene by H. Saint-Denis, an "Ultramartian interior" by Helen Smith, and two views of the ideal Palace by the Facteur Cheval. Then came a series of four exquisite corpses followed by a drawing by Max Morise. As for the *Trésor des jésuites,* its illustrations made its antireligious tenor explicit by depicting the toilets at the rue du Château, "the home of the poets Sadoul and Thirion," while the cover of the program for the "gala Judex" (where the play had not been performed) was followed by Musidora and the portraits of the authors.

Images made their contribution to the reinforcement of surrealist theories and the importance given to dreams, to collective creation, and to the partiality, which began

1 Jacques-André Boiffard, *Untitled* (ca. 1930).

2, 3 Jacques-André Boiffard, *Untitled* (1929); illustrations for "Le Gros orteil" (The big toe) by Georges Bataille, published in *Documents*, first year, number 6.

4 Jacques-André Boiffard, *Untitled* (1930); published in *Documents*. Pierre Prévert is behind the mask.

5 Jacques-André Boiffard, *Untitled* (1930). A very similar photograph (a heavy metallic necklace replacing the chain) illustrated the article by Michel Leiris, "Le 'Caput mortuum,' ou la femme de l'alchimiste" (The 'caput mortuum,' or the alchemist's wife) in *Documents*, second year, number 8. But it was taken by William S. Seabrook, an American writer and traveler who provided Leiris with the three illustrations for his text.

1

3

2

4

5

with Rimbaud, for "idiotic" painting or examples of art that was spontaneous and devoid of technical pretension. Thus images rewarded the privilege that the entire issue of *Variétés* seemed initially to grant to the literary or aesthetic aspect of the movement. With the exception of Crevel and Thirion, there were indeed very few contributions where the political aspect was explicitly stated: it was enough to compare "Le Surréalisme en 1929" to the last issues of *La Révolution surréaliste* to realize that ideology and politics took up very little place in the newer periodical. Exception might be made for the map (possibly due to Tanguy) that represented, on facing pages, "The World at the Time of the Surrealists," where countries and continents were distorted according to the group's relative interest. Beyond the fact that the Equator itself had become a fluctuating line, indicative of how much the usual separation between North and South had lost its value, Europe was represented by an outsize Ireland and by Germany, Austria-Hungary, and Russia. The only cities that figured on the map, however, were Paris and Constantinople (where Trotsky had taken refuge). Primitive peoples were clearly valued above others, and the indifference toward Greek and Roman Antiquity was obvious in the disappearance of the Mediterranean altogether. Obvious, too, was the importance granted to New Guinea (much larger than Australia), to the Bismarck Archipelago, and to Easter Island (the size of Peru, which was all that remained of Latin America). As for the North American continent, it consisted entirely of Alaska, Labrador, and Mexico: no trace of mainland United States. On such a planisphere, it was easy to see that whatever the importance given to Russia (and not the USSR), the territory allotted to primitive societies constituted a considerable counterweight. This was tantamount to declaring that the interest in communism was not in danger of lessening the group's interest in non-Western cultures, in their mentality and creativity. The "World at the Time of the Surrealists" showed that the group continued to profess an intellectual autonomy with regard to political leaders, warning them that they were not about to be brought to heel any time soon.

The Discovery of Dali; Ernst's *Romans-collages*

At the end of the summer of 1929, a private projection of the film by Dalí and Buñuel, *Un chien andalou,* was organized at the home of the Noailles and was attended by Breton and other members of the group.[123] They were full of enthusiasm: never before had the cinema attained such a degree of violence or cruelty, and compared with Buñuel's film, Man Ray's cinematographic endeavors, despite their qualities, seemed very timid indeed (*Emak Bakia* [1926], *Anemic Cinema* with Duchamp [1926], *L'Étoile de mer* [1928], from a poem by Desnos, *Les Mystères du château de Dé* [1929]). Shortly thereafter, Magritte, Goemans, Éluard, and Gala went to Cadaquès to meet Dalí, a visit that would lead to the formation of the "historic" couple, Dalí and Gala; Gala would leave Éluard for Dalí.

Dalí's first Parisian exhibition was held from November 20 to December 5, 1929, at the Galerie Goemans; the catalog preface was written by Breton, who already owned *Accomodations du désir,* exhibited alongside *Jeu lugubre, Plaisirs illuminés,* and *Visage du grand masturbateur.* In its way, Dalí's sudden appearance on the scene was of capital importance, precisely because he knew nothing of the history of the group and its convulsions. Moreover, his painting showed that it was not enough to seek out the mysterious or the imaginary, that one must also find a place for them in reality—in

pictorial practice, that is, if not in the actual life of the practitioner. Thus, Dalí's art offered an alternative to the political transformation of reality, against which there could also be a struggle through the play of substitutions, if it was true that desire could reform reality at will. Breton picked up on this in his text when he underlined the hallucinatory nature of Dalí's work, pointing to the manner in which the objects and beings that figured in the paintings "seem to want to remain in constant movement, yet their expression is unable to change, not only in the paintings but even within us, yes, in a sort of inner window display, resonating terrifyingly in the air as if the air itself suddenly proved to be a simple trick of mirrors, and it would be enough, imperceptibly but surely, to modify that trick for an immense gaping hole to open up, in which all the figures, whether they could be avoided or not, would appear at last to haunt a second landscape, of a second zone, that everything has caused us to sense." Foreseeing in this way a reconciliation between subjectivity and objectivity, between delirium and the apparitions that molded themselves to that delirium, between intimacy and the things it inhabits, Dalí's painting clearly shared surrealism's ongoing concerns and revived the possibility of dealing with them independently of the political exigency that, at the time, was so pervasive. The liberation this implied was twofold, both where the world was concerned and with regard to the divisions that troubled the group. "For three or four years, Dalí would be the incarnation of surrealism, making it blaze forth," Breton would say, at a time when hindsight enabled him to judge the vanity of the efforts devoted to creating ties with politicians.[124]

When Max Ernst's *La Femme 100 têtes* was published in December 1929, at the Éditions du Carrefour, there was a "Note to the Reader" from Breton. He insisted on the meaningfulness of the distortion of images in Ernst's collages, now enriched with captions that had no immediate connection with the plates and arranged in series as if in the form of a novel.[125] This first "novel in collage" in nine chapters was a clever concoction that simultaneously broadened one's vision and mocked the ordinary narrative structure of literature. While the illustrations used as material were initially realistic or pedagogical in intent, the dismembering and reorganization to which Ernst subjected them eliminated any descriptive effectiveness, conferring on them exploratory virtues instead, transforming figurative representations of the ordinary into manifestations of the hitherto unseen. Insofar as the elements that were used remained identifiable, however, it was the sum total of what they designated that was compelled to enter into new relations: an assumed female silhouette, if moved from the horizontal to the vertical, would perforce find itself invested with an ability to know something other than its usual past. Each figure, leaving behind its initial purpose, acceded to a new purpose of potentially unlimited exchanges and elicited what Breton would refer to as the "countless *illusions of true recognition* that it is up to us to have in the future and in the past."

Thus it was confirmed that surrealism aimed to pursue its work quite independently, even with regard to whatever it might consider its role in society to be.[126]

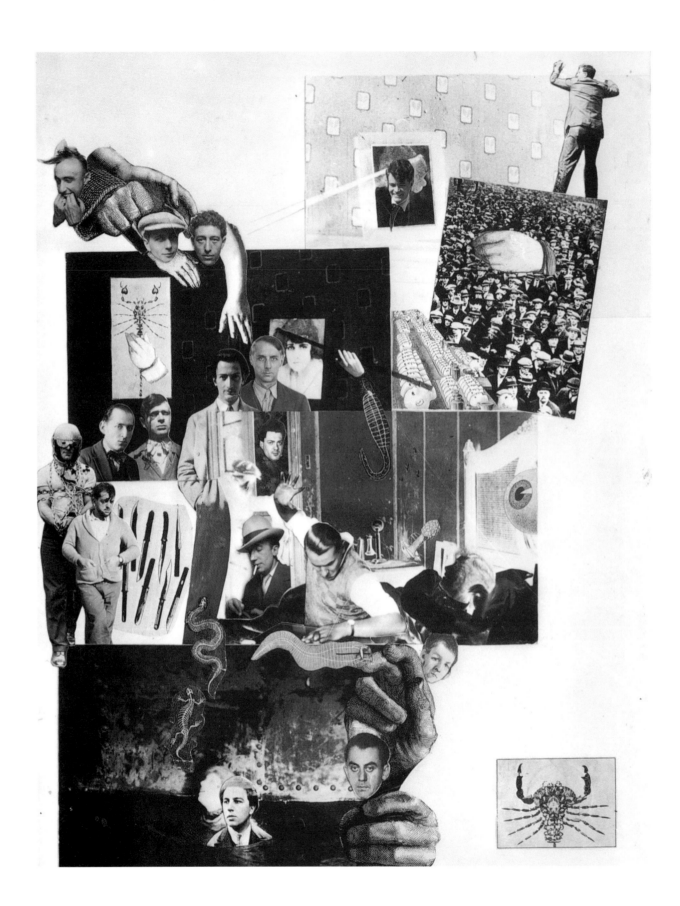

1929-1937

"ELEPHANTS ARE CONTAGIOUS"*

The Second Surrealist Manifesto

Opposite page: Max Ernst, *Loplop introduit des membres du groupe surréaliste* (Loplop introduces members of the surrealist group; 1931); cut-out photographs, pencil, 20 × 13²/₅ in. (50.1 × 33.6 cm). Museum of Modern Art, New York.

*Paul Éluard, *152 proverbes mis au goût du jour, en collaboration avec Benjamin Péret* (Paris: La Révolution Surréaliste, 1925), reprinted in Paul Éluard, *Œuvres complètes*, Bibliothèque de la Pléiade, 2 vols. (Paris: Gallimard, 1975), 1:155. This phrase seems to be Péret's.

The twelfth and last issue of *La Révolution surréaliste* was dated December 15, 1929: twenty-one months separated it from the previous issue, an indication of the considerable tension within the group.

It opened with a text that had not been singled out in any way in the table of contents on the cover: the "Second manifeste du surréalisme"—"Second Surrealist Manifesto." It was explicitly introduced by the formula: "Why *La Révolution surréaliste* suspended publication," followed by the imprint, in red, of seven pairs of female lips.[1] Breton wrote the text during the summer on the Isle of Sein, while rereading Hegel. An echo of Hegel resonated from the start in Breton's insistence on "the artificial nature of old antinomies, hypocritically intended to prevent any unexpected agitation on the part of man," before he went on to advance a theory destined to become as famous as the definition of surrealism in the first manifesto: "Everything leads one to believe that there exists a certain place in the mind where life and death, reality and imagination, past and future, the communicable and the incommunicable, high and low will cease to be perceived in opposition. Yet it would be fruitless to try to give surrealist activity any other motive than the hope to determine this point." The undertaking was thus clearly to take place outside any strictly literary or artistic practice, preferring to stand as "a dogma of absolute rebellion, total insubordination, and outright sabotage," expecting "nothing but violence." Belief in the supreme point could not exist without sharing an unmitigated despair, expressed thus: "The simplest surrealist act consists in going, pistol in hand, down into the street and shooting at random, for as long as one can, into the crowd."

Such a rebellion had no need of ancestors, and among those who were once praised only Lautréamont still found favor, having left no equivocal traces along his way. "Everything remains to be done, and all means are valid to demolish the ideas of *family,*

homeland, religion." Because such an attitude allowed no compromise, because it was, more than ever, a question of "having nothing in common with the smallest or greatest investors of the mind," reproaches multiplied against those who had lost their footing, for one reason or another; it was better to count on those who were "young and pure, and refused to bend to habit." Artaud, Jean Carrive, Francis Gérard, Georges Limbour, Masson, Soupault, and Vitrac were thus singled out as having disqualified themselves, morally, and were lumped together as "cowards, impostors, arrivistes, lying witnesses, and informers."

Once he had prepared the terrain, Breton could indicate surrealism's current direction: an interest in social issues and adherence to dialectical materialism and its application to "the problems of love, dreams, madness, art, and religion" (never mind the "few stubborn-minded revolutionaries" who could not grasp the urgency of such problems!). This would determine a further series of attacks and warnings, against Jacques Baron and Pierre Naville this time, considered to be "plotters" and " malicious revolutionaries."

But the problem of social action in itself was only one aspect of the more general problem of "human expression in all its forms": having situated surrealism as the "prehensile tail end" of romanticism, thus unveiling a desire to want "incontestably, all the evil," Breton then deplored the way in which automatic creations were increasingly affected by cliché, which could only be eliminated if self-observation during creativity were increased and intensified. For example, Desnos had displayed a lack of philosophical spirit and had also gone astray, devoured by his journalistic activity (he was also criticized for his collaboration "on *Bifur,* that remarkable repository for garbage")—and this despite the unshakable nature, long emphasized, of his support for surrealism: he would, henceforth, have to be excluded. It was also because they betrayed the trust and hope placed in them that a number of close collaborators were called to order: if Duchamp was only criticized for possessing an intelligence "heavily afflicted with skepticism," Ribemont-Dessaignes seemed to founder in "odious little detective stories," and even Picabia seemed ready to abandon any sort of provocation. A reconciliation, however, was undertaken with Tzara, whose poetry had the gift of "effectiveness," signifying a "step taken today in the direction of human deliverance." A message was also sent to René Daumal, who remained misguided in his obstinate intention to oppose one group to another.

The final quarter of the *Second Manifesto* was devoted to determining the immediate future of surrealism. Rimbaud's expression, "Alchemy of the Verb," demanded to be taken seriously: alchemical and surrealist research had analogous goals. "The philosopher's stone is nothing other than that which should allow man's imagination to take a splendid revenge upon everything." Whence the pressing invitation to proceed to the "DEEP AND TRUE OCCULTATION OF SURREALISM," which could be interpreted in a number of ways: both to flee public approval by refraining from "performing on a stage" and to experiment, by all means available, with sharing thought—already shown to be possible thanks to certain games—or to take on "sciences" such as astrology or metaphysics, "with a minimum of defiance"—the important thing being to maintain a flawless integrity, proof of total submission to "the strict discipline of the mind." The debate with Bataille would center on this point: Bataille was accused of idealism the moment his materialism seemed lacking in dialectics and, according to Breton in his

SECOND MANIFESTE DU SURRÉALISME

En dépit des démarches particulières à chacun de ceux qui s'en sont réclamés ou s'en réclament, on finira bien par accorder que le surréalisme ne tendit à rien tant qu'à provoquer, au point de vue intellectuel et moral, une *crise de conscience* de l'espèce la plus générale et la plus grave et que l'obtention ou la non-obtention de ce résultat peut seule décider de sa réussite ou de son échec historique.

Au point de vue intellectuel il s'agissait, il s'agit encore d'éprouver par tous les moyens et de faire reconnaître à tout prix le caractère factice des vieilles antinomies destinées hypocritement à prévenir toute agitation insolite de la part de l'homme, ne serait-ce qu'en lui donnant une idée indigente de ses moyens, qu'en le défiant d'échapper dans une mesure valable à la contrainte universelle. L'épouvantail de la mort, les cafés-chantants de l'au-delà, le naufrage de la plus belle raison dans le sommeil, l'écrasant rideau de l'avenir, les tours de Babel, les miroirs d'inconsistance, l'infranchissable mur d'argent éclaboussé de cervelle, ces images trop saisissantes de la catastrophe humaine ne sont peut-être que des images. Tout porte à croire qu'il existe un certain point de l'esprit d'où la vie et la mort, le réel et l'imaginaire, le passé et le futur,

le communicable et l'incommunicable, le haut et le bas cessent d'être perçus contradictoirement. Or, c'est en vain qu'on chercherait à l'activité surréaliste un autre mobile que l'espoir de détermination de ce point. On voit assez par là combien il serait absurde de lui prêter un sens uniquement destructeur, ou constructeur : le point dont il est question est *a fortiori* celui où la construction et la destruction cessent de pouvoir être brandies l'une contre l'autre. Il est clair, aussi, que le surréalisme n'est pas intéressé à tenir grand compte de ce qui se produit à côté de lui sous prétexte d'art, voire d'anti-art, de philosophie ou d'anti-philosophie, en un mot de tout ce qui n'a pas pour fin l'anéantissement de l'être en un brillant, intérieur et aveugle, qui ne soit pas plus l'âme de la glace que celle du feu. Que pourraient bien attendre de l'expérience surréaliste ceux qui gardent quelque souci de la place qu'ils occuperont *dans le monde*? En ce lieu mental d'où l'on ne peut plus entreprendre que pour soi-même une périlleuse mais, pensons-nous, une suprême reconnaissance, il ne saurait être question non plus d'attacher la moindre importance aux pas de ceux qui arrivent ou aux pas de ceux qui sortent, ces pas se produisant dans

1 *Le Second Manifeste du surréalisme* (The second manifesto of surrealism) by André Breton, published in *La Révolution surréaliste*, number 12 (December 15, 1929).

2 Georges Bataille, ca. 1930.

3 *Un cadavre*, collective pamphlet published on January 15, 1930, in reaction to the *Second Manifesto*. The first page is illustrated by a photomontage by Jacques-André Boiffard that represents André Breton, his eyelids closed, wearing a crown of thorns.

articles in *Documents* at the time, Bataille seemed to be solely preoccupied with everything that belittled man and ideas.

The *Second Manifesto* would end with the affirmation that "the surrealist operation has no chance of succeeding unless it takes place in conditions of moral asepsis, and there are very few people who are willing to even hear about this." Under any other conditions, it would be useless to "strive desperately," as surrealism did, to reach the limit where what "is" and what "is not" merged with or intercepted each other.

In their collective reply, which was published on January 15, 1930, at the expense of the periodical *Documents,* the authors of *Un cadavre,* using the title of the pamphlet that had greeted, in its way, the death of Anatole France, were responding more to the personal attacks they had just suffered in the *Second Manifesto* than to whatever the manifesto might have to offer in the way of new directions. And it should be noted that three of them (Morise, Queneau, and Prévert) had not even been mentioned in Breton's text; their disagreement stemmed from more anecdotal causes and had to do with Simone Kahn, Breton's first wife, whom he had just divorced. The testimony of Alejo Carpentier that closed that section seemed designed almost solely to foster mistrust between Éluard and Breton. Moreover, some of those who had been recently excluded, and not the most insignificant among them—Artaud, Masson, Soupault, and Naville—did not take part in the operation.

It was Desnos who first had the idea of a collective response. Bataille would organize it, then Desnos was on the verge of giving up, certain that such a reaction would only reinforce Breton's credibility rather than hurt him; Bataille himself would later acknowledge that gathering the signatories, most of whom were contributors to *Documents,* was proof above all of their "very weak coherence."[2] The first page of the pamphlet was illustrated with a photomontage, by Jacques-André Boiffard, showing Breton with his eyes closed (the picture had been borrowed from *La Révolution surréaliste)* and crowned with thorns—this refers both to Bataille's denunciation of surrealism as a religion and to the age of this new Christ: at the time when *Un cadavre* was published, Breton had just turned thirty-three. He was an obvious target, therefore, for their "spittle": "False brother and false communist, false revolutionary but a true poseur" (Ribemont-Dessaignes), "a rotting provocateur" (Leiris), "a lyrical charlatan" (Limbour), "good for the trash bin" (Morise), "representative of a loathsome species, an animal with a huge mop of hair and a face made for spittle: the eunuch Lion" (Bataille), " barnyard aesthete" (Baron), and so on. Even if Breton felt sharply the loss of certain friendships (particularly with Prévert and Queneau), he later feigned serenity when he said "that the subject which [the signatories] had selected had at least, up until then, managed to inspire them with a hitherto inexperienced state of exaltation."[3]

On the fourteenth of February, it was announced that the *Second Manifesto* would soon be published in book form, and two columns were devoted to refuting earlier declarations: ("Before") and more recent ones ("After"), by five signatories of *Un cadavre:* an expedient way in which to emphasize that Breton was not the only one who had changed his mind but also that such polemics were all the more useless insofar as it was possible to get anyone to face their own contradictions.[4]

Desnos however prolonged the offensive in a "Third Manifesto of Surrealism" which appeared on March 1, 1930 in *Le Courrier littéraire.*[5] There he reiterated his main accusations of racketeering (Breton made money by selling art works), artistic impotence ("He's never created a thing. His entire activity is based on literary or art criti-

cism, which to me is the depths of literature"), and a creeping religiosity ("Surrealism, as formulated by Breton, is . . . the best auxiliary for a renaissance of Catholicism and clericalism.").

When the *Second Manifesto* came out in the bookshops, on June 25, 1930, the text had been slightly modified to take some of these testimonies into account.[6] It was preceded, first and foremost, by an insert with fourteen signatures (Maxime Alexandre, Aragon, Buñuel, René Char, Dalí, Éluard, Ernst, Malkine, Péret, Sadoul, Tanguy, Thirion, Unik, and Valentin), which affirmed that the "Second Manifesto will enable one in all security to appreciate what is dead, and what is alive in surrealism. Subordinating all individual comforts to the marvelous aims of subversion, rejecting without appeal the specialists of false testimony, through the strictest moral asepsis, André Breton, in this book, has enumerated the rights and duties of the mind." A new group was thus restructured, convinced of the necessity of intervening in the social mechanism the moment anyone claimed to "give a rigorous description of the psychic mechanism of mankind."

Shared Writing

A note in the *Second Manifesto* recalled that "during the various experiments conceived in the form of 'parlor games,' and whose nature was to quash boredom and provide entertainment, which did not diminish their impact in any way," the surrealists felt that they had "aroused a curious possibility for thought, which was that it could be *shared*." The publication, in number 12 of *La Révolution surréaliste,* of "Notes on Poetry" by Breton and Éluard provided a particular illustration: the dual composition of these "Notes" not only implied an exchange between two writers but also inferred, as if with hindsight, the unwitting participation of Paul Valéry himself, since it was one of his texts that was dealt with here.

In 1930, shared writing was given a place of privilege: at the end of March, Breton, Char, and Éluard wrote short poems that were published on April 20 at the Éditions Surréalistes with the title *Ralentir travaux,* and then Breton and Éluard would collaborate on *L'Immaculée Conception,* which was also published at the Éditions Surréalistes in November (the printing was financed by the sale of the manuscript to Charles de Noailles and of the original drafts to Valentine Hugo). Undoubtedly, a desire to close ranks in order to overcome recent rifts played a part in these collaborative efforts, but the texts of *L'Immaculée Conception* did far more than merely prove a point, as they made use of a disturbing intertextuality (the word was not yet in use in 1930), which offered striking perspectives into the possibilities of thought that would not only be shared but which could also go well beyond the usual rules of communication in order to include what was normally considered a transgression of those very rules—to wit, "madness."

Char's first public participation in the movement was in number 12 of *La Révolution surréaliste,* where he published his text "Profession de foi du sujet" ("The Subject's Profession of Faith") and his responses to the survey on love; with the publication of his collection *Arsenal* in August 1929, he attracted the attention of Éluard. In November, he met Breton, Aragon, and Crevel in Paris, and in the third issue of his periodical *Méridiens* the following month he published an article that announced his new direction: "To pursue my activity at *Méridiens* or at any other newspaper or journal—with

1

2

3

the exception of *La Révolution surréaliste*—would be to betray my thought, my desire for action, and thus to approve the manifestations of a society which I intend henceforth to combat with all my strength."[7] When Breton and Aragon joined him in Avignon, it took them only a few days (from March 25 to March 30, according to the dates inscribed at the end of the collection) to write *Ralentir travaux,* as they came and went from their walks.

In his "Letter to André Rolland de Renéville," Breton underlined that a poetic collaboration could be "better written by three than by two, because the third element, continuously varying, acts as a meeting point, and a place of resolution, acting upon the two others as a *unifying* factor."[8] This affirmation can be fully tested by reading the poems in *Ralentir travaux,* in which the interwoven writing—most of the texts were written by all three authors—fuses on each page in a perfect unity, so to speak, both thematically and stylistically.[9] And insofar as each participant would read, at least quickly, the lines already written, the break that often characterized exquisite corpses was no longer a problem.

The twin signatures of *L'Immaculée Conception* seemed to leave the place of a "third element" vacant. But the third author was present in a number of ways: the book was colored with an obvious antireligious attitude, indicated not only by the title itself, by Dalí's illustration (which was clearly inspired by a passage in the last part), and by the insert (a photograph of the Virgin of Lourdes with a halo that reads: "I am the immaculate conception") but also by a reference to Hegelian anthropology. A number of passages consist of rewritten pieces (an article of musical criticism, excerpts from the Kama Sutra, fragments from *La Nature*) or of memories and allusions to other texts (psychoanalytic, in particular) and images as well (in particular, plate 120 of *La Femme 100 têtes,* published the previous year). The expression "the mediations" (another strongly Hegelian echo) was the title of the third part and collected in an ascending order the sequences "La Force de l'habitude," "La Surprise," "Il n'y a rien d'incompréhensible" (the formula was Lautréamont's, this time), "Le Sentiment de la nature," "L'Amour," and "L'Idée du devenir," in which it was easy to recognize Breton and Éluard's shared values, as well as their preoccupation with necessary social transformations.[10] "The Mediations" could equally be understood to refer to the different foreign voices that poetry can internalize, the better to know itself and to push back the limits of its effectiveness.

The voice that was apparently the most foreign was of course that which was simulated in the second part, "Possessions" (resonant, again, with anti-Christian sentiment; what possessed the two poets was no longer the devil but their declared intention to adopt the discourse of certain mental illnesses). The point was "to prove that the mind, trained *poetically* in a normal man, is capable of reproducing in broad outline the most paradoxical, eccentric verbal manifestations, that it is in the power of the mind to bend at will to the wildest ideas, without it necessarily being a question of a lasting disturbance, without there being any likelihood that the poet's *faculty* of equilibrium would be compromised in any way." And thus it was through a series of poetic experiments that an exploration of madness—according to the models it suggested and which Breton retained,[11] followed by a return to the "normal"—was possible, which indicated that poetry was indeed a faculty of knowledge, as was the inanity of the concepts that claimed to oppose, once and for all, rationality and irrationality in speech or thought. From the surrealist point of view, the idea was not to choose madness over reason,

since such a choice would be just as restrictive and arbitrary as the usual social choice, but, on the contrary, to form a synthesis that going beyond the ordinary opposition between the "normal" and the "pathological" would succeed in restoring to the mind all of its powers.

The lesson to be learned from such collaborations was emphasized in Éluard's preface to the Japanese translation of *L'Immaculée Conception* in 1936: "To be two to destroy, to build, to live, is already to be everyone, to be the other to infinity and no longer oneself. . . . A thoughtful and thorough examination of the possibilities of thought, of thought which is common to all, renders vain any hierarchy among men. Between man and woman, it would be the very negation of their own roles." Éluard's preface established the close and secret ties that connected writing to the hope of a greater community of mankind and to love. It was no longer simply an issue of fighting against minor literary vanity by challenging the classical status of the "author" as fully master of his text; it was now a question of articulating collective thought so that it would radiate from the individual to everyone.[12]

Surrealism at the Service of the Revolution

In March 1930, a pamphlet containing twenty-one signatures confirmed solidarity with Breton but also a resolution to "proceed to the application of the necessary conclusions reached in reading the Second Manifesto of Surrealism." Joining the signatories of the insert in the *Second Manifesto* were Joe Bousquet, Marcel Fourrier, Camille Goemans, Paul Nougé, Francis Ponge, Marco Ristitch, and Tzara, while Unik withdrew; they declared they had "decided to lend their support to a publication which will be entitled LE SURRÉALISME AU SERVICE DE LA RÉVOLUTION which not only would enable them to give a prompt and current response to the rabble who earn their living by thinking, but will also prepare the definitive rerouting of contemporary intellectual forces to the advantage of revolutionary inevitability." The present situation seemed extremely tense.

The first issue of the periodical thus announced came out in July 1930. The title alone (suggested by Aragon) clearly indicated the political and social commitment the group intended to make.[13] (Breton was the editor, using his home address for the magazine, and the Librairie Corti was used as a "general agent.") It was confirmed on the first page by the publication of a reply to a telegram from the International Bureau of Revolutionary Literature: "What will your position be if imperialism declares war on the Soviets." The response was unequivocal: "Comrades, if imperialism declares war upon the Soviets, our position will be, in accordance with the directives of the Third International, the position of the members of the French Communist Party." In the last paragraph, however, the response specified that, "in the present situation of unarmed conflict, we believe it is pointless to wait to place our own particular capacities at the service of the revolution." The alignment with the directives of the Communist Party was not really pressing, and the group had every intention of taking part in the fight against imperialism using its own specific means.

This was made doubly clear in the table of contents of the same first issue of *Surréalisme ASDLR* (*au service de la Révolution:* "at the service of the revolution"), which sought a balance between contributions of political or ideological import and actual surrealist texts. Setting the example, Breton published "Once upon a Time There Will

1 Marcel Jean, *On donne sa vie tout en la gardant* (One gives one's life as one keeps it), drawing published in *Le Surréalisme ASDLR*, number 6 (May 1933).

2 Mayakovsky in the film *Celui qui n'est pas né pour l'argent* (Those who were not born for money). Photograph published in *Le Surréalisme ASDLR*, number 1 (July 1930).

3 The Papin sisters, "before" (*top*) and "after" (*bottom*). Photographs published in *Le Surréalisme ASDLR*, number 5 (May 1933).

4 Yves Tanguy, *Poids et couleurs*, (Weight and colors); text and drawings published in *Le Surréalisme ASDLR*, number 1 (July 1930).

5 Lee Miller photographed by Man Ray; plate published in *Le Surréalisme ASDLR*, number 1 (July 1930).

On donne sa vie tout en la gardant.

MARCEL JEAN.

1

« *Sorties tout armées d'un chant de Maldoror...* » (Voir page 28).

3

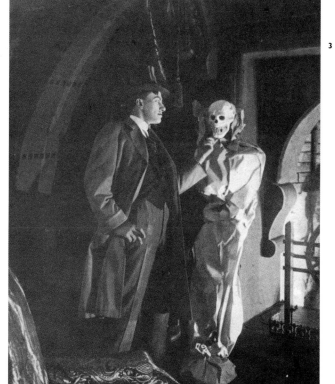

Не для денег родившийся Маяковскій Нептун

2

POIDS ET COULEURS

L'objet ci-dessus, de la grandeur de la main et comme s'il était pétri par elle, est en peluche rose. Les cinq terminaisons du bas qui se replient sur l'objet sont en celluloïd transparent et nacré. Les quatre trous dans le corps de l'objet permettent d'y passer les quatre grands doigts de la main.

Dans l'ensemble ci-dessus, l'objet de gauche est en plâtre peint de couleur zinzoline et l'ongle rose. Il est lesté dans le bas par une boule de plomb qui, permettant des oscillations, le ramène toujours à la même position.

Le très petit objet du milieu, plein de mercure, est recouvert de paille tressée rouge vif afin de paraître extrêmement léger. Le gros objet de droite est en coton moulé vert pâle, les ongles en celluloïd rose. Le dernier objet de droite est en plâtre couvert d'encre noire, l'ongle est rose.

L'objet de gauche est en cire molle imitation chair. L'appendice du haut est flottant et d'une couleur plus brune. Les trois formes arrondies du centre sont en matière dure, d'un blanc mat.

L'objet de droite est en craie bleu ciel. Dans le haut, des poils. Cet objet doit servir à écrire sur un tableau noir. Il sera usé par la base, pour qu'il ne finisse par subsister que la touffe de poils du haut.

YVES TANGUY.

4

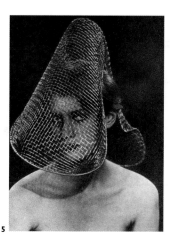

5

Be," a meditation on the imagination, which "must not be humiliated by life" and which was redefined as "anything which is striving to become real," a proposition for an enchanted home for a community enjoying "the position which seems to it to be poetically the most favorable."[14] "The boat of love has crashed against everyday life" was a tribute to Mayakovsky, who emphasized the possibility of contradictions between a revolutionary conscience and the most subjective emotionalism: "It has yet to be proven . . . that a man having attained the highest degree of consciousness . . . is the man with the best defense against the danger of a woman's glance." But the text also attacked *L'Humanité,* which had criticized the suicide of the Soviet poet: "We will deny, for a long time yet to come, the possibility of any poetry or art existing that could adapt to an extreme simplification—in the manner of Barbusse—of thought or feeling."

Every issue of *Surréalisme ASDLR* offered a balance—even in the way it was laid out, framing longer texts with short paragraphs taken from the press or from reactions to political news—between lyricism and an ideological stand: from the first issue, texts by Tzara, Dalí, or Péret were offset by more theoretical contributions by Alexandre, Thirion, or Valentin, while Crevel took on various celebrities (Julien Benda, Emmanuel Berl, Paul Morand, and Marcel Arland, among others) and then Aragon, who annihilated Desnos's recent work *Corps et biens.* (*Corps et biens* did contain verbal games by Rrose Sélavy but ended with recent poems, in regular verse: Desnos was clearly reverting to the amiable facility of his early work.) Once again, Aragon criticized the confusional efforts of the journalists of *L'Humanité* and *Monde,* who seemed to want to interest their readers in Claudel, of all people: "There will never be a lack of cranks ready to shout out that we want to keep workers in ignorance, and everything that implies. Ignorance? What's the point of learning the alphabet if it's all going to disappear tomorrow with this eroded world already collapsing on all sides?" The periodical's illustrations had the same twofold purpose: although *Surréalisme ASDLR* had a less luxurious design than *La Révolution surréaliste* and the photographs reproduced were grouped in one gathering rather than scattered throughout the issue, they covered both the group's artistic activities and its ideological positions. In the first issue, for example, there were four photograms from *L'Âge d'or,* a photograph by Man Ray, and two different plates from Dalí's *L'Homme invisible,* offset by the reproduction of a letter taken from the file of the suit brought against Sadoul for having threatened the major of Saint-Cyr with a spanking if he did not resign and with an image from the film *He Who Was Not Born for Money* that showed Mayakovsky tickling a skull. In the second issue, a number of line drawings were printed directly in the text, but photographs continued to appear in a separate gathering and alternated with reproductions (by Dalí, Man Ray, Tanguy, Ernst, a series of symbolic objects, Clovis Trouille, and others), which were certainly more numerous, and documents of a critical or theoretical thrust: the letter from a worker to *L'Humanité,* a letter by Freud, the twin portrait of the Papin sisters, and photographs of the exhibition *La Vérité sur les colonies* (The truth about the colonies).

"La Peinture au défi"

In February and March of 1930, an exhibition of collages was held at the Galerie Goemans (45, rue du Seine), bringing together works by Arp, Braque, Dalí, Duchamp,

Ernst, Juan Gris, Miró, Magritte, Man Ray, Picabia, Picasso, and Tanguy. The catalog's lengthy preface was by Aragon, "La Peinture au défi," and began by situating surrealism relative to the history that preceded it, in order to expound on a dialectical concept of the marvelous: "The relation which is engendered by the negation of reality by the marvelous is essentially of an ethical nature, and the marvelous is always the materialization of a moral symbol in violent opposition to the morality of the world into which it has emerged."[15] After the stifling influence of Christianity relegated the marvelous to magic, it was revived through Rimbaud and Lautréamont in the form of the diabolical, before "giving life to whatever surrounds us," be it among the hysterical or "in the images offered by dreams, madness, and poetry" now, thanks to Freud, open to interpretation. The historical consequence of this was the necessity of dechristianizing the world, and the potentiality offered by surreality, "this real thread which joins all the virtual images surrounding us."

Aragon gave a historical overview of the collage, beginning with cubism, and stressed that it was when the glued element was validated by the representative shape of an object that a passage from "white magic to black magic" took place—a passage that was taken one step further by Duchamp, Arthur Cravan, and Picabia, who "were conducting the trial of the artist's personality," reinventing incantation all the while: for Picabia, an electric light could become a young woman.

This disdain for both technique as savoir faire and the personality of the artist allowed one to imagine that painting would disappear altogether in the long run (as would versification and, added Aragon—as it would turn out, doomed prophet of his own fate—"the composition of novels"), whatever the trends toward a return to the past might be. De Chirico had provided a rather catastrophic example of this, by returning to the "profession" after he had imitated the effect of collages in his metaphysical interiors. Despite individual failures (André Derain also springs to mind), the general evolution of art over two decades showed that it had "truly ceased to be individual" and deserved to be qualified in the same manner in which Lautréamont qualified poetry: it was time for art to be "made by all." The collage thus appeared to be "absolutely capable of being contrasted with painting, beyond painting," since it brought art back "to the magical practices which are the origin and the justification for plastic representation." While painting was "luxurious," and therefore subject to "being tamed by money," collages were "poor" and lacked prestige.

After these theoretical considerations, Aragon continued with the history of collage, underlining Ernst's primordial importance and reiterating that "all painters whom we have been able to call surrealists . . . have used collages at least in passing": Arp, Man Ray (whose rayography was also a step beyond painting, "without any real connection with photography"), Tanguy, Malkine, Magritte (his words on the canvas had the same effectiveness as an object added on), Picabia (Aragon, echoing the *Second Manifesto*, evoked "certain statements on commitment, the profession, etc., which might have moved [him] if [he] had not known who was making them"), Picasso, Miró, and Dalí. Praise was not unreserved: one might reproach the way in which certain artists sometimes remained too attached to the particularities of a style, or sought to please (Picasso), or went on about nonexistent technical problems. Because they were friends, Aragon was particularly attentive to their capacities for innovation, but he was also impatient with regard to their weaknesses. Because, he said in conclusion, thought "is not disinterested. Thought is not the product of one isolated man. The discoveries of

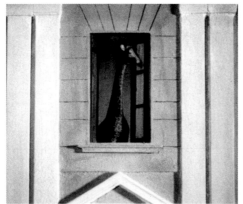

1, 2, 5, and 6 Scenes from *L'Âge d'or* by Luis Buñuel (1930). *2,* One of the shots that provoked the hostile reactions and ransacking of the theater on December 3, 1930.

3, 4 Scenes from *Un chien andalou* by Luis Buñuel.

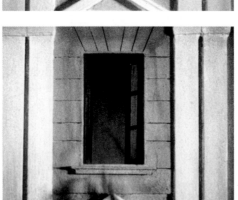

7 Pierre Batcheff in *Un chien andalou.*

8 Gaston Modot in *L'Âge d'or.*

9 Lya Lys in *L'Âge d'or.*

5

7

6

9

8

1 Luis Buñuel during the filming of *Un chien andalou* (1929).

2 Pamphlet subsequent to the demonstration against the screening of *L'Âge d'or* (1931).

« La critique du ciel se transforme en critique de la terre, la critique de la religion en critique du droit, la critique de la théologie en critique de la politique. »
KARL MARX.

« Il n'y a pas de spectacle aussi doux que celui de l'agonie d'un prêtre. »
MAURICE DE GUÉRIN.

Cette vue du film aurait provoqué l'intervention, auprès du Gouvernement français, de l'ambassadeur d'Italie, qui feindrait d'y reconnaître ses souverains.

Leurs Majestés italiennes, qui font massacrer les ouvriers révolutionnaires — telles qu'elles sont dans la triste réalité.

3 Letter from Salvador Dalí to Luis Buñuel in which he describes several scenes from *L'Âge d'or*.

4 Gaston Modot, Lya Lys, Jacques-Bernard Brunius, Claude Heymann, Luis Buñuel, and Jane Rucar during the filming of *L'Âge d'or*.

2

everyone lead to the evolution of each. . . . The marvelous must be made by all, and not just by one."

To consider the collage as a collective attitude, beyond individual performances, was to esteem that the undertaking was worthwhile because of the advances it could offer in the realm of thought: its effectiveness was of concern to both the contemporary marvelous and the social conditions governing artistic practice.[16] Aragon, as a coherent surrealist, made the connection between aesthetics and ethics and from the work to its effects and implications. Indisputably, this led him to go beyond the intentions of each of the artists that he presented, since he aimed to reveal the global significance that emanated from their combined endeavors. "La Peinture au défi" acted as a sort of annex to *Surréalisme et la Peinture*, based on the consideration of a technique (which wasn't one, strictly speaking, because of the very diversity among all the collages) and of that technique's consequences.

L'Âge d'or

In 1929, *Un chien andalou*, the first film coauthored by Buñuel and Dalí, enjoyed tremendous public success. The initial screening was to last two months at the Studio 28, but in fact the film played for eight months—which hardly pleased the authors, as it seemed to defuse the violence and subversive potential of their work. When the screenplay was published in the final issue of *La Révolution surréaliste*, Buñuel sought to clarify things: not only did this publication express his "complete adherence to surrealist ideas and activities" (without which the film would not exist), but he also declared himself incapable of opposing "this imbecilic crowd which found *beautiful* or *poetic* something which, basically, was nothing other than a desperate, passionate call to murder." As for Dalí, he felt that success had come from an "audience made mindless by periodicals and avant-garde 'revelations,' and, because they are snobs, they applaud anything which seems new and bizarre. Such an audience has not grasped the film's moral significance, which with unmitigated violence and cruelty is directed against the audience itself."

When Charles de Noailles offered Buñuel financing for a second film, which would be a full-length film, the director fully intended to produce a work that would be "beyond redemption," something Ado Kyrou would call "a poison." During the preparation of the screenplay, Dalí dreamt of a "tactile" cinema: "the spectators would press their hands against a keyboard on which a variety of substances would pass simultaneously with the image. . . . This would yield utterly surrealist effects, to make you shiver. A character on screen touching a dead body while your own fingers feel like they are sinking into butter!" He suggested a number of ideas to accentuate the "extraordinarily sensual poetry" and "genial eroticism" of the work (including a shot in which the unbuttoned fly of the main actor was later viewed as particularly subversive by the police).

The film was presented to the Board of Control with a summary synopsis that rendered it inoffensive and transformed it into "a work of obvious fantasy" enhanced by a "smiling philosophy," and it received its authorization.[17] A preliminary screening was given to the friends of the Noailleses, and the reception was chilly. The next morning, Charles de Noailles was excluded from the Jockey Club (and "his mother," according to Buñuel, "even had to journey to Rome to negotiate with the Pope, because there was talk of excommunication").

Public screenings began on November 28, 1930, at the Studio 28. The group took the opportunity to publish a collective declaration in the cinema program, signed by thirteen of its members and consisting of a collection of texts that showed the perfect convergence of their ideas and the film.[18] The aim of the declaration, if we are to believe the first paragraph, was to "measure carefully the wingspan of the bird of prey that totally unexpectedly has arrived today in a descending sky, in the descending western sky: *L'Âge d'or.*" This declaration was necessary to prevent any hypocritical admiration of a new "beauty" from once again defusing the film's subversiveness.

The six segments of the text, illustrated by, respectively, Ernst, Arp, Tanguy, Man Ray, Miró, and Dalí, along with photographs from the film, were titled "The Sexual Instinct and the Death Wish" (Breton), "It Is Mythology Which Is Changing" (Crevel), "The Gift of Violence," "Love and Disorientation" (Éluard), "Situation in Time" (Aragon), and "Social Aspect: Subversive Elements" (Thirion). They emphasized the explicit and implicit themes of the film, insisting in particular on the significance of passionate love and its antibourgeois, anti-Catholic and revolutionary impact. "We can judge a person's capacity for rebellion by the violence with which passionate love inhabits him, and we can, by setting aside the passing inhibitions to which his upbringing may have confined him, give him more than a symptomatic role, from the revolutionary point of view," said Breton. For Crevel, it was possible that "in the moral mythologies to come we may find . . . sculptural reproductions of various edifying allegories among which the most exemplary will be those of a blind couple devouring each other and of an adolescent with a nostalgic gaze 'spitting from sheer pleasure on his mother's portrait.'" And Éluard posited: "Man emerges from his shelter and, faced with the vain disposition of charms and disenchantments, grows drunk upon the strength of his delirium. The weakness of his arms is of little importance since his head is so utterly subjected to the rage with which it is shaking. . . . One of the high points in the purity of the film seems crystallized in the vision of the heroine in the toilet, where the power of the mind is able to sublimate a situation generally viewed as baroque into a poetical element of the purest nobility and solitude." Aragon, whose knowledge of the cinema amounted to a few Mack Sennett comedies, *Entr'acte, Ombres blanches,* Chaplin's films, and the "invincible call to revolution of the *Battleship Potemkin,*" esteemed that *Chien andalou* and *L'Âge d'or* "are above everything which exists." Once he had reiterated that "the struggle against religion is also the struggle against the world," Thirion concluded that, "in a period of 'prosperity,' the value which society can place upon *L'Âge d'or* must be established by satisfying the oppressed in their need for destruction."

The group's support for *L'Âge d'or* did not stop there: the film was presented along with an exhibition of works by Arp, Dalí, Ernst, Miró, Man Ray, and Tanguy, in the lobby of Studio 28. The screenings were therefore conceived as a collective event, representing the ideological and artistic choices of the movement. If *L'Âge d'or* took on so much importance, it was not just because it was the first film considered wholly satisfying from a surrealist point of view; fundamentally, it was because it was the first surrealist film, and up until then the cinema had been a domain in which only a few very disappointing attempts had been made. Paradoxically, this new endeavor had been made possible thanks to a member of the rich aristocracy, and Thirion was well aware of this: "My intolerance was so extreme at that point that the role played by rich, titled people in the production of this revolutionary work bothered me. It was a stain. And

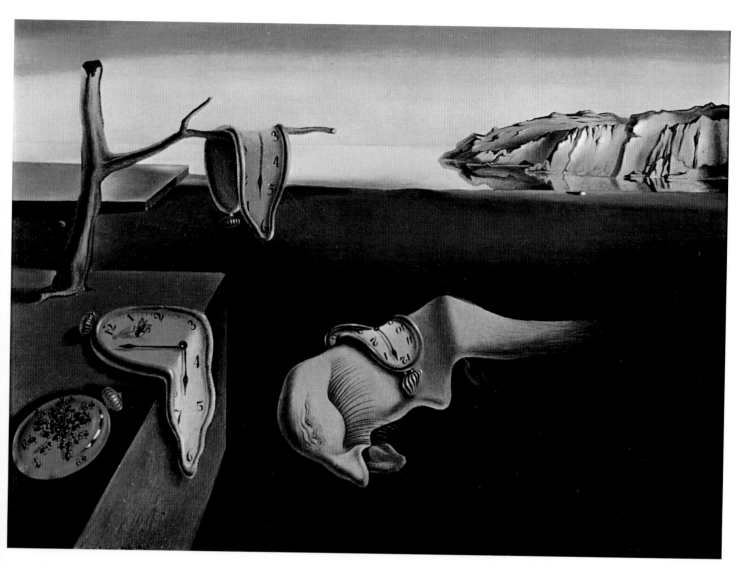

Salvador Dalí, *Persistence de la mémoire* (The persistence of memory; 1931); oil on canvas, 9³/₅ × 13¹/₅ in. (24 × 33 cm). Museum of Modern Art, New York.

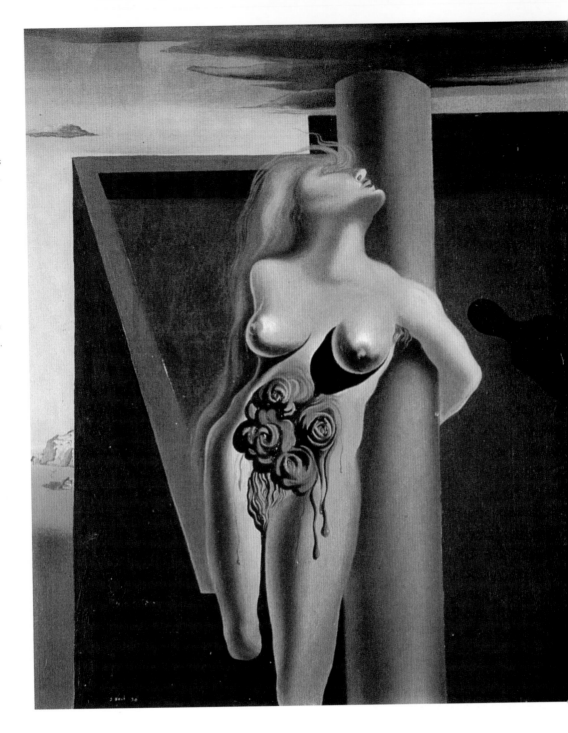

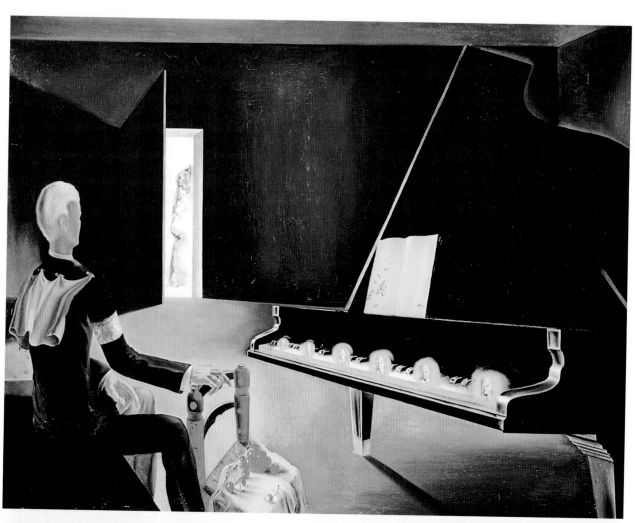

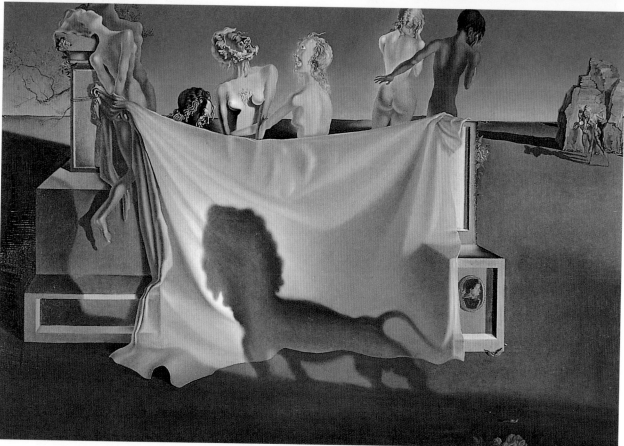

Left: Man Ray, *Self-Portrait* (1933); casting in bronze, glass, and wood, 14¹/₅ × 8¹/₃ × 5²/₅ in. (35.5 × 20.9 × 13.6 cm), National Museum of American Art, Smithsonian Institution, Washington, D.C.

Below left: Claude Cahun, *Objet* (1936); mixed media, 5³/₅ × 6⁴/₅ × 4 in. (14 × 17 × 9.8 cm), Zabriskie Gallery, New York.

Below right: Élisa Breton, *Il coud son ciel* (He is sewing his sky); 12³/₅ × 8⁴/₅ × 12²/₅ in. (31.5 × 22 × 31 cm).

Pablo Picasso, *Composition au papillon* (Composition with a butterfly; 1932); wood, fabric, plant matter, string, thumbtack, butterfly, and oil on canvas, 6²/₅ × 8⁴/₅ × 1 in. (16 × 22 × 2.5 cm). Musée Picasso, Paris.

Left: Pablo Picasso, *Femme assise*
(Seated woman; 1929); plaster, 32³/₅
× 8 × 12 in. (81.5 × 20 × 30 cm).
Private collection.

Right: Pablo Picasso, *Figure* (1935);
magnifying glass, hoes, wood, string,
and nails, 44⁴/₅ × 24³/₅ × 12 in. (112.1
× 61.5 × 29.8 cm).

Opposite page: Pablo Picasso, *Femme
au feuillage* (Woman with leaves;
1934); plaster, 15³/₅ × 8²/₅ × 10²/₅ (39
× 21 × 26 cm). Private collection.

André Breton, *Chapeaux de gaze
garnis de blonde* (Gauze hats trimmed
with blonde; 1934); collage, 7 x 8²/₅
in. (17.5 x 21 cm). Private collection.

yet, if I'd thought about it further, I would have had to concede that without the Noailles, there would have been no *Âge d'or*."[19]

On December 3, the members of the League of Patriots and the Anti-Jewish League ransacked the hall, slashed the paintings, and destroyed the books on display; they threw ink against the screen and set off smoke bombs in the cinema until the screening was interrupted. In the days that followed, right-wing newspapers took advantage of the incident (perhaps encouraged by police headquarters) to ask for the film to be withdrawn, and the League of Patriots protested against the "immorality of this Bolshevist spectacle," which, obviously, attacked family, religion, and *patrie*. Debates in the press, appeals to the City Council, the intervention of a "councilor from the Champs-Elysées" denouncing not only this film but also *Le Surréalisme ASDLR* and other films, particularly those of German origin, being projected "two steps from the Unknown Soldier,"—all led to the film's being banned on December 11. The group responded with a pamphlet, *L'Affaire de "L'Âge d'or,"* which related in detail the various stages of the affair, and concluded with a questionnaire.[20] Did the outlawing of this film mean that people who were hostile to religious propaganda were also authorized to interrupt the all too frequent events of such propaganda, and by any means at their disposal? The questionnaire also denounced in the provocation that had legitimized police intervention a "hint of the progression of fascism (a parallel case was that of Hitler's police banning *All Quiet on the Western Front*). Although it is difficult to know how many people sent their responses to Breton, one can nevertheless point out the reactions of Marcel Heine, who evoked the existence of a "headless fascism" and deemed that "the outlawing of *L'Âge d'or* is only one episode, albeit a serious and critical one, in the struggle now being waged [between surrealism and the bourgeois society]. The conspiracy of silence is over, boycotts and censorship have begun: you can expect worse." Other reactions were those of the psychoanalyst Jean Frois-Wittmann (close to the group since his participation in *La Révolution surréaliste,* no. 12)—who spoke ironically of "these very well-brought-up Ladies and Gentlemen, so idealistic, so right-thinking; their moral hygiene pushes them to ensure the periodical 'return of inhibitions,' regular as stools, and . . . they go to great pains, to this end, to maintain war, capital punishment, prostitution, commercial and banking thievery, the exploitation of slaves and the other priceless advantages of capitalist society"—and of Francis Ponge: "We are in a period of persecution. Loudspeakers are working, and it is clearly against the Soviet Union that the tanks and the perfume-launchers will roll, setting off behind the Cross."[21]

But at least the influence of *L'Âge d'or* was felt by both sides of the battle line: if the right was reacting with such violence, it was to fend off an attack that was not simply an artistic one; the film, thus, was effective, more than any manifesto, and the sacking of the Studio 28 confirmed the group in its hostility toward bourgeois ideology. The antireligious struggle remained, consequently, at the top of the agenda, alongside the relentless criticism of false bourgeois values, and the development of artistic offensives.

Dalí and the Paranoiac-Critical

It was Salvador Dalí who had the place of honor in *Le Surréalisme ASDLR,* which suffices to indicate the importance he had acquired within the group since his arrival in

Paris. In addition to his participation in the journal, and his collaboration with Buñuel, he would later contribute to *Minotaure,* publish four books with the Éditions Surréalistes (*La Femme visible* in 1930, *L'Amour et la mémoire* in 1931, *La Conquête de l'irrationnel* in 1935, and *Métamorphose de Narcisse* in 1937, not to mention a photographic album that seems to have remained in a draft form), *Babaouo* with the Éditions des Cahiers Libres (1932), the illustrations he provided for a number of works by his friends (Char, Breton, Éluard, Tzara) and for *Violette Nozières* (1933), and a special edition of the *Chants de Maldoror* (1934). These publications, naturally, were, in addition to his artwork (canvases, objects, and countless drawings), proof of a prolific activity, which Breton would qualify, even after they fell out, as "overwhelming." Dalí knew virtually nothing about the group's past, and this innocence gave him a license for unlimited audacity. And his creativity, soon to be combined with Magritte's enigmas and Giacometti's constructions, gave surrealism in the first half of the decade the means to resist the temptation of total immersion in political activity by injecting great bursts of humor, verbal and visual excess, eroticism, skillfully organized frenzy, and casual amorality.

"The Rotten Donkey" (published in the first issue of *Le Surréalisme ASDLR*) outlined the paranoiac-critical theory that Dalí would elucidate in subsequent texts. The article asserted his desire to contribute to the discrediting of reality by adding "a process which is paranoiac and active in nature" to the passive states of the mind (in which Dalí included automatism). The superiority of paranoia over other mental states resided in fact in its ability to take possession of the outside world and to interpret it according to an obsessive idea, "with the disturbing particularity of making the reality of this idea valid for others." The result of paranoiac activity would impose itself, therefore, without any possible debate, and immediately implied a significant modification of "reality" as one could perceive it or conceive it. The process was all the more interesting in that it passed extremely rapidly through one's thoughts and was very subtle in its effects. Dalí gave two examples. The first concerned what he called the double image, allowing two alternate readings of a same apparent motif. This double image could even become triple, or quadruple, and one began to wonder just how far such a proliferation could go: it would seem that the limit of the phenomenon depended solely on the "paranoiac function of each individual."

The second case was suggested by the "extraordinary decorative architecture of the Modern Style," whose buildings "in and of themselves constituted true realizations of solidified desire, where the most violent and cruel automatism painfully betrayed the hatred of reality and the need to find a refuge in an ideal world, as is the case in a childhood neurosis."[22]

"The Rotten Donkey" ended with a warning: the new surrealist images produced thanks to paranoia would cause "disappointment and repulsion" among critics, as they increasingly came to imply demoralization and confusion. Obviously, in this respect they were perfectly integrated with surrealism's ambitions and were thus "at the service of the imminent crisis of consciousness, at the service of the Revolution."

With his paranoiac-critical theories, Dalí seemed to be settling into the very place where the normal and pathological crossed paths, as did disordered lyricism and analytic coldness, and it was legitimate, from this point of view, for him to refer in a number of his texts to *L'Immaculée Conception:* the systematic development of subjective obsessions played simultaneously on borrowings from memories and the urgings of the unconscious, as well as the will to take whatever they might suggest in the way of a

2

3

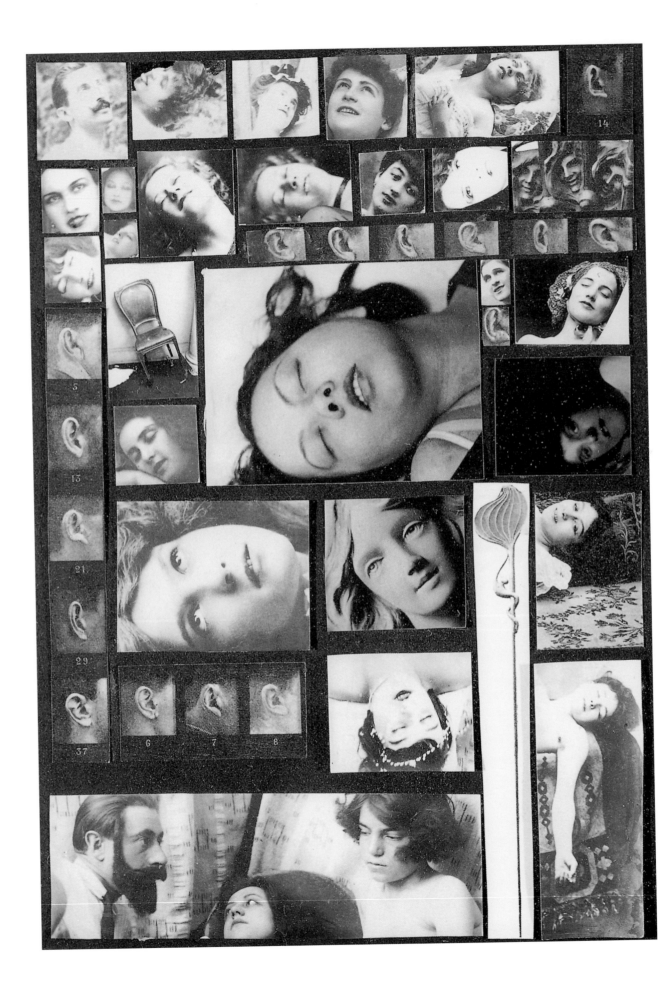

deformation and metamorphosis of the initial motif right to the end. Right to the end—that is, right to the fusion of the scatological and the exalted, of Eros and Thanatos, of infinitesimal detail and vast panoramas, of the appetizing and the slimy.[23] Permanent confession—erotic, in particular—went hand in hand with the transgression, if not the ignorance, of values, and every painting from this era, be it *Lion, cheval, dormeuse invisible* (1930) or the *Six apparitions de Lénine sur un piano* (1931), *La Tartane fantôme,* or *La Vieillesse de Guillaume Tell* (1931), offers an interpretation that moves from surprise to surprise, passing from one double meaning to another, so filled are they with juxtaposed symbols, incongruous details, alterations of relative proportion and more or less transparent autobiographical elements.[24]

When he discovered the famous "limp watches," for example (*Persistance de la mémoire* [The persistence of memory], 1931), Dalí specified that "they are nothing other than the paranoiac-critical camembert—tender, extravagant, and solitary—of time and space," which gave them no doubt a metaphysical dimension but did not account for either the serenity of the landscape that was the backdrop to the painting or the ambivalent pinkish form that was a prop for one of the watches. The most accomplished paintings brought to the surface elements that did not depend entirely on the method, as if the products of a certain automatism—or at least the results of urgings that were less lucid to the painter—came to mingle with the effects of the systematization of obsession.

The habitual proliferation of the ambiguities mastered was served, moreover, by an apparently flawless technique: the meticulousness with which Dalí enjoyed detailing each hair (reminding one that, for popular intuition, the hair already represented the "archetype of disorientation") was certainly not without humor but confirmed that each painting was a trap for the viewer caught in the net of its academic appearance. It was hardly surprising, from this point of view, that Dalí's work gradually became synonymous, for the public, with surrealism in painting: the alliance of the frenzied interpretation and the pictorial method—in the most traditional sense—would determine a fascination that made the greatest incongruities acceptable and transformed that which the painter himself might have sincerely wanted to be subversive into what was simply a bizarre version of "beauty." What Dalí deplored about the reception given *Un chien andalou* was precisely what would make his individual success,[25] but few were aware of the contradiction inherent in a labor that sought to disturb thought and reality by means of what was, in the end, traditional figurative painting, where objects and people, whatever alterations they might undergo in appearance, remained perfectly namable, qualifiable—the limp watches or a flaming giraffe, for example—even if the double or multiple images quite logically called for double or multiple names.

However, the objections to Dalí that surfaced increasingly within the group itself were more a result of the difference between automatism and Dalí's paranoiac-critical method. It is not enough to say, in Dalí's own words, that the first is "passive" and the second is "active"; one must add, as he did in reference to Lacan's thesis *De la psychose paranoïaque dans ses rapports avec la personnalité* (1932), that "paranoiac frenzy already constitutes in and of itself a form of interpretation"—which reintroduces in frenzied invention a predetermination of meaning that hinders subsequent interpretations.[26] That was precisely the reproach that Breton made in *Les Vases communicants* to the "animatable objects of erotic significance" that he had asked his friends to create in order "to follow up on Dalí's suggestion." Such objects, even if their explosive value left no

doubt, "allow[ed] interpretation a more narrow scope" than did objects less systematically determined. In fact, continued Breton, "the voluntary incorporation of predetermined latent content into manifest content serves in this case to weaken the tendency to dramatize and magnify that censorship, to the contrary, uses to supreme effect."[27]

Very quickly, serious ideological disagreements would compound these reservations about the real productivity of the method. In addition to the fact that he was extremely wary of attempts to show the group's solidarity with the Left—or even the Communist Left—and that this wariness would only increase after the "Aragon affair," Dalí multiplied his antihumanist declarations by calling on the spirit of the Marquis de Sade, seemed intent on treating Hitler's rise to power as a positive disturbance of all intellectual certainties, increasingly supported an academic pictorial stance à la Meissonier, and, in the opinion of certain members of the group, even went so far as to hold Lenin up to ridicule by depicting him in *L'Énigme de Guillaume Tell* (1933). Whatever the positive contributions of his artistic endeavors might be, his amoral attitude proved, in fact, to be incompatible with the rigor that was increasingly on the agenda, particularly where politics were concerned.

As a result, a general assembly was held at Breton's house on February 5, 1934 (at the suggestion of Brauner, Breton, Ernst, Jacques Hérold, Georges Hugnet, Meret Oppenheim, Péret, and Tanguy), to envision, quite simply, Dalí's exclusion. Dalí got off thanks to his clownish behavior (he showed up wearing six cardigans, which he removed one after the other during the session, and with a thermometer in his mouth on the pretext that he had a sore throat). He reiterated that his interest in Hitler was strictly apolitical, that someone as hysterical as he was would, moreover, be among the first victims of the German chancellor, and that he was ready to sign any text they wanted—but Éluard, Tzara, and Crevel declared that they were on his side.[28] After that evening, however, the relations between the artist and the group became increasingly strained, until they led to open conflict; meanwhile, Dalí entrusted his person and his career more and more to his muse, Gala.

Anticolonial Struggle

If there was one dimension of surrealist activity that clearly left Dalí indifferent, it was without doubt that of anticolonialism. And yet this activity led to the distribution of two pamphlets clearly delineating the radical position that the group intended to maintain.[29]

The *Colonial Exhibition,* held in Paris from May 6 to November 15, 1931, had all the trappings of a national event. It coincided with a moment when the exaltation of the benefits of colonization was particularly necessary—just as the first uprisings were occurring in Indochina and in North Africa—to reinforce the unity of a motherland threatened by the turmoil of class struggle. As the general *commissaire,* the Maréchal Lyautey, who at the age of seventy-five had earned a certain notoriety thanks to his action in Morocco (the war of the Rif had also had some positive consequences!) declared: "A visit to the Exhibition is a duty." The venue selected for the exhibition halls was no accident either: "The East of Paris, isn't that a region which is said to be won over to communism? It is in our interest to plant our colonial sprouts amidst working-class people."

The public expected not only information and proof of the grandeur of coloniza-

Ne visitez pas l'Exposition Coloniale

A la veille du 1ᵉʳ Mai 1931 et à l'avant-veille de l'inauguration de l'Exposition Coloniale, l'étudiant indo-chinois Tao est enlevé par la police française. Chiappe, pour l'atteindre, utilise le faux et la lettre anonyme. On apprend, au bout du temps nécessaire à parer à toute agitation, que cette arrestation, donnée pour préventive, n'est que le prélude d'un refoulement sur l'Indo-Chine.* Le crime de Tao ? Etre membre du Parti Communiste, lequel n'est aucunement un parti illégal en France, et s'être permis jadis de manifester devant l'Elysée contre l'exécution de quarante Annamites.

L'opinion mondiale s'est émue en vain du sort des deux condamnés à mort Sacco et Vanzetti. Tao, livré à l'arbitraire de la justice militaire et de la justice des mandarins, nous n'avons plus aucune garantie pour sa vie. Ce joli lever de rideau était bien celui qu'il fallait, en 1931, à l'Exposition de Vincennes.

L'idée du brigandage colonial (le mot était brillant et à peine assez fort), cette idée, qui date du XIXᵉ siècle, est de celles qui n'ont pas fait leur chemin. On s'est servi de l'argent qu'on avait en trop pour envoyer en Afrique, en Asie, des navires, des pelles, des pioches, grâce auxquels il y a enfin, là-bas, de quoi travailler pour un salaire et cet argent, on le représente volontiers comme un don fait aux indigènes. Il est donc naturel, prétend-t-on, que le travail de ces millions de nouveaux esclaves nous ait **donné** les monceaux d'or qui sont en réserve dans les caves de la Banque de France. Mais q̶ [...] préside à cet échange monstrueux, que des hommes dont le [...] d'en apprendre à travers des témoignages rarement désint [...] permis de tenir pour moins pervertis que nous et c'est pe [...] comme nous ne le sommes plus sur les fins véritables de l[...] l'amour et du bonheur humains, que ces hommes dont n[...] notre qualité de **blancs**, nous qui disons hommes de coulel[...] aient été tenus, par la seule puissance de la métallurgie eu[...] crever la peau pour un très bas monument funéraire collec[...]

* Nous avons cru devoir refuser, pour ce manifeste, les signatures de nos camarade[...]

I

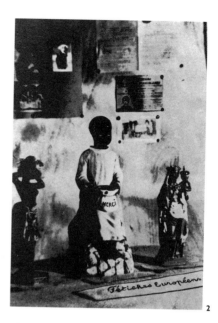

2

Premier bilan de l'Exposition Coloniale

> « C'est nous, les poètes, qui clouons les coupables à l'éternel pilori. Ceux que nous condamnons, les générations les méprisent et les huent. »
>
> EMILE ZOLA.

Dans la nuit du 27 au 28 juin 1931, le pavillon des Indes Néerlandaises a été entièrement détruit par un incendie. "Et d'un !" sera tenté d'abord de s'écrier tout spectateur conscient du véritable sens de la démonstration impérialiste de Vincennes. On s'étonnera peut-être que ne passant pas pour avoir le souci de la conservation des objets d'art, nous ne nous en tenions pas à ce premier réflexe. C'est, qu'en effet, de même que les adversaires des nationalismes doivent défendre le nationalisme des peuples opprimés, les adversaires de l'art qui est le fruit de l'économie capitaliste, doivent lui opposer dialectiquement l'art des peuples opprimés. Le pavillon que les journalistes ne rougissent pas d'appeler le pavillon "de Hollande" contenait indiscutablement les témoignages les plus précieux de la vie intellectuelle de la Malaisie et de la Mélanésie. Il s'agissait, comme on sait, des plus rares et des plus anciens spécimens artistiques connus de ces régions, d'objets arrachés par la violence à ceux qui les avaient conçus et desquels un gouvernement d'Europe, si paradoxalement que cela puisse paraître, n'avait pas craint de se servir comme objet de réclame pour ses méthodes propres de colonisation [1]. Ce n'était sans doute pas assez de la piraterie et de ce scandaleux détournement de sens par lequel elle semblait se parachever, car ces objets pouvaient encore servir à l'anthropologiste, au sociologue, à l'artiste. Ce n'est que par une vue tout à fait superficielle de la question que l'on peut considérer l'incendie du 28 juin comme un simple accident. Ce qui vient d'être détruit, malgré l'emploi que le capitalisme en faisait, était destiné à se retourner contre lui, grâce à la valeur d'étude qu'il constituait. Seule, la science matérialiste pouvait bénéficier de cette valeur d'étude, comme Marx et Engels reprenant les observations de Morgan sur les Iroquois et les Hawaïens l'ont mis parfaitement en lumière dans leurs recherches sur l'origine de la famille. Les découvertes modernes dans l'art comme dans la sociologie seraient incompréhensibles si l'on ne tenait pas compte du facteur déterminant qu'a été la révélation récente de l'art des peuples dits primitifs. De plus, le matérialisme, dans sa lutte contre la religion, ne peut utiliser qu'efficacement la comparaison qui s'impose entre les idoles du monde entier. C'est ce que comprennent très bien les missionnaires dont le pavillon n'a pas été brûlé lorsqu'ils mutilent habituellement les fétiches et qu'ils entraînent les indigènes dans leurs écoles à reproduire les traits de leur Christ selon les recettes de l'art européen le plus bas [2] (cette comparaison s'établit au mieux dans les musées anti-religieux de Russie). Toutes raisons excellentes pour que nous considérions comme une sorte d'**acte manqué** de la part du capitalisme la destruction des trésors de Java, Bali, Bornéo, Sumatra, Nouvelle-Guinée, etc. qu'il avait élégamment groupés sous un toit de chaume imitation. Ainsi se complète l'**œuvre colonisatrice** com-

(1) "Je tiens à adresser à votre Excellence l'expression de ma vive et douloureuse sympathie à l'occasion de l'incendie du pavillon principal des Indes Néerlandaises que nous avions inauguré ensemble et qui était un magnifique témoignage de l'œuvre colonisatrice de votre pays". (Télégramme de M. Paul Raynaud au ministre des Colonies des Pays-Bas.)

(2) Voir l'Année Missionnaire 1931.

1 "Do Not Visit the Colonial Exhibition"; manifesto signed by, among others, André Breton, Paul Éluard, and Benjamin Péret (May 1931).

2 "European Fetishes"; photograph published in *Le Surréalisme ASDLR*, number 4 (December 1931).

3 "First Evaluation of the Colonial Exhibition"; manifesto signed by, among others, Yves Tanguy, Georges Sadoul, Louis Aragon, and André Breton (July 3, 1931).

3

tion from the exhibition (as exalted, e.g., in March and April by the exhibition *Four Centuries of French Colonization* organized at the National Library) but also performances, exoticism, and something to dream about. The "splendor" of the exhibition halls, the participation of foreign countries (although England, the greatest colonial power of the era, did not participate), the care with which the parks and walkways and fountains were arranged—all inspired in advance the enthusiasm of the press, with the exception of *L'Humanité,* the *Canard enchaîné,* and Léon Blum, who expressed his reservations in *Le Populaire.*[30] The exhibition would draw 8 million visitors, among them a million foreigners.

Two days before the opening of the *Colonial Exhibition,* a pamphlet, which took an opposite stance from an indisputably "popular" expectation, was distributed, entitled *Ne visitez pas l'Exposition coloniale* (Don't visit the *Colonial Exhibition*), with an unusually high print run of five thousand copies.[31] Thirion handed it out at the gate of a number of factories, while other members of the group covered the street.

The text began by relating the recent arrest of Tao, a student from Indochina who had made the mistake of joining the Communist Party and who had "earlier demonstrated outside the Élysée against the execution of forty Annamites," and then delivered a violent protest against the economic and military exploitation of the colonized peoples. It attacked the "swindler-concept" of a "Great France," where the world of finance, church and army had gathered, one that aimed to "give the citizens of Metropolitan France the conscience of landlords which they will need in order to hear without flinching the echo of distant shootings." The surrealists reiterated, moreover, that Lenin "had recognized the colonial peoples as allies of the world proletariat" and urged their readers to demand "the immediate evacuation of the colonies."

Although the pamphlet also took a shot in passing at the "scandalous Socialist Party," one should remember that Léon Blum, in an article published by *Le Populaire* on May 7, also evoked the most recent events in Indochina: "Here we are rebuilding the wonderful staircase of Angkor," he wrote, "and we invite the sacred dancers to circle and turn before us, but in Indochina, people are being shot, deported, and imprisoned." *L'Humanité* expressed concern over the Tao case, which it compared to "a potential Sacco and Vanzetti affair," and launched a campaign that led to a rally of support on May 20. The surrealists were therefore not totally isolated in their denunciations: they were merely the ones who dared to take it as far as it could go. André Gide had not yet been that far, when in *Voyage au Congo* (1927) and *Retour du Tchad* (1928) he described the totally inhuman conditions of forced labor—which in principle did not exist—thanks to which the railroads in black Africa were being built.

During the night of June 27, the pavilion of the Dutch East Indies was entirely destroyed by fire. On July 3, twelve members of the group signed a new pamphlet: *Premier bilan de l'Exposition coloniale* (A first evaluation of the *Colonial Exhibition*), which deplored the loss of the "most precious testimonies of intellectual life in Malaysia and Melanesia, among the rarest and most ancient artistic specimens known from these regions, objects that had been taken violently from those who had created them."[32] It was while considering the "educational value" of the burned objects that the group recalled, on the one hand, the use that Marx and Engels had made of the ethnological information they had at their disposal and, on the other hand, the role played in the history of modern art by the revelation of primitive works. As on top of it all, "materialism, in its struggle against religion, can make a very effective use of the inevitable

comparison of idols from the world over," the fire took on the significance of a verita-ble "acte manqué" carried out on behalf of the Christian missions: "This is how the *work of colonization* is carried out—a work which began with massacres, and has contin-ued through conversions, forced labor and disease."

The battle was thus waged on three complementary fronts: anticolonialism, antireli-gion, anticapitalism.[33] This was confirmed on September 20 by the opening of a colo-nial counterexhibition, *La Vérité sur les colonies* (The truth about the colonies), set up in the constructivist pavilion built by the Vesnine brothers for the Soviet Union during the exhibition of decorative arts in 1925 and prepared by Thirion with the help of the Confédération Générale au Travail Unitaire syndicate as well as Aragon and Sadoul. On the ground floor the hidden side of the décor of Vincennes was revealed: a quotation by Lenin ("Imperialism is the final stage of capitalism") set the tone of the documenta-tion prepared about the organizers of the *Colonial Exhibition,* on the crimes of colonial conquest and the reality of forced labor. A section of the second floor was set aside for the demonstration of the "positive" nature of the Soviet Union's policy toward nation-alities that had once been colonized by tsarism. Another hall, designed by Tanguy, pre-sented a collection of works from Africa, Oceania, and America that were offset in a somewhat Manichean fashion by the fetishes of the West: Christian objects, objects of worship in the vein of Saint-Sulpice, and so on.[34]

In June 1932, a small group of students from Martinique had published the sole issue of a periodical called *Légitime défense* (this title, clearly, was not innocent and refers to Breton's volume of the same name), in which they embraced dialectical materialism. The virulence of these anticolonial demonstrations showed that these students had adopted surrealism without reservation and tied their fate to it. The tone, too, was cer-tainly virulent, even if at a distance it seemed somewhat stereotyped: "Among the loathsome bourgeois conventions, we abominate in particular humanitarian hypocrisy, a stinking emanation of Christian rot. We hate pity. We don't give a damn about feel-ings either." At least these were new voices to be heard, even if initially they addressed a black bourgeoisie, exhorting them to dismantle their own alienation; some of this black bourgeoisie (Jules Monnerot, Pierre Yoyotte) went on very quickly to join the group.

Surrealist Objects

Breton, in his *Introduction au discours sur le peu de réalité* (Introduction to a speech on the lack of reality), described the "somewhat curious" book he had dreamt about and regretted he had not found it on his night table on wakening, with its binding "con-sisting of a wooden gnome whose white beard, cut Assyrian style, went down to his feet" and the pages of which were of "thick black wool."[35] "I would like," he added, "to have a few objects like this placed in circulation, because their fate seems extremely problematic and troubling to me." Such an undertaking could help to discredit all things and beings "of reason." Despite Duchamp's readymades (but they corresponded to decidedly different intentions) and a few isolated projects (Man Ray's *L'Énigme d'Isidore Ducasse* in 1920 or his *Cadeau* the following year, then the "snowballs" of the Galerie Surréaliste, and the exhibitions of objects from the Islands and America), it was only during the 1930s that the debate about objects—something which could be expanded on—would gain importance within the group.

The starting point was Giacometti's *Boule suspendue* (Suspended ball), exhibited in the spring of 1930 at Pierre Loeb's, where Dalí and Breton first caught sight of it. Dalí would later describe it in these terms: "A wooden ball marked with a feminine hollow hung by a fine violin string above a crescent, with a narrow backbone scarcely touching the cavity. The viewer felt instinctively impelled to slide the ball along the backbone, but the length of the string only allowed one to do this partially," emphasizing its potential utilization as well as its erotic implication, but Dalí said nothing about the way it was presented: inside a cage, which placed it within space in the manner of a sculpture.[36]

The "objects with symbolic functions" made by some group members were clearly intended to mark a distance from sculpture as it was defined at the time; they were created by a montage of heterogeneous elements. There was something homemade about their appearance that immediately indicated that they had been conceived out of a necessity that had nothing to do with aesthetics and everything to do with fantasy. Or, in Dalí's words, "They leave no opportunity for formal concerns. They depend on nothing but the lovesick imagination of each individual; they are extra-plastic." The series reproduced in *Le Surréalisme ASDLR,* number 3 (Giacometti, Valentine Hugo, Breton, Gala, Dalí, along with an assemblage by Miró presented as a "sculpture"), confirmed fairly clearly that artistic preoccupations had been neglected; the satisfaction to be derived from these objects was in no way aesthetic and was concerned solely with fantasy and the unconscious—that of the artist, to begin with, and then possibly of the viewer. Whoever that viewer might be, the object would elicit a positive or negative reaction, since it could arouse urgings or memories that then conferred on the object an aspect of either fascination or repulsion. Obviously, it was also possible for the repulsion and fascination to be simultaneous, revealing thus to the viewer an unconfessed or even unconfessable ambivalence.

In the same issue of the *Le Surréalisme ASDLR,* the theme of the object was not limited to this series alone. There was a double page devoted to Giacometti, "Mobile and Mute Objects," on which eight possible objects were drawn (and framed), including the *Boule suspendue,* later entitled *L'Heure des traces,* and also *L'Objet désagréable,* a sort of tusk, narrower at one end and spiked with a few sharp points, as well as a *Cage,* the *Projet pour une place,* and *Trois figures mobiles sur un plan.* Although these drawings corresponded to sculptures that were created in plaster at the time, rather than to objects in Dalí's sense of the word, it is worth noting the way in which the sculptor found inspiration for these creations: "For years I have been creating sculptures that came fully formed to my mind, and I limited myself to reproducing them in space without any changes, without asking myself what they might mean (it was enough for me to begin to change one part, or to have to look for a dimension, to become completely lost and for the whole object to disintegrate)."[37] Giacometti also wrote, at this time: "Never for form, or plasticity, or aesthetics, but the contrary. Absolutely against."[38] It was clearly this scorn for aesthetics, together with the ability to welcome whatever came to him, that determined the origin of his *Table* in 1933, along with the discovery of an enigmatic mask in the flea market that led to the fortuitous completion of *L'Objet invisible* (1934), the last work of his surrealist period. Breton commented on it in "Équation de l'objet trouvé," emphasizing how much chance discovery, rationally impossible to program, could intervene to catalyze the process of invention, fulfilling "the same role as dreams, insofar as it liberates the individual from paralyzing emo-

Toutes choses... près, loin, toutes celles qui sont passées et les autres, par devant,

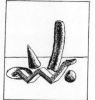

qui bougent et mes amies — elles changent (on passe tout près, elles sont loin) d'autres
approchent, montent, descendent, des canards sur l'eau, là et là, dans l'espace, montent,

descendent — je dors ici, les fleurs de la tapisserie, l'eau du robinet mal fermé, les dessins
du rideau, mon pantalon sur une chaise, on parle dans une chambre plus loin ; deux ou

trois personnes, de quelle gare? Les locomotives qui sifflent, il n'y a pas de gare par ici,

on jetait des pelures d'orange du haut de la terrasse, dans la rue très étroite et profonde — la
nuit, les mulets braillaient désespérément, vers le matin, on les abattait — demain je sors —

elle approche sa tête de mon oreille — sa jambe, la grande — ils parlent, ils bougent, là et
là, mais tout est passé.

ALBERTO GIACOMETTI.

1 Alberto Giacometti in 1930. Photograph by Jacques-André Boiffard.

2 Alberto Giacometti, *Main prise* (Trapped hand; 1932); wood and metal. Fondation Alberto Giacometti, Zurich.

3 Alberto Giacometti, *Table surréaliste* (1933); bronze, 57 1/5 in. tall (143 cm). Musée National d'Art Moderne, Paris.

4 Alberto Giacometti, *Objets mobiles et muets* (Mobile and mute objects); drawings published in *Le Surréalisme ASDLR*, number 3 (December 1931).

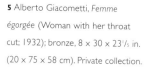
5 Alberto Giacometti, *Femme égorgée* (Woman with her throat cut; 1932); bronze, 8 × 30 × 23 1/5 in. (20 × 75 × 58 cm). Private collection.

1 Maurice Henry, *Hommage à Paganini* (1936); 9⁴/₅ × 20⁴/₅ × 4 in. (24.6 × 52 × 10.2 cm) Private collection.

2 View of the *Surrealist Exhibition,* Galerie Pierre Colle, Paris, June 7–18, 1933. *On the right:* Giacometti's *Table surréaliste; on the left:* his *Mannequin* (1933).

3 View of the *Surrealist Exhibition of Objects,* Galerie Charles Ratton, 14 rue de Marignan in Paris, May 22–31, 1936. In the display window to the left are Eskimo and Oceanian masks and Kachina dolls. To the right is *Arrivée de la Belle Époque* (Advent of the belle epoque) by Oscar Dominguez. Photograph by Man Ray.

4 View of the *Surrealist Exhibition of Objects.* Among the works exhibited (from left to right): Pablo Picasso, *Guitare,* Man Ray, *Boardwalk* (1917), Wolfgang Paalen, *L'Heure exacte* (The exact time), Alberto Giacometti, *Boule suspendue* (Hanging ball), Pablo Picasso, *Nature morte.* Photograph by Man Ray.

5

6

8

7

5 Salvador Dalí, *Objet scatalogique à fonctionnement symbolique* (Scatological object with a symbolic function; 1931–74). Private collection.

6 André Breton, *Objet à fonctionnement symbolique* (Object with a symbolic function; 1931); various objects on a wooden board, $9^4/_5$ x $16^3/_5$ x $12^4/_5$ in. (24.5 x 41.5 x 32 cm). Private collection.

7 Salvador Dalí, *Objet surréaliste;* exhibited at the Galerie Charles Ratton in 1936.

8 Pablo Picasso, *Figure* (1931). Musée Picasso, Paris. Work exhibited at the Galerie Charles Ratton in 1936.

tional scruples, reassuring him and enabling him to understand that the obstacle that he might have believed was insurmountable has in fact been overcome."[39]

Tanguy, in the same issue of *Le Surréalisme ASDLR,* also had a few objects, drawn and commented on, under the title "Weight and Colors": in pink plush and transparent mother-of-pearl celluloid, in plaster "painted the color zinzoline," in pale green molded cotton, and so on. The smallest, "full of mercury, is covered over with bright red woven straw in order to seem very light," reactivating the contradiction created by Duchamp in *Why Not Sneeze?* The last one, in sky blue chalk topped with a few hairs, "is to be used for writing on a blackboard. It will wear out from the base, so eventually all that will be left will be the clump of hairs at the top."[40]

Then in number 6 of the periodical, Max Ernst's *Objet surréaliste* was reproduced (a little box in which vaguely rounded forms were set into straw, so that one felt tempted to pick them up, but they were adorned with whitish claws of a different material); there were reports of experimental research "on the irrational knowledge of the object": participants were asked a series of questions about an object that would be "preferably simple, not too elaborate," and they were to answer rapidly. "The point," wrote Arthur Harfaux and Maurice Henry in their commentary, "was to get to know objects in their life, in their movement, and to gauge their possibilities. By placing them in every possible situation, through a collective experiment, you can get concrete and complete definitions, which will only be valid, of course, at a given moment, in a given place, and in given circumstances." Thus, the object was no longer altered materially, but the accumulation of responses provided variations whose convergence, always relative, allowed a collective definition. But the moment the definition seemed to be in danger of becoming rigid, one would clarify that it was indeed relative to a given place and a precise time. Such fruitful indecision was as much proof of the object's resistance as of the ruses deployed by subjectivity to get the better of it, for there could be no question of maintaining the banal opposition between the objective world and the subjective world. This was, precisely, one of those oppositions that the *Second Manifesto* had declared to be surmountable, and references to Hegel in *Le Surréalisme ASDLR* were too frequent for the dialectic to be forgotten in its ambition to surmount the dualism of exterior and interior, of real and imaginary, of the principle of reality and the principle of pleasure.

Therefore, whether the point was to question an existing object or to create a new one, it was in either case a relation between objective and subjective that was at stake: if, to simplify, one can accept that in the first case the objective world risks being made subjective, one will note that in the second case it is an objectification of the subjective that takes place. The object created therefore constitutes the intrusion into daily life of a desire that molds and transforms matter according to its requirements, meticulously creating the synthesis of extreme intimacy and the outside world. This suffices, on the one hand, to suggest the way in which the world of objects remains inadequate and, on the other hand, to upset rational order by the "local" or metonymic intrusion of that which will contradict it. In *Minotaure,* number 1, Crevel summed up the effectiveness of objects with a symbolic function: "After petrifying mirrors and deforming mirrors, these are metamorphosing mirrors. The various elements, assembled for the vital relations which compose them without any artistic concern and by means of liberated lines restored to movement, mark in space the echo of that desire which alone knows how to render its irradiated, irradiating density to time."[41]

1

2

3

4

5

1 Claude Cahun, *Object* (1936); 9¹/₅ × 6⁴/₅ in. (23 × 17 cm). Private collection.

2 Max Ernst, *Objets trouvés* (Found objects); exhibited at the Galerie Charles Ratton in 1936, since destroyed.

3 Salvador Dalí, *Téléphone blanc aphrodisiaque* (Aphrodisiac white telephone; 1936); modified telephone, 7¹/₅ × 5 × 12¹/₅ in. (18 × 12.5 × 30.5 cm). Mayor Gallery, London.

4 Yves Tanguy, *De l'autre côté du pont* (On the other side of the bridge; 1936); painted wood and fabric stuffed with sand, 4⁴/₅ × 8²/₅ × 18⁴/₅ (12 × 21 × 47 cm). Private collection. Object exhibited at the Galerie Charles Ratton in 1936.

5 Marcel Jean, *Le Spectre du gardénia* (The specter of the gardenia; 1936–68); plaster, zippers, wool flakes, photographic film, 10²/₃ in. (26.6 cm). Private collection. Object exhibited at the Galerie Charles Ratton in 1936.

But these objects, with their symbolic function, were far from being the only ones given a place of privilege by the surrealists: even if it was without the explicit intention of avoiding a predetermination of meaning, thus narrowing the possibilities for interpretation at a later date, there were numerous manipulators, or creators of objects, who were "content with" transforming or enriching a given object with a few unexpected additions.[42] The disturbing nature of these objects was all the more effective in that it gave everyone the freedom to interpret them according to their own desires. Humor, too, could add to this troubling nature, thus contradicting the ordinary definition of the object in question. Examples of this are the violin that Maurice Henry carefully wrapped in surgical bandages for his *Hommage à Paganini* (1936) or, less amusing, more threatening, the open umbrella that Paalen covered with sponges in 1938 as if, in opposition to its usual use and to obey its new title of *Nuage articulé* (Articulated cloud), it were meant to become a water container. More perverse, but most innocently so, the *Déjeuner en fourrure* (Fur breakfast) by Meret Oppenheim (1936) left the viewer somewhat perplexed as to what could be done with it, whereas it was obviously satisfying to use Kurt Seligmann's *Ultra-meuble* (1938) as a seat. With *De l'autre côté du pont* (1936) by Tanguy or with *Jamais* or the padded *Brouette* (wheelbarrow) by Dominguez, all sorts of erotic possibilities resurfaced—in an atmosphere of mystery in Tanguy's case and with humor for Dominguez.

In 1933, objects were presented alongside paintings, drawings, manuscripts, sculptures, exquisite corpses, and collages in a "surrealist exhibition" at the Galerie Pierre Colle. This event was the first collective exhibition since 1928, associating poets with painters, moreover. The invitation letter stated: "We have outgrown the period of individual exercises." There were a number of new arrivals in the group: Giacometti with his *Table* and a *Mannequin,* as well as Marcel Jean, Georges Hugnet, and even two former members of the Grand Jeu, Maurice Henry and Arthur Harfaux; Léon Tutundjian reappeared for the first time since 1926. Then, in May 1936, Breton organized the very important *Exhibition of Surrealist Objects* at the Galerie Charles Ratton, where two hundred items represented carefully differentiated categories. In addition to the surrealist objects, readymades, and objects by Picasso, there were also "natural" objects (of the three kingdoms—i.e., animal, mineral, vegetable), "interpreted" or "incorporated natural" objects (e.g., in one of Ernst's sculptures), "perturbed" objects (bottles deformed by the eruption of the Pelée mountain), "found" objects ("Any wreck within our reach must be considered a precipitate of our desire"), "found interpreted" objects (which thus revealed a hidden significance), "wild" objects (masks and statues, from America and Oceania, for the most part), "mathematical" objects, and so on. "This strange exhibition," said Breton, "showed not the last but the first stage of the poetic energy which could be found almost everywhere in a latent state but which, once again, had to be uncovered." Other objects displayed, besides those already mentioned by Giacometti, Tanguy, Oppenheim, or Henry, were: Duchamp's *La Bagarre d'Austerlitz* (1921), Arp's *Trousse de naufragé,* the *Veston aphrodisiaque* (decorated with four dozen glasses filled with peppermint), and a display window by Dalí containing a few "found" objects with an erotic connotation (a cone and its case, a paperweight ball, a terra cotta bird, a couple in painted plaster, a matchbook from the Subway Café, a pair of gloves in silver-plated wood, a box presenting three naked dancers around a roulette wheel, a plaster foot with the inscription of the date it was found [July 1910], and a plaster footprint), *Le Spectre du gardénia* by Marcel Jean (a female head sheathed in

black cloth whose eyelids were replaced by zippers), *Objets-livres* designed by Hugnet, *Ce qui nous manque à tous* by Man Ray (an earthenware pipe whose bowl was covered by a glass ball), and a *Mobile* by Alexander Calder, as well as contributions by Mesens, Nougé, Roland Penrose, Stanley William Hayter, Claude Cahun, and others. Léo Malet contributed extremely suggestive *Objets-reflets,* which he obtained by doubling the photograph of a face or hands with the help of a vertical mirror: "Recent avatar of the fortune teller's crystal ball, the mirror, placed on a perpendicular to the illustrated page of any publication, . . . will reveal, in the disturbing nakedness of their unconscious, mouths and genitals opening and closing, mumbling, crying or shouting equivocal proposals, poignant cries in the daylight."

The exhibition was cause for a special issue of the *Cahiers d'art,* with articles by Marcel Jean, Éluard, Hugnet, Dalí ("Honor to the object!": "I declare that the real and phenomenological swastika [not that of Hitler's men, who are unaware of it], the swastika as old as the Chinese sun claims as its own the honor of the object. . . . The surrealist object is impractical, it serves no purpose other than to deceive, to extenuate and to cretinize mankind . . . it exists only to honor thought"). Claude Cahun ("Beware of Household Objects") went from a reflection on the individual body as the first found and transformed object to advising one to "manufacture one's own irrational objects."[43] Breton's article, "Crisis of the Object," adopted a completely Hegelian perspective to show that the scientific object and the artistic object had, since the nineteenth century, undergone a comparable evolution, characterized by what he called an unprecedented "will to objectify."[44] Reverting to his 1925 proposal, Breton emphasized that the elaboration of dream objects was, above all, a means to depreciate objects that were reputed to be real and to unleash the forces of invention. But it was already a question of transferring the activity of dreams into reality, and Dalí's contributions were taking the same path toward objectification. The comparison between science and art suggested that, "just as contemporary physics tends to be based on a non-Euclidian foundation, the creation of 'surrealist objects' corresponds to a need to establish—according to Paul Éluard's decisive expression—a veritable physics of poetry."[45] The surrealist object did indeed act as a lever to "fortify the means of defense" that could combat the world of ordinary things and their use. In the opinion of artists and poets (but also of scholars—Breton quoted Gaston Bachelard), utilization in fact only corresponded to a still-incomplete aspect of the object: its manifest life, which was an authentic "milestone"—whence the necessity of restoring the object to the uninterrupted succession of its latencies, which demanded its transformation.

The story of objects did not end there. After the *International Exhibition* in 1938, where objects played a major role, they were to be seen ever more frequently, with the discovery of Joseph Cornell's boxes or Frederick Kiesler's architectural projects. Outside of the surrealist movement itself, the problematic of the object would have an impact on the entire history of modern sculpture and its successive periods, whether it was in the work of David Smith, American junk art, French new realism, pop art, Italian *arte povera,* or English sculpture in the 1980s. The fact that these currents, which in any case represent only strictly artistic attitudes, have evolved from activities that took place in the 1930s does not mean one should see in them the development of concerns on a same level with those of Dalí, Breton, or Dominguez, and during the 1960s certain members of the group would emphasize the distance that separated the critical point of view peculiar to surrealism from the all-out proliferation of what were simply

artistic projects and that, in some cases, went as far as a pure and simple approval of the state of the world—be it industrial or natural, it hardly mattered.

The Aragon Affair

In 1930, Aragon and Sadoul took a trip to Moscow, for private reasons, initially: Elsa Triolet wanted to see her sister again, and Sadoul feared that his trial over the postcard he had sent to the major at Saint-Cyr would end in imprisonment. During their stay they were invited to take part in discussions at the second International Conference of Revolutionary Writers held in November in Kharkov. As both had joined the Communist Party in 1927, they were still active members, but in keeping with the group's principles they were bound to defend the message of the *Second Manifesto* and the first two issues of *Le Surréalisme ASDLR:* this meant an agreement in principle with the Leninist version of historical materialism, the pursuit of autonomous surrealist activities, and the systematic denunciation of "Leftist" intellectuals who seemed too timorous, particularly Barbusse and his confused activity at the periodical *Monde.*

First invited to Kharkov as simple observers, then as delegates from France to the plenary session of the International Bureau of Revolutionary Literature, Aragon and Sadoul next seemed relegated to a purely advisory role; but they persisted in indicting Barbusse, with a degree of success it seems, since a resolution was passed that severely condemned the content of *Monde.* That did not, however, prevent Barbusse, who was not even present in Kharkov, from being elected to the Presidium of the Congress![46] As a number of the debates centered on the future of proletarian literature, Aragon declared during the meeting that the "only basis which one can and must propose to an organization of proletarian literature is the systematic development of the work of the *rabkors* [*rabotnye korrespondenti*]," that is, the more or less authentic letters that "readers" and "worker correspondents" sent to the press in order to inform them of the needs of the "base"—an affirmation that in appearance coincided with the party line at the time but that earned it an accusation of opportunism and right-wing beliefs.

In France, it would seem that the Communist Party was hardly pleased with the presence of two surrealist intellectuals at Kharkov, and all the less so as the Surrealist Movement was viewed as being representative of the extreme Left—this despite the fact that it had been defined elsewhere as a "reaction of the young generation of intellectuals from the petty bourgeois elite, provoked by the contradictions of capitalism in its third phase of development" and the "errors" of the *Second Manifesto* had been condemned. At any rate, before their return, Aragon and Sadoul were compelled to recognize their own mistakes.[47] (They had developed their activities outside the control of the party, had not been seriously militant within the party, and had allowed journalists to criticize the party in surrealist periodicals.) What was worse, they had vowed to renounce all idealism (Freudianism, in particular) and to combat Trotskyism, while withdrawing their support for the *Second Manifesto.* That added up to a considerable amount, and the group's reception on their return was chilly to say the least.

For the time being, however, there was as much of a reconciliation as could be expected, thanks in large part to the declaration "To Revolutionary Intellectuals," coauthored by Aragon and Sadoul, which stated that surrealists were definitely in the best position to bring about the union of revolutionary intellectuals.[48] In addition, psychoanalysis, which had helped them despite any deviations to leave behind any indi-

vidualistic positions, still remained "a weapon in the hands of revolutionaries." Another favorable factor was the article Aragon had published in *Le Surréalisme ASDLR,* "Surrealism and the Revolutionary Future," in which he aimed to prove the existence of a true objective agreement between surrealism and the Communist Party, founded equally on a shared philosophy (dialectical materialism), on similar aims (revolutionary action), and on a community of circumstances (bourgeois society exerted its repression equally on surrealists—who encountered difficulties in getting their work published—and purely political figures).

In July 1931, in *Littérature de la Révolution mondiale,* the periodical of the International Union of Revolutionary Writers, Aragon published a long poem of four hundred lines, "Front rouge" (Red front); the least one can say is that it was not of a rare quality, but it would create a scandal by virtue of the aggressiveness of certain lines.[49]

> Kill the cops
> Comrades
> Kill the cops
> Further, further to the West, where rich children
> and the first class whores are sleeping
> Past the Madeleine, Proletariat,
> let your furor sweep away the Élysée
> You have a weekday right to the Bois de Boulogne ...
> Fire on Léon Blum ...
> Fire on the scholarly bears of Social Democracy
> Fire Fire I can hear death
> assaulting Garcherry.[50] Fire I say.

In November 1931, the current issue of *Littérature de la Révolution mondiale* was banned and seized by the police; on January 16, 1932, Aragon was indicted for inciting soldiers to disobedience and provocation to murder: he risked a five-year prison sentence. The group immediately responded with a pamphlet called *L'Affaire Aragon,* along with a detachable flier for gathering signatures of support from the greatest possible number of intellectuals.[51] The main argument invoked in order to contest the accusation consisted in repeating that the poetic phrase "ran its own risks in the domain of interpretation, where consideration of its literal meaning was in no way able to exhaust it." Lyrical poetry could, indeed, only live on "extreme representations," depending on the "unleashing of violent inner movements"—expressions that obliged one to consider the fact that they seemed fairly ill-adapted to the composition of "Front rouge." In fact, Aragon was defended in the name of surrealist solidarity, while his poem in no way conformed to the requirements of the group. This caused considerable debate within the group, for Aragon's attitude displayed a certain reticence and ambiguity.[52] As for the members who were closest to the Communist Party, they expressed reservations with regard to the strategy adopted to defend Aragon.

Although the Paris group claimed that, as far as the poetry was concerned, the author was not responsible, having produced a meaning of which he was not the master, the situation in Belgium was not the same. On January 30, 1932, Magritte, Mesens, Nougé, and André Souris published another pamphlet, *La Poésie transfigurée,* which, after pointing out that by relegating poetry to pure "aesthetic contemplation," the bourgeoisie had succeeded in neutralizing it in a lasting fashion, went on to state that

the indictment of a poet was a positive thing insofar as it obliged the bourgeoisie to denounce its own ideology of "spiritual" freedom.[53] Nougé and his friends finally called on those willing to rebel to place themselves at the service of the political forces capable of breaking bourgeois domination.

L'Humanité felt that the group was taking advantage of the affair "to get publicity"—a reaction that Breton would not fail to criticize severely in the brochure he composed at the end of February 1932 and that was published with the title *Misère de la poésie*.[54] Breton reasserted surrealism's complete support for the policies of the Communist Party, reiterated that "Front rouge" (which was only a "one-off sort of poem" and actually "did not indicate a new direction for poetry") "should not be judged by the successive representations which it occasioned, but rather on the power of incarnation of an idea for which these representations, freed from any need for rational sequence, served only as a fulcrum." But in other respects he again attacked, very violently, the cultural editors of *L'Humanité,* who had recently voiced their shocked reaction to the erotic *Rêverie,* a very precise work, of rare beauty at the same time, that Dalí had published in number 4 of *Le Surréalisme ASDLR.* Dalí's text was deemed by the Communist Party to be pornographic and immoral and to complicate uselessly—in the words of an "imbecile" (Breton)—the relations "between man and woman which are so simple, so healthy." The specialists at *L'Humanité* were then denounced for their artistic and intellectual incompetence, for the poverty of their philosophical concepts, and, to use a quotation by Lenin, for their hardly respectable status of "parrots and Communist braggarts."

A few days after the publication of *Misère de la poésie, L'Humanité,* at Aragon's request, informed its faithful readers of his position: he was a complete stranger to the book's publication, he "disapproved of its contents in their entirety," and he felt that "all communists must condemn as incompatible with class struggle and consequently as objectively counter-revolutionary" the attacks in Breton's pamphlet against the party's cultural policies. There was no need to insist further: the surrealists published two more pamphlets, *Paillasse* (collective) and *Certificat* (written by Éluard) that finalized the break with Aragon. Sheltering behind the class struggle and his supposed hatred of counterrevolution, Aragon had chosen his side: henceforth it would be the Communist Party in its successive versions, including the most Stalinist—even, if necessary, when the party endeavored to distort surrealism and the meaning of its activities.

The break was surely painful, particularly for Breton, but also for some of the others. Moreover, it would determine the departure of those who were more committed on the communist side: Maxime Alexandre, Pierre Unik, and Georges Sadoul.[55] However it was not enough, or not immediately so, to strip the group of its "last illusions on the compatibility of surrealist aspirations and communist aspirations, in the doctrinal sense of the term, nor of the possibility that the Party might realign its political and cultural positions. The accusation against Aragon and a few others was that they surrendered without a fight, they adhered ... to the Party line, instead of trying to adapt it within the organization."[56]

The AEAR: Political Collaboration and Autonomous Research

In November 1930, Breton and Thirion spoke of the need to create an "Association of Revolutionary Artists and Writers," "a sort of trade union for literature, the arts, and

science, which would be based on the workers' movement" (Thirion). This union would exclude all liberals and those considered too lukewarm, like the collaborators on *Monde*. The project failed to materialize, but in January 1932, the Association des Écrivains et Artistes Révolutionnaires (AEAR; association of revolutionary writers and artists) was founded under the aegis of Paul Vaillant-Couturier. Some surrealists (from the artists' camp: Buñuel, Tanguy, Ernst, and Giacometti) were invited to participate from the start, while others (the writers' camp: Breton, Éluard, Thirion, and Crevel) were considered somewhat less desirable, perhaps because within the AEAR an image was considered less austere than a text and, for this reason, more easily used.[57] Crevel would not contribute to *Commune,* the AEAR's periodical, until 1934, while Thirion, who had been excluded from the Communist Party in November 1931, had to be even more patient than Breton, who was allowed to join the AEAR in October 1932. Breton was even quickly appointed a bureau member of the literary sector and, in so doing, occupied a more important position than Sadoul and Aragon themselves, who were simple cell members.

However, at the AEAR Breton and his surrealists often found themselves in the leftist, Trotskyist, opposition. This did not stop them from cosigning, for example, *Protestez!*—a lackluster declaration against fascist agitation in Germany, which stated, in passing, that "the enemy is imperialism. And for us, in France, it is French imperialism."[58]

Even if the AEAR criticized Barbusse and *Monde* with a certain virulence, the debate over the development of proletarian literature, which "is defined above all by the ideology it expresses," was not really enough to satisfy fully the contributors to *Le Surréalisme ASDLR.* When *L'Humanité* held a contest of "proletarian art and literature," stating that even before the victory of the revolution it was possible for a proletarian art to exist, over eight hundred entries were received.[59] And on February 23, 1933, Breton spoke of the conditions and the impasses (of the contest) in terms that conveyed little enthusiasm.[60] *L'Humanité* had another opinion altogether, of course, and Breton decided to stop attending the meetings of the association. The publication, in *Le Surréalisme ASDLR,* number 5, of a letter from Ferdinand Alquié that strongly criticized the Soviet film *The Path of Life* and deplored the "wind of cretinization which is blowing over the U.S.S.R.," would later serve as a pretext to exclude Breton from the AEAR in July. Crevel wrote to Vaillant-Couturier: "Today, July 6, 1933, the clear-sightedness and intellectual courage of André Breton seem to me to be at the service of the Revolution to a greater and finer degree than ever before. The AEAR, on the other hand, continues to prove that as far as it is concerned, the trend is toward neither clear-sightedness nor intellectual courage"—and he resigned, as did all of Breton's friends.

The previous month, the surrealists did have the opportunity to defend their position in the course of an international conference against war, organized at the initiative of Romain Rolland and Barbusse, who were accused in the pamphlet *La Mobilisation contre la guerre n'est pas la paix* (Mobilization against war is not peace) of representing little more than a "humanitarian mysticism, more pernicious on the whole than any abstract theology."[61] If the surrealists still intended to go to Amsterdam, it was to contradict the "devout idealism" and "mystique of nonviolence" with a truly revolutionary position, while showing once again that the only true peace, where the working class would not lose out, was that which was prepared by civil war. Crevel, who signed the pamphlet with his friends, was then excluded from the Communist Party.

Alongside their uneasy participation in the AEAR, the members of the group clearly sought, in the early 1930s, to prove their commitment to the revolution through their own texts. Commitment could contradict the call for occultation voiced in the *Second Manifesto*, since the debate over the nature of the public targeted by *Le Surréalisme ASDLR* had led Breton to announce in October 1931 that he would be capable of changing a text if it meant he could have a larger audience: "As I don't want to give any food to the aristocrats and the bourgeois, I claim to write for the masses."[62]

The table of contents of *Le Surréalisme ASDLR* did not display, however, any particularly strong desire to reach "the masses." Or, rather, the idea was not to lower the level of the periodical in order to reach them. Publication in number 6 of notes by Lenin on Hegel, presented by Thirion, amounted to an invitation to perfect one's knowledge of the classics of revolutionary theory; Crevel's contributions also worked in the direction of permanent engagement, as did Sadoul's social diatribes, the denunciation of various antirevolutionary manifestations, be it in the cinema (review of Rene Clair's film, *À nous la liberté*), in the bourgeois press, or in psychoanalysis (reexamination of statements made by the doctors Allendy and Laforgue), or the "Essay on the Situation of Poetry," by Tzara (number 4), who strongly emphasized that only surrealism offered a revolutionary path for poetry.[63] Nothing could attenuate the specificity of surrealism, in its research and in the values it promoted, as exemplified by the abundance of poetic texts by Péret, Char, and Éluard or by newcomers such as Hugnet, Gilbert Lély, Joë Bousquet, Dusan Matitch, and Greta Knutson. Still other examples were an ongoing reflection on nature and the power of poetry (Roger Caillois, Jules Monnerot, Paul Nougé, Reich), an appreciation for the Marquis de Sade (particularly by Heine), a celebration of the centenary of Arnim by Breton, reflections on humor or on painting (Ernst, in number 6), continuation of work on dreams by Breton, who published excerpts from *Vases communicants* in the periodical. The account of a variety of experiments and the place taken by Dalí's contributions—precisely Dalí, who was the least likely to engage in political activity—were proof of the continuing activities and concerns that should be of interest to communist intellectuals and served as a reminder that in no way could an economic and political revolution be satisfactory if it were not also accompanied by a revolution in social mores and thought.

In 1932 the publication, a few months apart, of Crevel's *Clavecin de Diderot* (Éditions Surréalistes, in April) and Breton's *Vases communicants* (Éditions des Cahiers Libres, in November) was seen as symbolic of the lasting determination to unify the struggle against the bourgeoisie. This struggle was to be founded on dialectical materialism and the choice of a range of proposals concerning the evolution of revolutionary thought, which were to be enriched—at least this was the surrealists' position—by borrowings from psychoanalysis and continued research into dreams.

Crevel displayed a frenetic ardor in confronting anything that in any way reflected a mentality he despised, both for reasons of family history and for political motives: anything subjective immediately led to a generalization in sociopolitical terms. Family, church, education, bourgeois morality, capitalism, colonialism, the dominant concept of love relations—all were attacked from a point of view that brought together a materialism à la Diderot, Marxist dialectics, psychoanalysis, and surrealism.[64] This fairly unusual intellectual mechanism attacked dualist thought first and foremost, the old distinction between mind and body—"The soul and the skin: on the one hand the Church where one prays, the salon where one chatters, and on the other hand the

whorehouse where one screws"—which is the condition of all human alienation. *Le Clavecin de Diderot* called for complete liberation, impossible to confuse "with the whims of an aesthete, or the fantasy and other little frills of individualism"—a liberation of the sort only surrealism, in the end, could conceive. Crevel was not a reasoning individual; he would gladly replace debate with a montage of quotations (Engels was often referred to) or a series of insults. Rebellion was visceral for Crevel, and everything he composed was the fruit of a permanent anger, lightened with moments of humor at the expense of those he called the *assis* (seated)—or the well endowed.

The motivation behind *Vases communicants* was quite different: Breton sought to show that it was in the interests of communism not only to support surrealist activity but also to follow their example and conduct research based on psychoanalysis. This could lead to a theory of dreams that would in turn reinforce revolutionary ideas. Since "all errors in the interpretation of man lead to an error in the interpretation of the universe" and constitute thereafter "an obstacle to transformation," it is of extreme importance, for those who claim to transform the world, to understand that the activity of dreams is the complement of diurnal life and that it is particularly enlightening for those who endeavor to take the exact measure of human desire; the desire for political transformation is only one aspect among many, underestimated, moreover, whenever one thinks one can account for it through a strictly material analysis of the conditions of existence. The motivation for *Vases communicants* was thoroughly dialectic: the aim was to show "the possibility of extreme compatibility between the two terms which tend to contrast the world of reality with that of dreams, for the sake of a confusional philosophy" and to carry out "the increasingly necessary conversion . . . of the imaginary into the experienced, or more precisely, that which must be experienced." In analyzing his own life and some of his dreams, Breton illustrated the constant exchange that takes place between the life of dreams and the waking life; his analysis was carried out within a philosophical context guaranteeing, with the help of a great number of quotations, the adoption of dialectical materialism. In the third part of the book, Breton dared to consider that the cultural policies of the Communist Party, officially inspired by Kharkov, would lead to a purely "pragmatic" attitude (not to say "idealistic"). When such a policy meant, for intellectuals, the obligation to act solely in keeping with the level of consciousness of the proletariat, this betrayed an ignorance of the proteiform nature of a desire that could never be satisfied by solutions concerning an economic infrastructure alone or by the cultural monolithism inspired by Moscow. The book's message was clear: for the revolution to be all-encompassing, the communists would have to give their attention to Freud, even if this meant, as it did for Breton himself, by using his theories in a somewhat unorthodox way.[65] The book's message fell on deaf ears, for the Communist Party, far from applying the Kharkov resolutions with rigor, was in fact about to give preference to a policy uniting as many intellectuals as possible, sympathetic in any way at all, with the revolutionary cause; theoretical rigor, therefore, was of less importance than ever, and that of the surrealists would seem increasingly out of place.

In his *Entretiens* in 1952, Breton admitted having a "particular soft spot" for *Les Vases communicants,* but he also recognized that he had worked stubbornly for the prevalence of materialism "even in the domain of dreams—something which is far from avoiding the arbitrary."[66] When the work was republished in 1955, it was enriched by photographic illustrations that gave it greater balance on the Freudian side: a photogram of

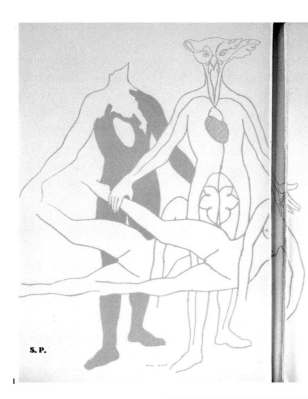

S.P.

André Bréton

Les Vases communicants

Éditions des Cahiers Libres Paris

1

LISEZ :	NE LISEZ PAS :	LISEZ :	NE LISEZ PAS :
Heraclite.	Platon.	Lautréamont.	Kraft-Ebbing.
	Virgile.		Taine.
Lulle.	St Thom. d'Aquin.	Rimbaud.	Verlaine.
Flamel.		Nouveau.	Laforgue.
Agrippa.	Rabelais.	Huysmans.	Daudet.
Scève.	Ronsard	Caze.	
	Montaigne.	Jarry.	Gourmont.
Swift.	Molière.	Becque.	Verne.
Berkeley.		Allais.	Courteline.
	La Fontaine.	Th. Flournoy.	M** de Noailles.
La Mettrie.		Hamsun.	Philippe.
Young.		Freud.	Bergson.
Rousseau.	Voltaire.	Lafargue.	Jaurès.
Diderot.			Durckheim.
Holbach.			Lévy-Brühl.
Kant.	Schiller.	Lénine.	Sorel.
Sade.	Mirabeau.	Synge.	Claudel.
Laclos.		Apollinaire.	Mistral.
Marat.	Bern. de St Pierre.	Roussel.	Péguy.
Babeuf.	Chénier.	Léautaud.	Proust.
Fichte.	M** de Staël.	Cravan.	d'Annunzio.
Hegel.		Picabia.	Rostand.
Lewis.		Reverdy.	Jacob.
Arnim.	Hoffmann.	Vaché.	Valéry.
Maturin.		Malakovsky.	Barbusse.
Rabbe.	Schopenhauer.	Chirico.	Mauriac.
A. Bertrand.	Vigny.	Savinio.	Toulet.
Nerval.	Lamartine.	Neuberg.	Malraux.
Borel.	Balzac.		Kipling.
Feuerbach.	Renan.		Gandhi.
Marx.			Maurras.
Engels.	Comte.		Duhamel.
	Mérimée.		Benda.
	Fromentin.		Valois.
Baudelaire.	Leconte de Lisle.		Vautel.
Cros.	Banville.		Etc., etc., etc...

IMP. UNION, 13, RUE MÉCHAIN, PARIS

2

Nosferatu the Vampire, Dalí's *Le Grand masturbateur,* De Chirico's *Le Vaticinateur,* Gustave Moreau's *Dalíla*—all of which were mentioned in the text—and then the Palais Ideal of the Facteur Cheval, which was not mentioned in the text. All of these provided clear examples, independently of their biographical significance, of the successful objectification of the unconscious and desire.[67] Some editions were also decorated with a cachet: "1932. Before the trials in Moscow. 1955. Yet the vessels still communicate."

The importance of political or ideological reflection within the group hardly slowed poetic or artistic production, particularly as there was an influx of new members who immediately participated in *Le Surréalisme ASDLR* and brought, in particular, new artistic solutions that further justified—if it was even necessary—the pursuit of independent research.

In 1932 the simultaneous publication at the Éditions des Cahiers Libres of *La Vie immédiate* by Éluard, *Où boivent les loups* by Tzara, and *Le Revolver à cheveux blancs* by Breton—all three sealed with the same paper band proclaiming a phrase by Albertus Magnus: "The subject of this book is a mobile being"—had the effect of a collective declaration of poetic autonomy. In the context of debate and tension produced by their relations with the Communist Party, it was important to remember, after Aragon's departure that poetry was everpresent (but if we are to believe Thirion, six months later Aragon had already been forgotten) and still had exploratory value. This was clearly confirmed moreover in the early pages of *Revolver à cheveux blancs* (White-haired revolver; the first half consisted of an anthology of texts already published in *Mont de Piété, Les Champs magnétiques* and *Clair de terre*—another way of ensuring continuity) and through the the revival of a genuine manifesto in the form of "Il y aura une fois" (Once upon a time there will be), which had already appeared in the first issue of *Le Surréalisme ASDLR* This collection also included the lyrical explosion of *L'Union libre,* which had first appeared in 1931, with no mention of the author or the publisher; thus far, no chronicler had mentioned it, with the exception of Francis de Miomandre, the only one who was capable of identifying the author. (This was an event of the type to make one reexamine the capacity of contemporaries—from whatever class they might be—to appreciate poetry, when poetry was not endorsed by a proper name of renown. It also served to remind one how bold the anonymity of a text or of a style could be when it resulted, for example, from a collective writing effort like those that the surrealists themselves periodically produced and, also, how anonymity flaunted social habits regarding the reception of works.)

In December 1933, the Éditions Nicolas Flamel (founded for the occasion by Mesens) in Brussels published a collaborative collection entitled *Violette Nozières:* eight poems, by Breton, Char, Éluard, Henry, Mesens, César Moro, Péret, and Guy Rosey, and eight illustrations, by Dalí, Tanguy, Ernst, Brauner, Magritte, M. Jean, Arp, and Giacometti; the cover was by Man Ray.[68] The work was to salute the woman accused of patricide, whose mother had barely escaped the same fate by poisoning; the daughter had accused her father of incestuous relations. The tribute was published a year before the trial took place; Nozières would receive the death sentence, ultimately commuted to life imprisonment, then pardon and rehabilitation. The point was that because she was a woman before she was a potential criminal, because she had dared to break one of the *comme il faut* society's major taboos (never to reveal incest), and because, like Germaine Berton or the Papin sisters—even if the circumstances were different—she appeared to be the victim of a social order that oppressed women in a particularly hyp-

VICTOR BRAUNER

De molles quantités d'herbes vénéneuses sous l'oreil-
 ler parce que c'est dimanche
la tête pleine de rames et de feuilles de mousseline aro-
 matisées c'est la forêt aux cinq cents branches de talc
immense et rigide la nuit fait face au gouffre sous les
 orties qui se cachent
sous leurs bras d'enfant pleurant contre un mur

De dix ans plus belle que l'enfant
au piano étrangleur de résine

Mais soudain tu n'as rien oublié
les yeux baissés derrière un buisson la bouche sévère
 rageuse rêvant de baisers

 MAURICE HENRY.

RENÉ MAGRITTE

L'impromptu de Versailles

9/10

Ô embrasseuse d'aubes

Fille d'une partie civile et d'un train
Fille de ce siècle en peau de cadenas
Malgré la boue et le temps menaçant
Malgré les jours livides et les nuits illusoires
Tu vivais ô combien anxieusement

Te voilà muette ou presque à présent
A la faible lueur des quinquets
Du labyrinthe judiciaire

Nous ne sommes hélas pas nombreux
Violette
Mais nous ferons cortège à nos ombres
Pour effrayer tes justiciers

Au tribunal du corps humain
Je condamnerai les hommes aux chapeaux melons
A porter des chapeaux de plomb.

 E. L. T. MESENS.

ocritical fashion and was unwilling to grant them the slightest right to rebel, however justified. And because she denounced the unbearable nature of the family by breaking the law of silence that ordinarily surrounded the existence of the least confessable relations, Violette Nozières deserved this collective praise, which clearly had nothing strictly political about it and seemed, moreover, to leave the Communist Party indifferent but which attacked more globally the morality of the social order.

Minotaure

Number 6 of *Le Surréalisme ASDLR* devoted an entire page of publicity to the publication, beginning May 25, 1933, of *Minotaure,* "an artistic and literary review," by the Éditions Albert Skira; Skira was coeditor together with Tériade. The first two issues came out simultaneously during the month of June; number 2 was entirely devoted to a series of articles on the Dakar-Djibouti mission by Marcel Griaule, Germaine Dieterlen, and Leiris.

It was not until February that Breton was contacted by Skira to give a sharper definition to the direction that the periodical would take. This new project was due to Tériade, and it initially sought to bring about a rapprochement between the group and dissidents from surrealism. While Éluard had considerable reservations about the idea of a collaboration with Bataille (whose reticences were continuing at that time in Souvarine's *La Critique sociale*), the discussions eventually led to the creation of a list of possible collaborators: Maurice Raynal, Pierre Reverdy, Masson, Leiris, Crevel, Dalí, Lacan, Tzara, and of course Éluard and Breton.[69]

Although *Minotaure* was not, strictly speaking, a production of the group, they would assume an increasingly obvious importance, particularly from the third issue on. The first two issues had still been characterized by a spirit close to that of *Documents,* particularly with the series of articles devoted to the Dakar-Djibouti mission. This did not mean, however, that the periodical represented only the group, nor that it gave an account of all its directions: in the series of covers (all designed specifically for the periodical), there were contributions by Derain, Francisco Borès, and Matisse, whose process was very different from that of the painters in the surrealist movement. And a publication that announces that it is looking for "plastic art, poetry, music, architecture, ethnography and mythology, theater, and psychoanalytical studies and observations" can hardly be said to be leaving room for a political dimension: that would be left to the pamphlets of the era.

The group was not always particularly pleased with the articles that appeared in the periodical or with some of the artists whose work was included: Henri Laurens, Jacques Lipchitz, Charles Despiau, Valéry, and Léon-Paul Fargue were only accepted on condition that they be offset by Ernst, Miró, Tanguy, Dalí, Péret, the Marquis de Sade, the German romantics or Gothic novels, Éluard, or Breton himself. Breton published major articles in *Minotaure,* "Picasso dans son élément" (no. 1) to begin with, followed, in particular, by "Le Message automatique" (no. 3–4), "Phare de la Mariée" (no. 6) and, in 1939, "Des tendances les plus récentes de la peinture surréaliste."

The luxurious aspect of *Minotaure,* moreover (which progressively became "the most beautiful and daring periodical in the world," according to Éluard), did cause some problems, insofar as it addressed an audience that the group was sure to despise: well-to-do middle-class people or snobs. However satisfying it might be to make the

1 Pablo Picasso, cover of *Minotaure* number 1 (February 15, 1933).

2 Brassaï, *Sculptures involontaires* (Involuntary sculptures), photographs published in *Minotaure* number 3–4 (December 14, 1933).

3 Photographs by Man Ray illustrating an article by Tristan Tzara, "On a Certain Automatism of Taste," *Minotaure*, number 3–4 (1933).

4 Manuel Alvarez Bravo, *Portrait posthume* (1939); gelatin and bromide, 7³/₅ × 9³/₅ (19 × 24 cm).

5 Manuel Alvarez Bravo, *Parabola optica* (1931); gelatin and bromide, 9³/₅ × 7²/₅ (24 × 18.5 cm).

SCULPTURES INVOLONTAIRES

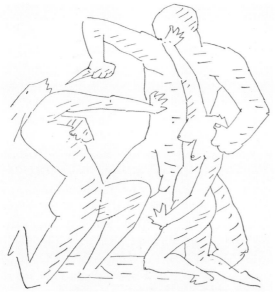

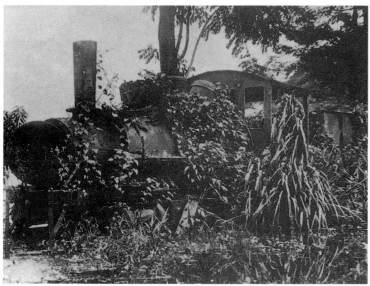

6 *Massacre,* drawing by André Masson published in *Minotaure* number 1 (February 15, 1933).

7 Anonymous photograph published in *Minotaure,* number 10 (winter 1937), illustrating an article by Benjamin Péret, "Nature Devours Progress and Surpasses It."

8 Brassaï, *Graffiti,* photograph illustrating his article "From the Walls of Caves to the Walls of Factories," *Minotaure* number 3–4 (December 14, 1933).

9 Raoul Ubac, *Le Triomphe de la stérilité* (The triumph of sterility; 1937); photograph published in *Minotaure,* number 10.

10 A page from *Minotaure,* number 3–4 (1933), with photographs by Man Ray.

movement's choices in painting known to the public and to give exposure to reproductions of its artists (including the most recent arrivals: Brauner, Hans Bellmer, Paalen, Dominguez, Seligmann, Roberto Matta, or, during the London exhibition of 1936, Stanley William Hayter, Eileen Agar, Roland Penrose, and Henry Moore), as well as showing—thanks to the images of Brassaï, Man Ray, Ubac, and Alvarez Bravo, that photography could be put to other uses than simply a flat and realistic reflection of daily life, the fact remained that the success of the periodical was ambiguous: Was it not in danger of depriving the movement of its revolutionary dimension? That, in any case, was Tzara's opinion; the shift from *Le Surréalisme ASDLR* to *Minotaure,* he said, "exhaust[ed] the creative phase of surrealism."[70] That was also—from a different point of view—the opinion of Emmanuel Berl, who held that "neither the writer, nor the public, nor anyone else, nor [I myself] believe any more in the moral, social, and political importance of literature. As for art . . . you can write what you like. The very poshest bourgeois ladies adore surrealism."[71]

In addition to its luxurious aspect, the insistence on the part of the surrealists themselves on marginal or nonofficial art productions, which made sense within their work as a whole to bring about a change in sensibilities, ran the risk of being viewed as a simple penchant for the bizarre or a tendency to shock but, in the end, in a fairly titillating way. Man Ray's ability, with just a few plates, to emphasize the erotic forms of hats, or the abandoned figureheads photographed by Bill Brandt, or the illustrations for *romans noirs* selected by Marcel Heine certainly did not resist as strongly as Bellmer's *Poupée* being appropriated or co-opted by a certain taste for the eccentric and the "next fashion," if not actual kitsch. By validating such elements in its unwavering antimodernism,[72] surrealism also took on the aspect of a treasure chest, or a Pandora's box, from which it might be exciting to extricate a few objects in order to decorate one's interior with "originality"—especially as *Minotaure,* even once the group had taken power in a certain way,[73] remained an eclectic periodical.

It was actually through the composition of the various issues, something Breton and Éluard worked on two or three hours a day, that surrealism would impose its mark—but how many readers were actually conscious of this, by going beyond the simple impression of unity that each issue gave? Thus issue number 3–4 developed around a latent theme: the various ways in which behavior and invention elude the control of attention and reason. Man Ray, to begin with, in "L'Âge de la lumière" (The age of light), asserted that "any effort driven by desire must also be based on an automatic or subconscious energy that helps toward its realization." Brassaï went on to provide photographs of anonymous graffiti; Tériade himself evoked "chance, spontaneity, and the absence of a model in modern painting," followed by an article by Claparède on sleep and another by Lacan on the crime of the Papin sisters. Then Péret imagined a dialogue about automats among the dead, Paul-Chardon read Rimbaud's horoscope, and Brassaï photographed the interior of studios where there was an abundance of works in progress and in disarray. Breton's text on the automatic message was followed by two pages by Ferdinand Brückner on "L'Âge de la peur" (The age of fear; "When he drops deep into his uniform, man renounces the individual that he was. When he 'shares himself with another,' he confirms and strengthens himself"); then came photographs of involuntary sculptures produced by uncontrolled gestures, and a text by Dalí on the modern style. Heine offered a classification of sexual paraesthesia, Frois-Wittmann expressed his interest in the pleasure principle in art, and Tzara wrote about "a certain

Clovis Trouille, *La Complainte*
(The lament; 1933); oil on canvas,
60 × 34²/₅ in. (150 × 86 cm).

Above: Maurice Tabard, *Révélateur-peinture, à Max Ernst* (1935); toned silver gelatin print, 7 x 9²/₅ in. (17.4 x 23. 5 cm). Musée National d'Art Moderne, Centre Georges Pompidou, Paris.

Right: Dora Maar, *29, rue d'Astrog* (ca. 1936); silver gelatin print enhanced with color, 11³/₄ x 9³/₄ in, (29.4 x 24.4 cm). Musée National d'Art Moderne, Centre Georges Pompidou, Paris.

Opposite page: Jacques Hérold, *Le Germe de la nuit* (The seed of night; 1937); 32²/₅ x 26 in. (81 x 65 cm). Muguette Hérold Collection.

Right: Victor Brauner, *Le Ver luisant* (The glowworm; 1933); oil on canvas, 20 × 24²/₅ in. (50 × 61 cm). Musée National d'Art Moderne, Centre Georges Pompidou, Paris.

Below: Victor Brauner, *Le Dernier voyage* (The last voyage; 1937); oil on wood, 5¹/₂ × 7¹/₅ (13.9 × 18 cm). Musée National d'Art Moderne, Centre Georges Pompidou, Paris.

Opposite page: Oscar Dominguez, *Machine à coudre électro-sexuelle* (Electrosexual sewing machine; 1934); oil on canvas, 40 × 32¹/₅ in. (100 × 80.5 cm). Private collection.

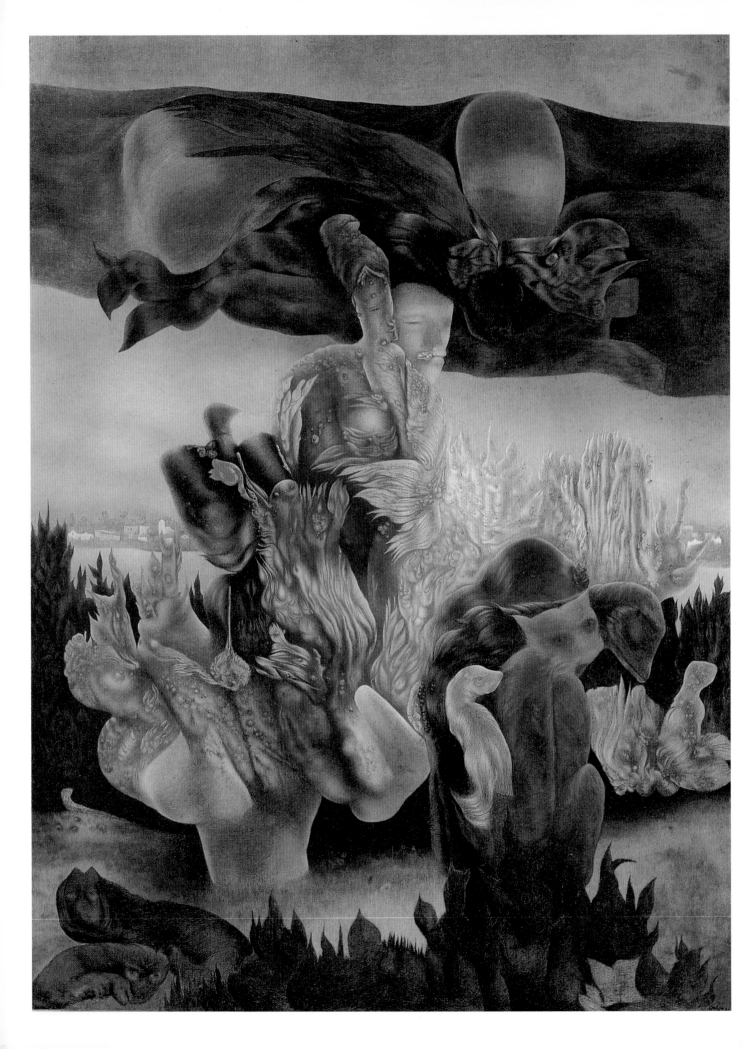

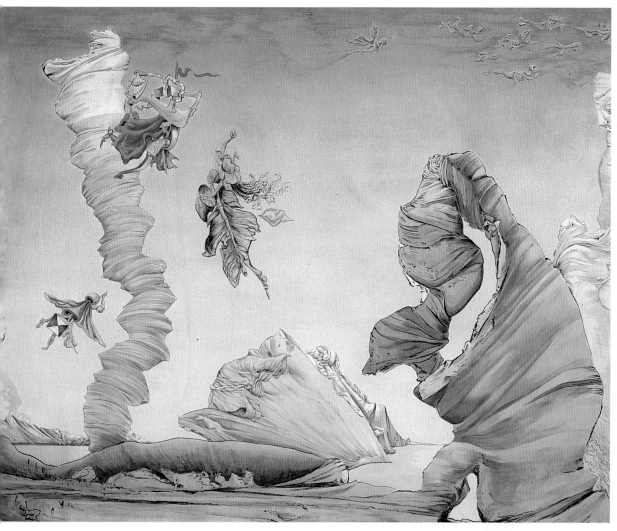

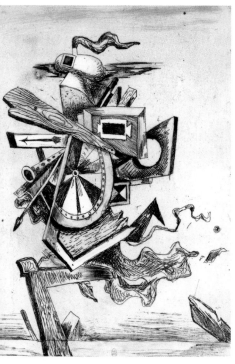

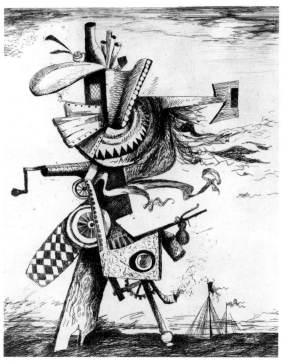

Above: Kurt Seligmann, *Memnon and the Butterflies* (1942); oil on Masonite, 44 × 48⁴/₅ in. (110 × 122 cm).

Below, left: Kurt Seligmann, *Protubérances cardiaques, Marathon* (Cardiac protuberances, Marathon). Bibliothèque Nationale de France, Paris.

Below, right: Kurt Seligmann, *Le Grand Flibustier* (The great buccaneer). Bibliothèque Nationale de France, Paris.

Opposite page: Richard Oelze, *Tourments quotidiens* (Daily torments; 1934); oil on canvas, 52 × 39¹/₅ (130 × 98 cm). Kunstsammlung Nordrhein-Westfalen, Düsseldorf.

Above: Max Ernst, *Jardin gobe-avion* (Airplane-swallowing garden; 1935); oil on canvas, 21³/₅ × 29¹/₅ (54 × 73 cm). Private collection.

Left: Max Ernst, *Fêtes de la faim* (Feast of hunger; 1935); oil on canvas. The Menil Collection, Houston, Texas.

automatism of taste" and Éluard about postcards. Everything culminated, in a way, in the 140 responses to a survey on encounters devised by Breton and Éluard—"Can you say what was the most important encounter in your life? To what degree did that encounter give you, or still gives you an impression of the fortuitous, and the necessary?"—where it might be, yet again, chance, desire, and the potentially destined nature of the most crucial events that were involved.

There is no need to demonstrate further the search for coherence that went into each issue of *Minotaure,* but it is worth pointing to certain juxtapositions that were particularly significant. In number 6, for example, Bellmer's *Poupée* appeared between Mallarmé's *La Dernière Mode* and a text by Dalí ("Apparitions aérodynamiques des êtres-objets"), and was followed by an article by Pierre Courthion on "The Sadism of Urs Graf." Number 7 was entirely devoted to the "nocturnal side of Nature," including, to follow Breton's *Nuit du Tournesol,* an article by Caillois on plant and animal mimicry, a study by Heine, "Romantic Nights under the Sun-King," dealing with a collection of seventeenth-century etchings; two of Young's *Nights* illustrated by photographs by Brassaï and Man Ray, a study by J. Delamain on "night birds," and a nightmare by Michaux—thus, a collection of different soundings in a double night, that of nature but also that of the unconscious.

The discrete arrangements by themes earned the periodical a surrealist label, even if it differed from the group's autonomous publications. But the constant concern with following innovations in artistic creation placed the periodical firmly within the movement, as did the feeling of rediscovery that drew attention not only to marginal creations and objects but also to the works of Piero di Cosimo or Caspar David Friedrich, to the etchings of Posada or the photography of Nadar, to Arcimboldo or even *King Kong.* Boundless curiosity and a reaction against the dominant taste, a discovery of poetry where it was least to be expected, an exaltation of anything and everything that could make daily life both more dignified and more precious: through these aspects *Minotaure* was totally in keeping with the movement, and it was not by chance alone that the last issue of the periodical, in May 1939, published a denunciation of nationalism in art side by side with a collection of studies about Lautréamont.

The Supremacy of Picasso

Picasso had designed the first cover of *Minotaure,* and now Breton's first contribution to the periodical was a long article, "Picasso dans son élément" (Picasso in his element), essentially devoted to presenting the artist's production other than paintings: sculpture, objects, prints (from the series, "L'Atelier du sculpteur"—forty-two etchings created between March 20 and May 5, 1933), and drawings (one based on Matthias Grünewald's *Crucifixion* but also an extraordinary series of "anatomies" made up of an assembly of more or less geometrical shapes). His plaster casts, which were accumulating during that time in the Boisgeloup studio, were photographed by Brassaï.

It was nevertheless by referring to a particular small painting that Breton began his text, but this was a very special painting, on which a butterfly was glued next to a leaf, in among a few matches and pieces of string: this marked the unity, found in total grace, of the animate and the inanimate, or of the objective and the subjective. But Breton also emphasized that the irreplaceable greatness of Picasso was due to the fact that "he was constantly on the defensive with regard to exterior things, including those

1

2

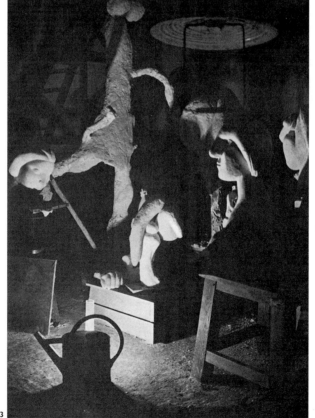

4

3

1 Pablo Picasso, *Une anatomie* (An anatomy); drawings published in *Minotaure*, number 1 (February 15, 1933).

2 Paul Éluard and Picasso on the beach at Juan-les-Pins, 1937.

3 Picasso's studio at Boisgeloup. Photograph by Brassaï published in *Minotaure*, number 1, February 15, 1933.

4 Picasso, *Projet pour un monument à Guillaume Apollinaire* (Project for a monument to Guillaume Apollinaire, 1928–29); construction in metallic wire, 40 × 32²/₅ × 14⁴/₅ (100 × 81 × 37 cm). Photograph by Brassaï published in *Minotaure*, number 1 (February 15, 1933).

he had drawn from within himself, to a degree that he never held them, between himself and the world, to be anything other than *moments* of intercession." If one agrees that the aim of artistic creation must be "to affirm the hostility which can animate one's desire with regard to the outside world" and to accept, as a complementary aspect, that "it will actually end up making the exterior object correspond to this desire, and thus reconcile one with the world itself, to a certain degree," one can see that the danger that stalks creativity is a sort of self-satisfaction leading to a relaxation of that hostility. There was nothing like this in Picasso's work, for his creative process seemed to be essentially dialectical, given the fact that lasting works were juxtaposed with more ephemeral productions, offered above all to intellectual speculation. Breton admired in passing the material aging of some cubist *papiers collés* and cardboard constructions made twenty years earlier: when such transformations took place, reality and desire found a way to join together, dialectically, as if the artist had allowed reality to play its role as a complement to his decisions.

Picasso's work at the beginning of the 1930s had everything to elicit the admiration of Breton and his friends, be it the variety alone. It was not versatility or mere unfortunate indecision that led to such variety but the desire to leave no aspect of invention unexplored. *Les Baigneuses,* painted in 1928–29 during his stays in Dinard—where Picasso often saw Hugnet—portrayed "monstrous" versions of the female body, which obeyed no other call than the artist's desire to experiment, as did the plaster busts from Boisgeloup, which offered unceasing play with the planes of the face: one could decompose and put them back together to obtain a maximum expressivity with the contrast of light and shadow. In similar fashion, the scrap metal sculptures, the assemblages of varying durability made from pieces of steel, feathers, children's toys, and string obviously belonged to the category of the object that was of such interest to the group at the time. This could also be said of the sanded reliefs of objects glued to the canvas that Picasso created in 1930: some of the painter's montages would fit in quite naturally with the collective exhibitions.

Beginning in April 1935, Picasso added poetry to his activities, a poetic writing in which automatism had a predominant role: an unpunctuated verbal flow, which could be very long or, inversely, not go beyond a few lines but where groups of words acted as colors, conferring a particular effectiveness on the images. No sooner had Breton seen these texts than he published a few of them in *Cahiers d'art* (no. 7–10, 1936), along with a preface, "Picasso Poet," which emphasized that their point of departure consisted of whatever happened to be surrounding Picasso at the moment he was writing and asserted that "this poetry will never fail to be plastic in the same way that this painting is poetic"—as shown by this excerpt: "listen in your childhood the hour which white in memory blue white in his blue blue eyes and piece of indigo of sky of silver gazes white crossing cobalt the white paper which the blue ink tears away bluish its ultramarine descending that white takes pleasure from the blue repose waving in the dark green wall green written by its pleasure pale green rain where green yellow swims in clear forgetfulness at the edge of his foot green the sand earth song sand of the earth afternoon sand earth."

It is astonishing that between 1935 and January 1941 (when he wrote *Le Désir attrapé par la queue*), Picasso wrote over two-thirds of his texts; this was also the period during which, in his painting, figures were frequently treated with extreme virulence, both formal and chromatic, and, during this same time, the political situation in Spain

1

6 FEVRIER - 25 MAI

Le 10 février :

Appel à la lutte

Avec une violence et une rapidité inouïes, les événements de ces jours derniers nous mettent brutalement en présence du danger fasciste immédiat.

Hier :

Emeutes fascistes.

Défection du gouvernement républicain.

Prétentions ouvertes de *tous* les éléments de droite à la constitution d'un gouvernement antidémocratique et préfasciste.

Aujourd'hui :

Gouvernement d'Union sacrée.

Répression sanglante des manifestations ouvrières.

Demain :

Rappel du préfet de Coup d'Etat.

Dissolution des Chambres.

Il n'y a pas un instant à perdre

L'unité d'action de la classe ouvrière n'est pas encore réalisée.

Il faut qu'elle le soit *sur le champ*.

Nous faisons appel à tous les travailleurs organisés ou non, décidés à barrer la route au fascisme, sous le mot d'ordre

UNITÉ D'ACTION

Cette Unité d'action, que les ouvriers veulent et que les Partis mettent à l'ordre du jour, il est nécessaire, il est urgent, il est indispensable de la réaliser en y apportant le *très large esprit de conciliation* qu'exige la gravité de l'heure.

C'est pourquoi nous adressons un appel pressant à toutes les organisations ouvrières afin qu'elles constituent sans retard l'organisme capable — et seul capable — d'en faire une réalité et une arme.

2

inspired in his work a reaction of fury and of horror (*Songes et mensonges de Franco, Guernica*)—and also invoked, in its way, in a phrase jotted down in September 1937: "Portrait of the marquise with her Christian ass throwing a *douro* to the Moorish soldiers defenders of the Virgin."

However, even when, as during this period, he was closest to surrealism in what was his own idiom, Picasso never gave up his solitude; at best he was a fellow traveler with the group, authorizing them to exhibit, reproduce, or comment on whatever interested them in his production. In 1936 he again met Éluard, briefly encountered ten years earlier; it was the beginning of a long and authentic relationship that would eventually have nothing more in common with surrealism but that, in the initial stages, was inaugurated by the etching where *Grand air* (an excerpt from *Yeux fertiles,* which Éluard was working on) was surrounded by figures from Picasso's own personal mythology.

Political Initiatives in 1934

The very evening of the fascist demonstrations on February 6, 1934, a meeting was held at Breton's instigation that led to the formulation of an *Appel à la lutte* (Call to struggle), demanding unity of action among all the trade union and political organizations of the working class and calling resolutely for a general strike.[74] The pamphlet was published on February 10, with nearly ninety signatures from intellectuals of all stripes (from Alain, Jean Guéhenno, and Élie Faure to Malraux and Paul Signac)—but not a single member of the Communist Party. Reiterating in passing "the terrible experience of our comrades in Germany," the text did indeed distance itself to the extreme from the line that the communist parties stubbornly held to in both Germany and France and that obstinately persisted in opposing "social traitors" rather than fascism—when that line did not simply lead to the sterile pacifism already denounced by *La Mobilisation contre la guerre n'est pas la paix.*

On March 3, the Committee for Antifascist Action and Vigilance was set up, which would later take the name of the Vigilant Committee of Antifascist Intellectuals; Breton, Crevel, Éluard, Hugnet, Marcel Jean, and Péret immediately joined. This committee elected a bureau made up of Paul Rivet (president), Alain, and Paul Langevin (vice-presidents), and in *Commune* (no. 7–8, March–April 1934), the journal of the AEAR, the position of which was now overwhelmed, they published an address "To the Workers," reconfirming the "resolution [of the intellectuals who had signed, and who would number more than two thousand by May] to join [the workers] in rescuing the public rights and freedoms won by the people from a fascist dictatorship."[75] Less offensive than the *Appel à la lutte* launched by the surrealists, who signed it all the same, the text voiced the determination of intellectuals gathered from different political camps (Rivet was closer to the socialists, while Langevin had communist sympathies and Alain defended the republican tradition) to offer their services to workers' organizations, particularly trade unions.

On April 18, the surrealists took the initiative of a "Survey on the Unity of Action," which was introduced by a letter deploring the fact that the workers' movement of antifascist action had not attained more quickly the results anticipated after the success of the unity rallies organized by the base on February 9 and 12.[76] To facilitate the continuation and development of their action, they joined a few other intellectuals, including Ramon Fernandez, Jean Cassou, and André Malraux, in addressing a certain

number of "political and trade union figures from the working class" in order to define the necessary conditions and organizational possibilities of a unified action that could ensure, if not the allegiance of the peasantry and the middle classes (where the fascist leagues were recruiting a considerable number of their members), then at least their well-meaning neutrality. The responses to the survey were to be published in a brochure ("Materials for Unified Action"), but given the rarity of reactions, the brochure never materialized. At the same time, Breton was assigned the task of contacting Leon Blum to "inform him of what many [of them] persisted in expecting of him," but their meeting, which Blum preferred to direct toward a literary discussion, yielded no results.[77]

Their stance being what it was, the surrealists drifted even further from the Communist Party; the party's reactions were neither as rapid nor as clear as those of the surrealists.[78] Or, rather, the surrealists showed that when it was urgent, one must in no way take the official party line into consideration but adopt a flawless revolutionary position indifferent to bureaucratic constraints or directives from Moscow's sister party. If there was not yet a state of open hostility, ties were maintained only very formally. And it was not the publication of *La Planète sans visa* that would restore any sense of reality.[79]

This pamphlet, published on April 24, 1934, denounced the expulsion of Trotsky, who had been a refugee in France for over a year, by the "truce" government in place since February. The surrealists viewed this as an indication of the government's efforts to calm and reassure the right, while *L'Humanité,* which no doubt felt that this marked the beginning of repressive measures against communist immigrants and revolutionary organizations, felt at the same time that the publicity generated around Trotsky was "biased," insofar as it could work in his favor. Given such a reaction, the surrealists, while declaring that they were "far from sharing all his present beliefs," wanted nevertheless to salute him, reiterating the importance of his role in the recent history of the Soviet Union ("Lenin's old companion, a signatory of the Brest-Litovsk peace agreement, an organizer of the Red Army").

New Propositions

The tensions aroused within the group by political debate did not prevent new personalities from finding a place and a role there: the surrealist group was special, for in the end, the succession of internal crises became the surest means of self-renewal. Breton, Péret, Ernst, Tanguy, and other long-time members were joined during the first half of the 1930s not only by Giacometti, whose importance has already been pointed out, but also by artists as diverse as Valentine Hugo, Clovis Trouille, Claude Cahun, and, in his distant way, Hérold, while Meret Oppenheim, Richard Oelze, Kurt Seligmann, Oscar Dominguez, Hans Bellmer, and Stanley William Hayter would be responsible for more immediately significant contributions.

Valentine Hugo offered, with discretion, a certain sense of the most pleasing enchantment, even if there were traces of anxiety in her work from time to time. Very close to Crevel and Éluard as well as to Breton, with whom she was in love, Hugo began to take part, after working with her husband Jean Hugo for the Ballets Russes and spending a great deal of time with Cocteau and his worldly friends, in surrealist activities, primarily from 1930 on. Her artistic talent attracted attention and led her to create numerous portraits of her friends, as well as take part in exquisite corpses. Her

2

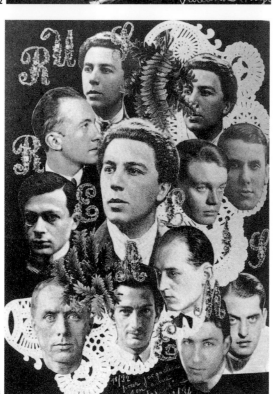

3

4

fine brushstroke traced an abundance of curves and arabesques, often against a black background, to recreate dream visions or dreamy compositions that filled with grace the illustrations she produced in 1933 for the new edition of Arnim's *Contes,* prefaced by Breton. There is nothing aggressive or tragic in her work: in each drawing, events unfold as if all contradictions had already been resolved. If this was an indisputable limitation to her creativity, at least her penchant for a certain "prettiness" was most often defeated by the sharpness of her line and the suggestion, on a number of pages, of an utterly unreal space, totally disconnected from the everyday, a space in which the most fruitful and fortunate encounters could take place.

It was after his participation in 1930 in the Salon des Artistes et Écrivains Révolutionnaires, where his canvas *Remembrance* (reproduced in *Le Surréalisme ASDLR,* no. 3) was shown, that Clovis Trouille—whose painting was indeed anything but "pretty"—met the surrealists. *Remembrance* indeed suggested enough antireligious and antimilitary virulence to attract their attention: "A German soldier and a French soldier are wondering what they have come to do in the war (for them it was the military cross); the Republic is handing out medals; the bishop is blessing the cowards and the military; white rabbits symbolize the soldiers' sacrifices."[80] Mingled with this was a popular eroticism, a sort of frankness and good humor that led one to conclude that such an artist could at least be a commendable fellow traveler. An employee in a factory that manufactured mannequins, Trouille had a classical training in art, which, after the First World War, he placed at the service of an anarchistic spirit of rebellion; he was clearly pleased with his meeting with the surrealists, with whom he undoubtedly shared many ideas and who in return appreciated his deliberately sacrilegious work, imbued with eroticism, with scattered homages to Sade (*Justine,* 1937) and Lautréamont, and with archetypes from popular novels or movie stars. If at times he kept a certain distance, it was, first of all, because he quickly grew weary of internal quarreling and, second, because he could not agree on what was at stake in painting: "What interests me most in my work is its intrinsic value: the color, the matter. And that was of no interest to Breton, he was not retinal, all he saw was history."[81] Because he sought to be first and foremost a painter, Clovis Trouille could not be surrealist in an integral way, but his imagery remains highly jubilant—it is a bit as if the Prévert of the *Tentative de description d'un dîner de têtes* had actually begun to paint (skillfully).

The subversion incarnated by Claude Cahun, whose career has recently been reevaluated, was another matter altogether.[82] There is nothing debauched about her work, and everything testifies to an exceptional inner tension, due no doubt to a profound sense of malaise but also to the ambiguous quest of an identity that as soon as it was established was immediately questioned. Until the end of the 1920s, her photographic work—self-portraits that were a series of contradictory versions of her subjectivity and photomontages created (especially for her work *Aveux non avenus*) with her companion Suzanne Malherbe—developed outside the surrealist movement, even though its artistic motivation was in line with that of the group. In 1932, Cahun joined the AEAR and signed a few political declarations but made no concessions in her stance: in response to the survey "Why Do You Write?" she replied, "It's enough to say that I write, that I want to write above all *against myself . . .* in the end, the choice of the person or the collectivity one is addressing is of very little importance." It was at roughly at the same time that she began to associate with Breton and the surrealists, and she would remain "an unshakable accomplice."[83] Fascinated by Breton, it was quite

possible that she troubled him with her provocative behavior that she willingly pushed right to the limit. In 1933 she replied to the survey on encounters, and in 1934 published *Les Paris sont ouverts* (The bets are open), an important reflection on poetry: from its very cover it indicated the multiple possibilities of poetry, with a quotation by Breton and a selection of contradictory statements by Aragon. To define the revolutionary dimension of poetry, Cahun contrasted poems that were dependent on a directed representation, where content sought immediate action, with poems expressing the activity of the mind, whose latent content was "fatally revolutionary"—although its effectiveness could only be indirect, as witnessed by the history of modern poetry from symbolism to surrealism. The entire second half of the text was a critique of Aragon's position and developed the themes set out in *Misère de la poésie*. Her conclusions about poetry could apply equally to the photographs and objects she produced at the time: beyond what she projected of her own fantasies into her work, it was truly within the thoughts of the viewer that their indirect action would resonate. The singularity of these images came from Cahun's ability to create juxtapositions of ordinary objects, transforming them into fantastic or marvelous miniature theater or into fairy-like, incongruous creatures. The illustrations she provided, for example, for *Le Cœur de Pic,* a collection of texts for children by Lise Deharme that was published in 1937, are proof of an elaboration as complex as the photomontages for *Aveux non avenus* created in 1930 with her companion Moore: each element was transformed by what surrounded it, gaining in polysemy and enigmatic presence and enjoying a veritable transfiguration. The portraits she made of her friends (Desnos, Michaux, Breton, Jacqueline Lamba) revealed, without recourse to any insistent dramatization but possibly by means of a play of superimpressions, the aura of each individual and the atmosphere that reigned in their presence. As for her self-portraits, often extremely cruel, they explored facets of a shifting personality, giving shape to multiple versions of possible femininity or androgyny—suggestions that were disconcerting and intriguing, and fascinating all the while, for they went far beyond usual conceptions of the body or the female face.[84] Whatever domain she chose to work in, Cahun produced images of an irreplaceable intensity.

In 1930 Jacques Hérold, a painter of Romanian origin, arrived in Paris, where he made a living doing odd jobs. He noticed a painting by Tanguy in a gallery, and it revealed to him "an unknown world"; through Tanguy he would be introduced to the group in 1933. But he initially preferred to refrain from the collective activities and would not be truly integrated until 1938. Through his work in relative isolation he developed a quest for the internal structure of things, which was magically effective, in keeping with an event that he had experienced years earlier in the working-class neighborhoods of Bucharest: "I found myself facing a house which was sinking into the ground; its windows were already half-buried. I set up my things on the opposite side of the road, and began to paint the house. While I was painting, the paint itself began to run, because I was sitting right in the sun. Then, out of the house came an old woman, shouting. When she saw my painting, her shouts got even louder: 'They want to destroy my house! They want to kick me out!' And she went after me, furious."[85] A composition like *Le Germe de la nuit* (1937) reveals its theme solely through the colored glistening of a labyrinthine space: the "night" invoked is rather more a secretive mood than the opposite of day, while the interweaving of fabrics that seem deliberately muscular suggests a veritable coenaesthesia.

3

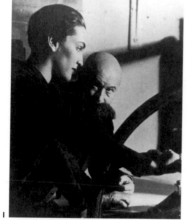

4

5

1

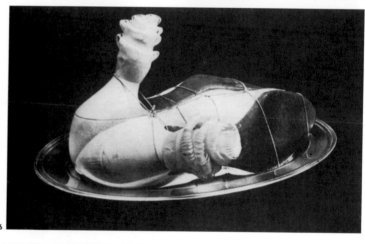

6

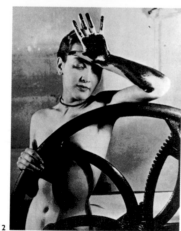

2

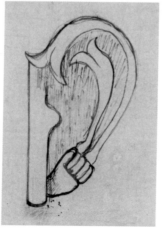

7

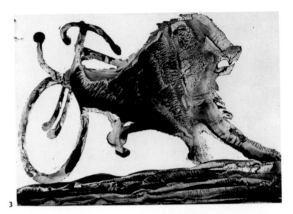

3

1

2

4

Meret Oppenheim, after meeting Arp and Giacometti (in 1932 she would draw *L'Oreille de Giacometti,* which was not cast in bronze until 1959), took part in the Salon des Surindépendants in 1933 and joined the surrealist group.[86] Before she was welcomed into the fold, in *Le Cahier d'une écolière* (1930) she posited the mathematically disturbing equation "X = a red rabbit," and in her hotel room composed poems and very free-spirited drawings, often enriched by *objets collés;* she extended her methods to similarly decorated ornate paintings (*L'Anatomie d'une femme morte* [Anatomy of a dead woman] [1934]), which joyfully mingled figurative allusions and abstract shapes. In 1936, Man Ray photographed a series of now-famous portraits exalting her singular beauty ("It did not affect me one way or the other to pose naked. Man Ray had already taken a lot of portraits of me and then he said, 'Do you want to come to Marcoussis' place, I'd like to photograph you naked in front of this machine,' a copper-plate press. It was undoubtedly a spirit of rebellion which drove me to accept that he reproduce it in *Minotaure.* It caused a minor sensation, so I've heard. I learned about it much later.")[87] Max Ernst wrote the preface for her first personal exhibition in Basle; in the meantime she took part in the group's collective events, particularly with her objects, *Le Petit Déjeuner en fourrure,* as well as *Ma gouvernante* (My governess), a pair of white evening shoes with the heels decorated with ruffs of paper and bound with string in a dish like a roast (this object was destroyed by mistake after her exhibition at Ratton's and would be reconstituted at a later date). Objects like this owed as much to anecdotal circumstances as to memories: the cup was covered with fur at a time when Oppenheim was earning a bit of money by selling fur-covered jewelry to Schiaparelli, and the color of the shoes reminded her of a governess dressed in white. These endeavors conveyed a symptomatic ease and freedom: Oppenheim broke very young with all convention, and until 1937, when she returned to Basle, she was carefree and generous in the way she shared what she called—scarcely mindful of feminist demands—the androgyny of thought: "If man, the genius, needs a muse, a feminine spiritual element, for a work to be produced, then the woman, the muse, has need of a genius, of the masculine spiritual element: as it happens man has this touch of the feminine element, and inversely."[88]

A carefree attitude could hardly be said to describe Victor Brauner, whom Tanguy brought along to the Café de la Place Blanche in 1933 after his contributions to the Salon des Surindépendants—definitely a bountiful year—were noticed. Although the Romanian painter had already been in touch with the group in 1927 during a first trip to Paris, it was only after his return in 1930 that the ties became serious. In Romania in 1924 he had published, with Ilarie Voronca and Stephan Roll, the unique issue of the periodical *75HP,* which had a Dada-constructivist slant; in the periodical he announced "the greatest invention of the century," his "pictophone," a sort of geometric abstraction in which words participated by making allusions to machines. But his painting rapidly evolved—while he was drawing illustrations for friends' poetry collections for the Éditions UNU—into what he would call "obsessional images of a nature aggressive to sight and to the eyes in particular," a path he would follow until roughly 1937. This aggressiveness would target human figures—deformed, made of up juxtaposed elements (*Le Déserteur* [The deserter] [1933]), or drawn out in a nightmarish environment (*Le Ver luisant* [The shining worm] [1933])—but it also targeted sight itself, which from 1925 on was partially or totally absent from the portrayal of certain figures (*La Porte* [1932]). The theme reached its culmination in *Le Dernier Voyage* (The

3

1

2

4

1 Stanley William Hayter, *Composition* (1937); mezzotint engraving on copper, 3½ × 6 in. (8.9 × 15.2 cm). Imperial War Museum, London.

2 Stanley William Hayter, *Woman* (1936); soft-ground etching, 4¼ × 4⅓. Private collection, New Zealand.

3 Stanley William Hayter, *Cronos* (1944); soft-ground etching, 16 × 20 in. (40 × 50.3 cm).

4 Stanley William Hayter, *Untitled* (1932); soft-ground etching.

last journey [1937]), where in three spots on the canvas an eye is anywhere but the place it belongs. In 1931 an *Autoportrait* would join this series of works as a premonition: the painter portrayed himself with an eye plucked out—an accident that would actually happen in Dominguez's studio seven years later. This theme allows for multiple interpretations: from the magical eye of the agnostics (Cabalistic signs would appear very early in his work) to a desire for self-punishment; from the psychoanalytical value of the eye to the necessity of closing oneself off from the outside world the better to explore subjectivity and the unconscious. It would seem to correspond, in Brauner's case, to a prophetic dimension of obsession, expressing, as described by Pierre Mabille in "The Painter's Eye" (1939), "the will to choose between ordinary reality where the eye gets its information, and the world opened up by the imagination, which would seem to be known by unconscious faculties."[89]

In 1934 Brauner had his own exhibition at the Galerie Pierre, for which Breton wrote a preface, noting that "desire and fear preside . . . over the game which [the painted figures] play with us, in a very disturbing visual circle where apparition struggles crepuscularly with the appearance" and underlining the importance of *L'Étrange cas de Monsieur K* (The strange case of Mister K.) who, through the more or less repugnant metamorphoses which were inflicted on him, "ceased long ago to make us laugh": nothing proved that this grotesque character, alternately covered in medals or victuals, was on the decline.[90]

It was also a diffuse and disturbing ambiance that seemed to run through the paintings of Richard Oelze. After a spell at the Bauhaus from 1921 to 1925, he lived in Paris from 1933 to 1936 and got in touch with the surrealists, becoming particularly friendly with Ernst, for one thing because of his poor mastery of French but also because there were certain superficial similarities to their artistic process. Richard Oelze's painting belonged to an extension of German romanticism, with his taste for dark and turbulent earth, grottoes, a lack of differentiation between the "background" and the figures, both treated equally in what was almost a monochrome, tones that were deliberately earthy or metallic. But Oelze's universe was far less likable or "light" than that of Ernst at that era; there were undercurrents of dark threats, as well as a turbulence that distorted faces and emptied gazes, or metamorphoses occurring in a viscous medium, in a disturbing silence (*Le Dangereux Désir*). The visionary automatism of the German painter seemed rich in warnings but offered no message, content to show what lay beneath appearances and what might be aroused in what was undoubtedly for Oelze an imminent future.

It was not until 1934 that Kurt Seligmann approached the group. He came to Paris in 1927 and created prints and canvases in which composite figures, whose assembly of heterogeneous elements recalled certain prints of traditional alchemy, mingled with geometric figures. Seligmann was in fact passionately interested in heraldry and traditional sciences, the imagery of which he revived in his series *Protubérances cardiaques* (Cardiac protuberances [1933]) and *Vagabondages héraldiques* (Heraldic wanderings [1934]), using a painstaking technique close to the old schools of printmaking from the Rhine region. Montages of shapes produced in this manner would then lead in a quite natural fashion to objects such as the *Ultra-meuble* from 1938.

Although it was also his objects from 1934–37 that brought a certain fame to Dominguez at that time, one should not forget his strictly pictorial production, which took over in certain cases where the objects conceived were impossible to produce by

1–4 Hans Bellmer, photographs of
The Doll (1935).

5 Hans Bellmer, photograph of *The
Doll* (1937).

any other means than with canvas and oils (*Machine à coudre électro-sexuelle* [Electrosexual sewing machine] [1935]). He had been painting since roughly 1929 and already considered himself a surrealist, although he initially worked independently from the group, organizing an exhibition in 1933 in Santa Cruz de Tenerife with the support of the *Gaceta de arte,* which was, at the time, the periodical most open to new ideas in the Canary Islands. The following year he contacted the Parisian surrealists, organized a collective surrealist exhibition in Santa Cruz, and very quickly came up with the principle of "decalcomania without preconceived objects" or "decalcomania of desire," which Breton would hail as the birth of "absolute" automatism in painting: one would first spread a sheet with gouache, then simply place another sheet over the first by exerting a slight pressure here and there. The exercise could be repeated several times with the same sheet, until the gouache dried. All that was left after that was to interpret the results and find a title. This technique, available to anyone, immediately aroused great enthusiasm, and *Minotaure* number 8 (1936) reproduced decalcomania by Breton and Jacqueline and by Hugnet, Marcel Jean, Dominguez himself, and Tanguy, along with a text by Péret, "Entre chien et loup," which was a poetic transposition of the technique.[91]

During this period, Dominguez's inventiveness was such that his pictorial work, which often manifested a voluntary negligence with regard to the finishing touches of each painting—some parts of which, those that interested him the least no doubt, might even seem botched—moved indifferently from figurative painting to the articulation of geometric shapes, evoking complex spaces, where crystallization was in conflict with the labyrinth of the void. Each canvas was the opportunity for an invasion of reality by an unapologetic dream world, yielding to an unstable and tormented universe, where only rare allusions to the ordinary visible remained.

Ernst would be the one to transfer the possibilities of decalcomania to oil. Numerous works followed, portraying an abundance of luxuriant vegetation, entire unprecedented landscapes and composite figures, equally pleasing or disturbing with their bird heads and their bloated bodies: the broken angles of *Jardins gobe-avions* (Airplane-swallowing gardens [1935]) gave way to the panorama of *La Ville entière* (The entire city [1935–36]) or to forests and foliage, where the powers of frottage were also used to define *Le Jardin des Hespérides* (1935) and the strange *Fêtes de la faim* (Feasts of hunger [1935]).

In 1933, Stanley William Hayter moved his print studio to 17, rue Campagne-Première; a good number of surrealists would pass through this "Studio 17" and be initiated into the techniques of copper-plating, soft varnish, and use of the burin. Tanguy, Giacometti, and Dominguez (*Machine à écrire folle* [1937]) would learn how to obtain specific effects from the plate, as did Miró, Masson, and Picasso. The role Hayter played in initiating others to the technique too often masked the interest of his own pictorial production, in particular from 1934 to 1940, when he was close to the group and took part in some of their collective events (exhibiting an object, e.g.—*Victoire ailée*—at the Galerie Ratton in 1936), both in France and in England. His painting, situated somewhere between predominately organic abstraction, juxtaposing cellular forms and short sticks, and pure automatism of the gesture, was also distinguished by a chromatism that was extraordinarily fresh, even when it made use of an overlapping of flat tints with sharp cutouts, as if they were shaped by an uncertain geometry (*Ophelia* [1936]). Naturally, his etchings from the same period also, thanks to their extraordinary

technical mastery, were proof of a rare ability to portray visions that were anything but rational (*Paysage anthropophage* [Man-eating landscape] [1937]), and were part of a sufficiently complex process that might be seen as the origin of the process explored several years later by Matta and Onslow Ford.

Hans Bellmer would be adopted by the surrealists thanks to the publication of thirteen photographs of his *Poupée* (Doll) in *Minotaure* number 6 (December 1934) that had been given to Breton. At that time he was staying in Paris, and he took part in the group's meetings. "The most captivating impressions of my stay in Paris are of the spiritual atmosphere of the Café de la place Blanche, to such a degree that from now on nothing could be more interesting to me than to receive news from you about the people I met there and their artistic activity," he wrote on his return to Berlin.[92]

The welcome he received from the surrealists was clearly justified by the unique nature of his art and its subversive power. The Doll was not only the subject of her creator's fantasies: the pictures Bellmer took of her also showed that photography could actively participate in a scenario of desire and obsession, which enhanced and multiplied their effect.

The photographs published in *Minotaure* were those of a first "articulated minor," depicted in the process of construction, made of oakum hardened with glue on a metal and wood structure, and the shape of which was refined with a rasp and a wood chisel.[93] An artificial creature, The Doll was suggested perhaps by a performance of Hoffman's *Tales* that Bellmer attended in 1932—he had decided by then to refrain from performing the slightest task that might in one way or another be useful to the state. Within her belly she hides a "panorama," visible through the bellybutton and controlled by a button located on her left breast; the panorama consisted of half a dozen boxes containing tiny objects and tasteless images. The details were not very visible on the illustrations in *Minotaure,* and the problem with this first mannequin, whatever her charm, perverse gentleness, erotic charge, or capacity to submit to sadistic dismemberings—all dimensions enhanced by the way she was displayed, and the play of light and shadow—was her relative stiffness.

After his return to Berlin, it was thanks to the "ball joint" that Bellmer was able to eliminate the rigidity of her torso. The doll was henceforth composed of balls for her belly, torso and double set of legs: this allowed all sorts of positions, even the least plausible or natural—provided they satisfy fantasy. Her easily manipulated body became the material equivalent—or fictively psychological equivalent—of the anagrams for which Bellmer also had a passion. In the existence of her creator, a desire for complete mastery over his relations with others was progressively asserted, along with an ambivalent attitude toward misfortune, simultaneously sought and denounced. The Doll was the support system, and her very passivity also signified a permanent defiance, an experience on the edge, like an echo from a biography obstinately attentive to the most "scandalous" eroticism belonging to the "darkest" aspects of desire, in the line of the Marquis de Sade himself. The second doll was photographed in turn, and some of these photos were colored in by hand; but this time she was placed among objects and real backgrounds, in order that, "full of emotional content but suspicious of being mere representation and fictional reality, [she] would seek in the outside world, in the shock of encounters, absolute proof of her existence. In a word," added Bellmer, who showed that he was completely in keeping with the aim of surrealist objects, "there must be an amalgam between the objective reality of the chair (for example), and the subjective

reality of the doll; an amalgam whose reality is superior, since it is both subjective and objective at once." Photographed in a tree, on a chair, hanging from a doorframe, or thrown onto the ground, her double set of legs arched with hysteria on a kitchen table or her dismembered body sprawled on the stairway, the doll endured various metamorphoses, a few of which were reproduced in Éluard's *Cahiers d'art*. Early in 1936 Éluard, with Henri Parisot and Robert Valençay, examined the possibility of publishing in French the brochure *Die Puppe*, first published in Karlsruhe in 1934, but he also envisaged a series of personal texts, *Jeux vagues de la poupée* (Vague doll games), poems in prose that were not completed until the end of 1938, when Bellmer, harassed by the Nazis, came to settle in Paris.[94]

In Belgium

After his exhibition at the Galerie Goemans with other painters from the group, Magritte returned to Brussels in 1930. In December 1929, he had contributed "Les Mots et les images" (Words and images) to the last issue of *La Révolution surréaliste*, which would later be reprinted in a number of works and catalogs. It was here that one could find the key to the domain the painter was exploring in his series of paintings known under the general title, "L'Usage de la parole." Magritte began the series during his stay in France and would continue to work on it throughout the 1930s, adding other types of production as well.

The formulas evoked and illustrated in "Les Mots et les images" displayed in various ways how an independence between the object represented and its name could be achieved and how a word could be substituted for the image of an object (or inversely); it also described the community of "substance" of words and images in a painting (although they are seen differently), and how an object's image could be replaced by any ordinary shape, and so on. Thus one could pinpoint the different ways in which there could be gaps, or play, between an object, its representative image, its name, and the handwritten (painted) designation of that name, all of which formed a sort of amusing linguistic game, causing a fertile expansion of the arbitrary relation between the signified and the signifier in the word, at the same time as a crisis was instigated in the relation between the signifier and its referent (or the painted image of the signifier—Magritte underlined that "everything tends to make one think that there is little relation between an object and that which represents it," a suggestion that was ironically emphasized by two equivalent drawings of a building, one representing the "real object," the other the "represented object"). Beyond linguistics, thought itself was being interrogated in this manner—the use it could make of words, concepts, and images (plastic and verbal), and the relations that could unite all three of these categories to the things themselves.

Even if it did not lead to this type of reflection, the painting commonly entitled *La Trahison des images* (The treachery of images), created in 1928 or 1929, which shows beneath the carefully painted image of a pipe the inscription "Ceci n'est pas une pipe" (This is not a pipe) may be considered exemplary.[95] In 1928, *L'Usage de la parole* (The use of speech) depicted against a gray background two simple ocher spots with their shadows; each spot was designated by a painted term connected to it by a straight line (not an arrow)—on the one hand, "mirror," on the other, "woman's body." In 1930, *La Clef des songes* (The key to dreams) set in meticulously painted frames six objects

LES MOTS ET LES IMAGES

Un objet ne tient pas tellement à son nom qu'on ne puisse lui en trouver un autre qui lui convienne mieux

Il y a des objets qui se passent de nom :

Un mot ne sert parfois qu'à se désigner soi-même :

Un objet rencontre son image, un objet rencontre son nom. Il arrive que l'image et le nom de cet objet se rencontrent :

Parfois le nom d'un objet tient lieu d'une image :

Un mot peut prendre la place d'un objet dans la réalité :

Une image peut prendre la place d'un mot dans une proposition :

Un objet fait supposer qu'il y en a d'autres derrière lui :

Tout tend à faire penser qu'il y a peu de relation entre un objet et ce qui le représente :

Les mots qui servent à désigner deux objets différents ne montrent pas ce qui peut séparer ces objets l'un de l'autre :

Dans un tableau, les mots sont de la même substance que les images :

On voit autrement les images et les mots dans un tableau :

2

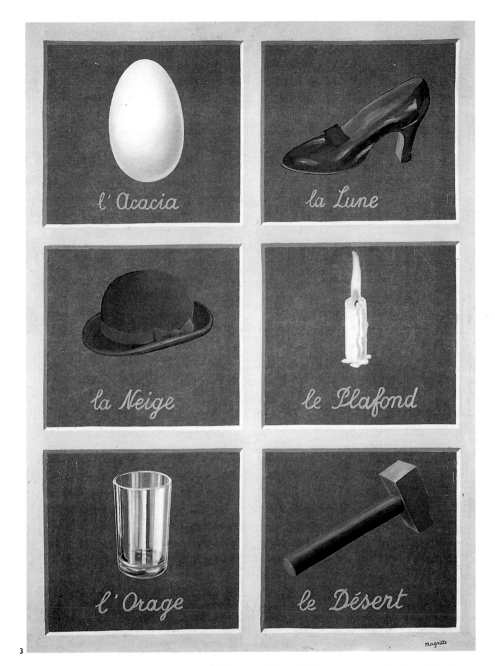

3 René Magritte, *La Clé des songes* (The key to dreams; 1930); oil on canvas, 32²/₅ × 24 in. (81 × 60 cm). Private collection.

4 Paul Magritte, René Magritte, and Marcel Mariën, 1938.

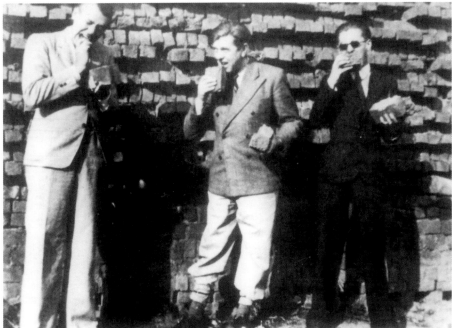

1

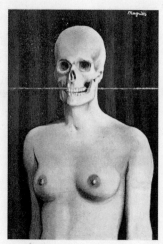

BULLETIN INTERNATIONAL
DU
SURRÉALISME

N° 3 Publié à Bruxelles
par le Groupe surréaliste en Belgique
20 AOUT 1935 PRIX : 1,50 Fr.

LA GACHEUSE

2

underlined by names that were not ordinarily theirs: corresponding to the image of an egg is "Acacia," to a slipper is "the Moon," to a derby hat, "the Snow," to a candle, "the Ceiling," to a glass "the Storm," and to a hammer, "the Desert." Those who were tempted to see nothing more in this painting than a series of translations revealing the meaning of dreamlike images, in the manner of ancient keys to dreams, should immediately feel unsettled, even if they are unaware of the extent of Magritte's knowledge of Freud, because of the relation existing between the painting itself and its title: Could it not be just as misleading as the titles they can see? This could lead to the hypothesis that the union of an image and a word is an invitation to integrate them into a metaphorical game: the egg is like the acacia, the slipper is like the moon, and so on (or the reverse?). But the aim was surely—from the paintings of the series "L'Usage de la parole" on—to understand a metaphor as something quite distinct from a forced relation between two realities, since *Ceci n'est pas une pipe* warned the viewer that because they are painted, neither the egg nor the acacia are realities.

José Pierre, commenting on the formulas suggested by "Les Mots et les images," judiciously likened them to the dialogue between Alice and Humpty Dumpty in *Through the Looking Glass,* which showed that they were in the tradition of games and paradoxes of logic.[96] If one considers, rather, the paintings that Magritte's propositions "justify," one can also interpret them as assigning a highly poetical exercise to one's vision, nothing less than a hallucination based on the double register of the image and the name, hence fairly close, in its singular register, to Rimbaud's *Alchimie du verbe*— "Quite frankly I saw a mosque in the place of a factory, a school of drums made by angels, carriages on the routes of the sky, a drawing room at the bottom of a lake"— where the idea was already to refer to things by something other than their usual name. In the same way, Magritte began by selecting objects in reality (in his work there was no use at all of automatism, and everything depended on a fairly cold and reflected calculation); he gave his objects a form that resembled the real thing but deprived them of their usual name and placed them next to another very legible title. In this way he suggested the creation of a coexistence—in spite of the appearance of the object, on the one hand, and the mental image that normally accompanied the word, on the other —between the two elements in juxtaposition, so that they would eventually merge, if not in the viewer's vision then at least in the mind of the viewer. A merging of this type might not be possible, might constitute, rather, a limitation, before which there is a vacillation, an indecision of the mind that can in fact no longer name what it sees and thus finds itself confronted with the poetic mystery of painting, which Magritte held to be the only possible rival of things themselves. "A view is always 'like' a view, a quasi-view: onto that which is not visible and has nothing but the visible in order to appear. . . . That which is sensitive (to vision, to the naked eye) is the means of transportation, of translation: it is where that which is not visible is transposed."[97] The vision that Magritte offers his viewers is first of all a quasi-vision, one that opens in turn on that which "has only the visible to appear" and cannot therefore be expressed in any other way than through painting—on condition that the painting itself disappear behind what it allows one to visualize, that it be as discreet, anonymous, or "style-less" as possible. The way in which Magritte practices this vision is by eliminating any subjective contribution to the process of creation (material, touch, etc.) and by feigning the aspect of a banal imagery, all the more subversive in that it takes on all the trappings of respectability.[98]

In a talk he gave in 1938, "La Ligne de vie I" (Lifeline I), Magritte, referring to his career, inventoried the means he had used systematically to obtain "an overwhelming poetic effect": the *dépaysement* of the most familiar objects, the transformation of substances, the use of words associated with images, etc.[99] He pointed out that he was also interested in working on objects that, if put together, could shock, not because of their initial differences but, on the contrary, through a more or less well known affinity. This was the case for *Le Modèle rouge* (The red model [1935]), which, he said, made one feel that "the customary union between the human foot and a shoe had something, in actual fact, totally monstrous about it," for *Le Viol* (The rape [1934]), and for *La Gâcheuse* (1935), in which a skull replaced the head of a female model.[100] It also applies to *La Condition humaine I* (1933), which shows a painting on an easel superimposed on a window, through which one can see a landscape, reproduced by the painting: this plays on the exchange between exterior space and interior space with an ironic commentary on their resemblance. The "problem of the window" would find an additional solution in 1934 in *La Clef des champs,* where the shards of the broken window retain the "memory" of the landscape outside. Every object can engender what Magritte calls a "problem," and the pictorial solution depends on three givens: the object itself, "the thing attached to it in the shadow of consciousness," and the light in which this thing must be revealed, but it is in fact through the mediation of this light (the canvas itself) that the object and its "other" can join together to convey the enigma of their interaction.

As soon as he returned to Belgium, Magritte exhibited in Brussels a series of paintings presented by Nougé, who emphasized how "certain paintings reach a level of virulence, and in their own way are the most ardent incitations to revolt. . . . It would be appropriate, and no doubt it will happen,[101] for the creators of these works to be hounded and chastised as hatefully as nowadays, in the most sensitive areas of our society, the communist agitators are hounded and chastised."[102] For Nougé, artists must assume responsibility. It was this principle that caused him, in January 1932, to refrain from signing the protest sent from Paris at the time of the "Aragon affair" and to publish "La Poésie transfigurée" with his friends.[103]

Despite such differences in opinion regarding the way in which relations between poetry or painting and justice were conceived, the Brussels group did take part in the *Violette Nozières* project. The year 1934 saw intense collaboration between the Brussels group and the Parisians: an exhibition about *Minotaure* was held at the Palais des Beaux-Arts in Brussels, and the periodical *Documents 34* published a special issue titled "Surrealist Intervention," prepared by Mesens.[104] To this list, one can add the publication, at the Édtions René Henriquez, of the *Histoire du surréalisme* by Guy Mangeot, which, although it was quite modest—a hundred pages or so—and of which only 130 copies were printed, was the first such volume in the world.[105]

Even if it had not been officially designated as such, the *Minotaure* exhibition could also be considered the first international surrealist exhibition. Organized by the Éditions Skira, it was set up by Mesens, who was careful to make a clear separation between works by the surrealists and those by Braque, Aristide Maillol, Matisse, and others by exhibiting them in different rooms. The director of the Palais des Beaux-Arts where the exhibition was held intervened, moreover, to hide behind a curtain a few "shocking" paintings: Magritte's *Le Viol* and Dalí's *Le Grand masturbateur,* in particular. On the closing day, at the Maison des Huit Heures, which housed the headquarters of the socialist trade unions, Breton gave a speech in which he reiterated the movement's

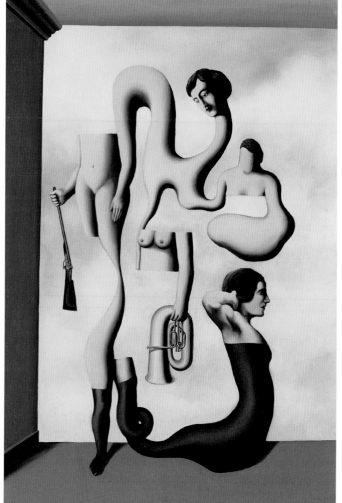

Above: René Magritte, *L'Usage de la parole* (The use of speech; 1928); oil on canvas, 21³/₅ × 29¹/₅ in. (54 × 73 cm). Private collection.

Left: René Magritte, *Les Idées de l'acrobate* (The ideas of the acrobat; 1928); oil on canvas, 46²/₅ × 32²/₅ in. (116 × 81 cm). Staatsgalerie moderner Kunst, Munich.

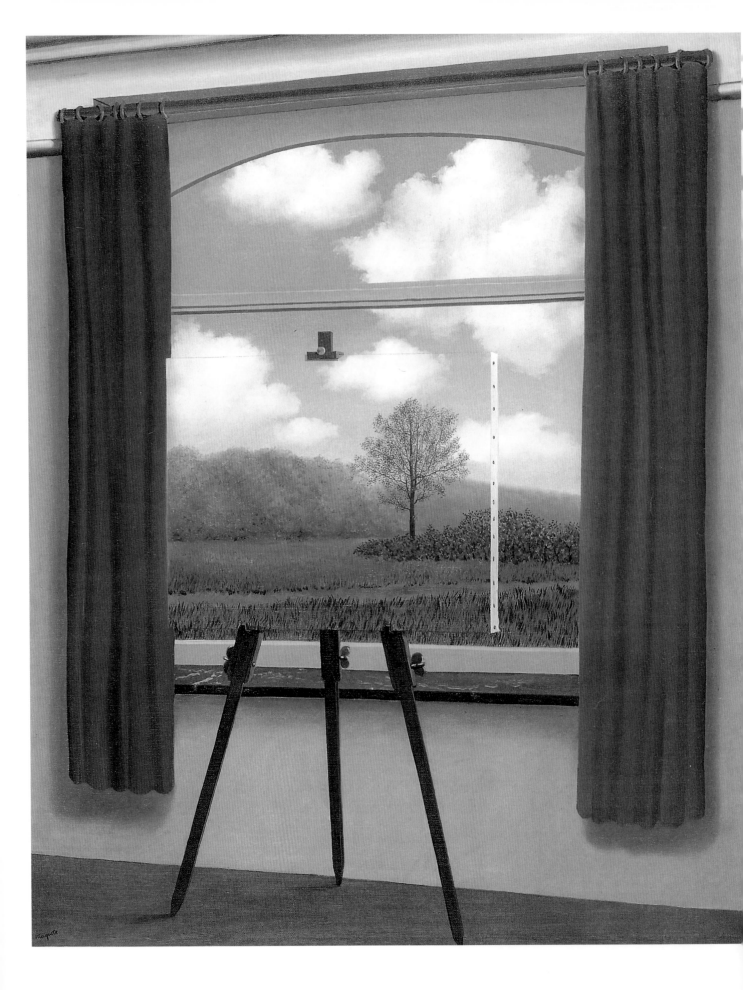

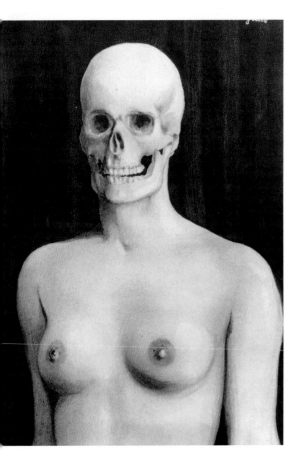

Above: Réné Magritte, *La Gâcheuse* (1935); gouache, 8 × 5²/₅ in. (20.1 × 13.6 cm). (Destroyed.)

Right: René Magritte, *Le Viol* (The rape; 1934); oil on canvas, 29¹/₅ × 21³/₅ in. (73 × 54 cm). The Menil Collection, Houston, Texas.

Opposite page: René Magritte, *La Condition humaine* (The human condition; 1933); oil on canvas, 40 × 32²/₅ in. (100 × 81 cm). Private collection.

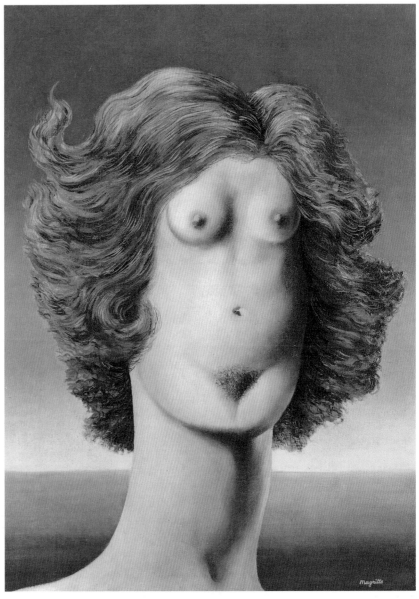

Left: Wilhelm Freddie, *Les Œufs de Giorgio De Chirico* (Giorgio De Chirico's eggs; 1941); oil on canvas, 38⁴/₅ × 34²/₅ in. (97 × 86 cm).

Below: Wilhelm Freddie, *Portrait of Jenny Kammersgaard* (1939); oil on canvas, 40 × 50 in. (100 × 125 cm).

Opposite page: Jindrich Styrsky, *The Bath* (1934); collage, 16²/₅ × 12³/₅ in. (41 × 31.5 cm). Private collection.

Right: Jindrich Styrsky, *The Cuttlefish-Man* (1934); oil on canvas, 40 × 29¹/₅ in. (100 × 73 cm). Bernard Galateau Collection, Paris.

Below: Toyen, *Femme magnétique* (Magnetic woman; 1934); oil on canvas, 40 × 29 in. (100 × 72.5 cm). Bernard Galateau Collection, Paris.

Opposite page: Jindrich Styrsky, *Palmeta* (1931); oil on canvas, 39 × 30 in. (97.8 × 74.7 cm). Moravska Gallery, Brno.

Above: Vitezslav Nezval, *Decalcomania* (1937); India ink on paper, 6 × 8^1/$_5$ in. (15 × 20.5 cm). Private collection, Prague.

Left: Toyen, *Ni cygne, ni lune* (Neither swan nor moon; 1936); collage on paper, 12 × 8^1/$_2$ (29.7 × 21.2 cm). Narodni Gallery, Prague.

principles, insisting, in particular, that the duty of artists and intellectuals was to struggle for the complete liberation of humankind without being subjected to the slightest control of any party.[106] He also underlined the nonexistence of any proletarian art and ended with a denunciation of the fascist threat, "as great in Brussels as in Paris."

It is not surprising, in this context, that "Surrealist Intervention" opened with a political declaration by Magritte, Mesens, Nougé, Louis Scutenaire, and Souris titled "Immediate Action." After concluding that they were not suited to the work that the Communist Party had asked them to do, the declaration demanded the option of elaborating a specific revolutionary action, which included the development of an authentic poetry that would not slip into the working-class mode that characterized the so-called prematurely proletarian literature; the reinforcement of the anti-religious struggle; the eventual recourse to violent methods and anonymity; and contact with workers who had been "abandoned by the militants in the Communist Party" because of the nature of their work, considered too local. This was followed by a reprint of the pamphlets published in Paris on February 10, April 18, and April 24. After this double ideological opening (which served the same purposes as the "À suivre" [To be continued] in Variétés),[107] the rest of the issue—copiously illustrated with photographic reproductions (Valentine Hugo, Balthus's La Rue, Dalí, Giacometti, Man Ray, Magritte, and others), vignettes by Ernst, drawings traced from illustrations for a dictionary by Tanguy, and a drawing by Magritte in homage to the Papin sisters—was balanced by poetry (Éluard, Péret, examples of the game of questions and answers entitled "Dialogue in 1934," an homage to Sade by Heine, Hugnet, Mesens, Tzara, Char, Henri Pastoureau, Scutenaire, Rosey, Marcenac, Maurice Henry, and Etienne Lero), more theoretical texts ("Equation of the Found Object," by Breton, "Poetical Evidence," by Éluard, "Analysis of two works by Raymond Roussel," by Jean Levy [the future Jean Ferry], reviews by Crevel of a few recent works, "Systematization and Determination," by Caillois, an article by Max Ernst calling for the extension of the frenzy of interpretation) and other contributions primarily political in nature and focused on the condemnation of fascism in all its aspects, signed by Jehan Mayoux and Yoyotte. At the end, Nougé delighted in the misfortune related in the press "which arose concurrently with the death of Albert I" (Marcel Mariën); with his collaborators from Brussels he denounced the latest "Labor Project" adopted in Belgium.

In November, the second issue of Documents 34 once again included a good number of contributions from the surrealists: Mesens, Scutenaire, Marcel Lecomte, Nougé, as well as Gisèle Prassinos, Breton, Péret, Crevel, and Léo Malet. In his introduction, Mesens provided both an overview of past activity and a program: emphasizing the absolute antiopportunism that had been the ongoing behavior of his friends, he allowed for the existence of "possibilities for the penetration of surrealism among the masses" and reaffirmed not only the revolutionary project but also the principle of freely criticizing Soviet productions. But in 1935 the periodical took on a more narrowly political focus, and the surrealists contributed less often. Contact was not broken altogether, however, insofar as Documents 35 sought to unite all the left-wing intellectuals who were concerned about the threat of fascism. In this capacity, Mesens, Lecomte, and Souris joined in the effort, and Mesens and Lecomte published an important article in the periodical: "Movement of Thought in the Revolution," in which they asserted their hostility toward socialist realism, showing that the understanding between surrealists and communists was not impossible since in countries other than

France or Belgium, particularly in Czechoslovakia, mutual respect existed. Finally, they declared that a "Marxist aesthetic" would be as despicable as any other, and the role of the surrealists consisted in struggling for the "unconditional defense of invention and discovery in Reality."

In January 1935, Souris was excluded from the Surrealist Group of Belgium when he announced his participation, as orchestra conductor, in a "Mass for Artists." Among the signatories of the text "Le Domestique zelé" (The zealous servant), which marked the split, were members of the group Rupture, which had formed somewhat earlier in Hainaut: Achille Chavée, Fernand Dumont, Marcel Havrenne, and Max Servais.[108] Their first collaboration with the group from Brussels was with the text "Le Couteau dans la plaie" (Knife in the wound) published in August 1935 as an opening to the third issue of the *Bulletin international du surréalisme;* this article, like the pamphlet in Paris entitled *Du temps que les surréalistes avaient raison,* finalized the break with the Communist Party.[109]

Rupture was founded in March 1934 in Haine-Saint-Paul; around Chavée, the only Belgian poet who favored automatism, were members whose political sympathies ranged from communism to anarchy (the latter in Marcel Dieu's case, in particular, who was the future representative of the Fédération Internationale de l'Art Révolutionnaire Indépendant in Belgium). There was even a writer who was also a miner, Constant Malva, who was perhaps the best equipped among them to be intimately acquainted with the problems of proletarian literature.

In 1935, Rupture had already established some ties with the group from Brussels and was responsible for two important events: a surrealist exhibition at La Louvière (organized by Mesens, in fact), and the publication of a first "annual journal": *Mauvais temps.* Along with a speech by Mesens, texts read by Irène Hamoir (who would soon use the pen name Irine) and the performance of "A Few Airs by Clarisse Juranville" by Souris, the exhibition grouped works of major artists from the movement, as well as those by Paul Colinet, Max Servais, Camille Bryen, and Raoul Michelet.[110] As for *Mauvais temps,* after a group foreword reasserting the adoption of the principles of surrealism and suggesting "the solution to a dynamically desperate despair which better than any other expresses the moral attitude absolutely required during a violently intermediary period," came the habitual alternation of commentary (Marcel Havrenne on Lautréamont, André Lorent on the political context) and poetry (Chavée, Dumont, Marcel Dieu).[111] Breton hoped for a more regular publication: "Politically in particular, I think the time has come to speak very loudly and to make ourselves heard by all," he wrote in 1935 to Dumont, but that would remain the only issue of the periodical.

Politically, indeed, Rupture and Paris would agree: Chavée set off on the side of the Trotskyists to fight in Spain. But he returned as a Stalinist.

Internationalization

Belgium was far from being the only country where surrealism was prominent during the 1930s, and in *Cahiers d'art* in 1935, Péret would take stock of how well it was read abroad in an article entitled "International Surrealism."[112] The movement, in his opinion, "should, to keep from drying out, go beyond the narrow framework of this country's borders and adopt an international aspect."[113] This international impact would be apparent in subsequent issues of *Le Surréalisme ASDLR* and then of *Minotaure.*

1

NADREALIZAM
DANAS I OVDE

JANUAR 1932 — BEOGRAD
BROJ 2 — GODINA II

AUTOKRITIKA

NA OVOM BROJU SU SARADJIVALI:

André BRETON, René CHAR, René CREVEL, Salvador DALI, Paul ELUARD, Max ERNST, Borde JOVANOVIĆ, Borđe KOSTIĆ, Koča POPOVIĆ, Marko RISTIĆ, Yves TANGUY, Tristan TZARA, Aleksandar VUČO, Vane ŽIVADINOVIĆ-BOR, ŽIVANOVIĆ-NOE.

STOGODIŠNJICA HEGELOVE SMRTI:
KARL MARX — PRILOG ZA KRITIKU HE
GELOVE FILOZOFIJE PRAVA / PREGLED
ŠTAMPE ● AUTOKRITIKA NADREALIZ
MA: NADREALIZAM DANAS / O JED
NOJ IMPLICITNOJ AUTOKRITICI / NE
KOLIKO REČI POVODOM »NACRTA ZA
JEDNU FENOMENOLOGIJU IRACIONAL
NOG« ● POKUŠAJI SIMULACIJA: GRA
DANSKOG OPTIMIZMA / SUJEVERJA /
MAŠTANJA ● ANKETE: DA LI JE HU
MOR MORALAN STAV / SEDAM PITA
NJA O ŽELJI UPUĆENIH SVIMA I SVA
KOME ● PESME I TEKSTOVI ● SNO
VI NA POSLU: IZVRNUTI SAN / SNOVI
O MENI / SIMBOLI NA JAVI ● HRONI
KA LUMBAGA ILI SLAVENSKA BINDA /
VIDNO POLJE ● SADA I OVDE: BELE
ŠKA O »KNEZU SRPSKIH PESNIKA« /
PROTIV MODERNISTIČKE KNJIŽEVNO
STI / PSIHOANALIZA ILI INDIVIDUALNA
PSIHOLOGIJA / POVODOM SLUČAJA
MILANA NERANDŽIĆA / I TAKO DALJE

5

2

L'impossible NEMOGUĆE Немогуће L'IMP SS BLE

НЕМОГУЋЕ

ЧЕЉУСТ ДИЈАЛЕКТИКЕ
БУДИЛНИК
МИСТЕРИЈА ЉУДСКЕ ГЛАВЕ
ДРУШТВЕНИ ЖИВОТ У 1930

ПИСМА И ОДГОВОРИ
ПЕСМЕ, ЧЛАНЦИ
ТЕКСТОВИ, СНОВИ
ГОВОРИ, ПИСМА
ИЛУСТРАЦИЈЕ

Jean Arp
Hans Bellmer
Luis Buñuel
André Breton
René Char
Salvador Dalí
Paul Eluard
Max Ernst
Benjamin Péret

НАДРЕАЛИСТИЧКА ИЗДАЊА
БЕОГРАД
1930

6

konkretion

interskandinavisk tidsskrift for kunsten af i dag

marcel jean: „rendez-vous demain"

specialnummer:
surrealismen i paris

marts
1936 nr. 5-6

københavn oslo stockholm

i kommission hos fischers forlag, københavn

3

WILHELM FREDDIE

4

In Belgrade, the Yugoslav surrealists brought out their first collective publication in May 1930. It was the almanac *Nemoguce* (The impossible), which came in the wake of earlier modernist periodicals (in particular, *Putevi* [1922–24] and *Svedocantsvo* [1924–25]) and after a preliminary declaration signed by thirteen artists. *Nemoguce* collected dreams, automatic texts, and the results of surveys on concepts of the family, defeat, dreams, despair, suicide, and so on, accompanied by reproductions of paintings, collages, and photomontages. The photomontages highlighted the originality of surrealism in Belgrade, through the relations they maintained with expressionism and zenithism (a Yugoslav version of constructivism). There were also, in *Nemoguce,* translations of texts by Breton, Éluard, and Péret.

In 1931, Marko Ristic and Kosta Popovic published their *Sketch for a Phenomenology of the Irrational,* which asserted that the irrational corresponds to expressions of the unconscious, just as the rational corresponds to expressions of consciousness, and then pointed out that recourse to psychoanalysis must occur in a materialist direction, in such a way as to elaborate an "ultraconsciousness," in which consciousness will be enriched by the expressions of its opposite.

Then came the periodical *NDO* (*Nadrealizam danas i ovde* [Surrealism today and here]) which, in its three issues (June 1931–June 1932) went deeper into the principles that had been outlined, notably thanks to surveys on humor and on desire (in which many surrealists from France took part: Breton, Éluard, Crevel, Dalí) but also through simulations—of bourgeois optimism, of superstition—and an article by Vane Bor on the relations between psychoanalysis and dialectical materialism.

This effervescence, which on several occasions found an outlet in *Le Surréalisme ASDLR,* was interrupted, however, by the advent in 1932 of a monarchical dictatorship: several members of the Belgrade group were arrested, and Crevel could do little more than alert the readers of *Le Surréalisme ASDLR* (no. 5): "Yugoslav surrealists are doing forced labor."

In 1935, Cesar Moro returned to Peru; he had lived in Paris since 1925 and contributed to *Violette Nozières.* Upon returning to Peru, he took part in a surrealist exhibition—the first in Latin America, organized at the Alcedo Academy in Lima; this marked the beginning of a truly authentic surrealist activity. Moro used several pseudonyms for the collages and drawings he produced; he grouped Chilean and Peruvian artists, and expanded the scope of the event with a controversy against Vicente Huidobro, who was accused of plagiarism. The beginning of the war in Spain then prompted the publication of *Cadre* (Committee of Friends of the Spanish Republic), but Westphalen, Moro's closest collaborator and author of a poetry collection *Les Îles étranges,* which came out in 1933, was thrown into prison. At the end of 1938, Moro and Westphalen published the only issue of the periodical *El uso de la palabra,* where translations of Breton, Péret, Éluard, and Mabille were compiled; but Moro later went into exile in Mexico, and surrealist activity in Peru became dormant.

In January 1935, the exhibition *International Kunstudstilling. Kubisme. Surrealisme* was held in Copenhagen; the choice of participants was finalized by Breton (who wrote the preface), Ernst and the Swede Erik Olson. Olson, along with his friends from the "Halmstadt group," had evolved from constructivism to surrealism (he had an exhibit with the surrealist group at the Surindépendants in 1933). His acquaintance with Vilhelm Bjerke-Petersen in 1934 was a determining factor leading to the decision to hold this exhibition, in which not only the main artists of the group were featured but also a

1

2

4

3

5

1 Karel Teige, *The Departure for Cythera* (1923–24); collage, 10³/₄ × 9 in. (26.7 × 22.2 cm). Municipal Gallery, Prague.

2 Karel Teige, *Untitled* (1942); collage, 16²/₅ × 9⁴/₅ in. (41 × 24.5 cm).

3 Jindrich Styrsky, *Two Beautiful Legs* (1934); collage, 19¹/₅ × 14 in. (48 × 35 cm), Radovan Ivsic Collection, Paris.

4 Jindrich Styrsky, *Untitled* (ca. 1934); collage, 16 × 9³/₅ in. (40 × 24 cm). Private collection.

5 Jindrich Styrsky, *The American Cardinal* (1941); collage, 16¹/₅ × 11³/₅ in. (40.5 × 29 cm). Private collection, Paris.

6 Jindrich Styrsky, *Untitled* (1934); collage, 13³/₅ × 9¹/₅ in. (34 × 23 cm). Private collection.

7 Toyen, *Untitled* (1922); oil on canvas, 15²/₅ × 20¹/₅ in. (38.5 × 50.5 cm). Radovan Ivsic Collection, Paris.

8 Toyen, *Untitled* (1937); India ink and watercolors, 3⁴/5 × 5⁴/₅ in. (9.5 × 14.5 cm). Radovan Ivsic Collection, Paris.

9 Toyen, *Untitled* (1932); watercolors, 3²/₅ × 5¹/₃ in. (8.5 × 13.2 cm). Private collection.

10

T. - V RÁJI EXOTŮ
(Kresba z r. 1931)
11

7

13

8

9

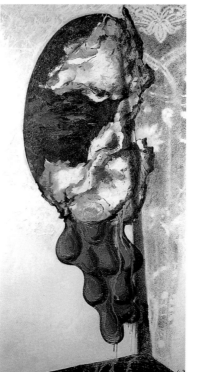

12

10 Jindrich Styrsky, *Titubni list* (1932); India ink, 5⁴/₅ × 5⁴/₅ in. (14.5 × 14.5 cm). Private collection.

11 Toyen, colored drawing for the *Eroticka Revue* (1930–31). Private collection.

12 Jindrich Styrsky, *The Melting Doll* (1934); oil on canvas, 43²/₅ × 23³/₅ (108.5 × 59 cm). Bernard Galateau Collection, Paris.

13 Toyen, *Young Girl Dreaming* (1930); drawing, 8 × 6¹/₅ in (20 × 17 cm). Private collection.

dozen Scandinavian artists, among them Nilsson, Stellan Mörner, Henry Heerup, Erik Olson, and Bjerke-Petersen themselves, as well as Freddie, to whom Bjerke-Petersen devoted a monograph at the same time.

In September, Bjerke-Petersen took over the editorial chair at the periodical *Konkretion,* whose last issue, number 5–6 (March 1936), was devoted exclusively to French surrealism, while earlier issues gave accounts of their collaboration with surrealists in London (in particular, David Gascoyne and Herbert Read). As for Freddie, he undoubtedly represented the most intransigent figure of Scandinavian surrealism (the members of the Halmstadt group, Olson to begin with, would evolve in the 1940s toward a mysticism that no longer had anything to do with surrealism). Freddie developed an intense aggressiveness—sexual, in particular—in his painting and applied a technique, which had also been part of constructivism, of extreme precision at the service of the most disturbing imagery. In 1937 Freddie displayed works under the title "Sex-Surreal," which were so virulent that the press began a campaign against him. His exhibition was closed down by the police, three of his works were seized as "pornographic" (they would later be kept for thirty years in the museum of criminology in Copenhagen), and he was sentenced to ten days in prison. Sixty years on, his bust *Sex-Paralysappeal* (1936) has lost none of its impact.

Relations between Paris and Prague were of another dimension altogether. In a letter on May 10, 1933, published in *Surréalisme ASDLR,* the members of the Devetsil association, encouraged by the poet Vitezslav Nezval, joined the surrealist movement.

The multidisciplinary association Devetsil (artistic union), created in 1920, initially favored "proletarian" poetry, and a sort of magical realism in painting. Very quickly, however, the "Poetism" advocated by Karel Teige and Josef Sima became predominant, and the best representatives of this trend were Toyen and Jindrich Styrsky, whose paintings and photomontages combined a rigorous construction with an unchained imagination. The concepts maintained by Devetsil included some principles of constructivism in parallel with poetism and were particularly effective in applied art, architecture, and typography (notably, the periodicals *Red* and *Disk*). The association had sustained contacts with the major trends in the European avant-garde, but at the end of the 1920s, the interest in surrealism became overriding, given the influence of Nezval and Teige; Crevel kept them informed of the activities of the group in Paris and the difficulties of collaborating with the Communist Party. In 1932, an important exhibition, *Poetry 32,* united in Prague both Czechs (Sima, Toyen, Styrsky, and Hoffmeister) and Parisian surrealists (Dalí, Ernst, Miró, Tanguy, De Chirico, and Klee). As for the libertarian spirit shared by both the French surrealists and their counterparts in Prague, it was largely present in the *Eroticka revue* (three issues in limited print runs, between 150 and 250 copies, from 1930 to 1933), published by Styrsky with contributions by Toyen, Hoffmeister, and a dozen of their friends, and with reproductions of Japanese etchings and works by Félicien Rops and Aubrey Beardsley. The copyright page indicated, however, that the Czech censorship was not very liberal at the time: it stated that the *Eroticka revue* must not be sold in public, or exhibited, or lent, or distributed, or become part of any public collection.

In March 1934, the official announcement of the founding of the surrealist group of Czechoslovakia was made, with Teige as its principal theoretician. Their aim was to develop a widespread activity in all sectors, thanks not only to exhibitions and publications but also to the presence of the poet Konstantin Biebl, the theatre director Jin-

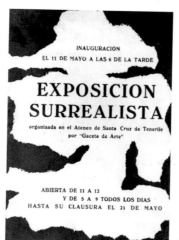

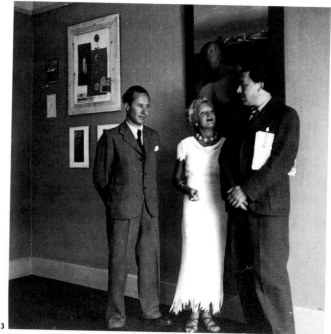

INAUGURACION
EL 11 DE MAYO A LAS 6 DE LA TARDE

EXPOSICION SURREALISTA

organizada en el Ateneo de Santa Cruz de Tenerife
por "Gaceta de Arte"

ABIERTA DE 11 A 12
Y DE 5 A 9 TODOS LOS DIAS
HASTA SU CLAUSURA EL 21 DE MAYO

1

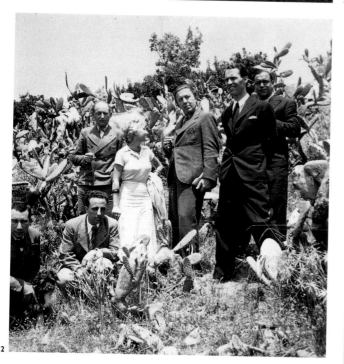

2

Bulletin international du surréalisme

Prague, le 9 Avril 1935.
Praha, 9. duben 1935.

Vydala Skupina surrealistů
v ČSR.
Publié par le Groupe surréaliste
en Tchécoslovaquie.

Cena 3 Kč
Prix 2 fr.

Štyrský: Sen 1935 - Le Rêve 1935

Mezinárodní buletin surrealismu

Ode dne, kdy našel surrealismus v dialektické myšlence jednoty vnějšího a vnitřního světa základ k neustálému vyrovnávání oné houpačky, kterou je člověk vzhledem ke skutečnému světu a k sobě samotnému, jakmile přestal viděti hranice mezi bděním a spánkem, vědomím a nevědomím, skutečností a snem, objektivitou a subjektivitou, jak by mohl ještě viděti hranice mezi národy a jazyky, jak by mohl nevstoupit prakticky do sféry internacionální aktivity, když tam ve skutečnosti směřoval odevždy poznáním a vyvrácením umělých antinomií.

Lidská psycha je internacionální, právě tak jako podmínky k plnému poznání rozvití a přeměně lidského individua jsou internacionální.

Hle, sen, ve kterém jsme procházeli v lese představ, které opustily slova a jež jsou našimi představami, v lese představ beze slov. Čím je nám dnes slovo, než-li nositelem představy a myšlenky, která je všelidská a jež se dá transponovati stejně snadno z jazyka do jazyka jako melodie z nástroje do nástroje. Už nezáleží na tom, jak tento nástroj zní, od chvíle, kdy zní už ne on, nýbrž světlo, jímž je rozehráván.

Dès lors que le surréalisme a trouvé, dans l'idée dialectique de l'unité du monde extérieur et du monde intérieur, le moyen d'équilibrer d'une manière permanente la balance qu'est l'homme en face du monde réel et de lui-même; dès lors qu'il a cessé de croire à l'existence d'une barrière entre la veille et le sommeil, entre le conscient et l'inconscient, entre la réalité et le rêve, entre l'objectivité et la subjectivité, comment pourrait-il tenir compte des frontières qui séparent encore les nations et les langues, comment pourrait-il ne pas entrer, pratiquement dans la sphère de l'activité internationale vers laquelle il s'est orienté depuis toujours par sa reconnaissance en même temps que par sa négation des antinomies artificielles ?

Le psychisme humain est international aussi bien que sont internationales les conditions d'une connaissance parfaite du devenir et du changement de l'individu humain.

Tel est le rêve où nous nous comportons en passants dans une forêt de représentations qui ont abandonné les mots et qui demeurent n o s représentations, dans la forêt des représentations sans mots. Que peuvent aujourd'hui être pour nous les mots sinon les véhicules de la représentation et de la pensée, représentation et pensée qui sont universellement humaines, qui sont transposables d'une langue à l'autre aussi facilement qu'une mélodie peut-être trans-

1

4

drich Honzl, and even a composer, Jaroslav Jezek. Moreover, the group established relations with the Prague Linguistic Circle, in which Roman Jakobson was a participant.

Very quickly a project for a periodical, *Surrealismus,* was under way, with Nezval in charge (its sole issue would not be published until February 1936). Nezval intended to work on the irrational elements of fascism, the threat of which was felt particularly keenly in Czechoslovakia. A translation of *Vases communicants* was planned, and the Prague group voiced its total agreement with its analysis and with the positions laid down in the *Second Manifesto.* At the end of 1934, Nezval invited Breton to give a series of talks in Prague. In January 1935, the first exhibition of the Czech surrealist group was held (Styrsky, Toyen, Tadeusz Makovsky). Breton eventually came to Prague from March 27 to April 10, together with Jacqueline, Paul and Nusch Éluard and Sima. He took the time to discover the six-winged castle of the Sterntiergarten park and the signs rich in esoteric symbols that made the city the "magical capital of all of Europe." He gave four speeches, two of which were particularly significant: "The Surrealist Situation of the Object, the Situation of the Surrealist Object" and "The Political Position of Art Today."[114] The first speech referred to Hegel, to emphasize the role of objective humor and objective chance in an art liberated from all inward withdrawal of the subject on itself, and developed the notion of the "object-poem"; the second evoked examples from Courbet and Rimbaud and resisted any enslavement of art to propaganda, inviting the artist, who must renounce his or her personality, to explore the "collective treasure" in order to assert the "invincible strength of that which must be." Éluard gave a talk on surrealist poetry, and Teige and Nezval also took part in the public evening organized at the headquarters of the Left Front. The quality of the attention shown to these declarations won the enthusiasm of the visitors from Paris, as described by Éluard: the radiance and influence of the Czech surrealists "are such that they are obliged to restrain or discourage them. Their situation in the Communist Party is exceptional. Teige edits the only communist periodical in Czechoslovakia. In every issue there are one or more articles about surrealism."[115]

The Czech communists really did listen attentively to what the surrealists had to say, and this was very surprising to the French, who were used to considerable reticence and prevarication. When the translation of *Vases communicants* was published, Zavis Kalandra wrote, for example, that "the Marxist critics who condemn surrealism and refuse its most mature project, that is Breton's *Vases communicants,* would, despite everything which is incomprehensible in their attitude and despite their errors . . . be entitled to do so if in his study André Breton had shown us the human individual in his 'eternal' subjectivity, thus separating him from the individual subjected to conditions of a historical and social nature, in the process of perpetual social change. But Breton never made such a mistake. *Les Vases communicants* is proof of quite the contrary."[116]

After Breton and Éluard had left, the interest in surrealism was far from waning: Honzl would use décors by Styrsky to stage Breton and Aragon's *Le Trésor des jésuites,* the homage written in 1928 to the cinema in episodes and to Musidora. And on a political level, it was not until 1938 that Teige was obliged, in *Le Surréalisme à contre-courant* (Surrealism against the tide), to denounce the misdeeds and impasses of the cultural policy of the local Communist Party.

In 1935 the *International Exhibition of Surrealism* organized by the *Gaceta de arte* and the Cercle des Beaux-Arts was held at the Ateneo of Santa Cruz de Tenerife. It is most likely that Dominguez began to prepare it in August 1934, and it received broad coverage in

the local press, as did the visit by Breton, Jacqueline, and Péret, who gave talks on "art and politics" and "the Marxist analysis of religion."[117] Breton gave an important interview to the socialist cultural periodical *Indice!;* he asserted that "the social element, by virtue of the considerable emotive factor which attaches to it nowadays, can play a role in painting, but it must also be assimilated by the painting and must not intervene in a way which seems added on."[118] In this regard he quoted from a recent opinion voiced by Picasso, who deemed that the "emblematic force" of a hammer and sickle would be more obvious "if the handles of the two tools were one, that one hand could grasp."

Under pressure from Catholic groups, a screening of *L'Âge d'or* was forbidden.[119] But the welcome of the Canary Island surrealists, progressively grouped around Westerdhal and the *Gaceta de arte* (Lopez Torres, Cabrera, Agustin Espinosa—president of the Ateneo) was especially warm; on a political level, they seemed to be in total agreement in their opposition to Stalinism and fascism.

The following year, the civil war took one of its first victims among the surrealists: Lopez Torres was slain by the Falangist militia, who then threw his body into the sea.

Several issues of the *Bulletin international du surréalisme* were proof of this international dimension. The first, dated April 9, 1935, was published in Prague, in a bilingual Czech-French edition. It included a text cosigned by French and Czech surrealists stating the aims and conditions for the formation of the Prague group and quoting a number of excerpts from texts and declarations of the various signatories. Number 2, published in October 1935, came out in Santa Cruz de Tenerife; it was also entirely bilingual, illustrated by Dominguez and Picasso. Breton, Péret, and members of the Canary Islands group contributed to show how important the surrealist movement was in the Spanish cultural landscape and in response to the fascist threat. This initial declaration was reinforced, according to the principle already applied in the Czech edition, by excerpts from Breton's speech and his interview in *Indice!* The third issue, dated August 20, 1935, came out in Brussels, illustrated by Magritte and Max Servais. After "Le Couteau dans la plaie"—cosigned by all the members of the Surrealist Group of Belgium, which attacked the sophism according to which the "nonfascist" countries were guarantors of peace and the proletarian revolution—it was entirely devoted to the speech Breton gave at the Conference of Writers for the Defense of Culture. Number 4 would be published in London, in September 1936.

Break with the AEAR

"I believe that Prague is the door to Moscow for us," wrote Éluard, still unaware that this door would open, before too long, to him alone. In the meantime the illustrated program of a "Systematic Cycle of Conferences on the Latest Positions in Surrealism" was distributed, its conception no doubt encouraged by the success of the talks given in Prague and the Canary Islands, with the advantage of informing the public about certain areas of research that could not be detailed in *Minotaure.* The program covered not only the artistic and poetic dimension of surrealism but also the question of its relation with middle-class society, objective chance and its role as a "pivot of the surrealist concept of life." It also examined the place given over to the surrealist object in daily life—Malet, for example, would create a presentation of posters cut into ribbons.[120] These talks were never given, however, perhaps because of a lack of sufficient subscribers to the cycle.[121]

When the AEAR announced that an International Conference for the Defense of Culture would be held in Paris in June, the surrealists decided to lend their support to the project, although its outline seemed a bit vague: from their point of view, "culture" was of no interest except through its future evolution, and that future would require a radical transformation of society through the revolution. This difference in interpretation indicated that the AEAR and the communists had hardly changed their stance in over a year and that the surrealists, as in February and March of 1934, were in danger of overwhelming them with their demands. The points they asked to be included in the conference's agenda confirmed this: "The right to pursue in literature as in art research into new means of expression; the right for writers and artists to probe the human problem in all its forms; the demand for the freedom of the subject; the refusal to judge the quality of a work on the basis of the size of its audience; resistance to all undertakings that would limit the field of observation and action of those who aspire to intellectual creation"—all of which were among their constant concerns.[122] Although the surrealists were left out of the preparations for the conference, they did get a chance to state their point of view: it was decided that Breton would take the floor as the representative of the other members of the group (Éluard, Hugnet, and Péret).

A few days before the opening of the conference, Breton, together with his wife, Péret, Toyen, Nezval, and Styrsky, ran into Ilya Ehrenburg near the Closerie des Lilas. Ehrenburg had lavishly insulted the surrealists in his work *Vus par un écrivain de l'U.R.S.S.* (Seen by a writer from the USSR): "The surrealists want to adopt Hegel and Marx and the Revolution, but what they refuse to do is to work. They have their occupations. They study pederasty and dreams, for example. One will spend his time eating up his inheritance, another his wife's dowry," and so on. Nezval gave the following account of their meeting:

> "I've come to settle up with you, Sir," said [Breton], stopping Ehrenburg in the middle of the street.
> "Who are you, sir?" asked Ehrenburg.
> "I am André Breton."
> "Who?"
>
> André Breton repeated his name several times, and each time he associated it with one of the epithets with which Ehrenburg had honored him in his lying pamphlet against surrealism. Each one of these presentations was followed by a slap on the face. Then Péret stepped up to settle his own accounts with the journalist. Ehrenburg did not resist. He stood there, protecting his face with his hand. "You were wrong to do that!" he cried once my friends had done with him.[123]

The evening ended at Man Ray's place, where the text that Breton had prepared for the Conference was read, to the approval of all present; according to Nezval "everyone gawped when they heard about the incident."

They did not reckon with Ehrenburg's influence, or that of the Soviet delegation, on the organizers of the conference: the Soviets threatened to withdraw, and Breton was informed that the committee no longer had the intention of inviting him to the session. Crevel was torn more than ever between the Communist Party and the surrealist group, and even if he had distanced himself from the group of late, he considered

CONTRE-ATTAQUE

Union de lutte des Intellectuels Révolutionnaires

I. — RÉSOLUTION

1. — Violemment hostiles à toute tendance, quelque forme qu'elle prenne, captant la Révolution au bénéfice des idées de nation ou de patrie, nous nous adressons à tous ceux qui, par tous les moyens et sans réserve, sont résolus à abattre l'autorité capitaliste et ses institutions politiciennes.

2. — Décidés à réussir et non à discuter, nous considérons comme éliminé quiconque est incapable, oubliant une phraséologie politique sans issue, de passer à des considérations réalistes.

3. — Nous affirmons que le régime actuel doit être attaqué avec une tactique renouvelée. La tactique traditionnelle des mouvements révolutionnaires n'a jamais valu qu'appliquée à la liquidation des autocraties. Appliquée à la lutte contre les régimes démocratiques, elle a mené deux fois le mouvement ouvrier au désastre. Notre tâche essentielle, urgente, est la constitution d'une doctrine *résultant des expériences immédiates*. Dans les circonstances historiques que nous vivons, l'incapacité de tirer les leçons de l'expérience doit être considérée comme criminelle.

4. — Nous avons conscience que les conditions actuelles de la lutte exigeront de ceux qui sont résolus à s'emparer du pouvoir une violence impérative qui ne le cède à aucune autre, mais, quelle que puisse être notre aversion pour les diverses formes de l'autorité sociale, nous ne reculerons pas devant cette inéluctable nécessité, pas plus que devant toutes celles qui peuvent nous être imposées par les conséquences de l'action que nous engageons.

5. — Nous disons actuellement que le programme du Front Populaire. dont les dirigeants. dans le cadre des institutions bourgeoises, accèderont vraisemblabl[ement] faillite. La constitution d'un gouvernement du peuple, d'une direction [...] INTRAITABLE DICTATURE DU PEUPLE ARME.

6. — Ce n'est pas une insurrection informe qui s'emparera du po[...] d'hui de la destinée sociale, c'est la création organique d'une vaste c[...] née, fanatique, capable d'exercer le jour venu une autorité impitoyab[...] forces doit grouper l'ensemble de ceux qui n'acceptent pas la course [...] la guerre — d'une société capitaliste sans cerveau et sans yeux ; elle [...] ne se sentent pas faits pour être conduits par des valets et des esclave[...] conformément à la violence immédiate de l'être humain — qui se refu[...] ment la richesse matérielle, due à la collectivité, et l'exaltation mor[...] sera pas rendue à la véritable liberté.

MORT A TOUS LES ESCLAVES DU CAPITALISME !

(1) Les de la Rocque, les Laval, les de Wendel.

1

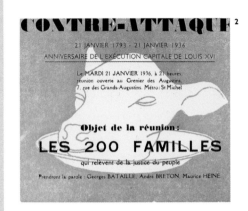

CONTRE-ATTAQUE

21 JANVIER 1793 - 21 JANVIER 1936
ANNIVERSAIRE DE L'EXÉCUTION CAPITALE DE LOUIS XVI

Le MARDI 21 JANVIER 1936, à 21 heures,
réunion ouverte au Grenier des Augustins.
7, rue des Grands-Augustins. Métro: St Michel

Objet de la réunion:

LES 200 FAMILLES

qui relèvent de la justice du peuple

Prendront la parole : Georges BATAILLE, André BRETON, Maurice HEINE.

2

CONTRE-ATTAQUE

APPEL A L'ACTION

— Qu'est-ce qui fait vivre la société capitaliste ?
— Le travail.
— Qu'offre la société capitaliste à celui qui lui donne son travail ?
— Des os à ronger.
— Qu'offre-t-elle par contre aux détenteurs du capital ?
— Tout ce qu'ils veulent, plus qu'à satiété, dix, cent, mille dindes par jour, s'ils avaient l'estomac assez grand...
— Et s'ils n'arrivent pas à manger les dindes ?
— Le travailleur chôme, crève de faim et plutôt que de les lui donner, on jette les dindes à la me[r]
— Pourquoi ne pas jeter à la mer les capitalistes au lieu des dindes ?
— Tout le monde se le demande.
— Que faut-il pour jeter à la mer les capitalistes et non les dindes ?
— Renverser l'ordre établi.
— Mais que font les partis organisés ?
— Le 31 janvier, à la Chambre, Sarraut s'écrie : « Je maintiendrai l'ordre établi dans la rue. »
— Les partis révolutionnaires (!) APPLAUDISSENT.
— Les partis ont-ils donc perdu la tête ?
— Ils disent que non mais M. de la Rocque leur fait peur.
— Qu'est-ce donc que ce M. de la Rocque ?
— Un capitaliste, un colonel et un comte.
— Et encore ?
— Un con.
— Mais comment le con peut-il faire peur ?
— Parce que, dans l'abrutissement général, il est le seul qui agisse !

CAMARADES,

Un Colonel s'agite et crie qu'il faut tout changer. Il est le seul à s'organiser pour la lutte et à prétendre qu'il saura faire que tout change. Il ment, mais il est le seul sur la scène politique qui ne soit pas parlementaire, alors que le dégoût de l'impuissance parlementaire est porté à son comble ! Les foules ont conscience qu'aux événements, il faut savoir commander, et non offrir le spectacle écœurant du parlementarisme bourgeois: désordre, bavardage et inavouable besogne. Les foules commencent à attendre en dehors du Parlement, un « homme », un maître... Et dans l'aberration générale, un Colonel de la Rocque semble déjà aux yeux d'un grand nombre l'homme attendu.

L'aberration va jusqu'à voir dans ce personnage le « maître » capable de commander aux événements. Jusqu'à voir un « maître » dans l' « esclave » le plus impuissant, l'esclave du système capitaliste, l'esclave d'un mode de production qui condamne les hommes à un gigantesque effort sans résultat autre que l'épuisement, la faim ou la guerre !

Nous affirmons que ce n'est pas pour un seul, mais pour TOUS, que le temps vient d'agir en MAITRES. D'individus impuissants, les masses n'ont rien à attendre. Seule, la RÉVOLUTION qui approche aura la puissance de COMMANDER aux événements, d'imposer la paix, d'ordonner la production et l'abondance.

TRAVAILLEURS,

La défensive qu'on vous propose ne signifierait pas seulement le maintien de l'exploitation capitaliste: elle signifierait la défaite assurée, hier en Allemagne et en Italie, demain en France, à tous ceux qui son devenus incapables d'attaquer.

Le temps n'est plus aux reculs et aux compromis.

Pour l'action — ORGANISEZ-VOUS ! Formez les sections DISCIPLINEES qui seront demain le fondement d'une autorité révolutionnaire implacable. A la discipline servile du fascisme, opposez la farouche discipline d'un peuple qui peut faire trembler ceux qui l'oppriment.

Il n'est plus question, cette fois, d'une lutte sans issue contre nos semblables, aux ordres des aveugles qui conduisent les peuples. La lutte contre tous ceux qui font de l'existence humaine un bagne exigera aussi l'abnégation, le courage héroïque et, s'il le faut, le sacrifice de la vie, mais l'enjeu est la libération des exploités et le désespoir de ceux que nous haïssons.

Camarades, vous répondrez aux aboiements des chiens de garde du capitalisme par le mot d'ordre brutal de

CONTRE-ATTAQUE!

3

1 Inaugural manifesto of the Con-
tre-Attaque group (October 7,
1935), with forty signatories, includ-
ing members from the surrealist
group such as Georges Bataille,
Jacques-André Boiffard, Henri
Dubief, Arthur Harfaux, and Pierre
Klossowski.

2 Announcement of the Contre-
Attaque group for a meeting against
"The 200 Families Who Are a Mat-
ter for the People's Justice" (January
21, 1936).

3 Pamphlet of the Contre-Attaque
group, "Call to Action," to the peo-
ple to thwart the activism of
François de la Rocque (1936).

their participation in the conference to be absolutely indispensable. He spared no efforts in attempting to redress the situation and managed to ensure that Breton's text could be read at the end of the session by Éluard. He was physically exhausted and had just learned that he had renal tuberculosis; perhaps he was overwhelmed, too, by the interminable discussions with the committee members in which he had participated in vain. During the night of June 18–19, Crevel committed suicide; a note was pinned to his jacket which read: "Please incinerate me. Disgust."

On June 25, Éluard finally read Breton's text, but the conditions were disastrous: it was at the very end of the session, to a hall that was emptying of participants, and the announcement of a power cut had just been made. Aragon would provide a response in the next morning's session, with an audience he had won over. Thus proof had been given, if any proof were needed, that the communists in charge showed absolutely no interest in the surrealists' point of view and even did everything they could to censure it.[124]

In July, Breton wrote *Du temps que les surréalistes avaient raison* [When the surrealists were right], published the following month as a political pamphlet, with twenty-six signatures, including those of the principal members of the Surrealist Group of Belgium. Because they intended to maintain their revolutionary position, particularly against the idea of the motherland and the most conformist morality, the group proclaimed its formal "defiance" not only with regard to the AEAR—which was the least they could do, given the way the conference had been organized—but also, this time, with regard to the Soviet regime and Stalin. Stalinist policy was extremely opportunist and in the end led to the reinforcement of nationalism, to the Franco-Soviet pact, and to the isolation of Germany.[125] To these motifs of deception and defiance one could add some particularly worrying symptoms: in addition to the mediocrity of socialist realism, it was also the "cult of personality" devoted to Stalin and the increasingly clear resurgence of an official respect for the institution of the family that led the group to observe that socialism in the USSR was rapidly regressing.[126] "We wonder if we really need to re-evaluate the situation to judge the regime by its works —in the case in point the present regime in Soviet Russia and the all-powerful leader under whom this regime is becoming the very negation of what it should be and what it once was."

Contre-Attaque

This break with the Communist Party and the denunciation of Stalin's role—even if it did not yet amount to equating Stalinism to totalitarianism—allowed for a rapprochement between the surrealists and the contributors to the periodical *La Critique sociale,* who, with Boris Souvarine and within the Democratic Communist Circle, devoted themselves to defining a revolutionary position strictly independent from the Communist International and showed they had no illusions with regard to the nature of the Soviet regime.[127] Thus Breton momentarily found himself again in the company of some of the authors of *Un cadavre* from 1930 (Bataille, Boiffard), but the urgency of the political situation suggested that the insults exchanged five years earlier should be forgotten.

The United Struggle of Revolutionary Intellectuals, who took the name of Contre-Attaque, was announced in a pamphlet on October 7, 1935.[128] Advocating the struggle against a democracy that the surrealists and Bataille's followers scorned in equal mea-

1 Sheila Legge at Trafalgar Square during the *International Surrealist Exhibition* of 1936. Photograph taken the same day illustrated the first page of the *Bulletin international du surréalisme,* number 4 (September 1936). It noted the appearance of the "apparition of the ghost of sex-appeal."

A SHORT SURVEY
OF
SURREALISM

DAVID GASCOYNE

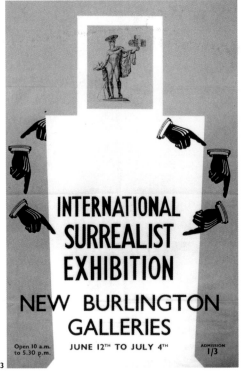

INTERNATIONAL SURREALIST EXHIBITION

NEW BURLINGTON GALLERIES

Open 10 a.m. to 5.30 p.m. JUNE 12TH TO JULY 4TH ADMISSION 1/3

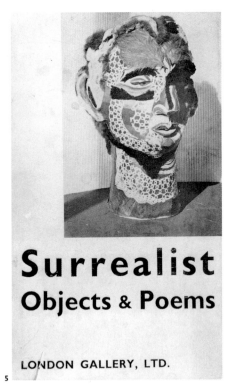

Surrealist
Objects & Poems

LONDON GALLERY, LTD.

2 Cover by Max Ernst for David Gascoyne's book, *A Short Survey of Surrealism* (London, 1935).

3 Max Ernst, poster for the *International Surrealist Exhibition,* New Burlington Galleries, London, June 11–July 14, 1936.

4 Cover by Roland Penrose for the first edition of Herbert Read's book, *Surrealism* (London, 1936).

5 Cover of the catalog for the exhibition *Surrealist Objects and Poems,* London Gallery, November 24–December 22, 1937, with a work by Eileen Agar.

SURREALISM
edited by
Herbert Read

BRETON ELUARD
HUGNET SYKES DAVIE

6

6 Humphrey Jennings, *House, Mountain, Swiss Roll* (ca. 1935); collage, 6¹/₅ × 8²/₃ in. (15.5 × 21.6 cm). Michael White Collection.

7 André Breton and Jacqueline Lamba at the International Surrealist Exhibition.

8 David Gascoyne, *Perseus and Andromeda* (1936, collage, 6¹/₃ × 9¹/₂ in. (15.9 × 23.8 cm). Tate Gallery, London.

7

8

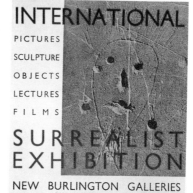

9

9 Eileen Agar, *Ladybird* (1936); photography, gouache, and ink, 29⁴/₅ × 19²/₃ in. (74.5 × 49.2 cm). Andrew Murphy Collection, London.

10 Invitation to the International Surrealist Exhibition.

INTERNATIONAL

PICTURES
SCULPTURE
OBJECTS
LECTURES
FILMS

SURREALIST
EXHIBITION

NEW BURLINGTON GALLERIES
BURLINGTON GARDENS
OPENING CEREMONY 3 p.m., THURSDAY, JUNE 11th, 1936
PRESS VIEW 10 a.m.
EXHIBITION OPEN JUNE 12th–JULY 4th, 10–5
ADMISSION 1/3 INCLUDING SATURDAYS

10

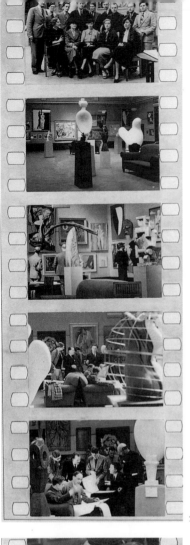

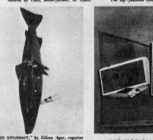
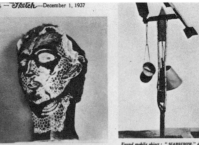

1 Series of photographs taken at the *International Surrealist Exhibition.*

2 Humphrey Jennings, circa 1942. Photograph by Lee Miller.

3 A page from the periodical *Sketch* (December 1, 1937) devoted to surrealist objects.

4 Members of the English surrealist group at Hyde Park on May 1, 1938. *From left to right:* Richard Carline, Peter Norman Dawson, Irina Moore, and Kathleen Raine.

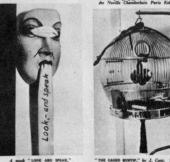

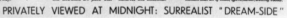

416 — *Sketch* — December 1, 1937

The well-modelled "ANGEL OF ANARCHY," by Eileen Agar, began life as a portrait, but, sundry other persons and distractions intervening, it turned out like this. The black markings are fur decorations.

Found mobile object : "SCARECROW," discovered by Cant, sailor-farmer, in Essex.

"THE SECRET OF THE GARDENIA," by Marcel Jean. The zip-fastened eyes are eloquent and symbolical.

"LOK-GOM-PA." An object Found by Paul Nash, the well-known painter.

"BRITISH DIPLOMACY," by Eileen Agar, requires looking into. The salmon has caught the angler, so the syringe gaff seems a little obscure. Recall the Neville Chamberlain Paris Exhibition fish !

"COLLAGE," by famous painter PABLO PICASSO.

A mask "LOOK AND SPEAK," by Man Ray.

"THE CAGED BUNYIP," by J. Cant. The floor of the cage and seed-boxes are filled with "hundreds and thousands."

R. Penrose's "THE DEW MACHINE"; designed to "moisten stale air of clubs, offices, banks, waiting-rooms."

PRIVATELY VIEWED AT MIDNIGHT: SURREALIST "DREAM-SIDE"

ARCHITECTS FOR SOCIALISM AND A PLANNED SOCIETY

A WARLIKE STATE CANNOT CREATE —WILLIAM MORRIS

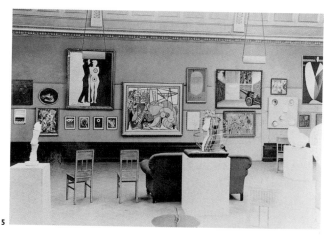

5 View of a hall at the International Surrealist Exhibition.

6 Paul Éluard, Roland Penrose, and Gala and Salvador Dalí at the *International Surrealist Exhibition* in front of Dalí's *The Dream*.

7 André Breton at the International Surrealist Exhibition next to Penrose's *Last Voyage of Captain Cook*, London, 1936.

8 Lee Miller, Paul Éluard, and Eileen Agar at Golfe-Juan in 1937.

9 Lee Miller in 1930. Photograph by Man Ray.

10 Roland Penrose, circa 1934.

sure, the pamphlet predicted the failure of a future popular front and called for the "organic creation of a vast assembly of forces—disciplined, fanatical, and capable, when the day comes, of exercising a pitiless authority," the only force capable of defeating the contemporary version of capitalism.

The following month a series of small leaflets "to be published from January 1936," was announced: its titles and summaries showed Contre-Attaque's intransigence but also its ambition: the themes chosen revealed the dominant influence of Bataille's ideas, which the surrealists supported. Among the items to be examined were the political situation ("Popular Front in the Street" by Bataille, a survey on militia, the definition of the autonomous peasants' movement) and the fundamental aspects of the economy, the question of morality, the Hegelian dialectic of master and slave, the opposition between patriotism and love of the land, the social aspect of sexuality (Bataille and Breton), and the "precursors of the moral revolution" (Sade by Heine, Fourier by Pierre Klossowski, Nietzsche by Ambrosino and Gilet).

During the first months of 1936, Contre-Attaque organized meetings (against family and homeland, against the "two hundred families") and distributed a few pamphlets (in reaction to a fascist aggression suffered by Léon Blum; a popular "Call to Action" to defuse the activism of François de la Rocque, "a capitalist, a colonel, and a count"; denunciation of the union of capitalist countries and the USSR against Hitler, and the reassertion of their preference, "without being naïve" for the "antidiplomatic brutality of Hitler" over the "drooling gesticulation of diplomats and politicians"). These texts defined a position that was quite frenzied but also strangely unrealistic: it was in the name of a universal "human community," unfamiliar with the double "infantile dementia" of French and German nationalism, that Bataille and the surrealists violently attacked parliamentarianism while underestimating the Nazi threat.[129]

Bataille was perfectly aware, however, of the "intrinsic perversity" of fascism; and yet he also considered that fascism had been the only movement capable of overturning democracy and providing a disoriented people with myths.[130] Bataille conceded to the effectiveness of the "superfascism" promoted by Contre-Attaque, even if he did not suggest calling it that: what it meant was taking up the very arms that had enabled fascism to gain power and turning them against that same fascism: "We intend in turn to use the weapons created by fascism, which knew how to manipulate the fundamental aspirations of men toward emotional exaltation and fanaticism," stated the first collective declaration by the group. But the term was ambiguous, to say the least, and on March 24, 1936, the surrealists announced that they "noted with satisfaction the dissolution" of Contre-Attaque and disavowed, in advance, any publication that might appear in its name. Bataille and the surrealists again set off down different paths that would keep them apart for years.

The London International Surrealist Exhibition

The *International Surrealist Exhibition* was held at the New Burlington Galleries in London, from June 11 to July 4, 1936. It was organized by Roland Penrose with the help of David Gascoyne and Humphrey Jennings and in liaison with Breton, Éluard, Hugnet, and Mesens. It confirmed the existence, cross-channel, of a strong interest in the movement, as symbolized, in particular, by David Gascoyne's activity the previous year: in the *Cahiers d'art,* number 10, he published a "First English Manifesto of Surrealism"

and brought out *A Short Survey of Surrealism*. (He translated into English Breton's speech "What Is Surrealism?" at the beginning of 1936, as well as texts by Éluard and Péret.) Penrose moved to France in 1922, where he had married Valentine Boué, who was herself a surrealist poet (*Herbe à la lune* [1935]); he was in contact with Ernst, Breton, and Éluard. He was a writer, an art critic, and a painter but was not unduly concerned with respecting a constant style or public image: what interested him very early on was the creation of visual surprise, carried to its greatest intensity. His meeting in Paris with Gascoyne convinced him, at a time when he was thinking of returning to London, that the moment had come to "export" surrealism.[131]

For several years now there had indeed been a curiosity in England about surrealism that was both intense and obviously limited to a few nonconformist individuals. This was largely confirmed by what Eileen Agar, Julian Trevelyan, and Jennings had been able to learn about surrealism during their stays in France at the beginning of the decade. It was in Paris, moreover, that in 1932 the first publication in English came out, giving a fairly complete overview of the surrealist movement (with the exception of its political dimension): this was the fifth issue of the periodical *The Quarter*, the editor of which, Edward W. Titus, had decided on its preparation by virtue of the interest shown by young readers (mainly French) in surrealism. The issue included theoretical and historical texts by Breton, Crevel (on sleep), Dalí, Éluard, Ernst ("How One Forces Inspiration"), prose by Char, Crevel, and Duchamp (*La Mariée*) and excerpts from *L'Immaculée Conception*, poems, a dossier devoted to the relation between surrealism and madness, the screenplay of *Un chien andalou*, and *Au 125 boulevard Saint-Germain* by Péret. This was an indisputably important sampling, illustrated by De Chirico, Ernst, Tanguy, Man Ray, and an exquisite corpse. In "Surrealism Yesterday, Today, and Tomorrow," Breton enriched the list of the precursors from 1924 with a few names belonging to Anglo-Saxon culture: to Jonathan Swift, already mentioned in the manifesto, he added Edward Young, Mathurin, the authors of "gothic" novels (Walpole, Radcliffe, Lewis), Lewis Carroll, Helen Smith, and Mack Sennett. He failed to mention, however, William Blake, whereas Herbert Read, who three months after the London exhibition would publish his volume *Surrealism* (in which there were excerpts from Breton, Éluard, Hugnet, and H. S. Davies), held Blake to be essential, on a level with the great English Romantics (Wordsworth, Coleridge, and Shelley), and confessed to his inability, alas, to read the gothic novelists.

In April 1933, the reopening in London of the Mayor Gallery was the opportunity for a collective exhibition, including works by Klee, Picabia, Arp, Miró, and others. The following June, Dalí would exhibit at the Zwemmer Gallery (distributor in Britain of the *Cahiers d'art* and *Minotaure*), at roughly the same time as the *Negro Anthology* by Nancy Cunard was published, which included, in particular, an anticolonialist declaration by the Parisian group. *Murderous Humanitarianism*, probably written in May and June of 1932 and translated by Samuel Beckett, picked up where the pamphlets against the *Colonial Exhibition* had left off.[132] Even if it evoked primarily the French colonial action and the situation in the United States or the West Indies (among the signatories were Monnerot and Yoyotte), it would obviously alert English readers to the group's political position: the transposition of its arguments to the British colonies was not especially difficult.

To these premises one ought to add the constitution, in June 1933, of Unit One, a group of artists that brought together—with Herbert Read's benediction—the parti-

sans of a resolutely modern art: sculptors (Henry Moore and Barbara Hepworth), architects (Wells Wintemute Coates and Colin Lucas), and painters (Ben Nicholson, Edward Burra, John Armstrong, and Paul Nash, among others). The association lasted hardly more than a year, but it did allow some of its members to make a clear stand for surrealism, while others moved on to a frank abstraction.

The *International Surrealist Exhibition,* thanks to Penrose's efforts, united more than sixty artists representing fourteen different countries, and it was an indisputable success, drawing more than twenty-five thousand visitors. During the opening, a woman with a head made of flowers wandered among the guests, embodying an idea of Dalí's. The exhibition made English participation in the movement official: of the 405 works on display, 102 were by twenty-three English artists; alongside the works of the Parisian group and those of Constantin Brancusi, Picabia, and Picasso were contributions from Belgium, Czechoslovakia, Scandinavia, and Spain.[133] There were also paintings by Paul Nash, drawings by Reuben Mednikoff and Grace Pailthorpe, which were totally automatic, sculptures by Moore, whose emptied, rounded forms recalled those by Arp, and works by Agar, Jennings, Trevelyan, and Burra. Among the "primitive," "found," or "surrealist" objects, Penrose's *Last Voyage of Captain Cook* was worthy of note.

A series of talks was given at the same time as the exhibition: Breton (a talk about the object on the opening night and "Limits Not Borders of Surrealism") was followed by Read (on art and the unconscious); then it was the turn of Éluard, with "Poetic Evidence," in which he began, moreover, to voice his particular concern over the social situation of the writer and found a new way to validate the fraternity among all humankind, perhaps in response to a collective debate held the evening before his own talk, titled the "Social Aspects of Surrealism."[134]

H. S. Davies ("Biology and Surrealism") was followed by Dalí, who was dressed in a diving suit and lectured the audience on "Authentic Paranoiac Phantoms." On the evening of June 26, Éluard recited poetry by Lautréamont, Picasso, and Breton, as well as his own, and Gascoyne and Jennings provided the English translation.

The event, which had the honor of being filmed for cinema newsreels, was not unanimously appreciated: the *Daily Mail* judged the exhibition "shocking," and the press was full of sarcasm and indignant reactions.[135]

Reactions of this nature may have been due—in the particular case of the British public—to the way in which that public traditionally perceived the role of the artist, most often viewed as an individualist: "Moral, ideological, and social irresponsibility is for [the English] at the basis of true art," asserted Read in the editorial of the fourth *Bulletin international du surréalisme,* which came out in September 1936. From this point of view, the principle of collective activity that surrealism espoused still more conclusively in its political and revolutionary dimensions, and as it appeared in spite of everything in the framework of the exhibition, became inadmissible. Surrealism, in England, would be viewed as a movement that was primarily artistic, and each of its "local" participants gave proof of his or her singularity.

The playful fantasy of Eileen Agar, particularly in her collages and objects, had little in common with the somewhat cruel tension underlying the works of a John Banting, with their games of false symmetry and their chromatic virulence, comparable at times to Man Ray's (*Femme passant entre deux musiciens* [Woman walking between two musicians] [1937]).

Along with his written work, Gascoyne produced a few collages, but it was Jen-

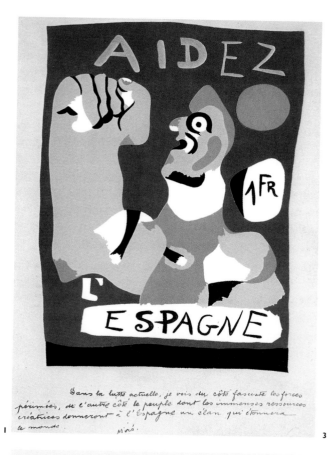

1

Dans la lutte actuelle, je vois du côté fasciste les forces périmées, de l'autre côté le peuple dont les immenses ressources créatrices donneront à l'Espagne un élan qui étonnera le monde. Miró.

3

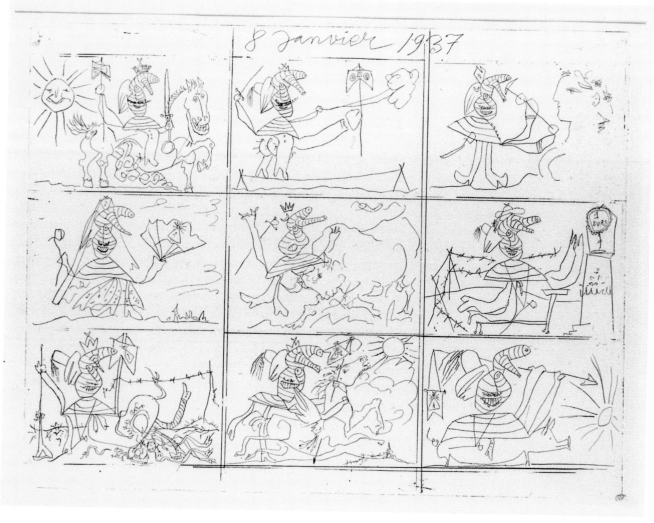

2

nings, a veritable jack-of-all-trades practicing with equal delight painting, photography, and the cinema, who elevated collage to the pure subversion of appearances and propriety: the simplicity of the images he obtained was equaled only by their power to disturb.

As for John Melville, he began to explore the world of dreams in the early 1930s, initially under the twin sign of "metaphysics" inspired by De Chirico and by Lewis Carroll's "nonsense." Very quickly, the precision of his figurative painting (which he did not practice exclusively, for he did mingle nonrepresentational elements into his work—his indifference with regard to stylistic unity likened him to Penrose and his experiments) led him to render the image as an obvious fact, despite its implausibility (*Mushroom-Headed Child* [1939]). Painting was a simple statement of accomplished metamorphoses, and its "scandalousness," if indeed it were scandalous, resided less in its apparent content than in the manner in which it imposed that content as something self-evident.

"To dream is to create," asserted Julian Trevelyan in 1928, before he had even visited Hayter's Studio 17; naturally, he took part in the exhibition in 1936, where his pictorial work, with its spindly figures and its graffiti-like aspect that seem to be carved into plastered backgrounds, suggests what might be a new mythology, illustrated by the spirit of childhood, something that could also be found in Klee's work or in certain Indian pictograms.

Grace Pailthorpe and her husband Reuben Mednikoff exhibited figures that were both highly improbable and determined by a purely inner necessity: the psychiatric knowledge of those who had discovered them, and their certainty regarding the psychological revelations that art made possible, led them to trust the most earnest form of automatism. This, in turn, gave rise, through representation or its absence, to the loosest possible forms, where humor merged with a delight in the marvelous.

Impact of the Spanish Civil War

The *Bulletin international du surréalisme* for September 1936 officially announced the grouping of all these artists, but it was difficult, nevertheless, to speak of the existence of an actual English group: "It's more of a collective desire, not formalized, but constantly being formalized," said Michel Rémy. The fact remains that in November 1937 the collective exhibition *Surrealist Objects and Poems* was held, and the English, even if they did not strictly speaking have their own periodical (*Contemporary Poetry and Prose* filled the slot before Mesen's *London Bulletin* was published), they could claim to have a coherent collective position in the political domain. In September 1936 they took part in a demonstration against Mosley's fascist groups, but it was the war in Spain that gave them the opportunity to express their point of view, in complete agreement with the Parisian group's: in November they signed a violent Declaration on Spain in *Contemporary Poetry and Prose*, which was immediately followed by Gascoyne and Penrose's departure for Barcelona, where they made radio broadcasts, acted as translators, and met up with Péret. In May 1937, the English surrealists again took part in demonstrations denouncing the noninterventionist policies of His Majesty's government, which seemed more preoccupied by an eventual expansion of bolshevism than the reality of fascism. It had maintained these policies for months, and Leon Blum's government in France had rallied to them when accused by the right-wing press—*L'Écho de Paris* and

Above: Roland Penrose, *The Eclipse of the Pyramid* (1936); colored pencils on paper, 12¹/₂ × 19¹/₅ in. (31.1 × 48 cm).

Right: Roland Penrose, *Octavia* (1939); oil on canvas, 30 × 24⁴/₅ in. (74.5 × 62 cm). Ferens Art Gallery; Hull City Museums and Art Galleries.

Previous page: Roland Penrose, *Mediterranean, Artistic Study* (1939); gouache, decalcomania, collage, and pencil on cardboard, 32 × 21³/₄ in. (80 × 54.3 cm).

Opposite page: Roland Penrose, *Nightfall* (1940); oil on wood, 29¹/₃ × 22¹/₄ in. (73.3 × 55.7 cm). Tony Penrose Collection.

Above left: Eileen Agar, *The Angel of Anarchy* (1936–40); mixed media, 20⁴/₅ × 12³/₅ × 13¹/₂ in. (52 × 31.7 × 33.6 cm). Tate Gallery, London.

Above right: Eileen Agar, *The Angel of Mercy* (1934); mixed media, 17²/₃ in. (44.1 cm). Edward Totah Gallery, London.

Below: Eileen Agar, *Box*, mixed media, 6¹/₂ × 9 × 2¹/₅ in. (16.4 × 22.4 × 5.5 cm). Private collection.

Above: Julian Trevelyan, *Dream* (1938); collage and mixed media, 14⁴/₅ × 21¹/₃ in. (37 × 53.3 cm). Private collection.

Left: Stanley William Hayter, *Murder* (1933); oil and rope on canvas, 32²/₅ × 40 in. (81 × 100 cm).

Opposite page, top: Humphrey Jennings, *Apples* (1940); oil on canvas, 10¹/₅ × 12²/₅ in. (25.5 × 31 cm). Private collection.

Opposite page, bottom: Humphrey Jennings, *Engine* (1935); oil on canvas, 12¹/₂ × 16¹/₄ in (31.4 × 40.6 cm). Mary Lou Jennings Collection.

Conroy Maddox, *La Rue de Seine*
(1944); oil on canvas, 50²/₅ × 30 in.
(126 × 75 cm). Private collection.

Above: Roberto Matta, *Psychologie morphologique* (1938); oil on canvas, 29$\frac{1}{5}$ × 36$\frac{2}{5}$ in. (73 × 91 cm). Private collection.

Right: Roberto Matta, *Nuit frontière* (1939); colored pencils and pencil on paper, 13$\frac{1}{2}$ × 20 (33.7 × 49.9 cm). Galerie de France Collection.

Left: Remedios Varo, *La Traversée* (The crossing; 1935); collage, $9^2/_5 \times 7^4/_5$ in. (23.5 × 19.7 cm). Private collection.

Below: Remedios Varo, *Yeux sur la table* (Eyes on the table), gouache on paper, $5^1/_5 \times 8$ in. (13 × 20 cm). Private collection.

Esteban Francès, *Untitled* (1941–42);
colored pencils and tempera on
paper, 14²/₃ × 23¹/₃ in. (36 × 58 cm).
Private collection.

Opposite page, top: Leonora Carrington, *Horses* (1941); oil on canvas, 26³/₄ × 32³/₅ in. (66.8 × 81.5 cm). Private collection.

Opposite page, bottom: Leonora Carrington, *Night Nursery Everything* (1947); oil on Masonite, 23¹/₅ × 24 in. (58 × 60 cm). Private collection.

Above: Roberto Matta, *Architecture psychologique-arbres volants* (Psychological architecture with flying trees; 1940); ink and colored pencil on paper, 17 × 21¹/₃ (42.6 × 53.3 cm). Galerie de France Collection.

Right: Gordon Onslow-Ford, *The Painter and the Muse* (1943); oil on canvas, 40²/₅ × 50¹/₄ in. (101 × 125.7 cm).

Below: Gordon Onslow-Ford, *The Transparent Woman* (1940–41); oil on canvas, 37³/₅ × 45¹/₂ in. (94 × 113.7 cm).

Previous pages, verso: Koga Harue, *Exterior Make-up* (1929); oil on canvas, 46²/₅ × 32²/₃ in. (116 × 81.6 cm). Museum of Modern Art, Kamakura.

Previous pages, recto: Togo Seiji, *Promenade of the Surrealists Number 2* (1929); oil on canvas, 25³/₅ × 19¹/₄ in. (64 × 48.2 cm). The Yasuda Kasai Museum of Art, Tokyo.

L'Action française to begin with—of dragging the country into a conflict that would be, if not global, at least European in nature.

Péret left for Spain in August 1936, a few days after the generals' *pronunciamento* (July 17–18) against the Popular Front government elected in February and after signing the pamphlet that, on July 20, called for the arrest of the Spanish right-wing leader Gil Robles, who had fled to Biarritz.[136] Péret was exultant at the spectacle of Barcelona "studded with barricades, decorated with burnt churches where nothing but the four walls remained." As soon as he arrived he denounced the Spanish communists' "intention to sabotage the revolution."[137] A few months later, he had to concede that "under the influence of the Stalinists the revolution is taking a downward turn that, if it is not rapidly checked, will lead straight to violent counterrevolution," and he attacked the "crookedness of the Stalinists who are *openly* sabotaging the revolution with the enthusiastic support, of course, of the petty bourgeois of every stripe."[138]

Wifredo Lam, who had been living in Spain since 1923, where he was finishing his artistic training (in Madrid, he took lessons from Fernando Alvarez de Sotomayor, Dalí's old professor), initially took part in the defense of the Spanish Republic in Cuenca, where he lived. Then, in 1937 he left for Madrid to fight alongside the Republicans; he would not meet Péret until 1938, in Paris.

Since the time of his first trip in 1934, Masson had been fascinated by Spain, and he was there during the military uprising. Although at first he tried to stay clear of the two camps, it was not long before he chose sides: "When I saw the first Italian airplanes flying overhead, bound for the new front at Aragon, I did not hesitate for a moment. I signed up at a union, an anarchist union."[139] He dashed off satirical drawings in ink, portraying the atrocities of the civil war and the role of the clergy in the repression, so violent that they were not published at the time: "One of these drawings represented a minotaurish bull wearing an enormous cross with a donkey-headed, upside-down Christ, (everything was in the drawing!) who was cutting off the ears of the wounded militia."[140] While he continued to be very close to Bataille, for whom he made illustrations for the periodical *Acéphale,* when he returned to Paris in November 1936 he was reconciled with Breton and once again took part in the activities of the "orthodox" group, which confirmed what he wrote to Daniel-Henri Kahnweiler: "There's nothing to be said, or done, it is the word 'surrealism' which represents now and forever a new stage in art."[141] At the end of the year his exhibition *Spain, 1934–1936* was held at the Galerie Simon: it displayed landscapes alongside bullfights, many drawings and pastels—notably a "project for a poster for the Catalan militia"—and a "banner." The exhibition was a great success.

In 1937, the pavilion of the Spanish Republic at the *International Exhibition* in Paris showed Picasso's *Guernica;* Picasso had been appointed director of the Prado by the Republicans at the beginning of the war. A young Chilean was a handyman in the crew hired to finish construction of the pavilion and observed Picasso at work: "The construction work was running late. There was the civil war in Spain, the architect was bad, everything was depressing. There was this huge painting on the wall which wasn't finished and never would be—everyone kept saying, 'The painting won't be finished!' They kept sending me over there to see the guy who was painting and ask him when it would be finished. It was Picasso—he was kind and full of humor. When I made the sign of the cross, he said: 'Oh là là! What's the matter? It doesn't matter,' and then he talked about shoes or something else, never about the pavilion. I liked him a great deal.

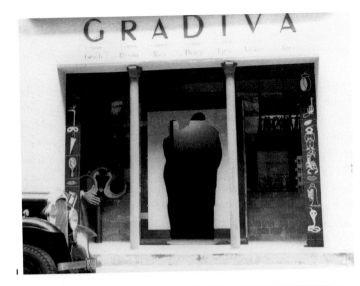

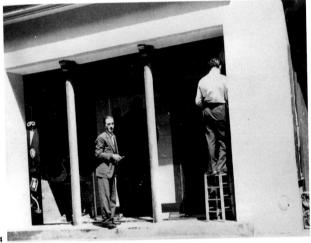

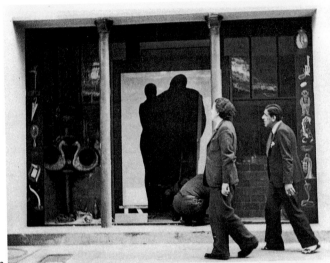

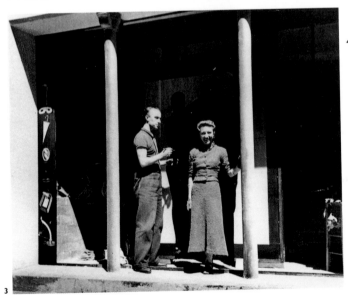

1 Window of the Galerie Gradiva. The door was designed by Marcel Duchamp.

2–5 In front of the gallery in 1937: 2, André Breton and Oscar Dominguez; 3, Yves Tanguy and Jacqueline Breton; 4, Marcel Duchamp; 5, Oscar Dominguez and Yves Tanguy.

But I couldn't begin with that. It was a drawing to begin with and at the end it was a drawing," said the young Roberto Matta, who had not even begun to try his hand at painting.[142] But thanks to an article by Gabrielle Buffet-Picabia he had read at the time of the *International Surrealist Exhibition* in London, where he had just completed his training as an architect, he had discovered that it was "possible to paint change."

For the same Spanish pavilion Miró also completed a large mural, *Le Faucheur,* made up of assembled panels, which have now disappeared. Miró had fled Montroig at the beginning of the civil war: "I had to leave because a friend came and told me, 'You've got to get out of here right away, the fellows from the FAI—the International Federation of Anarchists—want to eliminate you!' I was shocked! This is what happened: my sister had married an extreme right-wing imbecile. I attended the wedding and a local newspaper had published a list of the names of the guests, and of course I was on it. I had to leave double-quick."[143] This was the period when he drew the celebrated poster (or project for a postage stamp?) "Help Spain," an insert in number 4–5 of the *Cahiers d'art* devoted to Spain. (It also included Picasso's suite *Songes et mensonges de Franco,* a study of *Guernica,* and a poem by Éluard on Miró, illustrated by reproductions from earlier works.) Although for Miró painting, which as far as he was concerned took its source in permanent rebellion, was enough to implement the necessary overturning of ideas, without obliging one to take sides politically in any explicit way, he did, this time, accompany the image of his Catalan peasant with a few handwritten lines: "In the present struggle, I see the outdated forces of the Fascists on one side, and on the other, the people whose vast creative resources will give Spain a momentum to astonish the world"—a hope that history would not take long to destroy.

The Moscow "Trials"

In Moscow the three trials that were held between August 1936 and March 1938 were essentially an attempt to discredit Trotsky through the accusations brought against some of his former comrades, some of them bolsheviks from the very beginning. Zinoviev and Kamenev, during the first trial, were accused of having plotted with others in 1932 to eliminate Stalin and Zhdanov; this had led to the assassination of Kirov, which was most probably carried out on Stalin's orders by the NKVD, the People's Commissariat for Internal Affairs, which took over the GPU.[144] In January 1937, it would be the turn of Pyatakov, Radek, and their "accomplices" of the "Trotskyist Anti-Soviet Core" to be found guilty of high treason and collaboration with fascism. In March 1938, of the twenty-one who stood accused, including Bukharin, eighteen were sentenced to death, again for treason and espionage. The Stalinist bureaucracy sought to impose the image of Trotsky as an agent of Hitler or the Gestapo, and the police machine extorted the most improbable confessions with flawless efficiency.

On September 3, 1936, a meeting was organized in Paris, "The Truth about the Moscow Trial." Breton read a declaration signed by twelve members of the surrealist group (Éluard did not join them): the accusation brought against Zinoviev and his codefendants was rejected, and the theatrics of the trial were denounced as an "abject police enterprise"; Stalin was qualified henceforth as a "great negator and principal enemy of the proletarian revolution." But they also expressed concern about the situation in Spain, particularly as the Stalinists were doing their utmost to destabilize the

1

3

4

2

5

truly revolutionary elements. The text ended with praise for Trotsky, who was "clearly above suspicion."

On January 16, 1937, before the end of the second trial, Breton gave a speech in his name alone at the meeting organized by the Internationalist Workers' Party, a Trotskyist organization, in order to work for the creation of a commission of inquiry into the "trials" in Moscow. Underlining the mortal risks that the judiciary parody organized in Moscow was causing socialist thought to take, for reasons of immediate impact Breton clarified the goals to be attained: the USSR must revoke the death penalty in political matters. But he reaffirmed that Stalinist strategy was spilling beyond Soviet territory in order to spread through Europe, particularly in Spain, where Moscow's power was seeking to abort the revolution.[145]

For the time being, such warnings had little effect, drowned out by the grand organs of propaganda played by the European communists, as well as by the right-wing parties' satisfaction in observing the trials. The voice of the surrealists, like Trotsky's, remained too faint to be heard. But at least they had begun to resonate in tune, and this convergence would be confirmed before long, with Breton's voyage to Mexico.

The Galerie Gradiva

In February 1937, Louis Bomsel, a notary in Versailles, appointed Breton to take over a gallery at 31, rue de Seine: this was the Galerie Gradiva, baptized in honor of the heroine of Jensen's short story about whom Freud had written: Gradiva, "she who moves forward" or "tomorrow's beauty, hidden still to the greatest number and revealed at scattered intervals in the vicinity of an object, as one passes by a painting, as one turns the pages of a book." Duchamp had designed the gallery's door: the outline of a couple embracing was cut into the glass, and on its brochures, each letter of "Gradiva" became the initials of a woman's name: after all, Breton had just published *L'Amour fou*.

In May, the Galerie Gradiva was inaugurated with a collective exhibit displaying objects, sculptures from Oceania, books, and various works from the main representatives of the group, along with Louis Marcoussis and Picasso. Wolfgang Paalen's presence was particularly noteworthy: he had joined the group a year earlier, after his work had been discovered during the second Parisian exhibition at the Galerie Pierre. A child of abstraction, Paalen's painting turned to totemic figuration, haunted by childhood memories that seemed frozen in a rarefied atmosphere (*Fata Alaska* [1937]) The invention of "fumage"—a candle flame, moved at random over a layer of paint, produced haloed shapes suggestive of the painting's theme—would later cause this initial solemnity to shift toward compositions that were, on the contrary, surprisingly dynamic.

An exhibition by Magritte was then envisaged, but by the month of August the Galerie Gradiva was already running into financial difficulties. This did not however hinder the arrival of new artists in the group in any way: after Leonora Carrington, whom Ernst had met in London in 1937, and Remedios Varo, whom Péret brought from Barcelona to Paris, it was then the turn of Esteban Francès, Matta, and then of Gordon Onslow-Ford to make their entry, while Tanguy introduced the young Patrick Waldberg, who would subsequently become a wise commentator on the works of his friends.

Carrington and Remedios had only just begun their career in painting. Both of them would progressively show that the separation of kingdoms and beings was a mere

convention, as arbitrary as any other and in this respect open to any conceivable transgression. Carrington liked to set her characters in humorous surroundings, which gave the painting the atmosphere of a fairy tale, but she also seemed to be plagued by anxiety (*Autoportrait: A l'auberge du cheval d'aube* [1937–38]); Remedios was even more attentive to the possibilities of magic, portraying a universe whose laws clearly differed from those that govern our own.

An acquaintance of Remedios's in Barcelona was Esteban Francès, within the "logicophobist" group that since 1935 had been concerned with the "external representation of the internal states of the human soul." For Francès, the transition to surrealism was a natural one and made all the more easily in that his technique of "grattage" was greeted with approval. While he worked with a "wandering" razor blade on a layer of colors dispersed with no preconceived idea, "an invisible hand takes his own and helps it to retrieve the large hallucinatory figures latent" in the amalgam of colors.[146]

In October 1937 Matta, who had an introductory note from Dalí, came to the Galerie Gradiva to show a few drawings to Breton, who immediately bought two of them and invited him to participate in an illustrated edition of the *Chants de Maldoror* and in the next international exhibition of surrealism. According to Waldberg, who was present at the meeting, in Matta's drawings "strange draped figures, wrapped up in string as if they were held prisoner in a giant cocoon, seemed to act like sentinels in landscapes of incandescent rocks, boiling lakes, clouds of sulfur. Color was spread with a freedom, audacity, and mastery, the equivalent of which one had not seen for many years."[147] In the months that followed, Matta would attend the daily meetings at the Deux Magots. He gave up architecture (he had worked with Le Corbusier, who was obviously hardly compatible with the group's preferences) and embarked on a painting career that would soon lead to research into cosmogonies and "psychological morphologies," conducted jointly with Gordon Onslow-Ford, whom he introduced to both painting and surrealism.

"The Guaranteed Surrealist Postcard"

Most of the surrealists were longtime aficionados of postcards, which they used abundantly for their correspondence, generally choosing the illustration with great care, so that it would coincide at least in part with the message; they were also collectors. In this second case, they preferred, as did Éluard in his famous collection, the period of the "âge d'or—The Golden Age" for the mixture of naïveté, eroticism, fantasy, and involuntary poetry that was often apparent or for the talent of the modern style designers (Mucha, Raphael Kirchner, whom Breton especially appreciated).[148] To be sure, the postcard industry was also victim to the brainwashing of the First World War, both in Germany and in France, but it remained possible to circumvent that aspect by adding collage or a few motifs in gouache, as Max Ernst had done very early on, or as Hugnet would later do, preferring postcards that exhibited more or less "innocent" nudes.

In 1937, Georges Hugnet published a "first series" (it would remain the only one) of postcards, and the back bore the imitation of a postage stamp, a circular inscription that said "Guaranteed surrealist postcard" (this was Man Ray's idea). This was indeed proof of the interest in postcards but also suggested that the group meant to use the postcard as a means of disseminating some of the more significant images it had adopted. This

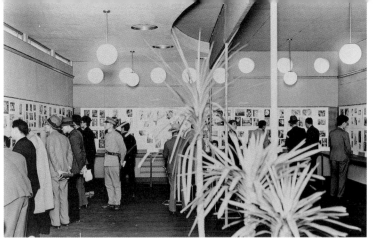

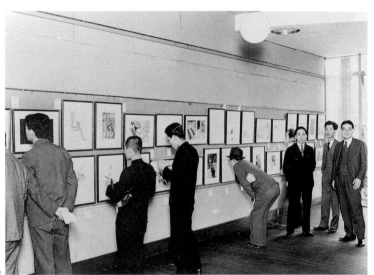

5 Program of the surrealist exhibition organized by the periodical *Mizue* at the San Kakudo Gallery in Osaka, July 1–5, 1937.

6 Taro Okamoto, *The Painful Arm* (1935); oil on canvas, 45²/₃ × 65 in. (114.2 × 162.3 cm). Private collection.

7 Harue Koga, *A Very Simple Sad Story* (1930); oil on canvas, 46²/₃ × 36¹/₂ in. (116.7 × 91.4 cm). Ishibashi Art Museum, Kurume.

1, 2 Surrealist exhibition, Japan (1937). *2,* The organizers of the exhibition are on the right.

3, 4 Invitation to the *International Exhibition of Surrealism*, Nippon Salon, Tokyo, June 9–14, 1937. Invitations were in either French or Japanese.

8 Taro Okamoto, *Heavy Industry* (1949).

9, 11 *Surrealist Album*, special issue of the periodical *Mizue* (May 1937), with decalcomania by Shuzo Takiguchi.

10 Harue Koga, *The Sea* (1929); oil on canvas, 52 × 65 in. (130 × 162.5 cm). National Museum of Modern Art, Tokyo.

12 Cover of the Japanese edition of *Le Surréalisme et la Peinture* by André Breton, translation by Shuzo Takiguchi (1930).

10

11

12

hope turned to disappointment, for the project was not a financial success. Twenty-one cards, printed in sepia (on a yellow, green, or white background) reproduced preexisting works, with the exception, it would seem, of Picasso's, entitled "April Fool's," which represented a rebus drawing that was not at all obvious to the reader: "L'Hache-chat d'os (7 carpes) porte mâle heure" (The ax-cat of bones [7 carps] brings male hour).[149] The main artists of the group were part of the series: Duchamp, "50cm³ of Paris air"; Ernst, "The Triumph of Love"; Miró, "Timetable"; Dalí, "The Senile Melancholy of Dogs Like a Vertiginous Descent on Skis," a fine example of a double image; Bellmer, the doll as "Two Half-Sisters"; Man Ray, "What We are All Missing"; Arp, "Open This End"; Oppenheim, "My Governess"; Magritte, "The Solution to the Rebus"; Tanguy, "The Sandman"; M. Jean, "Paris from a Bird's-eye View"; and Dominguez, "Opening," which, unintentionally no doubt, evoked the design of turn-of-the-century postcards where the name of the town included a few famous monuments in the tracing of its letters. Younger members also took part: Paalen, "On the Scale of Desire"; Dora Maar, "29, rue d'Astorg," and Penrose's "Earth in a Bottle." In his paintings of that period, Penrose tended to use the repetition of one and the same industrial postcard, set out like a fan or butterfly's wings. Finally, there were examples of "object-poems" by Breton and collages by Hugnet, Paul and Nusch Éluard, and Jacqueline Breton. Objects, paintings, mountains, drawings: the inventory of the techniques applied went hand in hand with the themes of desire, underlying violence, surprise, and poetry, which assured that these cards would represent the values upheld by the group. Perhaps a continuation of this type of publication would have been effective in the long run—all the more so that at the time the reproductions of contemporary art in postcard form was not at all common. But the surrealists would have had to accept competition, on the rack, with more banal productions: the print run of this series did not allow that, as it did not exceed a few hundred copies.[150]

It would be wrong to conclude from this attempt to use a popular medium that the members of the group cared only about their own work. In August 1937, twelve or more of them signed a *Lettre ouverte aux autorités des beaux-arts* (Open letter to the authorities of the school of fine arts) to deplore the absence of certain artists and trends at an *International Independent Art Exhibition* organized at the Jeu de Paume museum. Internationalism meant as much in this domain as in politics, and most of those whose absence was noted were artists who belonged to movements that the surrealists did not usually approve of (geometric nonfigurative painting, futurism, suprematism or constructivism, expressionism). But the problem was that the absence of certain artists not only implied the overexposure of others, it also distorted the picture that the exhibition sought so didactically to prove, and that picture was one of sensitivity, something that should under no circumstances be left out. To recall the importance of the Russian avant-garde from 1910 through the 1920s, of Italian futurism, or of German painting was also a way to object to "socialist realism" and to the notion of "degenerate art" denounced by the Nazis, thus reaffirming that Germany, the USSR, and Italy did not necessarily mean nothing other than Hitler, Stalin, and Mussolini.[151]

Japan

From June 9 to June 14, 1937, an international *Exhibition of Surrealism* was held first in Tokyo, then in Kyoto (originally titled *Surrealist Works Abroad*), which was organized by

the periodical *Mizue*—that is, by Shuzo Takiguchi and Nobuo Yamanaka with the help of Éluard, Hugnet, and Penrose. It was, in its way, a consecration of the work begun in Japan by Takiguchi, a poet and theoretician of prime importance who, even more than his professor Junzaburo Nishiwaki, with whom he had founded the periodical *Fukuikutaru kafu yo* in 1927, was the representative of an authentic surrealism.

In 1926, poems by Aragon, Éluard, and Breton had been translated into Japanese in the periodical *Bungei tanbi,* but the fact that Rimbaud and Lautréamont were unknown, as was the French intellectual context in which their texts had been created, made the deeper meaning of their texts hard to grasp. "Surrealism," for Japanese writers and artists, meant a mingled version of Dadaism and futurism, a "modern" mentality that would above all enable them to break with the realist or symbolist tradition. When the painter Ichiro Fukuzawa returned to Paris, where he had stayed from 1924 to 1931, his work showed multiple influences (from Chagall to Ernst) and remained tied to a figurative representation whose humorous quality was burdened by rather naïve symbols (*During the Meeting the Teachers' Minds are Elsewhere* [1930]), although locally his art enjoyed the advantage of protesting against both the idea of modernity and the reputation of technical perfection that the Japanese public seemed eager to ascribe to Western art. This also applied to the canvases created in the late 1920s by Harue Koga, whom Fukuzawa described as "scarcely polished," but Koga, after experimenting with a graphic art close to Klee's, had managed to perfect a mixture of geometrical planes and figurative parallels whose poetic strangeness is unquestionable (*The Sea* [1929], *Endless Flight* [1930]). In January 1931, Koga published some interesting reflections on the status of figurative elements in his painting: "The objects which figure in a work of art, even if they come from the world of one's actual experience are, for all that, no more than representations, and they will constitute the destructible matter of this world of experienced sensations. I am searching for that which, through reality, manages to free itself from reality."[152]

In 1930 a translation of *Surréalisme et la Peinture* by Takiguchi was published; at the same time, the periodical *Atelier* dedicated a special issue to the movement, entitled "Studies on Surrealism"; and in 1934, a collective work, *Homage to Paul Éluard,* was published by the Sea Star Publishers in Kobe. Thus, Takiguchi had every reason to assert, in number 5–6 of the *Cahiers d'art* (1935), that "recently, young [Japanese] poets and artists have begun to show a keen interest in surrealism, and several periodicals of surrealist tendency have been founded, where translations of surrealist texts as well as essays on the subject have appeared." In 1936 a translation of *L'Immaculée Conception* was published and, in Tokyo, *The Surrealist Exchange,* for which Takiguchi, who had also published that same year the first monograph devoted to Miró, specifically translated Breton's *Discours au congrès des écrivains pour la défense de la culture* (Speech at the conference of writers for the defense of culture), a text that was undoubtedly crucial for Japanese readers who, for a number of years now, had been involved in a debate about the relations between poetry (in the nonliterary sense) and politics.

The 1937 exhibition (the same year the Sino-Japanese conflict broke out, which meant that the issue surrounding the participation of artists in the war effort was keenly felt) was the culmination of this intellectual and artistic ferment, both with respect to the works presented and the publications that ensued. In addition to the *Surrealist Album,* a special issue of the periodical *Mizue* that came out in May and served as a catalog, there was also the publication of *Surrealism* by Fukuzawa in the series The

Idea and the Spirit of Modern Art, which also featured a work by Kiyoshi Hasegawa on abstract art and another by Kanbara devoted to futurism, expressionism, and Dadaism. *The Surrealist Album* (bilingual French and Japanese), whose cover reproduced Takiguchi's decalcomania without objects, gave a broad overview in 122 pages of surrealism at that time, lavishly illustrated with 136 reproductions—it certainly earned its title, and this was the richest collection available in Japan. In his book, Fukuzawa considered the possibility that surrealism might be "overtaken" by another movement, but in referring to haiku and the art of rocks and gardens, he was thinking mainly of a traditional vein of the Japanese spirit that might be capable of reinterpreting surrealism for its own purposes. Indeed, he wanted to counter the negative aspects of modernism, whose excessive rationality was leading, for example, to the creation of an urban space judged to be totally artificial.

In the article he devoted in 1938 to the problems related to avant-garde art, Takiguchi came back to the question of relations between art and politics, asserting that "antagonism is irreducible"; he emphasized that Japanese surrealism could not merely be a copy of the European version: "Surrealism, that is, the movement of 'surrealism' which has spread from France, cannot, in its original form, completely match the situation in our country. . . . Surreality is one of the universal values invoked by man's desire." But for the Japanese spirit surreality was revealed through the historical contributions of haiku, particularly those of Basho. This Japanese version of surrealism, capable of synthetizing the quest for the irrational through automatism, zen, and the feeling for nature developed in the classic haiku—like those of Ai-Misu who, welding a visionary gift like Max Ernst's to his knowledge of ancient painting, created an almost unique example with his *Paysage à l'œil* (Landscape with eye) in 1938—would very soon, however, encounter insurmountable difficulties of political origin. The relations between the surrealists and the Japanese communists led in 1940 to such extreme police repression that the surrealist movement in Japan died out.[153] It was only after the end of World War II that Taro Okamoto (who had left behind pure abstraction for the "neo-concretism" he adopted in 1936 with Seligmann and who had been familiar with the Parisian surrealists—his *Le Bras douloureux* [The painful arm] was shown at the *International Exhibition* in 1938) restored to Japanese painting an impetus toward the fantastic and toward dreams, thanks to a virulent use of color as well as to a formal freedom that allowed him to mingle figurative and abstract elements (*Industrie lourde* [Heavy industry] [1949]; *La Loi de la jungle* [The law of the jungle] [1950]) in order to obtain what he called "non-sense": "It is thanks to the resolution to remain firmly in non-sense that true sense appears."

Recognition to Jarry

In September 1937, Sylvain Itkine—a former member of the October group, who had been close to Prévert, Morise, Loris, Duhamel, and Roger Blin—organized performances of two plays by Jarry, *Ubu enchaîné* (décor by Max Ernst) and *L'Objet aimé* (décor by Jean Effel), which were the pretext for the publication of a collective volume with contributions by Breton, Rosey, Hugnet, Péret, Mabille, Éluard, Lély, Pastoureau, Malet, and Itkine himself for the texts, and illustrations by Effel (the cover), Picasso (whose portrait of Ubu Père was surrounded by a poetical text), Paalen, Tanguy, M.

Jean, Man Ray, Henry, and Miró, joined by Roger Blin, Lucien Coutaud, and "Lord" Loris.[154]

Jarry had earned Breton's admiration very early on: Breton had published an article about him in *Les Écrits nouveaux* in January 1919. He was also much admired by Péret, Prévert, and Dalí. Although *Ubu enchaîné* did not really provide the opportunity to praise the symbolist poet or the man who discovered the Douanier Rousseau, the group's book greatly emphasized the social and political significance of Ubu Père, thanks to Breton's participation (he insisted also that one acknowledge humor, in the character, as "a revenge of the pleasure principle attached to the superego upon the principle of reality attached to the ego"), as well as that of Heine, Itkine, and Malet. It was, said Breton, because "in counterpart to Ubu Roi's solid desire for domination, *Ubu enchaîné* offers a desire for solid servility," one might concede that "the events of these last twenty years confer upon the second Ubu an inestimable prophetic value," proven by an allusion to the Moscow trials. Itkine considered Jarry's work to be "a declaration of war, an act of separation which we would prefer as decisive as possible, and a promise of imminent aggression," because of his critique of "a democracy reduced to mystical formulas, a republic merely in form, acts of blind faith which were once the rights of man and of the citizen—in sum, everything which has become derisory and frozen in what is our very existence." In this way, Jarry denounced all the myths of the bourgeois mentality, that of "liberty conceived in social need" to begin with. Heine saw Ubu as "the modern prototype of the Dictator" and expected the performances to offer "total irreverence, perfect mockery, to give a slap in the face with all the abruptness one could hope for, to the hideous 'personalities of respect' venerated by the human herd." As for the celebrated "Merdre!" Malet viewed it as an indication of the highest development of the human personality when the individual is "capable of causing it to ring clearly in the terrified ears of fathers and leaders."

In his very short text Pastoureau compared the publication of *Ubu enchaîné,* in April 1900, with the imbecilic enthusiasm of the crowds of patriots cheering the army fourteen months earlier, in the example of Déroulède. The international political situation, which the group had viewed for months now as particularly somber, was cause to fear that such cheering would very soon be heard again.

1938-1944

"DURING THE SORDID YEARS"*

Opposite page: André Breton, *Tragics à la manière des comics* (Tragics in the manner of comics; 1943); collage using a photograph of the Facteur Cheval's Ideal Palace.

*Title of a collection by André Pieyre de Mandiargues (Paris: Gallimard, 1948).

The Galerie des Beaux-Arts left its vast premises of the Faubourg Saint-Honoré at the disposal of the surrealist group, with the freedom to arrange the halls as they liked; therefore, the *International Exhibition* that opened there on January 17, 1938, was proof of a desire to design the use of space as a work of art in and of itself. This exhibition grouped together three hundred works by sixty or more artists from fourteen different countries. Marcel Duchamp acted as "generator-referee," Man Ray was the "master of light," and Ernst and Dalí were "special advisers." (This would be Dalí's last significant activity with the group.) The opening drew a sizable crowd, all of whom were ready to be shocked and titillated, and a critic of the era commented that "never have so many society people been seen stepping all over each other since the fire at the Bazar de la Charité."[1] There was indeed plenty here to satisfy those who enjoyed varying degrees of thrilling sensations but also those who, on a deeper level, knew how to look for something more than an ordinary juxtaposition in the works on exhibit.

At the entrance, the visitor came upon Dalí's *Taxi pluvieux* (Rainy taxi): the driver, who had the head of a shark, and his blond passenger were subjected to the continual downpour flooding an environment of lettuce leaves crawling with snails.[2] Then one walked along the Rue surréaliste, inhabited by a series of mannequins decorated by members of the group (Ernst, Marcel Jean, André Masson, Dalí, Maurice Henry, Roberto Matta, Léo Malet, Arp, and others) and dotted with enameled street signs alternately designating streets that had a certain significance for members of the group (rue de la Vieille-Lanterne where Nerval committed suicide; rue Nicolas-Flamel), places with evocative names (passage des Panoramas), or simply invented street names that corresponded to a certain desire (rue aux Lèvres, rue Cerise, etc.).[3]

Then came the central hall, designed by Duchamp with a rare mixture of cold humor and a sense of supernatural disorientation: from the vaulted ceiling hung twelve

The *International Exhibition of Surrealism*, Galerie des Beaux-Arts, Paris, January–February 1938.

1 The central hall, designed by Marcel Duchamp, as it was being set up. Photograph by Denise Bellon.

2 Invitation.

3 Salvador Dalí and his mannequin. Photograph by Denise Bellon.

4 Salvador Dalí, *Taxi pluvieux* (The rainy taxi).

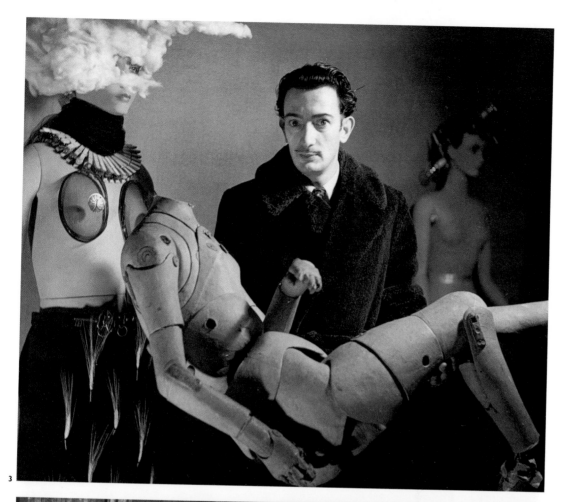

3

4

1

3

2

4

6

5

7

hundred coal sacks, and the undulating ground was covered with dead leaves, moss, and ferns, in the middle of which was a pond. At the center of this space, which was both womblike and rustic, stood a brazier (whence the diffuse fear that the coal dust falling from the sacks would start a fire) like an invitation to stand huddled together; in the four corners of the hall were beds of a somewhat garish luxury, like nothing other than an invitation to lie close together.

In addition to the paintings on the walls and the numerous objects displayed throughout (Seligmann's *Ultra meuble,* Duchamp's *Rotative demi-sphère,* Meret Oppenheim's *Déjeuner en fourrure),* Duchamp used the panels of two tambour doors to present the graphic works. To make it easier for visitors to move around, they were initially given electric lights, then as the stock ran out fairly quickly, fixed lighting was installed.[4]

For the inauguration, the presence of a robot had been announced, "an authentic descendant of Frankenstein"—but apparently he was absent. Fresh coffee, however, roasted (by Claude Rollin) behind a screen, wafted its odor to the musical accompaniment of a marching tune of the German Army: there was nevertheless something of the robot in the air. To such a degree, in fact, that certain aspects of the exhibition seemed premonitory of what would soon become reality. Ten years later, Breton himself would confirm how the commentaries in the press, negative on the whole, were wrong when they denounced the so-called gratuitousness of the exhibition's staging:

> Since then, all of that has more significance than ever, alas; [the exhibition] has turned out to be far too accurate in its forewarnings, far too prophetic, utterly justified in its use of darkness, of the stifling and the sinister. To those who so vehemently accused us then of having complied with this atmosphere, I would reply that we will have ample opportunity to show others that we remained strong in the face of the darkness and deceitful cruelty of the days to come. It was not up to us to make that atmosphere other than what it was, as long as we felt the approach of the 1940s with a particular acuteness. Perhaps surrealism, by opening certain doors that rationalist thought boasted of having definitively sealed off, enabled us to make incursions here and there into the future, on the condition that at the time we were unaware of the fact that it was the future into which we were penetrating, that we did not realize it, and that it would become patently obvious to us only *a posteriori*.[5]

José Pierre, although initially confirming this aspect of the event, also pointed out that the "dominant feeling of distress, and that everything was going to rack and ruin" was nevertheless offset by everything in their works and in their disposition in space that pointed to carnal love and its parade of fantasies.[6] From Dalí's *Taxi* to the beds, by way of the variations on fetishism offered by the mannequins, elements of a more euphoric reverie were also available to the visitor, who could, moreover, hardly remain insensitive to the very ambiguous atmosphere that Duchamp had created in the central hall.

A different version of the exhibition was on display from June 3 to August 1, 1938, at the Robert Gallery in Amsterdam, then from September 10 to September 30 at the Koninklijke Kunstzaal Kleykamp in The Hague. The exhibition was organized by Kristians Tonny (a painter and son of the owners of the Robert Gallery) and among the participants from Paris were Breton, Éluard, and, above all, Georges Hugnet, who took on the brunt of the work, as Breton was in Mexico and Éluard had little free time;

2

1

3

4

from London, Penrose took part, and Mesens, from Brussels. This at least confirmed the movement's desire to seem international, yet it was not particularly effective in Holland for, with the exception of Kristians Tonny, no Dutch painters were admitted in the exhibition. In Paris there was skepticism about the existence of Dutch surrealists, and, as Hugnet remarked, if there were any, the fact remained that "they never got in touch with us: we must be wary of confusion." (There was no doubt some confusion where Tonny's works were concerned, for they were not, strictly speaking, surrealist.)

The Concise Dictionary of Surrealism

Internationalization became apparent in other persuasive ways in the publication that accompanied the event in Paris: the *Dictionnaire abrégé du surréalisme* (The concise dictionary of surrealism).[7] Compiled by Breton and Éluard, the book devoted entries not only to all those who had participated thus far in the movement and to whom nicknames were given (Arp: "the eel of the dunes," Masson: "the feather-man," Tanguy: "guide to the era of mistletoe druids") but also to techniques such as frottage or decalcomania, as well as terms of everyday language, illustrated by quotations or redefined through poetic formulas.

These articles were illustrated with a good number of vignettes reproducing paintings, drawings, and objects by Ernst, Dalí, Magritte, Man Ray, and others, and forty-two pages (out of seventy-six) of photographic plates arranged in a way that was carefully planned, informing the reader of the movement's works as wells as their goals and some of their positions. The series of plates began with a photogram from *L'Âge d'or* (the bishops on their rock) and a scene from *Ubu enchaîné* as directed in 1937 by Sylvain Itkine with sets by Max Ernst. Thus, it was shown that, while the cinema and the theater were two artistic domains in which the surrealists actually intervened quite rarely, even there the surrealists should be taken into consideration. Three photographs by Ubac came next (two natural objects and a landscape) opposite a collage by Seligmann: *Les Animaux surréalistes,* in which photographs of a praying mantis, a chameleon, seahorses, a toucan, and a rhinoceros were integrated into a collage with a background of an irregular wall blocking an ocean horizon. Nature was thus depicted solely through a particular "bestiary" and its "bizarreries." The two pages that followed were subtitled "La Femme surréaliste" (three photographs by Man Ray, two by Ubac, three unsigned), and its images were ambivalent: woman viewed as from a distance, innocent and dangerous, modest and lascivious, capable of inciting all manner of desire and love. This was followed by eight examples of collages (two by Ernst and one each by Duchamp, Styrsky, Hugnet, Japanese artist Shigeru Imai, Éluard, and Breton—a reminder that this technique was available to everyone). The next seven plates called on the initiators of "surrealist painting": Duchamp (*Tu m', Pharmacie*) and De Chirico (*Portrait de l'artiste*), with works that were created well before the first manifesto; Ernst had two pages, with, in particular, a *Tableau détruit* from 1923; Man Ray; Picasso (three works from 1918 to 1936); and Masson with works dating from 1923 to 1925.[8] Then came three pages of objects, among them the *Rotative demi-sphère* by Duchamp (1922) but also contributions by four women (Gala Dalí, Meret Oppenheim, Jacqueline Breton, and Valentine Hugo). Miró, Tanguy, and Magritte then took up two pages each, and the reproductions of art work were interrupted by a page of photographs of the group (at the Centrale Surréaliste in 1924, the Belgian group in 1934, surrealists in

Prague in 1935 and London in 1936), with, on the facing page, Ernst's painting *Au ren-dez-vous des amis,* which dominated a photograph grouping Breton, Crevel, and Dalí amid a number of quotations.

The double pages that followed were organized according to similarity of theme or form. Woodcuttings and a *Concrétion humaine* by Arp figured alongside a *Figure inclinée* by Henry Moore. A photograph by Humphrey Jennings, *Bolton,* was superimposed on an aerial view of the Place de l'Étoile, opposite a play on space and the variations of scale: *Cadran lunaire* by Ernst, a view of Giacometti's studio, where one can see in profile the cast of *L'Objet invisible* and, also by Giacometti, *On ne joue plus,* a plate pitted with cavities of varying shape and size where rare figurines moved about, a sort of diseased chess board or an allusion to an African *awalé* gone completely awry. Two pages were devoted to Dalí (the *Jeu lugubre* from 1929, *Gradiva* from 1931, a *Girafe en feu* from 1937), before more spectral offerings from Jindrich Styrsky, Toyen, and Roland Penrose, announcing the suggestive distortions powerfully displayed in recent works by Wolfgang Paalen, Kurt Seligmann, Jennings, and Oscar Dominguez, dating from 1934 to 1937. The next four plates were formally "calmer" but troubled the mind in other ways, all the more so for the fact that the artists were not yet well-known in Paris: Shimozato, Suzuki, and Otsuka from Japan, Agustin Espinosa and Remedios, Paul Delvaux, the Scandinavians Bjerke-Pedersen, Freddie, and Elsa Thoresen, the Englishman Paul Nash, the Romanian Brauner, and Marcel Jean.[9] Three works that shared a polymorphous eroticism were then grouped together: Miró's *L'Objet du couchant;* a collage by Cornell where Lautréamont's umbrella was replaced under the sewing machine by a female figure; and a sculpture by Sergio Brignoni entitled *Érotique végétal.* This was followed by an embroidery by a lunatic woman that confirmed that the territory left to conquer could equally be that of an inner or an outer world; the outer world was alluded to by the two works surrounding the embroidery, *Agitation céleste* by Brignoni and *Inquiétude du soleil après le passage de deux personnages* (Anxiety of the sun after two people have passed by) by Matta. The series of illustrations then concluded with "La Ville surréaliste en 1938" (The surrealist city in 1938), where the place names evoked by the enameled signs at the exhibition surrounded a drawing by Bellmer: *Mains de demi-mijaurées fleurissant des sillons de parterre* (Hands of semi-precious women touching grooves in the floor).

Instead of including declarations of intent or analytical texts, the rather slim volume of the *Dictionnaire abrégé du surréalisme* contained a multitude of short-circuits and perspectives. The images referred to the actual entries that often, because of their brevity, created, in turn, a need for more information: a paradoxical dictionary that rather than containing a certain type of knowledge showed that knowledge cannot be attained and that it must be considered in that way. And could one of the "definitions" it gave of surrealism itself not be understood to be an allusion to the necessity of surpassing that which one tended to think of as solidly acquired: "An old piece of pewter cutlery dating from before the invention of the fork"?

Criticism and Its Clichés

When commentators and critics were presented with the proof, as suggested by desire and the imagination, of the shortcomings of intellectual activity alone, it was hardly surprising that they described the event in ways that, although diverse, proved their

M. E. : Extrait de *Une semaine de bonté* (1934)

M. D. : Moustiques domestiques demi-stock (1924)

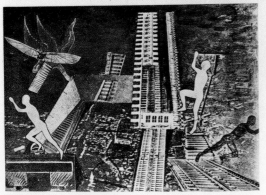

M . E . : Le Massacre des Innocents (1920)

1

3

Objets naturels et paysage (Photos *Raoul Ubac*).

2

1–3 Three pages of *Dictionnaire abrégé du surréalisme*.

1–3 Anthropomorphic pre-Columbian figures in terra cotta that belonged to André Breton.

4 André Breton and Leon Trotsky in Mexico in 1938. *To the left:* Diego Rivera and Frida Kahlo.

5 Cover of the catalog for the international exhibition in Mexico City, 1940, with a photograph by Manuel Alvarez Bravo.

near-total inability to grasp what was at stake. It was during the 1938 exhibition that a whole series of reactions surfaced that would later become veritable clichés: there was not much to be expected from surrealism in painting; it all concerned only a few snobs, or a public that in fact was already made up of bourgeois who hoped to be in fashion when in fact surrealism was already passé; such a bric-a-brac had nothing to do with the traditions of the French spirit (the proof of which was the fact that surrealism had recruited so many foreigners!), but it was surprising still to have to deal with it, insofar as it really was time to accept that surrealism was, if not altogether dead, then at least dying.[10] Few chroniclers were lucid enough to note that "every visitor is forced to accept the unacceptable and can only escape his discomfort through laughter or anger"—before going on to remark that "in all this, painting . . . is part of a whole, and if such a considerable importance has been granted to it, it is because it remains one of the most flexible means of expression, because it allows one to express all one's dreams, and an appearance of reality can be placed upon the most unexpected invention."[11] The tone was more often that adopted by the former fellow traveler of the Dadaist era, Drieu la Rochelle: "As I walked through this pitiful surrealist Exhibition where there seems to reign the obstinacy of a sickly, frightened child who would rather commit suicide than grow up, my heart sank. Such a waste of time, so many days lost; so much sinister melancholy."[12]

Breton in Mexico

On March 30, 1938, André and Jacqueline Breton set sail for Mexico, already acknowledged as a "chosen land for black humor."[13] The Ministry of Foreign Affairs, at the instigation of Saint-John Perse, had entrusted Breton with a mission to give a series of talks on French art and literature from the eighteenth century on. As a result, he would give up the management of the Galerie Gradiva (Tanguy would close it down in his absence) and the preparation of the next issue of *Minotaure.*

In addition to the emotional attraction Breton felt for Mexico—which seemed to have its origins in his very childhood and was also apparent in his collection of primitive artwork—the fact that Diego Rivera and Frida Kahlo had given refuge to Trotsky compounded Breton's passionate interest: here was a country whose particular genius was due to an astonishing combination of a rare exuberance of nature and a thirst for freedom that its inhabitants had displayed for over 130 years—a genius that, two years earlier, had also attracted Artaud and would soon captivate Benjamin Péret and Wolfgang Paalen.[14]

Breton was welcomed by Diego Rivera and Frida Kahlo to their house in San Angel and immediately learned of Trotsky's desire to meet him. Breton's presence was cause for the publication of a number of articles and translations of some of his works in the Mexican press, but members of the League of Mexican Revolutionary Artists and Writers, loyal to the directives of the pro-Stalinist Association of Revolutionary Artists and Writers, were not at all pleased with his visit.[15] On April 22 he attended the gallery opening for Gutierrez, and he met Trotsky at the beginning of May: they would meet several times before they set off on a trip to Michoacan, where Breton scouted for pre-Columbian objects, and then they went on to Morelos, where they climbed Popocatepetl. During their discussions on psychoanalysis, poetry, and the relation between art and politics (through Meyer Shapiro, Trotsky had obtained copies of the

1

2

4

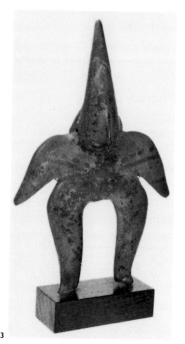

3

5

two manifestos, *Nadja, Les Vases communicants,* and *L'Amour fou,* and thanks to Naville he was aware of Breton's political positions), Trotsky spoke of the need to set up an International Federation of Revolutionary Artists and Writers and to draft its inaugural manifesto. Initially paralyzed in his writing by the intense admiration he had for Trotsky, Breton managed nevertheless to finish the text on July 25, once Trotsky had inserted paragraphs summing up some of his recent points of view.[16]

For an Independent Revolutionary Art

The manifesto, *For an Independent Revolutionary Art,* was not actually signed by Trotsky; "for tactical reasons" his signature was replaced by Diego Rivera's.[17] Acknowledging the threat that was hanging over the entire world, for "now it is all of the world's civilization and the unity of its historical destiny which are staggering under the threat of reactionary forces armed with all the modern technology," the manifesto began by emphasizing the importance of the subjective qualities at work in any philosophical, sociological, scientific, or artistic discovery. And it was precisely this irreplaceable contribution of the subjective that was forbidden under the two contemporary forms of totalitarianism: "Hitler's fascism . . . has forced those who could still consent to hold a pen or brush in hand to be the valets of the regime and to celebrate it upon command, to the farthest limits of the worst conventionality. Although less well-advertised, the situation has been the same in the USSR during this furiously reactionary period, which has now reached its height."

The point was not, obviously, once this twofold assault on creative liberty had been defined, to claim that only democracy could guarantee a satisfactory home to that liberty. On the contrary, it was an opportunity to insist on the revolutionary character of authentic art: such art "cannot . . . fail to aspire to a complete and radical restructuring of society." The major difficulty lay in the fact that one must recognize at the same time that "only social revolution can clear the path to a new culture."

This social revolution had nothing in common with its Stalinist caricature. With regard to the Soviet Union, the only posture could be that of opposition, as with regard to capitalist society, if it was true that by following its own movement the need for the emancipation of the mind would eventually merge with that of a general emancipation of mankind. A mind confined to the study of "extremely short-term pragmatic ends" must necessarily betray the twin exigencies of liberty and could only work henceforth in an objectively reactionary direction.

Referring to the young Marx, Breton and Trotsky reiterated that, for the artist, the work must constitute an end in itself and cannot be placed at the service of anything external. Consequently, it was important "that the imagination escape any and all constraints and under no circumstances allow anything to impose any restraining net." This led to a first conclusion that had the value of a slogan: "All license in art."

The manifesto then went back to the relationship between art and the needs of the revolution to ascertain that the above-mentioned formula should in no way imply a "so-called 'pure' art which ordinarily serves the aims of the forces of reaction, which are anything but pure." On the contrary, it was because artists would have integrated the necessity for the global transformation of society into their inner world that they would find themselves in the position of "serving the struggle for emancipation": at this point there could be an encounter between their private lives and the historical

dimension of the real outside world, without there being any need, however, for a "Stalinist organization" claiming to serve as an intermediary between the subjectivity of artists and the concrete world and to help them better to fulfill their mission by defining what they should do in advance. Allegiance to such organizations could, in fact, only be demoralizing, since it would start off by depriving artists of their freedom, and after that it is difficult to see how those artists could invite others to have an even deeper experience of something that they themselves had just renounced. *Pour un art révolutionnaire indépendant* might thus be seen as having sounded a final call to unite all those who had decided to "serve the revolution through the methods of art, and to defend the freedom of art against the usurpers of the revolution."

From this point of view, the Fédération Internationale de l'Art Révolutionnaire Indépendant (FIARI—the International Federation of Independent Revolutionary Art) would unite the "representatives of considerably divergent aesthetic, philosophical, and political leanings"—provided their main concern was to yield nothing of their inventiveness to the fascists, who saw it as a symptom of "degeneracy," or of their freedom to the Stalinists, who saw this as a hint of fascism.[18] In addition to individuals, the manifesto also addressed all the independent Leftist publications that might be ready to examine the tasks and methods of action of the FIARI. As for its goals, they were clearly stated in the last lines:

> What we want:
> *the independence of art—for the revolution;*
> *the revolution—for the definitive liberation of art.*

Constitution and Failure of the FIARI

As soon as he returned to France in August 1938, Breton felt obliged to sever his relations with Éluard. Éluard had in fact published a poem, "Les Vainqueurs d'hier périront" (Yesterday's victors will perish) in *Commune,* the French newsletter for the AEAR, which had urged its Mexican correspondents to sabotage Breton's talks in Mexico. When Éluard was asked to cease all collaboration with *Commune,* he replied that his poetry was of a nature to stand apart from any context and that he therefore had every intention of continuing to publish wherever he could. The break with Breton was henceforth inevitable.

Éluard's departure was not without consequences for the cohesiveness of the surrealist group itself or the membership of FIARI. While Masson lent his complete support to Breton, Max Ernst took his distances by retreating to Saint-Martin-d'Ardèche, and Georges Hugnet was excluded, in turn, first from FIARI, then from the group because of his friendship with Éluard.[19] The Belgian surrealists, divided into two rival groups around Achille Chavée and Paul Nougé, were hesitant and wary—to such a degree that Belgium would be represented within the FIARI by Hem Day, the pseudonym of Marcel Dieu, an anarchist and seller of used books. The group in London, led by Roland Penrose, who was very close to Éluard, remained undecided, while those in Prague stood behind Breton, which was not surprising insofar as they had just broken with Vitezslav Nezval, and Karel Teige's brochure *Le Surréalisme à contre-courant* (Surrealism against the tide) established their determination to put an end to their relations with the Communist Party.

1 "For the Liberty of Art"; letter from Leon Trotsky to André Breton published in *Clé*, number 2 (February 1939).

2 André Breton, Diego Rivera, and Leon Trotsky in Mexico in 1938.

3 The front page of *Clé*, a monthly bulletin of the Fédération Internationale de l'Art Révolutionnaire Indépendant, number 1 (February 1939).

Once the Éluard situation had been dealt with, Breton engaged in intense activity to consolidate the FIARI: a national committee was set up, on which surrealists (Pierre Mabille, Masson, Maurice Heine) sat as planned alongside representatives of different leanings (Yves Allégret, Jean Giono, Henri Poulaille, Marcel Martinet), who shared their anti-Stalinism.

Clé, the FIARI's newsletter, was edited by Maurice Nadeau and managed by Léo Malet. The first issue came out in January 1939, announced by formulas that were a reminder of the double aim the group had been pursuing for years: "Both through the culture they incarnate, and the emotional motives which command their vocation, writers and artists are called on to play a specific role in any prerevolutionary period, a role which no one else can play, for the revolution we want, destined to 'change lives,' destined to 'transform the world,' has the right to develop not in an improvised fashion but on the contrary to be formulated over a long period of time."[20]

From this first issue, the editorial, entitled "No Fatherland," emphasized the scope of artistic internationalism, endowed with the same significance as workers' internationalism and the necessity of struggling against the decrees recently passed against foreigners residing in France, most specifically political immigrants: "Art has no more homeland than workers do. To advocate today a return to a 'French' art, as not only the fascists but also the Stalinists have done . . . is to work toward division and incomprehension among peoples, and is a premeditated effort at historical regression."

The table of contents of this first issue respected the diverse tendencies coexisting within FIARI: Breton, Georges Hénein, and Maurice Heine were present, along with Jean Giono and Ignazio Silone. The names of members who had joined the federation were listed (a massive participation on the part of surrealists: Jacques Brunius, Claude Cahun, Nicolas Calas, Maurice Henry, etc.), and the reactions provoked by the manifesto *Pour un art révolutionnaire indépendant* (For an independent revolutionary art) were tallied: negative (Martin du Gard, Gaston Bachelard, Jean Painlevé) or positive (Victor Serge, Herbert Read, André Marchand).

The second issue of *Clé* was published in February 1939. There was, in particular, a letter from Trotsky to Breton on December 22, 1938, in which he reiterated that art must remain autonomous relative to any slogan imposed from the outside: "The struggle for the revolution's ideas in art must once again begin with the struggle for artistic *truth* . . . in the sense of the *unshakable loyalty of the artist to his inner self.*" This second issue was also the last: "The time," Maurice Nadeau would later say, "was no longer right for art, especially independent art."[21] Serious internal difficulties compounded the obvious political pressure after Munich. The tension provoked by Éluard and Hugnet's exclusion was now also felt within FIARI, and some of its members (the "proletarian" tendency, with Marcel Martinet, or "populist," with Henri Poulaille) did not hesitate to deplore what they viewed as the excessive influence of the surrealists. The failure of *Clé* and of FIARI, Breton would later say, "at such a moment merged with many others. Everything was happening as if intellectual activity, in whatever sector, was coming to a halt, as if the mind had already been warned that nothing now would have the strength to withstand the plague."[22]

Trajectoire du rêve

During Breton's stay in Mexico a "Cahier GLM" was published; Breton had prepared

POUR LA LIBERTÉ DE L'ART

Cher Breton,

De toute mon âme je salue l'initiative de Diego Rivera et de vous-même pour la création de la F.I.A.R.I., fédération des artistes véritablement révolutionnaires et véritablement indépendants ; pourquoi ne pas ajouter aussi : des VÉRITABLES artistes ? Il est temps, il est grand temps ! Le globe terrestre se change en une caserne impérialiste fangeuse et puante. Les héros de la démocratie, avec l'inimitable Daladier à leur tête, font tous leurs efforts pour ressembler aux héros du fascisme (ce qui n'empêche pas les premiers de se trouver chez les seconds dans un camp de concentration). Plus le dictateur est ignorant et obtus, plus il se sent appelé à diriger le développement de la science, de la philosophie et de l'art. Le servilisme moutonnier de l'intelligentsia est, à son tour, un signe non de peu d'importance de la pourriture de la société contemporaine. La France ne constitue pas une exception.

Ne parlons pas des Aragon, Ehrenburg et autres petites canailles ; ne nommons pas les messieurs qui avec un égal enthousiasme écrivent la biographie de Jésus-Christ et celle de Joseph Staline (la mort ne les a pas absous); laissons de côté le déclin pitoyable, pour ne pas dire ignoble, de Romain Rolland.... Mais impossible de se contenir assez pour ne pas s'arrêter sur le cas de Malraux. J'ai suivi non sans intérêt ses premiers pas littéraires. Il y avait déjà en lui, à ce moment là, un fort élément de pose et d'affectation. Assez souvent on se sentait mal à l'aise devant ses recherches, prétentieusement froides, d'héroïsme chez autrui. Mais il était impossible de lui refuser du talent. Avec une force indubitable il atteignit aux sommets des sentiments humains, à la lutte héroïque, au comble de la douleur, au sacrifice de soi-même. On pouvait attendre — personnellement je voulais l'espérer – que le sens de l'héroïsme révolutionnaire entrât plus profondément dans les nerfs de l'écrivain, le purifiât de la pose et fît de Malraux le poète important d'une époque de catastrophes. Qu'advint-il en fait ? L'artiste devint un reporter de la G. P. Ou., un pourvoyeur d'héroïsme bureaucratique en tranches de longueur et de largeur bien mesurées (il n'y a pas une troisième dimension).

Durant la guerre civile il me fallut mener une lutte opiniâtre contre les rapports militaires imprécis ou mensongers à l'aide desquels les commandants tentaient de dissimuler leurs erreurs,

insuccès et défaites dans un torrent de phrases générales. Les productions actuelles de Malraux sont de ces rapports mensongers des champs de batailles (Allemagne, Espagne, etc.). Cependant, le mensonge devient plus répugnant lorsqu'il se pare de la forme artistique. Le sort de Malraux est symbolique pour toute une couche d'écrivains, presque pour toute une génération : les gens mentent par prétendue « amitié » pour la révolution d'octobre. Comme si la révolution avait besoin de mensonge !

La malheureuse presse soviétique, évidemment par ordre d'en-haut, se plaint instamment dans ces derniers jours de l' « appauvrissement » de la production scientifique et artistique en U.R.S.S et reproche aux écrivains et artistes soviétiques de manquer de sincérité, de hardiesse et d'envergure. On n'en croit pas ses yeux : le boa qui tient une homélie sur l'indépendance et la dignité personnelle. Hideux et ignoble tableau, bien digne, pourtant, de notre époque.

La lutte pour les idées de la révolution dans l'art doit commencer une nouvelle fois par la lutte pour la VÉRITÉ artistique, non dans le sens de telle ou telle école, mais dans le sens de LA FIDÉLITÉ INÉBRANLABLE DE L'ARTISTE A SON MOI INTÉRIEUR. Sans cela il n'y a pas d'art. « Tu ne mentiras point », voilà la formule du salut.

La F.I.A.R.I. n'est pas, bien entendu, une école esthétique ou politique et ne peut le devenir. Mais la F.I.A.R.I. peut ozoniser l'atmosphère dans laquelle les artistes ont à respirer et à créer. La création véritablement indépendante à notre époque de réaction convulsive, de déclin culturel et de retour à la sauvagerie ne peut manquer d'être révolutionnaire par son esprit même, car elle ne peut pas chercher une issue à un intolérable étouffement social. Mais que l'art, dans son ensemble, que chaque artiste, en particulier, cherchent cette issue par leurs propres moyens, sans attendre quelque commandement du dehors, sans le tolérer, en le rejetant et en couvrant de mépris tous ceux qui s'y soumettent. Créer une telle opinion publique parmi la meilleure partie des artistes, telle est la tâche de la F.I.A.R.I. Je crois fermement que ce nom entrera dans l'histoire.

Vôtre,
LÉON TROTSKY

Coyoacán, D.F., le 22 décembre 1938.

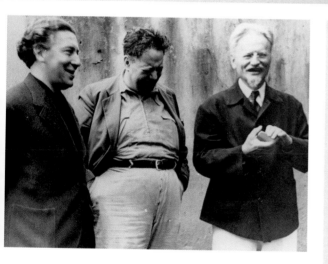

PRIX 1 fr. 50 N° 1 - 1ᵉʳ JANVIER 1939

CLÉ

BULLETIN MENSUEL DE LA F.I.A.R.I.
(FÉDÉRATION INTERNATIONALE DE L'ART RÉVOLUTIONNAIRE INDÉPENDANT)

RÉDACTION - ADMINISTRATION
Maurice NADEAU, 15, rue de la Vistule, Paris-13ᵉ
Chèques Po taux : ACKER 2.283-49 PARIS C
170, Rue du Temple, Paris-3ᵉ

COMITÉ NATIONAL :
Yves Allégret, André Breton, Michel Collinet, Jean Giono, Maurice Heine, Pierre Mabille, Marcel Martinet, André Masson, Henry Poulaille, Gérard Rosenthal, Maurice Wullens.

PAS DE PATRIE !

Les immondes campagnes menées tant sur le mot d'ordre « France réveille-toi » que « La France aux Français » commencent à porter leurs fruits empoisonnés. Les décrets de mai de M. Sarraut, certains dispositifs annexes des décrets-lois de novembre font entrer en vigueur, aux dépens des étrangers résidant en France et spécialement des émigrés politiques, une procédure scélérate qui s'inspire de celle des pays fascistes. Les mesures de refoulement déjà prises et les préparatifs d'internement auxquels nous assistons marquent l'accentuation d'une politique de panique et de coup de force tendant à l'établissement en France d'un régime « autoritaire » et bientôt totalitaire... ils témoignent de la contagion rapide à laquelle sont en proie les pays « démocratiques » entraînés dès maintenant, au mépris des considérations humaines les plus élémentaires, à renier le principe du droit d'asile, longtemps considéré par eux comme SACRÉ. La F.I.A.R.I. tient pour son premier devoir de flétrir ce nouvel avilissement de la « conscience » bourgeoise, à dénoncer les menées xénophobes comme un des principaux périls de l'heure. De même que nous faisons toute confiance à la classe ouvrière pour exiger l'abrogation des décrets-lois braqués contre elle seule, nous appuyons de toutes nos forces les protestations et les appels à la résistance lancés par les organisations révolutionnaires de la S.I.A., du P.S.O.P. et du P.O.I. contre les expulsions en masse et la création de camps de concentration dès le temps de paix.

Dans la sphère plus spéciale de notre activité, nous n'avons garde d'oublier que si Paris a réussi à se maintenir longtemps à l'avant-garde artistique, cela tient essentiellement à l'accueil hospitalier qu'y ont trouvé les artistes venus de tous les pays ; que si ont pris naissance dans cette ville quelques-uns des grands courants spirituels dont l'univers a tenu compte, c'est qu'elle a constitué un laboratoire d'idées vraiment international. L'art n'a pas plus de patrie que les travailleurs. Préconiser aujourd'hui le retour à un art « français » comme le font non seulement les fascistes mais encore les staliniens, c'est s'opposer au maintien de cette liaison étroite nécessaire à l'art, c'est travailler à la division et à l'incompréhension des peuples, c'est faire œuvre préméditée de régression historique. Nos camarades artistes étrangers sont aujourd'hui menacés au même degré que nos camarades ouvriers étrangers. Les uns comme les autres sont à même de reconnaître dès maintenant ceux qui les soutiennent, ceux qui les frappent, ceux qui les livrent. Quelle que soit l'actuelle dépression des forces, entretenue par les trahisons successives, il ne sera pas dit qu'ils se seront placés en vain sous la sauvegarde de la classe ouvrière.

Nous dénonçons en les décrets-lois visant les étrangers — indésirables pour la bourgeoisie réactionnaire — une tentative d'avilir dans ce pays la personne humaine en créant UNE PREMIÈRE catégorie d'hommes sans droit ni dignité légale, vouée à des persécutions perpétuelles du seul fait qu'ayant résisté à l'oppression ou fui des dictatures inhumaines, ils n'ont plus de « patrie » légale.

LE COMITÉ NATIONAL DE LA
F.I.A.R.I.

it before his departure, and it was entitled *Trajectoire du rêve* (The path of the dream).[23] The texts and illustrations it included clearly indicated that from the time of *Les Vases communicants* Breton's had consistently sought to take both Freud and Marx into account: if the manifesto he had written with Trotsky gave Marx more than his due, Freud was not totally neglected, since Breton referred in passing to "the mechanism of *sublimation*" and the way in which psychoanalysis had brought it to the fore, in order to assert that it was the ideal of the self that "raises up against the present unbearable reality the powers of the inner world."

On the very first page of *Trajectoire du rêve* a note by Breton relating the harassment Freud suffered in Vienna at the hands of the Nazis established that the desire to know more and more about the inner life of human beings, in which an "exclusive devotion to the cause of human emancipation conceived in the broadest form ever known" was evident, could have dramatic consequences on the conditions of existence that the political situation imposed on the scientist.

After this detailed introduction, the *Cahier* was divided into two sections. The first part included an anthology, presented by Albert Béguin, of "German Renaissance and pre-Romantic texts" (from Paracelsus to Lichtenberg), complemented with excerpts from Pushkin, Xavier Forneret, and Lucas.[24] The second part began with the recital and analysis of a personal dream by Breton, then compiled contributions from members (Leiris, Péret, Mabille, Éluard, Guy Rosey, and others) or close collaborators of the group (Marcel Lecomte, Ferdinand Alquié, Armel Guerne), in which dreams jotted down almost immediately alternated with their analyses. Almost all the illustrations were reserved for this second part—fourteen drawings (Tanguy, Masson, Dalí, Maurice Henry, Paalen, Jacqueline Breton, and others) and a collage by Max Ernst—as if to emphasize that it was through the second half of the publication that the first half would find a significance other than anecdotal or archeological. It is also worthy of note that if Albert Béguin stated in the introduction to the collection that "dreams are not yet *poetry*," it was because he would later specify that poetry, "inspired by dreams and by everything like them . . . , is an act in which one voluntarily surrenders to certain practices whose aim is to destabilize the world the way it 'is,' to reveal its astonishing underlying structure, the one which really *concerns* us." No doubt the first formula seems to contradict Ludwig Heinrich Jakob's quotation in the entry for "Dreams" of the *Dictionnaire abrégé du surréalisme*—"Dreams are nothing other than involuntary poetry"—but with the exception of this one restriction, Béguin and the surrealists did agree on the revolutionary impact of poetry itself.

The convergence between art and oneiro-poetical activity in the desire for revolution was reaffirmed throughout 1938. With hindsight, it seems to have been a decidedly crucial year where the defense of freedom in every aspect was concerned, with three events—the *International Exhibition* in Paris, the composition of *Pour un art révolutionnaire indépendent,* and the publication of the journal *Trajectoire du rêve* of varied significance—that were all part of one and the same project.

Nicolas Calas: *Foyers d'incendie*

Nicolas Calas would seek to embrace and refine the surrealist project in *Foyers d'incendie* (Centers of fire), which was also published in 1938. The book marked the culmination of its author's Parisian period within the group (1937–39). It was without doubt

an extraordinarily ambitious theoretical survey, concluding with the evocation of certain pre-Socratic figures (Anaxagoras, Zenon, Heraclitus) to sketch the portrait of a "Promethean superhero": this hero "makes fire the sex of his thought" and "seeks out the type of perfect knowledge which can only be complete memory and definitive judgment." The work embraced multiple domains (psychoanalysis and the history of religions, economy, poetry), analyzing both Sade and Proust, and Calas's entire thought process was driven by the search for a synthesis where words of an ideological nature—hitherto separated and considered heterogeneous—would merge. This sometimes led him to abrupt considerations, as when, for example, he wondered who would be the future master, in France, "of Rimbaud and the Banque de France": "Claudel and the two hundred families or the surrealists and the proletariat?"—considerations where the unity of the "spiritual" and the "material" were affirmed. And Calas, in order better to exalt the revolutionary impact of love, did not hesitate to suggest a list of "documents" of "educational" value: three books (*Lady Chatterley's Lover,* in spite of its "dreadful ethical and religious jumble"; *Nadja,* which "deals with the psychosocial problem"; and Raymond Roussel's *Impressions d'Afrique,* capable of acting "as a violent aphrodisiac"), two films (*Two Monks,* from Mexico, and *Peter Ibbetson*) and a few songs: *Le Chaland qui passe* by Lys Gauty and *Vivre dans la nuit* by Tino Rossi. "How I would have loved," added Calas, "to have a recording of Shakespeare's Sonnets performed by Tino Rossi!"[25]

Foyers d'incendie boldly enriched its premise and analysis with all the enthusiastic ideas the author's subjectivity might propose, allying surrealist values with Trotskyist stances; thus Calas's work constituted, as was made clear by Breton's insert, "a manifesto of unprecedented urgency and scope"—even if at the time it did not receive much attention.[26]

Dreams in the News

Frédéric Delanglade would be in charge of organizing an exhibition titled *The Dream in Art and Literature* in the early days of 1939. It was not, strictly speaking, a surrealist-sponsored event, but the participation of the group members was particularly noteworthy. An entire section was set aside for them, collecting works by Brauner, Dominguez, Esteban Francès, Jacques Hérold, Masson, Matta, Gordon Onslow-Ford, Paalen, Remedios, Kurt Seligmann, Tanguy, and Raoul Ubac—that is, "young" representatives: Breton would emphasize, in "The Most Recent Trends in Surrealist Painting," their clear commitment to the future. In the publication that accompanied the exhibition (no. 63, dated March 15, 1939, of the monthly periodical intended for the medical profession, *Visages du monde*), one could also read about the collaboration of Delanglade himself ("The Dream in Art") as well as of Gilbert Lély ("Notes on the Dream in French Literature": "The Liberation of the unconscious, which means a rethinking of the very essence of human beings, is a phenomenon shared by dreams and by poetry."), Jacques Brunius ("Dreams in the Cinema"), and Gaston Ferdière, whose article "Recipes to See from Within" was illustrated by three watercolors painted by a schizophrenic and by three surrealist paintings (Onslow-Ford, Francès, and Remedios). Ferdière said in passing that it was solely by calling on the memories of his own dreams that it had been possible for him, as a psychiatrist, to grasp the necessity, if not the logic, of the delirium affecting some of his patients. A few months after the *Trajectoire du rêve,*

Delanglade's exhibition confirmed, in its way, that the exploration of the universe of dreams was still very much in the news, however far removed it might seem from the sociopolitical demands of the moment.

News from Mexico

The various events organized in 1939 by the group itself remained rich in echoes of Breton's trip to Mexico. Mexico had clearly attained the status of "the country where the winds of liberation have not yet dropped," as described in "Memory of Mexico" (*Minotaure*, no. 12–13). Frida Kahlo was proof of this, for example, in both her person and her work, "wonderfully situated at the point of intersection between the political (philosophical) line and the artistic line, whence it is hoped they will unite in one and the same revolutionary consciousness, without it being necessary for the essentially different motives which characterize them to merge."[27]

Paintings by Frida Kahlo were shown in March at the "Mexico" exhibition that Breton organized at the Galerie Renou et Colle, along with works by Diego Rivera, naive retables, paintings of the eighteenth and nineteenth centuries, pre-Columbian or popular objects, etchings by Posada, and photographs by Manuel Alvarez Bravo. In this way, a synthetic approach to a country or its culture was given: its past, its "reality" as restored by photography, its upheavals and contradictions as captured in pictorial testimonies. Where words might fail to convey the passion he felt with regard to Mexico, "Breton recognized the right of vision alone to be imperial: to endeavor to see everything, both on the outside and within." In this context, Frida Kahlo's painting revealed what was for Breton an essential quality: there were no painters whose work appeared "better *situated* than hers in time and space." This notion of situation within time and space was, before the Second World War, sufficiently important for Breton to refer to it again in "Prestige d'André Masson"—but negatively. Breton actually deplored the fact that the "so-called art" practiced by painters who, unlike Masson, limited their work solely to the expression of a uniformly euphoric vision, appeared "now as *not situated*: what this means is that the problem is no longer what it once was, the need to know whether a painting 'holds up' for example when compared to a wheat-field" (allusion to a declaration by Braque) "but rather whether it holds up next to the daily newspaper which, open or closed, is a jungle."[28]

Latest Trends in Surrealist Painting

In response to this "jungle," which was becoming more and more stifling, rumbling with menace, what did pictorial surrealism suggest? One response was given by "Latest Trends in Surrealist Painting," which, although relatively short, determined what should be abandoned without regret, as well as the encouraging signs for the future.[29]

Breton began by insisting on "the clear return to *automatism*" visible among some of the more recent painters to join the group, and he emphasized that there was still "some ambiguity between the voluntary and the involuntary" in certain older techniques (collage, frottages, paranoiac-critical productions). Fortunately, the techniques practiced by Dominguez and Paalen removed all ambiguity. Dominguez created decalcomania without objects: paint was spread on a base, then transferred without any directing idea onto another base. Paalen practiced fumage, a technique he had been

1

2

3

5

6

4

using since 1937, which was a free interpretation of the traces of smoke left by a candle on a base. Matta (a welcome newcomer) and Gordon Onslow-Ford, like Dominguez and Paalen, could be described with the same words that referred to Esteban Francès and his grattages, where color was first spread indiscriminately: "An invisible hand takes his own and helps it to retrieve the large hallucinatory figures latent in this mixture."

It was certainly this desire to explore the latencies of what was immediately visible by obeying the suggestions of the material itself that gave the impression that these artists' creations were beckoning: however enigmatic or not immediately legible they might seem, the hardly describable shapes and fragmented figures (often one cannot easily decide whether they belong to a world that is disintegrating or crystallizing) categorically assert themselves, without hesitation or repetition, and constitute the differing approaches of possible universes.

Such probing work also led to an evaluation of Dalí's painting, which now seemed doomed to monotony; it was time to take leave of him for good. The recent declarations made by the Catalan painter—who was beginning to profess openly racist opinions—sufficed to show that in his case, the "inner model" he claimed to refer to hardly seemed acceptable: "I do not know which doors," concluded Breton, "will open . . . in Italy or in the United States, the two countries he is hesitating between, but I do know which doors will close to him."

At the opposite extreme, Tanguy's painting deserved to be considered the one most worthy of influencing the young members of the movement, who in their own work offered a confirmation of his principles. Uncompromising, its elements "are the words of a language one cannot yet hear, but that one will soon read and speak, and one will conclude that it is the best adapted to a new form of exchange."

Going beyond the Three Dimensions

Tanguy's importance would be confirmed in June, when Breton dedicated the poem "La Maison d'Yves Tanguy" to him. [30] One line "L'espace lié, le temps réduit" (Space connected, time reduced) may be an echo of the last paragraphs of "Latest Trends in Surrealist Painting," in which Breton had noted that the choice to use automatism, for the painters he was referring to, went along with a willingness to take on the most ambitious issues, and he ascribed to them a shared aspiration to "go beyond the three-dimensional universe"—as Matta and Onslow-Ford's work clearly showed. [31] They were in fact striving to discover a new and original pictorial space. In Brauner's case, it should be noted (he had come back to Paris from Romania in 1938), the possibility of entering a fourth dimension "tended to occur no longer on a physical, but psychic level"—he would cause sparks to fly in the exchange between great humor and great love.

Seligmann was then praised for the way in which his objects—like the *Ultra meuble*—had opened a "new direction" by revealing the possibility of a "petrifaction of time." In his painting, this direction was placed "entirely under the control of the sexual order, for in the entire animal kingdom it presides over the act of adornment and of dance." Bodies are drawn to each other, no longer as a result of chance encounters, but inexorably, obeying both their connection in space and a drive that comes solely from within.

Finally, Ubac was cited as an example of what photography could achieve when it

Right: Frida Kahlo, *The Suicide of Dorothy Hale* (1939); oil on Masonite, 23³/₅ × 19¹/₃ in. (59 × 48.3 cm). Phoenix Art Museum, Phoenix, Arizona.

Below: Frida Kahlo, *Roots* (1943); oil on metal sheeting, 12 × 20 in. (30.2 × 49.8 cm). Phoenix Art Museum, Phoenix, Arizona.

Opposite page: Frida Kahlo, *Cuando te tengo a ti* (1938); oil on wood, 22²/₅ × 14¹/₅ in. (56 × 35.5 cm). Private collection.

Previous page: Frida Kahlo, *Self-Portrait with Monkeys* (1943); Private collection.

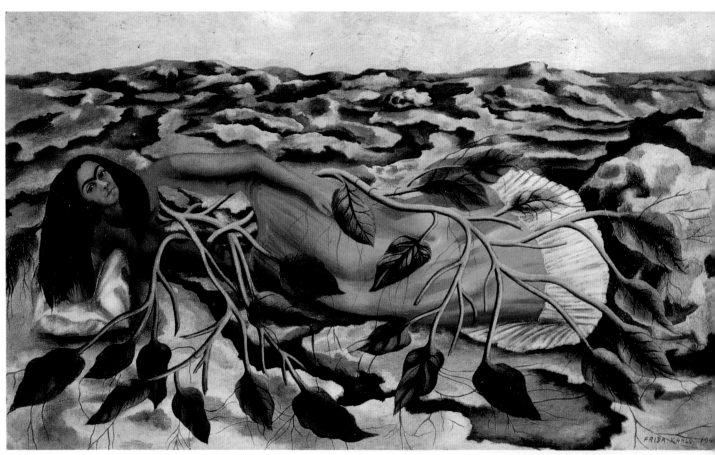

Cuando te tengo a ti; Vida cuanto te quiero. pintó Frida Kahlo 1938.

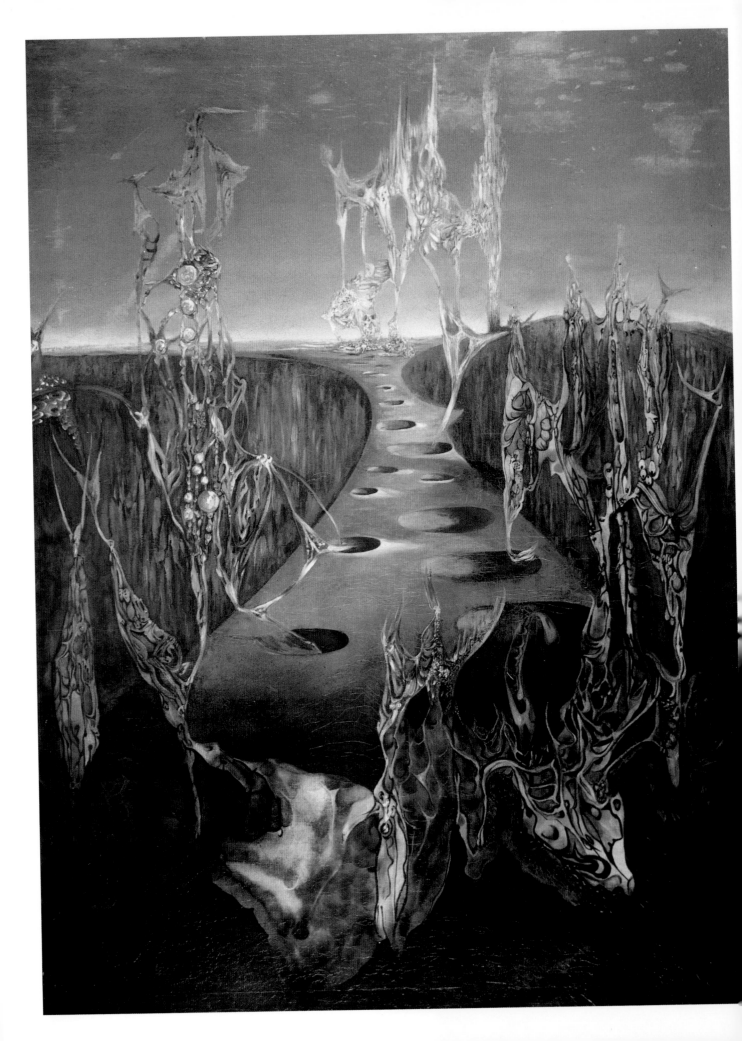

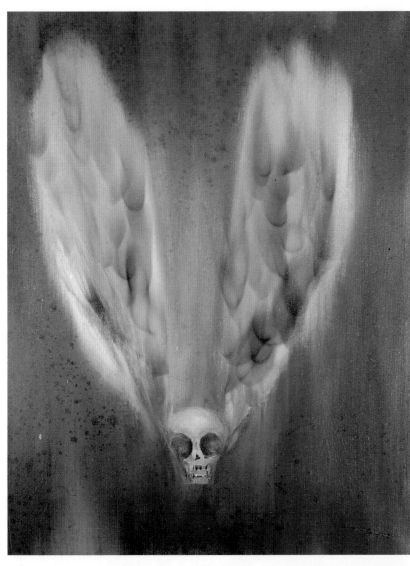

Left: Wolfgang Paalen, *East Wind* (1937); oil and fumage on canvas, 16²/₅ × 13¹/₅ in. (41 × 33 cm). Galerie 1900-2000, Paris.

Below: Wolfgang Paalen, *Untitled* (1938); fumage, 18²/₅ × 15 in. (46 × 37.7 cm). Private collection.

Opposite page: Wolfgang Paalen, *Untitled* (1938); oil on canvas, 58²/₅ × 45³/₅ in. (146 × 114 cm). Galerie F. Tournié, Paris.

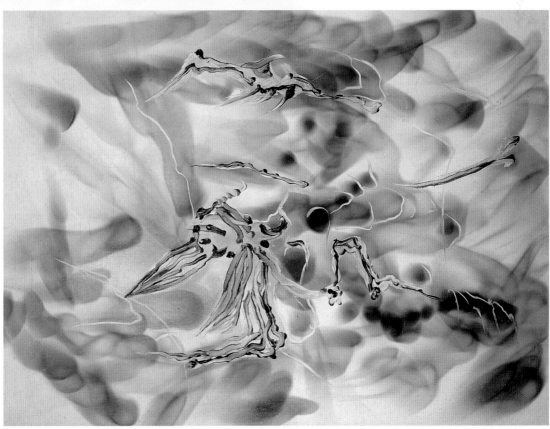

Yves Tanguy, *Divisibilité indéfinie*
(Indefinite divisibility; 1942); oil on
canvas, 16 x 14 in. (40 x 35 cm).
Albright-Knox Art Gallery, Buffalo,
New York.

Yves Tanguy, *Le Diapason de satin*
(The satin diapason; 1940); oil on
canvas, 40 × 32²/₅ in. (100 × 81 cm).
Private collection.

Raoul Ubac, *Le Triomphe de la sterilité* (The triumph of sterility; 1937); 16 × 12 in. (40 × 30 cm).

Opposite page: Joan Miró, *Oiseaux et insectes* (Birds and insects; 1938); oil on canvas, 45⁴/₅ × 35¹/₅ in. (114.5 × 88 cm). Private collection.

Left: Joan Miró, *Le Chant du rossignol à minuit et la pluie matinale* (The nightingale's song at midnight and the morning rain; September 4, 1940); gouache from the *Constellations* series, 14²/₅ × 17¹/₅ in. (36 × 43 cm). Private collection.

Following pages, verso, top: Dessin collectif (Collective drawing; Marseilles, 1940); pencil, colored ink, and colored chalk on paper, 13 × 20 in. (32.6 × 49.8 cm). Musée National d'Art Moderne, Centre Georges Pompidou, Paris.

Following pages, verso, bottom: Collective Drawing (Marseille, 1940); pencil, colored ink, brown wash on paper, 9¹/₅ × 11⁴/₅ in. (22.9 × 29.7 cm). Musée National d'Art Moderne, Centre Georges Pompidou, Paris.

Following pages, recto: André Masson, *Antilles* (1943); oil, tempera, and sand on canvas, 50²/₅ × 34 in. (126 × 85 cm). Musée Cantini, Marseille.

Victor Brauner, André Breton, Oscar Dominguez, Max Ernst, Jacques Hérold, Wifredo Lam, Jacqueline Lamba, and André Masson: the Marseille card deck, published in VV, number 2–3 (1943).

Wifredo Lam, *The Noise* (1943);
gouache on paper mounted on
canvas, 42 × 33³/₅ in. (105 × 84 cm).
Musée National d'Art Moderne,
Centre Georges Pompidou, Paris.

Wifredo Lam, *The Jungle* (1943);
gouache on paper mounted on
canvas, 95³/₄ × 92 in. (239.4 × 229.9
cm). Museum of Modern Art, New
York.

In the assemblage image, the following handwritten text appears:

ces terrains
vagues

et la lune

accrochée
à la
maison
de
mon cœur

où j'erre

vaincu
par l'ombre

Above: André Breton, *Poème-objet* (1941); assemblage of various objects and painting on drawing cardboard, 18¹/₃ x 21¹/₃ x 4¹/₃ (45.8 x 53.2 x 10.9 cm). Museum of Modern Art, New York.

Opposite page: Joseph Cornell, *Bell Jar* (ca. 1932); assemblage, 16¹/₃ x 9¹/₅ x 9¹/₅ in. (40.6 x 22.9 x 22.9 cm). Private collection.

Following pages, verso: Kay Sage, *Feste* (1947); oil on canvas, 16²/₅ x 13¹/₅ in. (41 x 33 cm). Private collection.

Following pages, recto: Kay Sage, *Untitled* (1947); oil on canvas, 18⁴/₅ x 14⁴/₅ in. (47 x 37 cm). Private collection.

à Germaine et M

mes amis

Kay Sage 47

Above: Dorothea Tanning, *Off Time
On Time* (1948); oil on canvas, 14$^{1}/_5$
× 20$^{2}/_5$ in. (35.5 × 51 cm). Private
collection.

Opposite page: Dorothea Tanning,
Children's Games (1942); oil on can-
vas, 11$^{1}/_5$ × 7 in. (27.9 × 17.8 cm).
Private collection.

Roberto Matta, *Les Grands Transpar-
ents* (The great transparencies;
1942); wax crayons and lead pencil
on paper, 23³/₅ × 29³/₅ (59 × 74 cm).
Private collection.

evolved along the same path as the above-mentioned painters: the woman portrayed by Ubac "is the incredible, possible flower, the fisherwoman who tames the moving sands," since the "petrifaction" occurs inside her outlined forms, thanks to which past and future enter into an understanding, or even a communion.

International Exhibition in Mexico City

Despite the depressing nature of the political situation in Europe (or rather, because of its very nature?), Breton felt the need to revive the movement, and his text "Latest Trends in Surrealist Painting" was only a partial expression of that need. His recent break with Éluard, which ended a twenty-year friendship, but also the failure of *Clé* undoubtedly convinced him that it was time to clarify the meaning of surrealism—just what was at stake, given the circumstances of the moment. In May and June he worked on the composition of a new manifesto, which remained unfinished; in August he spoke of creating a new periodical that would be rigorously surrealist. Events would eventually decide for him—he was mobilized on September 2, 1939, and appointed auxiliary doctor in Sucy-en-Brie, where he began to organize an international exhibition of surrealism with the Peruvian poet Cesar Moro and Paalen (who had arrived at the beginning of the year): it was planned for February 1940, at the Galeria de Arte Mexicano in Mexico City.

The event enabled Mexican artists to gain access to their first international recognition: in parallel to muralism, which before the war was the dominant trend of Mexican art, by virtue of its social impact and its references to Indian culture, there were also many artists who were producing work infused with a spirit of the magical or the fantastic and whose cultural origins were authentically local. Their endeavors were newly legitimized by the directions surrealism was taking, capable in vastly different ways than muralism of validating references to nature, to myths, to the reverie between nostalgia for the past and anticipation.[32] But the two local "celebrities" whose work was hung in the international section alongside the European surrealists were still, obviously, Frida Kahlo and Diego Rivera. Rivera's presence was no doubt justified more by the nobility of his political activity and his popularity than by the formal nature of his work, which remained firmly in the line of a domesticated cubism.[33]

Apparently the international exhibition of Mexico City had little success beyond the circles of the intelligentsia. Locally, critics reproached the juxtaposition of "old" and recent works and said that it was impossible to determine their value—or, consequently, that of surrealism. Also of note was the fact that the works were simply hung in juxtaposition (which was contrary to the principle generally applied to collective exhibitions), which certainly made it more difficult to determine the specificity of the surrealist program. In fact, despite the welcome Breton received in 1938 and the presence in Mexico of Wolfgang Paalen and his wife, Alice Rahon, for over a year, it would take an influx of other representatives of the movement for surrealism to have a real influence: it would not be long until this happened.

Marseille

As soon as war was declared, many of the surrealists were mobilized—Péret would say ironically, in a letter to Seligmann, "If you could see how good I look in uniform, so

valiant, what a bearing!" Masson and Tanguy were both exempted (Tanguy quickly left for New York, where Calas and Matta would join him in the early part of 1940); Jehan Mayoux, however, had been sentenced to five years in prison for insubordination, and Bellmer and Ernst were imprisoned because of their German nationality. During Ernst's internment in the camp at Milles, Leonora Carrington was afraid that the Germans would seize the house she shared with Ernst; thus, she registered it in the name of a Frenchman, who promptly acted as if he were the official owner. After his liberation, Ernst would have to come and steal his own paintings during the night, and he asked Peggy Guggenheim to certify that the sculptures that remained in the house were worth at least 175,000 francs. Since Peggy Guggenheim had seen reproductions in the *Cahiers d'art,* she agreed, and later financed Ernst's passage to the United States, after they met up in Portugal. However insignificant this anecdote might seem compared with the horrors that overcame France under Nazi occupation, it is indicative of the confusion and uncertainty experienced by those members of the group who, unlike Paalen, Man Ray, or Seligmann, did not have a chance to leave immediately for more peaceful territory.

Miró initially retired to Varengeville, then reached Palma de Majorca after the debacle in June 1940. There he finished his series of *Constellations* (while from Reno, Nevada, Tanguy complained in a letter to Seligmann that he had received little news, before adding, ironically, "I've heard only that Miró went back to Spain! There are definitely some strange things going on"). As for Magritte, he stayed in Carcassonne, at the home of Joë Bosquet, together with Louis Scutenaire and Raoul Ubac. But it was in Marseille and the surrounding area that a good many members of the group met up, as they flowed into the Free Zone after the armistice. Breton went first to Salon-de-Provence to the home of Pierre Matisse (Masson would join him there), then settled in Martigues, with Pierre Mabille; he was writing *Pleine marge* and seemed to have decided to leave for the United States, even though, as he wrote in October, "America in fact remains a completely negative choice: I don't like the idea of exile and I have no faith in exiled people."[34] In the meanwhile, he spent time observing the "superb fights among mantises," on the beach, while Seligmann, Tanguy, and Kay Sage were doing what they could in New York to get the papers and guarantees necessary for his departure. It was in Martigues that Breton learned of Trotsky's assassination in Mexico City.

At the end of October 1940, Breton, Jacqueline, and their daughter Aube moved into the villa Air-Bel in Marseille, where the Emergency Rescue Committee (the American committee for aid to intellectuals) had its offices, run by Varian Fry and Daniel Benedite.[35] Victor Serge was already staying there; others who would spend varying amounts of time there were Dominguez, Duchamp, Péret (who in August 1939, had contemplated "seeking refuge" in Belgium to avoid mobilization and who had then just been released from prison, to which he had been sentenced for subversive activities in uniform), Remedios, Char, Brauner, Ernst with Peggy Guggenheim, Wifredo Lam, Gilbert Lély, Jacques Hérold, Masson, Bellmer, Delanglade, Arthur Adamov, Tzara, Ubac, and René Daumal. In order to survive, Hérold and Brauner painted decors, for bars and theaters alike; but it was the little factory set up in an apartment and organized by Sylvain Itkine that was the most profitable: it produced sweetmeats (the "Fruit mordoré" or "Croque-fruit," blended from dates, almonds, hazelnuts and ground walnuts, which could still be found in abundance in Marseille).

3

1

4

2

5

Others who collaborated on this effort were Péret, Hérold, Prévert, Dominguez, Lély, and Jean Ferry, whom José Corti credits with having devised their advertising slogan:

I think, therefore I am (Descartes)
I eat therefore I munch fruit (no ration card!)[36]

So many people gathered at the villa Air-Bel—quickly nicknamed "Hope-for-Visa"—that this meant an abundance of collective activities: exquisite corpse, collective drawings (particularly by Lam, Brauner, Hérold, Dominguez, Jacqueline, and Breton), collective collages (Lam, Dominguez, Breton), and "communicated drawings": a sketch was briefly (for the space of a few seconds) shown to a participant, who then had to reproduce it from memory.[37] From time to time a fairly unusual auction of surrealist works might be organized: "Brauner bought Hérold's painting and Hérold bought X's painting, and X bought Z's painting. But in the end nobody paid for the paintings they had acquired. It was a purely symbolic auction, a way of mocking the system which was in the process of collapsing."[38]

Of the various methods implemented to "ward off the anxiety which followed exhausting and uncertain procedures," (Masson) it was the design of a pack of cards—the famous Marseille Deck—which was clearly the most striking.[39] It was proof of the critical importance of playful activity, given the realities of the period, as well as of the surrealists' wariness that "the sign outlive the thing signified" (Breton): if the suits and face cards of the traditional game could be modified, it was also because no one, among its users, cared any more about what they might have symbolized to begin with. So the surrealists' deck substituted, from the ace down, the genius, the mermaid, and the magus for the former king, queen, and jack and for new suits devised the flame (which signified love), the black star (which signified dreams), the wheel (and blood, which signified revolution), and the lock (which signified knowledge). As for the face cards, each one was "by common agreement . . . judged the most representative for its assigned place"—altogether they formed a sort of surrealist pantheon as defined by the constraints imposed by the rules that went to make up the game. The creation of each face card was assigned by drawing lots, but exchanges were later made according to personal preference: Hérold designed Sade and Lamiel (genius and mermaid of wheels), Masson the Portuguese nun and Novalis (mermaid and magus of flames), Brauner drew Hegel and Helen Smith (genius and mermaid of locks), Dominguez drew Freud (the magus of stars), Breton chose Paracelsus (magus of locks), and so on. The joker—by virtue of outside circumstances— represented Ubu, just as Jarry had drawn him.[40]

At the same time, the surrealists tried to have some of their work published, but it was not easy: in 1941, the distribution of the *Anthologie de l'humour noir* was banned by the censors because the book seemed to be contrary to "the spirit of national revolution."[41] In November 1940, J. Ballard's *Cahiers du Sud* published Breton's *Pleine marge,* and in March 1941, Masson gave his article "Painting: Attempting the Impossible" to the same periodical.[42] Although it never gained the full support of the surrealists because of its literary eclecticism and its more traditional preferences in art, in earlier years *Cahiers du Sud* had featured some articles ("The Romantic Soul and Dreams" by Albert Béguin, a special issue on German Romanticism) indicative of the possibility of a certain convergence. An exhibition was envisaged as well, to be organized by Breton and Jean Ballard and featuring works by painters who were refugees in Marseille, but it never came about.

The Permanence and Pertinence of Black Humor

In February 1941, just before the volume was to be presented to the censorship committee, Breton wrote to Léon-Pierre Quint about the *Anthologie de l'humour noir* (it was ready in 1936 but would only be distributed in 1945): "Nothing is of greater interest to me than to see its publication at a time like this. It seems to me that this is precisely the adventure . . . in store for this most deceitful and prickly of books, and that this *too* is its main chance."[43] The fact that humor, by virtue of the very attitude it described, could find a particular usefulness according to circumstances, was something that had already been confirmed in 1937, in *Limites non frontières du surréalisme*: "Humor, as a paradoxical triumph of the principle of pleasure over real conditions, at the moment when those conditions are deemed most unfavorable, is naturally bound to adopt a defensive value."[44]

The ultimate convergence of Vaché's antilessons and Hegel and Freud's approaches, black humor was also the culmination of one of the surrealists' preoccupations from the very beginning of the movement, which contrasted sharply with what their contemporaries of the jazz age and afterward appreciated: collections of little anecdotes and bons mots, light-hearted anthologies where one could find the best and the worst side by side in predictable proportions.[45] For a public like this, humor was easily either "English" or "Jewish"—what mattered was that it made one laugh, however "coarsely"; as for trying to give a more precise definition of its methods and insinuations, that seemed quite pointless.

The situation was very different for the surrealist group, where Vaché's formula— (h)umour as "a sensation—I nearly said a sense, also, of the theatrical (and joyless) uselessness of everything"—continued to inspire comment and reflection, and not only from Breton.[46] He defined what he initially called "modern" humor—whose precursors truly were, as Aragon had shown, Rimbaud, Lautréamont, and Jarry. Vitrac had tried in 1924 to analyze Jarry's resources in this domain and pointed out the convergence of dreams, intelligence, and imagination in humor. Soupault found in *Les Chants de Maldoror* a "tragic and splendid humor," which Desnos noted in Sade or Byron, then in *Un chien andalou*—and this allowed him to venture a definition of considerable import: humor was "a repression of the frenzy caused by an essential despair." Tzara would add his own comments to these somewhat dispersed, if not disparate, remarks in *Grains et issues* (1935), suggesting the possibility of making humor with a peculiar approach more socially widespread: "The lifting of words' autumnal privileges, which humor knows how to make objective, still benefits from the fanaticism of capriciousness. . . . It is insulting to everything which is outside it, insofar as it is too vivid an affirmation of a sado-tragic personality which has become immobilized in immense solitude. But as the individual adapts his experiences to the demands of the community, humor, in changing, takes on a more universal character." The different points of view would find a synthesis thanks, first of all, to the notion of objective humor that Breton borrowed from Hegel, then to an interpretation based on Freud.

For Hegel, humor was an attitude that indicated the extenuation of romantic art, which was itself indicative of the historical moment when, after the experimental phase of its "symbolic" moment and the harmony of its "classical" period, art reached its culmination. If in romanticism in general, as the philosopher perceived it, subjectivity focused on itself because it no longer found the forms likely to explain its wealth in

outside material, it still remained possible for the mind to focus on the random events of the outside world. It was at this point that humor, "subjective and reflective" by definition, would be captivated "by the object and its real form" and reach its objective variant.

Concepts of this type were best tested by the advent of the surrealist objects of the 1930s, which also seemed to offer a response to the anxiety formulated by Max Morise in 1929—that is, at a moment when the political issue had become particularly pressing—when he said, "I deplore the deep oblivion into which humor has fallen." In "Lightning Rod," the preface to the anthology, Breton referred to his own article, "Surrealist Position on Objects," to recall his prediction that "the black sphinx of *objective humor*" and "the white sphinx of *objective chance*" must meet. But he also observed in passing that it was normal, from a Hegelian point of view, for humor to have appeared "much earlier in poetry than in painting, for example." Evoking the exceptions constituted by the work of Hogarth and Goya, he emphasized that humor was only truly triumphant in Posada's work and that it was fully accomplished in Ernst's three collage-novels.[47]

To move from the "objective" to the "noir," the mind must so to speak remove itself from a sort of general passivity implied by the Hegelian philosophy of history (in which subjectivity is nothing more than a specific manifestation subjected to the universal mind) to attain a more solid autonomy or, if one prefers, a more authentically assumed "experience." As Annie Le Brun has quite rightly pointed out, what is still missing from objective humor is a "wrenching separation which has been tragically lived but not suffered."[48] Freud would allow this transition, specifically in his article "Humor" published in *Le Surréalisme en 1929;* and Breton would borrow several elements from Freud without, obviously, endorsing the rapprochement that Freud had approved between humor and "regressive or retrograde processes."[49] It was important that "humor not be resigned, but maintain a certain bravado: humor symbolizes not only the triumph of the self but also that of the pleasure principle, capable of asserting itself . . . despite the negative effect of actual circumstances." Freud's conception also allowed one to affirm that "the secret of the humorous attitude lies within the extreme possibility for some people, in cases of high alert, of removing their psychic accent from the *self* and placing it upon their *superego.*"

However, the necessary inclusion of Hegel and Freud in this way did not, strictly speaking, allow one to elaborate a definition of black humor. What would take the place of that definition was the *Anthologie* itself.[50] The terrain was sufficiently well prepared for the reader to know what to expect, but also for the group, and not only Breton, to be able to see its own values represented: Ducasse, Rimbaud, Jarry, and Roussel had a place of honor, followed by the likes of Lewis Carroll, Sade, and Swift, along with Duchamp, Arp, and Vaché.[51] Henceforth, black humor would be included among the attitudes that were part of the surrealist behavior.[52] In his notes, Breton consistently established a relation between the writing of Sade, Baudelaire, Corbière, and others and their conduct in life: humor, too, goes far beyond mere literature (even if it enables new forms to be introduced into literature), it engages the very significance of life—or the refusal of significance, if it is true, as Marko Ristitch emphasized, that humor "is the extreme expression of a convulsive failure to accommodate, of a revolt whose restraint and compression only add to its strength. . . . To feel the deplorable futility, the absurd lack of reality of everything, is to feel one's own pointlessness. . . . So one must either

annihilate oneself, or transform oneself, go beyond oneself through a substantial nega-
tion:Vaché killed himself, Dada became surrealism."[53]

The Antilles

On March 24, 1941, Breton, Jacqueline, and their daughter Aube set sail on the *Capi-
taine Paul Lemerle* for Martinique.[54] Together with 350 other voluntary exiles, they trav-
eled in the company of Lam,Victor Serge and his family, and Claude Lévi-Strauss, who
would evoke in his *Tristes tropiques* Breton's air of a "blue bear" as he strolled along the
deck of the little steamship in his plush coat. A "lasting friendship" sprang up between
Breton and Lévi-Stauss, one that would continue through an exchange of letters on
the relations between the work of art and the document or between aesthetic beauty
and the quest for absolute originality.[55] Masson set sail eight days later on board the
Carimare.

As soon as they arrived in Fort-de-France, Breton was singled out as a "dangerous
agitator" and taken to the camp at Lazaret; he was quickly released, however. He then
discovered the first issue of the periodical *Tropiques* and met its two principal editors:
René Ménil and Aimé Césaire. Breton was won over upon reading Césaire's contribu-
tions to *Tropiques:* "What was said was what had to be said, and not only was it
expressed in the best possible way but also in the loudest voice possible!"[56] Breton's
immediate enthusiasm was then confirmed when he read *Cahier d'un retour au pays
natal* (Notebook for a return to the homeland). Césaire's love of liberty and his practice
of a type of writing that wanted nothing more to do with " common sense" and his
specific demands as a black man—something that was a sign of encouragement for all
people—granted the West Indian writer full rights to belong to the family of surreal-
ists. "The words of Aimé Césaire are as beautiful as nascent oxygen": the last sentence
of Breton's preface to *Cahier,* written in NewYork in 1943, also indicated that with this
poet, surrealism was born differently.

In Césaire's company, Breton discovered the island: he condensed its landscapes, its
localities, and its atmosphere into a group of texts written in the immediacy of the
moment:"Des 'Epingles tremblantes.'" Masson joined up with him, and together they
wrote "Le Dialogue créole"; the artist sketched the women walking with their bun-
dles, or the moist luxuriance of the vegetation, to which he occasionally gave a crys-
talline structure. These different pieces and drawings went to make up *Martinique,
charmeuse de serpents;* Masson would say that it was the result of a collaboration that was
"organic, of an utterly exceptional nature."

In May 1941, Breton, Lam, and Masson left Martinique. During a stop in Pointe-à-
Pitre they met up with Mabille, and in Santo Domingo Breton met Eugenio Fernan-
dez Granell, who, after fighting for the Spanish Republic, had been forced into exile.
He was one of the editors of *La poesia sorprendida* (Surprise poetry), the title of which
sufficed to indicate its effervescent character. Granell, whose style was reminiscent of
certain distortions common to Picasso, produced a number of canvases on the theme
of the head of an extremely cross-eyed Indian.[57]

From Santo Domingo, Breton and Masson left for NewYork, while Lam went to
Cuba, which he had left eighteen years earlier. This new "return to the native land"
meant that he rediscovered—his vision and intelligence matured by his European
experience and his earlier endeavors in painting—not only a culture and its rituals but

1

2

3

4

5

also a natural environment where he could lose himself with a new fervor. His work evolved as a result, and he very soon abandoned the rigorously geometrical cut-outs that he had imposed on his figures in the late 1930s in favor of a more nervous and sharp style, equally capable of suggesting menace or tenderness. Shapes were divided in two or melted away into their surroundings, bodies became disjointed (*Femme nue* [1942]) and seemed to hesitate between the carnal and the vegetable (*Le Bruit* [1942]), and faces took on an allure of horned masks. The culmination of this period, during which Lam discovered both his singular pictorial domain and the resources of a thought process that dared to reanimate its archaic or primitive beginnings, was incontestably reached with *La Jungle,* an enormous composition on mounted paper (93" × 85") that created a sensation during its exhibition in New York in 1943. Crossovers from one kingdom to another are abundant, an intense sense of poetry blooms forth, all based on a curious tenderness for exuberance, for the complicity between the bamboo and the enigmatic faces and the seemingly relentless metamorphosis from bodies into offered fruit. One's gaze is drawn by the promise of secrets about to be revealed at the same time that one is repulsed by the impenetrable density of the shapes. But *La Jungle* goes far beyond a sort of primitivist manifesto suggesting the wealth of a scandalously neglected Third World: it revives the ancient Greek meaning of *Phusis*—generation, growth, and transformation—and, at the same time, murmurs with desire, with a latent violence, and an implicit eroticism that exceeds all cultural bounds.

New York

In his *Entretiens,* Breton mentions only two things when talking of his time in New York—except to refer, on a personal level, to the pleasure of occasionally dining with Duchamp and the joy he found with Elisa—and these refer to collective activity: "Surrealist activity in New York, over those years, amounted essentially to an international exhibition organized in 1942 by Duchamp and myself at the request and for the benefit of a charitable aid to prisoners and the publication of a periodical entitled *Triple V.*"[58] The opinions expressed by some Americans on the presence of the surrealists and its consequences were something quite different. William Copley said: "The surrealists were there. Nothing would ever be the same again," and Susanna Perkins Hare estimated that they "were 95% responsible for the appearance of the New York School," that is, the first American school in painting capable of competing with the Old World.

A divergence of this kind in one's perceptions of the surrealist presence can be easily explained. The intellectuals who were refugees in New York lived in a relatively isolated circle: cut off from the American population (particularly when they did not speak English—as was the case for Breton), they met primarily with each other, and, of necessity, irrespective of their views or background. Famous photographs show Mondrian, Ozenfant, and Léger side by side with the surrealists. This resulted in unavoidable tension, periodic crises among the alliances, and jealousy spreading even among members of the group. Moreover, the surrealists, in order to publish or exhibit, were obliged to cooperate momentarily with partners whom under normal circumstances they would refuse: compromises that gave some of them a sort of bad conscience bordering on aggressiveness.

The American artists, obviously, did not perceive the situation in the same way: this was a chance for them to meet prestigious Europeans, artists whose status and concepts

1

4

2

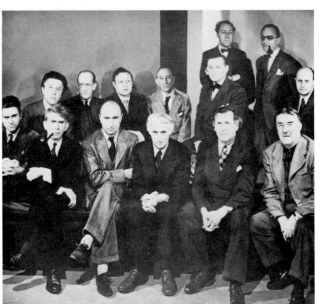

5

3

were very different from their own in 1940. If, in the course of these exchanges, some of the immigrants lost their aura, the young Americans not only learned a precious lesson but also gained greater confidence in their own capabilities as artists.

In February 1939, Breton had said in a letter "that almost all American painting and poetry derive more or less directly from surrealism."[59] This was being a bit optimistic, and Tanguy wrote to him shortly afterward that, on the contrary, "European artists seem to be utterly detested here, you only hear people speak about American art." American art was far from having reached maturity: on the one hand, the "regionalism" illustrated by Benton or Grant Woods in the 1930s was expiring and losing all relevance in the internationalist context brought by the war; on the other hand, the adepts of "social realism," such as Ben Shahn, Jack Levine, or Philip Evergood, had been disqualified in the eyes of the public and of American collectors because of their relations, seen as too close, with a sectarian and Stalinist Left. And the artists who were trying to take European modernity into account were only acquainted with that art through books, despite the direct contact they could have had with certain works by Léger, Matisse, or Picasso (particularly during the New York World's Fair in 1939, the year Picasso was also exhibited at the Museum of Modern Art [MoMA]), and as a result they had not yet succeeded in producing truly convincing work. Moreover, the vast majority of them suffered from the negative image of the artist that was held by American society: socially dependent yet unproductive, artists were acceptable when employed as a decorator or illustrator for the local ideology but incapable of having a serious impact on a social or intellectual level.[60] Under such conditions, "audacity" could lead, at best, to a semiabstraction, in the tradition of a Stuart Davis.[61]

Surrealism was not, however, completely unknown in the United States: in 1931, the Wadsworth Museum in Hartford, Connecticut, had shown De Chirico, Dalí, Ernst, Masson, Miró, and Picasso in an exhibition entitled *Newer Super-Realism,* with a catalog including excerpts from Breton's work. The other major museum event, in December 1936, was the MoMA's *Fantastic Art, Dada, Surrealism,* organized by Alfred H. Barr and the catalog for which included two pieces by Georges Hugnet and a chronology covering the years 1910–36 "with certain pioneers and forerunners" (the part of the exhibition devoted to fantastic art began, in fact, with the fifteenth century).[62] It was also in 1936 that Tanguy, thanks to Pierre Matisse, exhibited in New York, Hollywood, and San Francisco and that Julien Levy's *Surrealism* was published, the first work in English devoted with some seriousness to the movement, including, moreover, some pages by Bachelard devoted to "surrationalism" before they were even published in France.[63]

In 1931, Julien Levy had opened a gallery in New York at 602 Madison Avenue that was immediately devoted to European surrealists: in January 1932, the exhibition *Surrealism* consisted of a fairly open collection (it included Moholy Nagy), in which Dalí, Ernst, Man Ray, and Pierre Roy were displayed alongside Joseph Cornell, who would have a solo exhibition at the end of the same year, following Max Ernst's first one-man exhibition in the United States. Nevertheless, Cornell still kept a certain distance from the surrealist group, even during the war years. Already in 1936, the same year one of his works illustrated the dust jacket of Levy's *Surrealism,* he declared himself to be "a fervent admirer of a good part of their work" but also stated that "surrealism offers possibilities which are even more sane than those which have been developed." Cornell was certainly, during the 1930s, the only American artist whose very unusual style

of work could be recognized by Breton and his friends, and it was in this capacity that he participated in the 1938 *International Exhibition* at the Galerie des Beaux-Arts. His boxes and collages were certainly the result of permanent reverie rather than a purely dream-based production and were proof of his extreme meticulousness. But in this way Cornell was creating a body of work that was largely autobiographical, founded on a few obsessions and on his passion for the cinema, rich in conceptual echoes and formal rhymes. His intimate scenographs grouped recurrent elements: fragments of celestial charts, earthenware pipes, rings, parrots, chromolithographs, old papers, and glass baubles; the nonnarrative assemblages he obtained were both smooth and enigmatic. From 1936 on, Cornell began using fragments of recovered film to produce short features that displayed the same poetic richness, while the personal meditation that had engendered them belonged to an utterly private order, yielding to the public only glimpses that respected the initial secrecy.

Julien Levy, until 1939, displayed the great European names of the movement on the walls of his gallery: Man Ray, Dalí, Giacometti, Ernst, Magritte. His only serious rival, or accomplice, in this domain was Pierre Matisse, who showed Miró (almost yearly, from 1932 on), Tanguy, and Masson; with far less regularity, other galleries displayed works by Arp (John Becker Gallery, 1933), Ernst (Howard Pretzell Galleries, San Francisco, 1935, and the Mayo Gallery, New York, 1937), and Lam (Perls Gallery, New York, 1939).

Despite this relative presence—which remained discreet if one compares it to the number of exhibitions that were held in the United States over the same period—and the satisfactory distribution of *Minotaure* and *Cahiers d'art* throughout the country, it was Dalí who, in the public's eyes, symbolized the movement.[64] His talk at MoMA in January 1935 ("Surrealist Painting: Paranoiac Images") had an impact, and the major newspapers delighted in reporting his numerous gestures of extravagance.

In the domain of poetry, surrealism was even more discreet. Kenneth Patchen, who was also socially involved, expressed interest in the movement at the end of the 1930s, and Carl Rakosi acknowledged, at the beginning of the decade, that "French surrealist painting and poetry exerted a magnetic fascination upon me for a time," but the only American poet who could claim an authentic use of automatism was Charles-Henri Ford, the editor of the periodical *View,* which first appeared in October 1940.[65] *View* very quickly included Nicolas Calas among its contributors (he had just devoted an issue of *New Directions in Prose and Poetry* to the values of surrealism), along with Seligmann, Blanchard, and Tanguy, and in June 1941, Calas published an article clarifying the issue of "Dalí, the Anti-Surrealist."

It was therefore no surprise when, by issue number 7–8, Ford's periodical clearly had the look of a surrealist periodical. In addition to an interview with Breton, this October–November 1941 issue included pieces by Hénein, Masson, Seligmann, Calas, Ernst, and Péret and "communications" from Duchamp, Mabille, Paalen, Suzanne Césaire, Brauner, and Artaud. The illustrations moreover justified the description of "first surrealist issue" used by Breton in a letter to Roland Penrose: they were by Leonora Carrington, Stanley William Hayter, Morris Hirschfield, David Hare, Brauner, Kay Sage, Aube, Matta, Kurt Seligmann, Yves Tanguy, Gordon Onslow-Ford, Oscar Dominguez, André Masson, and Wifredo Lam.[66] When questioned on the changes that the war might bring to art, Breton deliberately evoked two nonsurrealist works, Hopper's *New York Movie* and Hirschfield's portrait of his daughter, to illustrate the need to

1

3

4

"read and look through the eyes of Eros . . . for whomever it falls upon to reestablish, in the coming era, the balance which was upset in favor of death." As for surrealism itself, he explained that given the current events, an individualism indifferent to the hazards of history was clearly coming to an end as far as surrealism was concerned, whereas surrealism must continue to foster that which was strange to the senses, to explore objective chance, and to prospect for black humor. It was the global failure of narrow-minded rationalism that gave the surrealist program "a vital interest"—if it confronted its experience and its achievements with those of *Gestaltheorie* and more recent theories on chance.

In April 1942, *View* published a special issue on Max Ernst (at the time he had an exhibition of decalcomania at the Valentine Gallery), and the following month another special issue on Tanguy (who was exhibiting at P. Matisse's gallery) and Pavel Tchelitchew. In April 1945 it was Duchamp's turn to be honored (the issue contained pieces by James Thrall Soby, Gabrielle Buffet, Desnos, H. and S. Janis, Calas, Frederick Kiesler, and the translation of Breton's *Phare de la mariée*). On top of these three special events, the surrealists were often featured, from Mabille to Seligmann or Masson by way of Calas, Cornell, or Man Ray. Moreover, after the third series (April 1943) and for the next two years, the majority of *View*'s covers were clearly designed by the surrealists. Ford opined in 1941 that "New York is now the artistic and intellectual center of the universe," but his periodical nevertheless remained fairly eclectic. In 1944 it would be defined, moreover, as "the periodical representing the avant-garde of all schools of art, poetry, and ideas." In November 1941, Breton wrote to Penrose that since his arrival in the United States he had never "ceased to call for the publication of a periodical which would express [them] all, and [he] absolutely counted on its realization" so that the experiments carried out the world over, be it in London or Mexico City, Cuba or New York, could be brought together, and so that the surrealists scattered by events could be united once again, at least by means of a shared publication.[67]

VVV

The much-awaited periodical came out in June 1942, coinciding with Duchamp's return to New York. Its editor was David Hare, a young photographer born in 1917 who began his art career as a sculptor. Kay Sage was his cousin, and he was introduced to the surrealists immediately upon their arrival.[68] During the summer of 1940 he invited Matta and Onslow-Ford, who had just arrived from England, for a visit on the coast of Maine: that is where the two of them would develop the theory of psychological morphology, which specified the possibility of delimiting worlds of time and space that were independent from the usual perception. ("A psychological morphology," wrote Matta in 1938, "would be the graph of ideas. It should be conceived before optical images give a form to ideas.") Psychological morphology found one of its first applications in Onslow-Ford's canvas *Propaganda for Love;* Onslow-Ford himself organized a series of talks at the New School of Social Research directed by Meyer Shapiro: works by Ernst, Miró, Tanguy, and, above all, Matta were analyzed through the optic of the theory of psychological morphology. Among the regular attendees were William Baziotes, Arshile Gorky, and Robert Motherwell, who traveled to Mexico in the summer of 1941 together with Matta, where he completed "in three months an apprenticeship of ten years in surrealism." As for Matta's work, it was clearly evolving:

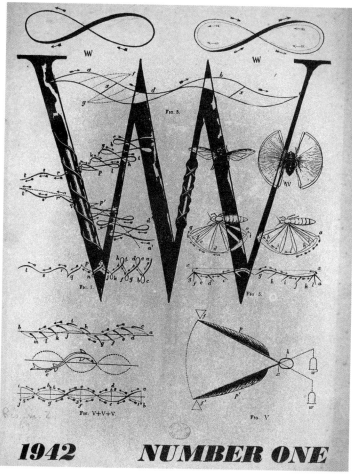

1942 **NUMBER ONE**

ALMANAC

FOR

1943.

1944 *No. 4*

3

he mixed drawing and colored areas as if they were suspended in a space with contra-dictory perspectives, using brushstrokes that did not correspond in the least to the painted forms among the atmospheric effects.[69]

Subtitled *Poetry, Plastic Arts, Anthropology, Sociology, Psychology*, *VVV* was bilingual, and seemed ready to revive, at least partially, the principles that had been those of *Minotaure*. Breton justified its somewhat disconcerting title in two ways: "Not only is V for *vœu* (wish)—and energy—the wish for a return to an inhabitable world . . .—but a double V signifies . . . V for victory over anything which tends to perpetuate the enslavement of man by man and . . . V also over everything which stands in the way of the mind's emancipation"; and in the second interpretation: "To the V which signifies . . . an eye turned toward the outside world . . . some of us have never ceased to oppose VV . . . , the eye turned toward the inner world . . ., whence *VVV*, a synthesis (of the principle of reality and the principle of pleasure), and a global outlook . . . which includes the myth in formation behind the VEIL of events."

From the very first issue, Breton and Ernst (who designed the cover) appeared alongside Hare as "advisers." Duchamp joined them in the same capacity for the next two issues, in March 1943 (no. 2–3, cover by Duchamp) and February 1944 (no. 4, cover by Matta). *VVV* would not go any further (as for *View*, its last issue came out in the spring of 1947; that of December 1946 had been devoted to "Surrealism in Belgium"). The lists of contributors were particularly strong and showed a clear intent to give the movement the most open representation possible; more than ever, the main concern was not to let the movement be seen as narrowly artistic or literary. To live up to its subtitle, the periodical included articles by Roger Caillois, Claude Lévi-Strauss, William Seabrook, and Alfred Métraux. Kiesler presented drawings by Professor Percy Goldthwait Stiles, whose concern in the 1920s had been to note down and draw his dreams, his style blissfully "stripped of any false artistic testimony" (no. 1); Seligmann provided translations of Paracelsus, and Robert Allerton Parker was particularly interested in Lovecraft and the stories published in science fiction periodicals, where he discovered a typically American contribution to the exploration of different worlds led by the surrealists.

VVV reproduced relatively few American artists, however. While it was clearly because of its publication that certain artists (Hare and Cornell, as well as Enrico Donati and Gerome Kamrowski) had grown closer to Breton and his friends, one can see that Cornell was not mentioned in the periodical and that Motherwell was only solicited as a critic, with his "Notes on Mondrian and De Chirico" (no. 1).[70] It was in *VVV* that the very young Philip Lamantia and Dorothea Tanning, Ernst's new companion, would get their start, but the last issue of the periodical was printed for the most part in French. Letters from Patrick Waldberg, Robert Lebel, and Georges Duthuit, under the title "Towards a New Myth? Premonitions and Mistrust" debated Georges Bataille's position, referring to issues that were of little concern to the American public or artists. Despite the collaboration of a few of those artists, *VVV* remained essentially a periodical representing the values and preoccupations of the exiled surrealists and, as such, was turned more toward Europe than toward America.

The Problematic of the Myth: The Great Transparencies

In 1935, in his preface to the *Position politique du surréalisme* Breton reiterated his desire

to "reconcile surrealism as *a means of creating a collective myth* with the much more general movement of the liberation of mankind." It was, first of all, the reference to Freud that oriented surrealism toward the correspondences between dreams and myths, both considered to be manifestations of the subconscious. Since the time of the *Second Manifesto*, the interest in Hegelian dialectics (a lasting interest, since one could sense its influence in the interpretation of the triple *V*) had been a call to direct the quest toward a collective myth, something that could be effective on a social level and no longer solely on the level of the individual psyche.

The myth, which is based on analogical reasoning, had for surrealism the double advantage of exceeding any form of rationality while offering at the same time an explanation of the world and the social structures that comprise it. The search for a new mythology might have seemed all the more urgent in the 1940s, given the fact that current events were proving not only the failure of rationalism but also that of earlier mythologies (beginning with those whose content was strictly religious, of course). If myths could be seen as a way to escape reality through the imagination, the purpose of this flight was a large-scale operation on reality and its accepted interpretations. The "refusal" of the belligerent context in New York in the 1940s was therefore justified by an attempt to create a distance from this context, as well as by its interpretation within a scope of thought that sought to decipher the most universal of mysteries: that of existence itself, above and beyond all circumstances.

The elaboration of a new myth did indeed go hand in hand with its potential practical impact: an effect on the individual and collective unconscious to direct desire toward a realization of the myth, and a change in the mental and social structures as they adapted to the program. Thus, the myth in itself would synthesize the interest shown by the surrealists—since the movement's early days—in primitive thought, and their desire for social change.

The *Prolégomènes à un troisième manifeste du surréalisme ou non* (Prolegomena to a third manifesto of surrealism or not) was published in the first issue of *VVV.* The very title—which seems to imply the pending composition of a longer text—announced its brevity, as it hinted at the hypothetical character of the final pages in which Breton proposed the Great Transparencies as an expression for the "new myth." The prolegomena constituted both a clarification and an attempt to revive the movement. Indeed, Breton did not hesitate to voice his skepticism with regard to "these abstract constructions known as systems" and pointed out that surrealism itself, twenty years after its foundation, seemed plagued "by the evils which are the ransom of any favor or notoriety": works that left and right claimed to be surrealist and that too often failed to conform "to what was *wanted*" and were based more on an exploitation of clichés from which all *integrity* was absent, on a "too deliberate conformity to surrealism."

What was needed could then be determined: "Man must escape from this ridiculous arena in which he has been placed: a so-called actual reality with the prospect of a real future which is hardly any better"; to accomplish this, "he must be allowed to make use of an instrument of knowledge which seems best adapted to each circumstance." Proof of this was provided by the fact that the concern was shared by very dissimilar minds. Breton supplied a list—Bataille, Caillois, Duthuit, Masson, Mabille, Carrington, Ernst, René Étiemble, Péret, Calas, Seligmann, Hénein—to reply to the question of whether it was possible to "choose or adopt, and *impose* a myth in relation to the society we would like to have." No response was conceivable unless one accepted that "all ideas

which triumph are on the road to ruin." It was in this intellectual context of an opposition "fortified in its principle" that the Great Transparencies appeared, at the end of the text; they were introduced, moreover, by an allusion to the anthropomorphic interpretation, to which even Trotsky deferred with regard to animals, and as a probe to "great utopian landscapes" and "setting off on voyages like Bergerac, like Gulliver."

The mythical hypothesis of the Great Transparencies suggested that "man is perhaps not the center, the focal point of the universe" and that "above him there exists, on the scale of animals, creatures whose behavior is as foreign to him as his might be to the mayfly or the whale." It was not inconceivable, added Breton, that these creatures "make themselves known to us in fear, and a feeling of chance" and that their structure could be examined through the study of phenomena—natural (like cyclones) or social (like war)—in the midst of which we concede our helplessness.

The Great Transparencies did at least offer the advantage of putting an end to all anthropocentrism: it was now up to human beings to make themselves receptive, to be prepared to listen to every element—micro- or macrocosmic—in order to establish genuinely *harmonious* relations with things and beings. So that human beings, instead of continuing to view themselves as focal points, might more modestly yet more effectively become sensitive points. This would, more than ever, open the way to analogical thought and poetic knowledge.

In *VVV,* the pages devoted to the Great Transparencies were accompanied by a drawing by Matta, *Los Grandes Transparentes,* which provided a plausible graphic transposition of the hypothesis and even seemed to be at its origin: the space invoked was not strictly Euclidian and allowed for unnamable biomorphic configurations, the contours of which were extended by lines, while the colored areas could be equally interpreted as allusions to the violence of the era or to alchemical operations. The fact that alchemy could offer a way to escape rationalism, and was capable of generating analogical relations, was something that the surrealists had known for years. It was therefore no surprise that alchemy could contribute to an elaboration of mythology, as could the ideas of the gnostics, the Cabbalists, and the entire esoteric tradition that Breton would call on two years later in the composition of *Arcane 17:* this time Matta would contribute the illustrations (four Tarot cards), and he designed the poster to greet its publication.

In his speech to French students at Yale University on October 10, 1942, which was published in *VVV,* number 2, under the title "The Situation of Surrealism between the Two World Wars," Breton, after recalling the lasting importance of automatism, of dialectical thought (from Heraclitus to Hegel by way of Master Eckhart), of objective chance "as an indication of the reconciliation possible of nature's aims with man's aims, in man's eyes," and of black humor, went on to emphasize yet again that, among surrealism's fundamental maxims was also "the practical preparation for *an intervention into mythical life.*"[71] That mythical life, he specified, should "first of all, on a large scale, act as a purification."

Proof that there were many who were working to elaborate a new myth was provided by the dozen or so articles published in *View* and *VVV* on the theme: two months before the prolegomena, Breton's "Legendary Life of Max Ernst, preceded by a brief discussion on the need for a new myth" was published in Ford's periodical; then in the first issue of *VVV* came an evaluation chart, where the sphinx received the best marks—its title was "Concerning the Present-Day Relative Attractions of Various

Creatures in Mythology and Legend"—along with illustrations accompanied by Max Ernst's text "First Memorable Conversation with the Chimera" (Ernst took the opportunity to explain the role played by the Chimera in his own work).[72] And again in *VVV*, in the fourth issue, was a series of articles grouped under the title "Towards a New Myth? Premonitions and Mistrust" and the article that Pierre Mabille devoted to Paradise.[73] This piece analyzed the many avatars of the "myth of Eden" and underlined its social consequences. The international revolutionary movement, in the form it took during the 1940s, had itself been contaminated by the mystique of Eden: the "brighter future" predicted on earth, was nothing more than a layman's caricature of the belief in an ulterior happiness. Equidistant from the mystical beyond and the so-called postrevolutionary golden age, the surrealists intended to "live from today on"—which implied a global revolutionary momentum, constantly rebelling against any confinement within a party, a dialectical thought eager to keep its contradictions active, and the reintroduction of the supernatural into everyday life. Mabille, not satisfied with taking part in the purge of ancient or more recent notions of Paradise, pointed out in a timely fashion that the surreal had nothing to do with any form of transcendence: it was, on the contrary, in everyday life that it must be revealed. "As life ceases to be systematically doomed in favor of illusory conditions of happiness, we want to be apprentices to this happiness through daily actions."

First Papers of Surrealism

The exhibition thus entitled, which was held at the Madison Avenue Gallery from October 14 to November 7, 1942, was not the first in which the surrealists took part as a group. There had already been, from March 3 to 28, the collection *Artists in Exile* at the Pierre Matisse Gallery, presented by James Thrall Soby and Calas. The difference in the titles of the two exhibitions is in itself significant: in March, eclecticism was de rigueur—and Amédée Ozenfant, Osip Zadkin, and Berman found themselves alongside Ernst, Masson, Tanguy, and Breton himself in the *Artists in Exile* exhibit.[74] (On this occasion, Breton presented his object-poem *Portrait de l'acteur AB dans son rôle mémorable de l'an de grâce 1713,* conceived in December 1941.) *First Papers,* in contrast, organized by Breton and Duchamp, chose strictly surrealist works, even if its title alluded, somewhat ironically, to the documents an immigrant might obtain before being definitively naturalized. The catalog included pieces by Sidney Janis and R. A. Parker, but North American participants (David Hare, William Baziotes, Robert Motherwell, Hedda Sterne, Morris Hirschfield, and Jimmy Ernst, among others) were in the minority compared to the list of European surrealists, nearly all of whom were represented, or of foreigners in the United States (Wifredo Lam, Matta, Frida Kahlo, and others). The event unfolded as if the idea was for the movement to adopt a few North Americans rather than to have the movement itself adopted by the United States. To present the various works, Duchamp threw the old-fashioned decor of the exhibition halls into confusion by means of an immense spider's web of five miles of white string. The catalog's design was surprising: the cover showed an old wall pierced by five bullet holes—the paper was actually punctured where the bullets "hit"—and the back showed a piece of Swiss cheese. As for the exhibitors, they were presented in the book by means of "compensation-portraits," anonymous documents that had only a very distant connection with their faces. It was obvious that their intention was not to make

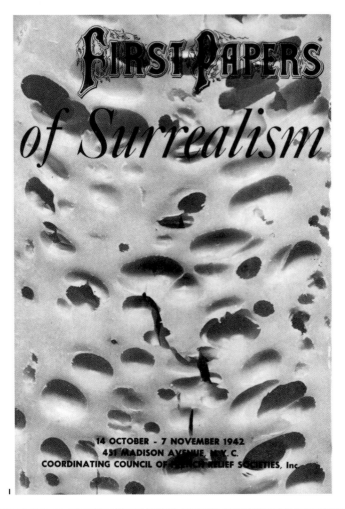

1

2

themselves too easily accessible to the public, and in a way they had succeeded: disconcerted by such clear sarcasm, visitors were few and far between.

First Papers of Surrealism did, however, give Breton the opportunity to reexamine the question of the myth, through the intriguing montage of images and quotations that he published in the event's catalog under the title "De la survivance de certains mythes et de quelques autres mythes en croissance ou en formation" (On the survival of certain myths and on some other growing or developing myths).[75] By juxtaposing a document on each page (an etching or the fragment of an ancient painting), a surrealist work and a phrase borrowed from Apollinaire, Gracq, Maupassant, or Jarry, Breton presented fifteen myths: it would subsequently prove difficult to determine whether they should be included in the "purification" that the Yale conference would evoke two months later or whether, on the contrary, they should be viewed in a favorable light. Particularly ambiguous were "Icarus," "The Grail," and "The Messiah" (which would readily be dropped from an entirely critical point of view), "Original Sin," "The Artificial Man," "The Execution of the King," "The Myth of Rimbaud," and "The Superman" (which nevertheless had rather positive connotations). The series concluded with a reference to the Great Transparencies (illustrated by an alchemical etching and a photograph by David Hare), the only myth created by surrealism and perhaps also the only one worthy of being considered as "growing or developing."

Art of This Century: The Beginnings of Abstract Expressionism

On October 20, 1942, while *First Papers* was under way, Peggy Guggenheim's gallery, Art of This Century, was inaugurated with a show of works acquired at the suggestion of Ernst, Duchamp, and Breton: 127 *Objects, Drawings, Photographs, Paintings, Sculptures, and Collages from 1910 to 1942,* in the midst of which surrealism occupied a dominant place. But the wealth of the collection was compounded by the originality of the location's concept: Frederick Kiesler had constructed concave walls in front of which the canvases—without frames, at Peggy Guggenheim's request—were fixed on baseball bats. Other paintings were hung on cables stretched from the ceiling to the floor, and sculptures and objects were placed on nonquadrangular plinths, all of which went to make up a chair with sinuous forms designed by Kiesler to serve seven different purposes. Through a hole in the wall one could view Duchamp's *Boîte en valise* (Box in suitcase), which seemed to sum up his career. The introduction to the catalog of the collection contained texts by Arp ("Abstract Art, Concrete Art"), Mondrian ("Abstract Art," written especially for the catalog), and Breton ("The Artistic Origins and Prospects of Surrealism"); it also included documentation on the artists, as well as the manifesto of futurism, the *Manifeste réaliste* by Gabo and Antoine Pevsner (1920), a text by Ernst, and "Notes on Abstract Art" by Ben Nicholson.

"The Artistic Origins and Prospects of Surrealism" (which would not be published in French until 1945, in the second edition of *Le Surréalisme et la Peinture*), was doubly important: as he no longer had to prove the legitimacy of "surrealist painting," which was now widely known, Breton could record its strict genealogy and at the same time outline its prospects for the future. But at the same time, it was most probably for young American artists the only direct source of information on the importance of automatism that they might have available at that time, in the absence of a translation of *Le Surréalisme et la Peinture*. The information was all the more precious in that Bre-

The Art of This Century Gallery,
New York, October 1942. Pho-
tographs by Beatrice Abbott.

1 *In the background, to the left,* Joan
Miró, *Dutch Interior II* (1928); *in the
center,* Paul Delvaux, *Dawn* (1937);
to the left, Max Ernst, *Forest* (1928);
left-hand wall, Max Ernst, *The Anti-
Pope* (1941–42); *right-hand wall,*
Giorgio De Chirico, *The Pink Tower*
(1913); *in the foreground,* Alberto
Giacometti, *Woman with Her Throat
Cut* (1932–33).

2 *Right-hand wall,* Joan Miró, *Sitting
Woman II* (1939), Leonor Fini, *La
Bergère des Spinx* (The shepherdess
of the Sphinx), René Magritte, *La
Voix des airs* (The voice of space)
(1932), and Victor Brauner, *Fascina-
tion* (1939). Seated in the chair is
Frederick Kiesler, designer of the
gallery.

3 *In the center,* Max Ernst, *The Kiss*
(1927); *on the left,* Alberto Gia-
cometti, *Nu* (1932–34).

ton, instead of lingering as he might have done on the distant origins of surrealism in early painting, emphasized its emergence in modern art, showing that the insurrection against the outside world had begun "around 1910" with cubism and Kandinsky, had continued through certain dimensions of futurism and in the "mechanical" works of Duchamp and Picabia, to reach, with Dada, "an absolute crisis of the model." He then evoked the decisive role played by De Chirico, praised Chagall for the "triumphant entry" of the metaphor into modern painting, reiterated the importance of Ernst's first collages, and underlined the importance of Masson's encounter with automatism.[76]

That encounter was decisive, for it opened the way to a total psychological field and brought about a rhythmic unity, "the only structure to respond to the nondistinction . . . of sensitive qualities and intellectual qualities . . . , of sensitive roles and intellectual roles." "There is a danger of going outside of surrealism if automatism ceases to make its way at least *underground*." After recalling the contributions of Miró, Tanguy, and Magritte, Breton gave a quick overview of surrealism in sculpture (Arp, Alexander Calder, Henry Moore, Giacometti) and summed up the situation with regard to Dalí: "The powers of the imagination . . . will not consent to being used up in advertising slogans." This was roundly illustrated by Brauner, well-established in "a fully hallucinatory domain"; Carrington; Paalen, whose art "aspires to the realization of the synthesis between the myth in development and those which are in the past"; Seligmann; and the works in which "the major artery of the dream is still pumping the surrealist sap" (Richard Oelze, Paul Delvaux, Bellmer, Cornell). After this panorama, Breton returned to the theme of automatism, the only device capable of producing "great physical and mental circulation": pointing out the diversity of the results obtained by Oscar Dominguez, Stanley William Hayter, and Jacques Hérold's varying techniques, he underlined the way in which Esteban Francès, Gordon Onslow-Ford, and Matta had placed their trust in automatism. Thus, the message indirectly addressed to American artists through the viewers at Art of This Century was clear: if they are going to claim their allegiance to surrealism, they must first of all turn to automatism.

In no time, Art of This Century became a meeting place and forum for all those who, near or far, were concerned with surrealism and, more broadly, with the diverse tendencies of modernism. The gallery was increasingly interested in supporting young American artists who, after their encounter with Matta, Hayter, Ernst, or Breton, were seeking their own stylistic autonomy: after the inaugural event at her gallery, which was a considerable success, Peggy Guggenheim mounted an exhibition of Duchamp and Cornell together, then organized a salon where the works were selected by a jury—this heralded the emergence of Jackson Pollock, William Baziotes, and Robert Motherwell, to whom she would soon devote solo exhibitions.[77] Given the personal taste of the gallery's owner (who, on the opening day wore one earring designed by Tanguy and the other by Alexander Calder "to show," she said, "[her] impartiality to both surrealism and abstract art"), Art of This Century would be one of the places ensuring the transition between surrealism and what might, in the United States, take the place of its strict tenets.

While Kamrowski, Baziotes, Motherwell, Rothko, and Pollock saw Matta fairly regularly between the autumn of 1942 and the spring of 1943 and, fascinated as they were by his astonishing intellectual agility, went on to integrate certain aspects of gestural automatism into their own process, Motherwell was a good indication of the gap that persisted between their interests and the surrealists': "The Americans wanted to trans-

form art, while the surrealists wanted to change life." In the course of the winter of 1940–41, Baziotes, Kamrowski, and Pollock did a group painting, which could be described equally as a sort of pictorial exquisite corpse or the unexpected invention of *dripping,* which would soon become Pollock's speciality.[78] So Matta, Ernst, Masson, and Hayter clearly helped young American painters to define, over time, what was at stake in their work, but that did not imply any allegiance of principle with surrealism on the part of those artists. Their references were often in contradiction with those of the movement: although for example they were interested in psychoanalysis, it was rather in its Jungian version than in Freud's approach, for they found more readily in Jung's work an anchor for their curiosity with regard to primitivism and Indian art. But it was from a strictly pictorial viewpoint that they were marking their distance from surrealism: when Mark Rothko and Adolph Gottlieb, with the help of Barnett Newman, sent a letter to the *New York Times* in June 1943, they moved progressively from proximity to criticism:

1. For us, art is an adventure into an unknown world, which can only be explored by those who are willing to take risks.

2. This world of the imagination is totally free and is violently opposed to common sense.

3. Our role as artists is to make the viewer see the world the way we do—and not in its way.

4. Our preferences are for simple expression and complex thought. We are partisans of a large format because it has the impact of the unequivocal. We mean to reassert the flatness of the painting. We are partisans of flat forms, for they destroy illusion and reveal the truth.[79]

While the American painters acknowledged the philosophical implications of their work and advocated the expression of thought in the broadest sense of the term, they also came out against any illusionism, and by asserting the necessity of flatness (something that originated with cubism) they cut themselves off from any exploration of non-Euclidian or irrational space, like that explored by Tanguy, Masson, Matta, and Ernst.

When, in the summer of 1944, Clement Greenberg published in *Nation* two articles that were favorable to Pollock, Baziotes, and Motherwell, he congratulated them for having found in automatism the encouragement to abandon themselves totally to pure pictorialism and for having left behind what he considered (he was neither first nor last to do so) the "literary" or "illustrative" aspects of surrealism in painting. In so doing, Greenberg obviously gave an interpretation of automatism that was restrictive, in ignoring its fundamental aims. But from his neo-Kantian point of view the exploration of the unconscious and the elaboration of revolutionary thought were incompatible with the actual practice of painting, which could only constitute a permanent research into its definition, freed of everything that did not belong to it exclusively: pictorial activity found its autonomy but at the same time lost the ability to participate in the elaboration of a globally revolutionary position, whether the aim was to express the true functioning of thought or to resolve life's major problems.

This was the beginning of a split, which after the war would become definite, between surrealism and American abstract expressionism.[80] Abstract expressionism became visibly indifferent to the possible political implications of artistic or pictorial

choices. Such a wariness with regard to the political was particularly visible in the opening text of *possibilities* (winter 1947–48), coauthored by Motherwell and Harold Rosenberg: "Whoever genuinely believes he knows how to save humanity from catastrophe has a job ahead of him which is certainly not a part-time one. Political commitment in our time means logically—no art, no literature."[81]

Nevertheless, *possibilities* published Hayter's reflections on automatic drawing, poems by Arp, and an interview with Miró but also pieces by Pollock and Rothko on their own art work. Pollock's illustrations included, among others, two of his totemic figures; and Rothko's, which also accompanied an article by Andrea Caffi on mythology, showed that he was still far from achieving flatness, and his watercolors in 1946 were filled with evocations of flagellated cells and shapes that owed a great deal to Miró and Masson. The break requested by Greenberg would in fact take years to come about and would seem more like a slow drifting apart than a brutal rejection.[82]

Arshile Gorky

One painter worthy of isolation from the current of abstract expressionism was Vosdanig Adoian, known as Arshile Gorky—as much for biographical (he died in 1948) as for pictorial reasons: he was clearly, among American artists of his generation, the one who came closest to integral surrealism (although he himself reproached surrealism in 1947 for being "an academic art in disguise . . . , anti-esthetic, of questionable superiority and [that] above all is opposed to modern art": the divisions of his private life seemed to have made him forget how much his work owed to automatism). During the 1930s, he was drawn first to Cézanne and Picasso and defined his own version of synthetic cubism, thanks notably to the influence of the painter and theoretician of Russian origin, John Graham. Miró and Kandinsky—whose paintings he analyzed in detail for hours—were his next sources of inspiration, but he never copied them: rather, he borrowed certain elements (separate forms in a supporting space) allowing him to define his singular path progressively—a path that would take into account his personal itinerary (he remained very attached to the Armenia of his childhood) as well as his imperatives where his art was concerned.[83] Painting must materialize in an image that is both dense and airy, originating in an emotional or sentimental need. For Gorky the "inner model" was part of a particularly complex subjectivity, woven with the ambiguity of exile, both necessary and painful, and it engendered an art that on occasion could seem hermetic by virtue of the metamorphoses the pretext had undergone, given the demands of composition. From 1941 on, improvisation, if not automatism, joined forces with a semiabstraction (*Garden in Sotchi I*). His subsequent meeting with Matta would encourage him to move toward forms that were ever more distant from the visible, possibly rich in sexual allusions, and that based their complex structure on an often intense chromatism: an increasingly subtle arabesque, equally capable of outlining a pale wash or weaving a sort of conjunction between the different parts of the canvas, both linked and autonomous. The stroke emerged from preparatory sketches, where it was particularly sharp, and now it not only separated the colored segments but could also contradict them, designating the double register on which the painting was conceived; while the style revealed an effort at rationalization, the color was completely given over to impulsiveness. It might be lightly diffuse (*Table-Landscape* [1945]) or spread in superimposed pourings like a series of veils concealing a hidden intimate

1

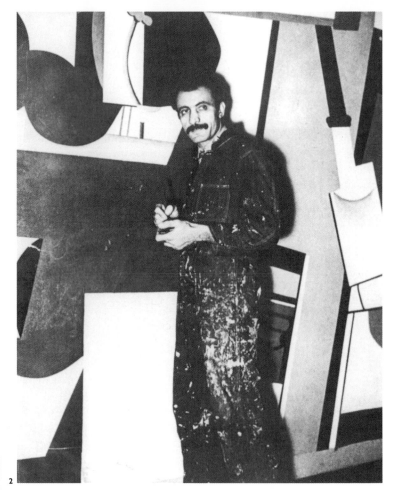

2

3

secret (*One Year the Milkweed* [1944]). Gorky's work showed that the objectification of the subjective could use the object itself with economy and produce a painting in which contradiction was still actively at work.

Péret Takes the Floor

In 1943, a message of prime importance arrived from Mexico. Péret was gathering the elements for a collection of myths, legends, and folktales from Latin America and was also preparing a preface; once word of this reached New York, it seemed sufficiently important to warrant separate publication in French. This would be *La Parole est à Péret* (Péret takes the floor); a note would advise the readers that "friends of the author" had asserted they would adopt all the conclusions in the text, and in tribute to Péret they decided to add the signatures of certain absent people to their own, people "whose earlier attitude implied a lasting solidarity like their own with regard to an unchanging spirit of freedom."

The existing list of cosignatories emphasized the international dimension of their allegiance—nine countries were represented in New York: England (Jacques Brunius and Valentine Penrose), Belgium (Magritte, Nougé, and Ubac), Chile (Braulio Arenas and Jorge Caceres), Cuba (Lam), Egypt (Hénein), France (Brauner, Dominguez, and Hérold), Haiti (Mabille), Martinique (the Césaires and René Ménil), and Mexico (Carrington and Francés). There were six coeditors: Breton, Duchamp, Charles Duits, Ernst, Matta, and Tanguy.

This list was doubly symptomatic, because of both the names that were on it and those that were missing, either because there was no news about them (Mesens was in London, Bellmer in France) or because their recent positions had signaled, if not a complete break, at least a certain distancing. This was the case for Masson, for example, and for Wolfgang Paalen.

Paalen, in Mexico, had founded the journal *Dyn;* its first issue (April–May 1942) contained his piece "Farewell to Surrealism." At the time he intended to direct his focus and his work toward a synthesis between science and art: if science constituted the "logical equation" of the world, art must be its "rhythmic equation"—and he felt it was necessary to have done with Hegelian philosophy and its Marxist offshoots: "For as long as surrealism offered the only working hypothesis for a collective action destined to liberate the most precious and most neglected human faculties, I found it futile to attempt a critical analysis of its philosophical basis. But now in 1942, after the bloody failures of Dialectical Materialism and the progressive disintegration of all the 'isms,' it seems to me that it is absolutely necessary to proceed to the most rigorous verification of any theory that claims to determine man's place in the universe, and the artist's place in our world." The six issues of *Dyn,* until November 1944, were nevertheless fairly close to the movement. The contributors (Cesar Moro, Valentine Penrose, Henry Moore) and illustrations could easily have been found in the table of contents of *VVV.*[84] Number 4–5 (December 1943), devoted to American Indian art, showed examples of pre-Columbian art and creations from the Pacific Northwest that at the same time, but in New York, aroused passionate interest among Breton, Ernst, Isabelle Waldberg, Georges Duthuit, Robert Lebel, and Claude Lévi-Strauss.[85] But Paalen's attitude, at least at that time (he would return to surrealism from 1951 on), obliged one to consider him as no longer belonging to the movement.

As for Péret's actual text, if his friends sought to underline its importance, it was because he suggested a decisive connection between poetry, myth, and the desire for the total liberation of humankind. *La Parole est à Péret* stipulated that from the moment language took over the elementary function of utilitarian communication, it was myth that, simultaneously prefiguring the pathways of science and philosophy, "constitutes both the primal state of poetry and the axis around which it continues to turn at an indefinitely accelerated speed." Science, which had formed by detaching itself from the magical interpretation of the universe, resembled "children from the primitive horde who have assassinated their father"—and the simple opposition of reason and poetry would be wrong to ignore their shared origin.

Whoever has, even once, had experience of the marvelous can understand how mutilating the strictly rational interpretation of things can be: the sudden entry of the marvelous into one's thoughts and one's everyday existence does not presuppose anything other than a state of vacancy—and Péret would provide an illustration of this in relating how when he was imprisoned in Rennes, he was convinced that he would be set free on a twenty-second of the month after he saw that number appear persistently for no objective reason on a pane of glass in his cell. If the capacity for prediction (Péret was released from prison on September 22, 1940) is reserved for poets, it is because poets' desire for liberty together with their practice of poetry gives them this ability. Poets, madmen, and sorcerers share a relation to magic (which also marginalizes them in relation to a society that tends more and more to impose its rational norms like a new religion). No doubt the initial mythical poetry became progressively ossified within religious dogma or moral precepts; it nevertheless remains conceivable that poetry can recover its mythical dimension, on the condition that society undergo a radical change, the only thing capable of putting an end to the illusory consolation of religion. The perennial nature of religious belief can in turn be explained by the satisfaction that it brings—but at "rock-bottom prices!"—to the need for the marvelous that persists in contemporary society. Another response to such a need is the formation of "atheist myths bereft of all poetry," which regarded political leaders as sacred (Hitler "envoy from Providence," Stalin "sun of the people"). This dual decadence of mythical thought was leading to gangrene in contemporary poetry itself—increasingly rare and reduced to the role of a consolatory escape—whereas authentic poetry must recover all at once the marvelous and a revolutionary significance, by breaking with all manner of conformity. *La Parole est à Péret* ends with the proud declamation of the poet's "curse," for it attests to the revolutionary position of poets "at the cutting edge of the cultural movement, where one receives neither praise, nor laurels, but where one is in a position to strike with all one's force to tear down the constantly rising barriers of habit and routine."

A dense and aggressive text in the concision of its arguments, *La Parole est à Péret* came to justify, through the very origins of poetry, the interest the surrealists showed in myths. But it went far beyond that by suggesting that the key to contemporary failures to progress could only be invented through poetry, by surpassing religion, society, and politics all at the same time: since it was the same society that claimed to organize humans and those ideas of theirs that perverted the meaning and impact of poetry, poetry must therefore be subversive and prepare the upheaval of society, at which point it would once again be "at the forefront."

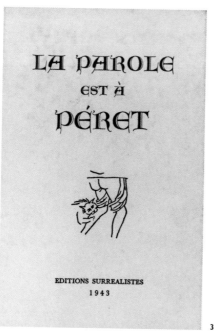

1

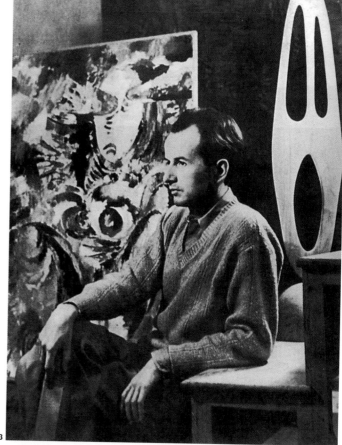

3

2

4

5

Tensions

The publication of *La Parole est à Péret,* in 1943–44, remains a rare example of a truly collective activity.

The presence of the surrealists in New York led to an increase in the number of solo exhibitions. Matta, Miró, Tanguy, Paalen, Lam, Ernst, and Masson (who published, with Curt Valentin, two collections of drawings: *Anatomy of My Universe* in 1943 and *Nocturnal Notebook* the following year). Then Dorothea Tanning, Isabelle Waldberg, and Gorky would have the chance to show their work in American galleries and museums.[86] Duchamp, in contrast, actually preferred to take part in group events, design periodical covers or window displays, continue to produce copies of the *Boîte en valise,* or place the *Large Glass* back on exhibit, for the first time since its repair, at the "Art in Progress" exhibition at MoMA in 1943.

There was no lack of publications either. In addition to the numerous texts that appeared in *View* or *VVV,* the surrealists also contributed to *Hémisphères,* published in New York by the Éditions de la Maison Française, edited by Yvan Goll and his assistant Alain Bosquet. Six issues would come out between 1943 and 1945, along with a collection of brochures. From the first issue, Robert Lebel would remark in his "Notes on Poetry in France from 1940 Onward" that when poetry sought to maintain its dignity, fleeing both "the official poetry of Vichy and the collaborationist poetry of Paris," "it retreated to its defensive positions"—an attitude to which he could easily oppose *Fata Morgana* (finally published at the Éditions des Lettres Françaises in Buenos Aires) and the existence of *Tropiques.* Issue 2–3 was proof of a serious offensive on the part of the surrealists: Breton and Masson urged readers to "discover the Tropics," with excerpts from *Martinique charmeuse de serpents* and the preface to Césaire's *Cahier d'un retour au pays natal* (this preface would show up again in 1944 in Algiers, in no. 35 of *Fontaine*): Césaire contributed some new pages and, later on, Charles Duits, Philip Lamantia, and Roger Caillois would also contribute. This double issue also announced plans to publish a bilingual edition of *Cahier,* with a preface by Breton and illustrations by Lam— but the project never materialized, unlike the *Masque à lame,* a collection by Lebel illustrated with seven constructions by Isabelle Waldberg. The periodical's eclecticism did not, however, lead to a more sustained collaboration, and Breton and Goll very quickly had a falling out.[87]

Friction, both within and on the periphery of the group, was not rare: during the summer of 1943, relations between Breton and Masson deteriorated, while Max Ernst left with Dorothea Tanning for a first stay in Sedona, Arizona, where very soon the couple would decide to settle.[88] At the end of the same year, plans for a group show fell through, given the priority most of the artists gave to their individual careers. In March 1944, Isabelle Waldberg informed her husband Patrick of the situation in terms that were hardly enthusiastic:

> Things are getting worse and worse between André [Breton] and his friends. He has fallen out more or less completely with Ernst, half and half with Matta and Duits, but on the other hand he is now again on speaking terms with Kurt Seligmann. One of the reasons for this falling out is the preface he wrote for Donati's exhibition. The attitude of his friends seems to have had a great effect on André, they take advantage of him wherever they can, but attack him mercilessly as soon as he does something they don't like. . . . I'm

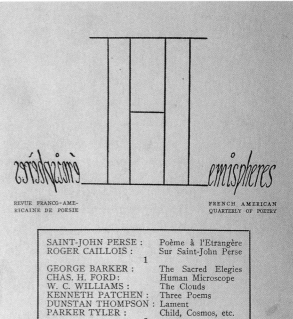

1 *Lettres françaises,* number 3 (January 1942).

2 Marcel Duchamp in 1936 repairing his *Large Glass,* broken ten years earlier on its way back from an itinerant exhibition in the United States and Canada.

3 *Hémisphères* (Brooklyn, New York), number 1 (1943).

beginning to get very tired of this habit they all have of violently criticizing each other whenever the opportunity arises.[89]

The text by Breton to which Isabelle Waldberg referred took great care, before dealing with Donati's work, to emphasize the reappearance, within surrealist painting, of a polemic opposing "the proponents of two systems of *figurative representation:* one that intends to keep direct contact with the outside world and . . . which manifestly has found its points of reference, the other which has broken with all immediate appearances, even claiming to have liberated itself from compliance with conventional space, demanding of the painting that it find its objective virtue in itself alone."[90] For Breton, there could be no choosing between these two tendencies which, when taken to the extreme, could only point to "two pitfalls in the midst of which art asks to be led by alternating changes of direction"—all the less so when one realizes they had until that point coexisted within surrealism.

As for Donati, who was a newcomer to the group, he was congratulated for having made it a priority to deliver a "message of harmony": even when he gave up the anecdotal representation of things, he remained attached to the idea of reconstituting their texture and used space dynamically in order to evoke them through a wealth of colors; he produced a lasting feeling of eclosion, both through his use of color and through the fugitive shapes depicted on canvas. One can easily understand that, rather than bringing them closer together, a text of this nature was an inconvenience to the two rival parties: not only did Breton refuse to decide between them, but on top of that he hinted that Donati's painting was richer, by virtue of its very ambiguity, than anyone's! "I love Donati's painting," wrote Breton, "the way I love the nighttime in May": the nocturnal bloom that Donati's painting seemed to promise would alas be short-lived, since Donati, several years later, would leave surrealism behind to devote himself to a very different style of painting.

Latin America

Although the main center of surrealist activity at that time was indeed New York, the events that took place outside North America should not be neglected, particularly in Latin America, where Paalen and Péret were not alone.

In Chile, a *Boletin surealista* began publication in 1941 for a brief time: it was edited by Braulio Arenas, cofounder in 1938 of the periodical *Mandragora*. In December 1942, Arenas brought out the periodical *Leitmotiv,* which featured in its two issues pieces by Breton (the *Prolégomènes*), Césaire, and Péret, as well as by Jorge Caceres, who was a poet, painter, and photographer (and even a *premier danseur* with the Santiago Ballet).

In Buenos Aires, Roger Caillois had been editing the periodical *Lettres françaises* since July 1941, thanks to financial support from Victoria Ocampo. In spite of everything that had kept him apart from the movement over the years, the community that grew out of exile and the defense of the spirit now warranted a collaboration, even if it remained somewhat distant. In the second issue (October 1941), Caillois enumerated the responsibilities of French writers abroad: it is up to them to "seek to be the attentive interpreters of their comrades who have been reduced to expressing themselves in whispers . . . independently of any personal preferences or sympathies for given people or schools." Such an ecumenical program, feeding the production of twenty issues until

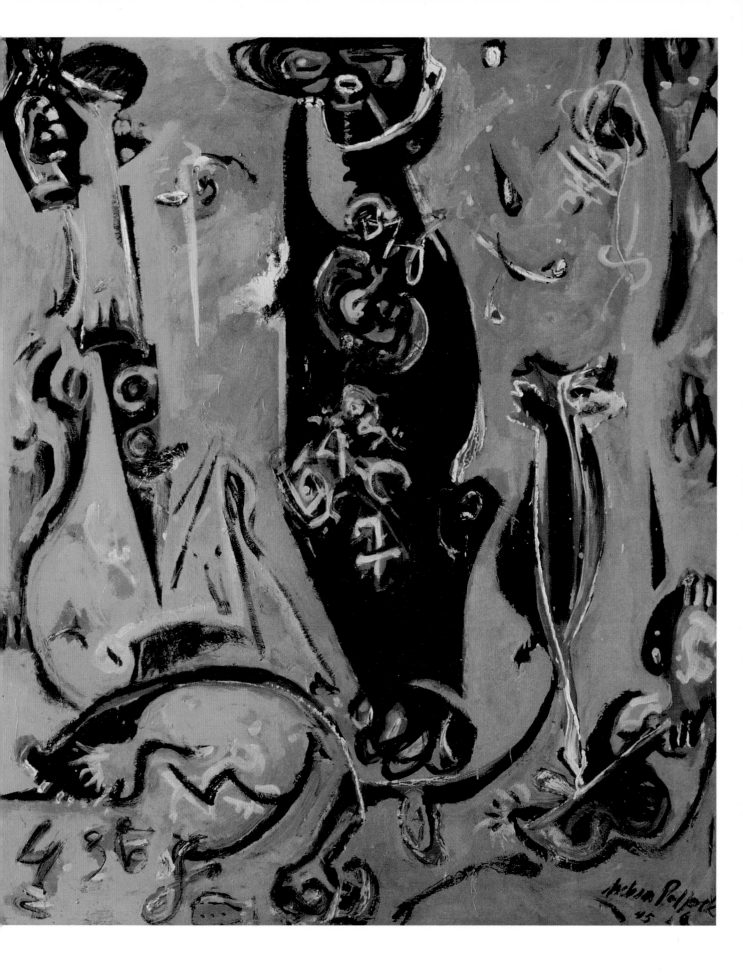

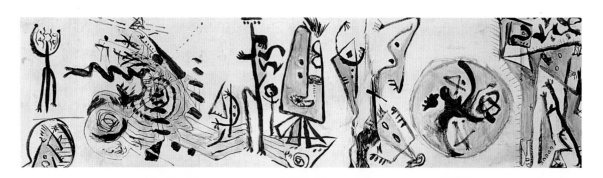

Above: Jackson Pollock, frieze (ca. 1945); oil on canvas mounted on Masonite, 7³/₄ × 27 in. (19.3 × 67.3 cm). Galerie 1900-2000, Paris.

Right: Jackson Pollock, *The Moon-Woman Cuts the Circle* (ca. 1943); oil on canvas, 43⁴/₅ × 41³/₅ in. (109.5 × 104 cm). Musée National d'Art Moderne, Centre Georges Pompidou, Paris.

Previous page: Jackson Pollock, *Totem Lesson II* (1945); oil on canvas, 73 × 70 in. (182.8 × 152.4 cm). National Gallery of Australia, Canberra.

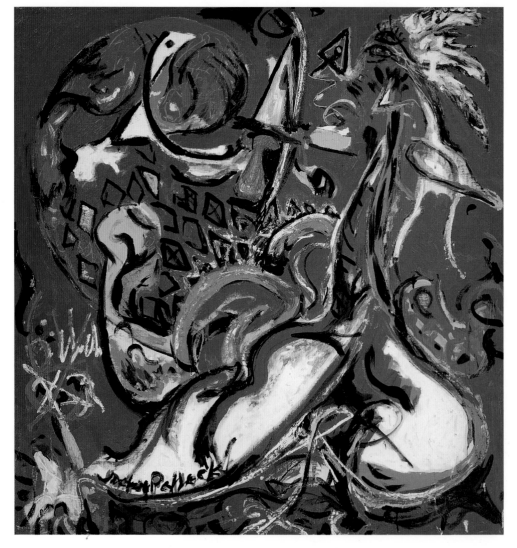

Left: Robert Motherwell, *Personage* (Self-portrait; ca. 1943); gouache and oil on paper mounted on cardboard, 41¹/₂ × 26¹/₃ (103.8 × 65.9 cm). Private collection.

Below: William Baziotes, *The Room* (1945); tempera on wood, 18¹/₄ × 24²/₃ in. (45.6 × 61 cm). Private collection.

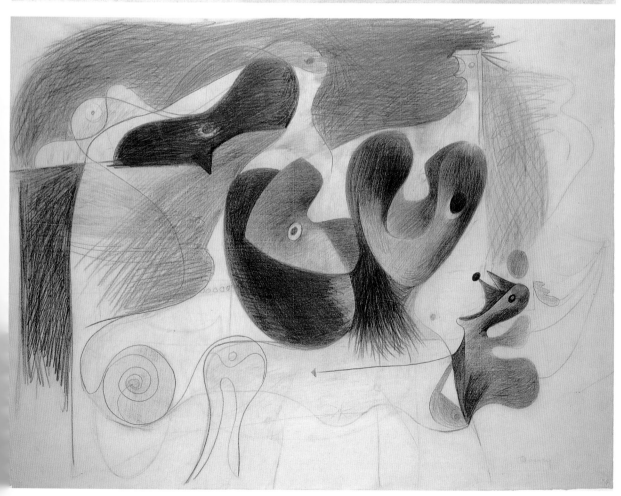

Left: Arshile Gorky, *Garden in Sotchi* (ca. 1943); oil on canvas, 31¹/₂ × 39³/₅ in. (78.7 × 99 cm). Museum of Modern Art, New York.

Below: Arshile Gorky, *Untitled* (ca. 1938–39); pencil on paper, 19¹/₃ × 25²/₅ in. (48.3 × 63.5 cm). Private collection.

Opposite page: Arshile Gorky, *Waterfall* (1943); oil on canvas, 61²/₅ × 45²/₅ in. (153.5 × 113 cm). Tate Gallery, London.

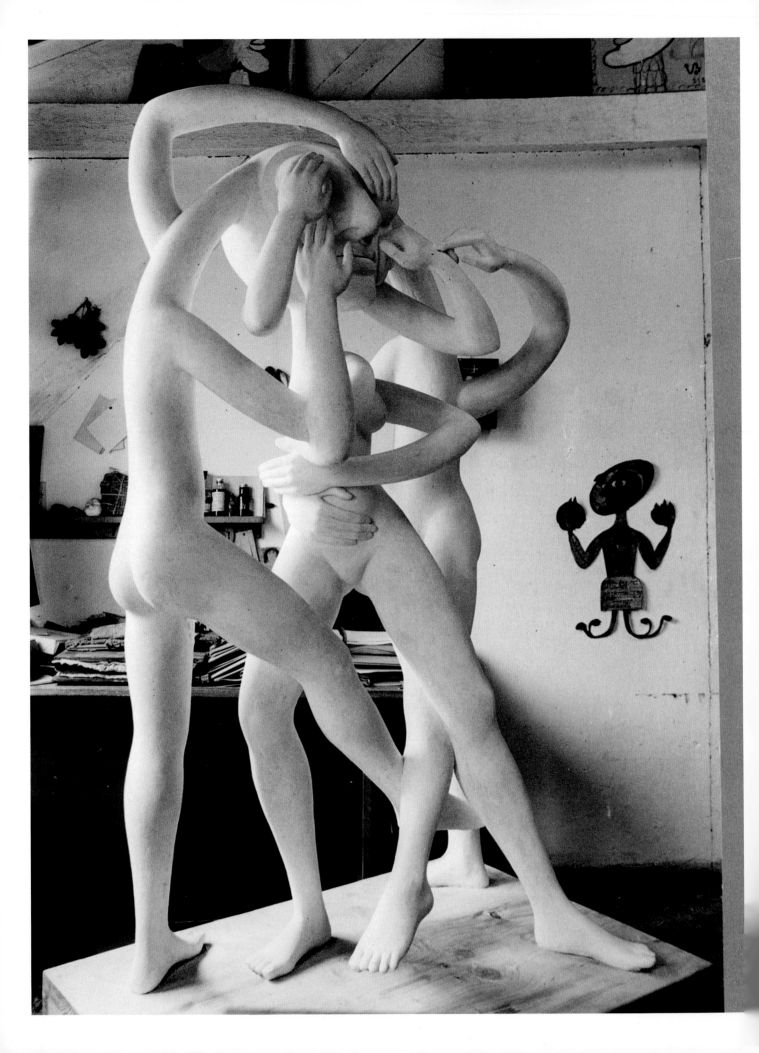

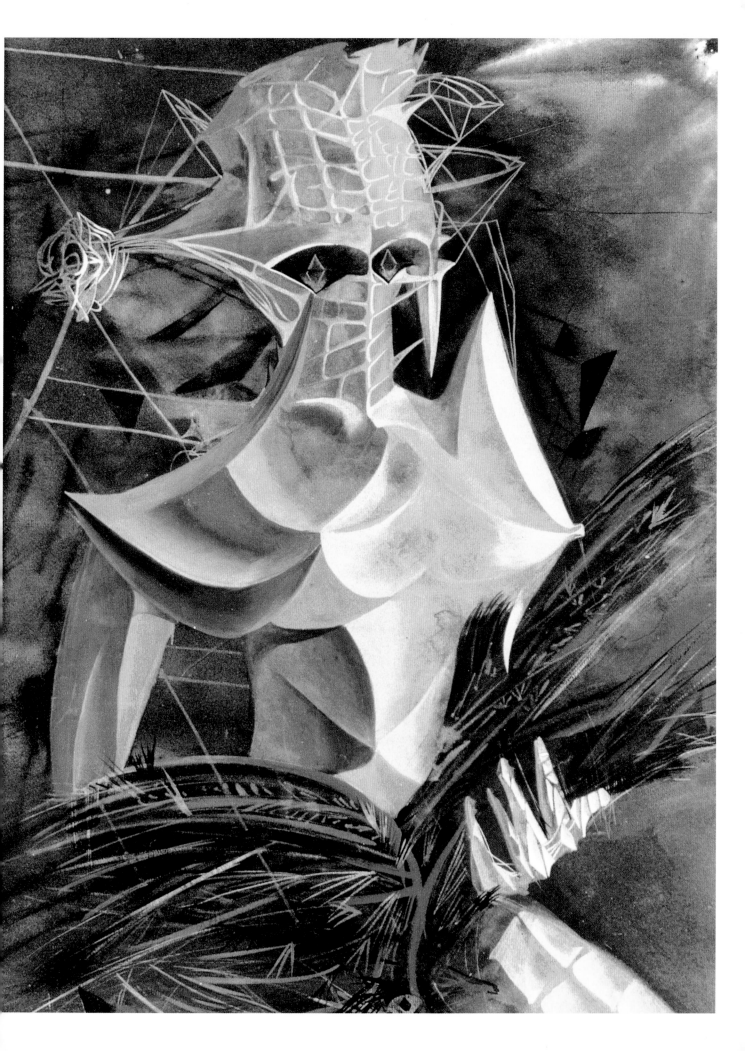

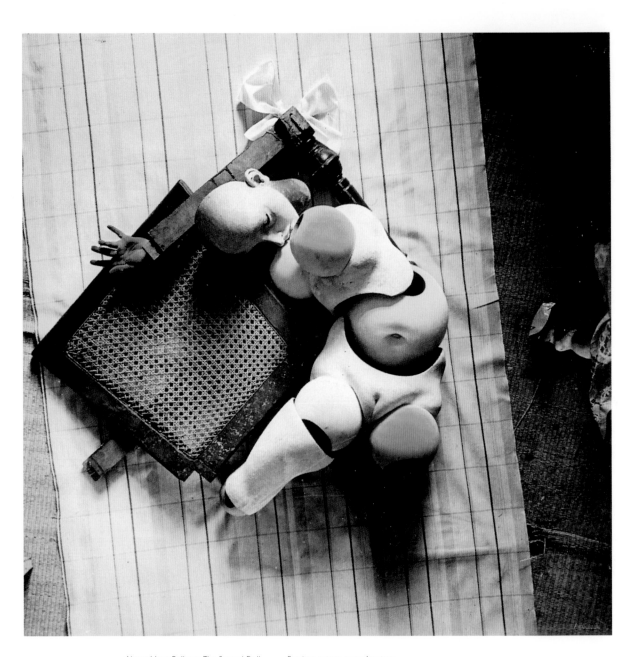

Above: Hans Bellmer, *The Second Doll* (1949); silver gelatin proof colored with aniline, 40²/₅ × 40²/₅ in. (101 × 101 cm). Musée National d'Art Moderne, Centre Georges Pompidou, Paris.

Previous pages, verso: Victor Brauner, *Conglomera* (photograph taken in the studio by Henrot). Private collection.

Previous pages, recto: Jacques Hérold, *La Liseuse d'aigle* (The eagle reader; 1942); gouache on canvas, 24 × 17⁴/₅ in. (60 × 44.5 cm). Isidore Ducasse Fine Arts, New York.

June 1947, could not win the allegiance of the surrealists, but *Lettres françaises* did nevertheless publish, in its third issue (January 1942), "The Creole Dialogue" by Breton and Masson, and the periodical, very classical in its presentation, offered regular columns devoted to literary news in France and to a "review of the reviews," listing the contents of what was published in occupied territory or the Free Zone; it also enumerated recent publications in Switzerland and America. Through its wide distribution in Latin America, *Lettres françaises* disseminated both information and texts, and thanks to this, one could keep abreast of the evolution of poetry in France, as published and defended in *Poésie 40* and subsequent publications (Pierre Seghers in Villeneuve-les-Avignon) or in *Confluences* (René Tavernier in Lyon)—poetry that was hardly to the surrealists' liking, something that would soon become quite obvious.

In France

In France under the Occupation, the surrealists who had not managed to go into exile were reduced to virtual clandestinity. Circumstances were obviously more favorable for some of their critics, among them Camille Mauclair, for example, the "drum-major of reactionary art critics" (André Lhote), obsessed more than ever with denouncing the "Jewish consortium" and cosmopolitanism that, in his opinion, had for years sought only to destroy "French art," a litany echoed in *La Crise de l'art moderne.*[91] This hate-filled volume, in which the 1938 event was qualified in passing as an "abject surrealist exhibition organized at the Wildensteins," used its illustrations to make a few deliberately significant points: while a canvas by Braque was shown next to "the work of a madman locked up at Villejuif," Picasso and Chagall earned captions such as "A Mad Talent!" and Ernst's *Œdipe* was featured opposite an anonymous sculpture from the fourteenth century. Ernst and Chagall earned particular notice, as they also figured among "the names of the principal Jews adopted by the Consortium." Thus the lesson of the exhibition that in Germany had denounced "degenerate" art was now servilely repeated in France.

In such an environment, in which works by Ernst, Klee, Masson, Miró, Picabia, and Picasso (among others) were destroyed in the gardens of the Jeu de Paume by the German authorities, opportunities to exhibit, obviously, had become rare. In 1941, the Galerie Jeanne Bucher displayed real courage in showing, among others, works by Dora Maar, Ernst, Kandinsky, and Miró, and in July 1942, a solo exhibition of Kandinsky was interrupted because the painter was included, very officially according to the German censorship, among the degenerate artists. The result was that until 1945 there would in fact be only one exhibition that openly referred to the existence of surrealism, that of Dominguez at the Galerie Louis Carré, from December 1 to 14, 1943.[92] In his preface to the catalog, Éluard greeted his "*haute peinture*, warm with metamorphoses, a painting where everyday objects sweat with color like a mirage, where gigantic figures, of the lightest anatomical formalism, are set free, made eternal by space." Dominguez saw Picasso fairly often at the time at the restaurant Le Catalan (and did not refrain from painting some forgeries of Picasso, with the same skill that he used to produce fake De Chiricos during that era—both artists were highly sought after in what was a booming wartime art market). He fell under Picasso's influence to such a degree that two years later Breton would speak of his canvases as " no doubt earning him encouragement from Picasso, but [they] have *nothing to do* with surrealism."

Although his forms do indeed seem to offer themselves to the rich metamorphoses evoked by Éluard, their expression was gradually becoming quite dry and corresponded more to the solution of a puzzle than to automatism.

Brauner took refuge in the Basses-Alpes after he left Marseille and had to make do with scant means for his work: his inventiveness made use of what was available—collages, leftover objects, coffee, walnut stain. In 1941 he began work on a sculpture that would occupy him until 1945: *Congloméros*, in which the theme of the double, already very present in his work, took on a new dimension. "*Congloméros*, anonymous plural your solitude is greater, body image of the multiple": the collective unconscious seemed crystallized in this character with three bodies (one woman and two men) and one head, its sinuously entangled arms evoking both the ambient menace and a withdrawal within the self. In 1943, *Nombre*, another sculpture, represented an androgynous body with limbs zigzagging around a frail, gutted torso (the niche presented a figurine whose hollowed-out torso served in turn as a receptacle for a third, tiny figure), tightly holding a snake in its left fist: fear is balanced by a sort of enigmatic serenity, gained from who knows what nocturnal powers. Simultaneously, Brauner was constructing statuettes (*Les Amoureux, Double Vivification* [1943]) and magical objects, casting spells and counterspells (*Portrait de Novalis* [1943]): his esoteric culture resonated closely with the atmosphere of the era through the materials used (earth, copper, wax, paper) and allusions to German romanticism. Unable to use traditional methods to prepare his canvases, in 1943 Brauner began to coat them first with wax, then used oils to paint over the wax; at times texts would help to direct the image. The *Tableau optimiste* (1943) had the following caption: "Oh, man, tired of your anguish seek / the image of reality uncreated in the secret / of the number seven. Seven openings / of the cosmic / fluidic / biological / social / economic correspondences / of the seventh revolution / that of the definitive liberation / Notice." Thus, esoteric poetry, beyond the inner resistance it offered to the realities of the world, allowed one to hope for a reconstruction of the human.

Bellmer, after his liberation from the camp at Milles (a former brickworks that he would describe thus: "all we saw were bricks, we slept on bricks, we even ate them!"), found himself in Toulouse in 1941 (the year he gave up his German citizenship), then in Castres. In 1942 he created *Tour menthe poivrée à la mémoire des petites filles goulues* (Peppermint tower in memory of greedy little girls), destined to become one of his most famous works, and one that sufficed to show that events had in no way altered his themes: the precision of the brushstroke serves an eroticism that is both cruel and deceitful, changing the anatomy in keeping with fantasies. There was only one possible response to the horror of the outside world, an obstinate immersion in the most secretive meanders of desire—not to compensate (still less to justify!) for horror through one's self-immersion but to oppose anonymous and mechanical death with the exploration of a certain subjective pleasure. In what appears to be a paradox, it was during the war years that Bellmer defined his style independently of the Doll, working incessantly on drawings and etchings. Reduced to the sole resources of his own individuality, he marked the boundaries of a graphic work that would not become known until after the return of peace.

In the Lubéron region, Hérold continued his work on the crystallization of shapes. In *Liseuse d'aigle* (1942), the irregular geometrical structure conveys something mineral to the body of the reading woman, while the eagle itself seems transformed into a spreading foliage: "There were eagles at that time in the caves of the Lubéron. And it

was as if these eagles had told me that I had to read them directly; I mustn't read a description of an eagle, but read the eagle itself; I had to dare to take them, with all the risks that involves, to spread them out, decipher them."[93] Using false documents, which he also fabricated for a few clandestine acquaintances, Hérold eventually returned to Paris, where he took part in the activities of the group La Main à Plume.

La Main à Plume

In spite of the circumstances, group activity of a surrealist nature did not cease altogether thanks to the group La Main à Plume. Their activity, which has recently been reevaluated, and however modest it may have been, was nonetheless indicative of a desire to maintain the shared imperatives of the poetry and intellectual research that were the most authentic because they had refused to be subjugated, be it by slogans or by the climate of the era.[94]

Some members of La Main à Plume had come from a group whose direction was somewhat neo-Dadaist, Les Réverbères: from April 1938 to July 1939, this group had published five issues of a periodical of the same name and the catalog of a group exhibition (June 1938), including artists as diverse as Aline Gagnaire, Michel Tapié, Jean Marembert (both founders of the group), and Lambert-Rucki. In November 1938, the Éditions des Réverbères published, in the collection of their "classics," Tzara's *La Deuxième Aventure céleste de M. Antipyrine,* immediately followed by a small volume of pieces by Cocteau, something that did not seem to guarantee a particularly rigorous selection. In 1940, Le Cheval de Quatre followed Les Réverbères: Aline Gagnaire, Michel Tapié, and Noël Arnaud were among its members. In July 1941, an exhibition attempted to reactivate Les Réverbères, but discord among the founders and the impatience of the younger recruits brought about the end of the little group. Noël Arnaud then joined another group of surrealists that continued to meet after Péret had left for Mexico and that had just brought out a little volume entitled *La Main à Plume,* full of texts and drawings, published anonymously. Among the contributors were Adolphe Acker, Jean-François Chabrun, Robert Rius, Gérard de Sède, the painters Gérard Schneider and Gérard Vuillamy, and, from Belgium, participants in the publication *L'Invention collective* (Chavée, Christian Dotremont, and Marcel Mariën). The new group would adopt the name of its first publication and would remain, until the end of the Occupation, the only one to oppose the Vichy regime and so-called resistance poetry in France with the values of surrealism.

Although the first publication by La Main à Plume (*Géographie nocturne* [September 1941]) had few participants (Noël Arnaud, Jean-François Chabrun, Marc Patin), there would be already more by the second publication (*Transfusion du Verbe* [December 1941]); most noteworthy was Éluard's participation. He had been recruited, so to speak, for tactical reasons despite his break with Breton: the aim was, regardless of the present circumstances, to gather as many writers as possible, and in the case of Éluard more specifically, to "allow him to seize the opportunity, at last, to take a clear and categorical stand with regard to those who on a daily basis disfigured him with their praise."[95] Since his exclusion from the group in 1938 Éluard had no objections to being hailed as a supremely French, if not downright classical, poet: this was acknowledged equally in the bourgeois press and in that of the Communist Party—and it was time to find out where he intended to situate himself.

1

ROBERT RIUS

SERRURES
EN
FRICHE

LES PAGES LIBRES DE LA MAIN A PLUME

10

2

Les *miroirs* prennent les fenêtres pour cible, élevant la figure au rang d'écorce.

Lunaisons qui fertilisez les *miroirs* vos intentions ne sont rien moins que lettre-morte.

Miroir qui tend l'oreille aux perspectives, tu simplifies la renommée en l'écorçant.

Dans un *miroir* rouillé, des virgules de soleil font lever le jour écaillé de fil de fer.

3

LA CONQUÊTE DU MONDE
PAR L'IMAGE

Noël ARNAUD
ARP
Maurice BLANCHARD
Jacques BUREAU
J.-F. CHABRUN
Paul CHANCEL
Paul DELVAUX
Oscar DOMINGUEZ
Chr. DOTREMONT
Paul ELUARD
Maurice HENRY
Georges HUGNET

Valentine HUGO
René MAGRITTE
Léo MALET
J.-V. MANUEL
Marcel MARIEN
Marc PATIN
Pablo PICASSO
Régine RAUFAST
TITA
Raoul UBAC
G. VULLIAMY
et l'USINE à POÈMES

Objet (1942). PICASSO.

Il faut que la force créatrice de l'artiste fasse surgir ces images, ces idoles demeurées dans l'organisme, dans le souvenir, dans l'imagination; qu'elle le fasse librement sans y mettre d'intention ni de vouloir; il faut qu'elles se déploient, croissent, se dilatent et se contractent, afin de devenir non plus des schémas fugitifs, mais des objets véritables et concrets.

GOETHE

LES ÉDITIONS DE LA MAIN A PLUME
11, Rue Dautancourt — PARIS (XVII)

4

Si vous n'êtes pas

CURÉ, GÉNÉRAL OU
BÊTE

Vous serez

SURRÉALISTE

CENTRES D'ACTION SURRÉALISTE

EN ZONE NORD	A PARIS	EN ZONE SUD
ANDRÉ STIL	NOËL ARNAUD	PIERRE MINNE
10, Rue Victor-Hugo	11, Rue Dautancourt	26, Rue Clément Michut
LE QUESNOY (Nord)	PARIS (17°)	VILLEURBANNE (Rhône)

5

CHEVAL 4
DE

PELOPONESE

Le Jugement de Paris

LA BETISE EST FEMME

LES HOMMES L'AIMENT

Arp, Léo Malet, Hugnet, and Blanchard were subsequently featured in *La Conquête du monde par l'image* (June 1942), then very young recruits like Édouard Jaguer appeared in *Décentralisation surréaliste,* which André Stil published at Le Quesnoy as a special edition of his "Feuillets du 81." In August 1943, *Le Surréalisme encore et toujours* combined all of these artists with Péret and Breton (with two forewords on Jarry and Vaché, excerpted from the *Anthologie de l'humour noir,* which was still not distributed); with the illustrations selected, this volume was an overview of both classical pictorial surrealism (Tanguy, Miró, Dalí) and more recent reproductions, along with poems by Blanchard, of three of the *dessins communiqués*—"communicated drawings"—made in Marseille.

The desire to expand seemed at first to be effective: in October 1942, Éluard's *Poésie et vérité,* after the publication of a few personal volumes, had a print run of five thousand copies and enjoyed enormous success thanks to the famous *Liberté.* La Main à Plume was clearly upholding the principles and habits of the prewar surrealist group: they launched surveys, declared their hostility to *engagé* poetry and to anything published in the Free Zone under the pretext of continuing the "humanist" or "national" tradition; and they printed open letters to several compromised public figures (Léon-Paul Fargue, Jean Follain).[96] Nor was it long before, like the prewar group, they fell prey to dissent and divisions. Éluard was rapidly "abandoned without remorse to a glory without honor." This in turn brought about the additional defection of Hugnet and a few others but, at the same time, did allow for the arrival of Brauner, Hérold, Henri Pastoureau, and Jean Ferry. The group, in the course of the next three years, would increase its publications, in what were obviously difficult conditions (a lack of paper, constant changes of residence because of the activities of varying legality of certain members, raids by the Gendarmerie or the Gestapo).[97] In addition to the issues of the periodical, twenty-six individual volumes were published, twelve of which were part of a special series, "The Free Pages of La Main à Plume" (including Arnaud, Blanchard, Chabrun, Breton's *Pleine marge,* Péret, Malet, and so on).

La Main à Plume was not content with merely maintaining surrealism: it also sought to reflect on surrealism in new ways. From this point of view, the presence of Boris Rybak was noteworthy, from the moment the idea of an evolution toward a "scientific" surrealism was voiced—or in early 1944, of reflecting on the possible status of the object (but the special issue in which the results of the research undertaken were to be presented was never published). There was a genuine effervescence in the group and a desire to resist without ambiguity the collapse that threatened more than ever the opportunities for ideas.[98]

It was precisely because the allegiance to surrealism was being experienced more and more in terms of resistance that a good number of the members would engage in activity against the Nazis—and this brought them within the orbit of the Communist Party. An internal crisis broke out in May 1944, when Boris Rybak and Gérard de Sède voiced their intention to separate from the "Stalinists." La Main à Plume broke up, but not before they had left the strong suggestion, at least among their participants, that under certain conditions allegiance to surrealism could be merged with a revolutionary practice. Some would recall this when, after the war, instead of rejoining the group that had once again formed around Breton, they would take part in the brief experiment of Revolutionary Surrealism.

In England

In a Europe ravaged by war, Great Britain enjoyed a freedom of thought, of exhibition, and of publication that elsewhere was nothing but a mere memory. Thus the English group was able to continue a wonderfully lively activity, although it was not without internal debate and dissent. Conroy Maddox, one of the most active members, had achieved a certain notoriety in 1936 when he sent a letter, cosigned by John and Robert Melville, in which he denounced the majority of English artists featured at the London exhibition in 1936 as camouflaged antisurrealists. Still, with the presence of Mesens, a refugee from Belgium, the group managed to reaffirm a certain coherence after a meeting at which the following principles were adopted: allegiance to the proletarian revolution (as a logical conclusion to the anarchist sympathies voiced thus far by some English artists, and the defense of the Spanish Republicans); no participation in any group other than the surrealists; no publications or exhibitions outside of the auspices of surrealism.

The principles had been adopted in order to gather forces and reconsolidate their strategy, but they brought about the departure of Grace Pailthorpe, Reuben Mednikoff, and Ithell Colquhoun, who disagreed; Herbert Read, although he criticized the third point, maintained his ties with the movement, which by the time of the exhibition *Surrealism Today* (1940) still included Paul Nash, Edward Burra, and Henry Moore. Among those who expressed no reservations were Penrose, Humphrey Jennings, Brunius, Eileen Agar, Hayter, and Onslow-Ford.

These different participants were featured together in the *London Bulletin*. First issued in April 1938, it would continue until June 1940. The *London Bulletin* was initially a newsletter containing artistic information from the London Gallery, which was not interested exclusively in surrealism; thus in its second issue (May 1938), there was a collection of pieces (including one by Samuel Beckett) devoted to Geer Van Velde; in number 3 a study of Léger, and so on. Progressively, however, surrealism became predominant, even when the *Bulletin* published (no. 8–9, January–February 1939) the catalog of the exhibition *Living Art in England;* this was because Mesens was now editor, assisted by Humphrey Jennings, and then Penrose. Only in its last issue would it actually claim to be "published by the surrealist group in England." (It was, moreover, from 1939 on that the London Gallery announced a series devoted to surrealist poetry, and its first publication, with a cover by Bellmer, was *The Road Is Wider Than Large* by Penrose, a journal illustrated with photographs of a trip taken to the Balkans in July and August 1938.) The last issues, 18, 19, and 20, were particularly rich, despite paper restrictions and the lack of financing that had begun to take its toll. The illustrations were a veritable visual anthology, and there were pieces by Breton ("La Maison d'Yves Tanguy," translated by Onslow-Ford and Mesens), Péret (two poems), and Mabille, a number of pieces by Mesens himself, a poem by Éluard (dedicated to Delvaux), and texts by Melville, Onslow-Ford and Conroy Maddox (on objects in surrealism). The cover page was inspired by poster art: "Fight HITLER and his ideology wherever it appears. You must. His defeat is the indispensable prelude to the *total liberation of humanity.*"

Only in March 1942 would a periodical claiming to be surrealist reappear in London. This was *Arson,* and only one issue was published, edited by Toni Del Renzio, a poet born in Russia in 1915, who, after transiting through Mussolini's Italy, through France, and then Spain, joined up with the English group in 1940. *Arson* collected

1

FEBRUARY 1939

LONDON BULLETIN

1s. 6d.

PARIS BRUXELLES AMSTERDAM NEW YORK

N° 10

Contributors in this Issue

ANDRÉ BRETON
ACHILLE CHAVÉE
ITHELL COLQUHOUN
AINSLIE ELLIS
PAUL ELUARD
MAN RAY
E. L. T. MESENS
F. E. McWILLIAM
HENRY MOORE
BEN NICHOLSON
ALICE PAALEN
W. PAALEN
JEAN SCUTENAIRE

28 PAGES — 17 ILLUSTRATIONS

PUBLISHED BY THE LONDON GALLERY LTD.
28 CORK STREET LONDON W.1

4

☞ manifesto

incendiary innocence

☞ toni del **renzio**

an *ARSON* pamphlet price one shilling

2

JUNE 1940

LONDON BULLETIN

FIVE SHILLINGS

EILEEN AGAR
JOHN BANTING
VICTOR BRAUNER
ANDRE BRETON
J. B. BRUNIUS
J. BUCKLAND-WRIGHT
PAUL DELVAUX
MATTA ECHAURREN
PAUL ELUARD
MAX ERNST
ESTEBAN FRANCES
S. W. HAYTER
LEN LYE
PIERRE MABILLE

F. E. McWILLIAM
CONROY MADDOX
JOHN MELVILLE
ROBERT MELVILLE
E. L. T. MESENS
LEE MILLER
HENRY MOORE
G. ONSLOW-FORD
ROLAND PENROSE
BENJAMIN PERET
E. RIMMINGTON
BRIERY RUSSELL
YVES TANGUY
JOHN TUNNARD

GIORGIO DE CHIRICO THE WAR

18-20

PUBLISHED BY THE SURREALIST GROUP IN ENGLAND
SOLE AGENT: A. ZWEMMER
76-80 CHARING CROSS ROAD, LONDON, W.C.2

5

*"It is never too late to learn to
write to be able to read."*
E. L. T. Mesens

ARSON

☆

AN ARDENT REVIEW. PART ONE OF A SURREALIST MANIFESTATION

3

JUNE 13 — JULY 3, 1940

Private View, WEDNESDAY, JUNE 12

10 a.m. — 6 p.m.

SURREALISM TO-DAY

Paintings,
sculpture,
objects, collages
and photographs by
Eileen AGAR, John BANTING,
J. B. BRUNIUS, John BUCKLAND-WRIGHT,
Edward BURRA, S. W. HAYTER, Len LYE,
F. E. McWILLIAM, Conroy MADDOX, John MELVILLE,
E. L. T. MESENS, Henry MOORE, Gordon ONSLOW-FORD,
Roland PENROSE, Edith RIMMINGTON, A. C. SEWTER.

and by
Victor BRAUNER,
Paul DELVAUX,
Matta ECHAURREN,
Max ERNST,
Esteban FRANCÉS,
Lee MILLER, Paul
NASH, Elisabeth
ONSLOW-FORD,
Briery RUSSELL,
John TUNNARD,
Yves TANGUY,
VERNER.

AT THE ZWEMMER GALLERY

26 LITCHFIELD STREET, OFF CHARING CROSS ROAD, W.C.2

1

3

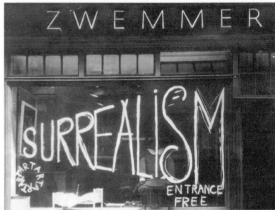

2

4

The exhibition *Surrealism Today,*
organized by E. L. T. Mesens at the
Zwemmer Gallery in London,
June–July 1940.

1 Invitation.

2, 3 Views of the exhibition.

4 The window of the Zwemmer
Gallery during the exhibition.

pieces by Breton, Calas, Mabille, Conroy Maddox, Melville, and Del Renzio himself and was explicitly addressed to all those, anywhere in the world, who claimed to be surrealists. But Del Renzio would soon fall out with Mesens, because of Mesens's publication, in the collection he edited for London Gallery Editions, of a translation by Penrose of Éluard's *Poésie et vérité 1942.*

Two years later, Mesens and Brunius published their pamphlet *Idolatry and Confusion,* a first public offensive (since the work by La Main à Plume had no distributor at the time) against the poetry in France that called itself "resistance" poetry and that was progressively winning the favor of the English public and London critics like Naomi Mitchison or Kathleen Raine. Recalling the existence of texts that were famous for other reasons (the *Lettre aux Anglais* by Bernanos, Breton's *Situation du surréalisme entre les deux guerres* and *Prolégomènes,* and *La Part du diable* by Denis de Rougement) but that seemed of little interest to English intellectuals, Mesens and Brunius could not explain the success of the resistance poetry among those same intellectuals (in particular the compilation entitled *L'Honneur des poètes,* or the "poems written by that phantom Jean Aicard who signs Aragon"), unless it were due to the unequivocal conformity that prevailed therein. Henceforth, any position that deviated from the "various aspects of conformism which are acceptable in time of war," practiced by Bernanos, Breton, and de Rougement each in his own way, could not expect to elicit a reaction. So for the two authors of the pamphlet, poets who used the pretext that the circumstances were restricting in order to renounce their freedom of creation were not only causing poetic invention to regress but also jeopardizing the anticipated freedom of the mind after the return of peace.

Despite such incontestable stringency, Mesens and Brunius spared Éluard, whose most recent production they could not quarrel with. On the contrary, they went after Del Renzio, precisely because, "having vaguely heard that Breton had fallen out with Éluard, he had launched an attack against the latter." Del Renzio responded in the four pages of *Incendiary Innocence* (April 4, 1944), a declaration of utter loyalty to Breton's principles, as well as an attempt to situate surrealism at the crossroads of Hegelian dialectics and esoteric tradition. The virulence of these reciprocal attacks indicates how severe the tension within the English group remained, and the title Mesens chose for the exhibition he organized in October 1945 took on a double meaning (even involuntary): *Surrealist Diversity* can be read as a reply to the monolithic character of all conformism, but it can also be seen to refer to the constant threat of disintegration within the movement itself, if the dispersion of its members continued to prevent them from achieving an effective recentering.

In Belgium

It was in the *London Bulletin* that a young Belgian poet published for the first time in 1938: Marcel Mariën was only eighteen at the time, and he had met Magritte, Scutenaire, Paul Colinet, and Nougé the previous year. Although he lived in Antwerp, he often stayed in Brussels, corresponding with Char and Éluard, and he would become not only a particularly unruly member of the Brussels group but also a commentator on Magritte's work and the scrupulous memorialist of surrealism in Belgium.

While it was, in Nougé's words, the "German shadow" that was the "most despairing reality," the Belgian players of the movement decided despite everything to pursue

their research. So they continued, as best they could, to publish books (less controlled by censorship than the periodicals) and to exhibit.

It was, however, a periodical edited by Ubac and Magritte that would be published, according to an announcement, "every two months from February 1, 1940." *L'Invention collective* would actually only last through two issues (February and May 1940), but it did try to bring together the Brussels group and the one from Hainaut, particularly active in illustration (Pol Bury). Breton found the first issue a bit timid but nevertheless collaborated on the second, contributing a poem and his response to the survey in the *Figaro littéraire,* "What do our Soldiers Read?" in which he recalled in passing the importance of Hegel and the value he ascribed to Péret's *Je sublime* and Julien Gracq's *Au château d'Argol.* Nougé, enlisted in France (he was a dual national) as a military nurse, was absent from *L'Invention collective:* on his return to Brussels he would give a fairly negative opinion of the periodical.

It was also under the sign of *L'Invention collective* that Mariën in 1940 published *La Chaise de sable,* a volume of essays devoted, among other things (according to the summary given by the dust jacket), to "the mind—objects—painting . . . poetry—morality—love." Mariën asserted that "the succession of movements [of thought] in history can only take place in the very framework of the life of surrealism, and one can say regarding any decline in surrealism, even if only a handful of people were left to transmit it, that the little that remained would still be, would always be, the surrealist movement surviving itself, independently of the changes and new denominations to which it might be subjected."[99] The movement's capacity for renewal or self-transformation would be further explored thanks to L'Aiguille Amantée, a publishing house Mariën founded that same year: he published his own *Malgré la nuit,* then *Le Corps grand ouvert* by Christian Dotremont, who was two years younger than him, *Moralité du sommeil* by Éluard (illustrated by Magritte), and *L'Érection expérimentale* by Gilbert Senecaux. The Éditions Ça Ira in Antwerp were also active at the time: they published *L'Oiseau qui n'a qu'une aile* by Mariën, who was decidedly verbose, Paul Colinet's *Les Histoires de la lampe* (1942), and Fernand Dumont's *Traité des fées* (1942; "You think [the fairies] are dead; they are just forgotten. I know of a few of them who, after the mysterious death of the Comte de Lautréamont, lived in immense solitude until my friends and I gave them back their luster, the brilliance of their youth, their virulence, and the fascinating beauty which makes us love them. Is this not true, oh you Fairies of strangeness, scandal, and freedom?"). To which one could add the first monograph devoted to Magritte by Mariën and, shortly thereafter, for the same publisher, *René Magritte ou les images défendues* by Nougé (a text written ten years earlier: several excerpts had been published in May 1933 by *Le Surréalisme ASDLR*), and *Les Poids et les mesures* by Mariën.[100] Mariën dispensed rather cynical remarks about the words and the values they could induce unbeknownst to their users, and turning at last to humor, he recommended reading Breton's *Anthologie* "at least when this work is reborn from the slush pile to which 'innocent' hands have consigned it: one still wonders why." Dotremeont, Mariën, and Magritte contributed to the publications of La Main à Plume (whose "Pages libres" included, in particular, *Lettres d'amour,* with an illustration by Magritte; Dotremont was experimenting with a marriage between automatism and chance and affirmed that "words are not only raw material, but have become models for objects").

The experimental dimension was, moreover, a constant characteristic of the Belgian group—even if this meant contesting the Parisian version of the movement symbol-

1 Cover of the periodical *L'Invention collective* (Brussels), number 2 (April 1940).

2 Raoul Ubac, *L'Ordre alphabétique—la campagne nocturne* (Alphabetical order—the nocturnal countryside; 1941).

3 Raoul Ubac, *Le Combat des Penthésilées* (1939).

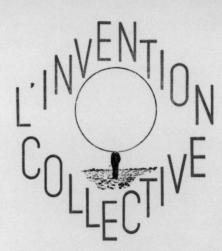

L'INVENTION
COLLECTIVE

Pierre MABILLE La Destruction du Monde
André BRETON Carte Postale
Irène HAMOIR Romantique Adéla
Paul MAGRITTE Le Cours d'Eau
Marcel MARIEN Le Miroir Universel
René MAGRITTE La Ligne de Vie
Jean SCUTENAIRE Léon Forton
Achille CHAVÉE Le Choix des Maux
 A l'Œil nu
Raoul UBAC Les Pièges à Lumière
Marcel LECOMTE A propos du « Point Blanc »
André BRETON Réponse à une Enquête
 NOTES
 ILLUSTRATIONS
de Pol BURY, Paul DELVAUX, M.-G. LEFRANCQ,
René MAGRITTE, Georges MARIEN, Raoul UBAC,
 Louis VAN DE SPIEGELE.
 Revue paraissant tous les deux mois
 Adresser la correspondance à
Raoul Ubac, 66, rue Vandernoot, Bruxelles

N° 2 AVRIL 1940
 IMPRIME EN BELGIQUE

1

2

3

ized by Breton. Nougé did not fail to do so, when he wrote the preface for the first event that was openly surrealist in spirit since the beginning of the Occupation, the exhibition in 1941 of photographs by Raoul Ubac (Galerie Dietrich, Brussels; this exhibition, which aroused the indignation of the rexist newspapers, was closed by the Germans sooner than expected).[101] Reiterating that liberty was without a doubt "the greatest conquest of the surrealists," he noted that "their doctrine and their theories—perishable like any doctrine or any theory, even cardinal ones—have little weight in the eyes of this *immediately* incommunicable treasure" and congratulated Ubac for showing the degree to which the artist was free to "use [the objective image] as he likes to produce the effects he deems appropriate." What this formula suggested in the way of controlled production obviously created a distance with regard to automatism, and this remained the major sticking point between Paris (even exiled in New York) and Brussels. It was noted, however, that "experiments in automatic writing" were planned on the invitation announcing a conference devoted to surrealism by Dotremont and Mariën (January 1943, at the Cercle littéraire de l'université de Louvain), an invitation where the phrase "The Future is a Member of Surrealism" wagered not only the continuation of the movement but also the role it would take on in a still uncertain postwar era.

Magritte, from 1942 to 1943, began to change the style of his painting. Would it not be apt to oppose the blackness of the outside world with an "optimism" that in itself would embody a combative value? So the canvases he painted until the end of the war were conceived in such a way as to seem less brutally shocking than his earlier work; on the contrary, they emanated a seductiveness, almost an impression of slight happiness, which were to persuade the viewer gently of their soundness. *La Plaine de l'air*, for example, contains nothing more astonishing than the size of the leaf that in the foreground replaces the tree (and that was, after all, only the visual translation of a classical metonymy); as for the background, "one finds oneself in the presence of one of those superb mountain landscapes in which the German and Swiss Romantics excelled" (José Pierre). Progressively, Magritte would modify not only his concept of the image, but his touch: as he stated in 1947, he intended to use "the impressionist technique in order to attain a level far surpassing the one where the impressionist painters could be found." Asserting that he was not one of those who accept that you can tell a real artist by his or her technical originality, he left behind the impersonal nature of his prewar manner to suggest right from the visual level that the new era demanded the reconquest of a love of life. The reference to Renoir's latter years, which defined what the Belgian painter called his "full sunlight" period, would eventually be expressed through less precise forms and an occasionally mawkish chromatism that no doubt preserved "poetry" in the canvas but a poetry that was intellectually much less complex or profound than that which emanated from *Viol* in 1934 or *Modèle rouge* in 1935. A replica of *Viol* that Magritte made at the time turned out to be "something of a horrible flatness, sadly reminding us of De Chirico's work at the end of his life, vainly attempting to recopy his works from the time when he was a genius" (José Pierre). The change in his manner brought with it a change in content, as the profound significance of a Magritte canvas was to be found as much, if not more, in its artistic treatment as in the irrationality of the image it conveyed.

Magritte, disowning his own earlier genius, would persist all the more stubbornly and determinedly along this path, given the fact that from 1945 on it would coincide

with the position of the communists, to whom the painter, together with his friends, had grown closer, and then with the preoccupations of Revolutionary Surrealism. To regain his early inspiration, after the inevitable break with Paris that this escapade would cause, he would have to live through the outrage, and failure, in 1947 and 1948, of his "période vache."

1944-1951

"FREEDOM, MY ONLY PIRATE"*

The Salon d'Automne

Opposite page: Frederick Kiesler, *Totem for All Religions,* work created in collaboration with Étienne-Martin and François Stahly for the *International Exhibition of Surrealism* at the Galerie Maeght, Paris, June 1947.

*Aimé Césaire, "Batouque," in Césaire, *Les Armes miraculeuses* (Paris: Gallimard, 1946), 90.

Well before the most famous surrealists returned to Paris, a certain public seemed to anticipate the movement's revival, even if it was only on an artistic level. Symptomatic of this were the articles penned by André Lhote, or those in *Les Lettres françaises,* where reticence and an effort to understand were intertwined: announcing the upcoming Salon d'Automne, Lhote pointed out that

> we will see an entire hall filled with surrealists who were unable to exhibit during the Occupation. . . . Surrealist paintings offer, for the majority, a fairly painstaking imitation of objects, but the fairly arbitrary disposition of the objects might be unsettling to our viewers. They will have to make an ever greater effort for these compositions which systematically group all too familiar objects according to laws which are deprived of any apparent logic . . . there is in Art, as in any other matter, only one truth . . . and the deepest one, poetic truth, defies present-day logic.[1]

Despite Lhote's fears, that year it was not so much the surrealist hall that created a sensation but Picasso. The day before the salon opening, Picasso had announced his adhesion to the Communist Party, (the same party that in 1937 had judged *Guernica's* aesthetic to be "antisocial" and "inappropriate for the healthy mentality of the proletariat"); for the inhabitants of Paris who wanted nothing more than to celebrate the joys of the Liberation, the paintings on display were hardly conducive: portraits of haggard faces, dark, austere still lifes of the "Royan" period, the sculpted *Tête de mort* (1943), which looked as if it had been plucked from a mass grave. The ensemble (seventy-nine pieces altogether) could have been perceived as "tragic" and viewed as the desire to express the suffering of the recent past; but this was not the case, and the critics preferred to emphasize the participation at the salon of "Young Painters of the French Tradition" (Roger Bissière, Alfred Manessier, Édouard Pignon, Francis Gruber,

André Fougeron). In describing Picasso's work they spoke of a "degraded" beauty, a "reduced" humanity, "systematic deformation," or "tortured grimaces." Two days after the opening, a group of visitors demonstrated noisily to express their hostility: "Take them down! Give us back our money!" while threatening to take the paintings down themselves. According to Lhote, the demonstration was organized by right-wing elements; according to other commentators, it may have been provoked by students from the Beaux-Arts. Picasso, moreover, was not the only victim of "the most spiritual people on earth": a canvas by Léopold Survage was scribbled on, and some change and metro tickets were left in the open palm of a recumbent statue by the sculptor Adam. "All of this, I suppose, in the name of freedom and with little tricolor flags in one's lapel," were the bitter comments of Jacques Gabriel in *Poésie 44*.[2] But the surrealist hall did not convince the same chronicler, although he claimed that he had expected a great deal from it "on emerging from these conformist years." It seemed to constitute a rather hasty sampling (it had indeed been prepared without any collective effort) and had very little significance: there was a fine painting by Miró, some "interesting" canvases by Ernst, Masson, and Tanguy, and one could only deplore Dalí's absence (and for good reason!). Gabriel's conclusion: "The exhibition would not have been organized any differently if the point had been to show that the movement was finished," but this did not prevent him from regretting that Lucien Coutaud, "not so unlike Max Ernst," had not yet found the place within the movement that he deserved. This was neither the last time the question of the movement's viability would be raised nor that its painters (of whom Coutaud was just one example) would be evaluated—painters who, as long as their work was judged only on appearance, might well be surrealists after all.

In Paris, there were several solo exhibitions in 1945: Lam at Pierre Loeb's, Ernst at Denise René's, Miró at the Galerie Vendôme. But they did not give any better indication of the recent advances made by the movement, insofar as they showed relatively old works. This was the case in particular for Max Ernst and Miró: for Ernst, the works shown dated from 1919 to 1937; for Miró, there was nothing later than 1938. (Louis Parrot wrote the preface to Miró's exhibition: "Miró's paintings are never simple entertainment. Whatever the subject inspiring them, there is always a constant search for a religious essence, a magical sense that things eventually lead us to discover, despite their disconcerting *parti pris*"—the confusion between "religious essence" and "magical spirit" made up the conclusion of his text.)

So while surrealism in painting remained discreet, the situation in the publishing world was not quite the same. In 1945, two works were published that each in its own fashion would attempt to assess the past and the significance of the movement and, in this way, to alert the public to the present situation.

The first work was Jules Monnerot's *La Poésie moderne et le sacré*.[3] Monnerot had joined the group in 1932, then associated with Georges Bataille and the Collège de Sociologie, with Michel Leiris, Roger Caillois, and Michel Fardoulis-Lagrange from 1939 on. Already in 1933, in *Le Surréalisme ASDLR,* he had defined the group and its activities in relation to "some traits peculiar to the civilized mentality" and considered that, through surrealism, "a group of men has foreseen the extraordinary return of poetry to its origins, from the expression of the world to participation in the world." Furthering this approach he sought in *La Poésie moderne et le sacré* (Modern poetry and the sacred) to define the specific meaning of surrealism from the point of view of its existence as a group and the point of view of its philosophical significance. He was

thus able to define the surrealist group as "what in English is called a set, a chance union without obligation or sanction which can be denounced with impunity at any moment with or without brilliance, under any pretext, for any avowed motive, confessable or otherwise, by every individual." Reiterating, too, the role played by dreams in the theories and the very existence of the group, and the rights one sought to recognize or attribute to them, Monnerot emphasized that the "surreal" is envisioned only from the point of view of its integration into accepted reality—that is, according to the concept of the dialectical enrichment (and not sterile opposition) of that reality: "A reintegration of the surreal into a reality made more comprehensive, one that would include everyday life, the logico-experimental conception of the world as a particular case just as the presently accepted physical concept incorporates Newtonian advances in its 'generalization', seems to be the epistemological desire of surrealism."[4] This type of approach, which called itself an attempt at "applied philosophy," had no equal at the time, and clearly had nothing in common with the commentaries of a literary or artistic slant that were much more frequent. Moreover, Monnerot was careful to situate surrealism's poetic enterprise relative to the magical tradition; if "the essence of magic is merely a nocturnal belief in the efficacy of desire and feeling," poetry as it was understood in the realm of surrealism took on the aspect of a "magic for magic's sake, magic without hope," and the poet became "a magician who devotes himself to the rites themselves, expecting nothing else from magic." Henceforth poetry could find its bearings as "unjustifiable confidence, unbearable in the efficacy of desire and vigor": rather than hope, it is the "lack of hope" that informs it, or a quest that is resolved in spite of everything, blindly in a way, because it finds its own significance within and its justification resides not so much in the goal that it can attain but in that which gives it birth. "Surrealism is a critique of the ways in which humankind has sought to resolve the cardinal problems of existence, singularly imperfect and of value more because of existence itself and the symptoms it represents than for the content it offers. There are few critiques whose content is more worthy of criticism, yet there are hardly any which are better. Surrealism's worth is not to be found in the critique it makes, but in the fact that it *is* itself a critique."

Monnerot, in the conclusion of his study, slips toward an interpretation of the movement that is no longer philosophical but religious. This would very quickly cause some concern within the group. Nevertheless, his work constituted the first endeavor of this scope to define the significance of surrealism in all the breadth of its activity and, above all, to discover its meaning, independently of the results obtained.

The second work, Maurice Nadeau's *Histoire du Surréalisme,* was destined to become a sort of classic. It was published in 1945 and offered precise information, not so much on the global significance of the movement, as Monnerot had done and to whose volume it was a complement, but about its chronology. It would be followed by a second volume in 1948, a compilation of *Documents surréalistes.*[5] He detailed the facts, texts, and acts that had characterized the movement from its origins. In the medium term, one is nevertheless obliged to wonder whether Nadeau was not in fact suggesting that the movement was finished, and one is forced to admit that the afterword added later by the author only confirm this suspicion. In 1957, Nadeau would assert that "until we have more information we are resigned to considering surrealism as a literary school, very different from all those which preceded it, and the most prestigious to come into being since Romanticism"—which is a limitation, to say the least!—and in a postscript

1

3

2

4

6

5

in 1963 he spoke of the "failure to grasp reality with which surrealism is stricken nowadays," before finally concluding from Jean-Louis Bédouin's book, *Vingt ans de sur-réalisme* (Twenty years of surrealism), that "when a history outlives itself, it inevitably disintegrates into anecdotes."

In 1945 the suggestion that surrealism was not only finished as a movement but also outmoded clearly served the interests of the communist intellectuals as well as those of the existentialists. Sartre, who was preparing his periodical *Les Temps modernes* (the first issue came out in October 1945), had cordial relations with Leiris and Queneau.[6] Hostilities would begin only when *Qu'est-ce que la littérature?* (What is literature?) was published (1947—this would not prevent Sartre from writing a friendly preface to an exhibition of sculptures by David Hare held at the Galerie Maeght at the end of the same year).[7] As for the communists, the struggle (which was not recent!) resumed with all the more vigor, for they now had important means at their disposal—in the press (*L'Humanité* now had the largest print run of any daily paper) and on the radio—as the "party of the *fusillés*" (executed by gunfire, an expression borrowed from Elsa Triolet's short story *Les Amants d'Avignon*). Thus, they could impose their theses in the artistic domain: Aragon, strengthened by his experience with "poetry of resistance," decreed the Alexandrine to be the "national" verse, and the sonnet would soon become virtually obligatory for any form of poetic work. As for painting, Aragon here, too, would quickly become the bard of a French brand of socialist realism that was perfectly in line with its incarnation of the previous ten years or more in the Soviet Union.

In *Entretiens,* Breton described how upon his return to France he had to come to terms with the fact that

> the Stalinists, the only ones who had a strong organization during the clandestine period, had managed to fill almost all the key positions in publishing, the press, the radio, the art galleries, etc. They were determined to stay there, by using means that had been defined long before for their own benefit, but that they had recently been able to perfect on an experimental level. No matter how long I had been aware of these means, I must admit that, in their application, wherever I looked, they went far beyond what I had anticipated. . . . On the intellectual level, it goes without saying that it was vital to neutralize and silence those who were in a position to denounce such an operation by breaking through to their true motives.[8]

Le Déshonneur des poètes

After the pamphlets of La Main à Plume and *Idolatry and Confusion,* the most radical reexamination of the resistance poetry as it had been practiced in France during the war would come once again from Mexico, in Benjamin Péret's words in February 1945.[9] Péret had become acquainted with this poetry through an anthology published in Rio de Janeiro entitled *L'Honneur des poètes* (The honor of poets). The title had been that of a volume initially published clandestinely (and symbolically, on July 14, 1943) by the Éditions de Minuit; it was followed by a second volume, entitled *Europe* (published May 1, 1944). But the contents of the anthology analyzed by Péret differed quite significantly from the volume that appeared in France (Loys Masson and Pierre Emmanuel, whom Péret quoted, did not figure in the Éditions de Minuit collections), even though Éluard (the Rio anthology included *Liberté,* omitted from the French

volumes) and Aragon were to be found in all three books.[10] Despite these differences, the tonality of the pieces selected was comparable, as was the concept of the poetry that informed them.

Le Déshonneur des poètes (The dishonor of poets) was, according to Claude Courtot, a veritable "paving stone in the mess tins of the *poètes casqués*" (the helmeted poets).[11] This paving stone proclaimed a position shared by all the surrealists and confirmed in a commentary by Patrick Waldberg, if such a confirmation was needed, after the reactions of La Main à Plume and of Mesens and Brunius. On May 26, 1944, Waldberg wrote from London to his wife Isabelle: "'Le Musée Grévin' by François La Colère [Aragon's pseudonym] is a very long pamphlet-poem attacking collaborators in Hugolian terms and reminding one of the very poor productions by Marie-Joseph Chénier and Fabre d'Eglantine. This work was written in France by a 'resistant' and published clandestinely, and therefore both here and in Algiers it has been awarded a welcome which is not in proportion with its literary value. The same story applies to the anthology entitled *L'Honneur des poètes,* whose mediocrity is appalling."[12]

Péret was not satisfied with pointing out the mediocrity of the poems compiled in the anthology; after all, hadn't there always been mediocre poets? What he deplored was the conjunction between "the lyrical level of pharmaceutical publicity" and the return of the majority of the authors to "rhymes and classical Alexandrines." Whence an initial conclusion: "The honor of these 'poets' consists in ceasing to be poets in order to become advertising agents." If one went on to examine the values they were publicizing, one would see that they combined "religious dogma and nationalist dogma"—religious dogma showing through even in the form or the rhythm of the poems, which frequently made use of litany; nationalist dogma using the defense of the motherland or of freedom as a pretext to accuse "the Germans" in terms that would not be at all out of place in the most exalted Nazi hymns. *L'Honneur des poètes* was doubly guilty: if the form and the content seemed unacceptable, it was first of all because they were the product of "poets" who had renounced their own freedom to illustrate nothing more than conventional themes. Such directed, controlled, ultimately order-obeying poetry lapsed, moreover, into a sort of idealism, while vindicating a totally abstract "freedom"—which could only remain unattainable and impossible, and there was the danger, in venerating such poetry that one would conceal the constraints that were only too real. "Any 'poem,'" said Péret, "which exalts a voluntarily undefined 'freedom'—when it is not embellished with religious or nationalist attributes—ceases first of all to be a poem, and then constitutes an obstacle to the total liberation of man, for it deceives him in showing him a 'freedom' which hides new chains."[13]

Péret's text, in its fashion, echoed the 1938 manifesto *Pour un art révolutionnaire indépendant,* and one might suppose that by attacking resistance poetry so violently, Péret was also, through poetry, targeting the "aesthetic" demands of the Communist Party. The news that had reached him from France since the Liberation confirmed, be it in Mexico City or New York, that Aragon and Éluard were now in the forefront and were becoming, in the words of Patrick Waldberg, "the great leaders of 'young poetry.' All these little people have now taken the stage of the Frenchman's poetry matinees, mixing motherland and religion and having their photo taken with Maurice Chevalier at the Wall of the Fédérés," while Aragon went so far as to reproach Gide "(1) for having spoken of Goethe while the 'Boches' were here, (2) for not preferring the motherland to the mind."[14] As for Éluard, he had founded *L'Éternelle revue* in clandestinity,

3

1

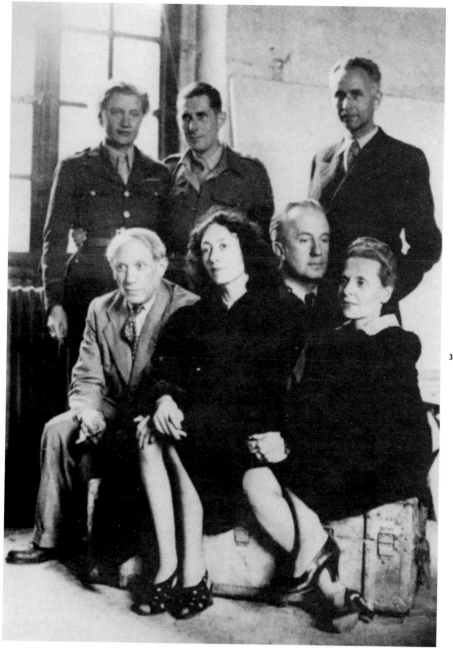

2

now "directed" by Louis Parrot: from the first issue, Waldberg would salvage the participation of Prévert, Queneau, and Leiris alone, for they "seemed to be the only ones who had kept a sense of humor. And at least they were not full of tearful stories, or allusions to the soul, to France, to the Good Lord, or other trifles." This choice was not due to some sort of ordinary old boys' network—all the less so in that Prévert, Queneau, and Leiris were hardly models of surrealist "orthodoxy," and had not been for a long time—but revealed the gap that more and more clearly separated two concepts of writing: one turned toward testimony and predetermined by "values" that it did not define, and the other devoted to an untrammeled exploration in which the future could be envisaged with a blueprint for very different values.[15]

Thus confronted with the views of a Communist Party that vaunted the spirit of the Resistance and occupied an increasingly significant place in French cultural life, Péret had no illusions about the future either for himself or for the surrealists, who all shared his opinion.[16] Since, in addition, the demands of the Communist Party, via Aragon in particular, would concern not only poets but also painters, the surrealists of the postwar era would have to insist on every front that, in artistic practice as elsewhere, any attempt to control freedom would carry serious moral consequences.

Dialectic of Dialectics

If there was any need to prove that surrealism had the wherewithal not to repeat itself and could, on the contrary, push its exploration ever further, the "Message Addressed to the International Surrealist Movement" by Gherasim Luca and Dolfi Trost, written in French and distributed from Bucharest (S Publishers) in 1945, would be more than enough. Reaffirming the fundamental relation between dialectical materialism and the "transformation of desire into the reality of desire," this message, after first recalling the isolation suffered by its signatories since 1939, deplored the existence, within surrealism itself, of "*artistic* deviations," of which the movement ought to rid itself—which coincided perfectly with Breton's earlier denunciation of surrealist clichés. For Luca and Trost, these deviations were particularly visible in the repetitive and mechanical (not dialectical) use of techniques that, when separated from the initial prerequisites guaranteeing their efficacy, could lead no further than an idealist production and, as a consequence, were incapable of working against the dominant culture since, on the contrary, such a production stood every chance of being harmoniously absorbed by that culture.

A second error of recent years had been that of grouping, in anthologies, examples that could only give a rigid vision of the movement, presenting it thus as a simple artistic trend in competition with others: by being integrated in a market where everything is thrall to competitiveness alone, it quite simply lost its revolutionary dimension.

It was precisely in order to consolidate the "continually revolutionary state" of surrealism that Luca and Trost advocated using the position that they themselves had adopted in their work and in the elaboration of their theories: "Dialectical position of permanent *negation* and *negation of negation*." The point was to renounce any heritage or attempt to define surrealism in terms of limitation, the condition for attaining "the expression of all our desires." From this point of view, "surrealism can only exist in a state of continual opposition to the entire world and to itself, in this negation of the negation fueled by the most inexpressible delirium," and its prime resource is located in objective chance, which allows one to understand love "as our most valuable insur-

1

2

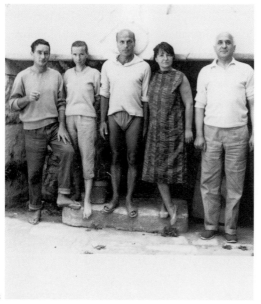

3

4

5

rectionary support." Love, when methodically "exasperated," that is, carried beyond all its known forms, reveals itself to be *objective love*. And it is through this immersion into what is ordinarily held to be the most subjective that the existence of a link with society is revealed, if it is true that "the unlimited eroticization of the proletariat constitutes the most precious guarantee one can find to assure it, in the midst of this dreadful era in which we live, of a real revolutionary development."

However disconcerting this last formula might be, it veils a frenzied opposition to the laws of nature and the "inner limitations of Oedipal complexes"—which only lead to situations where one is trapped in cycles of repetitiveness precluding any authentic advancement. The non-Oedipal position that was suggested (and to which Luca referred in his poetry to dislocate and dismember his linguistic heritage) simultaneously attacked the symbolic status of the family and whatever might subsist of it in the "inauspicious, unconscious folds which, unbeknownst to us, shape our attitude toward the outside world." This non-Oedipal attitude must be adopted in all domains and leads in particular to a modification of the concept of relations between the conscious and the unconscious as explored by psychoanalysis: for Luca and Trost, dreams should not be accepted on principle as the formulation of a positive desire, since "regressive traces of memory" can reside there (Oedipal yet again—which from the psychoanalytic point of view constitutes without doubt the majority, if not the totality of cases!).

The dialectic in the second degree suggested by the Bucharest manifesto no longer consisted solely in an acknowledgment of the fact that thought functioned independently in diurnal life, in dreams, and in madness. One ought to go beyond this first assertion by locating what might be regressive even in dreams and madness (when madness, e.g., took a religious turn).

In parallel, where plastic art was concerned, the idea was to renew classical methods of representation by fostering the expansion of surrealist painting thanks to the use of "nonplastic, objective, and completely nonartistic procedures," such as colored graphic works or cubomania, which offered the hope, by pushing automatism to concrete and absurd limits, of being able to capture chance at will where it would otherwise remain a rare thing.[17] Every method—whether inspired by a procedure used in pathology like ultrasounds or stereotypy or applying mechanical apparatuses like a pantograph or the paper-cutting machine used for cubomania—must henceforth be employed to increase the subject's receptive qualities and "tear out new lands from the objective world": automatism must no longer be conceived only from a subjective angle, since it was also possible to obtain revelations through automatism in material and concrete ways.

Mixed in with these assertions—and the least one can say about them is that they are hardly lacking in either ambition or an offensive character—were the titles of several other works by Luca and Trost that indicated that the non-Oedipal attitude had already proven itself. Among the titles mentioned was *L'Inventeur de l'amour* (The inventor of love), which fortunately had been translated into French by Luca himself.[18] It was a long poem that, after stating that "everything must be reinvented / there is nothing left on earth," explained the grievances against Oedipus: "the man of the castration complex / and of birth trauma / on whom are propped / love / professions / ties and handbags / progress, the arts / churches / / I detest this natural child, this Oedipus / I hate and refuse his fixed biology." This hatred of nature was in fact a hatred of everything that had already been played and that could be named: "life becomes a stage / where we play Romeo, Cain, Caesar / and a few other macabre characters / /

Inhabited by these corpses / like coffins we go along / the path that links / birth to death." In order to shake a fondness for an already ordered history and its parade of corpses, all trust is placed in the transgressions authorized by love: "nothing will make me believe / that love can be anything else / than a mortal entry / into the marvelous / in its lascivious dangers," the vanishing point of existence, which "contains in its secret warnings / the means to surpass the human condition / in all its oppressive aspects."

For a Lack of Anything Better

Outside of the daily press, increasingly serious debate was once again to be found on the pages of the weeklies and periodicals in particular, yet the surrealists had no vehicle of their own. There was *Fontaine,* which moved from Algiers to Paris, and which was certainly welcoming on occasion, but it would disappear when confronted with the competition of *Temps modernes.* The Communist Party continued to draw the support of a number of periodicals: in addition to *Les Lettres françaises, Europe,* and *Action,* it would also soon be able to count on *La Nouvelle critique,* in which its intellectuals would stubbornly repeat the mechanical formulas of the Stalinist catechism, which claimed to be the definitive version of dialectical materialism.

In 1946 Bataille founded the periodical *Critique,* and he published already in the second issue an article titled "Surrealism and Its Difference from Existentialism": contributors were primarily renegades from the group, but he would prove to be a watchful commentator, keeping his own distances.[19]

The group itself would not publish the first issue of *Néon* until January 1948. In the meanwhile, the surrealists found a welcome in *Les Quatre Vents,* which their friend Henri Parisot had begun to publish in June 1945, and in the series L'âge d'or, which he edited for the Éditions Fontaine and in which there appeared in succession (with cover art by Mario Prassinos) small volumes by Roland Penrose, Lise Deharme, Jean Ferry, Maurice Henry, Waldberg, Péret, Paul Colinet, and Marcel Piqueray. There were also texts characterized by a curiosity that was manifestly close to that of the movement, by Frantz Brentano, Lewis Carroll, Christian Dietrich Grabbe, Alfred Jarry, and Alberto Savinio.[20]

Les Quatres Vents published pieces by René Char, Georges Hugnet, Jarry, Bataille, Leiris, Clément Pansaers, Raymond Queneau, Julien Gracq, Mario Prassinos, Michel Fardoulis-Lagrange, Jean Arp, Jacques Prévert, Leonora Carrington, Picabia, André Pieyre de Mandiargues, Georges Hénein, and others.[21] This could not help but have an effect on its overall tonality; moreover, "The Poetic Imagination" and "Romantic Supernatural and Poetry," which were the themes of the sixth and seventh issues, were clearly themes that were in line with the group's concerns. Above all, it would devote two special issues to surrealism. "L'Évidence surréaliste" (no. 4, February 1946, thus before Breton's return to Paris) began with a quotation from the *Discours aux étudiants de Yale* (Speech to students at Yale), which gave the periodical the aspect of a collective reaction to the intellectual context: "However displeasing this might be to a few impatient gravediggers, I claim to know a lot more than they do about what a final hour will mean to surrealism: it will mean the birth of a more emancipatory movement.... One must believe that the new movement has not yet been, is not yet." There were prestigious names among the contributors, from Breton (the first publication in France

3

1

4

2

5

of *Fata Morgana,* carefully dated, to avoid any misinterpretations, from Marseilles, December 1940), to Artaud, by way of Arp, Péret, Bellmer, Aimé Césaire, Carrington, Paul Colinet, Gheerbrant, Gracq, Prassinos, Maurice Henry, Louis Scutenaire, Penrose, Mandiargues, Maurice Blanchard, Jacques Brunius, André Masson, the Piquerays, Mesens, Jean Ferry, Henri Pastoureau, and others. The panorama was vast, from the oldest to the youngest, but it did not really go beyond the bounds of the Paris-London-Brussels triangle, despite the presence of Vicente Huidobro and Hafez. Moreover, "L'Évidence surréaliste," despite the quality of the texts and contributions, resembled in a way the anthologies criticized by Luca and Trost: surrealism appeared to be full of life, to be sure, but solely through its poetic, or literary, works, which, unlike a publication originating with the group itself, could in no way take into account the research and experiments that were being carried out. The situation was roughly the same with "Le Langage surréaliste" (no. 8, March 1947), in which, although the most unexpected or least predictable participants had turned out in force (Yves Bonnefoy, Jean-Marie Paroutaud, Jacques Charpier, Claude Tarnaud, Yves Battistini, Robert Valançay, Iaroslav Serpan, Édouard Jaguer, Christian Dotremont), there was evidence that the movement was once again inspiring, if not complete allegiance, at least active support.

In 1946 a text written by Pierre Mabille in Mexico was published at the Éditions des Quatres Vents: *Le Merveilleux* (The marvelous), with a frontispiece by Victor Brauner and an illustration by Jacques Hérold. This short essay written during the war was dotted with excerpts from poems and tales and echoed some of the comments in *La Parole est à Péret:* "The Marvelous is the force for renewal, shared by all mankind, whatever their specific culture or the development of their intelligence; it allows one to glimpse a deeper understanding beyond borders and interests, a true brotherhood which has its universal language in poetry and true art. It is probably the only reality to preserve hope in mankind and in the future."[22]

Thus, although the surrealists still had their place in the intellectual landscape, they no longer had the impact they were assured of in the last issues of *Minotaure.* An additional sign of this was provided by an issue of the *Cahiers d'art* that came out in late 1946: there was an abundance of examples of surrealism in painting but only as a representation of one trend among others. The issue was especially thick (more than four hundred pages) and opened with an homage to Klee (who died in 1940), in which Georges Duthuit, René Char, Pierre Mabille, Roger Vitrac, and Valentine Hugo took part. Another, more modest, tribute was paid to Kandinsky (who died in 1944), and then Christian Zervos, loyal to his habit of conceiving his periodical as a veritable "imaginary museum," alternated text and reproductions that dealt equally with Bonnard, Picasso (almost thirty pages on *L'Homme à l'agneau* [The man with the lamb]), pre-Hispanic sculptures from Central America, Matisse, bronzes from India, Prinner, Domela, and the painting of the Van Velde brothers. In this very open context there were Char's reflections on Balthus, poems by Gilbert Lély (*Le Château-lyre*), Penrose, and Yves Battistini, an article by Nicolas Calas ("Introduction to Art Criticism"), reproductions of Miró (accompanied by some of his "Poetic Games"), Brauner (with a text by Breton), Roberto Matta, Wifredo Lam (texts by Césaire and Breton), Yves Tanguy, Wolfgang Paalen (with "Notes on the Art of Tomorrow"), Hérold (text by Mabille), and Enrico Donati (introduced by Nadeau). From the "margins" of the movement came contributions from Alexander Calder, Lacan, and Tzara, among oth-

ers. In all, it was a very respectable presentation but one that allowed an appreciation of surrealism from its artistic aspect alone. Moreover, the reproductions chosen concerned recent work, created for the most part during the war, and the general trend seemed to be to focus on individual trajectories, regardless of the fact that their values and ventures were shared ones.

An Exhibition in Brussels

The exhibition, organized in Brussels by the Belgian group—the first major group event since the Liberation—came on the heels of a certain number of publications: first of all, at the Éditions de la Boétie, *La Terre n'est pas une vallée de larmes* (Earth is not a valley of tears), which included texts and illustrations that had not been published during the Occupation for lack of financing. The choice of contributors was fairly ecumenical and included Noël Arnaud, Paul Nougé (rewriting Baudelaire), Breton, Char, Colinet, Oscar Dominguez, Dotremont, Éluard (whom Marcel Mariën, the editor, still trusted somewhat), Magritte, Mariën himself, Picasso, Queneau, and others. Contrary to what the title might suggest, it would seem to indicate a waiting mode: Magritte, at the time, preferred to wait for Breton's return where fundamental choices were concerned. Then in the spring of 1945 there came *Réponse* (unique issue), which included Colinet, Camille Goemans, Dotremont, Scutenaire, and Marcel Lecomte. In April 1945, a meeting at the Palais des Beaux-Arts in Brussels devoted to the poetry of the Resistance was disrupted: from the balcony, Marcel Broodthaers called loudly, "Louis Aragon, when will you stop compromising French poetry?" The following June, *Le Salut public,* "a political and literary weekly," published a special issue devoted to the surrealists: Nougé accepted its principles, provided the participation of his friends (Malet, Dotremont, Scutenaire, Colinet, Mariën, Achille Chavée, Magritte, and, yet again, Éluard) was clearly set apart from the rest of the periodical, and indeed they were to be found under the subtitle "Hors-texte," beneath a framed declaration by Nougé (this would in fact be his only contribution): "To public writers and poet poets / to expansion / to mania / to secrets confided / to vanity / to candor / to prophets / as to virtuosi / let us repeat indefatigably that / THE EXPERIMENT WILL CONTINUE."

Finally Magritte took the initiative of organizing an ambitious group show at the Galerie des Éditions de Boétie, destined both to highlight the importance of the movement and to give it a new impetus by proving that it had in no way "become tame" and that in no way did recent events justify the slightest relaxing of its positions. From December 15, 1945, to January 15, 1946, over 160 works were shown, both early (Arp, Klee, Ernst) and recent (Malet, Henri Goetz, Marcel Jean), and in particular a certain number by recent recruits (Boumeester, Francis Bouvet, Aline Gagnaire), some of which were quite debatable, moreover (Félix Labisse). Magritte's exhibition was a veritable anthology of works from 1927 to 1945, with twenty-one items, including the drawings destined to illustrate an edition of *Les Chants de Maldoror* to be published in 1948. As for the "Portrait of the Artist" attributed to De Chirico by the catalog, it was in fact made up of simple fragments of a mirror that Magritte had had framed. The participation of the young Bruxellois and the group from Hainaut (Pol Bury, Marcel Lefrancq, Marcel Havrenne, Armand Simon) was significant. On the walls were slogans (by Chavée, Lenin, Marx, Lautréamont, and Dominguez: "I want the death of 30,000 priests every 3 minutes"), a chair was hung from the ceiling by its legs, there was a set

1

3

GALERIE des ÉDITIONS La BOÉTIE
36, RUE DE LOXUM, BRUXELLES

DU 15 DECEMBRE 1945 AU 15 JANVIER 1946

SURRÉALISME

Exposition de Tableaux, Dessins, Objets, Photos et Textes de

ARP, BATTISTINI, BOTT, BOUMEESTER, BOUVET, BRAUNER, BRYEN, BURY,
CHAVEE, CHIRICO, DOMINGUEZ, DUHAMEL, DUMONT, DUMOUCHEL, ERNST,
GAGNAIRE, GOETZ, HAVRENNE, HEROLD, JEAN, LABISSE, LEFRANCQ,
MAGRITTE, MALET, MARIEN, NOUGE, NOVARINA, SANDERS, SAVINO,
SCUTENAIRE, SENECAUT, SIMON, UBAC, VANDESPIEGELE, WERGIFOSSE, WITZ

LE SAMEDI 22 DÉC. A 21 H., CONFÉRENCE DE M. MARIÉN :
LE SURRÉALISME EN 1945

LE SAMEDI 5 JANV. A 21 H., CONFÉRENCE d'Ach. CHAVÉE :
POINTS DE REPÈRE

2

GALERIE DES ÉDITIONS LA BOÉTIE

SURRÉALISME
CATALOGUE DE L'EXPOSITION

MAGRITTE LE VIOL (1945)

4

3

1 *Les Lèvres nues*, number 4
(December 1971).

2 René Magritte, *La Mémoire* (Memory; 1942); oil on canvas, 30 × 22 in.
(75.4 × 55.4 cm). This work was
exhibited at the Galerie des Édi-
tions La Boétie, 1945–46.

3 René Magritte, *Le Mal du pays*
(Homesickness; 1941); oil on canvas,
40 × 32²/₅ in. (100 × 81 cm). Private
collection.

4 Marcel Mariën, 1948.

LÂCHEZ LA PROIE

ET L'OMBRE

1

4

2

5 Pol Bury, *L'Étourdie* (Scatter-brained; 1945).

6 Armand Simon, *Untitled* (1944); India ink on paper, 10⅓ × 7⅔ in. (25.7 × 19.2 cm). Musées Royaux des Beaux-Arts de Belgique, Brussels.

7 Marcel Lefrancq, *La Dialectique* (1945); photomontage.

8 Marcel Mariën, *De Sade à Lénine* (1946).

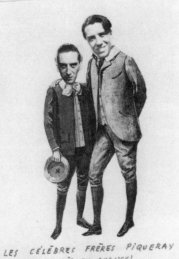

of false teeth repeating the word, "Mama," and, on a stand, a large dish presented a cat-echism book floating in a stew—"the gallery," said Mariën, "was in charge of renewing the stew as soon as the decomposition reached an extreme that was more unbearable to the sense of smell than to sight."[23] The catalog, in addition to a few reproductions, had a front cover illustrated by *Le Viol* in its 1945 version (somewhat faded by the "impressionist" touch that Magritte favored at that time) and contained a "Moral Por-trait of Surrealism" made up of excerpts by Breton, Nougé, Tzara, Éluard, Magritte-Scutenaire, and Mariën. Mariën, in particular, wrote that the lucid liberation that the movement sought to attain must be led "against oneself first and foremost, against one's own mental prison, one's habits and most secret tics, against the birdlime of intimate superstitions." During his opening speech, Nougé confirmed that "the idea is less to edify a doctrine than to establish a discipline, a method, which, to [my] mind, is far from having yielded all its fruit," before he went on to announce that "on the political level, the surrealists whose various propositions can be examined here have rallied without reservation around the Communist Party," (which might have been true of the Belgian surrealists but certainly not of Ernst, Brauner, Hérold, or Léo Malet!).

Obviously, the event first met with a *succès à scandale,* "causing one journalist to write: "Millions of men died so that the jokers could carry on," while another went so far as to regret the salubrity of the era of the Maréchal Pétain" (Mariën). It was no doubt disturbing for the public in Brussels, but one was forced to concede that a good number of the works displayed were more in the line of "fantasy" than of surrealism, strictly speaking. If the exhibition sought to emphasize the international dimension of the movement, it also portrayed an image that was not terribly rigorous and did not succeed in finding coherence around a real platform (what took its place: a declaration of adhesion to communism, which was from this point of view particularly unsatisfac-tory in 1945–46, as Breton would very quickly point out to Magritte). The sentence that follows, which Nougé wrote for the catalog, in addition to reprinting the box that had figured several months earlier in "Hors-texte," was alarmingly ambiguous: "Exegetes, if you hope to see clearly, cross out the word surrealism."

Breton's Return

Only in May 1946 did Breton return to France. "He came back from America," wrote Jean Schuster, "with splendors: agates from Gaspesia; Élisa; Hopi and Zuni kachinas; the complete works of Charles Fourier; Aube promised to mad passion; masks from the Pacific Northwest; the friendship of Claude Lévi-Strauss, Robert Lebel, and Georges Duthuit; the magic of his stay in the Antilles and his meetings with Aimé Césaire, Magloire Saint-Aude, Hyppolite."[24]

Before his return, he had published *Arcane 17* in New York, written in Gaspesia in the autumn of 1944, where he had reaffirmed the need for a systematic preparation for the advent of the woman-child to the entire sensible empire. Breton elaborated on his personal version of the "new myth," by relying both on Melusina (to whom he gave a second cry, of rebirth and victory over all the masculine tendencies toward distrust) and on Isis, who gathered up the limbs of Osiris. Breton replied to the historical cir-cumstances with a dreamlike vista, peppered with allusions to the esotericism and acts of clairvoyance of which Hugo, Nerval, and Rimbaud had been capable before him. *Arcane 17* opted for irrational hope against all caution and ratiocination.[25] And it was

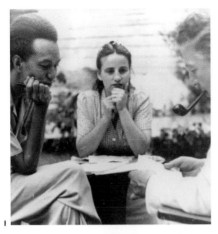

1 André Breton and Hélène and Wifredo Lam in Haiti in 1946.

2 André Breton's conservatory with Man Ray's *Dancer* (1920). *On the left*, a bottle in the shape of a violin; *on the right*, a *haume bambara* mask. Photograph by Sabine Weiss (1960).

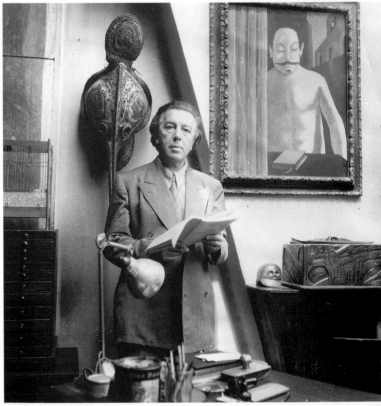

3 Cover by Frederick Kiesler for André Breton's *Ode à Charles Fourier* (Paris, 1947).

4 André Breton, circa 1950. Behind him on the right is Giorgio De Chirico's *Le Cerveau de l'enfant* (1914).

5

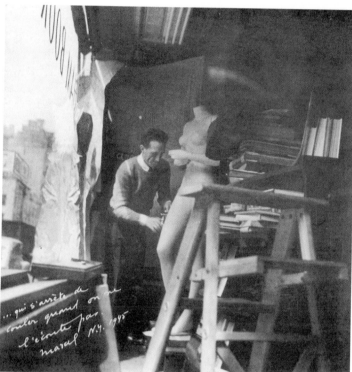

8

9

10

5 Matta's tarot cards illustrating the original edition of André Breton's *Arcane 17* (New York, 1944).

6 Marcel Duchamp working on the window display for *Arcane 17*, New York, April 1945. He is screwing a faucet into the right thigh of a headless female mannequin, similar to the "Faucet which stops dripping when one is not listening" of his *Boîte en valise* (Box-in-suitcase; 1941). This *Robinetterie paresseuse* (Lazy plumbing) provoked a protest from the right-thinking League of Women, who forced him to move the window display initially planned for the Brentano bookstore.

7 The window display for *Arcane 17* relocated to 41 West 47 Street, 1945.

8–10 Three pages from the manuscript of André Breton's *Arcane 17*.

not surprising to find references in the text to the black flag or to Fourier, whom he had truly discovered while in New York and to whom he paid a brilliant homage in the great *Ode à Charles Fourier* (written during a trip in the summer of 1945 as he traveled through Nevada, New Mexico, and Arizona, and in which the impassioned contact with the Pueblo Indians serves as a background to poetic reverie). These two texts exemplify how the imagination must henceforth take precedence over reasoning: the esoteric and utopian path of surrealism was shown yet again to be the path to follow, rather than debate and argumentation. It had the immense advantage of revealing, as if clearly etched, the unlimited nature of desire and expectation, counter to the shortcomings and restrictions that reality sought to impose.

The new direction thus given to the offensive against the world in its present form granted an accessory place to political solutions: for Breton but also at the same time for Brauner, Hérold and a few others, this was no time for dishonest compromises on the part of the outside world, for had the voice of surrealism not shown, at least in part, that it was capable of deciding on considerable practical consequences? Breton had specifically demanded to know "when youth would manage to have a major say in the matter and prevail over routine with its own audacious solutions"—had Breton's stay in Haiti from December 1945 to February 1946 not shown its effectiveness with the popular uprising that followed this demand and the subsequent destitution of the president Lescot? From a rational point of view, the exalted youth of Haiti—if only because of the poverty in which they languished—should have been judged politically immature; but they had understood perfectly the integral powers of liberation that resided in surrealism the moment they encountered one of the movement's major representatives. They also embraced surrealism because they had understood that it did not view the black population with the mixture of compassion and paternalism that ordinarily only served to maintain their subjugation: the stature granted to Césaire, the exhibition of works by Lam, presented by Breton, which was held at the end of January in the Centre d'art in Port-au-Prince, the attention paid to the painter Hector Hyppolite or the poet Magloire Saint-Aude, in whom one finds confirmation of the priceless resources of analogy, the interest that Breton, in Pierre Mabille's company, showed in the voodoo ceremonies he was able to attend—all these elements suffice to prove that surrealism expected a great blossoming from this place that had not yet been named the "Third World"—suggestions, if not solutions, for the total liberation of humanity.

In Paris Breton was welcomed with a pneumatique from Brauner, who had been waiting "five years for this moment of the utmost importance" that was Breton's return. His first public appearance was during the event devoted to Artaud and organized by Jean Paulhan and Arthur Adamov. In the speech he made that evening, he began by worrying how to "*place* [his] voice" in a city he had left for so long. But he immediately went on to express his concern over the fact that a "fairground spotlight . . . was dazzling certain procedures which [he and his] friends thought could adapt only to half-light. . . . The place where what has been sought will find its resolution and, I hope, will still be *authentically* sought under the name of surrealism, let's not be mistaken, could in no way in 1946 be *the public square*." Before evoking Artaud's career and praising his "boundless, heroic negation of everything which we are dying to live," he clearly underlined that, for him, "only scorn must greet any form of 'commitment' which falls short of this triple and indivisible aim: transform the world, change life, remake human understanding from scratch."[26]

Politics at a Distance

The aims of surrealism had not changed. This was precisely what would attract new members to the group that had reformed around Breton (Péret, however, would only return from Mexico two years later, Miró was in Spain, and Ernst, Matta, Tanguy, and Masson stayed in America), because they had discovered in these propositions something other than the rigidity of communism or existentialist pessimism.[27] This is also what would disappoint others, who felt, to the contrary, that the recent global conflict should lead to a rigorously political point of view, in the framework of those officially revolutionary parties.

This was clearly the case for Magritte and some of his friends, who, in October 1946, cosigned the "Manifesto Number 1" of *Le Surréalisme en plein soleil*.[28] Before distributing it, they sent the text to a number of their correspondents. The manifesto reproached surrealism for no longer wanting to change the world and deplored its shift to a purely artistic motivation; in passing, it had a dig at le Facteur Cheval, le Douanier Rousseau, "entertainers, children, and madmen" as "pathetically dominated by their means in such a pathetic world" and demanded that one no longer fear "the light of the sun": "Beneath new and charming features, sirens, doors, phantoms, gods, trees—all these objects of the spirit will be restored to the intense life of bright light in the isolation of the mental universe." Such a call for "charm" and "positive" images corresponded only too well with the directives of the communists, and Breton responded with a telegram: "Anti-dialectical and sewn with white thread besides"—to which Magritte and Nougé replied: "The white thread is on your spool. A thousand apologies." As for the other recipients, they did not seem very enthusiastic: Char asserted he would no longer sign anything, Marcel Jean didn't "understand very well," Mesens and Brunius were hardly any better at understanding what was wanted by *Le Surréalisme en plein soleil*. The result was that the split between Paris and Magritte and his friends was now inevitable (but in 1947 Magritte broke off with the communists—whereas Nougé would not budge from his position.)

In the important interview he granted to Jean Duché for *Le Littéraire,* Breton drew up a list of works informed by a "power of surpassing themselves—the function of *movement* and of *liberty*": Pierre Reverdy, Picabia, Péret, Artaud, Arp, Michaux, Prévert, Char, Césaire "remain in this respect *inimitable* models."[29] In painting, after deploring the regressive character shown in "the more or less capricious imitation (not excluding deformation) of the *physical aspects,*" he could include, while waiting to learn more, Brauner, Hérold, Dominguez (with a few restrictions), Miró, Ernst, Tanguy, Matta, Donati, Gorky, Lam, Eugenio Fernandez Granell, and others. When his collection of primitive art was mentioned, Breton said, "it is the art of the red race, in particular, which at present allows us to gain access to a new system of knowledge and relations." He then went on to evoke a recent motion by the Leningrad Committee of Writers that "limits to the extreme the right of expression of the writer and the artist, subject to communist discipline both beyond the borders of the USSR and within the country"; this seemed to be the most recent version of the fallacious precept that "the end justifies the means" (of which Trotsky himself had been victim in *Their Morality and Ours*).[30] He sought to specify that the surrealists were outside of existentialist pessimism and "believed that some day [the rock of Sisyphus] would split in half, abolishing as if by enchantment both the mountain and the ordeal." He closed by praising Fourier,

CAUSE

L'homme qui marche est une cause libre

(Logique de Port-Royal)

RUPTURE
INAUGURALE

DÉCLARATION

ADOPTÉE LE 21 JUIN 1947 PAR LE
GROUPE EN FRANCE POUR DÉFINIR
SON ATTITUDE PRÉJUDICIELLE A
L'ÉGARD DE TOUTE POLITIQUE
PARTISANE

ÉDITIONS SURRÉALISTES

PARIS JUIN 1947

1

Liberté est un mot vietnamien

Y a-t-il une guerre en Indochine ? On s'en douterait à peine ; les journaux de la France « libre », soumis plus que jamais à la consigne, font le silence. Ils publient timidement des résumés militaires victorieux mais embarrassés. Pour réconforter les familles, on assure que les soldats sont « économisés » (des banquiers se trahissent par le style des communiqués). Pas un mot de la féroce répression exercée là-bas au nom de la Démocratie. Tout est fait pour cacher aux Français un scandale dont le monde entier s'émeut.

Car il y a la guerre en Indochine, une guerre impérialiste entreprise, au nom d'un peuple qui lui-même vient d'être libéré de cinq ans d'oppression, contre un autre peuple unanime à vouloir sa liberté.

Cette agression revêt une signification grave :

d'une part, elle prouve que rien n'est changé : comme en 1919 le capitalisme, après avoir exploité tant le patriotisme que les plus nobles mots d'ordre de liberté, entend reprendre un pouvoir entier, réinstaller la puissance de sa bourgeoisie financière, de son armée et de son clergé, il continue sa politique impérialiste traditionnelle ;

d'autre part, elle prouve que les élus de la classe ouvrière, au mépris de la tradition anticolonialiste qui fut un des plus fermes vecteurs du mouvement ouvrier, en flagrante violation du droit mainte fois proclamé des peuples à disposer d'eux-mêmes, acceptent — les uns par corruption, les autres par soumission aveugle à une stratégie imposée de haut et dont les exigences, dès maintenant illimitées, tendent à dérober ou à invertir les véritables mobiles de lutte — d'assumer la responsabilité de l'oppression ou de s'en faire, en dépit d'une certaine ambivalence de comportement, les complices.

Aux hommes qui gardent quelque lucidité et quelque sens de l'honnêteté nous disons : il est faux que l'on puisse défendre la liberté *ici* en imposant la servitude *ailleurs*.

Il est faux que l'on puisse mener au nom du peuple français un combat si odieux sans que des conséquences dramatiques en découlent rapidement.

La tuerie agencée adroitement par un moine amiral ne tend qu'à défendre l'oppression féroce des capitalistes, des bureaucrates et des prêtres. Et ici, n'est-ce pas, trêve de plaisanterie : il ne saurait être question d'empêcher le Vietnam de tomber entre les mains d'un impérialisme concurrent car où voit-on que l'impérialisme français ait conservé quelque indépendance ; où voit-on qu'il ait fait autre chose depuis un quart de siècle que céder et se vendre ? Quelle protection se flatte-t-il d'assurer à tels ou tels de ses esclaves ?

Les surréalistes, pour qui la revendication principale a été et demeure la libération de l'homme, ne peuvent garder le silence devant un crime aussi stupide que révoltant. Le surréalisme n'a de sens que *contre* un régime dont tous les membres *solidaires* n'ont trouvé comme don de joyeux avènement que cette ignominie sanglante, régime qui à peine né s'écroule dans la boue des compromissions, des concussions et qui n'est qu'un prélude calculé pour l'édification d'un prochain totalitarisme.

Le surréalisme déclare, à l'occasion de ce nouveau forfait, qu'il n'a renoncé à aucune de ses revendications et, moins qu'à toute autre, à la volonté d'une transformation radicale de la société. Mais il sait combien sont illusoires les appels à la conscience, à l'intelligence et même aux intérêts des hommes, combien sur ces plans le mensonge et l'erreur sont faciles, les divisions inévitables : c'est pourquoi le domaine qu'il s'est choisi est à la fois plus large et plus profond, à la mesure d'une véritable fraternité humaine.

Il est donc désigné pour élever sa protestation véhémente contre l'agression impérialiste et adresser son salut fraternel à ceux qui incarnent, en ce moment même, le devenir de la liberté.

Adolphe ACKER, Yves BONNEFOY, Joé BOUSQUET, Francis BOUVET, André BRETON, Jean BRUN, J.-B. BRUNIUS, Eliane CATONI, Jean FERRY, Guy GILLEQUIN, Jacques HALPERN, Arthur HARFAUX, Maurice HENRY, Marcel JEAN, Pierre MABILLE, Jehan MAYOUX, Francis MEUNIER, Maurice NADEAU, Henri PARISOT, Henri PASTOUREAU, Benjamin PERET, N. et H. SEIGLE, Iaroslav SERPAN, Yves TANGUY.

2

1 *Rupture inaugurale*, "declaration adopted on June 21, 1947, by the group in France to define its prejudicial attitude with regard to all partisan politics."

2 *Liberté est un mot vietnamien*, pamphlet against the war in Indochina at the time of its onset, written by Yves Bonnefoy, André Breton, and Pierre Mabille (April 1947).

who managed the "cardinal junction between the concerns that have never ceased to animate poetry and art from the beginning of the nineteenth century and the plans for social reorganization that run a strong risk of remaining in a larval state if they persist in not taking them into account."

On April 11, 1947, Tristan Tzara, who was now a member of the communist intelligentsia alongside Éluard and Aragon, gave a speech at the Sorbonne titled "La dialectique de la poésie": he sought to show that a commitment to the communist cause was the logical conclusion to the surrealists' initial choices, and that anything else would result in a reactionary and "objectively" counterrevolutionary position.[31] The surrealists disrupted the event; Philippe Audoin, who was present, said:

When Breton and his escort came into the Richelieu amphitheater, we expected the worst—and the worst happened. . . . Jean Cassou, who was presiding, took it upon himself to introduce the speaker to the audience. Breton interrupted him violently: but we don't give a damn, my dear Monsieur Cassou! and began to rail against the false testimony that Tzara was getting ready to deliver. There was such a ruckus that the panel gave up trying to get a word in. A group of young communist intellectuals on duty, among them Crémieux and Marcenac, threw themselves upon Breton who, followed by his friends, rushed into the crowd, where they hit him; he hit people back, and it was a confused and noisy free-for-all which only ended with the surrealists' withdrawal, for they were indisputably inferior in numbers.[32]

But the hope to surpass surrealism on the political level was also expressed by the ephemeral Revolutionary Surrealism—which included a few Belgians (Dotremont in particular), and former members of La Main à Plume (Arnaud). As a result, the Parisian group published two declarations in April and June of 1947 that were aimed at forestalling any misunderstandings.

Liberté est un mot vietnamien grouped twenty-five signatories, reuniting prewar members (Breton, Brunius, Henry, Jean, Mabille, and Péret), Maurice Nadeau, and young recruits, in particular those who came from La Révolution la Nuit.[33] Yves Bonnefoy was, moreover, the initial editor of the pamphlet, which was revised by Breton and Mabille. The text reasserted the anticolonialist stance that had been that of the group since the Rif War in Morocco and constituted a reaction against the events signaling the beginning of a war that would not end until 1973. It simultaneously denounced the silence of the press, officials, and the "elect of the working class" and reiterated that the main demand of the surrealists had been and remained the liberation of mankind and that they had not given up calling for a radical transformation of society.[34] Also, those who in Vietnam were rising up against imperialist aggression were the incarnation "at this very moment, of the evolution of freedom."

As for the *Rupture inaugurale*, it was a "declaration adopted on June 21, 1947 by the group in France to define its prejudicial attitude towards all partisan policies."[35] Picking up where the brochure *Du temps où les surréalistes avaient raison* (1935) had left off, it was an anticipated response to all those who might think they could reproach the movement for its "idealism" or its rejection of "commitment"—well, they were or would be numerous, from Sartre who attacked Breton in "What Is Literature?" (in a serialized form in *Les Temps modernes* from February 1947) to Henri Lefebvre. Lefebvre tried to show in *L'Existentialisme* how dialectical materialism (in its pure, hard version of that era) had "surpassed" surrealism—which had been merely some sort of childhood ill-

ness, along with Sartrian existentialism, moreover.[36] Lefebvre and his friends had allegedly exhausted its charm and potential already by 1925; he launched a new attack in the first chapter of his *Critique de la vie quotidienne* (1947) criticizing surrealism, still in the name of dialectical materialism. As for *Rupture inaugurale,* it would elicit hostile reactions on the part of Christians, Stalinists, and Trotskyists alike.

The brochure published at the Éditions Surréalistes, which had been inactive since *La Parole est à Péret,* was the responsibility of the Cause Group, an offshoot of the movement, managed in France by Sarane Alexandrian, Hénein, and Pastoureau. After the text itself came a list of all the countries where there were Cause Groups: "England, Brazil, Canada, Chile, Denmark, Egypt, the United States, Guatemala, Haiti, Hungary, Iraq, Japan, Mexico, Portugal, Romania, Sweden, Czechoslovakia, and Turkey." This enumeration shows the willingness at that point in time to anchor the movement on an international level, "but the Cause Groups did not take form, and the idea of a Surrealist International was abandoned"—at least in this semiofficial form.[37] The fact remains that it was on the initiative of the Cause Group that a questionnaire was sent in May 1947 to all those who had been or still were connected with surrealism; the result of their responses would be *Rupture inaugurale,* which also had its origins in Pastoureau's article for the catalog of the upcoming group exhibition. Its definitive version, with corrections and amendments by certain members, was adopted during a meeting on June 21 at the Café de la Place Blanche where the group, since Breton's return, was now in the habit of meeting.[38] The brochure would be endorsed by fifty signatories, including a certain number of newcomers: Gaston Criel, Pierre Demarne, Jerzy Kujawski, Nora Mitrani, Jean-Paul Riopelle, Stanislas Rodanski, and others.

Rupture inaugurale was haughty in tone, approaching the political problem by way of ethics, something that had little chance of being properly understood at the time. The text conceded from its opening paragraphs that its hopes to convince anyone were fading: the idea was not to recruit but to take a stand. Accusing the Communist Party of practicing a veritable class collaboration, for purely tactical reasons—examples of which, from the Moscow trials to the patriotism so aggressively displayed with regard to the German people, by way of the sabotage of the war in Spain and the communists' participation in the running of the bourgeois French State, were carefully detailed—the brochure refused the false dilemma of ineffectiveness or dishonest compromise. Surrealism's aim was the total liberation of humanity, and it had no intention of getting caught in a trap of political action that might, for the sake of intermediary goals, be forgetful of its ultimate goals or show little interest in those matters that might exceed its short-term aims. So the group not only expressed extreme wariness with regard to the Communist Party but also said that it could place only a limited trust in the Trotskyists and anarchists (who might nevertheless be the easiest to deal with). Any party affirming that the political or economic revolution would suffice to bring about the complete liberation of humanity seemed to be forgetting that the revolution, to be integral, must include a change in morality and customs, and it was difficult to envisage how Christian morality could be destroyed by the proletarian revolution even though, according to *Rupture inaugurale,* Christianity predated capitalism.[39] In this domain, only Sade and Freud had thus far opened a breach.

In passing, the pamphlet had not forgotten Sartre's recent attacks and affirmed that "if tomorrow Parisian existentialism were to join forces with the Communist Party . . .

it would be all the better to prove to us that two ideologies that are off course do not make one just idea."

A text like this, while it revived hope for a new myth capable of leading "man towards the next stage of his final destination," outlined no precise program: it stated clearly what ought to be rejected and reiterated the distant objective, independently of any tactical concerns. Surrealism came across as a truly open site, where the major work remained to be done. Instead of resting on its laurels, the movement strove to move ahead. Thus it ran straight into dogmatic attitudes and certainties, theories that had been accepted once and for all and that doomed their own partisans to sterile repetition or intellectual regression.

In so doing, it could only inspire the hostility of the constituent political parties. In fact, *Rupture inaugurale* marked the beginning of a long period (until 1956) during which the group would cease all contact with political organizations. Apart from its "mondialist" interlude, its only appearance in public would be in 1950 to defend Zavis Kalandra, a Czech historian sentenced to death at the end of a trial inspired by the method that had been proving its effectiveness in Moscow since before the war. Breton wrote an "Open Letter to Paul Éluard," published in *Combat* on June 13, 1950, and the surrealists joined other intellectuals (Marcel Arland, Dominique Aury, Simone de Beauvoir, Albert Béguin, Camus, Jean Hélion, Maurice Merleau-Ponty, Jean Paulhan, Sartre, Jules Supervielle, and others) in signing a telegram addressed to the president of the Czechoslovak Republic, published in the same newspaper on June 17, to demand a stay of execution. In his letter to Éluard Breton called on their shared memories: Kalandra had shown himself, as one of those who had welcomed them in Prague in 1935, to be a particularly open individual: "It was he who, in the communist press, gave the most penetrating analyses of our books, the most worthwhile accounts of our lectures. He would not rest until he had put all the major venues where intellectuals and workers met at our disposition." A man like this, later deported by the Nazis, could not have "confessed" to what he had been accused of. Éluard's response to this appeal to his sense of friendship is well known: "I have too much to do with the innocents who proclaim their innocence to deal with the guilty who proclaim their guilt." Kalandra was executed. This sinister affair, which confirmed the degree to which Éluard was capable of internalizing the mental functioning of Stalinism, did nevertheless have the merit of showing once again that, for the surrealists, morality must prevail over immediate political goals; but this was only one more reason why, during the Cold War, they were alone in accepting such a principle.

For the time being, *Rupture inaugurale* spawned the reactions of the Revolutionary Surrealism group, which responded, on July 1, 1947, with the pamphlet *La Cause est entendue:* Breton and his friends were accused of abandoning dialectical materialism, of preparing an exhibition that would be nothing more than the invitation to a parareligious mass: "We are surrealists and will remain so. Breton and his lot are no longer surrealists."

Another reply would be provided by Roger Vailland, who in 1948 published the brochure *Le Surréalisme contre la révolution.*[40] His intention was to retrace the history of the movement as if it concerned his own youth (it is true he easily confused it with the Grand Jeu), and Vailland emphasized that the movement was only justified by its derisory attitude toward authority, institutions, and works of art saturated with the

bourgeois mentality. But it was not the time for derision: there had been a war, after all, which had shown that only the Communist Party knew how to combat the occupying forces. Henceforth, Breton would be condemned to finding refuge in esotericism and the sacred, and "those of integrity among the surrealists of another era are . . . elsewhere: the ambassador of a people's republic, like Marko Ristitch, or a general like another Yugoslav poet, or the director of a ministry like Hoffmeister, militants of the Communist Party like so many others."[41]

Surrealism in 1947

The exhibition titled *Surrealism in 1947* opened on July 7 at the Galerie Maeght and had a very different agenda from the exhibitions of 1938 in Paris or of 1942 in New York. The initial idea was to bring about a confrontation between recent surrealist works (particularly to find out whether the war had brought about significant changes in the movement as it developed in different places and under different circumstances) and also to mark a certain progression in the direction of a new mythology.

In the context of 1947, the exhibition signaled, first of all, the return of the surrealist movement to the public eye and was a response to all the gravediggers as well as those who sought to steer the surrealists onto a strictly political path. The "initiatory" environment in which the exhibition was held was ample confirmation of the positions stated in *Rupture inaugurale:* the response to commitment would be a probing into the mythical imaginary world.

The twenty-one steps that led up to the exhibition halls of the Galerie Maeght were decorated with "dust jackets of books with twenty-one titles corresponding in significance to the twenty-one major arcana of the Tarot (with the exception of the fool)" according to the invitation letter that Breton had sent out in January to the participants; the entire hall was swept with the greenish beams of a small spotlight. Then one arrived in the Hall of Superstitions, "which opens the theoretical cycle of ordeals, must complete the synthesis of the principal existing superstitions and oblige one to overcome them in order to continue the visit of the exhibition." Arranged by Frederick Kiesler, who had come from New York solely for that purpose, on the basis of a few suggestions by Duchamp, the egg-shaped hall was draped in green cloth and showed works from America, including Kiesler's own *Totem for All Religions,* a construction of wood and rope made in collaboration with Étienne-Martin and François Stahly: it represented a syncretic assembly of what were, theoretically, the least compatible religious symbols. In the next room, a curtain of colored rain purified the visitors who, once they had gone around the billiard players ("quickly condemned to inaction," according to Marcel Jean, "since the visitors had quite naturally pinched all the balls") would enter a room divided into alcoves, each of which was devoted to "a creature, a category of creatures, or an object *susceptible of being endowed with mythical life,* and to which an 'altar' was raised, on the model of pagan ceremonies (Indian or Voodoo, for example)."[42] These altars, designed by Brauner, Breton, Frédéric Delanglade, Jindrich Heisler, Hérold, Lam, Matta, Toyen, and a few others, represented twelve possible myths: the "Worldly Tiger" (adapted from a recent text by Ferry); the Tresses of Falmer (Song IV of the *Chants du Maldoror*), for which Lam had designed a torso with four breasts, arms equipped with butchers' carving knives, and covered with a long fishnet that veiled the face, to which flies were clinging; the Suspicious Helo-

LE SURRÉALISME EN 1947

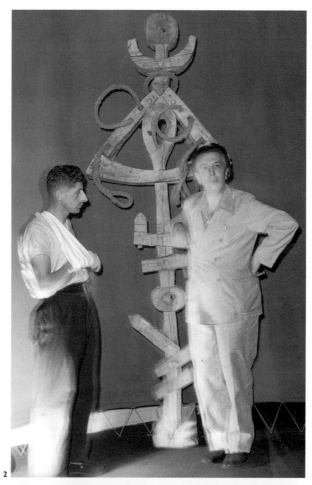

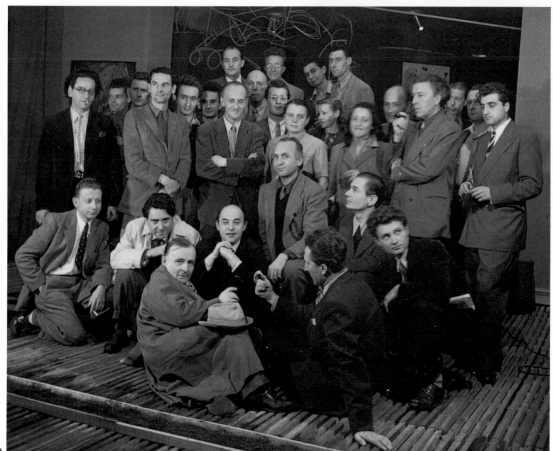

1 2

3

International Exhibition of Surrealism, Galerie Maeght, Paris, June 1947.

1 Entrance to the Labryrinth designed by Marcel Duchamp and created by Frederick Kiesler, with *Le Grand Transparent* by Jacques Hérold. On the partition is a canvas by Miró.

2, 3 "Le Labyrinthe." Photograph by Rémy Duval.

4 Yves Tanguy, *L'Échelle qui annonce la mort* (The ladder announcing death; a porthole enables one to see Marcel Duchamp's *Le Rayon vert* [The green flash]); Joan Miró, *La Cascade architecturale* (Architectural cascade); and Frederick Kiesler and David Hare, *L'Homme-angoisse* (Anxiety man).

5 Victor Brauner, *Le Loup-table* (The wolf table). Photograph by Denise Bellon.

6 Juliette Greco in the Superstition Room, designed by Frederick Kiesler. *From left to right:* Frederick Kiesler and David Hare, *L'Homme-angoisse* (Anxiety man); Joan Miró, *La Cascade architecturale* (Architectural cascade); Yves Tanguy, *L'Échelle qui annonce la mort* (The ladder announcing death).

7 Maria, *Le Chemin, l'ombre, trop longs, trop étroits* (The path, the shadow, too long, too narrow; 1947). Photograph by Rémy Duval.

7

8

8 The Superstition Room. *From top to bottom:* Frederick Kiesler and David Hare, *L'Homme-angoisse* (Anxiety man); Roberto Matta, *Le Whist;* and Joan Miró, *La Cascade architecturale* (Architectural cascade).

1

3

2

4

derm (a big lizard whose jaws do not open after he has clamped them around his prey—one of Max Ernst and Dorothea Tanning's neighbors in Sedona); Jeanne Sabrenas (*La Dragonne* by Jarry), for whom Heisler imagined a mechanism in the form of a weathervane propelled by white mice; Léonie Aubois d'Ashby (from *Dévotion* by Rimbaud) praised by Breton; the *Oiseau-secrétaire,* the Secretary-Bird, also dear to Max Ernst; the Condylure—"the crazed crone of old authors"; the "Caretaker of Gravity"; Brauner's *Wolf-table,* surrounded by carefully draped white mousseline; Raymond Roussel; the "Great Transparencies," incarnated in the sculpture by Hérold; and the window of "Magna sed Apta" from *Peter Ibbetson* by George Du Maurier (and in particular from its film adaptation by Henry Hathaway).[43] Breton allegedly would have liked to add Giacometti's *Objet invisible* to these twelve elements related to the signs of the Zodiac, but the sculptor refused to lend it.[44]

In addition to these special installations, which were "environments" well ahead of their time, and to which constructions designed especially for this exhibition were added, such as the "Scaffold" by Tanguy or Ernst's "Black Lake," new works were also introduced—even in Aimé Maeght's office, which was transformed for the event: *Euclide* (1945) by Ernst, *Le Mauvais Œil* (The evil eye), by Donati, *Le Chemin, l'ombre, trop longs, trop étroits* (The path, the shadow, too long, too narrow [1946]) by Maria, canvases by Miró and by Morris Hirschfield and Hector Hyppolite, as well as objects by mentally retarded artists, lent by Gaston Ferdière, as a reminder of the particular way in which surrealism, from the very beginning, had viewed "madness." A number of young painters also took part (Francis Bott, Roger Brielle, Iaroslav Serpan, Ramsès Younane, and Jean-Paul Riopelle, who had just arrived from Canada); they were selected by virtue of their work in automatism, but they would very soon move away down the path of a lyrical abstraction. In all, over a hundred artists took part, from twenty-four countries. A few famous names were absent, however: Dalí, obviously, but also Magritte (whose sympathies with Revolutionary Surrealism were all too obvious), Wolfgang Paalen, who was still keeping his distances, as were Masson, Picasso (whose enrollment in the Communist Party was unforgivable), and Dominguez, whose recent canvases were disappointing.[45]

A hefty catalog accompanied the event, and the cover of the first edition became famous: it showed a breast in relief above the caption "Please Touch" (an "object" chosen by Duchamp, and together with Donati he colored each catalog by hand). In his preface ("Before the Curtain"), Breton emphasized the permanence of an esoteric concept, both in poetical thought (Hugo, Nerval, traces in Lautréamont, Rimbaud, Mallarmé, Jarry, Jean-Pierre Brisset, or Raymond Roussel) and among the theoreticians of social transformation (Fourier)—it would be up to surrealism, therefore, to maintain or reinforce its relevance, because it was the only intellectual movement capable of bringing together the concerns of poetry and society. But this wager certainly did not mean that the myths suggested or created were to be considered definitive: the main thing was that "*everything happens* nowadays *as if* certain relatively recent poetic and artistic works enjoyed a power over the mind exceeding in every respect that of the work of art." The "rousing nature" (of the works in the alcoves and of certain surrealist works) and the "extreme *ease,* almost preecstatic, with which they can, on occasion, fill us . . . serve to validate the idea that a myth has originated therein"—a myth that was not yet ready to be defined and the contents of which could not yet be

described in detail: the exhibition merely sought to "give an utterly external glimpse into what such a myth could be—in the manner of a spiritual 'display.' "[46]

In "Comète surréaliste," which did not find a place in the catalog, Breton went into still other aspects. He first pointed out that works of art far too frequently were transformed into a pretext for financial investment, then went on to deplore the fact that such a situation interfered with the freedom of the artist and doomed the majority of painters to repetitiveness.[47] For the benefit of those who might be tempted by the surrealist path he recalled its principles, reaffirming that the criterion that enabled one to know whether a work was surrealist or not was never of an aesthetic nature and that the field of surrealist plasticity was limited on the one hand by realism, and on the other by "abstractivism" (from the moment it broke with any preliminary mental representation, precisely something that surrealism sought to reconcile with the physical perception): "Above all, that which qualifies a surrealist work is the spirit in which it has been conceived." Returning at last to the exhibition itself, Breton insisted once again that its initiatory setting (he predicted that it would inspire attacks and controversy) was not to be taken too literally: it served as an indication and did not imply any more religiosity than the *L'Immaculée Conception* implied true madness on the part of its two authors. Everything to which surrealism remained devoted consisted in an "initiation through poetry, through art." As for those who might seek to know where this initiation would lead, it should suffice for them to recall that from the moment the potential of automatism was discovered, it became necessary to forgo any predictions and to grant a place of privilege to "knowledge through ignorance."

Surrealism in 1947 enjoyed a lively success (roughly forty thousand visitors), particularly among young people,[48] although the press received it less enthusiastically than in 1938, while making use of its usual clichés. Duchamp, in a letter to Breton, wrote: "It's wonderful still to be greeted with such scorn *at our age.*" For Bernard Dorival, for example, the exhibition was something to recommend to the "good people" of the bland provinces, soft and placid," who would compare it to the festivities of a youth club, or the Musée Grévin Wax Museum, or the Universal Exhibition of 1867: surrealism was now nothing more than a benign phantom.[49] The commentators, with a few rare exceptions, seemed ready to admit that surrealism was now far too well known to have any real surprises up its sleeve.[50] It is interesting to note that from a strictly pictorial point of view surrealism was very poorly represented in the Musée National d'Art Moderne, which had just been inaugurated at the Palais de Tokyo, with Jean Cassou as its chief curator. Room 24, which was "devoted" to surrealism, displayed one canvas by André Beaudin, two oil paintings by Jean Fautrier and one by Suzanne Roger (one can legitimately ask whether these works are really representative of the movement, independently of their individual merit), alongside De Chirico's *Lutte antique* (a gift in 1932), a *Composition* by Dalí (1933), five canvases by Masson (all donated by Harold Rosenberg in 1946, the oldest dating from 1930), *Le Printemps* (1935) by Picabia (acquired in 1937), two paintings by Pierre Roy (acquired in 1947), and *Jours de lenteur* (Days of slowness) by Tanguy (1937): no Ernst, Magritte, or Miró, not to mention Brauner, Hérold, and a few others.[51]

At the end of the year, part of *Surrealism in 1947* was exhibited in Prague, at the Gallery Topic, thanks to Heisler and Toyen. In the preface he wrote for the event, Breton asserted that the ideas formulated twelve years earlier during the Prague exhibition of 1935 were still current and that surrealism had survived the recent cataclysm intact.

Jindrich Styrsky, *Mayakovsky's
Waistcoat* (1939); oil on canvas,
$25^2/_3 \times 23^1/_4$ (64.2 × 58.2 cm).
Musée National d'Art Moderne,
Centre Georges Pompidou, Paris.

Above: Toyen, *The Four Elements* (1950); oil on canvas, 28 × 42²/₅ in. (70 × 106 cm). Private collection.

Opposite page, top: Toyen, *At the Château La Coste* (1946); oil on canvas, 40 × 64 in. (100 × 160 cm). Private collection.

Opposite page, bottom: Toyen, *Safe* (1946); oil on canvas, 30²/₅ × 48²/₅ in. (76 × 121 cm). Private collection.

Jindrich Styrsky, *The Annunciation*
(1941); collage, 11³/₅ × 16¹/₅ in. (29 ×
40.5 cm). Private collection.

Above: Toyen, *Hide, war!* (1944); India
ink on paper, 16 × 22⁴/₅ in. (40 × 57
cm). Private collection.

Right: Jindrich Styrsky, *Untitled* (1941);
collage.

Right: Toyen, *I Thought I Saw a Sparrow* (1961); oil on canvas. Private collection.

Opposite page, top: Toyen, *Early Spring* (1945); oil on canvas, 35³/₅ × 58²/₅ in. (89 × 146 cm). Musée National d'Art Moderne, Centre Georges Pompidou, Paris.

Opposite page, bottom: Toyen, *Trembling in the Crystal* (1946); oil on canvas, 30 × 48¹/₅ in. (75 × 120.5 cm). Private collection.

Jindrich Heisler, *Poem-Object for Benjamin Péret* (1951); 13¹/₅ × 16²/₅ × 2 in. (33 × 41 × 5 cm). Radovan Ivsic Collection, Paris.

He reiterated that the true liberation of man was contingent on total independence from "a structure whose tortuous means and absolute disdain for the human person filled [him] with doubt," and he revived the lesson of the manifesto *Pour un art révolutionnaire indépendent:* "In art, no directives, ever, whatever happens!" If true decadence could find its bearings in the *survival of the sign over the thing signified,* it would more than ever be advisable to respond to the converging accusations of "degenerate" art and "decadent bourgeois" art, to "*consecrate* . . . the role of the intellectual and the artist," who must, to ensure their role, "voice an indomitable NO to all disciplinary formulas. 'Commitment,' that ignoble word . . . reeks of servility, something which poetry and art abhor."[52] Heisler and Toyen had just set the example for this "no" by settling definitively in Paris.

The War Years in Czechoslovakia

From June 3 to July 12, 1947, an exhibition of Toyen's most recent works was held at the Galerie Denise René, with a catalog preface by Breton.[53] This was the first public event informing people of what was happening in the art world in Czechoslovakia because surrealism, with the beginning of the Nazi occupation, had been condemned as "degenerate" art. Forced to go into clandestinity, the Prague group did not, however, cease its activities.

Karel Teige, in particular, was creating a number of collages that brought the female body into a fantasy series of erotic metamorphoses. Jindrich Styrsky (who died in 1942) finished his book of *Rêves* (Dreams) (published in part in 1941 by Teige, it would not be published in its entirety until 1970): texts, drawings, collages, and reproductions of paintings mingled humor, erotic urges, a high degree of fantasy and childhood references to create a particularly acute and scrupulous exploration of the world of dreams. Toyen produced a few paintings in which an ominously threatening atmosphere reigned symbolically (*Au château Lacoste* [1943], *À la lisière* [1945]), but it was above all in the drawing cycles produced during the dark years that she gave testimony to the terror that reigned over humanity. Already *Les Spectres du désert* (The specters of the desert [1939]), with text by Heisler—the collection was the first clandestine publication of the Prague group)—represented silhouettes of almost mineral forms facing each other across an empty space. *Tir* (Shot [1939–40]) and *Cache-toi, guerre!* (Hide, war! [1944]), which would not be shown in Prague until 1946, made use of an almost impersonal drawing style, not unlike dictionary illustrations, to evoke a universe of monumental skeletons and useless objects, while, along the ground, schools of fish faced the violence of an oncoming wind of unknown origin.[54] In her postwar canvases, mystery seemed to dominate, through the use of shadow play against a door perturbing the relations between the real and the surreal (*Mythe de la lumière* [Myth of light] [1946]), or piles of rocks aligned like tombstones and topped with shapes suggesting butterfly's wings to announce *L'Avant-printemps* (Early spring [1945]), or even a building in cross section revealing intimate activities devoted to irrational occupations (*Loi naturelle* [Natural law] [1946]). In each case, precise figuration evoked something other than an everyday physical and logical world.

Heisler, who joined the group in 1938, worked on collages and objects; during the war he had concentrated on the photography of fragile arrangements of tiny objects, accompanied by texts, in particular for the *Casemates du sommeil* (Pillboxes of sleep

1

5

2

3

4

6

[1941], a clandestine publication in collaboration with Toyen), and he perfected a new technique, "photographism," which, by spreading glue against a base, gave an invented image the same "objectivity" generally attributed to photography. Thus, the series *De la même farine* (From the same flour [1944]) produced creatures—humans or animals—who were at the limit of what was possible, reigning over lifeless domains but imposing their irrationality as if it were self-evident.

Néon

Jindrich Heisler had recently settled in Paris, and he would be the one to find the technical solution to bring about the revival of a group publication. For the publication of individual texts, however noteworthy, could not represent any group work—not to mention the fact that a number of different and frequently small (from an economic point of view, obviously) publishers were responsible for those texts.[55] "We knew," Jean Schuster would say in 1978, "that that which characterized surrealism historically, the surrealism of the past, from before the war, was the periodical. I remember that in those days all the discussions at the café, where we had what was virtually a ritual daily meeting, focused on the possibilities of launching a new periodical."[56]

Heisler, in putting to good use a technique that had had little use thus far, offset printing, came up with the presentation in 1947 of *Néon* and appointed a first editorial committee, which included Claude Tarnaud, Sarane Alexandrian, Stanislas Rodanski, Véra Hérold, and himself. This committee symptomatically gathered the newcomers in the group, something that gave the first issues of *Néon,* from January 1948, a particularly exuberant character that went well with its astonishing presentation: the format was that of a daily newspaper (60 × 40 centimeters, roughly) and contained a mixture of texts, in manuscript, typed, or typeset format, and drawings, which frequently overlapped each other or ran on to the next page. The title was deciphered to mean "N'être rien être tout ouvrir l'être" (Be nothing, be everything, open one's being) then, with the fourth issue (November 1948), the editorial committee of which now consisted of Jean-Louis Bédouin, Breton, Pierre Demarne, Heisler, and Benjamin Péret, "Naviguer éveiller occulter" (Navigate awaken occult).

In the first issue of *Néon,* Breton published "Signe ascendant," in which he reaffirmed his complete confidence in poetical analogy, which "differs fundamentally from mystical analogy in that it never presupposes, through the framework of the visible world, the existence of an invisible world striving to manifest itself." However empirical it might be, the poetical analogy was not reversible, however, insofar as one hoped for "more light"; it constituted, thus, an "ascendant sign" whose "mortal enemies [were] anything disparaging or depressive."[57] It was, moreover, precisely this poetical analogy, scattering in every direction from a core of sensual delight, which made the work *Sens plastique II* by Malcolm de Chazal a veritable revelation; it had been published in Paris during the last months of 1947, to the immediate praise of Paulhan and Aimé Patri. Chazal, who lived in Mauritius, seemed marked by an esoteric tradition (one of his ancestors was a Swedenborgian), but he was first and foremost a visionary poet of rare scope: "As sensual delight is the place where the senses, the mind, the heart, and the soul come together on a universal level, and because it is the place and state where birth and death meet half-way, and where man in his entirety 'confirms himself,' sensual delight is for this very reason the greatest source of knowledge and the

most expansive field of study of human beings' innermost workings." This study would engender images of a wealth and depth that, once again, caused what was ordinarily referred to as "poetry" to pale to nothingness and constituted what Breton called in *La Lampe dans l'horloge* (written in February 1948), one of the "great isolated messages" "of which there certainly has not been an abundance since this recent war." It was the body that, thanks to analogy, was rebuilt and impregnated with spirit: "The hip is the greatest deadpan individual. To laugh 'from within' the body: the hip wriggles with cold mockery." It was also the external world that revealed a network of correspondences through which, ultimately, each part of the microcosm could resonate with the macrocosm: "A sun shines in the pearl, and a moon lies there too, joining their coupled beams in one unique blaze, like crystal shining in mother-of-pearl, or like sparkling milk spitting flames of silver. The pearl is the only place on the surface of the land where sun and moon can be found within one same 'sky.' The pearl is a nacreous sun and a crystal moon, set in a bath of silver milk." Chazal was not even required to belong to surrealism: because his meditations originated in a startled movement ("Life is mere brainwashing, from birth to death") and then developed in a "divinatory intoxication" (Breton), trajectories intersected and signs could be exchanged, with a deep affinity between those who in Europe did not want, in spite of everything, to despair of the power of mankind, and the man on his island, "the prophet of joy, announcing not the end but the beginning of the world, and whose voice seems to emanate from the clouds together with lightning and wind."[58]

In the second issue of *Néon,* fragments by Magloire Saint-Aude—excerpts from his collections *Tabou* and *Dialogue de mes lampes* (published in 1941 in Haiti)—were additional examples of the powers of analogy when offered in its greatest density, "a single cog where the wheel of anguish engages with ecstasy" (Breton).

Néon mixed theoretical texts (by Mabille or Simon Watson Taylor) with poetical ones (Charles Duits, Alain Jouffroy, Jean-Pierre Duprey, Nora Mitrani), poetry (Tarnaud, Breton, Bédouin) and publishing news, humorous letters (Gaston Puel), and opinions (from Nadeau or Saillet, whose missives were published memorably as "the kick-in-the-ass tribunal" and the "tribunal of lying witnesses and cowards"). The illustrations were the work of Hérold, Brauner, Ernst, Maria, Riopelle, Adrien Dax, Henri Seigle, Heisler, Toyen, Matta, and others. But the periodical was not overseen by an editor, and each issue was financed by internal fundraising: it would eventually cease publication for lack of funds. Its fifth and last issue (April 1949) published a letter by Garry Davis in response to the surrealists' request to become "citizens of the world."

Internationalist Policy

In February 1948, the revolutionary surrealists began a series of lectures at the Salle de Géographie. Breton and his friends attended and disrupted the lectures, for once in unanimity with the communist militants (who no doubt reproached the revolutionary surrealists for uselessly clinging to their title of surrealists and not conforming enough to party directives) and with the group of the Lettristes, who claimed to go beyond surrealism through their discovery of a radical form of poetic expression in phonemes and onomatopoeia.[59] The first issue of the periodical *Le Surréalisme révolutionnaire* appeared in March–April 1948.[60] The editorial committee included Arnaud, Dotrement, Asger Jorn, and Zdenek Lorenc. In the table of contents, one could find a

This page and the two following: The five issues of the periodical *Néon* (January 1948–April 1949).

piece by Dotremont ("There is no valid art save that which liberates the poet for the masses, the poet for some of those who go to the masses, the poet to the knowledge needed by the masses and which is committed, whether through art or not, to the very heart of the political situation"); poems that were apparently not very committed by Marcel Broodthaers and Jean Laude; "Parler seul" by Tzara; a text by Jaguer; comments by Arnaud on Lefebvre, confirming that it was time to conceive of surrealism, and to live it, independently from Breton; pages by Jacques Kober, and excerpts from Tzara's lecture *Le Surréalisme et l'après-guerre* (Surrealism and the postwar period).[61] (Arnaud described Tzara as "a poet, the way one can be a poet after the war and towards the future, and in the only way one can be a poet, that is, the way the movement of history causes one to live.")

The first issue would be the only one; in fact Revolutionary Surrealism very quickly dissolved, but not without Péret's vigorous denunciation, "In the gutter!" in *Néon*. ("Their goal consisted in leading surrealism onto the path of the counterrevolution. They failed, and their failure would inevitably bring on, for those who were most compromised, their total submission to Stalinism.") Some of the members (Dotremont, Jorn) would quickly become founders of the Cobra movement. Decidedly, even at the cost of the worst concessions, the alliance between a memory of surrealism and the "revolution" in its communist version had become impossible.

As for the group gathered around Breton, they understood, and made it clearly known, that there could be nothing more to be expected from those who sought to impose a narrowly dogmatic interpretation of Marx, and it was not surprising that Fourier's silhouette came to replace Marx's with increasing ease. Since the point now was to be beyond the reach of political parties, it became perfectly natural to belong to Front Humain, as soon as the plans were revealed for its creation (in a speech given in April 1948 by Robert Sarrazac, its representative in France): Was it not the point to struggle for peace and the recognition of the right of every human being to belong to all the world, independently of states and all forms of national selfishness? On November 19, the surrealists were present when the former American aviator Garry Davis disrupted a session of the General Assembly of the United Nations at the Palais de Chaillot. As this was cause for his arrest, on the very next day Breton coauthored an article "All for One Except for a Few," which took up Davis's defense in *Combat,* and on December 13 he stood alongside Camus, Sartre, Paulhan, and Carlo Levi at the meeting of the Rassemblement Démocratique Révolutionnaire, the theme of which was the internationalization of the mind. Such formulas might seem naive, retrospectively, as does their ambition to become "citizens of the world." But set again in the context of the beginnings of the Cold War and the fear of the atomic bomb, they take on a different meaning: "Among the intellectuals mobilized against the threat of war, a little pink and blond man in a leather jacket spoke soberly of his life as a bomber pilot in the American air force. Who would have dared to smile at his accent as he declared with emotion: 'I don't want to do it again!' The entire auditorium stood up, shouting, applauding. Garry Davis, the first citizen of the world, had just found his audience."[62]

In February 1949, thirty-five surrealists signed a pamphlet in which they expressed their "effective and total solidarity" with Garry Davis: "We have resisted the temptation to compromise which political behavior might induce, and come forward today on another level in order to work towards the advent of the reign of freedom."[63] At the same time, Breton published a portrait of Garry Davis in *Caliban* (no. 24): "We will not

1

2

3

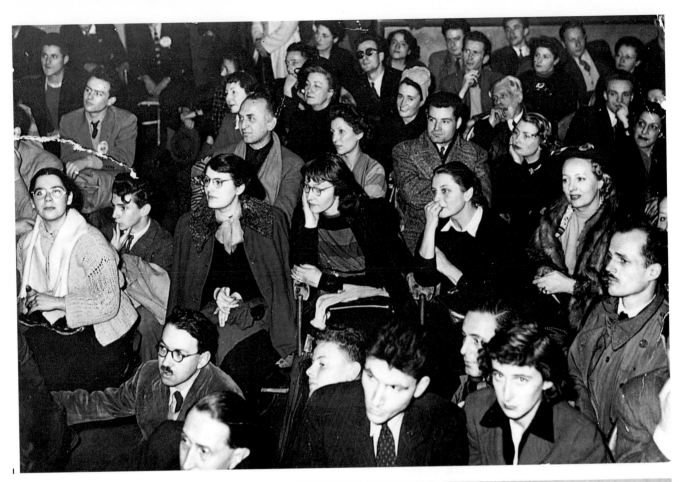

LES SURRÉALISTES

A GARRY DAVIS

PARIS, FÉVRIER 1949.

Cher Concitoyen,

nous avons entendu votre appel. Nous ferons tout ce qui est en notre pouvoir pour que cet appel parvienne jusqu'à nos amis, tant à l'intérieur qu'à l'extérieur de ces frontières que nous n'avons cessé de nier.

Dans la mesure où nous nous sentons citoyens, il va sans dire que nous voulons être citoyens du monde, et nous demandons ici notre inscription sur le registre qui consacrera enfin un état de fait qui fut toujours pour nous un état d'esprit. Nous entendons ainsi défendre de la façon la plus formelle notre droit naturel à la vie, le nôtre et celui de ceux que nous aimons. Or, ce droit est mis en péril à chaque seconde par ces mêmes nationalismes que nous avons toujours vomis, et dont nous avons dénoncé l'abjection meurtrière en toute circonstance. Il va donc sans dire que, lorsque les événements l'exigeront, nous sommes prêts par delà votre appel à faire bon marché, au profit de la citoyenneté mondiale, de notre citoyenneté nationale, où nous avons toujours vu une contrainte dont nous sommes encombrés bien malgré nous depuis le jour de notre naissance et que nous avons toujours appréciée publiquement à sa juste valeur. Cette valeur n'a jamais été, et ne sera jamais affectée à nos yeux d'autres indices que négatifs, parmi lesquels le barreau de la prison et la hampe du drapeau entrelacés s'essayent en vain à dessiner le symbole positif de l'addition, mais où nous ne pouvons reconnaître, purement et simplement, que le signe de la croix.

Car nous nous devons de vous le signaler : aux raisons évidentes pour tous qui motivent notre décision d'être dénombrés parmi les citoyens du monde s'ajoutent les raisons mêmes qui ont conditionné jusqu'ici notre activité collective, et dont relève la présente démarche. Elle s'inscrit tout naturellement dans notre effort continu pour dissiper les diversités funestes qui opposent l'homme à lui-même. En dépit de toutes les mauvaises volontés intéressées, elles ne sont pas pour nous un obstacle valable, ni qui doive être éternel.

Lors d'une manifestation récente en faveur de cette conception internationaliste de l'esprit commune à tous les véritables révolutionnaires, ceux qui luttent à la fois pour la libération de l'homme et celle de l'esprit, l'un d'entre nous rappelait le rôle émancipateur de l'automatisme. L'histoire du surréalisme n'est que la généralisation, de plus en plus large, de son propos initial : retrouver, par le moyen de l'écriture automatique, le jeu désintéressé des mécanismes psychiques. De là, nous avons été conduits à penser que ce jeu ne pouvait être différent dans le sommeil et dans la veille. Si donc l'antinomie du rêve et de l'action doit être réduite, nous avons le droit de conclure : tous les conflits opposant tragiquement la sphère des désirs de l'homme au monde extérieur régi par la plus implacable des nécessités, se trouveront, en fin de compte, résolus dans le règne de la liberté.

Dans notre impatience à hâter l'avènement de ce règne, nous avons pu un temps nous associer à des entreprises qui préparaient tant bien que mal, et plutôt mal que bien, la révolution prolétarienne. Ayant résisté à la tentation des compromis qu'entraîne tout comportement politique, c'est sur un autre plan que nous nous sommes aujourd'hui élevés pour travailler à l'avènement du règne de la liberté. Nous cherchons la clef, d'essence mythique, capable d'ouvrir n'importe quel aspect manifeste du monde pour livrer le secret (sens latent) qu'il renferme. Ainsi poursuivons-nous l'aventure exaltante qui, par la connaissance de son univers, changera la vie de l'homme.

Comme le surréalisme ne saurait pas plus manquer à cette mission que négliger son côté social, nous étions à votre côté, le dix-neuf novembre dernier, lorsque vous avez interrompu la séance de l'Assemblée Générale des Nations Unies. Nous ne pouvions pas ne pas y être, puisque ce jour-là vous avez réclamé un gouvernement mondial issu directement de la représentation des Peuples, et non de la fallacieuse représentation des Etats.

Avec vous, nous croyons à la disparition prochaine de ces Etats, avec vous nous y travaillerons. Croyez sur ce point, cher Concitoyen, à notre solidarité effective et totale.

Adolphe Acker, Maurice Baskine, Jean-Louis Bédouin, Jean Bergstrasser, Roger Bergstrasser, André Breton, Roland Brudieux, Jean Brun, Adrien Dax, Pierre Demarne, Jean-Pierre Duprey, Jean Ferry, Jindrich Heisler, Maurice Henry, Jacques Hérold, Vera Hérold, Marcel Jean, Nadine Krainick, Marcel Lecomte, André Liberati, Pierre Mabille, Jehan Mayoux, Francis Meunier, Nora Mitrani, René Nif, Henri Pastoureau, Benjamin Péret, Denise Prulhieur, Gaston Puel, Jean Schuster, Seigle, Jean Sequet, Toyen, Clovis Trouille, Isabelle Waldberg.

be opposed by the obstacles the old frameworks raise against action in favor of a world government . . . that is an argument of state . . . which, by focusing on the usual little waves on the beach, has forgotten the way in which a deep groundswell, as it rises up from the awakening of our common being, can sweep everything from its path." Events seemed to be unfolding as if the global citizenry was the latent content of the human universe, hidden by its manifest content (organization into rival states), or as if the project of becoming citizens of the world constituted the myth that could shatter universal sensibility. That myth, however new and appealing it might have seemed, would not survive for long, and the movement that had formed around Garry Davis quickly disintegrated: in October 1949, Breton distanced himself when he realized the confused nature of Davis's activities, for Davis had begun to accept the help of church authorities to obtain the status of conscientious objector from the French government. As it was feared that this status could only be granted for religious reasons, it was easy to foresee the consequences: "Seminarists will have the right to continue their studies *against us* . . . and specialists of all sorts will be able, with greater means at their disposal, to compete in crushing anyone who refuses to render thanks and pay tribute to their pathetic 'God.'"

À la niche les glapisseurs de Dieu!

In June 1948, a pamphlet very different in tone was published, designating those individuals with whom there would never be any question of sharing world citizenship. *À la niche les glapisseurs de Dieu!* (To the doghouse God's squealing followers!)—fifty-two signatures, including, in particular, Maurice Blanchard, Joë Bousquet, Charles Duits, Georges Hénein, Jean Schuster, Clovis Trouille, Patrick Waldberg, and Henri Pastoureau, who was the editor-in-chief and, with Jean Ferry, Marcel Jean, and Maurice Henry, the instigator of the pamphlet—was a vigorous attack against the multiple efforts at religious co-optation that for some time now had been turning their efforts toward surrealism or authors whom it considered to be particularly untouchable. First of all, mention was made of an article by a Benedictine ("André Breton's program contains aspirations that are perfectly in line with our own"), various commentaries by Claude Mauriac, a text that was published in *Foi et vie* claiming to subscribe to certain tenets of the article by Pastoureau "For an Offensive in Grand Style against Christian Civilization" (in *Le Surréalisme en 1947),* and the apologetic endeavors of Michel Carrouges in his study "Surrealism and Occultism" (in *Les Cahiers d'Hermès,* no. 2).[64]

But the pamphlet did not stop with this list alone; it also denounced a tactic that the apologists of the Christian faith were resorting to and that consisted in using every direct declaration of atheism as the indirect proof of a quest for transcendence, hence, for God. With even more subtlety, Pierre Klossowski had just suggested that the Marquis de Sade was not an atheist because in affirming the reign of evil, he could only define evil by referring to a "positive" God, the only one to dispense "the word of good, capable of causing him to discern everything, even evil."[65] Believers, therefore, were increasingly adopting an attitude that acknowledged that "to deny God is still to affirm him, and once this initial affirmation has been accepted, to fight him is still to support him, to despise him is still to desire him."

Thus upside down is right side up, the antithesis equals the thesis. It was not with the aim of finding a synthesis, continued *À la niche,* but within the framework of a very

conscious sort of double game, encouraged in particular by the ecclesiastical authorities: "Christians today have at their disposal arguments taken from fairly ill-assorted theological trash bins to prepare for the most diverse circumstances." Henceforth, all discussion became impossible, since the contradictor would win in every case. All that remained were "the 'vulgarities' of simplistic anticlericalism, of which the *Merde à dieu* inscribed on the cultural edifices of Charleville remains a typical example."

Although *À la niche* initially seemed to stem from the irritation of Pastoureau and his friends at the increasing number of attempts to win them and people like them over to Christianity, it might also have been seen, from a distance, as yet another response to those who reproached surrealism for edging toward a diffuse religiosity. In any case Bataille, once again, was not mistaken when he remarked in *Critique* (no. 28): "The numerous Christians who praise surrealism seem in the end to be naive, but inhibited by the commandments of the theological discourse that just as eagerly condemns their facility as it does the teachings of André Breton. Between surrealists and Christians the abyss is certainly the deepest."[66]

The Automatists

In 1948 in Montreal a collective work entitled *Refus global* was published: it opened with a manifesto of the same title, written by Paul-Émile Borduas alone, but signed by fifteen of his friends, including four painters who had exhibited together with him from June 20 to July 13, 1947, in Paris (Galerie du Luxembourg) under the heading "Automatism."[67] Borduas's manifesto, although poorly distributed in a few Montreal bookstores in a mimeographed form (it would not be printed in a published form until as late as 1972), was nevertheless received in Quebec as sufficiently scandalous for its author to find himself suddenly stripped of his employment as a teacher at the École du Meuble. The problem was that he had described the people of Quebec as "a little nation clinging to the cassocks who have remained their sole guardians of faith, knowledge, truth, and national wealth" before asserting that Christian domination had entered a period of decadence and that "a new collective hope will be born" ("MAKE ROOM FOR MAGIC: MAKE ROOM FOR OBJECTIVE MYSTERIES! MAKE ROOM FOR LOVE! / MAKE ROOM FOR NECESSITIES!"); "within an imaginable time span, we will see man freed from his useless chains, and, in the unforeseeable order required by spontaneity, in splendid anarchy, he will fulfill the promise of his individual talents."

Declarations of this type corresponded to a determination to catch up where culture was concerned: Quebec had only just begun to emerge from its intellectual lethargy, caused by the weight of the Church (e.g., the *Index des livres prohibés* [Index of prohibited books] still made it very difficult to gain access to an author like André Gide—never mind Sade!—and Breton, writing *Arcane 17* in Gaspesia, had noticed this, remarking that "classical theater is reduced to virtually nothing but *Esther* and *Polyeucte,* which are sold in great piles in the bookstores of Quebec: it is as if the 18th century had never existed. Hugo cannot be found"). For Quebec's most advanced intellectuals, surrealism seemed to be an "avant-garde" par excellence (Alfred Pellan was one of the few painters to have achieved recognition, precisely because he had spent fourteen years in Paris before the war and was reputed to have assimilated surrealism in painting), and Paris was the capital of the mind.

It was for that reason, moreover, that Jean-Paul Riopelle went to Paris in 1947: he

Right: Jean-Paul Riopelle, *Untitled*
(1947); ink on paper, 9$^1/_5$ × 12$^1/_5$ in.
(23 × 30.5 cm). Private collection.

Below: Jean-Paul Riopelle, *Bonne Bise*
(1950); oil on canvas, 32$^2/_5$ × 40 in.
(81 × 100 cm). Private collection.

Right: Friedrich Schröder-Sonnenstern, *Moralizing Lyre-Bird* (1956); 28⁴/₅ × 20 in. (72 × 50 cm). J. and M. Camacho Collection, Paris.

Below: Friedrich Schröder-Sonnenstern, *The Curse of the Plough* (1956); 29 × 40⁴/₅ in. (72.5 × 102 cm). J. and M. Camacho Collection, Paris.

Opposite page, top: Joseph Crépin, *Temple* (1941); oil on canvas, 21³/₅ × 28²/₅ in. (54 × 71 cm). Musée National d'Art Moderne, Centre Georges Pompidou, Paris.

Opposite page, bottom: Hector Hyppolite, *A Goddess* (undated); oil on cardboard, 24²/₅ × 30⁴/₅ in. (61 × 77 cm). Private collection.

Above: Roberto Matta, *Prisoner of Light* (1943); oil on canvas, 78¹/₅ × 100³/₅ in. (195.5 × 251.5 cm). Private collection.

Opposite page, top: Max Ernst, *Blue Flower;* oil on slate, 8¹/₂ × 11 in. (21.2 × 27.8 cm). Private collection.

Opposite page, bottom: Max Ernst, *Spring* (1961); oil on canvas, 10⁴/₅ × 14 in. (27 × 35 cm). Private collection.

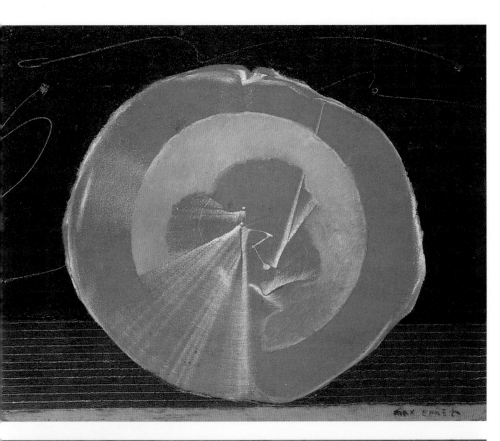

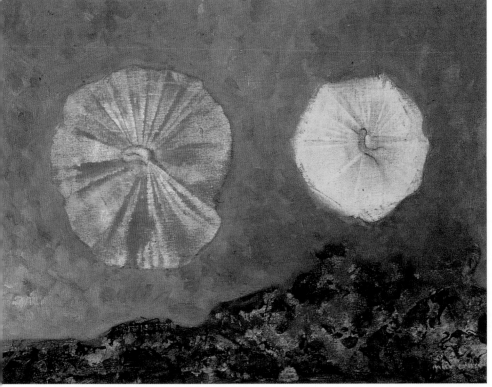

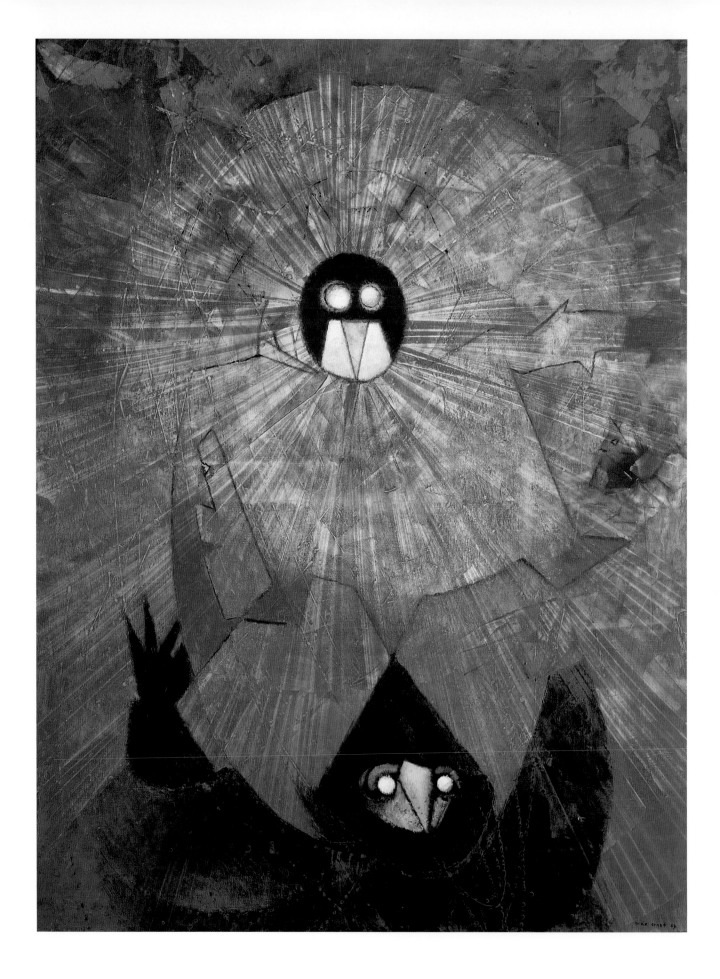

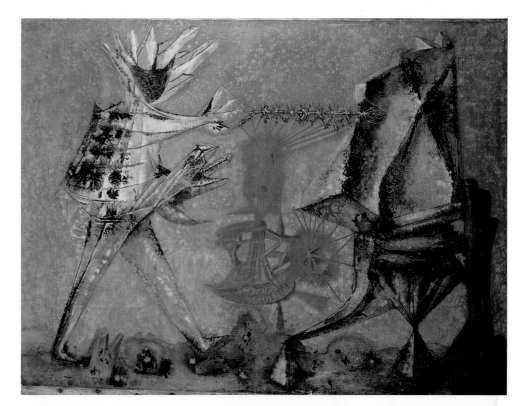

Right: Jacques Hérold, *The Philosopher's Egg* (1948). Private collection.

Below: Kurt Seligmann, *Magnetic Mountain* (1949); oil on canvas, 65¼ × 75 in. (163.1 × 187.9 cm). Andrew Murray Collection, London.

Opposite page: Max Ernst, *The Obscure Gods* (1957); oil on canvas, 46²/₅ × 35³/₅ in. (116 × 89 cm). Folkwangmuseum, Essen.

Adrien Dax, *Reliquary,* assemblage
of various objects. Private collection.

had been introduced to Breton by Pierre Loeb and took part in the group show at the Galerie Maeght, while his friends from Montreal, although they had been notified of the project, did not want to take part due to a lack of time to prepare. Fernand Leduc, who visited the exhibition at the Galerie Maeght but was already more concerned with issues of a strictly pictorial nature, on his way to an increasingly geometric abstraction, pointed out to Borduas that Riopelle looked like "someone gone astray, the way his work is executed," and "he takes a corner place in the bazaar where surrealist literature is sold." Despite the apparent similarity of opinions and intentions between *Refus global* and the surrealist positions, a fundamental difference remained: for the Quebecois, automatism was only a means to liberate painting from its conventions, and they showed little concern for what it might reveal about the subconscious or the access it could grant to new, extrapictorial truths. During the minor exhibition in 1947, Léon Degand, who could hardly be accused of sympathizing with surrealist principles, was on the right track when in his brief preface he seemed almost to question the use of the word: "Automatism? To be exact: an advantageous submission to the demands of spontaneity, to pictorial insubordination, to chance in the use of technique, to romanticism of the brush, and to an overflowing of lyricism."

Thus, it was not surprising that Riopelle, the most lastingly involved automatist among the surrealists, exhibited first with somewhat heterogeneous groups (like the one set up in December 1947 at the Galerie du Luxembourg by Georges Mathieu, Michel Tapié, and Camille Bryen, entitled *L'Imaginaire:* Mathieu, Hans Hartung, Bryen, Wols, Raoul Ubac, Brauner, Gérard Schneider, Jean Atlan, Arp, Gérard Vulliamy, Picasso, Fernand Leduc, and Riopelle, among others) and then in 1949, at the Galerie Nina Dausset, for which André and Elisa Breton, together with Péret, provided prefaces.[68] One could sense in his paintings, already abstract, a subjective interpretation of the Canadian landscape or a description, through the colored prism, of "the very instant in which everything opens out like a fan onto the Arctic" (Elisa Breton). He would soon bear the consequences of his strictly pictorial concerns: he left the group in 1950, and the following year, Michel Tapié congratulated him on avoiding "the stifling weight of automatism."

Art Brut

If there were any artists who clearly and totally neglected their career, their trade, or the specific problems related to painting, they were certainly those whom Jean Dubuffet had eagerly begun to assemble: asylum inmates, autodidacts, great eccentrics pursuing their work in solitude and obeying no other law than their need to do something or to express themselves. In November 1947, the opening of a Foyer de l'Art Brut in the basement of the Galerie Drouin made Dubuffet's interests known to the public, and when he officially founded the Société de l'Art Brut in May 1948 (it would include sixty-odd members), Breton joined, along with Paulhan, Tapié, the connoisseur of primitive art Charles Ratton, and Duchamp's longtime friend Henri-Pierre Roché. The creations that Dubuffet collected and exhibited (Joseph Crépin, e.g., in January 1948) were indeed those in which the surrealists had already had a keen interest for some time, precisely because these works were not subject to the dominant norms of morality or aesthetics: they were proof in a way of a primitivism that existed in the West, and already in 1925 the group had described the insane as "forced laborers of

sensitivity." At roughly the same time, Ernst and Arp, who were German-speaking, were able to introduce their friends to Prinzhorn's major work, published in Berlin in 1922: *Bildnerei der Geisteskranken*.[69] Bellmer also considered its publication to be a decisive event. The interest that was shown in the production of mediums—the "Martian" drawings by Hélène Smith, for example, or the automatic drawings that illustrated Breton's *Le Message automatique*—was clearly a complement to the desire to move beyond purely aesthetic criteria, as was the admiration expressed for the Palais of the Facteur Cheval or the recognition granted to the most authentic of the naïve painters, beginning with Rousseau.

This thread ran through the entire history of the movement, and in 1942 Breton wrote an article, "Autodidacts or 'Naïve' Artists," in which he said that Rousseau's *Le Rêve* seemed to him to include "all poetry, and with it, all the mysterious gestations of our era."[70] In the United States Breton had discovered Morris Hirschfield who, like Rousseau, decided on the figures in his paintings by the intensity of a "magical" gaze, capable of conferring on his imaginary creatures the proof of the world as he perceived it. As for Hector Hyppolite (a reproduction of one of his works opened the catalog of the exhibition *Surrealism in 1947*), it was another form of clairvoyance, due to Voodoo practices, which inspired the scrupulous figurative work of his syncretic pantheon.[71]

In 1948, "L'Art des fous, la clé des champs" (The art of the insane, free rein) reproached art criticism for being interested solely in artists who had been consecrated by the market or fashion and for being incapable of "searching out its well-being—and ours—in these trophies of true 'spiritual hunting' through the great aberrations of the human mind."[72] Breton advanced the "idea—paradoxical only on first examination—that the art of those whom nowadays we classify as 'mentally ill' constitutes a hidden reserve of moral health."

The interest in a totally free artistic expression, however, only partially coincided with Dubuffet's enterprise: in September 1951, Breton addressed a letter to the members of the Compagnie de l'Art Brut in which he deplored the fact that Dubuffet was acting dictatorial, particularly for having written the preface to the Exposition Générale sur l'Art Brut in October 1949 without having submitted it for discussion and that the exhibitions organized at the Foyer de l'Art Brut favored and highlighted the artwork of the insane alone ("yet we all know that there have been no new discoveries in this art for a long time"). Relations with the Compagnie de l'Art Brut became strained, but the surrealists continued nevertheless to insist on the importance of the irregular artwork they encountered, which was not solely the creation of the mentally ill but also of naïve artists (the young Algerian woman Baya, Demonchy, or Miguel Vivancos, who was discovered by Picasso and whose exhibition catalogs were introduced by Breton in 1947, 1949, and 1950), mediums (Joseph Crépin and Augustin Lesage), marginal figures like Friedrich Schröder-Sonnenstern, and "cranks" like Gaston Chaissac, Picassiette, or the "Hermit of Rotheneuf," Adolphe-Julien Fouéré.[73]

Surrealist Solution(s)

From October 1948 to the spring of 1949 there was, on the rue du Dragon, a Solution Surréaliste gallery, also known as La Dragonne, which revived to some degree the activities and purpose of the Centrale Surréaliste: every Wednesday, manuscripts, drawings, and ideas were received by two members of the group. Thus it was that Adrien

1

3

Dax, André Liberati, Gaston Puel, and Jean-Pierre Duprey came onto the scene. (Breton's immediate reaction on discovering Duprey's poetry has become almost legendary: "You are certainly a great poet, and your double is someone else, who intrigues me.") Before long they would join in the group activities and would be featured, in particular, in *Néon* from the third issue on. More unusual was Maurice Fourré, who showed up from time to time: in 1950 Breton published a story that was as enigmatic as it was exhilarating, "La Nuit du Rose-Hôtel." It appeared in the series Révélation, which Breton was managing for Gallimard. (This would remain its sole volume, although the intent had been, as announced in the preface to the work, to "promote a certain number of works that are truly *different* and that are not so readily accessible but whose virtue is to bring us to see the life we think we are leading as if from offshore, and thereby to free the deep forces of one's understanding from stereotypical and ossified thinking.")

Solution Surréaliste was also, if not first and foremost, a venue for exhibitions. The first one, held in October 1948, included exquisite corpses (drawn or made with collages), which still seemed "a foolproof way of voiding one's critical mind and fully liberating the metaphorical activity of the mind," according to the terms of the preface written by Breton, who also emphasized that the end result had the effect, graphically, of "taking anthropomorphism to a culminating point, prodigiously accentuating the relational life that joins the external world to the inner world."[74] A collective exhibition followed, as well as a solo one of the works of Edgar Jené, a young artist of German origin who had settled in Austria where he distributed texts and information about surrealism.[75] But Solution Surréaliste, like *Néon,* would cease its activities due to a lack of funds.

There were also a number of important exhibitions held elsewhere. In July 1947, Matta (who had just contributed three drypoints to the republication of the *Manifestes du surréalisme* by the Éditions du Sagittaire) had thirty-two works on display at the Galerie René Drouin, and the exhibition retraced the principal steps of his evolution. In the catalog were three texts by Breton, including the one that had been published in 1945 in New York at Brentano's, "La Perle est gâtée à mes yeux" (The pearl, to my eyes, is ruined), and new pages emphasizing the significance that might be attributed in the painter's work to the passage from "the line known summarily as 'nonfigurative'" to the reintroduction of the human figure in his work. "The point for Matta is to represent the inner man and his opportunities—and no longer, pathetically, the body of that man in relation to the objects immediately surrounding him. The element into which he is immersed has nothing to do with physically breathable air. It is *chance,* a sort of geometrical place in which his conflicts are resolved."[76] Indeed, when one compares earlier "cosmic" compositions, such as *La Terre est un homme* (1943), in which the field of the painting is lit with a sort of breathing internal to the space, crystallizing or diffracting, to recent canvases (*Octrui, Le Pélerin du doute,* or *Le Nœutre,* 1947), one is forced to note that space is now evoked by volumes with sharp edges, clearly outlined forms that might overlap and lead an eye seeking for a perspective astray, and that define the characters with whom relations of affinity as well as of imprisonment are established. As for the human figure, it is treated in such a way, with no attempt to make it realistic, that the faces are symbolic transpositions of passion, as are the exaggerated postures, the suggestive gestures, the multiplicity of limbs. The following year, Matta exhibited at Pierre Matisse's and at the gallery that William Copley had just

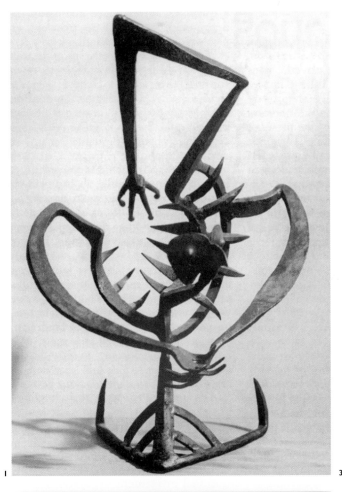

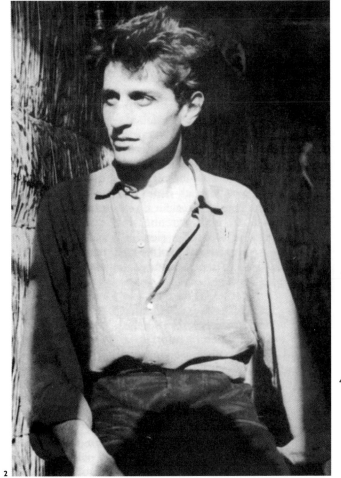

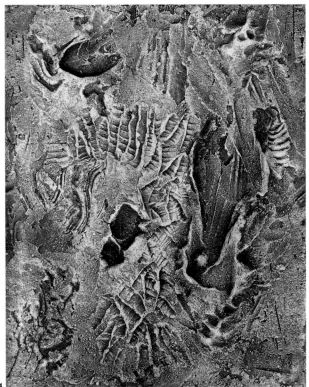

1

3

4

2

opened in Beverly Hills. He even wrote a text, "Infernallucinations," for Motherwell's publication of texts by Max Ernst (other contributors were Arp, Breton, Calas, Julien Levy, Ribemont-Dessaignes, and Tzara):

> History is the story of man's various hallucinations; as soon as one thinks of some of the influential people in this story—the devil, Venus, Christ, for example—it becomes clear that they owe their existence as historical characters in part to the fact that they were *painted* by men who were gifted in graphic hallucination. . . . The risk, with this power of creating hallucinations, is that an established authority might exploit them for its own purposes. . . . I believe that this is what fully justifies the path on which Max Ernst has embarked: to use hallucinations as a creator, in order not to be a slave to the hallucinations of others, as is generally the case. . . . His doves remind us incessantly how ridiculous it is to suppose that doves look upon the world as a place devoid of conflict.[77]

At the end of 1948, Matta left the United States (he would settle in Rome until 1954), where "everything seemed [to him] to be too much painting"; he was "increasingly involved in a painting which [sought] to give a material image of events"—a project that seemed "too literary" to American artists (and to Clement Greenberg): "For me, it wasn't literary at all, it was the true purpose of art," said Matta in 1965, thus confirming that at that time he totally agreed with the views of the surrealists. It was therefore not for reasons to do with his work that he found himself excluded from the group on October 25, 1948, but, as announced in *Néon,* number 4, "for intellectual disqualification and moral ignominy": Matta's affair with Gorky's wife seemed to be one of the reasons that had led to the American painter's suicide. "It is without doubt that Matta took this decision very hard—first of all because of all the painters connected with the movement he alone, with Tanguy perhaps, wanted to be a surrealist before he wanted to be a painter; and then because his emotional investment in surrealism was very deep" (José Pierre).

This expulsion immediately led to another, striking Brauner and those close to him (Sarane Alexandrian, Francis Bouvet, Alain Jouffroy, Stanislas Rodanski, and Claude Tarnaud), "for fractional work." In addition to the fact that Brauner did not sign his name to Matta's expulsion, he seemed to be manifesting a certain reserve with regard to group activities and encouraging his friends to neglect them.[78] This does not prevent his postwar painting from exerting a certain fascination, even if his compositions in wax evolved toward increasingly hieratic figures (by virtue of the material itself). When he returned to oil at the end of the 1940s, it was to express increasingly intense psychical states (*Totem de la subjectivité blessée* [1948]: "The teeth of the Stalinists mortally injured little Victor and imprisoned him; they would prevent him from reaching the socialist apple which is his physiological freedom. / The socialist apple / The apple sun black milk / The apple mama"), which led him progressively to the series of the *Rétractés* (1950–52), in which human shapes pull themselves to bits and fly about in shreds.[79] Nor did this prevent Rodanski either from emerging as a poet of capital importance, or so it seemed, who would then very quickly cut himself off from society by finding shelter in a "rest home," whence from time to time letters and stories would arrive, filled with a veiled sense of the marvelous as much as with sarcastic humor, forming the "account of one of the ventures most heavily laden with challenges ever pursued in the light of surrealism, one of the very few that did not withdraw from the prospect of traveling through its *dangerous landscapes,* and confronting their last risks."[80]

It was to less dangerous landscapes that Maria Martins invited the viewer in her sculptures, exhibited at the end of 1948 at the Galerie Drouin, with a catalog preface by Breton and Michel Tapié: "spirit blows upon warm land" and fills the bronze with such suppleness and vivacity that one can hear the rustling of a universe of lianas, of the genies of tropical forests and the echoes of ceremonies to celebrate the marriage of the human body with the most fertile sap.[81] Maria did not belong to the surrealist group, but like Malcolm de Chazal or Hector Hyppolite, she was proof of the persistence of magical powers, and it was already in this capacity that she took part in the group exhibition of 1947.

In 1949 Max Ernst returned to Paris, "with mixed feelings, but happy to be able to see my old friends again." Julien Levy could no longer support him in New York: his exhibition in 1948 at Knoedler's had been a complete fiasco, and the one in 1949 at Copley's persuaded only one buyer, Copley himself (but it gave him the chance to publish a collection of collages and poems: *At Eye Level: Paramythe*). In January 1950, his *Books, Illustrations, Etchings, 1919–1949* were collected at La Hune in time for the publication of *La Brebis galante* by Péret, which Ernst had illustrated (Éditions Premières). In April he exhibited at the Galerie Drouin, with a catalog preface by Joë Bousquet and Michel Tapié, and he showed (unsuccessfully, again) works he had produced during his stay in the United States. His technical virtuosity allowed the most heterogeneous stylistic appearances to live side by side on the same canvas. *Les Phases de la nuit* (1946), for example, was made up of a frottage set in a vegetal landscape, of oil painting defining the silhouettes of nocturnal birds in varying scales, the geometric depiction of a dwelling (where one could perceive, through a transparency, a fragment of landscape, and the shadow of an owl), and "mathematical" annotations. The entire canvas was united in a nocturnal atmosphere and was proof that the visionary power of the artist had lost none of its intensity. For Ernst, landscapes—whether tiny (a few centimeters in height) as in the *Microbes* from 1946, which he produced by means of decalcomania, or of more classic dimensions as in *La Nuit rhénane* (1944, 109 × 150 centimeters)—always refer to a mental state. And if there were inhabitants in those landscapes (*Noces chimiques* [1947–48]), they would henceforth be geometrical beings who resembled somewhat clumsy or sarcastic robots as closely as they did human beings, if not more so. In Sedona in 1944 he conceived a series of sculptures based on salvaged materials (*Un ami empressé*), imprints (*Tortue, Jeune femme en forme de fleur*), and a more or less rigorous geometry (*Le Roi jouant avec la reine*), which led in 1948 to *Capricorne*, a monumental family portrait where the display of the shapes found and the sculpted elements conferred an allure, as ironic as it was indisputable, upon an expression of personal mythology.

Upon his return to France Ernst resumed his collaboration with members of the group: he took part in the "globalization of Cahors" with Breton; he illustrated, in addition to *La Brebis galante, L'Antitête* by Tzara (with Tanguy and Miró), Lewis Carroll's *The Hunting of the Snark* in the translation by Henri Parisot, Henri Michaux's *Tranches de savoir,* and others. And of course he would contribute to the illustration, with Dorothea Tanning, of the *Almanach surréaliste du demi-siècle*.

Almanach surréaliste du demi-siècle

Published as a special edition of the periodical *La Nef,* this almanac, in keeping with

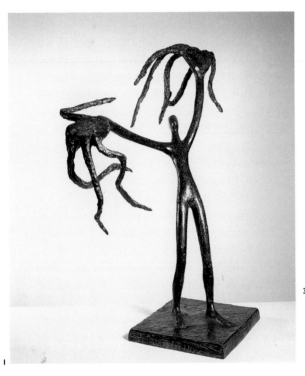

1

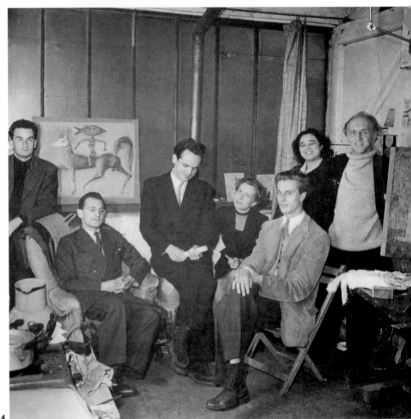

2

3

4

the genre, opened with a calendar listing a certain number of memorable events in the history of humanity.[82] More precisely, this list, drawn up by Breton and Péret, was a "Round-the-World Calendar of Tolerable Inventions," these inventions referring to household objects (ladders, shutters, snail forks, illuminated signs, mustard, mayonnaise) or less common and even somewhat outmoded items (kaleidoscopes, back-scratchers, beauty spots), whose reported origin might be one of chance, nonutilitarian desire, or poetic reverie.[83] In accordance with the principle that proved its validity in the 1930s for the creation of surrealist objects, once again the point was to unveil the latent side of the ordinary universe, without aggressiveness—on the contrary, with a certain gentleness: the latency would itself be directed by the ascendant sign.

At the end of the volume a "Panorama of the Half-Century" acted as a counterpart to the calendar: it was much more classical, listing year by year those events that were deemed significant, from a surrealist point of view, in politics, science, trivial news items, letters, and art—a panorama detailing history as selected by the movement. (It is worthy of note that the two world wars are only alluded to briefly.)

Between these two sections—which can be read as responses, first, to the pleasure principle and, then, to a principle of reality subjected, in turn, to a sufficiently powerful filter to sort the elements in an effective way (which tended to give the panorama a predominantly humorous tone)—the series of collected texts and contributions could be subdivided into different parts. These in turn carried a historical element and an offering of recent poetry, due, in particular, to the newcomers in the group.

The "Potlatch des grands invitants à leurs grands invités" (Potlatch of the great inviters to the great invitees) indicated by its title alone that the almanac was also a collection of donations and counterdonations as result of a reciprocal emulation within the movement: if one acknowledged one's admirable antecedents, one was also obliged at least to maintain their level, to set up what Nietzsche called a "stellar friendship," establishing an affinity through their divergences. Thus Wang Bi, Sade, Lycophron, Arthur Cravan, Maurice Heine, Artaud, Félix Fénéon, and excerpts from the *Book of Chilam Balam of Chumayel* as translated by Péret formed an overall picture of the conceptual and stylistic demands within which surrealism delineated its territory. "The Masters of the Half-Century" gave another circle of references: Kafka, Sade, Roussel, Duchamp, and Jarry were analyzed by contributors who were destined to become, in varying degrees, real "specialists."[84]

"Le Beau temps" included only two pieces, but they were enough to illustrate once again the way in which the surrealist attitude could overturn the order of things and values. In "Les Chefs-d'œuvre aux terrains vagues," (The masterpieces on the vacant lots), André Pieyre de Mandiargues took advantage of the shabby setting in the parc de Versailles reserved for Bernini's equestrian statue of Louis XIV (modified by Girardon)—he knew "in France, no more beautiful sculpted work than this convulsive statue so stripped of its basic dignity and thrown to the brambles"—in order to describe, once he had carefully noted the graffiti that were etched on the pedestal, the joy one felt in imagining "the *Mona Lisa* at the market in Saint-Ouen, the *Victoire de Samothrace* among the fur-lined jackets at the Temple market . . . or the *Vénus de Milo* in front of a seedy hotel I know."[85]

The few pages of Breton's "Pont-Neuf" are undoubtedly the finest and most concise example of a completely subjective topography, revealing the Place Dauphine as the female sex of Paris, depicting the Seine as the body of a woman, and, in one sover-

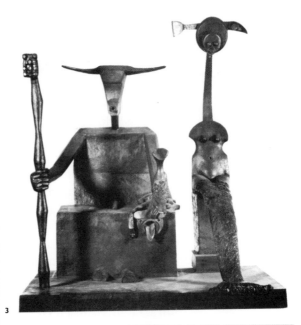

1 Max Ernst and André Breton photographed on the "Route sans Frontières" (Road without borders), at the entrance to the village of Saint-Cirq-la-Popie, circa 1948.

2 Max Ernst, cover for *La Brebis galante* by Benjamin Péret (Paris: Éditions Premières, 1950).

3 Max Ernst, *Le Capricorne* (1948); bronze, 98 × 82⁴/₅ in. (245 × 207 cm). Private collection.

4 Max Ernst, *The King Playing with the Queen* (1944–45); bronze, 40 in. (100 cm). Private collection.

Max Ernst with a Hopi Indian mask,
nailing the floor, Arizona, 1946.
Photograph by Lee Miller.

eign movement, condensing both the secret and popular history of the capital, as if it were the hidden side of its apparent geography.[86] This reverie invites one to grasp, almost physically, the elements that can transform a street, a quay, or a square into a place imbued with emotional resonance, capable of eliciting attraction or repulsion. Urban space is never neutral; it is, on the contrary, punctuated with signs to be deciphered poetically, where the historical and the imaginary, the anecdotal and the fictitious, have left their sediment.

The *Almanach surréaliste du demi-siècle* was also rich in theoretical contributions.[87] While Péret, in "La Soupe déshydratée" (Dehydrated soup) vigorously attacked abstract art, basing his comments on recent statements by the critics Charles Estienne and Léon Degand and underlining in passing that it was "improper to classify Kandinsky, Miró, or even Arp as abstract artists," Adrien Dax, in "Perspective automatique," reflected on the possible future of pictorial automatism: it was by wagering on the possible contributions of the materials used in automatic production that one should be able to avoid repetitive forms (for even "the finely interpreted decalcomania by Hans Bellmer" revealed nothing more than "a persistent taste for the equivocal body of an eternally underage woman") as well as the conventional rapprochement between automatic and natural productions. "The artist's intervention would improve by being more fully accomplished, and a new path could be found that would no longer be to interpret the result of automatism—which can quickly become contrived through certain practices—but rather to attempt to direct the material reactions during the creation of the work." In sum, the point would be to restore a real capacity for revelation to automatism in drawing or painting, thus avoiding the painter's own mental habits and allowing him periodically to give fresh insight into his own exploration. Adrien Dax's ideas were invaluable in a period where the propagation outside of the surrealist group of what José Pierre qualifies as the veritable "inflation of automatism" would soon lead certain artists (Ramsès Younane, Simon Hantaï, Iaroslav Serpan, among others, in Riopelle's path) to slide toward an informal style devoid of psychic content. Dax himself would, moreover, thanks to constant experimentation, move on to works of an exalting flight of lyricism, even though the material the artist initially worked with (interpreted posters, impressions in relief from 1955 on, for which scrap objects were arranged in random order between the stone and the paper during the printing of a lithograph) signaled a dreary banality: the passage from the cast-off item to poetry proved the effectiveness of an alchemy through which techniques were invented the better to entice the unexpected into the visible field.

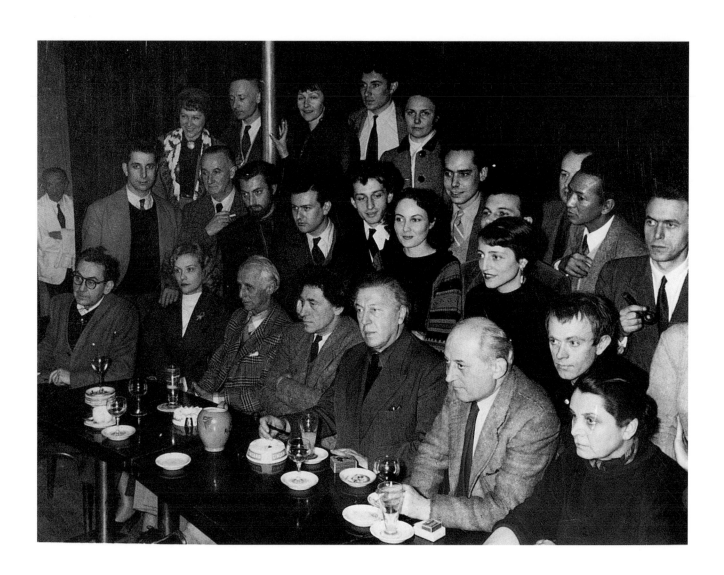

1951–1959

COMMITMENT, THAT IGNOBLE WORD*

The Carrouges Affair

Whatever a number of false witnesses might have been saying since the end of the war, surrealism was far from dead, and it continued to arouse intense curiosity among the public, as shown by the response in the press to the internal debate in the margins of the group that the presence of Michel Carrouges caused, provoking hostility among certain members. The "Carrouges affair," beyond its merely anecdotal aspect, also signaled the role that newcomers to the group were beginning to play in its ideological life and would be the source of a certain number of contradictory publications as well as a voluminous correspondence, both private and destined for limited circulation.

The origins of the debate were a lecture given by Michel Carrouges on February 12, 1951, at the Catholic Center of French Intellectuals (whose premises were next to the Saint-Séverin church) on the topic "How Is Surrealism Doing?" Carrouges was by no means ill-informed to deal with the subject: for a number of years he had been frequenting the surrealists, and they were clearly aware of his Catholic leanings; they thought he had "adopted some of their fundamental ideas, and the task of harmonizing these ideas with his own religious convictions were his business alone, provided he did not declare himself to be a surrealist."[1] Moreover, in 1950 his work *André Breton et les données fondamentales du Surréalisme* (André Breton and the fundamentals of surrealism) was favorably received by the entire group and by Breton himself, even when it seemed the author was completely occulting the political positions of the movement and, what was even more serious, when—despite the warnings in the pamphlet *À la niche les glapisseurs de Dieu!*—he indulged in an implicit rapprochement, clearly tendentious and rendered effective by the use of a few semantic liberties, between occultism and a spiritualism that one suspected had to be Christian. The fact remains that as soon as he was notified of the upcoming lecture, Henri Pastoureau made plans to disrupt it, at least to let the audience know that there was a clear division between Carrouges and

the surrealists. Accompanied by Marcel Jean, Robert Lebel, Patrick Waldberg, and Georges Duthuit, Pastoureau went along to the lecture and managed, even before it began, to read out a declaration confirming the "basic anticlericalism" of surrealism and denouncing Carrouge's deliberate attempt to confuse people. He then went on to read from *À la niche les glapisseurs de Dieu!* and named the fifty-two signatories, before leaving the premises with his friends.

When he told Breton and his friends what he had done, Pastoureau was disappointed by their lack of enthusiasm. He then wrote, and handed out, his *Aide-mémoire relatif à l'affaire Carrouges,* in which he implied that Breton seemed to want to have done with the surrealist group, and he called for a return, "on a spiritual, social, and political level, to a serene and effective revolutionary position."[2] Breton and Péret gave their response on March 16 in *L'Affaire Pastoureau et Cie (Tenants et aboutissants)* (The ins and outs of the Pastoreau Affair), in which Pastoureau's factual errors and tendentious interpretations were pointed out and in which he was accused of placing Breton "before a real ultimatum: either the dissolution of Surrealism, or the obstruction on his side and that of his partisans to any surrealist action. *In either case Surrealism will disappear.*"[3] Debated at the General Assembly on March 19, the text was approved: Pastoureau and Waldberg were excluded, and, as an indirect consequence, all relations with Carrouges were severed. A text was signed, which reiterated that the revolutionary position "remained one of the fundamental postulates of Surrealism" and that "anything which honestly seeks to reinforce this position will, as in the past, be warmly welcomed."

This was not the end of the polemic, however: on March 23 Pastoureau sent his *Observations relatives à l'opuscule de Breton-Péret: "L'Affaire Pastoureau et Cie" et au compte rendu de l'Assemblée du 19 mars 1951* "to individuals I have selected," in which he disputed the interpretations of his opponents and the validity of the General Assembly's account.[4] Dated the following day, a *Lettre à André Breton,* written by Maurice Henry, confirmed its author's solidarity with Pastoureau, called on Breton to acknowledge his lasting "weakness" with regard to Carrouges, and opined that "there is now the scent of the sacristy in the vicinity of the Place Blanche." Waldberg, in turn, published *Les Mystères de la Place Blanche,* a parody of popular serialized stories, which allowed him above all to ridicule his own exclusion; on May 24, *Combat* published *L'Ukase et la Romance* by Marcel Jean, which in turn asserted that it was now appropriate to let "Breton stew," with only Péret for company.[5]

That same day, however, a collective pamphlet, *Haute Fréquence* would appear, and it consecrated a new generation within the group.[6] Written mainly by Bédouin, with the help of Jean-Pierre Duprey, Nora Mitrani, Bernard Roger, René Guy Doumayrou and Schuster, and it was for all of them the first production of this kind, the brochure reiterated that surrealism could not be defined solely as an adventure—"It does not have to resemble literally what it was in earlier times" (something that implicitly accused Pastoureau and his friends of being outmoded and dogmatic)—but it also restored the principles of rebellion, the struggle against religion, and the reciprocal restoration of desire and freedom to the foreground.

Jean-Louis Bédouin, in *Vingt ans de surréalisme,* and José Pierre pointed out that half the signatories of *Haute Fréquence* were young people. While some of them (Duprey, Gérard Legrand, Jean Schuster) had belonged to the group for some time already, this

was the case neither for the three architects (Doumayrou, C. Rochin, and Bernard Roger) nor for the film enthusiasts Ado Kyrou, Robert Benayoun, and Georges Goldfayn, who produced the periodical *L'Âge du cinéma*. Its first issue came out in March 1951 and included a text by Benjamin Péret: "Against Commercial Cinema." Other significant new members included André Pieyre de Mandiargues (who signed the pamphlet but, more concerned with his literary work than with sharing experiences, would distance himself from the group activities in the years to follow), Octavio Paz, Maurice Raphaël, François Valorbe, Michel Zimbacca, and also Jean Brun, Jehan Mayoux, Jindrich Heisler, Toyen, Clovis Trouille, and even Man Ray. Far from disintegrating due to a generation gap, the group was finding renewal and now included most of those who would give it its allure right to the end.[7]

Julien Gracq Refuses the Prix Goncourt

In the autumn of 1951, it was yet another event at the periphery of the group that drew the attention of the literary columnists: Julien Gracq was awarded the Prix Goncourt for his most recent novel, *Le Rivage des Syrtes,* and he turned it down. Up until that point Gracq had been considered, more or less appropriately, to be a surrealist writer. Breton did indeed welcome the publication of his first novel *Au château d'Argol* in 1938 and the following year he met with the author in Nantes; but above all, he saw the novel to be a fictional version of surrealist thought, and it was in this capacity that Breton mentioned Gracq's novel at the end of his speech to the students at Yale. This speech was published in 1942 by the Éditions Fontaine, and in it Breton noted that surrealism, twenty years after the publication of *Les Champs magnétiques,* had led to "the realization of *Au château d'Argol,* by Julien Gracq, in which undoubtedly for the first time surrealism has turned of its own free will upon itself to confront the great experiments of the past in sensibility and to evaluate, both from the point of view of emotion and that of clairvoyance, the extent of its conquest." This was reason enough for Gracq to be labeled a surrealist, and it would not have bothered him, insofar as he did in fact share with the movement a strong sentiment of rebellion against the conditions imposed on mankind as well as hope for a possible reconciliation of man with the world and with himself. Moreover, he was very interested in, even fascinated by, German romanticism, and this clearly coincided with the sentiments of Breton and his friends toward the German romantics. Of the poems in prose that he published in 1947 under the title *Liberté grande,* some had initially appeared in the fourth issue of *Quatre Vents,* "L'Évidence surréaliste," and Gracq took part in the catalog of the 1947 exhibition and in the *Almanach surréaliste du demi-siècle.* There was also an affinity between his concerns as a writer and surrealism—or more precisely, Breton the actual individual, who in his eyes incarnated surrealism in its entirety.[8] He remained reserved, however, with regard to the political dimension of the movement (from his viewpoint, a writer must not allow political concerns to intervene in his work) as well as where collective public initiatives were concerned: Gracq would sign none of the pamphlets.

The fact remains that in January 1950, in the periodical *Empédocle,* Gracq published a text that took up the first thirty pages: "La Littérature à l'estomac," published in book form the following month by Corti.[9] While overall it deplored the mediocre state of affairs in literature since the end of the Second World War and vigorously attacked in passing the farce of literary prizes, it also insisted on the fact that the direct contact of

reader with text was increasingly being replaced by second- or third-hand journalistic information, in such a way that celebrity was more often established on the basis of rumors than on taste and reading itself: "A very, very large portion of today's *cultivated* public 'keeps abreast' of the latest strides in contemporary literature more or less in the same fashion that it 'keeps abreast' of the progress in nuclear science: both are things that escape direct understanding, things about which one is informed by the newspapers." Whence the confusion that reigned between literature and that which was not literature—and the instant success of the "existentialist novels," to which Gracq opposed the resistance encountered before the war by surrealist texts. Since the whole point was not to miss the latest fashion, writers found themselves transformed into pretexts for anecdotes, regardless of the value of what they wrote: the public no longer judged, but confusedly recorded names and praised them indiscriminately, while the "great nightmare which haunts the intellectual of the era has been described by Lautréamont: it is that of the child who is *running behind the bus.*"[10]

The distance taken by the writer Julien Gracq with regard to professionals of the pen coincided with the surrealists' disdain, from the time of the movement's origins or even its prehistory, for *littérateurs.*[11] It was no surprise that Breton, approached by the Municipal Council of the City of Paris to accept its Grand Prix, used Gracq's words to voice his opinion, quoting from one of the most virulent passages in his pamphlet: "As we are on the subject of literary prizes, allow me to point out to the police, who in principle punish indecent exposure, that it is time to put an end to the chilling spectacle of 'writers' trained from birth to sit on their butt and whom sadists on the street corner now entice with anything at all: a bottle of wine or a camembert." This ensured that, more often than not, Gracq would be considered one of Breton's "disciples," while a few years later he would acquire the status of a "great writer in the background," for he would only publish to the rhythm of his inner necessity.[12]

Film Enthusiasts

With the issue number 4–5 (August–November 1951), *L'Âge du cinéma* (which would suspend publication with the following issue) openly proclaimed its relation with surrealism: this was a special issue, and its title was designed in such a way that one could read either "Special Surrealist Issue" or "The Age of Surrealist Cinema." It opened with a double list: "Now you see it, now you don't," clearly inspired by the lists once devoted to literature. On one side were the recommended directors (Méliès, Émile Cohl, Louis Feuillade, Mack Sennett, Charlie Chaplin, and Harry Langdon, along with Fritz Lang, Hans Richter, Jean Renoir, Pierre Prévert, John Huston, Man Ray). On the facing page official representatives of "avant-garde" cinema (Abel Gance, L'Herbier, Cocteau) were set amid directors who were despicable for political reasons (Leni Riefenstahl, Nicolas Ekk, Aleksandr Dovzhenko), or by virtue of the adulterated nature of the "poetry" they thought they were putting in their films (Walt Disney), or because of their practice of the most voluntary "realism" (Julien Duvivier, Georges Rouquier, Roberto Rossellini).[13] To the recommended names was added a second list of films that "for various reasons are an exception in the body of their authors' works," where one might find, for example, Preminger's *Laura, Hellzapoppin* by H. C. Potter, *Peter Ibbetson* by Hathaway, and *Malombra* by Soldati (to whom an entire article in the periodical was devoted by the Romanian surrealist group): this was already an indication

that surrealist cinema was often involuntary, something confirmed in essays by Legrand, Nora Mitrani, Brunius, and Benayoun (who further emphasized, in "Détruisez cet enfant" [Destroy this child] the aggressiveness present in the heroic era of American comic cinema). While Goldfayn insisted that the cinema must be conceived "as an undertaking for the transmutation of life," and Péret offered a poem entirely composed of film titles, Bernard Roger did not neglect his architectural training and came up with a "Blueprint for a Cinema in the Bottom of a Lake" (a project where Rimbaud's memories and Captain Nemo's "Nautilus" would converge). Breton's text, which carefully pointed out that as far as he was concerned "the age of the cinema" seemed to have passed, further stated that the situation of the cinema was far from being the most dramatic in an era when writers and artists dreamed of nothing but "commitment" and where one could find a certain number of fairly scandalous comparisons with religion (Matisse and his chapel in Vence). He went on to recall how with Vaché they used to go into movie theaters in Nantes at random, changing films as soon as they began to feel bored, and this now enabled him to give a better definition of the power of the cinema as a power of *dépaysement,* of taking one elsewhere— because at the cinema one immediately shifts from real life into the imagination, because the cinema deals mainly with desire and love, and finally because one can be tempted, as described in *Nadja,* to settle into the theater as if one were at home and to bring along one's everyday activities. But in the end "Comme dans un bois" deplored the fact that the cinema had not kept what in the 1920s seemed to be its initial promises.[14]

Perhaps the most original contribution to this surrealist issue was the publication of Schuster's "Elements for the Irrational Expansion of a Film, Shanghai Gesture": twelve people (the editors of the periodical, but also Legrand, Péret, Schuster himself, and others) answered twenty-five questions dealing with elements absent from the film. ("At what point should there be a snowfall?" "How does Omar behave outside of the film?" "What are the duties of a Doctor in Nothing?" "Who is the character who is inside the dragon at Chinese New Year?") In keeping with the research undertaken in 1933 on the irrational knowledge of an object, the point was to "endanger the very notion of a work of art by revealing how it could be emptied of its subjective content, elaborated, and profitably replaced in an objective circuit by being integrated henceforth into the universal rhythm of time and space." Schuster, at the end of the notes that followed the answers submitted, concluded that "it would be wrong to assume the collective re-creation of the film." The goal of the experiment was to "assure the prevalence of a modern concept of the critical attitude" that he described as "objective-internal," an expression he explained in the following way: "So-called objectivity, which is nothing more than the so-called synthesis of contradictory opinions, is an offense against peace of mind. It is merely the expression most contrary to authentic subjectivity. Real critical objectivity is that which is spontaneously produced when a certain number of individuals, sharing a few basic ideas, are led to judge a performance, artistic activity, or other similar event. It is the third term resulting from the objective-subjective opposition: it is what is meant by objective-internal." Thus, it appears that the sharing of thought also contains a critical impact and that the collection of subjective opinions founded on a community of principles objectively outlines the desire or tendencies of a group. The fact that a film can be approached in this way does not mean that it is any more or any less than the exact equivalent of any other

form of artistic expression, and it is also important to situate it on that level, not only from a theoretical point of view but also through a collective practice.

The end of *L'Âge du cinéma* clearly did not disarm its director, Ado Kyrou. In 1953 he published *Le Surréalisme au cinéma* with the Éditions Arcanes, and it remains, even today, the best-documented work on the subject. It would obviously be inappropriate to expect of it any objectivity of an academic style: on the contrary, it was as a surrealist that Kyrou approached his subject, hiding neither the passionate hope that the surrealists placed from the start in the powers of the animated image, nor their disappointment, nor the demands of the movement with regard to a production that was too often bastardized and purely commercial. "The manifest content of life, for the first time, has been placed on the same level as its latent content, and the result is a surreality in which the public *believes* only when at the cinema. . . . The absolutely natural character of the cinema, similar to that of the dream, is perfectly accessible and acceptable to everyone." Relentlessly pursuing the slightest escape toward surreality in the reels of the world's production, Ado Kyrou wrote a precise history of all those films that since Dada had been of interest from a surrealist point of view. He recalled a number of screenplays written by members of the group, as well as the existence of films by Jacques Brunius; he analyzed *Dreams That Money Can Buy* by Richter (1944), as well as the four issues of a "surrealist review" filmed by Georges Goldfayn and Jindrich Heisler, in which the image was totally dissociated from the soundtrack in such a way as to intensify their effect, and *L'Invention du monde* (1952) by Michel Zimbacca and Jean-Louis Bédouin (commentary by Péret). And of course, an entire chapter was devoted to Buñuel.

Even if relative to the number of films produced since the beginning of cinema the sequences that correspond to surrealist criteria are extremely rare, Kyrou concluded his panorama on an optimistic note: "Guided by the surrealist spirit, cinema must make a one hundred-and-eighty degree turn; it must deny itself, the better to recover its flamboyant power and to offer the total spectacle of *what is*, the better to project us into total life. . . . Cinema is the new myth of mankind—because of its capacity to illuminate all the flamboyant motives of life, because of its power to expose man's unknown and magnetic forces, and because it reveals the true face of the liberated spirit. The cinema will be surrealist."[15]

In 1954 the Éditions Arcane published a study that Brunius had begun in 1947, *En marge du cinéma français*. Although the tone is less passionate than Kyrou's, the conclusion was very similar: "The role of an avant-garde today, if it wants to disrupt some of the comfortable habits into which the cinema is once again allowing itself to slide in utter bliss, will perhaps be to seek a true awareness of that cinema's potential, and of what it ought to leave behind." Brunius summarized the different stages of avant-garde cinema—particularly from a technical point of view—as it had developed in France and singled out the weaknesses of those directors who, officially, were most renowned (L'Herbier, Abel Gance, Germaine Dulac, and others). He then went on to voice his faith in the capacities for the "expression of thought" that still characterized the cinema, "capable of playing on whatever the register inspired by images, movements, sounds and languages," and to such a degree that film "has far more potential than any other plastic or literary art." Once again, however, it was because of its commercial infrastructure but also, and more generally, because of human idiocy that the cinema had not yet delivered what one might rightfully expect of it.

Films made by surrealists were still rare, however, for reasons that were above all financial.[16] Furthermore, their point of view was more easily expressed in the years that followed through film criticism rather than through actual filmmaking. After *L'Âge du cinéma,* film-enthusiasts of the Parisian group progressively joined the team of the periodical *Positif.* Kyrou was the first to join the editorial committee of the periodical, founded in 1952 in Lyon by Bernard Chardère, and Robert Benayoun would come on board in 1957; he would draw people's attention to Jerry Lewis ("Simple Simon, or the Anti–James Dean," no. 29) as well as denounce the use of Sade envisaged by Roger Vailland and Roger Vadim in *Le Vice et la vertu* ("Hands Off Sade," no. 39, a title that explicitly referred to "Hands Off Love," which in 1927 had taken Charlie Chaplin's defense). The presence of the surrealists began to make itself felt in the way in which "in the middle of articles of the utmost seriousness, the periodical would be dotted with word play, bad puns, jokes, insults, invectives" (this according to Éric Losfeld who became the editor after Jérôme Lindon and Jean-Claude Fasquelle from no. 30 on, in July 1959) and by the allusions made to surrealism itself, the emphasis placed on rebellion and desire, or the constancy of an antireligious standpoint. Thus number 40, for example, published a text by Richter, "I Am Not a Filmmaker," which emphasized the importance of Buñuel's *Viridiana* or of *L'Année dernière à Marienbad.* José Pierre would later declare that he "finds in the person of Brigitte Bardot the natural grace of a woman who, through her mere existence, reminds us that freedom is possible, that freedom remains desirable" (no. 45). Legrand chastised the viewers who, conditioned by left-wing cinema reviewers, came to laugh at the screenings of Stanley Kubrick's *Spartacus.*[17] Legrand also greeted René Clair's induction into the Académie Française in the following way: "This man, when he's mummified, must no longer make any films" (no. 47), while the periodical welcomed each new Buñuel film as a major event and published his *Illisible, fils de flûte* along with excerpts from the screenplay of *L'Ange exterminateur* (nos. 50–52 [March 1963]). Benayoun drew attention to "minor" filmmakers (Roger Corman) and to animators (nos. 54–55), and the charms of genres considered the least intellectual were often praised (epics, horror films, or cloak and dagger, in which one must be capable of "capturing poetry in fragments": "The fury of princes, the ruses of princesses, the anxiety of man when faced with his destiny, the power of the supernatural—this would after all be merely placing one's faith in the cinema," wrote Legrand).

It may have been issue number 61–63 (June–August 1963) of *Positif,* almost entirely devoted to eroticism, which most clearly testified to the importance of the group members on its team and who from the start held very different opinions. In addition to the fact that one could find in that issue a survey reminiscent of those periodically published by the group itself, there were also contributions by Legrand, Benayoun, and Kyrou (whose presence was very strong, with articles devoted notably to clandestine pornographic films), as well as Nelly Kaplan and Brunius. Number 66 published a dossier on the film Raymond Borde had devoted to Pierre Molinier (with an essay by Breton), while Legrand, under the pseudonym Jheronym Potocki, gave a serious comparison between the Racinian style of a certain Max Pécas and the Cornelian tone of José Bénazéraf.[18]

It would be going too far to consider *Positif* to be a fully surrealist periodical.[19] It is indisputable, however, that the presence of a few members of the group gave it a certain tone and a certain way of looking at the film industry and of making decisions (be

4

5

1

2

6

3

it about actresses or styles or directors) based more on subjective grounds—the personal equation always subjacent to the expression of desire—than on a rigorous knowledge of the history of cinema. Not that Kyrou, Benayoun, Goldfayn, and Legrand were lacking in their knowledge of the film industry, far from it; but it was not an exclusive determining factor. In this domain as well, the goal was "to love from the start," and independently of the usual hierarchies, since poetry could emerge—all the more marvelous in that it was unexpected—within the very heart of the film that seemed least burdened by artistic concerns: there were those who would remember the age-old lesson of the *Mystères de New York*.

Different Places to Speak Out

While the 1950s have often been considered a period during which surrealism was at an ebb, the movement not only continued to attract new members but also increasingly took up artistic and political positions and broadcast its viewpoints by diversifying the media it used for publication. The surrealists did not always have access to the most widely read newspapers or periodicals, but the fact remained that the collective voice had not ceased from calling on its peers to discuss a certain number of important issues.

Between 1952 and 1958, no less than four periodicals (or even five, if one includes *Le Quatorze juillet*) followed in succession: this can be seen either as proof that each of them failed or as an indication of an obstinate effort to get them going no matter what. Moreover, a regular collaboration was begun in October 1951 with *Le Libertaire,* the weekly newsletter of the Fédération Anarchiste, with whom there had already been some sporadic collaboration.[20] The weekly *Arts* occasionally offered one of its columns, particularly to Péret, and *Combat* would soon do the same.

Although it was clear that the Éditions Surréalistes, far from recovering the vitality of their prewar years, had fallen into a lasting slumber, Éric Losfeld would now in his way become the surrealist publisher par excellence.[21] As the Éditions Gallimard now virtually published only Breton among the older members of the group, it was Losfeld who would take the risks, mainly financial but sometimes also legal, since in order to finance these hardly profitable books he distributed a good number of erotic books, and this resulted in quite a few lawsuits for being "an affront to good morality."[22] He published not only Péret (who in the publishing world was still burdened by the scandal of the *Déshonneur des poètes*) but also new members of the group to whom access to the "major houses" was barred by virtue of their very youth.[23] And it was Losfeld who would ensure the publication of nearly all the periodicals (with the exception of *le surréalisme, même,* which was published by Pauvert at a time when, financially, Losfeld was in a desperate plight): these periodicals were still vital to the collective life of the group.[24]

Médium, informations surréalistes was initially, however, only a sort of modest newsletter, begun in November 1952, designed by Breton and Heisler a few months before Heisler's death. It was a good-sized two-sided sheet, and Schuster took over the editorial position from the third issue on. Among the regular contributors, in addition to Breton and Péret, there were Jean-Louis Bédouin, Adrien Dax, Jean-Pierre Duprey, Georges Goldfayn, Ado Kyrou, Gérard Legrand, and Nora Mitrani, although the shorter notes and articles did not necessarily have a byline. The aim was to take "the

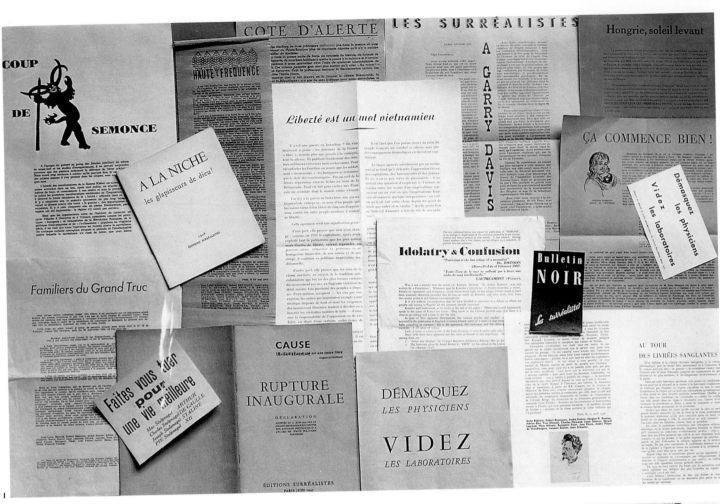

1

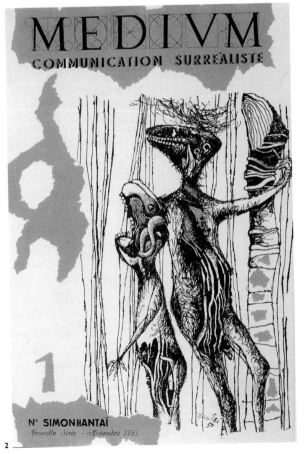

2

3

pulse of the world" (Schuster) by describing the specific events that attracted the attention of the group members in every domain: poetic, artistic, political (where Péret proved to be especially vigilant: almost all his contributions were devoted to denouncing the ambient Stalinism). In the first issue, a short text confirmed Brauner's lasting importance, despite his exclusion from the group: "Despite our differences of another order, masterpieces of vision." *Médium* was published monthly, and kept readers abreast of the latest developments, both within the group and in the outside world: announcements of upcoming publications, a cycle of lectures by René Alleau on classical texts on alchemy, and also (no. 1), the imminent opening of the Galerie L'Étoile Scellée (a name given by the same R. Alleau—the gallery, at 11 rue de Pré-aux-Clercs, was inaugurated in December 1952, with a collective exhibition of paintings, objects, and collages and represented, despite the conflicts and departures, a large range of artists). In *Médium,* number 4 (February 1953), Breton took to task an exhibition devoted to cubism at the Musée National d'Art Moderne: a poorly conceived selection, an over-representation of uninteresting epigones (Albert Gleizes, André Lhote), and negligence with regard to "authentic" artists like Juan Gris, Henri Laurens, or Louis Marcoussis. Legrand and Péret sharply criticized a recent *Anthologie de la poésie française depuis le surréalisme* edited by Marcel Béalu—from the very title, one could sense the implication: surrealism was passé. In number 6, a note referred to the presentation of "Four Imaginists" at the Galerie Babylone: this was the discovery of Max Walter Svanberg. "We wanted," confirmed Schuster, "to mark the date and leave a living testimony of what was happening," but the period chosen turned out to be extremely restrictive, as did the necessary brevity of the texts: just as the eighth issue had come out (June 1953), in which there was, in particular, a review by Breton full of praise for the *Premier bilan de l'art actuel* just published by R. Lebel at the Éditions du Soleil noir, Losfeld planned to transform *Médium* into a real periodical; this would be its second series.[25]

Le Libertaire's "Billets surréalistes"

In June 1947, *Rupture inaugurale,* seeking to distance itself from any political action tainted by the dilemma of inefficiency or compromise, hinted that, in all likelihood, it was in anarchy that "the moral scruples of surrealism would find more appeasement than anywhere else." But in fact, from the very beginning the movement had a sympathetic attitude toward anarchist theories that went well beyond the passing flirtation with communism or mere parentheses. Even quite recently, in *Arcane 17,* Breton had recalled his emotion at the age of seventeen upon seeing, at the Pré Saint-Gervais, something like a "flaming sea" of red flags, "punctuated here and there by the sudden flurry of black flags." The description continued two pages further on with another memory: "I will never forget the well-being, the exaltation and the pride which I felt as a child when I was taken for one of the very first times to a cemetery. . . . I discovered a simple slab of granite etched with red capital letters and the superb motto: NEITHER GOD NOR MASTER. Poetry and art will always have a weak spot for anything which transfigures mankind in this desperate, irreducible appeal which on rare occasions it ventures to make to life."

From the collective point of view, the surrealist movement had from the beginning taken a stance—against the family, against religion, against the power of the state, then for an antiauthoritarian form of communism—that converged with those of anarchy;

from this point of view, the encounter with *Le Libertaire* seemed to be completely justified, if not "normal."[26]

The texts, generally by very active newcomers and which the members of the Parisian group would publish in *Le Libertaire*, emphasized their common ground while carefully pointing out that the authors were nevertheless still speaking as surrealists and that they had no intention of forsaking their usual demands. Nor would they refrain from alerting their readers, when necessary, to the fact that a certain effort must still be made to escape the ossification that remained a constant threat to revolutionary thought: "One can say, without exaggerating, that Breton and his friends will play the role of a true 'popular university' within *Le Libertaire;* their task will consist essentially in preventing revolutionary thought from growing dispersed or rusty, and secondly, in better informing a public of militants of the issues that, as surrealists and intellectuals, they will also have to deal with, both from a moral point of view and from the point of view of literary or artistic expression" (José Pierre). Thus, all of the "Billets" described a certain number of issues that were perfectly representative of the group's ideas in 1951–52: defense of poetry, criticism of the failings of "modern" architecture, anticolonialism, attacks against religion, permanent critique of narrow-minded rationalism, exaltation of love and liberty, denunciation of the academic forms of art—including "socialist art" (André Fougeron), which Schuster qualified as "painting by the knout" before concluding that "the expression 'communist artist' is a contradiction in terms" (May 9, 1952). It is also quite possible that these attacks against the most recent versions of worker control in painting had caused a certain uneasiness among some anarchists, but the fact remains that it was because of an artist that the union between surrealists and anarchists worked most effectively: both groups signed a declaration—*À l'assassin!*—which disputed the presence, because of his Stalinist past, of David Alfaro Siqueiros in an exhibition of Mexican art. The text was published in *Le Libertaire* on May 23, 1952, and would also be distributed in pamphlet form.

In parallel with the billets, Péret published a series of articles on *La Révolution et les syndicats,* in which he showed that trade union organization tended toward bureaucracy and reformism and that only factory committees or councils could preserve a truly revolutionary aim.[27] The film enthusiasts in the group provided a few reviews of recent films (Kyrou, who held that Bresson, with *Les Dames du bois de Boulogne,* had created "one of the masterpieces of postwar French cinema," was dismayed by the *Journal d'un curé de campagne;* Goldfayn felt that *Les Mains sales,* adapted from Sartre's play, went no further than an "adulterated" anti-Stalinism, but he underlined how Buñuel's *Los olvidados* aroused in every viewer a sense of rebellion).

It was precisely because of a difference of opinion between the anarchists from *Le Libertaire* and the surrealists about the nature of revolt, and more precisely about Camus's *L'Homme révolté,* that the relations between the two groups became strained and, then, were severed.

Camus and Rebellion

An article by Camus entitled "Lautréamont and Banality" that appeared in *Les Cahiers du Sud* (first trimester, 1951) provoked a violent reaction from Breton in the pages of *Arts* (where he was inaugurating a collaboration that would eventually include other members of the group) with an article entitled "Sucre jaune" (Yellow sugar).[28] Camus

was accused of having not really understood the *Chants de Maldoror,* of lacking a dialectical spirit (he did indeed "hold Hegel responsible for the ills of our era") to such a degree that he could not even fathom the complexity of the connection between the *Poésies* and *Les Chants,* and above all of "positing the most dubious thesis imaginable, that is, that 'absolute rebellion' can only give rise to 'a taste for absolute servility.' That is an utterly gratuitous and ultradefeatist affirmation, which deserves nothing better than scorn."

"Lautréamont and Banality" was an excerpt from *L'Homme révolté* (The rebel), which was published in the autumn of 1951. Even after he had read the entire book, Breton did not revise his opinion: in an interview with Aimé Patri (*Arts* [November 16, 1951]), he reproached Camus for understanding neither poetry nor surrealism nor the revolution, since he claimed to separate "that which is inseparable, to change life and change the world." Breton accused him of wanting to replace " unlimited rebellion" with "limited rebellion"—"Once you have emptied rebellion of its passionate content, what do you expect will remain? Such a castrated rebellion could be nothing more than the 'wisdom of the poor man' which Camus denies. I don't doubt that many people will be taken in by this artifice: the name has been kept, but the thing has been removed." Unfortunately, the beneficiaries of such a maneuver might be the most reactionary.

This was not the position of the anarchists from *Le Libertaire,* and on January 4, 1952, the newspaper's editor, G. Fontenis, published a long article that was the "fruit of confrontations between a good number of our militants" and contained criticism and reservations (second-hand information, simplification regarding Stirner, Bakunin, "and even Lautréamont," the frequent ambiguity of the formulas expressed, the reduction of the idea of Revolution to Russia alone, etc.). It concluded on a positive note: "Camus has chosen his rebellion. Such a commitment cannot be abandoned lightly."

This article provoked an immediate letter from Schuster: "When [the forces of] reaction display Stalin's crimes in broad daylight with a caption 'This is the Revolution,' it is our duty to say that this is not the Revolution and to prove why it cannot be. This task, which should be that of all free-thinking people, was also that of Camus. Not only did he fail, he switched completely to the opposite direction."[29] But *Le Libertaire* did not publish this article, so it would be up to a billet by Kyrou on May 30, 1952, really to poison things: "The 'rebels' follow Camus, they talk of revolt, analyze it, dissect it and finally bury it (whether consciously or not) beneath their scalpel. All these batrachian types kneading ideas and words in their own image. But it is not because Camus violates the word 'rebellion' that the rebellion belongs to him. We are the rebellion." Feeling accused, the following week the anarchists published an article contesting Kyrou's "unacceptable tone." They were clearly beginning to feel that their surrealist guests (and without a doubt Kyrou had violated the "laws of hospitality") had gone too far; there would be a few more billets, but some of their initial trust had been destroyed.

The surrealists were far from having finished with Camus, however. Legrand, Péret, Bédouin, Dax, and Schuster organized a special surrealist issue for the Marseille periodical *La Rue* (no. 5–6 [June 1952]) devoted to *L'Homme révolté* and entitled "Rebellion Made to Order." In his text, "The Sunday Rebel," Péret reproached Camus not only for having no direct or sufficient knowledge of the theoreticians he criticized but also for wanting to "discredit all forms of revolution" by repeating that the revolution-

ary, inevitably, is transformed into a "policeman and bureaucrat who rises up against rebellion," without ever advancing a positive concept of the revolution. In *La Révolte en question* one could find many negative reactions on the part of the surrealists, or those close to them, with regard to the same book.[30]

Offensive against Socialist Realism

The denunciation of socialist realism was nothing new. When in 1935 the Éditions Surréalistes published Dalí's work *La Conquête de l'irrationnel,* the book was labeled with a red wrapper: "Confronting Socialist Realism." (This was the same year that Aragon published for the Éditions Denoël et Steele *Pour un réalisme socialiste,* a collection of lectures followed by a few speeches given by Soviet delegates at meetings held in the Soviet Union; the collection concluded with these lines from Avdeyenko, a "delegate from the Ural region" at the Seventh Congress of the Soviets: "When my beloved wife gives me a child, the first word I will teach that child will be, *Stalin.*") This hostility would find a new raison d'être in the 1950s, since it was now in France itself that the Communist Party had been trying, since the Liberation, to impose the depressing version of art that Moscow demanded.[31]

On December 27, 1951, *Les Lettres françaises* published an article by Aragon devoted to contemporary painting in the USSR; Breton replied, in *Arts,* on January 11, 1952: "Why Is Contemporary Russian Painting Being Hidden from Us?"[32] Aragon's article was indeed illustrated only with a self-portrait by Matisse, of all people. Basing his opinions on a translation of *L'Art soviétique* that had appeared in the same *Les Lettres françaises,* Breton felt a "bitter delight" in noting that the so-called rehabilitation of the subject advocated by socialist realism had led to a confusion between this "subject" and the "flattest, or most scathing, when it is not the most sordid, *anecdote.*" Breton also delighted in mentioning some of the "subjects" prescribed to artists in Hungary: *The First Tractor Arrives in the Village; Preparations for Stalin's Birthday,* and so on. The titles of the works quoted by *L'Art soviétique* were equally descriptive: *The Stakhanovists on Their Shift, Children Offering Wishes to Joseph V. Stalin on His 70th Birthday.* Criticism of such canvases was itself, in the USSR, extremely timid and at the same time striking for its policing tone. Breton gave a few examples of public reactions, as encouraged by the officials: it was deplorable that a Stakhanovist, even if he was "on shift," seemed to be idle (and in the foreground of the painting!—which undoubtedly made his case worse); a dove seemed to be larger than life and one might wonder where it was flying and where it had come from, and so on. "The truth, carefully sealed, is that contemporary Russian art, within the ridiculous limits in which it is allowed to function, has been incapable of producing anything which might go beyond what here passes for an old image from a department store calendar or the tasteless village print." Breton then demonstrated that the situation was the same in the "people's" republics: Picasso was referred to as "rotting," and it was loudly proclaimed that "Matisse does not know how to draw." Wherever Soviet power reigned, one was forced to concede that "one is dealing with an undertaking of systematic destruction, the extirpation by any means possible of that which for centuries people have learned to appreciate as art worthy of the name."

At the end of the article Breton turned to Picasso and Matisse, asking that they refrain from showing any friendship toward the political friends of a regime that sup-

ported something that was a mere parody of art and that they not be naively seduced "by the wild praise heaped upon them here by those who, there, would put them in the stocks," for they were taking a huge responsibility "when they approve in their name an undertaking which requires dealing a mortal blow to artistic conscience and freedom, something which had been the entire justification of their life."[33]

Perhaps for art lovers of the 1980s and 1990s, this attack seems excessive, given that the mediocrity, not to mention the nonexistence, of socialist realism both in painting and in literature has now been almost universally recognized, to such a degree that it now seems a cliché. But the atmosphere in the 1950s was very different and warranted a virulent reaction, particularly as in France itself the Communist Party was encouraged by the Cold War to extend the struggle into the cultural domain and sought to impose "works" similar to those authorized in Moscow.

"An exhaustive reading of the documents produced at the time leads one to conclude that these idiosyncratic works, now forgotten, held an important place in the life of the Party: the space devoted to them in the press, in publications, politico-cultural events, the numbers of militants who were involved, the attention given to them by leaders ... are all proof of this."[34]

In fact, Adrien Dax had already opened the debate in *Le Libertaire* (November 23, 1951) with a billet entitled "Subjugated Art—Committed Art" in which, after deploring the fact that "modern art is constantly offering its services"—both to the church and to the influential rich—seized the opportunity to point out the mediocrity of the handful of examples of socialist realism "à la française" at the Salon d'Automne: these were no more than mere results of propaganda, "the painted canvases of a juggler." "Art like this, by demanding to be assimilated with the most loathsome religious productions, can no longer allow one to invoke either realism, or socialism." A protest was published at the same time as this billet, in the name of freedom of expression, "against the removal by the police of a few 'socialist realist' paintings exhibited at the Salon d'Automne." The text was unequivocal: this was "bad painting in the service of a bad cause," but the lesson of the Breton-Trotsky manifesto was not forgotten: "all freedom in art."[35]

In the meantime, *Les Lettres françaises* published a few reproductions of Soviet art, so the French public could finally judge for itself. These works were meant to accompany Aragon's series of "Reflections on Soviet Art" (until April 3, 1952), in which he mixed a suspension of judgment ("Yes, Soviet art is another language. . . . I am not God the Father. I cannot change your taste"), with silence on the artistic avant-garde of 1910–30 (the Russian people had not chosen the path of abstraction, something that was not "as surprising as it might seem at first to art circles in Paris and New York"), pseudo-reflections on the conditions of public statuary, and admiration on command for the Stalin prizes, which he went on to describe.[36]

As there were reproductions available of these very official Stalin prizes, Breton raised the tone in a new article he wrote for *Arts* (May 1, 1952), "On 'Socialist Realism' as a Means of Moral Extermination."[37] "The evidence is that one has never gone to such extremes in this aberrant 'cemetery art,' nor in those platitudes which woo emphasis." He denounced Aragon's intention to crush art forever and pointed out that the enthusiasm with which Aragon supported the worst production was beginning to worry even the Communist Party painters. Breton emphasized how a surface approval of socialist realism led to a practice of mental restriction, reminiscent of a Jesuit partic-

ularity. And the artists of the Communist Party, during a meeting held on April 23 and 24, instead of resigning or agreeing to a few exclusions, sent two messages: one to Maurice Thorez to thank him for his enlightened counsel, which would allow them to progress toward "art inspired by socialist realism," the other to Picasso, to assure him of their "trusting affection"—while his very work represented the "boundless negation" of the very thing to which they claimed allegiance.[38]

Schuster, once again in *Le Libertaire,* renewed his attacks with "Painting by the Knout" (May 9, 1952): "From the petty bourgeois (who is delighted by the amateur art fair on the boulevard de Clichy) to the Stalinist militant, a common front has been established against the dangers of subversion represented by authentic art." The billet concluded with a new reference to the meeting on April 23 and 24, which had emphasized "an irreducible contradiction within the artistic policies of the Stalinist party," incapable of reconciling the admiration shown for Picasso with obedience to Zhdanov's principles.

In reexamining the Fougeron case in *Le Libertaire*'s last "Billet surréaliste" (January 8, 1953), José Pierre began by underlining the duplicity, however involuntary, of socialist realism in painting: the subjects chosen—man at work, for example, on the pretext of denouncing alienation—prevented the viewers one claimed to address from understanding or appreciating such "works."[39] "Do you know many workers who decorate their room or their kitchen with a photograph showing them hard at work? The calendar from the post office, more likely!" As a result, Fougeron's canvases were destined either to decorate bourgeois interiors for their picturesque or exotic side or to remain a political tool for the exaltation of work: "'Look at what a fine subject for a painting you are,' one says to the worker, 'look at your picture; well then! You'd better be faithful to your image: *Get to work!*'" Thus, this painting, which was felt to be "progressive," became "an act of betrayal of the working class," since it placed "work on a higher level than the liberation of mankind": artistic regression went hand in hand with social and political regression.

Diffusion or Disappearance?

It is commonplace to deplore the absence of any important new artists within the surrealist movement in the 1950s, something that can only be justified by a sort of retrospective illusion: insofar as a few painters in the group had begun to benefit from a certain public notoriety by then, it was easy to forget that this recognition was long overdue, since they had begun their careers already well before the Second World War. In addition, it was also at this time that Dalí, in the press (and not only the American press), attained the status of the surrealist par excellence—the rumors that revolved around his activities were at least partly responsible for the eclipsing of new artistic ideas being developed or encouraged within the group. Finally, one should remember that the 1950s were almost entirely devoted to the debate between partisans of figurative painting and those of abstraction (the best representatives of which were only now achieving recognition, although their work had also begun before the war).

Moreover, it was through the prewar surrealists that the movement at this point in time had a diffuse influence on quite a few artists. When they presented the results of a survey on the "Situation in Painting in 1954" (in *Médium,* no. 4 [January 1955]), Charles Estienne and José Pierre noted, first of all, that "it seems that the very idea of

surrealist painting has met with only limited approval. There has been a persistent attempt, despite evidence to the contrary, to reduce this painting to its smallest measure—the realism of the unexpected, trompe-l'œil, and its sundry paraphernalia. . . . There are those who want to lock surrealist painting away within historical limits, along with surrealism as a whole, the better to consecrate the 'renaissance' of realism for some, and the abstractivist tide for others." The two editors did note, however, the existence "in the margins of surrealism" of works that, in moving away from geometric abstraction, were gaining in poetic resonance and that could "modify the situation of surrealist painting in the contemporary art world." Their survey aimed, in particular, at pinpointing the aims that would allow for an agreement between the authors of these works and surrealism itself.[40]

In October 1956, the periodical *Preuves* published an article by Alain Jouffroy, "The Situation of Young Painters in Paris." Although Jouffroy was no longer part of the group, he remained quite faithful to the group's principles and, concluding that the situation was on the whole mediocre, he deplored the role of the market that prevented artists "from obeying the principle of inner necessity—the only law of artistic creativity." He also found that the majority of painters "are far more concerned with the way in which they paint than with what they are painting" and concluded that genius consisted in "immersing oneself in an inner world, as the surrealists so magnificently demanded of themselves. . . . I believe in searching for the formulation of a personal mythology, where mankind, love, the universe, and divinity would find new artistic definitions." Still more symptomatic was the synthesis in which he then, with K. Jelensky, put together the responses to a "Survey on Young Painting," underlining "the influence of the surrealists of whom the painters never speak in their responses, however—as if there were a taboo (and that is what still gives it its strength) associated with the surrealist movement itself. Young painters have declared almost unanimously that what interests them above all is *the exploration of the inner world,* something André Breton describes better than anyone else. We are therefore dealing with a group of Messieurs Jourdains, who are surrealists without knowing it." The fact remains that the gap between these "surrealists without knowing it" and those who proclaimed themselves surrealists was still, without a doubt, considerable.

The result was that a somewhat outmoded image of surrealism predominated: surrealism was history now, and the hasty judgment was that it could no longer come up with anything new and original. It was even feared that the recapitulation of the movement's history, by Breton himself in a series of radio interviews from March to June 1952, would, despite his insistence on the presence of a new generation in the group and the foreseeable future of the movement, have a perverse effect upon the public.[41] Since Breton himself had begun to speak of the movement in historical terms, would it not be fair to conclude that there was not much one could expect of surrealism in the way of new contributions? Might then its diffuse influence be interpreted as additional proof of its obsolescence?[42]

New Artistic Ideas

Now less than ever could surrealist painting be limited to an aesthetic or a style. In 1952, Breton published "The Work of the Twentieth Century" in *Arts*, fifteen days after "Socialist Realism as a Means of Moral Extermination."[43] Devoted to the exhibition at

the Musée d'Art Moderne presented by J. J. Sweeney, the article can be read as symptomatic of a breadth of vision that was shared, in varying degrees, by all the members of the group. While Breton did not refrain from deploring France's artistic policies, which allowed a number of masterpieces to be sold abroad, he was attentive not only to those artists he favored personally but also to Giacomo Balla, Modigliani, Mikhail Fyodorovitch Larionov, and Malevitch. He emphasized that the works included in the exhibition (even if some of them seemed a bit too weak to represent their creators in their best light) confirmed the only possible response to the "indigent figurative rendering" of the realism required by the different manifestations of totalitarianism: "an explosion of freedom." The history of modern or contemporary art over the previous fifty to seventy years now appeared, thanks to this exhibition, as a "great spiritual quest" that "sought the expression of the latent content of our era, the only one which matters as a 'good adventure' for which man is truly suited, with a view to reconciling his aspirations and his premonitions." Such a global interpretation of this history characterized the surrealist point of view, and it was rarely found among art historians. It had the advantage, while conferring meaning on the artistic adventure, of accommodating heterogeneous styles, and this would be confirmed by those painters recognized by the movement throughout the 1950s.

In November 1950, Breton and Jean Cassou wrote a preface to an exhibition of the Mexican painter Rufino Tamayo for the Galerie des Beaux-Arts.[44] Tamayo was born in 1899 and before the war had practiced a muralism that was far less politicized than Diego Rivera's. His Indian origins, as well as the work he had accomplished as a curator for the ethnographic drawing department of the National Museum of Archaeology, had led him to reflect on the ways in which the Indian identity could be given a universal significance. In the political context of the era—Breton's preface would open with a reminder of the existence of two "predatory ideologies" confronting each other—Tamayo's painting with its "measured" tone must be viewed as exemplary, insofar as it evokes daily life while conferring an unusual lyrical dimension upon it, one in which Breton could sense the resonance of the Mexico he loved: "In Tamayo's work, one inhabits a trembling world where man has retained direct relations with the forces of nature." Beyond any local color and far from any exoticism, what matters is the background of everyday magic that informs his paintings, validating their use of color and the distortion of the figures; the human communes with space and the plant world and establishes a harmony with the elements that goes beyond any traditional humanism. According to Octavio Paz, Tamayo's "refined and savage" canvases teach us that "the conquest of modernity is determined by the exploration of Mexico's underground. Not the historical and anecdotal underground of the muralists and realist writers, but the psychic underground. Myth and reality: modernity [is] the most ancient antiquity, but it [is] not a chronological antiquity; it [is] not in the time of before, but in the very moment, deep within each of us."

One is tempted to offset Tamayo's euphoric side with the very different dramatic element found in the works of Simon Hantaï or Judit Reigl, shown at L'Étoile Scellée in January 1953 and November 1954, respectively. The fact is that both of these painters looked out on a very different horizon: that of the far less "sunny" country that was Hungary.

Hantaï arrived in Paris in 1949, but it was not until December 1952 that he left at the door of Breton's studio on rue Fontaine a painting-object—a sort of dual signal, of

distress and affinity. One month later, sixteen of his works were exhibited at the group's "official" gallery, and in his preface Breton said that this was "something which might occur once in ten years, *a great departure*."[45] Hantaï's work did come across as being full of potential, capable of leading him very far along the path toward revealing his inner demons and the affinity between man and the other kingdoms. Varying his techniques (grattage, painting-objects, collage), he introduced into his vision of specters or monsters cellular forms that were transformed into memories of femininity. Using scrap material (fish bones, animal bones, scraps of newspaper) he unveiled the secret fermentation of the underground and marginal zones, capable of engendering very disturbing hybrids, and there is in his painting an ambiguous atmosphere of seduction and lurking catastrophe. By November 1953 his potential seemed to warrant inclusion of one of his works in the "Modest Proposition" for a surrealist exhibition that Jean-Louis Bédouin published in *Médium*, number 1 (also entirely illustrated by Hantaï).

Judit Reigl had come from Hungary in 1950 and was introduced to Breton by Hantaï himself. In her work, dream visions are unleashed to such a degree that Breton found her painting *Ils ont soif insatiable de l'infini* (They have an insatiable thirst for infinity) to be an image worthy of Lautréamont. Her vision seemed indeed able to unite in her work elements of authentic automatism—partly responsible for the disposition and scale of her figures, as well as for the use of gestures evocative of nonfigurative cosmic space—and a source deriving from dreams.

Yet this harmonious relation would be short-lived: in 1955, Hantaï and Reigl (whose increasingly gestural automatism now seemed, from a surrealist point of view, to be going nowhere) left the group. In December 1956, Reigl showed her most recent work at the Galerie Kléber, and the introductory texts, which she had written together with Hantaï and Mathieu, finalized the break. The pamphlet *Coup de semonce* (signed on March 25, 1957, with thirty-two names) would later respond, along with an article by Charles Estienne in *Combat,* to the "Commemorative Ceremonies of the Condemnation of Siger de Brabant" organized in 1957 by Georges Mathieu and Hantaï at the Galerie Kléber. While the two organizers of the festivities preached for a return to Christian values or for the recognition of a new feudalism, *Coup de semonce* denounced their obscurantist aims, their "feudal type of offensive" (Breton) and recalled "the right to demand at present that [every artist] make a *moral* commitment, however minimal, but unequivocally, with regard to the vile tyranny whose leader, whatever his mask, *is in Rome.*" Hantaï committed a second offense in 1958 by publishing "Notes confusionnelles accélérantes et autres pour une avant-garde réactionnaire non réductible" (Deliberately confusing, accelerating and other notes for a reactionary and irreducible avant-garde)—a title in and of itself indicative of a deliberate intent to connect the "avant-garde" with right-wing principles, which the atmosphere of the era made particularly threatening. And this time the painter claimed, moreover, to enroll Michaux, of all people, in his "reactionary avant-garde," and he launched a series of attacks on the subject of surrealism. Some of the expressions he used were reminiscent of the reception once reserved for Freudian theories by the majority of French "intellectuals": "libertinage of pleasure . . . bestiality sweeping over the wilderness left by atheist rationalism . . . uniformity of the lower depths . . . submission to the spirit of sex—religion of animal desire, voracity," etc. In an article published in number 59 of *Lettres nouvelles* (April 1958), Geneviève Bonnefoi, who could hardly be accused of systematically defending surrealism—she recalled in passing that its "shortcomings, its excess, its

1 Invitation to the Hantaï exhibition at the Étoile Scellée, Paris, 1953.

2 Simon Hantaï in 1957. Photograph by Denise Bellon.

3 Cover for the catalog of the Judit Reigl exhibition at the Étoile Scellée, Paris, 1954.

4 *Coup de semonce*, a pamphlet denouncing the exhibition at the Galerie Kléber, March 25, 1957.

COUP

DE

SEMONCE

À l'époque où, guitare au poing, des Jésuites assaillent les scènes de music-hall et les studios d'enregistrement, il ne devrait surprendre personne que des peintres endossent la défroque de frères prêcheurs. Nous avons trop tendance à oublier qu'ils peuvent être, le cas échéant, des *artistes* comme il s'en produit dans les cirques, sous une pluie de gros sous.

L'intérêt des manifestations de la Galerie Kléber est ailleurs. Qu'on puisse accrocher dans un lieu, après tout *public*, un crucifix de trois mètres de haut, et commémorer à son ombre et sous la protection de la police les premières manifestations médiévales de l'Inquisition, suffit à prouver la totale décadence de la « laïcité » officielle dans ce pays. Il y a cinquante ans, la moindre procession un peu trop tapageuse voyait se dresser contre elle toute « la gauche », des opportunistes aux socialistes. Il y a cent cinquante ans, en pleine Restauration, pareil exploit eût été impensable : le régime n'y aurait pas survécu.

Bien que les organisateurs aient eu l'habileté de consacrer un cycle d'études à Descartes et à Voltaire, considérés comme les prototypes « bourgeois » et rationalistes de la Révolution Française, de la politique franc-maçonne et de « l'avilissement » populaire au vingtième siècle, il est clair que toute l'opération est montée *contre le surréalisme*. On n'attaque certaine conception étriquée et périmée de l'intellectualité contre laquelle le surréalisme n'a cessé de lutter, que pour mieux

Above: Rufino Tamayo,
Nachtstück (1959).

Right: Rufino Tamayo, *La fuente*
(1951). Fine Arts Museum,
Caracas.

Above: Simon Hantaï, *Untitled* (1952). Private collection.

Right: Simon Hantaï, *Untitled* (1953); collage: string, painted cut-out photographs on paper mounted on canvas, 24 × 18⁴/₅ in. (60 × 47 cm). Musée National d'Art Moderne, Centre Georges Pompidou, Paris.

Above: Judit Reigl, *Thunder* (1956); oil. 60 × 70²/₅ in. (150 × 176 cm), Galerie de France, Paris.

Right: Judit Reigl, *They Have an Insatiable Thirst for Infinity* (1950); oil on canvas, 44¹/₅ × 39²/₅ in. (110.5 × 98.5 cm). Private collection.

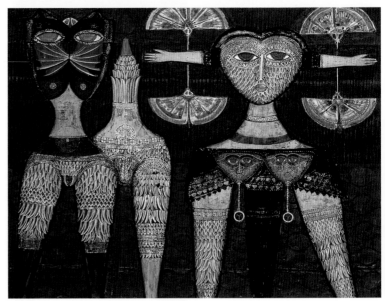

Above, right: Marcelle Loubchansky, *Untitled* (1959); 24 x 29¹/₅ in. (60 x 73 cm), Galerie Carole Brimaud.

Above, left: Max Walter Svanberg, *La Femme sombre à la rencontre de l'animal porcelainier* (The dark woman meeting the porcelain-bearing animal; 1959); gouache, 40 x 28 in. (100 x 70 cm). Private collection.

Right: Max Walter Svanberg, *Le Cœur de l'intangible* (The heart of the intangible; 1956); gouache, Private collection.

Jean Degottex, *Sang du cormoran*
(Blood of the cormorant; December
1955); oil on canvas, 52 × 64⁴/₅ in.
(130 × 162 cm). Private collection.

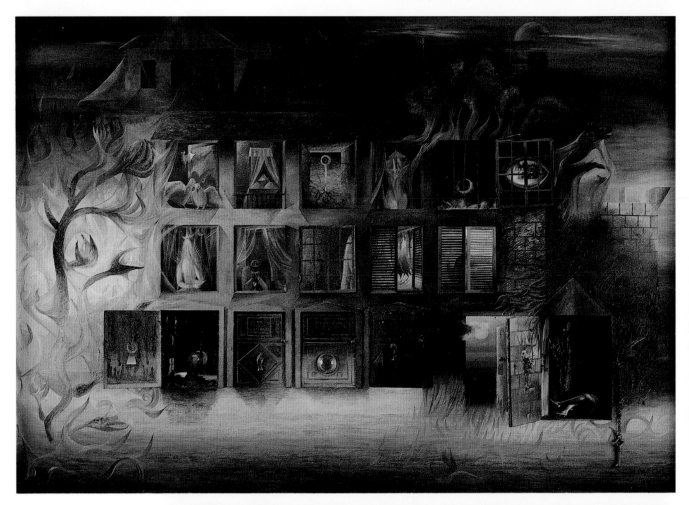

Above: Mimi Parent, *J'habite au choc* (I live in the shock; 1955); oil on wood, 23³/₅ × 33³/₅ × 3³/₅ in. (59 × 84 × 9 cm). Private collection.

Right: Mimi Parent, *Le Viol* (The rape; undated); painting in three dimensions, 24²/₅ × 31¹/₅ in. (61 × 78 cm). Private collection.

Above: Pierre Demarne, *La Forma-tion seule* (The formation alone; 1947); oil on canvas, 23²/₅ × 36¹/₅ in. (58.5 × 90.5 cm). Private collection.

Right: Édouard Jaguer, *D'un jardin à l'autre* (From one garden to the next; 1944); mixed media, drawing and collage, 11³/₅ × 16 in. (29 × 40 cm). Galerie 1900-2000, Paris.

Above: René Duvillier, *La Mer à Gwen-Trez* (The sea at Gwen-Trez; 1955); oil on canvas, 24 × 40³/₅ in. (60 × 101 cm). Galerie Mostini, Paris.

Right: Yves Laloy, *Le Mal est mon seul bien* (Evil is my only good; 1957); oil on canvas, 26 × 36⁴/₅ in. (65 × 92 cm). Private collection.

naïveté have been denounced hundreds of times"—pointed out that the publication of a manifesto of this kind coincided, typically, with a new edition of Nadeau's *Histoire du surréalisme,* as well as the publication of *La Question,* in which Henri Alleg denounced torture as it was being practiced on a systematic basis by the French army in Algeria. Bonnefoi stated that between the France of 1958 and the France of 1926 (the era of the Rif war in Morocco), "nothing has changed . . . , or very little. The forces in power that Breton and his friends were fighting against are still in power." As for those forces in question, she felt obliged to enumerate them: "bigotry, militarism, racism, narrow-minded chauvinism—in a word, all the components of fascism." In a "testimony" that accompanied Bonnefoi's article, Breton, in turn, recalled the "coincidence" that linked Hantaï's stance with *La Question,* the distribution of which the ruling powers were trying to prevent (Breton said that Goldfayn had been ordered to destroy the copy he was reading on the bus!), and concluded that Hantaï was, together with others, in the process of providing a pseudointellectual framework to the rise of fascism in France.[46]

Relations with Max Walter Svanberg were fortunately more lasting than with Reigl and Hantaï. Although the group did not discover his work until an exhibition of Swedish imaginists was held in April 1953, Svanberg had already had, in 1935, what was for him the revelation of "surrealist thought," and in 1949 the imaginists took part in the surrealist exhibition in Stockholm organized by Freddie and Gösta Kriland. The female body fascinated Svanberg, and this would strongly influence his style, as well as lead to an exchange of letters. (Svanberg would come to Paris for the first time only in 1964.) He was immediately solicited to contribute to publications, and would illustrate number 3 of *Médium* (May 1954), introduced by an "Homage" from Breton that emphasized the credit that was due to Svanberg for "a world which is nothing other than 'scabrous,' in the most subversive sense of the term." He exhibited at L'Étoile Scellée in March 1955, responded to the group's surveys, and took part in the major group shows; meanwhile, some of his poems were translated into French and published in *La Brèche* in 1964. To mark the event of his second solo exhibition at the Galerie Raymond Cordier in 1961, he received a collective tribute signed by ten surrealists.[47] This seamless harmony was also evidenced by the praise reserved for his illustrations for the first Swedish edition of Rimbaud's *Illuminations* ("There is nothing more beautiful!" exclaimed Breton when he received the book) or for the drawings that decorated the covers of some of the books by Bédouin, Mansour, or François Valorbe. And this harmony with the group was due largely to the ongoing and inspired miracle of his obsession with Woman, an obsession that "led only in the direction of a marvelous transfiguration, radically oblivious of depressing allusions, abject analogies, or nauseating descriptions" (José Pierre). It was also that "perhaps . . . the mortifying notion of *sin* had never been so superbly trampled underfoot—as if it were drawing ever closer to the altar of mad love."[48] A sense of adornment worthy of Gustave Moreau, the innocence of a world given over remorselessly to fantasy, woman perceived as the primary mediator granting access to all the secrets of the world: Svanberg's themes were fully in keeping with the movement's goals.

In 1955, someone "obsessed with Woman" of a very different kind would arrive on the scene. Pierre Molinier had already sent small photo portfolios to Breton of his canvases, as well as some of his poems, and they had begun to exchange letters.[49] Isolated in Bordeaux since the end of the 1940s, Molinier had led the life of a semirecluse amid occasional rumors of his "debauchery"; after painting landscapes and portraits in a

1

2

Solde

3

1 Max Walter Svanberg, *La Vision déployant son visage* (Vision displaying its face; 1956); color lithograph.

2 Max Walter Svanberg, *Solde*; illustration for Rimbaud's *Illuminations* (1957).

3 Max Walter Svanberg, *Hommage des constellations étranges à G. en dix phases* (Homage of the strange constellations to G. in ten phases; 1964); collage.

fairly conventional style, he had been developing a work of absolute singularity, inhabited by what Breton called "devouring *belles dames,*" who gave the work a "burning, searing climate." More fascinated by painted fingernails, long legs sheathed in fishnet stockings, pinched nipples (Molinier himself would confess to particularly sensitive nipples), fellatio, and fondling than by the sexual act itself, Molinier was a transvestite, played androgynous roles, had his picture taken rigged out in leather and wearing high heeled shoes; he would create erotic photomontages and transfer his fantasies onto each of his canvases in an atmosphere of secret magic and black masses. Eros in his work is more than merely sulfurous: it is made manifest in fetishism, in the reduction of the body to its obsessive parts alone, their dreamlike expression a function of the power of desire.[50]

In January 1956, Molinier was presented at L'Étoile Scellée with eighteen canvases and drawings; the catalog was prefaced by Breton: "From a fusion of jewels where the black opal dominates, Molinier's genius has given birth to a woman who is no longer thunderstruck but thunder-striking; he portrays her as a superb beast of prey." This woman gave a face to the heroines of *Moine* and *Rideau cramoisi,* as well as to Madame Edwarda and the Lucie in Joyce Mansour's *Jules César.*[51] Although the exhibition did not have a great deal of success with the public, Molinier felt that he had "found among the surrealists a total understanding of what was within [him]," which would later be confirmed by his contributions to four out of five issues of *le surréalisme, même* (including the cover photograph for issue number 2) and his participation, in 1959, in the *Exposition inteRnatiOnale du Surréalisme* (EROS).[52] Relations would eventually grow cooler, however, but not necessarily because of the "blasphemous nature" (P. Petit) of the canvas he prepared for a later event, even though he planned to exhibit a double-ended dildo at the same time. One might be forced to agree with Jean-Jacques Pauvert that, apart from Breton, "everyone, in the little group, was against it. There was a sort of traumatism: this completely sexual side to Molinier's painting was rather repulsive to them.[53] Raymond Borde's film about Molinier urges one to temper this opinion, even if the film is also an indication of the role played by collective decisions within the group. But perhaps one should also take into account—above and beyond the crudity (very relative, after all) of the sexuality displayed—its repetitive nature: Molinier's use of the imagination in his canvases remained, in his own domain, modest—most likely because his work was enough to satisfy his passion, but one can also understand why others grew tired of it. The fact remains that after 1963, and despite his friendly relations with Joyce Mansour and Clovis Trouille, his ties with the group were suspended.

Charles Estienne's Contributions

The issue of *Médium* that came out in February 1953 contained an excerpt from an article, "Abstraction and Surrealism," published by the critic Charles Estienne in *L'Observateur.* Noting the failure of purely "decorative" abstraction, along with the disappearance of "surrealist imagery," Estienne said that "with the most extreme examples of abstract art and a type of surrealism that has not expanded but, quite to the contrary, has been reduced to its principle, we have in hand the two essential keys to modern art." This article was the logical continuation of a reflection begun much earlier on the ossification that was threatening abstract art in its most geometric and controlled ver-

1

3

2

4

6

7

5

sion, a reflection that in the context of the 1940s and 1950s—during which there was a sterile debate between the proponents of abstraction and the partisans of realist figurative art—made its author the initiator of a "healthy mess among all these terribly serious intellectuals who walked around like bailiffs with their science dangling at the end of a chain."[54]

In March 1946, Estienne stated, in *Confluences*, that if a work is to appear authentic "the artist has to remain scrupulously faithful to the initial spark and to its unpredictable meanderings into the material into which it embarked."[55] This allowed him to refer in passing to Kandinsky and to dispel an ambiguity: "This is not only a dream world, but also a world of shapes without any utilitarian destination, the stuff of which, insidiously, is double that of the concrete world."[56] Placing his trust in "a certain automatism," he could then draw attention to the careers of Jean Atlan, Gérard Schneider, Hans Hartung, or Deyrolle.

It was in 1950, in the volume *L'Art abstrait est-il un académisme?*(Is abstract art an academicism?) that Charles Estienne would provide even more solid proof of his desire to bring the most fertile version of abstract art closer to surrealism, with extensive references to Kandinksy, Wilhelm Uhde, and Breton to support his argument.[57] He also advanced "something scandalous" that was totally in line with the group's own position: "Painting is not an end in itself, nor is it a satisfaction in itself, be it of an olfactory order or, on a higher level, cerebral. In any case, if one is motivated by the slightest intellectual courage, things will not stop there. However well-defined or even singularly lively a painting may be, it is not the living center—artificially living—of a dead world. Its perfection and imperfection, its grace and privilege are those of placing us in relation with an order of things that perpetually reevaluates the external order, the established order of things." It was not surprising that with principles like these Estienne would become a fellow traveler for Breton and his friends.

In March 1953, at L'Étoile Scellée, Estienne introduced four young representatives of what he would define as "lyrical abstraction": the work of Jean Degottex, René Duvillier, Marcelle Loubchansky, and Jean Messagier had, in appearance, nothing in common with the conventional image of surrealist art: no dream images, no arbitrary metaphors. Rather, the gesture was deployed on the canvas in response to various impulses that emerged from different inner recesses. As the foreword pointed out, "The most authentic abstract awareness does not stop at the 'no' addressing the comedy of appearances, but says the 'yes' of greatest risk to anxiety, as well as to the treasures of the buried world." These explorations of "the treasures of the buried world" had doubtless only just begun; they would continue to increase for some time in affinity with surrealism. Degottex had a solo exhibition at the same gallery in February 1955, with a preface written by Breton.[58] In June 1955, Duvillier was presented at L'Étoile Scellée, with three forewords, by Estienne, Breton, and Péret; and in February 1956, Loubchansky showed her canvases at the Galerie Kléber, with a preface by Breton.[59] At the same time, Estienne increased his participation in events organized around the convergence between "tachisme" and surrealism: in October 1953, his "Manifesto 22," a preface to the catalog of the Salon d'Octobre that he had organized, asked that "the interior of sight" become the "exterior of vision"; in March 1954, he published in *Combat* his text "Une révolution le tachisme," with an inset recommendation from Breton, "Leçon d'octobre": "It is time—given, in particular, the dubious way in which there has been a proliferation, with no end in sight, of art works purported to be 'abstract' in inten-

1 In Ouessant, September 1957.
From left to right: Sophie M., Toyen,
Benjamin Péret, Clarisse, Élie-
Charles Flamand, André Breton, and
Charles Estienne.

2 Christian d'Orgeix, *Untitled*
(1958); ink, watercolors, and
gouache on paper, 12 × 10 in. (30.2
× 24.8 cm).

3 Charles Estienne in 1955.

4 Jean Degottex, *L'Épée dans les
nuages* (The sword in the clouds;
1955); oil on canvas, 52 × 38⅛ in.
(130 × 97 cm). Private collection.

5 Christian d'Orgeix, *Les Clefs de la
naissance* (The keys of birth; 1953);
mixed media, 80 × 28 in. (200 × 70
cm).

tion—that we be given the thread to the labyrinth." The fourth issue of *Médium*, which came out in January 1955, published the results of the survey launched by Estienne and José Pierre, "The Situation in Painting in 1954." Of the forty-five responses that José Pierre used to compile a selection, it is interesting to note that they did not all come solely from members of the group or their sympathizers and that these responses were elicited by clearly chosen questions to "determine where the most vibrant form of art is to be found nowadays, and where it is going, from the surrealists to the extremes of abstraction." In this formula one can sense Estienne's concerns, and in *Combat* on March 7, 1955, he published an article entitled "Painting and Surrealism Belong to the Present as Much as to the Past" (where he placed Hantaï, Paalen, and Toyen in the orbit of Tanguy's "metaphysical space"; Tanguy had recently died). Meanwhile, at the Galerie Kléber, for his "Alice" exhibition, he brought together two generations of surrealists and lyrical abstract artists: Degottex, Duvillier, Loubchansky, Paalen, Toyen, and Hantaï.

In 1967, José Pierre judged the evolution of the works Estienne promoted in this fashion to be fairly disappointing: "The movement . . . was worth more than the canvases which he kept. . . . With two or three exceptions, we had nothing but fine promises and, as is often the case, a few clever craftsmen.[61] The fact remains that Estienne's suggestions and their favorable reception by the group show how attentive Estienne remained—and at a far remove from any strictly formal definition—to artistic ideas that could further advance the exploration of his own domains. This would be confirmed, for example, by the important contributions of a certain Christian d'Orgeix, who while he preferred to remain outside the group did enjoy friendly relations with some of its members (Ernst, from 1946 on) or close collaborators (Picabia, Bellmer, Henri-Pierre Roché). After the war, he devoted his attention to both surrealism and lyrical abstraction—he was the one who specifically introduced Hantaï to automatism—but, instead of succumbing to the immediate charms of gestural painting, his work focused on the revelation of a lavish interiority, as if overpopulated with undecidable creatures, all at once baroque, frightening, and hilarious. In his drawings, which demonstrated a rare acuity, he created montages of enigmatic objects, and he did not refrain from using incongruous materials (old radio lamps, scraps that looked as if they had been collected from the laboratory of a mad scientist) to give a particular look to figures or window displays—as if the border between an imaginary landscape and inner phantoms had quite definitely become porous.

In 1955, D'Orgeix discovered in Germany the work of the disconcerting Friedrich Schröder-Sonnenstern and showed it to the group. Schröder-Sonnenstern was an autodidact, the former inmate of a psychiatric hospital, and he placed drawing at the service of his obsessions, with no care for what was socially acceptable; with corrosive humor he exalted the opulent shapes and the filiform limbs of a population in which the female figure seemed to simultaneously exude every imaginable seduction or danger.

The qualification of the visible was far from self-evident, however, as indicated by the support lent to other artists at the edge of the group: Jan Krizek (L'Étoile Scellée, March–April 1956), Endre Rozsda (Galerie Furstenberg, March 1957), Yahne Le Toumelin (Galerie d'Orsay, November 1957), Yves Laloy (Galerie La Cour d'Ingres, October 1958), and Agustin Cardenas (La Cour d'Ingres, February 1959). Krizek was introduced by Estienne, the four others by Breton.[62] Their artistic approaches diverged

1

3

2

4

5

1

3

2

4

1 Friedrich Schröder-Sonnenstern,
Le Cours de la vie entre les jambes
(The flow of life between one's legs;
1958).

2 Friedrich Schröder-Sonnenstern,
Dr. Juckelche & Spuckelche (1950);
drawing.

3 Jan Krizek, ink on paper, 1956.

4 Agustin Cardenas, *Porte de l'his-
toire I* (The door of history I;
1960–61); wood, 79 1/5 in. (198 cm).
Private collection.

totally: from Krizek's sculpted and drawn forms—which displayed an abundance of possible allusions to a paganism capable of arousing the least docile minds, distantly sleeping in stone, wood, or ink—to the suggestion in Rozsda's graphic work both of something insidious, through its slender, precise style, and of an obstinate struggle awaiting the first opportunity to stifle silence. And while the fantastic aspect of Le Toumelin's representational painting was certainly "against the tide," as Breton pointed out, it was also because it was not based on any dream activity; on the contrary, his images, with their troubling perspective, clearly aimed to indicate an inner path to be offered to the viewer as a possible way out of the fears of the moment. Laloy was praised for uniting the symphonic concerns of a Kandinsky with the cosmogonic demands of a Navajo sand painting: through his geometric motifs, equally evocative of an alphabet he might have invented and the symbolic shaping of a catastrophe within matter or the organism, an itinerary began to take shape, made of a stubborn quest, unvanquished enigmas, and leaps defying failure.

As for Cardenas, his sculpture retained the lessons learned from Arp and Moore, which gave him an approach to his material and forms that was, above all, sensual while, fortunately, any directly exotic description was banned: plaster and wood yielded seductive displays that addressed the hand as much as the eye and made each sculpture the precipitate of an enamored desire—without ever heavily imposing its masculine nature.[63] Everything in Cardenas's allusive totems unfolds as if an alternation of the imagination in man and in woman were deciding on their shape, elongation, or mass, as if that imagination had united in order to mold the figures with a diffuse eroticism, without drama, yet all the more scandalous for the complete innocence of the eroticism displayed.

Another newcomer was Mimi Parent, who had settled in Paris with her husband Jean Benoît in 1948. They would not meet the group until 1959, but Parent's process had already begun, through her different techniques (from embroidery to objects by way of etching or oil), to explore a world open to apparitions and to the supernatural. *J'habite au choc* (I live at the shock [1956]) exemplified the union of a half-controlled dream life and an imaginary world acutely anticipating the least rational events.

"Phases": Group and Periodical

In January 1954, the first issue of *Phases* was published, a periodical edited by Édouard Jaguer. In the margins of the official group, the "Phases movement," which Jaguer had already envisaged founding in the early 1950s, would make a wide-ranging contribution, particularly in the arts, going from the fringe of surrealism in the strict sense of the word to abstraction in its most lyrical version. An opening of this kind was clearly due, in large part, to Jaguer's own personal evolution: he was a former participant in La Main à Plume, then in Dotremont's *Deux Sœurs,* and in Revolutionary Surrealism. At the end of 1949, together with Max Clarac-Sérou and Iaroslav Serpan, he founded the periodical *Rixes;* there would be two issues as well as accompanying exhibitions known as *Contre-espace* (in Paris, Berlin, Lille, Frankfurt, and Brussels) that brought together painters and writers, either those who were already active in surrealism (Matta, Jean-Paul Riopelle, Freddie, Georges Hénein, Yves Battistini) or artists who had similar approaches (Heinz Trökes, Christine Boumeester, Enrique Zanartu, Jerzy Kujawski, Michel Butor). Along with the Cobra movement, for whom Jaguer was a

correspondent in Paris, *Rixes* opted for, in the words of a pamphlet from 1949 a "con-
tinuous present" that should "be kept constantly alive and turbulent on the side of
man." Whence the refusal of all dogmatism or wariness with regard to occultism, per-
ceived as too fascinating by the surrealist group; at the same time, a permanent wager
on the freedom of spirit ensured a certain affinity with the group. Jaguer wrote of the
group, "the time of a seriously *measured opposition* in its diverse dialectical movements,
its dreams and repercussions, seems to have come."[64] And Riopelle wrote, in the same
catalog, "The halo, the fish, the cross, and the dove make up a system of signs which
suffice for the believer to find himself in a country he knows. The miscreant only per-
ceives them as isolated signs. They do not affect him except in their relations to prob-
lems caused by the living world. I place my trust in the miscreant."[65]

Phases was a lasting means of expression for those charting parallel courses to that of
the group, and this allowed the periodical to welcome and publish former Dadaists
(particularly Raoul Hausmann and Jefym Golyscheff) or artists from the Cobra move-
ment (Corneille, Dotremont, Alechinsky), group members (Hénein, Ghérasim Luca,
Benayoun, Hérold, Lam, José Pierre, Legrand, Toyen, and others), and also some who
had been excluded from the group (Jouffroy, Lebel, and Matta). But the periodical also
offered information on Eastern European countries, Spain (Tapiés, Antonio Saura), and
Italy (where *Il gesto,* published in 1955 under the supervision of Jaguer and Baj, served
as a relay). Some artists, after their passage in *Phases*—which acted as a sort of guide—
would grow closer to the surrealist group. This would be the case for, in particular, Baj,
who was in contact with Jaguer well before he met E. L. T. Mesens, Duchamp, and,
finally, Breton (in 1962), but also for Alberto Gironella and Konrad Klapheck, who
were invited to several Phases events before Jaguer introduced them to Breton in 1961,
or for Alechinsky who had always been aware of how much Cobra owed to surrealism
yet still spent some time with Phases (he would become technical director for the
periodical at the beginning, and in his own words, he acted as "errand boy, compositor,
and activist") before joining the group in 1963.[66]

From Gallic Art to Magic Art

In August 1954, in an article in *Arts,* Breton pointed out the publication of a scholarly
work devoted by Lancelot Lengyel to Gallic medallion art, *L'Art gaulois dans les
médailles* (Gallic medallion art).[67] After recalling the scorn that had been reserved for
Gallic coins for centuries—so great was the stubborn persistence in viewing them as
indications of an incapacity to reproduce properly their Greek and Roman models—
he deplored in passing Bataille's negative evaluation in *Documents* in 1929 and empha-
sized Malraux's courage for being the first, in *Les Voix du silence,* to proclaim their full
artistic quality. In his opinion, the Gallic medallions were proof of a worldview based
on what was no longer a static but was now a dynamic interpretation of the relation
between man and the cosmos. Better still, they proved that the privilege granted to
what was beyond the immediately visible, and the interest shown in going beyond
appearances—to read them in an abstract way and interpret them subjectively—were
hardly recent tendencies where the mind was concerned. In opposition to the "ossify-
ing rationalism" or the "Latin spirit," there had long been a philosophy of "true light,"
one that granted access to "forests of symbols," to which "surrealism and abstraction-
ism" were the sole authentic heirs.

1

PHASES

8

3

2

The reinterpretation of Gallic art thus confirmed that surrealism was reviving a buried history: coming so long before the painters who were normally the reference for surrealism, this Celtic culture, which the Roman Conquest had doomed to a lasting oblivion, now seemed to be one of the main guarantors of surrealism itself.[68]

This affiliation was clearly indicated in Breton and Estienne's organization of a section in the exhibition *Perennité de l'art gaulois* (1955) devoted to the evolution "from Gallic art to modern art." The first part of the exhibition assembled over three hundred medallions, sculptures, and everyday objects; the second, with a triple preface by Breton, Lancelot Lengyel, and Estienne, offered an "Ariadne's thread to help the art historian to better understand the periodic swings of Western art between Mediterranean classicism and more turbulent forms whose origins were until now very murky." In "Présent des Gaules," Breton suggested that the rediscovery of Gallic art risked having a particular impact on those thinkers who, for over half a century, had found no other means to react "against the Greek aesthetic and Mediterranean ways of thinking," than to search for lasting resources in "primitive" art forms: there was no uprooting to be feared this time, and what must also be preserved was the astonishing lesson of artistic freedom these medallions offered.[69] Clearly, there was a desire for abstraction at work in such a figuratively "sumptuous" coin, and this desire could go hand in hand with another version that offered nothing more than "a network of inextricably interwoven lines." The harmonious coexistence of such apparently contradictory results could only convince one of the sterility of the debate still seeking to contrast figurative painting and abstraction. And to indicate the basis of such a coexistence, Breton would quote recent declarations by Duchamp: the art that sought to be both the most ambitious and the most accomplished could only be nonretinal.

Proof of this were examples of popular art (imagery and sculpture, including six "leads from the Seine" belonging to Paalen) and especially a collection of works that represented the permanence of a "heretical line which is a common denominator for all those who have never accepted that everything could be resolved by simple optical fact—and artistically, in the realism of imitation alone," according to Charles Estienne.[70] After Redon, Seurat, Rousseau, Gauguin, and the "twentieth-century naive" or "primitive" painters (Louis Vivin, Séraphine, Camille Bombois, Joseph Crépin), the surrealists and their followers had a particular place of honor (Brauner, Matta, Ernst, Duchamp, Chagall, Kandinsky, Miró, Paalen, Picabia, Giacometti, Tanguy, and others), along with Constantin Brancusi, Stanley William Hayter, Hans Hartung, Serge Poliakoff, René Duvillier, Jean Degottex, and others.[71]

Breton had been working on *L'Art magique* together with Gérard Legrand for almost four years by the time it came out in 1957.[72] The introduction began by emphasizing, first, the complexity of the notion of magic in itself, depending on whether one interpreted it in the manner of traditional hermeneuts, philosophers, or ethnologists. Second, Breton noted that "when applied deliberately to the word 'art,' the adjective 'magical' adds an element of exigency which further thwarted any hope of rigorous codification." He therefore preferred to believe that magic consists, above all, in a quest for correspondences or analogies through which a possibility for interaction among beings exists; from this point of view, poetry (Baudelaire, Jarry, Rimbaud) and painting (Arcimboldo, Watteau, Rousseau) might be seen as exemplary of a magical behavior that, far from being "outmoded," was on the contrary still in force in the work of artists like De Chirico and Kandinsky, as well as Chagall, Duchamp, or even Mondrian

("transposing into the universal, to the very edge of Mallarmé's blank page, the tulip fields of his native Holland."). This just shows how greatly the approach of magical art, in the diversity of its historical expressions, required a poetic sensibility with regard to the world, something that criticism and the public in general were far from possessing. At the end of his opening text, Breton said that "the agreement that during the 19th century seemed to have been established between artists and poets on the one hand and poets and philosophers on the other (through Romanticism, Saint-Simonism, and even Symbolism) has been eroded to the great detriment of high culture." These lines also served to determine the significance of the survey that followed the introduction: eighty individuals had been questioned, including philosophers (Heidegger), sociologists (Caillois), ethnologists (Claude Lévi-Strauss, Robert Jaulin), writers (Pierre Klossowski, Jean Paulhan), poets (Octavio Paz, Benjamin Péret, Malcolm de Chazal), artists (Magritte, Paalen, Molinier), aestheticians (Étienne Souriau, René Huyghe), and "occultists and esoterists of every stripe" (Raymond Abellio, Denis Saurat, René Nelli). Their responses were classified according to their interests—not to lay claim to some fallacious objectivity but, on the contrary, to show that it remained possible, if one just took the trouble, not to succumb to a vulgarization that had already done sufficient damage.

The third part of the work, which is also the longest, recalls the history of the relations between art and magic, from prehistoric art and contemporary primitive art to surrealism, presented as a "rediscovered magic." Illustrations were abundant and served not only to accompany this vast panorama but also to reveal in a tangible way the secret ties that could connect a Hopi doll, a Rembrandt etching, Ernst's *Antipape,* or Brauner's *Chimère.* The collection of full-page plates that in the 1957 edition made up the second section of the work invited the reader on a journey from a Tarot card alleged to be of Charles VI, to a Navajo sand painting; other examples were added from the plastic arts (from Uccello to Maria Martins), of "brut" creations (Raymond C. and the Facteur Cheval), film images (*The Bride of Frankenstein, Nosferatu*), and a broad repertory of primitive works from Oceania, Easter Island, Alaska, and Mexico, for example.

Among the eleven documents in the survey that Breton asked his correspondents to classify in order of magical impact, there was a Gallic coin: the two domains clearly connected, once they were also removed from the strict desire to rationalize fully the world and its representations. *L'Art magique,* in its way, confirmed the lesson already provided by the reflections on Gallic art: surrealism was part of a very long history, going far back beyond its "official" birth; history would show that it had a deep connectivity with the unchanging aspects of the mind.

Reevaluations of perspectives of this kind went hand in hand with periodic calls to order over the requisite dignity and ambitions of various practices, even strictly artistic ones. The exclusion of Max Ernst, who had accepted the Grand Prix de la Peinture at the Venice Biennale in 1954, was decided for ethical reasons and independently of the effectiveness of his work, which would continue to be appreciated by many group members for years to come.[73]

On March 5, 1956, it was also morality—in the sense of the sum of demands, particularly intellectual ones, which could justify certain moves or procedures, in any domain of art—which underlay the page published in *Combat* titled "Sus au misérabilisme!" (Down with the sordid aspects of life!), in which contributions by Breton,

1

2

3

4

5

6

Benayoun, Estienne, and José Pierre figured side by side.[74] Breton defined "miserabilism" as "depreciation—instead of exaltation," anything that went against the quest for the "ascendant sign." Benayoun tracked down hints of it in a French film industry increasingly devoted to the description of the most insipid banality: "The attraction of the keyhole has transformed a bay-window cinema looking onto Tsalal Island into a miserable œil-de-bœuf peering into the neighbor's kitchen across the landing." Estienne sharply criticized Raymond Cogniat's choices for the Venice Biennale, in particular the presence of Bernard Buffet, who was considered the pathetic symbol of an artistic milieu that, sated with existentialism and dull Marxism, defined "life through its basest physiology, assumed to be the truest because it is the most humiliating and therefore most striking." As for José Pierre, who would progressively become the best-informed person in the group on the different trends in contemporary art worldwide, he in turn denounced an intellectual miserabilism, where certain artists were only too willing to delegate the formulation of their intentions to critics who were friends, failing thereby to examine their own process and, thus, depriving themselves of any sense of inner urgency. In opposition to defections of this kind he cited the examples of Duchamp, Malevitch, Arp, and Paalen—the companions of poets, not pedantic critics—as well as texts by Kandinsky, Ernst, and Mondrian. "The Spider and the Butterfly," in the end, would describe those artists whose process led to "the great jungles of poetry and the marvelous": Pollock (who in 1956, the very year of his death, scarcely aroused any interest at all in Europe), Hantaï, Sam Francis, and Clare Falkenstein—artists who did not all belong to the surrealist movement by any means—while "at the edge of the forest" were Svanberg, Toyen, Pierre Molinier, François Stahly, and Étienne-Martin.

Among the "Classics"

In November 1950, Breton wrote a text about Paalen, "A Man at the Crossroads of the Highways," which signaled the reconciliation between the founder of *Dyn* and surrealism.[75] Breton also wrote the preface to Paalen's first postwar exhibition in Paris, at the Galerie Pierre in 1951, the year of his return. Paalen was accompanied by Marie Wilson, an American, who was a practitioner of an automatic graphism that highlighted, in her drawings (some of which would later be reproduced in *le surréalisme, même* and in *Bief*) a pronounced taste for the symmetry of forms and convolutions.

Paalan was celebrated for having succeeded in finding a solution enabling him, as Valéry had wished, "to move continuously between the so apparently divergent domains of artist and scholar." Three years later, the painter would be entrusted with illustrating the second issue of *Médium*—proof of the importance granted an ambitious opus that found its inspiration at the intersection of scientific facts, the primitive cosmogonies that had fascinated him in Mexico, and "the most evolved forms of art" (Breton, in the presentation of the issue). In his response to José Pierre and Estienne's survey on the "Situation in Painting in 1954," Paalen spoke of the need for what he called a "spontaneous figurative painting," in which figuration and abstraction would alternate "at the whim of the mind's navigation, where the shoreline of the visible is sometimes revealed, and sometimes fades away into the vision of the open sea." Thus even those works that seem the most hermetic sometimes contained a human presence, if only under an aspect of allusive silhouettes (*Vous ici?* [1953]): an interplay of

curves, a few circular shapes sufficed to sketch the emergence of the lasting presence, in a "cosmic" context, of a face or a body. Paalen returned to Mexico at the end of 1954, where five years later he would commit suicide. By 1958, his work had enjoyed a sort of final, striking fullness, through the dissolution of shapes and the flamboyance of color that emerged, like the metaphysical secret of the energies that generate things and beings. Schuster, who praised Paalen as a "lord of the imagination," would emphasize the significance of his career: "The avenues of the imagination have united the burial mound of Novalis with the totems of the Queen Charlotte Islands. A dash which was never mad enough for Paalen's taste, who was ready with his stopwatch, spurring the participants on. A dark dash of the great questioners."[76]

Picabia died on November 30, 1953 (and Duchamp, on hearing of his death, sent him a telegram: "Dear Francis, à bientôt"). Although illness had virtually stopped him from painting over the last two years, an exhibition was organized in December 1952, at the Galerie Colette Allendy; the catalog included a letter from Breton recalling Picabia's role as a forerunner of abstraction: "There are a few of us here who are impatient to see the continuation of your lesson, which was so well done that one submits readily to the others, since it is, par excellence, a lesson of *antipedantry*."[77] Picabia's works from 1949–51 were an ultimate proof of his freedom of invention, his indifference to taste, and the constancy of his irony. Thus, the drawing titled *Tableau qui n'a pas encore de nom* (Painting which still has no name [1949]) showed nothing more, within the drawing of a frame, than three dots, the date, and the signature; and *Symbole* (1950, oil on canvas) superimposed two columns of multicolored dots, applied with supreme negligence. Beyond the rivalries and diatribes of the Dada era, what remained precious in the life and work of the artist who had said that "one must be a nomad, going through ideas the way one goes through countries and towns," was his freedom, which enabled him to be "one of the two or three great pioneers of what has been called, for lack of a better name, "the modern spirit."[78]

Tanguy had been a citizen of the United States since 1948, definitively settled in Woodbury, Connecticut, but he remained curious about the group's inner life, even when he said that the group "hasn't really existed since 1939"—although this did not prevent him from taking part in the *International Exhibition* in 1947.[79] He tried, through a few correspondents including Marcel Jean, to keep abreast of the "Carrouges affair" and periodically saw Ernst, Tanning, Donati, and Duchamp. When he learned that Breton had "made a speech at Picabia's funeral," he was surprised to say the least: "*Too good to be true!*" He also took part in the exhibition *Surrealist Painting in Europe* (Saarbrücken, 1952; catalog preface by Breton). In September 1953, a letter from Toyen invited him to resume his contacts with the group: it would "remain unanswered." His attempts to mount exhibits met with relative success, but sales were poor and the lack of money prevented him from returning to France, something he had periodically said he would do. In fact, his most recent canvases, from the American period, had a difficult reception. They marked an evolution in his work: forms seemed to accumulate in a foreground that stood out against a background without perspective (*Ce matin* [1951], or against an immense "sky," threatening perhaps, which transformed shapes into a fantastic city (*Du vert au blanc* [From green to white] [1954]), or frankly placed itself in opposition to a proliferation that it seemed to contain (*Multiplication des arcs* [1954]). In 1950, Mesens organized at the London Gallery an exhibition of drawings and paintings of works borrowed from private collections: none of them were recent.[80]

It was not until 1953 that his more recent paintings were exhibited, in Naples (Galleria dell' Obelisco), Milan (Galleria del Naviglio), and Paris (Galerie Renou et Poyet), meeting with little success. When he finally came to Paris in the spring of 1953, Tanguy met his old friends, with the exception of Breton (although Breton did write the text for the Neapolitan exhibition). Back in the United States he published a short article in *Art Digest* in January 1954 in response to a survey on the "creative process."[81] He stated that the most important element in the creation of a work is surprise, both for the artist and for others, and he gave *L'Amour fou* as an example. A painting cannot be predicted or even sketched, and it gives "a sensation of complete freedom." Indifferent to discussions on the ideology of art or techniques, Tanguy confirmed that his process could not be influenced either by places or by the general atmosphere of the moment and that the pace of his work was very irregular, even when he was working on only one canvas at a time. "If I had to search for the motivation for my painting," he concluded, "it would be a bit as if I were locking myself up in prison."

Tanguy died suddenly on January 15, 1955; in June, the Galerie Rive Gauche in Paris organized an *Homage to Yves Tanguy* that included, more symbolically no doubt than was truly justified, Arp, Brauner, Lucien Coutaud, Jean Dubuffet, Ernst, Giacometti, Hantaï, Félix Labisse, Man Ray, Matta, Miró, Tanning, and Toyen.

Toyen enjoyed special attention on the part of the group members during the 1950s. In 1953 the Éditions Sokolova published a monograph with texts signed by Breton, Heisler, and Péret. The letters making up the artist's name were cut out of the cover designed by Guy Doumayrou, and through them one could see a reddish paper, an invitation to the constant play, in Toyen's work, between what the canvas revealed and what lay underneath. An exhibition was mounted in parallel at the Étoile Scellée (where the work of Slavko Kopak was also displayed), and the invitation to the opening, cut in the shape of crossed hands, contained phrases by Bédouin, Breton, Schuster, Péret, and others. In May 1958, the exhibition of seven canvases at the Galerie Furstenberg, *The Seven Swords Unsheathed* (an expression of Apollinaire's) was accompanied by seven essays, by Benayoun, Yves Elleouët, Goldfayn, Mesens, Péret, Silbermann, and Breton: the tribute here worked as a collective event, and it was clear that on the heels of the exclusions of Matta, Brauner, and Ernst, Toyen had become the "symbol of surrealist intransigence."[82] Her painting was particularly suggestive of this now, having evolved from the earlier figurative work whose visions filled the entire canvas; the only elements that remained were those that seemed to owe their existence to an ambivalent movement between apparition and eclipse, images rising discreetly against a dark veined background susceptible of allowing them passage through a few interstices. Gentler colors were both diffuse and electrically flamboyant (*Sillage dans un miroir* [1959]), and identifiable objects, such as the pillow in *Flux et reflux de la nuit* (1955), seemed threatened by a space capable of devouring them. "To practice poetry," wrote Radovan Ivsic, "Toyen does not need the ruses of reason (à la Magritte) for she is perhaps the only painter to have given life to poetic creatures who are poetic by virtue of being there and of not being there."[83] For *The Seven Swords Unsheathed*, it was the female shapes that scarcely came to life and almost vanished: shadows captured in their semipresence of dawn or twilight, suggesting the fertility of metamorphoses and passages. In 1965, *L'Un dans l'autre*, using the title of the collective game devised twelve years earlier, would be a retrospective confirmation of the lasting trust granted to these moments of instability, the outcome of which was that "everything" (the world and its

1 Man Ray and Marcel Duchamp, circa 1950.

2 Yves Tanguy outside the Del Naviglio Gallery in Milan, 1953.

3 Yves Tanguy and Max Ernst at Ernst's home in Sedona, Arizona, in 1951.

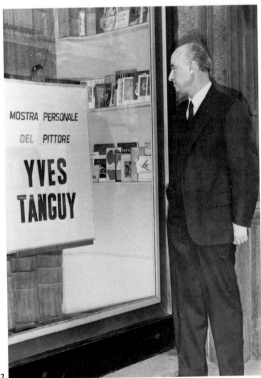

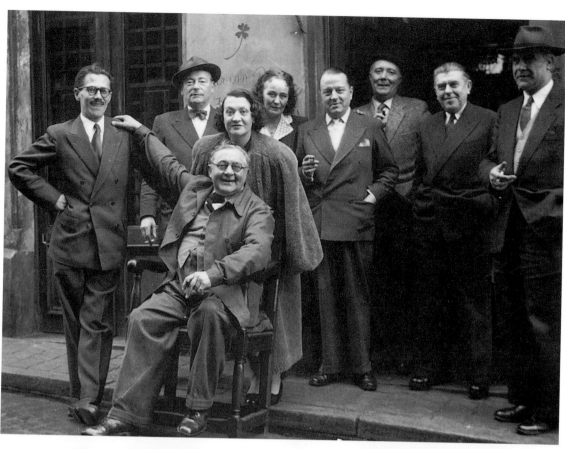

4 Wifredo Lam in Paris with *Presentimiento;* oil on canvas, 33¹/₅ × 40 in. (83 × 100 cm), 1953. Photograph by Michel Sima.

5 Marie Wilson in her studio in Montparnasse, 1959.

6 The Belgian group in 1953. *From left to right:* Marcel Mariën, Camille Goemans, Irène Hamoir, Georgette Magritte, E. L. T. Mesens, Louis Scutenaire, René Magritte, and Paul Colinet. *Seated:* Gérard van Bruaene.

7 Victor Brauner in 1957. Photograph by Denise Colomb.

8 Wolfgang Paalen, Anne Bédouin, and Marie Wilson in Moissac in 1953.

meanings, "reality" and its "certainties") could be knocked off balance since "anything can happen."

Toyen's work was still far from attracting a wide audience. This was not the case for Miró, however: his fame grew considerably during the same period. In 1948, his first exhibition at the Galerie Maeght signaled a new departure for his European career: his friends contributed to the catalog preface (Queneau, Limbour, Kahnweiler), and the exhibition revealed the importance of his ceramics—created with his childhood friend Josep Llorens Artigas—thanks to which Miró expanded his quest for a realm beyond painting: "These are not decorated ceramics," said Artigas, "these are ceramics, full stop, where you cannot tell where the ceramics artist leaves off and the painter begins." At the Galerie Maeght in 1953, then in 1955, Miró again exhibited his ceramics.[84] In his canvases, his line had achieved complete frankness—as if contours had been drawn in one go, when in fact they took long and thoughtful preparation; overlapping shapes determined the location of bright colors, perfectly balanced, which did not have to carry the weight of the painting but, rather, enlivened the composition in a pertinent way (*L'Aigle s'envole vers le sommet des montagnes creusées par les comètes annoncer la parole du poète* [The eagle flies toward the peaks of mountains pierced by comets to announce the word of the poet] [1953]). This sovereign line and the manner in which it simultaneously defined the situation of signs and spaces recalls Miró's work from 1940–41 in the series of the twenty-three *Constellations* created in Spain itself after Miró had returned to his native country to flee the Germans.[85] Breton insisted on the importance of these gouaches in an introductory text he wrote for the periodical *L'Œil* in December 1958, to which he would add poems in prose for a deluxe edition produced in 1959 by the Galerie Pierre Matisse.[86]

Arp and Lam would also have major exhibitions at the Galerie Maeght. Both, in their way, were affirming the secret marriage of nature and man. Arp exhibited bronze and marble sculptures, the shapes of which seemed to be born and grow in size as a result of their own inner movement, as if at the end of an actual germination; yet one hesitates to name what one sees, an indecision reflected in the titles of the works themselves: *Évocation d'une forme humaine, lunaire, spectrale* (1950), *Torse-gerbe* (1959). As for Lam, who was entrusted with the illustration of the fourth issue of *Médium,* he continued to explore his world of genies and more or less benevolent spirits: emerging from what was generally a plain background were horned heads, necks of exaggerated length, and empty eye sockets that attracted and challenged the viewer, dispensing the hope of a reunion with forgotten forces and the threat of being subject to their reactions, and taking every opportunity to reverse our everyday relation with reality or our ordinary routine (*Tant que je ne dors pas, je rêve,* [As long as I'm not sleeping, I'm dreaming] [1955]). "Nothing in appearance that is not from everywhere!" said Péret in referring to these creatures and their environment. "And yet, nothing can be found elsewhere, for the tension that reigns here is unique and permanent. . . . Here, nothing is abandoned. In the infraworld which he explores, the event which has been expected at any moment can just as easily turn out to be as beneficial as it is harmful. Yet it still contains, for all of us, elements of the marvelous which multiply ad infinitum."[87]

Magritte, once he had emerged from his "surrealism in full sunlight" and "vache" periods, entered in the 1950s into a time of overwhelming activity.[88] In addition to numerous exhibitions—in Belgium but also in Rome, New York, Venice (1954 Biennale), and Paris—he created a major mural decoration for the gaming room of the

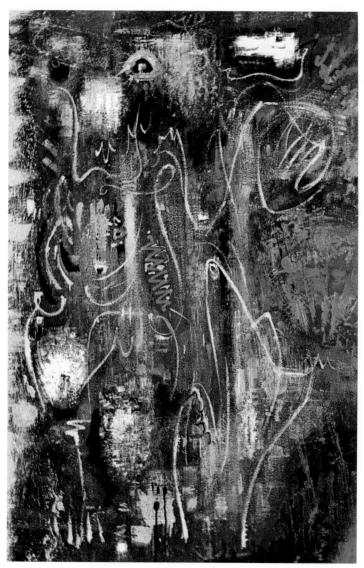

Above: André Masson, *Esprits ani-maux* (Animal spirits; 1957); 58²/₅ × 38⁴/₅ in. (146 × 97 cm). Galerie Louise Leiris, Paris.

Right: André Masson, *Éclosion V* (1956); 36⁴/₅ × 29¹/₅ in. (92 × 73 cm). Private collection.

Right: Conrad Klapheck, *Genealogy* (1960); oil on canvas, Private collection.

Below: Conrad Klapheck, *Die Selbstsicheren* (ca. 1960); oil on canvas, 16 × 28 in. (40 × 70 cm). Private collection.

Opposite page: Enrico Baj, *Ultrabody Modification in Switzerland* (1956); mixed media on canvas, 36²/₅ × 29¹/₅ in. (91 × 73 cm). Private collection.

Above: Pierre Alechinksy, *Central Park* (1965); acrylic and India ink on paper mounted on canvas, 64⁴/₅ × 77¹/₅ in. (162 × 193 cm) Private collection.

Right: Pierre Alechinksy, *Gymnastique matinale* (Morning gymnastics; 1949); gouache on paper, 13 × 16⁴/₅ in. (32.5 × 42 cm). Private collection.

Opposite page: Yves Tanguy, *Du vert au blanc* (From green to white; 1954); oil on canvas, 39²/₅ × 32²/₅ in. (98.5 × 81 cm). Private collection.

Below, top and bottom: René Magritte, *Le Domaine enchanté* (The enchanted domain; 1953); frescoes for the casino at Knokke-le-Zoute, oil on cement, 14 × 231 feet (4.3 × 71.2 m).

Opposite page, top: Joan Miró, *La Femme au miroir* (The woman with the mirror; 1957, lithograph, 15³/₅ × 22³/₅ in. (39 × 56.5 cm). Fondation Maeght, Saint-Paul-de-Vence.

Opposite page, lower left: Joan Miró, *L'Oiseau plonge vers le lac où les étoiles se mirent* (The bird plunges toward the lake where the stars are reflected; 1953); oil on cardboard, 22 × 18²/₅ in. (55 × 46 cm). Private collection.

Opposite page, lower right: Joan Miró, cover for André Breton's *La Clé des champs* (1953). Private collection.

Left: René Magritte, *Le Château des Pyrénées* (1961); oil on canvas, 80 × 52 in. (200 × 130 cm). Israel Museum, Jerusalem.

Below: Édouard-Léon-Théodore Mesens, *L'Éternité Maman* (Eternity, mother; 1961); collage.

Casino at Knokke-le-Zoute, inaugurated in July 1953: *Le Domaine enchanté* incorporates some of his favorite themes and acts as a veritable anthology of Magritte's work that could well, if his artistic quest in the name of poetry has been effective, disturb some of the gamblers on top of it. For years he had been repeating that this poetry had nothing to do with the work of the unconscious or with dream images, and he did not hesitate to tag as ridiculous a certain famous writer whose name he pretended to have forgotten, "who, upon going to bed, solemnly informed anyone who was interested, by means of a sign on the door of his room, and in all good faith: 'The poet is at work.' "[89] One can easily recognize the anecdote that Breton related so admiringly regarding Saint-Pol Roux, and one suspects that considerable differences still divided Brussels and Paris. For Magritte, the goal of poetry in painting is to reveal the mysteries of the world; thus, it can itself only be founded on a process restoring an original mystery to the world's elements, a mystery that will cause one to lose sight of the ordinary usage of those elements ("Poetry is a luminous art which restores to words their tenebrous meaning").[90] Every canvas must be the opportunity for a partial or local revelation of the general enigma that is the presence of the world. It can therefore only be inspired by a suggestion emanating from an uncontrolled functioning of our psyche—thus, it will be the "copy" or at least the repetition of a composition already envisaged. On the contrary, ideas for paintings must form "by surprise," depending on the painter's "inspiration"; and if the art of painting is truly, as Magritte says, "the art of resemblance," resemblance "is not concerned with adopting or defying 'common sense.' " It spontaneously unites figures of the apparent world in an order dictated by inspiration ("La Ressemblance" [1959]). Since it borrows its elements from the apparent world, painting has no need to strive for effect through its use of material; quite to the contrary, its technical neutrality accentuates the trap it sets for one's visual and intellectual perception, confronted by the most flagrantly unexpected event behind the reassuring appearance of the (almost) familiar. Thus "the image . . . is thought; it is identified with that which is thought."[91] To testify to that thought, based on mystery, came images as diverse—although linked by the presence in each one of a rock—as *Le Monde caché* (The hidden world [1953–54]), *Le Bal masqué* (The masked ball), or *La Bataille de l'Argonne* (The battle of the Argonne [1958]), and *Le Château des Pyrénées* (1959). The title of this last painting echoed that of a novel by Ann Radcliffe, but the literary allusion does not help to "explain" the fact that above the sea there is this massive rock crowned by a castle or to tell us how we can grasp the thought behind the image. The fact remains, however, that to see the canvas is to enrich our capacity for thought through the workings of its poetry, even though this poetry is in no way founded on a metaphor but owes its existence to the burst of power accomplished in relation to our usual perception of reality.

Médium; le surréalisme, même; Bief

In addition to these solo exhibitions, it was the periodicals that reflected the collective activities and positions of the group itself. In November 1953, the first issue of *Médium* (new series) was introduced (on the last page) as conforming to the desire "to be at the same time the present, passing, phenomenon, its laws, and the search for its laws." This was followed by a reminder, still necessary, if one believes the definition provided by the illustrated Petit Larousse dictionary quoted on the back of the cover—surrealism

was "the tendency of a school (born around 1924) to neglect any logical concerns"—to which the group's point of view was clearly opposed: "Surrealism is the encounter between the temporal aspect of the world and eternal values: love, liberty, and poetry." *Médium* intended to be "the vibrant, concrete, and modern angle" of this "aspect and of these values."

In its four issues—edited by Schuster and illustrated by Hantaï, Paalen, Svanberg, and Lam respectively—*Médium* alternated feature articles, reviews of books or exhibitions, news about literary or political life, and information on group activities.

Among the group activities, two new games had been devised: "Ouvrez-vous?" (Will you open?) in number 1 and "L'Un dans l'autre" (The one in the other) in numbers 2 and 3. The first game consisted in specifying whether one would allow a famous person (Balzac, Baudelaire, Cézanne, Fourier, Gauguin, Goethe, Lenin, Marx, etc.) to enter a room, the interest of the interrogation being, according to Breton, "to precipitate at that very second our feelings for that person, which are often very complex"; the suddenness of those feelings could reveal, in particular, "that individuals whose life cannot be separated from their work enjoy, because of the attraction they exert, a marked superiority over others." For example, the seventeen participants had very different reactions with regard to Hegel and Marx. Fourteen of them opened the door to Hegel, often worried that they would not be able to sustain conversation with the philosopher; among those who refused Gracq felt he "would not be able to keep up," and José Pierre declined "with admiration"; only Paalen asserted that "his philosophy is an excuse for all the totalitarian regimes"—a reaction that he also reserved for Marx ("his doctrine gave birth to the most oppressive of religions"), while the partisans of letting the philosopher in agreed to do so "coldly," "out of a sense of obligation" or "weariness," if not to "settle old accounts" or "to offer him a little glass of red wine" (Hantaï); Breton refused to let him in "out of weariness."

Introduced by a long preface by Breton, "The One in the Other" was of equal but different interest to surrealism, since it included a reformulation of the theory of analogy, which was the subject of lengthy experimentation during the summer of 1953 at Saint-Circq-la-Popie. The principle was simple: one posits that every object or being is implicitly "contained" in another, that the passage from one to the other can be carried out by an evocation that ultimately results in one being recognized in the other. Whence the rules of the game: "One of us 'went out' and had to decide to identify with a given object (except for himself)—let's say the staircase, for example. All the others, during his absence, had to decide that he would identify with another object (a champagne bottle, for example). He had to describe himself as a champagne bottle, providing details in such a way that gradually the image of the staircase would come to superimpose itself upon the image of the bottle." In case the riddle was not solved right away, questions could be asked until the solution became apparent. Breton emphasized that in over three hundred games there had never been a miss; thanks to "an unprecedented means for elucidation which the mechanism of 'The One in the Other' offers us, applied to those poetic images which seem boldest," it was possible to better understand the latent process that produced truly viable poetic images.

In the margins of the surrealist movement, one could find two instances that partially prefigured, "The One in the Other." In 1931 Bataille asserted, at the beginning of *L'Anus solaire,* that "it is clear that the world is pure parody, that is, that everything one observes is a parody of something else, or even the same thing in a deceptive form."

le surréalisme, même 1

directeur: André Breton.

2

LE SURRÉALISME,

DIRECTEUR
RÉDACTEUR EN CHEF
André Breton
Jean Schuster

MÊME

RÉDACTION : **17,** rue Gramme, PARIS XV
ADMINISTRATION : Jean-Jacques PAUVERT : 8, rue de Neele, Paris VI

1

le surréalisme, même 2

directeur : André Breton

revue trimestrielle printemps 1957

3

le surréalisme, même 3

directeur : André Breton

4

le surréalisme, même 4

directeur : André Breton

revue trimestrielle printemps 1958

5

LE SURRÉALISME, MÊME

6

IL EST NE

LE DIVIN

ENFANT

7

The multiplicity of possible responses was presented here in a disparaging way, although Bataille did immediately add that it was possible to locate a global meaning in this labyrinth. Three years later it was Duchamp who, in a note to *La Boîte verte* (The green box), said that "any form is the perspective of another form, according to a certain vanishing point and a certain distance"—no deception this time, but a neutrality in his observation. For parody and cold observation, "The One in the Other" substituted—in a manner that reflected the movement's ongoing direction—the elaboration of poetic analogies acquired during the reign of the "ascending sign."

At the end of *Médium*, number 4, it was announced that the next issue would be illustrated by Toyen, but that issue was never published, and the next periodical had a new publisher, as Losfeld was going through a particularly difficult period. Thus it was Jean-Jacques Pauvert who would publish *le surréalisme, même* (five issues, from October 1956 to the spring of 1959), edited by Breton himself; given the abundance of photographs that were used, it seemed to be something more of a luxury periodical. The names that had recently appeared in the group's publication (Nora Mitrani, François Valorbe) were now joined by Joyce Mansour, Octavio Paz, Guy Cabanel, Jacques Sénélier, Jean-Jacques Lebel, Alain Joubert, and Jean-Claude Silbermann (who initially participated as a poet); there were reproductions of works by Loubchansky, Degottex, Marie Wilson, Bona, Yves Elleouët, Manina, and Adolf Wölfli, among others.

Unlike *Médium*, the layout for which included articles, news, and diatribes, the bulk of the periodical was now devoted to long essays, while news was treated very briefly in a few columns at the end of each issue. In *le surréalisme, même*, there was a survey on striptease (no. 5), two others—more like games—on the possible interpretations of a painting by Gabriel Cornelius von Max and an anonymous painting (no. 3), and a presentation by Jean-Louis Bédouin of the "Analogy Cards" (no. 5) on which several people would collaborate, in stages, to produce the poetic characterization of a famous person. All the participants first received a questionnaire asking them to replace, anonymously, the usual items of an identity card with similar elements that they had several days to find. They were asked, for example, to indicate their residence with a painting, their eyes with a mineral, their skin color with a meteorological phenomenon, distinctive signs with any sexual proclivities, and so on. The different answers were read out, and a vote selected those responses that seemed most appropriate for each item. The identity photograph itself was replaced by the image of an animal chosen in the same way. As an example, here is the first part of the analogy card concerning Henri Rousseau:

Photograph: *A cradle bird.*
Parents: *The full moon and a closed shutter.*
Date of Birth: *The inauguration of the first greasy pole.*
Place of Birth: *A charcoal burner's hut in the forest of Fontainebleau.*
Nationality: *Civilization of Honey (Guayaquis Indians).*
Profession: *Merchant of forgotten things.*
Domicile: *Wood cuttings for the appendix of the Book of Monsters (Amboise Paré).*
Height: *Pumpkin.*
Hair: *Garden green.*
Face: *Noah.*
Eyes: *Carbuncle, etc.*[92]

In the five issues of *le surréalisme, même,* there would be a number of noteworthy contributions; a few examples will give an indication of its wealth. An "Open Letter to Jean Anouilh" by Legrand reproached the playwright with never having "ceased from drooling over anything that can still give an image of the grace of living and be the driving force of some high moral exigency." Another letter, this time by Schuster, congratulated Césaire, who had just publicly denounced the Communist Party's cultural policy and the role played by Aragon.[93] Legrand and A. Patri both asked the question: "Is Surrealism a Philosophy?"[94] A study by José Pierre examined "The Glove and Its Role in the Work of Klinger and De Chirico." A conversation between Schuster and Duchamp responded to a piece by Lebel on De Chirico (Lebel's work had come out in 1959). Simone Debout devoted a text to "Fourier's Psychology" and Péret related memories of his stay in Brazil, while Jehan Mayoux also described Péret's career in "Benjamin Péret, the Cutting Fork." One had to acknowledge, however, that *le surréalisme, même* seemed on the whole less devoted to an effervescent creativity than the group's other periodicals. This was probably due to its rather tame appearance, despite the inclusion of photographs, reproductions on glassine paper, and small-format supplements (Palau's *Les Détraqués,* described by Breton in *Nadja,* and *Le Royaume de la terre,* an unpublished screenplay by Abel Gance and Nelly Kaplan). The look of *le surréalisme, même* hardly differed from any other semiglossy periodical of the era. Jean Schuster's opinion of the periodical was very critical: "There's this sort of pretentiousness, a false luxury, with major spreads of typographical artifice which are nothing more than artifice, and a use of color which more often than not is awkward, in any case most of the time it is hardly justified. . . . The point is not to be in fashion, but if they're not in fashion, they think they have to be the opposite of what's in fashion. So, *le surréalisme, même* is neither fashionable nor the contrary of fashion."[95] The periodical did, nevertheless, bring to public attention a number of texts that the group rediscovered at the time: Darien, Pessoa, Heinrich von Kleist, and Panizza were added to the list of recommended authors.[96] Because of its sporadic publication (only five issues between October 1956 and the spring of 1959) and the almost total lack of response to news events, the fact that the periodical alternated poetry with theoretical texts, analyses of the group's internal events, and rediscoveries risked giving a somewhat static image to surrealist activity.

On November 15, 1958—that is, while the last issue of *le surréalisme, même* was being prepared—the first issue of *Bief* was released.[97] *Bief* was a mouthpiece for a "surrealist meeting point"; far more modest in appearance; it was edited by Gérard Legrand and administered by Silbermann, and Losfeld was once again the publisher.

The cover consisted of the only photographic reproduction in each issue (just to make things clear, the first issue, therefore, showed a nun armed with a rifle), and the four to six pages of text were devoted to a monthly summary of all the events, from their intellectual aspect (books, exhibitions, films) to more or less quirky news items (something Radovan Ivsic hunted down with delight). Some news was food for parody, as in Joyce Mansour's column, where the feminine press and the advice it gave to its readers were the target of her irony. The first issue announced the resumption of surrealist activity in Japan, through the constitution, thanks to Takiguchi, of a "surrealism study group."

The texts were short, most of them due to newcomers in the group (Marianne van Hirtum, Joyce Mansour, Pierre Dhainaut, Jean-Jacques Lebel—to whom, however, a warning of imminent exclusion was addressed in April 1960—Élie-Charles Flamand,

Alain Joubert, and others). The articles were occasionally the pretext for a reminder of the group's principles (Péret, in the first issue, would confirm the superiority of art and, more specifically, of poetry over scientific behavior); a reaction against the incompetence of certain critics as well as tendentious interpretations by former group members (Patrick Waldberg, for his work on Ernst and Marcel Jean for his *Histoire de la peinture surréaliste*); a welcome, as was appropriate, to Julien Gracq, Guy Cabanel, Gabriel Bounoure, and Don C. Talayesva, the author of *Soleil Hopi;* praise for the paintings of Arshile Gorky and Robert Motherwell or for Lionel Rogosin's film *Come Back Africa.* Aragon's insincere recollections were denounced, as was Jacques Villon's religious art, Chagall's remarks against Soutine, and Ionesco's conversion to humanism (Benayoun: "Eugène ou le pélican," no. 6).[98] In *Bief* number 7 (June 1959), Breton and Schuster together revived the reversal initially accomplished in Lautréamont's *Poésies* and earlier practiced by Breton and Éluard in their *Notes sur la poésie* in 1936: the victim who followed in Valéry's place was now Caillois, whose *Art poétique* had just been published; obviously, the same title was now used for the periodical's ironic version.[99]

In the first six issues of *Bief* there were questions to the readers, whose responses were anticipated: "What would you do if you were invisible for one hour, on January 7, 1959, between seven and eight in the evening?" "Would you like nighttime to disappear altogether? Or day?" "Are there any objects or phenomena which thrill your imagination whenever you look at them?" "What do stillborn children dream of?" "Can you pinpoint a place in your body which seems to be the center of your 'Ego'?" And so on. A certain number of the replies were published, some of them from people who were already familiar (Jehan Mayoux, André S. Labarthe, André Hardellet), and one series was provided by children, with a commentary by Legrand. After the eighth issue, the questionnaire gave way to a column called "L'Hénaurme," which collected from the press all the wrongful or ridiculous uses of the word "surrealism." The harvest was rich, as could be expected, and would be even more so during the *EROS* exhibition ("Cookies for the Road," no. 10–11).

Obviously, a number of contributions dealt with politics and the social mood of the moment, since now, only a few months after de Gaulle had taken power, one could hardly ignore this dimension of existence. The group, along with a good number of intellectuals, sensed an odor of fascism in the air, or at least its preparatory stage.

Political Vigilance

In January 1956, the pamphlet *Cote d'alerte*, signed by nineteen group members, with the solidarity of Charles Estienne, expressed its concern over the unexpected election of fifty-two deputies of the Poujadiste movement—"whom it would not be at all exaggerated to call fascists"—if for no other reason than some of their pasts and their shared positions.[100] While it remained true for the surrealists that "the interests which one must call those of the mind cannot be incarnated . . . in a social class or in a form of government," the group could not remain indifferent to the fate of the Algerians, who were being crushed by the sponsors of the above-mentioned deputies, and the group was afraid that the streets of Paris would quickly be transformed into a "human hunting ground.."[101] As a result, they asked the Intellectual Action Committee against the Continuation of the War in North Africa to immediately delegate an action committee against fascism and colonialism.[102]

JONCTION SURREALISTE

N° 1. 15 Novembre 1958

Editeur : LE TERRAIN VAGUE

Les indigènes [des îles Marquises] qui étaient jadis les plus beaux et les plus virils de la Polynésie tropicale, et qui pouvaient compter quelque 75.000 âmes, ne sont plus qu'une poignée d'hommes, parmi lesquels on ne trouverait sans doute pas plus d'un millier de pur-sang. Ils languissent dans leur décadence physique et morale, tout en gardant leur fierté ; ils méprisent les institutions étrangères, qu'elles soient administratives, commerciales, ou religieuses, mais ils sont honorables et fidèles en amitié pour peu qu'on leur témoigne une estime sincère.

E.S. Craighill Handy, Ph. D.
Ethnologist of the Bishop Museum.

(Introduction à l'Art des Iles Marquises, par Willowdean C. Handy. Paris, les Editions d'art et d'histoire, 1938.)

Photo F. Deithos.

OU TOUT VA S'OBSCURCIR

Un fait domine les commentaires qui durent la plus récente pilule « extra-terrestre » des Russes : tous les organes de la presse, — délirants à « gauche », hypocrites à « droite », — ont laissé entendre que le dérapage, sur quelques dizaines de milliers de kilomètres, qui a changé la fusée lunaire en satellite solaire, entrait dans les desseins de ceux qui l'ont lancée.

Tel qu'il fut magistralement énoncé par Nietzsche, l'instinct effréné de la connaissance sans choix qu'il bourgeonne à la manière des hydres. Les bigots de la vérité scientifique s'unissent, par-delà la rivalité pragmatique des impérialismes, pour nous faire croire que l'homme (quel homme ?) « réalisera ses rêves les plus fous » : le savant, — diplômé de physique et habitué à boire à propre haleine changée en eau potable, — préférera à ses autres planètes. Cette complicité déborde la compétition à laquelle elle s'entrelace. Au micro d'une station périphérique bien informée, un ingénieur français déclarait qu'il n'y a pas de problème pour la construction d'une fusée « cosmique » française, ou à tout le moins européenne : juste quelques difficultés financières, que la politique de grandeur y pourrait résoudre par ses méthodes expéditives.

Baluons donc la candeur des astrologues de Ceylan qui, toute affaire cessante, se sont réunis pour décider de l'existence d'un astéroïde métallique était de nature à perturber leurs calculs. Leur réponse négative ne fait pas de doute, eu égard aux lois constantes de l'art judiciaire. Et puisque M. Félix Lablisse a cru bon de s'extasier sur ce corpuscule, saluissons l'occasion de rappeler que ce qu'il peut écrire ou peindre ne nous engage point : le Lundi « n'est pas l'événement mythologique le plus considérable », ses prouesses militaires, sa fuite en Espagne ou nos débuts : « A Bouillon, j'ai eu la plus belle des jeunesses. Nous étions huit à la maison... Au printemps, nous dénichions les nids et gobions les œufs, tout chauds.

De la même enquête d'Arts (14 janvier 1959) je retiendrai l'analyse de Georges Friedmann, concluant au caractère de diversement « pascalien » de tout ce qui, dans cette entreprise, ne relève pas de la lutte pour l'hégémonie mondiale. Mais pour ma part, je pense, je crois du plus profond de moi-même, je l'écris ici, que l'expansion astronautique marquera le point culminant de la perversion des forces spirituelles, et préparera leur écrasement par le positivisme des technocrates « humanisées ». Jouant entre deux menaces de guerre « sidérale » agitées par les maîtres pour faire rentrer les peuples dans l'obéissance, le plus médiocre intellectualisme va nous submerger avec les sous-produits de désagrégation des terreurs religieuses, qui colorent les pénombres débiles et les confortables rêveries de la nouvelle manie ambulatoire. Opium, d'autant plus efficace qu'il sera réaliste, la petite promenade autour de la Lune est déjà réclamée, paraît-il, par 25 à 30.000 crétins, habitant, après tout, le même domicile que moi. Si les individus sont bien sages — ou s'ils le sont trop peu ? — ils auront le droit de visiter Mars.

Vous y voilà, dira quelqu'un. Sur la pente de cet obscurantisme qui vous fait tant de mal, vous vous retrouverez en compagnie du jésuite Daniélou, pour répéter « que tout cela ne change rien au drame de l'humanité, non plus qu'aux problèmes de la vie intérieure ». Ici tend à mon censeur cette perle de M. Gaetano Crocco (comme il enseigne l'astronautique à l'Université de Rome, je suis à penser s'il est moins chrétien que je le suis interrogé par Arts) : « Il est nécessaire de conquérir la lune pour accroître l'espace vital de l'espèce humaine. Chaque humain dispose actuellement de cent ares de terre. Au rythme d'accroissement de la population, il n'y aura plus

que quarante ares par personne dans un siècle ».

Tout, plutôt que la réduction des naissances, et la diminution du nombre des « âmes » à abrutir. Et c'est pour être resté à la terre qu'Hélène Smith fut la voyante qui nous troubla. Quant aux poètes de l'utopie, c'est faire bon marché de l'intérêt sexuel et des intentions satiriques ou ésotériques qui les animaient, que de les ranimaient en précurseurs à la taille d'un Jules Verne.

Il y aura bien quelques planteurs de croix pour adapter à la terminologie vaticane le mensonge selon lequel le voyage planétaire serait au progrès vécu par réaction ce qu'elle prétendait promouvoir. Depuis la dernière guerre, quel changement ! Ces mêmes classes ont perdu toute confiance en leur avenir ; elles savent qu'elles ne survivent uniquement parce qu'elles ne sont l'objet d'aucune attaque de la part des masses et des profiteurs du répit qui leur est accordé pour établir autour d'elles une zone de protection confiée aux éléments de soldat. Si, en conséquence, le curé couturier, Décidément, le curé couturier. Décidément, le curé couturier.

Ces propos semblent indifférents ou puérils à ceux qui flottent à la tiédeur de l'optimisme, qu'il soit chrétien, marxiste, ou simplement « humaniste ». Aux autres, je demande leurs avis, leurs avis, ou je concours (2). Si les éléments mis au mouvement sont trop énormes pour qu'il y ait chance de les arrêter, ce n'est pas une raison pour ne pas crier. Il n'est pas trop tôt pour préparer, par le défaitisme aussi bien que par la diffusion des cosmologies hétérodoxes (j'y reviendrai) le témoignage solennel que l'esprit, dans la totale liberté des aspirations et de ses activités, n'est pas concerné par cette caricature de l'infini.

Gérard LEGRAND.

(1) La Naissance de la Philosophie à l'époque de la Tragédie Grecque, trad. Geneviève Blanquis. Cf. le curieux essai de Karl Jaspers, Nietzsche et le Christianisme.

FEU !

Léon Degrelle, le Volksführer belge dont Hitler disait « J'aurais aimé qu'il fût mon fils », est présenté par Paris-Presse comme un sympathique héros. En vante la « vie intérieure » à l'aide de poèmes et de méditations, sa fuite en Espagne. Il n'est pas l'événement mythologique le plus considérable de notre temps « et n'accompagne pas la renaissance glorieuse du surréalisme. Factice et pernicieuse mythologie, totalement désaccordée de l'occultation aussi bien qu'à l'exaltation du surréalisme.

J. J. LEBEL.

(2) Une enquête est à l'étude. Cf. aussi Une Apparente de Suspicion dans Front Unique de J. J. Lebel, août 1958.

Patron pour Chaisières

De même que les cafards profitent des ténèbres pour envahir les cuisines mal tenues, les curés surgissent aujourd'hui de toutes parts dans au monde sur lequel pèse le plus éclatant aux yeux de plus en plus noire. Après les ratichons ouvriers, les contaxes de cinéma, de radio et de télévision, voici qu'à Turin « il apparaît le curé couturier. Décidément, le curé couturier. Décidément, le curé couturier « le sont à penser s'il est moins chrétien que je le suis...

Il suffit de rappeler qu'avant la dernière guerre aucun curé n'eût osé tenir une journée dans une usine de la région parisienne (il aurait été aussitôt reconnu sous son véritable aspect de flic et chassé incontinent par les travailleurs indignés) pour mesurer leur la régression qu'implique une semblable tolérance. Quant à tenter de régenter la mode, aucun curé n'y songeait, pas même dans l'Italie fasciste ! Par bonheur, la délicieuse coquetterie féminine aura vite fait justice de cet esprit béni par cette engeance.

Vous et voilà, loi sur la séparation des Eglises et de l'Etat avaient efficacement contenu la vague cléricale dans le domaine de la culture, dans la morale et des mœurs. Il est vrai que l'Eglise représentait alors pour les couches dirigeantes les plus éclairés vécu par réaction avoué opposé au progrès social qu'elles prétendaient promouvoir.

Benjamin PERET.

(1) L'Express, 22 janvier 1959.

Faut-il exterminer les Tortues ?

Devant les assises de Hanover, l'auto-stoppeur « Edi le flingue », âgé pourtant de trente-huit ans, a déclaré avoir tué surtout « pour s'habituer à tuer des cadavres » (1). Si cette déclaration pourrait tenir aux oreilles de Crapaud-dans-son-trou, on imagine bien sa nouvelle trouble. Quant aux livres de l'utopie, c'est faire bon marché du tréfonds sexuel et son désespoir ça gagnerait furieusement son « Biredôt... aux propos rudiments l'art aura péri » (2), ce mystérieux personnage de Thomas De Quincey se retirerait de nouveau, aura douté, chez lui pour de longues années.

Nous ne savons rien sur le domicile de Crapeau-dans-son-trou. Ce qui est pourtant certain c'est qu'en rentrant il ne risquait pas de trouver chez lui une capture pareille à celle qui attendait ces jours-ci Mme G. (3) après le retour des sports d'hiver : un superbe électronique que l'on nous décrit comme « une sorte à vivre couché ». Sans se lever et rien qu'en appuyant sur les boutons, on y est servi par multiples appareils : magnétophones, télévisions, téléphones, radios, cuisines automatiques, rasoirs, etc. Peut-on y dormir ? Ce serait dommage à mon avis, cette nouvelle invention laisse beaucoup à désirer. Les ingénieurs n'ont-ils pas oublié l'essentiel ? Une ou au besoin plusieurs poupées électroniques, en matières plastiques, pour sex-automation. Notre ami J.-F. Revel a calculé que dans les bordels italiens, les clients s'exécutent en trente au cinquante secondes. Une poupée plastico-électronique, rotative et ondulatoire, réduirait facilement ce temps à une seconde ou à une fraction de seconde, et cela sans que l'on ait besoin de détourner les yeux de l'écran téléviseur. Evidemment, puisque actuellement on se préoccupe tant de donner aux réalisations de la technique moderne une allure plus familière et plus gentille » (3), il ne faudrait pas oublier de trouver de jolis noms pour ces automates nucléo-érotiques, par exemple : Pantoufle du Pape, ou bien Hostie Sucrée, ou encore Moustache de l'Atome.

Mais sortons des alcôves conditionnées pour gagner l'air libre et au pas qui devrait être celui d'une souveraine, du moins au pas de souveraine, du moins au pas de souveraine, et qui vous revient

ADRIEN DAX.

RESPIRATION

Je suis de ceux qui admettent, avec les Marx Brothers, qu'un pique-nique est raté si les fourmis en sont absentes.

Je suis également de ceux pour qui une journée de plonge dans l'atmosphère des rues de Paris — l'ennui du grand air, pur et sain ! — ne saurait avoir de signification sans l'inévitable rencontre avec un minimum d'élément de contrariété.

Leur existence, qu'elle soit permanente ou manifestée seulement lors de mon passage, renforce singulièrement ma certitude d'avoir raison. Toujours.

Peu de choses, souvent, sont nécessaires.

Le sourire que vous lancez et à dérobée vers une jolie femme roissa (7). Et les prêtres y sont toujours en chair : à quand le curé-nylon ?

Radovan IVSIC.

comme un boomerang après avoir échoué sur les lèvres de glace, alors que seulement vous désiriez lui faire hommage de sa beauté : la déception qui naît dans votre tête, dans un café, la vulgarité des propos l'emporte quelquefois sur le vol du bruit des appareils à sous, code secret des fanatiques où il est question « d'éteindre le couloir central », « d'allumer les flèches rouges » et « de faire monter les flèches » — vers quel inaccessible point ?

Le mécontentement provoqué par les feux de crédibilité que l'on vous accorde si, au hasard des conversations, vous rapportez quelque fait à la signification cachée, sans l'expliquer davantage.

D'UNE LETTRE D'ANDRÉ HARDELLET

Que se passe-t-il entre deux rames de métro, leurs stations fermées « Rennes » et « Saint-Martin » ?

Il est probable qu'entre deux rames s'ouvrent les voyages qui font communiquer ces stations fermées avec leurs égouts, les Catacombes, les dessous de l'Opéra et quelques demeures somptueuses interdites aux touristes.

C'est là, également, grâce à des voies ordinairement bouchées, que se produisent (autrement) ces inexplicables (autrement) disparitions de rames entières signalées par plusieurs ouvrages sérieux.

Et aussi le mépris définitif d'une certaine forme de peinture moderne rencontrée au fil des galeries de la rive gauche, ou droite, ou ailleurs, et que je retrouvais l'autre jour en passant rue de Seine. A l'accrochage « 8 entre de 30 ans. Pourquoi ? Je reviendrai, certes, quand on affichera « 30 peintres de 8 ans ». Pourquoi pas ?

Ma soif est grande, si la coupe est petite et je joue moi-même au billard électrique.

Alain JOUBERT.

In the months that followed, Krushchev's official condemnation of Stalin's crimes (begun on February 25 during the twentieth Congress of the Communist Party of the Soviet Union, it took some time before it gained acceptance and recognition among fellow parties, including the French Communist Party) led to the publication, dated April 12, of the pamphlet *Au tour des livrées sanglantes!* written by Schuster and Breton and cosigned by fifteen group members.[103] The pamphlet reiterated that it was surely because the surrealist movement constituted "the pole of vigilance with regard to all the attacks upon the Revolution both as an idea and as a fact" that it had been fiercely anti-Stalinist for twenty years, without ever abandoning its revolutionary goal. The text exhorted its "communist comrades" to rid themselves of the lackeys of Stalinism, who had lastingly channeled the rebellion into a "religious adoration" of "the little father of the people," and, in so doing, were clearly guilty of having broken the revolutionary will, actually exploiting the proletariat as a result, and objectively allying themselves with capitalism. Sensing how lengthy a process of de-Stalinization would probably be in the French Communist Party, *Au tour des livrées sanglantes!* called on militants to overthrow their leaders, to expel the likes of "Aragon, Wurmser, Triolet, Stil, Kanapa, Courtade and other dogs of lesser pedigree, all of them paid apologists and accomplices of Stalin's crimes," and to demand the solemn rehabilitation of Trotsky along with the destitution of "bureaucrats in thrall to Thorez."

The group was thus waging battle on the complementary fronts of antifascism, anti-colonialism, and de-Stalinization, ending the isolation that, with the exception of the brief time spent in collaboration with the anarchists, had lasted since the early 1950s. The events in Budapest in November were an indication, however, that Russian impe-rialism could easily get on without Stalin. *Hongrie, soleil levant* (Hungary, rising sun) gave the moral lesson of the events, a lesson that was announced as pragmatic, of neces-sity, "in a period of insurrection": "Fascists are those who shoot their people," and "the defeat of the Hungarian people is the defeat of the proletariat"—even if it seemed probable that there were fascist elements among those who took part in the Budapest uprising.[104]

These events led the surrealists to join with other intellectuals to launch an "Appeal in Favor of an International Circle of Revolutionary Intellectuals."[105] According to the text, the role of intellectuals in the Budapest uprising was proof that "thoughts and words are one action." The uprising in the Hungarian capital, although crushed by the Soviet army, signified the necessity of reviving both the "liberation of revolutionary thought" and the "democratization of socialist thought." In order to do so there would have to be the beginning of an ongoing debate among all revolutionary intellectuals, whose priority must be to identify and elucidate any problems arising in the workers' movement with relation to power, to the organization of the economy, to the revolu-tionary party or parties, to the evolution of capitalism, to the various forms (colonial and other) of imperialism, and to the social function of revolutionary ideas.

In parallel, in December 1956, the Bureau of the Intellectual Action Committee against the Continuation of the War in North Africa began to issue statements regard-ing the Russian intervention in Hungary. As a result of the debate, a constitution was formulated for a Committee of Revolutionary Intellectuals, the aim of which would be to struggle not only against French colonialism but also against all forms of imperi-alism, including the Soviet one; a regular publication would assist them in this endeavor, although it was not founded there and then.

COTE D'ALERTE

Le résultat des élections ne nous préoccupe réellement que dans la mesure où pour la première fois siègent au Palais-Bourbon plus de cinquante députés qu'il n'y a aucune exagération à qualifier de fascistes.

Soutenus par toute la presse nazie de Paris, un ramassis de bistrots, de lutteurs de foire, de voyous d'épicerie, de bouchers habitués à mettre le pouce à la balance et à circuler dans le sang, s'apprêtent à nous gouverner avec l'aide de quelques microcéphales de la Faculté de Droit. Ces voleurs patentés n'en sont plus encore qu'à crier « Au voleur ! » selon une technique éprouvée. Déjà ils prétendent instaurer la discrimination raciale des Français et ressusciter l'étoile jaune.

Malgré le courage dont a fait preuve en la lançant le député Bokanowski, la formule : « Défendre la République » n'a pas de sens politique pour nous, surréalistes, ni même, à proprement parler, de contenu moral : il faudrait que le système parlementaire fût effectivement l'incarnation de la République pour que nous en discutions. Mais sur le terrain spécifique où nous nous situons, nous jugeons quand même l'air de la démocratie « bourgeoise » moins irrespirable que celui des ces arrières-boutiques où se cultive la nostalgie des baignoires du flic Dides et des fours crématoires de M. d'Halluin dit Dorgères.

Les intérêts qu'il faut bien nommer de l'esprit ne s'incarnent pas pour nous dans une classe sociale ou dans une forme de gouvernement : il ne s'en suit pas que nous devions contempler indifférents le massacre des populations d'Afrique du Nord par une soldatesque aux gages des bailleurs de fonds du Poujadolf. Il y a en effet d'ores et déjà un domaine où les exigences immédiates de nos néo-pétainistes sont intolérables : celui de l'Algérie.

Demain, si l'on n'y prend garde, ce seront les rues de Paris qu'ils transformeront en terrain de chasse à l'homme. Nous demandons donc au Comité d'Action des Intellectuels contre la répression en Afrique du Nord, qui, selon les paroles mêmes de Jean Cassou, constitue le plus important rassemblement qu'on ait vu depuis 1936, de déléguer sans distinction d'opinions politiques ou autres un Comité d'Action contre le Fascisme et le Colonialisme, d'organiser un boycottage systématique de la finance poujadiste, et de ne pas attendre que la violence la plus basse et la plus cynique l'emporte, pour « mettre en garde » une opinion publique complètement désorientée.

Paris, le 21 janvier 1956.

POUR LE MOUVEMENT SURRÉALISTE :

Anne BÉDOUIN, Robert BENAYOUN, André BRETON, Jacques BROUTÉ, Adrien DAX, Charles FLAMAND, Georges GOLDFAYN, Louis JANOVER, Alain JOUBERT, Gérard LEGRAND, Nora MITRANI, Benjamin PERET, José PIERRE, André PIEYRE DE MANDIARGUES, Jacques SAUTÈS, Jean SCHUSTER, Jacques SENELIER, Jean-Claude SILBERMANN, Jean-Claude TERTRAIS.

Notre ami Charles ESTIENNE se déclare entièrement solidaire de ce texte.

COTE D'ALERTE

In *le surréalisme, même,* number 2, a note from the editor ("The Events of These Last Months . . .") relating recent debates in the assemblies of the Intellectual Action Committee against the Continuation of the War in North Africa and the Committee for Liaison and Action for Workers' Democracy deplored the ongoing use of obstructionist Stalinist practices and noted that "those who are *for* the Hungarian revolution and *for* the Algerian revolution without restriction are not numerous." The surrealists, at least, who were *for,* were thus "aware of being rigorously faithful to the spirit they have always had" by stubbornly calling, in particular, "for an end to the disastrous war" in Algeria and demanding that the government "bring a halt to the imprisonment, torture, massacres and so-called pacification."

Although information in the press was rare regarding torture, massacres, and other means of coercion carried out in Algeria (newspapers that wrote about these topics were subjected to multiple forms of intimidation), the publication in October 1957 of the work by Georges Arnaud and Jacques Vergès, *Pour Djamila Bouhired,* publicized the practices of the French Army in a way that hardly pleased the government but did alert certain fringes of public opinion.[106] In May 1958, the end of the Fourth Republic and de Gaulle's accession to power were interpreted by the group as a confirmation of France's slide toward fascism pure and simple. These events determined the publication of a periodical, delayed since early 1957, which was meant to be an organ for the position of the Committee of Revolutionary Intellectuals. But many on the committee were still unsure; thus it was up to Schuster and to Dionys Mascolo to undertake the publication, with the help of the surrealists, of the review *Le Quatorze Juillet* (a title suggested by Breton), which from its editorial clearly proclaimed its advocacy of intellectual resistance to Gaullism and fascism.[107]

Independent, in the strict sense of the term, from the surrealist group, *Le Quatorze Juillet* nevertheless published contributions from some of its members: Benayoun, Bédouin, Breton, Lebel, Legrand, and Péret, amid articles written by participants in the Committee of Revolutionary Intellectuals (Robert Antelme, Marguerite Duras, Jean Duvignaud, Daniel Guérin, Edgar Morin, Elio Vittorini, and others); Maurice Blanchot would contribute from the second issue on. All the pieces were characterized by a certain rage (given what was threatening and a tendency among intellectuals to abdicate that was considered "unfathomable") and by the will to harden the resistance of the mind against historical contingency. Through each text runs a common thread, that of the struggle against all aspects of fascism—however different they might seem in appearance. Between the Franco-Algerian situation and the one in Warsaw (a letter from Warsaw, "Antitotalitarian Resistance," was published in the second issue, signed by Norman Babel, the pseudonym of Leszek Kolakowski) or in Budapest, there was no significant difference: as Schuster wrote, "Budapest, for us, is not so far away. Not in time—only two years—nor in space; it is as close to us as Algiers."

Before the publication of the second issue (a week before the referendum on the Gaullist constitution) a "Project for a People's Judgment" was distributed, on September 21, 1958: a long list of reasons led to the declaration that "the De Gaulle government and Charles de Gaulle the usurper" were illegal and that the referendum itself would be declared "null and void" in advance. Meanwhile, a new appeal was launched for a "resistance to oppression," to which a second appeal was joined, "for the union of free consciences to place A LACK OF CIVIC SPIRIT on the agenda" and "to propagate the spirit of insubordination on every level of society."

On April 10, 1959, a survey signed by Blanchot, Breton, Mascolo, and Schuster was distributed "among French intellectuals." There was concern, because of the apparent passivity of "writers" with regard to current events, about the future of ideas and the new conditions that those ideas might have to face. If ideas were a protest against a current state of affairs—and power in particular—then they must be linked to the "profound sense of democratic exigency" located in the movement, "which contrasts ideas with power, human demands with the state of things." The third and last issue of the periodical, symptomatically dated June 18, 1959, published twenty-eight responses, from Arthur Adamov to Jean Paulhan by way of Jean Beaufret, Pierre Klossowski, and Edgar Morin. But it also published the list of seventy-one other recipients of the survey who, for various reasons, had not replied after all. In "Closed for Repairs," Schuster was disillusioned: "The results of the survey . . . show, in their way, the failure of French intelligence, an intelligence which, if it ever knew how to say no, has completely forgotten, or which says no with caution." He would be still further disillusioned, but in another way, when the periodical was reprinted in 1990, at which point he said, it "shows that certain intellectuals, when they are not councilors to the Prince, renounce all lucidity in their diagnosis and all intuition in their prognosis." In his opinion, it should be acknowledged with hindsight that de Gaulle, far from incarnating or preparing fascism, "saved the Republic on two occasions: from the old fool of Vichy and from the seditious elements in Algiers."

The tone of the texts that appeared in *Le Quatorze Juillet* may seem excessive in retrospect, if not downright comical in the way in which they cry wolf, as if the point were to overestimate the danger in order to elicit strong reactions: this was undoubtedly proof of an exaggerated interpretation of the events of May 1958, suggesting, for example, that de Gaulle, who had established his power by means of an almost "religious" charisma, ran the risk of becoming a sort of French-style Stalin. But it also reflected the degree to which a response to the danger had become urgent and how people's consciences were troubled by the international situation and the war in Algeria. One might deplore the error in political judgment, but it would be inappropriate to fail to recognize that such judgment was determined by the concern for an unconditional defense of freedom and ideas that constituted one of the foundations of the surrealist ethic—all the more inappropriate in that the opposition of the intellectuals undoubtedly prevented the nascent Fifth Republic from giving way to the temptation of fascism. As for the call for a deliberate lack of civic spirit, it paved the way for the famous "Manifesto of the 121," which would soon have repercussions just as noteworthy as those of *Le Quatorze Juillet,* however different.

Hongrie, soleil levant

La presse mondiale dispose de spécialistes pour tirer les conclusions politiques des récents événements et commenter la solution administrative par quoi l'O. N. U. ne manquera pas de sanctionner la défaite du peuple hongrois. Quant à nous, il nous appartient de proclamer que Thermidor, juin 1848, mai 1871, août 1936, janvier 1937 et mars 1938 à Moscou, avril 1939 en Espagne, et novembre 1956 à Budapest, alimentent le même fleuve de sang qui, sans équivoque possible, divise le monde en maitres et en esclaves. La ruse suprême de l'époque moderne, c'est que les assassins d'aujourd'hui se sont assimilé le rythme de l'histoire, et que c'est désormais au nom de la démocratie et du socialisme que la mort policière fonctionne, en Algérie comme en Hongrie.

Il y a exactement 39 ans, l'impérialisme franco-britannique* tentait d'accréditer sa version intéressée de la révolution bolchevique, faisant de Lenine un agent du Kaiser ; le même argument est utilisé aujourd'hui par les prétendus disciples de Lenine contre les insurgés hongrois, confondus, dans leur ensemble, avec les quelques éléments fascistes qui ont dû, inévitablement, s'immiscer parmi eux. Mais en période d'insurrection, le jugement moral est pragmatique : **LES FASCISTES SONT CEUX QUI TIRENT SUR LE PEUPLE.** Aucune idéologie ne tient devant cette infamie : c'est Gallifet lui-même qui revient, sans scrupule et sans honte, dans un tank à étoile rouge.

Seuls de tous les dirigeants ''communistes'' mondiaux, Maurice Thorez et sa bande poursuivent cyniquement leur carrière de gitons de ce Guépéou qui a décidément la peau si dure qu'il survit à la charogne de Staline.

La défaite du peuple hongrois est celle du prolétariat mondial. Quel que soit le tour nationaliste qu'ont dû prendre la résistance polonaise et la révolution hongroise, il s'agit d'un aspect circonstanciel, déterminé avant tout par la pression colossale et forcenée de l'Etat ultranationaliste qu'est la Russie. Le principe internationaliste de la révolution prolétarienne n'est pas en cause. La classe ouvrière avait été saignée à blanc, *dans sa totalité,* en 1871, par les Versaillais de France. A Budapest, face aux Versaillais de Moscou, la jeunesse — par delà tout espoir rebelle au dressage stalinien — lui a prodigué un sang qui ne peut manquer de prescrire son cours propre à la *transformation du monde.*

Anne BÉDOUIN, Robert BENAYOUN, André BRETON, Adrien DAX, Yves ELLÉOUËT, Charles FLAMAND, Georges GOLDFAYN, Louis JANOVER, Jean-Jacques LEBEL, Gérard LEGRAND, Nora MITRANI, Benjamin PÉRET, José PIERRE, André PIEYRE de MANDIARGUES, Jacques SAUTÈS, Jean SCHUSTER, Jacques SENELIER, Jean-Claude SILBERMANN.

* *Qui vient de donner sa mesure en Egypte, selon ses techniques les plus éprouvées.*

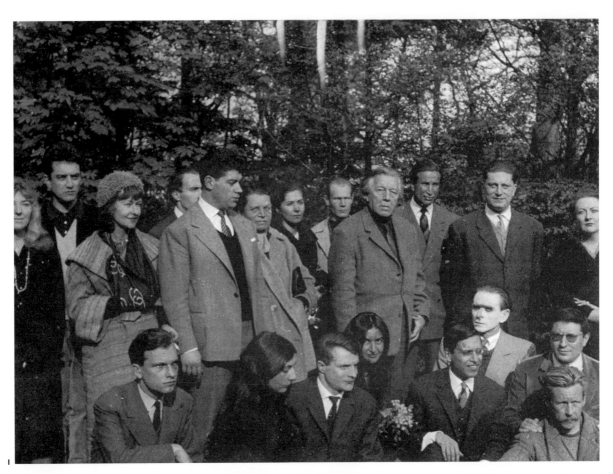

1

2

1959-1969

"IDEAS CRACKLING WITH IMAGES"*

EROS

Opposite page:

1 The surrealist group at the "Désert de Retz," an eighteenth-century folly near Saint-Nom-la-Bretèche, April 1960. Among those present are, *standing:* Aube and Élisa Breton, Georges Goldfayn, Toyen, André Breton, Édouard Jaguer; *sitting:* Gérard Legrand, Nicole Espagnol, Alain Joubert, Robert Benayoun, and José Pierre.

2 The same, masked.

Photographs by Denise Bellon.

*Gérard Legrand, "Le Soleil de minuit," in Legrand, *Des pierres de mouvance* (Paris: n.p., 1953), 63.

The eighth *Exposition inteRnatiOnale du Surréalisme* (*EROS*) opened on December 15, 1959, at the Galerie Daniel Cordier; Benjamin Péret had died three months earlier, after publishing his last political articles in *Bief,* and his photograph was on the cover of number 9.[1] In the same issue, the list of those who had attended his funeral or "written to express their regret" was simply entitled "Living among Us." In the next issue, excerpts from an article by Georges Munis devoted to his friend and fellow militant were published: "As a poet, Benjamin Péret was among the first surrealists; as a revolutionary, among the first communists. As a revolutionary, he was the opposite of a politician; as a poet, he was the opposite of a *littérateur.*" His death, followed by the suicides of Wolfgang Paalen and Jean-Pierre Duprey, was deeply felt within the group, for whom Péret's presence had sufficed in and of itself as a reminder of the refusal to compromise in any way as well as of the cost of the most uncompromising poetic or political freedom.

In August 1959, Breton invited artists to take part in *EROS,* which would include a retrospective section and a section devoted to new work; he also emphasized that participation was not limited to submitting one's work but would extend to "suggestions which would benefit the indispensable preparation of the whole event." The choice of eroticism as the central theme was a reminder of the place it had always occupied in surrealism, in all its diversity; but a theme like this was also a way to mark a distance from what was a fairly depressing state of affairs worldwide, especially politically.[2] It would also be an offensive against an increasingly oppressive moral order. In any case the theme met the approval of the artists contacted. Miró, for example, said that "this idea of returning to eroticism, which is an eternal thing, seems excellent [to me]"; Bellmer eagerly envisaged a new version of his Doll, perhaps a "catoptic box, three mirrors forming a triangle which multiply the object placed among them to infinity";

587

1 The Execution of Sade's Testament, ceremony presided over by Jean Benoit, December 2, 1959, at the home of Joyce and Sam Mansour in Paris, for the 140th anniversary of the marquis's death.

2 "Cannibal Feast" organized by Meret Oppenheim during the opening of the *EROS* exhibition at the Galerie Daniel Cordier, December 15, 1959. Photograph by William Klein.

3 A hall of the *EROS* exhibition at the Galerie Daniel Cordier, December 15, 1959–January 1960. *In the foreground:* Miró's *L'Objet du couchant. In the background:* Giacometti's *L'Objet invisible* next to Robert Rauschenberg's *The Bed.* Photograph by Henri Glaeser.

4 Deluxe edition of the *EROS* catalog: *Boîte alerte,* designed and created by Mimi Parent, destined to contain, among other things, postcards and "lascivious missives" (Marcel Duchamp's expression).

5 Yves Tanguy, *Nombres imaginaires* (Imaginary numbers; 1954). Thyssen Bornemisza collection. Work presented at the *EROS* exhibition.

1

2

3

4

5

Meret Oppenheim suggested "a mask, but according to people's reactions, it must have something erotic about it" and specified that "Eros, who for all primitive peoples" is "a spirit like all the others" had been sacrificed to a spiritual principle and sent to the devil"; and this time Giacometti agreed to take part, with *L'Objet invisible* and *Boule suspendue.* All told, seventy-five participants from nineteen countries were present, some of whom were from outside the movement, but their collaboration actually showed that even outside of surrealism, eroticism was a constant element in creativity.

The "stewards" of *EROS* were Breton and Duchamp. Duchamp had just declared on the BBC:

> Eroticism is something I hold dear, and I have certainly applied my taste for it, my love for it, to my *Large Glass.* In fact, I have thought that the only grounds to do anything is to give it the life of eroticism. . . . It's an animal thing which has so many different facets that it's a pleasure to use it like a tube of paint, so to speak, and to inject it into one's creations. That's what 'laying bare' is. I mean, with Christ it even had a perverse connection. You know that Christ was 'stripped naked,' and it was a perverse way to introduce eroticism and religion to each other.[3]

Breton and Duchamp were assisted by José Pierre, the montage was taken care of by Robert Benayoun, Pierre Faucheux was the chief operator, and as for Radovan Ivsic, he was in charge of the soundtrack that played a considerable role during the event as a whole.

Duchamp planned to design the entrance to the first room in the Galerie Cordier in the shape of "a rubber vagina, poorly made but evocative"—a project that was finally replaced by a curtain of pearls, less blatant. This first room, where the floor was covered with a thick layer of sand, had a ceiling that could be raised and lowered to the rhythm of breathing. It opened onto a "grotto" with walls draped in green velvet, rustling with the sound of lovers' sighing, and perfume on the air. Alongside works by Miró (*L'Objet du couchant*), Pierre Molinier, Simon Hantaï, and Max Walter Svanberg, Giacometti's *Objet invisible* seemed to keep watch over Robert Rauschenberg's *The Bed* (this was his first work to be exhibited in Paris, also the case for Jasper Johns with *Large Target Construction*). The third space, more modest, was draped with black velvet: a reliquary wall, designed by Mimi Parent, was covered with boxes placed into cell-like niches, presenting objects specially created for the exhibition—three objects by Breton, *With My Tongue in My Cheek* by Duchamp, Meret Oppenheim's *Le Couple,* an object by Adrien Dax, two by Roberto Matta, and one by Mimi Parent herself. In the last room, conceived by Oppenheim, pinned to the walls covered in red were the pieces of the costume that Jean Benoit had worn a few days before the opening for his ceremony devoted to the execution of the last will and testament of the Marquis de Sade. In addition, there was a vision of a "cannibal feast": a woman with a golden face lay spread out on a table, her nakedness gradually revealed as visitors tasted the refined dishes laid out on her body (she was replaced by a mannequin after the opening night).

December 2 was the 140th anniversary of the death of the Marquis de Sade, and Joyce Mansour had hosted a party during which Jean Benoit executed the "Grand Cérémonial"; at the end of the evening, wearing an astonishing costume where "primitive" shapes mingled with a flawless aggression, he stamped his chest with a branding iron in the name of the Divine Marquis. Matta, who was present that evening, grabbed

the iron and also branded himself. "We would be lacking in the spirit with which Jean Benoit infused us on December 2nd, and would no longer be worthy of life with all its pitfalls but also all its opportunities, if we failed to recognize that Matta revealed himself in a light which totally reevaluates him in our eyes," said Breton two days later in *Dernière heure*—a declaration that in passing would also ensure Victor Brauner that the old dispute that had alienated him from the group was now long forgotten.[4] Lending their support to Breton's declaration were Jean-Louis Bédouin, Nora Mitrani, Jean Schuster, and Toyen, the "signatories of the 1948 motion, now rendered null and void by this declaration." Matta and Brauner were thus reintegrated into the group and, to make certain that everyone was aware of the fact, *Dernière heure* was printed at the end of the *EROS* catalog.

The catalog opened with an introduction by Breton, who began by praising Bataille for his insistence that eroticism, far from being simply an opportunity for risqué stories, "is that which, in the conscience of man, calls his being to question."[5] He also stressed that "not everything is necessarily as black as Bataille would have it."[6] This was followed by a series of pieces by Octavio Paz, André Pieyre de Madiargues, Hans Bellmer (on Friedrich Schröder-Sonnenstern, who was one of the most striking discoveries of the exhibition), Man Ray, and others, as well as a *Lexique succint de l'érotisme,* a group compilation.[7] Eighteen authors wrote entries for this lexicon, five of them women—regardless of what those men who preferred to see women as mere "objects" for the surrealists might think, women were very active subjects. The title itself was obviously a nod to the lexicon that had come out in 1938, and it would seem that the 1960 version of a *Dictionnaire abrégé du surréalisme* was actually nothing more than a *Lexique succint de l'érotisme*. There was, in particular, this statement: "Eroticism, by its very individualism, escapes all (logical or moral) evaluation of a social nature."

The first editions of the catalog included a folder containing five prints by Miró, Svanberg, Toyen, Jacques Le Maréchal, and Dax. Each folder was placed in an "emergency box" (designed and produced by Mimi Parent), which held a wealth of items and anticipated what much later would become the fashion of multimedia or object-books: "lascivious letters" (from a sadist, from Vincent Bounoure, Benayoun, Mansour, Péret, Paz, Mandiargues—*La Marée*—Joubert, etc.), a *Couple de tabliers mâles et femelles* (Pair of male and female aprons), and a pneumatique ("Je purule, tu purules, la chaise purule. Grâce au râble de vénérien qui n'a rien de vénérable")[8] by Duchamp, a stamp by Toyen, a record by Joyce Mansour and Péret, and six postcards reproducing works by Dalí, Gorky, Miró, Svanberg, Bellmer, and Clovis Trouille.

In a more general fashion, it was the entire *EROS* exhibition that offered a new concept of the artistic event, related to the happening or the environment. No doubt it was partly for this reason that the event was not all that successful, with equal blame to be placed on the ritual reaction of the critics, who saw the exhibition as nothing more than a re-creation of the "climate of the 1920s," if not a return "to the finest years before the bloodbath of 1914." Once again there was cause to deplore the display of a "moral disintegration, so harmful for our youth, and so dangerous for the prestige of France abroad" (Jean-Paul Crespelle); there was even some astonishment that this "antechamber of the brothel" could be located "two kicks away" from the Ministry of the Interior, and the conclusion was that "the organizer (or the boss) of the exhibition [is] well placed at court."[9] The *EROS* exhibition was nevertheless held over by a fortnight: the negative reactions proved at least that its theme remained sensational. To pro-

long the impact of the event, a program of films was screened at the Studio Parnasse, including short features by Buñuel and Dalí, Hans Richter, Norman MacLaren, Ado Kyrou, Freddie, Borowicz, and Jan Lenica and excerpts from Charles Laughton's *The Night of the Hunter* and Vincente Minelli's *Bandwagon*.

In early February 1959, a pamphlet—*À vous de dire*—was distributed, which was addressed to those young minds who might share with the movement "a community of intellectual concerns and moral commitment."[10] The text suggested two fundamental points as a basis for an agreement: freedom and love, between which a demand for truth in all domains "appears as a necessary propeller." As those concerned might be widespread geographically, they had to find a way to make themselves known, and this could be achieved by answering a few questions about ways for connecting individual rebellion with collective dialogue. But this appeal garnered few notable reactions, and in the months that followed, there was actually more of a rapprochement with the group Phases, if for no other reason than that they shared their hostility toward certain painters (Georges Mathieu, Bernard Lorjou) or former group members who claimed to have "gone beyond" the group's rigor, which in their eyes was proof of a narrow-minded outlook.[11] Beyond the "fairly profound differences within the practical organization of the two movements," the agreement was important insofar as would confirm, at least, for Phases as for the actual group, the pressing need in 1960 to uphold certain values.

The agreement was confirmed in December 1960, by the cosigning of a pamphlet called *We Don't EAR It That Way,* which protested this time against Duchamp's recent favorable reception of a painting by Dalí (*The Antimatter Ear*) within the framework of the international exhibition of surrealism entitled *Surrealist Intrusion in the Enchanters' Domain* (D'Arcy Galleries, New York, November 28, 1960–January 14, 1961).[12] Initially planned by Breton, Duchamp, Édouard Jaguer, and José Pierre, the exhibition was actually mounted by Duchamp, the only one present in New York, and he agreed to include Dalí; moreover, Dalí himself was received at the opening "with the respect due to an honored guest." Obviously, the pamphlet was contesting his very presence, and emphasized that "now less than ever could his aesthetic ventures and self-interested and scandalous 'extras' suffice unto themselves." At the very moment when "qualified intellectuals are struggling with all their conscience to defend what remains of freedom of opinion and expression," *We Don't EAR It That Way* was a reminder that Dalí was "the former apologist of Hitler" and remained "a fascist, clerical and racist painter, a friend of the same Franco who opened Spain as a parade ground to the most abominable barbarity it had ever known." The pamphlet deplored the situation with veiled words, as if scarcely daring to believe that Duchamp could have been so taken in, in this business, by a pseudodialectic "according to which it is conformism nowadays which will be the ferment to subversion"—which recalls *a contrario* that authentic subversion can be attained only by choosing the path of nonconformism and resistance to all ease or convenience. In restoring the Dalí case to the context of the intellectual struggle of the day, the pamphlet revealed its political significance—although it remains likely that it left Duchamp quite indifferent.[13]

The Manifesto of the 121

In April 1960, Francis Jeanson held a press conference in Paris to explain his political position and his action in favor of Algerian independence. In the weeks that followed,

the news spread that there would be a trial in September of the "Jeanson network," accused of treason.[14] The government had to put a stop to the insubordination that was spreading among conscripts.

Under these circumstances, Dionys Mascolo suggested to Schuster the composition of a "collective declaration which, using the pretext of the trial, would lend support and approval to all those who [refused] to take up arms against the Algerian people, or all those who [were] actively [helping] the Algerians to rid themselves of colonialization" (Schuster). Once the text was finalized, it was submitted to a dozen or so surrealists who were in Paris at the time and who approved it. It was then sent to Maurice Blanchot—on whose support they could count from the time of his collaboration on *Le Quatorze Juillet*—who suggested a few changes. The new version, entitled "Address to World Opinion" was communicated to the surrealists, as well as to Sartre and Maurice Nadeau. The appeal was passed from one person to the next and garnered forty or more signatures. Between two hundred and 250 mimeographed copies were then distributed, but for tactical reasons they contained only four names of surrealists (Benayoun, Breton, Legrand, and Schuster); this time, 121 signatures were collected. Printed clandestinely thanks to Mascolo, the declaration was then retitled, at Blanchot's suggestion, *Déclaration sur le droit à l'insoumission dans la guerre d'Algérie* (Declaration on the right to insubordination in the war in Algeria; a title that greatly displeased Breton, for whom there could be no "right" to insubordination). The declaration, commonly known as "the declaration of the 121," became public on September 1, and by the end of October a second distribution took place, with 246 signatures this time.[15]

The text began by raising the issue that, "in increasing numbers, Frenchmen are being hounded, imprisoned, and condemned, for refusing to take part" in the war in Algeria "or for having come to the aid of Algerian combatants." The declaration then emphasized the particular nature of the conflict: "Neither a war of conquest, nor of 'national defense,' the war in Algeria has gradually become an action of the army alone, and of a caste who refuse to give way in the face of an uprising, the very significance of which even the civil powers, recognizing the general collapse of imperial colonies, seem ready to accept." Under these conditions, and by virtue of the duration of the war, the rebellion against the army itself seemed justified from a moral point of view: the declaration underscored the fact that movements of insubordination "had developed outside of any of the official political parties, without their help and, in the end, in spite of their disavowal."[16] It was therefore in order to gain the recognition of this type of resistance that the signatories said they respected and considered justified both the refusal to take arms against the Algerian people and the choice that some had made to help the combatants; they stated in the final paragraph that "the cause of the Algerian people, which is contributing in a decisive manner to bring the downfall of the colonial system, is the cause of all free men."[17]

The list of the 121 first signatories included personalities from the most diverse backgrounds: alongside the surrealists, there were writers, philosophers, actors, publishers, academics, trade unionists, leftists, entertainment or radio personalities, journalists, and others.[18] The impact of the declaration on public opinion was particularly important, although the press cautiously refrained from reproducing the text. The public prosecutor's office of the Seine district started a preliminary investigation against X: provocation to insubordination and desertion. Some of the signatories began to receive visits from the police, while the government informed the radio, television, and the-

aters that all the signatories were prohibited from appearing on the air or on stage: any organization that failed to respect the prohibition would immediately be stripped of any government support they might be receiving. The press published many letters from readers, particularly young ones, who voiced their confusion or anxiety, but who were clearly concerned about the moral issues raised by the declaration. On September 22, a ruling was adopted that increased the sentence for provocation to insubordination: the punishment would now be from one to three years in prison and from 200 to 100,000 francs. The first indictments were soon read out, but the celebrity of some of the signatories was a deterrent to a zealous application of the law. On September 22, Breton wrote to claim his full and entire responsibility: the composition of the text "should be considered no more than a *result;* it reached its definitive state only after many objections or corrections of viewpoint, *oral and written.* Therefore I consider myself to be one of its coauthors and I would like to insist that in signing it I have implicitly committed myself to do everything within my power to ensure its distribution."[19] As for Jehan Mayoux, who was convicted and suspended from his functions as primary school inspector (he would not be reinstated until 1965), he situated his position within an historical perspective that gave it added significance: "Monsieur Debré recently suggested that state employees had a 'particular obligation' toward the State. Must one be led to believe that men of my generation, who chose an administrative career in the 1920s, gave an oath of loyalty to the French State that was that of Maréchal Pétain or General de Gaulle's 5th Republic? Monsieur Terrenoire suggested that they were not obliged to remain state employees. So be it. But if the republicans had abandoned teaching under the Empire, and Gaullists under Pétain, how would our youth have been educated?"[20]

Progressively, the manifesto of the 121 and the legal proceedings it had instigated managed to upset not only liberal circles and foreign intellectuals (the laureates of the Pulitzer Prize voiced their support) but also the partisans of "national greatness" and of French Algeria who—mindful of opposing what Michel Debré described as " dreadful, mediocre agitation" and "the absurd errors of a small group of individuals" driven by "a distressing deviancy of ideas, an unhealthy love for publicity and even scandal"—published a "manifesto of the generals," of all things. At least the debate had been brought into the public square, and thus everyone had to voice his or her opinion. This was no doubt the first time in its history that the surrealist group was at the origin of a text of such considerable social impact: in comparison, the reactions aroused by the various anticolonial pamphlets, from the Rif war to that of Vietnam, seem insignificant. This was also due no doubt to the situation in France in 1960, as the war in Algeria was in the headlines every day. But it was also because, for the group, the declaration was no more than a continuation of their ideas on the nature of Gaullist power, the danger of fascism, and the necessity of resistance, a resistance that had been under way for several years already, in particular in the pages of *Le Quatorze Juillet.*

The *Mostra Internazionale* in Milan

In May 1961, a *Mostra Internazionale del Surrealismo* was held at the Galerie Schwarz in Milan, a far more modest exhibition than *EROS.* Only twenty-four works were presented, by artists who did not (yet) figure among the surrealist celebrities consecrated by the market: not Miró, Ernst, or Masson, or even Lam, were selected by Breton, José

1

2

4

3

5

1

3

2

Pierre, and Tristan Sauvage (Arturo Schwarz). Toyen, Oppenheim, Paalen, E. L. T. Mesens, Eugenio Fernandez Granell, and Moesman were represented, however, along with artists who had been recognized or adopted more recently, including Jean Benoit, Guy Bodson, Adrien Dax, Yves Elleouët, Robert Lagarde, Yves Laloy, Jacques Le Maréchal, Pierre Molinier, Mimi Parent, Endre Rozsda, Friedrich Schröder-Sonnenstern, and Max Walter Svanberg. This was indeed an international gathering and, as such, was a worthy representation of the movement in its present incarnation.

Until this exhibition, surrealism in Italy had been extremely discreet, if for no other reason than the national influence of futurism, then fascism. Still, signs of interest were there: certain proponents of spatialism, like Gianni Dova or Cesare Peverelli, practiced a gestural automatism, and at the end of the 1950s, the "nuclear" movement (painstakingly documented by Tristan Sauvage) gave birth, with Enrico Baj, to *Ultracorps:* the tonic style and impertinence of these works would be further reflected in Baj's collages.[21] In the exhibition *Il Gesto*, which followed, in 1955, the Albisola meetings, Hérold, Lam, Matta, and Marcel Jean showed their interest in various currents of artistic research in Italy, and later, Guido Biasi would found the periodical *Documento Sud,* which was a link between nuclear art and the Phases movement. In fact, it was primarily through the intermediary of Biasi that contacts were established between Paris and individuals like Baj or Dova, who were encouraged to take part in the exhibitions in Paris in 1959 or New York in 1961.

In such a context, the *Mostra* at the Galerie Schwarz, as José Pierre emphasized in his preface ("The Despair of Gardeners, or Surrealism and Painting from 1950") was "offered to the public of one of the countries least well-informed about surrealism"; this is also why it showed a majority of works by artists who did not seem to be "hiding in the shadow of their glorious elders." They were, on their own, representative of a "magical figuration," (Moesman, Parent, Toyen, Le Maréchal, Svanberg, Schröder-Sonnenstern) and automatism (Elleouët, Dax, Lagarde)—two aspects that Laloy incorporated when he suggested that clairvoyance was, so to speak, the end result of geometry. It remained to be seen whether an exhibition of this kind was capable of giving the Milanese viewers an adequate picture of the relations that existed in 1961 between surrealism and the plastic arts.

Although the works chosen could be said to exemplify the diverse aspects of pictorial surrealism at the time, it was really more of an inventory than a prospective overview. Among the notable absences were artists who several months later would be welcomed by *La Brèche* (Jean-Claude Silbermann, Jorge Camacho, Konrad Klapheck, and others), and there was not the slightest reference to what was emerging in the United States under the name of pop art. Despite the great vibrancy of a Schröder-Sonnenstern or, in a very different domain, of an Elleouët, for whom the pictorial substance, through the use of material and color, suggests the definition of shapes and themes, if one looks at the catalog today (its cover, typically, was a photograph of the group at the "Desert of Retz" [April 1960] and all of the members are wearing a mask), one gets the impression that pictorial invention, in the group, was beginning to stall, making no headway, and was too easily satisfied with a reference to automatism to replace ritual obligation or with a figurative oneirism incapable of self-renewal. Compared with the *EROS*, the Milan *Mostra* seemed altogether too tame, if not regressive, and did not really give a good idea of the issues at stake—perhaps because the main point was to initiate the public to the movement's accomplishments. The *Mostra* almost

contradicted what Bédouin, in June 1959, had written at the end of *Vingt ans de surréalisme,* which came out in November 1961: "Even if surrealism had managed to keep the indispensable *reserve for the future* intact, it would have already successfully fulfilled a part of the mission it had taken on. I think that it has done more than that. It has preserved, in a world where all *chance* seems on the verge of being excluded, a hope in that future. That is where, in my opinion, the secret of its vitality resides."

La Brèche

The last issue of *Bief* was published on April 15, 1960. It would be more than a year before *La Brèche* came out; its subtitle was "Surrealist Action," and it declared that, rather than focus on a "political action which has become more inexpressible than ever" (which does not mean that the periodical would ignore the predictable reactions to the expansion of the "flicocratie"),[22] it would concentrate on a "poetical reevaluation of thought which surrealism attributes, in its most recent conjectural phase, to the principle of analogy." The presentation of *La Brèche* was fairly sober, without any particular pretension in its layout, as there were relatively few illustrations and plates; Breton came on as editor, and on his editorial committee he included Robert Benayoun, Gérard Legrand, José Pierre, and Jean Schuster.

In the course of eight issues (October 1961–November 1965), the periodical drew attention to a certain number of forerunners or visionaries who shared the movement's principles in one way or another. Among those singled out for recognition were Alfred Kubin (with excerpts from *L'Autre Côté*), who died in 1959; Sade, Bataille, Strindberg (for his ideas on chance in artistic production), Oskar Panizza, Max Stirner (to whom a long article by Vincent Bounoure was devoted in issues 4 and 6), Fourier, of course (in three issues), Pierre Louÿs, and the roman noir (about which Annie Le Brun would provide an analysis that led her, in 1982, to the publication of *Les Châteaux de la subversion*).[23] The appearance in French of Trotsky's *Literature and Revolution* provided the opportunity for a whole cover story (no. 8), while the first issue published Breton's homage to Natalya Trotsky.

On a theoretical level, the group continued, through its periodical, to explore its classical themes—Radovan Ivsic (no. 1) and Robert Guyon (no. 6), were interested in objective chance. The attention devoted to poetry was confirmed in various ways: Joubert related the disruption caused at the Center for Marxist Study and Research by the organization of a conference titled "The Itinerary of Lautréamont"; Ivsic pointed out the "plagiarism of shells" in a recent edition of Lautréamont; the *Anthologie de la poésie française* concocted by Georges Pompidou was hardly to Legrand's taste. Religion still inspired great distrust, as Dumont recalled in number 5. The recent advances in psychoanalysis, in contrast, were examined with interest by Legrand, who gave a presentation of Norman O. Brown in number 5, and humor was welcomed in its present incarnation—the stories of "Marie-la-sanglante"—by Benayoun. Vigilance with regard to Moscow was ever-present, even though an article by J.-L. Simon found the recent evolution of poetry in the USSR to be fairly encouraging. The situation in literature and film was picked over: Philippe Audoin voiced his hostility toward Alain Robbe-Grillet's endeavors and toward the "Nouveau Roman," which he accused of being too easily accepting of the world as we know it, while Alain Joubert praised the plays of Jean Genet and Witold Gombrowicz (for *La Pornographie*) and the film by Nico Papatakis

relating "the crimes of the Papin sisters" called *Les Abysses;* Benayoun drew attention to the productions of Jan Lenica and studied the balloons in comic strips.[24] In number 5, excerpts from a recent talk by Legrand were included ("A Few Aspects of Surrealist Ambition"); Legrand was decidedly proving to be the most philosophical thinker in the group at the time, with his goal of reuniting the Hegelian legacy and analytical theory with his strong preference for poetical lyricism, something also evident in his article "Analogy and Dialectics" (no. 7):

> Far from being 'the negation of everything' . . . , surrealism today is, so to speak, the only bearer of well-being in the world. . . . The Freudian revelation that the human psyche is based on desire, and the philosophical revelation of the world's truly infinite relationship with thought seem to overlap within surrealism, not so much on different levels, but like two different copies of one and the same discovery, sketched with other colors. We are made sensitive to this discovery through poetry, through 'the Marvelous,' keystone of the surrealist edifice, which Artaud said was 'at the roots of the mind.' What is important to say about surrealism is that for the first time the world and existence have changed for certain people—and this through the virtue of poetry alone . . . as an approach to an entire range of conducts where what will sooner or later be the only 'dictatorship' capable of reconciling man with himself is being practiced: the concrete sovereignty, both passionate and rigorously lucid, of the mind.

Two surveys were launched. The first was titled "The World Upside Down," and it sought to determine the impact that future interplanetary journeys could have on the conditions governing thought (most of the answers suggested, as Legrand noted in no. 3, "that a chaotic collapse of human understanding could hardly be imagined, as it happens"). The second survey concerned erotic representations. Answers were illustrated with vignettes taken from *Barbarella,* the comic strip by Jean-Claude Forest that Eric Losfeld published in album form and that in 1964 enjoyed considerable success insofar as it seemed to be particularly bold and well-adapted for an "adult" or "informed" public, as it was called at the time.[25] These were two ways of prolonging the impact of *EROS,* and not a single opportunity to recall the diversity of eroticism and its modes of expression was lost.

A new game was also invented, or rather, as Schuster described it, a "group entertainment": "Enrich Your Vocabulary." On the basis of an invented word, the idea was to find a personal definition, illustrated, as in any good dictionary, by an appropriate example. "There is no need to point out that it is automatism, or at least the word's immediate power to evoke," that would be called on once again, whereas subjective invention is in the tradition of Lewis Carroll, Jean-Pierre Brisset, Raymond Roussel, Duchamp, and Michel Leiris. To the word given as an example, *Mamou,* Joyce Mansour gave the following response: "Young vampire, not yet weaned. Example: She was as fascinating and vulnerable as a *mamou.* To act the *mamou:* to place oneself in a lascivious attitude. *Mamourism:* narcissistic aggression still in a state of intention." Or Breton's example: "In 'incwedible' speech: mon amour (my love). Example: (Barras to Joséphine) 'Come, *mamou,* it's getting late.'" It is not difficult to find traces of each individual's personality in these examples.

Among the many poems and short pieces that came out in the *La Brèche* collection were those by more or less long-term members (Malrieu, Mansour—the only one to contribute to each issue—Alain Joubert, Silbermann, Schuster, Achille Chavée, Mal-

1

3

2

colm de Chazal, Jean-Louis Bédouin, Paul Nougé, Ghérasim Luca, Legrand, etc.) but also by a number of newcomers: Pierre Dhainaut, Hervé Delabarre, Pascal Colard, and Annie Le Brun. In September 1962, Fernando Arrabal published "Five Panic Tales," and his play *La Communion solennelle* (The solemn communion) was illustrated by Jean Benoit (who in 1963 also illustrated the cover of *La Pierre de la folie,* a "panic book," also by Arrabal). The fifth issue included excerpts of letters addressed to Breton by Ted Joans: in Benayoun's words, "the only authentic black surrealist who belongs to the American 'hip' generation." "I plan to write and paint in Africa until America rids itself of its racial violence and moral poverty. . . . The hipster dreams, but spends most of his days conveying his dreams to reality. . . . The Beat generation owes almost everything to surrealism."

Inadequacies of Pop Art

Where the plastic arts were concerned, the interest in marginal or "brut" expression had been maintained: Bounoure related the recent sensation caused in West Berlin by an exhibition of Schröder-Sonnenstern's drawings; Breton attributed a statuette to Henri Rousseau (no. 1); *La Brèche* number 2 presented "sexed dolls" by Madame Zka; Ivsic introduced the works of a Yugoslav naïve artist, Matija Skurjeni; and in the fourth issue appeared a letter from Robert Tatin, who "went around slapping on paint" in his estate at la Frénouse that he would soon decorate with his allegorical constructions in painted cement. Micheline and Vincent Bounoure contributed a long piece on the art of New Ireland, and Breton wrote "Main première" (First hand), in which he spoke of the enchantment produced by the bark paintings from Arnhem Land, thus providing a key to his own viewpoint: "To love, above all. There will always be time, later, to wonder about what one loves, until one will want to leave nothing unknown about that love."[26]

The illustrations in *La Brèche,* taken as a whole, exemplify the most recent endeavors of newcomers to the group: alongside Silbermann, Jean Benoit, or Mimi Parent, who had already taken part in *EROS,* Jacques Lacomblez, Jorge Camacho, Hervé Télémaque, Jean Terrossian, Konrad Klapheck, Gabriel Der Kevorkian, and Ugo Sterpini were proof that efforts to innovate in objects and formal outline had gained recognition; reproductions of Reinhoud, Asger Jorn, and Henry Heerup pointed to friends of Pierre Alechinsky's. Alechinsky had published only two texts to date: "Titres" (no. 5) and "Pains perdus" (no. 7), where in his ironic way he related anecdotes and memories intermingled with thoughts about painting.[27] Since 1958 Lacomblez had been editing the periodical *Edda,* on which a number of the Paris group members also collaborated and which offered a platform in Belgium for an abundance of potential experimentation; he now published "Cahier d'Eugénie" (Eugénie's journal) in number 5 of *La Brèche,* with recourse to both poetic and visual aspects, as usual.

In number 2 (May 1962), there was a dialogue between José Pierre and Robert Benayoun ("Alchemy of the Object, Trash Playacting"), the point of departure for which was the exhibition *Art of the Assemblage* organized by William C. Seitz at the Museum of Modern Art in New York in 1961, with 252 works from cubism to pop art and new realism. In addition to an homage to Cornell, there was a debate on the significance of assemblage and collage in the twentieth century: "Our information on the outside world is often presented as discontinuous, and these 'assemblages' represent a

desire to reconstitute, from that discontinuity, a sort of continuity—to reestablish a coherence where, at first glance, there did not seem to be one" (José Pierre). This quest for meaning readily implied, at last, an underlying desire to escape the ascendancy of things or their simple "artistic" repetition, and this enabled one to distinguish the works of someone like Rauschenberg, which went beyond aesthetics and the fascination exerted by detritus, from those of the French new realists (Arman, César) and all those artists who seemed to prefer working with scrap metal ("People like James Dine, John Chamberlain, or Richard Stankiewicz build ridiculous altars to the automobile industry, to plumbing, to ironmongery," said Benayoun). With the work of Tinguely and Niki de Saint-Phalle, said to create "an impoverished, devaluated picture of reality," Pierre and Benayoun contrasted the work of Alberto Gironella, whose recent exhibition *Transfiguration and Death of the Queen Marianna* (1961) had just shown how various modes of assemblage could be integrated in "an exploration of a nature that is both poetical and philosophical."

Showing a remarkable lack of respect for one of Velasquez's most famous paintings, Gironella made use of every sort of technique (assemblage of objects, dripping or material effects, huge brushstrokes, parodies of academic art, etc.) to "deconstruct" both the painting and the way the viewer ordinarily perceives it. Thus, he called on viewers to question the fascination or appeal of classical cultural works and to discover in the portrait they had claimed to know the potential for very different meanings. This was a fine example of freedom in actuality, where love and rage were intertwined, supremely indifferent to the commonly accepted criteria of what was good or bad taste. Cultural consumption was thus transfigured into a series of highly poetical discoveries of the potential impact of a work, which once again revealed its capacity to touch each individual on an intimate level.[28]

Later, Benayoun would renew his attacks against pop art:

The message of pop art is that of a fixed assumption, catatonic with slot machines, drugstore jars, comic strips, soda bottles, like so many spare parts from General Motors. An assumption tinged with sarcasm, but devoid of the slightest disavowal. . . . This is a domain of excess and stupor, in which thought stagnates amidst a vengeful yet moronic imitation. . . . Don't look at what we are reproducing, the pop art painters seem to be saying, look at our gesture, our torment. We are not *artistes maudits;* we thrive in everything we do, it's not the end of the world! Don't look at our work, look at us! We are the true heroes of the era. The perfect chameleons in an aesthetic desert.

The only exceptions to this condemnation were Robert Rauschenberg, whose assemblages "have always had a clearly antipatriotic and subversive intent about them," and James Rosenquist, whose painting "is based on a choice, a composition, even a montage, an individual activity of a superior order." These diatribes were clearly a result of the group's values but also stemmed from a more specific rationale: the early 1960s were indeed the beginning of the penetration of American pop art into the French art market, and this art was perceived by group members as being so perfectly indicative of an absence of thought in pictorial representation that some group members could not help but react against works that, predictably, contained all the elements of future success.[29]

This is why it is important to emphasize the difference between Rosenquist and Klapheck, for example, and pop art: it was symptomatic that in the issue containing

Benayoun's article (no. 6 [June 1964]), these painters were represented by two reproductions, and Rosenquist was praised in a text by José Pierre: "How to Make a Successful Work of Pop Art."

From 1956 to 1957, while he was staying in Paris, Klapheck met D'Orgeix, who introduced him to Duchamp's and Roussel's work, and this set him back on the path he had taken some time earlier in painting his first "typewriter," in the context of German abstract art. He also became acquainted with Édouard Jaguer and then with Breton, both of whom were drawn to his work, which displayed a totally novel relationship with machines. One would no longer parody the machine, or contest its power symbolically, nor would one exalt its virtues; the ruse of the painter would be to consider the machine as the material and visual support for secret analogies, linked to fantasies, desires, and a network of ambivalent urges that were, if not shameful, then at least impossible to transmit through any other means than pictorial. The glazed, seemingly cold realization of each canvas (because of this some saw in Klapheck a precursor of hyperrealism) actually conceals an extreme tension, both artistic (the composition simplifies shapes and modifies the proportions of the model-machine) and psychic—in both the spectator confronted with pseudo-idols and the painter himself. Flamethrowers, bicycles, typewriters, shoehorns, and showerheads composed a secret autobiography, a journal of fears and passions, open to the projections, however different, of each viewer: the evocation of a world of objects and mechanisms allowed one to explore and exalt different subjective worlds.

When he arrived in Paris in 1961, Hervé Télémaque brought with him from his New York stay, where he spent time with Julien Levy, not only the empty and repetitive nature of the final convulsions of abstract expressionism but, above all, a lesson from Arshile Gorky, whom he admired greatly: it is through automatism that a gesture produces meaning. His 1963 canvases featured in *La Brèche* indicate by their titles alone (*Portrait de famille* and *Baron Cimetière*) (Family portrait and Baron cemetery) one of the constant concerns of his painting, in which autobiographical elements were easily hidden behind what at the time was considered an extravagant gesture, violently sweeping aside forms and graphic or written signs. His work evolved rapidly to include a repertory of objects, some of which may have been borrowed from catalogs and which would be portrayed in clearly outlined or flatly tinted figures to compose a sort of rebus in which the viewer must trace his or her own mental trajectory. Close to pop art figuration but adding meaning through the montages he imposed on the motifs now included in his polysemic relationships, Télémaque would eventually be classified among the proponents of narrative figuration, even though his figurative system, which from 1966 to 1968 explored the creation of objects based on contradictory qualities, initially owed its rigor and apparent neutrality to Magritte.

With Silbermann, Camacho, Terrossian, and Der Kevorkian, the use of everyday objects was practiced in a fleeting and variable way that immediately precluded any confusion with pop art. Silbermann published some poems in the group's periodicals (and in *Au puits de l'ermite* [In the hermit's well], a collection that came out in 1959), and then in 1963 began to exhibit his "Signs" ("Enseignes"), which may have been inspired by "telephone drawings." Although their name initially seemed justified as a reference to heraldry, this link disappeared once the cut-out signs were presented in several pieces spread across the wall, where they offered a different lesson (*enseignement*) of painting, devoted to fantasies, to a disturbing humor, and to that which, because it

derived from an activity that was initially automatic and impetuous, could be laid out flat (on plywood, in this case) and thus in a presentable form. The result was characters, elements of décor, and objects onto which an abundance of disturbing elements were grafted, the whole suffused with a sort of overall uncertainty. Playing on incongruous proportions as well as a refined chromatism in their unreality, the signs showed that between the results of automatism and the activity of dreams a connection could be established, without there being any need whatsoever to copy a dream image. And their subversive impact was all the more "sly" in that their symbolism remained profoundly enigmatic.

Camacho's canvases were anything but "sly" and professed to be a theater subjected to "an entire system of trap doors, basement windows, and air vents" (Breton), where minerals, animals, and human shapes, frequently skulls or skeletons, interacted in a motionless saraband. In this gleaming world attenuated by earth tones, the relations between beings and elements occurred beneath the twin signs of perforation and the most ambivalent mutations. Bones, stakes, beaks, nails, and claws designated not only the danger of caresses but also the sweetness of scars, and it was as if one were witnessing the unfolding of multiple games between Eros and Thanatos, inseparably linked. Camacho had a passion for ornithology, jazz, and alchemy, and perhaps it was to his native Cuba that he owed his astonishing ability to suggest the alternately overflowing and controlled style that permeates his work and gives him a singularly fascinating power; but there are traces, too, of Sade and Roussel in his work.

Jean Terrossian's primary references were pictorial: his initial process was influenced by Matta, devoted to the revelation of overlapping spaces, sometimes lengthened indefinitely by the presence of "mirrors" where an "off-camera" of the canvas is reflected, giving it a more general impact, along with supple shapes evocative of membranes and moistness. After taking part in *L'Écart absolu* exhibition, where he displayed two objects, Terrossian evolved toward a clear figurative painting: in particular, he borrowed his objects of reference from commercial catalogs and dotted his work with words. Fantasies were staged, along with suggestions of the relation between terms and images that apparently had no immediate connection, and his work used metaphorical traps that were all the more effective for their smooth and seemingly innocent presentation.

In Gabriel Der Kevorkian's work, symmetry in composition rapidly prevailed, but this did not mean that Eros was repressed: anthropomorphic allusions were followed by less differentiated creatures, who were as similar to insects as to friendly monsters. Nocturnal colors, shot with a rare flamboyance where gazes were turned with increasing obstinacy to the viewer, were allied with a style where superimposed shapes and pseudocarapaces were clearly outlined, initiating disturbing ceremonies, products of an authentic oneirism. Like Silbermann, Der Kevorkian did not transcribe dream images but tamed "with the tail of the whip the beasts of an inner menagerie" (Bounoure), suggesting, rather, hitherto unrecorded reveries, of a kind that no one but he had ever known and that indicated that imagination had not yet surrendered the key to all its labyrinths.

A collective celebration was held in December 1964, inviting viewers to discover, in a gallery in Rome, the "surrealist" furnishings of the Officina Undici recently founded by Fabio De Sanctis and Ugo Sterpini. Audouin, Benayoun, Breton, Ivsic, Mansour, Pierre, and Silbermann celebrated the way in which furnishing had finally been given over to the irrational and the highest fantasy. An armchair or a buffet, independently of

1

2

3

1

2

3

their purpose (one could still sit down or put one's dishes away), might be made of borrowed materials (Fiat automobile doors for the buffet) and were prickly with sharp ends, paws with claws, or even a revolver, all of which gave these pieces a supreme distance with regard to the strictly utilitarian and the predominant tendencies of "modern" furniture. Sterpini and De Sanctis showed a violent humor in their opposition to ovoid forms and the spareness and right angles that reigned in design at that time and gave each of their pieces a singular aspect that went counter to the principle of mass production.[30] "Our preference," they declared, "is for error, the clumsy and awkward gesture that determines unexpected annoyances." In their domain they adopted an "antimodernism" that could not fail to delight the group, and they envisioned every interior as—in Benayoun's very apt expression—an "*unready-made* where one should be able to feel at home"—if only one dared leave behind "the vital pleonasm which consists in becoming further and further immersed in the ugliest mass-produced creations of the industrial civilization."

Defending Duchamp

While other young artists were beginning to stake out their territory, the elder statesmen of surrealism were increasingly attaining official recognition. In 1962, the Galerie André François Petit presented earlier works by Bellmer, Brauner, Dalí, Ernst, Magritte, Tanguy, and Delvaux (the following year, at the same gallery, Picabia would replace Delvaux, to advantage), while the Galerie de l'Œil paid homage to *Minotaure*. Miró and Arp were celebrated at the Musée National de l'Art Moderne, and Man Ray's photographic work was exhibited at the Bibliothèque Nationale. At the end of the year an ensemble of "surrealist collages" was shown at the Point Cardinal. In 1963, Bellmer had an exhibition at Cordier's, and this was the first time his work was shown in Paris on such a scale. On the walls around the Doll, who was lying on a sofa, were sketches on lined notebook paper (1956–57), pencil drawings from 1959, a few paintings and major drawings made on rose- or gray-tinted paper (*Le Coq ou la poule,* 1960): the delicate brushstroke, the sure hand with which the accents of white gouache are placed confirm both the immense talent of the draftsman and the crudeness of his visions. On each drawing, flesh is transformed into mucous membranes, a dark erotic reverie unfolds in which genitals are as rigorously scrutinized as if they were the folds of a cloth. The exhibition, whose catalog was introduced by Patrick Waldberg, caused some disturbances because of the nature of its themes; the bolder drawings were shown in a room where access was limited.

In 1964 the Schwarz gallery in Milan published eight editions of Duchamp's readymades and organized an itinerant homage from June to September; Man Ray exhibited thirty-one objects "of his affection" in the same gallery. It might have seemed a contradiction to produce multiple copies of readymades, the initial existence of which depended on their uniqueness, but the reproduction in a small series was another way of thumbing one's nose at mass production (which could hardly turn out only eight copies); however, this was not only an ironic glance toward the market of mass production, which had already been making serious inroads in Europe, but also a confirmation that a readymade could be a perfect replacement for a sculpture since traditionally no more than nine casts of a sculpture must be made if it were to be considered an original.[31]

The following year, the pamphlet *Le "Troisième degré" de la peinture* loudly protested against the exhibit, organized by G. Gassiot-Talabot within the framework of the event entitled *Narrative Representation in Contemporary Art,* of a series of eight canvases created by Gilles Aillaud, Eduardo Arroyo, and Antonio Recalcati and entitled *Vivre ou laisser mourir ou la fin tragique de Marcel Duchamp* (Live or let die, or the tragic end of Marcel Duchamp).[32]

Apparently forgetting the dispute that had recently arisen between the group and Duchamp, the pamphlet denounced the portrayal (fairly dreary from a strictly pictorial point of view) of Duchamp being "beaten up" then placed in a coffin draped with an American flag by Rauschenberg, Claes Oldenburg, Andy Warhol, Arman, Martial Raysse, and the critic Pierre Restany.[33] These were "vicious schoolboy pranks," said the pamphlet, and were an attack on the freedom of spirit, jeopardizing "an emancipatory concept of poetry to which we stubbornly cling."

"Aggression can be understood, can be qualified. But to spit on something, to soil it—that only ever has one meaning, one of the basest kind," said the pamphlet, which was signed by many members of the group and of Phases and also by three participants in the Gassiot-Talabot exhibition: Télémaque, Jacques Monory, and Peter Klasen. In fact, Aillaud, Arroyo, and Recalcati had wanted to denounce Duchamp's own very idealist concept of freedom and at the same time his blatant indifference to politics, and they found that the fetishization that he conferred on objects was proof of a fundamentally bourgeois culture, capable of putting up with anything.[34] Proclaiming a more or less "extreme" leftist position, the three painters were perhaps seeking to cause a scandal (at least this is how Duchamp interpreted their action, seeing it as a ploy to earn themselves publicity), but their painting was trapped in a style that, as the pamphlet pointed out, was somewhat reminiscent of the heyday of socialist realism and seemed altogether, alas, to point to the staging of a police action. Ideology caught up with them, and under the pretext that they were attacking a hypocritical idealism, their "materialism" could only be conveyed through an extremely simplistic imagery, devoid of any dialectical spirit.

L'Écart absolu

On December 7, 1965, the last exhibition organized by the group in Breton's lifetime opened at the Galerie de l'Œil, 3 rue Séguier. In reference to the method advocated by Charles Fourier, it was entitled *L'Écart absolu* (The absolute divide), and it led to the publication of a collective declaration with thirty-five signatures, *Tranchons-en,* which was inserted into the event's catalog.[35] Written by Gérard Legrand, the text began by emphasizing the originality of the event when compared with earlier international exhibitions. While previous events, through their organization and their accompanying texts "only gave an oblique glimpse into the renewed vision [they had] of the world," "this was the first time an art gallery was transformed into a place where a largely presupposed *ideological* grouping was able to manifest itself."

A presupposition of this nature did not imply that an authentic detailed program existed (one that would "generate from the start a void in poetry and poverty in art"); it did lead, nevertheless, quite clearly, to a "'fighting' Exhibition *directly* attacking the most intolerable aspects of the society in which we live." Thus, a radical mistrust would be preserved toward aesthetics alone (including whatever claimed to be *engagé*) and, in

609 1959-1969

Right: Hervé Télémaque, *Errer . . .*
(To wander . . . ; 1966, painting on
wood, 26²/₅ × 17¹/₅ and 16 × 13¹/₅ in.
(66 × 43 and 40 × 33 cm), ribbon.
Author's collection.

Below: Hervé Télémaque, *Éclaireur II*
(Scout II; 1962–65); oil on canvas,
52 × 78 in. (130 × 195 cm). Private
collection.

Previous pages, verso: Jorge Camacho,
Un cardinal, pierde la cabeza (1961);
oil on canvas, 58²/₅ × 45³/₅ in. (146 ×
114 cm). Private collection.

Previous pages, recto: Jorge Cama-
cho, *Self-Portrait* (1976).

Above: Jean Terrossian, *Décomposition (décor d'enfance)* (Decomposition [childhood decor]; 1980); acrylic on canvas, 40 × 29¹/₅ in. (100 × 73 cm). Private collection.

Right: Jean Terrossian, *Œdipe réconcilié* (Oedipus reconciled; 1989); acrylic on canvas, 46²/₅ × 29¹/₅ in. (116 × 73 cm). Private collection.

Above: Jean-Louis Bédouin, *Un héros des Malouines* (A hero of the Malvinas; ca. 1969); painted relief. Private collection.

Left: Robert Benayoun, *Antonin Artaud* (1955); 7^{1}/$_{2}$ × 5 in. (18.8 × 12.2 cm). Private collection.

Opposite page: Ugo Sterpini, *Armed Armchair* (1965); sculpted and silvered wood, revolver of an officer of the Deux-Siciles, 52 × 80 × 56 in. (130 × 200 × 140 cm).

Above: Alberto Gironella, *Transfigura-
tion of Queen Mariana* (1960); oil
on panel and pyrographed wood.

Right: Christian d'Orgeix, *Petrushka*
(1963–64); 40 × 32²/₅ in. (100 × 81
cm).

Opposite page: Christian d'Orgeix,
Le Perce-oreille (The ear-piercer;
1953); 78 × 38⁴/₅ in. (195 × 97 cm).

Above: Marcel Duchamp, *Couple de tabliers* (Pair of aprons; 1959); fabric, fur, and zipper, 8 × 7 in. (20.3 × 17.7 cm). Twenty copies were created for the deluxe edition (*Boîte alerte*) of the *EROS* catalog, Galerie Daniel Cordier.

Opposite page, top: Gabriel der Kevorkian, *Peinture* (1968); 38 × 51¹/₅ in. (95 × 128 cm). Private collection.

Opposite page, bottom: Gabriel der Kevorkian, *Nappeux sommeil des hématomes cristelles* (1974); oil on canvas. Private collection.

Hans Bellmer, *Unica avec l'œil sexe* (Unica with a sex eye; 1961); pencil and tempera, 26 × 20 (65 × 50 cm). Private collection.

Hans Bellmer, *Les Crimes
de l'amour, le sens commun*
(Crimes of love, common
sense; 1961); charcoal, pencil,
lightened with white
gouache on gray laid Ingres
paper, 26¼ x 20 in. (65.7 x
49.7 cm). Musée National
d'Art Moderne, Centre
Georges Pompidou, Paris.

1961.

Max Ernst, *Le Soleil sur la terre* (The sun on the earth; 1963); oil and collage on wood, 13¹/₅ × 9³/₅ in. (33 × 24 cm). Private collection.

particular, toward any alibis that aesthetics might have supplied the previous year in providing "a jumble of historical pretensions, dumped into one of the most official halls in Paris by a few of our grave-digging candidates."[36]

The expression, which was chosen by Philippe Audoin and served as a title for the policy adopted, referred to a famous phrase from the 1924 manifesto: "*Tranchons-en:* Le Merveilleux est toujours beau, n'importe quel merveilleux est beau, il n'y a même que le merveilleux qui soit beau" (Let's finalize the matter: the marvelous is always beautiful, anything marvelous is beautiful, indeed, only the marvelous is beautiful). This set the text in a direction where it could focus on an authentic marvelous, as distinct from a dime-store sort of marvelous—not only the one featured at the Galerie Charpentier in 1964 (Lucien Coutaud and Léonor Fini) but also, first and foremost, the one that the periodical *Planète* was seeking to promote at the time.

Against Planetary Consumption

As soon as it came out in 1961, *Planète* was denounced in a pamphlet titled *Sauve qui doit.*[37] The closing lines are a good reflection of the pamphlet's general tone: "To spend time with 'Planète' is to take part in the martial maneuvers of all kinds of reactionary thought, and to encourage generalized lobotomy. THE ROBOTS WILL NOT GET THROUGH!"

The periodical advocated a bastardized ideology that combined a fascination with the latest "scientific wonders" and an attraction to all forms of more or less traditional "thought" that claimed to go "beyond" science by referring to the shakiest sorts of explanations (parapsychological powers, extraterrestrial travel, etc.). An utterly imbecilic scientism revealed its affinity with what seemed to be its opposite. Both, in fact, were united in the exaltation of an ultimate knowledge that would ensure the power of a minority over "massified" populations. *Planète,* in the words of *Sauve qui doit,* was encouraging a movement toward a "perfected 'God'—bearer of bombs, launcher of rockets, spreader of psychochemical drugs." The editors Louis Pauwels and Jacques Bergier would, moreover, provide ample proof of their "intellectual rigor" when their periodical distributed, with the utmost seriousness, a false rumor that had originated with José Pierre.[38] The rumor was initially published in *La Brèche,* according to which a certain Professor Kazanov Laurentiev (the "Russianized" signature of Laurent Casanova, a theoretician of the Communist Party) was alleged to have submitted a report to the Academy of Fine Arts of Leningrad defending pictorial abstraction and thus allowing one to envisage "important changes in the aesthetic theses of Russian communism."[39]

Even mishaps like this one did not, however, prevent *Planète* from thriving and from reaching an ever-vaster audience, who were no doubt delighted to find in the pages of the periodical admirably complementary confirmations of the power and failings of science. *Tranchons-en* found it necessary to return to this theme, forcefully contradicting "the worship of a blind future, even one clothed in the flaming vapors of a 'fantasy' likely to revive ancient terrors and old taboos" and rejecting the advice of a new Church that, in the twenty-third issue of the periodical, was not afraid to assert: "We believe that the *duty* of writers and poets is to participate with all their being in the great work of gestation of the laboratories and thinkers."[40]

Exaltation of science, debasing of the marvelous: once again, the surrealists would

L'Écart absolu exhibition at the Galerie de l'Œil in Paris, December 1965.

1 *The Consumer,* collective work; washing machine, wedding dress, mattress, number plate. . . . Photograph by Radovan Ivsic.

2 A display window, containing among others: *Charles Cros—Portrait du Hasard,* by Pierre Faucheux; *Why Not Sneeze?* by Marcel Duchamp (1921); *Salomon Ier roi de Bretagne,* gouache by Charles Filiger; *Mies de pain* (Bread without crust) by Reinhoud and *Habitacles* for books, by Jean Benoit.

3 *The Consumer* and, on the left, Pierre Alechinsky's *Central Park.*

4 View of a hall. *On the wall, at the top:* Der Kevorkian, *Leurs majestés en quête de sublimation* (Their majesties in search of sublimation; 1965); Toyen, *À la roue d'or* (At the golden wheel; 1965); Mimi Parent, *En veilleuse* (1965). *In the center:* Yves Laloy, *Les Petits pois sont verts* (Peas are green; 1959).

On the bottom: Friedrich Schröder-Sonnenstern, *The Mystical Dance of the Swan-Dolls;* Crépin, *Painting on Canvas, number 126.* In the foreground, from left to right: *Armed Armchair* by De Sanctis Sterpini; *After the Fire,* burned wood by Cardenas, and *Cielo-Mare-Terra,* a dresser made with automobile doors (1964) by De Sanctis Sterpini. Photograph by Marcel Lannoy.

5 Opening of *L'Écart absolu* at the Galerie de l'Œil, December 8, 1965. *In the foreground:* Jean Benoit's *Le Necrophile* (Necrophiliac). Photograph by Marcel Lannoy.

1

4

2

5

3

L'Écart absolu

1 Jean Benoit, *Le Nécrophile* (The necrophiliac).

2 Robert Benayoun during the opening. Photograph by Marcel Lannoy.

3 Jean Benoit. Photograph by Radovan Ivsic.

4 The "Arc de Déroute" with a wooden leg. Photograph by Marcel Lannoy.

5 Eric Losfeld during the opening. Photograph by Marcel Lannoy.

have to denounce any possible confusion (certainly desired on the part of *Planète*) between the values they upheld and their sinister vulgarization; this denunciation was all the more necessary in that it was certainly more serious to degrade the marvelous than to trivialize what was at stake for painting in producing pleasing canvases at too little cost, as had been the case off and on for up to four decades. But these warnings with regard to the most misleading ideology would have remained mere anecdote had they not been followed by a massive denunciation of the consumer society, which was now in the process of taking hold in the early 1960s—a period that was economically euphoric and indisputably fertile in its new standards of comfort and technological development. Still, in 1965 it may have been too early to proclaim, as the surrealists did, one's mistrust of what seemed to be on the whole acceptable and of what were indisputable signs of social progress (from the household items that made the lives of housewives and mothers easier to the distribution of multiple art forms to the greatest possible number of homes).[41] Jean Baudrillard's analysis was still a few years in the future (*Le Système des objets* in 1968, *La Société de consommation, ses mythes, ses structures,* in 1970).[42] The surrealists thought it was urgent, however, to attack what for them was the obvious significance of "increasingly invasive compensations" for happiness: the insistence on what was "convenient" or "comfortable," the incursion into daily life of bargain-basement "myths," "which in fact honor only the basest of contemporary vanities." In the catalog of *L'Écart absolu* itself, the two pieces that followed Breton's preface, one by Jean-François Revel (*James Bond contre Docteur Yes*), the other by Philippe Audoin (*L'Air de fête*) quickly specified the angle of attack: if it turned out that, "in order to be tolerated, leisure must not give rise to any pleasure," it was also because "leisure itself has become an industry, free time has become time that you must buy back for the employer," said Revel. Audoin predicted that "'consumer societies' will gradually turn away from traditional forms of coercion in order to rely upon the intimate complicity of their slaves" and that "everything is conspiring to turn Desire away from its own goals and toward substitute satisfactions which pretend to be happiness; happiness is no longer a new idea, it is on special."

These are almost Marcuse's words—and indeed a few surrealists had discovered Marcuse and given thought to his ideas; one can see how Philippe Audoin would later think that "the 1965 exhibition, although inspired by a certain pessimism with regard to man's remaining chances to triumph over the specious alienation where Domination was leading him, seemed to anticipate May '68 and the youth uprisings in other countries which preceded the insurrection in Paris."[43]

The Windows of Refusal

At the center of the exhibition was *Le Consommateur* (The consumer), an anthropomorphic silhouette made out of a pink mattress (upon the directives of Jean-Claude Silbermann). Its head was a siren, and at the level of its stomach was the round window of a washing machine where newspapers were periodically sent spinning. Embedded in its back was a half-open refrigerator from which a bride's veil emerged. This was a talking monster: it uttered the confused and virtually incomprehensible calls of taxi radios.

A piece of furniture designed by Pierre Faucheux confirmed the critical aspect of the exhibition: this *Désordinateur* (Discomputer), a sort of buffet where a series of cells could be lit up depending on the button pushed by the viewer, was according to the

catalog an attempt to "render what might become of the essential components of the principle of reality caught in the very moment of its realization, when those components are subjected to the method of the absolute divide." Ten texts in the catalog corresponded to each of the ten objects set in corresponding cells, and they illustrated different aspects of the contemporary world with which the surrealists clearly intended to create an absolute divide:

1. A lure acted as a counterbalance to the conquest of space; Gérard Legrand denounced the relations of space research with the imperatives of the economy and the military, while reducing space conquest to its rigorously technical dimensions, which were therefore not poetical: "For a long time now we have been stringing the baby rattles of astronautics across Magritte's dialectical firmaments, when they have not been devoured by Max Ernst's *Jardins gobe-avions*" (*Une apparence de soupirail*).

2. An oval wheel ridiculed possession by the machine, and the fascination exerted by the "electronic brain": "The object must not be confused with the gaze one turns upon it, nor should the machine be confused with the image man has given himself of it," said Alain Joubert (*Mécanique populaire*).

3. A king of rats parodied the obsession with birth rates that Raymond Borde took on himself to denounce—this could hardly be surprising to readers of *L'Extricable* (1964): "From Sarcelles to New York and from Moscow to Cairo, nations behold with wonder the growth that sends them to the labor camps of economic expansion" (*Nous voulons un enfant*).

Jean Benoit's costume of the *Nécrophile* stood in sarcastic defiance some distance from the "functional eroticism and the chant of cradles."

4. An "alphabet of vagabonds," elaborated by Robert Benayoun in *L'Œuf fait nix* (The egg says no)[44] corresponded to the denunciation of the technocracy: "surrealism clearly represents a taboo" for the prefabricated mentality preferred by the "organizers" whose time seemed to have come, in France and the USSR, just as in the United States.

5. The broken drum of the next cell illustrated a phrase by René Alleau: "Break the drum of reasoning reason and contemplate the hole you've made," quoted by Philippe Audoin in *Haute Main* to reemphasize the relations between surrealism and hermetic philosophy and to dare to determine—at a distance not only from alchemy but also from Bataille's endeavors—how surrealism hoped to measure itself against the sacred.

6. A portrait of Napoleon accompanied by a one-armed man (along with a slogan vaunting "a good warm apartment")[45] summed up Jean Schuster's ideas on the role of advertising (*Raison sociale décousue main*): it ensured a constant increase in value by encouraging the consumption of products whose very need was itself fabricated.[46] Since advertising was invading public space in this way, let poetry demand its "Indian reservation!"—like the one populated in the exhibition by the works of Toyen, Silbermann, Télémaque, or Baj.

7. A modern style woman's torso indicated by its very aspect how much the ideal of modern female emancipation seemed a trap to José Pierre, since such an ideal would lead to a proliferation of "female soldiers, nuns, customs officers and lady cops." At the other extreme, *Changer la femme* recalled that "poets attempt, bit by bit, to put together the true face of woman . . . to help her become free, at last—both from the poets themselves, and from their own dreams."[47]

8. A traffic sign marked with the word "Chance" referred to Robert Lagarde's meditation on the "policies of leisure," which portrayed a "relief of the Churches" through

the uniformization of behavior blocking access to a true and extraordinary liberty (*Ouvrir à deux battants*).

9. A rugby ball wrapped with barbed wire and a stringless tennis racquet enabled Radovan Ivsic to denounce "a hideous elephantiasis" in the ideology of sport, a remarkable means of bringing people to a mindless state, and the pure transposition of a work producing nothing more than robots obsessed with performance (*Flammes sur mesure*).[48]

10. A chain of bread loaves represented Georges Sebbag's brief reflection on work: if to work is to "act consciously with the power of the subconscious . . . perhaps some day we will witness the first stirrings of a piece of this work; perhaps we're already working on it" (*Travail, que vaille?*).

The Trajectory of Refusal

The works displayed at the exhibition were clearly separate from the *Désordinateur* and its attendant theoretical reflections, but they had a similar resonance. Within the careful articulation of the exhibition, it fell to these works to show that in no way did they obey the principles of reality or its currency as applied by society in the 1960s. Far from being purely historical, the choice of paintings was in the line of a trajectory that had begun with certain precursors and passed through constitutive moments in the memory of the surrealist movement, finally to reach its current production; it had maintained a constant tension throughout, displaying the enduring possibility of an absolute divide as a means of emancipation with regard to reality and of discovery at the same time. The most important names were present: Aloïse, Adolf Wölfli with an object by a madman, Charles Cros, Joseph Crépin, Johann Heinrich Füssli, Jarry, Gustave Moreau, Münch, Kandinsky, Arp, Brauner, De Chirico, Ernst, Dalí, Duchamp, Picabia and Picasso, Magritte, Giacometti, Paalen, Matta, Miró, Hérold, Gorky, Tanguy, and others.[49] But of the ninety-three items listed in the catalog, there were many recent works, even from that same year. This was the case, in particular, for Alechinsky (*Central Park*), Jean Benoit, Camacho, Baj, Leonora Carrington, Adrien Dax, Gironella, Der Kervorkian, Klapheck, Robert Lagarde, Reinhoud, Ugo Sterpini, Svanberg, Télémaque, and Toyen.[50]

With its two themes (*Le Consommateur, Le Désordinateur,* and the explanation given by the ten written pieces in the catalog, on the one hand, and the works themselves, on the other), *L'Écart absolu* clearly displayed its method and its aims at the same time: it was becoming increasingly urgent to escape from an everyday existence bound by principles of reality and profitability by choosing the paths of the imagination and all the exalting and humorous aspects of the marvelous. Desire must clear its own path, in a stubborn yet lighthearted way, through the undergrowth of contemporary forms of alienation. The exhibition's lesson was unequivocal: resistance was possible, it had solid, proven models at its disposal as well as an immediate urgency—even if all that remained for it amid an increasingly structured and well-defined society was an "Indian reservation."

"Readymade" Reviews

Insofar as this social structuring was in danger of predetermining critical reactions, and because the surrealists had suffered for many years from the monotony of such reac-

tions, the catalog contained as a bonus, on loose-leaf inserts, three sample articles to be used as inspiration by "Messieurs les journalistes," which they could copy out verbatim, "depending on whether the current Exhibition has inspired feelings of good-will, hostility, or uncertainty."[51] The first of these "readymade" reviews, *Filles de joie et publicains* (Street girls and publicans; written by Philippe Audoin) postulated the "good will" of a Christian visitor to the exhibition concerned—using more or less subtle instances of spiritualist dialectic—with saving the "souls" of the exhibitors: "The surrealists have made us better aware of the impossibility of the absence of God. Fortunate are the lost sheep, for the Lord hath His eye upon them."[52] *Le Chou rouge et la chèvre noire* (The red cabbage and the black goat) by Robert Benayoun concluded with a triple question mark symbolizing the indecision of a commentator simultaneously seduced (by the great classics) and disappointed "by the unrewarding and inflexible rigor" of the movement—even though he pointed out in passing that "Pop Art, with its irresponsible dilution of Dada and surrealism, has never shown proof of a true spirit of re-creation, or of *thought*."

For a hostile point of view, *Le Capharnaüm obscurantiste ou les égarements de l'intelligence* (The obscurantist Capharnaum, or the wanderings of intelligence), written by José Pierre, summed up with its very title the most hackneyed reproaches addressed to the movement and rescued only Baj, Alechinsky, Klapheck, and Télémaque of all those in the exhibition, "but we have the right to wonder what attracts them to surrealism"—a movement that was most definitely moribund, if not senile.

Beyond their humorous dimension, these pieces were the confirmation of an appropriate dialectic for *L'Écart absolu:* the group would not contest everyday existence by any means that neglected or ignored the fundamental characteristics of that existence. On the contrary, it was with a full awareness of a predictable resistance on the part of the public that artwork and text together must bring their ideas to light.

The Cerisy *Décade*

The year 1966 was marked by a ten-day seminar in Cerisy devoted to surrealism, under the direction of Ferdinand Alquié. Group members were present and took part in the debate: "Vigilant, wary, intractable, violent when they felt the need, the 'group' came to talk, less of the past than of the present and the future, and allow no one—however well-intentioned—the opportunity to mention a funeral"—something even well-disposed commentators seemed, relentlessly, to be anticipating.[53] Gérard Legrand, Annie Le Brun, José Pierre, Jean Schuster (whose speech, the most directly "political," caused some unrest in the audience), Philippe Audoin, Henri Ginet, and, in their circle, Alain Jouffroy defended their principles with rigor against the point of view of the philosophers (accompanying Alquié were Jean Wahl, Maurice de Gandillac, Jean Brun, and Henri Gouhier) and a handful of other representatives in specialized fields.

A few months later, Philippe Audoin would draw his own conclusions from the lesson of these talks: "At Cerisy-la-Salle, the surrealists did not altogether behave like maniacs. They were distant, but polite. Some of them even drank toasts together with academics and other ordinary people. . . . Surrealism is rarely where one expects it to be . . . , the only scandal that the surrealists envisaged by appearing at the Décade, which hoped to consider them as objects, was to behave like subjects."[54]

1

3

2

4

1, 3 André Breton with friends at the café À la Promenade de Vénus, Paris, 1961. Photographs by Henri Cartier-Bresson.

2 Saint-Cirq-la-Popie, 1960. *From left to right and top to bottom:* Gérard Legrand, Élisa Breton, André Breton, Anne Ethuin, Adrien Dax, and Édouard Jaguer.

André Breton's Death and Debate over the Continuation of Group Activity

André Breton was too weak to go to Cerisy. He died on September 28, 1966, in Paris. Numerous articles appeared in the press emphasizing the different ways in which "one will continue to seek self-definition in relation to him." André Pieyre de Mandiargues, whose testimony had been requested among others, did not hesitate to warn: "Surrealism is his creation, his invention, and his property. It can only be understood or defined in relation to his work and his person. All the attempts that no doubt will be made to try to detach surrealism from Breton and his work will be in vain, I can say that in advance. And with sadness I might add that it now seems to me that surrealism will henceforth be a closed domain."[55]

After Breton's death, the question of whether to pursue a collective surrealist activity would become more and more crucial, until in October 1969, Jean Schuster publicly announced that it would be impossible. But before that, efforts to keep the movement going were numerous, although constantly troubled by a certain anxiety.

This anxiety was reflected in the internal document entitled *Pour un demain joueur* (For a playful future), issued in May 1967 by the "editorial committee of *L'Archibras* and its secretariat" and signed, in particular, by Elisa Breton, which gave it a particular emotional weight.[56] The text pointed out that if the option of a collective venture were to be more than a mere pious vow, it must implement "a new expression of the individual and the collective." To take part in an authentic group venture required that a few principles be respected: regular visits to *La Promenade de Vénus;* participation in publications and catalogs; prompt submission of articles and documents to *L'Archibras* (an indication that research into a so-called formal perfection demonstrating a hypertrophia of the Ego was being abandoned); and a preoccupation with making each issue of the periodical an event comparable to surrealist exhibitions and not simply a collection of texts with greater or lesser numbers of illustrations. (The authors deplored in passing that, on this point, there was a lack of ideas, notably for cover art.) And there should also be recourse to outside opinion (*La Quinzaine littéraire,* e.g.) allowing expression of a surrealist point of view, either individually or in the name of all of them.

Following this reminder came a warning against a poetic and formal ossification—that is, the danger of a conformism that would repeat formulas tried and tested over forty years of history. To ward against this possible temptation, there must be an openness of the kind that Breton himself had advocated: "any new form" must be welcomed, even if it came from nonsurrealist artists, even if it meant implementing a give-and-take on a case-by-case basis that obviously would not allow them to do just anything; nor would it demand on their part the attitude, particularly moral, that one had come to expect of the group members themselves.

Pour un demain joueur went on to say that it would also be necessary to rethink things on a political level: in order to leave the lofty "moral purity" behind, one would have to lend support to "movements which oppose the three powers that have divided up the world" (Russia, America, and China). But there, too, it would be useful to contrast the surrealist point of view with that of other intellectuals.

As for the group's internal life, although there was no question of preventing members from forming alliances wherever they wanted, those alliances should not lead to any kind of old boys' network or to the creation of factions.

For each of its recipients, participation in the ongoing activities of the group was contingent on signing *Pour un demain joueur*. In this way, the text could define as explicitly as possible "the main directions of the Movement for the present period and the immediate future"; these directions would be closely observed in the first issues of *L'Archibras*.

L'Archibras

The cover art of the first issue of the review, subtitled "Surrealism in April 1967," featured a collection of all the periodicals that had followed *La Révolution surréaliste*.[57] The publication thus reaffirmed its inclusion in the continuity of the movement and collective activity. Also on the cover was a phrase by Breton: "The God which inhabits us is not about to rest on the seventh day"—a way of clearly indicating that surrealism had every intention of continuing beyond the disappearance of its prime mover. Jean Schuster was editor of the periodical, and the article that inaugurated the series, "À l'ordre de la nuit. Au désordre du jour" (On night's orders. On day's disorders), opened with a realization: "Surrealism has just been stricken in all its being, and the question of its continuity is a very real one." The rest of the text replied in the affirmative: the surrealist program must be maintained, even if henceforth one would have to concede that "surrealism will have, yet it won't have, the same face. That is the least naïve of our certainties."

Maintenance of the program was assured by the planned opening of two exhibitions in 1967, one in São Paulo, the other in Bratislava.[58] These were places where authentic poetry was in constant danger of being stifled, by Pablo Neruda as much as by Zhdanovist conformism. But Schuster later recalled that it was all the world and its reality that were subject to what Marcuse called the "profitability principle"—and this enabled him to specify what the surrealist mission might be: "It consists, regardless of secondary differences, in marshaling the energies that help to drain the profitability principle or to invigorate the pleasure principle." *L'Archibras* would give its response to such a program: in successive installments, the unrelenting desire to explore the multiple paths of desire was openly reasserted. The first issue, of course, referred to Breton's death, including a series of declarations excerpted from letters or articles that had appeared in the press; it also published the photograph of the *Grand Tamanoir*—actually two pieces of rustic wood that Elisa Breton had found and that were simply laid one on top of the other—which Breton had destined for the periodical. The group members did not display their feelings in any other way, and their loyalty would be shown by their pursuit of the work they had undertaken with Breton. Essays, analysis, reproductions of theoretical pieces, and the call to order of a few "intellectuals" accumulated in the course of the installments, along with the presentation of new concepts.[59] Jean Michel Goutier, for example, in "Le Mulhiou," described drawings made by Giovanna with the characters of her typewriter alone and without any manual intervention: insect-like creatures and fantastic constructions born of the deliberate misuse of an ordinary writing tool.[60] In the second issue of the periodical, the last pages presented individual reactions to news items (particularly cultural and political) and were entitled "Le Fond de l'air" (What's in the air), proof of the desire to be in touch with everyday events, without fail.

1

2

3

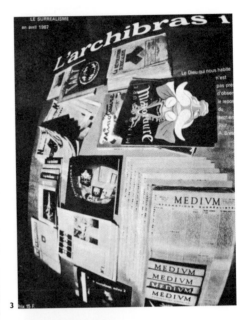

3

Pour Cuba

Le mouvement surréaliste :

— souscrit sans réserve aux conclusions du congrès de l'Organisation Latino-Américaine de Solidarité (O.L.A.S.) ;

— salue la mémoire du Commandant Guevara, dont l'exemple continuera d'animer la lutte armée en Amérique latine ; rend hommage à l'admirable combat du peuple vietnamien et à la lutte menée contre l'impérialisme par les Noirs des U.S.A. et d'Afrique sous domination portugaise ;

— dénonce les manœuvres des partis qui, cherchant à faire partout prévaloir les méthodes de la démocratie parlementaire, utilisent la mort de Guevara comme un argument contre la guerilla ;

— considérant la diversité des conditions objectives, estime que l'imagination créatrice est un ressort révolutionnaire essentiel et qu'il lui revient en chaque circonstance de définir les voies originales conduisant à la conquête du pouvoir ; après la prise du pouvoir, reconnaît l'action du même ressort dans la révolution cubaine et accueille avec les plus grands espoirs son refus de toute pétrification dans les domaines politique, économique et culturel ;

— retrouve les principes constants de son activité dans les propositions de Guevara et de Castro quant au rôle des intellectuels dans le processus révolutionnaire et entend, pour ce qui le concerne, contribuer dans tous les domaines de sa compétence à la lutte idéologique du peuple cubain.

Paris, le 14 *novembre* 1967

Philippe Audoin, Jean-Louis Bédouin, Jean Benoit, Vincent Bounoure, Bernard Caburet, Margarita et Jorge Camacho, Agustin Cardenas, Claude Courtot, Adrien Dax, Gabriel der Kevorkian, Aube et Yves Elléouët, Guy Flandre, Henri Ginet, Giovanna, Louis Gleize, Jean-Michel Goutier, Robert Guyon, Radovan Ivsic, Charles Jameux, Alain Joubert, Wifredo Lam, Annie Le Brun, Jean-Pierre Le Goff, Gérard Legrand, Joyce Mansour, Roberto Matta, François Nebout, Mimi Parent, Nicole et José Pierre, Bernard Roger, Huguette et Jean Schuster, Georges Sebbag, Marijo et Jean-Claude Silbermann, François-René Simon, Hervé Télémaque, Jean Terrossian, Maryse et Michel Zimbacca.

3

1

2

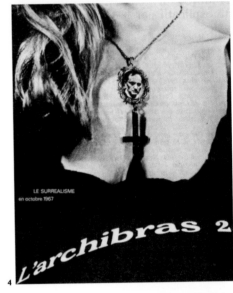

4

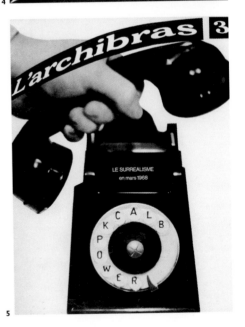

5

1 "Pour Cuba," collective declaration published in *L'Archibras*, number 3 (March 1968).

2 Photograph illustrating Jean Schuster's article "Flamboyant de Cuba, arbre de la liberté" ("Flame tree of Cuba, tree of liberty"), published in *LArchibras*, number 3 (March 1968).

3 Cover of *L'Archibras*, number 1, "Surrealism in April 1967."

4 Cover of *L'Archibras*, number 2, "Surrealism in October 1967."

The Cuban Temptation and May 1968

The political dimension was clearly present and increasingly insistent. In the third issue (March 1968) of *L'Archibras,* a collective declaration was published: "For Cuba," in which the last paragraph asserted, in particular, that the surrealist movement "has found the constant principles of its activities in the revolutionary process and, as far as it is concerned, intends to contribute in all domains in which it is competent to the ideological struggle of the Cuban people."

This short text was a continuation of "L'Exemple de Cuba et la révolution," which had been published in *La Brèche* in December 1964. It was accompanied by an enthusiastic piece by Jean Schuster, "Flamboyant de Cuba, arbre de la liberté" (The Cuban Flame tree of freedom): "Cuba, romantic and furious, is the island of revolutionary resistance to the methodical destruction of the inner man. The precariousness of Cuba is the precariousness of the inner man that the most generous of doctrines, falsified or simply grown old, can no longer defend against the myth of absolute efficiency incarnated by the technocracy."[61]

The interest in the Cuban revolution and the hope it instilled in the surrealists were due, in particular, to a stay that several of them (Jorge Camacho, Agustin Cardenas, Nicole and José Pierre, Huguette and Jean Schuster, Michel Zimbacca) had the opportunity to make on the island at the invitation of the government, to attend Wifredo Lam's introduction in July 1967 of the Salon de Mai in Havana. The surrealists were able to meet not only the Cuban leaders but also ordinary people, and they came back persuaded that this revolution, at least, was not headed for a bureaucratic softening. Schuster, on August 11, delivered an important speech in Havana titled "The Theoretical Basis of Surrealism."[62] Obviously, the surrealists were not the only intellectuals invited, nor were they the only ones to come away as converts to the ideas of Castro and Guevara. Other participants on the trip were Paul Rebeyrolle, César, Valerio Adami, Edmund Alleyn, Edouardo Arroyo, and Gilles Aillaud, and all of their paintings, although executed in Cuba, were in keeping with the work they had begun in France. Antonio Recalcati, Bernard Rancillac, Piotr Kowalski, Erro, and a few others, in contrast, gave a definite leftist slant to their usual themes, to produce works that were clearly more committed to the revolution. A collective mural (ninety participants) was painted "in an indescribable atmosphere of festivity," and Michel Leiris wrote in a "moving and tremulous script" a cordial "greeting to Cuba, the rose of the tropics and of the revolution."[63]

Alain Jouffroy unhesitatingly asserted that, "in Cuba, differences between the Tel Quel group, the pro-Chinese, the Trotskyists, the communists, the surrealist group, the Sartriens, the structuralists, the psychedelics and the happening beatniks absolutely do not have the same weight as in Paris." And if he later remarked that "there is no Cuban Aragon" nor any leader capable of "becoming another Breton + Sartre + Aragon + Foucault + Althusser," he consoled his readers by emphasizing that the existence of Castro and Guevara "has rendered many of the politico-cultural positions of the European intelligentsia obsolete." The surrealists, even caught up as they were in the festive atmosphere of the island, would most probably not have subscribed to declarations of this type: Jouffroy was describing the very region beyond which or adjacent to which the group had always sought to position itself—"literary politics" or "artistic politics." The fact remained that, at the time, the Cuban Revolution seemed an important

embodiment of the revolutionary spirit. To deplore it on the basis of what the Cuban regime would very quickly become would be to forget that Che Guevara, from the moment of his assassination in October 1967, became a hyper-romantic symbol with an enormous following among Western youth; it would also be to forget that, in August 1968, the surrealists withdrew their support the moment Castro approved the Soviet invasion of Czechoslovakia (the news of later arrests of Cuban writers and artists obviously did not induce them to return to the pro-Castro fold). At the end of his life Leiris would say, "I think it was inevitable we would fall into the trap." Schuster's reply: "And how!"[64]

Politics, however, also meant politics in France, and on May 5, 1968, a pamphlet was put together: *Pas de pasteurs pour cette rage!* (No shepherds for your rage!).[65] Its title implied a bit of advice addressed to the student rebels: above all, they must refrain from falling under the banner of any official shepherds! The pamphlet was distributed four days later, during a meeting open to all tendencies and organized by the Jeunesse Communiste Révolutionnaire (the Trotskyist communist revolutionary youth organization). In such a context, the pamphlet's meaning became patently clear, declaring that "youth has no lessons to learn from any person, institution, or political apparatus"; it denounced the Communist Party, Gaullist groups, and right-wing activists. In the last paragraph, the pamphlet modestly stated that "the surrealist movement is available to the students for any practical action destined to create a revolutionary situation in this country."

Number 4 of *L'Archibras,* dated June 18, 1968, a special edition, took the form of an unstapled sixteen-page leaflet; its essays contained no by-lines, but the list of contributors figured on the last page: Vincent Bounoure, Claude Courtot, Annie Le Brun, José Pierre, Jean Schuster, Georges Sebbag, and Jean-Claude Silbermann. Entirely devoted to the events of late May and early June, it described them in a tone alternating among rage, irony, poetry, virulent demands, and aggression toward official authority. Nothing could be further from journalism or a strict chronicle of events: the point here was to force a return of ill-gotten gains and to settle old scores. The editors wanted people to situate the ongoing events within the framework of unrestrained desire and unlimited resistance to the most unbearable aspects of social organization: "What is being born, magnificently, before our eyes, what is being born within us, is much more than a heresy or a Utopia: no end, no rest; every arrival is a departure. Whatever else might happen, we now know better that man is a new idea and that his desire is his unique reality." The brochure concluded with this unequivocal declaration: "Français, Françaises, we are calling upon your ill will." Such displays of virulence led to the issue being seized by the police, and a triple accusation of offense to the president of the republic, vindication of crime, and slander with regard to the police.

The Prague Platform

L'Archibras number 5 was again a special issue (with the same presentation as the previous one); the first page was stamped with blue letters, "Czechoslovakia." It contained "On n'arrête pas le printemps," a collective essay written on September 12 by "Czech surrealists who left Prague on August 30" (nine days after the Soviet invasion), as well as "Plate-forme de Prague" (The Prague platform). The platform was a document that had been put together between April 5 and April 18 and signed by twenty-eight French members of the movement, but it specified that, "under other circumstances, it

would have included the signatures of twenty-one Czech surrealists and eleven foreign surrealists residing in France." It opened by reasserting its role as guarantor of the agreement concluded in Prague during the *Pleasure Principle* exhibition with regard to the medium- to-long-term perspectives for surrealism and also with regard to an understanding of contemporary forms of repression and, consequently, the "will to implement indispensable theoretical readjustments." This "theoretical and practical platform" went on to develop seven points for consideration not as dogma but, on the contrary, as suggestions adaptable to given circumstances.

Radical monism and at same time a refusal of any restrictive specialization were reaffirmed, and surrealism, necessarily a minority movement, conceived its own reception "in proportion to the active rebellion within each individual." The platform hoped to "expand the dialogue with any and all individuals and organized movements that have helped bring repressive systems to their knees." It hoped for a "regeneration of revolutionary ideology"—particularly from the youth—and confirmed the superiority of "poetical thought" (particularly over philosophy or science), which had the advantage of enjoying "a free relationship with the principle of reality" and had proven its practical influence "since it formulates the imagination and thereby embraces the goal of transforming it into reality." Always hostile to art for art's sake as well as to *engagé* art, surrealism held that the specific role of artists was to "liberate the powers and desires held captive in the unconscious." The last paragraphs of the document asked that "global expressions of the surrealist movement as it is presently defined" be added to *L'Archibras* and to *Aura* (which should have come out in Prague)—contributions that would take into account the place, the circumstances, and the public. Thus, an appeal was launched for surrealist spontaneity to take every necessary initiative in this direction. Finally, the platform greeted "isolated comrades around the world"—the Rosemonts in Chicago, Nicolas Calas in New York, Aldo Pellegrini in Buenos Aires, Georges Gronier in Brussels, and "our surrealist comrades in Cuba."[66]

Even briefly summed up in this way, the Prague Platform had the impact of a real manifesto, destined to embody the goals and the means of the movement. The aim was clearly to lead to a revival of international activity—a revival that would be based on the movement's history; all the themes chosen were a reflection of that history, but the platform also took into account what the current situation might offer. The events in May and June showed that there was indeed perhaps more than ever a spirit of rebellion among youth, on a level with a repression that was itself perceived as stronger or more insidious than ever; moreover, the publication of this text at the very time when Czech surrealists were being forced into exile was a serious indication of its relation to a sinister moment of living history. It was a foregone conclusion that *Aura* would not see the light of day but, one might still venture, that was yet another reason for other publications to begin elsewhere.

Meanwhile, *L'Archibras* number 6 ("Le Surréalisme en décembre 1968") welcomed the Czechs: Stanislav Dvorsky, Vratislav Effenberger, P. Kral, and L. Svab collaborated on "Prague aux couleurs du temps" (Prague in the colors of time). Its publication (it had been written between December 1967 and January 1968) had intended to bring a full appreciation of what had elsewhere been termed the "rebirth" of their country; and the seventh and last issue of *L'Archibras* (March 1969) included P. Kral's "Le Relevé." The Czech surrealists were not otherwise featured in these two installments, which was definitely slimmer than the first three in the series, although they had lost

none of their virulence, humor, and poetic ideas.[67] The selected news items at the end of the issue, "Le Fond de l'air," did, however, reconfirm the desire for international exchange and were a response to the critical reactions of the Chicago surrealists to the exhibition organized by William Rubin, *Dada, Surrealism and Their Heritage*.[68] They also gave a favorable view of the activity undertaken since May 1967 by John Lyle and his friends in England.[69] But this was not such a lot of activity, after all.

Le Quatrième Chant

It is easy with hindsight to view the slim offerings of the last two issues of *L'Archibras,* or the absence of true innovation, as indications of a malaise. It would be up to a pamphlet to reveal the degree of the tension among group members, albeit with veiled words. On February 13, 1969, *Aux grands oublieurs, salut!* (Great forgetful ones, we greet you!) was signed by Philippe Audoin, Claude Courtot, Gérard Legrand, José Pierre, and Jean-Claude Silbermann.[70] Jean Schuster had just resigned from the group, and it was his withdrawal that led some of his friends to declare that from now on they preferred "chance hypotheses" to those that "expected a miracle from the joy of being together": they could counter the "tried rhythms" of the group with the idea that "life must be led without caution," and it seemed that the maintenance of group activity was implicitly assimilated to running a small business.[71]

Aux grands oublieurs, salut! heralded the group's disintegration, for some of its members deplored the repetition of their activities and techniques or the formulation of a set of clichés and an academic outlook. The fear expressed by Breton already in the 1930s had finally become a reality, after all. Under these conditions, the fixation on the term "surrealism" was in danger of concealing only an inability to innovate, and of masking an increasingly worrisome failing of poetic thought itself.

Five weeks later, *Sas,* a collective response (twenty-seven signatures) to the decision to dissolve the self-proclaimed surrealist group made it clear that the dissolution actually occurred on February 8.[72] This last pamphlet from a diminished group could do nothing more than reaffirm the "indispensable renewal" of surrealist activity and develop an almost contradictory argument: although at first it mentioned the withdrawal of the five authors of *Aux grands oublieurs, salut!* it then went on to describe the seventh issue of *L'Archibras* as the last collective expression of a surrealist group that had indeed ceased to exist.

And if anyone still had any doubts, *Le Quatrième Chant,* published by Jean Schuster in *Le Monde* on October 4, 1969, would remove all uncertainty.[73]

Schuster began by recalling the circumstances that, after André Breton's death, had initially seemed propitious for continuing group activity: a renewal not only of ideas but also of revolutionary action had actually come about, giving rise to a "euphoric illusion." Once that euphoria faded, it was time for the "dissolvent factors" to finish their work. Breton, when he was alive, had been able to withstand the power of their assault thanks to his rare ability to perceive, and transmit to his friends, "an essence common to the most disparate manifestations of the outside world," which alone was capable of ensuring the cohesion and strength of the group.

The *Archibras* series was proof of the way in which the group had tried to stay "on a par with both its past and current events." But that effort was fraught with sterile debate, with compromises, or even, at the other extreme, with forced takeovers whose

lasting repetition would lead, inexorably, "to an ignominious intellectual bankruptcy." Consequently, Schuster stated that the seventh issue of the periodical would be "the last event in France for surrealism as an organized movement."[74]

He then clearly distinguished "eternal" surrealism from its "historical" version: if the former was "an ontological component of the human spirit," the latter could only lead to a formidable idealism by claiming to be anything more than a "discontinuous inscription," within a particular history, of whatever it was immersed in at the moment. Since this "historical" surrealism did, indeed, have a beginning, it was normal—even if it was also painful—to conclude that it had reached its end, since to go on calling it surrealism risked concealing the progressive dissolution of that which had given it its reality, that is, the cohesiveness of the group.

It had indeed become obvious that the term "surrealism," through repeated indiscriminate use and a failure to refer to the values that ought to govern its use by guaranteeing its content, had come to refer to just about anything. One quickly became aware of the frequency of its use in the press, where a human interest story, a mood, a political speech, a high fashion model, or the quirks of a more or less public person were now almost automatically qualified as "surrealist." Such an extensive use of the label stripped it of all its precise significance as well as of any offensive connotation. What was the point in maintaining a term so emptied of substance when the intellectual cooperation that, beyond subjective differences, could have restored some meaning to the term regardless of the general meaningless chatter, was also lacking?

The only serious issue remained that of the succession to "historical" surrealism. *Le Quatrième Chant* announced the imminent publication of *Coupure*, "a publication founded on a particular, slightly perverse, treatment of the news," which should, at least partially, help to resolve the crisis of the imagination. The crisis could only be overcome by a dual effort that would consist, on the one hand, of evaluating the aftermath of the events in May and June 1968 and, on the other hand—taking into account the most recent advances of specialized ideas and disciplines (psychoanalysis, ethnology)— of elaborating a concept of the unconscious psyche and dream activity according to which dreams were "the true organizers of human destiny."[75] While Schuster insisted that these two axes did not form the basis of a program, he implied in passing that the defense and illustration of the powers of the imagination were in danger of leading once again to a serious debate with the avant-garde: "Bourgeois co-optation (art as merchandise) and neo-Stalinist co-optation (art as commitment) ought not serve as an alibi for 'revolutionary' idiocy."

Reactions to *Le Quatrième Chant*; the *Bulletin de liaison surréaliste*

There were those who disagreed with Schuster, and the publication of *Le Quatrième Chant* caused a stir, the impact of which was very different from the simple exchange of pamphlets in February and March. On October 25, 1969, Jean-Louis Bédouin published a "letter of rectification" in *Le Monde*: Schuster was not qualified to speak for the entire group, and some members protested against the fact that his essay might implicate others (and, no doubt, those who had signed *Aux grands oublieurs, salut!*).

On October 20, Vincent Bounoure published *Rien ou quoi?* (Nothing, or what?), an attempt to clarify the motives and modalities for continuing common action. There was a print run of a hundred copies, and the piece was distributed solely on an internal

basis, as would be the case in February 1970 for the responses to the issues raised: forty-four people reacted, among them the Czech surrealists, who in a collective letter unanimously declared "a profound sense of shared views and a desire to cooperate" with Bédouin, Bounoure, Camacho, "and a few others." Bounoure concluded his essay by emphasizing how isolated their "faraway friends" were (particularly in Holland and Czechoslovakia): "Not only is it out of the question for them to have an impact on the public evolution of things, but they are no longer in a position to form an opinion on the mutual articulation of any endeavors on the part of the surrealists from now on."

Whence the necessity of a bulletin to keep everyone abreast of the latest developments: this would be the *Bulletin de liaison surréaliste*. Its first issue came out in November 1970, and it would run until number 10, its last, in April 1976. The initial print run was a hundred copies, but by the end it had reached three hundred.[76]

The opening declaration, signed by Bédouin, Benoit, Bounoure, Camacho, Joyce Mansour, and Zimbacca referred to the notion of the "absolute divide" in relation to the world in which we live.[77] But it was to deplore its inadequacy: "We must also, at the risk of letting ourselves be dominated by our own contradictions, distance ourselves from what was, and from what could in no other way enable us to foresee the future. No one has the right to define a surrealist 'line,' still less to impose one upon us. But it is up to each one of us to describe his or her own trajectory, and to establish the points where it will intersect with others or, on the contrary, diverge from them."

Insisting on the internal nature of the *Bulletin de liaison surréaliste,* the last paragraph concluded that "criticism and polemics will find only a limited welcome, insofar as our aim is not, at least at present and with the means at our disposal, to intervene outside the group, but to give each other recognition and, if possible, again find pleasure in joint activity." Clearly, the stated intentions were modest, not to say cautious: nothing could guarantee, a priori, that joint action was indeed possible.

In addition to those who had signed this opening text, the most frequent contributors, for the bulk of the installments, were Jacques Abeille, Robert Guyon, Marianne Van Hirtum, Georges Henri Morin, and Roger Renaud. The participation of the Czechs was also particularly noteworthy, and in the very first issue a message from Albert Marencin justified this inclusion: the local authorities had declared that surrealism was "the Trojan horse of anticommunism," and the situation in Czechoslovakia was anything but easy ("an almost total lack of information on surrealist activity elsewhere in the world" and "the impossibility to publish abroad without authorization")—whence the importance of exchange and debate. Vratislav Effenberger, Marencin, Pavel Reznicek, Martin Stejkal, Karol Baron, and Jan Svankmajer sent articles, poetry, and drawings. But the desire to establish relations with every country seeking to maintain an activity one could qualify as "surrealist" was also reinforced by the participation of Nicolas Calas, Roger Cardinal, John Lyle, Franklin Rosemont, Ludwig Zeller, and St. Schwartz.

Several new collective games confirmed the intention to find constantly renewed ways to cement the unity of the group.

One year after the *Bulletin de liaison surréaliste* was suspended, the same group would put together a new publication, *Surréalisme,* in which one could find virtually the same participants and the same ambitions. Only two installments would be published, a sign that it was increasingly difficult to sustain a truly collective activity—a definitive confirmation, eight years later, of the diagnostic in *Le Quatrième Chant.*

Coupure

The format of *Coupure,* which appeared in October 1969, edited by Gérard Legrand, José Pierre, and Jean Schuster, clearly distinguished it from earlier periodicals—as did its direct connection with the news, established through reprints from the press (whence its title, which in French means "clipping"), and the unusual nature of its contributions.[78] The publication opened under the triple sign of passion by publishing photographs of Gabrielle Russier, Sharon Tate, and Bernadette Devlin, "annotated" with quotes from *Le Monde* and the *Nouvel observateur;* definitions taken from the *Nouveau Larousse universel* and the catalog of the *EROS* exhibition (the Scandal according to Nora Mitrani); and essays by José Pierre and Jean Schuster.[79] Contributions from the "directors" and their friends (Annie Le Brun, P. Kral, Jean-Claude Silbermann, Jean-François Bory, Philippe Audoin, and Jacques Baron) came with a note indicating the number of the issue in which they were published or were introduced as excerpts from works being published at the time.

The publication was the beginning of a relation characterized by biting irony when compared with the general mood at the time. One factor was the attitude adopted in intellectual debates—already in the first issue, José Pierre deplored the invasion of "commonplaces," that is, public manifestations of a so-called art accessible to passers-by who are not really interested; and, in number 5, Gérard Legrand attacked the "revolutionary" positions of the periodical *Tel Quel.*[80] Another factor was the montage of texts affirming the relentless demand for freedom, the right to passion and the imagination, and a taste for experiencing the unknown. The excerpts were included without any commentary, something that could leave readers undecided—not the usual way to incite them to reevaluate their own preferences and values. But insofar as *Coupure* was no longer the result of a group effort, one could find—alongside the more or less predictable references, depending on the contributors' past, to Man Ray, Duchamp, or Gustave Moreau—information about artists who were generally considered to be fairly distant from surrealism.[81] Therefore, what was at stake was a nondirective collection of attitudes, acceptable (or not) from the point of view of individuals who had "interiorized" the demands of "eternal" surrealism and who located the manifestations, the sudden appearances, or the impact of that surrealism in the commotion of present-day or more distant events.[82] The creation of such a network of references and events made it possible to inform readers about publications in which surrealist voices continued to be heard. It responded rapidly to anything that seemed scandalous, entertaining, or titillating in political life and was not afraid to place quotes from poets and revolutionaries alongside those of prominent and less respected individuals. Attention to political matters was particularly obvious in the successive issues, particularly with regard to anything that raised obstacles to freedom of expression and information; thus *Coupure* number 4 (announced as a "special issue," it came out on two pages in June 1970) consisted of articles that had first appeared in *La Cause du peuple,* a newspaper that had recently been banned and the editors of which had been sentenced to prison. *Coupure* also included a drawing by Hermann Paul (published in *Le Canard sauvage* in 1903) and an excerpt from Jarry. Schuster and Losfeld were put on trial for the publication of *Coupure,* while other publishers (Jérôme Lindon, Claude Gallimard) and a few writers would come and testify in their favor.[83]

But politics were also dealt with in *Coupure,* though less directly, in particular within

the framework of a survey on work, freedom, and the loss of time that was featured in the third issue and through the publication of photomontages by John Heartfield and of the libertarian imagery to which Flavio Constantini had been devoting himself since 1963.[84]

Now and Beyond

In his memoirs, Eric Losfeld noted with some bitterness that the surrealists were in the habit of suspending publication of a periodical just when it was beginning to be profitable for its publisher because they thought the formula had run its course. Was this the reason, once again, that *Coupure* did not go beyond the seventh issue (January 1972)? Perhaps a certain weariness had begun to take its toll; the trial over the fourth issue six months earlier had certainly not helped things, and *Coupure,* in spite of everything, had begun to look like the organ of if not a group then at least of a collective united by a community of thought and reactions.

While Schuster and José Pierre were collaborating on *La Quinzaine littéraire* (the former with a pleasant chronicle devoted to television, the latter with his preferred topic, the plastic arts), some of their friends got together in June 1972 to found the Éditions Maintenant, which would publish small volumes by Radovan Ivsic, Annie Le Brun, P. Peuchmaurd, Georges Goldfayn, Gérard Legrand, Toyen, and others.[85] They also published a collective essay in successive chapters (*Il faut tenir compte de la distance* [The distance must be taken into account]) and, under the title *Quand le surréalisme eut cinquante ans* (When surrealism turned fifty), a commemoration of the official birth of the movement. After warning those who traded in memories and historians tempted by "the most derisory critical activity" that they would not get their money's worth if they hoped to get a reaction from the contributors, who had decided to refrain from any form of protest, the essay gave a rapid summary of the different dimensions of the surrealist revolution to point out its relative successes as well as its impasses. But they eventually concluded that "the path of the surrealist revolution is still being followed," while "the idea of poetry, a rainbow with no other promise, has not bowed out."

Providing their own financing, the Éditions Maintenant, despite the apparent modesty of their production (the vigor of their poetic brilliance was in no way proportional to the slimness of the volume that contained it), could be compared somewhat to the Éditions Surréalistes, the final publication from which was Radovan Ivsic's *Le Roi Gorgodane* in 1968: the cooperation among the different authors certainly acted as a vital lead to this type of endeavor.

In later years other groups came together with varying degrees of longevity and success. And from time to time, individual efforts in poetry or painting would be rewarded—it would be futile to try to list them here, but these works continued to obey an impulse that took its source in historical surrealism.

And yet historical surrealism has failed to transform the world. Worse than that, as Julien Gracq has pointed out, it is the world in its present manifestation that more than ever deserves the anathema once regularly unleashed on it by the group: a reduction of all human activity to economic interest, "the advent of a society solely obsessed with the service of money and the production of merchandise," the stupefying effect and rampant disinformation deployed by the multiple media themselves, more and more obsessed not only with the stock market or television but also with what is sensational

or anecdotal, and an acceleration of "intellectual" fashions promoting concepts the way others promote washing powders.[86] To this list, one can add the postmodern disaffection with regard to Marxism and the lowering of the status of the work of art to that of a product, subject like any other to the fluctuations in value imposed by the market. This, then, is reality, a reality against which a poem by Péret, a page by Breton, a canvas by Ernst, Magritte, or Matta have little impact.

The fact remains that surrealism has kept its prestige. Not because it may have influenced a great many contemporary artists and writers—that is all true, but implies that only certain aspects, and then only partially, are being revived—but because it has created a constantly active center that remains, beyond philosophical and artistic schools or trends, the only movement of the twentieth century to espouse an ethic.

In the history of surrealism, André Breton's role has clearly been vital—not as a "Pope," as caricatures would have it, but as instigator and animator of a collectivity that he sought, to be sure, to steer in a direction that seemed to him, in the context of outside events, to be appropriate but that also included those who were collaborators, always few in number, rather than disciples—who by nature are called on to increase their number. The group was not conceived as capable of expanding to the dimension of a political party (however poorly—but so what—that dovetailed with its political endeavors, which decidedly make up the major dimension of its failure but which had at least some cautionary value) because its members were only too aware of the marginal status to which the values they upheld would perforce condemn them. Breton lived those values rigorously, whatever it may have cost him, but he was not the only one to claim that he was not behaving reprehensibly. The dissolution, a few years after his death, of the Paris group is a confirmation that his presence had guaranteed the collective dimension of surrealism, but this does not mean that surrealism has in any way become obsolete.

Although surrealism did not manage to change life, it managed nevertheless, as Gracq again has confirmed, "to infuse it with fresh air." By proving that "poetry" must now refer to things quite far removed from the writing of a professional attached to outside rules and confined by inefficient collections. By urging one to neglect autonomous works of art and at the same time reintegrate the artistic process at the very heart of everyday existence so that it may be transfigured. By teaching that banality has a wealth of hidden aspects waiting to be brought to life. By recalling that there is in every human being a radical seed of permanent dissatisfaction and that the various anesthetizing responses of society remain hopelessly inadequate. By exalting love over the banalization of emotional relations. All of these are warnings that the current climate periodically considers outmoded or "surpassed" by more recently prescribed ways of being—but is it possible to aspire for anything more exalting that love, poetry, and freedom?

It is precisely because within these three notions there resides a virtue of infinite exploration that surrealism—independently of what already constitutes its history and beyond eclipses or dormant periods of varying length—may well continue to arouse more than mere curiosity, to arouse a veritable passion among artists, poets, and anonymous souls who, in the twenty-first century, believe they have found the wherewithal to transform their lives into something more than the simple implementation of a planned course over which they have no control in any case.

Notes on the Principal Surrealists and Some of Their Close Followers

Birth dates and death dates (when applicable) are given beneath each name, followed by place of birth and place of death, respectively; a single city indicates place of both birth and death.

AGAR, EILEEN
1904–91, Buenos Aires/London

Painter. After classical art studies, she discovered surrealist work in Paris at the end of the 1920s. During that period she met Paul Éluard, and in 1933 joined the first surrealist grouping in London. Three years later she would be the only woman to participate in the international exhibition in London. Agar made frequent use of automatism in her canvases, characterized by brutal, semiabstract, and vividly colored shapes. She also created objects (*The Angel of Anarchy*) and collages made from found materials. The war interrupted her artistic activity, and she only began to paint again in 1946 and exhibited fairly regularly from then on until her death.

ALECHINSKY, PIERRE
1927, Brussels

Belgian painter and writer. During his first exhibition in his hometown, he met Magritte and later took part in Cobra, where his encounter with Asger Jorn and Christian Dotremont would be extremely influential. In his own words, "Cobra had one of its prime sources in surrealism, but then diverged," favoring the physical, or even material, aspect of automatism over its mental dimension. Alechinsky later studied printmaking with Stanley William Hayter, spent some time within the Phases group, then gradually grew closer to the Paris group, although he was never officially a member. This did not prevent him, however, from contributing to *La Brèche* and taking part in *L'Écart absolu* in 1965. Two years later, Breton would say how much he appreciated, in particular, Alechinksy's "power to interweave contours," which remains a hallmark of all his work, making easy use of charm, all the better to entice one into a world populated with goblins, sprites, carnival jesters and other gnomes of varying facetiousness. The humor that confers a particular disproportion to Alechinsky's graphic work is fully deployed in some of his written texts; he also movingly evokes, in *Roue libre* (1971), in particular, the memory of Breton.

ALEXANDRE, MAXIME
1899–1976, Wolfisheim/Strasbourg

Alexandre took part in the activities of the surrealist group from 1924 on and displayed a strong anticlerical streak. After publishing a few collections of poetry (*Le Corsage* [1931]), he distanced himself from the group at the time of the Aragon affair and sought an outlet for his despair in communism. "A mixture of Novalis and Stalin" (Breton) or a "sniper nostalgic for companionship," as he defined himself, he converted to Catholicism in 1949 but, disappointed by the half-heartedness and anti-Semitism of his new family, would distance himself from the church in his later years. In 1968, he published *Mémoires d'un surréaliste* (Paris: La Jeune Parque).

ALEXANDRIAN, SARANE
1927, Baghdad

French writer. He came into contact with the surrealist group following the Liberation and took part in the organization of the *International Exhibition* of 1947 (Galerie Maeght). A member of the Cause group, he represented the group's upcoming generation. In this capacity he cowrote a number of important pamphlets, such as *Rupture inaugurale* (1947) and *À la niche les glapisseurs de Dieu!* (1948), and was responsible for *Néon,* which he helped to finance. In November 1948, however, he was expelled from the group for defending Roberto Matta and Brauner (he would become a specialist in their art). His active participation in the group has been documented in his later work (*Le Surréalisme et le rêve* [1975], *Les Libérateurs de l'amour* [1977], *Le Socialisme romantique* [1979]). In 1990, Alexandrian published his memoirs, entitled *L'Aventure en soi.*

ALQUIÉ, FERDINAND
1905–85, Montpellier

Professor of philosophy. Alquié came into contact with the surrealist group in 1933 and sent Breton a letter deploring "the winds of systematic cretinization" emanating from the USSR: its publication in the fifth issue of *Le Surréalisme ASDLR* would precipitate the break with the Communist Party. In 1938, he took part in *Trajectoire du rêve,* and in 1955 he published his reference work entitled *La Philosophie du surréalisme,* in which he showed how the movement could enrich the rationalist tradition to which he belonged professionally. (He was, in particular, an editor of Descartes's works). Having gained Breton's trust, in 1966 he organized the "Décade de Cerisy" talks devoted to surrealism.

649

ARAGON, LOUIS
1897–1982, Paris

French writer. Born "of unknown parents" (he was the natural son of a former police prefect and ambassador), he was raised among women in an environment that could only contribute to his confusion: his mother, who only revealed his origins to him in 1917, pretended to be his sister, and his grandmother, his mother. As a child, he already wrote prolifically: prose and poetry, including *Quelle âme divine!*—later incorporated into *Le Libertinage*. As an adolescent, Aragon read voraciously, and was already very well informed of various aspects of modernity. In 1917, as an auxiliary field medic at Val-de-Grâce, he met Breton, who had the same status. Sent to the front, at Chemin des Dames he began to write *Anicet ou le panorama* (published in 1921). Back in Paris, he met Éluard and Soupault and immediately became an enthusiastic participant, first in *Littérature,* then in Dada. Having grasped through the experimental *Les Champs magnétiques* that everything was possible with automatism, Aragon became the one who best personified the dandyism of rebellion and exerted a fascination, through his obvious talent, on both his friends and other young writers. From the Barrès trial to "doddering Moscow," he would meet the challenge even if it resulted in paradox, and he displayed in every domain a flawless intransigence, never refraining from formulating cruel opinions about the events in which he took part (*Projet d'histoire littéraire contemporaine,* written in 1923). He then brought an indisputable enthusiasm to surrealism, the birth of which he announced in *Une vague de rêves,* and drew attention to the impact of collages ("La Peinture au défi" [1927]). Something of a nightowl, the man "with two thousand neckties" shared the life of the heiress Nancy Cunard, published *Le Con d'Irène* (1928) anonymously, and partially destroyed the manuscript of a huge novel, *Défense de l'infini,* which was begun in 1923 but was poorly received by the surrealist group. Aragon joined the Communist Party in 1927 and was among those for whom political commitment was absolutely essential. From the moment he met Elsa Triolet, he would attempt to fulfill in her company a singular version of "mad love." Sent in 1930 to the Kharkov congress to represent and defend the position of the surrealists, he returned having signed a declaration that condemned surrealism and had some difficulty in justifying his action. Aragon's break in 1932 with the surrealists was particularly painful for Breton but was irreversible: after the accusations brought against him because of his poem *Front rouge,* Aragon condemned the way in which the group had rallied to his defense. Henceforth, he would become a "realist" and, as a militant journalist for the party, would advocate socialist realism, while as a poet—with the exception of a few virulent pages in the *Traité du style*—Aragon would become a patriot during the Occupation. After the war, the three aspects of his personality converged to make him the most visible intellectual of the Communist Party, and his positions continued to concern surrealism only insofar as they symbolized the very thing that was unacceptable to Breton and his friends. Editor of *Lettres françaises* from 1953 to 1972, Aragon gave an official welcome to the various Stalin prizes, sought to impose André Fougeron and a return to traditional form in poetry, defended Communist Party policy during the Hungarian uprising, and only sought a relative freedom of opinion after 1960. His "realism" expanded to embrace Marc Chagall and André Masson as well as Fernand Léger. In later years he expressed a desire to reexplore his early years and tried in vain to bring about a reconciliation, even posthumously, with Breton. The author of *Communistes* had become the theoretician of a "mentir-vrai"—"lying the truth"—who played on his different masks and created multiple reflections, as if to avoid the condemnation—more moral than literary—with which successive generations of surrealists would judge him.

(Louis Aragon, *Œuvres romanesques complètes* [Paris: Gallimard, Pléiade, 1997], vol. 1; Y. Gindrine, *Aragon prosateur surréaliste* [Geneva: Droz, 1966]; P. Daix, *Aragon, une vie à changer* [Paris: Éditions du Seuil, 1975]; and G. Prevan, *La Confession d'Aragon* [Paris: Plasma, 1980].)

ARP, JEAN (OR HANS)
1886–1966, Strasbourg/Basle

Painter, poet, and sculptor. Brought up in both the French and German cultures, Arp was particularly affected by the absurdity of the First World War and, after his contact with the "Blaue Reiter" expressionism in Munich, was one of the founders of Dada in Zurich. From that point on, Arp would make use of chance and automatism: wood engravings and cut-out reliefs, initially geometric, would quickly be freed from angular forms to favor sinuous lines, evoking a vital sensuality and humor as well. In 1925 he took part in the first surrealist exhibition (he settled the following year in Meudon with his wife Sophie Taeuber) and, until 1965, would contribute to all the major collective events. At the same time, his relations with proponents of geometrical abstraction (notably the Cercle et Carré group) would lead him to insist even more, in his "torn" papers, on the prime materiality of the materials used. His ideas on sculpture, already in the early 1930s, developed within an affinity for natural forms, the inner growth of which he sought to reconstruct far from any realist framework; his shapes in the round, named "concretions," evoked not only bodies but also phenomena of generation evolving freely among the different kingdoms. In the 1950s, his sculptures, apparently more abstract, confirmed this universality of principle by becoming "configurations" or "cosmic forms." In Arp's poetry, written directly in French from 1925 on, there is a similar metamorphic vein, where he encourages verbal fun and thumbs his nose at seriousness, while a prudish gravity emphasizes the give and take between life and death. *Jours effeuillés* (1966), which contains the quasi-totality of his texts, is one of the most significant poetry collections of the postwar era, its brilliance comparable only to that of someone like Benjamin Péret.

ARTAUD, ANTONIN
1896–1948, Marseille/Ivry

French poet. Early in life Artaud was sent to a sanatorium: already in childhood he suffered from a "failure to be." In 1920, he went to Paris and began a career as an actor, both in theater and cinema. Already friendly with Michel Leiris, Max Jacob, and André Masson, between 1923 and 1924 Artaud exchanged letters with Jacques Rivière (*Correspondance avec Jacques Rivière,* published in 1927), which revealed his feelings of an enduring inner collapse and the futility of any artistic endeavor. At the end of 1924 Artaud began to mix with the surrealist group. He took over the management of the bureau

and planned the virulent third issue of *La Révolution surréaliste*. While he would later put his name to *La Révolution d'abord et toujours!* this was undoubtedly because the surrealists had proclaimed their "rebellion of the spirit," but discord arose during the debates over the necessity of political commitment. He announced the creation of the Théâtre Alfred-Jarry but was expelled from the group in November 1926. He responded to *Au grand jour*, where the motives of the rapprochement with the Communist Party were exposed, with *À la grande nuit ou le bluff surréaliste* (June 1927). From Artaud's point of view, the political question was negligible, and the only conceivable revolution was a spiritual and metaphysical one: this is the revolution he would try to encourage through his plays or during his travels in Mexico. Apart from a few examples of active cooperation (the surrealists joined with Artaud to protest against the film adaptation of *La Coquille et le clergyman* by Germaine Dulac), there was too great a divide between his individualism and the consent required by any collective movement. The failure of his staging of the *Cenci* (1935) led Artaud to question the very foundations of Western culture: the voyage "to the land of the Tarahumaras" taught him the possibility of other relations linking humankind, the sacred, and the world. This would be demonstrated in the anonymous publication in 1937 of the *Nouvelles révélations de l'être* and was the instigation for a journey Artaud undertook to Ireland that ended dramatically with his internment in Le Havre. Successive internments brought him by 1943 to Rodez where, thanks to Desnos, Gaston Ferdière would take care of him, but Artaud complained of the electric shock treatment. In 1947 he left Rodez, and an evening was organized at the Vieux-Colombier to honor him: Breton praised his "constantly inspired use of words," which anywhere else than in Europe might have "gone very far toward committing the collectivity." In the months that followed, Artaud wrote some of his most important works (*Artaud le Momo, Van Gogh le suicidé de la société* [1947]), prepared a radio broadcast that was eventually banned (*Pour en finir avec le jugement de Dieu* [1948]), and exhibited at the Galerie Pierre a series of astonishing drawings and portraits. He had no artistic or stylistic pretension, and the paper on which he sketched bore marks of rage or aggression, sometimes rubbed right through: these sheets were like weapons, "spells" against the alienation he felt; they reminded him of those he was once close to, protected him against enchantment, and helped him in his attempt to put a shattered self back together. In the same capacity as the texts or the "invented syllables," drawing was for Artaud a way to both combat and explore the meanders of his being, and for this reason, despite lasting disagreements, he was also relatively close to surrealism, in a way that was totally authentic.

(G. Durozoi, *Artaud, l'aliénation et la folie* [Paris: Larousse, 1972]; P. Thévenin, *Antonin Artaud, ce désespéré qui vous parle* [Paris: Éditions du Seuil, 1993].)

AUDOIN, PHILIPPE
1924–85, Paris

Audoin met Breton in person around 1950, but it was not until 1962 that he took part in the activities of the surrealist group: he contributed to *La Brèche*, wrote one of the prefaces for *L'Écart absolu*, then collaborated on *L'Archibras*. Author of a work on Breton (Paris: Gallimard, 1970) and a study—contested by some members

of the former Parisian group, such as Jean-Louis Bédouin—titled *Les Surréalistes* (Le Seuil, 1973), he gave a remarkable description of the "surrealist games" in *Le Dictionnaire des jeux* edited by R. Alleau (Tchou, 1964). He was also interested in Joris-Karl Huysmans and in Maurice Fourré (*Maurice Fourré rêveur définitif* [Paris: Le Soleil Noir, 1978]).

BAJ, ENRICO
1924, Milan

Italian painter. From the early 1950s, Baj's work has evolved in close collaboration with surrealism. Cofounder in 1951 of the "nuclear" movement, which grants unlimited powers of suggestion to pictorial material, Baj joined Asger Jorn in the Imaginist Bauhaus movement in 1953, where the Cobra spirit was preserved. In Albisola, where the International Ceramics Meetings were held, he made the acquaintance of Roberto Matta and Édouard Jaguer, with whom he started the periodical *Il gesto*, the counterpart of Phases in Italy. In the course of the coming years Baj would associate with E. L. T. Mesens, Marcel Duchamp, Arturo Schwarz, and finally Breton. In his work, Baj has proved to be an expert in the use of the most disparate materials: he enlivens amateur paintings found in flea markets with "ultrabodies," combines decorations, fabrics, and soft furnishings to form the silhouette of a puppet general, or makes use of marquetry to improvise an incongruous piece of furniture. This freedom of invention, which might be compared to Francis Picabia's, in which metamorphosis comes into its own, ensured his participation in the *International Exhibition of Surrealism* in 1959 and 1965. Further examples can be found in the illustrations he made for his poet friends, Benjamin Péret, André Pieyre de Mandiargues, and Joyce Mansour.

BARON, JACQUES
1905–86, Paris

At the age of sixteen Baron published his first poems in the periodical *Aventure*; he would subsequently be the youngest Parisian Dadaist, contributing to nearly every issue of the second series of *Littérature* as well as to *La Révolution surréaliste*. In 1929 he figured among the signatories of *Un cadavre*, but this would never cause him to question the choices he had made in his youth, as evidenced in his book of "memories," *L'An I du surréalisme*, rich in particularly sensitive portraits of the founders of the movement. In addition to his collections of poetry (*L'Allure poétique* [1924]—the collection published under the same title in 1974 included poems from 1924 to 1973; *Paroles* [1930]; *Les Quatre temps* [1956]; and *La Vie lavable* [1982]), his prose works were remarkable for their freedom of tone and a freshness all too rare in that which is normally called a novel (*Charbon de mer* [1935], republished by Gallimard in 1985; *Le Noir de l'azur* [1946]).

BATAILLE, GEORGES
1897–1962, Billom/Paris

French writer. While Bataille's relation with surrealism—in fact, mainly with Breton—was short-lived, he shared with the movement a kind of mutually complicit hostility of opinions that made him more than a simple gainsayer or, in his own words, "an old enemy

from the inside." He spent time with André Masson and Michel Leiris and, because of them, made his sole contribution to *La Révolution surréaliste: Fatrasies* (i.e., poems of an incoherent nature made up of maxims, proverbs, and so on, which are strung together and contain satirical allusions) from the Middle Ages, which was published, moreover, anonymously. He did not pursue relations with the group or with Breton himself after that: concerned with the exploration of the more obscure aspects of human existence, Bataille did not subscribe to automatism and was wary, more generally speaking, of poetic exaltation, which he faulted with being an "Icarian" and idealistic solution. The publication of his *Histoire de l'œil* in 1928 was nevertheless favorably received by Breton, but Bataille refused an invitation to attend the meeting at the rue du Château in March 1929 under a pretext that has often been quoted: "Too many damned idealistic nuisances." Bataille then took over the periodical *Documents,* which published numerous pieces by dissidents from the group (Leiris, Masson, Prévert, Desnos, etc.) and, consequently, found himself violently attacked in the *Second Manifesto*. Portrayed as obsessed with scatology, Bataille responded in *Un cadavre* with "The Castrated Lion," in which he summed up the reproaches to surrealism that he had made in texts that would long remain unpublished ("La Valeur d'usage de D.A.F. de Sade" and "La Vieille taupe et le préfixe sur dans les mots surhomme et surréaliste"): too much aestheticism and too many grand hollow words. During the years that followed, in his articles for *La Critique sociale,* Bataille did not refrain from ridiculing the group's publications, and it was only at the time of Contre-Attaque, during the winter of 1935–36, that there was any rapprochement with the group. It did not last for long, however, for the cooperation between surrealists and Bataille's close collaborators was founded on compromises that could not withstand the political pressures of the era. This was followed by the double exploit of the Collège de Sociologie and the periodical *Acéphale,* together with Leiris, Masson, Michel Fardoulis-Lagrange, Roger Caillois, Pierre Klossowski, and Isabelle Waldberg. After the war, during which Bataille wrote his *Somme athéologique,* there was again some degree of cooperation, both through his articles published in *Critique* and in the mutual recognition Bataille and Breton conceded to each other. This was because the author of *L'Érotisme* (1957) held that surrealism, even if it only produced works he considered to be negligible, remained unique "in its ability to enable man to tear himself away from himself."

(Michel Surya, *Georges Bataille, la mort à l'œuvre* [Paris: Séguier, 1987; reprint, Paris: Gallimard, 1992].)

BÉDOUIN, JEAN-LOUIS
1929–96, Neuilly-sur-Seine/Paris

Poet and creator of collages and objects. It was thanks to Claude Tarnaud that Bédouin discovered texts by Antonin Artaud, Robert Desnos, and Benjamin Péret. In 1947, encouraged by Char, he published his first poems, but at the end of the same year his meeting with Breton—to whom he would devote a monograph three years later (Paris: Seghers, 1950)—encouraged him to take part in surrealist activities. In 1952, with Péret and Michel Zimbacca, he made the film *L'Invention du monde,* which exalts "primitive" art. In 1961, he published *Vingt ans de surréalisme, 1939-1959,* the first work to group

together the movement's postwar activity; and in 1964, he brought out an *Anthologie de la poésie surréaliste,* which included newcomers to the group. In 1969, Bédouin was among those who fought against the dissolution of the Parisian group, and with Jorge Camacho, Vincent Bounoure, and Joyce Mansour he collaborated on *BLS* (1970–76). In addition to his collections of poetry (*Libre espace* [Paris: Seghers, 1967]; *L'Arbre descend du singe; L'Épaule du large, Pleine Marge* [1992]), Bédouin created collages or object-poems that he showed in some of the group events. In the 1970s his artistic activity, which had received considerable coverage through his solo exhibitions, would become increasingly important: montages or "tableaus" using driftwood and recycled objects placed Bédouin in the tradition of a Kurt Schwitters and were characterized by a penchant for reverie and a mellow use of color.

BELEN (PSEUDONYM OF NELLY KAPLAN)
Buenos Aires

After studying political science, Belen began a career in the cinema under her official name: as an assistant to Abel Gance she produced short documentaries on Gustave Moreau (commentary by André Breton), Bresdin, Picasso, and others, then feature films, the first of which, *La Fiancée du pirate,* was noted for its freedom of tone, rare in French cinema. This freedom was also evident in the poetic and often irreverent short stories, equally humorous and disturbing, which Belen published in 1959 and 1960 in three short volumes: *La Géométrie dans les spasmes, La Reine des sabbats, ". . . et délivrez nous du Mâle"* (Paris: Le Terrain Vague). In 1966, they were collected with a preface by Philippe Soupault under the title *Le Réservoir des sens* (Paris: La Jeune Parque). She continued her film career as Nelly Kaplan and published a film story, *Le Collier de Ptyx* (Paris: Pauvert, 1971), whose characters were named Ducasse, Duvalier, and Maldoror.

(See S. Behar, "Belen: Plaidoyer pour une aphrodite désenchaînée," *Mélusine,* no. 12.)

BELLMER, HANS
1902–75, Katowice, Germany/Paris

German painter, sculptor, and printmaker. Bellmer was trained in technical design, but once he had become friends with Georg Grosz, he could no longer envisage a career as an engineer. After his marriage, he managed a small advertising business with his wife, while pursuing his passion for Altdorfer and Grünewald. In 1932, a performance of the *Tales of Hoffman* revealed a way for Bellmer, through the doll Coppelia, to channel his private obsessions: he designed his first articulated Doll and then photographed her in settings where she would seem supremely provocative. Following his discovery of *Minotaure,* Bellmer sent eighteen slides to André Breton, who published them immediately in number 6 (December 1934) and in subsequent issues. The following year, Bellmer joined the movement's group exhibitions. The use of a ball joint enabled him to bend his model more easily according to his whim. After the death of his wife, Bellmer, despised by the Nazis, settled in 1938 in Paris. He would henceforth take part in the events of the surrealist group, but the war obliged him to go to the south. Interned for a few months in the camp at Milles as a "national of the German empire," he then sought refuge in Castres, and it was during this

clandestine period that he defined the style of drawing that would later make his fame: an extremely precise line, scrutinizing like a scalpel flesh and organs, landscapes and objects, devising a world in submission to a dark eroticism and capable of imposing infinite metamorphoses on the anatomy. Once he was back in Paris Bellmer lived in poverty and wrote out the thoughts inspired by his Doll and his fascination for anagrams (*Petite anatomie de l'inconscient physique*). His engravings illustrated texts by Aragon (*Irène*), Sade, and Georges Bataille and success came gradually, even though his exhibitions were shocking to those viewers who were more attentive to his apparent themes than to the authenticity of the work. His last years were darkened by illness, then the suicide, in 1970, of his companion Unica Zürn; he had pointed out in a letter to Gaston Ferdière in 1964 the strange way in which the malaise of his companions was "transferred" to his own body.

BENAYOUN, ROBERT
1928–96, Port-Liautey, Morocco/Paris

Writer, cineast, and creator of collages. Benayoun first came into contact with the Paris group in 1949, took part in the founding of *L'Âge du cinéma,* and then collaborated on *Positif,* where his special interests were Jerry Lewis (to whom he devoted a book in 1972), American directors, particularly "minor" ones, and animation (*Le Dessin animé après Walt Disney* [1961]; *Le Mystère Tex Avery* [1988]). In 1965, he published a book on eroticism, *L'Érotique du surréalisme.* His interest in Anglo-Saxon culture led him to devise an anthology of nonsense (*Anthologie du Nonsense* [1959, rev. 1977]) and to translate Edward Lear's limericks, Washington Irving's *Phantom Island,* and Fort's *Book of the Damned* (which would lead him to a severe criticism of Louis Pauwels and Jacques Bergier). His competence would then expand to encompass comic strips (*Le Ballon dans la bande dessinée* [1968]) and humor (*Le Taureau irlandais* [1974]; *Le Rire des surréalistes* [1988]). Benayoun's personal texts (*La Science met bas* [1959]) exhibited an unbridled sense of fantasy, echoes of which could be found in his collages and "imagomorphoses"—where the dual vision of borrowed forms produced effects that were as comical as they were slightly scabrous—as well as in his films (*Paris n'existe pas* [1969]; *Sérieux comme le plaisir* [1975]).

BENOIT, JEAN
1922, Quebec

In Montreal, like Mimi Parent whom he would marry in 1948, Benoit frequented Alfred Pellan's studio at the École des Beaux-Arts. He settled in Paris in 1948 and joined the surrealists in 1959. He would, however, only exhibit his work in circumstances that seemed compatible with their highly disturbing content: *EROS* (1959), *L'Écart absolu* (1965), *Petits et grands théâtres du marquis de Sade* (1989), and *Sauvages des Îles et Sauvages des Villes* (1992). As a result, he did not have his first solo exhibition until 1996 (Paris, Galerie 1900-2000). His objects and costumes are produced with a rare meticulousness in order for each of their elements to refer, in a way that is both clear and dense at the same time, to the darkest aspects of existence, such as those found in eroticism and demonology or where horror is accompanied by laughter. *Le Nécrophile, Le Bouldogue de Maldoror,* and the book bindings or boxes designed for a few

rare texts (manuscript of *Les Champs magnétiques,* Sade's letters), or a necklace called *Sauté au cou* on which was suspended a small vampire, displayed the importance of obsessively reworked detail for a mind animated by desire and the memory of a distant and inner savagery.

BIRABEN, JEAN-CLAUDE
1933, Arthès

A poet and creator of objects, Biraben lives and works in Toulouse. He began to exhibit in 1974 with objects that were a kind of visual sight gag, obeying a highly poetical logic. Whether in carved wood or made of hardly modified borrowings from reality, Biraben's objects are interesting for their apparent "simplicity," where the density of their metaphoric impact can be seen to correspond to their carefully chosen titles. The *Hache morte* (Dead ax) had an iron blade in the shape of a leaf; *Sommeil* (Sleep) replaces the body of an alarm clock with a wooden cylinder, while a dolphin takes the place of a handle on a suitcase to designate *L'Océan.* There are scattered tributes—to Benjamin Péret, Toyen, and others—throughout his work, where smiles alternate with a quiet anxiety, all of which make Biraben the true heir to Magritte or Joseph Cornell.

BJERKE-PETERSEN, VILHELM
1909–57, Copenhagen/Halmstadt

Danish painter and theoretician. A student of Klee and Kandinksy at the Bauhaus, upon his return to Denmark Bjerke-Petersen published the short work *Symbols in Abstract Art* (1933). His painting at the time was rigorously nonfigurative. But through the two periodicals he edited, *Linien* (1934–35), which he coanimated with Eljer Bille, and then *Konkretion* (1935–36), Bjerke-Petersen, along with Freddie, became a propagandist for surrealism in Denmark. His own work explores fantasies, notably sexual ones, through a technique where a concern for formal construction alternates with the more anecdotal model he found in Dalí. Bjerke-Petersen took part in the *International Exhibitions* in Paris in 1938 and 1947, but shortly thereafter he returned to a strictly geometrical art, bereft of all dream work.

BLANCHARD, MAURICE
1890–1960, Montdidier

French poet. From a modest background, all his life Blanchard would have to work in industry, primarily aeronautical (he would build a hydroplane and break world altitude records), and poetry alone enabled him to escape a condition that appalled him. His collections (*Solidité de la chair* [1935], *Les Barricades mystérieuses* [1937]) had small print runs and were poorly distributed, but among those who read him with enthusiasm were Breton, René Char, and later André Pieyre de Mandiargues and Fernand Verhesen. During the war, Blanchard took part in La Main à Plume and was also a member of the Resistance. While he was very much an adherent of surrealism, he did not often take part in group activities: a profound disgust for humanity and the constraints of regular work led him to an isolation that he desired as much as he endured. Only since his death has his work become better known, thanks to some new editions (*Débuter après la mort,* [Paris: Plasma, 1977]). His lengthy jour-

nal, written under the occupation, was published under the title *Danser sur la corde* (Toulouse: L'Ether Vague, 1994).

(See P. Peuchmaurd, *Maurice Blanchard* [Paris: Seghers, 1985].)

BOIFFARD, JACQUES-ANDRÉ
1903–61, La Roche-sur-Yon/Paris

Photographer. Boiffard was introduced into the surrealist group by Pierre Naville and, with Éluard and Roger Vitrac, cowrote the preface to the first issue of *La Révolution surréaliste,* where he would later publish some of his dreams and automatic texts. He was the "illustrator" for *Nadja,* in which his slides of Parisian monuments and places were reproduced anonymously, but he would gradually drift away from Breton's circle. He took part in *Un cadavre,* and in *Documents* he published his photographs to accompany Georges Bataille's essays ("Le Gros orteil"), underlining the most "trivial" aspects of everyday life. From 1932 on, he abandoned all artistic activity in order to devote himself to a medical career.

BORDUAS, PAUL-ÉMILE
1905–60, Saint-Hilaire/Paris

Canadian painter. After a classical education, which brought him to Paris to Maurice Denis's Ateliers d'Art Sacré from 1928 to 1930, Borduas took up a teaching position in Montreal. He first discovered surrealism through his reading but did not meet Breton until 1945. During the war, his painting evolved toward a nonfigurative expression. In 1946, he became leader of a group of automatists, and it was in this capacity that he wrote the preface for the manifesto *Refus global* (1948), which had an enormous impact. The text emphasized the necessity of breaking with the past and called on people to rid themselves of the sterile influence of the Church. It elicited violent reactions among conservative circles: Borduas lost his teaching position and went into exile in New York in 1953, where his painting was welcomed into the abstract expressionism movement. He moved to Paris in 1955, but did not find the success he had hoped for. Although his painting is only tangentially surrealist, his beliefs in the 1940s and 1950s and his use of automatism played a significant role in opening Quebec to modern art, which until then had been totally suppressed.

BOULLY, MONNY DE
1904–68, Terasije, Yugoslavia/Paris

Monny de Boully initially belonged to the Belgrade avant-garde, and it was on the advice of Dusan Matic that he came to Paris in 1925. There he met the surrealist group and contributed to *La Révolution surréaliste.* He quarreled with Breton in 1927, reproaching the movement for drifting too deeply into politics, and then moved closer to the Grand Jeu, where he would form his most lasting friendships. De Boully lived in The Hague and managed to survive the Occupation by adopting a false identity (his entire family would die in a concentration camp in Yugoslavia) and working as a broker for rare books. After the war, he had a stall at the flea market at Saint-Ouen. An anthology of his poetry was published in Belgrade fifteen days after his death: *Au-delà de la Mémoire* (Beyond memory) collected his poems, articles, and letters in French (Éditions Samuel Tastet, 1991).

BOUNOURE, VINCENT
1928–95, Strasbourg/Paris

Poet, theoretician and critic of primitive art (particularly in the periodical *L'Œil*). Between 1955 and 1969, Bounoure contributed to all the surrealist group's periodicals and collective events. Following Schuster's *Le Quatrième Chant,* he refused the dissolution of the Paris group and circulated a poll entitled "Rien ou quoi?" (Nothing, or what?), regarding the continuation of collective activities. As a result, from 1970 to 1976 he was a driving force behind the *Bulletin de liaison surréaliste (BLS),* editing the collective work *La Civilisation surréaliste* (1976) and the periodical *Surréalisme* (1977), which focused mainly on preserving contact and exchanges with the Czech surrealists. Some of his poetry was published with illustrations by Jorge Camacho (*Talismans* [Paris: Éditions Surréalistes, 1967], *Les Vitriers* [Paris: G. Visat, 1970]), and he devoted a study to *La Peinture américaine* (Lausanne: Éditions Rencontre, 1967).

BOUVET, FRANCIS
1929–79, Paris

Painter and designer of objects. Bouvet joined the group after the war, and at a very young age took part in collective exhibitions in Brussels (late 1945) and Paris (Galerie Maeght, 1947), where he displayed works, the sharp outlines and vibrant colors of which created objects halfway between the visible and the dream. He later contributed to *Néon* but was expelled for "factional activity" at the same time as Victor Brauner and Alain Jouffroy. He then worked for a few publishers (Éditions de Minuit, Flammarion; for Jean-Jacques Pauvert he prepared an edition of the *Vercingentorixe,* by the marquis de Bièvre, in the manner of a minor classic) and published a few periodical articles but seemed to have given up on personal creation.

BRASSAÏ (PSEUDONYM OF JULES HALASZ)
1899–1984, Brasso, Transylvania/Nice

Photographer of Hungarian origin. Following his studies in Budapest and a brief stay in Berlin, Brassaï settled in Paris in 1923. Initially a painter and draughtsman, he took up photography in 1930 thanks to André Kertesz, who lent him a camera and gave him some advice. On his nocturnal walks through Paris, together with Raymond Queneau and Jacques Prévert, among others, Brassaï discovered the unexpected and most sinister aspects of everyday life. From 1933 on he would contribute to *Minotaure* and, in his own words, " went part of the way with the *brain trust* of the irrational." Away from the group he worked for himself, tracking the dark side of the avowable and the multiple versions of desire—from the hotels used by prostitutes to graffiti. He was at the origin of numerous portraits of his writer friends, including surrealists, and he devoted two works to Picasso: *Sculptures de Picasso* (1949) and *Conversations avec Picasso* (1964).

BRAUNER, VICTOR
1903–66, Piatra Naemtz, Romania/Paris

Painter and sculptor of Romanian origin. Following his studies at the School of Fine Arts in Bucharest, Brauner developed an interest in the various currents of modernity and briefly took up nonfigurative painting from 1924 to 1925; at the same time he cofounded the

periodical *75HP* (only one issue) and devised with Iarie Voronca "picto-poetry," works that combined words and geometric forms. During a trip to Paris he discovered Giorgio De Chirico, and progressively his paintings would come to include human figures or animals susceptible of becoming archetypes. During a second stay in Paris in 1932, he met the surrealists through Yves Tanguy, and his work began to focus on two major themes, as shown in the exhibition prefaced by Breton in 1934: a series of canvases depicted "Monsieur K.," an Ubuesque character and derisory incarnation of an unshakable good conscience; another used obsessively the symbol of a gouged-out eye—so that in August 1938, when Brauner lost an eye during a fight witnessed by Oscar Dominguez, he thought he must be endowed with clairvoyant powers. As a refugee during the war in the Basses-Alpes, Brauner was obliged to modify his technique: he worked with wax, gave up on creating effects of depth and simplified his shapes, frequently enhanced by alchemical symbols: the result was the invention of composite creatures, part bird, part flower, part fish or face. These hybrids seemed to emerge from an inner struggle that was evoked, not without a certain humor, in the commentaries accompanying the works. At the same time, Brauner designed objects of "counterenchantment," where his singular mythology was concentrated; he also took up sculpture (*Nombre* [1943]). In 1947, he took part in the *International Exhibition* at the Galerie Maeght with his *Loup-table* (Wolf-table); the idea of the wolf had been haunting him since the early 1930s. But the following year he was expelled from the group for "factionalism" and indifference to collective activities. Increasingly persuaded that his painting was capable of transmitting a basic teaching, he turned toward a sort of didacticism that momentarily kept him from drifting or from an immersion into the unknown. In 1951, however, with his series *Rétractés,* the exploration of the inner world resurfaced with renewed strength, bearing witness to a violent crisis in which all figures were destroyed. Ultimately, Brauner would return to his subjective mythology based on magical properties and the imbrication of words and shapes: from this material he forged places and events comprising a world that could become a positive substitution for everyday life.

BRETON, ANDRÉ
1896–1966, Tinchebray/Paris

French poet. During his adolescence Breton began reading Mallarmé and the symbolists, finding in their work a demand for a poetic "standard" that would stay with him all his life. He then discovered Apollinaire and Valéry, who showed him the way to modernity and the exploration of thought. Breton's meeting with Jacques Vaché during the First World War was decisive in persuading him that poetry could not be just one literary particularity among others. The discovery of Freud must also be taken into account as part of Breton's intellectual education, alongside the disgust aroused by the global conflict signifying the collapse of all values that society claimed to uphold. When he heard about Dada, Breton was eager to embrace it; however, he was not prepared to forgo, in the name of total nihilism, his admiration for Lautréamont, an admiration that had already sealed his friendship with Louis Aragon and Philippe Soupault. Nor would he give up the discoveries of his experiments

in automatic writing with Soupault during the composition of *Les Champs magnétiques* (1919). Wearied, as were a good number of his friends, by the repetitiveness of Tristan Tzara and Francis Picabia's provocations, in 1921 he organized the "Barrès trial," during which the first demands of a restructured ethic began to break through. The sessions of hypnotic sleeping-fits, where Crevel and Desnos excelled, confirmed, along with automatism, the possibility of exploring what would be called "the true functioning of thought" in the *Manifeste du surréalisme* that consecrated this evolution in 1924. The beginnings of the surrealist group, and the running of the Bureau de Recherches, were beset by as many problems as there were solutions: a serious and binding consensus had to be achieved among the members regarding what was at stake; authentically collective work methods had to be found; and issues of *La Révolution surréaliste* had to be designed in such a way as to make sense as a whole and not just as a simple accumulation of individual contributions. To this, one must add the problems of everyday life (Breton would never know material prosperity and lived in large part from his trade in art works and his meager author's royalties) and the complexity of some of his emotional situations, as a man with a passion for women. Far from concealing this aspect of his life, Breton exhibited it clearly in a prose of unique authenticity, without ever excluding the possibility of exploring both himself and the world: there was also a profile of the evolving social and political climate of the era in the background of *Nadja* (1928), of *Vases communicants* (1932—perhaps the most theoretical volume of Breton's work, with the exception of the manifestos), and of *L'Amour fou* (1937; and at the risk of seeming banal, one must reiterate that this is one of the major texts of the century). Society and politics were of particular concern to Breton whenever the revolutionary nature of the movement he was leading was in question: the failure of relations with the Communist Party led him to Trotsky, with whom he wrote the manifesto *Pour un art révolutionnaire indépendant* in 1938; then, after the war, to the utopian theories of Fourier, at the very time when the cultural power of the Communist Party and its representatives (Aragon and Paul Éluard, his former comrades) seemed quite capable of silencing the surrealist voice.

Breton's work has two faces: along with his personal writing, there was also the periodic need to redefine the movement's orientation according to the evolution of history. When he returned to France from the United States at the end of the Second World War, the situation had changed dramatically—and not in the hoped-for direction. The group, too, had changed: there were a few old members, alongside a new generation eager to uphold its values. Breton still led the group, toward the Citizens of the World or a collaboration with the anarchists, but less than ever could he envisage a purely political solution to restore to mankind its lost powers (and when Roberto Matta and Camacho conveyed an invitation to visit Cuba, he declined the offer—from Castro's government). The themes developed during the international exhibitions of surrealism in 1947 (quest for a new mythology), 1959 (*EROS*), and 1965 (*L'Écart absolu*) were an indication of how, more than ever, one must rely on one's sensibility, and not on calculating or functional reason. Breton had granted a place of privilege to the contributions of sensibility since his youth and his discovery of Gustave Moreau and since

the revelation of De Chirico's canvases. From this point of view, *Le Surréalisme et la Peinture* (1928) was merely an official consecration of the necessity to bring about a conversion of one's way of seeing to the hitherto unseen, the intimate, and all that lay beyond appearances. In this domain, too, Breton's influence was considerable all through the century, not only on those artists whom he himself supported through his prefaces and commentaries (not all of whom were destined to become as important as he would have liked to believe, at least at the time), but because he contributed, following Apollinaire's example, to a substantial increase in the number and type of objects that could be considered artistic: primitive works, naive art, the creations of mental patients and the art later referred to as "brut" by Jean Dubuffet, unusual objects originating in nature or its manifestations, and cheap popular items. All of these found their way into museums, thanks to Breton, as did the "surrealist objects"—their immense advantage was that they could be made by nonprofessionals and could contribute to the disappearance of specialized practices.

Because Breton felt responsible for the future of surrealism, he was also intransigent, at times to the detriment of his own feelings. He has thus been accused of being excessively rigorous, of playing the part of an infallible Pope or, even, of exerting moral terrorism. This ignores the fact that wherever Breton went the debate was lively, that discord was not so rare at the café meetings, and that his opinion did not systematically triumph. This also ignores the fact that, beyond the expulsions handed down or the misunderstandings, Breton was capable of reconciliation whenever possible with his former friends; and he knew how to show his respect, be it of Antonin Artaud, Georges Bataille, or Picabia. And above all, this ignores the fact that a certain rigor applied for all those who wanted to be worthy of the three indissociable values that Breton had chosen to fight for, once and for all: love, poetry, and freedom. No one, it seems, has found anything better with which to replace them.

(André Breton, *Œuvres completes*, 3 vols. [Paris: Gallimard, Pléiade, 1988], vols. 1 and 2, and *Je vois, j'imagine* [Paris: Gallimard, 1991]; Gérard Legrand, *André Breton en son temps* [Paris: Le Soleil Noir, 1976]; *André Breton, la beauté convulsive:* Musée National d'Art Moderne, Centre Georges Pompidou [Paris: Editions du Centre Georges Pompidou, 1991].)

BRUNIUS, JACQUES B.
(PSEUDONYM OF JACQUES BOREL)
1906–67, Paris/Exeter

In 1927, Brunius produced, with E. Gréville, *Elle est Bicimidine,* a film that has since been lost. Actor for the Prévert brothers (*L'Affaire est dans le sac* [1932]) and for Renoir, Brunius made *Violons d'Ingres* in 1937, a groundbreaking film on "naive" artists. After taking part in the group's publications from *Minotaure* on, Brunius, along with E. L. T. Mesens, became one of the pivotal references for surrealism in England, where he was editor of the *London Bulletin* and coauthor of manifestos (*Free Unions* [1944]). A humorous poet (although his texts have never been collected), he was interested in Lewis Carroll as well as *Vathek* by Bedford. His passion for the elements of cinema that offered an escape into poetry and the irrational—in the way he captured them in his own collages—was clearly evident in *En marge du cinéma français* (Paris: Arcanes, 1954).

(J.-P. Paglio, *Brunius* [Paris: L'Âge d'Homme, 1987].)

BUCAILLE, MAX
1906–96, Sainte-Croix-Hague/Créteil

A mathematics teacher, in 1929 Bucaille began to create collages, to which twenty years later he would add painting and root sculptures. In 1947, he joined the revolutionary surrealism movement and illustrated poems by Noël Arnaud (*L'État d'ébauche* [1951]). He published several pieces accompanied by his artwork (*Images concrètes de l'insolite* [1936], *Les Pays égarés* [1937]) but is best known for his collections of collages (*Les Cris de la fée* [1949], *Le Scaphandrier des rêves* [1950], *Géomancie du regard* [1985]), in which he succeeded in introducing connections and surprises into an overall mood of serenity: in the world he depicts, everything becomes self-evident.

BUÑUEL, LUIS
1900–1983, Calanda/Mexico City

Spanish filmmaker. Buñuel frequented avant-garde circles in Madrid and was acquainted, in particular, with Federico Garcia Lorca and Salvador Dalí, and together with Dalí he wrote the screenplay for the film he made in 1929, *Un chien andalou.* The film was received enthusiastically by the Paris group, which Dalí and Buñuel quickly joined. With *L'Âge d'or* (1930), again written together with Dalí and financed by Charles de Noailles, "it was truly passion which broke through the dikes," and "Buñuel gave surrealism a thrust in the direction of the *act,"* said Breton in 1951. At the time, the film created an enormous scandal: the theater was trashed, and the group published a pamphlet exalting the film's subversive values, but it was banned. In 1932, Buñuel reemerged with a documentary. *Las hurdes* depicts a people in utter poverty, yet does not indulge in pity, making use, rather, of a collage of sound and image. With Pierre Unik, Buñuel then made a militant film about the war in Spain (*España leat en armas* [1937]) but was forced into exile to the United States, where he made a living from various jobs, before settling in Mexico from 1945 to 1955. There he made a dozen or more films of unequal quality, often to order, but in which the cold denunciation of material and moral poverty (*Los olvidados* [1950]), the interest in perversion (*El* [1952]), or serene amorality (*The Criminal Life of Archibald de la Cruz* [1955]) were nevertheless strongly expressed. After 1955, Buñuel returned to making films in Europe, and a number of works came in succession in which technical freedom went hand in hand with the affirmation of a supreme indifference with regard to traditional values: religion (*Viridiana* [1961]), the bourgeois mentality (*L'Ange exterminateur* [1962]), and family ties (*Tristana* [1970]) were not directly denounced but, rather, exposed as sources of ambiguity and absurdity. Buñuel was able to take the work of "minor" writers (Joseph Kessel for *Belle de jour* in 1966, Pierre Louÿs for *Cet obscur objet de désir* in 1977) and add to the texture of their stories a complexity that makes no concessions to common sense.

BURY, POL
1922, Haine-Saint-Pierre

Painter and sculptor of Belgian origin. A friend of Achille Chavée's, Bury became involved in surrealism through the periodical *L'Invention collective* in 1940. His painting was strongly influenced by Magritte at that time, and in his drawings he began to superimpose stems and fibrils, anticipating on flat surfaces his later work as a

kinetic sculptor. In 1949, he took part in Cobra, illustrating a collection by Marcel Havrenne, *La Main heureuse,* in particular; five years later, he took part in the exhibition *Le Mouvement* (Galerie Denise René, Paris), which inaugurated kinetic art; but in the meantime, he did not refrain, with humor and a sharp pen, from mixing elements of a deceptively awkward figurative art with bundles of pins or particularly complex structures (*L'Aventure dévorante* [1950]).

CABANEL, GUY
1926, Béziers

French poet. For Cabanel, poetry is the only way to move toward a horizon of perpetual enrichment. Automatism in his work is combined with a sense of responsibility, leading him to weigh each phrase in order to guarantee its impact: it took him almost ten years to write *À l'animal noir,* initially published privately with only fifteen copies and reprinted in 1992 by L'Ether Vague in Toulouse. While *Odeurs d'amour* (Paris: Éric Losfeld, 1969) inspired a number of illustrations from friends who were painters, it was with Robert Lagarde that Cabanel's work found a secret harmony. In 1995, Jorge Camacho illustrated *Croisant le verbe.*

CAHUN, CLAUDE (PSEUDONYM OF LUCY SCHWOB)
1894–1954, Nantes/Jersey

French writer and photographer. In 1914 Cahun published her first texts in various periodicals, including *Le Mercure de France.* In 1930, *Aveux non avenus* (Paris: Éditions du Carrefour) was published as a cryptic autobiography, illustrated by photomontages: for ten years or more, Claude Cahun had been creating photographic self-portraits in which she treated her face and her body as matter for multiple distortions. In 1933, she began her collaboration with the surrealist group, publishing, in 1934, the brochure *Les Paris sont ouverts,* in which she took a clear stand against the working-class positions of some of the AEAR members, and she signed declarations that punctuated relations with the Contre-Attaque group. Cahun then created photomontage illustrations for the "poems for children" by Lise Deharme (*Le Cœur de pic* [1937]). In 1939, she settled in Jersey with her companion Suzanne Malherbe. During the war, she was an active member of the Resistance, distributing pamphlets she had written. She would only renew contact with the group in 1953, but her oeuvre remained little known until the publication of the work by François Leperlier: *Claude Cahun, l'écart et la métamorphose* (Paris: J.-M. Place, 1992).

CAILLOIS, ROGER
1913–78, Rheims/Paris

French writer and sociologist. Caillois took part only very briefly in surrealist activities, from 1933 to 1934. Three years later, he was one of the cofounders, with Georges Bataille, Pierre Klossowksi, and Michel Leiris, of the Collège de Sociologie. His indifference to lyricism (*Les Impostures de la poésie* [1945]), his wariness with regard to Marxism (*Description du marxisme* [1950]), and psychoanalysis as well as dream analysis (*L'Incertitude qui vient des rêves* [1956]) clearly were hardly compatible with the group's positions—Breton and Schuster sharply criticized his *Art poétique* in *Bief* 1958. But the tide of events

(during the Second World War, the *Lettres françaises,* which he edited in Buenos Aires, recounted the activities and publications of New York) and converging interests (he was fascinated by animal mimicry and "figurative stones" and had a penchant for anything enigmatic, both in nature and in society) meant that there could be a kind of distant cooperation between this rationalist intellectual and the surrealists, even if it was not always a kindly one. For example, he was invited to reply to Breton's survey on magical art (*L'Art magique*)—something he did by insisting on his distance: "Art and magic are complementary, thus irreducible. Between them there can be nothing more than accessory relations."

CALAS, NICOLAS (PSEUDONYM OF NICOS CALAMARIS)
1907–86, Lausanne/New York

Raised in Greece, Calas came to Paris in 1934 and took part in the activities of the surrealist group from 1937 to 1939, offering a synthesis of its principles and aims in *Foyers d'incendie* (Éditions Denoël). He went to the United States in 1940 and continued to spread the movement's ideas: he was behind the issues devoted to surrealism for the periodicals *New Directions in Prose and Poetry* and *View* (October–November 1940). He contributed to *VVV,* then went on to teach in art schools. While he would continue to contribute to periodicals on an occasional basis (in particular to *L'Archibras* but also to *BLS*), he devoted his time primarily to the history of contemporary art and became a critic of pop art and of American abstractionism and minimalism (see Nicolas Calas and Elena Calas, *Icons and Images of the Sixties* [New York: E. P. Dutton, 1971]).

CALDER, ALEXANDER
1898–1976, Philadelphia/Saché

American sculptor. In Paris in the early 1930s, Calder began the elaboration of his famous *Cirque* (Circus) in animated wire and also began to produce sculptures whose geometrical shapes could be moved by a motor. Marcel Duchamp baptized them "mobiles," and Arp would later dub them "stabiles." In the catalog of the collection of the Société Anonyme, Duchamp described Calder's art as the "sublimation of a tree in the wind"; and in *Genèse et persepectives du surréalisme* (1942), Breton included Calder among those who had enabled sculpture to bring about its own revolution, where an appearance of life was conferred upon inert material. This did not suffice to qualify Calder as a surrealist sculptor, but it remains indisputable that Calder's works embody a spirit of childhood that brings it, even at a distance, very close to certain values shared by the movement.

CAMACHO, JORGE
1934, Havana

Painter of Cuban origin. Camacho abandoned his law studies very early on to devote himself to painting. A trip to Mexico persuaded him that muralism, whose social imagery seemed futile to him, was not an option, and he showed a greater interest in Torrès-Garcia and the Mayan culture. Camacho went to Paris in 1959, where he met up with Agustin Cardenas, who introduced him to the Galerie Raymond Cordier, and he held his first exhibition there in 1960. He

then came into contact with the surrealist group. Breton, in particular, welcomed his pictorial world, which seems inhabited by an acute sense of aggression and death. Camacho often conceived his paintings with particular poetry in mind ("Hommage à Oskar Panizza" [1962]; "Hommage à Jean-Pierre Duprey" [1966]; "Hommage à Raymond Roussel" [1969]), and he would transpose the phonetic conspiracy into the articulation of his figures, taking inspiration from the dark eroticism of Sade or Bataille. Camacho then turned to hermetic sciences ("Le Ton haut" [1969]; "La Danse de la mort" [1976]), yet his painting has never lapsed into mere illustration: he transposes symbols and uses veiled borrowings from alchemical themes, yet in every case imposes his sharp line and his use of alternately bright and muted colors. After Breton's death, Camacho contributed to *BLS,* then withdrew from any further group activity, preferring to create prints for collections by personal friends (Joyce Mansour, Vincent Bounoure, P. Peuchmard) or texts of traditional science. Passionate about ornithology (he has also had exhibitions of his photographs of birds) and about jazz and flamenco, Camacho has been able to infuse his enthusiasm for these varied domains into his canvases, creating the possibility of a marvelous world nevertheless enriched by the tragic side of life.

CARDENAS, AGUSTIN
1927, Matanzas, Cuba

Cuban sculptor. Following his studies at the School of Fine Arts in Havana (1943–49), Cardenas, in contrast to the reigning academicism, chose to create sculptures in the tradition of Dogons and learned whatever he could about Constantin Brancusi, Henry Moore, and Jean Arp. He came to Paris in 1955, and very soon his work was shown at the gallery À l'Étoile Scellée. His espousal of surrealism came as a matter of course, for his works—initially in wood (even burned wood), then in marble—contained both a formal nobility and an erotic tenderness. His shapes are neither openly masculine nor feminine but define a world where caresses are imminent and where a multitude of fully curved biomorphic allusions alternate with welcoming crevices. Although his sculpture depicts no discernable bodies as such, it evokes the energy and effects of desire. Through the variety of materials used and through his drawings, Cardenas has given himself fully to the poetic exaltation of vital tension, allowing no concessions to any disparaging attitudes.

CARRINGTON, LEONORA
1917, Clayton Green

Painter and writer of English origin. Carrington came from an affluent family, and learned to paint at Ozenfant's London academy. In 1937, she met Max Ernst and went with him to France, where they settled at Saint-Martin-d'Ardèche. In 1940, a fit of delirium, exacerbated by Max Ernst's detention in a camp for foreigners, led to her internment in a psychiatric ward. She portrayed the labyrinth of her madness in *En bas* (published in 1945). In her painting, with its atmosphere of fantasy and dreams, autobiographical projections allowed her, as in her writing, to retreat from her delirium and to objectify it by means of mythical propositions. Following her departure for Mexico in 1942, the esoteric iconography that she frequently makes use of would be complemented by allusions to

Indian cosmology. Her various tales have been collected in *Le Cornet acoustique* (1974), *La Porte de pierre* (1976), and *Le Septième cheval* (Montpellier: Coprah, 1977).

CARROUGES, MICHEL
(PSEUDONYM OF MICHEL COUTURIER)
1910–88, Paris

Catholic writer. In 1945 Carrouges published a first book on *Éluard et Claudel,* then in 1948, *La Mystique du surhomme,* devoted to Nietzsche. At the time he already enjoyed Breton's friendship, and it would be further strengthened by the publication of his work *André Breton et les données fondamentales du surréalisme* (1949). But his personal views were clearly incompatible with the group's outspoken anticlericalism, and in 1951 the "Carrouges affair" would lead Breton to acknowledge that Carrouges's study had occulted two fundamental aspects of surrealism: its atheism and its revolutionary orientation. A major split came about among group members at the same time. This did not prevent Carrouges from publishing an important study in 1954, *Les Machines célibataires,* exploring a major myth of the century, from Duchamp to Kafka; the work's impact was such that an exhibition in 1975 borrowed Carrouges's title. Carrouges would later become interested in flying saucers, and in 1963 he published *Les Apparitions des martiens.*

CÉSAIRE, AIMÉ
1913, Basse-Pointe, Haiti

Poet. Although Césaire began to publish before the Second World War, Breton would discover him in 1941 during his stay in Fort-de-France, through Césaire's periodical *Tropiques* as well as through his texts. Breton immediately recognized the authenticity of Césaire's poetry and his intellectual rigor, truly in keeping with the time and place. Césaire's poetry, and above all his *Cahier d'un retour au pays natal,* revive language through the power of their inspiration and the freedom of their images, creating a bridge between Lautréamont and the Caribbean. While Césaire, like Senghor and a few others, speaks with pride of his negritude—which he prefers to call *négrerie*—it is first and foremost to show the degree to which it can have an impact on the very language of the "dominator." The struggle for emancipation led Césaire to become a communist deputy in 1945, but he eventually broke with the party, for it seemed to show too little concern for decolonization (*Lettre à Maurice Thorez* [1957]). In his collected poetry (*Les Armes miraculeuses* [1946]; *Soleil cou coupé* [1948]; *Ferrements* [1960]) and in his plays, the lyrical quality is, in any case, a guarantee of a freedom that goes well beyond any political acceptation.

(Colloque International sur l'Œuvre Littéraire d'Aimé Césaire, *Aimé Césaire ou l'athanor d'un alchimiste: Actes du premier colloque international sur l'œuvre littéraire d'Aimé Césaire,* Paris-21-22-23 novembre 1985 [Paris: Éditions Caribéennes, 1987].)

CESARINY DE VASCONCELOS, MARIO
1923, Lisbon

Portuguese painter and poet. After meeting Breton, Victor Brauner, and Henri Pastoureau in Paris, Cesariny would be a driving force behind all the surrealist activities in Lisbon between 1947 and 1950, first of all in the context of a surrealist group that included, among

others, Candido Costa Pinto and J. Augusto França. Then, in 1948, he set up an "antisurrealist group of surrealists" in which the artist Artur Cruseiro Seixas also participated; the group's experiments, particularly pictorial, went so far as to prefigure the *tachisme* in some of Cesariny's own work and were characterized by an enviable excitement, although at the time their work remained unknown abroad. In the 1960s, Cesariny became the movement's historian in Portugal ("Chronologie du surréalisme portugais," *Phases,* no. 4 [1973]), and he compiled an important series titled Texts of Affirmation and Combat of the Worldwide Surrealist Movement, published in Lisbon in 1977.

CHAGALL, MARC
1887–1985, Vitebsk/Saint-Paul-de-Vence

French painter of Russian origin. In Paris in 1910, Chagall met Guillaume Apollinaire, who upon seeing his work is said to have used the expression "supernatural-surrealist." Chagall's painting, where lyricism alone determines not only the use of color but also its shapes and alogical silhouettes, might seem of a nature to correspond in every aspect with what would later be surrealism. Before surrealism became a movement, Chagall had lived through fairly disappointing "revolutionary" experiences in Russia (despite his efforts, his poetry was not understood by the new political authorities), and when he returned to Paris, he was asked to join the surrealist group. But he refused, for he considered that the painting practiced by the group was too subordinate to literature. Thus, it was not until 1941 that Breton would celebrate Chagall's "magical" work, "whose admirable colors of the prism take one away and transform modern anguish, while retaining the ancient ingenuity for the expression of that which in nature proclaims the principle of pleasure: flowers, and expressions of love." Following this brief period, during his exile in New York when Chagall was a fellow traveler to surrealism, Paul Éluard in turn hailed the painter's ability to evoke the power of passion, and André Pieyre de Mandiargues emphasized the ease with which Chagall's painting proved that one must really lose one's head; but the encounter between surrealism and the most liberated aspects of Chagall's work did not succeed, for it became self-evident that this painter, who illustrated the Bible and designed numerous religious stained glass windows, would not fail to encounter a certain resistance on the part of the group.

CHAR, RENÉ
1907–88, L'Isle-sur-Sorgue/Paris

French poet. Char did not stay for long in the surrealist group, but he had a lasting influence all the same. When he joined the group in late 1929, this meant the end of the periodical *Méridiens* that he had been editing in L'Isle-sur-Sorgue. It also meant that he would espouse the group's values without reservation: to begin with, a hatred of mediocrity and a recognition of the eminent place occupied by poetry, which in his opinion originated with the pre-Socratic texts. In 1930, together with André Breton and Paul Éluard, he wrote the poems of *Ralentir travaux* and, until 1935, played an active role in *Le Surréalisme ASDLR* and *Violette Nozières.* He signed the group's most important pamphlets and showed he was also prepared to make a physical contribution to the cause, receiving a stab wound during the destruction of the Maldoror bar. His collections (*Artine* [1930]; *L'Action de la justice est éteinte* [1931], *Le Marteau sans maître* [1934]) were published by the Éditions Surréalistes, and it was for personal rather than ideological reasons that he eventually left the group: he did not appreciate the fact that Benjamin Péret had shared with others a letter he had sent to him in private, and he also had to tend to the family business in Isle-sur-Sorgue. Char's later activity in the Resistance would not affect his concept of poetry. Although he readily preferred the mystery of haughty formulas, those formulas were initially the result of a sort of automatism: the poem retained something of a sudden inspiration, and he sought to preserve that energy at the very moment when it might begin to fade.

CHAVÉE, ACHILLE
1906–69, Charleroi/La Hestre

Belgian poet. Chavée settled in La Louvière in 1922 (he was practicing law in nearby Mons) and in 1934, together with Marcel Havrenne, founded the Rupture group (which the following year would publish the sole issue of the periodical *Mauvais temps*), independently from the Brussels surrealists. It was nevertheless with E. L. T. Mesens's help that he organized an exhibition on surrealism in 1936 that included artists from different backgrounds. That same year he joined the International Brigade fighting in Spain: politically he had been close to the Trotskyists but returned from Spain having more or less converted to the Soviet line. He now abandoned Rupture and inaugurated, with Fernand Dumont, the "surrealist group in Hainaut." During the war he took part in La Main à Plume and often had to go into hiding Because he was wanted by the Gestapo for his political opinions. These same opinions would bring him closer to revolutionary surrealism, after the founding of the newest group, Haute Nuit. His activity as organizer and his ability to discover new talent (he was notably the first to show interest in Pol Bury's painting) was complemented by an important poetic production, the singularity of which, within the Belgian context, and in relation to the Brussels group, was to trust implicitly in automatism. But Chavée was also a brilliant author of aphorisms, where he displayed an often cruel sense of humor—first and foremost against himself. Volumes 1 and 2 of his *Œuvres,* which included several smaller volumes, were published in 1977 and 1979 (La Louvière: Les Amis d'Achille Chavée).
(A. Bechet, *Achille Chavée* [Tournai: Unimuse, 1968].)

CHAZAL, MALCOLM DE
1902–81, Vacoas, Mauritius

A telephone engineer on the island of Mauritius, Chazal initially wrote works of political science. In 1948, the publication in France of his collection *Sens plastique* revealed to the group a work where lyricism and sensual delight were a means to apprehend and affirm the universal potential of metaphor. Chazal would henceforth be welcomed into the group's collective publications (*Néon, Almanach surréaliste du demi-siècle, La Brèche*); in 1954 he also began to paint (using only pure colors) to express his vision of a world before fragmentation. It was, moreover, Chazal's very presumption that he be included among the great initiates that sooner or later would lead to

the surrealists' mistrust: they reproached him for having too hastily confused the poetic spark and the knowledge one could apply to the world, while Chazal himself found the movement incapable of surpassing the contradictions that prevented mankind from attaining gnostic knowledge. From that time on he would continue to publish in Mauritius, primarily at his own expense, a number of works, including tales, plays, and essays, some of which he later destroyed in a bonfire on the beach. In 1968, the Éditions Pauvert published his *Poèmes,* and four years later his essay *L'Homme et la connaissance* (Man and knowledge), although this did not prevent him from spending the rest of his life in great solitude. Some of his texts (*Sens unique, Correspondance avec Jean Paulhan, La Bouche ne s'endort jamais, Pensées*) have been republished by L'Ether Vague in Toulouse.

(L. Beaufils, *Malcolm de Chazal* [Paris: La Différence, 1995].)

CHOPIN, FLORENT

1958, Caen

French painter and poet. At the age of seventeen, Chopin discovered surrealism and the situationists. After beginning his studies in social sciences, he turned to drawing in 1984, and enrolled briefly at the Beaux-Arts in Caen. He has devoted himself almost exclusively to painting and collage since 1986. He frequently makes use of figures and motifs borrowed from old-fashioned publications, and his use of space is full of nuance, animated with unusual rebuses and assembled using overlapping foreground and background and colors that appear to have been strained: any geometrical notions have been upset by the identifiable signs of a constantly changing world where a principle of fluidity seems to authorize the passage of a body or an object and its name into any other body or object. Too young to have known the group, Chopin is among those who are seeking to maintain certain prerequisites with regard to painting, and his works are situated somewhere in between those of Josef Sima and Roberto Matta.

CHRISTIAN (PSEUDONYM OF GEORGES FÉLI-CIEN HERBIER)

1895–1969, Amberes/Paris

Writer, artist, and bookseller. In 1917, he published his collection *Le Pérégrin de l'ombre,* then an essay entitled *André Gide et les données de l'homme moderne.* In 1919, he met Picabia; they would remain lifelong friends. For three years he had a bookstore, Au Bel Exemplaire, in Saint-Raphaël, and he contributed to Dadaist periodicals; of special note is his "Proof of the Existence of Da'" in the special installment of *Ça ira* on "Dada: Its Birth, Life, and Death." With Picabia he coedited the sole issues of *La Pomme de pin* and *De Mallarmé à 391* (P. de Massot). He then moved away from the surrealist movement, working after 1928 in Paris in construction and automobile import. Christian wrote his memoirs, but they remained unpublished.

COLINET, PAUL

1898–1957, Arquenne/Brussels

Belgian poet and artist. Colinet became friends with René Magritte when Magritte returned to Belgium from Paris, and he would join the Brussels group on an official basis after the exhibition at La Louvière in 1935. He was equally sensitive to friendship and to the different forms that the spirit of childhood could take and was less a militant in the group than a lover of riddles, naive imagery, and approximate wordplay, seeking to reveal their power of strangeness or subversion. With Christian Dotremont and Marcel Mariën, he put together the periodical *Le Ciel bleu* (1945), then collaborated on *La Carte d'après nature.* His own texts were frequently written together with Magritte (*Marie trombone chapeau buse* [1936], illustrations by René Magritte, music by his brother Paul), with Marcel Piqueray (*La Bonne semence; La Maison de Venose* [Paris: Éditions Fontaine, 1947]; *Le Délégué de la Guadeloupe* [Milan, 1964]), and with Marcel Lecomte (such as the short monograph published in Brussels in 1945 on the Italian painter Bruno Capacci, for whom Colinet also wrote poems to accompany a collection of drawings, *Écriture,* in 1947). These texts were later compiled to form a collected works in four volumes (Brussels: Lebeer-Hossmann, 1980–89).

COLQUHOUN, ITHELL

1906, Shillong, Burma

British painter and writer. Colquhoun did take some art courses, but she is largely self-taught. She took part in the 1939 exhibition *Living Art in England* on an independent basis, but that same year she met Breton in Paris and joined the English surrealist group. She then contributed to the *London Bulletin* but soon left E. L. T. Mesens's group in order to devote herself to studies of occultism. In 1940, she began working with texts to explore automatism and experimented in a wide variety of techniques (decalcomania, fumage, frottage, etc.) that she would describe in "The Mantic Stain" (*Enquiry* [1949]). Her art abounds in sexual allusions, connected to the mineral and vegetable kingdoms, and she portrays a world where the borders between fantasy and reality are abolished. She has also published poetry (*Grimoire of the Entangled Thicket* [1973], *Osmazone* [1983]) and tales of her travels in Ireland and Cornwall, where she now lives.

COPLEY, WILLIAM

1919–96, New York/Miami

American painter, art dealer, and collector. After fighting with the American Army in Italy during World War II, Copley mounted an exhibition in Beverly Hills from 1947 to 1948 at which he showed, among others, Man Ray, Max Ernst, René Magritte, Marcel Duchamp, Francis Picabia, André Masson, and Yves Tanguy. After the gallery openings, which were opportunities for much festivity, Copley actually sold fewer works than he bought for himself, and over the years he put together an important collection of works by his surrealist friends that he kept until 1979. At the same time, he produced his own canvases, in a pseudonaive style and signed Cply, where scenes of typical rural life in America ironically tempted by good-natured debauchery are featured alongside borrowings from famous masters (Velasquez or Matisse, e.g.). His figuration, with its vivid colors and rich style, anticipated pop art in its themes, referring to the banality of everyday life and the compensations offered by dreams; but it would differ from pop art in its humorous dimension. In 1954 Copley and his wife Norma created a foundation that awarded prizes and grants on the advice of its counselors (Jean Arp, Roberto Matta, Roland Penrose, and Man Ray) and codirectors

(Marcel Duchamp and Darius Milhaud). In 1968, Copley put together the six issues of his periodical *SMS (Shit Must Stop)* that, to bypass the laws of the art market, was a venue for both famous artists and unknowns, and used various media, from vinyl records to sculpture kits by way of serigraphs. Naturally, among the artists featured were a number of his surrealist cohorts.

CORNELL, JOSEPH
1903–72, Nyack, N.Y./Flushing, N.Y.

American artist. At the age of sixteen, Cornell interrupted his literary and scientific studies and began working as a textile and refrigerator salesman, cultivating all the while his passion for opera, the cinema, and music. Once he became familiar with Max Ernst's collages, he created his first montages of ancient images and very soon was able to exhibit them at Julien Levy's gallery. He collected objects in series (glass balls, rings, earthenware pipes), as well as producing prints with recurrent themes (parrots or birds, charts of the planets, hotel posters, etc.), which he carefully arranged in glass boxes. These were his original contributions to surrealism; his intention was actually to maintain a certain distance, despite the welcome from Breton and his friends in the 1940s and his subsequent participation in all of the group's collective events. His work is less inspired by dream work or automatism than by a rigorously organized reverie based on a few personal and secret obsessions. Thus the objectification of the subjective in his boxes does not claim to have any transgressive power: Cornell makes a peaceful use of subversion, and this subversion is indifferent to any social dimension. It is based on the poetic intensity of his "staging," which defies rational thought and is open to multiple interpretations, thanks to its formal rhythm and to the metamorphoses that the most ordinary objects have undergone. The same is true of his short films, which he began producing in 1936—after his discovery of Luis Buñuel—and which were made up of the outtakes from preexisting films. Cornell's work, in its various aspects, is the discreet revelation of an intimate world devoted to the unrelenting play of metaphor and contiguity.

CORTI, JOSÉ
1895–1984, Paris

French publisher. Corti had first believed in his vocation as a poet, and this led him, along with a few other adolescents of his age, including René Hilsum, to produce a periodical entitled *Vers l'idéal;* only one issue would be completed, in May 1912, but it included for the first time two poems by Breton. Corti went on to open a bookstore at 6, rue de Clichy, and progressively became the distributor, rather than publisher in the strict sense of the word, of the group's periodicals and of the volumes put out by the Éditions Surréalistes. After financing the publication of *L'Immaculée Conception* by selling the manuscript to the Viscount de Noailles and the drafts to Valentine Hugo, Corti produced a catalog in 1931 (the cover was illustrated with a collage by Max Ernst) in which he included his list "Lisez—ne lisez pas" (Read—don't read). During the 1930s, he published a few detective stories under a pseudonym. In 1938, he brought out the *Dictionnaire abrégé du surréalisme,* and the following year the essay *Lautréamont* by Gaston Bachelard, who would later entrust him with his major studies on the poetic imagination. He

was also, almost exclusively, Julien Gracq's publisher. He published two series of his: *Rêves d'encre* (1945 and 1969), and, in 1983, *Souvenirs désordonnés.*

COURTOT, CLAUDE
1939, Paris

French writer. Courtot planned a thesis on surrealism in 1964, and this brought him in contact with the group. Very quickly he abandoned his initial project and become a very active member. In 1965, he published an *Introduction à la lecture de Benjamin Péret* (Paris: Le Terrain Vague) and, in 1969, a study on René Crevel (Paris: Seghers). He played an important role in maintaining contacts with Czechoslovak surrealists, as during the exhibition *Le Principe de plaisir* (1968). He contributed to *L'Archibras,* then to *Coupure.* He was interested in Victor Segalen, Blaise Cendrars, and Paul Léautaud. Courtot's taste is reflected in his unconventional "novels," where fiction, literary erudition, erotic reverie, and personal memories are interwoven (his memories include, in particular, his meetings with André Breton, *Une épopée sournoise* [1987], and his friendship with Gilles Ghez and his "double," Lord Dartwood, *L'Obélisque élégiaque* [1991]).

CRASTRE, VICTOR
1903, Perpignan

French writer. Crastre became interested in philosophy and began very early to meet with the painters passing through Céret. In Paris, from 1924 on, he would contribute to *Clarté,* of which he became one of the coeditors, along with Armand Bernier and Marcel Fourrier in 1925. It was in this capacity that he developed an authentic interest in surrealism and worked to bring the Clarté and the surrealists closer together. He went to the Cyrano and the rue Fontaine but also visited André Masson and Michel Leiris at the rue Blomet. In October 1925, Crastre, together with Louis Aragon, wrote the manifesto *La Révolution d'abord et toujours!* He should have been the one to lead *La Guerre civile,* and its failure seemed to have a serious impact on him, although he was in no way responsible. After a spell as a literary critic for *L'Humanité,* he returned to Céret for good in 1928. He stayed in touch with his former friends and thus took part in the *Almanach surréaliste du demi-siècle* in 1950. In addition to *Le Drame du surréalisme* (Paris: Le Temps, 1963), which described the political debate within the group from 1925 to 1927, he wrote a work about Breton (Paris: Arcanes, 1952), followed in 1971 by *Trilogie surréaliste* (Paris: Éditions Universitaires) devoted to *Nadja, Les Vases communicants,* and *L'Amour fou,* as well as an analysis of the possible relations between poetry and mysticism (*Poésie et mystique* [Neuchâtel: La Baconnière, 1966]).

CRAVAN, ARTHUR
(PSEUDONYM OF FABIAN LLOYD)
1887–1920, Lausanne/Gulf of Mexico

Cravan often introduced himself as Oscar Wilde's nephew. He was a boxer and anticipated the Dada spirit in his creation of the five installments of *Maintenant* (1912–15), which he handed out from a car with arms. Using his visit to the Salon des Indépendants in 1914 as a pretext, Cravan invented an atmospheric and humorous review

that attacked the intellectualism and seriousness of the artists of the era. In 1917, he became acquainted with Francis Picabia and Marcel Duchamp in New York and provoked a police raid by replacing a conference on modern art with an improvised striptease. Cravan led an itinerant life in the United States until he married the poet Mina Loy in Mexico in January 1918. Several months later he disappeared, either at sea or gunned down by the border police. His refusal, very early on, to "become civilized" and the abrasive vigor of his texts earned him a place of honor in the *Anthologie de l'humour noir.* Following the republication of *Maintenant* (Paris, 1957, 1977, and 1996), his poems, articles (on sport, in particular), and letters were collected in an edition of his *Œuvres* (Paris, 1987).

(José Pierre, *Cravan le prophète* [Cognac: Le Temps qu'il Fait, 1992]; M. L. Borras, *Cravan: Une tragédie du scandale* [Paris: J.-M. Place, 1996].)

CRÉPIN, JOSEPH
1875–1948, Hénin-Liétard

Self-taught painter. A plumber and zinc worker by trade, Crépin frequented the spiritist circles of Pas-de-Calais in the 1930s and was interested primarily in music. But in 1938 he began drawing decorative, rigorously symmetrical shapes that were dictated to him by "voices." This then led to his oil paintings, which were carefully plotted (with divider and ruler) to define palaces and temples and then decorated with flowers, wings, or stars. Vivid colors, dripped onto the canvas, stood out against a plain background. Faces were rare but were always full face, surrounded by unknown animals. Crépin was compelled to produce two series of works in this way, the last of the first three hundred canvases set to coincide with the end of the war, and the end of the second series with that of his own existence—which is more or less what happened. Crepin's work, like Lesage's, was derived from a spiritism with a supernatural orientation, and Breton felt that it offered a particularly convincing example of automatism.

CREVEL, RENÉ
1900–1935, Paris

French writer. Initially linked to the editorial team of the periodical *Aventure* (with Georges Limbour, Roger Vitrac, and Max Morise), Crevel met the Dadaists and took Tristan Tzara's side at the time of the project for a "Congrès de Paris" that Breton hoped to organize. He became acquainted with Breton in 1922 and introduced the future surrealists to the practice of induced sleeping-fits, where the faculties of automatism could be verified. Crevel nevertheless had reservations with regard to automatism. For personal reasons (complex family relations, the acceptance of his homosexuality, bouts of tuberculosis), as well as ideological ones (an authentic hatred of the bourgeois mentality), he was initially an advocate of rebellion. And it was this aspect of surrealism that brought him to play an active role in the group but only when his stays in rest homes did not keep him away. In his largely autobiographical novels (*La Mort difficile* [1926]; *Êtes-vous fous?* [1929]; *Les Pieds dans le plat* [1933]) and essays (*L'Esprit contre la raison* [1928]; *Le Clavecin de Diderot* [1932]), Crevel would deploy every available argument—some of which were owed to dialectical materialism, which he fully embraced—against society and its shortcomings, against its official representatives, and against

the dominant mentality. His criticism was frenetic, for it reflected an existential exigency rather than an intellectual attitude. That is also why he was particularly enthusiastic in his attempts to bring the surrealists and the Communist Party together, and he did not hesitate to reproach the surrealists with a certain half-heartedness at the end of 1934. The problems that arose between Breton (because of the thrashing he had given Ilya Ehrenburg) and the organizers of the Congress of Writers in Defense of Culture, which included Crevel, deeply affected him, exacerbating what was already his extreme exhaustion; moreover, he had just received news that his illness was getting worse. He would commit suicide by "forgetting to light the match" above the gas, just as he had imagined in *Détours.*

(M. Carassou, *Crevel* [Paris: Fayard, 1989]; *Europe* no. 679–680 [November–December 1985].)

CRUZEIRO-SEIXAS, ARTUR MANUEL RODRIGUES DO
1920, Amadora

Portuguese painter and poet. In 1947, Cruzeiro began creating objects and drawings that would be exhibited, in particular, during *Os Surrealistas,* a group event that was very controversial for its time. In 1950, he traveled as a sailor to India and the Far East before settling in Luanda, Angola, where he held his first solo exhibition (1952); he exhibited there again in 1959, scandalizing the most conservative circles, but returned to Lisbon five years later, unable to stomach the atmosphere of colonial warfare that reigned in Angola. He then perfected his graphic style, which was characterized by the presence of carefully silhouetted hybrid beings against a dark background of landscapes balanced between mineral and geometric elements. He illustrated collections for friends, in particular Mario Cesariny and M. H. Leira. Cruzeiro was also a poet, but it was not until 1986 that he revealed the scope of his work with his first collection, *Eu falo em chamas* (I speak in flames), where poetic images follow one another in a sporadic yet obvious way.

DALÍ, SALVADOR
1904–89, Figueras

Spanish painter. Dalí studied at the School of Fine Arts in Madrid, where he quickly mastered academic techniques, while pursuing his interest in avant-garde trends. He became friends with Federico Garcia Lorca and Luis Buñuel, discovered Freud's theories, and began to exhibit in 1925. He wrote the screenplay of Buñuel's film *Un chien andalou,* which earned them both the enthusiastic welcome of the surrealist group. When he arrived in Paris in 1929, Dalí met Picasso and Breton and put himself at the service of the group with ideas and behavior that were all the more welcome in that they provided a counterweight, at least to a certain degree, to the difficulties encountered on the political level. Dalí very systematically developed his "paranoiac-critical" method, inspired by Lacan, and this enabled him to make a rigorous connection between outrageous associations and interpretations: with the help of this meticulous technique, he unveiled his obsessions and private fantasies to raise them to the level of the collective imagination. *Le Jeu lugubre, Le Grand masturbateur, Accomodation du désir* (1929), and *Persistance de la mémoire* (1931) all portrayed a world where the constant transformation of the primary

significance of shapes predominates, shapes that, limp or not, conveyed entire series of unexpected double meanings, converging toward eroticism and scatology. Dalí was clearly fascinated by the phenomenon of decay. In addition to his pictorial production, he created drawings and etchings of uncontestable violence, as well as poetry (*La Femme visible* [1930]; *L'Amour et la mémoire* [1931]), objects (*Smoking aphrodisiaque* [1936]), installations (the *Taxi pluvieux* at the *International Exhibition* in 1938), and essays (*La Conquête de l'irrationel* [1935]). His relations with Gala, who had been the companion first of Paul Éluard then of Max Ernst, were also very special. He displayed extraordinary intellectual ease when, for example, he was required to interpret the volutes of modern style.

These activities made Dalí a major figure in the group during the 1930s, all the more so in that he managed to combine theoretical commentary and lyrical creativity and made use of a rich ambiguity, accompanying the revelation of his most intimate "secrets" with a humor that enabled him to veil them once again or turn them to ridicule. The paranoiac-critical method nevertheless implied control over his more extreme moments, which no doubt radically contradicted the use of automatism, and Dalí was reproached for creating works that, in the long run, were less open to interpretation and therefore less rich in potential meaning than those that were the result of a more authentic aberration of the subject. The fact remains that Dalí wielded considerable influence. His apparent indifference to political questions brought him, by 1934, to express a certain interest in Hitler, and a break with the group was narrowly avoided at the time. Five years later it would be definitive, when Dalí stood behind Franco: in his opinion, to be surrealist meant, above all, to discredit reality, without it necessarily requiring the elaboration of new positive values, and all positions were valid provided they accelerated the universal impression of decay. This obviously was not Breton's position or that of his friends, even though Éluard remained loyal to the Catalan painter; but then Éluard, too, had just been expelled from the group. Dalí then turned to perfecting his legend as the genial eccentric, first in the United States until 1948, then in his estate at Port Ligat after his return to Spain, and he understood perfectly that worldly miniscandals were an excellent way to increase his notoriety—to such a degree that he would eventually become "the" surrealist par excellence. His painting, however, would lose some of its virulence, although he maintained his (apparent) technical virtuosity: the subjects preserved only an attenuated "unreality," whether they were multiple portraits of Gala's incarnation as muse and madonna, "experiments" carried out on anamorphoses and relief, or a return to earlier themes, now reduced to a role of decorative effects. This clearly was no longer of any concern to surrealism but does not exclude one from recognizing Dalí's importance within the movement during those ten years that were so rich in invention that it is easy to forget what came afterward.

DAX, ADRIEN
1913–79, Toulouse

Painter. Initially a member of the Communist Youth, Dax would be attracted to surrealism at the end of the 1940s, and despite his distance from Paris he later contributed to the surrealist group's publications and collective events. As shown in the article published in the *Almanach surréaliste du demi-siècle,* he was primarily interested in automatism and sought vigorously to avoid any ossification or repetition in its use. With this aim in mind Dax created his "impressions in relief," in which chance played a mechanical role in the realization of a print and then in the "interpreted posters" that directed advertising imagery away from its intended use toward an expression of desire. His drawings were particularly supple and rich in curves, impulsive and inspired by the whim of the hand's movement. The skill he demonstrated in drawing would also apply to the use of color in his canvases.

DE CHIRICO, GIORGIO
1888–1978, Volos/Rome

Italian painter. De Chirico was born in Greece, and began his art studies in Athens. He then continued them in Munich, where he discovered Max Klinger's etchings, developed an enthusiasm for Böcklin's paintings, and read Nietzsche and Schopenhauer. It was in Italy, in Florence and Turin, in particular, that he began to convey the effects of his reading into images. Since adolescence, he had been subject to bouts of melancholy. This particular temperament and his culture inspired paintings that Guillaume Apollinaire, upon seeing them in Paris, qualified as "metaphysical": "plastic riddles," where an irresistible feeling of strangeness prevails, produced by elements that are clearly borrowed from reality but that are laid out in an unusual way. Deserted squares surrounded by dark arcades, statues larger than life, trains, clocks, and factory smokestacks are displayed against violent, often incompatible perspectives and set with shadows that emphasize an ominously threatening atmosphere of irrational origin. In the foreground are a few recurrent objects: artichokes, gloves, spheres, volumes of uncertain meaning. *L'Énigme de l'oracle* (1910), *La Tour rouge* (1913), *L'Angoisse du départ* (1914), and *Le Grand métaphysique* (1917) all suggest a world that seems devoid of any identifiable intention, the elements of which are confronted solely for their nonfunctional presence. Something unnamable is lurking, and yet nothing is happening on canvas, as it were: everything is in a state of suspension. With works like these, De Chirico aroused great enthusiasm among the future surrealists. In 1916, Breton would succumb to the irresistible attraction of the *Cerveau de l'enfant* displayed in the window of the art dealer Paul Guillaume, as would Yves Tanguy not long thereafter. A few letters were exchanged with De Chirico, who was said to have the powers of a medium, but when the painter finally met his admirers, his work had already taken a very different direction, more classical in style and theme (self-portraits, horses by the seaside, landscapes bereft of mystery).

Ultimately, although relations were maintained until 1925, De Chirico would be accused of betraying his earlier genius, and he would respond by reproaching Breton and his friends for wanting to get rich by speculating with his earlier works. The publication, in 1929, of his Hebdomeros was welcomed, nevertheless, for De Chirico had reconstituted the mental universe of 1910–15. But since the end of the First World War he had been trying to bring Italian painting—and his own, first and foremost—back to its fundamental values, as witnessed in 1923 when he joined Valori Plastici, which advocated neoclassicism. Even though from that point on De

Chirico could have no positive connection with surrealism, the work of his "metaphysical" period would continue to exemplify how art could lead one happily astray—including the artist himself. His works would continue to influence, to varying degrees, Tanguy, Magritte, Dalí, and Ernst and were an irreplaceable source for the definition of surrealism's own ambitions.

DEHARME, LISE
(PSEUDONYM OF ANNE-MARIE HIRTZ)
1898–1980, Paris

From a well-to-do family, Deharme began writing as an adolescent. Under the name of Lise Meyer, she aroused a veritable passion in André Breton from 1925 to 1928; she would appear in *Nadja* as "the lady with the glove." She joined the surrealist group, and her first collection was illustrated by Miró (*Il était une petite fée* [Paris: Éditions J. Bicher, 1928]). In her published poetry, grace vies with humor (*Cahier de curieuse personne* [1933]), and from 1926 on, she attracted a wide range of contributors to her periodical *Le Phare de Neuilly,* including Robert Desnos, Man Ray, Lee Miller, Léon-Paul Fargue, J. Follain, and A. de Richaud; she also published a "serialized novel" by Georges Ribemont-Dessaignes. In 1945, her first collection of short stories contained a foreword by Paul Éluard; she would write fifteen or more volumes, including *Ève la blonde* (1952); *La Comtesse soir* (1957); and *L'Amour blessé* (1955), in which the marvelous or an astonishingly "fresh" eroticism prevailed (*Oh! Violette* [1969]): "Her reason for being here on earth is to astonish those who read her," said Éric Losfeld. Deharme put together the collection *Farouche à quatre feuilles* (1954), which included texts by Breton, Julien Gracq, J. Tardieu, and her own works, some of which were used for a radio broadcast. In 1955, she published a journal, *Les Années perdues, 1939-1949.*
("Lise Deharme," *Cahier bleus* (Troyes), no. 19 [autumn–winter 1980].)

DELANGLADE, FRÉDÉRIC
1907–70, Bordeaux

Painter and lithographer. After serious studies in psychiatry, Delanglade held his first exhibition in 1932. He spent some time traveling, then defined his "oneiric" style, and in 1937 he showed his "Apparatus for Obliterating Complexes" at the Surindépendants, which caught the attention of the surrealists. Two years later, he organized the exhibition *The Dream in Art and Literature,* in which the participation of the surrealists was particularly noteworthy. Delanglade became acquainted with Gaston Ferdière in Rodez during the war and, eventually, went to Marseilles, where he was among those who devised the Marseille Card Deck; he would later standardize the drawings. In 1946, he invited his artist friends to the "collective decoration" of the guardroom at Sainte-Anne and then took part in the *International Exhibition* at the Galerie Maeght. He later left the group to devote himself to the creation of a series of lithographs (poems and drawings) on the theme of "A Lys," collected in a volume in 1962.

DELTEIL, JOSEPH
1894–1978, Villar-en-Val/La Tuillerie de Masane

French writer. For a time the surrealists were taken with what they saw as a joyful irreverence in Delteil's work; he would contribute, in particular, to the pamphlet against Anatole France. The first surrealist manifesto counted him among those who had shown "proof of absolute surrealism," and he would include Louis Aragon and Philippe Soupault in his story *Les Cinq Sens.* While he had a lasting admiration for Barrès and Francis Jammes, was interested in *Jeanne d'Arc* (1925), and exalted *Les Poilus* (The soldiers [1926]), the break was inevitable, and as Breton said, it was "useless to insist" with Delteil.
(S. Faucherau, "Savoureux Delteil," *La Quinzaine littéraire,* no. 423 [September 1, 1984].)

DER KEVORKIAN, GABRIEL
1932, Paris

French painter. Der Kevorkian first made his surrealist tendencies known through *La Brèche.* He took part in *L'Écart absolu,* and then joined *BLS* after the group was dissolved. His canvases combine a somewhat geometric decor with nocturnal creatures depicted in mellow colors, creatures that seem to have borrowed their carapaces from the insect world as they take part in secret ceremonies, in which symmetry plays a major role.

DE SANCTIS, FABIO
1931, Rome

Italian sculptor. Trained as an architect, De Sanctis designed several buildings in Rome, where in March 1963 he founded the Officina Undici with the painter Ugo Sterpini, born in Rome in 1927. The following year, the first collective creations were exhibited in Naples: chairs, tables, dressers, and beds were pretexts for a mixture of materials and shapes that gave this furniture a highly irrational aspect, contradicting its very purpose. The dresser exhibited during *L'Écart absolu* was built using two recycled car doors. De Sanctis also created sculptures that made an unusual use of alabaster and steel. In 1971, his series *Crossing the Alps* depicted the adventures of a suitcase. His object-sculptures became more and more paradoxical: associating sinuous or sexualized shapes with elements representing industry or modernity, these creations seemed to condense possible narration into a brief performance in which matter easily contradicted the functioning of the object parodied.

DESNOS, ROBERT
1900–1945, Paris/Terezin

French poet. Desnos briefly met Benjamin Péret and André Breton as early as 1919, but his military obligations kept him from truly participating in Dada. It was from 1922 on that he would play an important role in surrealism's gestation, with a whole-hearted devotion to automatism and hypnotic sleeping-fits. Desnos showed an aptitude for producing puns that rivaled Marcel Duchamp's, and on occasion he would "borrow" Duchamp's double, Rrose Sélavy. He also explored all the possibilities of dismembered language (*Langage cuit* [1923]), and his poetry, informed by the permanent themes of love and a mythology borrowed from "popular" literature (from Fantomas to Jules Verne), is proof of the total freedom of his writing. Until 1927, Desnos took part in the periodicals and activities sponsored by the group, but he was hostile toward the movement's

political commitment and had to earn a living as a journalist: the break would take place in 1928. Breton attacked Desnos in the *Second Manifesto*, and Desnos responded in *Un cadavre*, then with the *Troisième manifeste du surréalisme* (1930). There would be no reconciliation: occupied by his various bread-winning activities, by the articles he devoted to the cinema, and by new friendships, Desnos left the group. He was arrested by the Gestapo in 1944; deported to the camp at Terezin, Czechoslovakia, Desnos died shortly after his liberation by the Red Army.

(M. Murat, *Robert Desnos: Les grands jours du poète* [Paris: José Corti, 1987]; "Robert Desnos," *Cahier de l'Herne*, no. 54 [1987].)

DOMINGUEZ, OSCAR
(PSEUDONYM OF OSCAR MANUEL DOMINGUEZ PALAZON)
1906–57, La Laguna, Canary Islands/Paris

Painter. Dominguez was from a wealthy family, and it was to keep an eye on his family's investments that he first came to Paris, where he spent time in Montparnasse perfecting the painting techniques he had learned from his father. He created his first canvases in 1929. In 1933, he organized a surrealist exhibition in Santa Cruz and only joined the Paris group a year later. He would play a particularly active role in the group until the war: decalcomania from 1935 on, objects (*Arrivée de la Belle Époque* [1936]), and canvases in which, by 1938, automatism had led to a geometric crystallization of dehumanized shapes. In his figurative vein, canvases would take the place of objects that were too complicated to be constructed (*Machine à coudre electro-sexuelle* [1935]). During the war, Dominguez strengthened his ties with La Main à Plume and enjoyed the friendship of Paul Éluard and Picasso, whose influence could be clearly seen in his work. He joined the revolutionary surrealism movement and, in 1947, published a small volume, *Les Deux qui se croisent* (The two who meet; L'âge d'or series). Subsequently, he would further experiment with different styles and seemed himself to be dissatisfied with the ease with which he could move from decalcomania to bullfights or the exploration of a more personal mythology. A retrospective of Dominguez's work was held in Brussels in 1955; two years later he committed suicide.

DONATI, ENRICO
1909, Milan

American painter of Italian origin. After his studies in Milan, Donati spent some time in France and then emigrated to New York, where he met the surrealists in exile. He would become particularly close to André Breton, Yves Tanguy, Marcel Duchamp, and Roberto Matta. His painting was abstract to begin with and then was enriched by biomorphic allusions amid a background of shimmering folds. Breton wrote the preface in 1944 for Donati's exhibition at the Galerie Passedoit (and also provided titles for Donati's canvases). In 1947, Donati was a participant in the Room of Superstitions at the *International Exhibition of Surrealism* held at the Galerie Maeght, and he helped Duchamp to create the foam breasts for the catalog's cover. Very soon thereafter, however, his work would lose any connection with surrealism.

DOTREMONT, CHRISTIAN
1922–79, Tervuren/Beuzingen

Belgian writer and artist. At the age of eighteen, Dotremont took part in the final activities of *L'Invention collective,* and in the last months of 1940, he published his first collection, *Ancienne Eternité.* The following year he became one of the leaders of La Main à Plume and collaborated on all its publications and collective declarations. In Paris he visited Paul Éluard, Picasso, and Gaston Bachelard, and on his return to Belgium in 1943 he took part in a number of publications before proclaiming, in the third issue of his periodical *Les Deux Sœurs* (May 1947), the urgency of a revolutionary surrealism. This new movement would be short-lived, however, and consequently left Dotremont extremely wary of Stalinism. The following year, together with Asger Jorn and Constant, he founded the international Cobra group, where he practiced "word paintings," combining a pictorial process (by Jorn or Jean Atlan) with improvised poetic formulas. The variety of his contributions (theory, poetry, art) did not fail to impress the younger members of Cobra, including Pierre Alechinsky, while the group itself maintained a deliberate critical distance from surrealism, favoring an automatism rooted in the play of materials rather than in the life of the mind. From 1962 on, Dotremont would devote himself primarily to the creation of his "logograms," which associated, in a hitherto unseen way, poetic creativity and the use of gesture: the text, to be seized at the very moment of its hasty and "illegible" creation, would then be calligraphed at the bottom of the page in order to render its meaning.

(J.-C. Lambert, *Grand Hôtel des Valises* [Paris: Galilée, 1981].)

DRIEU LA ROCHELLE, PIERRE
1893–1945, Paris

French writer. Drieu la Rochelle was greatly affected by the First World War (he was wounded on three occasions) and was fascinated by the figures of the "leader" and by "virile" friendship—as was made apparent in *La Comédie de Charleroi* (1934). He was close, above all, to Louis Aragon (with whom he shared a taste for dandyism and whorehouses), Paul Éluard, and Jacques Rigaut (whose suicide would inspire him to write *Le Feu follet* in 1931). He frequented Dadaist circles and collaborated to some degree on *Littérature* but without really adhering to the radical principles of the movement, although he did take part in the Barrès trial and in *Un cadavre* against Anatole France. The transition to surrealism did not leave him totally convinced, and in 1925 he began to distance himself from the group. He retained a certain affection for Breton, however: he would dedicate *Le Jeune Européen* to Breton in 1927, but in July of that same year he published his third *Lettre aux surréalistes* in which he voiced his disappointment: "I had hoped that you would be better than the *littérateurs,* that you were men for whom writing is action." As far as he was concerned, action was to be found in what was an increasingly clear espousal of fascism, and in 1939 he produced a worldly, caricatured version of surrealism in *Gilles;* Drieu la Rochelle would later collaborate to a certain degree with the Nazis.

DUCHAMP, MARCEL
1887–1968, Blainville/Paris

Artist of French origin, naturalized American in 1955. Duchamp

took up painting very early, creating his first watercolors in 1902. After passing his *baccalauréat* exam he joined his brothers (Jacques Villon and Raymond Duchamp-Villon) in Paris, contributed a few drawings to the satirical newspapers, and until 1910, dabbled in postimpressionism, symbolism, and fauvism, producing a few canvases. Duchamp retained a few principles of schematization from cubism and took an early interest in exploring ways to suggest movement, borrowing from futurism (*Jeune homme triste dans un train* [1911]). In 1912, his *Nu descendant un escalier n° 2*—which the cubists had removed from the Salon des Indépendants—would cause him to break with all these tendencies, for as his subject was prohibited by the futurists, its artistic treatment did not suit them any more than it did the cubists, insofar as it was hardly an exaltation of the machine. His subsequent research explored nondynamic representations of movement (*Le Roi et la Reine traversés de nus vite, Vierge n° 1, Mariée* [1912]) or the neutral figurative representation of an impersonal machine (*Broyeuse de chocolat n° 1* [1913]). In 1914, *La Glissière*, created on glass, would be a synthesis of all these works, already indicative of a certain scorn for that which was ordinarily referred to as "painting."

Duchamp arrived in New York in 1915, and it was there that he would earn great notoriety following the scandal provoked by the *Nu* at the Armory Show, and Duchamp went on to renounce "retinal" art. He met Man Ray, perfected his choice of manufactured objects, which he dubbed "readymades" (but given the inscriptions he added to them, they were as much to be read as to be seen; some of the readymades, and some of his declarations, he would attribute to his female alter ego Rrose Sélavy). Duchamp then began the meticulous design of *La Mariée mise à nu par ses célibataires, même,* a mechanism on glass that, thanks to a very complicated coding, evoked a transposed erotic relationship under the aspect of more or less mechanical operations. This "Large Glass" kept him busy until 1923 but remained unfinished. Together with Man Ray, Duchamp inaugurated a parallel Dada in New York, before the events in Zurich, which was written up by various periodicals. Together with Katherine Dreier, Duchamp founded the Société Anonyme, for which he would work as secretary and later write a part of the catalog. Soon thereafter he returned to Paris, where he met Breton, who immediately recognized the relevance of Duchamp's creative process. That did not suffice to convince Duchamp, however, to join any group whatsoever. On the contrary, he reaffirmed his total lack of interest, henceforth, in artistic activity, and he devoted himself, with the exception of a few special orders and/or kinetic experiments, to chess, managing to earn a living, together with his friend Henri-Pierre Roché, by periodically selling works from his Constantin Brancusi collection.

In 1934, Duchamp published in *Boîte verte* the notes that had helped him to design the Large Glass, which he would have to repair two years later, after it was damaged in transport. Dividing his time between France and the United States, he periodically cooperated with the surrealists, coorganizing, in particular, the international exhibitions in Paris in 1938, New York in 1942 and 1947, and Paris in 1959 and misguidedly accepting works by Dalí for the 1960 exhibition in New York. In 1957, he gave a lecture in Houston, where he declared that the artist is not the only creator of a work since the viewer also adds his or her own interpretation to the work. Even as his influence was growing (he was one of the sources, via John Cage and Robert Rauschenberg, for pop art and Fluxus, as well as for new realism and numerous object manipulators), he would be satisfied with minimal participation: a few drawings or prints, telegrams. Only after his death would the work that he had been secretly perfecting for twenty years be revealed, to be directly installed at the Philadelphia Museum along with the Large Glass and the Arensberg collection, which brought together the bulk of his production: *Étant donnés: 1° La Chute d'eau 2 Le Gaz d'éclairage*. The theme of the *Mariée* was revived in three dimensions, in a totally illusionist staging that, this time, transformed the viewer into a pure and simple—and vaguely frustrated—voyeur. This call to reconsider the speculations brought on by his "inactivity" was also a way of reminding people that, decidedly, anything that remains retinal can never be totally satisfying. This might be Duchamp's message: art results, above all, from an intellectual decision. It was, in any case, this way of seeing things that formed the basis of the surrealists' passionate interest in Duchamp's creative process.

DUHAMEL, MARCEL
1900–1977, Paris/Saint-Laurent-du-Var

In the 1920s, Duhamel had some financial means, and he placed a house at 54, rue du Château at the disposal of his friends Jacques Prévert and Yves Tanguy: this refuge became a mecca for nascent surrealism, where people could meet on a daily basis to exchange humor, play exquisite corpse, or have sleeping-fits. Raymond Queneau and Benjamin Péret also spent quite a lot of time there, but it was the entire group that, as Breton remembered it, felt a deep "organic unity" there. As for Duhamel, he would sign some of the manifestos, but he gradually left the group without making a fuss, refusing any formal act of separation. After the Second World War, he would invent the *Série Noire* (detective stories). In his memoirs (*Raconte pas ta vie* [1972]), Duhamel drew warm portrayals of his friends at the Rue du Château.

DUITS, CHARLES
1925–91, Neuilly-sur-Seine/Paris

French writer; Duits's mother was American and his father was Dutch. It was in New York, at the age of seventeen, that Duits met André Breton, and in *VVV* he published texts where his taste for the most intransigent rebellion became obvious—a rebelliousness that would ultimately lead him to break with Breton, the very man who was the incarnation of the first worthy authority to guide Duits's taste for the absolute, which had been frustrated by his Puritanical upbringing. Back in Paris in late 1947, Duits briefly reconnected with the surrealist group, spending time primarily with the dissidents (Sarane Alexandrian, Alain Jouffroy). In 1954, he had some success with his first novel, *Le Mauvais mari* (Paris: Éditions de Minuit) but was torn between the temptation of Christianity and the quest for new mystical values. Drawn to a modern version of gnosis, Duits hoped to have visions from mescal: these were ultimately disappointing (*Le Pays de l'éclairement* [1967]) In *La Conscience démonique* (1974), he sought to determine the psychic activities that escaped rationalism. At the same time, he wrote erotic texts (*La Salive de l'éléphant* [1970]; *Les Miférables* [1971]) and a gnostic novel (*Ptah Hotep* [1971]), in which he deliberated the association of sexual and spiritual ele-

ments with the possibility of transcendence. From 1978 to 1988, he wrote 5,000 pages of an unpublished work, *La Seule femme vraiment noire*. In 1995, a diary that he had kept from 1968 to 1971 was published: *La Vie le fard de Dieu* (Paris: Éditions Le Bois d'Orion).

DUMONT, FERNAND
1906–45, Mons/Bergen-Belsen?

Dumont founded Rupture with Achille Chavée, and the group published his first collection *À ciel ouvert* in 1937; then he founded, again with Chavée and Marcel Lefrancq, the Hainaut Surrealist Group, which published *La Région du cœur* in 1939. Fundamentally opposed to fascism, Dumont was arrested in 1942, the year his *Traité des fées* was published by Éeditions Ça Ira in Antwerp. He disappeared three years later, somewhere in Bergen-Belsen. His other texts were published posthumously: *La Liberté* (Paris: Haute Nuit, 1948) and *L'Étoile du berger* (Brussels: Éditions Labor, 1955). And it was not until 1979 that his *Dialectique du hasard au service du désir* was published by the Éditions Brassa in Brussels, with a preface by Louis Scutenaire. Dumont had worked on it from 1935 to 1942, and the ideas he puts forth are of a rare intensity, mingling theoretical considerations and noteworthy events of everyday life, concerning the possible relations between automatism, chance, and individual desire.

DUPREY, JEAN-PIERRE
1930–59, Rouen/Paris

French poet and sculptor. During his adolescence, Duprey discovered Lautréamont, Jarry, Artaud, and Rimbaud; continuing their tradition, from 1948 on he published his own poetry. That same year, Duprey settled in Paris and submitted his manuscript *Derrière son double* to the Galerie la Dragonne; Breton greeted it with enthusiasm. Duprey wrote feverishly and participated modestly in group meetings. In 1950, his text was published by the Soleil Noir (with a frontispiece by Jacques Hérold—with whom he designed a "prediction poster" at the end of that same year), and Breton included it in the second edition of the *Anthologie de l'humour noir*. Duprey learned to work wrought iron and took up sculpture, fashioning haunting creatures with ragged and aggressive shapes. He then went on to produce reliefs in concrete, conveying both a seemingly rigid existence and an imminent rebirth. These works were exhibited at L'Étoile Scellée and then, after 1955, in the events of the Phases group. In 1959, Duprey went back to writing, but that spring he was caught urinating on the flame of the Arc de Triomphe, a sacrilege that led to his arrest and an internment of three weeks in Sainte-Anne. Once he was released, he polished his manuscript *La Fin et la manière*, and while his wife was on her way to mail it to Breton, he hanged himself in his studio. First published by Soleil Noir, his *Œuvres complètes* would be reprinted in 1990 by the Éditions Christian Bourgois.

(J.-C. Bailly, *Jean-Pierre Duprey* [Paris: Seghers, 1973].)

EFFENBERGER, VRATISLAV
1923–86, Nymburk/Prague

Czechoslovak writer. Effenberger met Karel Teige in 1945, and after Teige's death, he became the leading spokesman for the postwar generation in Prague. He wrote plays and scenarios that emphasized the absurdity—particularly social and political—of everyday life. In the 1960s, Effenberger designed a theory of "disintegrating" systems that he opposed to all those movements—including surrealism—which attempted to unify their principles or their discoveries according to one unique perspective. In his work, the utopian dimension of classical surrealism "à la française" gave way to a critical function that had no intention of being easily taken in—by anything that claims either to be reality or to replace it. It was in accordance with these principles that he maintained his contacts with the team at *L'Archibras* and then with Vincent Bounoure and his friends.

ELLEOUËT, AUBE
1936, Paris

The daughter of André Breton and Jacqueline Lamba. At the end of *L'Amour fou*, Aube is Écusette from Noireuil, whom her father hopes will be "madly loved"—which indeed is what happened when she met Yves Elleouët in 1955. She began producing collages in 1970 but only began to exhibit them four years later (in Tours, to begin with). Her work is in the tradition of Max Ernst but has nevertheless been quite innovative, combining elements (in color, against a black background) that reveal the secretly dreaming side of their apparent purpose; subversion thus becomes a process that seems self-evident, for the results obtained are clearly imbued with a new evidence.

ELLEOUËT, YVES
1932–75, Fontenay-sous-Bois/Saché

Painter and writer. A graduate of the School of Applied Arts, Elleouët spent his first vacation in Brittany in 1953 and would return regularly. It was there that he met Breton, along with his daughter Aube, whom he married in 1956. Despite his positive interest in surrealism, he would not participate in the group's collective events; Elleouët worked for a printer and divided his time, from 1958 to 1968, between painting and writing. He was a friend of Charles Estienne's and was sensitive to certain forms of abstraction (Serge Poliakoff, Nicolas de Staël). He began to exhibit his "frescoes" (actually paintings on plaster) in 1959. These were vividly colored signs in which elementary symbols came together. His painting soon evolved toward an allusive figurative representation, enabling him to explore the landscape of Brittany and its mythology. *La Proue de la table*, a "timeless journal" of poetry, illustrated by Alexander Calder, who was his neighbor in Saché, was published in 1967 (Paris: Éditions du Soleil Noir). Seven years later, Elleouët would publish the astonishing *Livre des rois de Bretagne*, which combined his childhood memories with mythical elements, fused with humor and a cosmic sense of eroticism. *Falch'un* (1976; published posthumously with a preface by Michel Leiris) would confirm the rare impact of his literary contribution, condensing into two books the enormous potential of mixing fables with the real world.

(Yves Elleouët, *Yves Elleouët, peintre-écrivain* [Hôtel de Ville de Tréguier, 1996].)

ÉLUARD, PAUL
(PSEUDONYM OF EUGÈNE GRINDEL)
1895–1952, Saint-Denis/Charenton

French poet. When Éluard was sixteen, he contracted tuberculosis

and spent two years in a sanatorium in Davos. While he was there he discovered poetry (from Baudelaire to Lautréamont and the German romantics), read some Marx, and met a fascinating young Russian woman, Helena Diakonova, whom he called Gala and married in 1917 while on leave from the army. Éluard was a soldier during the war, was gassed, and spent time in various hospitals before being demobilized; when he met Max Ernst, they realized that they could actually have killed each other. The poetry of Éluard's youth, full of tenderness and rebellion, already defined what would become his style. When he joined the team on *Littérature*, he planned to be a poet above all—something that could have divided him from his new friends but did not prevent him from being one of the major figures of surrealism for over sixteen years. During the Dada era, Éluard published six issues of his periodical *Proverbe*, which "exist[ed] only to justify words": words must be constantly renewed in order to ensure the exchange between minds. This was why Éluard felt that automatism offered up material that was too raw and had to be reworked; he also insisted, during surrealism's early days, on maintaining a careful distinction between poetry and dreams, for dreams, in his opinion, could not contain the dignity of poetry.

During the 1920s he was, like Breton, interested in artists: Max Ernst, whom he met in 1920, and with whom he had an extremely close relationship, Giorgio De Chirico, Man Ray, Picasso, Dalí, and Valentine Hugo; he would often associate his work to theirs through poetry rather than theoretical essays. By virtue of his concept of language, he was among those who eagerly carried out experiments in collective writing: with Benjamin Péret he published *152 Proverbes mis au goût du jour* (1925); with René Char and Breton, *Ralentir travaux;* and with Breton alone, *L'Immaculée Conception* (1930). His personal collections (*L'Amour la poésie* [1929]; *La Vie immédiate* [1932], which illuminated by his new love for Nusch; *La Rose publique* [1934]; and *Les Yeux fertiles* [1936], a new hymn to Nusch) contained a wealth of metaphors that were susceptible to justifying the accusations of idealism or Icarian temptations brought by Georges Bataille against surrealism in general. But in reality Éluard sought to make writing a means of connecting not only loving bodies but also loving minds, even if misfortune threatened (*Capitale de la douleur* [1926]). In 1936, in the speech he made at the London exhibition, Éluard insisted on the rights of the imagination to contest any imposed social order: in his case, joining the Communist Party coincided first and foremost with a belief in the ability of poetry to bring about the transformation of the mind. But when Éluard began to justify his collaboration on the periodical *Commune*—the editors of which had been slandering Breton during his stay in Mexico—by insisting that his poetry had worth independently of any context, the break was inevitable, despite the turmoil it provoked among surrealist groups the world over. Later, Éluard grew closer to Aragon, became one of the most famous resistance poets thanks to his *Liberté* (distributed by La Main à Plume until they too severed relations), and did not hesitate to sing the praises of Stalin, while for the public he remained the poet of pure love and, on occasion, the inspired companion of his artist friends.

(Paul Éluard and Lionel-Marie Annick, *Éluard et ses amis peintres* [Paris: Centre Georges Pompidou, 1982]; J.-C. Gateau, *Paul Éluard et la peinture surréaliste* [Geneva: Droz, 1982].)

ERNST, MAX
1891–1976, Brühl/Paris

Painter, sculptor, and creator of collages; of German origin. Ernst first studied philosophy, psychiatry, and art history but, in 1911, discovered that he wanted to be a painter. In 1913, he exhibited along with the Rhineland expressionists. He was in the artillery in the First World War, then settled in Cologne, where with Johannes Theodor Baargeld he led a particularly aggressive Dada group. It was at this point that he recognized, in Giorgio De Chirico's "metaphysical" canvases, "something which had long been familiar to [him]." In tribute, he created the eight lithographs of *Fiat Modes* and explored the possibilities of collage, seizing the hallucinations caused by objects displayed en masse in catalogs or on didactic signboards. What would become surrealist collage differed from cubist *papiers collés* through its power to surprise. Very early on, Ernst developed the procedure with photomontage and collages on canvas that produced a systematic disturbance of the visible. In 1920, he corresponded with Tristan Tzara and the Dadaists, who the following year organized an exhibition of his collages at the Au Sans Pareil bookstore. This would be the beginning of a solid cooperation with the future surrealists and, in particular, with Paul Éluard: Ernst provided illustrations for *Répétitions* and *Les Malheurs des immortels*. In 1922, he moved to Paris, where he exhibited his canvases and painted reliefs (*Au rendez-vous des amis, Deux enfants menacés par un rossignol*) at the Salon des Indépendants. During the summer of 1925, he perfected his frottage technique, which intensified the "meditative and hallucinatory faculties" by suggesting shapes that could be readily fixed on a support covered with a sheet of paper (the *Histoire naturelle* album). Having refined his techniques, over the next few years Ernst would determine his favorite themes: torn shapes, ghostly apparitions, transfigured forests or cities, bird-people from the "Loplop" series, landscapes of crystals and shells. His canvases combined diffuse anguish with visual splendor. In 1929, he began to publish his "collage-novels" (*La Femme 100 têtes, Histoire d'une petite fille qui voulut entrer au carmel* and *Une semaine de bonté*), which enhance, through the text, the disturbing virtues of the altered illustrations. Although his canvases from the late 1930s retained their brilliance and rich air of seduction, they now had something threatening about them (*L'Ange du foyer*). Ernst protested against Éluard's exclusion from the group and would himself withdraw, retiring to the Ardèche with Leonora Carrington.

Later accused of spying, Ernst was interned at the camp in Milles at the same time as Hans Bellmer was but managed to get to the United States, thanks to Peggy Guggenheim, with whom he lived in New York for a time. While in the United States, he met up with the exiled surrealists and collaborated on their publications. Through his use of projection in painting, Ernst contributed to the creation of the dripping that would be used by future abstract expressionists. With his new companion Dorothea Tanning, he lived in Arizona until 1949. He sculpted a series of emblematic characters (*Le Capricorne* [1948]) and painted "deserts" in small formats, with a crystalline structure. Ernst returned to France in 1953 but was excluded from the group the following year for having accepted the prize in painting from the Venice Biennale. By his latter years he had acquired international renown, and his work went on to include collages made from every-

day objects (cages, lace, blowtorches), as well as frottages and ironic bronzes. Even at a distance from the group, his work, despite some repetitiveness in his later years, would continue to explore that which was "beyond the visible," to which it was integrally devoted.

ESTIENNE, CHARLES
1908–66, Paris

French writer and art critic. Estienne was among those who "neither tell nor evoke, but lead one to a point where one feels an ineffable grace just in being there, and then in the disgrace of leaving again can convey a sense of vertigo" (Jean Schuster). He began writing for *Combat* and *France-Observateur* in 1946, in which he defended the idea of a quest for a "what lies beyond painting" rather than for a system, something he had discovered in Gauguin, to whom he devoted a monograph in 1953. He professed an interest in abstraction (nongeometrical—see his 1950 pamphlet, *L'Art abstrait est-il un académisme?*), as well as in the Cobra movement, naive painters, and Jean Dubuffet. Very close to the surrealist group, he regularly urged them to look into lyrical or gestural abstraction (René Duvillier), insofar as it seemed compatible with automatism.
(Charles Estienne, *Charles Estienne et l'art à Paris, 1945–1966* [Paris: Fondation Nationale des Arts Graphiques et Plastiques, 1984].)

FERDIÈRE, GASTON
1907–90, Saint-Étienne/Meudon

French psychiatrist, close to the surrealist group. He worked first at Sainte-Anne in Professor Claude's service, then frequented the team of *L'Évolution psychiatrique* (H. Ey, E. Minkowski). In 1931, he published a collection of poetry, *Ma Sébille* (Lyons: Éditons de l'Élan). Four years later, he took part in the International Conference for the Defense of Culture and was a regular militant in libertarian circles. Ferdière obtained a doctorate in medicine in 1937 (*L'Érotomanie: Illusion délirante d'être aimé*) but was barred access to a university career because of his nonconformism. It was during his tenure as head physician at the psychiatric hospital in Rodez (where the Vichy government sent him because of his political commitment) that Antonin Artaud became his most famous patient, from 1943 to 1946. Artaud would subsequently complain of the treatment he received, particularly electric shock treatment; nevertheless, it was in Rodez that Artaud began to write again. Ferdière published a collection called *Humour* in 1945, which included *La Place de l'Étoile* by his friend Robert Desnos. In 1948, Ferdière opened a private practice, developing an interest in portmanteau words and drawings by schizophrenics. Through his medical practice he would continue his contacts with artists (see Hans Bellmer and Unica Zürn, *Lettres au docteur Ferdière* [Paris: Éditions Séguier, 1994]). In 1978, he published his memoirs under the title *Les Mauvaises Fréquentations*.

FERRY, JEAN
(PSEUDONYM OF JEAN ANDRÉ LÉVY)
1906–74, Capens/Paris

After working in the Merchant Marine, Ferry became set director for the Pathé-Nathan Film Company. A man of immense culture, he was particularly interested in humor and the unexpected and was passionate about the works of Raymond Roussel. Ferry's collabora-

tion with the surrealist group began in 1933, and he also took part in the theatrical activities of the Octobre group with Jacques Prévert and Marcel Duhamel. In 1950, his collection *Le Mécanicien et autres contes* was prefaced by Breton (Gallimard; republished by Calmann-Lévy in 1992), as was his *Une étude sur Raymond Roussel* three years later (Paris: Éditions Arcane; later expanded into *L'Afrique des impressions* [Paris: Édition Pauvert]). His multiple roles as a writer of screenplays and dialogue—although he himself ridiculed this work—nevertheless did not allow him to develop his own work. Only *Fidélité* (Paris: Éditions Arcane, 1953), which he was never able to film, was really important to him. In the last twenty years of his life he would cultivate his interest in deciphering rare manuscripts at the Collège de Pataphysique.

FORD, CHARLES-HENRI
1913, Hazlehust, Miss.

American poet. With his collection *A Pamphlet of Sonnets* (1936), he injected into American poetry an echo of French surrealism, with which he had become acquainted during his time in Paris in the late 1930s when he had met the group. He welcomed them to his journal *View* during the war but declined André Breton's request that he become editor of *VVV*. Ford gave up *View* at the "height of its success" when his friends went back to Europe in 1947. Ford was also the editor of the anthology of Breton's poems in English, *Young Cherry Trees Secured against Hares*. In his own collections (*Poems for Painters* [1945]; *Sleep in a Nest of Flames* [1949]; *Silver Flower* [1968]), he excelled at including collages and allusions to painters and writers he admired (Pavel Tchelitchew, Yves Tanguy, Paul Éluard, Breton, and so on) and the use of slang and excerpts from popular songs. This mixture assured his texts of a seeming ingenuity that was actually the result of great mastery.
(S. Fauchereau, "Questions à Charles-Henri Ford," *Digraphe*, no. 30 [June 1983].)

FOURRÉ, MAURICE
1876–59, Angers

French writer. Fourré published a few texts at the turn of the century, but it was not until the age of seventy-three that he wrote *La Nuit du Rose-Hôtel*, which he presented in passing at the Galerie la Dragonne. It was with this novel that André Breton inaugurated the Révélation series for Gallimard in 1950, although it would remain the sole title of the series. Fourré then published *La Marraine du sel* (1955). Michel Butor compared the two works to the candies "which the Mexicans make for their carnivals, covered with shiny sugar but in the shape of a skull." Fourré transformed elements of his stories to offer varied approaches, making use of a style that could switch without warning from extreme precision to the evocation of phenomena apparently devoid of any direct relation with the main framework of the story that was, in any case, always discreet. His third novel, *Tête-de-Nègre*, which was not published until 1960, contained the same elements of fantasy and veiled humor as his earlier titles.
(Philippe Audoin, *Maurice Fourré rêveur définitif* [Paris: Le Soleil Noir, 1978].)

FOURRIER, MARCEL
1895–1966, Batna/Paris

Lawyer and journalist. In 1919, Fourrier joined Henri Barbusse's

group Clarté, and three years later he would take up the coeditorship of its journal with Jean Bernier. He sought to preserve its independence from the Communist Party, of which he was a member, and this enabled him to work on bringing his group closer to surrealism in 1925 and to fulfill the project of a joint periodical, *La Guerre civile.* As the two groups were unable to bring about a fusion, he relaunched *Clarté,* this time with Pierre Naville, in June 1926. Expelled from the Communist Party in May 1928, he collaborated on the communist opposition newspaper *Contre le courant* and moved ever closer to a Trotskyist position. Only under the Occupation would he renew ties with the Communist Party, and then in the early 1950s he joined the Unified Socialist Party.

FRAENKEL, THÉODORE
1896–1964, Paris

French doctor of Russian origin. Fraenkel met André Breton at the Lycée Chaptal in 1910, joined him in Nantes in 1915, and became one of Jacques Vaché's correspondents. In 1917, "he played tricks on literary people by sending fake letters" and published a pastiche of Jean Cocteau in *SIC.* He then took part in Dada publications, acted in plays by Breton, Philippe Soupault, and Tristan Tzara, signed a certain number of the surrealist group's pamphlets, and cowrote, with Robert Desnos, a "Letter to the Head Physicians of Insane Asylums." He broke with Breton in 1932, devoted himself to his medical practice (he remained the personal physician of Desnos, Georges Bataille, and others), fought in the Spanish Civil War, and in 1943, joined the Free French Forces in England, then the Normandy-Niémen squadron in the Soviet Union. In 1946, Fraenkel wrote an article about Robert Desnos for *Critique,* and he was one of the signatories of the "Manifesto of the 121" in 1960. His *Carnets, 1916–1918,* detailed his early friendship with Breton, including discussions of books they both had read, and was full of a humor not unlike the work of Vaché, who persuaded him, no doubt, of the pointlessness of action.

FREDDIE, WILHELM
1909–95, Copenhagen

Danish painter. Initially a constructivist, Freddie discovered surrealism in 1927. Influenced in particular by Dalí in the years to follow, his painting was extremely meticulous, capable of expressing the most aggressive fantasies. With Bjerke-Petersen, he produced the first periodicals (*Linien* and *Konkretion*) of the Scandinavian surrealist nucleus, and they did not shy from shocking the public: in 1937 the police closed down an exhibition of Freddie's work, confiscating three works deemed pornographic and entrusting them to the museum of criminology in Copenhagen (where they would remain for twenty-six years). In 1942, Freddie fled to Sweden after threats from local Nazis and stayed there for eight years, influencing Max Walter Svanberg and the imaginists. After his return to Denmark, his painting evolved: bodies became more geometrical, and far from detracting from the eroticism that remained central to his work, this seemed to enhance its impact and gave it a totemic richness. Even when it was close to abstraction, Freddie's painting retained an incandescent lyricism.

FUKUZAWA, ICHIRO
1898, Gunma

Japanese artist. Fukuzawa went to France in 1924 after studying literature and sculpture. He was principally interested in the Renaissance and early Flemish artists. At the end of the 1920s, he came under the influence of Ernst and De Chirico; the canvases that he sent in 1929 to the Salon Nika were surrealist, as were his collages in the years that followed. Back in Japan in 1931, he emphasized the satirical or critical aspect of his irrational montages of images. In 1939, he founded the Bijutsu Bunka Kyokai (Art and Culture Association), in which artists linked to surrealism came together to work for the development of surrealism in Japan. Suspected of having procommunist sympathies, Fukuzawa, like Takiguchi, was arrested in 1941. After the war, he worked for the democratization of the art world in Japan, producing artwork that symbolically denounced the chaos of the era. After 1952 he would travel to Latin America, Europe, and the United States. In his later paintings, he explored the theme of Hell, as well as Japanese myths.

GASCOYNE, DAVID
1916, London

English poet and one of the founders, along with Roland Penrose, of the London group. In 1935, Gascoyne published "Premier manifeste anglais du surréalisme" in *Cahiers d'art,* and his essay, *A Short Survey of Surrealism,* had a notable impact on the movement's expansion in Britain. The following year, he took part in the organization of the London exhibition and studied dialectical materialism, but his time as a fellow traveler of the Communist Party—which he reproached for an absence of metaphysics—was short-lived. His years in Paris were difficult, something he related in his journal; he then departed to fight in the Spanish Civil War. Upon his return he would view his own imbalance as an authentic form of grace: the echo of the world's chaos within the individual. A translator of Breton, Benjamin Péret, and Pierre-Jean Jouve, the majority of his own poetry (*Hölderlin's Madness, Miserere, Metaphysical Poems*) was written before 1942. A nomad who lived by his wits, during the war he become increasingly addicted to amphetamines. Expeled from the British group in 1947 for mysticism, Gascoyne grew more and more depressed and was interned on a number of occasions. In 1964, he settled on the Isle of Wight and gained a late recognition as a *poète maudit,* something he objected to.

(See M. Rémy, *David Gascoyne ou l'urgence de l'inexprimé* [Nancy: Presses Universitaires, 1984].)

GENGENBACH, ERNEST
1903–79, Gruey-lès-Surance/Chateauneuf en Thymerais

French writer. Gengenbach initially studied for the priesthood, but the beginnings of an idyll with an artist brought about his expulsion from the religious institution where he was completing his education after the seminary. Upon discovering surrealism, he sent an autobiographical letter to *La Révolution surréaliste,* where it was published in October 1925. He began to frequent the group at that point, while continuing to experience a religious conflict that briefly brought him closer to Jacques Maritain. In April 1927, he gave a lecture, introduced by Breton, on "Satan in Paris" and then

published a book on the same theme. His later years would be divided between multiple spiritual retreats, moments where he disappeared from public life, and periods of amorous exaltation. In 1938 he published a short volume, *Surréalisme et christianisme,* in which he tried to prove a convergence between the two ways of seeing. He reestablished his links with Breton for a few months in 1946 and three years later brought out his main work, *L'Expérience démoniaque,* which constitutes, even more so than did *Judas ou le vampire surréaliste,* which was published the same year, a "fictionalized fantasmo-biography." In it, Gengenbach tells the story of his successive crises of conscience; it includes his abundant correspondence with a great variety of people and announces, with his renunciation of the "Luciferian religion" his evolution toward a mystic love for the Virgin Mary, in whom he could sublimate the mad love conceived for Eternal Woman.

(J. Decottignies, "La Vie poétique d'Ernest de Gengenbach," *Revue des sciences humaines,* no. 193 [January–March 1984].)

GÉRARD, FRANCIS (PSEUDONYM OF GÉRARD ROSENTHAL)

1904, Paris

Gérard began as one of the editors of the periodical *L'Œuf dur* (spring 1921–summer 1924), along with Mathias Lübeck, Pierre Naville, Maurice David, and Georges Duvau. When this group split up, Gérard, Lübeck, and Naville joined the surrealist group. Secretary at the bureau, Gérard published a few texts in *La Révolution surréaliste,* but after his military service in 1925, he did not return to the group, preferring, like Naville, to engage in political action. In 1927, he published *Les Dragons de la vertu* (Paris: Éditions du Sagittaire), a text written two years earlier that sought to determine the most open dimensions of thought; Gérard was particularly interested in works of art as "concrete representations of the postures of invention." That same year, he went to Moscow with Naville and met Trotsky, with whom he would collaborate for the next twelve years (see G. Rosenthal, *Avocat de Trotski* [Paris: Laffont, 1975]). It was thus through this struggle against Stalinism that Gérard later developed closer links with surrealism again, at the Committee of Inquiry into the Moscow trials in 1936, within the FIARI in 1939, and on the Truth Commission investigating Stalin's crimes after the war.

GERBER, THÉO

1928, Oberhofen-am-Thunersee

Swiss painter. In his early years, Gerber made use of figurative elements or evocations of nature in a nonfigurative context: he held that the two sides of the imagination, far from being in contradiction, must exalt each other by exacerbating their differences. In the late 1960s, the colored background of his compositions was determined by purely subjective means, while allusions to nature evolved into an increasingly rhythmic organization of ample movement. This did not prevent him from using fragments of images: in the foreground of *Tout étonné, S. Dalí découvre que son tableau s'est transformé* (1975), a portrait of Dalí, looking right at the viewer, emerges against shapes subjected to a metamorphosis that causes the very structure of the composition to seem threatened. Gerber displays an extraordinary ease in his drawings, and his automatism does not refrain from deconstructing an initial motif, which only remains perceptible thanks to the fragile equilibrium established between the sovereignty of the line and the subjective value that attaches to the motif, perhaps less chosen by the artist himself than mysteriously imposed on him.

GHEZ, GILLES

1945, Paris

French artist. Ghez was first noted for his boxes, in the early 1960s, which attracted the attention of the last Paris group. Within the boxes are set miniature figures and decors that he designs and paints himself, thus creating an inner theater that unveils the successive episodes of a sort of autobiography where the imagination plays the leading role. References to certain Hollywood films go hand in hand with an overt dandyism, in allusions to both texts (Raymond Roussel) and places, familiar or not (from Naples to the India of *The Lives of a Bengal Lancer,* more a fantasy than a reality). The glass on each box—which are also reliquaries—is revealing, yet holds indiscretion at a distance: Ghez transfers his own adventures onto an outrageously British double, Lord Dartwood, in such a way that any open confession becomes a labyrinthine trap where true and false, experience and imagination are indissociable. When one is so easily led astray, the only certainty is that of the poetry emanating from the most hermetic anecdotes.

GIACOMETTI, ALBERTO

1901–66, Stampa, Switzerland/Paris

Swiss painter and sculptor. At the age of thirteen, Giacometti sculpted his first bust from life. After studying classical art in Geneva, he came to Paris in 1922 and for three years frequented Antoine Bourdelle's studio, creating a few works that testified to his knowledge of cubism and Cycladic or primitive art. He also worked on hollowed-out shapes, which gave him a distance from the model. His encounters with André Masson, Michel Leiris, and Robert Desnos brought him closer to surrealism. After exhibiting in 1930 with Miró and Jean Arp, Giacometti met Aragon and Breton and collaborated with the group, for whom his contribution was of prime importance. Until 1935, his object-sculptures were based on semiorganic shapes, with a strong sexual connotation (*Cage* [1932]) or an extreme cruelty (*Femme égorgée* [1932]). He perfected the first "object with a symbolic functioning" with *La Boule suspendue* (1930–31), worked on "sculptures which rendered themselves fully formed to [my] mind," and integrated "found" objects (such as the mask that completed *L'Objet invisible* from 1934–35, which Breton commented on in *L'Amour fou*) into full-fledged sculptures (*Table surréaliste* [1935]). In 1948, Giacometti would look back and consider that this creativity had been headed "in fairly divergent directions," but it was when he realized that the people sitting next to him in a cinema made up "a completely unknown spectacle" that he abruptly changed course in 1935 to apply all his efforts to defining "reality" in his sculpture, drawing, and painting. Three years later, the *Dictionnaire abrégé du surréalisme* would qualify Giacometti as a "former surrealist sculptor," and his work—exclusively devoted, until the end of his life, to capturing the nascent visual impression of bodies and heads—indeed no longer had anything in common with the beliefs

of the movement. Although Giacometti remained friends with Michel Leiris and Georges Limbour, who would write about his creative process, only his earlier works would be displayed in group exhibitions. There are indeed hardly any similarities between the aggressive *Pointe à l'œil* from 1931 and the emaciated silhouettes that he relentlessly reworked until they measured only a few inches high—unless one is to conclude that with these figures Giacometti was actually seeking an invisible reality that could be a basis for everything.

GILBERT-LECOMTE, ROGER
1907–43, Rheims/Paris

The leading figure, with Daumal, in the Grand Jeu and its journal (three issues from June 1928 to October 1930). Since his adolescence, Gilbert-Lecomte had been in search of an alternative existence that would be both poetical and metaphysical. This quest was not unlike that of surrealism, but there could be no fundamental agreement between the two groups. Each was equally concerned for its autonomy, and the failure of the meeting in March 1929 would lead Gilbert-Lecomte to denounce what he called Breton's "machiavellianism." The Grand Jeu itself would not last beyond the end of 1932. The following year, Gilbert-Lecomte joined the AEAR The increasing material difficulties of his life led Gilbert-Lecomte to drug addiction, and hounded by a nostalgia for the womb, he wrote little, but his collection *La Vie l'amour la mort le vide* (1934) earned the admiration of Artaud. It was not until the 1970s that his *Œuvres complètes* were compiled (vol. 1, *Proses;* vol. 2, *Poésies* [Paris: Gallimard, 1974–77).

GIOVANNA (PSEUDONYM OF ANNA VOGGI)
1934, Reggio Emilia

Giovanna was the inspiration behind the two spectacles written by her companion Jean-Michel Coutier (*La Carte absolue* [1965]; *La Crête de l'incendie* [1967]), which marked their arrival in the surrealist group. She experimented with automatism in the most unexpected ways: typewriter drawings with which she created a sort of bestiary, recourse to her passion for crosswords to generate shapes, strokes of sinuous lines defining interwoven spaces—all are to be found in her painting, where a strong use of cutouts goes hand in hand with the highly improbable nature of the structures or an apparent diffusion of color. Under her real name, she published texts (*William Blake, "Innocence and Experience"* [1976]) in which irreverence and unbridled humor coexist superbly.

GOEMANS, CAMILLE
1900–1960, Louvain/Brussels

In 1922, Goemans came onto the scene in the periodical *Le Disque vert,* the publishing house for which also brought out his first collection, *Périples,* in 1924, the year he founded *Correspondance* together with Paul Nougé. He wrote pamphlets number 2, 5, 8, 10, 14, 17, 20, and 22, devoted respectively to Paul Éluard, Marcel Proust, Philippe Soupault, Louis Aragon, Valery-Nicolas Larbaud, Éluard again, Marcel Arland, and André Gide; each used quotations from the author and was an "extension" of that author but in the periodical's particular style. In 1925, Goemans was in Paris, where he soon opened his own gallery on the rue de Seine. He signed contracts with Jean Arp, Salvador Dalí (whom he presented in Belgium in 1929), René Magritte, and Yves Tanguy, and it would be on these premises that the exhibition of collages prefaced by Aragon was held in 1930 ("La Peinture au défi"). In 1928, again with Nougé, Goemans founded *Distances* in Brussels. After his return to Brussels in 1930, he held several official positions (in tourism and public relations), and although he later stated that he had "left the group in around 1930," he nevertheless continued to be involved with art, opening galleries in Brussels in 1942 and in Antwerp in 1946, and publishing a few texts. His *Œuvres, 1922-1957,* was compiled with great care by Marcel Mariën (Brussels: André de Rache, 1970).

GOETZ, HENRI
1909–89, New York/Nice

French painter and printmaker. Goetz arrived in Paris in 1930 and created his first nonfigurative work in 1935: Richard Oelze told him about Dalí. With his wife Christine Boumeester, he contacted the surrealist group through their neighbors Mary Low and Juan Brea. He grew close to Oscar Dominguez and Benjamin Péret, then met Breton, who was very interested in the transformations he wrought on reproductions of ancient works. He then collaborated on La Main à Plume and, as a refugee in the south of France, would spend time with Francis Picabia. In 1947, he was one of the exhibitors at the *International Exhibition of Surrealism,* then joined the Rixes group with his wife. His work, both in painting and in printmaking (at the end of the 1960s he would invent carborundum engraving), gradually evolved into a personal version of "lyrical abstraction," but he acknowledged the ongoing presence in his work, even when his initially "visceral" forms became sharper, of a "surrealist climate."

GOUTIER, JEAN-MICHEL
1935, Montreal

French poet. Goutier met Radovan Ivsic while he was director of a theater group and, soon thereafter, joined in the activities of the surrealist group. In 1965, together with Giovanna, he produced the spectacle *La Carte absolue,* initially planned for the *L'Écart absolu* exhibition. Two years later, they would mount *La Crête de l'incendie* for the exhibition *La Fureur Poétique.* In collaboration with the publisher François Di Dio, he edited the series Cahiers noirs du soleil, then the series Le récipiendaire, in which he published collections by Jean Schuster, José Pierre, and Jean-Claude Biraben; he also wrote *Chanson de geste* and organized the collective *Discours.* Editor of a collective work on Benjamin Péret (1982) and Breton's artwork (*Je vois, j'imagine* [1991]), where his own work was concerned, Goutier did not go any further than to produce private editions of his poetry (*Pacifique que ça!* [1995]).

GRACQ, JULIEN
(PSEUDONYM OF LOUIS POIRIER)
1910, Saint-Florent-le-Vieil

French writer. Gracq's first novel, *Au château d'Argol* (1938) was hailed by Breton as assuring the confluence of German romanticism and surrealism. He maintained friendly relations with the surrealist group but, from 1947 on, above all with Breton himself (to whom

he devoted a study in 1948). It was primarily because of the political positions voiced in *La Littérature à l'estomac* (1950), in which he violently attacked the mores of the literary "milieu," and his subsequent refusal of the Prix Goncourt for *Le Rivage des Syrtes,* that his reputation as a "surrealist novelist" was established. Although he contributed to a number of the periodicals, he remained fairly indifferent to group activities and had no intention of mixing his strictly literary concerns with political issues. Thus his solid espousal of a number of the movement's values can be found, above all, in the themes of his work: a transfiguration of "reality" through the mastery of his refined writing; the definition of an imperative "quest" for meaning; meticulous attention to the conjunction of places and people; a taste for the "fantastic" inherited from the German writer Jean Paul and from some of Balzac's stories. Independently of his novels, Gracq also wrote poems in prose (*Liberté grande* [1947–69]) and reveries about his childhood, about places, and about other texts (*En lisant, en écrivant* [1980]; *La Forme d'une ville* [1985]), which showed that he also shared some of Breton's essential beliefs.
(S. Grossman, *Julien Gracq et le surréalisme* [Paris: Corti, 1980].)

GRANELL, EUGENIO F.
1912–86, La Coruna/Madrid

Spanish painter. After running the newspaper of the Partido Obrero de Unificación Marxista militia, Granell went into exile in 1939 following Franco's victory, and during the Second World War he played an important role in making surrealism known in Latin America, particularly in the Dominican Republic, Guatemala, and Puerto Rico. He then went to Los Angeles and New York (1957), and only returned to Spain in 1985. His painting used a great variety of stylistic effects, and during the last twenty years of his life, Granell devoted himself to a fantastical rediscovery of the figures and myths of Spain's Golden Century.

GRAVEROL, JANE
1905–84, Ixelles/Fontainebleau

A painter of French origin, Graverol was closely linked to the development of surrealism in Belgium. After traditional education, she began to exhibit in 1927. She would progressively consider her canvases to be "waking, conscious dreams," and her encounters after the war with Magritte, Louis Scutenaire, and Paul Nougé, then Marcel Mariën, with whom she collaborated on the periodical *Les Lèvres nues,* merely reconfirmed her in her beliefs. Her painting *La Goutte d'eau* is a collective portrait of the Belgian surrealists. During the last twenty years of her life, she was Gaston Ferdière's companion, and she offered an original, dreamy version of "feminine sensibility" in painting, served by a figurative technique that was both precise and cold.

HAMOIR, IRÈNE
1906–94, Brussels

Belgian writer. As an adolescent, Hamoir was already militant in the Young Socialist Guards. Then in 1928, she met the Brussels surrealists (she would later portray them in rough outline as hooligans in her novel *Boulevard Jacqmain* [1953]; reprinted in 1996 by the Éditions Devillez). She became Scutenaire's companion in the early 1930s and engaged in the activities of the Brussels group. Her poems and tales, highly fantastical, were first collected in 1949 in a thin volume with a print run of 200 copies under the pseudonym Irine; in 1976, the collection *Corne de brune* featured her contributions to periodicals and collective works, as well as the prefaces she wrote for her friends: this volume would enable one to better appreciate her humor. Before her death, she bequeathed the works by Magritte from the Scutenaire collection (twenty-three canvases, thrity-one drawings, and so on) to the Brussels museum.

HANTAÏ, SIMON
1922, Bia, Hungary

Painter of Hungarian origin. Hantaï settled in Paris in 1949 and came into contact with the surrealist group three years later. His work was immediately welcomed for its affinity with the movement's beliefs. It abounded in a wealth of disquieting but fascinating creatures that came to life through collages (bones, animal skulls) superimposed on surfaces worked in varying thicknesses, according to the technique of grattage. This figurative painting made use of a hybrid combination of genres that seemed to be motivated by mythological concerns. Following his discovery of Jackson Pollock, however, Hantaï gradually abandoned this technique and grew closer to Georges Mathieu. His views turned reactionary, and he was violently attacked in the pamphlet *Coup de semonce.* Later, what remained of automatism in his work—and that would influence French analytical abstraction—no longer had anything to do with the functioning of thought and was based more on a physical labor of folding and unfolding the work's support in such a way that the painting materialized all by itself.

HARE, DAVID
1917, New York

American artist. Although he had no particular technical instruction, in 1941 Hare began to produce "heated" photographs (exhibited in 1944 at the Art of This Century Gallery). As editor-in-chief of *VVV,* he spent time with the exiled surrealists in New York and took up sculpture, participating all the while in the meetings led by Robert Motherwell. The influence of Max Ernst and Roberto Matta would progressively give way to his interest in Native American art, but Hare preserved his aggressive humor. With Frederick Kiesler he designed a totem for the Superstition Room at the 1947 *International Exhibition,* in which Jacqueline Lamba, who had become his wife, also took part. Hare then took up painting and collage, displaying the same poetic spirit that transformed naturalist shapes into less probable configurations, richer in ambiguity.

HARFAUX, ARTHUR
1906–95, Cambrai

Artist and photographer. Harfaux joined his fellow disciple from the Lycée de Cambrai, Maurice Henry, in the Grand Jeu from the very beginnings of the Rheims group (December 1927); he provided illustrations for its periodical with drawings and photomontages. He would be responsible for the most important photographic record of the members of the Grand Jeu; in 1929, he was present at the group's first exhibition at the Galerie Bonaparte. Three years later,

he distanced himself from them and moved closer to surrealism. Again with Maurice Henry, Harfaux worked on the irrational knowledge of objects (*Le Surréalisme ASDLR,* no. 6) but later limited his activities to signing a few collective declarations.

HAYTER, STANLEY WILLIAM
1901–88, London/Paris

Painter and printmaker. Hayter initially studied organic chemistry and geology (traces of which can be found in his prints) and began to frequent the surrealists in 1926. Very soon his printmaking studio (17, rue Campagne-Première) became a learning and production center for artists of the group. In the 1930s, Hayter himself created canvases situated somewhere between an allusively organic abstractionism and an automatism that yielded particularly sharp lines. He illustrated his friends' collections (*Apocalypse* by Georges Hugnet [1932]) and designed a few objects (*Victoire ailée* [1936]). His research into space prefigured that of Roberto Matta and Gordon Onslow-Ford, whom he met in New York, where he exiled himself in 1940 and where he would continue to operate his "Studio 17." His penchant for abstraction progressively won over in his painting, and after the Second World War and his return to France he turned to a geometric use of surfaces that distanced him from the surrealists, although the vigor of his palette still seemed determined by a reference to the irrational or to desire rather than by any purely artistic concerns.

HEINE, MAURICE
1884–1940, Paris/Vernouillet

Heine initially studied medicine, then became a journalist, pursuing all the while his interest in the printing trade (a domain in which he would win a gold medal at the Exposition des Arts Décoratifs in 1925, before he became an adviser to the art dealer Ambroise Vollard). In 1919, he joined the Socialist Party and collaborated on *L'Humanité* after the congress in Tours; Heine was viewed as too "liberal," however, and was excluded from the Central Committee of the Communist Party in 1923. His first book, *La Mort posthume,* was published in 1917 in Mâcon; it was during the 1920s that he first developed his passionate interest in Sade and begin to edit his texts. In 1926, Heine published a *Recueil de confessions et observations psycho-sexuelles tirées de la littérature médicale* (Collection of psycho-sexual confessions and observations from medical literature [Paris: Éditions Crès; reprint, Paris: Terrain Vague, 1957]). When he met the surrealists in 1930, he brought along his scrupulous passion for Sade and considerably enriched the group's knowledge about the marquis, although he did not publish the results of his biographical research during his lifetime (this would fall to his spiritual successor, Gilbert Lély). Heine also contributed pieces about his favorite author to *Le Surréalisme au service de la révolution,* to *Minotaure,* and to the periodical of "medical humanism," *Hippocrate.* He was among the founders of the Contre-Attaque movement and signed the group's pamphlets up until the war.

HÉNEIN, GEORGES
1914–73, Cairo/Paris

French-speaking Egyptian writer. Hénein discovered surrealism in 1934 while he was a student in Paris. Back in Cairo, he founded the group Art and Freedom, which contested accepted values; the group continued its activities after the war through the Éditions La Part du Sable, whose journals (two issues) published René Char, Henri Michaux, Ghérasim Luca, Henri Pastoureau, and others. In 1944, Hénein organized the Egyptian section of the Fourth International and was a Trotskyist militant until 1948. Upon his return to Paris, he was in charge of Cause together with Sarane Alexandrian and Henri Pastoureau. In 1950, he left the group, although he remained anti-Stalinist and anti-Christian and contributed to a number of marginally surrealist periodicals (*Rixes* and *Phases,* in particular). Hénein wrote over a dozen works, among them *Déraison d'être* (Paris: Corti, 1938), and *Qui êtes-vous, Monsieur Aragon?* (Cairo: Masses, 1945); unpublished works were collected in *La Force de saluer* (Paris: Éditions de la Différence, 1978), and his short stories appeared in a volume entitled *Notes sur un pays inutile* (reprinted by Le Tout sur le Tout, 1982).

(Sarane Alexandrian, *Georges Hénein* [Paris: Seghers, 1981].)

HENRY, MAURICE
1907–84, Cambrai/Milan

Henry joined the Grand Jeu movement in 1926 and published texts and drawings in the group's periodical, while pursuing his early career as a journalist. He began to participate in surrealist events in 1933 (and would not leave until 1951, after the Carrouges Affair). In 1936, he exhibited his object *Hommage à Paganini.* Although he created humorous drawings to make a living (he is alleged to have produced over 25,000 for the most diverse publications), Henry injected a virulent nonconformism into his humor, which was deliberately black; Breton found in Henry's work "the surrealist idea-image in all its original freshness." His texts (*L'Adorable cauchemar*) were proof of the same penchant for disquieting yet irrefutable absurdity found in his graphic works (*Les Métamorphoses du vide* [Paris: Éditions de Minuit, 1955]; *Hors mesure* [Paris: Éditions Losfeld, 1969]). Henry retired to Italy in his latter years (it was in Milan in 1972 that he published an *Anthologie du dessin surréaliste*) and developed a style in his painting still governed by a disturbing malaise (see his *L'Humeur du jour* [Paris: Éditions G. Fall, 1979]).

HÉROLD, JACQUES
1910–87, Piatra/Paris

Painter of Romanian origin. Hérold studied painting at the Fine Arts School in Bucharest and came into contact with the young poets (Ilarie Voronca) of the periodical *Unu,* who were fascinated, as he was, by what was happening in Paris. Hérold went to Paris in 1930, and his first years were difficult. He survived thanks to odd jobs (dishwasher, restaurant bellboy, and factotum for Constantin Brancusi, with whom his relations became quite strained but who enabled him to meet Marcel Duchamp and Robert Desnos, e.g.). In 1934, Yves Tanguy introduced Hérold into the surrealist group, but he did not feel an immediate sense of belonging. Marked by childhood experiences that he would reveal in his *Maltraité de peinture* (first edition in 1957), he sought to convey through his art at that time the secret structure of reality, by "stripping bare" every form. This "stripping" would be followed by a "crystallization," the beginnings of which coincided roughly with, by 1938, his full participa-

tion in the group. In 1940, he took part, in Marseille, in the design of the surrealist playing cards, then he sought refuge in the Lubéron, near Sade's château, and continued his efforts, through crystalline forms, to restructure appearances capable of alluding to physical phenomena as well as to mental processes. In 1947, for the *International Exhibition* at the Galerie Maeght, Hérold created the Altar of the Great Transparencies. In 1951, he officially left the group subsequent to the Carrouges Affair, but this did not change his concept of art in any way. Gradually, however, his sparkling style grew lighter, and his painting turned to more serene, if not evanescent, inner landscapes. He provided the drawings and prints to illustrate a number of his poet friends' collections.

HILSUM, RENÉ
1895-1990, Paris

Publisher. A fellow student of André Breton and Théodore Fraenkel's at the Lycée Chaptal and, already passionately interested in poetry in 1913, Hilsum founded a little periodical, *Vers l'idéal,* which ran for only one issue (and where Breton, using the pseudonym René Dobrant, published his first poem). He came across Breton and Fraenkel again at Val-de-Grâce. After the war, Hilsum founded the Éditions Au Sans Pareil at the rue du Cherche-Midi. (The name was selected in order to ridicule hardware and haberdashery shops.) Hilsum became the primary distributor of Dadaist publications in France in his bookshop on the avenue Kléber, where exhibitions were also held (Francis Picabia, e.g.). In 1920, however, he had a falling out with Breton, and only continued to see Louis Aragon and Philippe Soupault; this was due to not only his interest in Blaise Cendrars but also for political reasons. Having joined the Communist Party after the congress at Tours, Hilsum would not publish the surrealists—with a few notable exceptions, such as Paul Éluard.
(P. Fouché, *Au Sans Pareil* [Paris: IMEC, 1989]; S. Faucherau, J. Ristat, and É Ruiz, "Conversation avec René Hilsum," *Digraphe,* no. 30 [June 1983].)

HOLTEN, RAGNAR VON
1934, Gleiwitz, Germany

Swedish writer and artist. In 1960, Holten published a work on Gustave Moreau (Paris: Pauvert) and came into contact with the Parisian surrealist group. In 1969, he published his book *Surrealism i Svensk Konst,* and the following year, he was among the designers of the exhibition *Surrealism?* in Stockholm. He practiced collage and frottage, developing a style in painting in which borrowed figurative elements inhabit backgrounds that are almost monochrome or are animated by an undulating movement of undeniable fantasy. This fantasy can also be found in his montages of objects, in which discreet irony often yields to frank sarcasm. In using perfectly recognizable debris, von Holten gives it a more disturbing existence, full of apparently arbitrary connections that only reveal their perverse necessity to those viewers who are willing to abandon their ordinary frame of reference.

HOOREMAN, PAUL
1903–77, Brussels/Uccle

Belgian poet and musician. In 1925 Hooreman published a small volume entitled *Lieux communs* and cofounded, together with André Souris and as a counterpart to Paul Nougé's *Correspondance,* the series *Musique* (two issues, the first of which was a tribute to Erik Satie, who had recently died). Hooreman spent quite a bit of time with the Brussels group from the beginning, and it was again with Souris in 1926 that he altered a barrel organ so that it would play the Belgian national anthem backward. He was among those who received the survey on concerted action in 1929, and his reaction was very skeptical. Later, he was close to Magritte, suggesting titles for his works, and it was not until 1977 that he published a few late poems (*Solitude et autres textes* [Brussels: Le Vocatif]).

HUGNET, GEORGES
1906–74, Paris/Saint-Martin-de-Ré

Hugnet's childhood was spent in Argentina, then he returned to France in 1913, and his traveling thenceforth would be primarily mental. He took part in the activities of the surrealist group from 1932 to 1939, publishing poetry (*Enfances, Onan, La Septième Face du dé*), making collages that exalted the female body and creating object-bindings for a few selected texts (Bellmer's, in particular). In 1957 came his *L'Aventure Dada,* a worthy anthology. In 1962, a remark he made about Péret was construed as an insult, and Hugnet was attacked by Jean Schuster, Jehan Mayoux, and Vincent Bounoure (see the volume *De la part de Péret* [1963]). His collection of articles in *Pleins et déliés* (1972) drew severe criticism, this time from André Thirion and Eric Losfeld.

HUGO, VALENTINE (NÉE VALENTINE GROSS)
1887–1968, Boulogne-sur-Mer/Paris

Married to Jean Hugo in 1919, Valentine Hugo initially collaborated with her husband on decors and costumes for spectacles organized by Jean Cocteau. She met the surrealists in 1928 and became particularly close to René Crevel and Paul Éluard, and for a time she lived with Breton, who compared her to Leonardo's *Portrait of an Unknown Woman* (*La Belle ferronière*). She took part in the group's activities between 1930 and 1939 with exquisite corpses and objects. But she was primarily known for her drawings, where a fine line against a dark background created an abundance of decorative volutes and superimposed elements. Her portraits of the leading surrealists and her illustrations for texts by René Char and Paul Éluard and for the edition of Achim von Arnim's *Strange Tales* prefaced by Breton in 1933 are particularly interesting. After the war, she went back to stage design for choreography, while continuing to create her paintings "in secret," saving "the haunting element of surprise and chance for the end."

HYPPOLITE, HECTOR
1894–1948, Saint-Marc/Port-au-Prince

Haitian painter and voodoo priest. Born into a family of voodoo priests, Hyppolite started out as a shoemaker, then began to copy the decors of display windows onto postcards that he sold to American Marines. After a trip to Cuba, New York, and Equatorial Africa during the First World War, he settled in Saint-Marc as a house painter and occasional priest. It was not until 1945, encouraged by De Witt Peters, that he went to Port-au-Prince and devoted himself

to art; this is when Breton discovered his works at the Centre d'Art and enthusiastically recognized Hyppolite's desire to unify, by means of magical solutions, the accomplishments of Christianity and the traditions of African origin. As a result, Hyppolite came to be viewed as the founder of "naive" Haitian painting, inaugurating it with true authenticity.

IVSIC, RADOVAN
1921, Zagreb

Poet of Yugoslav origin, and the translator of André Breton and Benjamin Péret into Croatian. He has lived in Paris since 1956, contributing to *Bief,* in which he was very attentive to the incongruities of current events, to *La Brèche,* and to *L'Archibras.* After 1969, he was the driving force behind the Maintenant publishing house, where he reprinted his own *Mavena* (1972, first published in 1960 by the Éditions Surréalistes) and *Autour ou dedans* (1974). Ivsic devoted a monograph to Toyen; in 1967, she illustrated his *Le Puits dans la tour* and, the following year, his *Le Roi Gordogane.* In *Quand il n'y a pas de vent, les araignées. . .* (Paris: Éditions Contre-moule, 1990), Ivsic tired to show how Marko Ristic, like Louis Aragon in France or Vitezslav Nezval in Czechoslovakia, had actually betrayed surrealism very early on while claiming to serve it.

JEAN, MARCEL
1900–1993, La Charité-sur-Loire/Louveciennes

A student at the École des Arts Décoratifs from 1919 to 1924, Jean worked in the United States as an industrial draftsman. He took part in the activities of the surrealist group from 1932 to 1951, publishing his collection *Mourir pour la patrie* (Paris: Éditions Cahiers d'Art) in 1936 and creating *Le Spectre du Gardénia* that same year. He also produced decalcomania without preconceived objects, frottages, drawings, and paintings. Jean lived in Budapest from 1938 to 1945; there he met Arpad Mezei, with whom he published *Maldoror* (1945), an annotated editon of Lautréamont's *Œuvres complètes* (1959), and his important *Histoire de la peinture surréaliste* (1959). Jean also designed playful furnishings (domino dresser, tree drawer, etc.) and published his memoirs under the title *Au galop dans le vent* (1991).

JOANS, TED
1928, Cairo, Ill.

American painter and poet. A famous saying by Breton qualified Joans as the "only African-American surrealist"—and his biography is worth every book he happened to publish during his wanderings: he settled first in New York, taking part in beat poetry sessions and in the civil rights struggle, then he traveled to Europe (London, Berlin, Amsterdam, and Paris, where he exhibited in 1969) before going to Africa. In 1969, he recited his poetry at the Panafrican Festival of Art in Algiers, accompanied by Archie Shepp's improvisations. Writing, for Joans, is contingent on the intensity of the experience that inspires it.
(Ted Joans, *Proposition pour un manifeste black power* [Paris: Losfeld, 1969].)

JOUFFROY, ALAIN
1928, Paris

Poet, art critic, essayist, and novelist. At the age of eighteen, Jouffroy met Breton, then began to frequent the surrealist group, and published his poetry in *Néon.* Particularly close to Victor Brauner, Stanislas Rodansky, and Claude Tarnaud, he was expelled at the same time as his friends in 1948: it was both because they deplored the moral sanctions imposed on Roberto Matta at that time and because they had little enthusiasm for group activities. The fact remains that, in his later work, Jouffroy continued to uphold the group's central beliefs: independence of opinion (which allowed him to make his poetry and art known to others, something he accomplished by adhering to various freedom movements, from the American beat generation to the poets of the "Cold Manifesto" by way of Monory or Michaux); the significance of rebellion (he conceived of a "revolutionary individualism" to reconcile it with revolution); and a taste for autobiography as challenging any so-called "private" life by linking it to the sociopolitical circumstances that made it possible (*Le Roman vécu* [1978]). His poetry was illustrated by Victor Brauner, Matta, Magritte, and Jacques Hérold, among others. However, this lasting cooperation seems paradoxical, given his friendship with Louis Aragon and his claim purporting that Aragon, until the end of his life, had remained close to Breton.
(Philippe Sergeant, *Alain Jouffroy, l'instant et les mots* [Paris: Éditions de la Différence, 1986].)

KIESLER, FREDERICK J.
1896–1966, Vienna/New York

American architect and sculptor of Austrian origin. After working in Europe on stage and cinema design, Kiesler soon began to advocate "magical architecture" and provided an example of this in 1942 when he designed Peggy Guggenheim's Art of This Century Gallery: frameless canvases were suspended in the air or projected away from the wall by means of baseball bats. During the same era, he contributed to *VVV,* publishing in the second issue designs for multiuse furnishings and his "Twin Touch Test," the aim of which was, by slowly rubbing the two sides of a mesh frame embedded in the cover of the periodical with both hands, to reproduce the impression of caressing a stranger's hand. For the *International Exhibition* of the Galerie Maeght in 1947, he designed the Superstition Room in the shape of an egg. Simultaneously, Kiesler's "corealist" sculpture contained heterogeneous elements that called on the viewer to find formal or thematic associations justifying their problematic coexistence.

KLAPHECK, KONRAD
1935, Düsseldorf

German painter. Initially influenced by Max Ernst and René Magritte, in 1955 (five years before he would meet the surrealists), Klapheck discovered the mainspring of his work when, in painting a typewriter, he noticed that it aroused an emotional reaction in him. Objectivity would now coincide on the canvas with subjectivity since the typewriter "obliged one to confess one's most hidden desires and wishes" (even though the image was not realistic: the typewriters in question were subjected to a few distortions and placed in vacant surroundings that stripped them of their purpose). Painting was a form of veiled autobiography, and these psychic resonances within the work constituted an unwritten chapter on the

relations between painting and mechanization in the twentieth century: what stood for derision in Francis Picabia's work, or was only one material among many others for Max Ernst, was for Klapheck a means of self-analysis, something that the viewer, in turn, must practice by examining his or her own reactions to the canvas and to the ambiguous figures—sexed, threatening, or enticing—depicted therein.

KYROU, ADO
1924–85, Greece/Paris

Surrealist and film enthusiast: it was in this dual capacity that Kyrou wrote *Le Surréalisme au cinéma* (1952, reprinted by Ramsay in 1985) and *Amour, érotisme et cinéma* (Paris: Losfeld, 1957 and 1966), which remain entirely subjective models of criticism. Editor of the periodical *L'Âge du cinéma,* Kyrou would later work for *Positif.* Kyrou greatly admired Luis Buñuel (to whom he devoted a monograph in 1962) and, above all, the actress Louise Brooks, who for him was the definitive incarnation of woman at her most fatale and free. In 1965, he made the film *Bloko,* in which a political theme allowed him to exalt the struggle against all forms of oppression; in other films, he displayed his taste for fantasy (*La Chevelure* [1961]) and his humor (*Un honnête homme* [1965]; a work by the same title published by Terrain Vague included the postcards used to narrate the "exploits of the bandit Vampiras"). In 1966, Kyrou published an illustrated anthology called *L'Âge d'or de la carte postale* (The golden age of postcards), and in 1972 he adapted Lewis's *The Monk* to the screen.

LACOMBLEZ, JACQUES
1934, Brussels

Painter and poet. Lacomblez held his first exhibition at the age of seventeen, and his work evolved initially toward a nonfigurative painting in which one could detect "memories" of Klee or Ernst. In 1955, he became close to Édouard Jaguer and became the correspondent for *Phases* in Belgium; he then ran the periodical *Edda* (five installments between 1958—the year he met Breton—and 1965), which aimed to incorporate all the most diverse aspects of surrealism at that time. In his texts, the lyrical quality was muted. After taking part in the collective activities of the surrealist group and of Phases, in 1966 he would move on. Ten years later, his painting would again feature composite figures, the hieratic quality of which was attenuated with discreet humor.

LAGARDE, ROBERT
1928–97, Béziers/Montpellier

Artist and designer of objects. Lagarde joined the surrealist group in 1959, having already fully explored the resources of graphic automatism. He contributed to several of the group's periodicals and to *Phases,* then later to *BLS.* His undulating line, in which downstrokes and upstrokes seem to scan through space, was particularly gifted in defining forms that were not explicitly figurative, suggesting the omnipresence of a desire that permeates the animal, vegetable, and mineral kingdoms. His illustrations for Guy Cabanel's poetry (all his collections from 1961 to 1983) harmonized perfectly with the text: the meanders of language were echoed by those of the artist's pen.

LALOY, YVES
1920, Rennes

Painter. After studying to be an architect, in the 1950s, Laloy began to produce vividly colored geometric paintings, often in series. They might evoke the perspective of a utopian city or the intuitive discovery of Navajo sand paintings. In each case, imagination was invited to wander into an alluring labyrinth. Other canvases, their shapes vague as if borrowed from an underwater universe, revealed the fluid side to his rigorous art. In 1965, a composition by Laloy based on the analogy between sound and image (*Les Petits pois sont verts . . . les petits poissons rouges*) was featured on the dust jacket of the reprint of *Surréalisme et la Peinture.*

LAM, WIFREDO
(PSEUDONYM OF WIFREDO OSCAR DE LA CONCEPCION LAM YAM Y CASTILLA)
1902–82, Sagua la Grande, Cuba/Paris

Painter of Cuban origin. After his studies in Havana, Lam left for Madrid, where he pursued his interest in Bosch and Bruegel and realized the potential of introducing primitive art to European baroque. After the Spanish Civil War, where he fought on the Republican side, Lam went to Paris and met Picasso. Picasso was impressed by the synthesis Lam had already achieved between African sources and cubism and arranged to organize an exhibition of his work at Pierre Loeb's gallery. Lam's painting rapidly evolved, searching for a realm beyond formal appearances, and when he met the surrealists in 1939, they found they had much in common. The Occupation took him to Marseille, where he took part in the collective design of the playing cards, then he went with Breton to Martinique (he would illustrate the first editions of *Cahier d'un retour au pays natal* by Aimé Césaire), and finally returned to Havana. There he created the work that best defined his territory: *La Jungle* (1942–43) is a surface saturated with female figures with starlike heads and liana-like limbs, melting into an asphyxiating vegetation. Any anthropomorphological certainties emerged with difficulty from this vegetable world and would evolve toward a voodoo mythology during Lam's visit to Haiti in 1947. Horns and claws, beaks and talons now qualified his winged creatures as they shattered space like so many cries of rebellion, reviving the primeval relation of man with the secret forces of nature. This hirsute populace, alternately beneficent and threatening, inhabited not only Lam's drawings and canvases but also his sizable collection of lithographs, and it would take form in the sculptures and terra cotta works produced after the 1960s.

LAMBA, JACQUELINE
1910–93, Paris/La Rochecorbon

Once the obscure author of *Tournesol,* a premonitory poem about her meeting with Breton in 1934, Lamba became his second wife. She was a painter but also a photographer (she published plates in the first issues of the periodical *Du cinéma* in 1928) and contributed to the illustration of *Trajectoire du rêve* (1938), along with producing objects (*La Femme blonde* [1936]) and collages. In Mexico in 1938, Breton and Lamba met Trotsky (her memories of their encounters were chronicled by André Schwarz in his *Breton/Trotski*). After con-

tributing to the design of the Marseille Deck, Lamba left for the United States with Breton and their daughter Aube. It is there that Breton and she would part; if one is to believe Charles Duits, it was because she was "an artist above everything" and believed in "painting" as such. She later married David Hare, took part with him in the *International Exhibition* of 1947, and then gradually turned away from surrealism, producing paintings that evoked nature in a sufficiently allusive way to border on nonfiguration.

LEBEL, ROBERT
1904–86, Paris

Lebel had flirted with surrealism already in the 1930s, but it was during the Second World War, as an exile in New York, that he frequently visited Breton and his friends, whose interest in the primitive art of the Americas he shared. In 1943, for the publications of the periodical *Hémisphères,* he brought out *Masque à lame,* a poetry collection accompanied by Isabelle Waldberg's work. A specialist on Géricault, Lebel later became an established art historian with his *Léonard de Vinci ou la fin de l'humilité* (1952), then *Chantage de la beauté* (1955). His interest in contemporary art was clear in his *Anthologie des formes inventées* (Paris: Éditions du Cercle, 1962), a bold panorama of sculpture covering over half a century, in which a large section is devoted to surrealism and to the artists inspired by surrealism. But it was as an expert on Marcel Duchamp that Lebel's reputation was established, with a work published in 1985 (Paris: Éditions Belfond). He also wrote short stories in which humor held a nuance of discreet anxiety (*La Double vue* [1964]; *L'Oiseau caramel* [1969]; *La Saint-Charlemagne* [1971]).

LE BRUN, ANNIE
1942, Rennes

Annie Le Brun began to participate in surrealist activities in 1963, particularly during the Cerisy talks on black humor. Her collection *Sur le champ,* illustrated by Toyen, was one of the last to be published by the Éditions Surréalistes in 1967, followed by an anthology of surrealist quotations (*Les Mots font l'amour* [1970]). After the dissolution of the Paris group, she published short volumes for the Éditions Maintenant (*Les Pâles et fiévreux après-midi des villes* [1972]; *Tout près, les nomades* [1973]; *Annuaire de lune,* with illustrations by Toyen [1977]). In these texts, the abundant use of metaphor reinforces the sense of derision, and the exuberant release of words contributes effectively to an interrogation of everyday life. Sweeping aside the noir or gothic novel, *Les Châteaux de la subversion* (1982) is an in-depth analysis of the relations between the imagination and revolutionary desire. In 1978, Annie Le Brun would voice opinions violently critical of recent manifestations of feminism, and in *Lâchez tout* she condemned the reactionary, if not "Stalinist," aspects of feminism. Eager to denounce any intellectual weakness or weakening of poetry's imperative capacity for subversion, Le Brun did not hesitate to break with her former friends when they selected a text by Robert Sabatier as a preface to a volume of Benjamin Péret's complete works, and in the name of the most intransigent rigor, she chastised not only intellectuals who had become too fashionable but also the West Indian authors who had felt justified in attacking Aimé Césaire. Her interest in the Marquis de Sade

led her to write a biography in 1986 (although it would not supplant the one by Gilbert Lély) and to accept the commission for a major exhibition devoted to Sade, the *Petits et Grands Théâtres du Marquis de Sade* in 1989.

LECOMTE, MARCEL
1900–1966, Brussels

Belgian poet and writer. Lecomte was first initiated to Dada by Clément Pansaers, while he was studying philosophy and literature. He contributed to *Correspondance,* then, in 1928, to *Distances.* His texts became more and more subtly restrained, and he could pass seamlessly from the everyday to the beyond. Thus from 1922 on, Lecomte began to publish discreet little volumes (*Démonstrations* [Antwerp: Éditions Ça Ira], sometimes illustrated by his friends (Magritte, Raoul Ubac, Rachel Baes, and Pierre Alechinsky in 1948 for *Le Sens des tarots*). He also contributed, from a distance in his usual fashion, to the periodicals *L'Invention collective, Le Ciel bleu,* and *Edda.* His *Œuvres complètes* were published in 1980 (Paris: Éditions Jacques Antoine), and some of his rare texts have been collected in *Les Minutes insolites* (Cognac: Le Temps Qu'il Fait, 1981).
(M.-T. Bodart, *Marcel Lecomte* [Paris: Seghers, 1970].)

LEFRANCQ, MARCEL
1916–75, Mons

Primarily a photographer, Lefrancq took part in Rupture, then cofounded the Hainaut Surrealist Group with Achille Chavée and Fernand Dumont. His photographs often appeared in the group's publications alongside those of Raoul Ubac, and they demonstrated alternative experimental processes such as burning and solarization in their quest for unexpected and spontaneous discoveries in everyday life. After a solo exhibition at the Galerie La Boétie in Brussels in 1945, Lefrancq opened a studio, La Lanterne Magique, in his hometown and divided his time, thereafter, between earning a living and activities within the short-lived revolutionary surrealism movement and then the group Haute Nuit, which published his collection of poetry and photography, *Aux mains de la lumière,* in 1948. He also spent time with Cobra, but his growing interest in local prehistory and his collection of naive art would eventually eclipse his considerable contribution to surrealism in photography.

LEGRAND, GÉRARD
1927, Paris

Legrand met Breton in 1948 and quickly became one of the best representatives of the new generation in the group. In 1953, he published his first collection of poetry, *Des pierres de mouvance,* in which automatism alternated with lofty demands, and *Puissances du jazz,* which pointed out the possibility for a common ground between a Charlie Parker improvisation and automatic writing. (It was, moreover, one of the rare texts of the era to refer to the existence of Boris Vian's *L'Écume des jours.*) A great lover of film (he often contributed to *Positif*) and a philosopher who did not shy from bringing together in the same batch the pre-Socratics, Hegelian dialectics, and Freud, Legrand showed himself to be a demanding thinker, first in his contributions to the group's periodicals (*Bief,* which he directed, and *La Brèche*), then in his *Préface au système de l'éternité*

(1971) and *Sur Œdipe* (1972). Following the dissolution of the Paris group, he took part in *Coupure* and in the collective management of the Éditions Maintenant, before withdrawing from all group activity. In 1972, the publication of his poem *Le Retour au printemps* (Paris: Éditions du Soleil Noir), which he had begun writing twenty years earlier, demonstrated the scope of his uncompromising concept of what poetic invention could be. The close collaboration between Legrand and Breton during the preparation of *L'Art magique* and the anthology *Poésie et autre* (1960) gave Legrand's commentaries a rare relevance in *André Breton en son temps*, for example (Paris: Éditions du Soleil Noir, 1976). In 1993, he collected his first volumes of poetry and unpublished work in a book titled *L'Âge de varech, précédé de rétroviseur* (Rébus: Les Éditions du Rébus).

LEIRIS, MICHEL
1901–90, Paris/Sainte-Hillaire

French poet and writer. It was thanks to André Masson that Leiris came into contact with the surrealist group in 1924. He gained prominence for his research into language, in the tradition of Raymond Roussel, with whom he was acquainted (*Glossaire, j'y serre mes gloses* [1925]). Leiris was very attentive to the significance of dreams, as shown in *Aurora* (written in 1928 but not published until 1946). However, Leiris considered himself ill-adapted for collective activity, left the group in 1929, and began to collaborate on *Documents*. But his concern for absolute sincerity, such as that which he would later display in the successive volumes of his autobiography, and the moral rigor that would guide all of his principles, such as those regarding the Third World, for example (from China to Cuba), were a testimony to the importance of the few years he did spend with the surrealists. It was largely in order to flee not only personal problems but also society that he took part in 1931–33 in the Dakar-Djibouti expedition led by Marcel Griaule. Taken on as secretary, Leiris would learn the methods as well as the pitfalls of ethnology and returned to France with not only his scientific work but also a journal that closely combined scrupulous self-exploration with the discovery of the Other. *L'Afrique fantôme* was thus a piece of autobiography at the same time as it was one of the first examples of critical ethnology: once again, the aim was to transgress the classical opposition between subjective and objective.
(R. H. Simon, *Orphée médusé: Autobiographies de Michel Leiris* [Lausanne: L'Âge d'Homme, 1984].)

LE MARÉCHAL, JACQUES
1928, Paris

French poet and painter. Le Maréchal was raised in religious schools that he quickly found oppressive, and he turned to reading (Baudelaire, Rimbaud) and poetic writing as a form of mental survival. In 1952, he took up drawing, in which a dense and sharp style, also supremely executed in his engravings, would characterize what was most often an extremely complex and almost stifling urban space. After a stay in Algeria, Le Maréchal exhibited first in London in 1955, then Paris in 1957—canvases in which cities seem prey to a proliferation of vaguely vegetable organisms. The postapocalyptic atmosphere of his painting was counterbalanced, however, by the refinement of its execution. Although Breton hailed his attempt in 1960 to "move closer, from bark to bark, to the incandescent kernel," Le Maréchal would refrain from any collective activity and merely consented to the illustration of a few texts with his drawings (notably *La Reine des sabbath* by Belen).

LEVY, JULIEN
1906–81, New York

American art dealer. After studying to be an art historian, Levy went to Paris with Duchamp in 1927, where he discovered the works of Max Ernst. Four years later, he began to exhibit Ernst's works in the gallery he opened in New York at 602 Madison Avenue, and then came a collective event that featured Picasso, Ernst, Dalí, Duchamp, and Man Ray. The Levy gallery thus became the first place where surrealism gained a foothold in the United States, exhibiting Giacometti and Magritte, in particular. In 1936, Levy published his own work, titled *Surrealism,* and he was also Dalí's publisher (*The Conquest of the Irrational* [1936]; *The Metamorphosis of Narcissus* [1937]). It was Levy, too, who in 1939 organized Joseph Cornell's first one-man show. After the war, he showed a keen interest in certain aspects of abstract expressionism, in particular the work of Arshile Gorky, to whom he devoted a monograph. In 1976, he published his *Memoirs of an Art Gallery.*
(D. Travis, *Photographs from the Julien Levy Collection, starting with Atget* [Chicago: Art Institute of Chicago, 1977].)

LOEB, PIERRE
1897–1964, Paris

Parisian art dealer. Loeb never belonged to the surrealist group, but his interest in an art that was first and foremost emotion and spirit of adventure led him to exhibit Miró in 1925, then to organize *La Peinture Surréaliste,* thus defining a lasting basis for his work. He would show Giacometti, Max Ernst, Wifredo Lam, and Victor Brauner; and it was also at Loeb's gallery on the rue des Beaux-Arts that Antonin Artaud exhibited his drawings in 1947 and wrote his *Van Gogh, le suicidé de la société.*
(André Berne-Joffroy, *L'Aventure de Pierre Loeb* [Paris: Musée d'Art Moderne de la Ville de Paris, 1979].)

LOSFELD, ÉRIC
1912–79, Mouscron/Paris

Surrealist publisher. Losfeld practiced a number of professions before founding the Éditions Arcane in 1952, where he would publish over a hundred titles (Xavier Forneret, Benjamin Péret, Michel Carrouges). In 1955 came Le Terrain Vague (baptized by Breton, who had no idea that he was actually translating the Flemish meaning of the owner's name), where surrealist texts by Mesens, Benjamin Péret, and Gérard Legrand and the series Le désordre, edited by Jean Schuster, alternated with fantasies, comic books "for adults," essays on the cinema, and erotica (much of which was clandestine, which helped financially). He published, in succession, the periodicals *Médium, Bief, La Brèche, L'Archibras,* and *Coupure,* as well as *Positif* at a time when the surrealists were emphasizing their interest in film. Victim of many lawsuits and a finicky censorship, Losfeld eventually had to abandon his publishing ventures, and he painted his own self-portrait as an intractable libertarian in *Endetté comme une mule ou la passion d'éditer* (1979).

LÜBECK, MATHIAS
(PSEUDONYM OF ROBERT ENOCH)
1903–44, Paris/Portes-lès-Valence

Lübeck belonged to the group L'Œuf Dur, where he published abrasively humorous poetry and prose. After his military service, he joined his friends Pierre Naville and Francis Gérard in the surrealist movement, but he did not contribute to the group's periodicals; he left the movement at the time of the *Second Manifesto* and became a journalist. Arrested by the Gestapo in the suburbs of Lyons, where he happened to be merely by chance, he was shot along with a group of hostages. His *Poèmes et proses de "L'Œuf dur"* constitute his entire work, for he never took much trouble to write; his friend G. Rosenthal wrote a preface for the book in 1963 (Paris: Julliard).

LUCA, GHERASIM
1913–95, Bucharest/Paris

Poet, artist, and creator of collages, which he called "cubomania." Gherasim Luca initially contributed to a good number of avant-garde periodicals in Romania. He stayed in Paris before the war (exhibiting at the Surindépendants in 1938), and after his return to Bucharest, he formed a surrealist group in 1944, along with Dolfi Trost, Gellu Naum, Paul Paun, and V. Teodorescu. They brought their publications out under the label Infra-Black, and in his own work, Luca endeavored to push his experiments in language and his vision of the world as far as possible. This would be demonstrated by the publication, in 1945, of *Dialectique de la dialectique,* which sought to relaunch surrealism by enabling it to go beyond its own routine: Luca was wary of dreams inasmuch as he had no assurance of their prospective nature. As for language, he undertook to make it "non-Oedipal," to rid it of cultural myths and renew it through its very disjunction. By 1948, activities in Bucharest had been suppressed, and in 1952 Luca moved to Paris where he would publish, primarily for François Di Dio, various collections that were remarkably well served by the decision to make the page layout faithful to the works' intentions: *Héros limite* (1953), *Le Chant de la carpe* (1973), and *Paralipomènes* (1977). At the same time Luca gave public recitals that informed the audience of his quest to render text in a newborn state, free from all mental habits. After 1963, he also exhibited objects, drawings, and cubomania in various galleries. The indifference of the wider audience probably had something to do with his suicide, despite the republication of his collections and new editions of unpublished works in French by the Édtions Corti (*L'Inventeur de l'amour* [1994]; *La Voici la voie silanxieuse* [1996]).

MAAR, DORA
1907–97, Paris

Photographer and painter. Maar spent her childhood in Argentina, then studied with André Lhote in 1925 while working as a model for a number of photographers, including Man Ray. From 1931 to 1934, she had a photography studio in Neuilly and produced a number of reportages and publicity work. A close friend of Bataille's, she would join Contre-Attaque and contributed to surrealist activities with her photographs of frighteningly distorted architectural elements. In 1935, Éluard introduced her to Picasso, and she became his companion and muse, taking his picture in the studio at the Grands Augustins, tracking the successive stages of *Guernica,* and later acting as model for the *Monument à Apollinaire.* They drifted apart in 1943–44, and Dora Maar exhibited her first canvases at the Jeanne Bucher gallery. The final break with Picasso precipitated a nervous breakdown and exacerbated her mystical tendencies. After a brief internment at Sainte-Anne, she went into treatment with Lacan and continued her pictorial work, quickly rejecting any of Picasso's influence. In her landscapes, fragments of reality are transformed by emotional demands, and during the 1950s, it would seem that her composition and palette were determined, above all, by a reverie tinged with automatism.

(Édouard Jaguer, Dora Maar: *Œuvres anciennes: Exposition du 10 au 27 juillet 1990* [Paris, Galerie 1900-2000, 1990].)

MABILLE, PIERRE
1904–52, Paris

Physician and writer. Mabille turned to surrealism in 1934 and was a regular contributor to *Minotaure,* with articles devoted to popular prejudices, symbolism, and mirrors. In 1937, he became interested in the mystical neurosis of Thérèse de Lisieux, and the following year he published *Egrégore, ou la vie des civilisations,* an ambitious synthesis that sought to determine the cycles into which one could insert "Permanent Human Rebellion." In Haiti in 1945 he introduced Breton to voodoo, the magical side of the marvelous that he had described in *Le Miroir du merveilleux* (1940; with a preface by Breton): "The marvelous finds its origins in the permanent conflict opposing the desires of the heart with the means available to satisfy those desires." During the war, Mabille perfected his famous "village test." He later contributed to a number of periodicals, including *Néon.* In 1981, some of his articles were collected, somewhat haphazardly, in *Traversées de nuit* and *Messages de l'étranger* (Paris: Éditions Plasma), and his essays on painting were published in *Conscience lumineuse, conscience picturale* (Paris: Corti, 1989).

(See R. Laville, *Pierre Mabille: Un compagnon du surréalisme* [Clermont-Ferrand: Université de Lettres et Science Humaines, 1983]; "Pierre Mabille ou la route vers l'Âge d'Homme," *Mélusine,* no. 8.)

MAGRITTE, RENÉ
1898–1967, Lessines/Brussels

Belgian painter. Magritte studied briefly at the Beaux-Arts in Brussels, had a passing flirtation with nonfigurative art (along with Servranckx), but then discovered De Chirico through reproductions and Max Ernst's illustrations. Henceforth his path was clear: once he had met Paul Nougé, Marcel Lecomte, Camille Goemans, and E. L. T. Mesens, and while still working for a firm where he designed wallpaper projects, he began to contribute to the Brussels group's first publications. Very quickly, Magritte's paintings began to stage recurrent figures in a deliberately "anonymous" style that he would perfect over the next few years: jockeys, bowling pins, trees, musical instruments, curtains, faux wooden surfaces, and other elements, which actually constituted a mental game to which he felt his painting must be devoted. In 1927, he was staying in the outskirts of Paris and spent some time with the group but did not enjoy it very much (nor did he speak much at the meetings). At the end of his stay, he published his program "Les Mots et les images" in the twelfth issue

of *La Révolution surréaliste,* indicating the different treatments he would now impose on his motifs as well as on language, as ordered by the figurative elements: a disjunction between shapes and materials (stone clouds or a sailboat made of seawater) or between a word and the thing it normally designates (*La Trahison des images* or "Ceci n'est pas une pipe"); dissimulation of one thing behind another; modification of the apparent substance (musical instruments in flames); play on transparencies and motifs (*La Condition humaine* [1933]). All of these discrete methods (described in detail in *L'Art de la ressemblance* in 1961) were totally counter to any use of automatism (something the Brussels group mistrusted in any case) and engendered figures placed in abnormal situations amid disturbing decors, as well as grafts between the different kingdoms of nature, which depicted the states of "absolute" thought or "thought whose significance remains just as unfathomable as that of the world." Painting, therefore, was of the same substance as the "mystery" of the world: to the general enigma of any presence, the painter must reply, if possible, with an even more impenetrable enigma.

With the exception of a few short trips and one more stay in France due to the invasion of Belgium, all of Magritte's career was spent in Brussels: this is where he could share his ideas in affinity with Nougé and Louis Scutenaire, from whom he often requested titles for his works. In 1945, he was behind the exhibition *Surréalisme* at the Galerie La Boétie but then failed in his attempt to launch a "full sunlight" version of surrealism (which preached a deliberately optimistic attitude toward reality). In fact, for political reasons Magritte had joined the Belgian Communist Party for the third time in 1945. For a short time his work took on an "impressionist" pose, which caused it to fade to a dangerous degree. He then went back to his earlier style, but when he was invited to mount a solo exhibition in Paris for the first time in 1948, he selected, with Scutenaire's cheerful cooperation, the works of his "période vache," in aggressively bad taste. The exhibition was a bitter failure and confirmed that it would henceforth be impossible for Magritte to abandon his particular method, which was to eradicate pictorialism, while the "vache" period had garishly exhibited it. After this escapade, Magritte would return to the patient exploration of his pictorial poetry (*La Mémoire* [1948]; *Perspective: Le Balcon de Manet* [1949]), even when this meant repeating certain images he had already used—as if the artist were bordering on self-plagiarism at times. In his last years, he found in sculpture a material way to turn his mental visions into reality, a way of resolving the contradiction between the subjective and the objective, all of which confirmed that Magritte's personal agenda, despite occasional disagreements, dovetailed perfectly with that of surrealism.

MALET, LÉO
1909–96, Montpellier/Châtillon-sous-Bagneux

French writer. Orphaned at the age of four, Malet went to Paris in 1925 and worked at a number of odd jobs (sanitary material delivery man, newspaper boy) while frequenting anarchist circles. By chance, he discovered *La Révolution surréaliste* in the window display of the Librairie José Corti, and in it he would recognize a voice that was already his own. He took part in the group's activities during the 1930s, wrote poetry (*Ne pas voir plus loin que le bout de son sexe*

[1936]; *J'arbre comme cadavre* [1937]), invented the practice of shredding posters, and decorated one of the models for the 1938 exhibition. Held prisoner during the war, he was released for health reasons; he went on to contribute to La Main à Plume, then began to write detective stories, at first using an "American" pseudonym before inventing "Nestor Burma, ace detective," who was an investigator for several arrondissements in Paris. Although his detective stories, which made Malet the "father of the French noir novel," were scattered with allusions to surrealism and its members, the fact that he even wrote them seemed incompatible with the movement's principles, and he would eventually leave the group. His *Poèmes surréalistes* (1930–45) were collected in 1975 (Paris: Éditions A. Eibel), and his novels have had numerous reprintings since 1970.
(See *Les Cahiers du silence,* no. 2, Éditions La Marge-Kesselring, 1974.)

MALKINE, GEORGES
1898–1970, Paris

Malkine took up painting in 1920, and two years later he met Robert Desnos, who introduced him into the surrealist group. He contributed texts to *La Révolution surréaliste* and produced significant canvases (*L'Orage, La Nuit d'amour*) in which an automatism of great lyrical intensity prevailed, freed from figuration. His exhibition in 1927 was so successful that he preferred to leave Paris and began to travel, something he would do periodically, working at various jobs. In 1932, Malkine signed "L'Affaire Aragon" but then broke with the group. He became an actor, escaped from a concentration camp where he was sent for his Resistance activities, then became a proofreader at *Ce soir* (directed by Aragon), and finally settled in the United States in 1948, where he wrote his "novel," *À bord du violon de mer* (not published until 1977); he began painting again in 1950. Back in Paris in 1966, Malkine displayed the canvases he called "dwellings," which portrayed the characters (Nerval, Bach, Breton) to whom they were dedicated in a thickly textured architectural transposition.

MAN RAY
(PSEUDONYM OF EMMANUEL RUDNITSKY)
1890–1976, Philadelphia/Paris

American painter, photographer, and filmmaker. In 1911, he painted his first abstract canvas and presented vaguely cubist works at the Armory Show: from the very beginning, style was of less interest to him than the moment of invention, with all its mental excitement. He took up photography in 1915, the year he met Marcel Duchamp. Three years later, he began to use the aerograph, which enabled him to obtain photographic effects in painting. Man Ray cofounded the Société Anonyme in 1920 with Katherine Dreier and Duchamp. It was with Duchamp that he produced *New York Dada,* which did not have much of an impact. Logically enough, as soon as he arrived in Paris, Man Ray was welcomed by the future surrealists: he exhibited almost immediately at the Galerie Six, and it was then that he created his famous *Gift,* which was subsequently stolen during the opening. He worked as a photographer to make a living, experimenting with different possibilities, from the rayographs (which he perfected in 1922) to fashion photography, nudes (*Le Violon d'Ingres* [1924]), and "solarized" portraits. He also made

some short films: *Le Retour à la raison* (1923), *Emek Bakia* (1926), *L'Étoile de mer* (1928; script by Robert Desnos), and *Les Mystères du Château du Dé* (1929; filmed in the Noailles villa). He invented objects (*Objet à détruire* [1923], renamed *Objet indestructible* after its destruction) and painted whenever he felt the need, for the sake of his own astonishment; this enabled him to create a number of canvases that would leave a lasting mark on the memory of the era, be it the immense lips flying over an ordinary landscape in *À l'heure de l'observatoire, Les Amoureux* (1932–34), or the *Portrait imaginaire de D. A. F. De Sade* (1940), with its face melted into the walls of the Bastille prison. From 1940 to 1951, Man Ray lived in the United States, where he continued to explore different domains with apparent ease, never repeating his discoveries or worrying about his "career." Because the mental process behind each work was never explicit, everything he produced seemed to confirm his own words: "The least possible effort, for the greatest possible result: that is my rule." To move from least to greatest might be called inspiration or a certain state of grace.

MANSOUR, JOYCE
1928–86, Bowden/Paris

Mansour was of Egyptian origin and, as "an unknown of twenty-five," was acclaimed with her very first book, *Cris,* by Jean-Louis Bédouin in *Médium.* At that point, she joined the surrealist group, by virtue of her talent—although her beauty did fascinate a number of the members. She also contributed to *Bief,* with columns that were a sarcastic parody of the "feminine" press of the era, and her hatred of sentimentality was behind everything she sought to achieve in her successive collections of poetry and prose tales: the revelation of the indissociable nature of Eros and Thanatos. By giving free rein to her fantasies and obsessions, she produced images the rawness and violence of which were comparable only to the most scathing and immodest drawings of someone like Hans Bellmer. The way she unveiled the dark side of eroticism was always accompanied by a humor that made it more likable. Her various collections, initially illustrated by her comrades Wifredo Lam, Roberto Matta, Max Walter Svanberg, Jorge Camacho, and Pierre Alechinsky, were published in a volume *Prose et poésie* in 1991 (Arles: Actes Sud).

MARIËN, MARCEL
1920–93, Antwerp/Brussels)

A writer, Mariën was also an editor, filmmaker, photographer, and creator of collages and objects. He met Magritte when he was seventeen and immediately took part in a collective exhibition at the London Gallery. He then worked tirelessly to promote surrealism, thus giving the postwar movement in Belgium a good deal of its exuberance and singularity. Released from captivity in 1941, he founded the Éditions de l'Aiguille Aimantée, which would be followed by the Miroir Infidèle, then a number of periodicals: in *Le Ciel bleu* and *Les Lèvres nues* (1954–79), where he published series of his own texts or those by Magritte and Paul Nougé. In his "theoretical" texts (*La Chaise de sable* [1940]; *Les Corrections naturelles* [1947]), he mixed all the genres, from the private diary to more or less serious philosophical digressions in order to make people think. A great traveler (as far as China), Mariën made his living through a string of

professions and contributed to any domain where his relentless attachment to the freedom of the mind could find a foothold. His prolific artistic inventiveness was invariably abrasive and irreverent, whether he was attacking the famous names of art history by means of collages made with incongruous elements or using his distortions and photomontages to transform once innocuous images into insolent erotic machinations. His humorous rage spared no one, not even Magritte: in 1963, for example, Mariën distributed a pamphlet announcing a "major decrease" of his friend's value on the art market (Magritte took it rather badly), and in his memoirs (*Le Radeau de la mémoire* [1983]) he alleged that Magritte, "to keep the pot simmering," had, between 1942 and 1946, forged a number of Braques and Picassos. It was, however, with the utmost seriousness that in 1979 he became historiographer for *L'Aventure surréaliste en Belgique.*

MASSON, ANDRÉ
1896–1987, Balagny-sur-Thérain/Paris

French painter. Masson first studied painting in Brussels, then at the Beaux-Arts in Paris, until he was mobilized in 1914. Wounded in 1917, he was hospitalized, then interned in a psychiatric ward for insubordination. The horror of the war—as well as its unexpectedly beautiful side—would leave a lasting mark on him. In 1922, he set up a studio in Paris at 45, rue Blomet while doing odd jobs to survive. Miró was his neighbor, and he had already met Max Jacob and Daniel-Henry Kahnweiler, who would be his dealer. Masson's studio became a popular meeting place: those who dropped in included Antonin Artaud, Georges Bataille, Armand Salacrou, Jean Dubuffet, Georges Limbour, and Marcel Jouhandeau; they would listen to music and discuss Nietzsche, Dostoyevsky, Lautréamont, Rimbaud, or even Sade. Masson's literary and philosophical culture was already considerable, and it would clearly influence his work. His painting— initially a continuation of cubism to which he had added symbolic elements—would abandon its geometrical structure the moment it came into contact with surrealism and after he had already produced his first erotic drawings. During Masson's first exhibition at the Galerie Simon, Breton bought *Les Quatres éléments,* then the two men met, and the group from the rue Blomet merged with the surrealist group. In 1926–27, he produced his first "sand paintings"—a solution to the problems posed by automatism in painting. His canvases had a rare freedom of conception, producing the most unexpected metamorphoses, enhanced by an often-violent use of color.

Masson, however, could not tolerate the discipline of the group: he left and was subsequently attacked in the *Second Manifesto.* He then strengthened his ties with Bataille, with whom he worked closely while they were living in Spain. Masson produced a series of virulently anti-Franco caricatures while absorbing the desolate landscapes and telluric atmosphere. The sole illustrator of *Acéphale,* he displayed in his work a truly Dionysian spirit, attentive to the relation between Eros and Thanatos, to the secret presence of death at the heart of life. His second "surrealist period" began in 1940, when with his family he went to Marseille and took part in the creation of the collective deck of cards. With Breton, he visited Martinique, drawing and writing the pages that would later become part of *Martinique charmeuse de serpents.* He then settled in Connecticut; his painting became calmer and reached a high point with *Méditation*

sur une feuille de chêne (1942), which would influence abstract expressionism. In 1943, he broke definitively with the group. In New York, Curt Valentin published three anthologies of Masson's texts and drawings: *Mythologie de l'être* (1942), *Anatomy of My Universe* (1943; French edition in 1988 for André Dimanche), and *Nocturnal Notebook* (1944). It was also during his time in America that Masson discovered Chinese painting, from which he would, after his return to France in 1945, derive several series of works in which signs and faint touches of color were dispersed in varying intensity on transparent backgrounds. Masson later returned to his favorite themes in his canvases, drawings, prints, and sculpture: the omnipresence of sex, cruelty, and imminent death, all of which cause the work to emanate an intense graphic energy, always served by a virulent use of color—which in itself begins to seem shocking—in order to rise to the level of immoderation and excess that Masson observed in life itself. He would periodically publish his meditations on art: *Le Plaisir de peindre* (1950), *Métamorphose de l'artiste* (1956), and *La Mémoire du monde* (1974). In his *Entretiens avec G. Charbonnier* (1958; reprinted by Ryoan-Ji in 1985), he clarified his relations with the surrealist group; he reiterated his respectful distance from the group both in *Vagabond du surréalisme* (1975) and in the anthology of his texts published under the title *Le Rebelle du surréalisme* (1976).

MASSOT, PIERRE DE
1900–1969, Lyons/Paris

French writer. Massot was initially close to Francis Picabia and, through him, met Tristan Tzara and the other Dadaists. With *De Mallarmé à 391,* he became the first historian of Dada and took over from Georges Ribemont-Dessaignes as the manager of *391.* During the Soirée Cœur à Barbe (Bearded heart evening), his arm was broken when Breton struck him with a cane. He was nevertheless reconciled with Breton in 1925 and, after signing the manifesto *La Révolution d'abord et toujours!* Massot made occasional contributions to the surrealist publications. Living (poorly) from the various works he sold, he published a few slim volumes of poetry, before devoting his last work to Breton (*André Breton le septembriseur* [1967]). His poetry has been collected in *Le Déserteur: Œuvre poétique, 1923-1969* (Paris: Éditions Arfuyen, 1993).

MATTA (PSEUDONYM OF ROBERTO SEBASTIAN MATTA ECHAURREN)
1911, Santiago, Chile

Chilean artist. With a degree in architecture, Matta began work as a decorator, and when he came to France in 1933, he joined Le Corbusier's agency, then collaborated with Gropius and Moholy-Nagy in London. He met Magritte, and thanks to an article on Duchamp in *Cahiers d'art,* he envisaged the possibility of "painting change." In 1937, he took part in the production of the Spanish pavillion at the Paris exhibition and met Picasso, but it was Gordon Onslow-Ford who urged him to contact Salvador Dalí; it was thanks to Dalí that Matta entered the surrealist arena. An immediate advocate of automatism, he was quickly chosen to be included among the artists represented at the 1938 *International Exhibition*. Fascinated by Tanguy, Matta made a complex use of space to accommodate "psychological morphologies": veritable inner landscapes (in the United States, he

would call them "inscapes") enhanced by an extremely fine line that made the vaguely anthropomorphic suggestions of spots rubbed on with cloth more explicit. Early in 1940, Matta exhibited at Julien Levy's gallery and soon had met Arshile Gorky, Robert Motherwell (with whom he traveled to Mexico), and David Hare. He would have a strong influence on all of them, even though he reproached them with a lack of poetic vision. In Matta's opinion, the task of art was to reaffirm the fusion of the space within and without. After starting with a semiabstract version, he introduced a new image of the human being: *Science, conscience et patience du vitreur* (1944) was created in accordance with the myth of the Great Transparencies. "The role of the revolutionary artist," said the painter at the time, is to "rediscover new emotional relations among human beings."

In 1948, he was expelled from the surrealist group, as he was held partly responsible for Gorky's suicide. This rejection was surely painful to him, because Matta had a visceral attachment to the movement's principles. Between 1949 and 1954, he lived primarily in Rome but continued his exploration of increasingly complex images (partially interconnected cubes, incompatible perspectives), which he enlivened with totemic figures. Current political events periodically inspired him with works that were also a moral response, though they went beyond mere illustration: for example, *La Question Djamila* (on the war in Algeria [1957]) and *Burn, baby burn* (on Vietnam [1965–67]). In 1959 Matta was reincorporated into the surrealist group, and this reinforced his desire to use his art as a powerful means of protest. His work in the 1960s asserted his unflagging hostility toward anything that might place constraints on man, while in his prints, where he was particularly prolific, the relation between Eros and revolutionary desire was explored with the same grave incisiveness. Stripped of his Chilean nationality in 1974 (he sided with Salvador Allende following his election), Matta has henceforth considered himself to be "renaturalized French, Cuban, and Algerian, resident on earth."

MAYOUX, JEHAN
1904–75, Chèvres-Chatelard/Ussel

Poet. As a member of the teaching profession, he was successively schoolmaster, professor, and inspector. He joined the surrealists quite early on and was close friends with Yves Tanguy and Benjamin Péret (to whom he devoted a long article in *le surréalisme, même*). Mayoux shared Péret's uncompromising libertarian spirit: a conscientious objector, he was imprisoned in 1939, and when he signed the "Manifesto of the 121," he was removed from his functions. His poetic work is of great intensity, not only in the way he expresses love but also in his quest for the marvelous and the constant fusion he creates between what is imaginary and what is real. His work would remain little known, however, for lack of adequate distribution (his *Œuvres complètes* were published between 1976 and 1978 in Ussel by the Éditions Peralta).
(See P. Kral, "Jehan Mayoux, poète exemplaire," *Mélusine*, no. 5).

MESENS, ÉDOUARD-LÉON-THÉODORE
1903–71, Brussels

Mesens initially embarked on a musical career, having met Erik Satie when he was young. Moreover, it was while giving piano

lessons to Paul Magritte that he met his brother René, to whom he introduced Giorgio De Chirico's work. After publishing a few aphorisms in *391* and *Mécano,* together with Magritte he conceived *Œsophage* and then *Marie,* which led to the encounter with Paul Nougé and his friends and the genesis of the Brussels surrealist group. Mesens managed the Galerie L'Époque in 1927 and would exhibit Miró, Magritte, and Ernst. A close collaborator of the periodical *Variétés,* Mesens organized the memorable special issue "Le Surréalisme en 1929." In 1933, he founded the Éditions Nicolas Flamel, where he published his collection of texts and images entitled *Alphabet sourd-aveugle,* then the collective tribute to *Violette Nozières* in 1934. That same year, he helped with the production of the "Intervention surréaliste" issue of the periodical *Documents.* Two years later, Mesens, Breton, and Roland Penrose organized the London exhibition; Mesens settled in London in 1938 and would be as influential there as he had been in Brussels. Until 1940, he was a codirector of the London Gallery, which became a renowned center for surrealist events—which were also chronicled by the *London Bulletin* (twenty issues). Mesens worked for the BBC during the war and, in 1944, published with Jacques Brunius the pamphlet *Idolatry and Confusion,* followed by the collection *Messages from Nowhere* (Breton, Alfred Jarry, Brunius, Penrose, and others). After he returned to Brussels, Mesens took up his artistic activities again, sketching with colored pencils, which he also used to color his collages. In this last domain, Mesens made use of all sorts of materials: illustrations, photographs, typographical signs, reversed cutouts of shapes. These collages broke altogether with Ernst's model and assumed the fragmentation of their elements without seeking to create a new "image"; they were a parody of narration through their organization into different registers or through the introduction of musical staves, and they greatly enhanced the enigma of their own meaning. Mesens's *Poèmes, 1923–1958* were published by Losfeld in 1959, with illustrations by his fellow artist Magritte.

(Louis Scutenaire, *Mon ami Mesens* [Brussels: Louis Scutenaire, 1972].)

MILLER, LEE
1908–77, Poughkeepsie, N.Y./Muddles Green, Sussex

Photographer of American origin. She came to Paris in 1929, worked with Man Ray, was his companion until 1932, returned to New York to open her own studio, and exhibited the following year at Julien Levy's gallery. She was very close to the fashion world and returned to Paris in 1937, at which point she married a rich Egyptian. Then Miller met Roland Penrose and went to live with him in England, eventually marrying him in 1947. She worked for *Vogue* periodical and became their war correspondent, taking a picture of herself in Hitler's bathtub and providing the first images of the concentration camps. Her "surrealist period" had been brief— 1929–33—but she was a coinventor of the solarization procedure that Man Ray would use more extensively. Pretending to scorn a technique in which she was actually very interested, Lee Miller was fond of saying that to be a photographer "all one has to do is focus and press the button." Her friendship with the surrealists (she published illustrations in Lise Deharme's *Le Phare de Neuilly* and in the *London Bulletin*) and her life with Penrose meant that she accumulated a wealth of photographic documentation, be it about Max Ernst in Arizona or the meetings held at her Muddles Green home, where she also displayed her talent in the culinary arts.

(See Berenice Abbott et al., *Atelier Man Ray: Berenice Abbott, Jacques-André Boiffard, Bill Brandt, Lee Miller, 1920–1935* [Paris: Centre Pompidou, 1982]; A. Penrose, *Les Vies de Lee Miller* [Paris: Arléa-le-Seuil, 1994].)

MIRÓ, JOAN
1893–1983, Barcelona/Palma

Catalan painter and sculptor. After dabbling in business and an initiation to painting that was hardly academic, Miró met Francis Picabia, who published *391* in Barcelona in 1917. Miró's painting during that era was so eagerly descriptive that it eventually brought about the disintegration of any motifs (*Nu debout* [1918]). Miró made his first trip to Paris in 1919, where he met Picasso and visited the Louvre but did not paint. The following year, he began to divide his time between Montroig, where he loved to "come back down to earth," and Paris, where he set up his studio on the rue Blomet, near Masson. He spent most of his time with poets: Tristan Tzara, Pierre Reverdy, and Max Jacob and then Robert Desnos, Michel Leiris, and Antonin Artaud. In 1923, *Terre labourée* revealed his capacity to transform reality and drift toward dreams: each motif evolves autonomously toward a sign. The background lost any referential value, and Miró invented a personal vocabulary (eye, flame, cone, big foot, etc.) capable of transposing what was immediately visible (*La Sieste* [1925]). Until 1927, Miró was the "finest feather in the surrealist cap" according to Breton, even though theoretical debates bored him and he preferred the perfection of each canvas to automatism: he made use of a number of preparatory sketches (thus, the figures in *Carnaval d'Arlequin* emerged from the hunger-induced hallucinations he often endured at the time). Consequently, there was what Patrick Waldberg called a "Mirómonde"—a Miró-World—that was instantly recognizable in the poem-paintings and in the pictograms set out as if by chance (in fact, it was no such thing) against plain backgrounds created with large brushstrokes. In the late 1920s, a trip to Holland inspired him to reinterpret a few classic paintings: portraits and objects were integrated, through the use of distortions and vivid colors, into the Mirómonde. Subsequently, Miró would assert his desire to "assassinate painting" through aggressively humorous collages and assemblages of various materials. The years leading up to the Second World War inspired more serious work: the poster *Aidez l'Espagne* (Help Spain) and a major mural (*Le Faucheur*) for the Spanish Pavillion in 1937, for example. In 1939, Miró settled in Varengeville and began work on a series of twenty-two gouaches of astonishing thematic complexity: his *Constellations* would be completed in Palma and published in 1959 with text by Breton. Miró returned to Barcelona in 1942 (which surprised a great number of his friends) and determined what would henceforth be his themes throughout the range of the art forms he practiced: women, birds, spots, stars, sun signs. At the risk of serious misinterpretation, the use of these elements gave him the reputation of a painter of the joy of life: Miró periodically reacted against this reputation by injecting a sense of brutality into the ceramics he created with Artigas, through the violence contained in the assemblages of discarded objects with which he made his sculptures, or through the use he made, at his retrospective exhibition at the Grand Palais in 1974, of large burned canvases.

Some would view these burned canvases as a little boy's familiar games, but for Miró they were proof of his insubordination. For despite the world fame he had enjoyed since the 1950s, and although he had left surrealism behind, he was sustained right to the end by a permanent feeling of rebellion, and as a result he advocated an art that had nothing decorative about it but that, on the contrary, sought to recover essential symbols, as weighted with meaning as prehistoric signs.

MOLINIER, PIERRE
1900–1976, Agen/Bordeaux

Painter. Molinier learned to draw while he was studying with the Jesuits. His career was relatively quiet in the beginning, but by the end of the 1940s his art was exclusively devoted to the expression of his obsessions with the most hidden aspects of sexuality: fetishism, cross-dressing, necrophilia. He came into contact with Breton in 1955 and had an exhibition at L'Étoile Scellée, but his relations with the group only lasted a few years. Later, he produced photomontages in which transvestites, models, and sexual exhibitionism prevailed. His increasing attempts to bring about a convergence between art and everyday existence would ultimately lead to suicide.

MONNEROT, JULES
1909–95, Fort-de-France/Saint-Germain-en-Laye

Writer and sociologist. In 1932, Monnerot was among those who asserted their faith in surrealism in the periodical *Légitime défense*. The following year, in *Le Surréalisme ASDLR,* he began an analysis of the poetic act based on its sociopolitical context, in which, in conclusion, he upheld the idea that the surrealist platform would be an appropriate complement to the classless society of the future. In 1938, he took part in the creation of the Collège de Sociologie with Georges Bataille. In 1945, he published three "fictions," among them, *On meurt les yeux ouverts* and, above all, *La Poésie moderne et le sacré,* hailed by the group as emphasizing the affinities between surrealist thought and "primitive," magical thought. Four years later, Monnerot published an important *Sociologie du communisme,* in which he was very critical of the evolution of the Soviet revolution, demonstrating, in particular, that the communist "church" had displaced the feeling of the sacred onto a future "perfect State" that was nothing other than an eschatological belief justifying totalitarianism in advance. He then published a *Sociologie de la révolution,* which completed this analysis. During the 1960s, Monnerot veered completely to the right, becoming an ultraconservative and president of the "Scientific Council" of the National Front; from which he would resign in 1990.

MORISE, MAX
1900–1973, Versailles/Paris

With his friends from *Aventure*—Jacques Baron, Roger Vitrac, René Crevel—Morise joined the nascent surrealist movement. He contributed to *Littérature,* was present during the sleeping-fits, and took part in the sessions of exquisite corpse. He also joined in the vagabonding spirit that emerged after Breton's order to drop everything ("Lâchez tout"), and together with Louis Aragon, Vitrac, and

Breton himself, he set off from Blois in search of adventure, but their trip came to a sudden end. It was in response to what Morise considered the impossibility of a surrealist art per se, as it had been postulated in *La Révolution surréaliste*—where he also published the accounts of his dreams and a few rare drawings—that Breton wrote *Le Surréalisme et la Peinture.* Although he remained close to the regulars at the rue du Château, where a lasting friendship bound him to Marcel Duhamel, Morise was expelled from the surrealist group in 1929; he then responded by signing *Un cadavre.* Later, he joined the October group, then worked in the cinema and did not seem concerned with producing any lasting works.

MORO, CESAR
1902–56, Lima

Peruvian poet. Moro met the surrealist group in Paris in 1925; he contributed, in particular, to *Surréalisme ASDLR* and to the collective tribute to *Violette Nozières.* In 1935, back in Lima, he used a number of pseudonyms and was in fact the only exhibitor at the first Peruvian surrealist event, "in favor of sleep-disturbing art against soporific poppy-art." He then went to Mexico where, in May 1938, in *Poesia,* he published an anthology of surrealist poetry illustrated with reproductions of artwork. He was one of the coorganizers of the surrealist exhibition in Mexico City in February 1940 and then collaborated on *Dyn,* Wolfgang Paalen's periodical, rather than on *VVV,* to which he had been invited: he reproached Breton for his friendship with Trotsky and Rivera and considered that henceforth surrealism had been "surpassed."

NASH, PAUL
1889–1946, London/Boscombe

British artist. Nash's early work was in the tradition of the English landscapists, but in 1929 he began to introduce heterogeneous elements into his motifs, and by 1933 he had published a letter in the *Times* emphasizing the necessity of breaking with naturalism. After this, he began to participate in English surrealist events, showing not only canvases but also photographs and objects, although he did remain somewhat reserved with regard to group activities and the group's existence. By 1940, he was once again an official artist, devoting most of his work to depicting landscapes in ruins. His autobiography was published in 1949: *Outline: An Autobiography and Other Writings.*

NAUM, GELLU
1915, Bucharest

Romanian writer and poet. In the early 1930s, Naum discovered the work of Victor Brauner, his "double" in painting, who would later introduce him to Breton and to Benjamin Péret. Before the Second World War, he endeavored to restore a sense of the concrete to surrealism to a greater degree than the members of the group producing the periodical *Unu* had managed to do. In *Médium* in 1945 (the year he met Lydgia, the woman of his life), he insisted on the meaning of the marvelous and the "miraculous" that must inhabit any authentic poetry; along with Dolfi Trost and Gherasim Luca, he struggled to sustain the dynamic evolution of surrealism in a country that was about to be handed over to the directives of socialist

realism. Naum could not go into exile, for although he might be allowed to leave Romania, Lygdia was ordered to stay in Bucharest, so Naum preserved his dignity as a poet by doing translations (of René Char, Jacques Prévert, Samuel Beckett) and writing children's books. In 1985, he wrote *Zenobia,* a dreamlike story of love that relates the "secret" life he shared with the "predestined" woman of his life. (The French translation was published by the Éditions Maren Sell/Calmann-Lévy in 1995).

(See R. Laville, R., *Gellu Naum: Poète roumain prisonnier au château des aveugles* [Paris: L'Harmattan, 1994].)

NAVILLE, PIERRE
1903–93, Paris

Poet, revolutionary theoretician, and sociologist. Naville initially collaborated on the periodical *L'Œuf dur,* then joined the surrealist group in 1924; coeditor, with Benjamin Péret, of the first issues of *La Révolution surréaliste,* he would maintain that painting and surrealism were incompatible, which led Breton to respond to both Naville and Morise by writing *Le Surréalisme et la Peinture.* In 1926, Naville would call on his friends in the same way to clarify their relations with the Communist Party though his brochure *La Révolution et les intellectuels,* exhorting them not to be satisfied with supporting "in principle" the transformation of society. A thorough materialist, he later left the group to devote himself to purely political activity. He turned against Stalin very early on (he was one of the founders of the Trotskyist Fourth International), and after the war pursued a vast study on the sociology of work (*Le Nouveau Léviathan,* 8 vols. [1957–75]). In 1977, he returned to the surrealists in *Le Temps du surréel,* emphasizing, in particular, the way in which the marvelous must be capable of immediately transforming our relation with the real world.

NEMES, ENDRE
1909–85, Pecsvarad/Stockholm

Painter of Hungarian origin. It was in Prague during the 1930s that Nemes first painted interiors characterized by tormented souls and mannequins reminiscent, perhaps, of the legend of the Golem. After he resettled in Sweden at the beginning of the Second World War, his work evolved into a lyrical or gestural abstraction, and it was only in the 1960s that Nemes would return to his early style, creating canvases and collages in which the idols of the contemporary world—particularly the technological one—are subjected to ironic transformations that confer on them the ability to act as props for one's desires and dreams.

(See T. Millroth, *Endre Nemes* [Stockholm: Liber Förlag, 1985].)

NEUHUYS, PAUL
1897–1984, Antwerp

Belgian poet. Neuhuys was interested in Dada and surrealism, as shown in his first collection, *Le Canari et la cerise* (Antwerp: Éditions Ça Ira, 1921), in the already pertinent pages he devoted to Dada in *Poètes d'aujourd'hui* (1922), and in the special issue of his periodical *Ça ira* (1919–21), which came out in November 1921 with the title "Dada, sa naissance, sa vie, sa mort" (Dada: birth, life, and death); contributions to the issue were compiled by Clément Pansaers in

Paris. As an editor at *Ça ira,* he would publish texts by Pansaers, Henri Michaux, Francis Picabia, Benjamin Péret, Paul Éluard, and others. His own poetry, however, gradually diverged from his initial orientation, following the path of a more modest reverie. Examples can be found in *Le Pot-au-feu mongol* (Belfond, 1980).

NEZVAL, VITEZSLAV
1900–1958, Biskoupky/Prague

Czech poet and essayist. After incorporating into his own writing the advances made by Rimbaud and Apollinaire in substituting the rights of the imagination for tradition, Nezval became one of the driving forces, with Karel Teige, of "poetism," which made a strong demand for the pleasures of invention. In 1934, with Jindrich Styrsky and Toyen, Nezval cofounded the Prague surrealist group, which he directed with Teige. It was as a surrealist that he was invited to Paris in 1935 (the year in which his collection *Anti-lyrique* was published by the Éditions Surréalistes in an adaptation by Benjamin Péret) to attend the International Conference of Writers for the Defence of Culture. He was not able to give his talk, however, but the speech he had prepared—which can be read in *Rue Gît-le-Cœur* where he gives a poetic account of his stay (1936; 1988 for the French translation)—accentuated the importance attached, in Prague, to Breton's *Les Vases communicants.* In 1938, Nezval refused to criticize openly the Moscow trials and left the surrealist group (he declared it dissolved) to join the clan of official Communist Party writers; this provoked a violent response from Teige, *Le Surréalisme à contre-courant.* Until the end of his life, Nezval would maintain his status of official eulogist of the ruling party and of Stalinism.

(Vitezslav Nezval, *Poèmes choisis* [Paris: Seghers, 1954, reprint 1984], *Valérie ou la semaine des merveilles* [Paris: Laffont, 1984], and *Prague aux doigts de pluies et autres poèmes* [Paris: Éditeurs Français Réunis, 1960].)

NOUGÉ, PAUL
1895–1967, Brussels

Belgian poet. Nougé worked as a biochemist beginning in 1919, the same year he joined the Belgian Communist Party, and in 1924 he put together *Correspondance,* which, at the very moment the surrealist group was being formed in Paris, heralded the existence in Brussels of a handful of individuals who had decided not to be taken in by grand declarations or posturing, avant-garde or otherwise, and who would devote themselves to hunting down the slightest hints of contradiction or laisser-aller in writing and ideas. Thus by virtue of his personal interests, which left him more inclined toward Paul Valéry than Lautréamont, Nougé would from the start give a very particular orientation to what became known as the "Brussels group." Extremely scrupulous and careful not to be swayed by easy formulas, Nougé preferred systematic experimentation over impulse, and coolness over rigor, even if the effects were discreet. His first collection, for example, *Quelques écrits et quelques dessins de Clarisse Juranville* (1927), was the result of minor modifications made in an ordinary instruction manual. From this point of view, Nougé made a considerable contribution toward determining what was at stake for Magritte in his art; he was, in any case, the artist's first meaningful critic with *Les Images défendues* in 1929. Nougé felt that Magritte's work exemplified the effects—particularly social—that

could be obtained through the cunning of art; and when, after the Second World War, worldly success stifled to some degree the creativity of the man he had helped to invent, he would put an end to all discussion of the matter with a definitive "the fellow is no longer of interest to me."

It was also because, in his opinion, a poet must assume the consequences of his texts that Nougé was hostile to automatism: he felt there was a risk of repetition and an alienation of thought. He also disagreed with the way in which people were coming to the defense of Aragon during the accusations provoked by *Front rouge:* for Nougé, it was not necessarily a bad thing for a text to be the subject of a trial, since that proved that there was a fear of how effective it might actually be. Despite these differences of opinion, Nougé did take part in the Franco-Belgian issues of *Variétés* and *Documents 34,* as well as in the *Bulletin international du surréalisme* published in Brussels in 1935. But in 1945 he joined Magritte in conceiving of a surrealism "in full sunlight," and this led to the exchange of sarcastic telegrams between Paris and Brussels and a cooling off of relations. Nougé also lent his support to those who were seeking to define a revolutionary surrealism, and it was not until a few years later that he once again agreed to a collaboration, this time with Mariën and his periodical *Les Lèvres nues.* Lacking the motivation to promote his own work during his lifetime, Nougé partially occulted his lyrical gifts—particularly evident in his erotic pieces—behind his activities as a theoretician. His most important texts have been collected in *Histoire de ne pas rire* (1980), *L'Expérience continue* (1981), and *Des mots à la rumeur d'une oblique pensée* (1983), published by Éditions Cistre–L'Âge d'Homme. Nougé's *Journal (1941-1950)* has been reprinted by the Éditons Devillez (1995), who also put together a collection entitled *Érotiques* (1994).
(Paul Nougé, *Quelques bribes* [Brussels: Éditions Didier Devillez, 1995]; O. Smolders, *Paul Nougé: Écriture et caractère: À l'école de la ruse* [Brussels: Éditions Labor, 1995].)

OELZE, RICHARD
1900–1980, Magdeburg/Postcholz bei Hameln

German painter. A former student of the Bauhaus, Oelze discovered the works of Ernst and Magritte in 1929, and this would have a definitive impact on the orientation of his own work. In Paris from 1932 on he came into contact with the leading surrealists but rarely joined in their activities, preferring to work quietly on his canvases (*Tourments quotidiens* [1934]), which the group recognized as being in keeping with their principles. Oelze depicted signs of imminent catastrophe: landscapes in shreds, devastated by winds of mysterious origin; figures prey to an uncertain waiting (*Expectative* [1935]); an ominous atmosphere that never revealed the actual nature of the threat. For Oelze, painting was a companion to clairvoyance: like a blind man, it was capable of prophesy, and even the most sinister moments of history could only confirm that prophecy. (Oelze had directly suffered the effects of history: interned during the war, he had ceased all activity for ten years.) The canvases that came after the 1950s attest to his experience: vaguely human silhouettes glimpsed in improbable landscapes and decors that were mere remnants, sometimes almost hilarious, of the humanity that survived the cataclysm. And yet one cannot ascertain the significance of their very survival, which can be seen as a sign of either hope or exhaustion.

OKAMOTO, TARO
1911–96, Tokyo

Japanese artist. Okamoto left for Paris in 1929, where three years later he showed his work at the Salon des Indépendants. In 1933 he joined the movement Abstraction-Création, and in 1936, together with Kurt Seligmann, he conceived his theory of "neoconcretism," which kept him at a distance from abstraction. In 1938, having met the surrealists, he took part in the movement's *International Exhibition.* Back in Japan in 1940, after taking courses in ethnology, he would give a considerable boost to postwar Japanese art, and in particular he founded The Group of the Night with K. Hanada. His work can be readily interpreted, for he did not hesitate to mingle dreamlike representational elements with abstract ones, as if conferring a critical impact on them. He preferred a theory of "nonmeaning" to a social reading of his work: "It is through a resolution to stay in nonmeaning that true meaning emerges." The contradictory elements of his compositions were bound together by a cool humor. In the 1950s, he achieved international renown, exhibiting at the Biennales in São Paulo and Venice. In 1970, he became artistic director of the Osaka World's Fair. In his latter years, he published numerous works devoted to Japanese mysticism and Buddhism.

OLSON, ERIK
1901–86, Halmstad

Swedish painter. Olson stayed in Paris from 1924 to 1935, where he studied with Léger. In 1929, he was one of the founders of the Halmstad group (with his brother Axel, E. Thoren, and S. Mörner), which in 1934 joined up with the movement led by Bjerke-Petersen, who was the leading exponent of surrealism in Scandinavia. In 1935, Olson was delegated by his friends in the Paris group to prepare the exhibition *Cubism-Surrealism* in Copenhagen. He later took part in the international exhibitions in Paris and London with canvases on which meticulous figurative craftsmanship was occasionally disrupted by a transformation of the shapes that had seized on his imagination. His inspiration could not withstand the onslaught of the Second World War, however: at this point, Olson, like most of his friends, returned to Christianity and the imagery that was its logical consequence.

ONSLOW-FORD, GORDON
1912, Wendover

English painter. After an early career as a naval officer, Onslow-Ford met Roberto Matta in Paris in 1937, and both of them began to experiment with automatism. This quickly led them to the discovery of the "psychological morphologies," of which they would become the theoreticians. In 1940, Onslow-Ford went back to England, where he collaborated on the *London Bulletin* (publishing an article on Henry Moore). Until 1947, he would divide his time between the United States and Mexico. In the United States, he introduced Robert Motherwell to the virtues of "coulage," where unexpected effects are obtained from the cracks produced when industrial varnish is spread on an oil base and then is accompanied by an arbitrary geometrization of shapes. In Mexico, Onslow-Ford collaborated on Wolfgang Paalen's periodical *Dyn,* and together with Paalen he founded the group Dynaton, which, although offi-

cially a separate movement from surrealism, continued to explore the possibilities of an art of unbridled lyricism. As indicated by the title of his 1978 book *Création,* Onslow-Ford asserted the reality of pictorial creation and sought to situate himself in the line of those—Miró, Tanguy, Matta—whose work was capable not only of revealing unexpected aspects of reality but also of replacing reality with a totally new, hitherto unseen world, where the signs we thought we could name (stars, biomorphic cells, planets, and so on) are in fact only invitations to a total drifting of the mind.

OPPENHEIM, MERET
1913–85, Berlin/Basle

Swiss artist. One of her most famous collage-drawings, which depicted the mathematical equation between the letter "x" and a red rabbit, was created when Oppenheim was only seventeen, and her work would preserve and sustain this "adolescent" ability to discover unexpected but highly poetic equivalencies. In 1932, through Giacometti and Jean Arp, she met the Parisian surrealists. It was thanks to Oppenheim that Man Ray produced a number of significant photographs, which made her the androgynous symbol of the era of machinery. She made costume jewelry to earn a living, and a few scraps of leftover fur inspired her, as if by chance, to design her *Déjeuner en fourrure* for a collective exhibition—an ambiguous object, both familiar and disturbing, implicitly charged with eroticism. Eroticism was displayed with a frankness implying actual innocence and would be one of the constant mainsprings of her work, which consisted of sketches, objects, sculptures, and paintings. While on occasion it was tinged with sadism (*Ma gouvernante*), it could also be conveyed by the solid sensuality of color in her nonfigurative canvases. And when it seemed to be absent, it was nevertheless implied, as in the fairy tales or werewolf stories that Meret Oppenheim adapted into personal versions throughout her work, which was as polymorphous as childhood perversity. The "Festin sur le corps de la femme nue" (Banquet on the body of the naked woman), which she organized in 1959 for the inauguration of *EROS,* created a scandal at the time, but nowadays seems more like an invitation to play on the multiplicity of ways one can move from the latent to the manifest.

PAALEN, WOLFGANG
1905–59, Vienna/Mexico

Austrian painter. At first Paalen was a member of a group in Paris called Abstraction-Creation, then he joined the surrealists in 1936. He introduced his technique of fumage (the interpretation of the marks left on a surface by a candle flame) and a style able to grasp a host of disturbing figures, half-human and half-animal; shortly before the war these figures had evolved into the threatening *Combat des princes saturniens* (Combat of the Saturnian princes [1939]). At the same time, Paalen produced objects that exhibited contradiction, in particular, as a way of being (*Nuage articulé*). He took refuge in Mexico in 1939 and was one of the organizers of the international exhibition in Mexico City. Greatly interested in Indian art, he found it expressed his own ambitions, that is, to seize in one gesture all aspects of life, both real and imaginary. It was with this in mind that he gradually abandoned surrealism and edited the periodical *Dyn* from 1942 to 1944, planning to reconcile the contributions of

science with those of art. He seemed to be abandoning "representation" in his work, but through the arcs, traces, and signs that he used with increasing frequency, each painting would always seek to project the air, if not the shape, of what might emerge. Back in Paris in 1951, Paalen had no difficulty rejoining the group and provided illustrations for the second issue of *Médium.* He then left again for Mexico and, tormented by a task for which the "prophetic" dimension exceeded his own strength, he committed suicide at the very time his art was beginning to be appreciated at its just worth.

PAILTHORPE, GRACE
1883–1971, Saint Leonards on Sea

Painter and psychoanalyst. Pailthorpe studied medicine and was a surgeon in Australia during the First World War; she traveled around the world and only returned to England in 1922. She then became a renowned Freudian psychoanalyst, notably thanks to her research into the psychology of delinquency (she was in favor of solutions that were not too repressive). In 1935, she met Reuben Mednikoff (born in 1906), who had followed a similar path, and they married; both studied "psychological art" and began to explore its impact and potential on their own. This brought them to take part in the international exhibition in London, where Pailthorpe's drawings attracted a lot of attention. She was actually totally trusting of automatism, with a rare freedom. In her painting, she also used automatism to define her shapes, which she would later rework, and she was convinced that surrealism allowed for a reconciliation of the entire psyche. Still with Mednikoff, whose work was equally capable of moving effortlessly from a joyously ironic figurative painting to abstract work where new spaces were created, Pailthorpe also took part in the English group's events and published drawings in the *London Bulletin.* For the *Bulletin,* she wrote an article on the "Scientific Aspects of Surrealism," where she sought to prove that surrealism allows one to balance the psyche by expressing its inner tensions. The couple exhibited their works in 1939 at the Guggenheim Jeune gallery, and two years later they left the English group to continue their work on their own, never seeking the gratification of fame. By the time Mednikoff died in 1976, it had become virtually impossible to find their work anymore, and most of it seems to have disappeared.

PARENT, MIMI
1924, Montreal

Mimi Parent studied at the École des Beaux-Arts in Montreal, particularly at the studio of Alfred Pellan, who was the first nonconformist artist in Canada. In 1948, she married Jean Benoit, and they left for Paris for good. From 1959 on she officially joined the surrealist group, designing the poster for *EROS* and setting up the alcoves for the Fetishism Room. She was later represented at all the major collective exhibitions (Milan, 1960; *L'Écart absolu,* 1965; São Paulo, 1967; *The Pleasure Principle* in Czechoslovakia in 1968), as well as at the events that took place after the dissolution of the Paris group (London, 1978; Lausanne, 1987). In her canvases and then in the boxes that followed, there is a sense of a potential story left hanging: figures, objects, and decors are joined in an enigmatic way, while a palette that is alternately frank and diffuse enhances the irregularity

of the poetry thus expressed. Mimi Parent also illustrated texts by Guy Cabanel, Pierre Dhainaut, and José Pierre.

PARISOT, HENRI
1908–79, Paris

After meeting René Char in José Corti's bookstore, Parisot joined the group in 1933. In 1935, he was one of the signatories of *Du temps que les surréalistes avaient raison* (and he also took part, after the war, in *Rupture inaugurale* and in *À la niche les glapisseurs de Dieu!*) and introduced Gisèle Prassinos to the surrealists. Also a translator (Lewis Carroll, Coleridge, Kafka), Parisot edited first the series entitled Un divertissement (Prassinos, Benjamin Péret, Jean Arp, and Louis Scutenaire, among others) then the periodicals *K* and *Les Quatre Vents* as well as the *L'âge d'or* series for successive publishers; texts ranged to the "fantastic," and poetry was always a priority. After 1968, he devoted himself primarily to translating works by Lewis Carroll, scrupulously improving them from one edition to the next.

PASTOUREAU, HENRI
1912–96, Alençon

French poet. Pastoureau joined the surrealist group when he was twenty; he had studied philosophy, discovering Hegel, Sade, Marx, and Freud all at the same time. In 1936, his first collection, *Le Corps trop grand pour un cercueil,* was prefaced by Breton; it was followed by *Le Cri de la méduse* in 1937 and *La Rose n'est pas une rose* in 1938. After the war, during which he had written *La Blessure de l'homme* (1946) in captivity, he collaborated on Cause, the Bureau de Liaison Surréaliste International, *Néon,* and the *Almanach surréaliste du demi-siècle.* His radical anticlericalism led him to disagree with most of the group members on the position to be adopted regarding Michel Carrouges: Pastoureau left the group in 1951. Later, he contributed to *Phases,* then published *Ma vie surréaliste* in 1992.

PAZ, OCTAVIO
1914–98, Mexico City

Mexican poet. Paz came to Europe in 1937, to fight for the Republicans in Spain, and this is when he came into contact with surrealism. In 1942, he published the first translation into Spanish of Lautréamont in the review he had founded, *El hijo prodigo.* As cultural attaché to the Mexican embassy in Paris from 1946 to 1951 Paz frequented the surrealist group, became good friends with Benjamin Péret (who would translate his *Stone of Sun* in 1957), as well as with Breton and André Pieyre de Mandiargues. His poetry at the time, rich in imagery, often made use of pre-Columbian mythology. To the rhythm of his travels throughout his diplomatic career, Paz found inspiration for his poetry from very different sources (India, Japan), but it was always based on the word as a whole, liberated from time and set into a perpetual present that, by giving meaning to experience as much as to dreams, introduced a presence that could not possibly be compared with appearances. In 1968, Paz resigned from his post as ambassador in protest against the shooting massacre in Mexico City: poetry also has a moral standard. That same moral standard would be a stimulus to the invaluable criticism he devoted to other poets and to Duchamp.
(*Gradiva* [Brussels], no. 6–7 [February 1975].)

PENROSE, ROLAND
1900–1984, London

English artist and writer. After living in Paris from 1922 to 1935, when he came into close contact with the surrealists, Penrose would be one of the founders and most active members of the London surrealist group. Together with David Gascoyne, he would organize the London exhibition. In 1938 he became secretary and treasurer of the London Gallery and published the *London Bulletin* with E. L. T. Mesens and Jacques Brunius. Together, the three of them wrote *Idolatry and Confusion* in 1944, and in 1947, the year he got married for the second time, to Lee Miller, Penrose organized the English participation in the exhibition at the Galerie Maeght. He then founded the Institute of Contemporary Arts (ICA) in London, where a number of exhibitions would be held, including one devoted to Picasso. In his own painting, and also in his collages and objects, Penrose experimented with new relations between shapes and colors. An art historian, he published noteworthy biographies of Picasso (1958) and Man Ray (1975). In 1978 he helped to organize the exhibition *Dada and Surrealism Reviewed.* He published an autobiography (*Eighty Years of Surrealism*), which contained a wealth of memories about his friends and his significant collection (he had acquired, in particular, a large part of the works that had belonged to Paul Éluard).

PENROSE, VALENTINE (NÉE VALENTINE BOUÉ)
1898–1979, Mont-de-Marsan/England

French poet; Roland Penrose's first wife. Her poetry in verse (*Herbe à la lune* [1935]; *Le Nouveau Candide* [1936]; *Les Magies* [1972]) and in prose (*Martha's Opera* [1945]) testified to an inspiration that made use of automatism to elicit unexpected images: writing as clairvoyance, lurking in wait for whatever might emerge, in secret. When she published a biography of the rather Sadean countess *Erzsebet Bathory* (1962), Valentine Penose led the genre to the margins of pure reverie. She also produced collages (*Don des féminines* [1945]) inspired by Max Ernst to combine borrowed images in an atmosphere where serenity frequently triumphs over the ability to shock.

PÉRET, BENJAMIN
1899–1959, Rézé/Paris

French poet and militant revolutionary. In his youth, Péret learned industrial drawing but was then called up by the army during the First World War. In January 1920, freshly demobilized, Péret met the group from *Littérature* and immediately joined them. During the Barrès trial he acted as the unknown German soldier; after the failure of the "Paris Congress" project, he took part in the experimental activities that prepared the birth of surrealism. Thus Péret became coeditor of *La Révolution surréaliste,* where he contributed to all the collective declarations. In 1926, he joined the Communist Party and worked for *L'Humanité* as a proofreader (the only profession in his entire lifetime that would bring him any financial resources, however meager). Péret's poetry (*Le Grand jeu* [1928]) immediately exemplified the potential of pure automatism: in his work, images follow one another at an accelerated rhythm and can introduce various additional narratives, grafted on a metaphorical term—without, however, the main "thread" being broken for all that. Every sense is alert at once, for the text enables the different kingdoms to commu-

nicate, with no respect for usual classification, and Péret cultivates a sense of humor that runs the gamut from the most refined to the most outrageous—something that would also hold true for his prose "tales." In 1929 he went to Brazil, but as he had espoused Trotskyism, he was incarcerated for subversive activity and deported in 1931. In 1936, he published a collection, *Je ne mange pas de ce pain-là*, in which his ongoing use of automatism was directed toward strictly political purposes, but it thereby lost its relevance, which would, however, return that same year in an absolutely pure form in the lyrical collection, *Je sublime.*

He joined the Republicans to fight in Spain from the beginning and, faced with the dissent dividing the anti-Stalinist Left, chose to fight alongside the anarchists of the Durruti column. While in Spain, he met Remedios Varo, who would become his companion. Back in France, Péret was mobilized in 1940 and imprisoned in Rennes for political agitation in the armed forces. Released during the debacle, he went to Marseilles, then to Mexico, where he stayed until 1948, having broken with the Fourth International two years earlier. It was in Mexico that he would write the story of his liberation from Rennes, and Breton published it in New York as soon as he heard about it (*La Parole est à Péret* [1943]). Péret also wrote *Le Déshonneur des poètes* as a reaction against Resistance poetry. When he returned to France, he naturally met up with the surrealist group again, collaborating on successive periodicals and on the *Libertaire,* but his material circumstances were very difficult (Jean-Louis Bédouin housed him for a time). He traveled again to Brazil during the second half of 1956, visiting tribes in the Amazon and collecting documentation for his project for an anthology on myths, legends, and folk tales of the Americas (*Anthologie des mythes, légendes et contes populaires d'Amérique,* which would only be published posthumously in 1960). Back in Paris, Péret rejoined the surrealist group, countersigning their political declarations and collaborating on *Bief,* but his health was poor. His death was a great blow not only to his surrealist friends but also to his political comrades. Breton, in 1952, had called him "my dearest and oldest fellow combattant," and the lasting friendship that had bound the two men had actually worked against Péret, who was easily considered to be the (overly) faithful disciple by critics and "literary" circles—who in fact had not forgiven him for *Le Déshonneur des poètes.* His complete works have been collected in seven volumes (published by Éric Losfeld, then José Corti).

(J.-L. Bédouin, *Benjamin Péret* [Paris: Seghers, 1961]; C. Courtot, *Introduction à la lecture de Benjamin Péret* [Paris: Le Terrain Vague, 1965]; J.-C. Bailly, *Au-delà du langage: Une étude sur Benjamin Péret* [Paris: Éric Losfeld, 1971]; J.-M. Goutier, ed., *Benjamin Péret* [Paris: Veyrier, 1982].)

PICABIA, FRANCIS
1879–1953, Paris

French painter and poet. Picabia achieved success quite early on with paintings of a postimpressionist mold. He then took up fauvism but soon became friends with the Duchamp brothers and Apollinaire: modernity required one to rethink painting, and Picabia turned toward a nonfigurative art. This ensured his recognition when he exhibited at the Armory Show in New York, where he was living in 1913, and where he was part of the circle close to the photographer Alfred Stieglitz and his gallery. But as soon as he moved away from that particular direction, he created his most dazzling

canvases (*Je revois en souvenir ma chère Udnie*). In 1915, he was back in New York and joined up with Marcel Duchamp. He painted his first "mechanical" works, posing the question of the image in a Dada spirit. He would be a major player in Dada until 1922, both in Paris and in Barcelona. In 1918, he published his *Poèmes et dessins de la fille née sans mère,* and with his periodical *391* he circulated ideas and information, reproduced works and poetry, and took on the role of a sarcastic troublemaker, even—or above all—where his friends were concerned; no sooner did he seem to approve of a project than he would turn and criticize it, and his relations with the other Dadaists, be it the Parisian ones or Tristan Tzara himself, swung wildly from storm to fair weather.

In July 1921, the *Pilhaou-Thibaou* was an official statement of his withdrawal. Not long thereafter he made fun of the project for a Paris Congress but then provided a series of remarkable cover art for *Littérature* that marked his return to figurative work, as well as texts that wearied even Breton in the end. At the time surrealism was taking shape as a movement, Picabia published a new installment of *391* to ridicule the movement (something he also did in his novel *Caravansérail,* which remained unpublished at the time). He belonged to an earlier generation than the Dadaists and surrealists, and this, together with his marked spirit of independence, no doubt prevented him from joining any group that was made up of people younger than himself. Despite the break in 1924, the surrealists remained very attentive to his work, insofar as throughout his successive phases Picabia offered a permanent lesson in the sovereign freedom of invention, thumbing his nose at fashion and revealing his ability to produce something very different from what one expected. In 1925, Picabia would be reconciled with Breton, and their relations remained courteous, even when they were at a distance or when Picabia, in the 1930s, seemed more interested in the social life on the Riviera than in aesthetic revolution. His gift for provocation, once again, would enable him—through his "erotic" representational work (loosely based on the photographs in "light" periodicals) and by flaunting any notion of taste—to disappoint some of his admirers and reassure those who missed the aggressiveness of "monsters" and the audacity of "transparencies."

PICASSO, PABLO
(PSEUDONYM OF PABLO RUIZ BLASCO)
1881–1973, Malaga/Mougins

With *Les Demoiselles d'Avignon* in 1907, which inaugurated cubism by breaking with the sum of Western aesthetic tradition, Picasso ensured his importance to surrealism: Breton insisted that Jacques Doucet make the acquisition of what seemed to him to be one of the leading works of the century. And cubism remained the epitome of a radical rejection of the tyranny imposed until that point by the exterior model. Apollinaire had not been wrong, and in 1917 Picasso created the decor for the *Mamelles de Tirésias.* In 1924, he painted the backdrop for the ballet *Mercure* (Erik Satie and Léonide Massine), and the surrealists welcomed it with enthusiasm. As a result, the place that Picasso would occupy in *Le Surréalisme et la Peinture* was in no way surprising: what was at stake in Picasso's creative process, beyond the mere history of painting, was the very potential of a new way of thinking. But Breton warned, at the same

time, that it would be impossible to put a label on Picasso, as a "sur-
realist" or anything else. Picasso maintained close ties with the group
until 1937—he was a good friend of Miró, Éluard, and Aragon—but
he also contributed to the group by virtue of his creative power,
evident in a series of works that fascinated Breton and his close cir-
cle: the bathing women of the Dinard period, the Boisgeloup sculp-
tures, and the collages and objects of the 1930s (in particular, the
collage *Composition au papillon* from 1932, which Breton wrote
about in "Picasso dans son élément," *Minotaure,* no. 1).

Some of Picasso's early drawings bordered on automatism, even
though they were in fact the result of the extreme schematization of
a motif. But it was in his poetry (and his plays) in the springtime of
1935—an emotionally troubled period where writing briefly took
over from painting—that Picasso was closest to pure automatism.
Moreover, his recurrent themes reinforced this closeness in other
ways: the female body and eroticism; humor (in the rebus drawing
published in the series of surrealist postcards, e.g.); the exploration of
mythology (the *Minotauromachie* series); and, on an even deeper level,
the way in which his entire oeuvre comprised a series of public con-
fessions, an uninterrupted quest for affects and authenticity. It was
precisely when this quest gave way to less personal themes, or themes
at least partially determined by outside concerns, that a distance
opened up between the painter and surrealism—or it may have been
the moment he joined the Communist Party in 1944. After this,
quite logically, only Paul Éluard and Louis Aragon continued to
praise Picasso's work, and Breton emphasized—but in vain—that the
official admiration that Picasso enjoyed within the French Commu-
nist Party could be nothing but a deceit, insofar as the type of art
conceived by Picasso had been refused in other cases and to other
artists by the same party. If any further proof were needed, there was
the scandal that ensued when Aragon thought fit to publish Stalin's
portrait in *Les Lettres françaises* to honor the memory of "the little
father of the people." But Picasso seemed to have a vision of com-
munism that was independent of any party: for him it was a source of
hope, or a call, and not a system. "Picasso," said Pierre Daix, "treated
communism the way others treat religion outside of the church." It
was precisely this dissociation that was inadmissible to the surrealists:
whence the note of reservation in the title of the article Breton
devoted to Picasso in 1961: "80 Carats . . . but a Shadow."

PIERRE, JOSÉ
1927–99, Bénesse-Maremme/Paris

Critic and writer. Pierre joined the surrealist group upon his arrival
in Paris in 1952 and became an extremely active member. First of all
in the movement's periodicals: from *Médium,* in which, with Charles
Estienne, he published an important survey on "the situation of
painting" in 1955, to *L'Archibras,* and *Coupure* thereafter, in which
Pierre was one of those in charge, following the dissolution of the
Paris group, and then—proof of his love of painting—as an orga-
nizer of exhibitions. Although he was obviously very attentive to the
different versions of pictorial surrealism, he was also open to work
being created outside the group that might share certain of its ideas
or principles. Thus, Pierre was one of the first to insist on the
importance of someone like Robert Rauschenberg or certain
aspects of pop art (*Dictionnaire du pop art* [1975]). A historian of sur-

realism (*L'Univers surréaliste*) and author of an important thesis titled
André Breton et la peinture, his critical work demonstrates, through his
lively antiacademic stance, his qualities as a polemicist—with regard
to existentialism or the review *Planète*—and as a writer, capable of
crafting dramatic works as well as prose that seems narrative in form
but that in fact has been affected by his knowledge as a critic (*Gau-
guin aux Marquises*) or by an eroticism that is both raw and innocent
(see—*Qu'est-ce que Thérèse?*—*C'est les marronniers en fleurs, Eva
Viviane et la fée Morgane*).

PIEYRE DE MANDIARGUES, ANDRÉ
1909–91, Paris

French writer. While Pieyre de Mandiargues had read the surrealists
before the war (along with the Elizabethan and Baroque authors,
among others), it was not until 1947 that he joined the group. He
had already published poetry (*Hedera, L'Âge de craie* [1945]) and
short stories (*Le Musée noir*) that offered a new conception of the
fantastic. Eager to preserve his independence, however, he did not
join in collective activities and was actually only bound to the group
by what he called "close spiritual affinity." The most important thing
was the importance he gave in his life and work to women and to
love; love was something to be exalted in every aspect, from extreme
eroticism (*L'Anglais décrit dans le château fermé* [1953]) to a purified
passion (*Astyanax* [1947]). To this one might add his interest in irreg-
ular if not "scandalous" forms of beauty: the point was to go beyond
ordinary taste and find in ruins or degraded forms an opening that
could lead to a marvelous manifestation of desire—as shown in the
text he contributed to the *Almanach surréaliste du demi-siècle.* The
marvelous was, moreover, the element to which he was most sensi-
tive in the works of those artists he appreciated and to whom he
devoted studies (in the different volumes entitled *Belvédère*); highest
ranking of these was his own wife, Bona de Pisis, whose work fluc-
tuated from a dreamlike eroticism to a private mythology that made
use of natural "oddities" or created portraits from scraps of fabric.
(José Pierre, *Le Belvédère d'André Pieyre de Mandiargues* [Paris: Artcurial, 1990].)

PRASSINOS, GISÈLE
1920, Istanbul

Gisèle Prassinos was introduced to the surrealist group at the age of
fourteen; she stunned them by the ease and innocence with which
she surrendered to automatism. Welcomed as the perfect example of
the *femme-enfant,* her first collection *La Sauterelle arthritique* was pub-
lished in 1935, and no less than six small volumes would follow
before the war. (These surrealist texts, written until 1944, were col-
lected in *Trouver sans chercher* and published in 1976 by Flammarion.)
In her poetry and prose, the unexpected becomes a natural substi-
tute for the ordinary, and her world contains a wealth of aberrant
phenomena presented as if they were banality itself. This hidden side
of things and creatures would turn up after the war in the objects
and tapestries she produced with random materials, as well as in her
short stories and novels (*La Voyageuse* [1959]; *Brelin le fou* [1975]; *La
Lucarne* [1990]). A nocturnal streak enriches the everyday life of the
characters in her prose, and they seem poised to seize the slightest
opening in the structure of things to slip away into a perfectly ami-
able fantasy.

PRÉVERT, JACQUES
1900–1977, Neuilly-sur-Seine/Ormonville-la-Petite

French writer. In 1925, Prévert was one of the most turbulent visitors at the rue du Château and only officially belonged to the group in the three years that followed. While he took part in a few of the games, he was wary of automatism and showed little interest in dreams. Paradoxically, his first important text was the one he contributed to the group pamphlet *Un cadavre,* written by those who had been expelled in 1929 in protest against Breton. It was later that his poetic vitality developed freely, a poetry in which one could find many things in common with the movement's values: scorn for established values, fierce anticlericalism and antimilitarism, and a sense of humor that concealed a certain pity aroused by mankind's misfortune. These elements were already at work in the skits he composed for the Octobre group and continued to characterize not only his poetry (*Paroles* [1945], one of the most successful books of the postwar era) but also his numerous contributions to the cinema as a writer of screenplays or dialogue (*L'Affaire est dans le sac* [1932]; *Drôle de drame* [1937]) and his collages—although here his lyricism occasionally slipped into sentimentality. Even though he carefully kept his distances from the group, the virulence of his *Tentative de description d'un dîner de têtes* or *La Crosse en l'air* justified his inclusion in the *Dictionnaire abrégé du surréalisme* in 1938: with Prévert, the surrealist spirit encountered the brash tradition of the working class neighborhoods.

(R. Golson, *Jacques Prévert: Des mots et des merveilles* [Paris: Belfond, 1990].)

QUENEAU, RAYMOND
1903–76, Le Havre/Neuilly

French writer. Queneau came into contact with the surrealist group through Pierre Naville and began by collaborating on *La Révolution surréaliste.* After his military service, he began to frequent the group, in 1928, at the rue du Château (Jacques Prévert, Yves Tanguy, Marcel Duhamel). He cowrote the pamphlet *Permettez,* proving to be, in Michel Leiris's words, "a conscientious, even scrupulous surrealist, but no doubt more by nature than by genuine conviction." Queneau was Breton's brother-in-law, but he broke with the group in 1929 for reasons that were personal more than doctrinal (although he had always expressed reservations with regard to the potential of automatism). He collaborated next on *Un cadavre,* then on *Documents* and Boris Souvarine's *Critique sociale.* His novel *Odile* (published in 1937) contained a few stories of his time with the group; its critical dimension was not its most successful aspect. In later novels, he gained importance as a forerunner of the Nouveau Roman—Queneau was very concerned with the formal construction of his texts, whereas his poetry was characterized by an ironic use of what were very classical forms in appearance only.

(E. Souchier, *Je n'aime pas ce qui m'enserre ou Raymond Queneau face au surréalisme,* Petite Bibliothèque Oulipienne, no. 5–6 [Limoges: Sixtus, 1991].)

RAHON, ALICE
1916–87, Chenecey-Buillon/Mexico City

French painter and poet. Rahon's first canvases, at the age of seventeen, were influenced by impressionism. She married Wolfgang Paalen that same year, and they both joined the surrealists in 1935.

The following year she published her first collection of poetry, *À même la terre* (illustrated by Tanguy), creating works in which a vision focused closely on childhood powers of wonder forged unexpected relations between things. In 1939, she settled in the outskirts of Mexico City. She collaborated on *Dyn* and in 1945 held an exhibition at Peggy Guggenheim's gallery. Her texts were close to automatism (*Noir animal* [1941], illustrated by Paalen) and evolved into a style in painting that incorporated the lessons of primitive art, frequently making use of unusual materials (sand, cement, marble powder mixed with pigments) in the service of an allusive figurative style, in which emotion is nearly always triumphant, expressed through luminous and suave colors.

READ, HERBERT
1893–1968, Kirkbymoorside/London

Writer and critic. It was initially as a historian of modern art that Read became interested in surrealism, and he introduced it in Great Britain, endeavoring to show that it was compatible with that country's traditions of art and literature (particularly with William Blake, e.g., whom the group in Paris tended to neglect). A coorganizer of the *International Exhibition* in 1936, Read was nevertheless forced to concede—despite his own communist leanings—that collective activity, in particular with a revolutionary aim, was not something that English artists, with their tradition of individualism, could really understand. Read collaborated on the *London Bulletin,* and left the surrealist movement in 1940 to devote himself to other modernist trends.

REIGL, JUDIT
1923, Kapuvar

French painter of Hungarian origin. Reigl settled in Paris in 1950 and belonged to the group from 1950 to 1953. Her canvases from that era were figurative, characterized in their expressive distortions and disturbing agitation by a lyrical furor that justified their comparison with the frenzy of someone like Lautréamont: automatism mingled with dreams to lead the viewer to a territory filled with threats or premonitions. It was not long, however, before Reigl, along with Simon Hantaï, turned to the lyrical abstraction typical of Georges Mathieu, and she did not seem to be overly concerned with the ideological implications of this shift. After the break with surrealism, she nevertheless retained the practice, learned from automatism, of moving her hand over the canvas to record the effects of chance, but her work was no longer surrealist in any way.

REMEDIOS
(PSEUDONYM OF REMEI LISSARAGA VARO)
1908–63, Anglès, Catalonia/Mexico City

Painter. After a childhood spent traveling throughout Europe and North Africa with her engineer father, Remedios studied in Madrid, then settled in Barcelona in 1935, where she met Esteban Francés. In 1936, she met Benjamin Péret and became his companion. She began to take part in the activities of the Paris group, then went to Mexico in 1941, where Péret soon followed. She settled in Mexico for good, and following her early efforts reminiscent of Oscar Dominguez's work, in 1953 she began to devote all her time

to painting. Her canvases evoke metamorphosis and the logic emanating from an authentically magical spirit: the different kingdoms intermingle with ease, animal and vegetable displaying a deep complicity that points to the unity of a world the secrets of which women, like alchemists, seek to unveil—not, however, to give them away but to render them ever more fascinating.

RIBEMONT-DESSAIGNES, GEORGES
1884–1975, Montpellier/Saint-Jeannet

A writer, poet, and occasional musician, Ribemont-Dessaignes became convinced even before the First World War that the Western world was doomed: his commitment to Dadaism was therefore quite logical. He was a very active participant, was very loyal to Francis Picabia, and took Tristan Tzara's side during the debate about the possible Paris Congress. Ribemont-Dessaignes published his first work for the Dada Collection of the Éditions Sans Pareil: *L'Empereur de Chine suivi de Le Serin Muet.* In 1924, however, the year his first "novel" was published, *L'Autruche aux yeux clos,* along with a monograph that was the first ever to be devoted to Man Ray, he would confirm that he belonged to "the surrealism labeled Breton," thus clearly setting himself apart from a passing potential rival, Paul Dermée. But for the group, he was more of a fellow traveler than an active member. He wrote a number of novels: *Ariane* (1925), *Céleste Ugolin* (1926), *Clara des jours, Le Bar du lendemain* (1927). He collaborated on the Grand Jeu, and after the meeting at the rue du Château that condemned the Grand Jeu, he left Breton's group. He became editor-in-chief of the periodical *Bifur* and welcomed the dissidents from surrealism, a number of whom he would also find in *Documents.* Violently attacked in the *Second Manifesto,* Ribemont-Dessaignes helped to write *Un cadavre.* Obliged to leave Paris in 1934, he continued to publish novels that were always characterized by an authentic spirit of rebellion, something that led him to fight, with his specific means, for the Spanish Republic, and then to work for clandestine newspapers during the Occupation. After the Liberation, *Les Lettres françaises* rejected one of his articles for excessive anticlericalism, but he collected his poetry in *Ecce Homo* (1945). He made a living working for various book clubs, and in 1958 published his memoirs, *Déjà jadis.* Because of his isolation, Ribemont-Dessaignes would have to wait until his eightieth birthday to have his second solo exhibition (Galerie Chave, in Vence), but his uncompromising nature had earned him the friendship of some of the most brilliant minds of the era: Jacques Prévert (who illustrated his *Ballade du soldat* in 1972) and Max Ernst; and, despite their public disagreements, Ribemont-Dessaignes had earned Breton's lasting respect.

(Georges Ribemont-Dessaignes, *Dada: Présentation, biographie et bibliographie par Jean-Pierre Begot,* vol. 1, *Manifestes, poèmes, articles, projets, 1915–1930,* vol. 2, *Nouvelles, articles, théâtre, chroniques littéraires, 1919–1929* [Paris: Éditions Champ Libre, 1974–78]; F. Jotterand, *Georges Ribemont-Dessaignes* [Paris: Seghers, 1966].)

RIGAUT, JACQUES
1898–1929, Paris/Chatenay-Malabry

Secretary to the painter and writer Jacques-Émile Blanche after his demobilization, Rigaut took part in Dada and published a few brief pieces in *Littérature* but did not join the surrealist group. After 1924,

he led a more worldly life, although it was sometimes difficult, as his time was divided between Paris and New York. He eventually married an American heiress in 1926. The marriage failed soon thereafter, however: Rigaut took to drink and heroin. Late in 1928, he returned to France, where he tried to recover through treatment in various clinics, but he finally shot himself in the heart. In the aphorisms, short stories, and sketches that were collected in his *Écrits* (Paris: Gallimard, 1970), the lure of suicide—even if it was the "easy way"—was constantly present, as was a sense of humor not unlike Jacques Vaché's, which created a definitive distance between the dandy and the burden of globally indifferent events that everyday life imposed on him.

RIOPELLE, JEAN-PAUL
1923, Montreal

Painter, originally from Quebec. Riopelle came to Paris in 1947, met some of the surrealists, took part in the *International Exhibition of Surrealism* at the Galerie Maeght, and contributed to *Rupture inaugurale.* In 1949, Benjamin Péret, with André and Élisa Breton, wrote the catalog preface for his solo exhibition at the Galerie Nina Dausset, and Riopelle frequented the group until 1950. At the same time, he remained very close to Paul-Émile Borduas in Montreal, who had been his teacher, and he became one of the founders of the group of "automatists": in 1948 he signed their manifesto *Refus global.* But in 1951, he published some disenchanted comments on automatism in *Rixes* and set off on a path of "informal" art alongside Michel Tapié. His art, initially rich in allusions to the most intimate secrets of subjectivity or of nature, would evolve, particularly through his use of the knife, into a lyrical abstraction that may have gained in purely pictorial quality but, at the same time, lost some of its intensity and exploratory virtues.

RISTIC, MARKO
1904–84, Belgrade

Poet, writer, and primary theoretician of Serbian surrealism. At the end of 1924 Ristic gave a very favorable account of the surrealist manifesto in the periodical *Svedocanstva* (Testimonies). In 1926, he went to Paris and met the most important members of the group there. Back in Yugoslavia, he published books of poetry and, together with Dusan Matic, put together the almanac *Nemoguce* (The impossible [1930]), which featured translations of the Paris surrealists. His next project was the periodical *Nadrealizm danas i ovde* (Surrealism here and today [1931–32]), which criticized Aragon at the time of the "affair," and Ristic then launched a survey on desire, to which Breton and Dalí, in particular, provided responses. (Ristic replied to the Paris surveys on humor in *Le Surréalisme ASDLR* and on the "significant encounter" in *Minotaure.*) His "paranoiac-didactic rhapsody," *Turpituda,* was banned in 1938 by the censorship of the ruling monarchy. After the war, Ristic became the first ambassador to Paris of the new Yugoslavia, and he renewed his ties with Aragon and Éluard. In his texts, at least the prewar ones, Ristic displayed a rare aptitude for moving from theoretical considerations to an authentic poetic density. His later poetry, some of which can be found in translation in French (see *Ville-âge,* texts introduced by B. Aleksic [Thaon: Amiot-Lenganey, 1991]), seems much drier, even

sterile at times; as for his aesthetic positions, they moved away from surrealism to favor a "committed" art.

RIUS, ROBERT
1910–44, Perpignan/?

Rius was a poet who joined the surrealists in 1938. He was particularly close to Victor Brauner, who illustrated his collection *Frappe de l'écho* (the final publication of the Éditions Surréalistes in May 1940, before their activities in France were interrupted until 1947). He then took part in the activities of La Main à Plume, which published his book *Serrures en friche* in its series Free Pages in October 1943. In 1944, he joined the Resistance but was captured in the forest of Fontainebleau; he was tortured and executed by the SS.

RODANSKI, STANISLAS
1927–81, Lyons

French poet. As an adolescent Rodanski was sent to a Nazi labor camp, but managed to escape, and came at the age of seventeen to live with Jacques Hérold, who introduced him in 1947 to the surrealist group. He played an active role in the early editions of *Néon*. (He invented its first formula, "N'être rien. Être tout. Ouvrir l'être," which would later be replaced by "Naviguer. Éveiller. Occulter," after his departure.) But the following year he was excluded from the group, along with those to whom he was closest: Victor Brauner, Alain Jouffroy, and Claude Tarnaud. He was briefly imprisoned for misdemeanors, then set free again, but on January 1, 1954, after entrusting his manuscripts to Julien Gracq, he went of his own free will to a sanatorium in Lyons, where he stayed until his death, only beginning to write again in his last years. *La Victoire à l'ombre des ailes* was the only volume to be published during his lifetime (Paris: Éditions du Soleil Noir, 1975), with a preface by Gracq. Other texts have been published since his death (*Spectr'acteur* [Angers: Éditions Deleatur]; *Des proies aux chimères* [Paris: Plasma, 1985]; *Journal, 1944–1948* and *La Montgolfière du déluge* [Angers: Deleatur, 1991]), all of which confirm the intransigency of his quest, eventually obliterating any lasting significance through a game of reflections and factitious poses, where everything seems to have a false bottom.
("Stanislas Rodanski," special issue of the periodical *Actuels* [Lyon] [1984]).

ROSEY, GUY
1896–1981, Paris/Ascona, Switzerland

Poet. Rosey joined the surrealist group in 1932, and published a few memorable volumes: *La Guerre de 34 ans* (Paris: Éditions des Cahiers Libres, 1932); *Drapeau nègre*, with a drawing by Yves Tanguy (Paris: Éditions Surréalistes, 1933); *Les Moyens d'existence* (Paris: Éditions Sagesse, 1933); and *André Breton, poème épique*, with a portrait by Man Ray (Paris: Éditions Surréalistes, 1937). In 1941, he joined Breton and Benjamin Péret in Marseille, then went into hiding in Provence to escape from the Gestapo. After the war, he worked for an import-export business with Eastern European countries and settled in Paris again in 1960. He reworked some of his older poems to publish in *Œuvres vives* in two volumes (*Tirer au clair de la nuit* and *Seconde ligne de vie* [Paris: Corti, 1963–65]); he also published new work of an authentic density: *Ces furies sont sous mes doigts de la main droite* (with a frontispiece by Roberto Matta [Paris: Phases, 1967]),

Les Moyens d'existence (with Magritte [Paris: Éditions Georges Visat, 1969]), and *Électro-magie* (with Man Ray [Paris: Éditions Georges Visat, 1969]). Rosey eventually retired to Switzerland, and nothing more was heard from him.

ROY, PIERRE
1880–1950, Nantes/Milan

French painter. Roy had a classical training and initially produced canvases that were in a tradition of subdued fauvism. From 1919 on, however, perhaps influenced by De Chirico, he embarked on more disturbing compositions: a few objects, treated almost as trompel'œil, were arranged in totally unrealistic montages. He took part in the first two collective surrealist exhibitions, and in 1926 he showed fifteen paintings at the Galerie Pierre; Louis Aragon wrote the catalog preface. But in fact, Roy shared neither the principles nor the activities of the group. He created very effective if somewhat repetitive arrangements of his favorite objects —cart wheels, ribbons tied in bows, shells, stem glasses, sheaves of wheat, and so on—on the basis of veritable models that he would make before painting. He cared more for purely optical effects than for the surreal. Roy left the group in 1928, having published a collection of *Cent comptines* (One hundred nursery rhymes) two years earlier, rhymes that he had gathered over a long period of time and illustrated with remarkable woodcuttings. His subsequent work was often more pleasingly decorative than a real stimulus to thought. In 1930, he had a very successful exhibit at Julien Levy's gallery in New York and was represented in 1936 at the MoMA exhibition *Fantastic Art, Dada, Surrealism*. He may well have had a certain influence on Joseph Cornell with the fake boxes he used to frame certain compositions.

SADOUL, GEORGES
1904–69, Paris

Writer and cinema critic. Sadoul first frequented the group at the rue du Château and joined the surrealists in 1926, drawn, in particular, to the debate on social and religious questions. In 1929, he wrote a letter with Jean Caupenne to the major at Saint-Cyr proclaiming an unequivocal antipatriotism. He was sentenced to three months in prison. (Caupenne, in contrast, sent an apology to the military, something that put an end to his relations with the surrealists.) To avoid imprisonment, Sadoul left for the congress in Kharkov with Louis Aragon, and by the time this journey had led to the Aragon Affair, his break with surrealism would be definitive. In later years, Sadoul became the Communist Party's most famous cinema critic and historian; he remained loyal to the party, but this did not prevent him from maintaining a few distant relations with the group.

SAGE, KAY
1898–1961, Albany, N.Y./Woodbury, Conn.

Painter and poet. Sage belonged to a wealthy family and was able to study in Milan; her early productions were nonfigurative canvases. She arrived in Paris in 1937 and exhibited the following year at the Salon des Surindépendants: her works portrayed a world of ghostly objects and vacant structures and attracted the attention of Breton, Nicolas Calas, and Tanguy. Tanguy went to see Kay Sage in New York, and they were married in 1940. In their Woodbury studio,

Sage continued to explore improbable places, windowless perspectives, and nonfunctional accumulations of geometric shapes, examples of which were reproduced in the surrealist issue of *View* and shown in 1947 at the surrealist exhibition of the Galerie Maeght. Her poetry, which she wrote in Italian, English (*The More I Wonder* [1957]) and French (*Demain Monsieur Silber* [Paris: Seghers, 1957]), periodically replaced her artwork—something with which she claimed to have "no ties"—and often took the shape of nursery rhymes or limericks. Her poetry would be suffused with unbearable solitude following Tanguy's death in 1955. After she committed suicide, a last volume of poems, *Mordicus,* was published in 1962, with drawings by Dubuffet.

SCHÉHADÉ, GEORGES
1907–89, Alexandria/Paris

A French-speaking writer of Lebanese nationality. Schéhadé studied law in France and then occupied a number of positions in the French administration in Lebanon. From the very beginning, his poetry was influenced by surrealism, but that which he preserved, above all, was a sense of wonder before the powers of language. His writing was frequently characterized by a generosity tinged with malice. *Rodogune Sinne,* a novel "written as a school-leaver" at a time when he described himself as a "pigeon house for words, for turtle doves," was published in 1947 and was an immediate success, something that was later confirmed by his ventures into theater. These began with *Monsieur Bob'le* in 1951 and continued with *Histoire de Vasco* in 1956, *Les Violettes,* and *L'Émigré de Brisbane,* where his pacifist and even ecological principles were displayed. Schéhadé would become one of the most frequently performed playwrights worldwide, alongside Beckett and Ionesco, and he represented the sunny—though never sentimental—side of surrealism in theater. Yet one must not neglect the quality of his poetry, rich in light aphorisms influenced by the East and its storytellers and by the imagination.

SCHRÖDER-SONNENSTERN, FRIEDRICH
1892–1982, Kuckernsee, Lithuania/Berlin

German poet and self-taught painter. Schröder-Sonnenstern chose to live on the fringes of society, a society whose rules he rejected. He dabbled in a variety of professions (smuggler, astrologist, and so on) and was interned for long periods in a psychiatric hospital. It was not until 1949 that he took up drawing, exhibiting a graphic style that was both "childish" and aggressive in his depiction of scenes rich in fantasy and heedless of propriety. Women are portrayed as dominating, but in his representational works his particular humor, a mixture of derision and despair, can also be observed in the way in which each drawing expresses obscenity and vaguely suggests an imagery in the German Gothic tradition. Christian d'Orgeix came upon Schröder-Sonnenstern's work in 1955, and later Hans Bellmer introduced him to the Paris group: they would include his works in *EROS,* for they viewed it as the indisputable expression of a definitive hatred of society and convention.

SCHUSTER, JEAN
1929–95, Paris

Schuster joined the Paris group in 1948 and rapidly became one of the most important members of the postwar generation. His political and moral rigor, his vigilance with regard to oppression, be it traditional (Christian, among others) or Stalinist, would bring him to contribute not only to anarchist publications but also to the group's periodicals: he was successively editor of *Médium,* editor-in-chief of *le surréalisme, même,* and editorial committee member for *La Brèche.* In 1958, together with Dionys Mascolo, he wrote *Le Quatorze Juillet,* "the organ of intellectual resistance" against fascist influence, and this led to the manifesto of the 121, which Schuster coauthored. Upon Breton's death, Schuster was thought to be the only person capable of sustaining collective activity, something he would undertake to do in *L'Archibras,* but by 1969, with the publication of *Le Quatrième Chant,* he was forced to concede that the task had grown impossible due to internal dissent. He then took part in the *Coupure* venture and subsequent trial. In 1969, some of his texts were compiled in *Archives 57–68,* clearly subtitled *Batailles pour le surréalisme.* Ten years later, he surprised those who were unfamiliar with his work by publishing a short collection of incisive poems: *Les Moutons.* Far from nurturing any "career" ambitions, he contented himself with sharing his reactions to the absence of news with a few kindred spirits: *Les Fruits de la passion* (1988), *T'as vu ça d'ta fenêtre* (1990), and *Le Ramasse-miettes* (1991).

SCHWARZ, ARTURO
1924, Alexandria

Of Italian origin, Schwarz was one of the first leaders of the clandestine Egyptian Trotskyist party. Expelled from Egypt in 1949, he founded a publishing house in Milan and a bookstore/gallery devoted to surrealism and avant-garde works. Using the pseudonym Tristan Sauvage, he began to publish poetry in French in 1951, then a work on *L'Art nucléaire.* In 1955, he came into contact with the Paris group and grew particularly close to Marcel Duchamp, to whom he devoted several significant works (and whose readymades he would "publish" in 1964). In 1959, he brought out the bilingual anthology *La Poesia surealista francese* by Benjamin Péret, and in May 1961 held at his gallery a *Mostra internazionale del surrealismo.* He became the exegete of Francis Picabia and Man Ray and published *New York Dada* in 1973 and *Breton/Trotski* in 1974 (French translation in 1977). In 1976, his collection *Méta.Morphoses* was illustrated by André Masson. Always interested in revolutionary theory, in 1981 he was at the origin of a vast survey titled *Anarchia e creativita.* Passionately interested in alchemy as well, which he studied from the aspect of universal analogy, in 1986 Schwarz organized the *Art and Alchemy* section of the Venice Biennale.

SCUTENAIRE, LOUIS
1905–87, Ollignies/Brussels

Belgian writer, of "Andalusian-Provençal origin." Already in childhood, he was writing poems that were virtually automatic in nature, and in 1927 he sent a few pieces to Camille Goemans and Paul Nougé, thus integrating the Brussels group without difficulty. He became close to Magritte (and would assemble an impressive collection of his work, bequeathed upon the death of his wife to the Museum of Modern Art in Brussels). He published poetry collections (*Les Haches de la vie* [1937]; *Frappez au miroir* [1939]—illustrated

by Magritte) and began to collect his aphorisms, the notes he took on his reading (which was both "popular" and scholarly), and reflections that often displayed an elegantly black humor in the successive volumes entitled—in homage to Restif de la Bretonne—*Mes inscriptions* (1945, 1976, 1981, and 1984), which made up what was clearly his most personal work. Scutenaire had an unusual mind, pushing nonconformity to the extremes of calling himself a Stalinist until his death, and curious about everything in everyday life or idle conversation suggestive of a dissoluteness that could enable one to better "look reality in the farce" (*sic*). Scutenaire also wrote a novel, *Les Vacances d'un enfant* (1947); a work on Magritte (1950), and an impressive number of volumes of poetry and short pieces. His *Textes automatiques* was published in 1976, with illustrations by Adrien Dax. (*Plein chant*, no. 33–34 [1986]; R. Vaneigem, *Louis Scutenaire* [Paris: Seghers, 1991].)

SELIGMANN, KURT
1900–1962, Basle/Sugar Loaf, N.Y.

Painter of Swiss origin. Seligmann joined the surrealist group in Paris at the end of the 1920s. He was the creator of prints (the series *Vagabondages héraldiques* [1934]) and canvases and was fond of characters made up of heterogeneous elements, often captured in ambiguous poses—in movement or in a state of panic—in the midst of inhospitable surroundings. He also produced objects, including the famous *Ultra-meuble*. In 1939, Seligmann left Europe for the United States, where he stayed until his death by suicide—and where his passion for Native American art joined his earlier curiosity in heraldry, alchemy, and the Kabbala. In his painting, anthropomorphic figures disappear beneath ample draperies as if easily broken and soon leave them all the space: volutes, whirlwinds of fabric, and imposing crystallizations take the place of figures. In 1946, two years after he left the group following a disagreement about Fourier, Seligmann designed the costumes for a ballet by Balanchine: the dancers were wrapped in long strips of cloth or disappeared beneath flowing folds of fabric. In 1948, he published *Miroir de la magie,* where he put the impressive library he had collected on the subject to good use. Right up to the end of his artistic life, Seligmann explored ways to discover new shapes or structures shared by both life and death.

SILBERMANN, JEAN-CLAUDE
1935, Paris

Painter and poet. Silbermann joined the surrealist group in 1956 while he was still a philosophy student. He soon published poetry and articles in the group's periodicals (*le surréalisme, même, Bief, La Brèche*); from 1962 on, he took up painting as an autodidact, experimenting with different methods (drawing with his left hand, telephone doodles) to try to avoid predictable compositions. He cut out plywood figures and produced what he called "signs," in which the juxtaposition of more or less fairy-like characters, objects, and animals favored the play of metamorphoses and the reconciliation of contradictory elements. When he painted on canvas or on more regular formats, moving from tenderness to sarcasm, it was always with the aim to unveil a poetic universe rooted in his fantasies. Combining art and poetry meant frequent poetry "exhibitions" at which verbal material was treated like his pictorial material: wordplay and phonetic approximations facilitated the transfer from one form to the other.

SIMON, ARMAND
1906–81, Pâturages/Frameries

Belgian artist. Quite by chance, Simon came upon a copy of *Les Chants de Maldoror* in a second-hand bookstore in 1923. Fascinated by the text, he devoted thousands of drawings to Lautréamont's work, drawings that were not so much illustrations as images transposing the book's spirit into any possible setting. Between 1937 and 1945, he undertook a series of thirty-seven drawings explicitly created for an illustrated edition of Lautréamont. He joined the Hainaut Surrealist Group as soon as it was created in 1939 and then contributed, along with Achille Chavée, Dumont, and Marcel Lefrancq, to the first issue of *L'Invention collective*. He then participated in the Mons group, Haute Nuit, and finally, although he did not like leaving his native town, became a member of Revolutionary Surrealism. He later provided illustrations for texts by Monique Watteau and Marcel Brion and for Chavée's *Sept poèmes de haute négligence.*

SMEJKAL, FRANTISEK
1933–88, Prague

Czech art historian. Smejkal was one of the rare individuals to defend historical avant-gardes and surrealism during the reign of socialist realism. Thus, together with Vera Linhartova, he organized the exhibition *Imaginative Painting from 1930 to 1950*—the first devoted to such works—at the Hluboka museum in 1964. He included little-known works by Toyen, Jindrich Styrsky, Jindrich Heisler, Janusek, and Musika. In 1966, he wrote a short book about Musika, and then went on to publish studies on the periodical *Red,* on Styrsky, and on the Ra group (about whom he would also organize an itinerant exhibition in Bohemia and Moravia shortly before his death), as well as producing an important monograph on Sima.

SOUPAULT, PHILIPPE
1897–1990, Chaville/Paris

French poet. Soupault came from a family with links to the haute bourgeoisie, for which he would profess an undying hatred. He was bored in secondary school and learned nothing other than "a violent taste for freedom." Mobilized in 1916, he was used as a guinea pig for a new experimental vaccine against typhoid and was then posted to the Ministry of Transports. In 1917, his first poems, which he had sent to Apollinaire, were published in *SIC;* he made the acquaintance of Pierre Reverdy and Blaise Cendrars, and it was Apollinaire who introduced him to André Breton. Soupault worked as a prompter during the performance of *Mamelles de Tirésias* and was elated by the discovery of the *Chants de Maldoror.* His first collection, *Aquarium,* was self-published. In 1918, he wrote a narrative tale, *Voyage d'Horace Pirouelle,* which was published in 1925. Tzara's *Manifeste Dada, 1918* had the same impact on him as on his friends, and together with Breton he directed *Littérature* and financed its first issues; this is where they published the first chapters of *Les Champs magnétiques,* composed with great enthusiasm as they discovered the powers of automatism. Very active in the Paris Dada events and coauthor, again with Breton, of the plays *S'il vous plaît* and *Vous*

m'oublierez, Soupault also contributed to numerous periodicals and met James Joyce, Ezra Pound, and Raymond Roussel. He took part in the Barrès trial, and it was at the Librairie Six, run by his wife, that the first exhibition of Man Ray's work was held.

As Soupault had some reservations regarding the impact of the sleeping-fits, he would for the first time take some distance from his friends by abandoning the codirectorship of *Littérature,* but he continued to submit articles and poetry to a number of publications. In 1922 he took over the management of *Écrits nouveaux,* André Germain's periodical, and turned it into *La Revue européenne,* for which he would garner contributions from a wide variety of writers. His novel, *Le Bon Apôtre,* was published by the Éditions Kra in 1923, followed by *À la dérive,* which he dedicated to Breton, and *Frères Durandeau* in 1924. He published *Le Paysan de Paris* in *La Revue européenne* and edited *The Surrealist Manifesto,* but the surrealists refused to be included in the *Anthologie de la nouvelle poésie française* that he was editing for Kra. Soupault contributed to the first issue of *La Révolution surréaliste,* took part in the activities of the Bureau Centrale, where he met De Chirico, and attended the Saint-Pol Roux banquet. In 1925, yet another novel: *En joue!* and still more contributions to periodicals were published. The following year, tired from his many activities, Soupault dropped out of the group, went away traveling, and eventually broke with surrealism: he did not approve of what he saw as a pointless drifting toward political concerns and stated, at the same time, that his numerous contributions to periodicals had had no serious significance and that nothing was really important.

Spending more and more time traveling and "aggravating" his dilettantism, he was violently attacked in the *Second Manifesto,* but in spite of this he was not motivated to participate in *Un cadavre,* preferring to concentrate on his novels, critical pieces, and countless articles. He was the first to show an interest in William Blake and Uccello, and he published essays on Charlie Chaplin and Baudelaire. In fact, Soupault's indifference to what he was actually writing was such that some of his texts have completely disappeared. Having become a professional journalist, he watched the rise of Nazism in Germany and was far more lucid about its significance by 1933 than the members of Contre-Attaque were. In 1937, his *Poésies complètes* were published by GLM. After war was declared, he was appointed Director of Information in Tunis: this would lead to his arrest in 1942 for "high treason," and he was imprisoned for several months. He carried out a number of missions in North Africa, Canada, and the United States (where he met up again with Breton); he reorganized the French Press Agency in Latin America and gave talks in Pennsylvania. Back in France, Soupault alternated missions for Unesco, writing, and radio productions, traveling the world over. In 1965, after his wife of twenty years committed suicide, he moved into a hotel, where he would live for the next eight years. In 1966, he began to write his memoirs, while *Les Champs magnétiques* was reissued in a paperback edition and his earlier novels were progressively rediscovered. In 1974, he moved into a simple one-room apartment, with no desire to form any attachments, and he did not even have any paintings or books. Often invited to give lectures, he would evoke surrealism and poetry and enjoyed a certain late recognition. Soupault died before he had the chance to finish proofing

the fourth volume of his *Mémoires de l'oubli* (published by Lachenal & Ritter), having confirmed through his chosen lifestyle his lasting desire to be independent from everything. And although he had played a leading role in the early years of surrealism, it was this same desire that kept Soupault apart whenever he felt he might be obliged to conform to a group discipline.

(Philippe Soupault, *Vingt mille et un jours, conversations with Serge Fauchereau* [Paris: Belfond, 1980]; B. Morlino, *Philippe Soupault* [Lyons: La Manufacture, 1987]; L. Lachenal, *Philippe Soupault, chronologie* [Paris: Lachenal & Ritter, 1997].)

SOURIS, ANDRÉ
1889–1970, Marchienne-au-Pont/Paris

Belgian musician. In 1925, after studying to be an orchestra conductor, Souris joined the *Correspondance* group and cofounded, with Paul Hooreman, a parallel series, *Musique.* On February 2, 1926, he attended the session at the Salle Mercelis, the aim of which was to discredit modern art and create a specific poetic climate by bringing about a confrontation between heterogeneous forms: where Souris was concerned, this meant wrong refrains, barrel organ cylinders played backward, and jazz mixed with the *Quadrille des lanciers* and refined composed pieces. He set Paul Nougé's poems to music, contributed to the periodical *Distances,* and was expelled from the group in 1936 for having agreed to direct an orchestra at what were actually official ceremonies. He then filled a number of different positions before becoming a director of research at the Centre National de Recherche Scientifique; he also contributed to Marcel Mariën's *Lèvres nues* during the same era.

(See André Souris, *Conditions de la musique et autres écrits* [Brussels: Éditions de l'Université de Bruxelles, 1976].)

STYRSKY, JINDRICH
1899–1942, Cermna/Prague

Czech painter, photographer, and poet. In 1927, Styrsky and Toyen founded artificialism (a pictorial version of poetism, which favors the rights of the imagination). In 1934, Styrsky was among the first members of the Czech group. His photographs were often created in "cycles": *L'Homme aux œillères* (1934) and *Après-midi parisien* (1935). Hostile to purely artistic values, Styrsky was interested, above all, in the relation between the "form" and "content" of a painting.

SUQUET, JEAN
1928, Cahors

Reporter and photographer. It was, above all, through his work on Marcel Duchamp that Suquet became involved in surrealism, although he only passed through the group quite briefly, from 1948 to 1950. In 1963, he received the Niepce prize for his photography. His analysis—praised already in 1949 by Duchamp himself ("You are the only person in the world who has been able to reconstruct the gestation of the Glass in all its details, even the numerous intentions that were never carried out")—was becoming known by the time of the *Almanach surréaliste du demi-siècle,* and his work continued with *Miroir de la mariée* (Paris: Flammarion, 1974), *Le Guéridon et la virgule* (Paris: Bourgois, 1976), *Le Grand verre rêvé* (Paris: Aubier, 1991), and *In vivo, in vitro* (Paris: L'Échoppe, 1994). Jean Suquet also published personal accounts (*Le Scorpion et la rose* [Paris: Bourgois,

1970]) and a collection of prose and photographs in *Oubli, sablier intarissable* (Bourdeaux: Éditions Liard, 1996).

SVANBERG, MAX WALTER
1912, Malmö

Swedish painter. Cofounder of the group of Imaginists in 1946, Svanberg's painting was by that time already entirely devoted to the exaltation of woman. The surrealists were enchanted when they came across Svanberg's work in the early 1950s: he subsequently illustrated the third issue of *Médium*. An exhibition of his canvases was held in 1955 at the Étoile Scellée, for which Breton wrote the catalog preface, and in 1959 he was featured in *EROS*. And yet it was not until 1964 that he came to Paris to meet his friends. Paintings, prints, pearl embroidery, and drawings made up the relentless song to a female beauty both innocent and perverse, offered and hidden. Whether portrayed as the idol of one's fantasies or a magical chimera, a sphinx or a Gorgon, woman was capable of every metamorphosis and revived the myth of the original androgynous being. For Svanberg, passion and the marvelous are a harmonious blend and concentrate all intimate perversions into an "ascendant sign."

TAKIGUCHI, SHUZO
1903–79, Toyama/Tokyo

Japanese poet, critic, and painter. After a spell as a teacher, in 1927, Takiguchi returned to the literary studies he had interrupted in 1923. In 1928, he translated Aragon's *Traité du style,* and two years later published the Japanese version of *Surréalisme et la Peinture.* From that point on, he became the leading proponent of surrealist activities in Japan, organizing, in particular, the 1937 surrealist exhibition, the same year he published his poetry collection *Distance of the Fairies.* In 1938, he joined the Circle of Studies of Materialism and, in 1940, published the first monograph on Miró. The police suspected him of being a communist and arrested him in 1941. Takiguchi spent ten months in preventive detention and was held in police custody until Japan's defeat. After the war, he revived the club of avant-garde foreign artists that he had founded in 1938 and joined or supported various groups of progressive artists. It was only in 1958, as a representative to the Venice Biennale, that he finally had the opportunity to travel to Paris to meet Breton and then Dalí and Duchamp. From 1960 on, his production would include sketches, decalcomania, and burned drawings. His friendship with Duchamp would lead to the publication, in 1968, of an object-book entitled *To and From Rrose Sélavy: Paroles de Marcel Duchamp,* illustrated by Arakawa, J. Johns, and Tinguely.

(J. Ebara, "Takiguchi: L'éternel inachevé," in *Pour un temps: Écritures japonaises,* ed. Alain Jouffroy [Paris: Centre Georges Pompidou, 1986].)

TAMAYO, RUFINO
1899–1991, Oaxaca/Mexico City

Mexican painter of Zapoteca origin. Within the muralist movement, Tamayo was an exception, for his works lacked an explicitly political dimension, something for which Breton would congratulate him in the preface he wrote for Tamayo's first exhibition in Paris in 1950. While he began by using muted colors, his painting grew lighter from 1938 on, as he worked the paste to avoid flatness and give poetic depth to his palette. His entire work is devoted to the exaltation of Mexican elements—his native province, to be exact—which he elevates to the dimensions of a universal mythology. Tamayo also illustrated texts by Octavio Paz and Benjamin Péret.

TANGUY, YVES
1900–1955, Paris/Woodbury, Conn.

French painter, naturalized American in 1948. Tanguy met Jacques Prévert during his military service and decided to take up painting in 1923 after spotting two canvases by De Chirico as he rode by on a bus. In the turbulent atmosphere of the rue du Château, his first endeavors as an autodidact quickly evolved: in 1925, *Rue de la Santé* united expressionism and a metaphysical mood. His entry into the surrealist group was marked by a radical evolution: he now began producing automatic drawings, scattering a handful of recognizable elements into a deserted landscape. In 1927, he exhibited at the Galerie Surréaliste, and Breton wrote a preface for the catalog; he also illustrated a collection by Péret. Identifiable elements were gradually disappearing from his canvases, and his creative process now included a combination of automatism (covering the background with haphazardly mixed colors) and a provoked semihallucination: chance results in which the texture of the canvas suggested shapes, whose credibility the artist then enhanced by adding shadows. The dominant result is that of a "landscape" seen from the air, inhabited by "beings" and "objects" that seem to predate the genesis of the known world, while the line of the horizon separates a fairly empty "sky" from a "ground" on which whitish shapes are accumulated as if petrified, dotted with rare cells of vivid colors. These shapes group together as if in families (*L'Extinction des espèces II* [1938]) and are proof of the triumph of the inner world, a triumph so great that they were chosen to illustrate the cover of the *Dictionnaire abrégé du surréalisme.*

Tanguy clearly influenced Roberto Matta's work, as well as that of Oscar Dominguez and Esteban Francès. His recognition by the group did not automatically imply public success: he lived in poverty. Declared unfit for service in 1939, Tanguy left for the United States, where he married Kay Sage, whom he had met the previous year in Paris. The couple settled in Woodbury and gradually attained a certain material comfort. Exhibitions came more and more frequently, but Tanguy's later work was not always well received: while the color improved, it seemed more tragic. In 1946, Pierre Matisse published a work (with a layout by Duchamp) collecting all the essays Breton had written on Tanguy, but Tanguy himself, even though he was visited in Woodbury by Miró, David Hare, Frederick Kiesler, Enrico Donati, and Duchamp, had grown indifferent to the group's activities: at best, he followed their evolution with amusement. Nor did he have the slightest curiosity in American painting and held it to be poor and without content; its evolution in what Breton called the "kingdom of Mothers" was hardly compatible with abstraction.

TANNING, DOROTHEA
1912, Galesburg, Ohio

American painter. Tanning abandoned the fairly academic realism of her canvases after she visited the exhibition *Fantastic Art, Dada, Sur-*

realism in 1936. In 1942, while taking part in an exhibition of thirty-one women painters at Peggy Guggenheim's, she met Max Ernst, with whom she went to settle in Sedona, Arizona, and whom she would marry in 1946. She would share Ernst's life until his death, trying all the while to develop her own work independently from his influence. The canvases from the 1940s emanate an atmosphere of the fantastic, tinged with eroticism. Later, her scrupulous representational renderings of adolescents and monsters gave way to a play of diffuse colors in fairly vague, dreamlike spaces. At the end of the 1960s, Dorothea Tanning returned to a more aggressive inspiration for her sculptures made of padded fabric, decorated with lace and fur, and suggestive of ambiguous creatures, half furniture, half human, born of ineffable reveries.

TARNAUD, CLAUDE
1922–91, Maisons-Laffitte/Apt

Together with Yves Bonnefoy and Serpan, in 1945 Tarnaud founded the group called La Révolution la Nuit, and the following year joined in the surrealist activities. In particular, he was one of the animators of *Néon;* in 1948 he was expelled, however, for belonging to the Victor Brauner faction. Five years later, he embarked on a collaboration with *Phases,* which lasted until 1966. He lived for lengthy periods abroad (Somalia, United States, Switzerland), then finally retired to Provence and avoided all collective activity. In 1954, he published *La Forme réfléchie* (Paris: Éditions du Soleil Noir), which was followed by a few collections illustrated by friends (E. F. Granell, Vielfaure, J. Lacomblez) and a few pages in *La Brèche.*
(Sarane Alexandrian, "Claude Tarnaud ou le dandy transcendant," *Supérieur inconnu,* no. 1 [October–December, 1995].)

TATIN, ROBERT
1902–83, Laval/Cossé-le-Vivien

Painter, poet, and builder. From a modest background, Tatin began as a carpenter (inducted as a master guildsman in 1926) and practiced a number of trades; in Laval in the 1930s, he frequented Oswald Wirth, who reformed the symbolism of Tarot cards and Freemasonry. But Tatin had no taste for the sedentary life, and he ended up in South America, where he created ceramics and decorated cafés. Dubuffet classified his work as art brut, and Breton corresponded with Tatin. In fact, Tatin is unclassifiable, and his painting combined the most diverse references: primitive art, hermetic symbolism, and folk art are vigorously blended. The final work of his life would be the construction, begun in 1962, of his house at La Frénouse, which was a personal museum and a dwelling all at the same time: one entered the property along a lane lined with painted concrete statues depicting Joan of Arc as well as Breton and Le Douanier Rousseau. Through the multiple symbols that abound on his bas-reliefs and make friendly monsters seem possible, Tatin endeavored to reconcile not only styles but also ways of thinking and man with the universe, as well. The marvelous, so dear to surrealists, is evident in all his work, enhanced, moreover, by a Rabelaisian sense of humor.

TCHELITCHEW, PAVEL
1898–1957, Kaluga, Russia/New York

Self-taught artist. Tchelitchew arrived in France in 1923 and worked for the Ballets Russes. He met René Crevel, then embarked on lengthy trips all over the world for his profession as a stage designer; settling finally in the United States. In New York, he came into contact with the exiled surrealists. His painting creates a fantastic mix of anatomical notes with deformed figures and warped perspectives, and his work was praised in the second half of the issue entitled "Tanguy" from March 1942 of *View;* Tchelitchew was not, however, among the contributors to *VVV.*

TÉLÉMAQUE, HERVÉ
1937, Port-au-Prince

French painter of Haitian origin. From 1957 to 1960, Télémaque studied at the Art Students League in New York with J. Lévi. He realized that abstract expressionism was finished, but he was interested in Arshile Gorky. He settled in Paris in 1961 and very soon made contact with the surrealists, who were intrigued by the somber violence of his painting and the way in which he relied on the impulsiveness of gesture to evoke anxiety and fantasies. His interest in pop art, however, led him to adopt a cold, figurative style juxtaposing clearly defined objects borrowed from consumer catalogs, and thanks to which he was able to invent metaphorical itineraries expressing a subjective drifting. Often, contradictory sign-objects were left open to the viewer's mental interpretation. Télémaque left the group before Breton's death, having concluded that the surrealists were too easily satisfied with hackneyed solutions. In 1966 and 1967, hoping to leave painting behind, he worked on a series of paradoxical objects, but he quickly returned to it and enhanced his work with collages that allowed him, by including scrap material from his studio, to show the process of composition of each work (the series *Selles,* then *Maisons rurales*). Since the 1980s, preparatory sketches have replaced his use of the episcope, giving rise, in turn, to rich associations between words, shapes, and memories. Télémaque resorts to all the means at his disposal to create impeccably precise montages, for in his constant concern with the intellectual and moral impact of the work, he enumerates the ailments of the contemporary spirit but also its boldness.

TERROSSIAN, JEAN
1931, Paris

French painter. Terrossian took part in the surrealist group's activities from 1961 on and contributed to *BLS.* His painting started out as allusive, containing few identifiable objects, but shifted toward clear figurative representation in 1967. Clearly recognizable objects were set according to variable scales into a complex space of sharp-edged surfaces and reflections, while words or formulas, dotted lines, and arrows crossed the surface here and there, giving one's thoughts the chance to wander off in many directions. Terrossian's exhibitions were rare. He slipped his fantasies into the shelter of his compositions, but, without making them explicit, they were nevertheless available to everyone. This movement of veiling and unveiling was reminiscent of Magritte in some ways, but a Magritte who might have set out to make up for the mental shortcomings of American pop art, for example.

THIRION, ANDRÉ
1907, Baccarat

In his memoirs, *Révolutionnaires sans révolution* (1972), Thirion has carefully traced the stages of his career. It was when he was already a militant Marxist trade unionist that he met the cohorts of the rue du Château—Yves Tanguy, Georges Sadoul, Jacques Prévert, then Louis Aragon; he was active in the surrealist group from 1928 to 1934. Thirion was one of the rare authors who wrote about issues of work and economy ("Notes sur l'argent," *La Révolution surréaliste,* no. 12, and "À bas le travail" in the special issue of *Variétés*). Loyal to his initial commitment, Thirion tried to facilitate relations between the group and the Communist Party, but he was also aware of the group's "illusions" with regard to the party's openness or willingness to include them. After Thirion left the group, he joined the Resistance and eventually became a supporter of de Gaulle.

TONNY, KRISTIANS
1907–77, Amsterdam

Dutch artist. Tonny came to Paris in 1925, met René Crevel and Georges Hugnet, and took part in the first surrealist exhibition at the Galerie Pierre. His painting, however, was too phantasmagorical to comply with the ideological principles of the group. In 1929, Hugnet wrote the preface for Tonny's first solo exhibition. Tonny left for the United States in 1937 and had an exhibition at Julien Levy's gallery; he would then instigate the *International Exhibition of Surrealism* held the following year in Amsterdam and was, moreover, the only Dutch artist featured. After the war he was in contact with the Surrealist Research Bureau in Holland but had virtually no more ties with his friends in Paris.

TOVAR, IVAN
1942, San-Francisco–de-Macoris

Painter from the Dominican Republic. When Tovar arrived in Paris in 1963 he met Agustin Cardenas, who had an initial influence on him. But within a few years he had developed an original artistic vocabulary: each canvas seems to be the venue for a loving or treacherous battle, where prickly figures covered in scales carry various instruments for puncturing or suffocating: they have nothing human about them save a vague silhouette or posture and are set against a background that often seems closed and seminocturnal, its decor replaced by a few geometric elements. The rituals or dances of death in which these creatures are engaged seem to obey a code as ancient as it is indecipherable, and despite its semirepresentational character, Tovar's painting seems to be in quest of an ultimate secret, of which we can catch only a few glimmering reflections. Tovar returned to Santo Domingo in 1979, and it is difficult to know the most recent evolution of his quest.

TOYEN (PSEUDONYM OF MARIA CERMINOVA)
1902–80, Prague/Paris

Czech painter. Toyen began by participating in the activities of the Devetsil association, which briefly united the advocates of constructivism and proponents of poetism; in the late 1920s, she would facilitate the transition to surrealism. She lived with Styrsky in Paris from 1925 to 1929 (Soupault wrote the catalog preface for their 1927 exhibition at the Galerie Vavin), and together they defined artificialism, which took painting in a dreaming direction capable of bringing the irrational to the surface. Back in Prague, Toyen collaborated on a series of erotic publications with serenely daring illustrations, and she was among the first members of a Czech surrealist group. Ambivalent symbolic objects prevail in her canvases—eggs, stones, ropes—while fantastic creatures emerge from a hallucinatory ambience. Before and during the Second World War, Toyen produced cycles of drawings of an extreme acuity (*Les Spectres du désert* [1937]; *Tir* [1940]; *Cache-toi guerre!* [1944]): the aggressiveness of the imagination reinforces the lucid acceptance of horror. Radically hostile to Stalinism, Toyen fled to Paris in 1947 in the company of Jindrich Heisler, after years of living in hiding. She became a leading figure of the Paris group, insofar as her work suggested independent alternatives to the "models" provided thus far by the artists of the movement. Her figurative borrowings are integrated into a profoundly magical atmosphere, where they are redirected, through the grace of transformation, into the veiled expression of a polymorphous desire. In Toyen's work the erotic charge is alternately obvious (in her drawings and prints) or veiled (in her canvases), but she is always in control of her choice of forms as well as of their artistic treatment

TROST, DOLFI
1916–66, Braila, Romania/Chicago

Romanian writer and artist. One of the five members of the Bucharest surrealist group founded in 1939, he clearly had a strong influence on their evolution, through his tendency toward permanent dissatisfaction and his taste for unbridled experimentation. In 1945 he wrote *Dialectique dans la dialectique* with Gherasim Luca and insisted on the need to go beyond all of surrealism's previous accomplishments to prevent it from lapsing into repetitiveness. Trost placed his faith in chance (which could even intervene to explain the meaning of dreams), and he envisaged a "negation of painting" thanks to a "superautomatism" and the recourse to nondirected techniques such as fumage, vaporization, painting with one's eyes closed, and so on. He took part in the *Infra-black* exhibition along with Luca and Paul Paun held in Bucharest in 1946; a collection of the same name would follow, for which Trost published two short volumes, *The Pleasure of Floating* and *The Same of the Same*. He left Romania in 1948 and lived first in Israel, then in Paris, where he published two pieces confirming the singularity of his creative process: *Visible et invisible* (Paris: Arcanes, 1953) and *Librement mécanique* (1955).

TROUILLE, CLOVIS
1889–1975, La Fère/Neuilly-sur-Marne

French painter. After studying at the School of Beaux-Arts in Amiens, Trouille worked almost his entire life in a factory that made shop mannequins, since he felt that painting could not be a paid profession. In 1930, exhibiting at the Salon des Artistes et Écrivains Révolutionnaires, he was noticed by Breton and would, henceforth, be invited to take part in the group's events, although he never really belonged ("I belong only to myself"), despite signing a few collective declarations up until 1951. His representational works glorifying

woman and love are imbued with a radical anticlericalism as well as a folk humor that eagerly joins in any play on words or shapes. Trouille's spirit of rebellion is close to that of Sade or Lautréamont, whose portraits he sets amid vampires, pin-ups, and blood-filled posters, all juxtaposed on his canvases in the manner of a collage.

TUAL, ROLAND
1902–56, Paris/Saint-Cloud

Tual met Michel Leiris, and then Breton and Aragon, through Max Jacob. He joined in the group activities from 1925 to 1927, signing a number of manifestos and managing the Surrealist Gallery in 1926. A member of "Prévert's gang," he then moved to a career as cinema producer and director that took him away from the surrealist movement, but he maintained cordial relations with Antonin Artaud, André Masson, and a few others.

TZARA, TRISTAN
(PSEUDONYM OF SAMI ROSENSTOCK)
1896–1963, Moinesti, Romania/Paris

Romanian and French poet. Cofounder of the Cabaret Voltaire in Zurich, Tzara rapidly became the leading proponent of Dada, inspiring increasing numbers of events and publications. When he met Francis Picabia in Switzerland, he was able to give new life to an otherwise declining activity in Zurich. Breton and his friends impatiently awaited his arrival in Paris in 1919, and over the next two years Tzara would organize a series of events that did indeed place Dada in the spotlight for a certain audience. Some people quickly grew tired of Dada, however, and were eager to find new values to replace those that Dada had swept aside with such ease: the Barrès trial separated those who wanted to continue Dada (Tzara, Georges Ribemont-Dessaignes, and Picabia, for the time being) from Breton and his close circle. Tzara was opposed to the idea of the Paris Congress, and this finalized the break; there were certain shifts within the two groups that led to open and violent confrontation in 1923 at the performance of Tzara's play, *Le Cœur à barbe*.

Although Dada was definitively dead by 1923, Tzara nevertheless staged his play *Mouchoir de nuages* the following year and avoided any participation in the early official surrealist events. Only in 1929 did collaboration once again become possible: Tzara participated in *Le Surréalisme ASDLR* with an essay on the situation in poetry and then in *Minotaure* ("D'un certain automatisme du goût"); his analyses were valuable theoretical contributions to surrealism. His poetry, too (*L'Homme approximatif* [1931]; *Où boivent les loups* [1932]), offered rare examples of an authentically epic lyricism. In 1935, Tzara joined the Communist Party: he now felt that poetry must primarily serve as a liaison to revolutionary activity, and he would long defend this position. In a speech in 1947, "Le Surréalisme et l'après-guerre," he declared that authentic surrealism could be found among those who had understood the necessity of armed struggle against the forces of occupation and that poetry should directly address those combatants. Breton and the group disrupted his speech, considering his analysis to be simplistic and deceiving, and it would only have a passing impact in the sole issue of *Surréalisme révolutionnaire*.

UBAC, RAOUL
1910–85, Malmédy/Paris

Photographer, painter, and sculptor of Belgian origin. In 1930, Ubac contacted the Paris group, but it was from 1936 to 1939 that he actually joined in the activities, with collages, solarizations, and photomontages (a few examples were published in *Minotaure*): bodies were diffracted as if to reveal the secrets of their inner space. During the war, Ubac contributed to La Main à Plume and also to the periodical *Messages;* he later drifted away from surrealism and turned to abstraction in painting, sculpture, and engraving on slate—work that was outstanding in its rigor and austerity.

UNIK, PIERRE
1909, Paris; disappeared in Central Europe in 1945

Writer, journalist, and screenwriter. Unik discovered surrealism while he was studying for the baccalaureate examination, and he published a few pieces in *La Révolution surréaliste*. He joined the Communist Party in 1927 and, along with Louis Aragon, André Breton, Paul Éluard, and Benjamin Péret, he signed *Au grand jour* as a response to those who questioned the nature of their commitment. In number 12 of *La Révolution surréaliste* he published his "Soldier's Prayer" anonymously, at the very time he was beginning his military service; it was a violent antimilitary pamphlet. During the Aragon affair he remained loyal to Aragon and to the party, and with Maxime Alexandre he wrote the pamphlet *Autour d'un poème*, marking his departure from surrealism. He later became a screenwriter, notably for Buñuel in 1937 for *España leat en armas*, and a journalist for *L'Humanité;* he was held prisoner in 1940, managed to escape from Silesia before the end of the war, but then disappeared somewhere in Slovakia. It was not until 1972 that an unfinished novel, *Les Héros du vide*, was published, as well as the collection *Chant d'exil* (Paris: Éditeurs Français Réunis).

VACHÉ, JACQUES
1895–1919, Lorient/Nantes

In his youth, Vaché published symbolist poetry in the newspapers organized by his fellow students at the lycée and produced a few elegant drawings. Mobilized in 1914, he was wounded two years later and sent to the military hospital in Nantes. That is where he met Breton, who was immediately impressed by Vaché's air of detachment. After he returned to the front, the two men began to correspond. In his letters Vaché ridiculed all poetic and artistic endeavor and defined his concept of "umour." Breton saw him a few more times in Paris after the war, most memorably at a performance of Apollinaire's *Mamelles de Tirésias* during which Vaché fired in the air with a revolver as a sign of defiance. He died of an opium overdose, perhaps deliberately. That is, at any rate, what Breton concluded; Breton would be marked forever by the dandyism and sovereign detachment of the man who had also prevented him from ever being simply a poet. Breton edited Vaché's *Lettres de guerre*, adding successive prefaces. But through Breton, Vaché had a lasting influence on all of surrealism.
(M. Carassou, *Jacques Vaché et le groupe de Nantes* [Paris: J.-M. Place, 1986].)

VALENTIN, ALBERT
1908–68, La Louvière/Paris

Belgian writer. Valentin only took part in the surrealist activities

from 1929 to 1931, but his contributions to *Le Surréalisme ASDLR* were incontestably acrimonious, not only against the police and the upcoming colonial exhibition but also in defense of Baudelaire, Rimbaud, and Lautréamont. He also produced collages from photographs. Before long, however, he left the surrealist group, reproached for having collaborated on the film *À nous la liberté,* which the surrealists found despicable. Valentin had been René Clair's assistant and would continue to work with him.

VALORBE, FRANÇOIS
1914–77, Bordeaux/Paris

After publishing a volume of poetry (*Soleil intime* [Paris: G.L.M., 1949]), Valorbe met Breton and took part in the group's activities and publications (*Le Libertaire, Médium*) until early 1955. He made a living playing small parts, but he had an aristocratic background (Viscount of Vibraye) and contacted his relatives whenever it was time to lend support to the Éditions Losfeld, where he published his jazz-inspired poetry (*Carte noire* [1953], with a cover design by Lam; *Magirisée* [1965]) and abrasively funny short stories (*La Vierge chimère* [1953]; *Napoléon et Paris* [1959], the title of which combined "the two most easily marketable names in the publishing industry"). "The greater density one injects into humor, the more absurd it will seem to imbeciles." In 1970, he published *Voulez-vous vivre en eps?* (Paris: Bourgois).

VAN BRUAENE, GEERT (OR GÉRARD)
1891–1964, Courtrai/Brussels

Van Bruaene began his career as an actor, then in 1921 opened the Galerie du Parlement in Brussels, warning his visitors with a sign that "this is not art" (the artists represented were Rops, Ensor, or Laermans). Late in 1923, he founded the Cabinet Maldoror and exhibited a large selection of European avant-garde (Dix, Grosz, Klee, Kandinsky, and Magritte, who showed his *Nus construits*); then, in November 1924, it was the turn of the Cabinet des Estampes Philosophiques, which was rarely open to the public because Van Bruaene had trouble looking after both venues alone, as they were relatively far apart. In the spring of 1925 he also inaugurated a third venue for puppet shows. Then, in collaboration with *Correspondance,* he organized the Cinematographic Sessions of the Cabinet Maldoror (Abel Gance, Lherbier, D. W. Griffith); the screenings were organized by Paul Nougé, but the venture was not a success. A first Galerie de la Vierge Poupine operated from June 1925 to March 1926. The second, located on Avenue Louise, was run jointly by Van Bruaene and Camille Goemans from the end of March 1926; it lasted until late 1927 and exhibited, among others, Jean Arp (who opened in Brussels with nothing more than sketches of his work, done in one night and on the spot) and frottages by Ernst. After the gallery closed, Goemans left for Paris, where he opened his own gallery on the rue de Seine, and Van Bruaene took over the management of a long succession of taverns and a few more galleries, where he continued to deal in art in his very special way—very low prices, even forgeries to satisfy certain snobbish clients—and he enjoyed the friendship of the Belgian surrealists, as well as the members of the Cobra group and a few others.

(See Rik Sauwen, *Geert Van Bruaene le petit homme du Rien* [Verviers: Temps Mêlés, 1970].)

VAN HIRTUM, MARIANNE
1935–88, Namur/Paris

Van Hirtum came to Paris in 1952, met Breton four years later, and took part in the activities of the surrealist group (particularly in *Bief*). She created paintings, drawings, "magical" statuettes, and objects in which humor and a taste for the unusual served a quest for a "childlike" purity that also characterized her poetry (*La Nuit mathématique* [1976], *Le Cheval arquebuse* [1978]).

VIOT, JACQUES
1898–1973, Nantes

Viot was introduced into the art world by Louis Marcoussis, who he had met during the war, a traumatic experience for him. He began working as a journalist, then in 1924 he became the secretary of the Galerie Pierre, met René Crevel and Joan Miró, and organized their first exhibition. He then began working for himself as an art broker, offering contracts to Miró, Max Ernst, and Jean Arp. He also contributed to *La Révolution surréaliste* during this period. He coorganized the surrealist exhibition at the Galerie Pierre in November 1925, and sponsored Pierre Roy. But his relations with the group deteriorated rapidly; in June 1926, he left for Tahiti and, for a year, worked as a bailiff and notary under a false identity before leaving for Shangai as an "antiques expert." An expedition to New Guinea enabled him to collect artifacts, particularly in the waters of Lake Sentani, and he wrote *Déposition de blanc,* an anticolonialist essay published in 1932. After his return to France, Viot renewed his ties with the group, who were passionately interested in the art of Oceania; he was quickly dubbed a "specialist," but he withdrew from the group because of his individualism. He then wrote detective novels under a pen name and, from 1935 on, worked as a screenwriter. In 1995 a collection of Viot's *Poèmes de guerre* was compiled (Paris: Éditions J.-M. Place).

(See P. Peltier, "Paris-Nouvelle-Guinée, 1925–35," *Gradiva,* no. 8 [1990].)

WALDBERG, ISABELLE
1911–90, Ober-Stammheim/Chartres

French sculptor of Swiss origin. Waldberg studied in Zurich and Florence, then settled in Paris in 1936. There she met Jean Arp and Alberto Giacometti, and Georges Bataille: she became the only woman in the "secret society" around "Acéphale." During the war she lived in New York, kept up a significant correspondence with her husband Patrick, and visited the exiled surrealists. During this period she produced "constructions" made of bound beech branches—architectural sketches hollowed out by space—which she exhibited in 1943 at the gallery Art of This Century. After her return to France, Waldberg experimented in more resistant materials—plaster and bronze—and created shapes that were frequently sinuous or torn apart, full of crevasses, in which matter captured a reverie respectful of fruitful indecision, crystallizing all the while a diffuse anxiety.

WALDBERG, PATRICK
1913–85, Santa Monica, Calif./Paris

French-American writer. From 1938 to 1940 he was secretary of the Collège de Sociologie. During the war he worked for various infor-

mation services for the Allies, traveling to North Africa, London, and New York. During his brief passages through New York he joined his wife Isabelle and took part in the meetings and activities of the exiled surrealists. The Carrouges affair in 1950 caused him to leave the Paris group, but he would nevertheless continue to share some of their preoccupations, as shown in his articles (compiled in 1961 in *Mains et merveilles* by Mercure de France), in his *Éros modern' style* (Paris: Pauvert, 1964), and in the monographs he devoted to Max Ernst (1958), René Magritte (1965), and Yves Tanguy (1978). In 1964, Waldberg organized an exhibition on surrealism for the Galerie Charpentier that was much contested by Breton and his close circle. He nevertheless organized another exhibition in 1972 at the Musée des Arts Décoratifs and compiled his most important essays on his artist friends in *Les Demeures d'Hypnos* (1979).

ZURN, UNICA
1916–70, Berlin/Paris

Following a happy childhood and various jobs at the UFA company, in 1949 Zurn began publishing in German and Swiss periodicals. After divorcing an unfaithful husband, Zurn experienced considerable hardship. In 1953, she met Hans Bellmer and would be his companion for the next seventeen years. In Paris, she produced her first automatic sketches and anagrams. During her second exhibition, in 1957, she came into contact with the surrealist group; she took part in *EROS* in 1959. From 1962 on, she would be interned in psychiatric homes on several occasions, in Berlin, Paris, and La Rochelle: echoes of her stays there resonated in *L'Homme-jasmin* (1971). In her artistic work, the increasingly frequent portrayal of aggressive creatures and uninhabitable places testified to a profound malaise, which ultimately led to her suicide.

Notes

CHAPTER ONE

1 The article by André Breton was reprinted in 1924 in *Les Pas perdus,* vol. 1 of *Œuvres complètes,* ed. Marguerite Bonnet, with the collaboration of Philippe Bernier, Étienne-Alain Hubert, and José Pierre, 3 vols., Bibliothèque Pléiade (Paris: Gallimard, 1988–2000), 2; English trans.: *The Lost Steps,* trans. Mark Polizzotti (Lincoln: University of Nebraska Press, 1997).

2 Soupault was not featured in the first issue, for financial reasons. Although he was paying for the printing, thanks to a small inheritance, the volume as planned was too thick; a page had to be removed, and it was his poem that was left out. The title *Littérature* was taken from a suggestion by Valéry (Breton had thought of "Le Nouveau monde," and Max Jacob, "Ciment armé"); it was chosen ironically and was not meant to be a reference to Verlaine's line "Et tout le reste est littérature," although Valéry had surely thought of it.

3 André Breton, "La Confession dédaigneuse" (The disdainful confession); the text was begun in late 1920 and was later used again in *Les Pas perdus.*

4 Letter to André Breton, April 29, 1917.

5 Tristan Tzara, *Dada manifeste sur l'amour faible et l'amour amer* from 1920,

6 On February 18, 1919, Breton announced in a letter to Tzara the imminent publication of *Littérature* and asked him not to condemn the undertaking too quickly because of the list of the first contributors; he added, in particular, "there is not one omission—Dermée, Picabia, Pierre Albert-Birot, Cocteau, etc.—which has not been thought through." In another letter, dated April 4, he clarified that Cocteau, Albert-Birot, and Dermée were among those who, in memory of Jarry, he called *palotins.* [Ubu's coconspirators—somewhat ridiculous officials. *Trans.*]

7 ["Allumeuse" is from the French "allumer," to light; an allumeuse is a "seductive woman, who seeks to excite men" (*Le Petit Robert: Dictionnaire de la langue françise,* ed. A. Rey and J. Rey-Debove [Paris: Le Robert, 1985]). *Trans.*]

8 See M. Sanouillet, *Dada à Paris* (Paris: Pauvert, 1965), 140. This date was recorded because of a note on the identity card issued to Tzara in July. Before his departure from Zurich, Tzara wrote, in French, a first series of fliers and a pamphlet for insertion in avant-garde periodicals, including *Littérature.* Éluard collaborated on the composition of the fliers that were pasted on walls throughout Paris at the very beginning of 1920 (see Y. Poupart-Lieussou and M. Sanouillet, eds., *Documents Dada* [Paris: Weber, 1974], nos. 2–6.

9 Louis Aragon would write, somewhat later: "Finesse is Tzara's saving grace and justification. Still, when we first met, we were all I think—Éluard, Philippe Soupault and André Breton—a bit disconcerted: this was not our man. I know that as far as Breton was concerned it was Vaché's image that put the newcomer at a disadvantage; but in any case when we came out of Picabia's I was maybe the only one who still felt somewhat enthusiastic. Soupault really didn't take to Tzara" (*Projet d'histoire littéraire contemporaine* [Paris: Mercure de France, 1994], 57). Soupault wrote:

> Tzara came into the living room, ill at ease. We looked at him . . . the way you look at a 'strange beast.' What struck me first of all, and I think my friends were as astonished as I was, was his diminutive size. There he was, with a Napoleonic lock of hair over his forehead, and he wore what we used to call a pincenez, and he spoke French quite fluently but with a strong Romanian accent. He burst out laughing at everything that was said. I got the impression that he was disconcerted by our attitude and our physical aspect of young petty bourgeois intellectuals. He understood that he could easily dominate us and Picabia, who was cackling away as usual, trusted him. It was fairly relaxed.
>
> (*Mémoires de l'oubli,* 3 vols. [Paris: Lachenal & Ritter, 1981–97], 1:119–20)

10 Aragon, *Projet d'histoire littéraire contemporaine,* 63–64.

11 Soupault gave a slightly different version of the event, but he wrote it down later and seems to have confused his memories of the event with his what he later read: "Tzara appeared, came forward and began to cut up an article by Léon Daudet, then tossed the pieces into a hat on the pretext that he was improvising a poem. Aragon had been told he was in charge of the bell ringing that punctuated the reading. Since Tzara expected the bell ringing and was delighted by it, his presentation created quite a stir" (*Mémoires de l'oubli*, 1:121).

12 Aragon, *Projet d'histoire littéraire contemporaine*, 74.

13 Cocteau had already included Tzara in his periodical *Le Coq*.

14 Léo Poldès was the author of several plays with significant titles (*Faites donc des enfants!* [1909]; *La Grande Marcelle,* "play in one act on morphine" [1917]; and later, *Le Forum,* "a play in 3 acts on electoral mores" [1920]; or *Le Réveil,* "a play in 3 acts on Soviet Russia" [1924]). Poldès held the meetings of his Club du Faubourg in an abandoned church; it was a sort of "popular" university, which boasted of attracting "the best-known speakers," of arousing "the most passionate controversies," and of being "the only truly free forum, absolutely independent, above any party."

15 Musidora, the performer of Louis Feuillade's *Vampires,* would exert a lasting fascination on the Parisian Dadaists and her prestige lasted all through the first years of surrealism. It was in a cinema at the Palais des Fetes, the same venue as for the first "Literary Friday," that Aragon discovered the actress, dressed in black tights ("An entire generation fell in love with Musidora" [*Projet d'histoire littéraire contemporainte,* 7]). Later, in Nantes, in Vaché's company, Breton would fall hopelessly in love with her; as for Soupault, he was totally subjugated by the cinema, finding in cinema "the poetry of our era," and he sensed its coming influence on the collective imagination.

On October 21, 1917, Breton attended a performance of the play that the actress wrote in collaboration with G. Beaumont and F. Vareddes, *Le Maillot noir,* and at the end of the performance he tossed a bouquet of roses to her. In 1928, he wrote with Aragon *Le Trésor des jésuites,* an homage to the cinematographic series, in which Musidora herself was supposed to act. This project did not materialize, however, and the text was published the following year in *Variétés* (see P. Cazals, *Musidora la dixième muse* [Paris: Veyrier, 1978], chap. 4).

16 René Edme and André du Bief, eds., *Non;* reprinted in *Documents Dada,* ed. Poupart-Lieussou and Sanouillet, 38 ff.

17 Benjamin Péret appeared in public for the first time on this occasion, making a particular impression on stage with his vociferations: "Vive la France et les pommes de terre frites" (Long live France and French fries).

18 "Chacun son Dada" (To each his own Dada), a column signed by Jacqueline and known as the "Billet de la Parisienne" in *Lectures pour tous* (May 1920). In her memoirs, the actress Eve Francis confirmed the speed with which Dada became "high society" and pointed out that at the time, at the dinner parties and gatherings where she would recite poetry, "everyone asks for Rimbaud, particularly the *Illuminations.* Irene Hillel-Erlanger, a friend of *Littérature,* requests the *Chants de Maldoror,* because her guests are quite daring . . . it's so amusing to look for the inspiration behind these eccentric images" (*Temps héroiques* [Gand and Paris: Denoël, 1949], 376). In 1921, the journalist Pierre Mille published a novel titled *Les Mémoires d'un Dada besogneux* (Paris: G. Crès, 1921); the jacket illustration was vaguely reminiscent of Delaunay or Picabia. The text itself was of little interest, but Tzara kept a copy in his library until his death.

19 Gide's epithets of "foreigner" and "Jew" are whence Picabia's response: "If you read Gide out loud for ten minutes, you'll have bad breath."

20 *Pour Dada* was reprinted in 1924 in *Les Pas perdus.*

21 Confirmed in a letter to his future wife, Simone Kahn, on August 31: he declined to write a preface to a book by Picabia, "not to have to put myself back in a position that was once mine but that definitely no longer is."

22 Jacques Rivière, "Reconnaissanceà Dada" (Gratitude to Dada), *La Nouvelle revue française* (August 1920); reprinted in Jacques Rivière, *Nouvelles études* (Paris: Gallimard, 1947), 294 ff.

23 This exhibition was meant to "launch" two works: *Jésus-Christ Rastaquouère* by Picabia (Paris: Au Sans Pareil, 1920) and the fairly alarming monograph that his former codisciple from Cormon's, Marie de la Hire, had just devoted to him. But the tension aroused by Picabia's production and attitude was nothing new: in January 1919, Aragon wrote to P. Albert-Birot that the painter's latest book "is quite simply disgusting," before referring to the author, one month later, as "fine trash."

24 Aragon, *Projet d'histoire littéraire contemporaine*, 103.

25 "Dada soulève tout" is reproduced in *Documents Dada,* ed. Poupart-Lieussou and Sanouillet, 52–53

26 In Zurich, Tzara was in contact with several Italian futurists, but he was very quickly put off by what he called, in a letter in 1922 to J. Doucet, these "overly enthusiastic people" and, in particular, by the persistent "sentimental moment, or the romantic and fussy display of their conjectures," something Tzara deplored in the texts of the futurists (see M. Dachy, *Dada et les dadaïsmes* [Paris: Gallimard, 1994], 82 ff.).

27 Breton to J. Doucet, March 3, 1921, quoted in the critical bibliography, *André Breton: La Beauté convulsive* (Paris: Éditions du Centre Pompidou, 1991), 106.

28 Max Ernst, *Notes pour une biographie,* in *Écritures,* Le Point du Jour (Paris: Gallimard, 1970), 28.

29 Ibid., 42.

30 Omitted from *Le Surréalisme et la Peinture,* rev. ed. (Paris: Gallimard, 1965); English trans.: *Surrealism and Painting,* trans. Simon Watson Taylor (New York: Harper & Row, 1972), Breton's preface can be found in *Documents Dada,* ed. Poupart-Lieussou and Sanouillet, 59; and in Breton's *Œuvres complètes,* 1:245. (Unless otherwise stated, all references to *Le Surréalisme et la Peinture* throughout the notes are to the 1965 edition.)

31 The expressions used prefigure the conception of the poetic image to be exposed by the *Manifeste du surréalisme* in 1924: one could see that Breton already had this conception in 1921. As for Ernst himself, he told of the discovery of the "collage" in 1919 in the following manner:

> One rainy day in a town on the banks of the Rhine I was struck by the obsession exerted upon my irritated gaze by the pages of a catalog illustrated with objects for anthropological, microscopic, psychological, mineralogical and paleontological demonstration. I found united there elements of figuration that were so removed from one another that the very absurdity of such a juxtaposition brought on a sudden intensification of my visionary faculties, and gave birth to an extraordinary succession of contradictory images—double, triple, multiple, superimposed one on the other with the persistence and rapidity that are the very stuff of the memories of love and the visions of half-sleep. These images in turn invoked new ones, a space where they could meet in a new unknown (the space of impropriety). All that was necessary was to add to these catalog pages, with paint or pencil, reproducing quite mildly only *that which I saw within,* a color, some lines of pencil, a landscape foreign to what was represented, the desert, a sky, a geological section, a floor, or a straight line signifying the horizon, to obtain an image both faithful and fixed of my hallucination; to transform something that until then had been no more than banal pages of advertising into a drama revealing my most secret *desire.*
>
> (*Écritures,* 258).

32 Rosalind E. Krauss, *The Optical Unconscious* (Cambridge, Mass.: MIT Press, 1992), 48 ff.

33 It is interesting to compare Breton's statement of twenty years later: "Surrealism felt immediately at home in the 1920 *collages,* in which one could find a visual organization that was absolutely virgin but that corresponded to the aims of the poetry of Lautréamont and Rimbaud. I remember the emotion that overcame us upon discovery of the work, Tzara, Aragon, Soupault and myself—the quality of it never to be experienced again—these packages that had only just arrived at Picabia's place from Cologne" ("Genèse et perspective artistiques du surréalisme" [1941], in *Le Surréalisme et la Peinture,* 64).

34 Obviously, Picabia was preaching to the converted, giving a birth date to Dada well before the events in Zurich. The quote is from Picabia, *Écrits* (Paris: Belfond, 1978), 2:14–15.

35 However, Ribemont-Dessaigne's accusation and Soupault's pleading were missing, as they were intended for the following print run, but the first series of the periodical stopped there. The entire file was published and edited by M. Bonnet in *L'Affaire Barrès* (Paris: Corti-Actual, 1987).

36 On the Salons des Incohérents, see C. Charpin, *Les Arts incohérents (1882–1893)* (Paris: Syros-Alternatives, 1990); see, in particular, 83 ff.

37 ["Pode bal" is a pun on *peau de balle* or "balls to you"; see Marjorie Perloff, "Dada without Duchamp/Duchamp without Dada: Avant-Garde Tradition and the Individual Talent" (http://wing.buffalo.edu/epc/authors/perloff/dada.html, 1998). *Trans.*]

38 This controversy in no way discouraged Picabia, who was more indifferent than ever to the "purity" of Dada, from organizing an evening at his home, after the opening of *Mariés de la tour Eiffel,* where he invited Dadaists, futurists, worldly sorts and friends of Cocteau. He then published a lively account of the evening in his periodical *Pilhaou-Thibaou,* its pages filled with biting witticisms about Dada and the Dadaists.

39 In 1922, Picabia covered over *Les Yeux chauds* and made the composition disappear beneath another: *La Feuille de vigne.*

["L'Onion fait la force" is translated as "onions give strength" and is a pun on "L'Union fait la force": Unity makes strength. *Trans.*]

40 When it was hung at the Salon d'Automne in 1921, *L'Œil cacodylate* was not quite finished; it was subsequently enriched by a few additional flourishes during the "réveillon cacodylate" (cacodylatious New Year's Eve party) organized by Picabia at the end of the year at the home of his friend, the opera singer Marthe Chenal.

41 Roger Vitrac was cofounder, with Crevel, Jacques Baron, Max Morise, and Marcel Arland, of the periodical *Aventure,* the first issue of which came out in November 1921. Despite the presence of the Dadaists among the contributors, *Aventure* was concerned with literary quality; its third and last issue (January 1922), however, drifted toward a certain "surreal" quality.

42 Tzara to Breton, February 3, 1922, cited in Sanouillet, *Dada à Paris,* 329.

43 The details of the controversy are given in ibid., 336 ff.

44 The expression "love for novelty" qualifies Tzara and his "search for novelty" among simple people, at the same time that it confirms that, for Breton, Duchamp's behavior could in no way be attributed to Dada.

45 Breton to Doucet, December 1921, cited by François Chapon, *Mystère et splendeurs de Jacques Doucet* (Paris: Lattès, 1984), 267.

46 Chapon, *Mystère et splendeurs de Jacques Doucet,* 268. Doucet would subsidize the new series of *Littérature* from the fourth issue on, at which time Breton took on the editing by himself, while Gaston Gallimard was responsible for printing and distribution.

47 Dada's international dimension makes its history particularly complex, and all the more so for the abundance of debates about it—alliances followed by splits, reciprocal accusations of betrayal or bad faith, and so on. It may well be that the "name Dada" suggests, as Marc Dachy affirms in his preface to Aragon's *Projet d'histoire littéraire contemporaine,* a "moment of affirmation of a demanding art." The formula may correspond to what Dada was in Berlin (see Richard Huelsenbeck, *En avant Dada: Eine Gechischte des Dadaismus* [Hannover and Zurich: P. Steegemann, 1920]; French trans.: *En avant Dada: L'Histoire du dadaisme,* trans. and ed. Sabine Wolf [Dijon: Presses du Réel, 2000]) or to what it became when it was aligned with constructivism, although in this case, it is difficult to see what it may actually have contributed to constructivism. Still, in Paris, under the impetus of Tzara himself, it was hardly the "affirmation of a demanding art" that came across in Dada's events. Nearly all historians of Dada, including Dachy himself, tend to reproach surrealism with relegating Dada's inventiveness to the confines of a simnple literary school that would later be devoted to polical waywardness; but such a reproach tends to gloss over what was truly at stake for surrealism, as well as the ultimate evolution of Dada outside of Paris (which might cause one to wonder if the historical moment of Dada's conception, interpreted by the group members as an atmosphere of universal dissolution—not only of values but also of power structures and of culture—did not actually induce the movement to conceive its own instability and self-derision and, up to a point, to exist only through disappearing). Equally hasty have been the assessments of the later collaboration between Tzara and Breton (from 1930 on) or of Tzara's own political waywardness, similar to that of many others.

48 André Breton, *Entretiens, 1913–1952, avec André Parinaud [et al.]* (Conversations, 1913–1952, with André Parinaud [et al.]), Le Point du jour (Paris: Gallimard, 1952), 58; English trans.: *Conversations: The Autobiography of Surrealism,* trans. and with an introduction by Mark Polizzotti (New York: Paragon House, 1993).

49 Aragon, in his *Projet d'histoire littéraire contemporaine,* was even more critical of Dada than Breton. Only the "plan" of the work was published in *Littérature,* the new series, no. 4 (September 1922), and it was only in 1994 that Marc Dachy published the text in its entirety, composed on the spot in 1923, for the series Digraphe.

50 André Breton, " Après Dada," *Comœdia* (March 2, 1922), reprinted in *Les Pas perdus,* 259 ff.

51 *Littérature,* n.s., no. 4 (September 1922), published "En Avant Dada" by Huelsenbeck, in which he protested quite vehemently against Tzara's role in Zurich, and even his real understanding of Dadaism, reproaching him notably for affirming its compatibility with abstract art. Breton's article "Clairement" appeared in the same issue.

52 Breton, "Après Dada." Jacques Rigaut attributes a decisive role to Breton in the demise of Dada: "Yesterday, in the garden of the Palais-Royal, the corpse of Dada was found. It was first presumed to be a suicide (for the unfortunate creature had been threatening since its birth to put an end to its days), when André Breton made a full confession" (*Écrits,* ed. Martin Kay [Paris, Gallimard, 1970], 42).

53 "Lâchez tout," *Littérature,* n.s., no. 2 (April 1922).

54 Breton, *Les Pas perdus,* 262 ff.

55 André Breton, "Clairement," *Littérature,* n.s., no. 4 (September 1922).

56 Péret, who took Tzara's side in the affair of the Paris Conference, was not named in "Clairement." But he reappeared in the very next *Littérature* (n.s., 5 [October 1, 1922]) with "À travers mes yeux," which also was a farewell to Dada: "Many have been waiting for a 'Dadaist poetry in twenty lessons.' I am taking off my Dada spectacles and am ready to head off, looking to see which way the wind is blowing, with no concern for what it will be and where it will take me" (reprinted in Benjamin Péret, *Œuvres complètes,* 7 vols. [Paris Éric Losfeld, 1969–95], 7:15).

57 Text of Breton's talk "The Characteristics and Nature of Modern Evolution" was reprinted in *Les Pas perdus,* in 1924, after Breton had tried in vain to publish it in the *Nouvelle revue française;* it is placed symbolically at the end of the volume to emphasize its dual role as a clarification and as the closure of an era.

58 Beyond the Parisian version of Dada, Breton also refers to Dada in Cologne, as evoked by Ernst: "My friend Baargeld and I distributed our periodical *Der Ventilator* at the factory gates. Our rage aimed for total subversion. We had witnessed the collapse into ridicule and shame of everything we had been given to believe was just and beautiful and true. My work from that period was not designed to please but to make one scream" (*Écritures,* 412).

59 Breton, "The Characteristics and Nature of Modern Evolution."

60 Beginning in May 1922, Soupault began to keep a distance from *Littérature* and resigned from his coeditorial role. In no. 4 of the new series, his only contribution was *Vous m'oublierez,* composed together with Breton in 1920. Jacques Baron mistreated his recent collection *Westwego* ("I reproach you only for changing your point of view, since you added nothing to yourself. It's downright sad. If at least you became a minister...") He had to make use of his right to respond in the following issue, and subsequently received another answer from Baron: "Petit commentaire pour personnes usagées" (Little commentary for worn-out people). In no. 10 (May 1923), Breton published four blank pages with the inscription "Philippe Soupault," recalling the publication—by then a part of surrealist history—under both of their names of *Les Champs magnétiques* ([Paris: Au Sans Pareil, 1920]; English trans.: *The Magnetic Fields,* trans. David Gascoyne [London: Atlas Press, 1985]). At this time Soupault began to publish novels (in 1923, *Le Bon Apôtre* and *À la dérive*) that, however charming or undeniably interesting, no longer had very much in common with the "surrealist" activities.

61 An account of Picabia's exhibition and Breton's talk was published in *Littérature* (no. 9) by M. A. Cassaynes, who approved of Breton's point of view but added the names of Klee and Kandinsky to the artists mentioned. He announced the imminent publication of the lecture, "adorned with reproductions and unpublished poems by the artists discussed, which will make it an anthology, with no present-day equivalent, of the newest trends." This publication never saw the light of day, however.

62 René Crevel, "La Négresse aux bas blancs aime tellement les paradoxes!" *Littérature,* no. 6, pp. 6 and 7.

63 Baargeld, Raphaël, and Dostoyevsky were part of the painter's personal history: when Breton met Masson in 1924, Breton affirmed that Dostoyevsky, along with Nietzsche, were among those he "detests the most." As for De Chirico, Ernst found several reproductions in 1919 in the Italian periodical Valori Plastici: "It was as if I recognized something that had always been familiar to me." In De Chirico's honor he composed the eight lithographs of *Fiat Modes,* in which the truncated sense of perspective, mannequins, and enigmatic objects hinted toward metaphysical painting.

64 René Lalou, *Histoire de la littérature française contemporaine (1870 à nos jours)* (Paris: Cres, 1922), 422 ff.; Paul Neuhuys, *Poètes d'aujourd'hui: L'Orientation actuelle de la conscience lyrique* (Anvers: Ça Ira, 1922), chap. 4. In the latter chapter is a reprint, with some revisions, of an article published in no. 14 of the periodical *Ça ira.* In addition to the works of Lalou and Neuhuys, one should include Pierre de Massot's *De Mallarmé à "391,"* written in the summer of 1921 and published early in 1922 (Saint-Raphaël: Au Bel Exemplaire): an enthusiastic panorama of the events punctuating the history of an avant-garde that had its origins with Mallarmé and Apollinaire. *De Mallarmé à "391"* shows limitations, however, in its references to Dada and to the Parisian version, and it is strongly guided by the sympathy Massot felt for Picabia (who helped him to finance the printing). Published at the time of the debate surrounding the Paris Conference, the work was hardly read at the time, except by those it was concerned with.

65 Clément Pansaers organized the special issue of the periodical *Ça ira:* "Dada, sa naissance, sa vie, sa

mort" ([Dada, its birth, its life, its death], no. 16 [November 1921])—which Tzara called a "horrible machination."

66 The play was part of "a spectacle" because musical numbers were also planned (Auric, Satie, Milhaud, and Stravinsky), along with poetry recitals, dance, texts recited in "zaoum," the transrational language created by Ilia Zdanevitch—who rented the Théâtre Michel on behalf of Tzara, thanks to his drama company of Russian amateurs who were passionate about theater—and films by Man Ray, who, for the occasion, hastily filmed *Retour à la Raison* (alternating shots showing a spiral in movement and others exalting the beauty of Kiki de Montparnasse, who was the photographer's lover); by Hans Richter (*Rythme 21*, made up of nonfigurative shapes); by Charles Sheeler, a friend of Man Ray and Duchamp's from New York who at the time was defining the foundations of "Precisionism" in painting; and by Paul Strand, with *Fumées de New York*.

67 Roger Vitrac, "Guet-apens," in *Les Hommes du jour*, quoted by Sanouillet, *Dada à Paris*, 384.

68 ["Zaum" is an alogical poetry created by the Russian poet Velimir Khlebnikov. *Trans.*]

69 The quote is from Aragon, *Projet d'histoire littéraire contemporaine*, 135. In this volume there is an account (121 ff.) of the "Soirée du Cœur à barbe," in which Aragon shows great hostility—although not lasting, in the end—toward Tzara, reproaching him for having denounced his former friends to the police, something Tzara would later deny. Breton reiterated the accusation, then regretted it. The editor's notes, systematically favorable to Tzara, can be tempered by reading the pages that Sanouillet devoted to the evening (*Dada à Paris*, 380 ff.).

70 It is worth noting that Freud was absent from this double page.

71 André Breton, "La Confession dédaigneuse," *La Vie moderne* (February–March 1923) and reprinted at the beginning of *Les Pas perdus*, 193 ff.

72 André Breton, "Distances," *Paris-Journal* (March 23, 1923), reprinted in *Les Pas perdus*, 287 ff.

73 Aragon was receiving a monthly payment from Doucet in return for his chapters of *Projet d'histoire littéraire contemporaine*, but his work was going very slowly, particularly as he had just begun at the same time to write his novel *La Défense de l'infini*, which he almost entirely destroyed in 1927.

74 Desnos published, in March 1923, an article praising *Mesure de la France*, published a year earlier by Drieu la Rochelle: "This virile voice exposes the problems whose solution is vital for our existence. Read *Mesure de la France*, all of you who really are living the present day in the uncertain expectation of a more total and acceptable cataclysm than a strike, you won't learn a single thing, but your sacred anxiety will come out of it greatly increased." Drieu was a Dada sympathizer, and he had befriended Crevel, Rigaut, and Aragon, but in his book there was an apocalyptic tone ("tomorrow there will be no more nations, only an immense unconscious, uniform, obscure thing—global civilization."), which began with an exaltation of "strong men" and ended with an admiration extending from Breton, Cendrars, and Giraudoux to Aragon and Radiguet.

75 Ribemont-Dessaignes was a regular contributor to *La Revue européenne*, giving summary accounts of his reading between June 1923 and February 1927. In addition to the periodical, Soupault also had to edit, for Simon Kra of the Éditions du Sagittaire, the "Collection de la revue européenne," in which he first published his novel *Le Bon Apôtre* (1923), then works by Gorky, Delteil, Max Jacob, Gomez de la Serna, and Tagore, as well as Crevel (*Mon corps et moi*, *La mort difficile*, and *Babylone*) and Ribemont-Dessaignes (*Céleste Ugolin*).

76 André Breton, interviewed by Vitrac, *Le Journal du peuple* (April 7, 1923). Quoted in Sanouillet, *Dada à Paris*, 377, and reprinted in Breton's *Œuvres complètes*, 1:1214 ff. Sanouillet makes the hypothesis that this renunciation might have been "the fruit of a movement of emulation" created by Duchamp, who had just announced that he was ceasing all artistic activity and giving up his *Large Glass*. As there is no way to verify this hypothesis, one might concede that Duchamp overdetermined (as suggested—but denied at the same time—by the last poem in *Clair de terre*, "À Rrose Sélavy," whose epigraph takes up the formula used by the *Journal du peuple*: "André Breton will give up writing"), as a result first of all of authentic disgust, and of a painful feeling of emptiness, further revealed in a letter to Picabia on September 19: "I am tired (I'm referring to the people I see every day) of this perpetual and pointless conspiring, this theater that shows nothing but repeat performances. I'm in search of an incognito, and I'd be ready to cobble together some sort of existence to achieve that. I don't want to limit myself any more to gestures of superior despondency, or to consent to legitimize everything I do for the sake of a few idle onlookers" (quotes in Sanouillet, *Dada à Paris*, 533).

77 Later covered over, these wall paintings have been partially recovered. Compare Max Ernst, *Peintures pour Paul Éluard* (Paris: Denoël, 1969).

78 As early as October 1922, Michel Leiris, who had known Masson personally for several months, noted that "beneath his fingers, a tree, a pipe, the fold of a garment become as naked and as pathetic as the human bodies he entangles. Mouths and genitals are flowers that love one another and it seems that their coupling will give birth to a Milky Way" (*Journal, 1922–1989* [Paris: Gallimard, 1992], 28)

79 It is common knowledge, however, that Breton in general had no particular passion for music. In this case, his reservations regarding Satie, apart from a few virulent exchanges following the performance, led to a chill in his relations with Picabia, who stood up for the musician. On Mercure, see R. Maillard's entry in the *Dictionnaire du ballet moderne* (Paris: Hazan, 1957): these "plastic poses in three tableaux," created at the "Soirées de Paris" held by the count de Beaumont, were cause for scandal at the time but won the enthusiasm of Diaghilev, who restaged them three years later.

80 Letter quoted in *André Breton: La Beauté convulsive*, 170.

81 "Homage to Pablo Picasso," reprinted in *Tracts surréalistes et déclarations collectives*, ed. José Pierre, 2 vols. (Paris: Éric Losfeld, 1980–82), 1:16. Among the fourteen signatures are those of the musicians G. Auric and F. Poulenc.

82 *André Breton: La Beauté convulsive*, 170.

83 Cutting out phrases from the newspaper seemed to be a return to Tzara's recipe "for composing a Dadaist poem"—with the one difference that they took from the newspapers not isolated words but entire phrases. As in automatic writing, grammar was, for Breton and his friends, a sort of obligatory given, a structural minimum without which any possibility of meaning would collapse. In the case of newspaper phrases, their respect for the structures of language conferred, moreover, an additional ironic dimension to the collaged text, given the usual journalistic "style" and its clichés.

84 Breton, *Les Pas perdus*. This was Breton's first work published at Gallimard, where he joined Aragon, who was taken on in 1921 for *Anicet ou le panorama, roman* (he also published *Les Aventures de Télémaque* in 1923 and *Le Libertinage* in 1924). Éluard also begin to publish with *Nouvelle revue française* from 1924 on (*Mourir de ne pas mourir*, in the series Une œuvre, un portrait—with the portraits by Ernst). Some found in this convergence a confirmation of the "literary" concerns that, unlike Dada, characterized the nascent surrealist movement, but one might also conclude that if the idea was to get published in any case, one might as well be published with the most influential publisher of the time, if the opportunity were there.

85 The letter in question read, "My dear father. I've had enough, I'm setting off on a voyage. I'm leaving you all the business you had undertaken for me. But I'm taking what money I have with me, about 17,000 Francs. Don't send the police, public or private, after me. The first one who gets in my way, I'll deprive him of any means to harm me. And that would be a pity for the honor of your name." The money in question had been entrusted to Éluard by his father, in the framework of the real estate dealings he was looking after. Éluard's departure was the result of a number of factors, no doubt: in addition to his lack of interest in working in real estate and the contradiction he could feel between that type of occupation and the values he claimed to uphold with his friends, his marriage with Gala, who was having a long-lasting affair with Ernst in the Eaubonne house, was foundering; and on top of that, there might have been some concern over his health.

86 At the end of January 1924, Éluard sent a power of attorney from Nice authorizing Gala to sell part of their collection. The sale, which would pay for Gala's trip to Saigon, was held on July 7 and included prints and canvasses by Braque, De Chirico, Derain, Ernst, Klee, Laurencin, Man Ray, Picabia, Picasso, and so on.

87 Breton, *Entretiens*, 76

88 Edited by Léon Treich, the *Almanach des lettres françaises et étrangères* grouped writers systematically, according to tendency: in 1924 there were entries for Breton, Tzara, Soupault, Aragon, Picabia, and Ribemont-Dessaignes.

89 The end of a recent edition of Louis Aragon's *Une vague de rêves* (Paris: Séghers, 1990) alludes to the decor and the aims of the Centrale Surréaliste, 15, rue de la Grenelle, which only opened on October 11: it would seem that Aragon was able to finish his text at the last minute, if one presumes he gave the bulk of it to *Commerce* in June.

CHAPTER TWO

1 Quoted by Paule Thévenin, editor of *Bureau de Recherches Surréalistes: Cahier de la permanence*. Archives de surréalisme, vol. 1. (Paris: Gallimard, 1988), 8. On July 29, 1924, Leiris wrote in his *Journal* about his

meeting the previous evening with Desnos, who "intended to start a periodical: *La Révolution surréal-iste.*" He then noted: "It won't be long before the Dada group becomes some sort of Freudian off-shoot, as boring as the worst literary temples were. The only real destroyers are isolated individuals. As soon as you put people together, they build. It was impossible therefore for the Dada movement to remain one of destroyers." His opinion on the future of the "Dada group" would change in the autumn, when he began to keep company with the surrealists in earnest.

2 In his *Mémoires d'un surréaliste* (Paris: La Jeune Parque, 1968), Maxime Alexandre spoke of "punches" between Breton and Goll; Claire Goll, in contrast, mentions canes, and a black eye for Breton, but her memories are not very reliable (*La Poursuite du vent* [Paris: O. Orban, 1976]).

3 André Breton et al., "Encore le surréalisme," *Le Journal littéraire;* reprinted in *Tracts surréalistes et décla-rations collectives,* ed. José Pierre, 2 vols. (Paris: Éric Losfeld, 1980–82), 1:17. On August 24, Breton alone published a letter in *Comœdia,* specifying the way in which the term "surrealism" now had a meaning distinct from that which it might have had for Apollinaire or Reverdy: "Surrealism is for us a means of expression that consists in the free determination and organization of thought by the word. Inspiration is no longer enough: there can be no more waiting for help from the imagination, particularly where it eludes the systematic and fictive constructions of memory. A poem by Reverdy is systematic, in the same way that a battle plan is systematic. For us, there is no more battle plan" (*Œuvres complètes,* ed. Marguerite Bonnet, with the collaboration of Philippe Bernier, Étienne-Alain Hubert, and José Pierre, 3 vols., Bibliothèque Pléiade [Paris: Gallimard, 1988–2000], 1:1334; English trans.: *The Lost Steps,* trans. Mark Polizzotti [Lincoln: University of Nebraska Press, 1997]).

4 Worthy of note is the fact that the first page of the bureau's notebook records that correction letters were sent to *L'Intransigeant* and to the *Figaro.* Along with Goll's periodical, the same group launched a series called Collection surréaliste, but its only publication was a slim volume of poems by Claire and Ivan Goll, *Poèmes d'amour* (1921), with illustrations taken from four drawings by Chagall.

5 The group had not seen the last of Morhange and his friends, who would be the subject of debate in 1925, during the preparation of the pamphlet *La Révolution d'abord et toujours!* and again in 1929, dur-ing the meeting at the rue du Château (see below).

6 In September and October 1924, and again in February and April 1925, Péret published interviews with various writers in *Le Journal littéraire* and systematically asked them, "What do you think of sur-realism?" This was also a manner of obliging them to clarify what set them apart from the movement. Carco qualified surrealism as "bullshit" ("C'est de la foutaise"), while Reverdy confirmed that surre-alism was "a superior reality, as perceptible to the mind as objective reality is to the senses." This implicitly stated the problem of what the relation between the movement and its practice might be.

7 The responses to the questions are not found in the manifesto, which was more of a "Discourse on the Method"—even if the surrealist conception of the imagination obviously had nothing in com-mon with that of Descartes—establishing a horizon toward which research could be led (some, notably, would lead to *Vases communicants*) than an outline of established theses. Of further interest is the fact that the Cartesian discourse was also a methodological preface, which was to be illustrated by scientific results, just as the manifesto was illustrated by *Poisson soluble,* and intellectual biography occupied as much space in Breton's work as in Descartes's.

8 The manifesto confirmed that it was indeed in homage to Apollinaire that Breton and Soupault began to use the term "surrealism," following the publication of their joint work, *Les Champs magné-tiques* ([Paris: Au Sans Pareil, 1920]; English trans.: *The Magnetic Fields,* trans. David Gascoyne [Lon-don: Atlas Press, 1985]); but it also pointed out that "Nerval had a perfect mastery of the spirit we embrace, while Apollinaire on the other hand had only the *letter,* still imperfect, of surrealism, and proved unable to give us a theoretical description that could hold us."

9 Poetic surrealism was only one aspect of surrealism in general: Breton reiterated, at the end of the manifesto, that his "study" was "devoted" to poetic surrealism, still referring to *Poisson soluble.* The expression "poetic surrealism" seemed more valid than "surrealist poetry"; it enabled one, moreover, to qualify other eventual aspects of surrealism, such as "graphic surrealism," "pictorial surrealism," and so on.

10 When Breton included this example of typographic poetry in the *Manifeste du surréalisme* (and when he used it again later, retitled "L'Angle de mire," in *Le Revolver à cheveux blancs* [Paris: Éditions des Cahiers Libers, 1932]), he clearly intended to show that a poem of that sort differed in both its inten-tion and its elaboration from the problematical practices of the Dada period: besides the fact that for the surrealist the idea was to use predetermined fragments of sentences, and not isolated words as

Tzara advised, there was also a respect for "ordinary" syntax so that a minimum of communication could be ensured (*Manifeste du surréalisme* [Paris: Éditions du Sagittaire, 1934]; English, trans.: *Manifestoes of Surrealism,* trans. Richard Seaver and Helen R. Lane [Ann Arbor: University of Michigan Press, 1969]). In other words, the "Dadaist poem" accumulated breaks that were equally syntactic and semantic, which prevented the image from asserting itself, while poetic surrealism, when it made use of such collages, sought, on the contrary, to multiply the number of striking images from arbitrary material. For Dada, resorting to chance was a method of negation; for surrealism, it provided elements from which it was possible to (re)build.

11 On surrealism referring only to the movement led by Breton, see A. Thibaudet, in the *Nouvelle Revue française* (March 1925): "Surrealism exists. It exists and will exist through its works." From this point of view, the effectiveness of the manifesto could be compared to Marx's "theoretical practice" in *The Communist Manifesto.* In both cases, the idea was to provide the precise definition of an attitude in such a way that only those who accepted all the terms could claim to adhere to the movement—communists on the one hand, "absolute surrealists" on the other.

12 Henri Poulaille, *Le Peuple* (December 14, 1924); Jean de Gourmont, *Le Mercure de France* (May 1, 1925); Louis Laloy, *Comœdia* (November 12, 1924); Edmond Jaloux, *Les Nouvelles littéraires* (March 21, 1925); and Jean Cassou, *La Nouvelle revue française* (March 1, 1925).

13 Émile Malespine, *Manomètre,* no. 7 (February 1925). The first issue of Malespine's periodical, published in Lyon, came out in July 1922. Influenced by Dada, Malespine (1892–1953) advocated a "polyglot and international" expression and was eager to publish Arp (whom he met in 1919), Tzara, and Soupault, as well as Guillermo de Torre, Jorge Luis Borges, and Lajos Kassak. He had a passion for the theater and for painting (he was a painter himself), and would later move closer to surrealism, even participating in the *International Exhibition* in 1947. The issues of *Manomètre* were reprinted in 1977 by Éditions J.-M. Place, Paris.

14 Aragon, in *La Revue européenne* (February 1, 1925).

15 Number 1 of *La Révolution surréaliste* included Éluard's poetic prose, along with a column of press clippings that were more or less favorable to the movement; of particular interest was the column by Camille Mauclair, who already evoked the "Jackal" morality of the surrealists and would never cease to hate them. Victor Crastre, in *Clarté,* no. 74 (May 1925).

16 It should nevertheless be noted that an exception was provided by an article by Bernard Fay, according to which Anatole France became a sort of institution comparable on a national level to the baccalauréat examination or the kilogram, because he knew how to instill democratic sentiments into the context of the empire or even the ancien régime (*Les Nouvelles littéraires* [May 3, 1924]). In its first issue (April 1924), the periodical *Demain* juxtaposed the admiring "Secrets d'Anatole France" by J.-J. Brousson, a former secretary of the writer, and an article by Paul Souday celebrating "Le Jubilé de M. Anatole France," with "photographie en couleurs" by Soupault, which evoked the impatience, mental and practical dispersion, and impotence of a person whose attention was divided among "poetry," sports, bars and love.

17 Anatole France was known for his antimilitaristic position since the time of the Dreyfus Affair, which did not, however, prevent him from publishing a collection of texts in 1916—sold, it is true, "to benefit the work of war invalids"—exalting the French army and its courage in the struggle against the "Boches": he asserts, e.g., that "among the most beautiful verses inspired by the Great War" must be included a sonnet by a soldier, ending with this tercet, "Dormez, nobles guerriers, sur la noble colline, / La gloire vous a ceints de ses plus purs rayons, / Et la Patrie est là qui vous pleure et s'incline" (Sleep, noble warriors, on the noble mount / Glory has graced you with its purest beams / And the Motherland weeps and bows before you; *Sur la voie glorieuse* [Paris: Libraire Champion, 1916]).

18 The quote in the first part of this sentence earned Aragon a reprimand from Jean Bernier in the paracommunist periodical *Clarté,* which published a special issue on November 15: "Clarté contre Anatole France/Cahier de l'anti-France/Pamphlet de Jean Bernier, Édouard Berth, Marcel Fourrier, Georges Michaël," the virulence of which was just as strong as that in *Un cadavre,* and which, with that text, constituted the only collective reaction to France's death. Aragon responded in rage to Bernier, but in such a way, Breton would say later on, that he "gave some of us the impression he getting into deeper and deeper water" (*Entretiens, 1913–1952, avec André Parinaud [et al.],* Le Point du jour [Paris: Gallimard, 1952], 118; English trans.: *Conversations: The Autobiography of Surrealism,* trans. and

with an introduction by Mark Polizzotti [New York: Paragon House, 1993]): "The problems caused by human existence have nothing to do with the wretched little revolutionary activity that has taken place to our east over the last few years. I might add that it is really a misuse of language to qualify that activity as revolutionary," and Bernier might easily deplore his idealism. Aragon reiterated, however, his praise for the revolutionary spirit for its hostility to all organization, in *La Révolution surréaliste,* no. 2 ("Communism and Revolution"). This difference of opinion would not prevent a closer relation to form between the surrealists and *Clarté* at the time of the Rif war in Morocco.

19 See *Tracts surréalistes,* ed. Pierre, 1:379.

20 *L'Ami du lettré: Année littéraire et artistique* (Paris: Éditions Crès, 1925). Paul Jamati contributed an article about Anatole France.

21 The break would only be final in 1927, when Aragon and Breton joined the Communist Party. See François Chapon, *Mystère et splendeurs de Jacques Doucet* (Paris: Lattès, 1984), 304 ff.

22 It is interesting that among these "surrealist texts," only Éluard's was written in the form of a "poem." Éluard's insistence on the "poetic" quality of everything he wrote, his claim, e.g., to distinguish carefully between a dream and a poem indicated his desire to be considered, above all, a man of letters, and this would create increasing tension. His request to include *Dessous d'une vie* quickly showed (1926) that "one does not confuse a dream with a poem. Both are living realities but the first is a memory, immediately depleted, transformed, an adventure; but of the second, nothing is lost, nothing changes."

23 On October 14, Vitrac "suggested calling the chronicles: Fashion is a Dream, Life is a Dream, and so on" (*Bureau de Recherches Surréalistes,* ed. Thévenin, 21).

24 And his "regular chronicle" would quickly disappear from the periodical. In the "correspondence" between Delteil and Breton, published in no. 4, Breton would, among many other reproaches, refer to the "unspeakable jokes made about love, like those published in *La Révolution surréaliste.*"

25 In passing, Morise pointed out that "a dream is no more typical of surrealism than a painting by De Chirico: the images are surrealist, their expression is not"—opening the debate as to whether a plastic expression is in itself surrealist, strictly equivalent, in the visual context, to automatic writing. His chronicle was nevertheless illustrated with an automatic drawing by Masson. But the fact remains that in such a remark one could sense a divide between two concepts of surrealism in painting: one seeking to reproduce dreamlike or hallucinatory visions (De Chirico; some of Ernst; later on, Dalí, or, in his way, Magritte), the other concerned with producing work that would completely disconcert one's vision, by basing itself on variations of automatism (Masson, already and, before long, Tanguy).

26 In *Bureau de Recherches Surréalistes,* ed. Thévenin, 45.

27 "On Suicide: Special Issue," *Le Disque vert* (January 1925); among the contributors were Artaud, Crevel, and Rigaut.

28 Vaché would be present again in the issue 9–10 of *Le Disque vert,* with a text by Nougé and two drawings.

29 In *Bureau de Recherches surréalistes,* ed. Thévenin, 38. Soupault, at this time, was putting together a fairly eclectic anthology for the Editions du Sagittaire, an *Anthologie de la nouvelle poésie française,* in which the principal members of the group refused to participate because of this eclecticism. "I believe they were wrong. They remained inflexible, I don't know why," wrote Soupault. (*Mémoires de l'oubli,* 2:104). The idea of figuring next to Albert-Birot, René Arcos, Cocteau, Duhamel, Goll, Robert de Montesquiou, and a few others obviously did not appeal to Aragon, Breton, Éluard, or Péret. An advertisement for this anthology did, nevertheless, appear at the end of no. 3 of *La Révolution surréaliste.*

30 "Dédé Sunbeam" (who would contribute two more drawings to issues no. 3 and 7, and a surrealist text to no. 5) and Georges Bessière (no. 2 would also publish a "surrealist text" and his response to the survey on suicide) were two visitors to the bureau who would later disappear from the group, but whose passage, however brief, was proof enough that the existence of a Bureau for Research open to the public was not totally useless.

31 In *Bureau de Recherches surréalistes,* ed. Thévenin, 70. Breton nevertheless judged the second issue of *La Révolution surréaliste* to be inadequate, with the exception of the texts by Artaud and Leiris.

32 Pierre Naville, *La Révolution et les intellectuels,* Collection Idées (1928; reprint, Paris: Gallimard, 1975), 73.

33 It is always a problem to harmonize individual tastes in a collective practice, as witnessed by these comments by Aragon in the bureau's logbook on March 16:

It is extraordinarily easy for me to understand, and I can often feel how painful any collective activity can be for individuals who are subjected to it, and I know how the casual manner of those who fail to anticipate each person's desire for solitude can irritate everybody. I am not unaware that everyone has the right to preserve his place in the shade, or rather that this issue would not be raised otherwise. However I do ask my friends to consider that their attitude risks irretrievably compromising an undertaking that I can only too readily agree is somewhat derisory, but so what, it is an undertaking all the same for which no one has suggested any alternative.

(In *Bureau de Recherches Surréalistes,* ed. Thévenin, 91 ff.)

34 The first issue of *La Révolution surréaliste* mentioned the survey launched by *Les Cahiers du mois*, "De la pénétrabilité réciproque de l'Orient et de l'Occident" (On the mutual penetrability of east and west). The special issue of the *Cahiers du mois* (no. 9–10, February–March 1925) was titled "Les Appels de l'Orient" ("The call of the east"). Breton wrote in response to the survey, on his own: "I find it pleasing that western civilization is at stake. Enlightenment now comes from the Orient. I do not expect 'the East' to bring riches or renewal to us in any way, but rather for it to conquer us" (*Œuvres complètes,* 1:898). Others who responded were Crevel, Delteil, and Soupault. In the bureau's notebook, Breton asked, on January 16, "that we examine very closely the question of to what degree *La Révolution surréaliste* can or must join in a campaign *for the Orient.*" On the Jewish question and bolshevism, see *Bureau de Recherches Surréalistes,* ed. Thévenin, 110 ff.

35 Robert Desnos, "Déclaration du 27 janvier 1925," *La Révolution surréaliste* 3 (April 15, 1925); reprinted in *Documents surréalistes, ed.* Maurice Nadeau (Paris: Éditions du Seuil, 1948), 42–43; *Tracts surréalistes,* ed. Pierre, 1:34; and *Bureau des Recherches Surréalistes,* ed. Thévenin, 119.

36 Breton, *Entretiens,* 109.

37 In his *Journal, 1922–1989* (Paris: Gallimard, 1992), Leiris noted on March 13, 1924, that his favorite word was "transmute"; at that time he was very sensitive to all the variants of puns and wordplay.

38 Louis Aragon, "Fragments d'une conférence" (Madrid, April 18, 1925), in *La Révolution surréaliste,* no. 4.

39 *Bureau de Recherches Surréalistes,* ed. Thévenin, 123, 97, and 127.

40 The collection has been reprinted in *Tracts surréalistes,* ed. Pierre, 1:41 ff. On March 24, Leiris copied four verses by Saint-Pol Roux into his *Journal,* three days after he noted, among other things: "I have doubts about surrealism and other such research into the mind."

41 Should one, from the point of view that the tribute revived the group's interest in writing, consider it symptomatic that Artaud did not take part in the homage? Perhaps he was simply poorly acquainted with Saint-Pol Roux, whose luxurious style was, in any case, the opposite of what he sought in writing.

42 Breton to Camaret, September 18, 1923, reprinted in Théophile Briant, *Saint-Pol Roux,* Poètes d'aujourd'hui (Paris: Seghers, 1951), and in A. Jouffroy, *Les Plus belles pages de Saint-Pol Roux* (Paris: Mercure de France, 1966).

43 Saint-Pol Roux, *Reposoirs de la procession,* ed. Jacques Goorma, 2 vols. (Paris: Gallimard, 1997), vol. 2.

44 ["Open letter to Paul Claudel, French Ambassador to Japan." *Trans.*]

45 The appeal would be reprinted in *Clarté* on July 15, 1925, with additional signatures, including first of all those of the editorial board of *Clarté* itself, then of the surrealist group and the Groupe Philosophies. This revived the collaboration with *Clarté,* which would soon lead to the collective declaration *La Révolution d'abord et toujours!*—although, coming from Barbusse, it left some of the signatories dissatisfied, as J. Bernier and M. Fourrier explained: "The tone, and certain passages of this document belonged—need one be reminded?—to principles that we find truly inacceptable. Some of us simply could not be satisfied with this Platonic, derisory protest" (*Clarté,* no. 77 [October 1925]).

46 Breton, *Entretiens,* 113–14.

47 Artaud had to prepare the third issue of *La Révolution surréaliste* on his own, and Naville left in May 1925 to perform his military service. It was only after the fifth issue that *La Révolution surréaliste* was in Breton's hands.

48 The works of such artists as those named were hung together, e.g., when the Viscount de Beaumont organized an exhibition in the Salle des Antiquaires of the rue Ville-l'Évêque during the summer of 1925 and for the display at the Galerie Vavin-Raspail. The painter Georges Papazoff, of Bulgarian origin, developed from that point on cordial ties with Éluard, Desnos—who would dedicate a few poems to him—and Ernst. Through the intermediary of Henri-Pierre Roché, Duchamp would become acquainted with Papazoff and include him in events at Catherine Dreier's Société Anonyme from 1926 on. Ernst invited him to the meetings at the café, but he did not adhere to the group's concerns; he felt that Breton was leading the meetings as an "absolute master" and commented that "events like this were at the other extreme from my simplistic nature. The spirit and the atmosphere

of these meetings seemed far too 'Protestant,' and they did not correspond to my taste as an independent man."

Maurice Raynal provides one example of confused reporting; a former collaborator on *L'Esprit nouveau,* he considered that the "painting section" of the "surrealist society" was "borrowed from a movement whose origins were Romantic and German . . . that in turn was an offshoot of expressionism. This movement is characterized by the delicate and charming endeavors of Paul Klee, the Bulgarian Papazoff, Heinrich Hoerle, and of the 'Neue Sarlichkeit.' Surrealist works are above all ventures driven by taste, a taste that is often charming and personal, like that of Miró." (Raynal had already organized the exhibition *Art français d'avant-garde* in Barcelona, where he presented three paintings by Miró, among those by Picasso, Signac, Dufy, Matisse, etc., and prefaced Matisse's first Parisian exhibition, organized by Dalmau, an art dealer from Barcelona, in April–May 1921 a the Galerie La Licorne). "Beyond their poetic intentions, they remind one, technically, of the mischief of old, the mystic works of the 16th and 17th centuries, the drawings of Granville, Hoffman, or Edgar Allen Poe; the freak shows at fairs, vintage 1830 curios, or certain anatomical plates, or aspects of the German cinema, baroque, rococo trifles that is, amusing in their pretentiousness, and particularly attractive as practiced by Klee, Papazoff, or Miró." This statement dates from 1927, so it would seem that the publication of *Le Surréalisme et la Peinture* and the exhibitions that quickly followed based on its choices had not alerted all the critics of the era. But Breton, nevertheless, in *La Révolution surréaliste,* no. 6, protested that the articles by Raynal, as well as those by Louis Vauxcelles and Florent Fels, went "beyond the limits of imbecility" and that "whether X or Y manages to be taken for a surrealist or not was the business of these gentlemen employees of the Grocery."

49 Breton was adopting a point of view already developed by Hegel, for whom the idea of art imitating nature left art with "a purely formal aim, that of conceiving for a second time, with the means at man's disposal, what exists in the outside world. But this repetition can be seen as an idle and superfluous occupation, for what need have we to see again, in painting or on the stage, the animals, landscapes or human events with which we are already familiar?" Nevertheless, Breton evoked the "magical power of figuration," and such an adjective had obviously not been used by the philosopher.

50 In no. 4 of *La Révolution surréaliste,* a reproduction of *Les Demoiselles d'Avignon* had been published for the first time (exhibited solely in July 1916, at the Salon d'Antin organized by André Salmon), along with four other works by Picasso, who was the artist most often reproduced in the collection of the periodical (twenty-two reproductions as opposed to nineteen for Masson, eighteen for Ernst, seventeen for De Chirico, and twenty for Man Ray, many of which were photographs).

51 This condemnation was in keeping with the reproduction, right up to the last issue of *La Révolution surréaliste,* of work from the "period of genius." In his *Mémoires,* De Chirico gave a completely different interpretation of the conflict that henceforth opposed him to the surrealists: if we are to believe him, it was only because the surrealists wanted to speculate on his earlier work that they refused his recent production, and he insisted on denying members of the group the slightest importance, made up as it was of "lazy, apathetic sorts, daddy's boys" as witnessed by their "hysterical rancour" (*Mémoires,* trans. Marin Tassilit [Rome: Astrolabio, 1945; Paris: La Table Ronde, 1965], 140 ff.; English trans.: *The Memoirs of Giorgio De Cirico,* trans. and with an introductin by Margaret Crosland [New York: Da Capo Press, 1994]). Duchamp speculated, in the notice he wrote on De Chirico for the catalog of the Société Anonyme in 1943 that "posterity might have something to say" on the turning point of the 1920s.

52 Picabia's "failure to understand" was made public in *391,* and it was also pointed out, in an ironic fashion in *Caravansérail,* that the story Picabia had decided against publishing in 1924 had been turned down by Gallimard (where the surrealists were published) and that Breton, who knew the text, described it `as a "very boring novel."

53 Max Ernst, "Au-delà de la peinture" (1936), in *Écritures,* Le Point du Jour (Paris: Gallimard, 1970), 242–43. The words in italics are the titles of works, some of which were exhibited in March 1926 at the Galerie Van Leer, in Paris (the catalog included poems by Éluard, Desnos, and Péret). The same year, Ernst exhibited in Cologne, where he also took part in the collective event *Kölner Sezession 1926.*

54 Louis Aragon and André Breton, "Protestation," *La Révolution surréaliste,* no. 7.

55 According to Ernst himself, *La Vierge corrigeant l'Enfant Jésus devant trois témoins: André Breton, Paul Éluard, et l'artiste* was a "Manifesto-painting, executed according to an idea by André Breton." The lasting friendship between Ernst and Éluard, beyond their shared life with Gala, also led to poetry collec-

tions by Éluard, illustrated by Ernst: *Les Malheurs des immortels, Répétitions* (1922), *Mourir de ne pas mourir* (1924), *Au défaut du silence* (1925), *Les Dessous d'une vie ou la pyramide humaine* (1926).

56 The first monograph on Man Ray was published by Ribemont-Dessaignes in 1924, the same year that Man Ray took part, along with Duchamp, Picabia, and Satie, in René Clair's film *Entr'acte.* Breton seemed to be less demanding with regard to Man Ray than toward Ernst or Miró. In 1924, Man Ray provided a frontispiece for Péret's *Immortelle maladie,* then the following year he contributed a rayograph to Cocteau's *L'Ange Heurtebise.* It is true that he produced slides that were destined to be etched on everyone's memory (*Le Violon d'Ingres* [1924]) and that a photographer, even one who worked in the fashion world, was not, at that time, subjected to the same "market" temptations as a painter might be.

57 Other artists, obviously, were shown in the periodical but were not featured in *Le Surréalisme et la Peinture,* either because they appeared on the scene after publication (Dalí, Magritte) or because their work did not really contribute a great deal to the advances Breton was concerned with. This may be the case for Malkine, despite the indisputable lyrical quality of *La Nuit d'amour,* a painting full of lightness in its nonfigurative invention; it was without doubt the case for Pierre Roy. Roy did stop by the Bureau Surréaliste on December 20, 1924, and his painting *Adrienne pêcheuse* (1919) was reproduced, less its title, in no. 4 of the periodical, followed by two other paintings in no. 7. He took part, moreover, in the group's first two collective exhibitions; in May 1928, Aragon wrote the preface for the catalog of his exhibition at the Galerie Pierre ("The one who sticks to it") but despite the enigmatic mood of his works, his vision of painting was completely foreign to the movement's concerns, and he would distance himself from them completely that same year.

58 Miró, *Écrits et entretiens* (Paris: Daniel Lelong, 1995), 115.

59 Ibid., 97–98.

60 The first Parisian exhibition of Paul Klee's watercolors was held from October 21 to November 14, 1925, at the Galerie Vavin-Raspail. Although Aragon had written a preface for the catalog ("the grace, which is that of poets, enabling [the artist] to reach the limits of the imagination, is known in our time as childishness or dementia, depending on the lawyer or the laborer who is judging," *Écrits sur l'art moderne* [Paris: Flammarion, 1981], 19), Breton gave ideological reasons for boycotting the exhibition: "This event has no political significance" (in Maguerite Bonnet, ed. *Vers l'action politique: De la Révolution d'abord et toujours! [juillet 1925] au projet de la guerre civile [avril 1926].* Archives du surréalisme, vol. 2. [Paris: Gallimard, 1988], 49). If one is to believe Miró, Masson, Éluard, and Crevel were as interested in Klee as they were in Miró himself. "As for Breton, he scorned him" (*Écrits et entretiens,* 116). In fact, Klee was cited, in the manifesto, among the artists who had been affected by the "surrealist voice," but he was reproduced on only one occasion in *La Révolution surréaliste,* in the third issue and at Artaud's request. Whatever his talent, he remained far removed from the concerns and the choices of surrealism.

61 Opinions recorded in the exhibition catalog *L'Aventure de Pierre Loeb, La Galerie Pierre, Paris, 1924–1964* (Paris: Musée d'Art Moderne de la Ville de Paris, 1979), 116.

62 Whatever Breton's role, the artists selected had the support of all the surrealists, despite certain variations due to differing subjective opinions: the common experience of certain values (revolt, rejection of pure literature, negation of dominant values) produced similar expectations in the pictorial domain. Leiris spoke already in 1924 of the "magic of modern painting (Picasso, De Chirico, Masson)" (*Journal,* 41), and in 1926 he published two articles on Miró and Masson in *The Little Review.* In his column "Portrait du jour" for Paris-Soir, Desnos wrote about certain artists in the group, and in 1926 he published an article titled "Surrealism" in *Cahiers d'art,* where he commented on Picabia, Picasso, Duchamp, De Chirico, Masson, Miró, Ernst, Klee, and Arp. Tual considered Miró's painting to be "the shortest path from one mystery to another," and the way in which the first one to discover a work would inform the others showed how they all were in search of a pictorial world that might correspond to their aesthetic and ethical principles.

63 As for Miró, thanks to Jacques Viot he had his own contract with Loeb, who showed his works either in the gallery (1927 and 1930) or in other venues (Galerie Bernheim in 1928, Galerie Le Centaure in Brussels in 1929).

64 Pierre Naville confirmed that Breton brought Nadja there, and Georges Sebbag would point out that it was at the Surrealist Gallery that the passionate relation between Breton and Lise Meyer, begun earlier at the bureau, would find its conclusion (*Les Éditions surréalistes* [Paris: Institut Mémoires de

l'Édition Contemporaine, 1993], 173). On a lighter note, Youki Desnos told the story of a visit she made to the gallery with a friend, where she saw "four or five young men reading periodicals and newsletters. They never lifted their eyes from their papers. It was an impressive sight." But later, she said, once they had left the premises, she found that "my fine indifferent fellows were all at the window, standing on tiptoes" (*Les Confidences de Youki* [Paris: A. Fayard, 1957], 83 ff.).

65 Two snowballs were fabricated from projects by Picasso and Man Ray. There were also projects for objects by Tanguy, Malkine, Arp, and "L'Âme des amants" (The soul of lovers) by N. D., that is, Nadja.

66 This is what Georges Sebbag did (*Les Éditions surréalistes*, 174).

67 Benjamin Péret, *Dormir, dormir dans les pierres* (Paris: Éditions Surréalistes, 1927).

68 In fact, anonymity in the visual arts was suggested, among the illustrations in *La Révolution surréaliste*, by the reproductions of primitive work, drawings by mediums, and works by mentally disturbed people. This was another type of "wildness" for the eye. It was when the *cadavres exquis* appeared in issue 9–10 that a certain nonprofessionalism reappeared.

69 *Clarté* began as a newpaper (October 1919 to March 1921), a liaison for H. Barbusse for the movement he was leading, and it advocated egalitarianism without "total suppression of private property"; it was favorable to the Soviet revolution in its interpretation as a model of rationality (for "every one of us is a creature of reason, and reason is in nature a divine straight line, and the light of light," as described in 1920, in Henri Barbusse, *La Lueur dans l'abîme: Ce que veut le groupe Clarté* [Paris: Éditions Clarté, 1920]). It then became a "periodical of proletarian culture" (the illustrations were often by Grosz, Masereel, or Otto Dix) supportive of the Communist Party's activities without being governed by it. Barbusse left the governing committee in 1923 and was replaced by Marcel Fourrier, Jean Bernier, and Georges Michaël (A. Varagnac). From 1924 on, the periodical began to devote some attention to surrealism, and this would intensify with the arrival of Victor Crastre, whose twofold aim was to inform revolutionaries of the group's position and grow closer to them. The surrealists themselves (Aragon, Desnos, Éluard, Leiris, Breton, and Péret) collaborated with *Clarté* by submitting articles and poems from November 1925 to March 1927; the periodical then became specialized in economic, political, and social domains. Reciprocally, *La Révolution surréaliste* accepted writings by Crastre, Fourrier, and Naville from its sixth issue on; Naville was even appointed by Breton to edit no. 9–10. (A detailed list of their collaboration can be found in *Vers l'action politique*, ed. Bonnet, 152 ff.) Beginning in autumn 1927, the periodical, which was coedited by Fourrier and Naville, adopted a Trotskyist line.

 Philosophies was published between March 1924 and March 1925. Founded by Pierre Morhange, Georges Politzer, Norbert Guterman, Henri Lefebvre, and Georges Friedman while they were still philosophy students, the periodical claimed to be "the voice of the New Literary movement" that aimed to "bring about CONTEMPORARY HUMANISM," but its editorial policy, which included poetry, philosophical essays, prose, and numerous book reviews, was fairly eclectic (Salmon, Max Jacob, Léon Pierre-Quint, Supervielle, Cocteau, Soupault, Drieu la Rochelle, Delteil, Crevel). In the first issue, Crevel praised Cocteau for bearing the "mark of the true aristocracy of the soul" and considered *Thomas l'imposteur* to be a "perfect book" (Guterman was of the opposite opinion), and Francis Gérard wrote a positive review of Radiguet's *Le Diable au corps*.

70 See *Tracts surréalistes*, ed. Pierre, 1:54 ff.

71 *Clarté*, no. 76 (July 1925). According to V. Crastre, Aragon supposedly collaborated with him on the first draft of "La Révolution d'abord et toujours!" Aragon's new attitude caused him to be harshly criticized by Drieu la Rochelle, who considered that the surrealists were wrong to take a stance on political events in the way they did in their *Lettre ouverte à Paul Claudel* ("La véritable erreur des surréalistes" [The real error of the surrealists], *La Nouvelle revue française*, no. 143 [August 1, 1925]): "Now that you have reinforced your poetic art with a political line of support , in accordance with a procedure periodically used by literary figures in France . . . you walk right into the trap and howl: Long live Lenin!"—to which Aragon replied the following month, "I don't want to answer that I didn't shout Long Live Lenin! But I will howl tomorrow since you won't allow me to shout that shout which, after all, salutes the sacrifice and genius of a man's life."

72 Reprinted in *Vers l'action politique*, ed. Bonnet, 36.

73 The complete text can be found in *Tracts surréalistes*, ed. Pierre, 1:63 (the version that appeared in *L'Humanité*) and in *Vers l'action politique*, ed. Bonnet, 102 ff. (Aragon's text). At the evening held by the Club of Rebels, a number of anarchists gave speeches, but there was also a priest, which explains Éluard's comments in a letter to the committee on the fourth: "Nobody knew about this, and

nobody, committed to discipline, dared protest as they should have, which is extremely regrettable. In my opinion it is impossible for such a thing to happen again. The idea of God in France must no longer, under any pretext, be tolerated. Combatting militarism is still an illegal action; combatting religion and its priests isn't even that" (reprinted in *Vers l'action politique*, ed. Bonnet, 104).

74 In his review on October 24, Noll underlined the symbolic import of the cover of no. 5 of *La Révolution surréaliste* (October 24, 1925): on a photograph are gathered the group's previous publications, in a worn condition, and the caption states, "The Past." Noll could thus express his desire to "liquidate" the past. Péret's reviews are collected in the *Œuvres complètes*, 7 vols. (Paris Éric Losfeld, 1969–95), 5:231 ff. and 7:109 ff.

75 André Breton, "The Strength to Wait," *Clarté*, no. 79 (December 1925); reprinted in *Œuvres complètes*, 1:917 ff.

76 In fact, a new series of *Clarté* would follow no. 79, beginning in June 1926.

77 In *Vers l'action politique*, Marguerite Bonnet reproduces (16 ff.) the minutes of a meeting of the Political Bureau, during which a first issue of the periodical was examined and criticized. It seems increasingly obvious that certain members of the Political Bureau feared that *L'Humanité* might end up "seeming the appendix of the surrealist grouping," whose proletarian sentiments seemed to lack depth. During the discussion, Fourrier did not miss an opportunity to invoke "the absence of cultural thesis of the French Communist Party," emphasizing that the principle of enrolling the largest possible number of well-known intellectuals was not (yet) preponderant, even in Moscow.

78 *L'Humanité* (April 28, June 30, June 1, and July 17, 1926), quoted by C. Reynaud Paligot, *Parcours politique des surréalistes, 1919–1969* (Paris: Centre National de Recherche Scientifique Éditions, 1995), 60 ff.

79 *L'Humanité* (April 1, 1927), quoted by Naville in his presentation of *La Révolution et ses intellectuals*, 34.

80 Éluard, unpublished letter to *L'Humanité*, October 31, 1926 (in Naville, *La Révolution et ses intellectuels*, 36).

81 Compare Breton's statement on September 30: Naville's brochure was very useful. It is one of those things that did the most to shake people out of their apathy (Marguerite Bonnet, ed., *Adhérer au parti communiste?* [Paris: Gallimard, 1992], 55).

82 Letter dated October 23, 1926, in André Masson, *Les Années surréalistes: Correspondance, 1916–1942*, ed. Françoise Levaillant, Classiques de La Manufacture (Paris: La Manufacture, 1990), 125.

83 There was contact with other representatives of revolutionary thought, even if these were only the noncommunist members of *Clarté*, such as Jean Bernier and Boris Souvarine, excluded from the Communist Party in 1924 because of the support he gave to Trotsky's positions and whom certain members of the group would soon "consult" regarding their own membership (see Boris Souvarine's introduction to the reprint edition of *La Critique sociale* [Paris: Éditions de la Différance, 1983], 9). But the Communist Party was, for Breton and his circle, the major reference, by virtue of its organization and its relations, alleged or real, with the Soviet revolution and with what *Légitime défense* called the "admirable Russian difficulties," which still seemed to them to be exemplary. Whence their fairly persistent ignorance of the Trotskyist tendency, toward which *Clarté* was increasingly turning, and even of the realities of the USSR.

84 The retraction of *Légitime défense* would never take place: after its publication in the brochure, the text was reprinted in the December issue of *La Révolution surréaliste* of that same year (no. 8 [1926]), and Breton inlcuded it among the texts he published in *Point du jour*, 4th ed. (Paris: Gallimard, 1934). Éluard confirmed, on December 24, that he would not take back what he had said in *Légitime défense*. In a letter to R. Gaffé in March 1930, Breton told him that "the price and the presentation (of the brochure), extremely modest, are proof of my desire to make it something that will be easily distributed, and above all fall into the hands of those who are not my usual readers. If I am not mistaken, the print run was of 5,000 copies, but it turned out that only a few hundred actually made it onto the market, and at the request of the Political Bureau of the French Communist Party I destroyed the rest, at the beginning of 1927" (*Surréalisme-Dadaisme-Cubisme*, sale catalog, Nouveau Drouot, Paris, March 23–24, 1981, no. 304).

85 Soupault was indeed an extraordinarily active person: although he was represented in only four issues of *La Révolution surréaliste*, he published a dozen novels between 1923 and 1929, as well as essays (on the Douanier Rousseau, Apollinaire, Blake, Lurçat, Uccello) and poems; his criticism appeared in *La Revue européenne*, and he also contributed to *Demain*, *Les Feuilles libres*, *Les Cahiers du mois*, *Europe*, and so on. He was also the codirector of the Kra publishing house. One must note, however, that the

indifference he showed for his own texts was unwavering: until the end of his life, he could hardly be bothered to keep track of them.

86 Péret would join a few months later.

87 These reproaches had already been formulated by the two commissions in charge of approving his membership: "What invariably drove them mad were, above all, the reproductions of Picasso's work. Did I think I had time to lose with all this petty bourgeois nonsense, did I think it was compatible with the Revolution, etc" (Breton, *Entretiens,* 127).

88 Louis Aragon et al., *Au grand jour* (May 1927); reproduced in *Tracts surréalistes,* ed. Pierre, 1:67 ff., and in Breton's *Œuvres complètes,* 1:928 ff. Artaud would respond with *À la grande nuit ou Le Bluff surréaliste* (June 1927), then with *Point final* (September 1927), in collaboration with Ribemont-Dessaignes (see A. Artaud, *Œuvres complètes,* rev. ed., 6 vols. [Paris: Gallimard, 1976], vol. 1, bk. 2:59, 67.) Apart from his indifference to politics per se, the organization of his Théâtre Alfred Jarry with Robert Aron and Vitrac was one of the reasons for his exclusion. But he was still among the contributors to *La Révolution surréaliste* in March 1928; it was Breton who imposed silence on a tumultuous audience during the second performance (January 1928) of the Théâtre Alfred Jarry, during which an act by Claudel, whom Artaud referred to as an "infamous traitor," was presented. The surrealists took Artaud's side against the cinematographic adaptation by Germaine Dulac of his screenplay *La Coquille et le clergyman* (February 1928). However, they disrupted the Jarry's second performance (June 9, 1928) of Strindberg's *A Dream Play* because a number of the seats were reserved for the Swedish embassy and Artaud, while acknowledging that it was "loathsome," called the police—something Breton would obviously reproach him for in the *Second Manifeste.*

89 Breton, *Entretiens,* 131–32.

90 In 1921, Mesens set to music a poem by Soupault, *Garage* (score published in 1926).

91 *Période* was reprinted in 1993 by the Éditions Didier Devillez, Brussels.

92 The authors being addressed were Éluard, Soupault, Paulhan, Proust, Drieu la Rochelle, Valéry, Lhote, Cassou, Aragon, Breton, Delteil, Arland, Gide, et cetera.

93 André Breton, *Introduction au discours sur le peu de réalité* (1924) (Paris: Gallimard, 1927).

94 In 1926, the poems *La Publicité transfigurée* were accompanied by a musical composition by André Souris for four narrators and nine percussion instruments.

95 Paul Nougé, *Subversion des images* (Brussels: Les Lèvres Nues, 1968), 15.

96 *Adhérer au Parti communiste?* ed. Bonnet, 95.

97 Goemans, Magritte, Mesens, Nougé, and Souris, *Défiez-vous* (October 6, 1926); reprinted in Marcel Mariën, *L'Activité surréaliste en Belgique, 1920–1950,* Le Fil rouge (Brussels: Lebeer-Hossmann, 1979), 132.

98 *Les Mariés de la Tour Eiffel* (November 3, 1926); reprinted in Mariën, *L'Activité surréaliste en Belgique,* 133.

99 The first issue of *Marie: Journal bimensuel pour la bonne jeunesse* was dated June–July 1926; the last of four issues, probably February or March 1927, was titled *Adieu à Marie.* The collected issues were reprinted in 1993 by Didier Devillez, Brussels.

100 [In French, a "chapeau melon" is a derby hat. *Trans.*]

101 On March 3, 1928, an exhibition opened at the Galerie l'Époque of nearly all of De Chirico's most recent work. At the same time, another De Chirico exhibition was held at the Galerie Le Centaure from March 10 to 20, but it displayed older works that had been shown the month before at the Galerie Surréaliste (where they were prefaced by Aragon with a text violently opposed to the "new" De Chirico: "The series has changed its author"—see Queneau's account in *La Révolution surréaliste* no. 11). A catalog was printed for the Galerie L'Époque, prepared by E. L. T. Mesens and van Hecke, and it included excerpts favorable to the painter by Apollinaire, Breton, Ribemont-Dessaignes, Aragon, Éluard, and Soupault. The pamphlet *Avis* (reprinted in *Tracts surréalistes,* ed. Pierre, 1:91)—signed by Aragon, Breton, Goemans, and Nougé, who most probably wrote it—seemed therefore to be wrong in denouncing the Galerie Le Centaure: it was indeed the gallery's exhibition that inflicted a rejection of "a painter who has taken for himself the right to betray an idea that long ago ceased to belong to him." It seemed, moreover, that the catalog from L'Époque was destroyed by van Hecke, as Breton requested (see Marcel Mariën, ed., *Lettres surréalistes (1924–1940)* [Brussels: Les Lèvres Nues, 1973], no. 134).

102 Péret, writing in *L'Humanité* (October 25, 1925); reprinted in *Œuvres complètes,* 6:239 ff. In June 1928, Breton read Chaplin's book *My Trip Abroad* ([New York: Harper & Brothers, 1922]; French trans.: *Mes*

voyages, trans. P. A. Hourey [Paris: Kra, 1928]) with enthusiasm, comparing it to Trotsky's *Lenin.* In 1931, Soupault would publish *Charlot,* La Grande Fable: Chroniques de personnages imaginaires (Paris: Plon). Such admiration for Charlie Chaplin was, at the time, shared by most avant-garde artists, both French (Léger, Gromaire, Delluc) and foreign (Severini, Youtkevitch), but the surrealists emphasized, in particular, the asocial dimension of the now-mythical little man.

103 Paul Éluard, "D. A. F. de Sade, Writer of Fantasy and Revolutionary," *La Révolution surréaliste,* no. 8 (December 1926).

104 Two original works by Vertès were also included in the Nouveau Drouot sales catalog *Surréalisme-Dadaisme-Cubisme* (March 23–24, 1981). As for Éluard's erotic concepts, his *Lettres à Gala, 1924–1948* (Paris: Gallimard, 1984) is essential reading.

105 The Breton quote is taken from a letter to Simone on August 19, 1928, quoted in the catalog *André Breton: La Beauté convulsive* (Paris: Éditions du Centre Pompidou, 1991), 188.

106 Péret's text, *Les Couilles enragées,* would only be published in 1954 by Losfeld: twenty-one hundred copies were printed, the majority of which were destroyed in a flood. The cover title was modified by a spoonerism, *Les Rouilles encagées,* and it would be reprinted in the series Le Désordre (Paris: Éric Losfeld, 1970), with a series of illustrations by Tanguy. Meanwhile, the poems and cantatas that emphasized the narration were used the year following their composition in *1929.* As for Aragon's work, it appeared under the pseudonym of Albert de Routisie, and Aragon would subsequently deny any connection with the text (see, e.g., a letter to Pauvert in October 1955, in which Aragon asked that this text not be mentioned in the bibliography included in the catalog *XX siècle: Manuscrits et lettres autographes* (Nouveau Drouot, June 17, 1991, no. 8).

107 Jean-Jacques Pauvert, preface to *Irène* (Paris: L'Or du Temps, 1968), viii.

108 "Research into Sexuality," *La Révolution surréaliste,* no. 11 (March 15, 1928).

109 There were few women among the forty participants (and this has been often pointed out), perhaps half a dozen, and although their participation came late and remained very modest—no doubt because Gala and Elsa Triolet, the two most active Egerias, did not take part in the meetings—it was far from being totally negligible in the context of the era.

110 José Pierre, preface to *Recherches sur la sexualité,* ed. José Pierre, Archives du surréalisme, no. 4 (Paris: Gallimard, 1990), 9.

111 The answers published came primarily from members or those close to surrealism. Francis de Miomandre and Édouard Dujardin had some very sympathetic comments: de Miomandre admired the terms of the survey: "This represents great courage. The courage of those who turn their backs on the universal preoccupation with money, to look elsewhere. . . . For the surrealists, love is like its sister, poetry, a 'desperate attempt' to capture truth. And what is pathetic about this situation, to which they intend to remain faithful, is what makes them so unlike other writers, and so much more interesting." As for this dissimilarity, some writers set out to prove it: "If man lived normally, that is, in a wild state, only rutting would exist. But then came the poets . . . and they invented this perfectly ridiculous thing, Love" (Jules Rivet). "You get love all entangled with literature. Love is nothing but a deformation of the reproductive instinct" (Clément Vautel). "There is only one form of love, cruel love, in which I place all my hopes, and which is worth the sacrifice of a part of freedom" (Fernand Marc). "I place only one hope in love: the hope of despair. Everything else is literature" (Cendrars).

112 Initially hospitalized at Sainte-Anne in March 1927 (her relations with Breton had ended the previous month), "Nadja" was later transferred to the hospital at Perray-Vaucluse, then to the north of the country (which is where she was from) in May 1928. She died in January 1941, after fourteen years of confinement for what was judged at the time an incurable psychosis.

113 The theme of asylums causing patients to become insane would be taken up again by certain partisans of "antipsychiatry" in the 1960s. See, e.g., R. Gentis, *Les Murs de l'asile* (Paris: Éditions François Maspero, 1970).

114 "Satan in Paris" figures in Breton's *Œuvres complètes,* 1:923 ff.

115 *Lautréamont envers et contre tout* is reproduced in *Tracts surréalistes,* ed. Pierre, 1:65 ff. In February 1930, the surrealists ransacked the Bar Maldoror in Montparnasse (Char was fairly seriously injured): once again, they could not stand the idea that the name of Lautréamont was being debased by commercialism.

116 The montage of quotations can be found in *Tracts surréalistes,* ed. Pierre, 1:84 ff.

117 [The Concours Lépine is a show held every year in Paris for inventors. *Trans.*]

118 André Breton and Louis Aragon, eds., *Le Surréalisme en 1929,* special issue of *Variétés* (June 1929), foreword by Philippe Dewolf (Brussels: Didier Devillez. 1994). One can also find "À suivre" in *Tracts surréalistes,* ed. Pierre, 1:96 ff., as well as in Breton's *Œuvres complètes,* 1:951 ff.

119 "I am persuaded that individuals with a strong or excessive personality—sickly perhaps, or fateful if you like, it's not even something you can discuss—those individuals will never be able to submit to the army-barracks discipline that a joint action requires whatever the cost" (Joan Miró, quoted by Louis Aragon and André Breton, "To Be Continued: A Small Contribution to the File of Certain Intellectuals with Revolutionary Tendencies," *Variétés* [Special Issue: "Le Surréalisme en 1929"] [March 11, 1929]).

120 In its second issue (spring 1929), *Le Grand jeu* featured a hitherto unpublished letter by Rimbaud and essays devoted to him. It was also in 1929 that Gilbert-Lecomte wrote a foreword for the Éditions des Cahiers Libres for an edition of Rimbaud's *Correspondance inédite* (Unpublished correspondence) and that A. Rolland de Renéville published *Rimbaud le Voyant* (Rimbaud the seer) with Au Sans Pareil, dedicated to Soupault.

121 From the point of view of Bataille's desire for philosophical materialism, his response to the invitation to the rue du Château meeting was symptomatic: "Too many bloody boring idealists"—and from his point of view this included the surrealists.

122 Participation by Goemans and Magritte did not work out, apparently for financial reasons.

123 *Un chien andalou*'s public premiere was held at Studio 28 on October 1.

124 The quote is from Breton, *Entretiens,* 159.

125 Thirty years later, in *Le Poème de la femme 100 têtes* (Paris: Éditions Jean Hughes, 1959), Ernst would compile all the captions on their own from the collection of collages; they took on an even greater autonomy in this way.

126 A. Pieyre de Mandiargues asserted, from another point of view, in the article he devoted to a new edition of *La Femme 100 têtes* (*Monde nouveau* [April–May 1957], reprinted in *La Nouvelle revue française,* no. 62 [February 1958]) that Ernst's "triumphant images" were "capable of moving crowds" and, to prove it, said that in Monte Carlo the "wild men and women" to whom he showed the albums "avidly turned the pages, started back at the beginning, asked questions, exclaimed." He could "conclude that surrealism, from this angle, among others, could beat hands down anything that socialist realism might have to offer people in their leisure time."

CHAPTER THREE

1 "Those of Suzanne (Musard), Elsa, Gala, la Pomme, Jeannette Tanguy, Marie-Berthe Ernst, and Goeman's wife (or girlfriend)," according to André Thirion (*Révolutionnaires sans révolution* [Paris: Robert Laffont, 1972; reprint, Paris: Le Pré aux Clercs, 1988], 232). It was significant that these women's lips were in response, in the periodical's conception, to the results of the survey on love and to the presence, in those responses, of the montage of portraits of sixteen members of the group around a reproduction of Magritte's, which bore the inscription "I cannot see the . . . hidden in the forest."

2 See Georges Bataille in *Le Pont de l'épée,* no. 41 (October 1969).

3 In a note in the *Second manifeste du surréalisme* when it was published in book form (Paris: Éditions Kra, 1930).

4 This double column would be reprinted in the *Second Manifesto* at the end of the volume.

5 Robert Desnos, "Troisième manifeste du surréalisme," *Le Courrier littéraire* (March 1 1930); reprinted in Maurice Nadeau, *Histoire du surréalisme suivie de documents surréalists* (Paris: Éditions du Seuil, 1964), 306 ff.

6 The list of changes is given in José Pierre, ed., *Tracts surréalistes et déclarations collectives,* 2 vols. (Paris: Éric Losfeld, 1980–82), 1:430.

7 Text quoted in J.-C. Mathieu, *La Poésie de René Char* (Paris: Éditions José Corti, 1988), 1:69.

8 André Breton, "Letter to André Rolland de Renéville," *La Nouvelle revue française* 7 (February 1932); reprinted in André Breton, *Point du jour,* 4th ed. (Paris: Gallimard, 1934), 9. To see to whom each verse was attributed, refer to the footnotes in André Breton's *Œuvres complètes,* ed. Marguerite Bonnet, with the collaboration of Philippe Bernier, Étienne-Alain Hubert, and José Pierre, 3 vols., Bibliothèque Pléiade (Paris: Gallimard, 1988–2000), 1:1576 ff.; English trans.: *The Lost Steps,* trans. Mark Polizzotti (Lincoln: University of Nebraska Press, 1997).

10 [The listed sequences can be translated as, respectively, "Force of Habit," "Surprise," "There Is Nothing Incomprehensible," "The Feeling of Nature," "Love," and "The Idea of the Future." *Trans.*]

11 As shown by A. Rauzy in 1970 in *À propos de "L'Immaculée Conception" d'André Breton et Paul Éluard: Contribution à l'étude des rapports du surréalisme et de la psychiatrie,* quoted by M. Bonnet and E. A. Hubert in their notice on the book in Breton's *Œuvres complètes,* vol. 1: the illnesses referred to were remarkable for the rich imagery of their language and were of interest to Breton because of their double value, "expressive" and "creative."

12 Maxime Alexandre gave examples that were clearly less fraught with consequences: "The time critics were completely taken in was when we collaborated, and even exchanged a few poems: in *Le Corsage* (1931), for example, there are a few segments of poems that are Éluard's, and inversely there are certain fragments of my poems in Éluard's collections" (*Journal, 1951–1975* [Paris: Éditions José Corti, 1976], 220–21).

13 Something Breton qualified in the *Entretiens, 1913–1952, avec André Parinaud [et al.]* (Le Point du jour [Paris: Gallimard, 1952]; English trans.: *Conversations: The Autobiography of Surrealism,* trans. and with an introduction by Mark Polizzotti [New York: Paragon House, 1993]) as "a considerable concession on the political level." He found the periodical's collection "far and away the richest . . . , the most balanced, best constructed and also the most lively (of an exhilarating and dangerous life). It is here that surrealism has given its strongest burst of flame: for a time, no one saw anything but this flame, and no one was afraid to be consumed" (153–54). The periodical, however, was not a success: the first two issues sold only 350 copies (seven hudnred less than *La Révolution surréaliste*), and the release of the various print runs was proof of the problems on the material level: after no. 1 in July 1930, no. 2 came out in October, but there would be a lapse of more than a year until nos. 3 and 4 came out simultaneously (December 1931). As for the two final issues, they also came out at the same time, May 15, 1933, and Corti was no longer the agent, having passed this role on to the Éditions des Cahiers Libres (R. Laporte), paid on this occasion by Paul Éluard, who found himself obliged to convert his manuscripts and paintings into cash with the Viscount de Noailles.

14 A proposition that took the opposite stance with regard to the "blind present-day architecture, a thousand times more stupid and more revolting than that of earlier eras," at the same time as it took over from the château, the chosen site for the spirit of demoralization, evoked in the first manifesto but also, more recently, by Limbour in *Un cadavre.*

15 Louis Aragon, "La Peinture au défi" (February 1930); reprinted in his *Écrits sur l'art moderne* (Paris: Flammarion, 1981), 27 ff.

16 In the surrealist group, collage—which did presuppose, in fact, less a savoir-faire than a spirit turned toward the supernatural (this would also be the case in the creation of *objets*), did allow for nonspecialization; Breton and Éluard, e.g., took the opportunity for putting together a few rapid collages. In addition to those painters mentioned by Aragon, others would follow: Bellmer, Jindrich Heisler, Toyen, Cornell, Penrose, and Bucaille and then Mariën, Enrico Baj, Jean-Jacques Lebel, Hervé Télémaque, Anne Ethuin, Aube Elleouët, et cetera. Meanwhile, among the "writers," there were Hugnet and Mesens, and in the postwar generation, Gérard Legrand, Robert Benayoun, Jean Schuster, and Edouard Jaguer, among others.

17 See "Special Issue: L'âge d'or: Correspondance Luis Buñuel–Charles de Noailles—lettres et documents (1929–1976)," *Cahiers du Musée National d'Art Moderne* (1993), 80.

18 Reproduced in *Tracts surréalistes,* ed. Pierre, 1:155 ff.

19 Thirion, *Révolutionnaires sans révolution,* 283.

20 *L'Affaire de "L'Âge d'or,"* reproduced in *Tracts surréalistes,* ed. Pierre, 1:188 ff.

21 See their letters to Breton in "Special Issue: L'âge d'or: Correspondance Luis Buñuel–Charles de Noailles—lettres et documents (1929–1976)," 117 ff.

22 In 1929, in *La Femme visible* (Paris: Éditions Surréalistes, 1930), Dalí stated his interest—siding with the antimodernist wing of the group—in Modern Style, which led to the publication in *Minotaure,* no. 3–4 (December 1933) of a famous article: "De la beauté terrifiante et comestible de l'architecture Modern Style." "Extraplastic" above all, the "cannibalistic imperialism" of the Modern Style, subjected to a "total convulsive-formal trituration," offered a fundamentally psychical interest in designating the revenge of the most "confused, disqualified and unavowable" desires over the functionalist preoccupations of all known forms of architecture. The captions to the illustrations (Gaudi, Guimard's *métro* entrances) evoked, e.g., when speaking of the Guell Park, "the extra-fine undulating polychrome guttural neurosis" or the fact that "the bones are on the outside." This article, significantly, was followed by a paragraph by Dalí on "the phenomenon of ecstasy" (described as the "mortal veri-

fication of the images of our perversion"), illustrated by a montage of photographs.

23 The fusion of the scatological and the exalted was a characteristic that was perfectly suited to Dalí's poetry, giving the most authentic lyricism a totally novel dimension, mingling the noble with the trivial with unparalleled mastery:

Gala . . . and once again
it is outside feelings
that your pure and unique representation
gives me a hard-on and makes me discharge
outside
the supplementary hypnagogic images
of masturbation
outside
the nostalgic curve
of perverse commonplaces
outside the clocks made sensibilizable
by means of
a multitude of inkwells
confabulated in balance
the length of your body stretched out
on a pillow of seaweed
the color of shit. . . .
 (*L'Amour et la mémoire* [Paris: Éditions Surréalistes, 1931])

24 On erotic confession, in particular, see René Crevel: "The right of thought to paranoia . . . is the same as the right of sex to erection, ejaculation. So, no more slipcovers on things, no more French letters on ideas" (*Dalí ou l'anti-obscurantisme* [Paris: Éditions Surréalistes, 1931]).

25 Taking into account only the production of 1930–35, independently of later renunciations of his "revolutionary" position.

26 Salvador Dalí, "Nouvelles considérations générales sur le phénomène paranoïaque du point de vue surréaliste," *Minotaure,* no. 1 (1933).

27 André Breton, *Les Vases communicants* (Paris: Éditions des Cahiers Libres, 1932); English trans.: *Communicating Vessels,* ed. Mary Anne Caws, trans. Mary Ann Caws and Geoffrey T. Harris (Lincoln: University of Nebraska Press, 1990).

28 As well as Pierre Yoyotte, who also was in danger of exclusion that day.

29 Dalí, moreover, did not sign the pamphlets in question.

30 Michel Leiris, who sailed from Bordeaux on May 19 to take part in the "Dakar-Djibouti" expedition with Marcel Griaule and would only return to France on February 17, 1933, was one of the few people to point out that one of the exhibition halls, the Afrique Occidentale Française building, inspired by the Great Mosque of Djenné, was nothing more than the copy of a copy, as the mosque in question had been entirely rebuilt by the French at the beginning of the century. The major role attributed to architecture (native or colonial) in artistic expression within the *Colonial Exhibition* was anticipated in *L'Art de reconnaître les styles coloniaux de la France* ([Paris: Garnier Frères, 1931], preface by Lyautey); its author, Émile Bayard, would deal at length with the architecture and monuments of the colonies but devoted only a few hasty paragraphs to statuary, particularly African, and said, e.g., that the "canaque" masks of New Caledonia "could not possibly have any charm for us beyond that of an 'amusing' caricature."

31 *Ne visitez pas l'exposition coloniale,* reprinted in *Tracts surréalistes,* ed. Pierre, 1:194.

32 *Premier bilan de l'exposition coloniale,* reprinted in *Tracts surréalistes,* ed. Pierre, 1:198.

33 These three aspects were already implicitly connected in the text by Jacques Viot that appeared in the first issue of *Surréalisme ASDLR* (July 1930), "N'encombrez pas les colonies" (Do not burden the colonies): "There is no trace of religion in either fetishism or totemism. We spend our time trying to reconnect primitivism to civilization. We will not succeed. It's an egg. It is smooth and if we break it, it will cease to be." Viot's piece is an excerpt from his novel *Déposition de Blanc,* which, despite the support of Crevel, Thirion, and Cahun, would only be published in 1932 by Stock, when Viot had already left the group.

34 The objects from Africa, Oceania, and America were on loan from Breton, Éluard, and Tzara; Aragon and Elsa would take care of the sonorization by bringing phonograph records—"what we could find in 1931 in the way of Polynesian or Asian music, in specialized shops" (Thirion). During the *Colonial Exhibition* there was a sale at the Hotel Drouot on July 2 and 3 of "Sculptures from Africa, America,

and Oceania" from Breton and Éluard's collections; a portion of the money from the sale would go to finance *Surréalisme ASDLR.*

35 André Breton, *Introduction au discours sur le peu de réalité* (Paris: Gallimard, 1927).

36 Salvador Dalí, in *Le Surréalisme ASDLR*, no. 3 (1931).

37 "I can only speak indirectly of my sculptures," *Minotaure*, no. 3–4 (December 1933); reprinted in Alberto Giacometti, *Écrits* (Paris: Hermann, 1990), 17.

38 Ibid., 135.

39 André Breton, "Équation de l'objet trouvé," *Documents 34* ("Special Issue: Intervention surréaliste"); reprinted in André Breton, *L'Amour fou* (Paris: Gallimard, 1966), pt. 3.

40 Tanguy, "Poids et couleurs" (Weight and colors), *Le Surréalisme ASDLR*, no. 3 (December 1931.

41 R. Crevel, "L'Enfance de l'art," *Minotaure*, no. 1; text reprinted in René Crevel, *Révolution, surréalisme, spontanéité* (Paris: Plasma, 1978).

42 Breton's reservations in regard to narrowing the possibilities for interpretation were also voiced, from a somewhat "professional" point of view, by the psychoanalyst Jean Frois-Wittmann in "L'Art moderne et le principe de plaisir" (*Minotaure*, no. 3–4 [December 1933]): if one considers that the value of a work depends on "the wealth and depth of the associations that it is able to evoke in the viewer," he reproaches Dalí with "making his fantasies so clear that there is hardly any room left for the viewer to create other associations"; Dalí, therefore, was something of a "Meissonier of the unconscious." Max Ernst, however, "knows how to remain more vague." Frois-Wittmann was expanding on a reflection about the rapport between modern art and pathological art, the unconscious and the representation of reality, which he had begun in 1929 in his "Considérations psychanalytiques sur l'art moderne," published in the *Revue française de psychanalyse.*

43 Claude Cahun, "Prenez garde aux objets domestiques" (Beware of household objects), *Cahiers d'art*, special issue on the surrealist show at the Galerie Pierre Colle 1993; reprinted in *Pleine marge*, no. 14 (1992).

44 André Breton, "La crise de l'objet" (Crisis of the object), *Cahiers d'art*, special issue on the surrealist show at the Galerie Pierre Colle 1993; reprinted in André Breton, *Surréalisme et la Peinture*, rev. ed. (Paris: Gallimard, 1965), 275 ff.; English trans.: *Surrealism and Painting*, trans. Simon Watson Taylor (New York: Harper & Row, 1972).

45 André Breton, "La crise de l'objet."

46 André Thirion's commentary: "Our two friends did not have enough political experience to gauge the influence of Barbusse's supporters in the Komintern and in the Soviet ruling circles. Barbusse and Romain Rolland were a recourse to pacifist propaganda to which the 'politicals' attached more importance than to *Monde's* ideological content, or to the anger of the surrealists" (*Révolutionnaires sans révolution*, 297).

47 See their "self-critical letter" in *Tracts surréalistes*, ed. Pierre, 1:185.

48 Louis Aragon and Georges Sadoul, "To Revolutionary Intellectuals," reprinted in *Tracts surréalistes*, ed. Pierre, 1:186.

49 Commenting on the quality of the poem, Thirion wrote: "The end of the poem is as banal and weak as the worst articles in *L'Humanité* at that time, despite the introduction of onomatopoeia. . . . The middle section, which seeks to have a political content, is a fabric of ineptitude" (*Révolutionnaires sans révolution*, 330).

50 Garcherry was a former Communist deputy who had joined a group of independent Communists.

51 *L'Affaire Aragon*, reprinted in *Tracts surréalistes*, ed. Pierre, 1:204. The text gathered over three hundred signatures, later enumerated in *Misère de la poésie* (also reprinted in *Tracts surréalistes*), as well as those of the "entire French Section of the International Red Assistance (sixty thousand members)." A note in the manifesto of 1924 had already pointed out the problem of the "responsibility" to be attributed to the author of a surrealist text: "The defendant published a book that offends public morality. . . . For his defense he does no more than plead that he does not consider himself to be the author of his book . . . that he did no more than copy a document without giving his opinion, and that he is at least as much of a stranger to the incriminating text as the presiding judge of this Tribunal" (Breton, *Œuvres complètes*, 1:344). His argument was taken up again in the pamphlet but with regard to a text that had nothing "surrealist" about it, in the 1924 sense of the word.

52 See the description of the letters exchanged within the group at the time of the Aragon affair in the catalog for the sale of R. Gaffé's library (Hotel Drouot, April 26 and 27, 1956) or the summary given by José Pierre in *Tracts surréalistes*, 1:457.

53 René Magritte, E. L. T. Mesens, Paul Nougé, and André Souris, *La Poésie transfigurée,* reprinted in *Tracts surréalistes,* ed. Pierre, 1:206.

54 André Breton, *Misère de la poésie,* reprinted in *Tracts surréalistes,* ed. Pierre, 1:208.

55 Together, Maxime Alexandre and Pierre Unik would publish a pamphlet in April, *Autour d'un poème* (reprinted in *Tracts surréalistes,* ed. Pierre, 1:230), which distanced itself from *Misère de la poésie* and reproached Aragon for calling Breton an antirevolutionary, but it was too late to hope for a reconciliation. The break was painful, and Breton himself would testify to that effect; yet it was not sufficient reason to assert, as Pierre Daix did in his *Vie quotidienne des surréalistes, 1917–1932* (Paris: Hachette, 1993), that the break meant that "what had begun between 1917 and 1920, with Aragon, Breton, and Soupault, was totally finished." This would suggest the end of surrealism itself, unless one takes "what had begun" to refer to nothing other than a particularly dense network of friends.

56 Breton, *Entretiens,* 168.

57 Apparently, in March 1932, Buñuel wanted to reedit *L'Âge d'or,* to make it shorter and to circumvent the ban that was preventing the film's screening; the ban would not be lifted until 1980. At that point he said, "I am quite far removed from the state of mind of *L'Âge d'or,* and I've been thinking about new things that are quite distant from my latest film." He also gave the new version a new title, borrowed from Marx's Communist manifesto: "In the Icy Waters of Selfish Calculation . . ."; it was this version—and Dalí was furious about the project—which Breton referred to in *L'Amour fou,* deploring the fact that Buñuel had given way to "a few cheap and nasty revolutionaries." It is possible that a few copies were in circulation before the Second World War but apparently none have been recovered.

58 This was also the moment when the German Communist Party, applying directives from Moscow, found it more useful to combat the Social Democrats than the Nazis.

59 Selected texts from the *L'Humanité* contest were published in 1934 with the title *Des ouvriers écrivent.*

60 An excerpt from Breton's speech was published in *Le Surréalisme ASDLR* no. 5 (1933), then later reprinted in *Point du jour,* and in his *Œuvres complètes,* 2:332; Breton referred explicitly to the Kharkov theses but also relied heavily on Lenin and Engels to reiterate that working-class people were influenced, above all, in their attempts to write, by what they had learned at school and through the newspapers they read. Whence the effort that must be undertaken to initiate them to a true history of progressive literature, and the desirability of putting together a "Marxist manual of general literature" that could complement "courses in Marxist literature." It was obvious that Breton and his friends, at the time, went as far as they could to collaborate with the AEAR.

61 *La Mobilisation contre la guerre n'est pas la paix,* reprinted in *Tracts surréalistes,* ed. Pierre, 1:240.

62 Thirion, *Révolutionnaires sans révolution,* 324.

63 René Allendy (1889–1942) was one of the founders, in 1926, of the Société Psychanalytique de Paris, and president of the group L'Évolution Psychiatrique. A homeopath with a passionate interest in the occult, he published nearly two hundred articles on very diverse subjects—from alchemy to the noisiness of schoolboys by way of calcium in the organism—and a number of scholarly works: *Les Tempéraments* (Paris: Vigot Frères, 1922), *Orientation des idées médicales* (Paris: Vigot Frères, 1929), *La Justice intérieure* (Paris: Denoël & Steele, 1931; reprint, Paris: Éditions du Piranha, 1980), *Capitalisme et sexualité: Le Conflit des instinct et les Problèmes actuels* (Paris: Denoël & Steele, 1932)—which Yoyotte criticized severely in *Le Surréalisme ASDLR, Rêves expliqués* (1938), and others. Beginning in 1924 he would take a stance, unlike many of his more timid colleagues, in favor of the sexual etiology of neuroses. Very briefly he would treat Artaud, who interpreted the cure as a psychic rape. In 1926, he collaborated with René Laforgue on *Le Rêve et la psychanalyse* (Paris: F. Alcan, 1926); his loyalty to Freud was very relative, and his "work forms a conglomerate of unequal theories" (Elisabeth Roudinesco). Also a cofounder of the Société Psychanlytique de Paris, René Laforgue (born in 1894) read Freud in German at an early age and devoted himself to the study of schizophrenia; he would write his thesis on the subject in 1919. An assistant at Sainte-Anne, he corresponded with Freud between 1923 and 1937 and sought to make Freud's work better known in France but had no real theoretical rigor. Along with his medical and psychiatric works, he devoted a number of studies to the psychopathology of failure, inaugurated in 1931 by *L'Échec de Baudelaire,* quoted by Yoyotte in a fairly appalling chapter in *Le Surréalisme ASDLR.*

64 In *Le Clavecin de Diderot* (Paris: Éditions Surréalistes, 1932; reprint, Paris: J. J. Pauvert, 1966), René Crevel attacked the mediocrity of ordinary family relations, and at the same time he denounced the masculine, or rather desexed, nature of his own mother, always distant and incapable of affection toward him. He commented that her lack of femininity may only have been a pretext "found by

nature . . . to [excuse] everything that, in puberty, would seem to be, precisely, not a result of nature." The "Recherches sur la sexualité" published in 1928 in *La Révolution surréaliste* indicated marked differences among the surrealists with regard to homosexuality: Queneau, Duhamel, and Aragon found nothing wrong with it, whereas it disgusted Unik and enraged Breton, who accused pederasts, with the exception of Sade and Jean Lorrain, of a "mental and moral defect." Crevel was absent from these sessions, and nobody mentioned him. The group tacitly accepted his sexual habits, even if they deplored some of the friendships (Jouhandeau) and the difficulties they engendered. Relations with Claude Cahun confirmed that Breton's virulence was not the rule among the group.

65 Whence the lasting reservations that orthodox Freudians and psychoanalysts expressed with regard to surrealism in general and Breton in particular. As an example, and a pleasing one at that, here is a recent diagnostic: "In *Les Vases communicants* . . . [the] need for a fusion of contraries on the discursive level is always connected in part with an unconscious structure that denies the difference of the sexes, posits the primacy of the phallus, denies the reality of the female sex, and is haunted by the figure of a woman with a phallus" (F. Migeot, "Que diable allait-il faire dans cette galère?" *Europe,* no. 743 [March 1991]).

66 Breton, *Entretiens,* 169. When the work was published however, Henri Lefebvre condemned it for its incompatibility with Marxism.

67 On the suggestiveness of certain illustrations to someone browsing through the book, before they even read it, see Gérard Durozoi, "Les Vases communicants: Marx—Freud," in *Surréalisme et philosophie* (Paris: Éditions du Centre Pompidou, 1992).

68 All of which are reprinted in *Tracts surréalistes,* ed. Pierre, 1:247 ff., and in a separate edition, *Violette Nozières* (Paris: Éditions Terrain Vague, 1991).

69 In the end Bataille, who chose the title of the periodical with Masson, would only participate once, in no. 8 in 1936—the period of Contre-Attaque, where a rapprochement between Breton and himself seemed a real possibility—with a poem inspired by Masson's painting. All issues of *Minotaure* have been republished in three volumes (Geneva: Skira, 1981).

70 Tristan Tzara, *Œuvres complètes,* ed. Henri Béhar, 6 vols. (Paris: Flammarion, 1975–91), 5:693. To which Sarane Alexandrian replied: "To consider *Minotaure* to be less revolutionary than *Le Surréalisme ASDLR* simply because polemics have been left out and the presentation is quite luxurious would be a reactionary and narrow-minded way of thinking. In revolutionary action, violence is only a last resort; the main strength remains persuasion. . . . To renounce luxury is a reactionary attitude, because the point is to make luxury available to all. By putting together a periodical whose layout, illustrations, and format give free rein to an idea of luxury and beauty, surrealism is loyal to its struggle against the sordid aspects of life, the masochistic degradation of human ideals" (*Le Surréalisme et le rêve* [Paris: Gallimard, 1975], 202).

71 Emmanuel Berl, *Frère bourgeois, mourez-vous?* (Paris: Grasset, 1938), 116.

72 The mission statement that was included in each issue stated that *Minotaure* "will assert its desire to find, gather, and give an account of the elements that have contributed to the spirit of the modern movement, in order to expand its range, and it will endeavor, by means of an encyclopedic focus, to clear the artistic terrain in order to restore to art in movement its universal ascension." "The spirit of the modern movement" is to be taken in the sense that, already in 1923, the aim was to determine its directives and to defend it, and not in the sense given by Le Corbusier, Léger, or the Union des Artistes Modernes. Three new paragraphs were added to the mission statement in issue no. 3–4, reflecting even more clearly the way the ambitions of surrealism were resonant with the tone of the *Second Manifesto*: each issue "is justified in our eyes inasmuch as we are constantly getting closer, on the intellectual level, to an incontestable neuralgic point, and that we are striving to achieve balance on that point, that is, the unity of differences in order to give a new and authentic face to thought as it evolves."

73 It was only with the tenth issue (winter 1937), however, that Tériade would cease to be coeditor, and an editorial committee, made up of Breton, Duchamp, Éluard, Heine, and Mabille indicated that the group actually had the possibility of fully controlling of the periodical.

74 André Breton, *Appel à la lutte,* reprinted in *Tracts surréalistes,* ed. Pierre, 1:262.

75 "Aux travailleurs" (To the Workers), reprinted in *Tracts surréalistes,* ed. Pierre, 1:264.

76 "Enquête sur l'unité d'action" (Survey on the unity of action), reprinted in *Tracts surréalistes,* ed. Pierre, 1:265.

77 The quote is from Breton, *Entretiens,* 174.

78 When "To the Workers" was published in *Commune,* the commentary was fairly critical.

79 *La Planète sans visa,* reprinted in *Tracts surréalistes,* ed. Pierre, 1:268.

80 Clovis Trouille, "Toute ma vie," reprinted in Raymond Charmet, *Clovis Trouille* (Paris: Éditions Filipacchi, 1972).

81 Ibid.

82 François Leperlier, *Claude Cahun: L'Écart et la métamorphose* (Paris: J.-M. Place, 1992).

83 Ibid.

84 Some have found a prefiguration of Cindy Sherman's work in Cahun's self-portraits. But beyond their shared practice of travesty, their motivations were exactly the opposite: Cahun rebelled against all social preconceptions of the body, while Sherman parodied stereotypes of cinematographic or historical origin. On the part of one of them, there was the fierce assertion of a reduced singularity that violently confronted shared thought; on the part of the other, an ironical game with that shared thought.

85 In M. Butor, *Hérold* (Paris: Éditions G. Fall, 1964), 8–10.

86 In 1933, the group's participation in the Salon des Surindépendants was particularly important, and Breton sought to integrate Kandinsky as a guest of honor. Kandinsky had just been expelled from the Bauhaus by the Nazis. Relations between the painter and the surrealists remained distant, however: although Kandinsky appreciated some of their work (Ernst, but his drawings rather than his paintings; Tanguy; and perhaps Dalí, above all), he was reticent with regard to the collective dimension of the movement and the importance given to eroticism.

87 "Interview de Meret Oppenheim," by Suzanne Pagé and Béatrice Parent, in the catalog *Meret Oppenheim* (Paris: ARC Musée d'Art Moderne de la Ville de Paris, 1984).

88 Ibid.

89 Pierre Mabille, "L'Œil du peintre," *Minotaure,* no. 12–13 (May 1939).

90 The quote is from André Breton, preface to *Brauner* (Paris: Galerie Pierre, 1934); reprinted in *Le Surréalisme et la Peinture,* 121. During a brief return to Bucharest in 1935, Brauner joined Romania's clandestine communist party (he would quit during the Moscow purges).

91 Péret, "Entre chien et loup," *Minotaure,* no. 8 (1936); reprinted in his *Œuvres complètes,* 7 vols. (Paris Éric Losfeld, 1969–95), 7:37.

92 Hans Bellmer, letter to R. Valençay, quoted in *Hans Bellmer photographe* (Paris: Filipacchi–Centre Georges Pompidou, 1983).

93 The photographs that appeared in no. 6 of *Minotaure* were followed by three more in no. 7 (June 1935), two in no. 9 (June 1936), and one in no. 10 (winter 1937). The issue of *Cahiers d'art* devoted to the object also published one. Bellmer took part in all the collective exhibitions held in subsequent years: Santa Cruz de Tenerife in 1935, then London (1936), Tokyo (1937), Paris, and Amsterdam (1938)—proof of the recognition he deserved.

94 Hans Bellmer, *Die Puppe* (Karlsruhe: Th. Eckstein, 1934); French trans.: *La Poupée,* trans. Robert Valençay (Paris: GLM, 1935). Éluard published a number of "Jeux vagues de la poupée" in *Messages,* no. 2 (1939), and later published them in book form, with photographs by Hans Belmer, as *Les Jeux de la poupée: Quatorze poèmes* (Paris: Éditions Premières, 1949).

95 Magritte then went on to transform the painting into a series of images, multiplying the variations and refrains. See the commentary (which the author confessed to be incomplete) by A. Blavier in *Ceci n'est pas une pipe: Contribution furtive à l'étude d'un tableau de René Magritte* (Verviers: Temps Mêlés, 1973).

96 José Pierre, *Magritte* (Paris: Somogy, 1984), 39 ff.

97 Michel Deguy, *Choses de la poésie et affaire culturelle* (Paris: Hachette, 1986), 82.

98 The fact that Magritte's stylistic withdrawal eventually came to make up his *image de marque,* rendering his painting immediately recognizable, is proof only of his obstinacy in ignoring all the formal evolution of painting in the twnetieth century, once his method had been perfected. It is a well-known fact that anonymity and banality were a way of life for Magritte—in his daily background, the suit he wore, his wife's dogs, etc. Such taste, which was deliberately "common," was, moreover, indirectly responsible for the chill that came between the painter and the Parisian surrealists in 1930, after Breton had pointed out that it was fairly indecent to exhibit a Christian cross, one day when Georgette Magritte was in fact wearing such a piece of jewelry, which she had inherited in the most banal way from her mother.

99 René Magritte, "La Ligne de vie I" (Lifeline I), in *Écrits complets* (Paris: Flammarion, 1979), 103 ff.

100 In the collection of the Museum at Épinal there is a wooden clog with its tip sculpted in the shape of toes. Magritte's *Le Modèle rouge* was reproduced (in black and not in a red-chalk drawing, as Duchamp had suggested) on the cover of the second edition of *Le Surréalisme et la Peinture* (1945), and in the display window created by Duchamp and Enrico Donati to launch the book was a pair of boots wearing make up, echoing Magritte's canvas. In 1986, the couturier Pierre Cardin created a pair of shoes using the same concept (Richard Martin, *Fashion and Surrealism* {New York: Rizzoli, 1987], 97).

101 In the text there was a note here where Nougé referred to the ban on *L'Âge d'or.*

102 Preface reprinted in Marcel Mariën, *L'Activité surréaliste en Belgique, 1920–1950,* Le Fil rouge (Brussels: Lebeer-Hossmann, 1979), 205 ff.

103 Nougé initially thought he would sign the protest, clarifying in a letter to Breton, however, that the judge who accused Aragon "was not lacking in clear-sightedness, in sum," and that the aim was "simply to defend ourselves."

104 The periodical *Documents* was published in Brussels between 1933 and 1936. It was the organ of the Association Révolutionnaire Culturelle (ARC) run by Jean Stéphane (alias Stéphane Cordier).

105 Jan Topass, *La Pensée en révolte: Essai sur le surréalisme* (Brussels: René Henriquez, 1935), regrouped articles published in 1920 and 1934 in *La Grande Revue.* The text was muddled in places, referring to Cocteau as an initiator of the movement and including Cendrars among its members; the author considered surrealism in painting to have achieved nothing more than vague experimentation or premonition, and he saw the movement as the symptom of a general malaise: the individual impatience of the surrealists hardly seemed compatible with the "masses" (communist in particular)—but, far from concluding that these difficulties signaled a failure, Jan-Topass was confident in the future, however unknown, of surrealism.

106 The cover of André Breton, *Qu'est-ce que le surréalisme?* (Brussels: Éditions Henriquez, 1934) shows Magritte's *Le Viol;* the new edition of Breton's work (Paris: Actual-Le Temps qu'il Fait, 1986) shows a vignette by Arp that was first used for the English language edition, *What Is Surrealism?* trans. David Gascoyne (London: Faber & Faber, 1936). Breton stated, in particular: "The activity of our surrealist comrades in Belgium has always been parallel to ours, closely connected to ours"—recognition that gave an official status, if one believes André Souris, to a "Belgian surrealism," while as far as the Belgians were concerned, they were getting along very well without the surrealist label (see "Les Pieds dans les pas," in *Magritte: Bibliothèque municipale de Bordeaux, 24 mai–17 juillet 1977* [Bordeaux: Centre d'Arts Plastiques Contemporains de Bordeaux, 1977]).

107 See pp. 178 ff. for further discussion.

108 "Le Domestique zelé," reprinted in Mariën, *L'Activité surréaliste en Belgique,* 305.

109 For more on the break with the Communist Party, see p. 299.

110 Raoul Michelet was the pseudonym adopted by Ubac: with Camille Bryen in 1935 he published *Actuation poétique* (Paris: Éditions R. Debresse), which featured his first photographs—among others, the reconstitution of an automatic drawing by Bryen and the famous head of a woman with a slice of liver hanging between her teeth, framed on either side by a poem; in 1936 a poster of this work would be stuck to a few walls in Paris with the title *Affichez vos poèmes—Affichez vos images* (Post your poems—post your images).

111 Three hundred and fifty copies of *Mauvais temps* were published; this single issue was reprinted in 1993 by the Éditions Didier Devilliez, Brussels.

112 Péret, *Œuvres complètes,* 7:138.

113 In 1935 Crevel was concerned that the movement would dry out and reiterated, in a letter to Péret, that "the intermittences of thought express its real functioning with more exactness than the expression of a thought that has been stereotyped for good. In other words, even if the river is surrealist, one doesn't bathe in it twice in a row" (quoted in Michel Carassou, *René Crevel* [Paris: Fayard, 1989], 247).

114 These two lectures, "Situation surréaliste de l'objet, situation de l'objet surréaliste" (The surrealist situation of the object, the situation of the surrealist object) and "Position politique de l'art d'aujourd'hui" (The political position of art today), are reprinted in André Breton, *Position politique du surréalisme,* Les Documentaires (Paris: Éditions du Sagittaire, 1934).

115 Paul Éluard, *Lettres à Gala, 1924–1948* (Paris: Gallimard, 1984), 252.

116 *Doba,* no. 15–16, reprinted in *Bulletin international du surréalisme* (Prague), no. 1, and quoted by Lecomte and Mesens in "Mouvement de pensée dans la révolution."

117 Breton would relate his strong impressions of the Canary Islands and Tenerife—"a dream world, a real world of surrealism in a primitive state"—in "Le Château étoilé," published first in *Minotaure,* and then in *L'Amour fou.*

118 Interview of Breton, reprinted in *Position politique du surréalisme.*

119 The announcement forbidding screening of *L'Âge d'or* appeared in the newspaper *La Tarde:* "Given the nature of the film, and the moral and sexual violence of a number of scenes, the Enterprise advises women and young ladies to refrain from attending this performance and thus avoid any natural unpleasantness of feeling hurt or attacked in their moral judgments." An article by Agustin Espinosa would respond to these warnings the following day. See *Docsur,* no. 7 (March 1989).

120 Léo Malet took part in "the enrichment of the methodological treasure of surrealism" (Breton) with his concept of ripping off strips from a poster in order to reveal the poster(s) hidden underneath and, thus, bring about unexpected encounters between images or texts: in this way surrealism could go into the street through the practice of a new "mural painting," with poetry on walls. The "poster artist" Villegié was careful to give the credit to his precursor that he deserved: "Leo Malet," in *Urbi et Orbi* (Mâcon: Éditions W., 1986).

121 In a letter dated June 23, 1935, to Mesens, Éluard seemed, moreover, to establish a link between Crevel's suicide and the abandonment of the project: "The surrealist talks will not take place. We wouldn't have the heart for it" (*Le Cache-sexe des anges* [Brussels: Les Lèvres Nues, 1978], 15).

122 The quote is from André Breton, *Du temps que les surréalistes avaient raison* (Paris: Éditions Surréalistes, 1935).

123 Vitezslav Nezval, *Rue Gît-le-Cœur* (Paris: Éditions de l'Aube, 1988), 21.

124 In response to the Communist obstruction, Breton's text was rapidly distributed: in *Les Humbles,* vol. 7 (July 1935), then in *La Bête noire* (Maurice Raynal and Tériade), in the Brussels edition (August 20) of the *Bulletin international du surréalisme,* and in September in *La Gaceta de arte,* no. 35. Breton's "Discours au Congrès des écrivains pour la défense de la culture" (Speech to the Conference of Writers for the Defense of Culture) would be reprinted in *Position politique du surréalisme.*

125 It was no doubt on this last point that the group failed to show any political clear-sightedness: Germany, in the opinion of Breton and his friends, was still far more the homeland of German Romantics than a state that was now totally given over to fascism; they did denounce the dangers of fascism, but in France. . . . A very surprising blind spot, especially when one thinks that Bellmer, Oelze, and above all Max Ernst were very well situated to inform the surrealists of contemporary German reality. When the leaflet was published, Ernst seemed, moreover, to have momentarily favored a solution sparing Stalinism, by virtue of what he knew of Hitler's regime, but he still went on to sign *Du temps que les surréalistes avaient raison.*

126 For a contemporary work on Stalin, see Henri Barbusse, *Staline: Un monde nouveau vu à travers un homme* (Paris: Flammarion, 1935); English trans.: *Stalin: A New World Seen through One Man,* trans. Vyvyan Holland (London: John Lane, 1935).

127 *La Critique sociale* was published from March 1931 to March 1934 (no. 11 was the last). For the complete run of issues in one volume, see *La Critique sociale* (Paris: Éditions de la Différence, 1983). A periodical that was principally devoted to political analysis from a Marxist point of view, it was also open to literary and cultural debate and hailed Freud in passing as the "greatest psychologist of the era"; they did not miss the opportunity to emphasize, in issue no. 5 (March 1932), that "the so-called Soviet police state has decreed that psychoanalysis is reactionary" and, consequently, banned it. But the surrealists were systematically criticized in the periodical, both for the naïveté with which they persisted in their efforts to reach an agreement with the Communist Party and for failing to understand that they should not credit the "confessions" of those indicted by Soviet "justice" (no. 9 [September 1933], 151); as for the criticism of the Stalinist system, Souvarine and his followers were clearly ahead of the group in this matter.

128 The pamphlet announcing the formation of Contre-Attaque can be found in *Tracts surréalistes,* ed. Pierre, 1:281.

129 Contre-Attaque, it would seem, did not number more than between fifty and seventy people. Michel Leiris did not belong, and Michel Surya related that he found the project utopian or "a hoax" (Georges Bataille, *La Mort à l'œuvre* [Paris: Librairie Séguier, 1987], 224). The surrealists included Jacques Brunius, Claude Cahun, Éluard, Arthur Harfaux, Maurice Heine, Maurice Henry, Georges Hugnet, Marcel Jean, Léo Malet, Suzanne Malherbe, Henri Pastoureau, Benjamin Péret, Yves Tanguy, and Robert Valençay. Dalí wrote to Breton: "Honestly I can't take an active and militant part because

I don't believe in it. . . . You can't just decide to become a fanatic all of a sudden, you have to define and find REALITIES capable of awakening human fanaticism."

130 See Georges Bataille, "La Structure psychologique de fascisme," *La Critique sociale,* no. 11 (March 1934); and H. Dubief, "Témoignage sur Contre-Attaque," *Textures,* no. 6 (1970).

131 During the years that followed, Penrose became a very important collector, particularly of surrealist works and of Picasso; he acquired a few pieces at the the *London International Surrealist Exhibition,* including an *Objet-Poème* by Breton, and a *Tête* by Picasso (1913), which Breton, in financial need, gave up to him even though he was very fond of the piece. In 1938, Éluard, who also needed money, sold him the entire collection he had been putting together since 1921: "One hundred items, including 6 De Chiricos, 10 Picassos, 40 Max Ernsts, 8 Mirós, 3 Tanguys, 4 Magrittes, 3 Man Rays, 3 Dalís, 3 Arps, 1 Klee, 1 Chagall and other paintings and various objects, all for the sum of 1500 pounds sterling"—a price set by Éluard himself (see Roland Penrose, *Quatre-vingts ans de surréalisme* [Paris: Éditions du Cercle d'Art, 1983], 170).

132 *Murderous Humanitarianism,* reprinted in *Tracts surréalistes,* ed. Pierre, 2:441 ff.

133 The contributions from Belgium did not include Magritte, whose first one-man show in England would be held in April 1938 at the London Gallery.

The catalog of the *London Exhibition* was fairly modest (thirty-one pages), but at the same time a work by Carl V. Petersen was published in Copenhagen, purportedly "especially for the occasion of the International Surrealist Exhibition at the New Burlington Galleries" and titled *The Art of the Surrealists in Denmark and Sweden* (Copenhagen: Fischers Forlag, 1936). It included thirty-two reproductions of works by Jonson, Bjerke-Petersen, Mörner, Olson, Freddie, Heerup, and others.

134 But it was in April 1936 that Éluard announced to Gala that he had "broken with Breton for good" because "surrealism must not become a school, a literary chapel"—a break that was confirmed on May 5 in a letter to Louis Parrot, where he felt that collective activity was "a bit too erratic"; his participation in the events in London was, therefore, one of his last contributions of any significance to the group's activities.

135 The indignation would no doubt have been greater had the canvases that Freddie had selected for the exhibition not been held at customs because of their "impropriety"; only a few of his drawings were displayed.

136 *Arrêtez Gil Robles,* reprinted in *Tracts surréalistes,* ed. Pierre, 1:301. Gil Robles, the leader of the Confederacion Espanola de Derechas Autonomas, represented a traditionalist Catholicism that was deeply hostile to the Frente Popular; therefore, he was targeted by the Republican storm troops who, in the extremely tense days preceding the *pronunciamento,* sought to eliminate the right-wing leaders; only his flight from Madrid on July 15 saved his life, but as a result he did not take part in the antidemocratic plot. On August 20, 1936, the group published a second pamphlet, motivated by the noninterventionist policy and calling for a reconsolidation of the Popular Front with regard to the "'nationalist' half of France," already won over to fascism—a reconsolidation that would be reinforced by the organization of proletarian militia (*Neutralité? Non-sens, crime et trahison!* [Neutrality? nonsense, crime and treason!], reprinted in *Tracts surréalistes,* ed. Pierre, 1:302).

137 Péret, letter to Breton, August 11, 1936, in Claude Courtot, *Introduction à la lecture de Benjamin Péret* (Paris: Le Terrain Vague, 1965), 28. Breton himself, at the time, said he was ready to leave for Spain to fight, as did Max Ernst: he began to prepare his departure but then decided against it after the birth of his daughter Aube and instead joined the Comité pour l'Espagne Libre founded by Louis Lecoin, among others.

138 Péret, letter to Breton, March 7, 1937, in ibid., 36.

139 Georges Charbonnier, *Entretiens avec André Masson* (Paris: Juilard, 1958; reprint, Marseille: Ryôan-ji, 1985), 116.

140 Ibid., 115.

141 Letter dated July 15, 1936, in André Masson, *Correspondance, 1916–1942: Les Années surréalistes* (Paris: La Manufacture, 1990), 336.

142 Matta, quoted in Alain Sayag and Claude Schweisguth, eds., *Matta* (Paris: Centre Georges Pompidou, 1985), 266.

143 Joan Miró, *Ceci est la couleur de mes rêves: Entretiens avec George Raillard,* Traversée du siècle (Paris: Éditions du Seuil, 1977), 112. After his departure, Miró found himself alone in Paris, separated from his wife and daughter. Until 1939, he produced few paintings, but he did write a series of poetic texts

that were a substitute for his artwork. It is interesting to note that this resort to poetry, at a time when Miró was not shy about pointing out on occasion all the things that separated him from the surrealists (who in his opinion had become, from 1934 on, "official personalities in Paris"), occurred thanks to automatism: certain passages, where scatological images that may have emerged from his acquaintance with Jarry mingle with an uninterrupted verbal flow, defying logic and narrativity, might be compared with texts of a similar orientation written during the same period by Picasso. Perhaps the publication of Picasso's poems in *Cahiers d'art* had encouraged Miró, in turn, to give it a try: his first text dates from November 25, 1936 (see Miró, *Écrits et entretiens* [Paris: Daniel Lelong, 1995], 147 ff.).

144 Aragon was in Moscow when the hunt for Kirov's assassins began; in Leningrad, more than three thousand people were arrested and a hundred thousand more expelled. He dictated an article by telephone that appeared in *L'Humanité* on January 20, 1935: "In homes, at intersections, the radio proclaimed: 'Our hearts are not only filled with pain. They are overflowing with anger.' Anger against the assassin and his accomplices. It was the voice of the factories and kolkhozes that ordered opening fire against the White Guards. Firing on the center of Leningrad against the Zinoviev-Trotsky bloc!" (quoted by Fred Kupferman, "Le Parcours du stalinien," in *Staline à Paris,* ed. Natacha Dioujeva and François George [Paris: Ramsay, 1982], 82).

145 The text of Breton's speech can be found in *Tracts surréalistes,* ed. Pierre, 306, 308.

146 Breton, *Le Surréalisme et la Peinture,* 146.

147 Patrick Waldberg, *Mains et merveilles* (Paris: Mercure de France, 1961), 107.

148 See Ado Kyrou, *L'Âge d'or de la carte postale* (Paris: Balland-Le Terrain Vague, 1966).

149 See Pablo Picasso, *Écrits* (Paris: Réunion des Musées Nationaux–Gallimard, 1989), 164–65, 406–7. The sketches of the drawing dated from March, and it was the rebus that justified the title: "L'Achat de cette carte porte malheur" (The purchase of this card brings bad luck).

150 In 1940 in London, Mesens published a series of twelve postcards "published by the surrealist group in England": presented in an envelope, they reproduced, in color, works by Eileen Agar, Buckland-Wright, De Chirico, Matta, Esteban Francès, Len Lye, Mesens, Moore, Onslow-Ford, Penrose, Man Ray, and Tanguy.

151 It is interesting to note that among the artists mentioned in the *Lettre ouverte aux autorités des beaux-arts* (see *Tracts surréalistes,* ed. Pierre, 311), Marc, Moholy Nagy, Nolde, Hans Richter, Schmidt-Rottluff, and Schwitters did take part in the exhibition *Entartete Kunst* organized in Munich in 1937. (Schwitters, incidentally, was generally neglected, strangely enough, by the surrealists—Aragon did not even mention him in "La Peinture au défi," and Breton would only mention him briefly in 1941 in *Genèse et perspectives artistiques du surréalisme,* reprinted in *Le Surréalisme et la Peinture, suivi "Genèse et perspectives artistiques du surréalisme"* [New York: Brentano's, 1945]). Also taking part in the exhibition was one of the signatories, Otto Freundlich (who even had the honor of seeing one of his sculptures used as the cover illustration for the exhibition's catalog), as well as Chagall, Ernst, Klee, and Kandinsky. Breton's interest in Kandinsky—he bought two of his drawings in 1929 during Kandinsky's first exhibition in Paris—would not wane: in the preface he wrote in 1938 for his exhibition in London (at the Guggenheim-Jeune Gallery), he praised him as "one of the greatest revolutionaries of vision."

152 In *Japon des avant-gardes, 1910–1970,* ed. Oka Mariko (Paris: Centre Pompidou, 1987), 160.

153 For example, the people arrested and indicted in 1941 had to repeat a formula imposed by the judge who was presiding over their trial: "I practiced surrealism as a means to impose the proletarian and communist revolution, denying the emperor and aiming to destroy the Japanese empire."

154 "Lord" Loris refers to Fabien Loris, who traveled to the Gulf of Guinea and Tahiti and who was a member of the October group, an actor and future performer of songs by Prévert, and a painter and designer who wasn't concerned with making use of his real talent, though he would later use of it as a drawing instructor in psychiatric hospitals.

CHAPTER FOUR

1 Quoted by André Breton in "Devant le rideau" (Before the curtain [1947]), reprinted in André Breton, *La Clé des champs* (Paris: J. J. Pauvert, 1967); English trans.: *Free Rein = Le Clé des champs,* trans. Michel Parmenter and Jacqueline d'Amboise (Lincoln: University of Nebraska Press, 1995).

2 For a fairly lengthy description of this exhibition, see Marcel Jean, *Histoire de la peinture surréaliste* (Paris: Éditions du Seuil, 1959) or the new edition of this work, with the collaboration of Arpad Mezei (Paris: Éditions du Seuil, 1967), 280 ff.; English trans.: *The History of Surrealist Painting,* trans.

Simon Watson Taylor (New York: Grove Press, 1960).

3 Malet had planned to place a goldfish bowl below the waist of his mannequin, where the fish would wriggle. The suggestive effect of this was guaranteed, but Breton, it would seem, rejected it. Many commentators have seen this as an act of censorship; it may also be the disapproval of an error in the orientation of the metaphor. From the female sex to the goldfish, the sign hardly seems "ascendant." With regard to the "ravishing mannequins displayed along the corridor," A. Rolland de Renéville asserted, in "Le Surréalisme en 1938" (*La Nouvelle revue française,* no. 299 [August 1938]), that they were "like those characters who come to mind when one is just dozing off, and whose mission seems to be to introduce the dreamer, by degrees, into the hypnogogic realm."

4 Duchamp had initially planned to make use of a lighting system that would be set off as visitors walked by each canvas, but this proved to be too complicated technically.

5 Breton, *La Clé des champs,* 106.

6 José Pierre, ed., *La Planète affolée, surréalisme, dispersion et influences, 1938–1947* (Marseille: Musées de Marseille; Paris: Flammarion, 1986), 27.

7 André Breton and Paul Éluard, comps., *Dictionnaire abrégé du surréalisme* (Paris: Galerie des Beaux-Arts, 1938; reprint, Paris: José Corti, 1969).

8 The entry under "Masson" in the *Dictionnaire* specified: "Surrealist painter from 1923 on," but he was not represented after 1925 because of his relative estrangement from the group—although he would become active again in 1938—and because of his lasting friendship with Bataille (particularly at the time of the journal *Acéphale*). In February 1939, Breton was approached for a collective work that was being compiled by Desnos and Armand Salacrou about Masson; instead of evoking the sand paintings from 1926 and 1927 as they had planned, Breton preferred to emphasize the importance of more recent canvases. It was a chance for him to oppose "the ribbon-work of art," drearily repetitive in the exploitation of its themes and its effects, to the "event-work of art," based on its love for risk-taking and justified by its "revelatory power"—but also to assert that "eroticism, in Masson's work, must be seen as the keystone" and that the painter, as a person, reconciled "the authentic artist and the authentic revolutionary" ("Prestige d'André Masson," in Jean-Louis Barrault et al., *André Masson,* a work printed in a limited edition, without a publisher's name, in 1940, it would not be distributed until 1945 [reprint, Marseille: André Dimanche, 1993]; Breton's text also appeared in *Minotaure* in May 1939 and can be found in the last edition of *Le Surréalisme et la Peinture* [Paris: Gallimard, 1965]; English trans.: *Surrealism and Painting,* trans. Simon Watson Taylor [New York: Harper & Row, 1972]).

9 *Dictionnaire abrégé du surréalisme,* comp. Breton and Éluard, was one of Delvaux's rare appearances in the group's publications. Even though he was often taken for a surrealist because of the (somewhat repetitive) strangeness of his work, this Belgian painter never joined the movement; Breton mentioned his name twice in *Genèse et perspectives artistiques du surréalisme,* reprinted in *Le Surréalisme et la Peinture, suivi "Genèse et perspectives artistiques du surréalisme"* (New York: Brentano's, 1945). In the small volume published in 1948 for an exhibition at the Galerie René Drouin—introduced, moreover, by a poem by, of all people, Paul Éluard (who had already written the commentary three years earlier for the film about Delvaux by Henri Storck)—it was made amply clear that between 1936 and 1939 the painter, "master of his trade, evolved in parallel to the surrealist movement, without being a part of it." In 1964 Magritte recalled his participation in a program by Flemish television in terms that were hardly flattering: "Delvaux was also talking and said nothing but rubbish" (*Lettres à André Bosmans* [Paris: Seghers, 1990], 388), and José Pierre would eventually contradict Breton: "Paul Delvaux, arbitrarily assigned to surrealism, whom I would consider an old-fashioned symbolist. Go on dreaming, provided the trains leave on time! This habit of 'sugarcoating the pill' is an idealistic lie" ("La Belgique ressuscitée," *La Quinzaine littéraire,* no. 135 [February 15, 1972]).

10 See "Des biscuits pour la route," *Bief,* no. 10–11 (February 15, 1960).

11 Raymond Cogniat, "L'Exposition internationale du surréalisme," *XXe Siècle,* no. 1 (March 1938).

12 Pierre Drieu la Rochelle in *Je suis partout* (March 11, 1938).

13 *Minotaure,* no. 10 (winter 1937) reproduced etchings by Posada.

14 Regarding the childhood origins of Breton's love of Mexico, Jean-Clarence Lambert ("André Breton's Imaginary Mexico," *Pleine marge,* no. 12 [December 1990]) *Pleine marge* found similarities between some of Breton's concepts and *Costal l'Indien,* a novel from 1855 by Gabriel Ferry (whose real name was Louis de Bellemare, 1809–52; he also wrote *Le Coureur des bois ou les chercheurs d'or,* which was honored with a preface by George Sand). Breton, who had read this novel in his child-

hood, said that "my love of independence was probably born there . . . the fact remains that fiction and history support each other wonderfully in Mexico."

Breton's attraction to Mexico can also be seen in the fact that five of the objects that he lent to the exhibition *Ancient Art of the Americas* were Mexican in origin (Musée des Arts Décoratifs, *Les Arts anciens de l'Amérique: Exposition organisée au Musée des Arts Décoratifs, Palais du Louvre, Pavillon de Marsan, mai–juin 1928* [Paris: G. van Oest, 1928], nos. 71, 115, 145, 270, 272).

15 In addition to publication of his work in the Mexican press, on May 17, Breton presented an evening of cinema at Bellas Artes: screenings of *Un chien andalou*, a documentary on the recent *International Exhibition of Surrealism*, a Charlie Chaplin film, and a documentary on the nationalization of oil.

16 On Breton's stay in Mexico, see *Docsur*, no. 2 (April 1987); a study compiled by G. Roche and E. Sanchez; and Breton's *Œuvres complètes*, ed. Marguerite Bonnet, with the collaboration of Philippe Bernier, Étienne-Alain Hubert, and José Pierre, 3 vols., Bibliothèque Pléiade (Paris: Gallimard, 1988–2000), 2:1827 ff.; English trans.: *The Lost Steps*, trans. Mark Polizzotti (Lincoln: University of Nebraska Press, 1997), where the notes for Breton's talks can also be found (2:1260 ff.). On the composition of the manifesto and its successive versions, see Gérard Roche, "Breton, Trotski: Une collaboration," *Pleine marge*, no. 3 (May 1986). Arturo Schwarz gives a description of the understanding between the two men in *André Breton, Trotski et l'anarchie*, trans. Amaryllis Vassilikioti, 10/18, no. 1174 (Paris: Union Générale d'Édition, 10/18, 1977); originally published as *André Breton, Leone Trotskij: Storia di un'amicizia tra arte e rivoluzione* (Rome: La Nuova Sinistra, 1974).

17 *For an Independent Revolutionary Art*, reprinted in Breton's *La Clé des champs*.

18 Evidence of the fascists' view of inventiveness as degenerate can be seen in that the previous year, Goebbels had organized an exhibition of "degenerate art" in Munich (Entartete Kunst) collecting works that had been removed from German museums because they did not correspond to the Nazis' aesthetic standards. All the avant-garde movements since 1910 were denounced: expressionism, Dadaism, surrealism, Neue Sachlichkeit, Bauhaus, constructivism, etc. The exhibition circulated until 1941 in nine cities in Germany and Austria.

Relevent to the Stalinists' stance, in a letter to Breton on October 27, 1938, Trotsky clarified the meaning he wanted to give to this "eclecticism": "I don't believe Marxism can be identified with one school of art. It must have a critical and friendly attitude toward the various artistic schools. But each artistic school must remain faithful to itself. That is why it would be absurd, for example, to advise the surrealists to become eclectic" (in Schwarz, *Breton/Trotski*, 129).

19 In nos. 4 and 5 of the periodical *Plastique* edited by Sophie Taeuber-Arp (five issues from 1937 to 1939), Éluard, Ernst, and Arp published a short story in serial form: "The Man Who Lost His Skeleton," in which Breton was parodied as a female fortune-teller, while Péret and Tanguy were portrayed as performing dogs by virtue of their loyalty.

20 An insert in *Clé*, quoted by Maurice Nadeau. *Histoire du surréalisme* (Paris: Éditions du Seuil, 1964), 478; and in *Tracts surréalistes et déclarations collectives*, ed. José Pierre, 2 vols. (Paris: Éric Losfeld, 1980–82), 1:343.

21 Nadeau, *Histoire du surréalisme*, 175.

22 André Breton, *Entretiens, 1913–1952, avec André Parinaud [et al.]*, Le Point du jour (Paris: Gallimard, 1952), 192; English trans.: *Conversations: The Autobiography of Surrealism*, trans. and with an introduction by Mark Polizzotti (New York: Paragon House, 1993)..

23 These "Cahiers GLM," published by the typographer-publisher Guy Lévis Mano, welcomed the surrealists from the start. Among the contributors to earlier issues one could find Gisèle Prassinos, Valentine Penrose, Éluard, Mabille, M. Blanchard, Lise Deharme, Alphonse Chavée, and others; and there were illustrations by Bellmer, Masson, Man Ray, and Seligmann. In general, Mano, in parallel to the Éditions Corti, had always published a good number of short volumes by members of the group: Breton, Péret, Man Ray, Duchamp, Char, Schéhadé, Bellmer, and so on. It was also Mano who would reprint Lautréamont's *Œuvres complètes* (1938), with a preface by Breton and a series of strictly surrealist illustrations. However, this cooperation did not mean a total devotion to the choices and values of the movement, as GLM also published a number of poets who were utterly foreign to the movement and used illustrators whose work, while rich in fantastic imagery or apparent irrationality, did not in fact share any of the principles of surrealism (Lucien Courtaud, e.g.).

24 Among the texts presented by Béguin there was in particular a dream, translated by Max Ernst, from Albrecht Dürer—the printed biographical dates, both in the body of the text and in the table of contents, "dreamily" repeated those of Carl-Philipp Moritz: 1756–93, instead of 1471–1538.

Lucas was an extraordinary mathematician (1842–91). At the age of twenty-two, he published a treatise on the squaring of the circle, which included three commented dreams; Scutenaire had offered the volume to Breton.

25 Nicolas Calas, *Foyers d'incendie* (Paris: Éditions Denoël, 1938), 207.

26 In 1940, Nicolas Calas published an article in the issue of *New Directions in Prose and Poetry* devoted to the tenets of surrealism, significantly titled, "Toward a Third Surrealist Manifesto." As for *Foyers d'incendie,* it did unquestionably have a certain impact within the group and on its fringe: the book was cause for a biting review by Queneau, "Minotaurisme et monogamie," *Volontés,* no. 15 (March 1939); and Edouard Jaguer, in *Le Surréalisme face à la littérature* (Paris: Actual/Le Temps qu'il Fait, 1989), described Calas's book as "one of those books that served as *footholds* at the beginning of the 1940s for the young surrealists that we were, on the verge of turning twenty." *Foyers d'incendie*'s impact, however, seems to have alienated other readers, and it has not been reprinted since 1938.

27 André Breton, "Frida Kahlo de Rivera" (1938) in *Le Surréalisme et la Peinture,* 144. Despite Breton's praise, the Mexican artist would keep her distances from surrealism, even after her brief stay in Paris during the "Mexico" exhibition. She felt, in general, that intellectuals were "poisoning the air with theories, and ever more theories that never become reality."

28 André Breton, "Prestige d'André Masson," *Minotaure,* no. 12–13 (May 1939); this article also later appeared in the work compiled by Desnos and Salacrou on André Masson: reprinted in the final edition of *Le Surréalisme et la Peinture,* 151 ff.

29 André Breton, "Des tendances les plus récentes de la peinture surréaliste" (Latest trends in Surrealist Painting), *Minotaure,* no. 12–13 (May 1939); reprinted in *Le Surréalisme et la Peinture,* 145 ff.

30 André Breton, "La Maison d'Yves Tanguy," reprinted in Breton, *Poèmes* (Paris: Gallimard, 1967), 163.

31 This would situate their artistic and intellectual program—beyond the obvious formal differences—in the legacy of Duchamp, who had already been exploring, particularly in the *Large Glass,* the figurative representation of a universe with *n* dimensions.

32 Alfredo Cruz Ramirez (in *La Planète affolée,* ed. Pierre, 94) indicated the presence, at this exhibition, of Mexican works "in a surrealist spirit," which was created at a time that corresponded to the visits by Artaud and Breton—endeavors that had little hope of achieving more than what J. Pierre would call "honest provincialism."

33 The absence of the other "great" Mexican muralist, Siqueiros, can be explained, however, by his commitment to the most orthodox "communism" of the day: in 1947, he would assert that "one of the greatest honors of [his] lifetime" was to have taken part in a plot against Trotsky. Five years later, the surrealists would remind him of his "honor" in the article "À l'Assassin!" (reprinted in *Tracts surréalistes,* ed. Pierre, 2:124).

34 "Letter to Maud," December 13, 1940.

35 Benedite relates the history of the committee and its activities in *La Filière marseillaise: Un chemin vers la liberté sous l'occupation* (Paris: Clancier-Guénaud, 1984).

36 See J. Corti, *Souvenirs désordonnés* (Paris: Éditions Corti, 1983), 226 ff. Hérold maintains that Breton composed the two lines.

37 Three examples of such "communicated drawings" were later printed in August 1943 to illustrate poems by Maurice Blanchard, in *Le Surréalisme encore et toujours,* Cahiers de Poésie, no. 4–5 (Paris: n.p., 1943), the last publication of La Main à Plume (see below).

38 André Gomès, quoted in Maurice Fréchuret and Danièle Bourgeois, eds., *Le Regard d'Henriette: Collection Henriette et André Gomès* (Antibes: Musée Picasso, 1994).

39 Breton described it in detail in "Le Jeu de Marseille," *VVV,* no. 2–3 (March 1943); text reprinted in *La Clé des champs.*

40 "Forgotten" for a long period of time, the Marseille Deck was republished in 1984 by A. Dimanche. But the original sketching of its face cards had been standardized by Delanglade in such a way that the collective aspect of its elaboration has been emphasized but it is now harder to attribute each drawing to its author.

41 In December 1940, Breton, considered to be a "dangerous anarchist long sought by French police," was detained for four days during Pétain's visit to Marseille. Already in September, Henri Bidou had given a speech in Vichy entitled "The End of an Imbecilic Literature," in which the surrealists were labeled "painters of accident-victim monsters" and "builders of ruined cities."

42 The *Cahiers du Sud* were published from 1925 to 1966 as the continuation of a periodical, *Fortunio,*

that was founded in 1914 by Marcel Pagnol and a few of his friends. Léon-Gabriel Gros wrote reviews that were generally favorable to the surrealists. On the history of the periodical, see Alain Paire, *Chronique des "Cahiers du Sud," 1914–1966* (Paris: Institut Mémoires de l'Édition Contemporaine, 1993).

Breton's *Pleine marge* was published in a luxury edition of fifty copies with an engraving by Seligmann(New York: Nierendorf Gallery, 1940), then in France, clandestinely (Paris: La Main à Plume, 1942), and is reprinted in his *Poèmes* (Paris: Gallimard, 1948; reprint, Paris: Gallimard, 1967).

43 André Barton's letter to Léon-Pierre Quint is quoted in a carefully documented afterword by E. A. Hubert to Breton's *Anthologie de l'humour noir* in *Œuvres complètes,* 2:1749. Or see, for the English translation, *Anthology of Black Humor,* trans. Mark Polizzotti (San Francisco: City Lights Books, 1997).

44 André Breton, *Limites non frontières du surréalisme,* reprinted in Breton's *La Clé des champs.*

45 As examples, one might momentarily retrieve from oblivion a few pages from Curnonsky, the miserably moralizing *Anthologie des humoristes anglais et américains du XVIIe siècle à nos jours,* ed. Michel Epuy (1910; reprint, Paris: Delagrave, 1920), or *Le Rire dans le brouillard* by Maurice Dekobra (Paris: Flammarion, 1927). In his preparatory notes in 1936, Breton referred to this last title (*Œuvres complètes,* 2:1763).

46 The quote is taken from a letter from Vaché to André Breton on April 29, 1917, first published in *Littérature,* no. 3 (July 1919).

47 The presentation of Posada's etchings at the "Mexico" exhibition was thus overdetermined.

48 Annie Le Brun, "L'Humour noir" (Black humor), in *Entretiens sur le surréalisme,* ed. Fernand Alquié, Centre Culturel International de Cerisy-la-Salle, n.s., no. 8 (Paris: Mouton, 1968), 103.

49 Sigmund Freud, "L'Humor," published in French in *Le Surréalisme en 1929,* a special issue of *Variétés* (June 1929). The article completed Freud's remarks on humor appearing in *Le Mot d'esprit et ses rapports avec l'inconscient,* the French translation of his *Der Witz und seine Beziehung zum Unbewussten* (Wit and its relation to the unconscious). It appeared in German in 1928 in the periodical *Imago,* and the group wanted to publish it in translation as quickly as possible (*Der Witz und seine Beziehung zum Unbewussten,* 2d ed. [Leipzig and Vienna: Deuticke, 1912]; French trans.: *Le Mot d'esprit et ses rapports avec l'inconscient,* trans. Marie Bonaparte and M. Nathan, 9th ed. [Paris: Gallimard, 1930]; English trans.: *Wit and Its Relation to the Unconscious* [London: R. Fisher Unwin, 1916]).

50 When the *Anthologie de l'humour noir* was republished in 1950, excerpts were added from Fourier, Péret, Ferry, Carrington, and Duprey, but after that Breton resisted the temptation to add other names.

51 On the subject of the reader knowing what to expect, Breton's preparatory notes show that he had examined the case of Edward Lear, but in the end chose not to include him in the anthology: nonsense did not belong to black humor. One should note, however, that in 1946 Henri Parisot began, with Jacques Papy, to translate Lear's nonsense rhymes, and in 1968 a French edition of his *Limericks* was published, with reworkings of his Lewis Carroll adaptations: perhaps the interest in nonsense was also a reaction to what was periodically depressing during that era. At the same time as Parisot, Robert Benayoun compiled delightful anthologies devoted to the most absurd forms of comedy (*Anthologie du Nonsense* [Paris: J. J. Pauvert, 1959], and *Le Taureau irlandais,* [Paris: Filipacchi, 1974]).

The seriousness of the surrealist project did not in any way preclude its partisans from being receptive to various forms of comedy. Breton's indifference to music was shown to contain a few exceptions (Offenbach, *le comique troupier* [form of vulgar, soldiers' humor popular in 1900. *Trans.*], precisely those forms of entertainment that were likely to amuse him with their silliness or their more or less contrived comedy. There is an abundance of burlesque in André Breton and Philippe Soupault, *Les Champs magnétiques* ([Paris: Au Sans Pareil, 1920]; English trans.: *The Magnetic Fields,* trans. David Gascoyne [London: Atlas Press, 1985]), taken to an even higher degree in the exquisite corpse, whether written or drawn, or in the collective games (particularly those where one gave answers to unknown questions). Prévert was not the only one who had a delightfully absurd sense of humor: it was shared in the wit and non sequiturs that were hardly rare in the cafés and was also found in the unproduceable scenarios written by Desnos and Péret—whose pieces, even more than Prévert's, caused great hilarity, through the ridiculousness of the adventures depicted and the way in which they merrily ridiculed the distinctions between the species. The works that the group was in the process of reevaluating—from Jarry to Panizza or Brisset—had used all the colors of the palette to create laughter, from the most clownish to the most aggressive. Nor did the surrealists look down on the more lowbrow manifestations of comedy, for they applauded the lucky finds of music-hall and

cinema—provided they were not limited to simple off-color humor or a too classical cuckoldry, scenarios that were clearly incompatible with passionate love. Péret saw behavior of this style in everyday life:

> A ground floor on the Avenue de Ségur. Inside, in front of the window, a family of three concierges and their children are having lunch. The mother brings the steaming soup tureen to the table. The father, who has a mustache, inspects his offspring. And suddenly, through the window comes a little round head, slightly balding, who asks politely, "Is it good, that shit?"
>
> It's Benjamin Péret. It's noon. And every day, right on time, he comes by at the same time and asks the same question, very pleasantly, in front of the gawping and delighted children and the concierge, fuming with impotent rage.
>
> This lasts for a good fortnight.
>
> One day, he shows up as usual, but the fellow with the mustache is waiting for him. Before he even has time to open his mouth, the fellow hails him, "Dirty Kraut!"
>
> Then he sits down again, content that he has finally found the appropriate response.
>
> (Marcel Duhamel, *Raconte pas ta vie* [Paris: Mercure de France, 1972], 160)

52 Dating from 1945, to be exact—since it was only at that time that the *Anthologie* would be distributed. But it would seem that those close to Breton were aware of his principles much earlier—not only because a humorous attitude was common in the group but also because the preparation of the anthology gave rise, in 1937, to a lecture on the theme by Breton, and that same year, two small volumes were published by GLM.

53 Marko Ristitch, "L'Humour, attitude morale," *Le Surréalisme ASDLR,* no. 6 (May 1933).

54 The Breton family's passage was paid for by Peggy Guggenheim, after some initial hesitation: when Kay Sage approached her to help Mabille, Ernst, and the Bretons, Guggenheim replied that "Dr. Mabille was not an eminent artist, any more than Jacqueline or little Aube" (Peggy Guggenheim, *Ma vie et mes folies* [Paris: Plon, 1987], 185; originally published as *Out of This Century: Informal Memoirs* [New York: Dial Press, 1946]).

55 Their correspondence can be found in *Regarder écouter lire* (Paris: Plon, 1983), a work by Lévi-Strauss; Gérard Legrand's point of view on this work can be found in *Le Periodical littéraire,* no. 311 (June 1993).

56 André Breton, preface (1943) to Aimé Césaire, *Cahier d'un retour au pays natal* (Paris: Bordas, 1947). Many parts of this volume had been published in Paris in 1939, to little attention, in the periodical *Volontés.*

57 J. Pierre notes that during his new exile in Guatemala in 1947 Granell would discover that for the Mayas, squinting was a sign of distinction.

58 Breton, *Entretiens,* 197.

59 André Breton, letter date February 16, 1939, "to a friend," published in part in the catalog *L'Amour et la mémoire* (Drouot Richelieu, October 16, 1992, no. 42).

60 The action of the Works Projects Administration had just reminded people of the social dependence of artists: from 1935 to 1939, two thousand mural paintings were subsidized by the federal government, and artists and painters received a monthly allowance of $95.00. This aid did, however, allow De Kooning, Pollock (who received it until 1943), and Gorky to find out that they could in fact live, however modestly, from their work as artists.

61 Unknown in Europe, Gorky hailed Davis as the only American to count among the inventors of art in the last century, on a par with Picasso, Léger, or Kandinsky.

62 Alfred H. Barr said in 1938 that "surrealism has had partisans in America, but none of them has done much to contribute to the success of the movement" (*Trois siècles d'art aux États-Unis* [Paris: Jeu de Paume Museum, 1938], 14).

63 The Museum of Modern Art in New York bought two paintings from Tanguy's early years: *Maman, Papa est blessé* and *Extinction des lumières inutiles.*

64 On the matter of the relative presence of surrealists, it should also be noted that enough surrealists were present for the periodical *Art Front,* published by the Artists' Union, to devote several articles to surrealism between November 1934 and the end of 1937. Its editors, from their Marxist point of view, were of diverging opinions: Samuel Putman and Jerome Kline denounced the surrealists' "idealism," but Charmion von Wiegand was far more positive toward them in his account in "Fantastic Art, Dada, Surrealism."

65 The quote is taken from a letter from Carl Rakosi to Serge Fauchereau, quoted in "Des poètes qu'on appelait 'objectivistes,'" *Europe,* no. 578/579 (June–July 1977).

66 Letter from Breton to Roland Penrose, quoted in *André Breton: La Beauté convulsive* (Paris: Éditions du Centre Pompidou, 1991), 350.

67 Ibid.

68 He very quickly became Jacqueline Lamba's companion; she and Breton would separate in the autumn of 1942.

69 This research would influence Gorky and Rothko.

70 After meeting Seligmann in 1939, thanks to Meyer Shapiro, and then making friends with Matta, Motherwell was quite frequently found in the company of the exiled artists, taking part in the group's meetings and luncheons and occasionally serving as a translator. In fact, he was so closely connected to the exiled surrealists that he was slated, during the preparation of the first issue of *VVV,* to be its editor, but he left the job to David Hare alone when the periodical was published. In 1942, he composed automatic pieces together with Baziotes and Pollock.

71 "The Situation of Surrealism between the Two World Wars," *VVV,* no. 2; reprinted in *La Clé des champs.* In 1944, the text appeared in no. 36 of *Fontaine,* the periodical edited in Algiers by Max Pol Fouchet. "The issue of *Fontaine* where André's speech was published sold in incredible numbers. There's no doubt that the success was due to the interest that surrealism aroused," ventured Patrick Waldberg from London (Patrick Waldberg and Isabelle Waldberg, *Un amour acéphale: Correspondance, 1940–1949,* ed. Michel Waldberg [Paris: Éditions de la Différance, 1992], 227).

72 A reproduction of the original drawing and a translation of the text that accompanied it can be found in Max Ernst, *Première conversation mémorable avec la Chimère,* which can be found in, with its accompanying text, Branko Aleksic, *Amour, nature et plaisir en picto-poésie* (Thaon: Éditions Amiot-Lenganey, 1991), a work in which Aleksic trances the early stages of the Chimera in Ernst's work. A delightful coincidence was the fact that in 1942 the periodical *Chimera* was published in New York, and in 1944 it included four poems by Corbière and a special issue devoted to myth; Calas collaborated on that issue.

73 Pierre Mabille, "Le Paradis," *VVV,* no. 4 (February 1944); reprinted in Mabille, *Traversées de nuit* (Paris: Plasma, 1981), 19 ff.

74 Before the war, Berman (born in Saint Petersburg in 1899) favored a decorative style that was fairly close to that of a Christian Bérard and that caused him to be categorized among the "neo-humanists." In 1930 he illustrated, with five lithographs, the first edition of a work by Georges Hugnet, *Le Droit de varech* (Paris: Éditions de la Montagne). During his stay in the United States from 1937 on, his painting evolved toward the evocation of dreams, and he began to collaborate with American ballet companies.

In its issue of July 1945, devoted to "The Paris School in New York," which devoted a large section to surrealism, the periodical *L'Amour de l'art* qualified him as a "conquest of surrealism." Two reproductions, *La Muse sombre* (1944) and *Parmagianina* warranted a brief commentary: "His New York works borrow from surrealism its principles of objective realization and its tendency to express dreams through symbols."

75 André Breton, *First Papers of Surrealism,* afterword by J. Pierre (New York: Coordinating Council of French Relief Societies, 1942; Paris: Terrain Vague-Losfeld, 1988).

76 Chagall took part in the *First Papers of Surrealism,* a first sign of rapprochement with a painter who had always been suspected of mysticism. In his autobiography (*Ma vie,* trans. Bella Chagall [Paris: Stock, 1931]; English trans.: *My Life* [New York: Orion Press, 1960]), Chagall wrote that when he returned to Paris in 1923 he had the impression of discovering in the surrealists' work that which he had "sensed obscurely and at the same time secretly from 1908 to 1914"—but then he immediately voiced his wariness with regard to automatism.

77 The jury was made up of Alfred H. Barr, James J. Sweeney, James T. Soby, Mondrian (who was among the first to approve of Pollock's research), Harry Putzel, Duchamp, and Peggy Guggenheim herself.

78 Gérome Kamrowski described how they came to "invent" the dripping process in a letter:

> Baziotes was enthusiastically talking about the new freedoms and techniques of painting and, noticing the quart cans of lacquer, asked if he could use them to show Pollock how the paint could be spun around. He asked for something to work on, and a canvas that I had been pouring on and was not going well was handy. Bill then began to throw and drip the white paint on the canvas. He handed the palatte [*sic*] knife that he was dripping to Jackson, and Jackson, with his concentration, was flipping the paint with abandon . . . soon several brushes were wielded by us to develop into a very free kind of activity.
>
> (Quoted in Dawn Ades, *Dada and Surrealism Reviewed* [London: Arts Council of Great Britain, 1978], 388)

79 Letter quoted in Dore Ashton, *L'École de New York* ([Paris: Hazan, 1992]; originally published in English: *The New York School: A Cultural Reckoning* [New York: Viking, 1972]), 142.

80 This split concerned the serious exercise of painting. There was another split, more frequent and superficial, which led to the use of a vague rhetoric that recalled surrealism through graphic design and advertising. As for advertising—not to insist any further on the degrading way in which surrealism was portrayed as kitsch—a brief article by Ruth York (*Art Présent,* no. 4–5 [1947]) was naively explicit:

> Surrealism—conceived, developed, ripened, and prefabricated in France, landed in America on a ship full of refugees and was accepted. Yet another French import. When . . . Dalí began to leap through shop windows, scattering shattered glass and cutting declarations, when bathtubs were lined with fur . . . , the mad excitement became chit-chat and advertising pricked up its ears. . . . Surrealism? A new thing, a French import, a new toy, a childish entertainment. Everything that is young and new as a baby has a chance to succeed in the United States. The client could not be shocked. . . . Sales figures soared. Surrealism and advertising were now one.

(On the distortion of Magritte's images by advertising from the 1960s on, see Georges Roque, *Ceci n'est pas un Magritte: Essai sur Magritte et la publicité* [Paris: Flammarion, 1983].)

81 The fourth work in the series Problems of Contemporary Art was *Possibilities: An Occasional Review* (New York: Wittenborn, Schultz, 1947). The first was *Form and Sense* by Wolfgang Paalen (New York: Wittenborn, Schultz, 1945). This series of publications complemented the Wittenborn, Schultz series Documents of Modern Art, edited by Robert Motherwell, in which texts by Apollinaire, Moholy Nagy, Mondrian, and Kandinsky had already appeared and in which pieces by Arp, as well as Max Ernst's *Dada Anthology* and *Beyond Painting* were also published in 1948, this last with a preface by Motherwell himself. Among the abstract expressionists, Motherwell, because of his great curiosity and his vast culture, would retain a lasting interest in his years spent in the company of surrealism: he would, moreover, have preferred that abstract expressionism be called "abstract surrealism." In 1953, he wrote a preface for an exhibition by Cornell, whom he hailed as the only American artist capable of taking the past into account. In his preface to *Beyond Painting,* Motherwell indeed asserted: "Most of us . . . came here to break our ties with the past. To consciously abandon the past is a fundamentally American creative act." With regard to Cornell he explained, moreover, that the purely plastic nature of his work constituted a "true miracle," insofar as it was rich with ideas "that could also be expressed verbally" (text published in 1976 and, in French, in *Joseph Cornell* [Paris: Galerie Baudoin Lebon and the Museum of Toulon, 1980]). Robert Motherwell quotes Picasso abundantly in "The Painter and the Public," *Profils* (1954), and he concludes that ethical conscience was just as necessary to the painter as to the public (reprinted in *L'Échoppe* [1989]). In 1959, he published a text on Miró in *Art News;* in 1971, he wrote a preface to Pierre Cabanne, *Dialogues with Marcel Duchamp,* trans. Ron Padgett ([New York: Viking, 1971]; originally published in French: *Entretiens avec Marcel Duchamp* [Paris: P. Beldon, 1967]).

82 By the early 1950s, the split was finalized, and Tanguy, in a letter to Marcel Jean in January 1952, would say, ironically: "As you know, abstraction is now the fashion here. All you have to do is pour some paint on a large canvas, then you cut it up in small pieces to sell it. Et voilà! It's no more difficult than that" (Tanguy, *Lettres de loin à Marcel Jean* [Paris: Le Dilettante, 1993], 138). In his article "New Canvases and Picture Mouldings in the United States" (*Preuves,* no. 68 [October 1956]), Cranston Jones noted the end, after ten years or so, of abstract expressionism and deplored in passing the weakness of New York criticism, pointing out that even abstract expressionism, which had united "several hundred painters," had only Greenberg to defend it—which might explain, at least in part, the slow pace of its development.

83 Gorky spent a lot of time in Julien Levy's gallery in 1936 and took the time to read all of Levy's *Surrealism:* at the time, he wanted to know as much as possible about the movement. It is often forgotten that he took part in *Three Centuries of Art in the United States* between May and July of 1938 (an exhibition organized at the Jeu de Paume Museum in Paris in collaboration with the MoMA), with a *Composition* from the Whitney Museum collection. In his preface, Alfred H. Barr spoke of Gorky as "one of the most constant protagonists of abstract art, still under the influence of Miró and Picasso." In 1942 Gorky spent time with Masson in Connecticut and was undoubtedly exposed to the influence of Matta. By the time he met Breton (winter 1943–44), he was already making considerable use of automatism, in his own way.

84 José Pierre confirmed, moreover, that "one is astonished, in leafing through this elegant periodical, that [Paalen] never realized that he was basically alone in it."

85 They acquired Indian works of various origins: masks from British Columbia or the Inuit territories; masks in hard stone from Mexico, pre-Columbian pottery, Kachina dolls and masks of the Hopis, and so on. From 1943 on they spent a great deal of time at the American Museum of Natural History and at the shop of the antique dealer J. Carlebach (who may well have dealt in doubloons from the same museum) The Indian creations, obviously, called for a taste in myths and in magic; it was noteworthy, moreover, that the Kachinas that Duchamp acquired were generally not as colorful and were more simple or "worn" than those that his friends seemed to like. See *Kachina: Poupées rituelles des Indiens Hopi et Zuni,* catalog of an exhibition, Marseille, Musée d'Arts Africains, Océans, Amérindiens (Marseille: Musées de Marseille; Paris: Réunion des Musées Nationaux, 1994), nos. 8, 9, 38, 58, 64, 84, etc.; and a photograph of Breton's New York studio and one of the Parisian studio in 1960 in the catalog *André Breton: La Beauté convulsive,* 74 and 76. Two other Kachinas from André Breton's collection were reproduced in Galerie D. Benador, *Tradition des arts primitifs,* Collection d'un amateur, no. 18 (Geneva: Dumaret & Golay, 1963). A famous photograph of "Max Ernst with his Hopi Dolls" taken in 1942 is featured in *Max Ernst,* Galerie Nationales du Grand-Palais (Paris: Centre National d'Art et de Culture Georges Pompidou, Musée National d'Art Moderne, 1975), 116; and another in William Rubin, ed., *"Primitivism" in 20th Century Art: Affinity of the Tribal and the Modern,* 2 vols. (New York: Museum of Modern Art, 1984), 2:566.

The surrealists and their friends had shown their interest in Indian art from 1928 onward to such a degree that, in September 1945, there was talk of producing a collective work (Breton, Lévi-Strauss, Lebel, Ernst) to be titled *Les Grands arts primitifs d'Amérique du Nord* (Major native art of North America) and scheduled to be published by the Éditions Jeanne Bucher, but the project failed to materialize. The collections of Indian art that were thus put together were quite rich—while they did not conform with the dominant taste—because the majority of Kachinas and masks of American origin displayed in 1959 at the exhibition *The Mask* at the Musée Guimet came from collections belonging to Duthuit, Breton, Lebel, and Isabelle Waldberg (see *Le masque* [Paris: Éditions des Musées Nationaux, 1959], nos. 19–22, 25, 42–59, 66–79, 82, 83).

86 As an indication of the increase in the number of solo exhibitions, what follow is by no means a complete list:

Matta: 1940 (Julien Levy), 1942 (Pierre Matisse), 1943 (Julien Levy), 1944 (Chicago Arts Club and Pierre Matisse), 1945 (Pierre Matisse);
Miró: solo exhibitions with Pierre Matisse in 1940 (older work), 1941, 1942, 1944, and 1945 (ceramics and the series of *Constellations*); retrospective at the MoMA from November 1941 to January 1942; exhibition at the Chicago Arts Club in March and April 1943;
Paalen: 1940 (Julien Levy);
Tanguy: 1940 (Hartford, Chicago, and San Francisco, itinerant exhibition), 1942, 1943, and 1945 (Pierre Matisse);
Lam: 1942 and 1944 (Pierre Matisse);
Ernst: 1942 (Valentine Gallery), 1943 and 1945 (Julien Levy);
Masson: 1942 (Baltimore Museum);
Tanning: 1944 (Julien Levy), 1945 (Crosby Gallery, Washington, D.C.);
I. Waldberg: 1944 (Art of This Century)
Gorky: 1945 (Julien Levy, catalog preface by Breton);
Donati: 1944 (Gallery Passedoit, New York, catalog preface by Breton); and
Arp: 1944 (Art of This Century).

87 Number 5 of *Hémisphères,* devoted to magic and poetry, was put together by Seligmann alone.

88 Breton's chill toward Masson was also a consequence of Breton and Tanguy's critical reception of the panel *Liberté, égalité, fraternité* for which Masson accepted the commission to celebrate July 14, 1942.

89 Waldberg and Waldberg, *Un amour acéphale,* 170.

90 Breton, preface to Donati's exhibition, reprinted in *Le Surréalisme et la Peinture,* 195 ff.

91 Camille Mauclair's offensive began in 1929 with *La Farce de l'art vivant* (Paris: Éditions de la Nouvelle Critique) and continued throughout the following year with *Les Métèques contre l'art français* (Paris: Éditions de la Nouvelle Critique, 1930): Mauclair denounced, all in the same batch, cubism, fauvism, expressionism and anything that claimed to belong to modernity. As for surrealism, he noted, e.g., that, "based on everything that painting cannot and must not express, these Freudians lay claim, with hateful provocation, to results that, because they cannot fall under art criticism, can only belong to

psychiatry" or that the "hitherto unseen" that surrealism might offer is "an invisible and crackpot novelty." As for Max Ernst, he belonged to those for whom "it is a bit fastidious for a Frenchman to add 'Bless you!' each time one says their name." See also Camille Mauclair, *La Crise de l'art moderne* (Paris: Éditions CEA, 1944).

92 In the same year, 1943, Dominguez also illustrated André Thirion's *Le Grand ordinaire*, but the edition was clandestine and backdated to 1934 (*Le Grand ordinaire*, Le Désordre, no. 8 [Paris: Éric Losfeld, 1970]).

93 Jacques Hérold, in Michel Butor, *Hérold* (Paris: G. Fall, 1964), 18.

94 For a reevaluation of the group's activity, see Michel Fauré, *Histoire du surréalisme sous l'Occupation* (Paris: La Table Ronde, 1982) or the summary version, "En France sous l'Occupation," in *La Planète affolée*, ed. Pierre, 66 ff.

95 From "Letter to André Breton," symbolically written during the night of July 13–14, 1943, which never reached its destination, but can be read in Fauré, *Histoire du surréalisme sous l'Occupation*, 263 ff. The break with Éluard occurred on May 2, 1943, during a sudden visit on the part of Arnaud. It is true that Éluard had seen Aragon in Paris at the beginning of April for the first time since 1932, and his reenrollment in the Communist Party had taken effect in March.

96 P. Seghers's periodicals (*Poésie 41, 42,* etc.) and *Messages* were, in particular, targets of their hostility in two pamphlets: *Vos gueules* (January 1943) and *Nom de Dieu* (May 1, 1943); on their very eclectic table of contents they would juxtapose—in the name of what Jean Lescure called "the obscure passion that links us to the duration of a civilization"—Christian spiritualism and traditional versification, more or less transparent allegories and facile "Aragoneries." With these two pamphlets, La Main à Plume entered the tradition of the manifesto *Pour un art révolutionnaire indépendant* by André Breton and Diego Rivera, anticipating at least in part the argument that Péret would develop in *Le Déshonneur des poètes* (Paris: J. J. Pauvert, 1945). Maurice Blanchard, in contrast, would condemn *Poésie 42* in these terms: "It's the Town Hall Bazaar. They call on everyone and everything, they tell all the poets that each one of them is best in all the world, and they end up with a magmatic product where the best takes on the appearance of the worst. All of them subscribe, and a periodical that reaches two or three thousand subscribers is therefore the top periodical in France" (*Danser sur la corde, journal 1942–1946* [Toulouse: L'Ether Vague, 1994], 101).

97 In 1942, only 15 percent of the paper used in 1938 was available to the entirety of publishers in France.

98 The pamphlets and collective texts by La Main à Plume can be found in *Tracts surréalistes,* ed. Pierre, 2:3–19.

99 Marcel Mariën, *La Chaise de sable* (Brussels: L'Invention Collective, 1940), 78.

100 Marcel Mariën, *Magritte* (Brussels: Les Auteurs Associés, 1943), and *Les Poids et les mesures* (Brussels: Les Auteurs Associés [which had now become the Éditions La Boétie], 1943); and Paul Nougé, *René Magritte ou les images défendues* (Brussels: Les Auteurs Associés, 1943).

101 The rexist movement, founded in 1935 by Léon Degrelle, advocated authority and displayed a fierce antiparliamentarianism. It dissolved in 1944.

CHAPTER FIVE

1 André Lhote, writing in *Les Lettres françaises* (September 23, 1944), reprinted in Lhote, *La Peinture libérée* (Paris: Grasset, 1956), 16. Obviously, not everyone shared Lhote's expectations: in his overview, *La Peinture française de 1918 à 1939* (Geneva: Milieu du Monde, 1948), François Fosca devoted scarcely more than six pages (out of 135) to the surrealists. Asserting that the use of automatism "concerns literature alone," he was disconcerted by some of the procedures he cataloged: "putting his helmet on backwards won't stop [De Chirico] from being a fireman"; Dalí was content with reversing the qualities of what he depicted; Miró and Masson offered nothing more than "dreary inventions"; and only Pierre Roy was worthy of a certain indulgence by virtue of his profession. Ernst's collages, in contrast, resulted in "obscene, scandalous or downright stupefying images." Referring to "La Peinture au défi" to express his astonishment that Aragon, now so respectful of the poet's vocation, could have hoped in 1930 for the annihilation of painting, Fosca appreciated only a balanced figurative painting, with a chromatism devoid of violence: cubism, or the abstraction of the "Slav Kandinsky," were no more satisfying than surrealism, which he viewed as an extension of studio farces. This judgment in itself is unimportant but does reflect a commonly held opinion that, after the war, had expected a

return to the most hackneyed values.

2 Jacques Gabriel writing in *Poésie 44,* no. 21 (1944), 133.

3 Jules Monnerot, *La Poésie moderne et le sacré,* Les Essais, no. 16 (Paris: Gallimard, 1945); a new edition "with an added foreword" (devoted to Maurice Nadeau's *Histoire du surréalisme* [Paris: Éditions du Seuil, 1964]), was published in 1949.

4 Monnerot's approach here resembled Gaston Bachelard's path, particularly as displayed in *La Philosophie du non: Essai d'une philosophie du nouvel esprit scientifique* (1940), 4th ed. (Paris: Presses Universitaires de France, 1994): the history of science shows that "classical" rationalism (that of Euclid, Newton, and Kant) was only a specific or "local" case of "complex" rationalism (non-Euclidians and Einstein), which in turn would be integrated into a "dialectical" rationalism (Dirac and polyvalent logic), which finally incorporated it.

5 Maurice Nadeau, *Histoire du surréalisme* (Paris: Éditions du Seuil, 1945); and Maurice Nadeau and Pierres Vives, eds., *Documents surréalistes* (Paris: Éditions du Seuil, 1948). Both would be bound in a single volume in 1964, with a few additions. In 1947, to read this *Histoire* was to feel, according to José Pierre, e.g., "the impact of a revelation." (And reading it would also, in large part, lead to his desire to join the group.)

6 Sartre and Breton met in January 1945 in New York (see Patrick Waldberg and Isabelle Waldberg, *Un amour acéphale: Correspondance, 1940–1949,* ed. Michel Waldberg [Paris: Éditions de la Différance, 1992], 310), and Sartre confirmed the role played by Éluard and Aragon, as well as the Communist Party, in cultural life in Paris.

7 Jean-Paul Sartre, preface to the catalog of an exhibition, Paris, Galerie Maeght, 1947, *Sculptures à n dimensions* (Paris: Éditions Pierre à Feu, 1947). Sartre's preface is reprinted in *Les Écrits de Sartre: Chronologie, bibliographie commentée,* ed. M. Contat and M. Rybalka (Paris: Gallimard, 1970), 663 ff.

8 The critique of Stalinism was not something new for the group, but for those who might find that Breton exaggerated somewhat in his description of the intellectual situation in France after the war, it might suffice to remind them how Maurice Blanchard, having lived through the Occupation and the Liberation, appreciated the activism of certain people: "The Mafia is all-powerful. I would like to believe that next year it will also parade in uniform. Aragon, Cassou, Éluard, and Guillevic with gas masks and machine guns, that will be well worth just as good as the performing fleas from Moscow" (*Danser sur la corde, journal 1942–1946* [Toulouse: L'Ether Vague, 1994], 704). To understand the Communist Party's cultural ambitions one must also take into account its indisputable success at the ballot box: during the legislative elections of 1946, their candidates won 28.2 percent of the vote, two points more than in 1945.

9 Although Péret's *Le Déshonneur des poètes* was nominally published in Mexico in the series Poetry and Revolution, the pamphlet was in fact published in 1945 in Paris by K. Éditeur, the editor-in-chief of which, Alain Gheerbrant, had received the manuscript from Péret through the post. K. Éditeur would go on to publish Jean Arp, *Le Siège de l'air* (1946), Georges Bataille *Histoire de l'œil,* texts by Artaud, Benjamin Péret, *Feu central* (1947), and a new edition of Jacques Vaché's *Lettres de guerre,* with four prefaces written by Breton. In 1946–47, Gheerbrant prepared, for the periodical *Vrille,* "a reference work, with an initial evaluation of the activity of the surrealists and related artists and intellectuals during the war years that had scattered them to the four corners of the earth," but this project did not materialize. See Alain Gheerbrant and L. Aichelbaum, *K. éditeur* (Cognac: Le Temps qu'il Fait, 1991).

10 One of the collective volumes published by Éditions de Minuit, *L'Honneur des poètes* (Paris: Éditions de Minuit, 1943), includes contributions by Éluard (who wrote the preface, evoking Whitman, Hugo, Rimbaud, and Mayakovsky: "It is to action that poets with great vision are drawn, sooner or later."), Aragon, Seghers, Hugnet, Lescure, Tardieu, and Ponge; and, in *Europe,* Aragon, Éluard, Desnos, Leiris, Hugnet, Lise Deharme, Monny de Boully, and Tardieu. Both anthologies were compiled by Éluard.

11 *Poètes casqués* was the title of a periodical "founded in the Armies" by Pierre Seghers, which was followed by *Poésie 41, 42, 43,* etc. That same year, the anthology *Poètes prisonniers,* Poésie, no. 43 (Paris: Pierre Seghers, 1943), which was presented as "the one where the most vibrant French poetry appears in all its diversity . . . *romancero* of French suffering . . . unforgettable choir." In other words: "The poetry of the prisoners of war is welcomed with open thighs. Our dear prisoners, France's best sons, the future and our resurrection!" (Maurice Blanchard).

12 P. Waldberg, *Un amour acéphale,* 210. Compare Maurice Blanchard: "Aragon copies Hugo on a bad day, when he needed three hundred verses every morning, or sometimes Béranger [writer of popular

patriotic songs, first half of the nineteenth century] the great ninny. And Emmanuel digs huge clods out of the bog with his shovel and piles them up in regular piles" (January 5, 1943, in *Danser sur la corde,* 119).

13 In an interview in the *Figaro littéraire* (April 24, 1948), Péret would later declare: "If I had been there, I would have taken part in the Resistance—by fighting. But not by writing poems. Pamphlets, yes, or articles of propaganda" (*Œuvres complètes,* 7 vols. [Paris Éric Losfeld, 1969–95], 7:211).

14 Waldberg and Waldberg, *Un amour acéphale,* 286. So Aragon had succumbed to the rather hysterical patriotism that he himself had derided after the First World War.

15 On the salvaging of Prévert, Queneau, and Leiris alone from the first issue, see ibid., 313. The "new series" of the *Éternelle revue* was published with a cover illustrated by Picasso and defined itself as "a periodical that belongs to its time the way one belongs to a party. A periodical that is French the way one is universal." In the table of contents of the first issue (December 1944), in addition to the "poetic" testimonies on the war and the Resistance, there were not only the names mentioned by Waldberg but also Char, Ponge, Max Jacob, Fardoulis-Lagrange, Tzara, and Hugnet (relating how his library was ransacked by the Germans). Number 2 (February 1945) featured, alongside the texts dealing with recent events, Lise Deharme, Colinet, and Scutenaire (Colinet and Scutenaire were in the midst of their communist euphoria, and Scutenaire would declare himself to be a Stalinist until his death), Bataille, Monnerot, Jarry, and Forneret; there were also automatic "Fragments" by Picasso, "justified" by a paragraph by Éluard: "Soon, the only effort of poets will be to liberate images and relax the forms enslaved by the limited minds of masters." Of course by now Picasso had joined the Communist Party, and Éluard and Aragon were virtually about to become its official commentators.

16 Paalen also shared this position, despite the fact that he had left surrealism, temporarily, as shown by these declarations: "For the artist who must be a soldier, there is no more art, and for art there is no uniform. War never resolves any problems of thought, and for all those who have something serious to do it is nothing more than a stupid, or deadly, interruption. . . . As it is the very purpose of art to vanquish chaos, no work is valid except insofar as it goes beyond wars or other individual or collective calamities. . . . Those works that will proclaim the most profound victory over war will contain no allusion to this war" ("Pendant l'éclipse," *Dyn,* no. 6 [November 1944]).

17 In his cubomania Ghérasim Luca, after cutting out an image (generally the reproduction of a famous painting) in even squares, would rearrange the fragments to form a new composition in order to disturb readability and produce incongruous formal connections.

18 Ghérasim Luca, *L'Inventeur de l'amour* (Paris: Éditions José Corti, 1994). In Bucharest, Gherasim Luca, Trost, Paün, and Teodorescu showed their work under the title *Infra-Black:* in September 1946, the first three had an exhibition (the preface to the catalog was coauthored by Naum), and in February 1947, three notebooks written directly in French made up the "Infra-Black Surrealist Collection" (*L'Infra-Noir* [Paris: La Maison de Verre, 1996]).

Their desire to experiment with the non-Oedipal paths of language was confirmed, as was their desire to mingle waking and dreams. They put every effort into a total liberation of poetic forces, the only ones capable of leading to a revolutionary community of thought. Very quickly, however, these activities would come to an end: Trost went into exile in 1948, and Luca and Paün were reduced to silence until they finally left Romania in 1952 and 1961, respectively. As for Teodorescu, he quickly rallied to the local form of Zhdanovism and became one of the eulogists of the regime. (Their publications in this series were republished as *Cahiers de la collection Infra-Noir* [Paris: La Maison de Verre, 1996]).

19 The distance would be made clear in 1957 by a short autobiography written for a tribute awarded him when *Bleu du ciel* was published: "Bataille imagines that, appearances notwithstanding, his intentions are prolonging a violent movement of which in France, after the war, surrealism was the most blatant symptom."

20 Print runs numbered between four hundred and five hundred copies, and these volumes now show up in the catalogs of more or less specialized booksellers, their pages often uncut—which would seem to indicate that they did not have a great deal of success at the time they were published. In the early 1950s, the Âge d'or series was revived, first of all by the Éditions Premières, then by the bookstore Les Pas Perdus. Ernst designed the cover, and Parisot published, in particular, Schwitters (with the *Fiat Modes* series by Ernst), Carrington, Michaux, and Yeats. He also edited the series L'envers du miroir for the publisher Robert Marin: Ernst designed the cover art for them, too (frottages and col-

lages), as well as for the novels by Melville published in special editions. Toyen would design a cover for the same publisher of a work by Jean Louis Bouquet, *Alastor, ou Le Visage de feu* (Paris: Robert Marin, 1951). In the 1960s L'Âge d'or showed up again at Flammarion, and Parisot would remain faithful to his initial choices: Savinio, Carrington, Lewis Carroll, De Chirico, Hoffmann, and others.

21 There were nine installments of *Les Quatres Vents* between June 1945 and June 1947; the table of contents planned for no. 10 included pages by Brisset.

22 In 1940, the Éditions du Sagittaire published Mabille's *Le Miroir du Merveilleux* (with seven drawings by Masson, cover by Tanguy), which would be reissued in 1962 with a preface by Breton at the Éditions de Minuit—the first edition also included etchings by Ernst, Brauner, Hérold, Lam, and Matta.

23 Marcel Mariën, *L'Activité surréaliste en Belgique, 1920–1950,* Le fil rouge (Brussels: Lebeer-Hossmann, 1979), 358.

24 *André Breton, La Beauté convulsive* (Paris: Éditions du Centre Pompidou, 1991), 398.

25 Breton automatically drew upon himself the hostility of the Communist Party, in this case through the pen of G. Falco, a pseudonym for Jorge Semprun, who devoted an article to him in *Action* on October 4, 1946, titled, "Arcane 17, ou Le Sermon sur le rocher percé" (Arcane 17, or the sermon on the pierced mount); as for Seghers, he would take up seven pages in the January–February issue of *Poésie 47* to give an ironic commentary on the book (carefully mixing feigned admiration, conventional reverence, and a fairly venomous double meaning), in particular about the way in which Breton claimed to go beyond politics through love and poetry (a poetry that, of course—and this is also what stuck in Seghers's throat—was unscathed by any commitment): "To suggest individual ethical or aesthetic satisfactions to those one assumes are tired of struggling—satisfactions that are valid only for those who prefer the cape to the sword—is to attempt to disable the weapons of political effectiveness." He did praise the "stylist" in Breton, the poet of love, but then immediately thought it was perfectly all right to place him alongside Éluard and Aragon in a common "knighthood of courtly love"!

26 André Breton, "Hommage à Antonin Artaud," in Breton, *La Clé des champs* (Paris: J. J. Pauvert, 1967), 99 ff.; English trans.: *Free Rein = Le Clé des champs,* trans. Michel Parmenter and Jacqueline d'Amboise (Lincoln: University of Nebraska Press, 1995).

27 The members of the "group of surrealist action LA RÉVOLUTION LA NUIT" had made their positions clear and unambiguous in 1946, even before Breton's return: "against the reaction with the face of Sartre and Éluard" and "for a surrealism in movement." "We think that the most effective aid that surrealism can bring to the cause of the Revolution is to start again, in 1946, the trial of the fundamental values of our society, and our only regret is to see how the revolutionary militants have not freed themselves enough from those values" (see *Tracts surréalistes et déclarations collectives*, ed. José Pierre, 2 vols. [Paris: Éric Losfeld, 1980–82], 2:21–22). Some of its members (Claude Tarnaud, Iaroslav Serpan) would very quickly be among those signing the group's more important declarations.

28 Joë Bousquet, Mariën, Jacques Michel, Nougé, Scutenaire, and Jacques Wergifosse also signed this tract, but René Magritte himself was the author of "Manifeste no. 1," which was reprinted in Magritte, *Le Surréalisme en plein soleil* (Brussels: Les Lèvres Nues, 1974).

29 André Breton, interview by Jean Duché, *Le Littéraire* (October 5 and 12, 1946), reprinted in *Entretiens, 1913–1952, avec André Parinaud [et al.],* Le Point du jour (Paris: Gallimard, 1952), 239 ff.; English trans.: *Conversations: The Autobiography of Surrealism,* trans. and with an introduction by Mark Polizzotti (New York: Paragon House, 1993). Recent publications by those on Breton's list included Aimé Césaire, *Les Armes miraculeuses,* Collection "Poésies" (Paris: Gallimard, 1946)); Jean Arp, *Le Siège de l'air;* and Benjamin Péret, *Main forte* (Paris: Éditions de la Revue Fontaine, 1946).

30 In *Their Morals and Ours* ([Mexico City: Pioneer, 1939]; French trans.: *Leur morale et la nôtre,* trans. Victor Serge, 7th ed. [Paris: Éditions du Sagittaire, 1939]), Trotsky denounced the universality of classical morality (or Kantian: that which holds that human beings must never be treated as a means but must always be considered as an end in themselves) as purely bourgeois and ideological, and countered with a proletarian morality for which the end did indeed justify the means.

31 Tristan Tzara's "La dialectique de la poésie," reprinted in Tzara *Le Surréalisme et l'après-guerre* (Paris: Nagel, 1947) was enriched by a certain number of notes on publication (one of which reproached the pamphlet *Liberté est un mot vietnamien* [reprinted in *Tracts surréalistes,* ed. Pierre] for being nothing more than an indictment of those "elected by the people"). One could read there, e.g., that the true crisis of surrealism had begun in 1931 "when Aragon, upon his return from Kharkov where he had attended the Congress of Soviet Writers, left his companions" or that "a book like *Le Déshonneur des*

poètes, by its title alone, is an insult to the poets who died because of the Occupation, and by its immodesty, it soils forever what little ideology it had taken for inspiration."

32 Philippe Audoin, *Les Surréalistes* (Paris: Éditions du Seuil, 1973), 114–15.

33 *Liberté est un mot vietnamien,* reprinted in *Tracts surréalistes,* ed. Pierre, 2:27. The pamphlet was dated April 1947. In January 1949, Breton, in a personal capacity, was among those who signed a manifesto that appeared in *Esprit* denouncing a war "waged against an entire people"; he would be in company with Sartre, Simone de Beauvoir, Étiemble, Merleau-Ponty, Paulhan, Vercors, and even Cocteau.

34 In 1947, the Communist ministers who still had positions in government voted for military funds for Indochina—actually taking up a stance against Ho Chi Minh himself. This was, on the one hand, in order not to divide, as J. Duclos wrote, the ministerial solidarity and to show "how much the Communist Party carried the interests of the country among its concerns, and an acute sense of responsibility" and, on the other hand, to prevent the "colonized" people from being seduced by the Americans and, finally, because the colonies were economically, and therefore politically, underdeveloped. It was only once they were ousted from government (in May) that the position of the Communist Party would change: they denounced a war that they considered to be "for the profit of American imperialism" (see A. Chebel d'Appollonia, *Histoire politique des intellectuels en France, 1944–1954* [Brussels, Éditions Complexe, 1991], vol. 2).

35 *Rupture inaugurale,* reprinted in *Tracts surréalistes,* ed. Pierre, 2:30 ff.

36 Henri Lefebvre, *L'Existentialisme* (Paris: Éditions du Sagittaire, 1946).

37 Georges Sebbag, *Les Éditions surréalistes* (Paris: Institut Mémoires de l'Édition Contemporaine Éditions, 1993), 200.

38 See *Tracts surréalistes,* ed. Pierre, 2:316 ff.

39 This was one of the points with which Péret would disagree, justifying the absence of his name among the signatories of *Rupture inaugurale;* see his letter from October 1947, quoted by Claude Courtot, *Introduction à la lecture de Benjamin Péret* (Paris: Le Terrain Vague), 46 ff.

40 Roger Vailland, *Le Surréalisme contre la revolution* (Paris: Éditions Sociales, 1948); the text was dated July 1947.

41 Marko Ristitch did indeed become Tito's ambassador for Yugoslavia in Paris from 1945 on. He remained faithful to his prewar surrealist preferences in appearance (even though his most frequent visitors at the Embassy in actual fact were initially Éluard, Aragon, and Elsa Triolet), but Radovan Ivsic has shown that in fact Ristitch had betrayed the surrealists: already in 1936 he allowed for an equivalency between poetry and the literature of struggle, although he never clearly formulated his change in attitude. See Radovan Ivsic, *Quand il n'y a pas de vent, les araignées . . .* (Paris: Éditions Contre-Moule, 1990). As for Hoffmeister, it is difficult to see what might have qualified him as a surrealist. And the Yugoslav poet who became general of a brigade was Kosta Popovic, who later became Minister of Foreign Affairs and would complete his rise to power as vice-president of the republic in 1966.

42 Marcel Jean, *Histoire de la peinture surréaliste* ([Paris: Éditions du Seuil, 1959]; new ed., with the collaboration of Arpad Mezei [Paris: Éditions du Seuil, 1967]), 343; English trans.: *The History of Surrealist Painting,* trans. Simon Watson Taylor (New York: Grove Press, 1960). The second quote is from Breton: see *Le Surréalisme en 1947,* catalog of the *Exposition Internaionale du Surréalisme* (Paris: Éditions Maeght, 1947), 135–36.

43 The "Le Soigneur de gravité" (Caretaker of gravity) was the "missing" element from Duchamp's *Large Glass:* created in 1947 by Matta (but later destroyed, and only two photographs remain; see Jean Suquet, *In vivo, in vitro: Le Grand Verre à Venise* [Paris: L'Échoppe, 1994], 85 ff.), it was shaped like a lopsided coffee-table, one leg poised on a pale breast set in a plate (which in turn might refer to the breast on the catalog's first edition), while around it various offerings were scattered: the place settings were laid, a tilted clip frame held rows of baguettes, a cheese grater was placed at the back of the alcove, etc.

44 This may be because this work no longer corresponded to his postwar creations, which were entirely devoted to recreating faces or bodies in his desire to seize them as they emerged; or perhaps his refusal was a way to punish Breton for his reaction to Giacometti's new quest: everyone knows how a face is made, after all. Their distancing was inevitable; and it was Sartre who would comment on Giacometti's new style, while waiting for the more subtle words of Leiris.

45 In *Vivre avec Picasso* ([Paris: Calmann-Lévy, 1965, reprint, Paris: Calmann-Lévy, 1991]; English trans.:

Life with Picasso [New York: McGraw-Hill, 1964]), Françoise Gilot and C. Lake describe how Breton, in Golfe-Juan, refused to shake Picasso's hand because of his political positions: while Picasso placed "friendship above political differences," Breton had "principles that left no room for compromise" (30 ff.). In November 1965, Breton sent a short note to *Paris-Match*—in which excerpts from the book had been published—disputing the story: "We never got into politics and I never refused to shake his hand or even hesitated to do so." Perhaps Gilot, who maintained her version of events in the more recent version of the book, hadn't forgiven the article written in celebration of Picasso's eightieth birthday: "80 carats . . . but a shadow" (*Combat* [November 2, 1961], reprinted in *Le Surréalisme et la Peinture* [Paris: Gallimard, 1965]; English trans.: *Surrealism and Painting,* trans. Simon Watson Taylor [New York: Harper & Row, 1972]), in which Breton reproached the painter for betraying the lesson of freedom offered by his work by showing too much tolerance for Stalinism.

46 André Breton, "Devant le rideau" (Before the curtain [1947]), reprinted in *La Clé des champs,* 104 ff.

47 Picasso was an exception to this repetitiveness, and Breton did not miss the opportunity to show just how far the privilege granted to him could go: "Everything would seem to indicate that it is because he has been granted some sort of *occult dispensation,* that those who shape opinion have decided once and for all that he could have an official monopoly on novelty. This has become such standard acceptance that even within the Communist Party the strictest directives that, as you know, have led in Russia to the suppression of anything that is not *academically directed art,* dissolve to nothing at the doors of Picasso's studio" ("Comète surréaliste," reprinted in *La Clé des champs,* 115 ff.).

48 It was during his visit that Jean Schuster, who had until then been "a totally resistance-oriented and Stalinist 'communist' conscience," decided to meet Breton (see *Le Ramasse-miettes, suivi d'une lettre différé à Philippe Soupault* [Bordeaux: Pleine Page/Opales, 1991], 110 ff.

49 Bernard Dorival, writing in *Les Nouvelles littéraires* (July 17, 1947). One can also quote Marie-Louise Barron, "Surréalisme 1947: En retard d'une guerre comme l'État-Major" (Surrealism 1947: one war late, like the staff), *Les Lettres françaises* (July 18, 1947): "A funeral . . . , a rehashing of old things worn out from overuse; an old story, always the same, told over and over for the thousandth time; a *parti pris* to shock but shocking no one any longer; systematic nonconformity, the worst kind of conformity. . . . What was the point of being Breton—the Breton of before Mexico and 'Le Déshonneur'—if it is to offer us in the name of who knows what sort of loyalty a betrayal with these outmoded display windows," etc., where it appeared that at least the agreement with Trotsky and Péret's pamphlet were clearly unforgivable where the Communist Party was concerned.

50 Exceptions included, in particular, Pierre Guerre in *Les Cahiers du Sud,* no. 284 (1947).

51 It is true that Beaudin had made an appearance in *Minotaure,* but only thanks to Tériade. André Thirion also devoted a few pages to him in *Poésie 46,* no. 35 (1946), but by then Thirion had already distanced himself from the group.

On surrealism's representation in the museum, see the *Catalogue-guide du Musée National d'Art Moderne* (Paris: Éditions des Musées Nationaux, 1947), 83 ff. Jean Louis Bédouin ("Au décrochez-moi ça," *Médium,* no. 1 [November 1953]) virulently denounced the exhibition (Dorival of all people was in charge of it) and the incomplete nature of the museum's collections seven years after its inauguration—concerning not only surrealism but modern art as a whole: everything had evolved as if the Musée d'Art Moderne "sought to credit the general perception that modern art was 'incomprehensible.'" He added a "modest proposition" that aimed to constitute an acceptable representation of the movement: not only paintings (from Arp to Wolfli) but also sculptures, surrealist objects, and wild objects.

52 André Breton, "Seconde Arche," *Fontaine,* no. 63 (November 1947), reprinted in *La Clé des champs.* In 1948, in Santiago, Chile (Gallery Dedalo), a new but more modest international exhibition of surrealism was held. Among the participants were Breton, Duchamp, Brauner, Hérold, Magritte, and Matta, the *enfant du pays* who became world famous. This exhibition marked a high point in the collective activities organized since 1938 around the periodical *Mandragora* (seven issues published until 1943) by the poets Braulio Arenas, E. Gomez Correa, and J. Caceres.

53 Breton's preface was not reprinted in *Le Surréalisme et la Peinture,* but was in the catalog *Styrsky, Toyen, Heisler,* ed. Jana Claverie (Paris: Le Centre, 1982), 40.

54 The cycle *Tir* was published in France in 1973, by the Éditions Maintenant, with a text by Ivsic. The first editions were enhanced by two drypoints by Toyen dating from 1974.

55 Among the individual texts that were published at that time were Breton: *Ode à Charles Fourier* (1947) and *Martinique: Charmeuse de serpents* with Masson, *Poèmes,* and *La Lampe dans l'horloge* (1948);

Blanchard: *La Hauteur des murs* (1947); Schéhadé: *Rodogune Sinne* (1947) and *Poésies II* (1948); Hénein: *Un temps de petite fille* (1947); Lély: *Ma civilisation* (1947); Gracq: *Liberté grande* (1947) and *André Breton* (1948); Mandiargues: *Le Musée noir* (1946) and *Les Incongruités monumentales* (1948); Césaire, *Soleil cou coupé* (1948); and of course the small volumes that continued to be published in Parisot's series *L'âge d'or.*

56 Jean Schuster, *Les Fruits de la passion,* Collection Griffures (Paris: L'Instant, 1988), 72.

57 André Breton "Signe ascendant," *Néon,* no. 1 (1948), reprinted in *La Clé des champs.*

58 Sarane Alexandrian, preface to M. de Chazal, *Ma révolution* (Cognac: Le Temps qu'il Fait, 1983). Malcolm de Chazal's *Sens plastique II* was published in one volume, with a preface by Paulhan (Paris: Gallimard, 1948; reprint, Paris Lachenal & Ritter, 1983). It would be followed by *La Vie filtrée* (1949), then by a choice of aphorisms, *Penser par étapes,* printed by Pierre Bettencourt (1950). The other very numerous volumes by Chazal were published in Mauritius, with the exception of *Poèmes: L'Homme et la connaissance* (Paris: Pauvert, 1968, 1974), a selection of "works previously unpublished in France," with a preface by O. Poivre d'Arvor and published under the title *La Vie derrière les choses* (Paris: La Différence, 1985), *Sens unique,* and *Correspondances avec Jean Paulhan* (Toulouse: L'Ether Vague, 1985, 1986).

59 In their relations with the surrealists, the Lettristes would alternate expressions of intellectual respect and an indication that they wished to have done with their inconvenient "fathers." Isou, e.g., published "Homage to Benjamin Péret," *Poésie nouvelle,* no. 10 (January 1960), coauthored by M. Lemaître; but Lemaître asserted in *Le Lettrisme devant Dada et les nécrophages de Dada* (Paris: Centre de Créativité, 1967) that "Dada and surrealism are too limited for our indignation [provoked by a few 'falsifications' by the two movements] to stay for long at its height": surrealism, in the end, was nothing more than a "fundamental stage of Knowledge" finally attained by Lettrisme. Breton, in his *Entretiens,* acknowledged that in the beginning he had felt a "certain sympathy" for the Lettristes, and in 1946, Dr. Malespine hoped to reconcile surrealism and Lettrisme in his periodical *Humanisme,* which never went beyond the issue no. 0.

60 The necessity for revolutionary surrealism was announced by Dotremont in the third and last issue of his periodical *Les Deux Sœurs* (Christian Dotremont, ed., *Les Deux Sœurs no. 1 à 3, 1946–1947* [Paris: J.-M. Place, 1985]), which was however the richest one in terms of contributions from Paris (Breton, Brauner, Hénein, Mézei, Hérold, Tanguy, Pastoureau, Lély, etc.) and seemed to indicate, if one does not take Dotremont's opening article into account, a desire to regroup (after the first two issues that were "Belgian" for the most part). But the group that formed again around Breton clearly could not agree, as requested by Dotremont, to grant any "favorable prejudice" to the communist parties, "first and foremost [to] the Bolshevik Party."

61 Jacques Kober was a collaborator at the Galerie Maeght: his signature—in spite of himself—was among those at the bottom of the pamphlet *Le Surréalisme en 1947,* which was distributed by the revolutionary surrealists during the exhibition *Surrealism in 1947:* this would lead Breton to complain, in his *Entretiens,* of the somewhat skimpy "good will" on the part of Aimé Maeght. According to A. and M. Gall (*Maeght le magnifique* [Paris: C. de Bartillat, 1992], 95), Kober wrote to the revolutionary surrealists to have his signature removed, but he clearly continued to take part in their activities and publications.

62 Audoin, *Les Surréalistes,* 113. On December 9, 1948, Garry Davis drew nearly twenty thousand spectators to the Vélodrome d'Hiver; he was supported not only by Camus and the surrealists, but also by Paulhan, Vercors, Mounier and his periodical *Esprit,* and the black American author Richard Wright; even the communists had a fairly tolerant attitude toward him (after they had initially accused him of being an "agent of American imperialism"), as did the anarchists. Only Sartre and Mauriac refused to succumb to his charm.

63 In *Tracts surréalistes,* ed. Pierre, 2:43.

64 This would not be the last time one would hear of Carrouges, since he would be at the origin of the serious crisis in 1951 known as "l'affaire Carrouges."

65 Maurice Nadeau read excerpts of Pierre Klossowski's work, *Sade mon prochain* ([Paris: Éditions du Seuil, 1947]; English trans.: *Sade My Neighbor,* trans. and with an introduction by Alphonso Lingis [Evanston, Ill.: Northwestern University Press, 1991]), and in the essay that preceded the selected texts by Sade that he compiled (*Œuvres,* Le Cheval parlant, no. 3 [Paris: Éditions de la Jeune Parque, 1947]), he contested Klossowski's thesis, asserting in particular that Christians could only loathe the

work of Sade and that if the "divine Marquis" used so much energy to destroy the idea of God, discovered "in the mind of men . . . and not in the heavens," it was because of the "difficulties his century had in ridding themselves of Christianity."

66 Bataille would also be subjected to a co-optive reading on the part of Carrouges, for the publication of *L'Expérience intérieure* ([Paris: Gallimard, 1943]; English trans.: *Inner Experience,* trans. and with an introduction by Leslie Anne Boldt [Albany: State University of New York Press, 1988])*:* a man "cannot cause . . . God to cease to be invisibly present and active in the world and in his being: thus, unbeknownst to man, he will experience God's grace. Moreover, in Bataille's case it can be noted that despite the requisite rigor and the persistence with which he applies this type of 'inner experience,' the idea of God has not been erased . . . , on the contrary, he continues to confront it on multiple occasions" (Michel Carrouges, "La Signification de *L'Expérience intérieure*" [The significance of *L'Expérience intérieure*], in *Jeux et poésie,* La Pensé catholique [Paris: Éditions du Cerf, 1944]). In a speech given in 1949 in Lille and Antwerp, Julien Gracq also noted that "for several years now, surrealism has been the subject among certain Christians of an extremely suspicious open hand policy," before he went on to assert the movement's "open and total hostility" toward Christianity, because of the restrictions it imposes on freedom, of the perfectly "terrestrial" nature of the surreal that must be conquered, and the flagrant contradiction between the limits imposed on the spirit by the idea of an "original" sin and the state of rebellion or permanent exasperation confirmed as the "most effective lever" of thought ("Le Surréalisme et la littérature contemporaine," in *Œuvres complètes,* ed. Bernhilde Boie, 2 vols., Bibliothèque de la Pléiade [Paris: Gallimard, 1966], 1:106).

67 In October 1943, Borduas wrote to Breton: "It is not easy for us to formulate our allegiance to the surrealist movement; we can contribute the faith of neophytes; we believe that surrealism is at present the only living movement that contains a reserve of collective power sufficient to rally every generous display of energy and lead to a full bloom of life."

68 These texts are reprinted in *Le Surréalisme et la Peinture,* 218–19.

69 Hans Prinzhorn, *Bildnerei der Geisteskranken* (Berlin: J. Springer, 1922); French trans.: *Expressions de la folie: Dessins, peintures, sculptures d'asile,* ed. Marielène Weber, Connaissance de l'inconscient (Paris: Gallimard, 1984). The "Hommage to Hans Prinzhorn" by José Pierre (*Art et Thérapie,* no. 30–31 [August 1989]) showed the depth of the relation between the surrealists and Prinzhorn, who had broken with the strictly psychiatric view and asked that the works of the mentally ill be considered on a same level with those of "normal" artists.

70 André Breton, "Autodidactes dits 'Naïfs,'" reprinted in *Le Surréalisme et la Peinture,* 291.

71 Among other exhibitors at the 1947 exhibition was Raymond C., a schizophrenic who had been interned on several occasions and treated by Jean Delay; his painting *La Beauté et la laideur* was reminiscent in certain aspects of Magritte or Brauner. There is a summary of his case in the book by Robert Volmat (*L'Art psychopathologique* [Paris: Presses Universitaires de France, 1956], 35–36), with a list of the works collected at Sainte-Anne for the *International Exhibition of Psychopathological Art* at the first world convention on psychiatry in 1950. In the essays that followed the overview, a few pages were devoted, moreover, to a sympathetic analysis of surrealism, something that Dr. Vinchon had done before Volmat, in the second edition of *L'Art et la folie* (Paris: Stock, 1950), 68 ff.; the first edition, which was much less exhaustive, dates from 1924.

72 Breton wrote "L'Art des fous, la clé des champs" for an almanac of art brut that was never published, but the article appeared in the *Cahiers de la Pléiade,* no. 6, and is reprinted in *La Clé des champs,* 270 ff., and in *Le Surréalisme et la Peinture,* 313 ff. Breton referred, among other things, to Marcel Réja's *L'Art chez les fous* (Paris: Mercure de France, 1907 [and not, according to Breton, 1905], reprint, Nice: Z'éditions, 1994, with an introduction by F. Hulak). Réja, whose real name was Paul Meunier—the use of a pseudonym seems to indicate that his opinions were far from acceptable, at the beginning of the century, to medical circles—was one of the first French psychiatrists who dared to postulate that the pathological origin of the art works did not prevent one from appreciating them from an aaesthetic point of view; he ventured a few comparisons with the children's drawings and primitive art and also emphasized the interest of the patients' literary productions.

The expression "spiritual hunting" was particularly pertinent in May 1949, with the publication of a text of the same title attributed to Rimbaud. Upon coming across a few excerpts in *Combat,* Breton immediately denounced it as a fake, counter to the opinion of a certain number of critics and "experts." (It was indeed a fake: it was a pastiche conceived by two actors, Akakia-Viala and Nicolas Bataille, who wanted to make fun of the critics, Aragon among them, who had given a cold recep-

tion to their adaptation of *Une saison en enfer* (A season in hell), as briefly related in "Comment on fait du Rimbaud" (How one does Rimbaud), *La Table ronde,* no. 78 [June 1954].) Two months later Breton published *Flagrant délit* (Paris: Éditions Thésée, 1954), reprinted in *La Clé des champs,* Collection libertés (Paris: Pauvert, 1964), in which he retraced with precision the various stages of the polemic, put the critics of the era on trial, and specified the conditions for direct access to beauty. Nadeau, Maurice Saillet (alias Justin Saget), and Pascal Pia were especially targeted because the exercise of their "profession" was symptomatic of a general, intellectual, and moral state of the public, who were too attached to sensationalism and the commercialization of works, the worth of which was based more on a conventional reputation than on what they really had to offer. From a surrealist point of view, the texts and paintings that enjoyed an "exceptional aura" could not be understood, or even recognized, outside of a state of passion, and then only independently of any "scholarly" baggage: "love first of all," when "our need to understand is limited, like all the rest." Passion for a work of art allowed an opening to its own necessity, a way of reexperiencing that which made it exceptional; any other approach would keep the viewer on the outside and would preclude the overwhelmingly moving experience of the unique voice that offers itself to be heard (be it that of Rimbaud or any other great intermediary). This position was obviously shared by all the surrealists and was not Breton's alone; this attitude, and this attitude alone could exert a magnetic power over the listener or viewer to direct them toward ideas that were capable of "changing mankind"; the demands of intellectual comprehension were always secondary.

73 Gilles Ehrmann, *Les Inspirés et leurs demeures* (Paris: Éditions du Temps, 1962). This work was a collection of Ehrmann's photographs with a preface by André Breton, "Belvedere," that had first appeared in *Arts.* The "deluxe" editions included pieces by Péret, Ghérasim Luca (who had become a lasting friend of Ehrmann's), and Tarnaud.

74 André Breton, "Le Cadavre exquis, son exaltation," in *Le Surréalisme et la Peinture,* 288 ff.

75 In 1950 and 1954, Edgar Jené, with Max Holzer, brought out the two issues of *Surrealistische Publikationen,* where the first translations into German were published of Breton, Artaud, Gracq, Péret, and others, with texts by Lautréamont, and illustrations by Brauner, Donati, Tanguy, Ernst, and Toyen.

76 Texts reprinted in *Le Surréalisme et la Peinture,* 183–94.

77 Robert Matta, quoted in Alain Sayag and Claude Schweisguth, eds., *Matta: Centre Georges Pompidou, Musée national d'art moderne, 3 octobre–16 décembre 1985,* Les Classiques du XXe siècle, no. 6 (Paris: Le Centre, 1985), 281. Ernst's dove can obviously be compared with Picasso's, which shortly thereafter, in the name of the Communist Party, would circle the globe in favor of peace: one might wonder if Picasso's dove can still remind us how ridiculous it is to suppose that a dove looks on the world as a place devoid of conflict.

78 Sarane Alexandrian evoked the existence of a "countergroup H," which rejected any political commitment in the name of a dandyism of pure revolt (*L'Aventure en soi* [Paris: Mercure de France, 1990], 271).

79 For Brauner, what was at stake for painting was clearly—far beyond mere aesthetic satisfaction—the survival of individual integrity: "The world is getting more and more oppressive, unlivable, taking on the form of imminent danger, growing into a total and harmful bewitchment; I must therefore manage to find an essential and active support in a *created image,* a support that will act strongly as a counterbewitchment indispensable to my survival in these currents of terror" (response to the "Enquête sur la peinture" [Survey on painting] with an introduction by Camille Bourniquel, *Esprit,* no. 6 [June 1950]).

80 J. Gracq, preface to *La Victoire à l'ombre des ailes* (Paris: Le Soleil Noir, 1975).

81 The text from 1947 was written for an exhibition in New York at J. Levy's; reprinted in *Le Surréalisme et la Peinture,* 318 ff.

82 André Breton, ed., *Almanach surréaliste du demi-siècle* (Paris: Éditions du Sagittaire, 1950). The periodical *La Nef,* of which the above was a special issue (no. 63–64 [March–April 1950]), was edited by Robert Aron, one of the cofounders of the Théâtre Alfred Jarry, and by Lucie Faure.

83 On the reprint of *Almanach surréaliste du demi-siècle* (Paris: Éditions Plasma, 1978), see Jean-Pierre Cauvin, "Petites histoires d'almanach: Tour du monde des inventions tolérables," *Pleine marge,* no. 12 (December 1990). The "round-the-world" calendar went through the list of its inventions by means of a series of rebuses—which also served as collages—and J.-P. Cauvin points out that they are "of antiquated origin, if one is to judge by the shapes and the drawing," but also because they were not

meant to be included in the manuscript he consulted. These rebuses are indeed very old, since they have been attributed to the French-speaking poet of Italian origin, Giovanni Giorgio Alione, whose works were published in 1521 in his native town of Asti (for a modern edition of Alione, see Jacques-Charles Brunet, *Poésies françaises de J.-C. Alione [d'Asti], composées de 1494 1520* [Paris: Silvestre, 1836]); they depict two love rondeaux, and each cartouche is meant to be deciphered as a half line or a whole line. But their disposition in the almanac (pp. 6–12) interweaves the second rondeau with the first, interrupted at the bottom of page 5 to conclude only on page 13—which hardly makes it any easier to read them and would seem to indicate that Breton and Péret used these images solely for their enigmatic quality, without taking their meaning into account (unless this layout was simply an error of formatting). When the images are deciphered, these two poems are revealed:

1.
Amour fait moult sargent de li se mesle
Car mes cinq sens sont en travail pour celle
De qui louange / ast ore est anoblie
C'est mon escu envers mélancolie
Et mon déport, mon / mire et ma tutelle
Corps et vis a de / figure immortelle
Puis a franc cœur et l'œul / qui ne dépelle
Mon bon espoir, enté de n'oublie-mie
Amour fait moult.
J'ai sûr accès / vers sa ronde mamelle
Qu'a touchier ose et me / repais sur elle
D'un franc baiser au / [this is where the layout of the almanac interrupts the first poem] remain, je dis pys.
Las! s'elle truffe et / joue à la toupie
De moy ne say sy ne / la croy point telle
Amour fait moult.

2.
Ce n'est qu'abuz d'amour / et sa querelle
Pensez que c'est / foly universelle.
Autres servantes / et je sommes très las
De ses faux tours / et mis mors en ses las.
Et dieux je crois que / raison ne s'en mesle
Attrapez feuz et / mis à la coupelle
Dedens sa court / si vins languir pour celle
Qui or me trompe / et par qui diz : hélas
Ce n'est qu'abuz.
Je la cognois si ne / lenz pas pucelle Force monnoye a / corde sa vielle
Et maint cocquart y / muse à bourseaux platz
Pour ce y renonce et re/metz telz solas
Aux nouveaulx qui mieulx dansent / au chant d'elle
Ce n'est qu'abuz.

(See Jean Céard and Jean-Claude Margolin, *Rébus de la Renaissance: Des images qui parlent,* 2 vols. [Paris: Maisonneuve et Larose, 1986], 1:188 ff.)

84 In addition to Ferry-Roussel (*Une étude sur Raymond Roussel* was published in 1953 by the Édtions Arcane, but the text dated from 1933–48, and "Fronton-Virage," the preface by Breton, from 1949), this was the first public instance of the interest shown by Jean Suquet in Duchamp's *Grand Verre.*

85 André Pieyre de Mandiargues, "Les Chefs-d'œuvre aux terrains vagues," reprinted in *Le Belvédère,* La Galerie, no. 8 (Paris: Grasset, 1958).

86 André Breton, "Pont-Neuf," reprinted in *La Clé des champs.*

87 The "rarest" of all the collaborators on the almanac was undoubtedly Robert Caby (1905–92), who published "excerpts" (?) from a "Préface aux cryptogrammes." Linked with Trotskyite circles in the 1920s, familiar with artists (Brancusi, Picabia), musicians (Sauguet, Milhaud), and poets (Éluard, Prévert) but not a member of the group, Caby exhibited at the Galerie J. Bucher at the end of the 1920s. His drawings show dreamlike silhouettes that lack neither charm nor originality. He was the director of the periodical *Du cinéma.* Later he would turn predominantly to musical composition (see "20 ans de mort d'Erik Satie: De sa place dans la musique française et des raisons qui le font oublier," *Poésie 45,* no. 25 [June–July 1945]), composing the music for "La Nouvelle ronde" with lyrics by Aragon (published in *Chants révolutionnaires* [Marseille: Éditions de l'Ecole Émancipée, 1935), and in particular a score for Jarry's *L'Objet aimé,* and his artwork was forgotten. Only in 1994 did the Galerie Coligny in Paris exhibit a selection of drawings and pastels from 1920–40: virtuosity does

battle with automatism to define a brightly colored world, filled with humor, in which the unexpected takes on an amiable aspect.

CHAPTER SIX

1 Jean-Louis Bédouin, *Vingt ans de surréalisme, 1939–1959* (Paris: Denoël, 1961), 175–76. In 1945, Carrouges published *Éluard et Claudel* (Paris: Éditions du Seuil); throughout the 1940s he contributed to various publications, from the very Christian Éditions du Cerf (see n. 66, chap. 5, about his article on *L'Expérience intérieure* by Bataille), but also, and more lastingly, to the periodical *Paru,* edited by Aimé Patri, where on several occasions he showed his interest in texts that were also of concern to the surrealists (Sade, in particular). In 1950, the Club Français du Livre published Thomas à Kempis's *L'Imitation de Jésus-Christ,* with a preface by Carrouges, something that was already less encouraging. Nevertheless, his study *Les Machines célibataires* (Paris: Arcanes, 1954) was noteworthy both for the rapprochement it suggested between literary works (Poe, Kafka, Roussel, Jarry) and works of art (Duchamp's *La Mariée*) and for its identification of a "modern myth" exalting the self-regulated and impassible mechanism as the culmination of art, even if it was at the same time a synonym of repetition and of death.

2 Pastoureau's *Aide-mémoire relatif à l'affaire Carrouges* dates from February 28 and was reprinted in *Tracts surréalistes et déclarations collectives,* ed. José Pierre, 2 vols. (Paris: Éric Losfeld, 1980–82), 2:51 ff.

3 André Breton and Benjamin Péret, *L'Affaire Pastoureau et Cie (Tenants et aboutissants),* reprinted in *Tracts surréalistes,* ed. Pierre, 64 ff.

4 Pastoureau, *Observations relatives à l'opuscule de Breton-Péret: "L'Affaire Pastoureau et Cie" et au compte rendu de l'assemblée du 19 mars 1951,* reprinted in *Tracts surréalistes,* ed. Pierre, 2:76 ff.

5 All of these texts, of course, can be found in *Tracts surréalistes,* ed. Pierre, and the historian eager to know all the details of this long affair will be well served to read the notes, 388 ff.

6 Jean-Louis Bédouin et al., *Haute Fréquence,* republished by *Le Libertaire* (July 6, 1951); reprinted in *Tracts surréalistes,* ed. Pierre, 2:107.

7 Pastoureau and his friends published a poster-pamphlet in June–July 1951 as a last-ditch effort: *À l'ombre de lion diffamé et tiaré chargé en abîme d'une valise d'argent* (reprinted in *Tracts surréalistes,* ed. Pierre, 2:110). The lion was often invoked by this group (as early as *Un cadavre* in 1924) and was often used in reference to Breton. The 1951 pamphlet gives a chronology of the affair and a summary of reports on it in the press (*Opéra, Figaro littéraire, Combat,* and *Monde nouveau-Paru,* a periodical edited by Aimé Patri that was generally sympathetic to surrealism and attentive to publications by members of the group). *À l'ombre de lion* points out some contradictions—Pieyre de Mandiargues really did receive the Prix des critiques, despite Gracq's *La Littérature à l'estomac* (Paris: José Corti, 1950)—but the tone of the text is not, in fact, all that aggressive. By that time Pastoureau, Maurice Henry, Adolphe Acker, and Marcel Jean knew that their faction had lost and that the movement would carry on without them.

8 Gracq's feelings about Breton's embodiment of surrealism are made particularly clear in the work *André Breton: Quelques aspects de l'écrivain* (Paris: José Corti, 1948): as indicated by the subtitle, Gracq deals more with the aspect of the "writer" than the theoretician, but through his text one can constantly sense the assimilation—or one might say, more aggressively, the reduction—of all surrealism to the figure of Breton. An excerpt of this book was published in advance in *Fontaine,* no. 58, at the same time as Breton's *États généraux* (in his *Poèmes* [Paris: Gallimard, 1967])—an additional justification, if one was needed, for Gracq's designation as a surrealist. In addition, he would later contribute to *Médium* (nos. 1 and 2), and *surréalisme, même* (no. 2).

9 Julien Gracq, "La Littérature à l'estomac," *Empédocle,* no. 7 (1950). In the table of contents of that issue, one also finds texts by M. Blanchard, *Rêves* by Melville, a review of the new work by Monnerot, *Sociologie du communisme* (Paris: Gallimard, 1949), which "gives a vivid account of the destructive mechanism that Stalinism instills at the heart of every nation," according to the reviewer J.-C. Salel), and an article, of considerable interest, by B. Menzel, "French Writers and Soviet Criticism." Referring to recent issues of *Novy Mir* and *Literaturnaya Gazeta,* Menzel pointed out that surrealists represented to perfection the "rotting world," victim of capitalism and of the individualist ideology denounced in several columns by reporters. He emphasized in particular that, seen from Moscow, the case of Éluard seemed quite "typical": as long as he was close to Breton, "all he met on his way was despair and nothingness." Luckily, the Resistance enabled him to rediscover "the people," something

that could only improve his production, even if his poetry, according to the "poetess" Leona Zonina, "still contained too many superfluous complications." The path was henceforth clearly marked: "Paul Éluard's activity in serving the cause of the people must lead him to create an authentically patriotic poetry, imbued with the spirit of the Party." This would indeed not be long in coming: in 1949 Éluard wrote and recorded the commentary for a film by the Communist Party celebrating Stalin's seventieth birthday, for which he wrote these unforgettable lines: "And thousands upon thousands of brothers have carried Karl Marx / And thousands upon thousands of brothers have carried Lenin / And Stalin for us is present for tomorrow / . . . Forever, forever Stalin is among us." Parallel to Éluard's case was that of Aragon, although he was reproached, in particular, for requiring an additional effort on the part of his readers by omitting punctuation and using lines for which the "form" still had to be "perfected." Aragon would greet Maurice Thorez upon his return from the USSR with a long poem on the front page of *L'Humanité:* "He is coming back, he is coming back, he is coming, he will come. Onward! the happiness of all is in our hands."

10 Need one point out that *La Littérature à l'estomac,* with time, has come to seem even sharper in its clinical description of the literary milieu?

11 This was undoubtedly the point at which Gracq begged to differ from surrealism: he defined himself as a writer, and only a writer, while members of the group were something else altogether.

12 On the reactions of the "literary" press with regard to Gracq up to the time of his refusal of the Goncourt Prize, see Alain Coelho, Franck Lhomeau, and Jean-Louis Poitevin, eds., *Julien Gracq, écrivain,* Temps singulier (Laval: Éditions Siloé, 1988), 21 ff.

13 In 1931, Nicolas Ekk made *Chemin de la vie;* his denunciation by Alquié led to Breton's exclusion from the AEAR.

14 André Breton, "Comme dans un bois," reprinted in *La Clé des champs* (Paris: J. J. Pauvert, 1967); English trans.: *Free Rein = Le Clé des champs,* trans. Michel Parmenter and Jacqueline d'Amboise (Lincoln: University of Nebraska Press, 1995).

15 In 1957, Kyrou's second volume, which would become a classic work of reference, undertook to prove the powers of film in a domain that was of primary interest to the surrealists. *Amour, érotisme et cinéma* (Paris: Le Terrain Vague) exalted every version of womankind—from Louise Brooks to Marilyn Monroe by way of Marlene Dietrich—wherever the screen presented woman as an object of desire or of dreams and the unbridled passions that she could unleash. Although somewhat different in tone, the *Manuel du parfait petit spectateur* (Paris: Le Terrain Vague, 1958) was a humorous return to the expectations of the surrealists with regard to cinema: hostile to any form of censorship, it gave the spectator every right to rebel against the conformity and conventional morality with which the majority of films were infected—it is because film, far from being a passing art, is "above all a lever, a motor of life" that spectators must, this time, "shout out [their] love of the cinema, and [their] hatred of the cinema that is forced upon them."

16 With the exception, of course, of Buñuel, and of Benayoun who made, in 1972, *Paris n'existe pas* and in 1975, *Sérieux comme le plaisir.*

17 The very audience that, "at the end of the game, week after week, month after month, year after year would only leave its apprenticeship to join the army, and leave the army (if they survived Algeria) for a job, and would only leave the job for the family dump or the company of prostitutes."

18 Nowadays one must be reminded that Max Pécas and José Bénazéraf were, in the 1960s, specialists of a fairly gentle "eroticism."

19 Here we have been dealing with the issues of *Positif* from the 1960s, which was still at the opposite extreme from *Cahiers du cinéma,* preferring Resnais over Godard, e.g., gladly poking fun, in particular for political reasons, at whatever was said to be "new wave" in French cinema—its "Losfeld years," in other words.

20 See José Pierre, ed., *Surréalisme et anarchie: Les "Billets" surréalistes" du Libertaire, 12 octobre 1951–8 janvier 1953,* Collection en dehors (Paris: Plasma, 1983). Before the series of "Billets surréalistes," *Le Libertaire* had reproduced in 1947 the tract *Liberté est un mot vietnamien* (reprinted in *Tracts surréalistes,* ed. Pierre), then published Breton's speech at the Mutualité (October 21, 1949), a text by Péret denouncing David Rousset's Atlanticism (support for NATO) on the issue of concentration camps (December 9, 1949), a response by Breton to a survey on Céline's trial (January 20, 1950): "The Horror of This *littérature à effet*"), and a presentation of Vivancos by Breton (April 21, 1950). After the "billets" there would be a few more contributions on the part of the surrealists.

21 After 1945, only *Rupture inaugurale* and *À la niche les glapisseurs de Dieu!* were published by the Édi-

tions Surréalistes. In 1954, a second issue of *Surrealistische Publikationen* (the first came out in 1950) was published, edited by E. Jené and M. Hölzer; this German-language periodical collected pieces by Arp, Hölzer, R. Wittkopf, and others and illustrations by Toyen, Tanguy, Ernst, and Arp, among others. Printed in West Germany, this booklet was quickly withdrawn from circulation, for Hölzer considered it "less successful than the previous one." It was not until 1960 that the imprint of the Éditions Surréalistes would be seen again, and this would be for a very limited edition (nintey-five copies) of Radovan Ivsic's *Mavena*, illustrated by a lithography by Miró. See G. Sebbag, *Les Éditions Surréalistes* (Paris: Institut Mémoires de l'Édition Contemporaine Éditions, 1993).

22 Despite his notoriety, Breton still encountered difficulties: when the collection *La Clé des champs* was published by Le Sagittaire in 1953, the first printer who was contacted refused to complete the job because of the antimilitarist and antireligious tenor of certain texts.

23 During the 1950s, well-established publishers on the whole ignored not only the surrealists but also new texts of a strictly literary nature—it would be a "small" press like the Éditions de Minuit who published Beckett, e.g.; thus, Jérôme Lindon could not fail to attract the authors of the "nouveau roman." On the relations between Losfeld and the members of the group, see not only Losfeld's memoirs but also the testimonies of José Pierre and J. Schuster in *La Légende du Terrain Vague* (Paris: Le Dernier Terrain Vague, 1977).

24 According to Sarane Alexandrian, in November 1947, Gaston Gallimard asked Breton to edit a journal. A title was chosen (*Supérieur inconnu*) and a layout was prepared (by M. Jean), but the project failed to materialize due to its excessive cost.

25 In his correspondence in December 1952, Péret alludes twice to preparing a journal to be called *La Mante surréaliste,* which would "come out every other month from the end of January," but it never materialized (*Œuvres complètes,* 7 vols. [Paris Éric Losfeld, 1969–95], 6:386, 389).

26 And all the more so in that the collaborators from *Le Libertaire* showed their interest in the surrealist positions: in April 1947, A. Julien warmly welcomed Breton's return; in July the periodical published an account of the international exhibition at the Galerie Maeght; in December 1948, G. Fontenis praised an article by Breton, and so on. The *libertaires* also voiced their support for Garry Davis.

27 Benjamin Péret, *La Révolution et les syndicats,* reprinted in one volume with a second part by G. Munis and a preface by Mayoux (Paris: Éditions Losfeld, 1968). Péret's thesis was far from gaining unanimous support within the group: Breton and others did not accept it, which at least had the advantage of recalling that surrealism was in no way monolithic.

28 André Breton, "Sucre jaune," reprinted in *La Clé des champs.*

29 In Pierre, ed., *Surréalisme et anarchie,* 210.

30 *La Révolte en question,* Positions, no. 1 (Paris: Editions du Soleil Noir, 1952), which contained texts by Nora Mitrani, Jean-Pierre Duprey, Stanislas Rodanski, Antonin Artaud, Gilbert Lély, Aimé Césaire, and Julien Gracq. Two additional questions were asked by François Di Dio and Charles Autrand: Is the condition of the rebel justified? What, in your opinion, is the meaning of rebellion in today's world? Among those who responded were Ernest de Gengenbach, Maurice Blanchard, Pierre Demarne, Magritte, Pierre Loeb, and Bellmer, who explained what now separated him from the group: Breton, "since his stay in the USA, has been trying to introduce moral criteria into literary and art criticism," which seems to point to an ignorance on Bellmer's part of the movement's ongoing ethic or a misinterpretation of the welcome given before the war to his Doll. For the surrealists, this meant the exploration of a dark continent or passion (somewhat in the manner of Sade), but this dark aspect was not the only one for them—while it undoubtedly was for Bellmer. In June 1952, the second book of the Positions series came out under the title *Le Temps des assassins,* this time with a survey on capital punishment. Mitrani and Rodanski once again took part. Among those who responded to the survey were Carrouges, Demarne, Henri Goetz, Gracq, Maurice Henry, Marcel Jean, Henri Pastoureau, and Péret. Although it was not a surrealist publication, "Positions" was close to the movement. Simon Watson Taylor, Goetz, and J.-A. França figured among its foreign correspondents, and François Di Dio, who had a passionate interest in poetry and book-objects, published Sade (*Justine,* with a preface by Bataille) in 1950, then in 1953, *Héros-Limite* by Ghérasim Luca, before Claude Tarnaud's publication. During the 1960s and 1970s he published Joyce Mansour, Stanislas Rodanski, Yves Elleouët, Alain Jouffroy, Robert Lebel, Michel Fardoulis-Lagrange, Charles Estienne, José Pierre, Gérard Legrand, and Philippe Audoin, and illustrated their texts with contributions from Duchamp, Pierre Alechinsky, Magritte, Télémaque, Ernst, Jorge Camacho, Tovar, Jacques Hérold, Gia-

cometti, Alexander Calder, Jean-Claude Silbermann, and others.

31 It is also relevant to note that at the same time, in 1949 and on the orders of Moscow, the French Communist Party officially condemned psychoanalysis.

32 André Breton, "Pourquoi nous cache-t-on la peinture russe contemporaine?" (Why is contemporary Russian painting being hidden from us?) *Arts* (January 11, 1952); reprinted in *La Clé des champs*. Aragon's article, however, was not included in his *Écrits sur l'art moderne* (Paris: Flammarion, 1981): one must be content with excerpts from his later "Reflections on Soviet Art" (*Les Lettres françaises* [January 24–April 3, 1952]) and to delight in the illustrations, which fully support Breton's opinion.

33 Breton's article was reprinted as the first contribution in a supplement to the periodical *Preuves* devoted to "problems of contemporary art" (July 1953). This supplement, titled *L'esprit de la peinture contemporaine: Enquête sur le réalisme socialiste,* focused on a survey of socialist realism: it was obvious that both artists (Jean Atlan, Carra, André Masson, Picabia, Mario Prassinos, Rufino Tamayo, Villon, Osip Zadkine, etc.) and critics (Jean Cassou, Herbert Read, Clement Greenberg) were totally hostile to socialist realism.

34 J. Verdès-Leroux, *Au service du Parti: Le Parti communiste, les intellectuels et la culture (1944–1956)* (Paris: Fayard-Minuit, 1983), 59. At the same time as the campaign for "realism" in painting, there were, between 1950 and 1952, "battles for the book," designed to increase the numbers of direct encounters between Communist Party writers and their readers and to facilitate the familiarization "of the people" with classics (from Balzac to Zola) as well as the distribution of Soviet literature; thus Tzara could be found dedicating *Grains et issues* to a handful of peasants who, no doubt, had been misled by the title of the collection.

35 The censorship applied to seven canvases, two of which (*Maurice Thorez va mieux,* by Milhau, in particular) were later rehung; Aragon would devote a very long article to the event, "Au Salon d'Automne, peindre a cessé d'être un jeu: L'art et le sentiment national" ([At the Salon d'Automne, painting is no longer a game: art and the national sentiment], *Les Lettres françaises* [November 15, 1951], reprinted in *Écrits sur l'art moderne,* 78 ff.), in which he listed examples by Le Nain, de Chardin, Géricault, Daumier, and Courbet to justify the trend toward realism; he compared the situation of painters with that of poets under the Vichy regime.

36 Aragon, "Réflexions sur l'art soviétique," reprinted, in part, in *Écrits sur l'art moderne,* 86 ff.

37 Breton, "Du 'réalisme socialiste' comme moyen d'extermiantion morale" (On 'socialist realism' as a means of moral extermination), *Arts* (May 1, 1952), reprinted in *La Clé des champs*. The title of this article has a certain interesting connection with the formula that, in 1948, viewed the "art of the insane" as a "reserve of moral health."

38 [Maurice Thorez was a leading French Communist, a one-time party secretary and president (1900–1964). *Trans.*]
 Following the publication of Breton's article, Aragon's series was suspended in *Les Lettres françaises*. By February 1953, he was singing the praises of Bernard Buffet. In November that year, he abandoned Fougeron and would not return to Soviet art until 1957 ("What's New in Soviet Art?") to report on the relative liberation of artistic circles following the Twentieth Congress of the Communist Party: he noted an "experimental trend" among certain young artists—had they not been influenced by Cézanne, or even Van Gogh?

39 The reason Fougeron was particularly targeted by the surrealists, as a symbol of socialist realism "à la française," was first of all because he had been—even more than someone like Taslitzky or Amblard—promoted by the Communist Party as an example for other painters to follow. His exhibition *Le pays des mines* (The mining country [January 1951]) was the result of a directive by the party, and his stay was financed by the Fédération du Mineurs du Nord-Pas-de-Calais. The preface to the catalog for this exhibition, written by André Stil, a former participant in La Main à Plume, was widely distributed and is reprinted in *La Nouvelle Critique,* no. 22 (January 1951) as well as in an album (Paris: Cercle d'Art, 1951) and in the author's small volume *Vers le réalisme socialiste* (Paris: Éditions de la Nouvelle Critique, 1952). In fact, Fougeron's painting was an answer to the questions asked "in the name of authentic humanism, that of the communists," by J. Kanapa in "Absence de l'homme" (*Les Temps modernes,* no. 4 [January 1946], an article published in reaction to Masson's "Peinture tragique," which deplored—but from a very different point of view—the fact that contemporary artists, surrealists included, had abandoned the expression of tragedy): "Why doesn't today's painter paint his peasants, his workers? Why does one encounter mandolins and scissors on canvas—and not farm tractors and sewing machines? In what way, I wonder, is the worker overseeing the work at the foundry any less

noble . . . than a young girl reading. . . . Something is 'missing' from pictorial Beauty. And that something is the present-day expression of human reality—in a word, the advent of mankind's liberation." In 1946 Kanapa was, so to speak, somewhat ahead of Aragon, and one can see how Aragon would have to work twice as hard to outdistance him.

40 Among the responses worthy of attention are: Gérard Legrand—to give credit to painting where credit was due—affirmed that "the *memory* of Picasso does not exalt [me] any more than that of the great Ziegfield, and that Max Ernst's works do not necessarily appeal to [me] any more than those of Duke Ellington and Orson Welles—the criterion of *morality* aside, as is customary"; Goldfayn, in turn, said, "A painting does not strike a sensitive chord within me any more than certain films do, or the rendition of a musical theme by Thelonius Monk."

41 Breton's *Entretiens, 1913–1952, avec André Parinaud [et al.]*, Le Point du jour (Paris: Gallimard, 1952), 58; English trans.: *Conversations: The Autobiography of Surrealism*, trans. and with an introduction by Mark Polizzotti (New York: Paragon House, 1993) first came out in book form in 1952. Maurice Blanchot devoted a few pages to them ("Continuez autant qu'il vous plaira" [Go on for as long as you like], *Nouvelle revue française*, no. 2 [February 1953]; reprinted with a few variations in *L'Espace littéraire*, 4th ed. [Paris: Gallimard, 1955]), which gave a supreme demonstration of how the ambiguity of automatic writing (both a liberation from constraint and an access to a conceivably endless text, since it seems that everything can be captured in words) revealed in fact the very heart of the phenomenon of poetic inspiration and its proximity to aridity: inspiration "is powerful, but on the condition that the artist who receives it is very weak. Inspiration has no need of the world's resources, or personal talent, but one must also have renounced those resources, have no more support in the world and be free of one's self. Inspiration, it is said, is magical, it acts instantly, without the long meanderings of time, without intermediary; this means that one must lose time, one must lose the right to act and the power to do so." More marginally than the *Entretiens*, the little volume by René Gaffé, *Peinture à travers Dada et le surréalisme* (Brussels: Éditions des Artistes, 1952), precisely because it was the work of a famous collector of the movement's books and works, might lead one to think that it would henceforth be possible to make a more or less definitive synthesis of the topic. Although its analysis remains quite mediocre, the book gave a good indication of the reception granted to surrealism in the early 1950s.

42 Similarly, David Sylvester declares in his preface to Dawn Ades, *Dada and Surrealism Reviewed* (London: Arts Council of Great Britain, 1978): "If no major artist has emerged within the surrealist movement during the last thirty years, it is because the spirit of Surrealism, rather than being canalised into producing new surrealist adherents, has come to be diffused into most of the outstanding art of the time. (In the same way, attitudes to characteristic of Dada and Surrealism have become commonplace in the subversive mores of those who have grown up in the last decade or two.)" Michel Rémy responded to these reflections in *Flagrant délit*, no. 1 (1978).

43 André Breton, "Le Œuvre du XX siècle," *Arts* (May 1, 1952); reprinted *Le Surréalisme et la Peinture* (Paris: Gallimard, 1965), 349 ff.; English trans.: *Surrealism and Painting*, trans. Simon Watson Taylor (New York: Harper & Row, 1972).

44 Breton and Cassou's preface to the catalog for Tamayo's exhibition is reprinted in *Le Surréalisme et la Peinture*, 230 ff.

45 Breton's preface to the catalog for Hantaï's work is reprinted in *Le Surréalisme et la Peinture*, 237.

46 The debate continued in no. 5 of *le surréalisme, même*, in which José Pierre published "Les Templiers de la barbouille, ou la peinture au service du fascisme" (Knights Templar of dabbling, or painting in the service of fascism.) He retraced, in particular, the career of Mathieu, who had been entrenched in his ultraroyalist positions since 1948, calling an exhibition in 1954 "Les Capétiens partout!" and exhibiting in May 1958, his "Bataille de Tibériade," which celebrated the founding of the order of the Knights Templar, who vowed to combat Islam.

47 The surrealists signing the tribute were Robert Benayoun, Gabriel Bounoure, Breton, Radovan Ivsic, Gérard Legrand, Jehan Mayoux, André Pieyre de Mandiargues, Joyce Mansour, José Pierre, and Jean Schuster.

48 José Pierre, *Max Walter Svanberg et le règne du féminin* (Paris: Le Musée de Poche, 1975), 68.

49 Pierre Molinier's poems would not be published until 1979, under the title *Les Orphéons magiques* (Bordeaux: Éditions Thierry Agullo).

50 The montage of breasts, buttocks, mouths, and thighs that is prevalent in certain of Molinier's works

shares similarities with the physiological anagrams that Bellmer had devised with his *Poupée:* the body has no stable reality, and it is at the disposition of fetishism that magnifies fragments (by enlargement, repetition, or the play of mirrors).

51 Breton's preface for Molinier's show is reprinted in *Le Surréalisme et la Peinture,* 245 ff. It was used as a commentary for the film that Raymond Borde devoted to Molinier in 1963 (see *Positif,* no. 66 [January 1965]).

52 The quote by Molinier is from P. Petit, *Molinier, une vie d'enfer* (Paris: Ramsay/Pauvert, 1992), 85.

53 Ibid., 91.

54 José Pierre, "Le Gouvernement de l'écume," in *L'Abécédaire, précédé par "Le Dialogue monotone" et suivi de "Le Gouvernement de l'écume"* (Paris: Éric Losfeld, 1971), 495.

55 Charles Estienne, "La Peinture et l'époque," *Confluences,* no. 10 (March 1946).

56 Kandinsky is for Estienne the prime reference, the moment one begins to reflect on the riches of the nonfigurative path. See, e.g., Wassily Kandinsky, "L'Art abstrait au XXe siècle," in *Pour et contre l'art abstrait,* Cahiers des amis de l'art, no. 11 (Paris: Les Amis de l'Art, 1947).

57 Charles Estienne, *L'Art abstrait est-il un académisme?* (Is abstract art an academicism?), Collection le cavalier d'épée (Paris: Éditions de Beaune, 1950).

58 André Breton, "L'Épée dans les nuages, Degottex," reprinted in *Le Surréalisme et la Peinture,* 341 ff.

59 Péret, for once, seemed to set aside his ongoing hostility toward nonfigurative painting. But this was because he found in Duvillier's work an original way of imposing movement on selected "objects": "His sea, his horses, his curlews, his rocks are not out of keeping with the traditional view that each of us might have kept within, but the movement that brings them to life transforms them and confers upon them almost supernatural attributes" ("A gros bouillons," in *Œuvres complètes,* 6:348). Breton's preface for Loubchansky is reprinted in *Le Surréalisme et la Peinture,* 344 ff.

60 André Breton, "Leçon d'octobre," reprinted in *Le Surréalisme et la Peinture,* 337 ff.

61 Pierre, *L'Abécédaire,* 496–97.

62 See Breton, *Le Surréalisme et la Peinture,* 249, 251 ff., and 254 ff. The dust jacket of the 1965 edition of this work was decorated with a reproduction done not by one of the long-time artists of the movement but by Yves Laloy. As for Rozsda, he had just arrived from Hungary when he met Breton through Simone Collinet, to whom he had shown his drawings; he would later have an exhibition, again at the Galerie Furstenberg, in 1963, and Joyce Mansour would provide a poem and a little text for the event: "A painting by Rozsda, makes one think . . . of the awakening of someone who thought he was sleeping on a precipice, and who was no longer waiting for death to fly away."

63 Cardenas had arrived from Cuba in 1955, and his work was discovered by José Pierre before Breton went on to praise it; in 1956, he took part in a group show at the Étoile Scellée.

64 Édouard Jaguer, *D'un objet qui ne fait pas l'éloge du passé à un présent qui fait l'objet d'un éloge* (From an object which does not praise the past to a present which is the object of praise), catalog of the exhibitions organized between January and July 1951.

65 Ibid.

66 Alechinsky's first solo exhibition in Paris was held in 1954 at the Galerie Nina Dausset (the catalog for which is prefaced by Dotremont). Numerous surrealists or close followers of the group attended, and Brauner and Matta lent a hand to try to help sales, without too much success, however.

67 André Breton, "Triomphe de l'art gaulois" (Triumph of Gallic art), *Arts* (August 1954), reprinted in *Le Surréalisme et la Peinture,* 324 ff. Another article with the same theme, Adrien Dax, "Actualité de l'art celtique" (Celtic art in the present day) appeared , alongside contributions by J. Markale ("Mystères et enchantements des littératures celtiques" [Mystery and enchantment of Celtic literature]) and L. Lengyel ("La Découverte de l'art celtique bouleverse l'histoire de l'art occidental" [The discovery of Celtic art upsets Western art]) in *Médium,* no. 4 (January 1955).

68 As for the "literary" side of the culture of the Celtic world, now totally lost, Breton showed his appreciation for what little was known of it in "Braise au trépied de Keridwen," in his preface to Jean Markale, *Les Grands Bardes gallois* (Paris: Falaize, 1956); reprinted in *André Breton en perspective cavalière,* ed. Marie Claire Duman (Paris: Gallimard, 1996), 130 ff.

69 André Breton, "Présent des Gaules," reprinted in *Le Surréalisme et la Peinture,* 333 ff.

70 Charles Estienne, "La Ligne de l'hérésie," in the catalog to the exhibit *Perennité de l'art gaulois* (Paris: Musée Pédagogique, 1955), 86.

71 Breton had serious reservations about Redon's work, for he did not appreciate his "sort of mythology" or his bouquets, as shown by one of his texts quoted in the catalog *André Breton: La Beauté con-*

vulsive (Paris: Éditions du Centre Pompidou, 1991), 419. Still, Redon was among those on show in 1958 at the exhibition *Dessins symbolistes* organized and prefaced by Breton for the Bateau-Lavoir (the preface "Du symbolisme" was reprinted in *Le Surréalisme et la Peinture,* 357 ff.).

72 André Breton and Gérard Legrand, *L'Art magique,* 2 vols., Formes de l'Art (Paris: Formes & Reflets, Le Club Français de l'Art, 1957). This work was the first volume of a series titled Formes de l'art. Successive volumes in the series included Philippe Verdier, *L'Art religieux* (1957), Louis Hautecoeur, *L'Art classique* and *L'Art baroque,* and Aandré Chastel and P.M. Grand, *L'Art pour l'art* (1955). The concept of the series was subtle but not very practical: two bound leaflets were glued to the inside of the binding—on the left-hand side was the text, on the right-hand side full-page illustrations. If one unfolded the two flaps at the same time, the volume was over eighty centimeters in breadth, which hardly made it an easy work to consult (the other volumes in the series did not receive such a "special" treatment). When Breton and Legrand's *Art magique* was republished (Paris: Éditions Phébus-Adam Biro, 1991), the original layout was not used, and the illustrations were better harmonized with the continuity of the text.

73 Max Ernst's exclusion was made public in January 1955 in the fourth issue of *Médium.* See *Tracts surréalistes,* ed. Pierre, 2:135: "À son gré" emphasized, in particular, that by accepting the prize, Ernst "is cheerfully sacrificing the superior interests of the mind . . . to his material interests" and that his attitude "is of a nature to disorient youth." In April 1956, however, an exhibition was held in Antwerp entitled *Les Points cardinaux du surréalisme* (The cardinal points of surrealism), with a preface to the catalog by Mesens: Ernst was definitely one of the "points" in question, along with Magritte, Tanguy, and Miró. But once he was rejected by the group he would very quickly present himself as the only authentic surrealist and was encouraged by Patrick Waldberg to play this borrowed role in 1964 for the exhibition at the Galerie Charpentier (see chap. 7), where he was the best represented painter in terms of the number of works displayed.

74 See *Tracts surréalistes,* ed. Pierre, 2:146 ff.

75 André Breton, "Un homme à la jonction des grands chemins" (A man at the crossroads of the highways), reprinted in *Le Surréalisme et la Peinture,* 138 ff.

76 Jean Schuster, writing in *Bief,* no. 9 (December 1959).

77 Letter from Breton on Picabia as a forerunner of abstraction, reprinted in *Le Surréalisme et la Peinture,* 224 ff.

78 Francis Picabia, quoted in "Adieu ne plaise," a speech given by Breton at Picabia's grave and reprinted in *André Breton en perspective cavalière,* ed. Duman, 29 ff.

79 The quote is from Yves Tanguy, *Lettres de loin à Marcel Jean* (Paris: Le Dilettante, 1993),129.

80 And David Sylvester, writing about the exhibition, drove home the nail: "His imagination lacks scope: it is excessively repetitive. And like all self-respecting artists, his early works are the best" (quoted in *Yves Tanguy: Retrospective, 1925–1955,* ed. Agnès Angliviel de La Beaumelle and Florence Chaveau, trans. Anne Hindry [Paris: Le Musée, 1982], 226).

81 Tanguy's article in *Art Digest* (January 1954) can be found in French translation in an appendix to *Lettres de loin,* 191.

82 See *Tracts surréalistes,* ed. Pierre, 2:357.

83 Radovan Ivsic, in the catalog by Jana Claverie of an exhibition at the Musée d'Art Moderne, Centre Georges Pompidou, *Styrsky Toyen Heisler* (Paris: Le Centre, 1982), 44.

84 A technique thanks to which he would be able to create, in particular, plaques designed for major mural creations (like that in 1958 for the Parisian headquarters of UNESCO).

85 Miró's stay in Spain, during and after the Second World War, would, as in Picasso's case, have an impact on a good number of young artists and "made a strong contribution to an awareness that was clearly not limited to problems of aesthetics but that extended to life in its entirety, as one hopes of every creator." "Faced with the monstrous pride of the powerful, he showed that we are all equal because we are all made of the very flame of the heavenly bodies" (Antoni Tàpies, "Le Triomphe de Miró," *XXe Siècle* ["Special Issue: Hommage à Miró"] [1972]). From 1947 to 1951 the Catalan review *Dau al Set* was published in Barcelona. It was there that the poet Joan Brossa and his friends—among them Tapiés, who had visited Miró's studio—sought to defuse the heavy atmosphere in the country; under the double influence of Klee and Miró, Tapiés's painting entered fully into its "magical period," rich in imaginary and dreamlike landscapes (*Sofar* [1949]).

86 Breton, introductory text for *L'Œil* (December 1958), reprinted in *Le Surréalisme et la Peinture,* 257 ff.

87 Benjamin Péret, "Wifredo Lam," *Médium,* no. 4 (January 1955); reprinted in *Œuvres complètes,* 6:345.

88 It was during his period away from the Paris group that Magritte held his first solo exhibition in Paris (Galerie du Faubourg, May–June 1948): nearly all of the seventeen canvases and over twenty gouaches that were part of his *période vache* were shown. Created in five weeks and with the perfect cooperation of Louis Scutenaire, who wrote the catalog preface, they were designed to affront viewers, both by means of their deliberately botched and "vulgar" aspect and the caricature of the "Belgian" spirit as exhibited by the painter. Disappointed at not finding Magritte's "normal" style—who clearly conceived the exhibition as an authentically surrealist incongruity—viewers did not catch on; Magritte immediately abandoned this *vache* tactic, revelatory of his tendency toward a "slow suicide"; it was above all, he said, to "please Georgette," who preferred his "painting from the old days."

89 René Magritte, "Discours de réception à l'Académie Picard" (Acceptance speech at the Académie Picard), in Magritte, *Écrits complets,* ed. André Blavier (Paris: Flammarion, 1979), 440.

90 René Magritte, *Lettres à André Bosmans* (Paris: Seghers, 1990), 66.

91 Ibid., 328.

92 In Emmanuel Garrigues, ed., *Les Jeux surréalistes: Mars 1921–septembre 1962* (Paris: Gallimard, 1995), one can find the detailed questionnaire and the answers given by the participants for some of the cards.

93 Shortly thereafter, Césaire would resign from the party, disappointed by the slowness of its de-Stalinization.

94 Gérard Legrand and Aimé Patri's article ("Le Surréalisme est-il une philosophie?" [Is surrealism a philosophy?], *le surréalisme, même*) was a response to the work by Ferdinand Alquié, *Philosophie du surréalisme* (Paris: Flammarion, 1956).

95 Jean Schuster, *Les Fruits de la passion,* Collection Griffures (Paris: L'Instant, 1988), 80–81.

96 In the first issue, the periodical published chap. 5 of Darien's *Les Pharisiens,* and in 1955 Breton would write a preface for *Le Voleur:* "His work . . . is found at the antipodes of 'literature,' in the sense where poets can detest it. It is the most rigorous assault I know of upon hypocrisy, imposture, stupidity, and cowardice."

Number 5 of *le surréalisme, même* included excerpts from Panizza's *Le Concile d'amour;* Breton wrote a preface for the play's integral publication by Pauvert.

97 *le surréalisme, même* was also a commercial failure, as shown, on the one hand, by the diminishing print run (in no. 5 it was announced that to reflect "the new concerns of the era," the print run would drop to 1,975 copies; it had been 5,030 for the second issue) and, on the other, by a letter to Pauvert on June 23, 1959, in which Breton asked the publisher to go back on his decision to suspend publication of the periodical. The timing was all the more awkward in that the international exhibition of surrealism was set to open at the end of the year, which would "offer a totally exceptional chance to sell the periodical. . . . At the very moment when surrealism is called upon to return to the main stage and sensational new contributions will assure it of a maximum impact, you will understand," insisted Breton, "that the disappearance of *le surréalisme, même* is in my opinion, a disaster" (letter quoted in the sales catalog of *Manuscrits et lettres autographes,* Hôtel Drouot, Maître Loudmer, June 17, 1991, no. 40). The publication of *Bief,* which took up, in a way, where the first series of *Médium,* in broadsides, had left off, before the actual public end of *le surréalisme, même,* was also a way of warding off the "disaster."

98 In 1953, the first volume of Ionesco's *Théâtre* (including *La Cantatrice chauve, La Leçon, Jacques ou la soumission,* and *Le Salon de l'automobile*) was published by Losfeld, with a foreword by J. Lemarchand. When *Jacques ou la soumission* was first performed at the Théâtre de la Huchette in 1955, Breton wrote a text for the program titled "Toupie ronflante" (republished in *Cahiers des saisons,* no. 15 [winter 1959]): "Let us—if we are in a mood for looking for antecedents—watch for Kierkegaard's distant nod to Hegel and the haughty sign that was given in response, but above all let us savor, as with a master's hand Ionesco places us at the limits of spasmodic laughter and anxiety, the bitter pleasure of watching our privileged-subaltern position bare itself, as if in a trance, so that it makes us take part in both a mass of madmen and the rounds of prisoners." By the time of *Rhinocéros,* this was already no longer the case.

99 Roger Caillois, *L'Art poétique, suivi de traductions de la Vajasameyi, Sambita (XXIII, 45–62)* (Paris: Gallimard, 1958; reprint, Cognac: Le Temps qu'il Fait, 1991).

100 *Cote d'alerte,* reprinted in *Tracts surréalistes,* ed. Pierre, 2:145 ff.

101 While there were some readers at the time who might have felt that the group was excessively pessimistic on this point, they would change their mind when the "racist attacks" did indeed become quite frequent in the streets of the capital.

102 Set up in November 1955, the Intellectual Action Committee against the Continuation of the War in North Africa gathered several hundred members from greatly divergent political backgrounds (Communist Party, non-Stalinist Marxists, anarchists, Christians, surrealists, Sartriens, and so on). While it was divided between those who intended to support the Algerian "insurrection" and partisans of simple pacifism, the minimal proposal of substituting negotiation for war had unanimous support.

103 Jean Schuster and André Breton, *Au tour des livrées sanglantes!* reprinted in *Tracts surréalistes,* ed. Pierre, 2:154 ff.

104 *Hongrie, soleil levant,* reprinted in *Tracts surréalistes,* ed. Pierre, 2:161. In *le surréalisme, même,* no. 2 (spring 1957), Péret returned to the events in Hungary in "Calendrier accusateur" (reprinted in *Œuvres complètes,* 5:295 ff.).

105 "Apel en faveur d'un Cercle international des Intellectuels révolutionnaires" (Appeal in favor of an international circle of revolutionary intellectuals), reprinted in *Tracts surréalistes,* ed. Pierre, 2:162.

106 Georges Arnaud and Jacques Vergès, *Pour Djamila Bouhired,* Documents (Paris: Éditions de Minuit, 1961). This work was a continuation of one by Germaine Tillion, *L'Algérie en 1957,* Documents (Paris: Éditions de Minuit, 1958); English trans.: *Algeria: The Realities,* trans. Ronald Matthews (New York: Knopf, 1958). It preceded Jean Dresch et al., *La Question algérienne,* Documents (Paris: Éditions de Minuit, 1958): Henri Alleg, *La Question,* Documents (Paris: Éditions de Minuit, 1958); English trans.: *The Question* (New York: G. Braziller, 1958), which was seized as soon as it was published in February of that year, and Pierre Vidal-Naquet, *L'Affaire Audin,* Documents (Paris: Éditions de Minuit, 1959). In February 1959, *La Gangrène* (Paris: Éditions du Minuit); English trans.: *The Gangrene,* trans. Robert Silvers (New York: L. Stuart, 1960), a joint work by seven Algerians living in France at the time of their arrest, was also seized. In April 1959, a novel by "Maurienne," a pseudonym for Jean-Louis Hurst, *Le Déserteur,* Les Jours et les nuits (Paris: Éditions du Minuit, 1959), suffered the same fate. On all of these works, see *Provocation à la désobéissance: Le Procès du "Déserteur"* [Paris: Éditions de Minuit, 1962]).

107 The three issues of *Le Quatorze Juillet* were reprinted in a special issue of *Lignes* (A periodical under the editorship of Dionys Mascolo published in Paris by Éditions Séguier). The first issue of *Le Quatorze Juillet* was preceded by a manifesto dated May 17, 1958, asserting that, to respond to the coup in Algiers, there was no other solution in France than a general strike. "Only the committees of antifascist struggle and a sustained action by the people, founded on the demand that the war in Algeria come to an immediate halt, will be able to break a movement in France itself that is merely the measure of our passivity."

CHAPTER SEVEN

1 Benjamin Péret, "Écrasé entre deux blocs," (Crushed between two blocs), *Bief,* no. 1 (November 15, 1958). With regard to the award of the Nobel Prize for Literature to Boris Pasternak, the article confirmed that "artists and poets worldwide can express nothing other than irreducible hatred" toward the Moscow regime; and in "En flicocratie" (no. 5 [March 1959]) he denounced the official leniency toward policemen. In the preface to *La Poesia surrealista francese* (ed. Benjamin Péret, trans. Roberto Sanesi and Tristan Sauvage, La poesia del novecento, no. 2 [Milan: Schwartz, 1959])—which was unpublished in French until it was included in Péret's *Œuvres complètes* (7 vols. [Paris Éric Losfeld, 1969–95], vol. 7)—Péret insisted that selection criteria include "loyalty to authentic poetry, of which surrealism is the present era's most brilliant avatar"—whence the absence, in particular, of Tzara (who had put an end to the "misunderstanding" on which his "accidental participation" in the movement was based "the moment Stalinism was willing to take him into its hovel"), and the inclusion of poets who were newcomers to the group: Cabanel, Duprey, Flamand, Lebel, Legrand, Mansour, and others. The *Anthologie des mythes, légendes et contes populaires d'Amérique,* on which Péret had been working for years, was not published until 1960 (Paris: Albin Michel).

2 In a way, the survey "on erotic representations" launched in *La Brèche,* no. 6 (June 1964) may be considered to be the "continuation, through other means," of *EROS.*

3 Marcel Duchamp in *Bief,* no. 9 (December 1959).

4 Breton's comments in *Dernière heure* are reprinted in *Tracts surréalistes et déclarations collectives,* ed. José Pierre, 2 vols. (Paris: Éric Losfeld, 1980–82), 2:182.

5 Georges Bataille's *L'Érotisme* (Paris: Éditions de Minuit, 1957; reprint, Paris: Unon Générale d'Éditions, 1972). When Bataille was preparing his *Les Larmes d'Éros* (Paris: J. J. Pauvert, 1961), he paid

equal attention to Breton: in a letter to Lo Duca he wrote, "It is out of the question for me to neglect anything for 'Les larmes d'Éros.' In particular, from today on I want to speak to you of the idea of a talk I could give when the book comes out. I'll try to come to an understanding with André Breton about the subject of the lecture."

6 The quoted material is from André Breton, *Le Surréalisme et la Peinture* (Paris: Gallimard, 1965), 377 ff.; English trans.: *Surrealism and Painting,* trans. Simon Watson Taylor (New York: Harper & Row, 1972).

7 *Lexique succint de l'érotisme,* Le Désordre, no. 5 (Paris: Galerie Daniel Cordier, 1959; reprint, Paris: Éric Losfeld, 1970.)

8 ["I suppurate, you suppurate, the flesh suppurates. Thanks to the poor venereal fool who is scarcely venerable." *Trans.*]

9 J. Bardiot, in *Finance,* quoted in "Des biscuits pour la route," a piece signed "Le Movement surréaliste in *Bief,* no. 10–11 (February 15, 1960).

10 *À vous de dire,* reprinted in *Tracts surréalistes,* ed. Pierre, 2:183.

11 On the animosity toward former group members, see *La Bénédiction de l'un vaut l'autopsie de l'autre,* in *Combat-Art,* signed by Breton, Legrand, Pierre, and Schuster, as well as Alechinsky, Baj (the "editor of the periodical *Il gesto*"), Jaguer, Lacomblez (whose periodical *Edda* was the equivalent in Brussels of *Phases*), Lambert (as editor-in-chief of the *Cahiers du Musée de Poche*), and Linas (for the Buenos Aires periodical *Boa*). See also the *Mise au Point* sent at the same time to A. Parinaud; and *Tir de barrage,* which targeted Lebel and Jouffroy, the organizers of an "antitrial" based on principles that mixed moral concerns with a policeman's spirit, signed by fifteen members of the Phases group (in *Tracts surréalistes,* ed. Pierre, 2:191, 194, 197).

12 *We Don't EAR It That Way,* reprinted in *Tracts surréalistes,* ed. Pierre, 2:209. Another indication of the rapprochement was the exhibition devoted to *greffage,* in response to William Chapin Seitz, *The Art of Assemblage* (New York: Museum of Modern Art, 1961) in New York—jointly organized at the Galerie Ranelagh in 1962, at which there were forty-six exhibitors (Alechinsky, Baj, Benoit, Brunius, Gironella, Heisler, Lacomblez, Parent, Silbermann, etc.).

13 As for the reasons why Duchamp welcomed Dalí to the exhibition . . . one might suppose that it was in order to play a tasteless practical joke or to emphasize once and for all the need to finish with any form of taste. But it also seems very possible that Duchamp actually appreciated Dalí's work.

14 The text that Jeanson submitted to the Éditions de Minuit, which came out under the title *Notre guerre,* was dated June 6.

15 This is a summary of the exhaustive account in *Tracts surréalistes,* ed. Pierre, 2:390 ff.

16 At the time of the declaration, the Communist Party advised its militants to leave for Algeria or, at least, to stay in France and, within the army, disseminate a counterpropaganda.

17 A formula that clearly revived the title of the 1947 pamphlet *Liberté est un mot vietnamien.*

18 When the text was distributed, there were a good number of surrealists who followed the four initial volunteers: after Benayoun, Breton, Legrand, and Schuster came Bédouin, Borde, Bounoure, Cabanel, Dax, Elleouët, Jaguer, Joubert, Lagarde, and Losfeld, as well as Leiris, Mandiargues, Masson, and Estienne.

19 Breton's letter is quoted by Charlotte Delbo, *Les Belles Lettres* (Paris: Éditions de Minuit, 1961), 104.

20 Ibid., 118.

21 Tristan Sauvage, *Art nucléaire* (Paris: Éditions Vilo, 1962).

22 ["Flic" is French slang for policeman. *Trans.*]

23 Strindberg's fragmentary remarks on chance in art are available in a translation by Vincent Bounoure. The can now be compared with the 1894 translation and Strindberg's own French translations; thanks to the publication of some of his works (Caen: L'Échoppe, 1990).

24 Robert Benayoun later expanded his research significantly in *Le Ballon dans la bande dessinée* (Paris: Balland, 1968).

25 *Barbarella* was initially serialized in *V Periodical,* a "light" publication of the era.

26 "Main première" was the preface written for the work by Karel Kupka, *Un art à l'état brut: Peintures et sculptures des Aborigènes d'Australie* (Lausanne: Éditions Clairefontaine, 1962).

27 These texts would be reprinted, enriched, and wonderfully illustrated in Pierre Alechinsky's *Titres et pains perdus* (Titles and French toast) (Paris: Denoël, 1965). In 1967, Alechinksy edited the volume *Le Test du titres* (The test of titles), for which sixty-one artists—*tireurs d'élite,* including Audouin, Baj, Chavée, Gracq, Henry, Lam, Mansour, Matta, Mesens, and others—submitted plates. This work was in

the tradition of Tanguy, for their extremely arbitrary juxtaposition of images and titles, or in that of Magritte, who often left it to those close to him to think of a title for his works.

28 Later, Gironella's virtuosity would lead him away from his initial process, and his work would have very little to do with surrealism.

29 The exhibition *New Realists* was held in New York at the Sidney Janis Gallery from October 31 to December 1, 1962. In their introductory texts, Ashbery and Janis described the participants as being in the tradition of Duchamp and Dada. Pop artists and French New Realists were featured, but also Baj, Fahlstrom, and Utveld. Rauschenberg was not present, but Rosenquist was. In Paris, the Galerie Sonnabend, in its premises on the quai des Grands-Augustins, exhibited J. Johns in 1962, and Rauschenberg, Dine, Lichtenstein, and two collective shows in 1963. Warhol, Chamberlain, Rosenquist, and Oldenburg were featured in 1964, and so on. The same gallery would feature Klapheck in 1965 (but no canvases by Klapheck were in the "Sonnabend Collection," which was exhibited as *Collection Sonnabend: 25 anées de choix et d'activités d'Ileana et Michael Sonnabend* at the Musée d'Art Contemporain in Bordeaux in August 1988). On June 21, 1965, José Pierre published an article in *Combat,* "Pour une déclaration sur le droit à l'insoumission dans la peinture contemporaine" (For a declaration on the right to insubordination in contemporary painting), in which he further reproached pop art with being a submission and acceptance of the actual world (but in the mean time, his opinion of Niki de Saint-Phalle had changed, and her work was viewed favorably).

30 On the prevailing design of that time, see Raymond Guidot, *Histoire du design, 1940–1990* (Paris: Hazan, 1994). The samples at the Officina Undici could not even be considered to be forerunners of what the Studio Alchimia would produce in the late 1970s, or the Memphis group after that, or the "neo-Barbarian designers," all of whom would accumulate references that were either artistic (comic strips, ethnic arts) or historical (1940s design revised and corrected, postmodernism intertwining the periods); De Sanctis and Serpini, in contrast, were concerned with the shapes that were inspired by the unconscious and were independent from any history of "styles."

31 Soon, this market of mass production in Europe would be overrun with "original" lithographs by Dalí; the size of the print run generally remained a mystery.

32 *Le "Troisième degré" de la peinture,* reprinted in *Tracts surréalistes,* ed. Pierre, 2:238.

33 For the first time since 1938, Duchamp did not take part in the organization of the 1965 international exhibition. He was represented, however, by three readymades, two of which were from the Schwarz edition.

34 One year later, they remained faithful to the same declaration of intent in "Comment s'en débarrasser" (How to get rid of it): see *Opus international,* no. 49, 102, and the text by Gassiot-Talabot that preceded it. Later, still with the intention of denouncing bourgeois culture, Arroyo produced his series *Miró refait* (Miró done over)—provoking this time an individual reaction from José Pierre (see *L'Abécédaire,* 341 ff.)—and Recalcati created his canvases titled *La Bohème De Chirico.*

35 *Tranchons-en* was a sheet measuring 54 x 21 centimeters, printed in black on a green background on the front, and a white background on the back. Reproduced in *Tracts surréalistes,* ed. Pierre, 2:241 ff., and commented on in the same work, pp. 412 ff.

36 The reference here was the exhibition *Le Surréalisme: Sources—Histoire—Affinités,* organized at the Galerie Charpentier by Raymond Nacenta and, above all, Patrick Waldberg. The Galerie Charpentier was indeed one of the most principal showcases for surrealist art since it usually devoted its space to tributes and retrospective exhibitions of the École de Paris. The exhibition catalog of the same name, edited by Raymond Nacenta and with texts by Nacenta and Patrick Waldberg (Paris: Galerie Charpentier, 1964), included 550 items, divided into such categories as "old correspondence," "presurrealism and surrealism," "artists with surrealist leanings" (Lucien Coutaud, Léonor Fini, Alberto Savinio, and so on), "books, periodicals, documents," "anonymous objects," "natural objects," and "wild objects." On the eve of its opening, the event was denounced by a group text, *Face aux liquidateurs,* published in *Combat* (April 13, 1964) and reprinted in *Tracts surréalistes,* ed. Pierre, 2:227. This did not prevent the show from being a great success with the public, despite the reservations of some of the media and a warning from Breton himself: "No one has the authority to draw up a review of surrealism" (interview with Michel Conil-Lacoste, *Le Monde,* April 15, 1964). José Pierre compiled the most meaningful excerpts from the articles that came out before and during the exhibition in "Cramponnez-vous à la table (Petite suite surréaliste à l'affaire du bazar Charpentier)" (Hold onto the table [a little surrealist suite to the affair of the Charpentier bazaar]), *Le Petit Écrasons illustré,* no. 2 (1964).

37 *Sauve qui doit,* reprinted in *Tracts surréalistes,* ed. Pierre, 2:214.

38 Pauwels and Bergier were "old acquaintances," notably through their hardly scrupulous use of Charles Fort's work *The Book of the Damned* (New York: Boni & Liveright, 1919). In January 1955, the fourth issue of *Médium* included a few excerpts of Fort's book, which motivated Pauwels and Bergier to publish it in its entirety, with a translation and introduction by Robert Benayoun. The book came out in November 1955 with the Éditions des Deux Rives. In 1956, Louis Pauwels took a political position that earned him a reputation as a fascist, and when in 1960 Pauwels and Bergier, the future editors of *Planète,* brought out *Le Matin des magiciens* ([Paris: Gallimard, 1960]; English trans.: *The Morning of the Magicians,* trans. Rollo Myers [New York: Stein & Day, 1964])—with which readers would be completely infatuated—Benayoun noted with utter surprise that fragments of Fort's text and his own preface had actually been appropriated. Nor did they stop there, for in *Planète,* no. 29 (July–August 1966), Benayoun again found more than fifty lines from his preface, again without the slightest mention of his name. The new edition of Fort's *Le Livre des damnés* (Paris: Éric Losfeld, 1967) would later settle the score with a new preface: "Les Bricoleurs du surconscient." As for Pauwels, in May 1968 he published *Dalí m'a dit* (reprint [?], Paris: Ergo Press, 1989) to the glory of the master of Cadaqués, which clearly didn't help his reputation.

39 See José Pierre, "Les Fausses cartes transparentes de Planète," *Le Petit Écrasons illustré,* no. 3 (Paris: Le Terrain Vague, 1965).

40 It is difficult when one comes across the word "laboratories" not to think of the declaration on January 18, 1958, *Démasquez les physiciens: Videz les laboratoires* (reprinted in *Tracts surréalistes,* ed. Pierre, 2:172): "Religion was for a long time the opium of the people, but science now stands poised to take over."

41 André Breton himself had hardly envisaged such a theme for inclusion in an exhibition primarily devoted to the exaltation of womankind and love.

> It was difficult to put together a group of works devoted to such a topic. But Breton wouldn't budge. . . . When a few of us . . . came out . . . in favor of a counter exhibition and fair demystifying the world of household appliances, information technology, and aeronautics, and unmasking the fraud wherever there was an invitation to "happiness," Breton, far from protesting again, asked a few questions and then went thoughtful for a moment. "We could," he said, or something to this effect, "call this *the absolute divide.*" He had remembered a passage in which Fourier suggested that in order to attain any sort of truth one must take the opposite road from what is ordinarily done within the extraordinary empire of civilization.
>
> (Philippe Audoin, *Les Surréalistes* [Paris: Éditions du Seuil, 1973], 152)

42 In 1965, however, the novel by Georges Perec was published: *Les Choses: Une histoire des années soixante,* Les Lettres Nouvelles (Paris: Juillard, 1965); English trans.: *Less Choses: A Story of the Sixties,* trans. Helen R. Lane (New York: Grove Press, 1968). But between his irony and the surrealist offensive there was a certain distance.

43 Audoin, *Les Surréalistes,* 147.

44 [Here, a pun is intended: *L'Œuf fait nix = Le Phoenix. Trans.*]

45 [Another pun: *Bonaparte manchot* (One-armed Bonaparte) = *Bon apartement chaud* (Nice warm apartment). *Trans.*]

46 Jean Schuster, *Raison sociale décousue main,* is reprinted in Schuster, *Archives 57/68: Batailles pour le surréalisme* (Paris: Éric Losfeld, 1969), 73.

47 From Nora Mitrani to Annie Le Brun, by way of this warning from Benayoun, the surrealists' demands for women to be freed from the constraints imposed on them by society were of a totally different mold than that of "official" feminism. In 1957, Nora Mitrani said ironically, "They imagine, these poor women, that liberation is within reach because in their hands they hold a ballot slip and a personal checkbook. They haven't understood, or have misunderstood, Rimbaud's great hope: he wanted them to be human, but different, poets in a way hitherto unknown on earth" (*le surréalisme, même,* no. 3). Twenty years later, Annie Le Brun would cross swords with the "neo-feminists" (*Lâchez tout* [Paris: Éditions du Sagittaire, 1977]) and notably accused them of imagining nothing better, in terms of liberating ideas, than a "Stalinism in petticoats" ("Un stalinisme en jupons"—title of one of the articles collected in Le Brun, *À Distance* [Paris: J. J. Pauvert aux Éditions Carrèrre, 1984]).

48 It goes without saying that this text, thirty years on, has actually gained in pertinence, given the omnipresence in the press, on television, and in "leisure" activities of everything that has to do even remotely with "sport."

49 Artists who had earlier been excluded from the group were only represented by works dating from

the era when they were members—a far remove from the laxity that governed the selection of works figuring in Patrick Waldberg's exhibition in 1964.

50 In Reinhoud's case, his sculptures in bread dough, many examples of which also featured in Alechinsky's work, *Titres et pains perdus* (Paris: Denoël, 1965). And Télémaque was represented there with *Confidence,* a painting-object that measured 1.95m x 1.30 meters [76 x 50 inches], later destroyed.

51 Concerning the impact of social structuring on critical reactions, "Des biscuits pour la route" ([Cookies for the road] *Bief,* no. 10–11 [February 1960]; reprinted in *Tracts surréalistes,* ed. Pierre, 2:185 ff.) contained a delightful anthology of critical reactions from the exhibitions of 1938, 1947, and 1959.

52 The surrealists were particularly put upon by that "dialectic" during the 1950s: see above, 491 ff.

53 The quote is from Jean-Pierre Gorin, "Surréalisme pas mort?" *Le Monde,* August 27, 1966.

54 Philippe Audoin, "La Culture allant se rhabiller pour les surréalistes même" (Culture went and got dressed for the surrealists themselves), *L'Archibras,* no. 1 (1966). The text denounced, in passing, the intellectuals who were "disappointed" by the group's docility at Cerisy, like René Lourau who felt that he had taken part in an involuntary version of the One in the Other game, where surrealism was transformed into university culture, and that academia was slowly beginning to welcome a movement that had become presentable ("Un surréalisme 'désintéressé,'" *Combat* [August 13, 1966]).

55 *Le Nouvel observateur,* October 5, 1966.

56 *Pour un demain joueur* (May 1967), reprinted in *Tracts surréalistes,* ed. Pierre, 2:259.

57 Although one might initially have been tempted to see the formula in the subtitle as an allusion to the special installment of *Variétés,* "Le Surréalisme en 1929" (reprinted with a foreword by Philippe Dewolf [Brussels: Didier Devillez, 1994]; see also 178 ff.), it quickly became apparent that every issue of *L'Archibras* was dated in this way: clearly, the publication sought to evaluate the state of surrealism, its initiatives and offensives, at a given moment.

58 The exhibition in São Paulo would be titled *Thirteenth International Exhibition of Surrealism,* and it was the occasion for a major catalog in August 1967, presented as the first (and in fact the only) issue of *A Phala,* a periodical announced as the "Revista do Movimente Surrealista." The catalog contains pieces in "Brazilian, Portuguese, Spanish, and French": a declaration by the surrealist movement of São Paulo; summary articles by Leila F. Lima and Sergio Claudio De Franceschi Lima; a group of texts about Fourier (excerpts from his *Nouveau monde amoureux*—available as vol. 7 of Fourier's *Œuvre complètes,* ed. Simone Debout-Okeszkiewicz [Paris: Éditions Anthopors, 1966]—and Breton's *Ode à Charles Fourier* [Paris: Fontaine, 1947]; English trans.: *Ode to Charles Fourier,* trans. Kenneth White [London: Cape Goliard, 1969], as well as a study by S. Debout); and pieces by Annie Le Brun, Alain Joubert, José Pierre (a "dramatic" tribute to Leonora Carrington), Cruseiro Seixas, Vincent Bounoure, Aimé Césaire, and others. A special tribute was devoted to Benjamin Péret by Sergio Claudio De Franceschi Lima, and illustrations balanced out the contributions from Paris and "local" participation (Cassio M'Boy, R. Ferra, J. Rodrigues, and others). The catalog included a statement, in French, by the Parisian surrealist group, "Chirologie surréaliste," which was published separately in translation in pamphlet form as *Gogo-de-Sola* (Paris: Éditions Surréalistes, 1967), which in Paris that same year brought out *Talismans* by Vincent Bounoure and Jorge Camacho, *Le Ça ira* by José Pierre, *Le Puits dans la tour* and *Débris de rêves* by Radovan Ivsic and Toyen, and Annie Le Brun's *Sur le champ.*

 The Bratislava exhibition, *The Pleasure Principle,* which would be the movement's last international event, did not actually materialize until 1968, when it was shown successively in Brno (from February 18), Prague (April 9–May 2), and Bratislava (June 15–early July), after lengthy negotiations. The groups in Bratislava (Albert Marencin) and Prague (Vatislav Effenberger, Peter Kral) were wary of each other at first, and it would be up to Vincent Bounoure, José Pierre, and Claude Courtot to define the exhibition's theme in 1967, from Paris. Courtot had to negotiate with the different groups in Czechoslovakia to get them to agree, and after concessions on all sides, the agreement was finalized on the basis of three principles: "an insistence . . . upon the difference between *formal* fantasy . . . and the deep and aggressive ideological content of surrealism"; a desire to emphasize current research (of the twenty artists represented, only Matta, Schröder-Sonnenstern, and Toyen could be considered relatively "old"), and an absence of political dimension (the inhabitants of Prague showed little interest in Vietnam or in guerrilla fighters, and they were already disillusioned with Cuba). The catalog contained four essays and many illustrations accompanied by quotes: praise of the unusual (Courtot),

hope in a surrealist civilization (Bounoure), symbols and myths of alchemy (Audoin), artistic invention in tune with authentic desire (José Pierre, whose piece "Sifflera bien mieux le merle moqueur" [The mocking blackbird sings far better], also came out in *L'Archibras,* no. 3). The event was an unqualified success with the public. Although it confirmed the existence of a "different accent" (P. Kral) between French and Czechoslovak surrealists (who favored imagination that was ironic rather than erotic and felt that the fundamental values upheld in Paris—love, poetry, freedom—were closely tied to a given historical situation), the event also led to the composition of a "Prague Platform" that would be published in the September 1968 issue of *L'Archibras* (see Claude Courtot, Marie-Claire Dumas, and Peter Kral, "Le Principe de plaisir," in *Du surréalisme et du plaisir,* ed. Jacqueline Chénieux-Gendron [Paris: Éditions José Corti, 1987], 261 ff.).

59 One example of the calling to order of "intellectuals" includes Philippe Sollers's responses to Joyce Mansour were replaced by empty columns the moment Sollers began to praise Aragon.

60 In 1965, J.-M. Goutier and Giovanna sealed their adhesion to the group with their show *La Carte absolue,* initially conceived to be included in *L'Écart absolu.* In 1967, they organized a second show, *La Crête de l'incendie,* on the occasion of the exhibition *La Fureur poétique.*

61 Jean Schuster, "Flamboyant de Cuba, arbre de la liberté," reprinted in Schuster's *Archives 57-68,* 161 ff.

62 Jean Schuster, "The Theoretical Basis of Surrealism," reprinted in Schuster's *Archives 57-68,* 143 ff.

63 See G. Gassiot-Talabot: "La Havane, peinture et révolution," in *Opus international,* no. 3 (October 1967). This issue also published the declaration "Pour le Congrès culturel de La Havane" ("all it takes is to go around Havana or the rest of the island to see that the Cuban revolution, be it through the posters alone that are its expression in words and in images, literally makes poetry step down into the street"); seventy-seven artists and intellectuals signed the declaration, an exceptionally ecumenical gathering, including Leiris, Jouffroy, Jorge Semprun, Marguerite Duras, Jean Schuster, Ghérasim Luca, Peter Weiss, José Pierre, and others. Camacho had traveled with his wife Margarita for five months across the island and had already formed an opposite opinion, for he had discovered a real police dictatorship, which he would denounce on numerous occasions after he returned to Europe. In 1988, with his friend Reinaldo Arenas, who was by then an exile in New York, he wrote an open letter to Castro, calling for free elections and the liberation of all political prisoners—a document that would garner over two hundred signatures from intellectuals the world over (see Reinaldo Arenas and Jorge Camacho, *Un plebiscito a Fidel Castro* [Madrid: Editorial Betania, 1990]).

64 Michael Leiris, and Jean Schuster, *Entre augures* (Paris: Le Terrain Vague, 1990), 40.

65 *Pas de pasteurs pour cette rage!* reprinted in *Tracts surréalistes,* ed. Pierre, 2:276 ff.

66 Franklin (1943) and Penelope (1942) Rosemont organized the first surrealist group in America in 1966 and would be joined by Lamantia and Kamrowsky, both former contributors to *VVV.* Poets and plastic artists, they sustained group activity, evident most notably in the exhibition *Marvelous Freedom—Vigilance of Desire,* which in 1976 gathered 150 participants, and in the periodical *Arsenal,* founded in 1978. Aldo Pellegrini (1903–73) was one of the most active ambassadors of surrealism in Latin America. In 1926 he founded a group in Argentina. He was a poet, translator, and critic and edited a number of collections open to the major currents of modern art. Pellegrini also published a remarkable *Antologia de la poesia surrealista,* Colección los poetas (Buenos Aires: Compañia General Fabril Editora, 1961). Georges Gronier (1934), thanks to his professional travels, had the opportunity to nurture a friendship with Duchamp, Breton, Luca, Jaguer, and others. He was a regular contributor to Jacques Lacomblez's periodical *Edda* and to the activities of Phases before becoming a member of the collective Maintenant.

67 The exception to the near absence of Czech surrealists in the two installments was an obituary by P. Kral devoted to Zbynek Havlicek (1922–69), poet and translator of Breton and Freud into Czech.

Concerning the surrealists' watchfulness with regard to the different creations of the mind, among other indications of this vigilance, one might note, in *L'Archibras,* no. 6 (December 1968), a fairly favorable account by Annie Le Brun of Juan Dubuffet's *Asphyxiante culture* (Libertés nouvelles, no. 14 [Paris: Éditions de Minuit, 1968]; English trans.: *Asphyxiating Culture and Other Writings,* trans. Carol Volk [New York: Four Walls Eight Windows, 1988]), a work that received scant attention from journalists.

68 *Dada, Surrealism and Their Heritage* moved from the Museum of Modern Art, New York (March 27–June 9, 1968), to Los Angeles (July 16–September 8), and finally to Chicago (October 19–December 8). Franklin and Penelope Rosemont reproached Rubin for having obliterated the revolutionary nature of surrealism in order to "immerse it in a bath of pseudo-critical formalin." Equally regrettable

was the fact that the exhibition presented, as belonging to the "heritage" of surrealism, works by Adami, Jenkins, Yves Klein, and Maurice Lemaître. Even the presence among the 331 items in the catalog of two works by Michaux was not, whatever their merits, rigorously warranted. As for the catalog's chronology, it stopped in 1945.

69 In 1967, John Lyle (1932) organized an exhibition entitled *The Enchanted Domain* in Exeter, with the help of Brunius, Conroy Maddox, and Mesens. The following year he founded the periodical *Transfor-maCtion;* its tenth issue, in 1979, would be a collective tribute to Mesens.

70 Philippe Audoin, Claude Courtot, Gérard Legrand, José Pierre, and Jean-Claude Silbermann, *Aux grands oublieurs, salut!* (February 13, 1969), reprinted in *Tracts surréalistes,* ed. Pierre, 2:285.

71 Jean Schuster was still listed as the editor for *L'Archibras,* no. 7 (March 1969), but it was ready to print in January of that year and his only contribution in the issue was a short paragraph on "Le Fond de l'air" that concluded with "Let it be well understood that I have nothing but scorn for those who may try to follow me wherever I go."

72 *Sas,* reprinted in *Tracts surréalistes,* ed. Pierre, 2:286.

73 With some cuts: the unabridged text of *Le Quatrième chant* can be found in *Tracts surréalistes,* ed. Pierre, 2:291 ff.

74 Schuster thereby implied the possibility of "surrealist groups" continuing their activities outside France, by taking their strength, in particular, from the 1968 Prague Platform.

75 There is clearly, in this formulation, a response to but also an amplification of the long-term aims that André Breton had already voiced in *Les Vases communicants* (Paris: Éditions des Cahiers Liberes, 1932; reprint, Paris: Gallimard, 1970); English trans.: *Communicating Vessels,* ed. Mary Ann Caws, trans. Mary Ann Caws and Geoffrey T. Harris (Lincoln: University of Nebraska Press, 1990).

76 The *Bulletin de liaison surréaliste* was republished in 1977 at the Éditions Savelli.

77 Joyce Mansour had not signed the *Sas* declaration.

78 The format of *Coupure* was similar to that of a daily paper and was also reminiscent of *Néon* or the first series of *Médium,* but *Coupure* also had color.

79 Gabrielle Russier was a schoolteacher who had been sentenced for corruption of a minor because she had been having a love affair with one of her students; she commited suicide through gas inhalation. Sharon Tate was the American actress murdered in her villa by a "visionary." Bernadette Devlin was an Irish revolutionary: "It is scandalous even today, for a woman, to be beautiful, to want to be loved, or to desire freedom" (José Pierre).

80 In his *Histoire de Tel Quel* (Paris: Le Seuil, 1995), Philippe Forest evokes "*Tel Quel* contre le néo-sur-réalisme" (pp. 432 ff.). He begins by reminding readers that Breton was "one of the strongest references . . . of the nascent periodical," then goes on to say that Breton's death "allowed for the constitution of a common front of Aragonism/Surrealism among the writers of the French Communist Party" and that "in addition to Jean Schuster, Alain Jouffroy has been one of the main promoters of the surrealist renewal" since May 1968—which seems proof of a certain taste for confusion. In 1971, the aim, at *Tel Quel,* was to "struggle against the dissemination of a neo-surrealism that at the same time was multiplying and aggravating the characteristic misunderstandings of Breton's ideas"—which implied that surrealism could be summed up by "Breton's ideas." As for the very notion of "neo-sur-realism" designating a period during which the group—to which surrealism owed its existence—had disappeared, it is difficult to see what it might refer to. In fact, the hostility of the former members of the group stemmed primarily not from a jealousy of an old "avant-garde" toward a new one, as Forest had suggested (it is true that he moved easily from *Coupure* to the periodicals *Change* or *Action poé-tique*) but from the political positions of Philippe Sollers and his friends: the rapprochement with the French Communist Party and then the adherence to "the thought of Mao-Ze-Dong" might suggest that this was a comic reenactment of the dramatic events within the surrealist group that followed the 1920s.

81 The Bechers and their "anonymous sculptures" in the first issue; Joseph and Eva Beuys in the sec-ond—this was true for the Exquisite Corpses created with Konrad and Lido Klapheck and Kali-nowski.

82 For the term "interiorized," see José Pierre, *Le Surréalisme, aujourd'hui* (Paris: Éditions de la Quinzaine littéraire, 1973): "Surrealism has now entered . . . a phase of interiorization."

Readers were notified of the exhibition *Surrealism?* (Stockholm, Göteborg, Sundsvall, and Malmö, March 6–June 30, 1970) in an article by Ragnar von Holten, who was the exhibition's coor-

dinator along with José Pierre; the article was borrowed from the *Chroniques de l'art vivant* (April 1970), and it actually used the original introductory text from the catalog, where it was accompanied by a fragment from Schuster's *Le Quatrième chant.* Its originality, signaled by the question mark of the title, stemmed from the fact that it took into account the surrealist idea in its contemporaneous sense, particularly insofar as it opened onto "an expanded desire for subversion." The two directors of the exhibition were assisted by Silbermann, Télémaque, and K. G. Pontus Hulten, and the exhibition itself was organized as a suite of cubes (one cube per letter, including the question mark) in which works and objects on a given theme were shown: Poetic Fury, Dream, Love Object, Perversity, and so on. Works by "precursors" (from Archimboldo to Munch) and initiators (De Chirico, Miró, Man Ray) were featured, but the exhibition also included recent work by individuals who did not necessarily belong to the group (Barbieri, Tsoclis, Gilardi), as a token of the desire for "openness" and exchange affirmed by the Prague Platform.

83 The minutes of the trial were published in *Procès à Coupure,* Le Désordre (Paris: Éric Losfeld, 1972). This series, edited by Schuster, began in 1970 at the same time as *Coupure* and followed similar principles: classics of the movement (Cravan, Vaché, Péret, Thirion), hitherto unpublished pieces (José Pierre, C. Courtot, Schuster, Jean-Christophe Bailly on Péret), and contributions deemed worthy of debate from intellectuals (Dionys Mascolo, *Du rôle de l'intellectuel dans le mouvement révolutionnaire selon Jean-Paul Sartre Bernard Pingaud, et Dionys Mascolo,* Le Désordre [Paris: Éric Losfeld, 1971]).

84 A greater selection of images than the eight sepia ones featured in *Coupure,* no. 7 (1972) was reproduced in a large format and in color in Jacques Baynac, ed., *Ravachol et ses compagnons* (Paris: Éditions du Chêne, 1976).

85 This would enable him to review the new exhibition organized in 1972 by Patrick Waldberg, this time at the Musée des Arts Décoratifs in Paris: in addition to an arbitrary time frame, ("Le Surréalisme, 1922–1942"), which was not even respected, the event suffered from confusion, and José Pierre felt that the spirit of surrealism was absent. This led him to pose an essential question: "I had reached the stage of wondering whether surrealist painting had not betrayed surrealism. On the one hand by helping to place the works (the letter) above the spirit. And on the other by drawing surrealism, through the media of galleries, the art market, market value, and collectors, into a sort of prostitution that was anything but sacred, alas." He nevertheless decided to illustrate his article with a reproduction of Tovar's *La Fontaine mélancolique* (1969), which enabled him to conclude on a note of optimism: "Surrealist painting continues to be invented" ("Le Surréalisme à l'heure de la consécration," *La Quinzaine littéraire* (August 1, 1972).

86 "Des rendez-vous décevants avec l'histoire" (Disappointing appointments with history), *Le Monde,* April 16, 1996; reprinted in M.-C. Dumas, ed., *André Breton en perspective cavalière* (A casual look at André Breton) (Paris: Gallimard, 1996).

Bibliography

REPRINTED PERIODICALS

Almanach surréaliste du demi-siècle (1950). Paris: Éditions Plasma, 1978.

Bulletin de liaison surréaliste (1970–76). Paris: Éditions Savelli, 1977.

Clé (1939). Foligno: Centro Studi Pietro Tresso, 1995.

Correspondance (1924–1925). Brussels: Didier Devillez, 1993.

Les Deux Sœurs (1946–47). Ed. Christian Dotremont. Collection des réimpressions des revues d'avant-garde, no. 20. Paris: Jean-Michel Place, 1985.

Distances (1928). Brussels: Didier Devillez, 1994.

Documents 34: Intervention surréaliste. Foreword by Stéphane Massonet, Collection Fac-similé. Brussels: Didier Devillez, 1998.

Infra-noir (1947). Collection of Publications by the Romanian Surrealist Group. Paris: La Maison de Verre, 1996.

L'Invention collective (1940). Ed. René Magritte, and Raoul Ubac. Brussels: Didier Devillez, 1995.

Légitime défense (1932). Paris: Jean-Michel Place, 1979.

Les Lèvres nues (1954–58). Ed. Marcel Mariën. Paris: Éditions Plasma, 1978; Paris: Éditions Allia, 1995.

Littérature (1919–1924). Paris: Jean-Michel Place, 1978.

Marie (1926–1927). Brussels: Didier Devillez, 1993.

Mauvais temps (1935). Preface by Pol Bury. Collection Fac-similé. Brussels: Didier Devillez, 1993.

Minotaure, 1933–1939. Geneva: Skira, 1981.

Néon (no. 1 [1948]). Ed. Sarane Alexandrian et al. Thonon-les-Bains: Maison des Arts Thonon-Évian, 1996.

Œsophage (1925). Introduction by Rik Sauwen Brussels: Didier Devillez, 1993.

Le Quatorze Juillet (1945–59). Special issue of *Lignes.* Paris: Éditions Séguier, 1990.

La Révolution surréaliste (1924–1929). Paris: Jean-Michel Place, 1975.

Le Sens propre (1929). Brussels: Éditions Didier Devillez, 1995.

Le Surréalisme au service de la Révolution (1930–33). Paris: Jean-Michel Place, 1976.

"Le Surréalisme en 1929." Foreword by Philippe Dewolf. Special issue of *Variétés.* Brussels: Didier Devillez, 1994.

La Terre n'est pas une vallée de larmes (1945). Ed. Marcel Mariën. Brussels: Éditions Didier Devillez, 1996.

Tropiques (1941–45). Ed. Césaire Aimé and René Ménil. 2 vols. Paris: Jean-Michel Place, 1978.

MEMOIRS, REMINISCENCES, AND CORRESPONDENCE

Alexandre, Maxime. *Mémoires d'un surréaliste.* Paris: La Jeune Parque, 1968.

Alexandrian, Sarane. *L'Aventure en soi.* Paris: Mercure de France, 1990.

Aragon, Louis. *Projet d'histoire littéraire contemporaine.* Paris: Mercure de France, 1994.

———. *Lettres à Denise.* Paris: Maurice Nadeau, 1994.

Audoin, Philippe. *Les Surréalistes.* Paris: Éditions du Seuil, 1973.

Baron, Jacques. *L'An I du surréalisme suivi de l'an dernier.* Paris: Denoël, 1969.

Bédouin, Jean-Louis. *Vingt ans de surréalisme, 1939–1959.* Paris: Denoël, 1961.

Blanchard, Maurice. *Danser sur la corde, Journal, 1942–1946.* Toulouse: L'Ether Vague, 1994.

Brasseur, Pierre. *Ma vie en vrac.* Paris: Calmann-Lévy, 1972.

Breton, André. *Entretiens, 1913–1952, avec André Parinaud [et al.].* Le Point du Jour. Paris: Gallimard, 1952. English translation: *Conversations: The Autobiography of Surrealism.* Translated and with introduction by Mark Polizzotti. New York: Paragon House, 1993.

Buñuel, Louis. *My Last Sigh.* Translated by Abigail Israel. New York: Knopf, 1984.

Cabanne, Pierre. *Entretiens avec Marcel Duchamp.* Paris: Belfond, 1967. English translation: *Dialogues with Marcel Duchamp.* Translated by Ron Padgett. New York: Viking Press, 1971.

Charbonnier, Georges. *Entretiens avec André Masson.* Paris: Juillard, 1958. Reprint, Marseille: Ryôan-ji, 1985.

———. *Entretiens avec Marcel Duchamp* (1960–1961). Marseille: André Dimanche, 1994.

Corti, José. *Souvenirs désordonnés.* Paris: Éditions José Corti, 1983.

Dalí, Salvador. *Diary of a Genius.* Translated by Richard Howard. New York: Doubleday, 1965.

De Chirico, Giorgio. *The Memoirs of Giorgio De Chirico.* New York: Da Capo Press, 1994.

De Gengenbach, Ernest. *L'Experience démoniaque.* Paris: Éditions de Minuit, 1949.

Desnos, Youki. *Les Confidences de Youki.* Paris: A. Fayard, 1957.

Drot, Jean Marie, and Dominique Polad-Hardouin. *Les Heures chaudes de Montparnasse.* Paris: Hazan, 1995.

Duhamel, Marcel. *Raconte pas ta vie.* Paris: Mercure de France, 1972.

Duits, Charles. *André Breton a-t-il dit passe.* Paris: Denoël, 1959.

Éluard, Paul. *Lettres à Gala, 1924–1948.* Paris: Gallimard, 1984.

Ernst, Jimmy *L'Écart absolu: Un enfant du surréalisme.* Translated by Nicole Ménant. Paris: Balland, 1984.

Fraenkel, Théodore. *Carnets, 1916–1918.* Paris: Éditions des Cendres, 1990.

Gascoyne, David. *Collected Journals, 1936–1942.* London: Skoob Books, 1991.

Guggenheim, Peggy. *Out of This Century: Confessions of an Art Addict.* Foreword by Gore Vidal, introduction by Alfred H. Barr. New York: University Books, 1979. Reprint, New York: Ecco Press, 1997.

Hugnet, Georges. *Pleins et déliés.* Paris: Guy Authier, 1972.

Jean, Marcel. *Au galop dans le vent.* Paris: Éditions J.-P. de Monza, 1991.

Josephson, Matthew. *Life among the Surrealists,* New York: Holt, Rinehart & Winston, 1962.

Jouffroy, Alain. *La Fin des alternances.* Paris: Gallimard, 1970.

Leiris, Michel. *Journal, 1922–1989.* Paris: Gallimard, 1992.

———. "45 rue Blomet." In *Zébrage.* Collection Folio Essais, no. 200. Paris: Gallimard, 1992.

Leiris, Michel, and Paul Lebeer. *Au-delà d'un regard: Entretien sur l'art africain.* Lausanne: La Bibliothèque des Arts, 1994.

Leiris, Michel, and Jean Schuster. *Entre Augures.* Paris: Le Terrain Vague, 1990.

Levy, Julien. *Memoirs of an Art Gallery.* New York, G. P. Putnam, 1977.

Magritte, René. *Lettres à André Bosmans, 1958–1967.* Paris: Seghers-Isy Brachot, 1990.

Man Ray. *Self-Portrait.* 1963. Reprint, Boston: Little, Brown, 1999.

Mariën, Marcel. *Le Radeau de la mémoire.* Paris: Le Pré aux Clercs, 1983.

Masson, André. *Les Années surréalistes: Correspondance, 1916–1942.* Edited by Françoise Levaillant. Classiques de La Manufacture. Paris: La Manufacture, 1990.

Miró, Joan. *Ceci est la couleur de mes rêves: Entretiens avec George Raillard.* Paris: Éditions du Seuil, 1977.

Nadeau, Maurice. *Grâces leur soient rendues, mémoires littéraires.* Paris: Albin Michel, 1990.

Naville, Pierre. *Le Temps du surréel.* Paris: Galilée, 1977.

Nezval, Vitezslav. *Rue Gît-le-Cœur* (1936). Translated by Katia Krivanek. Preface by Bernard Noël. La Tour-d'Aigues: Éditions de l'Aube, 1988.

Pastoureau, Henri. *Ma vie surréaliste.* Paris: Éditions Maurice Nadeau, 1992.

Penrose, Roland. *Scrapbook, 1900–1981.* London: Thames & Hudson, 1981.

Pieyre de Mandiargues, André. *Le Désordre de la mémoire.* Paris: Gallimard, 1975.

Ribemont-Dessaignes, Georges. *Déjà jadis, de Dada à l'abstraction.* Paris: Juillard, 1958. Reprinted as *Déjà jadis, ou du mouvement Dada à l'espace abstrait.* 10/18. Paris: Union Générale d'Édition, 1973.

Rosenthal, G. *Avocat de Trotski.* Paris: Robert Laffont, 1975.

Soupault, Philippe. *Vingt mille et un jours: Entretiens avec Serge Fauchereau.* Paris: Belfond, 1980.

———. *Mémoires de l'oubli.* 3 vols. Paris: Lachenal & Ritter, 1981–97.

Tanguy, Yves. *Lettres de loin à Marcel Jean.* Paris: Le Dilettante, 1993.

Tanning, Dorothea. *Birthday.* Santa Monica, Calif.: Lapis Press, 1986.

Thirion, André. *Révolutionnaires sans révolution.* Paris: Robert Laffont, 1972. Reprint, Paris: Le Pré aux Clercs, 1988. English translation: *Revolutionaries without Revolution.* Translated by Joachim Neugroschel. New York: Macmillan, 1975.

Tual, Denise. *Au cœur du temps.* Paris: Carrère, 1987.

Waldberg, Patrick, and Isabelle Waldberg. *Un amour acéphale: Correspondance, 1940–1949.* Edited by Michel Waldberg. Paris: Éditions de la Différence, 1992.

ARCHIVES OF SURREALISM

Bonnet, Marguerite, ed. *Adhérer au parti communiste? Septembre–décembre 1926.* Paris: Gallimard, 1992.

———. *Vers l'action politique: De la révolution d'abord et toujours! (juillet 1925) au projet de la guerre civile (avril 1926).* Archives du surréalisme. Vol. 2. Paris: Gallimard, 1988.

Garrigues, Emmanuel, ed. *Les Jeux surréalistes: Mars 1921–septembre 1962.* Paris: Gallimard, 1995.

Pierre, José, ed. *Recherches sur la sexualité: Janvier 1928–août 1932.* Paris: Gallimard, 1990. English translation: *Investigating Sex: Surrealist Research, 1928–1932.* Translated by Malcolm Imrie. Afterword by Dawn Ades. London: Verso, 1992.

Thévenin, Paule, ed. *Bureau de Recherches Surréalistes: Cahier de la permanence, octobre 1924-avril 1925.* Archives du surréalisme. Vol. 1. Paris: Gallimard, 1988.

PRINCIPAL GENERAL STUDIES

Abastado, Claude. *Introduction au surréalisme.* Paris: Bordas, 1971. New ed., edited by Claude Abastado and Danielle Deltel. Paris: Bordas, 1986.

———. *Le Surréalisme.* Faire le Point; Espaces Littéraires. Paris: Hachette, 1975.

Alexandrian, Sarane. *Le Surréalisme et le rêve.* Paris: Gallimard, 1975.

Alquié, Ferdinand. *Philosophie du surréalisme.* Paris: Flammarion, 1956.

Balakian, Anna. *Literary Origins of Surrealism.* New York: King's Crown Press, 1947. Reprint, New York: New York University Press, 1966.

———. *Surrealism: Road to the Absolute.* New York: Noon Day Press, 1959. Reprint, New York: Dutton, 1970.

Bancquart, Marie-Claire. *Paris des surréalistes.* Paris: Seghers, 1972.

Bartoli-Anglard, Véronique. *Le Surréalisme.* Paris: Nathan, 1989.

Behar, Henri. *Le Théâtre Dada et surréaliste.* Paris: Gallimard, 1967. Rev. ed., Collection Idées, no. 406. Paris: Gallimard, 1979.

Behar, Henri, and Michel Carassou. *Le Surréalisme.* Paris: Le Livre de Poche, 1984.

Benayoun, Robert. *Érotique du surréalisme.* Bibliothèque internationale d'érotologie, no. 15. Paris: J.-J. Pauvert, 1964.

Bénézet, Mathieu. *Portrait d'André Breton, seul.* Vitry-sur-Seine: Éditions Monologue, 1989.

Biro, Adam, and René Passeron, eds. *Dictionnaire général du surréalisme et de ses environs.* Paris: Presses Universitaires de France, 1982.

Blanchot, Maurice. "Réflexions sur le Surréalisme." Pages 92 ff. in *La Part du feu.* Paris: Gallimard, 1949.

———. "L'Inspiration, le manque d'inspiration." Pages 235–50 in *L'Espace littéraire.* 4th ed. Paris: Gallimard, 1955.

Bonnet, Marguerite. *André Breton, naissance de l'aventure surréaliste.* 1975. Reprint, Paris: Corti, 1988.

Bonnet, Marguerite, and Jacqueline Chénieux-Gendron. *Revues surréalistes françaises: Autour d'André Breton.* Millwood, N.Y.: Kraus International Publications, 1982.

Brochier, Jean-Jacques. *L'Aventure des surréalistes.* Paris: Stock, 1977.

Caminade, Pierre. *Image et métaphore: Un problème de poétique contemporaine.* Paris: Bordas, 1970.

Carassou, Michel. *Jacques Vaché et le groupe de Nantes.* Paris: Jean-Michel Place, 1986.

Cardinal, Roger, and Robert Stuart Short. *Surrealism.* London: Studio Vista, 1970.

Carrouges, Michel. *André Breton et les données fondamentales du surréalisme.* Les Essais, no. 43. Paris: Gallimard, 1950. Reprint, Collection Idées, no. 121. Paris: Gallimard, 1967. English translation: *André Breton and the Basic Concepts of Surrealism.* Translated by Maura Prendergast. Tuscaloosa: University of Alabama Press, 1947.

Caws, Mary Ann. *The Poetry of Dada and Surrealism.* Princeton, N.J.: Princeton University Press, 1970.

Cazaux, J. *Surréalisme et psychologie (Endophasie et écriture automatique).* Paris: Éditions José Corti, 1938.

Chadwick, Whitney. *Myth in Surrealist Painting, 1929–1939.* Studies in the Fine arts, Avant-garde, no. 1. Ann Arbor, Mich.: UMI Research Press, 1980.

———. *Women Artists and the Surrealist Movement.* Boston: Little, Brown & Co., 1985.

Chapon, François. *Mystère et splendeurs de Jacques Doucet.* Paris: Lattès, 1984.

Chénieux-Gendron, Jacqueline, Françoise Le Roux, and Maïté Vienne. *Le Surréalisme autour du monde, 1929–1947.* Paris: Éditions du Centre National de la Recherche Scientifique, 1994.

Clébert, Jean-Paul. *Dictionnaire du surréalisme.* Paris: Éditions du Seuil, 1996.

Crastre, Victor. *Le Drame du surréalisme.* Paris: Les Éditions du Temps, 1963.

Daix, Pierre. *La Vie quotidienne des surréalistes, 1917–1932.* Paris: Hachette, 1993.

De Cortanze, Gérard. *Le Monde du surréalisme.* Paris: Veyrier, 1991.

Decottignies, Jean. *L'Invention de la poésie: Breton, Aragon, Duchamp.* Lille: Presses Universitaires de Lille, 1994.

Drachline, Pierre. *Dictionnaire humoristique des surréalistes et des dadaïstes.* Point-virgule. Paris: Éditions du Seuil, 1995.

Ducornet, Guy. *Le Punching-ball et la Vache à lait: La Critique universitaire nord-américaine face au surréalisme.* Paris: Actual-Deleatur, 1992.

Duplessis, Yvonne. *Le Surréalisme.* Que sais-je? Le Point des connaissances actuelles, no. 432. Paris: Presses Universitaires de France, 1961. English translation: *Surrealism, by Yves* [sic] *Duplessis.* Translated by Paul Capon. Sun Book, SB no. 8, Literature and the Arts. New York: Walker, 1963.

Dupuis, Jules-François. *Histoire désinvolte du surréalisme.* Nonville: Éditions P. Vermont, 1977.

Durozoi, Gérard, and Bernard Lecherbonnier. *Le Surréalisme, théories, thèmes, techniques.* Paris: Larousse, 1971.

Ey, Henri. *La Psychiatrie devant le surréalisme.* Paris: Centre d'Éditions Psychiatriques, 1947.

Fauchereau, Serge. *Expressionisme, Dada, surréalisme et autres ismes.* Les Lettres Nouvelles. Paris: Denoël, 1976.

Faure, Michel. *Histoire du surréalisme sous l'Occupation.* Paris: La Table Ronde, 1982.

Fisette, Jean. *Le Texte automatique: Essai de théorie/pratique de sémiotique textuelle.* Montreal: Presses Universitaires de Québec, 1977.

Fontanella, Luigi. *Il surrealismo italiano.* Rome: Bulzoni, 1983.

Fouché, Pascal. *Au Sans Pareil.* 2d ed. Paris: Institut Memoires de l'Édition Contemporaine, 1989.

Gascoyne, David. *A Short History of Surrealism.* London: Cobden-Sanderson, 1935.

Gautier, Xavière. *Surréalisme et sexualité.* Paris: Gallimard, 1971.

Guiol-Benassaya, E. *La Presse face au surréalisme de 1925 à 1938.* Paris: Éditions du Centre National de la Recherche Scientifique, 1982.

Held, René. *L'Œil du psychanalyste: Surréalisme et surréalité.* Paris: Payot, 1973.

Jaguer, Edouard. *Le Surréalisme face à la littérature.* Paris: Actual; Cognac: Le Temps qu'il Fait, 1989.

Janover, Louis. *Le Rêve et le plomb: Le Surréalisme de l'utopie à l'avant-garde.* Paris: Jean-Michel Place, 1986.

———. *La Révolution surréaliste.* Collection Pluriel. Paris: Plon, 1995.

Jean, Marcel. *Autobiographie du surréalisme.* Paris: Éditions du Seuil, 1978.

Kapidzic-Osmanagic, Hanifa. *Le Surréalisme serbe et ses rapports avec le surréalisme français.* Paris: Les Belles Lettres, 1968.

Larrea, Juan. *El surrealismo entre Viejo y Nuevo Mundo.* Mexico City: Cuadernos Americanos, 1944.

Le Brun, Annie. *Les Mots font l'amour (citations surréalistes).* Paris: Éric Losfeld, 1970.

———. *Qui vive! Considérations actuelles sur l'inactualité du surréalisme.* Paris: Ramsay-Pauvert, 1991.

Lecherbonnier, Bernard. *Surréalisme et Francophonie.* Toulouse: Publisud, 1993.

Legoutière, E. *Le Surréalisme.* Paris: Masson, 1970.

Levy, Julien. *Surrealism.* New York: Black Sun Press, 1936.

Lewi, Alain. *Le Surréalisme.* Paris: Bordas, 1989.

Maillard-Chary, Claude. *Le Bestiaire des surréalistes.* Paris: Presses de la Sorbonne Nouvelle, 1994.

Matthews, J. H., *Surrealist Poetry in France.* Syracuse, N.Y.: Syracuse University Press, 1969.

———. *Theatre in Dada and Surrealism.* Syracuse, N.Y.: Syracuse University Press, 1974.

———. *Languages of Surrealism.* Columbia: University of Missouri Press, 1986.

Michel, Jean-Claude. *Les Écrivains noirs et le surréalisme.* Sherbrooke: Éditions Naaman, 1982.

Monnerot, Jules. *La Poésie moderne et le sacré.* Paris: Gallimard, 1945.

Morel, Jean-Pierre. *Le Roman insupportable: L'Internationale littéraire et la France (1920–1932).* Paris: Gallimard, 1985.

Nadeau, Maurice. *Histoire du surréalisme suivi de Documents surréalistes.* Definitive ed. Paris: Éditions du Seuil, 1964. English translation: *The History of Surrealism.* Translated by Richard Howard.

Introduction by Roger Shattuck. New York: Macmillan 1965. Reprint, Cambrdige, Mass.: Belknap Press, 1989.

Noël, Bernard. *Marseille–New York, 1940–1945: Une liaison surréaliste.* Marseille: Éditions A. Dimanche, 1985.

Passeron, Roger. *Encyclopédie du surréalisme.* Paris: Somogy, 1975. English translation: *The concise Encyclopedia of Surrealism.* Translated by John Griffiths. Secaucus, N.J.: Chartwell, 1975.

Picon, Gaëtan. *Journal du surréalisme, 1919–1939.* Geneva: Skira, 1976. Reprinted as *Le Surréalisme.* Paris: Flammarion, 1988. English translation: *Surrealists and Surrealism.* Geneva: Skira; New York: Rizzoli, 1983.

Pierre, José, *Le Surréalisme.* Dictionnaire poche. Paris: Hazan, 1973.

———. *Le Surréalisme aujourd'hui.* Paris: La Quinzaine Littéraire, 1973.

———, ed. *Tracts surréalistes et déclarations collectives.* 2 vols. Paris: Éric Losfeld, 1980–82.

———. *L'Univers surréaliste.* Paris: Somogy, 1983.

———, ed. *Surréalisme et anarchie: Les "Billets surréalistes" du Libertaire, 12 octobre 1951–8 janvier 1953.* Collection En dehors. Paris: Plasma, 1983.

Raffi, M. Emanuela. *André Breton e il surrealismo nella cultura italiana (1925–1950).* Padua: Cooperativa Libraria Editrice dell'Università di Padova, 1988.

Read, Herbert. *Surrealism.* London: Faber & Faber, 1936.

Rispail, Jean-Luc. *Les Surréalistes: Une génération entre le rêve et l'action.* Découvertes, Gallimard Littérature, no. 109. Paris: Gallimard, 1991.

Robert, Bernard-Paul. *Le Surréalisme désocculté.* Ottawa: Éditions de l'Université, 1975.

Rosemont, Franklin. *André Breton and the First Principles of Surrealism.* London: Pluto Press, 1978.

Scheerer, Thomas M. *Textanalytische Studien zur "Écriture automatique."* Bonn: Romanisches Seminar der Universität Bonn, 1974.

Schuster, Jean. *Archives 57/68.* Paris: Éric Losfeld, 1969.

Sebbag, Georges. *Les Éditions surréalistes, 1926–1968.* Paris: Institut Memoires de l'Édition Contemporaine, 1993.

———. *Le Surréalisme: "Il y a un homme coupé en deux par la fenêtre."* Paris: Nathan, 1994.

Seigel, Jerrold. *Bohemian Paris: Culture, Politics, and the Boundaries of Bourgeois Life, 1830–1930.* Baltimore: Johns Hopkins University Press, 1991.

Topass, Jan. *La Pensée en révolte: Essai sur le surréalisme.* Brussels: René Henriquez, 1935.

Tzara, Tristan. *Le Surréalisme et l'après-guerre.* Paris: Nagel, 1947.

Vailland, Roger. *Le Surréalisme contre la révolution.* Paris: Éditions Sociales, 1948.

Vigée, Claude. *Révolte et Louange.* Paris: Éditions José Corti, 1962.

Waldberg, Patrick. *Chemins du surréalisme.* Brussels: Éditions de la Connaissance, 1965.

ANTHOLOGIES

Billeter, Erika, and José Pierre, eds. *La Femme et le surréalisme.* Preface by André Pieyre de Mandiargues. Lausanne: Musée Cantonal des Beaux-Arts, 1987.

Bougnoux, Daniel, and Jean-Charles Gateau, eds. *Le Surréalisme dans le texte.* Grenoble: Publications de l'Université des Langues et Lettres, 1978.

Bounoure, Vincent. *La Civilisation surréaliste.* Paris: Payot, 1976.

Breton, André, and Paul Éluard. *Dictionnaire abrégé du surréalisme.* Paris: Galerie des Beaux-Arts, 1938. Reprint, Paris: José Corti, 1969.

Caws, Mary Ann, Rudolf E. Kuenzli, and Gwen Raaberg, eds. *Surrealism and Women.* Cambridge, Mass.: MIT Press, 1991.

Chefdor, Monique, and Datton Krauss, eds. *Regard d'écrivain, parole de peintre.* Nantes: Joca Seria, 1994.

Chénieux-Gendron, Jacqueline, ed. *Du surréalisme et du plaisir.* Paris: Éditions José Corti, 1987.

Chénieux-Gendron, Jacqueline, and Marie-Claire Dumas, eds. *Jeu surréaliste et humour noir.* Paris: Lachenal & Ritter, 1993.

Chénieux-Gendron, Jacqueline, and Timothy Mathews, eds. *Violence, théorie, surréalisme.* Paris: Lachenal & Ritter, 1994.

Hulak, Fabienne, ed. *Folie et psychanalyse dans l'expérience surréaliste.* Nice: Z'Éditions, 1992.

Lefort, Daniel, Pierre Rivas, and Jacqueline Chénieux-Gendron, eds. *Nouveau monde, autres mondes, surréalisme et Amériques,* Paris: Lachenal & Ritter, 1995.

Lexique succinct de l'érotisme. Paris: Galerie Daniel Cordier, 1959. Reprint, Le Désordre, no. 5. Paris: Éric Losfeld, 1970.

Mélusine. Cahiers du Centre de Recherche sur le Surréalisme, ed. Behar, Henri. Paris: L'Âge d'Homme, 1980–2000. Fifteen volumes according to theme have been published to date.

Moura Sobral, Louis de, ed. *Surréalisme périphérique: Actes du Colloque Portugal, Québec, Amérique latine, un surréalisme périphérique?* Montreal: Université de Montréal, 1984.

Murat, Michel, and Marie-Paule Béranger, eds. *Une pelle au vent dans les sables du rêve: Les Écritures automatiques.* Lyon: Presses Universitaires de Lyon, 1992.

Permanence surréaliste. Paris: Klincksieck, 1975.

Pierre, José, ed. *La Planète affolée, surréalisme, dispersion et influences, 1938–1947.* Marseille: Musées de Marseille; Paris: Flammarion, 1986.

Procès à Coupure. Le Désordre. Paris: Éric Losfeld, 1972.

Regards sur Minotaure, la revue à tête de bête. Geneva: Musée d'Art et d'Histoire, 1987.

Le Rêve d'une ville, Nantes et le surréalisme. Paris: Réunion des Musées Nationaux; Nantes: Musée des Beaux-Arts de Nantes, 1994.

Le Surréalisme. Colloque de Cerisy-la-Salle. Paris and The Hague: Mouton, 1968.

Le Surréalisme dans "L'Humanité" des années vingt (1924–1930). Paris: Université de la Sorbonne Nouvelle, 1983.

Surréalisme et philosophie. Papers presented at the Séminaire "Surréalisme et philosophie," Centre Georges Pompidou, Paris, 1992. Paris: Centre Georges Pompidou, 1992.

Surrealismus und Kritische Theorie: Zur Aktualität einer versäumten Begegnung. Frankfurt: Goethe-Universität, 1995.

Thompson, Christopher W., ed. *L'Autre et le sacré: Surréalisme, cinéma, ethnologie.* Paris: L'Harmattan, 1995.

SURREALISM AND ART

Alexandrian, Sarane. *L'Art surréaliste.* Paris: Hazan, 1969.

Aragon, Louis. *La Peinture au défi.* Paris: Galerie Goemans, 1930. Reprint, in *Les Collages.* Miroirs de l'art. Paris: Hermann, 1965.

Baron, Jacques. *Anthologie plastique du surréalisme.* Paris: Filipacchi, 1980.

Baum, Timothy, *Anthologie plastique du surréalisme.* Paris: Filipacchi, 1990.

Bonet Correa, Antonio, et al. *El surrealismo.* Madrid: Cátedra, 1983.

Breton, André. *Le Surréalisme et la Peinture.* Rev. ed. Paris: Gallimard, 1965. English translation: *Surrealism and Painting.* Translated by Simon Watson Taylor. New York: Harper & Row, 1972.

Breton, André, and Gérard Legrand, *L'Art magique.* Paris: Club Français de l'Art, 1957. Reprint, Paris: Adam Biro–Phébus, 1991.

Buffet-Picabia, Gabrielle, *Aires abstraites.* Geneva: P. Cailler, 1957.

Calas, Nicolas, and Elena Calas. *The Peggy Guggenheim Collection of Modern Art.* New York: Henry Abrams, 1967.

Chadwick, Whitney. *Myth in Surrealist Painting, 1929–1939.* Studies in the Fine Arts, Avant-garde, no. 1. Ann Arbor, Mich.: UMI Research Press, 1979.

Chénieux-Gendron, Jacqueline, and Marie Claire Dumas, eds. *L'Objet au défi.* Paris: Presses Universitaires de France, 1987.

Desnos, Robert. *Écrits sur les peintres.* Paris: Flammarion, 1984.

Elgar, Frank, et al. *Le Papier collé du Cubisme à nos jours.* XX siècle, n.s., no. 6. New York: Wittenborn, 1956.

Estienne, Charles. *Le Surréalisme.* Paris: Gründ-Somogy, 1956.

Foster, Hal. *Compulsive Beauty.* Cambridge, Mass.: MIT Press, 1993.

França, Jose-Augusto. *A pintura surrealista em Portugal.* Lisbon: Artis, 1967.

Goldwater, Robert. *Primitivism in Modern Art.* Rev. ed. 1938. Reprint, Cambridge, Mass.: Belknap Press, 1986.

Greenberg, Clement. "Surrealist Painting." *The Nation,* vol. 159, nos. 7, 8 (August 12 and 19, 1944).

Janis, Sidney. *Abstract and Surrealist Art in America.* New York, 1944.

Jean, Marcel. *Histoire de la peinture surréaliste.* Paris: Éditions du Seuil, 1959. New ed., with the collaboration of Arpad Mezei. Paris: Éditions du Seuil, 1967. English translation: *The History of Surrealist Painting.* Translated by Simon Watson Taylor. New York: Grove Press, 1960.

Kral, Petr. "L'Âge du collage, suite et fin." *Phases,* no. 5 (1975).

Krauss, Rosalind E. *The Optical Unconscious.* Cambridge, Mass.: MIT Press, 1993.

Lebel, Robert. "Le Surréalisme en 1953." In *Premier bilan de l'art actuel,* ed. Robert Tebel. Le Soleil Noir, positions, nos. 3–4. Paris: Le Soleil Noir, 1953.

Levaillant, Françoise. "L'Analyse des dessins d'aliénés et de médiums en France avant le surréalisme." *Revue de l'art,* no. 50 (1980). Reprinted in Pierre Amrouche et al., *La Mesure des irréguliers: Symptôme et création.* Preface by Pierre Gaudibert. Nice: Z'Éditions, 1990.

Lippard, Lucy R. "Notes on Dada and Surrealism at the Modern." *Art International,* vol. 12, no. 5 (May 1968).

Loeb, Pierre. *Voyages à travers la peinture.* Paris: Bordas, 1946.

Myers, John Bernard. "The Impact of Surrealism on the New York School." *Evergreen Review,* vol. 4, no. 12 (March–April 1960).

Passeron, Roger. *Histoire de la peinture surréaliste.* Paris: Le Livre de Poche, 1968.

Pierre, José, *Le Surréalisme.* Histoire générale de la peinture, gen. ed. Claude Schaeffner. Vol. 1. Lausanne: Rencontre, 1967.

———. *L'Abécédaire précédé par "Le dialogue monotone" et suivi de "Le gouvernement de l'écume."* Paris: Éric Losfeld, 1971.

———. *L'Aventure surréaliste autour d'André Breton.* Paris: Filipacchi, 1986.

———. *André Breton et la peinture.* Lausanne: L'Âge d'Homme, 1987.

———. "Une révolution dans l'accrochage: Les Expositions internationales du surréalisme." *Cahiers du Musée National d'Art Moderne,* no. 17–18 (1986).

———. "Hommage à Hans Prinzhorn." *Art et thérapie,* no. 30–31 (August 1989).

Riese-Hubert, Renée. "Les Surréalistes et Picasso." *L'Esprit créateur* (summer 1968).

Rioux, G. "À propos des expositions internationales du surréalisme." *Gazette des beaux-arts* (April 1978).

Rodari, Florian. *Le Collage.* Geneva: Skira, 1988.

Rubin, William S. *Dada and Surrealist Art.* New York: Henry Abrams, 1968.

Sandler, Irving. "The Surrealist Emigrés in New York." *Artforum,* vol. 4, no. 9 (May 1968).

Sawin, Martica. *Surrealism in Exile and the Beginning of the New York School.* Cambridge, Mass.: MIT Press, 1995.

Schwarz, Arturo. *I surrealisti.* Milan: Mazzota, 1989.

Spies, Werner. "L'Art brut avant 1947." *Revue de l'art,* no. 1–2 (1968).

Stich, Sidra. *Anxious Visions: Surrealist Art.* New York: Abbeville, 1990.

Le Surréalisme. XX siècle. Paris, 1975.

Le Surréalisme I. XX siècle, n.s., no. 42. Paris: Société Internationale d'Art XXe Siècle; New York: Wittenborn, 1974.

Le Surréalisme II. XX siècle, n.s., no. 43. Paris: Société Internationale d'Art XXe Siècle, 1974.

Tomkins, Calvin. *The World of Marcel Duchamp.* New York: Time-Life, 1966.

Vitrac, Roger. *L'Enlèvement des Sabines.* Paris: Deyrolle, 1990.

Waldberg, Patrick. *Le Surréalisme.* Geneva: Skira, 1962.

Waldman, Diane. *Collage, Assemblage and the Found Object.* New York: Henry Abrams, 1992.

Wechsler, Jeffrey. *Surrealism and American Art, 1931–1947.* New Brunswick, N.J.: Rutgers University Art Gallery, 1977.

Wescher, Herta. *Die Collage: Geschichte eines Kunsterlischen Ausdrucksmittels.* Cologne: DuMontSchauberg, 1968. Reprinted as *Die Geschichte der Collage,* 1980. English translation: *Collage.* New York: Henry Abrams, 1968.

PRINCIPAL GROUP EXHIBITION CATALOGS

Les Années cinquante. Paris: Centre Georges Pompidou, 1988.

Années 30 en Europe: Le temps menaçant. Edited by Suzanne Pagé et al. Paris: Paris-Musées-Flammarion, 1997.

Armes et bagages. Lyon: Galerie Verrière, 1975.

The Art of Assemblage. New York: Museum of Modern Art, 1961.

Il cadavere squisito, la sua esaltazione. Edited by Arturo Schwarz. Milan: Schwarz, 1975.

Cadavres exquisitos. Madrid: Museo Thyssen Bornemisza, 1996.

Catálogo do décimo terceiro exposição internacional de surrealista. Vol. 1. of *A Phala.* São Paulo: Gráfica Editôra Hamburg 1967.

Le Collage surréaliste en 1978. Paris: Galerie Le Triskèle, 1978.

Dada and Surrealism Reviewed. London: Arts Council of Great Britain, 1978.

The Dada and Surrealist Word-Image. Los Angeles: Los Angeles Country Museum of Art, 1989.

Dada, Surrealism, and Their Heritage. New York: Museum of Modern Art, 1968.

Dans la lumière du surréalisme. Bari: Provincial Pinacotheca, 1984.

Der Geist des Surrealismus. Cologne: Baukunst Galerie, 1971.

Dessins surréalistes: Visions et techniques. Paris: Musée National d'Art Moderne, 1995.

L'Écart absolu. Paris: Galerie de l'Œil, 1965.

Exposition surréaliste d'objets. Paris: Galerie Charles Ratton, 1936.

Fantastic Art, Dada, Surrealism. Edited by Alfred J. Barr, Jr., with essays by Georges Hugnet. New York, Museum of Modern Art, 1936.

La Femme et le surréalisme. Edited by Erika Billeter and José Pierre. Preface by André Pieyre de Mandiargues. Lausanne: Musée Cantonal des Beaux-Arts, 1987.

First Papers of Surrealism. New York: Coordinating Council of French Relief Societies, 1942.

La Fureur poétique: Animation, recherche, confrontation. Preface by José Pierre. Paris: Musée d'Art Moderne de la Ville de Paris, 1967.

International Exhibition of Surrealism / Exposición internacional del surrealsimo. Mexico City: Galeria de Arte Mexicano, 1940.

International Surrealist Exhibition. Preface by André Breton. London: New Burlington Galleries, 1936.

The Interpretative Link, Abstract Surrealism into Abstract Expressionism: Works on Paper, 1938–1940. Newport Beach, Calif.: Newport Harbor Art Museum, 1986.

In the Mind's Eye: Dada and Surrealism. Edited by Terry Ann R. Neff. Chicago: Museum of Contemporary Art; New York: Abbeville Press, 1985.

Marvelous Freedom, Vigilance of Desire: Catalog of the World Surrealist Exhibition, with the Participation of the Phases Movement. Chicago: Black Swan Gallery, 1976.

Mostra internazionale del surrealismo. Milan: Galleria Schwarz, 1961.

1936 / Surrealism / Objects / Photographs / Collages / Documents. New York: Zabriskie Gallery, 1986.

Paris–New York. Paris: Centre National d'Art et de Culture Georges Pompidou, Musée National d'Art Modern, 1977. Reprint, Paris: Éditions du Centre Pompidou–Gallimard, 1991.

Permanence du regard surréaliste. Lyon: Espace Lyonnais d'Art Contemporain, 1981.

Pérennité de l'art gaulois. Paris: Musée pédagogique, 1955.

"Primitivism" in Twentieth Century Art: Affinity of the Tribal and the Modern. Edited by William Rubin. 2 vols. New York: Museum of Modern Art, 1984.

Princip slasti: Surrealismus. Brno: Dum umení, 1968.

Salon de Mayo. Havana: Pabellon Cuba, 1967.

Surrealism. Tel Aviv: Tel Aviv Museum, H. Rubenstein Pavilion, 1966.

Surrealism and American Art. By Jeffrey Wechsler and Jack J. Spector. New Brunswick, N.J.: Rutgers University Art Gallery, 1977.

Surrealism and Its Affinities: The Mary Reynolds Collection. 1956. Reprint, Chicago: Art Institute of Chicago, 1973).

Surréalisme. Brussels: Galerie des Éditions La Boétie, 1945.

Le Surréalisme en 1947: Exposition internationale du surréalisme. Paris: Éditions Maeght, 1947.

Le Surréalisme et l'amour. Paris: Gallimard–Paris Musées, 1997.

Le Surréalisme et le livre. Paris: Galerie Zabriskie, 1991.

Le Surréalisme, 1922–1942. Munich: Haus der Kunst; Paris, Musée des Arts Décoratifs, 1972.

Le Surréalisme: Sources—Histoire—Affinités. Edited by Raymond Nacenta, with texts by Raymond Nacenta and Patrick Waldberg. Paris: Galerie Charpentier, 1964.

El surrealismo en España. Madrid: Museo Nacional de Arte Reina Sofia, Ministerio de la Cultura, 1994.

El surrealismo entre viejo y nuevo mundo. Santa Cruz de Tenerife: Cabildo Insular de Gran Canaria, 1989.

Surrealism Unlimited. London: Camden Arts Centre, 1978.

Die Surrealisten. Frankfurt: Städtische Galerie im Städelschen Kunstinstitut, 1989.

I surrealisti. Edited by Arturo Schwarz. Milan: Mazzotta, 1989.

Surrealist Intrusion in the Enchanter's Domain. Edited by André Breton and Marcel Duchamp. Translated by Claude Tarnaud. New York: D'Arcy Galleries, 1960.

Women in Surrealism. Beverly Hills, Calif.: 1977.

SURREALISM AND THE CINEMA

L'Âge d'or: Correspondance Luis Buñuel–Charles de Noailles—lettres et documents (1929–1976). Edited by Jean-Michel Bouhours and Nation Schoeller. Special issue of *Les Cahiers du Musée d'Art Moderne,* nos. 43–46 (Paris: Centre Georges Pompidou, 1993.

Aub, Max. *Conversations avec Luis Buñuel.* Paris: Belfond, 1991.

Bandier, Norbert. "Man Ray, les surréalistes et le cinéma des années 20." *Actes de la recherche en sciences sociales,* no. 88 (June 1991).

Benayoun, Robert. *Bonjour Monsieur Lewis.* Paris: Éric Losfeld, 1972.

———. *Le Regard de Buster Keaton.* Paris: Herscher, 1982.

Brunius, Jacque-B. *En marge du cinéma français.* Paris: Arcanes, 1954. Reprint, Lausanne: L'Âge d'Homme, 1987.

Buñuel, Luis. *Goya (1928).* Paris: Jacques Damase, 1987.

Buñuel, Luis, and Jean-Claude Carrère. *Le Moine d'après Lewis.* Paris: Éric Losfeld, 1971.

———. *Le Fantôme de la liberté.* L'Avant-scène cinema, no. 151. Paris: L'Avent Scène, 1974.

Buñuel, Luis, and Salvador Dalí. *Un chien andalou, L'âge d'or, L'ange exterminateur: Buñuel surréaliste.* L'Avant-scène cinéma, nos. 27–28. Paris: L'Avant Scène, 1963.

Cinéma dadaiste et surréaliste. Paris: Centre Georges Pompidou, 1976.

"Le Cinéma des surréalistes." Special issue of *Les Cahiers de la cinémathèque,* no. 30–31 (1980).

"Cinéma 33." Special issue of *Les Cahiers jaunes,* no. 4.

"Dada and Surrealist Film." Special issue of *Dada/Surrealism* (New York), no. 15 (1987).

Desnos, Robert. *Les Rayons et les ombres-cinéma.* Paris: Gallimard, 1992.

Ferry, Jean. *Fidélité, scénario précédé d'une lettre de H.-G. Clouzot.* Paris: Arcanes, 1953.

Frémaux, Thierry. "L'Aventure cinéphile de *Positif,* 1952–1989." *XXe siècle: Revue d'histoire,* no. 23 (July–September 1989).

Goudal, J. "Surréalisme et cinema." *Revue hebdomadaire* (February 1925). Reprinted in Alain Virmaux and Odette Virmaux. *Les Surréalistes et le cinéma.* Paris: Seghers, 1976.

Hammond, Paul. *The Shadow and Its Shadow: Surrealist Writings on the Cinema.* London: British Film Institute, 1978.

Janicot, Christian, ed. *Anthologie du cinéma invisible:100 ans de cinéma.* Paris: Jean-Michel Place, 1995.

Kral, Petr. *Le Burlesque ou morale de la tarte à la crème.* Paris: Stock, 1984.

——. *Les Burlesques ou parade des somnambules.* Paris: Stock, 1986.

Kyrou, Ado, *Le Surréalisme au cinéma.* Foreword by Jean Ferry. Collection Ombres blanches. Paris: Arcanes, 1953. Reprint, Paris: Le Terrain Vague, 1963; Paris: Ramsay, 1985.

——. *Amour, érotisme et cinéma.* Paris: Le Terrain Vague, 1957. Reprint, Paris: Éric Losfeld, 1966.

——. *Manuel du parfait petit spectateur.* Paris: Éric Losfeld, 1958.

——. *Immalie ou l'homme en noir.* Paris: Éric Losfeld, 1971.

Lacassin, Francis. *Pour une contre-histoire du cinéma.* Paris: Union Générale d'Édition, 1972. Rev. ed., with preface by Raymond Chirat, Lyon: Institut Lumière; Arles: Actes Sud, 1994.

Legrand, Gérard. *Cinémanie.* Paris: Stock, 1979.

"Luis Buñuel." Special issue of *Études cinématographiques,* pt. 1, no. 20–21 (winter 1962–63); pt. 2, no. 22–23 (spring 1963).

Matthews, J. H. *Surrealism and Film.* Ann Arbor: University of Michigan Press, 1971.

——. *Surrealism and American Feature Films.* Twayne's Theatrical Arts Series. Boston: Twayne, 1979.

Mitry, Jean. *Le Cinéma expérimental.* Paris: Seghers, 1974.

Rondolino, Gianni. *L'occhio tagliato.* Turin: Martano, 1972.

Soulpault, Philippe. *Écrits de cinema, 1918–1931.* Paris: Plon, 1979.

"Spécial surréalisme." Special issue of *L'Âge du cinéma,* no. 4–5 (1951).

"Le Surréalisme." Special issue of *Ciné-Club,* no. 1 (October 1948).

Surréalisme et cinéma. Études cinématographiques, nos. 38–39, 40–42 2 vols. Paris: Letres Modernes, 1965.

Virmaux, Alain, and Odette Virmaux. *Les Surréalistes et le cinéma.* Paris: Seghers, 1976.

Wills, David. "Langage surréaliste, langage cinématographique." *Le Siècle éclaté,* no. 3 (1985).

SURREALISM AND PHOTOGRAPHY

Los cuerpos perdidos en la fotografia y los surrealistas. Madrid: Fundación "la Caixa," 1996.

De Naeyer, Christine. *Paul Nougé et la photographie.* Brussels: Didier Devillez, 1995.

Hall-Duncan, Nancy. *Photographic Surrealism.* Cleveland: New Gallery of Contemporary Art, 1979.

Jaguer, Edouard. *Les Mystères de la chambre noire.* Paris: Flammarion, 1982.

——. "Zoom sur la photographie surréaliste en Europe." *Mélusine,* no. 14 (1994).

Krauss, Rosalind, and Jane Livingston, with an essay by Dawn Ades. *L'amour fou: Photography and Surrealism.* Washington, D.C.: Coran Gallery of Art; New York: Abbeville Press, 1985. French translation: *Explosante-fixe: Photographie et surréalisme.* Paris: Hazan–Centre Georges Pompidou, 1986.

Mousseigne, Alain. *Surréalisme et photographie: Rôle et place de la photographie dans les revues d'avant-garde artistique en France.* Saint-Étienne: Université de Saint-Étienne, 1978.

Nougé, Paul. *Subversion des images.* Brussels: Les Lèvres Nues, 1968.

Surrealismus und fotographie. Essen: Museum Folkwang, 1966.

SURREALISM AND POLITICS

Bernard, Jean-Pierre. *Le PCF et la question littéraire, 1919–1939.* Grenoble: Presses Universitaires, 1972.

Ferrua, Pietro. *Surréalisme et anarchisme.* Paris: Le Monde Libertaire, 1982.

Janover, Louis. *Surréalisme, art et politique.* Paris: Éditions Galilée, 1979.

Lewis, Helena. *The Politics of Surrealism.* New York: Paragon House, 1980.

Lourau, René. *Le Lapsus des intellectuels.* Toulouse: Privat, 1981.

Naville, Pierre. *La Révolution et les intellectuels.* Paris: Gallimard, 1927. Reprint, Collection Idées. Paris: Gallimard, 1975.

Palayret, Guy. "Attirances et répulsions: Aragon, Breton et les écrivains révolutionnaires autour du PCF (1930–1935)." *Mélusine,* no. 5 (1983).

Reynaud Paligot, Carole. *Parcours politique des surréalistes, 1919–1969.* CNRS littérature. Paris: Éditions du Centre National de la Recherche Scientifique, 1995.

Rose, Alan. *Surrealism and Communism in the Early Years.* New York: Peter Lang, 1991.

Short, Robert. "The Politics of Surrealism, 1920–1936." *Journal of Contemporary History,* no. 2 (1966).

Sirinelli, Jean-François. *Intellectuels et passions françaises.* Paris: Fayard, 1990. Reprint, Collection folio histoire. Paris: Gallimard, 1996.

SURREALISM IN BELGIUM

À couteau tiré, surréalisme et avatars. Brussels: Galerie Quadri, 1997.

L'Apport wallon au surréalisme. Liège: Musée des Beaux-Arts, 1955.

L'Art en Belgique, Flandre et Wallonie au XXe siècle: Un point de vue. Paris: Musée d'Art Moderne de la Ville de Paris; Brussels: Lebeer-Hossmann, 1990.

The Belgian Contribution to Surrealism. Edinburgh: Royal Scottish Academy, 1971.

La Belgique sauvage. Phantomas, nos. 100–111. Uccle-Brussels: Phantomas, 1973.

Bussy, Christian. *Anthologie du surréalisme en Belgique.* Paris: Gallimard, 1972.

Dachy, March, et al., eds. *René Magritte et le surréalisme en Belgique.* Brussels: Musées Royaux des Beaux-Arts de Belgique,1982.

Delaunois, Alain. "Discours de presse et surréalisme en Belgique (1924–1950)." *Mélusine,* no. 7.

"Une dynamique surréalisante." Pages 115 ff. in *Lettres belges entre absence et magie.* By Marc Quaghebeur. Brussels: Labor, 1990.

Introduction au surréalisme en Belgique. La Louvière: Musée Communale, 1969.

Jaguer, Edouard. "Sessant'anni di pittura surrealista in Belgia." *Terzoocchio,* no. 33 (December 1984).

Juin, Hubert. "Les Surréalistes belges." *Magazine littéraire* (December 1984).

Mariën, Marcel, *L'Activité surréaliste en Belgique (1920–1950)*. Le Fil rouge. Brussels: Lebeer-Hossmann, 1979.

———, ed. *Lettres surréalistes (1924–1940)*. Brussels: Les Lèvres Nues, 1973.

Nougé, Paul. "Evidence et occultation." Pages 77 ff. in *Lettres belges entre absence et magie*. By Marc Quaghebeur. Brussels: Labor, 1990.

Peintres de l'imaginaire: Symbolistes et surréalistes belges. Galeries Nationales du Grand Palais, Paris, 1972. Brussels: Laconti, 1972.

Quaghebeur, Marc. *Alphabet des lettres belges de langue française*. Brussels: Association pour la Promotion des Lettres Belges de Langue Française, 1982.

———. *Lettres belges entre absence et magie*. Brussels: Labor, 1990.

Le Rasoir dans la plaie, Dada et surréalisme. Brussels: Galerie Quadri, 1995.

Spinette, Alberte, ed. *Surréalisme en Hainaut, 1932–1945*. Institut des Arts et Métiers, La Louvière; Palais des Beaux-Arts Brussels; Centre Culturel de la Communauté Française de Belgique. La Louvière: n.p., 1980.

Le Surréalisme à Mons et les amis bruxellois, 1935–1955. Mons, 1986.

Surréalisme en Belgique. Maubeuge: Idem + Arts, 1995.

Surréalisme en Wallonie. Savoir et beauté, 41e année, nos. 2–3, Services éducatifs des provinces francophones. La Louvière: Savoir et beauté, 1961.

"Surrealism in Belgium." Special issue of *View* (New York), vol. 7, no. 3 (1947).

Tendances surréalistes en Belgique: Choix d'œuvres appartenant à nos collections. Brussels: Musées Royaux des Beaux-Arts de Belgique, 1970.

Toussaint, Françoise. *Le Surréalisme belge*. Brussels: Labor, 1986.

Vovelle, José. *Le Surréalisme en Belgique*. Brussels: André de Rache, 1972.

———. "En Belgique." In *La Planète affolée, surréalisme, dispersion et influences, 1938–1947*. Edited by José Pierre. Marseille: Musées de Marseille; Paris: Flammarion, 1986.

Warmoes, Jean, ed. *Cinquante ans d'avant-garde, 1917–1967*. Preface by Serge Fauchereau. Brussels: Bibliothèque Royale Albert Ier, 1983.

SURREALISM IN CANADA

Baudoin, Dominique. "Le Surréalisme au Québec." *Mélusine*, no. 2.

Borduas et les automatistes, Montreal, 1942–1945. Museum of Contemporary Art, Montreal, Galiers Nationales d'Exposition du Grand Palais, Paris. Montreal: Museum of Contemporary Art, 1971.

Bourassa, André. *Surréalisme et littérature québecoise*. Montreal: Les Herbes Rouges, 1986.

Ethier-Blais, Jean. "Borduas et Breton." *Études françaises*, vol. 4, no. 4 (1968).

Gagnon, François-Marc. "Les Artistes canadiens en Europe depuis 1945." Catalog of Première Triennale des Amériques. Maubeuge: Idem + Arts, 1993.

Imbert, Patrick. "Réception des surréalistes québecois." *Mélusine*, no. 4.

Jaguer, Edouard. "Au Canada." In *La Planète affolée, surréalisme, dispersion et influences, 1938–1947*. Edited by José Pierre. Marseille: Musées de Marseille; Paris: Flammarion, 1986.

Laurette, Pierre. "Alfred Pellan et le texte surréaliste." *Mélusine*, no. 4.

"Surrealism? B.-C." Special issue of *Capitano Review*, no. 29 (1983).

SURREALISM IN CZECHOSLOVAKIA

Budik, Arnost. *La Poésie surréaliste tchèque et slovaque*. Brussels: Gradiva, 1972.

Bydzovská, Lenka, and Karel Srp, eds. *Cesky Surrealismus, 1929–1953*. Prague: Argo and Galerie Hlavního Mesta Prahy, 1996.

Ceska fotografie. Brno: Moldau Gallery, 1981.

Fisera, Vladimir Claude. "Trop loin de Paris, trop près de Moscou: Les surréalistes de Tchécoslovaquie et de Yougoslavie." *Mélusine*, no. 14 (1994).

Jaguer, Edouard. "Volti e immagini del surrealismo cecoslovacco." *Terzoocchio*, no. 31 (June 1984).

Kral, Petr. *Le Surréalisme en Tchécoslovaquie*. Paris: Gallimard, 1983.

Marencin, Albert. "Breton et les destinées du surréalisme tchécoslovaque." *Preuves* (February 1967).

Mayer, D. "Le Surréalisme tchèque." *Cahiers du Musée National d'Art Moderne*, no. 10 (1982).

Menanteau, Jacqueline, ed. *Prague, 1900–1938: Capitale secrète des avant-gardes*. Dijon: Musée des Beaux-Arts, 1977.

Peinture surréaliste et imaginative en Tchécoslovaquie, 1930–1960. Planisphère surréaliste, no. 2. Paris: Galerie 1900-2000, 1983.

Smejkal, Frantisek. "Surréalisme et peinture imaginative en Tchécoslovaquie." *Phases*, no. 10 (1965).

———. "Styrsky and Toyen." In *Alternative attuali, 3, rassegna internazionale d'arte contemporanea*. Edited by L'Aquila Castello Spagnolo. Florence: Andro di, 1968.

SURREALISM IN DENMARK

Nilsson, B.-O. *Danska Surrealister: 1933–1947*. Lund, 1972.

Pedersen, Carl-Henning. *Surrealist Art in Denmark and in Sweden*. Copenhagen: Fischer Forlag, 1936.

Shield, P. "Au Danemark." In *La Planète affolée, surréalisme, dispersion et influences, 1938–1947*. Edited by José Pierre. Marseille: Musées de Marseille; Paris: Flammarion, 1986.

SURREALISM IN EGYPT

Luthi, Jean-Jacques. "Le Mouvement surréaliste en Égypte." *Mélusine*, no. 3.

SURREALISM IN GREAT BRITAIN

Ades, Dawn. "Le Surréalisme en Angleterre." In *Surréalisme et philosophie*. Paris: Centre Georges Pompidou, 1992.

Britain's Contribution to Surrealism of the 30s and 40s. London: Hamet Gallery, 1971.

British Surrealism Fifty Years On. London: Mayor Gallery, 1986.

Grid (Paris), no. 5 (winter 1986–87).

Peinture surréaliste en Angleterre, 1930–1960. Paris: Galerie 1900-2000, 1982.

Ray, Paul C. *The Surrealist Movement in England*. Ithaca, N.Y., and

London: Cornell University Press, 1971.

Remy, Michel. *Surrealism in England: Towards a Dictionary of Surrealism in England, Followed by a Chronology.* Nancy: Marges, 1978.

———. "La Pittura surrealista in Inghilterra." *Terzoocchio,* no. 30 (March 1984).

———. "Londres, 1936: L'Année de tous les dangers." *Mélusine,* no. 8 (1986).

Wilson, S. "En Angleterre." In *La Planète affolée, surréalisme, dispersion et influences, 1938–1947.* Edited by José Pierre. Marseille: Musées de Marseille; Paris: Flammarion, 1986.

SURREALISM IN JAPAN

Album surréaliste: Nippon Salon. Tokyo: Ginza Galleries, 1937.

Eito, Takio. "Un point de vue japonais sur le surréalisme européen." *Mélusine,* no. 14 (1994).

Japon des avant-gardes, 1910–1970. Paris: Centre Georges Pompidou, 1987.

Linhartova, Vera. "La Peinture surréaliste au Japon (1925–1945)." *Cahiers du Musée National d'Art Moderne,* no. 11 (1983).

———. "Au Japon." In *La Planète affolée, surréalisme, dispersion et influences, 1938–1947.* Edited by José Pierre. Marseille: Musées de Marseille; Paris: Flammarion, 1986.

———. *Dada et surréalisme au Japon.* Paris: Publications Orientalistes de France, 1987.

Matsuura, Hisaki. "Shuzo Takiguchi et le surréalisme au Japon." *Mélusine,* no. 3.

SURREALISM IN LATIN AMERICA

Baciu, Stefan. "Mémoires du surréalisme chilien." *Mélusine,* no. 10.

Balakian, Anna. "Réception du surréalisme dans la poésie latino-américaine." *Mélusine,* no. 4.

Becker, Heribert, et al. *Lateinamerika und der Surrealismus.* 2 vols. Bochum: J. Kordt, 1993.

Cruz-Ramirez, Alfredo. "Au Mexique." In *La Planète affolée, surréalisme, dispersion et influences, 1938–1947.* Edited by José Pierre. Marseille: Musées de Marseille; Paris: Flammarion, 1986.

Palencia, J., *Surrealism in Mexican Paintings.* Mexico City, 1973.

Pierre, José. "Le Surréalisme et le Mexique." CAS (Centre National de la Recherche Scientifique), *Bulletin de liaison,* no. 11 (1979).

Rivas, Pierre. "Le Surréalisme au Pérou." *Mélusine,* no. 3.

Rodriguez Prampolini, Ida. *El surrealismo y el arte fantastico de Mexico.* Mexico City: Universidad Nacional Autonoma de Mexico, 1983.

SURREALISM IN PORTUGAL

França, Jose-Augusto. "Le Surréalisme portugais." *Mélusine,* no. 7.

Judice, Nuno. "Le Surréalisme: Une référence souterraine dans la culture portugaise du XXe siècle." *Mélusine,* no. 14 (1994).

SURREALISM IN ROMANIA

"L'Avant-garde roumaine." Special issue of *Le Rameau d'or,* no. 2 (1995).

Pop, Ion. "Repères pour une histoire du surréalisme roumain." *Mélusine,* no. 11.

———. "Surréalisme roumain et dialogue européen." *Mélusine,* no. 14 (1994).

SURREALISM IN SPAIN

Gaceta de arte y su epoca, 1932–1936. Las Palmas, Canary Islands: Centro Atlántico de Arte Moderna, 1997.

Garcia-Gallego, Jesus. *La recepción del surrealismo en España, 1924–1931.* Grenada: Antonia Ubago, 1984.

Gimenez Frontin, Jose-Luis. *El surrealismo: En torno al movimiento bretoniano.* Barcelona: Montesinos, 1983.

Morris, C.-B. *El manifesto surrealista escrito en Tenerife.* La Laguna, Canary Islands: Universidad de La Laguna, Instituto de Estudios Canarios, 1983.

Perez-Minik, Domingo. *Faccion espanola surrealista de Tenerife.* Barcelona: Tusquets Editor, 1975.

Personneaux-Conesa, Lucie. "Le Surréalisme en Espagne: Mirages et escamotage." *Mélusine,* no. 3.

———. "Histoire et historiographie du surréalisme espagnole." *Mélusine,* no. 11.

SIGNIFICANT PERIODICAL ARTICLES AND SPECIAL ISSUES

"Actuelle surrealisme: Essays over surrealisme in buitenlandse literatuur." Special issue of *De Gids* (Amsterdam), no. 5 (June–July 1984).

Alquié, Ferdinand. "Athéisme surréaliste et poésie." *Courrier du Centre International d'Études Poétiques* (Brussels), no. 1 (1955).

"André Breton et le surréalisme aujourd'hui." Special issue of *La Quinzaine littéraire,* no. 114 (March 16, 1971).

Aragon, Louis. "Lautréamont et nous." *Les Lettres françaises* (June 1 and 8, 1967). Reprint, Toulouse: Sables, 1992.

Artforum, vol. 5, no. 1, special issue on surrealism (September 1966).

Balmand, Pascal. "Les Surréalistes et les communistes." *L'Histoire,* no. 127 (November 1989).

Bataille, Georges. "La 'Vieille taupe' et le préfixe *sur* dans les mots *surhomme* et *surréaliste*" (1930). *Tel Quel,* no. 34 (summer 1968). Reprinted, pages 2:93 ff. in *Œuvres complètes.* By Georges Bataille. Paris: Gallimard, 1970.

———. "Le Surréalisme et sa différence d'avec l'existentialisme." *Critique,* no. 2 (July 1946).

———. "Le Surréalisme et Dieu." *Critique,* no. 28 (September 1948).

Beaujour, Michel. "Surréalisme et psychanalyse: Sublimation." *Le Siècle éclaté,* no. 3 (1985).

Belaval, Yvon. "La Théorie surréaliste du langage." *Courrier du Centre International d'Études Poétiques* (Brussels), no. 3.

Berenice (Rome), no. 8, (July 1983).

Bertrand, Jean-Pierre, Jacques Dubois, and Pascal Durand. "Approche institutionnelle du premier surréalisme (1919–1924)." *Pratiques,* no. 38 (June 1983).

Bonnet, Marguerite. "L'Orient dans le surréalisme: Mythe et reel." *Revue de littérature comparée,* no. 4 (October–December 1980).

Bruno, J. "André Breton et la magie quotidienne." *Revue métapsychique* (Paris), no. 27 (1954). Reprinted in *L'Art et l'occultisme.* Edited by Robert Amadou. Paris: Revue Metapsychique, 1954.

Burger, P. "Surréalisme et engagement." *Avant-Garde* (Amsterdam), no. 0 (1987).

Calas, Nicolas. "Liberté, amour et poésie." *Artforum,* no. 16 (May 1978).

Carrouges, Michel. "Le Surréalisme et l'occultisme." *Cahiers d'Hermès,* no. 2 (1949).

Change (Paris), nos. 10 and 25 (1972 and 1975).

Chénieux-Gendron, Jacqueline. "Lectures surréalistes du roman noir." *Europe,* no. 659 (March 1984).

———. "Sade et Saint-Just: Quelques têtes révolutionnaires dans le surréalisme." In *La Légende de la Révolution.* Edited by Jean-Claude Bonnet and Philippe Roger. Colloque de Cerisy, Collection Cinémas. Paris: Flammarion, 1988.

Décaudin, Michel, ed. "Apollinaire et les surréalistes." Special issue of *Revue des lettres modernes* (Paris), no. 104–7 (1964).

Decottignies, Jean. "L'Œuvre surréaliste et l'idéologie." *Littérature,* no. 1 (1971).

Documentation française, no. 5306–7 (June–July 1970).

"Le Domaine poétique international du surréalisme." Special issue of *Le Puits de l'ermite,* no. 29–31 (March 1978).

Drijkoningen, Fernand. "Surréalisme et anarchisme entre les deux guerres." *Avant-Garde* (Amsterdam-Atlanta), no. 3 (1989).

Eberz, I. "De l'identité rationaliste à l'hétérogénéité surréaliste: Du même au Même." In *Pour l'objet. Revue d'esthétique,* no. 3–4. 10/18.Paris: Union Générale d'Éditions, 1979.

Europe, no. 475–76 (November–December 1968).

Evard, Jean-Luc. "Défaire." In "Art et désordre." Special issue of *Confrontation,* no. 4 (autumn 1980).

"La Femme surréaliste." Special issue of *Obliques,* no. 14–15.

Fouchet, Max-Pol. "Le Surréalisme en Amérique." *Fontaine,* no. 32 (1944).

Frois-Wittmann, Jean. "Considérations psychanalytiques sur l'art moderne." *Revue française de psychanalyse,* no. 2 (1929).

"Le Groupe, la rupture." Special issue of *Change* (Paris), no. 7 (1970).

Houdebine, Jean-Louis. "Le Concept d'écriture automatique: Sa signification et sa fonction dans le discours idéologique d'André Breton." *La Nouvelle critique* (December 1970).

Janover, Louis. "Le Surréalisme, l'art et la politique." *Études de marxologie,* no. 19–20 (1978).

———. "Breton/Blum: Brève rencontre qui en dit long." *Mélusine,* no. 8 (1986).

———. "Les Vases non communicants: Surréalisme et politique." *Critique communiste,* no. 108–9 (June–July 1991).

Jenny, Laurent. "Les Aventures de l'automatisme." *Littérature,* no. 72 (December 1988).

Lefebvre, Henri. "De la littérature et de l'art modernes considérés comme processus de destruction et d'auto-destruction de l'art." In *Littérature et société: Problèmes do méthodologie en sociologie de la littérature.* Brussels: Éditions de l'Institut de Sociologie; Paris: École Pratique des Hautes Études, Section des Sciences Économiques et Sociales, 1967.

———."Le Renouveau philosophique avorté des années trente" (Interview with M. Trebitsch.). *Europe,* no. 683 (March 1986).

"Les Manifestes." Special issue of *Littérature,* no. 39 (October 1980).

Mascolo, Dionys. "Le Surréalisme, demain." *La Quinzaine littéraire* (December 15, 1966).

———. "Surréalisme, morale, musique." *La Quinzaine littéraire* (March 15, 1971).

"Naissance du surréalisme." Special issue of *Digraphe* (Paris), no. 10 (June 1983).

Navarri, Roger. "Les Dadaïstes et les surréalistes devant la révolution d'Octobre." *Europe* (September–October 1967).

———. "Au grand jour/À la grande nuit, ou la double postulation de la critique surréaliste." *L'Information littéraire* (March–April 1981).

"Permanence du surréalisme." Special issue of *Cahiers du 20e siècle* (Paris), no. 4 (1975).

Pierre, José. "La Seconde Guerre Mondiale et le deuxième souffle du surréalisme." In *Paris 1937–Paris 1957: Créations en France.* Paris: Centre Georges Pompidou, 1981.

———. "Les Cartes postales surréalistes de 1937." *CPM Magazine,* no. 5 (November 1985).

Riese-Hubert, Renée. "Characteristics of an Undefinable Genre: The Surrealist Prose Poem." *Symposium* (summer 1968).

———. "La Critique d'art surréaliste: Création et tradition." *Cahiers de l'Association Internationale des Études Françaises,* no. 37 (May 1985).

Riffaterre, Michel. "La Métaphore filée dans la poésie surréaliste." *Langue française,* no. 3 (September 1969).

Rolland de Renéville, André. "Dernier état de la poésie surréaliste." *Nouvelle revue française* (February 1932). Reprinted in *Univers de la parole.* Paris: Gallimard, 1944.

Schuster, Jean. "La Psychanalyse et le surréalisme." *L'Âne,* no. 17 (July–August 1984).

"60 ans de surréalisme." Special issue of *Magazine littéraire,* no. 213 (December 1984).

Sollers, Philippe. "La Grande méthode." *Tel Quel,* no. 34 (1968).

"Surréalisme et psychiatrie." Special issue of *Évolution psychiatrique,* vol.44, fasc. 1 (January–March 1979).

Surréalisme international. Opus international, no. 19–20 Paris: G. Fall, 1970). Revised and republished as *André Breton et le surréalisme international. Opus international,* no. 123–24. Paris: G. Fall, 1991).

"Les Surréalistes." Special issue of *Revue des sciences humaines* (Lille), vol. 193, no. 1 (1984).

Tel Quel (Paris), no. 46 (summer 1971).

Vovelle, José. "Échos ambigus du surréalisme en Hollande." *Archives de l'art français,* no. 25 (1978).

———. "Le 'Bel été' surréaliste d'Amsterdam, 1938." *Les Cahiers du Musée National d'Art Moderne,* no. 23 (spring 1988).

Waldberg, Patrick. "Aurore du surréalisme." Pages 153–69 in *Académie des Beaux-Arts,* 1972–73. Paris: Institut de France, 1977.

PRINCIPAL INDIVIDUAL EXHIBITION CATALOGS

Eileen Agar

Eileen Agar: A Decade of Discoveries. London: New Art Centre, 1976.
Eileen Agar: A Retrospective. London: Birch & Conran Gallery, 1987.
Eileen Agar: Retrospective Exhibition. London: Commonwealth Art Gallery, 1971.
Eileen Agar: Retrospective Exhibition of Paintings and Collages, 1930–1964. London: Brook Street Gallery, 1964.

Pierre Alechinsky

Alechinsky. Paris: Galerie Nina Dausset, 1954.

Alechinsky, Pierre. *Titres et pains perdus.* Paris: Denoël, 1965.
————. *Le Test du titre.* Paris: Éric Losfeld, 1967.
————. *Roue libre.* Geneva: Skira, 1971.
————. *Peintres et écrits.* Paris: Yves Rivière–Arts & Métiers Graphiques, 1977.

Jean (Hans) Arp

Arntz, Wilhelm F. *Hans (Jean) Arp: Das graphische Werk, 1912–1966.* Haag, Germany: Gertrud Arntz-Winter 1980.
Arp. Paris: Musée National d'Art Moderne, 1962.
Arp. Milan: Schwarz Gallery, 1965.
Arp, Jean. *Jours effeuillés: Poèmes, essais, souvenirs, 1920–1965.* Paris: Gallimard, 1966.
Arp. Paris: Musée d'Art Moderne de la Ville de Paris, 1986.
"Arp, poète plasticien." Special issue of *Mélusine*, no. 9. Actes du colloque de Strasbourg. (1987).
Arp, sculptures et papiers de 1913 à 1966. Angers: Présence de l'Art Contemporain, 1993.
Buffet Picabia, Gabrielle. *Arp.* Paris: Presses Littéraires de France, 1952.
Cathelin, Jean. *Arp.* Paris: G. Fall, 1959.
Hans/Jean Arp, le temps des papiers déchirés. Paris: Centre Georges Pompidou, 1983.
Hommage à Jean Arp. Paris: Galerie Denise René, 1974.
Michaud, Éric. "Jean Arp ou le sens du hasard." *Critique,* no. 479 (April 1987). Reprinted in his *La Fin du salut par l'image.* Collections Critiques d'Art. Nîmes: Éditions Jacqueline Chambon, 1992.
Read, Herbert. *The Art of Jean Arp.* London: Thames & Hudson, 1968.
Saisons d'Alsace, no. 93 (September 1986).
Soby, James T. *Arp.* New York: Museum of Modern Art, 1958.
Weber, Sylvia C., ed. *Arp.* Museum Würth, Sigmringen, 1994. Sigmaringen: J. Thorbecke, 1994.

Antonin Artaud

Antonin Artaud. Les Sables-d'Olonne: Museum of the Abbaye Sainte-Croix, 1980.
Antonin Artaud, dessins. Paris: Centre Georges Pompidou, 1987.
Antonin Artaud, œuvres sur papier. Marseille: Museums of the City of Marseille, 1995. English translation: *Antonin Artaud: Works on Paper.* Edited by Margit Rowell. New York: Museum of Modern Art, 1996.
Le Bot, Marc. "La Maladresses sexuelle de Dieu." *Corps écrit* (Paris), no. 1 (1982).
Meredieu, Florence de. *Antonin Artaud, portraits et gris-gris.* Paris: Blusson, 1984.
Portraits et dessins par Antonin Artaud. Paris: Galerie Pierre, 1947.
Thévenin, Paule, and Jacques Derrida. *Antonin Artaud, dessins et portraits.* Paris: Gallimard, 1986.

Hans Bellmer

Bellmer. Paris: Galerie André-François Petit, 1962, 1963.
Bellmer. Paris: Galerie Daniel Cordier, 1963.
Bellmer. Geneva: Galerie Benador, 1966.

Bellmer. Berlin: Deutsche-Gesellschaft für Bildende Kunst, 1967.
Bellmer. Paris: Obliques, 1975.
Bellmer, Hans. *Die Puppe.* Karlsruhe: Karlsruhe: Th. Eckstein, 1934. Reprint, Berlin: Gerhardt Verlag, 1962. French translation: *La Poupée.* Translated by Robert Valençay. Paris: GLM, 1936.
————. *Les Jeux de la poupée.* Paris: Éditions Premières, 1949.
————. *L'Anatomie de l'image.* Paris: Le Terrain Vague, 1957.
Bellmer, Hans, and Unica Zurn. *Lettres au docteur Ferdière.* Paris: Séguier, 1994.
Brun, Jean. "Analogie, anagrammes et anatomie dans l'œuvre de Bellmer." *Cahiers du Sud,* no. 341 (1957).
Hans Bellmer. Paris: Galerie du Luxembourg, 1947.
Hans Bellmer. Paris: Centre National d'Art Contemporain, 1971.
Hans Bellmer graveur. Paris: Musée de la Seita, 1997.
Hommage à Bellmer. Paris: Galerie André-François Petit, 1975.
Jelenski, Constantin. *Les Dessins de Hans Bellmer.* Paris: Denoël, 1960.
————. *Bellmer: Œuvre gravé, 1939–1971.* Paris, 1969.
Le Brun, Annie. *Hans Bellmer et son graveur Cécile Reims.* Issoudun, 1992.
Morgan, R.-C., and Timothy Baum. *A Hans Bellmer Miscellany.* New York: Jan Turner Gallery, 1993.
Sayag, Alain. *Bellmer photographe.* Paris: Filipacchi, Centre Georges Pompidou, 1984.

Jean Benoît

Benoît, Jean. "Notes concernant l'exécution du testament de Sade." In *Petits et grands théâtres du marquis de Sade.* Edited by Annie Le Brun, with the collaboration of Jean Benoît et al. Paris: Paris Art Center, 1989.
Ivsic, Radovan. "Le Théâtre irréversible: Jean Benoit et Sade."
Le Brun, Annie. *Jean Benoît.* Paris: Filipacchi, 1996.
Sauvages des villes-sauvages des Îles. Noyers-sur-Serein: Centre d'Art Contemporain, 1992.

Jean-Claude Biraben

Biraben, Jean-Claude. *Ci-gît l'horizon.* Paris: Le Récipiendaire, 1977.
————. *La Niche dans le chien.* Liège, mensuel 25, no. 25–26, January 1979.
————. *La Cible maladroite.* Brussels: Le Vocatif Collection, 1979.
————. *Extrait du catalogue.* Toulouse, 1996.
Goutier, Jean-Michel. "L'Enjeu en jeu." *Ellébore,* no. 5 (1981).
Pierre, José. *Biraben: L'Enfance préservée de Jean-Claude Biraben ou les nouvelles aventures de l'objet.* Toulouse: Éditions Loubatières, 1993.
Pillet, A.-P. "Les Passages à niveau sont des sémaphores." *Pleine marge,* no. 1 (1985).

Vilhelm Bjerke-Petersen

Bjerke-Petersen, Vilhelm. *Freddie.* Copenhagen: Illums Bog-Avdeling, 1935.
————. "Pourquoi je suis surréaliste." *Cahiers d'art,* no. 5–6 (1935).
————. *Des symboles dans l'art abstrait* (1933). Paris: Yves Rivière, 1980.
Vilhelm Bjerke-Petersen en retrospektiv udstilling. Silkeborg: Silkeborg Kunstmuseum, 1986.

Paul-Émile Borduas

Borduas, Paul-Émile. *Écrits / Writings.* Montreal: Éditions F.-M. Gagnon, 1978.

Ferron, Marcelle. "Témoignages sur Paul-Émile Borduas." *Aujourd'hui, art et architecture,* no. 26 (April 1960).

Gagnon, François-Marc. *Le Refus global en son temps: Ozias Leduc et Paul-Émile Borduas.* Montreal: Presses Universitaires, 1973.

———. *Paul-Émile Borduas.* Montreal: Montreal Museum of Fine Arts, 1988.

Paul-Émile Borduas. Montreal: Montreal Fine Arts Museum, 1988.

Robert, Guy. *Borduas.* Montreal: Presses de l'Université du Québec, 1972.

Victor Brauner

Alexandrian, Sarane. *Victor Brauner, l'illuminateur.* Paris: Cahiers d'Art, 1954.

———. *Les Dessins magiques de Victor Brauner.* Paris: Denoël, 1965.

Brauner. Preface by André Breton. Paris: Galerie Pierre, 1934.

Brauner. Paris: Galerie Henriette, 1939.

Brauner. Paris: Le Point Cardinal, 1963.

Brauner. Paris: Galerie Patrice Trigano, 1987.

Cahier Victor Brauner I. Saint-Étienne: Musée d'Art Moderne, 1988.

Dessins de Victor Brauner au Musée National d'Art Moderne. Paris: Centre Georges Pompidou, 1975.

Fêtes et mythologies de Victor Brauner. Paris: Galerie Iolas, 1974.

Formes rituelles II. Tanlay: Centre d'Art Contemporain, 1987.

Jouffroy, Alain. *Brauner.* Paris: G. Fall, 1959. New edition, revised and corrected, Paris: G. Fall, 1996.

———. *Victor Brauner le tropisme totémique.* Creil: B. Dumerchez, 1996.

Mabille, Pierre. "L'Œil du peintre." *Minotaure,* no. 12–13 (May 1939).

Omaggio a Victor Brauner. Milan: Schwarz Gallery, 1966.

Onomatomanie de Victor Brauner. Paris: Galerie Iolas, 1975.

Semin, Didier. *Victor Brauner.* Paris: Filipacchi, 1991.

Victor Brauner. Vienna: Museum des 20. Jahrhunderts, 1965.

Victor Brauner. Paris: Musée National d'Art Moderne, 1972.

Victor Brauner. Paris: Galerie Didier Imbert Fine Art, 1990.

Victor Brauner. Saint-Étienne: Musée d'Art Moderne; Colmar: Musée d'Unterlinden, 1992.

Victor Brauner: "Cahier de dessin." Paris: Galerie Iolas, 1968.

Victor Brauner: Documents d'atelier. Paris: Galerie Iolas, 1967.

Victor Brauner: Miti, presagi, simboli—Opere dal 1929 al 1965. Lugano: Villa Malpensata, 1985.

Victor Brauner: Ses frontières noires. Paris: Galerie Iolas, 1970.

Victor Brauner dans les collections du Musée National d'Art Moderne. Paris: Centre Georges Pompidou, 1996.

Victor Brauner Dipinti, 1939–1959. Rome: Gallery L'Antico, 1961.

Victor Brauner ou la clé des mythes. Paris: Galerie René Drouin, 1948.

Pol Bury

Pol Bury. La Louvière: Maison des Loisirs, 1949.

Pol Bury. Brussels: Galerie Apollo, 1950.

Pol Bury. Charleroi: Galerie Le Parc, 1950.

Jorge Camacho

Brousse au-devant de Camacho. Paris: Galerie Mathias Fels, 1964.

Camacho. Geneva: Galerie Jan Krugier, 1974.

Camacho. Barcelona: Galerie Joan Prats, 1979.

Camacho. Caracas: Gallery Minotauro, 1982.

Camacho: Peintures sur papier, eaux-fortes, lithographies, livres illustrés. Geneva: Éditart, 1987.

Camacho, Jorge. *L'Arbre acide / Ohcamac.* Paris: Éditions Surréalistes, 1967.

———. *Le Mythe d'Isis et d'Osiris et sa relation avec le symbolisme hermétique.* Paris: La Table d'Émeraude, 1995.

Camacho, Jorge, and Bernard Roger. *Le Hibou philosophe.* Brussels: La Pierre d'Alun, 1991.

Le Chant des Arènes. Brussels: Galerie Epsilon, 1987.

Franqui, Carlos. *Jorge Camacho.* Barcelona: Polígrafa, 1979.

HARR: Hommage à Raymond Roussel. Paris: Galerie Mathias Fels, 1969.

Histoire des oiseaux. Paris: Galerie Maeght, 1982.

Hommage à Jean-Pierre Duprey. Brussels: Galerie Maya, 1966.

Hommage à Oscar Panizza. Paris: Galerie Cordier, 1962.

L'Idée du Sud. Paris: Galerie C. Brimaud; Brussels: Galerie Epsilon, 1991.

Jorge Camacho. Paris: Galerie de Seine, 1973.

Jorge Camacho. Lima: Gallery Camino Brent, 1983.

Jorge Camacho. Paris: Galerie Vallois, 1993.

Jorge Camacho: Cibles. Paris: Galerie Gloria Cohen, 1993.

Jorge Camacho: Impressions—catalogues des éditions et tirages limités. Paris: Galerie du 7, rue Princesse, 1983.

Jorge Camacho: La Idea del Sur. Huelva, 1990.

Jorge Camacho: La Nature des choses, les bois des sables. Paris: Galerie Thessa Hérold, 1996.

Jorge Camacho: Les Détours de soi. Maubeuge: Idem + Arts, 1997.

Jorge Camacho, "La danse de la mort." Paris: Galerie de Seine, 1976.

Oiseaux (photographs). Paris: Galerie Mathias Fels, 1982.

La Philosophie du paysage. Paris: Galerie Albert Loeb, 1984.

Le Ton haut. Paris: Galerie Mathias Fels, 1969.

Agustin Cardenas

Agustin Cardenas: Marbles, Woods, Bronzes. Caracas: Galeria Durban, 1990.

Agustin Cardenas: Trente années de sculpture. Paris: Galerie JGM, 1988.

Agustin Cardenas, sculptures—Fayad Jamis, peintures. Paris: À l'Étoile Scellée, 1956.

Cardenas. Paris: La Cour d'Ingres, 1959.

Cardenas. Paris: Galerie du Dragon, 1961.

Cardenas. Milan: Galleria Schwarz, 1962.

Cardenas. Paris: Galerie du Dragon, 1965.

Cardenas. Brussels: Galerie Arcanes, 1968.

Cardenas. Turin: Galleria La Bussola, 1969.

Cardenas. Milan: Galleria Gruppo Credito Valtellinese, 1997.

Cardenas: Bois. Paris: Galerie JGM, 1990.

Cardenas: Marbres et bronzes, 1975–1979. Paris: Galerie Le Point Cardinal, 1979.

Cardenas sculpteur. Paris: Fondation Nationale des Arts Graphiques & Plastiques, 1981.

Pierre, José. *La Sculpture de Cardenas.* Brussels: La Connaissance, 1971.

Leonora Carrington

Carrington, Leonora. *La Maison de la peur.* Paris: H. Parisot, 1938.
———. *La Dame ovale.* Paris: GLM, 1939.
———. *En-bas.* Paris: Fontaine, 1945.
———. *Une chemise de nuit de flannelle.* Paris: Flammarion, 1951.
———. *El mundo magico de los Mayas.* Mexico City: Instituto Nacional de Antropologie e Historia, 1964.
———. *La Porte de pierre.* Paris: Flammarion, 1976.
———. *Le Septième cheval.* Montpellier: Coprah, 1977.
———. *The Oval Lady: Six Surreal Stories.* Translated by Rochelle Holt. Foreword by Gloria Orenstein. Santa Barbara, Calif.: Capra Press, 1975.
———. *The House of Fear: Notes from Down Below.* New York: E. P. Dutton, 1988.
———. *The Seventh Horse and Other Stories.* Translated by Kathrine Talbot and Anthony Kerrigan. New York: E. P. Dutton, 1988.
Leonora Carrington. New York: Gallery Pierre Matisse, 1948.
Leonora Carrington. New York: Brewster Gallery, 1988.
Leonora Carrington, Retrospective Exhibition. New York: Centre for Inter-American Relations, 1976.
Plaza, Monique "Leonora Carrington: De la folie à l'utopie." *Frénésies,* no. 1 (spring 1986).
Ponce, Juan-Garcia, and Leonora Carrington. *Léonora Carrington.* Mexico City: Ediciones Era, 1977.

Florent Chopin

Chopin, Florent. *Le Bureau des longitudes.* Brive: Éditions Myrddin, 1991.
———. *La Balançoire du sorcier.* Paris: L'Embellie Roturière, 1992.
———. *She's Like a Rainbow.* Brive: Éditions Myrddin, 1993.
———. *Le Mouvement que décrit la pirogue.* Rennes: Éditions Wigwam, 1994.
———. *Tu dors quand il pleut?* Brive: Éditions Myrddin, 1996.
Florent Chopin: L'Atelier de brousse. Maubeuge: Idem + Arts, 1995.
Florent Chopin: Le Bout du monde. Aulnay-sous-Bois: Espace Gainville, 1996.
Florent Chopin: Les Notions les plus simples. Prague: Vysehrad Gallery, 1993.

Ithell Colquhoun

Ithell Colquhoun. Cheltenham: Cheltenham Art Gallery, 1936.
Ithell Colquhoun: An Exhibition of Surrealist Paintings and Drawings from 1930–1950. London: Leva Gallery, 1974.
Ithell Colquhoun: Paintings. London: Mayor Gallery, 1947.
Ithell Colquhoun: Paintings and Drawings, 1930–1940. London: Parking Gallery, 1970.
Ithell Colquhoun: Surrealism. Cornwall: Newlyn Orion Galleries, 1976.

William Copley

Copley. Paris: Galerie du Dragon, 1956.

Copley. Paris: Musée National d'Art Moderne, Centre Georges Pompidou, 1980.
Copley, William. "Portrait de l'artiste en jeune marchand de tableaux." In *Paris–New York.* Paris: Centre National d'Art et de Culture Georges Pompidou, Musée d'Art Moderne, 1977. Reprint, Paris: Éditions du Centre Pompidou–Gallimard, 1991.
SMS. Paris: Librairie Lecointre-Ozanne, 1989.
William Copley. Paris: Galerie 1900-2000, 1988.

Joseph Cornell

Ashton, Dore. *A Joseph Cornell Album.* New York: Viking Press, 1974.
Jaguer, Edouard. *Joseph Cornell: Jeux, jouets et mirages.* Paris: Filipacchi, 1989.
Joseph Cornell. Paris: Galerie B. Lebon and Musée Toulon, 1980.
Joseph Cornell. Paris: Musée d'Art Moderne de la Ville de Paris, 1981.
McShine, Kynaston, ed. *Joseph Cornell.* New York: Museum of Modern Art; Munich: Prestel, 1980.
Starr, Sandra Leonard, ed. *Joseph Cornell Portfolio.* New York, Castelli/Corcoran Foreign, 1976.
Waldman, Diane. *Joseph Cornell.* New York: G. Braziller, 1977.

Salvador Dalí

Ades, Dawn. *Dalí.* London: Thames & Hudson, 1982.
Alexandrian, Sarane. *Dalí et les poètes.* Paris: Filipacchi, 1976.
Bosquet, Alain. *Entretiens avec Salvador Dalí.* Paris: Belfond, 1966.
Dalí. Paris: Centre Georges Pompidou, 1979.
Dalí et les livres. Barcelona: Generalitat de Catalunya; Nîmes: Ville de Nîmes, 1984.
Dalí, Salvador. *La Femme visible.* Paris: Éditions Surréalistes, 1930.
———. *L'Amour et la mémoire.* Paris: Éditions Surréalistes, 1931.
———. *La Vie secrète de Salvador Dalí.* Paris: La Table Ronde, 1952. English translation: *The Secret Life of Salvador Dalí.* Translated by Haakon M. Chevalier. New York: Dover Publications, 1993.
———. *Les Cocus du vieil art moderne.* Paris: Fasquelle, 1956.
———. *Le Mythe tragique de l'Angelus de Millet.* Paris: Pauvert, 1963.
———. *Journal d'un génie.* Paris: La Table Ronde, 1964. English translation: *Diary of a Genius.* Translated by Richard Howard. New York: Doubleday, 1965.
———. *Oui.* Paris: Denoël-Gonthier, 1979.
———. *Dalí on Modern Art: The Cuckolds of Antiquated Modern Art.* Translated by Haakon M. Chevalier. New York: Dover Publications, 1996.
Descharnes, Robert. *Dalí, l'homme et l'œuvre.* Lausanne: La Bibliothèque des Arts, 1984.
Gaya Nuno, Juan-Antonio. *Salvador Dalí.* Barcelona: Ediciones Omega, 1950.
Gérard, Max. *Dalí de Draeger.* Paris: Draeger, 1968.
"Hommage à Dalí." Special issue of *XXe Siècle* (Paris), no. 54 (1980).
Maddox, Conroy. *Dalí.* New York: Crown Publishers–Fletham Publishing Group, Ltd., 1979.
Michler, Ralf, and Lutz W. Lopsinger. *Salvador Dalí: Catalog raisonné of etchings and mixed-media prints, 1924–1980.* Munich and New York: Prestel, 1994.

Roger, Alain. *Hérésies du désir.* Seyssel: Éditions Champ Vallon, 1985.

Salvador Dalí, 1904–1989. Stuttgart: Staatsgalerie, 1989.

Adrien Dax

Adrien Dax. Brussels: Galerie La Marée, 1976.

Dax, Adrien. *Le Passeur d'angles.* Poquettes volantes, no. 40. La Louvière: Le Daily Bul.

Roque, S. *Adrien Dax.* Paris: Galerie Carole Brimaud, 1994.

Giorgio De Chirico

Bruni, Carlo. *Catalogo generale Giorgio De Chirico.* Venice and Milan: Electa, 1971–83.

Carrieri, Raffaele. *Giorgio De Chirico.* Milan: Gaezanti, 1942.

Cavallo, Luigi, and Maurizio Fagiolo dell'Arco. *De Chirico, disegni inediti.* Milan: Tega, 1985.

De Chirico: Gli anni venti. Milan: Palazzo Reale, 1987.

De Chirico par De Chirico. Paris: Damase, 1978.

De Chirico, Giorgio. *Hebdomeros.* Paris: Éditions du Carrefour, 1929. Reprint, Paris: Flammarion, 1983.

———. *Memorie della mia vita.* Rome: Astrolabio, 1945.

———. *Poèmes poésie.* Paris: Solin, 1981.

Giorgio De Chirico. Milan: Palazzo Reale, 1970.

Giorgio De Chirico. Galleria Nazionale d'Arte Moderna, 1981–82, Rome. Rome: De Luca, 1981.

Giorgio De Chirico. New York: Museum of Modern Art, 1982; Paris: Musée National d'Art Moderne, 1983.

Lebel, Robert. "De Chirico ou la Peinture à Rebours." *L'Œil,* no. 193 (January 1971).

Lista, Giovanni. *De Chirico et l'avant-garde.* Lausanne: L'Âge d'Homme, 1983.

———. *De Chirico.* Paris: Hazan, 1991.

Soby, James T. *The Early Chirico.* New York: Dodd Mead & Co., 1941.

———. *Giorgio De Chirico.* New York: Museum of Modern Art, 1955.

Vitrac, Roger. *Georges De Chirico.* Paris: Gallimard, 1927.

Waldberg, Patrick. *Giorgio De Chirico, la nascita della metafisica e la sua influenza sul surrealismo.* Milan: Fabbri, 1968.

Gabriel Der Kevorkian

Der Kevorkian. Paris: Galerie AAA, 1973.

Der Kevorkian. Paris: Galerie R. Duperrier, 1984.

Der Kevorkian. Paris, Pleine Marge, 1989.

Fabio De Sanctis

Cortenova, Giorgio, Annie Le Brun, and Radovan Ivsic. *La Traversée des Alpes.* Paris and Rome: Éditions Maintenant, 1972.

De Sanctis. Paris: Galerie du Dragon, 1982, 1991.

De Sanctis: Sculptures. Paris: Galerie Le Triskèle, 1979.

De Sanctis, Fabio. *Déménagement.* Paris and Rome: Éditions Maintenant, 1974.

Jaguer, Edouard. *Fabio de Sanctis.* Paris, 1982.

Officina Undici: Mobili di Fabio de Sanctis e Ugo Sterpini. Rome: Galleria d'Arte Il Centro, 1964.

La Poésie dans ses meubles. Paris, 1964.

Oscar Dominguez

Dominguez. Brussels: Galerie Apollo, 1950.

Dominguez. Paris: Galerie Rive Gauche, 1957.

Dominguez, Oscar. *Les Deux qui se croisent.* Paris: Fontaine, 1947.

Guigo, Emmanuel. *Oscar Dominguez.* Translated by Marta Bertrán. Tenerife: Viceconsejeria de Cultura y Deportes, Goberno de Canarias, 1996.

Oscar Dominguez: Antologica, 1926–1957. Las Palmas, Canary Islands: Centro Atlántico de Arte Moderno; Santa Cruz de Tenerife: Dentro de Art La Granja; Madrid: Museo Nacional Reina Sofia, 1996.

Sueños de Tinta: Oscar Dominguez y la decalcomania del deseo. Las Palmas, Canary Islands: Atlántico de Arte Moderno, 1993.

Westerdhal, Edouardo. *Oscar Dominguez.* Barcelona: Gustavo Gili, 1968.

Xuriguera, Gérard. *Oscar Dominguez.* Paris: Filipacchi, 1973.

Enrico Donati

Calas, Nicolas, and Clement Greenberg. *Enrico Donati.* Milan: Edizioni del Milione, 1954.

Donati. New York: Durand-Ruel Gallery, 1949.

Donati. Paris: Galerie André Weil, 1949.

Donati. New York: Jolas Gallery, 1952.

Donati. Venice: Gallery del Cavallino, 1954.

Donati. Munich: Neue Galerie im Künstlerhaus, 1962.

Donati. New York: Staempfli Gallery, 1973.

Enrico Donati. Paris: Galerie Zabriskie, 1987.

Enrico Donati: A Retrospective Exhibition. Saint Paul: Minnesota Museum of Art, 1977.

Enrico Donati: Recent Paintings. New York: Staempfli Gallery, 1972.

Peintures de Donati. Paris: Galerie Drouand-David, 1947.

Recent Paintings by Enrico Donati. Houston: Wildenstein Art Center, 1978.

Selz, Peter Howard. *Enrico Donati.* Paris: Éditions G. Fall, 1965.

Christian D'Orgeix

Christian D'Orgeix: Zeichnungen. Düsseldorf: W. Wittrock Kunsthandel, 1991.

Von Holten, Ragnar, and José Pierre. *D'Orgeix.* Paris: Le Musée de Poche, 1975.

Marcel Duchamp

Bailly, Jean-Christophe. *Marcel Duchamp.* Paris: Hazan, 1984.

Cabanne, Pierre. *Entretiens avec Marcel Duchamp.* Paris: Belfond, 1967. Rev. ed., Paris: Somogy, 1995. Rev. ed. with audio recordings, Marseille: André Dimanche, 1995. English translation: *Dialogues with Marcel Duchamp.* Translated by Ron Padgett. New York: Viking Press, 1971.

Chénieux-Gendron, Jacqueline. "Patience et impatiences chez Marcel Duchamp." *Nouveau commerce* (Paris), no. 24–25 (1973).

Clair, Jean. *Duchamp ou le grand fictif.* Paris: Galilée, 1975.

———. *Duchamp et la photographie.* Paris: Le Chêne, 1977.

Dadoun, Roger. *Duchamp, ce Mécano qui met à nu.* Paris: Hachette, 1996.

De Duve, Thierry. *Nominalisme pictural: Marcel Duchamp, la peinture et*

la modernité. Paris: Éditions de Minuit, 1989.

———. *Au nom de l'art.* Paris: Éditions de Minuit, 1989.

———. *Résonances du Ready-Made.* Nîmes: J. Chambon, 1989.

D'Harnoncourt, Anne, and Kynaston McShine, eds. *Marcel Duchamp.* New York: Museum of Modern Art, 1973.

"Dossier Marcel Duchamp." Special issue of *Art Press,* no. 178 (March 1993).

Duchamp, Marcel. *Marchand du Sel.* Edited by Michel Sanouillet. Paris: Le Terrain Vague, 1959.

———. *Duchamp du Signe.* Edited by Michel Sanouillet and revised and supplemented with the collaboration of Elmer Peterson. Paris: Flammarion, 1976.

"Duchamp et après." Special issue of *Opus international,* no. 49 (March 1974).

Gibson, Michael, *Duchamp Dada.* Paris: Nouvelles Éditions Française–Casterman, 1991.

Hopps, Walter, Ulf Linda, and Arturo Schwarz. *Marcel Duchamp: Ready-Made, etc., 1913–1964.* Milan: Galleria Schwarz; Paris: Le Terrain Vague, 1964.

Lebel, Robert. *Sur Marcel Duchamp.* Paris: Trianon, 1959.

———. *Marcel Duchamp.* Paris: Belfond, 1975.

Leiris, Louise. "Arts et Métiers de Marcel Duchamp." *Fontaine,* no. 54 (summer 1946).

Lyotard, Jean-François. *Les Transformateurs-Duchamp.* Paris: Galilée, 1980.

"Marcel Duchamp." Special issue of *L'Arc,* no. 59, 4th trimester (1974).

Marcel Duchamp. Colloque de Cerisy. 10/18. Paris: Union Générale d'Éditions, 1975.

Marcel Duchamp. 4 vols. Paris: Centre Georges Pompidou, 1977.

Marcel Duchamp. Antwerp: Galerie Van de Velde, 1991.

Marcel Duchamp. Milan: Bompiani, 1993.

Marcel Duchamp: Multiples et éditions. Paris: Galerie Thorigny, 1991.

Marcel Duchamp: The Lovers. Milan: Schwarz Gallery, 1969.

Mink, Janis. *Duchamp.* Cologne: Taschen, 1996.

Par Marcel Duchamp ou Rrose Sélavy. Pasadena: Pasadena Art Museum, 1963.

Partouche, Marc. *Une vie d'artiste: Marcel Duchamp, j'ai eu une vie absolutment merveilleuse.* Marseille: Images en manœuvre, 1992.

Schwarz, Arturo. *Marcel Duchamp.* Paris, G. Fall, 1974.

Suquet, Jean. *Miroir de la Mariée.* Paris: Flammarion, 1974.

———. *Le Guéridon et la Virgule.* Paris: Bourgois, 1977.

———. *Le Grand Verre rêvé.* Paris: Aubier, 1991.

———. *In vivo, in vitro: Le Grand Verre à Venise.* Paris: L'Échoppe, 1994.

Aube Elleouët

Aube Elleouët: Collages. Paris: Galerie Le Triskèle, 1978.

Yves Elleouët

Elleouët, Yves. *Le Livre des rois de Bretagne.* Paris: Gallimard, 1974.

———. *Falc'hun.* Paris: Gallimard, 1976.

———. *La Proue de la table.* Paris: Le Soleil Noir, 1967.

Yves Elleouët. Tréguier, 1996.

Max Ernst

Adhémar, Jean, and Mariel Frèrebeau, eds. *Max Ernst: Estampes et livres illustrés.* Paris: Bibliothèque Nationale, 1975.

Alexandrian, Sarane. *Max Ernst.* Paris: Somogy, 1986.

Baatsch, Henri Alexis, Jean-Christophe Bailly, and Alain Jouffroy. *Max Ernst.* Paris: Éditions Étrangères and Christian Bourgois, 1976.

Di San Lazzaro, Gualtieri, ed. *Homage to Max Ernst: Special Issue of "XXe siècle."* New York: Tudor, 1971.

Ernst, Max. *Histoire naturelle.* Paris: J. Bucher, 1926. Reprint, Paris: Pauvert, 1960.

———. *La Femme 100 têtes.* Paris: Éditions du Carrefour, 1929. English translation: *The Hundred Headless Women / La Femme 100 têtes.* New York: G. Braziller, 1981.

———. *Le Rêve d'une petite fille qui voulut entrer au Carmel.* Paris: Éditions du Carrefour, 1930. Reprint, Paris: Pauvert, 1983.

———. *Une semaine de Bonté.* Paris: J. Bucher, 1934.

———. *Paramyths.* Beverly Hills, Calif.: Copley Gallery, 1949.

———. *Paramythen.* 1955. Reprint, Cologne: Galerie der Spiegel, 1970.

———. *Paramythes.* Paris: Le Point Cardinal, 1967.

———. *Écritures.* Paris: Gallimard, 1970.

———. *Première conversation mémorable avec la Chimère.* In *Amour, nature et plaisir en picto-poésie.* By Branko Aleksic. Thaon: Éditions Amiot-Lenganey, 1991.

Gianelli, Ida, ed. *Max Ernst: Sculture.* Castello di Rivoli, Museo d'Arte Contemporanea, 1996. Milan: Charta, 1966.

Lascault, Gilbert. *Sur la planète Max Ernst.* Paris: Maeght, 1991.

"Max Ernst." Special issue of *View* (New York) (1942).

Max Ernst. Paris: Galerie R. Drouin, 1950.

Max Ernst. Knokke-le-Zoute: Casino Communal, 1953.

Max Ernst. Paris: Musée National d'Art Moderne, 1959.

Max Ernst. Propos et Présence, Paris: Gonthier-Seghers, 1960.

Max Ernst. New York: World House Galleries, 1961.

Max Ernst. Stockholm: Moderna Museet, 1969.

Max Ernst. Paris: Orangerie des Tuileries, 1971.

Max Ernst. Galeries Nationales du Grand-Palais, Paris, 1975. Paris: Centre National d'Art et de Culture Georges Pompidou, Musée d'Art Moderne, 1975.

Max Ernst. New York: Guggenheim Museum, 1975.

Max Ernst. Paris: Centre Georges Pompidou, 1991.

Max Ernst: Cap Capricorne. Paris: Galerie Alexandre Iolas, 1964.

Max Ernst: Écrits et œuvre gravé. Cologne: Konnertz, 1977.

Max Ernst: Le Musée de l'homme suivi de la pêche au soleil levant. Paris: Galerie Alexandre Iolas, 1965.

Max Ernst: Le Néant et son double. Paris: Galerie Alexandre Iolas, 1968.

"Max Ernst: Œuvres de 1919 à 1936." Special issue of *Cahiers d'art* (Paris) (1937).

Max Ernst: Œuvre gravé, 1913–1961. Paris: Le Point Cardinal, 1961.

Max Ernst, lieux communs: D'écervelages. Paris: Galerie Alexandre Iolas, 1971.

Le Monde frotté à la mine de plomb: Frottages de 1925 à 1965. Geneva: Galerie D. Bénador, 1965.

Quinn, Edward, et al. *Max Ernst.* Paris: Cercle d'Art, 1976; New

York: Graphic Society, 1977. Reprint, Cologne: Konemann, 1999.

———. *Max Ernst*. Barcelona: Polígrafa, 1983.

Rainwater, Robert, ed. *Max Ernst: Beyond Surrealism—a Retrospective of the Artist's Books and Prints*. New York: New York Public Library; Oxford: Oxford University Press, 1986.

Russell, John. *Max Ernst: Life and Work*. New York: Harry Abrams, 1967.

Sala, Carlo. *Max Ernst et la démarche onirique*. Paris: Klincksieck, 1970.

Spies, Werner. *Max Ernst: Frottages*. Translated by Andrée Daniel. Stuttgart and Paris: Pierre Tisné, 1968. Reprint, Paris: Herscher, 1986. English translation: *Max Ernst: Frottages*. Translated by Joseph M. Bernstein. London: Thames & Hudson, 1969.

———. *Max Ernst: Les Collages, inventaire et contradictions*. Paris: Gallimard, 1984.

———. *Max Ernst, Loplop: Die Selbstdarstellung des Künstlers*. Munich: Prestel-Verlag, 1982. French translation: *Max Ernst, Loplop*. Paris: Gallimard, 1997.

Waldberg, Patrick. *Max Ernst*. Paris: Pauvert, 1958.

———. *Max Ernst*. Paris, Hazan, 1975.

Anne Ethuin

Anne Ethuin. Lisbon: Dao-Mamede Gallery, 1973.

Anne Ethuin. Paris: Galerie Mains Libres, 1973.

Anne Ethuin: Collages revêtus—Objets habillés. Paris: Libraire-Galerie "Pleine Marge," 1989.

Ethuin, Anne, and Edouard Jaguer. *Regards obliques sur une histoire parallèle*. Paris: Oasis, 1977.

Zeller, Ludwig. *Le Belvédère géologique d'Anne Ethuin*. Toronto, 1976.

Wilhelm Freddie

Bjerke-Petersen, Vilhelm. *Freddie*. Copenhagen: Illums Bog-Avdeling, 1935.

Jaguer, Edouard. *Wilhelm Freddie ou les flèches de l'arc électrique*. Copenhagen: Svend Hansen, 1969.

———. *Wilhelm Freddie*. Paris: Lincoln Publishing, 1990.

Schmidt, Palle. *Wilhelm Freddie den evige aprærer*. Copenhagen: Eriksen Ferlag, 1976.

Vovelle, José. "Wilhelm Freddie: Plaisir/souffrance ou le sens de la famille." In *Du surréalisme et du plaisir*. Edited by Jacqueline Chénieux-Gendron. Paris: Éditions José Corti, 1987.

Wilhelm Freddie. Copenhagen: Bjerregaard-Jensen, 1962.

Wilhelm Freddie. Copenhagen: Statens Museum for Kunst, 1989.

Ichiro Fukuzawa

Fukuzawa, Ichiro. *Surrealism*. Tokyo: Studio-sha, 1938.

Fukuzawa. Tokyo: Central Museum, 1974.

Fukuzawa. Takasaki: Museum of Modern Art of the Province of Gunma, 1976.

Théo Gerber

Gerber, Théo. *Autrement dit* (Paris), no. 1 (1981).

———. *Ghiribizzi*. Zurich: Waser Verlag, 1984.

Théo Gerber. Avignon: Palais des Papes, 1986.

Gilles Ghez

Ghez, Gilles. "Bris de boîte." *Ellébore*, no. 5 (1981).

Gilles Ghez: Dioramas, 1972–1990. Montbéliard: Centre d'Art Contemporain de Montbéliard, 1990.

Gilles Ghez. Figeac: Centre d'Art Contemporain, 1996.

Alberto Giacometti

Dupin, Jacques. *Alberto Giacometti*. Paris: Maeght, 1962.

Giacometti, Alberto. *Écrits*. Paris: Hermann, 1990.

Alberto Giacometti. Paris: Orangerie des Tuileries, 1969.

Alberto Giacometti. Paris: Musée d'Art Moderne de la Ville de Paris, 1991.

Arshile Gorky

Arshile Gorky. New York: Museum of Modern Art, 1962.

"Arshile Gorky." Special issue of *Arts Magazine* (March 1976).

Arshile Gorky: Collection Mooradian. Paris: Fondation Calouste Gulbenkian, Centre Culturel Portugais, 1985.

Delgado, Gerardo, ed. *Arshile Gorky (1904–1948)*. Madrid: Fundación Caja de Pensiones, 1989; London: Whitechapel Art Gallery, 1990.

Jordan, Jim M., and Robert Goldwater. *The Paintings of Arshile Gorky—a Critical Catalog*. New York: New York University Press, 1982.

Lader, Melvin P. *Gorky*. Modern Masters. New York: Abbeville Press, 1985.

Levy, Julien. *Arshile Gorky*. New York: Henry Abrams, 1968.

Rand, Harry. *Arshile Gorky: The Implication of Symbols*. Berkeley: University of California Press, 1991.

Rosenberg, Harold. *Arshile Gorky: The Man, the Time, the Idea*. New York: Horizon Press, 1962.

Rubin, William S. "Arshile Gorky, Surrealism, and the New American Painting." *Art International*, no. 7 (February 1963).

Schwabacher, Ethel K. *Arshile Gorky*. New York: MacMillan Co., 1957.

Waldman, Diane, ed. *Arshile Gorky, 1904–1948: A Retrospective*. New York: N. W. Abrams, Solomon R. Guggenheim Museum, 1981.

Eugenio Granell

Colleción Eugenio Granell. Santiago de Compostela: Consorcio de Santiago, 1996.

E.-F. Granell. Paris: À l'Étoile Scellée, 1954.

E.-F. Granell: Exposicion antologica, 1942–1986. La Coruna: Palàcio Municipal de Exposiciones Kiosco Alfonso, 1987.

Eugenio F. Granell. Santa Cruz de Tenerife: Sala de Arte y Cultura, 1984.

Tarnaud, Claude. "Braises pour E.-F. Granell." *Phases* (1965).

Jane Graverol

Blavier, André. *Jane Graverol*. Brussels: Fantasmagie, 1962.

Graverol, Jane. *Pastels*. Brussels: De Rache, 1979.

Jane Graverol. Verviers: Société des Beaux-Arts, 1951.

Jane Graverol. Verviers: Temps Mêlés, 1953.

Jane Graverol. Brussels: Galerie Le Verseau; Paris: Le Soleil dans la Tête, 1956.

Jane Graverol. Paris: Galerie Le Ranelagh, 1957.

Jane Graverol. Buenos Aires: Antigona Gallery, 1958.

Jane Graverol. Brussels: Galerie Ptah; Geneva: Galerie Connaître, 1961.

Jane Graverol. Brussels: Galerie Albert Ier; Paris: Galerie Furstemberg, 1972.

Jane Graverol. Paris: Galerie Furstemberg, 1978.

Jane Graverol. Brussels: Galerie Albert Ier, 1979.

Jane Graverol: 40 ans de peinture. Brussels: Galerie Isy Brachot, 1968.

Scutenaire, Louis. *Peinture de Jane Graverol.* Brussels: Les Lèvres Nues, 1962.

Solier, René de. *Jane Graverol.* Brussels: De Rache, 1974.

Arthur Harfaux

Daumal, René. *Je ne parle jamais pour ne rien dire: Lettres à Arthur Harfaux.* Amiens: Le Nyctalope, 1994.

Harfaux, Arthur. *Demain il sera trop tard.* Amiens: Le Nyctalope, 1985.

Henry, Maurice. "Arthur Harfaux, qui est-ce?" *Phases,* no. 4 (December 1973).

Sima: Le Grand Jeu. Paris: Musée d'Art Moderne de la Ville de Paris, 1992.

Stanley-William Hayter

Atelier 17, 1927 Paris–New York 1950. Paris: Galerie de Seine, 1981.

Limbour, Georges. *Hayter.* Paris: G. Fall and Le Musée de Poche, 1962.

Jindrich Heisler

Claverie, Jana, ed. *Styrsky, Toyen, Heisler.* Paris: Le Centre, 1982.

Goldfayn, Georges. "J.-H." *Phases,* no. 8 (1963).

Heisler, Jindrich, and Jindrich Styrsky. *Sur les aiguilles de ces jours.* Berlin: Éditions Sirène, 1984.

Heisler, Jindrich, and Toyen. *Z kasemat spánky realisované básne.* Prague: Edice Surrealismu, 1940.

Linhartova, Vera. *Jindrich Heisler.* Toronto: Sixty-Eight Publications, Inc., 1977.

Toyen. *Les Spectres du désert—Accompagné des textes de Henri Heisler.* Paris: Éditions Albert Skira, 1939. Reprint, Paris, 1953.

Maurice Henry

Gassiot-Talabot, Gérald. *Maurice Henry: L'Humeur du jour.* Paris: G. Fall, 1979.

Henry, Maurice. *Les Abattoirs du sommeil.* Paris: Sagesse, 1937.

———. *Les Paupières de verre.* Paris: Fontaine, 1945.

———. *Les Mystères de l'Olympe.* Paris: Société des Éditions Modernes Parisienne, 1945.

———. *Les Métamorphoses du vide.* Paris: Éditions de Minuit, 1955.

———. *À bout portant.* Paris: Gallimard, 1958.

———. *Vive la fuite!* Paris: Horay, 1958.

———. *1930–1960.* Paris: Pauvert, 1961.

———. *Le Moulage de l'absence.* La Louvière: Daily Bul, 1966.

———. *Hors mesures.* Paris: Éric Losfeld, 1969.

———. *L'Adorable cauchemar.* La Louvière: Daily Bul, 1983

Maurice Henry. Paris: Galerie des Deux Iles, 1947.

Maurice Henry. Livorno: Galleria Peccolo, 1989.

Jacques Hérold

Alexandrian, Sarane. *Jacques Hérold.* Paris: Fall Edition, 1995.

Breton, André. *Jacques Hérold.* Paris: Cahiers d'Art, 1947.

Butor, Michel. *Hérold.* Paris: G. Fall, 1964.

Clébert, Jean-Paul. "Jacques Hérold et le surréalisme." *Revue des sciences humaines,* no. 193 (January–March 1984).

Coron, Antoine. *Hérold illustre: Catalogue des livres illustrés.* Paris: Arenthon, 1985.

Crispolti, Enrico. *Jacques Hérold.* Milan: Galleria Milano, 1966.

Hérold, Jacques. *Maltraité de Peinture.* Paris: Falaize, 1957. Reprint, Paris: G. Fall, 1976; Montpellier: Fata Morgana, 1985.

Jacques Hérold. Brussels: Palais des Beaux-Arts, 1954.

Jacques Hérold. Paris: La Cour d'Ingres, 1959.

Jacques Hérold. Chicago: William and Norma Copley Foundation, 1962.

Jacques Hérold. Paris: Galerie de Seine, 1972.

Jacques Hérold. Paris: Galerie Patrice Trigano, 1985. Reprint, Paris: Galerie Patrice Trigano, 1987.

Jacques Hérold: Œuvres récentes. Paris: Galerie Furstemberg, 1954.

Jacques Hérold, le surréaliste autre. Rome: Carte Segrete, Centre Culturel de France, 1982.

Jacques Hérold, Michel Butor: La Parole est aux couleurs. Geneva: Galerie Sonia Zanettacci, 1989.

Jouffroy, Alain. "Jacques Hérold, poète de la vision." *XXe Siècle,* no. 43 (November 1974).

Luca, Gherasim. "Pierre ambiante." *Phases,* no. 2 (1955).

Py, Françoise. "La Preuve par Hérold, 'le grain de phosphore aux doigts,'" *Mélusine,* no. 12 (1991).

Ragnar von Holten

Ragnar von Holten. Ahus: Keljdoskop, 1994.

Ragnar von Holten. Paris: Galerie 1900-2000, 1996.

Valentine Hugo

Margerie, Anne de. *Valentine Hugo, 1887–1968.* Paris: J. Damase, 1983.

Valentine Hugo: Peintures, dessins, gravures. Troyes: Centre Culturel Thibaud de Champagne, 1977.

Marcel Jean

Jean, Marcel. *Au galop dans le vent.* Paris: Jean-Pierre de Monza, 1991.

Marcel Jean. Cologne: Kölnischer Kunstverein, 1981.

Marcel Jean. Paris: Galerie 1900-2000, 1987.

Frida Kahlo

Frida Kahlo and Tina Modotti. London: Whitechapel Art Gallery, 1982.

Herrera, Hayden. *Frida: A Biography of Frida Kahlo.* New York: Harper & Row, 1983.

Jamis, Rauda. *Frida Kahlo: Autoportrait d'une femme.* Babel Poche. Arles: Actes Sud, 1995.

Kahlo, Frida. *The Diary of Frida Kahlo: An Intimate Self-Portrait.* Introduction by Carlos Fuentes; essay and commentaries by Sarah M. Lowe. New York: H. N. Abrams, 1995.

Zamora, Martha. *Frida el pincel de la augustia.* Mexico City: La Herradura, 1987; English translation: *Frida Kahlo: The Brush of Anguish.* San Francisco: Chronicle Books, 1990.

Frederick Kiesler

Frederick Kiesler: Artiste architecte. Paris: Musée National d'Art Moderne, Centre Georges Pompidou, 1996.

Kiesler, Frederick. *Inside the Endless House: Art, People, and Architecture—a Journal.* New York: Simon & Schuster, 1964.

Phillips, Lisa. *Frederick Kiesler.* New York and London: W. W. Norton, 1989.

Konrad Klapheck

Hofmann, Werner, Konrad Klapeck, and Peter-Klaus Schuster. *Konrad Klapheck: Retrospektive, 1955–1985.* Munich: Prestel Verlag; Hamburg: Hamburg Kunsthalle, 1985.

Klapheck. Paris: Galerie I. Sonnabend, 1965.

Klapheck. Milan: Galleria Schwarz, 1972.

Klapheck. Brussels: Palais des Beaux-Arts, 1974.

Klapheck. Paris: Galerie Maeght, 1980.

"Klapheck." Special issue of *Repères* (Paris), no. 20 (1985).

"Klapheck." Special issue of *Repères* (Paris), no. 62 (1990).

Pierre, José. *Klapeck-œuvre.* Cologne: Dumont, 1971.

Yves Laloy

Jouffroy, Alain. "Yves Laloy." *Opus international,* no. 19–20 (1970).

Yves Laloy. Paris: La Cour d'Ingres, 1958.

Wifredo Lam

Benitez, Helena. *Wifredo Lam, Interlude Marseille.* Copenhagen: Éditions Blondal, 1993.

Borras, Maria-Luisa, Ulrich Krempel, and Lowery Stokes Sims. *Catalogue raisonné de l'œuvre de W. Lam.* Vol. 1, *1923–1960.* Paris: Éditions Acatos and Galerie Lelong, 1996.

Charpier, Jacques. *Lam.* Paris: G. Fall, 1960.

Fouchet, Max-Pol. *Wifredo Lam.* Paris: Le Cercle d'Art, 1976.

Lam: Œuvre gravé. Gravelines: Musée de Gravelines, 1994.

Leiris, Michel. *Wifredo Lam—le grandi monografie: Pittori d'oggi.* Milan: Fratelli Fabri; New York: H. N. Abrams, 1970.

Taillandier, Yvon. *Wifredo Lam, dessins.* Paris: Denoël, 1970.

"Wifredo Lam." Special issue of *XX Siècle,* no. 52 (1979).

"Wifredo Lam." Special issue of *Repères* (Paris), no. 33 (1987).

"Wifredo Lam." Preface by Ulrich Krempel. Special issue of *Repères* (Paris), no. 49. (1988).

Wifredo Lam. Düsseldorf: Kunstsammlung Nordheim-Westfalen, 1988.

"Wifredo Lam." Preface by Serge Sautreau. Special issue of *Repères* (Paris), no. 63 (1990).

Wifredo Lam: Les Années cubaines. Paris: Maison de l'Amérique Latine, 1989.

Wifredo Lam, 1902–1982. Paris: Musée d'Art Moderne de la Ville de Paris, 1983.

Xuriguera, Gérard. *Lam.* Paris: Filipacchi, 1974.

Jacqueline Lamba

Jacqueline Lamba. New York: Norlyst Gallery, 1944.

Jacqueline Lamba. Paris: Galerie Pierre, 1947.

Jacqueline Lamba. New York: Passedoit Gallery, 1948.

Jacques le Maréchal

Le Maréchal. Paris: Le Terrain Vague, 1957.

Le Maréchal. Vienna: Ernst Fuchs Gallery, 1958.

Le Maréchal. Paris: Galerie Cordier, 1960.

Le Maréchal. Bonn: Witsch Gallery, 1968.

Le Maréchal. Paris: Galerie du Dragon, 1988.

Le Maréchal–G. Siroux. Paris: Galerie Inna Salomon, 1968.

Mouizel, Gérard. *Le Maréchal: catalogue de l'œuvre gravé, 1956–1985.* Paris: OGC, 1985.

René Magritte

Blavier, André. *Ceci n'est pas une pipe.* Verviers: Temps Mêlés, 1973.

Deknop-Kornelis, E. *Hommage à Magritte.* Paris: Centre Wallonie-Bruxelles, 1985.

Foucault, Michel. *Ceci n'est pas une pipe.* Montpellier: Fata Morgana, 1973.

Gablick, Suzi. *Magritte.* London: Thames & Hudson, 1970; Brussels: Cosmos, 1978.

Gimferrer, Pere. *Magritte.* Paris: Albin Michel, 1986.

Haddad, Hubert. *Magritte.* Paris: Hazan, 1996.

Hammacher, Abraham Marie. *Magritte.* Paris: Cercle d'Art; New York: H. N. Abrams, 1974. Reprint, London: Thames & Hudson, 1986.

Magritte. Brussels: Palais des Beaux-Arts, 1954.

Magritte. Milan: Galleria Schwarz, 1962.

Magritte. Paris: Galerie Brachot, 1979.

Magritte. Montreal: Fine Arts Museum, 1996.

Magritte. San Francisco: Museum of Modern Art, 2000.

Magritte: Bibliothèque municipale de Bordeaux, 24 mai–17 juillet 1977. Bordeaux: Centre d'Arts Plastiques Contemporains de Bordeaux, 1977.

Magritte: Les Images en soi. Paris: Galerie A. Iolas, 1967.

Magritte: La Période vache. Marseille: Musées de Marseille, 1992.

Magritte: Retrospective Loan Exhibition. London: Marlborough Fine Art, 1973.

Magritte, le sens propre. Paris: Galerie A. Iolas, 1964.

Magritte, René. *La Destination: Lettres à Marcel Mariën (1937–1962).* Brussels: Les Lèvres Nues, 1977.

———. *Écrits complets.* Edited by André Blavier. Paris: Flammarion, 1979.

———. *Lettres à André Bosmans, 1958–1967.* Paris: Seghers-Isy Branchot, 1990.

Magritte, René, and Harry Torczyner. *Letters between Friends.* New York: Henry Abrams, 1994.

Mariën, Marcel. *Apologies de Magritte.* Brussels: Éditions Didier Devillez, 1994.

Meuris, Jacques. *René Magritte.* Cologne: Taschen, 1990.

———. *Magritte et les mystères de la pensée.* Brussels: La Lettre Volée, 1992.

Michaux, Henri. *En rêvant à partir de peintures énigmatiques.* Montpellier: Fata Morgana, 1972.

Noël, Bernard. *Magritte.* Paris: Flammarion, 1976.

Nougé, Paul. *Magritte ou les images défendues.* Brussels: Les Auteurs Associés, 1943.

———. *Histoire de ne pas rire.* Brussels: Les Lèvres Nues, 1956.

———. *René Magritte (in extenso).* Brussels, Didier Devillez, 1997.

Paquet, Marcel. *Magritte ou l'éclipse de l'être.* Collection Différenciation, no. 6. Paris: Éditions de la Différence, 1982.

Passeron, Roger. *Magritte.* Paris: Filipacchi, 1970.

Photographies de Magritte. Paris: Contrejour, 1982.

Pierre, José. *Magritte.* Paris: Somogy, 1984.

René Magritte. Lausanne: Fondation de l'Ermitage, 1987.

Rétrospective Magritte. Brussels: Palais des Beaux-Arts, 1978; Paris: Musée National d'Art Moderne, 1979.

Robbe-Grillet, Alain. *La Belle captive.* Brussels: Cosmos Textes, 1975.

Robert-Jones, Philippe. *Magritte, poète visible.* Brussels: Laconti, 1972.

Roque, Georges. *Ceci n'est pas un Magritte: Essai sur Magritte et la publicité.* Paris: Flammarion, 1983.

Schiebler, Ralf. *Die Kunsttheorie René Magrittes.* Munich: Hanser, 1981.

Schneede, Uwe. *René Magritte, Leben und Werk.* Cologne: Dumont Schauberg, 1973.

Schwilden, Tristan. *Magritte et la musique: Les Partitions musicales illustrées par René Magritte de 1924 à 1938—essai de catalogue raisonné.* Brussels: Galerie Bortier, 1995.

Scutenaire, Louis. *Magritte.* Antwerp: De Sikkel, 1948.

———. *Avec Magritte.* Brussels: Lebeer Hossmann, 1977.

Soby, James T. *Magritte.* New York: Museum of Modern Art, 1965.

Sylvester, David. *Magritte.* New York: F.-A. Praeger, 1969.

———, ed. *René Magritte: Catalogue raisonné.* 5 vols. London: Menil Foundation, Philip Wilson Publishers, 1992–97.

Torczyner, Harry. *Magritte.* Paris: Le Soleil Noir, 1977.

———. *L'Ami Magritte: Correspondance et souvenirs.* Antwerp: Fonds Mercator, 1992.

Waldberg, Patrick. *Magritte.* Brussels: A. de Rache, 1965.

Georges Malkine

Aragon, Louis, et al. *Hommage à Malkine.* Paris: Galerie Mona Lisa, 1966.

Malkine. Brussels: Galerie Govaerts, 1970.

Malkine, Georges. *À bord du violon de mer.* Paris: Éditions de la Différence, 1977.

Man Ray

Alexandrian, Sarane. *Man Ray.* Paris: Filipacchi, 1973.

Baldwin, Neil. *Man Ray: American Artist.* New York: Clarkson N. Potter, 1988.

Baum, Timothy, *Man Ray: Portraits, 1921–1939.* Paris, 1989. Rev. ed., St. Petersburg, Fla.: Salvador Dalí Museum, 1989.

Bourgeade, Pierre. *Bonsoir, Man Ray.* Paris: Belfond, 1972.

Bramly, Serge. *Man Ray.* Paris: Belfond, 1980.

Foresta, Merry A. *Man Ray.* Paris: Centre National de la Photographie, 1988.

Man Ray. Los Angeles: Los Angeles County Museum of Art, Lytton Gallery, 1966.

Man Ray. Paris: Galerie des 4 Mouvements, 1972.

Man Ray. Paris: Musée National d'Art Moderne, 1972.

Man Ray. Antwerp: R van de Velde Gallery, 1994.

Man Ray. Nice: Musée d'Art Moderne, 1997.

Man Ray: Assemblages. Paris: Galerie Marion Mayer, 1990.

Man Ray: Assemblages, dipinti, fotografie, disegni dal 1912 al 1972. Parma: Galleria d'Arte Niccoli, 1982.

Man Ray: Opera grafica. 2 vols. Volume 1, Turin: L'Anselmino, 1973. Volume 2, edited by Maria Bianca Pilat, Milan: Studio Marconi, 1984.

Man Ray: Peintures et dessins provenant de l'atelier. Paris: Galerie 1900-2000, 1988.

Man Ray: Photographie. Paris: Musée National d'Art Moderne, 1981.

Man Ray et ses amis. Paris: Filipacchi, 1986.

Man Ray. *Self-Portrait.* Boston: Little, Brown, 1963. Reprint, Boston: Little Brown, 1998.

———. *Les Treize clichés vierges.* Milan: Sergio Tosi, 1968.

Martin, Jean-Hubert, and Rosalind Krauss. *Objets de mon affection: Catalogue des multiples.* Paris: Éditions Philippe Sers, 1983.

Penrose, Roland. *Man Ray.* Paris: Éditions du Chêne, 1975.

Perpetual Motif: The Art of Man Ray. Washington, D.C.: National Museum of American Art, Smithsonian Institution; New York: Abbeville Press, 1989.

Ribemont-Dessaignes, Georges. *Man Ray.* Paris: Nouvelle Revue Française, 1924.

Schwarz, Arturo. *Man Ray, the Rigour of Imagination.* London: Thames & Hudson, 1977.

Marcel Mariën

Canonne, Xavier, et al. *Marcel Mariën.* Prague: Ceské Muzeum Výtvarných Umení, 1996.

Exposition rétrospective. Dunkirk: École Régionale des Beaux-Arts, 1987.

Introduction obscure à la fin de tout. Brussels: Galerie Isy Brachot, 1976.

Marcel Mariën: La Citation esthétique. Brussels: Galerie La Marée, 1980.

Marcel Mariën: Resucées et dissemblances. Brussels: Galerie La Marée, 1975.

Marcel Mariën: Rétrospective et nouveautés. Brussels: Galerie Defacqz, 1967.

Mariën: Rétrospective des rétrospectives. Paris and Brussels: Galerie Isy Brachot, 1989.

Mariën, Marcel. *Trattato della pittura ad olio e aceto.* Milan: Communicazione, 1972.

———. *Crystal Blinkers.* Sidmouth: Transformaction, 1973.

Mines de rien. Namur: Maison de la Culture, 1982.

André Masson

André Masson. Tours: Galerie J. Davidson, 1973.

André Masson. Musée de Nîmes, 1985.

André Masson: Dessins, 1922–1960. Paris: Galerie Louise Leiris, 1960.

André Masson: Dessins surréalistes, 1925–1965. Joinville: Association Française d'Action Artistique and the Château du Grand Jardin, 1993.

André Masson: Lieux communs. Paris: Galerie Louise Leiris, 1970.

André Masson: L'Insurgé du XXe Siècle. Rome: Carte Segrete, 1989.

André Masson: Peintures récentes et anciennes. Paris: Galerie Louise Leiris, 1957.

André Masson: Works from 1923–1944. New York: Kouros Gallery, 1986.

André Masson en España, 1933–1943. Zaragoza: Centro de Exposiciones y Congresos-Museo Camon Aznar, 1992.

André Masson et le théâtre. Paris: Théâtre du Rond-Point, Éditions F. Birr, 1983.

Barrault, Jean-Louis, et al. *André Masson.* 1940. Reprint, Marseille: André Dimanche, 1993.

Benincasa, C., and C. Polcina. *André Masson.* Rome: Editrice 2 C, 1980.

Clébert, Jean-Paul. *Mythologie d'André Masson.* Lausanne: Cailler, 1971.

Meredieu, Florence de. *André Masson: Les Dessins automatiques.* Paris: Blusson, 1988.

Hahn, Otto. *Masson.* Paris: Tisné, 1965.

Huré, Antoinette, ed. *André Masson.* Paris: Musée National d'Art Moderne, 1965.

Juin, Hubert. *André Masson.* Paris: G. Fall, 1963.

Lambert, Jean-Clarence. *André Masson.* Paris: Filipacchi, 1979.

Leiris, Michel, and Georges Limbour. *André Masson et son univers.* Geneva and Paris: Éditions des Trois Collines, 1947.

Levaillant, Françoise. *Masson: Les Livres illustrés de gravures originales.* Royaumont: Fondation Royaumont, 1985.

Masson and Bataille. Orléans: Musée des Beaux-Arts, 1993; Tossa de Mar: Municipal Museum, 1994.

Masson, André. *Le Plaisir de peindre.* Nice: La Diane Française, 1950.

———. *Métamorphose de l'artiste.* Geneva: P. Cailler, 1956.

———. *La Mémoire du monde.* Geneva: Skira, 1974.

———. *Vagabond du surréalisme.* Paris: Éditions Saint-Germain-des-Prés, 1975.

———. *Le Rebelle du surréalisme: Écrits.* Paris: Hermann, 1976.

———. *Massacres et autres dessins.* Foreword by Michel Leiris. Paris: Hermann, 1971.

Noël, Bernard. *André Masson: La Chair du regard.* Paris: Gallimard, 1993.

Passeron, Roger. *André Masson et les puissances du signe.* Paris: Denoël, 1975.

Pia, Pascal. *André Masson.* Paris: Gallimard, 1930.

Rubin, William, and Carolyn Lanchner. *André Masson.* New York: Museum of Modern Art, 1976; Paris: Centre Georges Pompidou, 1977.

Saphire, Lawrence. *André Masson: The Complete Graphic Work.* Vol. 1, *Surréalisme, 1924–1949.* New York: Blue Moon, 1990.

Saphire, Lawrence, and Patrick Cramer. *Catalogue raisonné des livres illustrés.* Geneva: P. Cramer, 1994.

———. *André Masson.* Milan: Mazzotta, 1988.

Roberto Matta

Brunori, M., and F. Portone. *Matta: Dialogo con Tarquinia.* Rome: Arco Incontri Roma, 1975.

Ferrari, Germana. *Matta: Index dell'opera grafica dal 1969 al 1980.* Viterbo: Staderini, 1980.

Manifestazione di solidarita con il popolo cileno: Insieme a Matta per il Cile. Bologna: Museo Civico, 1973.

Matta. 1947. Reprint, Paris: Galerie Drouin, 1949.

Matta. London: ICA, 1951.

Matta. New York: Galerie Iolas, 1952, 1953.

Matta. Paris: Galerie Nina Dausset, 1952.

Matta. Frankfurt: D. Cordier Gallery, 1959.

Matta. Rome: Galleria L'Attico, 1961, 1962.

Matta. Geneva: Galerie Iolas and Galerie E. Engelberts, 1963.

Matta. Amsterdam: Stedelijk Museum, 1963.

Matta. Berlin: Nationalgalerie, 1970.

Matta. Ferrara: Galleria Civica d'Arte Moderna, 1973.

Matta. Hanover: Kestner Gesellschaft, 1974.

Matta. Rome: Galleria L'Attico, 1982.

Matta. Florence: Centro Tornabuoni, 1984.

Matta: Cinquante-cinq dessins depuis 1937. Paris: Galerie du Dragon, 1978.

Matta: Dessins, 1936–1989. Paris: Galerie de France, 1990.

Matta: Don Qui, 1605–1985—labour in progress. Paris: Galerie de France, 1985.

Matta: Le Cube ouvert. Lucerne: Kunstmuseum, 1965.

Matta: Paintings. New York: Pierre Matisse Gallery, 1947.

Matta—a Totemic World: Paintings, Drawings, Sculpture. New York: Andrew Crispo Gallery, 1975.

Matta "Être avec. Réveil Matta" (Pour une politique révolutionnaire, Matta). Paris: Musée de Saint-Denis, 1968.

Matta, 1919–1953. Venice: Sala Napoleonica, 1953.

Matta (œuvre gravé). Silkeborg: Kunstmuseum, 1968.

Matta "Terres nouvelles." Galerie du Dragon, 1956.

Matta, Roberto. *Entretiens morphologiques: Notebook no. 1, 1936–1944.* Paris: Sistan, 1987.

Rubin, William. *Matta.* New York: Museum of Modern Art, 1957.

Sabatier, Roland. *L'Œuvre gravé de Matta.* Stockholm: Sonet; Paris: G. Visat, 1975.

Sayag, Alain, and Claude Schweisguth. *Matta.* Paris: Musée National d'Art Moderne, Centre Georges Pompidou, 1985.

Schuster, Jean. *Développements sur l'infra-réalisme de Matta.* Paris: Éric Losfeld, 1970.

Sculptures de Matta. Paris: Galerie du Dragon, 1960.

Sebastian Matta: 15 former au trivel/15 Forms of Doubting. Stockholm: Moderna Museet, 1959.

Sebastian Matta: Mostra antologica in Bologna. Bologna: Museo Civico, 1963.

Édouard-Léon-Théodore Mesens

L'Éternel surréalisme (Hommage discret à E.-L.-T. Mesens). Brussels: Galerie Isy Brachot, 1970.

Lyle, John, comp. *Hommage à Mesens.* Sidmouth: Transformaction, 1979.

Mesens. Brussels: Palais des Beaux-Arts, 1959.

Mesens. Brussels: Galerie de la Madeleine, 1966.

Mesens. Turin: Galleria Il Fauno, 1970.

Mesens. Brussels: Galerie Isy Brachot, 1971.

Mesens, 125 collages et objets. Knokke-le-Zoute, 1963.

Mesens, E.-L.-T. *Poèmes, 1923–1958, illustrés de dix dessins de René Magritte.* Paris: Le Terrain Vague, 1959.

Scutenaire, Louis. *Mon ami Mesens.* Brussels: L. Scutenaire, 1972.

Joan Miró

Alexander Calder–Joan Miró. New York: Perls Galleries, 1961.

Arts Council of Great Britain. *Joan Miró.* London: Tate Gallery; Zurich: Kunsthaus, 1964.

Catala-Roca, Francesc. *Miró, noranta anys.* Barcelona: Editions 62–Joan Miró Foundation, 1984.

Cirlot, Juan Eduardo. *Miró.* Barcelona: Cobalto, 1950.

Combalia, Victoria. *El descubrimiento de Miró.* Barcelona: Destino, 1990.

Corredor-Matheos, Jose, and Gloria Picazo. *Miró: Les affiches originales.* Paris: Cercle d'Art, 1981.

Cramer, Patrick. *Miró, les livres illustrés.* Geneva: Patrick Cramer, 1989.

Dessins de Miró provenant de l'atelier de l'artiste et de la Fondation Joan Miró de Barcelone. Paris: Musée National d'Art Moderne, Centre Georges Pompidou, 1978.

Diehl, Gaston. *Miró.* Paris: Flammarion, 1974.

Dupin, Jacques. *Miró, Life and Work.* Translated by Norbert Guterman. New York: H. N. Abrams, 1962.

———. *Miró.* Paris: Flammarion, 1961.

———. *Miró sculpteur.* Barcelona: Polígrafa, 1972.

———. *Miró graveur.* 3 vols. Paris: LeLong, 1984–91. English translation: *Miró Engraver.* 2 vols. New York: Rizzoli, 1984.

———. *Miró.* Paris: Flammarion, 1994.

Gimferrer, Pere. *Colpir sensa nafrar.* Barcelona: Polígrafa, 1978.

Greenberg, Clement. *Miró.* New York: Quadrangle, 1948.

"Hommage à Miró." Special issue of *XXe Siècle* (1972). English translation: *Homage to Miró,* ed. Gualtieri di San Lazzaro. New York: Tudor, 1972.

Hunter, Sam. *Joan Miró: His Graphic Work.* New York: Henry Abrams, 1958.

Joan Miró. Brussels: Palais des Beaux-Arts, 1956.

Joan Miró. New York: Museum of Modern Art, 1959.

Joan Miró. Saint-Paul-de-Vence: Fondation Maeght, 1968.

Joan Miró. Paris: Grand Palais, 1974.

Joan Miró. Barcelona: Miró Foundation, 1993.

Joan Miró: A Retrospective. New York: Solomon R. Guggenheim Museum, 1987.

Joan Miró Lithographe / Miró Lithographs. 6 vols. Paris: Maeght, 1972–92.

Jouffroy, Alain. *Miró.* Paris: Hazan, 1987.

Jouffroy, Alain, and Joan Teixidor. *Miró: Catalogue des sculptures.* Paris: Maeght, 1973.

Krauss, Rosalind E., and Margit Rowell. *Joan Miró: Magnetic Fields.* New York: Solomon R. Guggenheim Museum, 1972.

Lassaigne, Jacques. *Miró.* Geneva: Skira, 1963.

Leiris, Michel. "Joan Miró." *Documents,* no. 5 (October 1929).

L'Œuvre graphique de Joan Miró. Krefeld: Kaiser Wilhelm Museum, 1957.

Malet, Rosa Maria. *Joan Miró.* Barcelona: Éditions 62, 1992.

"Miró." Special issue of *Cahiers d'art,* no. 1–4 (1934).

Miró. Paris: Musée National d'Art Moderne, 1962.

Miró. Tokyo: National Museum of Art, 1966.

Miró. Knokke-le-Zout: Casino Communal, 1971.

Miró. Paris: Galerie Melki, 1974.

Miró: "Peintures sauvages," 1934 to 1953. New York: Pierre Matisse Gallery, 1953.

Miró: Peintures, sculptures, dessins, céramiques, 1956–1979. Saint-Paul-de-Vence: Fondation Maeght, 1979.

Miró: Retrospective. Barcelona: Galeria Maeght, 1975.

Miró Sculptures. Minneapolis: Walker Art Center, 1971.

Miró, Joan. *Carnets catalans, dessins et textes inédits présentés par Gaetan Picon.* Geneva: Skira, 1976.

———. *Écrits et entretiens.* Paris: Daniel Lelong, 1995.

Pellicer, Alexandre Cirici. *Miró.* Barcelona: Omega, 1950.

Penrose, Roland. *Miró.* London: Thames & Hudson, 1990.

Pierre, José, and Jose Corredor-Matheos. *Miró et Artigas: Céramiques.* Paris: Maeght, 1974.

Punyet-Miró, Joan, and G. Lolivier-Rahola. *Joan Miró: Le Peintre aux étoiles.* Découvertes Gallimard, no. 186, Peinture. Paris: Gallimard, 1993.

Queneau, Raymond. "Miró." In his *Batons, chiffres et lettres.* 2d ed. Paris: Gallimard, 1950.

Raillard, Georges. *Miró.* Paris: Hazan, 1989.

Le Rêve interrompu de Miró. Paris: Centre Culturel Espagnol, 1988.

Rose, Barbara, ed. *Miró in America.* With essays by Judith McCandless and Duncan Macmillan. Houston: Museum of Fine Arts, 1982.

Rowell, Margit. *Miró, peinture = poésie.* Paris: Éditions de la Différence, 1976.

Sculptures de Miró, céramiques de Miró et Llorens Artigas. Saint-Paul-de-Vence: Fondation Maeght, 1973.

Stich, Sidra. *Joan Miró: The Development of a Sign Language.* Saint Louis: Washington University Gallery of Art, 1980.

Sweeney, James Johnson. *Miró.* New York: Museum of Modern Art, 1941.

———. *Atmosfera Miró.* Barcelona: Editorial RM, 1959. English translation: *The Miró Atmosphere: Photoscope: Gomis, Prats.* New York: G. Wittenborn, 1959.

Les Trois "bleu." Paris: Centre Georges Pompidou, 1985.

Verdet, André. *Joan Miró.* Geneva: Roger Kister, 1956.

Pierre Molinier

Borde, Raymond, and André Breton. *Pierre Molinier.* Paris: Le Terrain Vague, 1964.

Molinier. Geneva: B. Letu, 1979.

Molinier. Winnipeg: Plug in Editions; Santa Monica, Calif.: Smart Art Press, 1997.

Molinier: Peintures, photos et photomontages. Paris: Centre Georges Pompidou, 1979.

Molinier, Pierre. *Cent photographies érotiques.* Paris: Images Obliques, 1979.

———. *Les Orphéons magiques.* Bordeaux: Thierry Agullo, 1979.

Molinier, Pierre, and Peter Gorsen. *Pierre Molinier, lui-même: Essay über den Surrealistischen Hermaphroditen.* Munich: Rogner & Bornhard, 1972.

Petit, Pierre. *Molinier, une vie d'enfer.* Paris: Ramsay-Pauvert, 1992.

Villeneuve, Roland. *Le Chaman et ses créatures.* Bordeaux: William Blake & Co., 1995.

Paul Nash

Causey, Andrew. *Paul Nash.* Oxford: Clarendon Press, 1980.
Eates, Margot. *Paul Nash.* London: Lund Humphries, 1973.
Paul Nash. London: Tate Gallery, 1948.
Paul Nash. London: Redfern Gallery, 1961.
Paul Nash. London: Hamet Gallery, 1970.
Paul Nash's Photographs. London: Tate Gallery, 1973.

Richard Oelze

Jaguer, Edouard. *Richard Oelze.* Paris: Filipacchi, 1990.
Oelze. Hanover: Kestner-Gesellschaft, 1964.
Richard Oelze. New York: D'Arcy Galleries, 1960.
Richard Oelze, 1900–1980: Gemälde und Zeichnungen. Berlin: Akademie der Künste, 1987.

Taro Okamoto

Courthion, Pierre. *Okamoto.* Paris: GLM, 1937.
Haryu, Ichiro, and Pierre Klossowski. *Okamoto.* Tokyo: Heibon-sha, 1979.
Idomu-Okamoto Taro. Tokyo: Gallery of the Odakyu Department Store, 1980.
Okamoto. Yamanashi: Provincial Art Museum, 1981.
Okamoto, Taro. *L'Esthétique et le sacré.* Paris: Seghers, 1976.
Waldberg, Patrick. *Okamoto, le baladin des antipodes.* Paris: Éditions de la Différence, 1976.

Gordon Onslow-Ford

Gordon Onslow-Ford: Retrospective Exhibition of Paintings (1937–1975). Washington, D.C.: Pyramid Galleries, 1975.
Onslow-Ford: Retrospective. Oakland, Calif.: Oakland Museum, 1977.
Onslow-Ford, Gordon. *Towards a New Subject in Painting.* San Francisco: Museum of Modern Art, 1948.
———. *Painting in the Instant.* London: Thames & Hudson, 1964.
———. *Creation.* Basle: Schreiner Gallery, 1978.
———. "Recréez le Monde." *Pleine marge,* no. 12 (December 1990).

Meret Oppenheim

Calas, Nicolas. "Meret Oppenheim: Confrontations." *Artforum* (summer 1978).
Curiger, Bice. *Meret Oppenheim: Defiance in the Face of Freedom.* Zurich: Parkett Publishers; Cambridge, Mass.: MIT Press, 1989.
Matthews, J. H. "Meret Oppenheim." *Paris Review,* no. 36 (1950).
Meret Oppenheim. Basel: Schultess Gallery, 1936.
Meret Oppenheim. Milan: Galleria Schwarz, 1960.
Meret Oppenheim. Stockholm: Moderna Museet, 1967.
Meret Oppenheim. Paris: Galerie Zerdib, 1974.
Meret Oppenheim. Solothurn: Museum der Stadt, 1974.
Meret Oppenheim. Hamburg: Levy Gallery, 1978.
Meret Oppenheim. Vienna: Nächst St. Stephen, 1981.
Meret Oppenheim. Genoa: Palazzo Bianco; Milan: Padiglione d'Arte Contemporanea, 1983.
Meret Oppenheim. New York: Kent Gallery, 1988.
Meret Oppenheim, Retrospective. Bern: Kunsthalle; Paris: ARC; Frankfurt: Kunstverein, 1984.

Meyer-Thoss, Christiane. *Oppenheim, Meret: Aufzeichnungen 1928–1985—Träume.* Bern and Berlin: Verlag Gachnang & Springer, 1986.

Wolfgang Paalen

Morales, Leonor. *Wolfgang Paalen, introductor de la pintura surrealista in Mexico.* Mexico City: Universidad Nacional Autonoma de Mexico, 1984.
Paalen, Wolfgang. *Form and Sense.* New York: Wittenborn & Co., 1945.
———. "Voyage sur la côte nord-ouest de l'Amérique." *Pleine marge,* no. 20 (December 1994).
Paz, Octavio. *Préface à une rétrospective Wolfgang Paalen.* Paris: Librarie Loliée, 1960.
Pierre, José. *Le Domaine de Paalen.* Paris: Galanis, 1970.
———. *Paalen.* Paris: Filipacchi, 1980.
Regler, Gustav. *Wolfgang Paalen.* New York: Nierendorf, 1946.
Homage to Wolfgang Paalen. Mexico City: Museo de Arte Moderna, 1967.
Paalen. Vienna: Museum Moderner Kunst, 1993.

Mimi Parent

Boîtes. Paris: Musée d'Art Moderne de la Ville de Paris, 1976.
Mimi Parent. Bochum: Museum Cochum, 1984.
Sauvages des villes-sauvages des Iles. Noyers-sur-Serein: Centre d'Art Contemporain, 1992.

Roland Penrose

Penrose, Roland. *Quatre-vingts ans de surréalisme.* Paris: Éditions du Cercle d'Art, 1983.
Roland Penrose. Barcelona: Centre d'Estudis d'Art Contemporani, 1981.

Francis Picabia

Arnaud, Noël. *La Religion et la morale de Francis Picabia.* Verviers: Temps Mêlés, 1958.
Arthaud, Christian. *Picabia et la Côte d'Azur.* Nice: Musée d'Art Moderne et d'Art Contemporain, 1991.
Bois, Yves Alain. *Picabia.* Paris: Flammarion, 1975.
Borras, Maria Luisa. *Picabia.* Barcelona: Polígrafa; Paris: Albin Michel; London: Thames & Hudson, 1985.
Camfield, William. *Francis Picabia.* Paris: Éric Losfeld, 1972.
———. *Francis Picabia: His Art, Life, and Times.* Princeton, N.J.: Princeton University Press, 1979.
Francis Picabia. Bern: Kunsthalle, 1962.
Francis Picabia. Düsseldorf: Städtische Kunsthalle, 1983.
Francis Picabia, Galerie Dalmau, 1922. Paris: Musée National d'Art Moderne, Centre de Création Industrielle, Centre Georges Pompidou, 1996.
Francis Picabia, 1879–1954. Paris: Orbes, 1955.
Francis Picabia (1879–1953): Exposició antològico. Madrid: Ministerio de Cultura, Dirección General de Bellas Artes y Archivos; Barcelona: Fundació Caixa de Pensions, 1985.
Le Bot, Marc. *Francis Picabia et la crise des valeurs figuratives.* Paris: Klincksieck, 1968.

Martin, Jean-Hubert, and Hélène Seckel. *Picabia*. Paris: Centre National d'Art et de Culture Georges Pompidou, 1976.
Massot, Pierre de. *Francis Picabia*. Paris: Seghers, 1966.
Picabia. Marseille: Musée Cantini, 1962.
Picabia. Leverkusen: Städtisches Museum Schloss Morsbroich, 1967.
Picabia. Antwerp: R. van de Velde, 1993.
Picabia vu en transparence. Paris: Galerie Mona Lisa, 1961.
Picabia, Francis. *Choix de poèmes*. Paris: GLM, 1947.
———. *Caravansérail*. Paris: Belfond, 1975.
———. *Écrits*. 2 vols. Paris: Belfond, 1978.
———. *Arc en ciel*. Paris: Galerie 1900-2000, 1987.
Sanouillet, Michel. *Picabia*. Paris: Éditions du Temps, 1964.
———. *Francis Picabia et "391."* Paris: Éric Losfeld, 1966.
Tapié, Michel, ed. *491, 50 ans de plaisir (Cinquante ans de plaisir)*. Galerie R. Drouin, 1949.
Temps mêlés, no. 31–32 (1958).

Pablo Picasso

Breton, André. "Picasso dans son élément." *Minotaure*, no. 1 (1933). Reprint, Geneva: Skira, 1984.
Daix, Pierre. *Dictionnaire Picasso*. Bouquins. Paris: Robert Laffont, 1995.
Éluard, Paul. *À Pablo Picasso*. Geneva and Paris: Les Trois Collines, 1944.
Penrose, Roland. *Picasso*. Paris: Grasset, 1961.
Picasso: Œuvres reçues en paiement des droits de succession. Paris: Grand Palais, 1979.
Picasso, Pablo. *Écrits*. Paris: Réunion des Musées Nationaux–Gallimard, 1989.
Rubin, William, ed. *Pablo Picasso: A Retrospective*. New York: Museum of Modern Art, 1980.

Alice Rahon

Alice Rahon. Mexico City: Palacio de Bellas Artes, 1986.
Rahon, Alice. *Salamandre, Salamandre*. Mexico City: El Tucan de Virginia, 1996.

Judit Reigl

Judit Reigl. Paris: L'Étoile Scellée, 1954.

Pierre Roy

Pierre Roy. Paris: Galerie André-François Petit, 1967.
Pierre Roy: Nantes, 1880–Milan 1950. Paris: Somogy; Nantes: Musée des Beaux-Arts de Nantes, 1994.

Kay Sage

Kay Sage, 1889–1963. Ithaca, N.Y.: Herbert F. Johnson Museum of Art, Cornell University, 1977.
Kay Sage–Yves Tanguy. Hartford, Conn.: Wadsworth Atheneum, 1954.
Miller, S. R. "The Surrealist Imagery of Kay Sage." *Art International 26*, no. 4 (September 1983).
A Tribute to Kay Sage. New York: Galerie Catherine Viviano, 1960.
Vieuille, Chantal. *Kay Sage ou le surréalisme américain*. Paris: Les Éditions Complicités, 1995.

Henri and No Seigle

Seigle. Paris: Galerie Creuze, 1951.

Kurt Seligmann

Derrière le miroir, no. 19 (April 1949).
Seligmann. Brussels: Galerie La Boétie, 1973.
Seligmann. Geneva: Galerie Benador, 1974.
Seligmann. Zurich: Stunskaja Gallery, 1974.
Seligmann. Bonn: Pudelko Gallery, 1975.
Seligmann, Kurt. *Le Miroir de la magie* (1948). Paris: Fasquelle, 1956. Reprint, Paris: Éditions du Sagittaire, 1961.

Jean-Claude Silbermann

Cargo (Paris), no. 1 (1983).
L'Humidité (Paris), no. 12 (1973).
Marcade, Bernard, Philippe Audoin, José Pierre, Anne Tronche, and Jean-Claude Silbermann. *L'Objet du délit*. Paris: Éditions Sixtus and Galerie Samy Kinge, 1991.
Silbermann, Jean-Claude. *Au puits de l'ermite*. Paris: Pauvert, 1959.
———. *Le Ravisseur*. Paris: Le Terrain Vague, 1966.
———. *La Fée ficelle*. Paris: Douai, 1981.
———. *Bateau autour du cou*. Paris: Bordas, 1985.
———. *Pièces détachés*. Limoges: Sixtus, 1989.
———. *Le Troisième coup*. Brussels: La Pierre d'Alun, 1993.
———. *Le Saumon, la cerise et le gardien du trait*. Mulhouse: Arthothèque, 1994.

Joseph Sima

Char, René. *Se rencontrer paysage avec Joseph Sima*. Paris: Jean Hugues, 1973.
Linhartova, Vera. *Joseph Sima, ses amis, ses contemporains*. Brussels: Éditions de la Connaissance, 1974.
Sima. Prague: Aventiska Mansarda, 1928.
Sima. Paris: Galerie Povolozky, 1929.
Sima. Paris: Galerie Povolozky, 1930.
Sima. Prague: Topicuv Salon, 1947.
Sima. Paris: Galerie Kléber, 1954.
Sima. Paris: Galerie Paul Fachetti, 1955, 1960.
Sima. Rheims: Musée des Beaux-Arts, 1963.
Sima. Paris: Musée National d'Art Moderne, 1968.
Sima. Geneva: Galerie Engelberts, 1969.
Sima. Paris: Le Point Cardinal, 1966, 1968, 1972, 1975, 1981.
Sima: Le Grand Jeu. Paris: Musée d'Art Moderne de la Ville de Paris, 1992.
Sima, Joseph. *Kaléidoscope*. Paris: Revue K, 1992.
Smejkal, Frantisek. *Sima*. Paris: Cercle d'Art, 1992.

Armand Simon

Armand Simon. Cologne: Maison Belge, 1973.
Armand Simon. Brussels: Galerie La Marée, 1975.

Jindrich Styrsky

Kriz, Vilem. *Jindrich Styrsky, fotographie*. Brno, 1966.
Styrsky. Paris: Galerie Nina Dausser, 1948.
Claverie, Jana, ed. *Styrsky, Toyen, Heisler*. Paris: Le Centre, 1982.

Max Walter Svanberg

Pentacle. Paris: Musée des Arts Décoratifs, 1968.
Pierre, José. *Max Walter Svanberg.* Paris: Pauvert, 1968.
———. *Max Walter Svanberg et le règne féminin.* Paris: G. Fall, 1975.
Svanberg. Paris: À l'Étoile Scellée, 1951.
Svanberg. Paris: Galerie Raymond Cordier, 1961.

Rufino Tamayo

Paz, Octavio. *Tamayo en la pintura mexicana.* Dirección General de
 Publicaciones, no. 6. Mexico City: Universidad Nacional
 Autónoma de México, 1959.
———. *Tamayo: Peintures, 1960–1974.* Musée d'Art Moderne de la
 Ville de Paris, 1974.
Paz, Octavio, and Jacques Lassaigne. *Rufino Tamayo.* Paris: Cercle
 d'Art, 1984.

Yves Tanguy

Angliviel de La Beaumelle, Agnès, and Florence Chauveau. *Yves
 Tanguy: Retrospective, 1925–1955.* Paris: Le Musée, 1982.
Breton, André. *Yves Tanguy.* New York: Pierre Matisse, 1946.
Calas, Nicolas. *Exhibition of Gouaches and Drawings by Yves Tanguy.*
 New York: Pierre Matisse Gallery, 1963.
Marchesseau, Daniel. *Yves Tanguy.* Paris: Filipacchi, 1973.
Onslow-Ford, Gordon. *Yves Tanguy and Automatism.* Inverness:
 Bishop Pine Press, 1982.
Riou, Liliane. *Ma vie blanche et noire: Notes sur Yves Tanguy.* Quim-
 perlé: Éditions La Digitale, 1996.
Sage–Tanguy. Hartford, Conn.: Wadsworth Atheneum, 1954.
Sage, Kay. *Yves Tanguy: Un recueil de ses œuvres.* New York: Pierre
 Matisse, 1963.
"Tanguy-Tchelitchew." Special issue of *View,* vol. 2, no. 2 (May
 1942).
Waldberg, Patrick. *Yves Tanguy.* Brussels: De Rache, 1977.
Yves Tanguy. New York: Pierre Matisse Gallery, 1939.
Yves Tanguy. New York: Museum of Modern Art, 1955.
Yves Tanguy. New York: Acquavella Galleries, 1974.
Yves Tanguy: Painting, Gouaches and Drawings. New York: Pierre
 Matisse Gallery, 1950.

Dorothea Tanning

Bosquet, Alain, *Dorothea Tanning.* Paris: Pauvert, 1966.
Dorothea Tanning. Paris: Le Point Cardinal, 1961.
Dorothea Tanning. Knokke-le-Zoute: Casino Communal, 1967.
Dorothea Tanning. Paris: Galerie Alexandre Iolas, 1969.
Dorothea Tanning. Paris: Centre National d'Art Contemporain, 1974.
Dorothea Tanning: Peintures récentes, petites sculptures d'or. Paris: Le
 Point Cardinal, 1966.
Tanning, Dorothea. *Ouvre-toi.* Milan: Galleria Alexandre Iolas, 1971.
———. *Birthday.* Santa Monica, Calif.: Lapis Press, 1986.

Karel Teige

Karel Teige: Collagen, 1935–1951. Essen: Museum Folkwang, 1966.
Teige, Karel. *Surrealismus proti proudu.* Prague: Surrealistická Skupina,
 1938.

Hervé Télémaque

Enguerrand-Gourgue, Jacques. "Ad Hominem." *Pleine marge,* no. 7
 (1988).
———. "Télémaque paradoxal." *Conjonction,* special issue (June
 1993).
Franqui, Carlos. *Télémaque.* Barcelona: Polígrafa, 1977.
Hervé Télémaque. Paris: Galerie Adrien Maeght, 1981.
Hervé Télémaque: Dérive graphique. Mauberge: Musée de Mauberge,
 1993.
Hervé Télémaque, le passage mental. Paris: Musée d'Art Moderne de la
 Ville de Paris, 1976.
Images à cinq branches. Paris: Galerie Mathias Fels, 1967.
Lamarche-Vadel, Bernard. "Un point de suspension: Télémaque." In
 Gérald Gassiot-Talabot et al., *Figurations 1960/1973.* 10/18, no.
 811, série S. Paris: Union Générale d'Éditions, 1973.
Télémaque. Preface by Christopher Finch. Paris: Galerie Mathias
 Fels, 1967.
Télémaque. Barcelona: Galerie Maeght, 1983.
Télémaque. Paris: Galerie Louis Carré, 1994.

Jean Terrossian

Jean Terrossian. Paris: Galerie Le Triskèle, 1979.

Ivan Tovar

Ivan Tovar. Paris, Galerie Albert Loeb, 1974.

Toyen

Benayoun, Robert. "Entre chiens et loups: Énigmes et sortilèges de
 Toyen." *Edda,* no. 3 (1961).
Breton, André, Jindrich Heisler, and Benjamin Péret. *Toyen.* Paris:
 Éditions Sokolova, 1953.
Claverie, Jana, ed. *Styrsky, Toyen, Heisler.* Paris: Le Centre, 1982.
Ivsic, Radovan. *Toyen.* Paris: Filipacchi, 1974.
Legrand, Gérard. "Espaces transmurés, envergure de Toyen." *Phases,*
 no. 5 (1975).
Toyen. Paris: Galerie Denise René, 1947.
Toyen. Paris: L'Étoile Scellée, 1955.
Toyen. Paris: Galerie Cordier, 1960, 1962.
Toyen. Stockholm: Moderna Museet, 1985.
Toyen: Les 7 épées hors du fourreau. Paris: Galerie Furstemberg, 1958.
Von Holten, Ragnar. *Toyen: En surrealistik visionär.* Köping, Sweden:
 Lindfors Förlag, 1984.

Clovis Trouille

Campagne, Jean Marc. *Clovis Trouille.* Paris: Pauvert, 1965.
Charmet, Raymond. *Clovis Trouille.* Paris: Filipacchi, 1972.

Raoul Ubac

Bryen, Camille, and Raoul Michelet. *Actuation poétique suivie d'exem-
 ples.* Paris: R. Debresse, 1935.
Raoul Ubac: Photographies des années trente. Paris: Galerie Adrien
 Maeght, 1983.
Raoul Ubac: Photographies, peintures, sculptures, dessins et gravures. Brus-
 sels: Bibliotheca Wittockiana, 1987.

Raoul Ubac: Rétrospective, 1936–1983: Ardoises, dessins, peintures, photographies. Paris: Galerie Thessa Herold, 1997.

Ubac, Raoul. "Note sur le Mouvement de l'œil." *La Conquête du monde par l'image* (Paris) (1942).

———. "La Beauté aveugle" (1946). *IIIe convoi: Collection complète.* Edited by Philippe Blanc. Tours: Farrago, 1999.

Remedios Varo

Jaguer, Edouard. *Remedios Varo.* Paris: Filipacchi, 1980.

Kaplan, Janet. *Unexpected Journeys: The Art and Life of Remedios Varo.* New York: Abbeville Press, 1988.

La obra Remedios Varo. Mexico City: National Museum of Modern Art, 1964.

Paz, Octavio, and Roger Caillois. *Remedios Varo.* Mexico City: Ediciones Era, 1966.

Remedios Varo. Mexico City: Museum of Modern Art, 1983.

Isabelle Waldberg

Isabelle Waldberg: Sculptures—New York 1943–Paris 1983. Paris: Arcturial, 1984.

Waldberg, Michel, et al. *Isabelle Waldberg: Mémoire(s), sculptures.* Paris: Éditions de la Différence; Chartes: Musée des Beaux-Arts, 1999.

Unica Zurn

Frénésies, no. 1 (spring, 1986).

Le Nouveau commerce, supplement to no. 49 (spring 1981).

Riese-Hubert, Renée. "Portrait d'Unica Zürn en anagramme." *Pleine marge,* no. 7 (June 1988).

Transitions, no. 8 (December 1981).

Unica Zürn: Dessins, gouaches. Paris: Le Point Cardinal, 1963.

Zürn, Unica. *Hexen Texte.* Berlin: Springer Gallery, 1954.

———. *Sombre printemps.* Paris: Belfond, 1970.

———. *L'Homme-jasmin.* Paris: Gallimard, 1971.

Index of Names

Index of Magazines

Illustration Credits

The illustrations without credits are the property of the French publisher, Hazan, or of collectors who wish to remain anonymous.

Michel Sima/Archive photos, Paris: 264, fig. 1; 562, figs. 1, 4.
Denise Bellon, Paris: 225, fig. 6; 340, fig. 1; 341, fig. 3; 342; 467, figs. 2, 3; 469, fig. 5; 470, figs. 1, 3; 586.
Stefano Bianchetti, Paris: 106; 112; 146; 379; 476; 477 (top); 480; 495; 543 (top); 613.
Bibliothèque Littéraire Jacques Doucet, photography by Stefano Bianchetti, Paris: x, 10, figs. 1–4, 7; 16, fig. 2; 25, figs. 1, 3; 29, fig. 3, 33, fig. 8; 39, fig. 1; 58; 69, fig. 3; 75; 76; 91, fig. 1; 120, figs. 1, 2; 128; 135, fig. 2; 155, fig. 1; 191, figs. 1, 3; 194, fig. 2; 197, fig. 4; 219, figs. 1, 3; 237, fig. 1; 301, figs. 7, 10; 340, fig. 2; 347; 353, figs. 1, 3; 413, figs. 1, 3; 426, figs. 3, 5; 458, fig. 3; 467, fig. 1; 526, figs. 2, 3; 570 (bottom left); 580, figs. 2, 3; 600, figs. 1, 2.
Bibliothèque National de France, Paris: 15; 251 (bottom); 372–73; 397.
Henri Cartier-Bresson/Magnum, Paris: 633, fig. 4; 634, figs 1, 2.
Archives Marie-Claude Char, Paris: 194, fig. 1; 256, fig. 2.
Courtauld Institute of Art, London: 430, fig. 3.
Archives Fabio De Sanctis, Rome: 605.
Descharnes & Descharnes, Paris: 215, fig. 3.
Édimédia, Paris: 2, fig. 2.
Archives de la Fondation Érik Satie, Paris: 56, figs. 1, 2, 4–6.
Archives Bernard Galateau, Paris: 291, fig. 12.
Galerie 1900-2000, Paris: 36, fig. 1.
Galerie Christine et Isy Branchot, Brussels: 150, fig. 1; 158; 274, fig. 1; 562, fig. 1.
Galerie Thessa Hérold, Paris: 113.
Archives Elda Henry, Milan: 224, fig. 1.
Archives Muguette Hérold, Paris: 246; 385, figs. 1, 2; 390, figs. 4, 5; 447, figs. 2, 3; 499 (top).
Archives Radovan Ivsic, Paris: 287, figs. 1, 5, 6; 289, fig. 1; 290, figs. 3, 6; 291, figs. 7, 8, 11; 293, fig. 4; 411, figs. 4, 5; 482, figs. 1, 6.
Radovan Ivsic, Paris: 626, figs. 1, 3; 628, fig. 3.
Archives Édouard Jaguer, Paris: 64, figs. 2, 5; 237, fig. 2; 293, fig. 1; 344; 395, fig. 3; 402, fig. 1; 411, fig. 1; 433, fig. 1; 482, fig. 4; 490, fig. 2; 508, fig. 2; 536, figs. 1, 3, 4; 555, figs. 1, 2; 576, figs. 1, 6; 580, fig. 1; 582; 585; 589, fig. 4; 600, fig. 3; 634, fig. 2.
Archives Mrs. Frederick Kiesler, New York: 404.
William Klein, Paris: 588, fig. 2.
Kunsthaus, Zurich: 32, fig. 2.
Marcel Lannoy, Paris: 16, fig. 3; 280 (top); 616; 626, fig. 1; 627, fig. 2; 628, figs. 2, 4, 5; 637.
Étude Loudmer, Paris: 2, fig. 3; 552, fig. 4; 617 (left).
Mayor Gallery, London: 228, fig. 3; 266, figs. 1, 2; 300, figs. 1, 2, 4–6; 301, fig. 6; 302, fig. 1; 303, fig. 9; 315 (top); 429, figs. 3, 5; 499 (top).
Archives Lee Miller, Chiddingly, East Sussex: 328, fig. 2; 511.
Mission du Patrimoine Photographique, Paris: 174, fig. 2; 175, fig. 9; 536, fig. 2; 558, fig. 6; 563, fig. 7.
Moderna Museet, Stockholm: 287, fig.4.

Archives Andrew Murray, London: 300, fig. 3; 301, fig. 9.
Musée d'Art et d'Histoire, Saint-Denis: 26, fig.1.
Museo Nacional Centro de Arte Reina Sofia, Madrid: 225, fig. 7.
Museum of Modern Art, New York: 188; 205; 226, fig. 1.
Documentation du Musée National d'Art Moderne, Paris: 5, fig. 4; 19, fig. 3; 32, fig. 3; 117, fig. 1; 272, fig. 1; 274, fig. 2; 332, fig. 4; 392, figs. 1–4; 508, fig. 1.
Photothèque du Musée National d'Art Moderne, Paris: 5, fig. 3; 29, fig. 2; 125, figs. 1–3; 223, fig. 1; 241; 248 (bottom); 289, fig. 5; 303, fig. 10; 307, fig. 2; 416 (bottom); 473; 494 (top); 510, fig. 1; 562, figs. 2, 3.
Archives Penrose, Scottish National Gallery of Modern Art, Edinburg: 303, figs. 5–7; 332, figs. 1, 2; 430, fig. 1.
Archives Manou Pouderoux, Paris: 490, fig. 1; 519, fig. 2.
Documentation Photographique de la Réunion des Musées Nationaux, Paris: 209; 307, fig. 2.
Roger-Viollet, Paris: 17, figs. 4, 5; 40; 175, fig. 11; 295, fig. 1; 442, fig. 1, 2, 4; 458, fig. 4; 519, fig. 1; 558, fig. 2.
Archives Arturo Schwarz, Milan: 212; 228, fig. 5; 264, figs. 2, 4; 290, fig. 4; 320 (top); 419 (bottom).
Telimage, Paris: 33, fig. 5; 85, fig. 1; 120, fig. 4; 224, fig. 2.
Archives Lucien Treillard, Paris: 29, fig.4; 64, figs. 3, 4, 6; 72; 85, fig. 2; 149, fig. 4; 163, fig. 4; 295, fig. 2; 332, fig. 5; 426, fig. 4; 429, fig. 4.
Sabine Weiss/Rapho, Paris: 458, fig. 2; 633, fig. 3.
Zabriskie Gallery, Paris and New York: 228, fig. 1; 260, fig. 1; 287, fig. 3.

© ADAGP, Paris, 1997, for the works of Alechinsky, Arp, Bellmer, Brassaï, Brauner, Bury, Cardenas, Carrington, Dalí, De Chirico, Degottex, Demarne, Dominguez, Dubuffet, Duchamp, Duvillier, Ernst, Fougeron, Freddie, Giacometti, Glaeser, Hayter, Henry, Hérold, Hugnet, Hugo, Klapheck, Koyia, Magritte, Mariën, Masson, Matta, Miró, Picabia, Pollock, Tanguy, Tanning, Télémaque, Ubac, Varo.
© Man Ray Trust/ADAGP, Paris, 1997.
© 1997, Demart Pro Arte B.V. Genève, ADAGP, Paris, 1997, for the works of Dalí.
© Succession Picasso, 1997.